THE ROUTLEDGE HISTORY OF ITALIAN AMERICANS

The Routledge History of Italian Americans weaves a narrative of the trials and triumphs of one of the nation's largest ethnic groups. This history, comprising original essays by leading scholars and critics, addresses themes that include the Columbian legacy, immigration, the labor movement, discrimination, anarchism, Fascism, World War II patriotism, assimilation, gender identity and popular culture. This landmark volume offers a clear and accessible overview of work in the growing academic field of Italian American Studies. Rich illustrations bring the story to life, drawing out the aspects of Italian American history and culture that make this ethnic group essential to the American experience.

William J. Connell is Professor of History and holds the Joseph M. and Geraldine C. La Motta Chair in Italian Studies at Seton Hall University.

Stanislao G. Pugliese is Professor of History and the Queensboro UNICO Distinguished Professor of Italian and Italian American Studies at Hofstra University.

THE ROUTLEDGE HISTORIES

For a full list of titles in this series, please visit www.routledge.com

The Routledge Histories is a series of landmark books surveying some of the most important topics and themes in history today. Edited and written by an international team of world-renowned experts, they are the works against which all future books on their subjects will be judged.

THE ROUTLEDGE HISTORY OF ITALIAN AMERICANS

Edited by William J. Connell and Stanislao G. Pugliese

LONDON AND NEW YORK

First published 2018 by Routledge

2 Park Square, Milton Park, Abingdon, Oxfordshire OX14 4RN
52 Vanderbilt Avenue, New York, NY 10017

Routledge is an imprint of the Taylor & Francis Group, an informa business

First issued in paperback 2019

Library of Congress Cataloging-in-Publication Data
A catalog record for this book has been requested

ISBN: 978-0-415-83583-1 (hbk)
ISBN: 978-0-367-23093-7 (pbk)

Typeset in Bembo
by Apex CoVantage, LLC

A whole nation walked out of the middle ages, slept in the ocean, and awakened in New York in the twentieth century.

—Robert Viscusi, *Astoria*

They shall sit under their own vines and their own fig trees and no one shall make them afraid.

—*Book of Micah*, 4.4

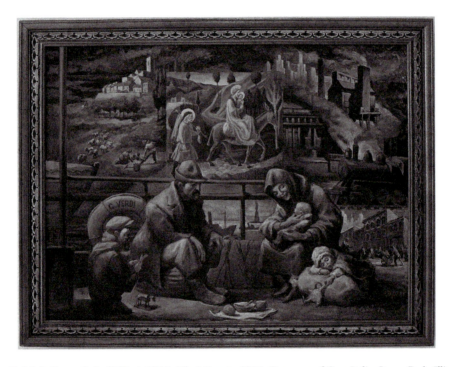

John Cadel (b. Fanna, Italy, 1905, d. 1977), *The Migrants, 1976.* Courtesy of Casa Italia, Stone Park, Illinois.

DEDICATED TO

ANTHONY DI BATTISTA, FORTUNATO PROCOPIO,

&

ANGELO PUGLIESE AND LENA CURRÀ PUGLIESE

CONTENTS

CONTENTS

FIGURES

Photo Essay

COLOR PLATES

TABLES

ACADEMIC ADVISORY BOARD

CONTRIBUTORS

Richard Alba is Distinguished Professor of Sociology at the Graduate Center, City University of New York. His teaching and research interests include race, ethnicity and immigration and increasingly have taken a comparative focus on North America and Western Europe. He has conducted research in France and Germany with support of the National Science Foundation; Fulbright grants; and fellowships from the Guggenheim Foundation, the German Marshall Fund and the Russell Sage Foundation. His books include *Ethnic Identity: The Transformation of White America* (1990), *Italian Americans: Into the Twilight of Ethnicity* (1985) and the award-winning *Remaking the American Mainstream: Assimilation and Contemporary Immigration* (2003), co-written with Victor Nee. His latest book, co-authored with Nancy Foner, is *Strangers No More: Immigration and the Challenges of Integration in North America and Western Europe* (2015).

Lawrence Baldassaro is Professor Emeritus of Italian and former director of the Honors College at the University of Wisconsin-Milwaukee. In addition to articles on Italian film, politics and culture, he has published numerous essays on Dante in American and Italian journals and has served on the Executive Council of the Dante Society of America. In 1990–91 he directed "An Oral History of the Italians in Milwaukee," a yearlong project funded by the Wisconsin Humanities Committee. His writings on sports have appeared in numerous publications, including *NINE, Twentieth Century American Sportswriters*, and *Sports in America from Colonial Times to the Twenty-First Century: An Encyclopedia*. He is the editor of *Ted Williams: Reflections on a Splendid Life* (2003) and co-editor of *The American Game: Baseball and Ethnicity* (2002). His latest book is *Beyond DiMaggio: Italian Americans in Baseball* (2014).

Marcella Bencivenni is Associate Professor of History at Hostos Community College, City University of New York. Her research focuses on the histories of immigration, labor and social movements in the modern United States, with a particular interest in the Italian American experience. She is the author of *Italian Immigrant Radical Culture: The Idealism of the Sovversivi in the United States, 1890–1940* (2011) and co-editor of *Radical Perspectives on Immigration*, a special issue of the journal *Socialism and Democracy* (2008). She has also published over a dozen book chapters, articles and historiographical essays and is currently working on a biography of Carl Marzani. She is the editor of the *Italian American Review*.

Mary Jo Bona is Professor of Italian American Studies and Women's and Gender Studies at Stony Brook University and is past president of the Italian American Studies Association. A specialist in the field of multiethnic American literary and feminist studies, her authored books include *Women Writing Cloth: Migratory Fictions in the American Imaginary* (2015), *By the Breath of Their Mouths: Narratives of Resistance in Italian America* (2012), *Claiming a*

Tradition: Italian American Women Writers (1999), and a book of poetry, *I Stop Waiting For You* (2014). Bona is also editor of *The Voices We Carry: Recent Italian American Women's Fiction* (2006), co-editor (with Irma Maini) of *Multiethnic Literature and Canon Debates* (2006) and series editor of *Multiethnic Literature* for SUNY Press. Bona is a past recipient of the Elena Lucrezia Cornaro award, which recognizes outstanding Italian American women in higher education who have made significant contributions to their profession and community.

Dominic Candeloro studied with Rudolph Vecoli who sparked his interest in Italian American Studies. Candeloro went on to lead the NEH Italians in Chicago project at the University of Illinois Chicago 1978–1981. He contributed an essay to *Ethnic Chicago*, served as president and executive director of the American Italian Historical Association (now IASA), received a Fulbright Fellowship to Italy, published dozens of reviews and articles and published eight books in the Arcadia Series, mostly relating to Chicago Italians. An activist, Candeloro has organized hundreds of events to promote Italian American culture at Casa Italia Chicago where he serves as curator of the Florence Roselli Library. He is a co-editor of *Reconstructing Italians in Chicago* (2011) and *Italian Women in Chicago* (2013), both published by Casa Italia. For fifteen years he edited H-ItAm, a listserv for Italian American Studies, and coproduced an exhibit "The Dream . . . per non dimenticare" at the Italian National Archives (Rome 2005). He is co-chair of the fundraising committee that established the Endowed Italian American Studies Professorship at Loyola University Chicago.

Nancy C. Carnevale is Associate Professor of History at Montclair State University where she teaches the history of immigration, race and ethnicity in the nineteenth- and twentieth-century U.S., Italian American, and women's history. She is the author of *A New Language, A New World: Italian Immigrants in the United States, 1890–1945* (2009), winner of a 2010 American Book Award, and her articles and essays appear in a number of journals and edited collections. She has twice been a National Endowment for the Humanities Fellow. Her work has also been supported by the Social Science Research Council and the Rockefeller Foundation. Currently, she is working on a comparative study of African American and Italian American relations in twentieth-century urban and suburban New Jersey. She is co-editor of the *Critical Studies in Italian America* series from Fordham University Press.

Peter Carravetta is the Alfonse M. D'Amato Chair in Italian and Italian American Studies at Stony Brook University, New York. He is the founder of *Differentia: Review of Italian Thought* (1986–1999), and translator of Gianni Vattimo and Pier Aldo Rovatti's *Weak Thought* (2012). Carravetta has written in poetics, critical theory, migration, history of ideas, and various authors in Italian, French and American culture. Editor of several anthologies, he is author of eight books of criticism, including *Prefaces to the Diaphora: Rhetorics, Allegory and the Interpretation of Postmodernity* (1991); *Del Postmoderno: Critica e cultura in America all'alba del duemila* (2009); and *The Elusive Hermes: Method, Discourse, Interpreting* (2012). He has collected a number of his studies in *After Identity: Migration, Critique, Italian American Culture* (2017). He is also the author of eight books of poetry. In 2008 he launched the Forum in Italian American Criticism, which brings to Stony Brook leading intellectuals and artists, and he has organized seven major conferences and published the proceedings of three of them.

Mark I. Choate is a history professor at Brigham Young University, specializing in migration and colonialism. Professor Choate has been supported in his research by the Fulbright,

Mellon and Pew Foundations, and has published articles in *International Migration Review*, *French Colonial History*, *Modern Italy*, *California Italian Studies*, and *Italian Culture*; his book *Emigrant Nation: The Making of Italy Abroad* (2008) won the Council for European Studies Book Award and the Marraro Prize from the American Catholic Historical Association. He is a Fellow of the Royal Historical Society, London, and the Società Italiana per lo Studio della Storia Contemporanea. Choate is a lieutenant colonel in the United States Army Reserve, having served in the Army for twenty-six years, including service with U.S. and NATO forces in Afghanistan, Korea, Kuwait, Kyrgyzstan, Germany, Slovakia and Italy.

Simone Cinotto is Associate Professor of Modern History at the Università degli Studi di Scienze Gastronomiche in Pollenzo, Italy. He has been Visiting Professor at the Department of Italian Studies at New York University (2008–2010) and at the School of Oriental and African Studies at the University of London (2015 and 2016). He has also been Visiting Scholar at the Center for European and Mediterranean Studies at NYU (2013–2015) and Fellow of the Italian Academy for Advanced Studies in America at Columbia University (2004). Cinotto is the author of *The Italian American Table: Food, Family, and Community in New York City* (2013) and *Soft Soil Black Grapes: The Birth of Italian Winemaking in California* (2012), and the editor of *Making Italian America: Consumer Culture and the Production of Ethnic Identities* (2014), which won the 2015 John G. Cawelti Award for the best textbook/primer of the Popular Culture Association/American Culture Association. His most recent book, co-edited with Hasia Diner, is *Global Jewish Foodways: A History* (2017).

William J. Connell is Professor of History and holds of the Joseph M. and Geraldine C. La Motta Chair in Italian Studies at Seton Hall University, where he was founding director of the Charles and Joan Alberto Italian Studies Institute. His books include *La città dei crucci: fazioni e clientele in uno stato repubblicano del '400* (2000); *Florentine Tuscany: Structures and Practices of Power* (co-edited with A. Zorzi, 2000); *Society and Individual in Renaissance Florence* (ed., 2002); a major translation of Machiavelli's *Prince* (2005; 2nd ed., 2016); *Sacrilege and Redemption in Renaissance Florence* (co-authored with G. Constable, 2005; 2nd ed., 2008); *Anti-Italianism: Essays on a Prejudice* (co-edited with Fred Gardaphé, 2011); and a collection of his essays in Italian: *Machiavelli nel Rinascimento italiano* (2015). He writes and lectures widely on Italian and Italian American themes, and he has been a Fulbright Scholar, a Harvard/I Tatti Fellow, and a member of the Institute for Advanced Study, Princeton.

George de Stefano is a journalist, author and critic. His work has appeared in *The Nation*, *Film Comment*, *Newsday*, *Gay City News*, *PopMatters*, *I-Italy*, *La Voce di New York*, *Rootsworld*, *The Advocate*, *Cineaste*, *In These Times*, *Voices in Italian Americana (VIA)* and *The Italian American Review*. His book, *An Offer We Can't Refuse: The Mafia in the Mind of America* (2007), explores some of his long-standing preoccupations as a writer: cultural mythologies and their social impact; ethnic identity and stereotypes; popular culture, especially film, and how such social categories as race, class, sexuality and gender interact in American society. He has contributed essays to other books, including *Our Naked Lives* (2013), *The Essential Sopranos Reader* (2011) and *Mafia Movies: A Reader* (2011). Mr. de Stefano is currently working on a new project tentatively titled *Gumbo Italiano: How the Sicilians Made New Orleans*.

Don H. Doyle, McCausland Professor of History at the University of South Carolina, is the author of several books and essays, including *Nations Divided: America, Italy, and*

the Southern Question (2002) and *The Cause of All Nations: An International History of the American Civil War* (2015). He is currently working on "*Viva Lincoln!*," a study of the international response to Lincoln's death and a book of essays, *American Civil Wars: The United States, Latin America, and Europe in the 1860s* (2017). He has served as a Fulbright Professor of American History at the University of Rome, the University of Genoa and the Catholic University in Rio de Janeiro.

Francesco Durante teaches the Culture and Literature of Italian Americans at the Università degli Studi Suor Orsola Benincasa in Naples. As one of Italy's foremost journalists and literary critics, he has written for various Italian newspapers and journals. He is the author and editor of numerous books, including the groundbreaking *Italoamericana. Storia e letteratura degli italiani negli Stati Uniti, 1776–1943*, in two volumes (the second translated and published by Fordham University Press in 2014); *Figli di due mondi. Fante, Di Donato & C: narratori italoamericani degli anni Trenta e Quaranta*; *Scuorno (vergogna)*; *I napoletani*; and, together with the late Rudolph J. Vecoli, *Oh Capitano! La vita favolosa di Celso Cesare Moreno in quattro continenti*. He has edited two volumes of Mondadori's prestigious Meridiani series on John Fante and Domenico Rea. In addition to various editions of Mannerist and Baroque poets and American writers, he has translated seven volumes of John Fante, two by Bret Easton Ellis and other writers such as William Somerset Maugham, George Arnold, and William Dean Howells. Durante is the artistic director of the annual Salerno Literary Festival.

Teresa Fiore is Associate Professor and Theresa and Lawrence R. Inserra Chair in Italian and Italian American Studies at Montclair State University. The recipient of several fellowships (De Bosis, Rockefeller, and Fulbright), she was Visiting Assistant Professor at Harvard University, New York University, and Rutgers University. She is the editor of the 2006 issue of *Quaderni del '900*, devoted to John Fante, and the author of numerous articles on Italian American culture, migration to/from Italy, and twentieth- and twenty-first-century Italian literature and cinema. Her essays have appeared in Italian, English, and Spanish, both in journals (*Annali d'Italianistica, Diaspora, Bollettino d'italianistica, Zibaldone, El hilo de la fábula*) and in edited collections such as *Teaching Italian American Literature, Film, and Popular Culture* (2010); *The Cultures of Italian Migration* (2011); and *Postcolonial Italy* (2012). Her most recent book is *Pre-Occupied Spaces: Remapping Italy's Transnational Migrations and Colonial Legacies* (2017). She served as vice president of the American Italian Historical Association from 2009 to 2011.

Fred Gardaphé is Distinguished Professor of English and Italian American Studies at Queens College, City University of New York and the John D. Calandra Italian American Institute. He is past director of the Italian American and American Studies Programs at Stony Brook University. His books include *Italian Signs, American Streets: The Evolution of Italian American Narrative* (1996); *Dagoes Read: Tradition and the Italian/American Writer* (1997); *Moustache Pete Is Dead!* (2010), *Leaving Little Italy* (2003), *From Wiseguys to Wise Men: Masculinities and the Italian American Gangster* (2006) and *The Art of Reading Italian Americana* (2011). He is a co-founding co-editor of *VIA: Voices in Italian Americana* and editor of the Italian American Culture Series of SUNY Press.

Maria Susanna Garroni has taught North American History at the Università degli Studi di Napoli "L'Orientale" for over ten years. She is now affiliated with the Università degli Studi di Roma Tre where she holds seminars and lectures for students in political science and in contemporary literature. She holds an MA in history from the State University of New York at Buffalo and a PhD in American studies from the Sapienza Università di

Roma. Her subjects of interest and research are Italian American history, gender history and the history of pacifist women. She has published a number of articles, which appeared in various journals and books, both in English and in Italian. She is the author of *La Formazione degli Stati Uniti* (1993) and edited a book on the female religious who immigrated to the United States from Italy, *Sorelle d'oltreoceano. Religiose italiane ed emigrazione negli Stati Uniti: una storia da scoprire* (2008). She now studies and writes about American pacifist women and their international connections. She is a member of the Italian Society of Women Historians (SIS) and of the Italian Society of North American Studies (AISNA). MariaSusanna (one name—shortened often to "Susanna") lives and works in Rome, where since 1975 she has been a professional city guide lecturer.

John Gennari is Associate Professor of English and Critical Race and Ethnic Studies at the University of Vermont. He is an American Studies-trained U.S. cultural historian with specializations in jazz and popular music, race and ethnicity, Italian American culture, food, sports and cultural criticism. He is the author of *Blowin' Hot and Cool: Jazz and Its Critics* (2006), winner of the ASCAP-Deems Taylor Award for Excellence in Music Criticism and the John Cawelti Award for the Best Book in American Culture. Gennari has held fellowships from the National Endowment for the Humanities, the W.E.B. Du Bois Institute at Harvard University and the Carter G. Woodson Institute at the University of Virginia. His latest book is *Flavor and Soul: Italian America at Its African American Edge* (2017).

Richard N. Juliani, Emeritus Professor of Sociology, introduced courses on the Italian experience in America and on "Italy as a Modern Society" during thirty-four years at Villanova University. In 2012–13, he offered "Exploring Ethnicity: The Italian American Experience" as a Visiting Scholar in Italian Studies at the University of Pennsylvania. He is the author of *The Social Organization of Immigration: The Italians in Philadelphia* (1980). With over sixty articles, chapters and reviews, he edited *The Family and Community Life of Italian Americans* (1984); *Italian Americans: The Search for a Usable Past*, with Philip V. Cannistraro (1989); and *New Explorations in Italian American Studies*, with Sandra P. Juliani (1994). His also wrote the award-winning *Building Little Italy: Philadelphia's Italians before Mass Migration* (1998), and *Priest, Parish and People: Saving the Faith in Philadelphia's Little Italy* (2007). He was a consultant for the National Conversation on American Pluralism of the National Endowment for the Humanities and a member of the advisory council of the New-York Historical Society for its exhibit on the Italians of New York. After serving on the executive council and as vice president, Juliani became president of the American Italian Historical Association for 1988–1992.

Jerome Krase, Emeritus and Murray Koppelman Professor, Brooklyn College, City University of New York, was American Italian Historical Association President (1975–84) and Brooklyn College Center for Italian American Studies Director (1993–97). His individually and co-published books include *Self and Community in the City* (1982); *The Melting Pot and Beyond* (1988); *Ethnicity and Machine Politics* (1992); *Italian Americans in a Multicultural Society* (1994); *Industry, Labor, Technologies and the Italian American Communities* (1997); *The Review of Italian American Studies* (2000); *Race and Ethnicity in New York City* (2005); *Italian American Politics* (2005); *Ethnic Landscapes in an Urban World* (2006); *The Staten Island Italian American Experience* (2007); *Italian Americans before the Mass Migration* (2007) and *Seeing Cities Change* (2012). An "Italians of Staten Island" Visiting Scholar, Wagner College (2006), he received the University of Rome La Sapienza Rector's Award (1998) and the *Italian Americana*'s Monsignor Gino Baroni Award (2005). An activist-scholar, he co-founded New York City's American Italian Coalition of Organizations in 1977.

Salvatore J. LaGumina is Professor Emeritus and Director at the Center for Italian American Studies at Nassau Community College, State University of New York, and a founding member of the American Italian Historical Association (now the Italian American Studies Association). He is the author or editor of twenty-one books, including *Wop. A Documentary History of Anti-Italian Discrimination* (1999); *The Italian American Experience: An Encyclopedia* (2003); *From Steerage to Suburb: Long Island Italian Americans* (1989); *The Humble and the Heroic: World War II Italian Americans* (2006); *The Great Earthquake* (2008); *Hollywood's Italians: From Periphery to Prominenti* (2012) and *Long Island Italian Americans: History, Heritage, and Tradition* (2013). His latest book is *The Office of Strategic Services and Italian Americans: The Untold Story* (2016).

Dennis Looney is Director of Programs and Director of the Association of Departments of Foreign Languages at the Modern Language Association. He was a professor of Italian at the University of Pittsburgh from 1986 to 2015. His research interests include the reception of the classical tradition in the European, especially Italian, Renaissance and the reception of Dante over the centuries. His publications include *Compromising the Classics: Romance Epic Narrative in the Italian Renaissance* (1996), which received honorable mention, MLA Marraro-Scaglione Award in Italian Literary Studies, 1996–97; *'My Muse will have a story to paint': Selected Prose of Ludovico Ariosto* (2010) and *Freedom Readers: The African American Reception of Dante Alighieri and the* Divine Comedy (2011), which received the American Association of Italian Studies Book Award in 2011. His most recent book is *Carmina: Ariosto's Lyric Poems*, co-authored with Mark Possanza (2017).

Stefano Luconi teaches U.S. History at the universities of Firenze, Napoli "L'Orientale," and Padova. He specializes in Italian immigration to the United States, with special attention to Italian Americans' political behavior and transformation of ethnic identity. His publications include *From* Paesani *to White Ethnics: The Italian Experience in Philadelphia* (2001); *The Italian-American Vote in Providence, Rhode Island, 1916–1948* (2004) and *La faglia dell'antisemitismo: italiani ed ebrei negli Stati Uniti, 1920–1941* (2007). He also edited, with Dennis Barone, *Small Towns, Big Cities: The Urban Experience of Italian Americans* (2010) and, with Mario Varricchio, *Lontane da casa: donne italiane e diaspora globale dall'inizio del Novecento a oggi* (2015).

Giuliana Muscio was Professor of History of Cinema at the Università degli Studi di Padova, Italy, where she served as director of the international MA in Atlantic and Globalization Studies and of the Master's in Audiovisuals and Media Education. Muscio has been a Visiting Professor at UCLA and the University of Minnesota. She is the author of *Hollywood's New Deal* (1997) and of the forthcoming *Napoli/New York/Hollywood*. With Anthony Julian Tamburri, Joseph Sciorra and Giovanni Spagnoletti, she was co-editor of *Mediated Ethnicity: New Italian-American Cinema* (2010). She is the author of works both in Italian and English on film history, film relations between the United States and Italy, American film, screenwriting and women screenwriters in American silent cinema. Muscio was a member of the European program *Changing Media, Changing Europe* and of the Women Film History international program.

Antonio Nicaso is a bestselling author and an internationally recognized expert on organized crime. He is a regular consultant to governments and law-enforcement agencies around the world and a lecturer at several universities. He teaches graduate courses on the History of Organized Crime at the School of Language of Middlebury College at Mills (California) and undergraduate courses at Queen's University in Kingston, Canada. He sits on the Advisory Board of the Nathanson Centre on Transnational Human Rights,

Crime and Security at York University (Toronto) and on the International Advisory Council of the Italian Institute of Strategic Studies "Niccolò Machiavelli" in Rome. He has written twenty-nine books. The latest, *Business or Blood* (2015), will be the subject of a television series.

Amy Pastan is an independent photo researcher, editor, writer, and book producer. She has been responsible for the publication of hundreds of titles. Before starting her own business in 1998, she held staff positions at the National Gallery of Art and the Smithsonian Institution Press, where she developed an award-winning list of books in photography and fine arts. In addition to creating and producing works in all genres for print publishers, she writes features for the Web and provides visual content for film and digital media.

James J. Periconi, an independent scholar, is the foremost noninstitutional collector of Italian-language American imprints. His *Strangers in a Strange Land: A Catalogue of an Exhibition on the History of Italian-Language American Imprints (1830–1945)* (2012) was reprinted by Bordighera Press in 2013. He has lectured at the University of Central Florida (Neil R. Euliano Lecture), at the Roxburghe Club in San Francisco, as well as directly in connection with exhibitions of his collection at the Grolier Club of New York (2012), Brooklyn College (2013) and Seton Hall University (2014). He was Bibliographic Editor of *Italoamericana: The Literature of the Great Migration, 1880–1943* (2014), edited by Francesco Durante. He received his BA in English literature from Columbia College, and was a Danforth Graduate Fellow at the University of Virginia (MA, 1972), after which he graduated from New York University School of Law. He practices environmental law in Manhattan.

Stanislao G. Pugliese is Professor of Modern European History and the Queensboro UNICO Distinguished Professor of Italian and Italian American Studies at Hofstra University where he has directed numerous scholarly conferences on topics as diverse as Primo Levi, international soccer and Frank Sinatra. A specialist on modern Italy, the Italian anti-Fascist Resistance and Italian Jews, Dr. Pugliese is the author, editor or translator of fifteen books on Italian and Italian American history, including *Carlo Rosselli: Socialist Heretic and Antifascist Exile* (1999). *Bitter Spring: A Life of Ignazio Silone* (2009) won the Fraenkel Prize in London, the Premio Flaiano in Italy, the Howard Marraro Prize from the American Historical Association and was nominated for a National Book Critics Circle Award. Together with Pellegrino D'Acierno, he is the editor of *Delirious Naples: A Cultural History of the City of the Sun* (2017). He is currently working on a new book *Dancing on a Volcano in Naples: Scenes from the Siren City*.

John Paul Russo is Professor and Chair of the Classics Department, University of Miami. He is the author of *The Italian in Modernity* (2001, co-written with Robert Casillo), *I.A. Richards* (1989), and *The Future without a Past: The Humanities in a Technological Society* (2005; Bonner Prize 2006). The winner of three Fulbright Fellowships (Palermo, Rome, Salerno), he was elected for two terms to the editorial board of *RSA* (*Rivista di Studi Nord Americani*) and is currently book review editor of *Italian Americana*.

JoAnne Ruvoli teaches in the Department of English at Ball State University. Previously, she was a Mellon postdoctoral fellow in the Department of Italian at the University of California, Los Angeles. Ruvoli's PhD in English is from the University of Illinois at Chicago where she specialized in multiethnic American literature and also earned an interdepartmental concentration in Gender and Women's Studies. She has published articles on literature, cinema, comics and Italian American culture and history. She is a co-editor

of the special issue of *Voices in Italian Americana* that focuses on "Reconsidering Mario Puzo" (2008).

Ilaria Serra is Associate Professor of Italian and Comparative Studies at Florida Atlantic University. Her teaching and research interests include Italian cinema and literature, Italian song and the history of Italian immigration to the United States. In addition to several articles and book chapters, she has published *The Value of Worthless Lives: Writing Italian American Immigrant Autobiographies* (2007) and *The Imagined Immigrant: Images of Italian Emigration to the United States between 1890 and 1924* (2009). She is the co-editor, with Alan Gravano, of *Southern Exposures: Locations and Relocations of Italian Culture. Selected Proceedings of the 42nd Annual AIHA Conference* (2013), and the co-editor, with Andrea Bini and Daria Mizza, of the AATI Working Papers.

Rosemary Serra is a university researcher in General Sociology and professor at the Università degli Studi di Trieste in Italy. In 2012 and 2013, she was a visiting research scholar at the John D. Calandra Italian American Institute (Queens College—CUNY). She is the editor of *Fiori di Campus: Writings in Sociology and Social Work*, (2013) and numerous essays, including "Linguistic Interweavings: Italian Languages and Dialects among Young Italian Americans in the Greater New York area," in *Forum Italicum*, Spring 2017; "The American Reaction to the Great War: The Academic and Cultural Contribution of George Herbert Mead," in Cipolla and Ardissone (eds.) *Major Sociologists on The Great War* (2015); "Dark Desire: Addictive Sexuality between the Pathological and the Normal" and "The Poisoned Apple. Eating Addictions and Disorders," in B. Cattarinussi (ed.), *I Can't Help Myself: Social Aspects of Addictions* (2013) and "Italy: An Overview of Criminology," in C. J. Smith, S. X. Zhang, R. Barberet (eds.), *Routledge Handbook of International Criminology* (2011).

Anthony Julian Tamburri is Distinguished Professor of European Languages and Literatures and Dean of the John D. Calandra Italian American Institute, Queens College, City University of New York. He is past president of the Italian American Studies Association and of the American Association of Teachers of Italian. His fourteen authored books include *Una semiotica della ri-lettura: Guido Gozzano, Aldo Palazzeschi, Italo Calvino* (2003); *Narrare altrove: diverse segnalature letterarie* (2007); *Una semiotica dell'etnicità: nuove segnalature per la letteratura italiano/americana* (2010); *Re-viewing Italian Americana: Generalities and Specificities on Cinema* (2011); and *Re-reading Italian Americana: Specificities and Generalities on Literature and Criticism* (2014). He is co-editor for translations, with Robert Viscusi and James Periconi, of the English edition of Francesco Durante's *Italoamericana: The Literature of the Great Migration, 1880–1943* (2014); with Paul Giordano and Fred Gardaphè, *From The Margin: Writings in Italian Americana* (2000); and other collections. He is executive producer and host of the TV program, *Italics*, and one of the co-founders of the Italian American Digital Project.

Maddalena Tirabassi, a former Fulbright Scholar, is the Director of the Altreitalie Center on Italian Migration in Turin and editor of the journal *Altreitalie*. She is vice president of AEMI (European Migration Institutions) and past consultant for the exhibition "Fare gli italiani," which celebrated Italian unification in 2011. Among her main publications are *La meglio Italia. Le mobilità italiane nel xxi secolo* (with Alvise del Pra', 2014); *I motori della memoria. Le donne piemontesi in Argentina* (2010); *Itinera. Paradigmi delle migrazioni italiane* (2005); *Il Faro di Beacon Street. Social Workers e immigrate negli Stati Uniti* (1990); *Ripensare la patria grande. Amy Bernardy e le migrazioni italiane* (2005); "Bourgeois Men, Peasant Women:

Rethinking Domestic Work and Morality in Italy" in *Women, Gender, and Transnational Lives* (2002).

Michael Topp is an associate professor at the University of Texas, El Paso. He specializes in racial and ethnic history, working-class history and the history of social movements in the United States. He is the author of *Those Without a Country: The Political Culture of Italian American Syndicalists* (2001) and *The Sacco and Vanzetti Case: A Brief History with Documents* (2004), as well as numerous essays on the Italian American Left, masculinity and nationalism, immigrant historiography and its relevance to the border and racial and ethnic identity in the United States. He received an NEH summer stipend that he used to work on his first monograph. His next project is a history of cultural identity and mental illness in the United States.

Edoardo Tortarolo is Professor of Early Modern History at the Università del Piemonte Orientale. He has been a Fulbright Distinguished Lecturer in Italian History; a visiting professor at the University of Leipzig, Freiburg im Breisgau, and Northwestern University; and a member of the Institute for Advanced Study, Princeton. He is a fellow of the Academy of the Sciences of Turin and of the National Committee for the Historical Studies, Rome. His books include *The Invention of Free Press: Writers and Censorship in Eighteenth Century Europe* (2016), *Diesseits und jenseits der Alpen. Deutsche und italienische Kultur im 18. Jahrhundert* (2011), *L'illuminismo. Dubbi e ragioni della modernità* (1999), and *Illuminismo e rivoluzioni. Biografia politica di Filippo Mazzei* (1986). He is currently working on a book on the process of secularization in Europe in the late eighteenth century.

Donald Tricarico has a PhD in sociology from The New School for Social Research and is a professor at Queensborough Community College, City University of New York. His publications include *The Italians of Greenwich Village: The Social Structure and Transformation of an Ethnic Community* (1984); articles in academic journals, encyclopedia entries; and chapters in edited volumes including *The Ethnic Enigma* (1989), *Notable Selections in Race and Ethnicity* (2001), *The Men's Fashion Reader* (2007), *Anti-Italianism: Essays on Prejudice* (2010), *Making Italian America: Consumer Culture and the Production of Ethnic Identities* (2014), and *New Italian Migrations to the United States* (2017). His research interests have focused on Italian Americans in New York City, specifically ongoing adaptations in ethnic group life such as within urban neighborhoods, youth culture, and suburban outposts.

Peter G. Vellon is Associate Professor of History at Queens College, City University of New York. His research interests focus on late nineteenth- and early-twentieth-century immigration to the United States and questions of race, whiteness, and identity. He is the author of *A Great Conspiracy Against Our Race: Italian Immigrant Newspapers and the Construction of Whiteness in the Early 20th Century* (2014). Some of his recent publications include "'For Heart, Patriotism, and National Dignity': The Italian Language Press in New York City and Constructions of Africa, Race, and Civilization" in the *Ethnic Studies Review* (2011) and "Between White Men and Negroes: The Perception of Southern Italian Immigrants Through the Lens of Italian Lynching" in *Anti-Italianism: Essays on a Prejudice* (2010). He also co-edited *Advocacy and Activism: Italian Heritage and Cultural Change*, IASA's 2010–2012 conference proceedings. His new research project examines Italian Americans and African Americans in Harlem in the 1930s.

Robert Viscusi, Professor of English and Executive Officer of the Wolfe Institute for the Humanities at Brooklyn College, City University of New York, is also founding president of the Italian American Writers Association. His books include *Max Beerbohm, or the*

Dandy Dante (1986); *An Oration upon the Most Recent Death of Christopher Columbus* (1993); *A New Geography of Time* (2004); *Buried Caesars and Other Secrets of Italian American Writing* (2006), which won the John Fante and Pietro di Donato Literary Award; *Astoria: A Novel* (1995), winner of the American Book Award; and *ellis island* (2012). Viscusi has edited the volume *Victorian Learning* for Browning Institute Studies (1989) and the American edition of Francesco Durante's anthology *Italoamericana: The Literature of the Great Migration, 1880–1943* (2014). His essays on Italian and Italian American culture have appeared in many journals and collections. He has been a fellow of the National Endowment for the Humanities and the John D. Calandra Italian American Institute.

ACKNOWLEDGMENTS

A book like this involves the collaboration of many people over a number of years. Above all, the editors would like to thank our contributors, who have been generous with their ideas, time and patience. It has been a pleasure to work with them. The members of our Advisory Board who are formally listed and thanked at the front of this book have offered important assistance and insights at various times throughout the project.

Encouragement and generous funding from the UNICO National Foundation and the Club Tiro a Segno Foundation—two organizations that have stood out for their support of Italian and Italian American Studies in our colleges and universities—have been crucial. Seton Hall University, home to the Joseph M. and Geraldine C. La Motta Chair in Italian Studies, the Alberto Italian Studies Institute, and the Valente Italian Library, and Hofstra University, home to the Queensboro UNICO Distinguished Professorship in Italian and Italian American Studies, have supported our research and provided assistance with the many practical tasks involved in assembling a book such as this one. A grant from Hofstra supported the color printing of the cover painting of *The Migrants* by John Cadel. The Italian American Caucus of the New York State Legislature invited William Connell to speak in Albany. The CUNY Graduate Center and Club Tiro a Segno offered valuable meeting space.

The enthusiastic staff at Routledge has been a constant resource. We owe particular thanks to Kimberly Guinta, Genevieve Aoki, Margo Irvin, Daniel Finaldi, Eve Mayer, Theodore Meyer, Tina Cottone and Laura Pilsworth, each of whom has been a reliable hands-on partner at different times during the many stages of writing and production. The anonymous readers consulted by Routledge offered valuable and guiding suggestions.

Our independent photo editor, Amy Pastan, worked very hard to gather possible images for us from libraries and archives around the United States. Her persistence, good cheer, and common sense have helped to make this a book that is as much a pleasure to page through as to read.

The Library of Congress and the New York Public Library deserve special thanks for access to their digital collections. Again and again Dominic Candeloro came through for us with suggestions from the visual resources of the Chicago area's Casa Italia in Stone Park, Illinois. Karen Arakelian, Teodolinda Barolini, Fr. August Feccia, Luisa Del Giudice, Lee Lorenz, Giulia Pugliese and Shawn Smith each went out of their way to help us acquire images included here. Gregory Pell of Hofstra translated one of the essays when the editors were too busy to do it themselves.

Frank Cannata first broached to us the idea of doing something like this, and he has been tireless in bringing this project to fruition. When we were halfway through Marc Corea embraced it so that we could make it to the finish line. Joe La Motta passed away while we were correcting the proofs: he and his wife Deena were enthusiastic from the start. Among the many others who have helped along the way: Manny Alfano, Anthony Bengivenga, Al

Branchi, John Buschman, Elisa Coccia, Mickey D'Addato, Chris DiMattio, André DiMino, John DiNapoli, Anthony Fornelli, Edvige Giunta, Alan Gravano, Joseph Guasconi, James Hankins, James Kimble, Dominick Nicastro, Linda Osborne, the late Nazario Paragano, Steven Pelonero, Glenn Pettinato, Alessandro Pugliese, Barbara Ritchie, Laura Ruberto, Joan Saverino, Joseph Scelsa, Joseph Sciorra, Nikki Shepardson, Michael Spano, Robert Tarte, Ralph Torraco, Salvatore Valente, Michael Veselka, Ann Walko, Ronald West.

It used to be common among Italian academics to crack jokes about the sincere American sociologists who were coming to study family life in Italy. Reversing the terms of Columbus's voyage, these Italian professors would refer ironically to "*la scoperta americana della famiglia italiana*" [the American discovery of the Italian family], suggesting it was incredible that something so obvious and powerful as "the Italian family" needed to be "discovered." The two editors, for our part, are mindful of our families, real and affective, and to them this book stands as a deeply felt tribute.

ABBREVIATIONS
AND A NOTE ON SURNAMES

Abbreviations

AIHA = American Italian Historical Association

DBI = *Dizionario biografico degli italiani* (Rome: Istituto della Enciclopedia italiana, 1960–)

Durante, *Italoamericana* [American ed.] = Francesco Durante, ed., with Robert Viscusi (American editor), Anthony Julian Tamburri (translations editor) and James J. Periconi (bibliographic editor), *Italoamericana: The Literature of the Great Migration, 1880–1943* (New York: Fordham University Press, 2014).

Durante, *Italoamericana* [Italian ed.] = Francesco Durante, ed., *Italoamericana. Storia e letteratura degli italiani negli Stati Uniti*, 2 vols. (Milan: Mondadori, 2001–2005).

Storia dell'emigrazione = *Storia dell'emigrazione italiana*, ed. Piero Bevilacqua, Andreina De Clementi and Emilio Franzina, 2 vols. [vol. 1, "*Partenze*"; vol. 2, "*Arrivi*"] (Rome: Donzelli, 2001–2002).

A Note on Surnames

The spelling of Italian surnames is apt to confuse the unwary. There are multiple variants of almost all of the common Italian surnames. The names, moreover, that begin with an additional preposition and/or article— "D'," "Da," "Dal," Dall'," "Dalla," "Dallo," "De," "Del," "Dell'," "Della," "Dello," "Di," "La," or "Lo"— sometimes comprise a space between an initial word and a word that follows (e.g. "De Pretis"), although in other instances the space is suppressed (e.g. "Depretis"). In a name that begins with a prepositional "D-," if there is a space between the two words, the letter "D" is sometimes written in lower case (e.g. "de Pretis").

Italian *American* naming practices are further complicated even by a history that comprises dislocation, widespread illiteracy, changing immigration and naturalization procedures, the practices of schools, newspapers, censuses, draft boards and telephone directories, and personal choices that sometimes have favored assimilation or (more recently) Italian "authenticity." Hence the spelling of the names of the individuals and their families that appear in a book like this has been more difficult to standardize than if these were the names of Italians residing in Italy. It is not uncommon to find slight differences in the way an Italian American surname over the course of several generations or even within the lifetime of a single person. The name of actor Robert De Niro, for instance, has also been written as "de Niro" and "DeNiro" at different times in his career. In such cases the Editors have made every effort to respect common and most recent usage.

INTRODUCTION

A New History for a New Millennium

William J. Connell

The Triumphant 1980s

It was in the 1980s that Italian Americans finally "made it" in American society. Such was the conclusion of the mainstream media. In 1983 *The New York Times* ran a Sunday magazine feature story under the headline "Italian-Americans Coming into Their Own."[1] The article cited numerous instances of people of Italian heritage who had recently assumed leadership roles in politics, culture and business—individuals like New York Governor Mario Cuomo, Los Angeles Dodgers Manager Tommy Lasorda, architect Robert Venturi, U.S. Representative Geraldine Ferraro, choreographer Michael Bennett, U.S. District Court Judge John Sirica, Cardinal Joseph Bernardin of Chicago and National Organization for Women President Eleanor Cutri Smeal—as evidence that Italian Americans were climbing unfettered to the highest plateaus of achievement. Confirmation of Italian American success was easy to find in those years. Governor Cuomo was considered a likely candidate for the presidency, especially after his famous Keynote Address at the Democratic National Convention in 1984. In 1986, Antonin Scalia became the first Italian American named to the Supreme Court. In Hollywood, actors and film directors who had had breakthroughs with Mafia films in the previous decade were demonstrating an astonishing range of talent. In 1983 *LIFE* magazine ran a story about the efforts of Chrysler CEO Lee (Lido) Iacocca to restore Ellis Island.[2] The magazine featured as its centerfold a picture of the elderly Esterina Mazzuca, who entered the country through Ellis Island, posing with eighty-one of her living descendants in the Great Hall of the former immigration center. (See Color Plate 18.) In 1990 the Immigration Museum on Ellis Island opened its doors. Understandably, many Italian Americans considered the 1980s a time of validation, while the American establishment congratulated itself on the latest version of the story that says hard work wins out.

Interestingly, the writer of the *Times* article of 1983 sought the views of a series of academics who offered their insights concerning why, after decades of slow and fitful acceptance, Italian Americans were experiencing a swift entrance into American prominence. Particularly important was the idea of loyalty—of loyalty to the family, loyalty to one's hometown or *paese* in Italy, and loyalty to one's neighborhood in America. Loyalty, they argued, was often a hindrance to assimilation. As the late Rudolph Vecoli of the University of Minnesota stated,

> If you are inculcated with the values of a group, then to reject, to challenge, to give them up means a conflict of loyalty—a kind of *dis*loyalty. You're being untrue to your family, your parents and your ancestral heritage. That is true of many ethnic groups. But to make that break is perhaps more of a trauma for Italian-Americans than for others.[3]

Yet this same virtue of loyalty to the family and to one's group, as opposed to a single-minded individualism, was thought by some ultimately to have resulted in a more rounded and fair-minded approach to American life. Benjamin Civiletti, a U.S. Attorney General in the Carter administration, put it this way: "Italian-Americans are not generally rigid in terms of their professions being all-consuming. . . . That gives them not only a diversity of views, and a healthiness of mental outlook, but also the ability to endure problems and cope."[4]

The prevailing atmosphere of success in the 1980s found expression in a popular book, *La Storia: Five Centuries of the Italian American Experience*, which was first published in 1992, although the research and writing had begun much earlier.[5] The authors of *La Storia*, Jerre Mangione and Ben Morreale, were both fine writers who were also professors. Mangione taught literature at the University of Pennsylvania, while Morreale, although he taught history at SUNY Plattsburgh, is best known as a novelist who drew on his deep knowledge of Sicily and Sicilians. Many teachers and professors still assign *La Storia* to their students, since it remains the only book that covers the full range of Italian American history from Columbus to the twentieth century. But there are also numerous errors—including even spelling mistakes with Italian words—and recent scholarly work has far outpaced the information it presents. The moment is ripe for a new history book that both corrects older errors and covers all that has happened and all that has been learned in the time intervening.

The readers of our new Italian American history will find here a series of innovative and up-to-date essays, organized chronologically by subject matter (although many look backward and forward in time), written by today's leading scholars. Each has been asked to bring together both new and old learning so as to give an accurate account of what can now be said about their topics. Unlike *La Storia*, the present volume does not offer a continuous story. The narrative format has a way of rounding edges, smoothing difficult transitions and explaining too easily developments that are significant precisely because they are so difficult of explanation. One positive consequence of publishing a history composed by multiple hands is that it includes material that might have been omitted in a work by a single author. The curious student, the curious teacher and the curious reader, regardless of their perspectives, will find much here that is new and truly interesting.

The New Italian Americans

Perhaps the most obvious way in which today's Italian American history differs from what was written in the 1980s is that there is more of it to be written and more people are writing it. Three additional decades need to be reckoned with. A burst in graduate school enrollment in the late 1980s and early 1990s meant that there was more research being done. Above all, in terms of sheer numbers, there are more Italian Americans today than there were in the 1980s. Even as it becomes rarer for Italian American heritage to be noticed in daily interactions, the number of Americans who claim Italian ancestry continues to grow. Marriages of Italian Americans to spouses stemming from other ancestry groups are so frequent that there are now a great many people who, although they identify themselves as "Italian American," have names with nothing Italian about them at all: Brown, Muller, Ferreira, O'Boyle. . . . Not without reason did sociologist Richard Alba suggest, already in 1985, that Italian Americans were entering what he termed a "twilight of ethnicity."[6] Note that he did not say ethnicity would be absent. Rather it was coming into a period in which fluctuating boundaries would make the phenomenon all the more interesting and important to understand. Although the descendants of immigrants who *circa* 1900 settled

in Little Italies are now likely to live in suburbs, the continuation, revival, and, in some cases, the creation *ex novo* by these descendants of attitudes and practices that are "Italian" or "Italian American" remain far more common than there is allowance for in the prevailing Steven Spielberg/Stephen King vision of American suburban life. In Italian American youth styles that enjoy temporary notoriety—"Guido," for instance, or "hip-wop"—there is a vibrancy that social scientist Donald Tricarico describes as geared toward the future not the past: ". . . more a narrative about 'routes' than 'roots,' a narrative about 'becoming.'"[7] And even when styles like these are antihistorical, they still exist in time, which means they have cultural and social histories of their own that demand attention within the framework of Italian American history. Meanwhile, American culture's bond with Italians and Italy continues to grow thanks to food, fashion, tourism and education. Among U.S. college and university students studying abroad in 2014–2015, 11 percent went to Italy, the country that was the second most popular destination after the United Kingdom, which attracted only a slightly higher percentage (12 percent).[8] Furthermore, a new generation consisting of immigrants from Italy, most of them in their twenties and thirties, has been coming to the United States since the 1990s. New Italian immigrants tend to be well educated; they already speak English; and they settle especially in urban centers like Boston, New York, Philadelphia, San Francisco and San Diego.[9] They, too, are Italian Americans. In short, since the 1980s there has been an abundance of fresh material for Italian American historians to work with.

A 1960s–1970s Blind Spot

A second way in which Italian American history has been changing is that it is now easier to study the difficult years that immediately preceded the 1980s. Scars were left over from the late 1960s and 1970s that were difficult to address in the 1980s, but now, with the passage of time and with sources becoming available, historians can pay critical attention to episodes that some people still find disturbing. The 1960s and 1970s were stressful for many Italian Americans in ways they can hardly have anticipated. A great opening of American society had begun for them during World War II.[10] In the 1950s, some of the trends that pointed toward the acceptance of Italian Americans as "normal" (and "white") Americans included the popularity of Italian American singers, the emergence of spaghetti and pizza as mainstays of the American diet and significant growth in the number of elected officials of Italian ancestry. But the decades of the 1960s and 1970s again and again seemed to challenge Italian American assumptions of "Americanness." As late converts to America's civic religion, many Italian Americans were among its most fervent adherents. Yet in the 1960s many of that religion's tenets were being overturned. In older urban areas there were severe racial and ethnic tensions. Some Italian American neighborhoods were razed in the name of "urban renewal"—or "urban removal," as some preferred to call it[11]—whereas others were damaged in riots. A renewed popular obsession with Italian American gangsters and the Mafia, fed by mass media that found eager audiences, was under way well before the publication of Mario Puzo's *Godfather* in 1969, or the release in 1972 of the first film in Francis Ford Coppola's *Godfather* trilogy. *LIFE* magazine, for instance, in 1967, published a two-part story that set off alarm bells throughout the country. The magazine described what its headline called a "Brazen Empire of Organized Crime" existing right under American noses, often in suburbia.[12] The resulting fear only added to the difficulties of Italian Americans who were moving out of urban neighborhoods. The more prestigious suburbs, they discovered, were off-limits to "Mediterranean types."[13]

Adopting a Blonde

A startling story from 1966 gives a sense of the frustration felt by many Italian Americans even as they were attempting to assimilate into middle-class white American society. On the front page of the *New York Times* of 5 November 1966 there appeared an article by reporter Edith Evans Asbury under the headline, "Brunet Couple Forbidden to Adopt Blond Girl, 4."[14] The article explained that Mr. and Mrs. Michael Liuni, an Italian American couple who lived in Tillson, New York, were denied permission to adopt their four-year-old foster child, Beth. The little girl had lived with them since she was five days old, but the Ulster County Welfare Commissioner ruled that the Liuni's "coloring and ethnic background" made them inappropriate parents for a blond-haired, blue-eyed little girl (Figure I.1). When the Liunis, who had raised Beth together with their three natural children, appealed the ruling, a Family Court judge supported the Welfare Commissioner, ordering the Liunis to give up the child. As Mr. Liuni, a World War II veteran and an IBM employee, told the *Times* reporter, "Being quiet and legal didn't seem to be getting us anywhere. We couldn't sleep nights for worrying. Beth was beginning to notice something was wrong." "I'm the only mother she ever knew," Mrs. Liuni said, "I had everything but the pains of birth with her." "As for the coloring business—one of our sons is blond and they both have light eyes," Mr. Liuni said. Mrs. Liuni asked, "And what's this ethnic background business? We're all Americans, aren't we?"

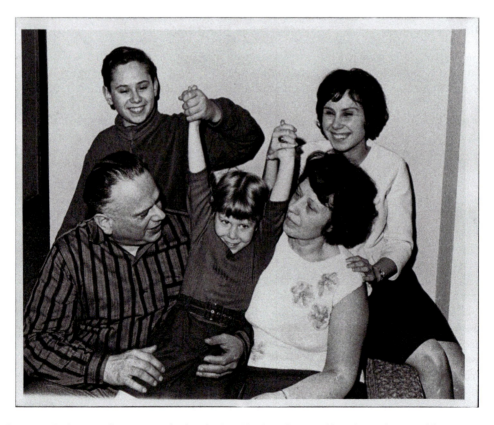

Figure I.1 Beth, age 4, between Michael and Mary Liuni, with two of her three adoptive siblings, Joseph, 13, and Alberta, 18, after the denial of Beth's adoption was overturned. 13 January 1967. Photo: Arthur Pomerantz/© *New York Post* holdings via Getty Images.

With the publication of the *Times* article the matter of Beth Liuni's adoption became a *cause célèbre*; eventually the rulings were reversed; and the Liunis were permitted to adopt her. Still, the case served as a well-publicized reminder that, at least in some eyes, Italian Americans were not fully "white."

The Anti-Defamation Debacle

Attempts by Italian Americans to organize to defend their rights and interests in the 1960s and 1970s had a way of backfiring, sometimes appallingly so. In 1967, Frank Sinatra, who had been active in the African American Civil Rights movement, accepted the role of national chairman of a new American Italian Anti-Defamation League with the major aim of combatting stereotyping of Italian Americans as being connected to the mob. Alas, Sinatra was swiftly criticized by the *New York Times* editorial page for having his own mob connections (which turn out to have been real);[15] and then the Anti-Defamation League of B'nai B'rith (which had honored Sinatra in the past), filed a lawsuit against the new organization over the use of the word "anti-defamation," which the Jewish organization claimed as its own. The comic nature of the situation did not pass unnoticed. The normally staid *Times* printed the semiserious headline: "Italians and Jews to Go to Court";[16] while a cartoon by Lee Lorenz for the satirical magazine *The Realist* (Figure I.2) showed two men entering their

Figure I.2 A cartoon by Lee Lorenz, originally published in *The Realist*, 75 (June 1967), 21, here redrawn by the artist (in 2008). Collection of William J. Connell. © Lee Lorenz, by permission.

respective "Anti-Defamation" offices calling each other: "Kike!" and "Wop!" As Mario Puzo put it in an essay for the *Times*, "New York is 25% Jewish and 20% Italian. . . . The rivalry is between two siblings . . ."[17] In the end the Italian group ceded to the Jewish group; Sinatra distanced himself; and the Italian "League" declined into a skeletal existence under the name "Americans of Italian Descent."

But there were still Italian Americans who wanted an organization to look after their particular interests, and in 1970 a new Italian American Civil Rights League was established. Unfortunately its founder, Joseph Colombo, was himself a mafioso, although he claimed his only business was a legitimate real estate company in Brooklyn. Colombo's argument that he was treated unfairly by authorities who were only stereotyping him as a mobster engendered sympathy in some quarters. Meanwhile disputes in New York City over housing and educational policy had left many Italian Americans feeling disenfranchised, so that the League's first "Unity Day" rally, held at Columbus Circle, attracted a crowd of between 10,000 and 15,000 people, including many politicians.[18] Yet the following year, at what was to have been the League's second annual rally, its organizer, Colombo was shot three times in an alleged mob hit that sent him into an irrecoverable coma.[19] And since the shooting appeared to shred the credibility of a movement opposed to the stereotyping of Italian Americans as gangsters, the League folded.

Even so, the story was not yet over. One of the mobsters thought to have arranged the Colombo shooting was Joey Gallo, who was then in prison on an earlier charge. Some months after Colombo was shot, Gallo was released on parole on condition he perform community service. Community service . . . combating anti-Italian discrimination. And so Gallo joined what was left of the organization that Sinatra formerly led, the Americans of Italian Descent. And in the days before Gallo was himself killed—in a still famous assassination at Umberto's Clam House in New York's Little Italy—he was supposedly working to combat prejudice against Italian Americans.[20] Defending the civil rights of Italian Americans became for some people a dangerous business in these years. For a great many others it was an embarrassment they preferred to forget.

Re-Visioning Italian American History

The publication of a new history of Italian Americans means we can seriously address the Italian American experience in the decades both before and after the 1980s, as well as during them. But this book involves more than filling chronological gaps. Since the 1980s scholarship has dramatically revised our understanding of nearly every period in Italian American history from the voyages of exploration down to the present. It has changed what we know.

More successfully than most historical fields, Italian American history has interacted in productive ways with other academic disciplines. The insights and research of scholars and writers in such diverse fields as anthropology, psychology, literature, sociology, semiotics, demographics, religious studies, gender studies, political science, food history, the history of sport, history of the book, musicology, film history and material culture have made major contributions to the field. The result was a broadened area of inquiry that gave birth in 1966 to the interdisciplinary American Italian Historical Association, which recently changed its name to the Italian American Studies Association. This broader scope has increased the field's influence on research and teaching within the larger realm of "American history," in which subjects as diverse and important as republicanism, racial difference, local religion, family structure, immigration policy, women's work, social mobility, assimilation and urbanism (along with many others) can no longer be discussed properly without referring to the Italian experience in America.

This said, there are three particular areas where changes in the way Italian American history is written have been the most dramatic. In each of these areas insights from other disciplines have been shaping our understanding of the Italian American experience, while at the same time Italian American history has been changing scholarly perceptions of American history and culture. The three areas are (1) the history of women and gender in Italian America, (2) the role played by Italian Americans in the history of race in America and (3) the study of the linguistic and literary interaction of Italian Americans with American culture.

Women and Gender in Italian America

The serious appreciation of the role of women and of issues involving gender in the Italian American experience dates from the late 1970s and 1980s. There was little place for women in the early esteem-building histories of Italian Americans—the sort of history that prided itself on discovering that the U.S. Army's quartermaster general from 1792 to 1794 was of Italian ancestry. Even as the field matured, with social historians plumbing immigration and census records and delving into the history of labor, it largely failed to capture the experience of Italian American women. Statistics revealed little about women and their lives, and the non-Italian visitors in the 1900s who described the Little Italies had few interactions with women who lived there. It was assumed they led uninteresting, if difficult, lives within their tenement apartments, remaining "women of the shadows."[21] But pioneering work by Virginia Yans-McLaughlin and Donna Gabaccia, in books published in 1977 and 1984 respectively, argued for new approaches to Italian American history that in effect gave them a history. For Yans-McLaughlin the value system of the Italian American family, which she explored in illuminating personal interviews, had a major impact on the lives and development of women, offering a standard against which to measure change over time.[22] Gabaccia's work argued that immigration from Sicily to Little Italy actually opened new horizons for female immigrants, who acquired greater liberty and new economic importance once established in Little Italy.[23] Pushing beyond statistics to look at women's memoirs and at novels by and about Italian American women as historical sources became a new priority, furthered by the publication in 1985 of Helen Barolini's influential anthology, *The Dream Book*.[24] It is no accident that much of the best work on the experience of Italian American women is now done in departments of English and Literature.[25] Jennifer Guglielmo's work on Italian women who were working-class radicals in the late nineteenth and early twentieth centuries has been a major contribution to American women's history.[26] The perspectives of material culture and food history have been shown to offer especially rich matter for understanding the past lives of Italian American women.[27] The push in the 1970s and 1980s to study women has led to a broader interest in gender relations and in the forms masculinity has taken in the Italian community. There is a remarkable persistence in the way mainstream American culture plays out its own fantasies about sex and gender roles in novels and films involving Italian Americans.[28] There is thus a tense and deeply interesting ongoing discussion concerning what Italian American reality and the American cultural imagination can be said to reveal about one another.

Were Italians Gray?

A second area in which scholarship on Italian Americans has made powerful contributions is in the study of race and racial relations. The involvement of Italians with this complex and tragic history goes all the way back to the discovery of the New World. Of the two "original sins" that pertain to the American republic—slavery and the dispossession

of Native Americans—Columbus initiated both in the New World. But Columbus hardly invented these things. And rather than shun this history, the world needs to learn from it: to learn how Giuseppe Garibaldi's opposition to slavery became a reason for turning down a Union generalship—because President Lincoln had not decided on emancipation; to learn how Italian immigrants were sometimes lynched in the racially charged American South; to learn that Neapolitan *malincunia* (melancholy) influenced American blues; to learn that Frank Sinatra stood up for the black entertainers in Las Vegas who were not permitted to stay in the very hotels where they performed; but also to learn how Mussolini's war on Ethiopia in 1935–36 stoked racial tensions in Harlem; and how Italian Americans in Bensonhurst taunted African American marchers after the murder there of Yusuf Hawkins in 1989 (see no. 10 in the Photo Essay). The relationship between Italian Americans and African Americans is a rich and powerful subject seeded with episodes of collaboration and mutual admiration, but also of distrust and violence.

Music has been especially important in creating cultural ecologies where race, which matters, matters in a positive sense. As critic Thomas Ferraro observes,

> It is a curious fact that the Italian Americans who have over the years been held most dear by black America, and the Italian Americans who have been most engaged in civil rights and other race-identified causes, have been entertainers—the actors and the athletes, but especially the musicians.[29]

From blues to jazz to doo wop to the E Street Band the symbiosis between African American and Italian American musicians and styles has been remarkable—and it bleeds into other art forms.[30] An early painting by Frank Stella, called *Hyena Stomp* (Color Plate 15), with its pleasing but insistent color variation, and its four large triangles designed *not* to meet at a central point but to sidestep the center, is a famous homage by the Italian American artist that captures beautifully the syncopation and laughter in Jelly Roll Morton's classic song of the same title.

Some of the more innovative historical writing in recent years has attempted to study Italian Americans by gauging how they stood with regard to past standards of "whiteness." Taking "white" and "black" as opposite poles, some historians argue that Italian Americans were really an "in-between" people who in the past occupied an interstitial space in American society.[31] As Nell Irvin Painter points out, as late as 1969 it could be said by a Yale professor, after an Italian American had announced his candidacy for New York mayor, "If Italians aren't actually an inferior race, they do the best imitation of one I've seen."[32] One of the arguments these historians make is that in "working toward whiteness" Italian Americans paid a price that involved losing some of their *italianità* or "Italian-ness." The point is a good one, but it is also the case that Italian Americans had and have an identity so strong that it can't be captured in black-and-white. The prejudices they encountered in the early 1900s were not the result of an in-between status, but of their being identifiably "Italian." When Castenge Ficarrotta was hanged by a lynch mob outside of Tampa in 1910 (see no. 9 in the Photo Essay), the pipe that was placed in his mouth marked him as Italian and not as something "in between."

Yet another allowance that has to be made with respect to the "whiteness" thesis involves the ways blackness and whiteness in American society continue to change over time. Differences in skin color have not meant that cultural identities are fixed at the opposite ends of a spectrum nearly to the degree that is sometimes supposed. As David Hollinger argues, "the widespread sense that color and culture have a natural intimacy" is in decline.[33] What

is perceived as black and what is perceived as white have been continually altered, and often Italian Americans have been the agents of change. As one friend of mine likes to ask, "How many white people still think of mayonnaise as a spice?"

Speaking and Writing "Italian American"

In a third area, Italian American scholarship has cleared vast forests and dug deep mines, namely the study of the language and literary production of Italian Americans. The work has ranged from the careful study of phonetics and dialects, to the preservation and transcription of early recordings, to the publication and translation of primary sources, to the collecting of information concerning the Italian American publishing industry, to the refined analysis of the fiction and poetry of Italian American authors.[34] Compared with thirty years ago, one of the major advantages enjoyed by today's scholars is that almost all of them have formal training in the Italian language. Not only can they work comfortably with written sources in Italian, but they interact comfortably on a professional level with the growing number of scholars in Italy who are taking as their special subjects the history and culture of the Italian diaspora. Several of these Italian scholars have contributed essays that are translated in this book.

So the Italian language has become fundamental in this line of work. But what about "Italian American"? What was involved linguistically and culturally when an Italian American author wrote a novel in English? Or in Italian? Much has been said and written about Italian American writing in recent decades, but there are two studies that function like paired searchlights for all students of Italian American literature. The first is Rose Basile Green's survey, *The Italian American Novel*, published in 1974. With persistence and understanding, she described the work of seventy-five Italian American authors, from the late nineteenth century down through the early 1970s. Most of her authors wrote in English, and for them she covered neglected texts, suggested critical openings, and leavened her treatments with helpful biographical information. The best Italian American writers, she concluded, are engaged in a "search for true identity involved in social problems."[35] The bibliography of Italian American writing continues to expand,[36] and important older texts have been found in recent years,[37] but Green's ambitious book did a superb job of identifying the milestones in the Italian American literary tradition. It thus opened the way for the next generation of critics to apply new methods to reading and interpreting texts as they explored Italian American ethnicity.[38]

More recently a scholar in Naples (one of our contributors), Francesco Durante, has published two massive anthologies of texts written by Italians in the Italian language concerning the period from 1776 to 1945. The second of these volumes, which begins in 1880 with the Great Migration, was published in 2014 in an American edition that translates an astonishing array of texts ranging from poems to plays to short stories to newspaper editorials. Durante writes of them,

> These works . . . represent a moment of passage or, to put it a better way, the necessary link between the experience of the fathers who came to America armed only with their cultural baggage from home, and that of their children who, merely a generation or two later, would recount their moving saga directly in English.[39]

If Green made it possible to discuss a canon of Italian American novels, Durante's collection gives a powerful sense of the culture in which they were rooted, a culture that was previously obscured by the fact that so many of its products were written in Italian (or dialect) for a select readership.

In spite of these achievements, an important question that hovers over Italian American literature, and especially over the major works written in English, is the extent to which ethnicity remains of critical concern when considering a canon established in the United States. To which tradition do novels written by Italian American authors belong and by what standards should they be judged? In 1986 Werner Sollors criticized an emphasis on the "descent" (i.e., ethnicity) of so many American authors at the expense of their larger role and cultural achievements relevant to all Americans.[40] Even with respect to a first-generation immigrant, to an author like Pascal D'Angelo, for instance, whose *Son of Italy* of 1924 recounts his youth in Abruzzo and his subsequent life as a "pick-and-shovel" man,[41] it might easily be objected that to classify him as "Italian American," and to read him together with such later Italian American authors as Pietro di Donato, John Fante and Don DeLillo, diminishes a book that belongs instead to the broader tradition of memoirs and novels about arriving in America: a genre of wide resonance that thrives in the present. With books by second-, third- and fourth-generation authors the problematics of descent and culture become even more acute.

In all honesty, historians don't worry in the same way about questions involving literary genre and taste. Historians are generally satisfied when they find revealing "sources," and they will take them where they can get them. Italian American critics, on the other hand, understand correctly the need to explain what makes a book "Italian American," and why it should be studied within an ethnic tradition. Their most winning solutions involve a return to the matter of language, to the idea that there is something special about the way Italian Americans express themselves—even in English, and even several generations removed from the American arrival of their forebears. Robert Viscusi, in his book *Buried Caesars*, suggests that Italian Americans have a particular way of communicating that tends to be circular rather than linear. From a starting point of noncomprehension—like the immigrant's, but known as well to later generations—it creates communicative circles that either expand or contract. Italian American writing, he argues,

> deals with problems of mutual understanding beginning with the narrowest of circles, the ones enclosed by nonsense effects or heteroglossolalia. Around that circle of isolation, it inscribes wider and wider circles. This process of continual reencirclement is a figure for how a community disseminates a communication, how it reaches out to its surrounding communities. . . . Such a circle may widen communication or else preclude it.[42]

That Americans of Italian ancestry, people who ordinarily speak and write American English, may yet possess ways of understanding one another that are proper to themselves is an intriguing proposition. Much as writers in African and African American studies often claim the shared consciousness of being black that poet Aimé Césaire called "*négritude*," this would involve a sense of connection to others and to a shared heritage. Piero Bassetti, an Italian intellectual, has argued in recent years that globalization provides the needed stimulus for recognition on the local level of the Italian-ness that he calls "Italicity."[43] Critic Pellegrino D'Acierno likes to speak of "dagotude,"—what has been called a "style of self-presentation redolent with extroverted charisma"—which is only an above-water facet of what he sees as a powerful Italian American identity, rooted in a common historical experience, that has remained too often submerged or poorly tended.[44]

Whether or not, and in what way, Italian Americans have a sense of themselves as "Italian" that, even in the present, affects how they speak and write in American English, is something Italian Americans are likely still to be discussing many years from now. Meanwhile, as

a counsel to the reader of this new history of Italian Americans, be assured it will add to the interest and enjoyment of the chapters that follow if, while immersing yourself in their many themes and topics, you look for the contours of an underlying *italianità*.

Notes

1 Stephen S. Hall, "Italian-Americans Coming into Their Own," *New York Times* (15 May 1983), Sunday Magazine, 28ff.
2 "Welcome Back to Ellis Island," *LIFE* (1 July 1983), 44–49.
3 Hall, "Italian-Americans," 37.
4 Ibid., 32.
5 Jerre Mangione and Ben Morreale, *La Storia: Five Centuries of the Italian American Experience* (New York: HarperCollins, 1992).
6 Richard Alba, *Italian Americans: Into the Twilight of Ethnicity* (Englewood Cliffs: Prentice Hall, 1985).
7 Donald Tricarico, "Narrating Guido: Contested Meanings of an Italian American Youth Subculture," in *Anti-Italianism: Essays on a Prejudice*, ed. William J. Connell and Fred Gardaphé (New York: Palgrave Macmillan, 2010), 163–199 (192). On hip-wop, see Joseph Sciorra, "The Mediascape of Hip-Wop: Alterity and Authenticity in Italian American Rap," in *Global Media, Culture, and Identity: Theory, Cases, and Approaches*, ed. Rohit Chopra and Radhika Gajjala (New York: Routledge, 2011), 33–51.
8 Institute of International Education, Open Doors Data, "U.S. Study Abroad: Leading Destinations." There were 31,166 study abroad students in Italy in 2013–14 and 33,768 in 2014–2015: an increase of 8.3 percent.
9 See especially Teresa Fiore's essay (Chapter 36).
10 As recounted in Dominic Candeloro's essay (Chapter 22).
11 For the phrase "urban removal," see Mary Ann Castronovo Fusco, "How a Church Brings Life to Newark's Little Italy," *New York Times* (10 October 1999), quoting Monsignor Joseph Granato, then pastor of St. Lucy's Parish, Newark.
12 The two-part story was published in *LIFE* (1 and 8 September 1967). In northern New Jersey the first of these *LIFE* numbers is still remembered because of its stunning photos of the Livingston estate of Richie (Ruggiero) Boiardo. See also Richard Linnett, *In the Godfather Garden: The Long Life and Times of Richie "the Boot" Boiardo* (New Brunswick: Rutgers University Press, 2013).
13 From a conversation (2007) with New Jersey real estate developer Nazario Paragano, Sr.
14 Edith Evans Asbury, "Brunet Couple Forbidden to Adopt a Blond Girl, 4," *New York Times* (5 November 1966), 1.
15 The harsh editorial was titled "Image in a Curved Mirror," *New York Times* (5 May 1967), 37. On Sinatra's mob ties, see Anthony Summer and Robbyn Swann, *Sinatra: The Life* (New York: Random House, 2005), which reviews the material in the FBI file. For the man in full, Pete Hamill's *Why Sinatra Matters* (Boston: Little, Brown, 1998), is indispensible; whereas James Kaplan's two-volume biography: *Frank: The Voice* (New York: Doubleday, 2010) and *Sinatra: The Chairman* (New York: Doubleday, 2015) delivers the music along with the man.
16 Paul Hofmann, "Italians and Jews to Go to Court," *New York Times* (4 June 1967), 74.
17 Mario Puzo, "The Italians, American Style," *New York Times* (6 August 1967), *Sunday Magazine*, 7ff. (14).
18 Paul L. Montgomery, "Thousands of Italians Here Rally Against Ethnic Slurs," *New York Times* (30 June 1970), 1.
19 William E. Farrell, "Colombo Shot, Gunman Slain, at Columbus Circle Rally Site," *New York Times* (29 June 1971), 1.
20 Robert D. McFadden, "Scores of Detectives Study Leads in Search for Clues in Gangland Slaying of Gallo," *New York Times* (9 April 1972), 22.
21 The phrase of Ann Cornelisen, *Women of the Shadows: Wives and Mothers of Southern Italy* [1976], 2nd ed. (Hanover: Steerforth Press, 2001), who herself shone light on these Italian shadows.
22 Virginia Yans-McLaughlin, *Family and Community: Italian Immigrants in Buffalo, 1880–1830* (Ithaca: Cornell University Press, 1977).
23 Donna R. Gabaccia, *From Sicily to Elizabeth Street: Housing and Social Change Among Italian Immigrants, 1880–1930* (Albany: SUNY Press, 1984).
24 Helen Barolini, *The Dream Book: An Anthology of Writings by Italian American Women* [1985], rev. ed. (Syracuse: Syracuse University Press, 2000).

25 Mary Jo Bona, *Claiming a Tradition: Italian American Women Writers* (Carbondale: Southern Illinois University Press, 1999); Edvige Giunta, *Writing with an Accent: Contemporary Italian American Women Authors* (New York: Palgrave, 2002). See also the essays by Bona (Chapter 23) and JoAnne Ruvoli (Chapter 24).

26 Jennifer Guglielmo, *Living the Revolution: Italian Women's Resistance and Radicalism in New York City, 1880–1945* (Chapel Hill: University of North Carolina Press, 2010).

27 Edvige Giunta and Joseph Sciorra, eds., *Embroidered Stories: Interpreting Women's Domestic Needlework from the Italian Diaspora* (Jackson: University of Mississippi Press, 2014); Simone Cinotto, *The Italian American Table: Food, Family and Community in New York City* (Urbana: University of Illinois Press, 2013), chapter 2.

28 Fred Gardaphé, *From Wiseguys to Wise Men: The Gangster and Italian American Masculinities* (New York: Taylor and Francis, 2006); Joseph A. Lo Giudice and Michael Carasone, eds., *Our Naked Lives: Essays from Gay Italian American Men* (New York: Bordighera Press, 2013). See also the essays by Ilaria Serra (Chapter 33), Fred Gardaphé (Chapter 34), and George De Stefano (Chapter 35).

29 Thomas J. Ferraro, *Feeling Italian: The Art of Ethnicity in America* (New York: New York University Press, 2005), 175.

30 See John Gennari's essay (Chapter 25); Joseph Sciorra, "Who Put the Wop in Doo-Wop? Some Thoughts on Italian Americans and Early Rock and Roll," *Voices in Italian Americana*, 13.1 (2002), 16–22; and Simone Cinotto, "Italian Doo-Wop: Sense of Place, Politics of Style, and Racial Crossovers in Postwar New York City," in *Making Italian America: Consumer Culture and the Production of Ethnic Identities*, ed. Cinotto (New York: Fordham University Press, 2014), 163–177.

31 David R. Roediger, *Working Toward Whiteness: How America's Immigrants Became White* (New York: Basic Books, 2005); Jennifer Guglielmo and Salvatore Salerno, eds., *Are Italians White? How Race Is Made in America* (New York: Routledge, 2003); Maria C. Lizzi, "'My Heart Is as Black as Yours': White Backlash, Racial Identity, and Italian American Stereotypes in New York City's 1969 Mayoral Campaign," *Journal of American Ethnic History*, 27.3 (2008), 43–80; and Peter Vellon's essay below (Chapter 12).

32 Nell Irvin Painter, *The History of White People* (New York: Norton, 2010), 381, quoting from Nathan Glazer and Daniel Patrick Moynihan, *Beyond the Melting Pot: The Negroes, Puerto Ricans, Jews, Italians and Irish of New York City*, rev. 2nd ed. (Cambridge, MA: MIT Press and Harvard University Press, 1970), who borrowed the anecdote from Michael Lerner, "Respectable Bigotry," *The American Scholar*, 38 (1969), 606–617 (616).

33 David A. Hollinger, *Postethnic America: Beyond Multiculturalism*, rev. 2nd ed. (New York: Basic Books, 2000), 178.

34 On language, see Herman W. Haller, *Una lingua perduta e ritrovata: l'italiano degli italo-americani* (Florence: La Nuova Italia, 1993); and Nancy C. Carnevale, *A New Language, a New World: Italian Immigrants in the United States, 1890–1945* (Urbana: University of Illinois Press, 2009).

35 Rose Basile Green, *The Italian-American Novel: A Document of the Interaction of Two Cultures* (Rutherford: Fairleigh Dickinson University Press, 1974), 373.

36 See the "Bibliography of the Italian American Book," edited by Fred Gardaphé and James J. Periconi for the Italian American Writers Association, originally published in hardcopy in 2000 and continually updated online at www.iawa.net/database.htm.

37 Carol Bonomo Albright and Elvira G. Di Fabio, eds., *Republican Ideals in the Select Literary Works of Italian-American Joseph Rocchietti, 1835–1845* (Lewiston: Mellen Press, 2004), for instance, published Joseph Rocchietti's *Lorenzo and Oonalaska*, a novel written in English and originally published in 1835. On Rocchietti, see also John Paul Russo's essay (Chapter 3).

38 Fred L. Gardaphé, *Italians Signs, American Streets: The Evolution of Italian American Narrative* (Durham: Duke University Press, 1996); Anthony Julian Tamburri, *A Semiotic of Ethnicity: In (Re)cognition of the Italian/American Writer* (Albany: SUNY Press, 1998); Bona, *Claiming a Tradition*.

39 Francesco Durante, ed., *Italoamericana. Storia e letteratura degli italiani negli Stati Uniti*, 2 vols. (Milan: Mondadori, 2001–2005), abbreviated for this volume as Durante, *Italoamericana* [Italian ed.], 1:ix. See also Durante, ed., with Robert Viscusi (American editor), Anthony Julian Tamburri (translations editor) and James J. Periconi (bibliographic editor), *Italoamericana: The Literature of the Great Migration, 1880–1943* (New York: Fordham University Press, 2014), abbreviated for this volume as Durante, *Italoamericana* [American ed.].

40 Werner Sollors, *Beyond Ethnicity: Consent and Descent in American Culture* (New York: Oxford University Press, 1986).

41 Pascal D'Angelo, *Son of Italy* [1924] (Toronto: Guernica, 2003).

42 Robert Viscusi, *Buried Caesars, and Other Secrets of Italian American Writing* (Albany: SUNY Press, 2006), 113–114.

43 Paolino Accolla and Niccolò d'Aquino, *Italici: An Encounter with Piero Bassetti*, trans. Robert Brodie Booth (New York: Bordighera Press, 2008); Piero Bassetti and Niccolò d'Aquino, *Italic Lessons: An On-Going Dialog*, trans. Gail McDowell (New York: Bordighera Press, 2010); and Piero Bassetti, *Let's Wake Up, Italics: Manifesto for a Glocal Future*, trans. Gail McDowell (New York: Bordighera Press, 2017).

44 D'Acierno discussed what he calls "dagotude," at a conference at Hofstra University in 2010. See, for now, John Gennari, "Sideline Shtick: The Italian American Basketball Coach and Consumable Images of Racial and Ethnic Masculinity," in *Making Italian America*, ed. Simone Cinotto, 207–224. D'Acierno's broader thinking and his argument for a more assertive ethnicity are finely displayed in his "The Making of the Italian American Cultural Identity: From *La Cultura Negata* to Strong Ethnicity," in *The Italian American Heritage: A Companion to Literature and the Arts*, ed. Pellegrino D'Acierno (New York: Garland, 1999), xxiii–liv.

Part I

EXPLORATIONS AND FOUNDATIONS

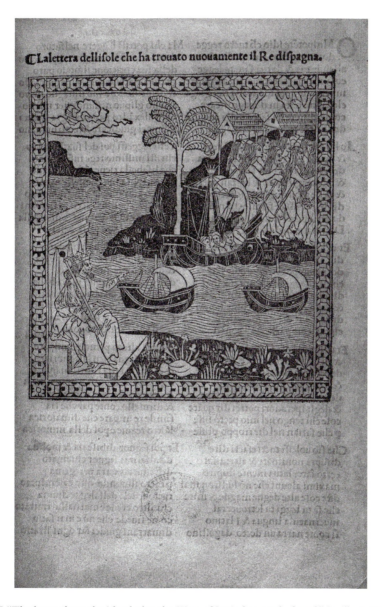

Frontispiece I "The letter about the islands that the King of Spain has newly found." An illustration depicting King Ferdinand the Catholic, Columbus with his three ships, two islands, and a group of island-ers. Published in Florence, 26 October 1493, in the Italian verse translation by Giuliano Dati of Columbus's first letter about his discovery. Photo: © The British Library Board.

1

ITALIANS IN THE EARLY ATLANTIC WORLD

William J. Connell

Landfall

In the early hours of 12 October 1492 three Spanish ships, the *Niña*, the *Pinta* and the *Santa Maria*, anchored off the coast of an island in the Bahamas. It was probably the island now known as San Salvador. As morning broke the men on board saw pink beaches, trees, and streams with fresh water. Naked islanders appeared, gawking at the strange large ships that were unlike anything they had seen. Christopher Columbus, accompanied by two captains, a notary, and a representative of the Crown of Castile, went ashore. With royal banners flourishing he announced formally that "in the presence of all, he would take, as in fact he did take, possession of said island for his lords, the King and Queen."[1] Sailing further among the islands Columbus recounted in his *diario* or logbook how the inhabitants, who belonged to the Taíno people, swam out to the ships. They were "people of very beautiful appearance," who painted their faces and even their whole bodies. They were "very gentle" and he thought they might easily become Christians. The natives "would be delivered and converted to our faith better by love than by force," he wrote.[2] Soon, however, he began to hear stories of another island people, the Caribs, who lived by raiding and who, he was told, consumed human flesh, a particular that Columbus initially doubted. (The word "cannibal" is derived from "Carib.")

Simple exchanges between the Taínos and the Spaniards convinced Columbus that there were possibilities for commerce, but the islands he visited lacked the spices he had expected to find in the Far East. And since the first natives Columbus encountered possessed small quantities of gold, which they willingly exchanged for the tiny bells tied to hawks' feet in falconry or for glass beads, this encouraged him to search for more.[3] The quest for a larger gold source was grafted onto Columbus's hopes of finding the large island of Japan, and the result was an exploration of the north coasts of Cuba and then of Hispaniola (called "Haiti" by the natives), which he reached on 5 December. Modern archeologists tell us that Taíno artifacts from Hispaniola show a sophistication superior to what Columbus must have encountered on the first islands he visited, and the political organization was more structured there. What mattered most to Columbus, however, was that Hispaniola was home to some modest deposits of gold. Cordial relations were established with a local chieftain, Guacanagarí, through whose good graces he received a number of gifts, including gold that he could present in Spain to his royal backers. After Columbus's *Santa Maria* was driven aground and damaged irreparably, Columbus decided there was not enough space on the remaining two ships to make the return voyage with all of the men. With Guacanagarí's permission, thirty-nine of the crew were left behind. They built a simple fortress, La Navidad, in which they were to await Columbus's return. Columbus set sail for home on 4 January 1493. Sailing eastward along the coast of Hispaniola his men were for the first time violently attacked by a group of indigenous men armed with clubs and bows and arrows. They paddled canoes "almost

as big as galleys," and they spoke a different dialect. Columbus concluded these hostile folk were the Caribs.

After a stormy ocean crossing and a stop at the Azores, the poor condition of his ship forced Columbus to sail into Lisbon harbor on 4 March 1493. There he was taken into custody by the Portuguese, who were in competition in the Atlantic with the Spanish. Only after an interview with King João II was the explorer released and permitted to travel to Spain with his crew and with the seven Taíno Indians he had brought with him. In Europe the news of Columbus's return and of his discovery of new lands across the western ocean was electrifying. A letter of Columbus's that described his new findings was rushed to press and it circulated rapidly throughout Europe. (See, for instance, the Frontispiece to Part I). Dramatic, irreversible change ensued on both sides of the Atlantic.

Italians and the Atlantic

Italian American history began here. This is not simply because Columbus—like Amerigo Vespucci, John Cabot (Giovanni Caboto) and Giovanni da Verrazzano—were individuals who happened to be Italian. The memory of Columbus and the other Italian explorers has affected and continues to affect questions of American identity in ways that are fundamental to American and Italian American history. Equally important is the realization, thanks to recent research, that Europe's push outward into the Atlantic was in many respects an "Italian" effort. Although these early explorers sailed under the flags of Atlantic monarchies, they were really the standard-bearers of a general movement of ideas and financial resources that stemmed from Italy. The Atlantic monarchies were in fact slow to move out into the Atlantic, and the Italian networks and financial backing that were crucial for these Italian navigators provided the additional element that made these first voyages possible.[4]

In these early expeditions the Italian sea captains and their investors cared about profits, not sovereignty, which was an approach the Genoese and Venetians had pioneered in the Mediterranean. The Atlantic monarchs on the other hand found it gratifying to extend their sovereignty, both for its own sake and because it would become the basis on which they shared in any profits. Of course the Italian investors did understand that the protections provided by states with sovereignty—in the form of monopolies, courts of recourse under civil and criminal law, and defense against the corsairs backed by rival European states—were advantageous in making these ventures successful. One way of looking at what happened in the years before and after 1492 is to see it as an attempted commercial conquest of the Atlantic by several groups of Italian venture capitalists. In the end the Atlantic World proved too large and risky and distant for the Italian commercial networks to be able to dominate it. In later years the monarchies that had established sovereignty came to develop their own methods of control. But there was an Italian character to much of the initial thrust into the Atlantic. Columbus and the other Italian navigators were the agents of Italian financiers even as they represented the royals under whose banners they sailed.

The first European attempt to reach Asia by way of the Atlantic occurred in 1291, when the Genoese brothers, Ugolino and Vadino Vivaldi, commanded two galleys that sailed past Cape Non in Morocco never to be heard from again. A few decades later, in his *Divine Comedy* (composed 1308–1320), the great Florentine poet Dante Alighieri imagined the Greek hero Ulysses sailing through the Strait of Gibraltar into the south Atlantic "in pursuit of virtue and knowledge" (*Inferno* XXVI.120) before his ship foundered in a tempest. Genoese captains played such an important role in the naval affairs of Europe's western shores that in 1317 one of them, Emanuele Pessagno, was awarded the hereditary title of Admiral of the Crown of Portugal. In 1312 a Genoese, Lancelotto Malocello, landed on one of the Canary

Islands, where he settled for two decades. When Malocello returned to Europe after a revolt in the 1330s by the island's aboriginal inhabitants, known as "Guanches," there followed a Portuguese mapmaking expedition commanded by captains from Florence and Genoa that was described in a popular treatise written by Giovanni Boccaccio.[5] The Canaries would later be conquered by Spain in a long series of wars with the Guanches between 1402 and 1495.

The uninhabited islands of the Madeiras and the Azores were meanwhile settled by the Portuguese in the 1420 and 1430s. Among the first settlers of the Madeiras was Bartolomeo Perestrello, the son of an Italian nobleman from Piacenza who had moved to Portugal in 1385.[6] Today Perestrello is most famous for releasing the pregnant rabbit whose feral offspring destroyed the island's original vegetation.[7] But the fact that he was awarded the island of Port Santo as a fief he could pass to his descendants created a precedent for Christopher Columbus (who would later marry this man's daughter) in his negotiations with the Crown of Spain. The levitation in social rank involved in such a conferral would be satirized a century afterward in *Don Quixote*, where it is the promise of the future governorship of an "island" that induces Sancho Panza to join the knight from La Mancha in his adventures.[8]

Further Italian endeavors in the Atlantic included the discovery by a Venetian merchant, Alvise Cadamosto, of the uninhabited islands of Cape Verde in 1455–56, which he claimed for Portugal. In 1474, a mistaken calculation of the size of the earth led the Florentine mathematician and cosmographer Paolo Toscanelli to write a famous letter to the Portuguese court suggesting the possibility of reaching the Indies by sailing westward, and it was probably then, in Portugal, that Columbus obtained the copy that he would later use in pursuing support for his first voyage.[9] Italians were active in Spanish service too. After the Portuguese established the first European trading post in sub-Saharan Africa at São Jorge da Mina (now St. George of the Mine, Ghana), the Spanish sent an armada in 1478 hoping to oust the Portuguese. The concession for the enormously profitable Guinea trade was promised to an Italian, Francesco Buonaguisi of Florence, although, unfortunately for him, the Spanish fleet was defeated by the Portuguese.[10]

With the creation of a reasonably well-connected area of thriving commerce in the eastern Atlantic, Italian merchant bankers, who were in some ways similar to today's venture capitalists and always on the lookout for new sources of profit, began investing in the Atlantic trade. Genoese commercial interests in Portugal and Spain had been growing since the 1300s.[11] The Bardi Bank of Florence is recorded as active in Portugal from 1338, and documents from the 1420s show the Bardi acting as correspondents for the Medici Bank in Seville, the city that would take the lead in Spain's Atlantic trade.[12] By the 1460s the Medici Bank was directly involved in the Spanish trade. Their agents in Spain included a number of Florentines from prominent families. One of them, Piero Capponi, had previously traveled all the way to Karachi.[13] Especially important in encouraging Italian financial involvement was the extent to which these foreign bankers living in Spain enjoyed privileges that were denied native Spaniards. Jewish moneylenders traditionally financed many of the activities of the Crown of Castile, including the *reconquista* of the Iberian peninsula from the Moors. But when Jews began converting to Christianity in large numbers in the fifteenth century, they became subject to Castilian laws on usury that limited them to interest rates of 4 percent. The important role of funding the government's operations passed instead to the Italian bankers, who enjoyed conditions of extraterritoriality. For example the members of the Genoese "nation" who lived in the cities of Seville, Córdoba and Toledo were subject to Genoese law, not Castilian law, as administered by Genoese officials, and they were thus permitted to charge higher interest rates.[14]

In addition to moneylending, Italian merchants in the Iberian countries were involved in the export of grain, wool and leather; their chief import, however, was slaves. Genoa, in fact,

was the major center of the slave-trading business in Europe.[15] From the late 1200s the chief source of the slaves that the Genoese merchants brought to Europe was the Black Sea city of Caffa (now Feodosia in Russian-occupied Crimea), which Genoa controlled as part of a far-flung trading empire. One Spanish traveler who visited Caffa in the winter of 1437–38 described it this way:

> The city is very large, as large as Seville, or larger, with twice as many inhabitants, Christians and Catholics as well as Greeks, and all the nations of the world. They say that the Emperor of Tartary would have taken and destroyed it many times, except that the lords and common people of the surrounding countries would not consent to it, for they use the place for their evil doings and thefts, and their great wicked-nesses, such as fathers selling their children, and brother selling brother. . . . They say, further, that the selling of children is no sin, for they are a fruit given by God for them to use for profit, and that God will show the children more favor in the places whither they go than with their parents. In this city they sell more slaves, both male and female, than anywhere else in the world. . . . The Christians have a Bull from the Pope, authorizing them to buy and keep as slaves the Christians of other nations, to prevent their falling into the hands of the Moors and renouncing the Faith. These are Russians, Mongolians, Caucasians, Circassians, Bulgarians, Armenians and diverse other people of the Christian world. I bought there two female slaves and a male, whom I still have in Córdoba with their children.[16]

In the second half of the fifteenth century, however, the supply of the mostly white-skinned slaves from the eastern Mediterranean and Black Sea diminished steadily, as ever-larger areas, including Constantinople and much of the Balkans, were conquered by the Ottoman Turks. Caffa itself was seized by the Turks in 1475. Genoese and Florentine traders, operating with local partners, responded by finding new supplies of slaves: among the Muslims who were captured in the Christian conquest of the Iberian peninsula; among captive Guanches of the Canaries (who ceased to exist as a people); and along the West African coast. Black-skinned Africans became more common as domestic servants in European households (as can be seen in Renaissance paintings), but they were also used to work sugar plantations that were estab-lished in the Canaries and the Madeiras. In Lisbon the trade in African slaves was dominated by a Florentine, Bartolomeo Marchionni; and, from 1485, Marchionni's agent in Seville became another Florentine named Giannotto Berardi, who would become an important backer of Columbus.[17] It was within this larger context of exploration and commerce that Christopher Columbus migrated first from Italy to Portugal and then to Spain.

The Columbus Plan

Columbus was an Italian who came from Genoa. Many theories have been advanced over the years that state otherwise, but by now all reputable historians agree that Columbus was born in 1451 to a Genoese wool worker named Domenico. The Admiral's birth to an *artifex*, a man of the humble working class, was a source of deep embarrassment that resulted in silences that later writers attempted to fill. Columbus's family did not belong to one of the noble clans known as *alberghi* ("hostels") that dominated the city socially, politically and economi-cally. Even after he became famous there were Genoese noblemen who made sure to men-tion his "mean birth."[18] The shame and the disparity with his later status were so great that on Hispaniola in 1499 or 1500, when two Spanish women were reported as saying that Columbus and his brothers Bartholomew and Diego were from the lower classes, and

that Diego had been a weaver before coming to Castile, Bartholomew, as governor, ordered that one of the women be whipped and the other have her tongue cut out. Columbus himself, when he learned of this, wrote his brother a letter of approval: "What you have done is good, for whoever speaks ill of us deserves death, and this is the law."[19]

His working-class origins notwithstanding, the young Columbus entered a world dense with social connections. Although some historians have imagined late medieval Italian city-states as stratified societies in which there were few points of contact between the upper and lower classes, the Genoa in which Columbus was raised was instead rich in networks that mutually bound the well-off with individual members of the working classes. And whereas economic historians of this period once emphasized the role of Genoa's state-sponsored trading networks, it is now clear that in the decades before and after 1500 the initiative of individual Genoese merchants was crucial to commercial prosperity.[20] Political factions, neighborhood structures, guilds, religious associations and the ties of family and marriage all appear to have been worked to his advantage by Columbus. Especially important was a familial and lifelong attachment to the Genoese faction of the Fieschi, which had valuable international ties that resulted in introductions and support throughout Columbus's career.[21] From 1470, as a consequence of political change in Genoa, the Columbus family resided in the neighboring coastal city of Savona, resulting in a connection to the Della Rovere family of Savona, which provided two popes in this period: Sixtus IV (1471–1484) and Julius II (1503–1513). Also in Savona, Columbus's father established a rapport with Corrado da Cuneo, from a family of rich merchants. Later in Columbus's career, the son of Corrado, Michele da Cuneo, would figure as the Admiral's most trusted companion apart from his immediate family. It was possibly on one of the ships of the da Cuneo that the young Columbus sailed to the island of Chios in the Aegean.[22]

More substantial experience appears to have been gained under the leadership of a pirate-corsair from Provence called Colón the Elder, who, given his name, may or may not have been a relation of some kind.[23] From 1461 to 1483 Colón the Elder raided the shipping of a series of nations at the behest of King Louis XI of France, and from 1470, as France allied with Portugal against the Catholic monarchs of Spain, he began raiding Atlantic shipping on behalf of the Portuguese, too. Colón the Elder's earliest base was at Marseilles, the port from which Columbus made his earliest known voyage, but in the 1470s and '80s Colón the corsair was sending out ships from Lisbon and Harfleur to seize English, Spanish and Venetian ships along the Atlantic coasts of Europe and Africa. It was in these years that Columbus sailed from Iceland in the north to Guinea in the south, and as far west as the Azores. He gained experience and technical knowledge, including an understanding of the easterly trade winds found farther south in the Atlantic, as opposed to the winds from the west that prevailed in European latitudes. In 1479 Columbus is recorded in the Madeiras, and also in that year he married Felipa Perestrello, the daughter of the first governor of Porto Santo, thus becoming a Portuguese citizen.

Felipa's family had close connections at the Portuguese court. It was certainly during these Portuguese years that Columbus began formulating plans for an expedition into the western ocean that would draw on his particular knowledge of winds and ocean currents and on the belief (drawn from Toscanelli) that the distance between Europe and Asia is considerably smaller than it is. Meanwhile, Columbus's brother, Bartolomew, set up shop in Lisbon as a mapmaker. It is possible that Columbus first presented to King João II the plan of sailing west to the Indies in 1483 or 1484. If so, the plan was rejected. And in 1485 the King's suppression of a plot by the court faction to which Columbus's wife's family belonged forced him to depart for Spain.

The move to Spain, as a political exile, must have been difficult, but Columbus was ever resourceful. He was assisted at first by a powerful Franciscan friar, and after an initial request

for an audience at the Spanish royal court was refused, he nevertheless continued to follow the court until an audience was granted on 20 January 1486. To Ferdinand of Aragon and Isabella of Castile Columbus presented a map of the world, and he promised to find land within 3,000 miles across the sea from Spain. A commission was appointed that year that in Salamanca heard Columbus's proposal and examined him about it. In January 1487, stating its in fact correct belief that the world is larger than Columbus imagined, the commission rejected his plan.

The commission that turned down Columbus believed the earth to be round, and not, as legend later had it, flat. There was indeed an ancient school of thought, traceable as far back as Homer's *Iliad*, which held that the earth is a flat disc surrounded by and floating upon a great body of water called Oceanus.[24] But the spherical view was dominant already in antiquity, and by Columbus's time it was universally accepted that the earth was round. The popular notion that Columbus's project was turned down by a benighted committee of flat-earthers was introduced by the American author Washington Irving, in his popular biography of Columbus, first published in 1828.[25]

Although Columbus's plan was not adopted at Salamanca, he continued to be taken seriously at court. The Catholic monarchs were sufficiently impressed to begin paying a stipend for his expenses. Moreover, in 1488 Columbus was invited back to Portugal by their rival, King João II, who offered him a safe-conduct so he could learn more or hear again about Columbus's project. Unfortunately for Columbus, while he was in Lisbon Bartolomeu Dias made his successful return to that port after having rounded the Cape of Good Hope and seen the sun set over land in Africa to the west. For the Portuguese this indicated clearly that the best passage to Asia lay to the south and east, around Africa, rather than to the west as Columbus was proposing. So Columbus returned to Spain to persist in his campaign for a western crossing. Meanwhile, farther north, across the Pyrenees, his brother Bartholomew attempted unsuccessfully to secure backing first from King Henry VII of England and then from King Louis XI of France for Columbus's project.

It was only in the spring of 1492, after the Muslims in Granada had been defeated in the last chapter of the *reconquista*, that Columbus finally received the support of the two Spanish monarchs. At Santa Fe, the site of the royal camp outside Granada, the terms known as the "Capitulations of Santa Fe" were agreed upon on 17 April 1492. Columbus was to receive the title of "Admiral, Viceroy, and Governor-General over all of the islands and mainland which by his labor and industry shall be discovered or acquired." He was granted one-tenth of all the treasure and merchandise produced or obtained in these domains, free of taxes. And his titles and prerogatives were to be enjoyed by his heirs and successors in perpetuity.[26] These were generous terms, but they would take effect only in the event of success.

One of the legends concerning Columbus has it that Queen Isabella was ready to pledge her jewels to make the voyage possible, but this is an invention again traceable to Washington Irving.[27] Modern research has demonstrated that although the monarchs endorsed the expedition, they advanced far fewer funds than were necessary, and to make up the substantial difference, far beyond his means, Columbus turned elsewhere. Interestingly, the Genoese in Spain did not back their countryman on this risky first venture. Later they would be only too happy to invest in Columbus's second expedition, but in 1492 it was instead a Florentine, the slave trader Giannotto Berardi, who made up the difference. Berardi contributed more than one-eighth of the cost in exchange for a share in future returns.[28] As would continue to be the case with many of the European ventures across the Atlantic, the need to satisfy investors back home imposed certain constraints on the explorer. The goals of discovering new sea routes, claiming new lands and spreading Christianity were all attractive, but it was incumbent on these expeditions that they turn a profit quickly.

Calamity on Hispaniola

From a commercial point of view Columbus's first expedition of 1492–1493 was not a success. In the reports he gave upon his return, Columbus exaggerated the possibility of winning future riches. Gold and spices would be secured cheaply. The indigenous people were docile and ready to accept both Spanish sovereignty and the Christian religion. The great markets of Asia lay just over the horizon. Expectations were high, and a large expedition of colonists who intended to settle on Hispaniola was put together for the next voyage. This second expedition comprised seventeen ships and more than 1,200 Europeans. By way of contrast, a century later there were 115 people in the Lost Roanoke Colony, 104 in the original Jamestown settlement, and only 102 at Plymouth. The confident, celebratory atmosphere in which the 1493 flotilla left to cross the Atlantic is captured in an account of Columbus's friend, Michele da Cuneo, who referred to an old amour of Columbus's with a female governor in the Canaries, Beatriz de Bobadilla, at the ships' last stop before making the crossing:

> If I were to recount for you how many festivities, salvoes and salutes we performed in that place, it would take too long; and it was all for the sake of the lady of the said place, for whom in a former time the Admiral had been smitten with love.[29]

All did not work out as planned. Arrival in the West Indies was marked ominously at a first stop on the island of Guadeloupe, where they discovered a hostile tribe of Caribs together with credible evidence that these Caribs were eaters of human flesh. Dr. Diego Chanca, the royal physician who accompanied the expedition, wrote of them,

> They say that human flesh is so good that there is nothing like it in the world; and this must be true, for the human bones we found in their houses were so gnawed that no flesh was left on them except what was too tough to be eaten. In one house the neck of a man was found cooking in a pot. They castrate the boys that they capture and use them as servants until they are men. Then, when they want to make a feast, they kill and eat them, for they say that the flesh of boys and women is not good to eat. Three of these boys fled to us, and all three had been castrated.[30]

Modern commentators have sometimes attempted to deny such European accounts of indigenous cannibalism in the Caribbean, but the evidence for it seems fairly clear.[31]

Moving on and arriving at Hispaniola the large Spanish expedition discovered that the fort at La Navidad had been destroyed and all of the crew that Columbus left there had been killed. The chieftain Guacanagarí at first attributed this to an attack by a rival chieftain from the western portion of the island, but it soon became clear that the men left behind brought disaster on themselves by raiding the natives for gold and women. There were men in Columbus's party who wanted to punish Guacanagarí, but Columbus instead reestablished good relations, so that soon a city was founded, called Isabela, and the new colonists began building 200 grass-roofed log houses. A new governing structure took shape under Columbus as Viceroy (literally "in place of the King") and his brother Bartholomew, who arrived in June 1494, as *Alcalde* or Governor.

Columbus was by all accounts a commanding figure both at sea and on land. He was a remarkable navigator. He was both courteous and forceful in negotiation. For a man of his social origins, he was widely read and also a prolific writer who left an unusually large body of written work in the form of journals, notes and commentaries. His deep Christian faith

was tinged with a millenarianism that was reinforced by a belief, which he successfully conveyed to many others, that God had chosen him in particular to make the great voyage of 1492. And he continued to extend the boundaries of the world known to Europeans, even if his calculations were off and he never found a way to Japan. In 1498, for instance, after his third crossing from Spain, when he witnessed the enormous amount of fresh water released by the Orinoco River into the Caribbean, he wrote in his journal: "I believe this is a very large continent which until now has remained unknown."[32] Thus Columbus, not Vespucci, as was later claimed, discovered South America. The Admiral's merits as a sea captain and explorer were unquestionable; he was not, however, cut out to govern a province. This was amply seen in the course of the often horrific events that took place on Hispaniola under his stewardship between 1493 and 1500.

The people who suffered most were the indigenous islanders. A savage and unrealistic system of tribute was imposed by which individuals were required to provide a specified quantity of gold (to fill a "hawks' beak") every three months or face the amputation of a hand. The island in fact did not house great veins of gold, and what gold the inhabitants had gathered and worn as ornaments for generations was quickly exhausted. The resulting meager tribute generated fierce reprisals from the Spaniards, which in turn stimulated resistance among the inhabitants. Refusal to do forced labor led to Spanish campaigns of enslavement, even as natives headed for the hills. Starvation became a major cause of death, while even more islanders were dying of disease. According to Bartolomé de Las Casas, the campaigns of Spanish settlers against the natives that began in late 1494 resulted in the deaths of approximately 50,000 islanders. Peter Martyr put the loss at two-thirds of the indigenous population.

The need to turn a profit in the absence of large quantities of gold, led unsurprisingly to attempts to export natives for sale as slaves in Spain. For Columbus and his investors, most of whom participated in the slave trade of the Canaries and the Guinea coast, the capture and sale of slaves was a "normal" way of making a profit. Here Columbus and his backers in Seville encountered a serious difficulty, however. For several years Ferdinand and Isabella had been pondering with increasing doubt the legitimacy of enslaving persons who were potential converts to Christianity. In early 1495, Columbus shipped 500 indigenous persons as slaves to Spain, although only 300 of them survived the voyage.[33] Troubled by this, the monarchs announced that sales of Columbus's slaves would be only provisional and dependent on the results of a theological and judicial consultation. Then, in 1500, the King and Queen simply prohibited the sales of potential Christians from the New World. As historian Helen Nader puts it, moral communities exist "in time," and for Columbus, who set out with certain expectations, it was as though the ground was shifting beneath his feet.[34] The new policy, which did not ban slavery outright but significantly circumscribed it, eliminated the major source from which Columbus's investors could hope to be repaid.

Meanwhile, for their part, most of the Spanish colonists on Hispaniola were dissatisfied. Disappointment followed disappointment. Some settlers returned to Spain bearing with them complaints that resulted in a first investigation of 1495 that more or less cleared Columbus. But when Columbus returned to Spain in 1496, leaving his brother Bartholomew in charge, matters worsened. They continued to deteriorate even after Columbus returned to the island in 1498. Spanish colonists complained about missing payments, a scanty food supply, and arbitrary and severe punishments by the Columbus brothers. A full-scale revolt by some of the colonists, who set themselves up in another part of the island, was resolved in an unsatisfactory manner. In 1500 a new official was sent by the Spanish monarchs to investigate Columbus's conduct on the island. This was Francisco de Bobadilla, a cousin of Columbus's female friend in the Canaries. In 2006, in the Spanish state archive at Simancas, the original register was discovered that recorded the testimony of the witnesses who were examined by Bobadilla.[35]

The responses of the colonists paint a stark picture of Columbus's activity. Food was always scarce and its supply was controlled by Columbus. Any gold that came in as tribute remained in Columbus's coffers and was not shared with the settlers. Acts of petty disobedience and even simple griping were met with severe punishments that included whippings, judicial amputations, and hangings. Columbus used his title as Viceroy as a license to treat offenses against himself and his administration as crimes of *lèse majesté*—crimes against the Crown that were punishable by death. Rumors were spread that Columbus, a Genoese who had sailed previously for Portugal, was plotting to surrender Hispaniola to a foreign power. The Franciscan friars who were with Columbus complained that he had given orders against baptizing natives without his permission, since making them Christians would interfere with their export as slaves.[36]

Columbus was accustomed to methods of command at sea—in which small offenses commonly resulted in floggings and mutinous sailors were hanged from a ship's yardarms—that were hardly appropriate in governing a large territory and population and were difficult for Spanish landsmen of good social standing to accept. An engraving that appeared in Theodore de Bry's *America*—a massive collection of texts about the discovery published at the end of the sixteenth century—shows a scene from Hispaniola (see Figure 1.1) in which a Franciscan friar tries to stop Columbus from hanging several Spanish colonists.[37]

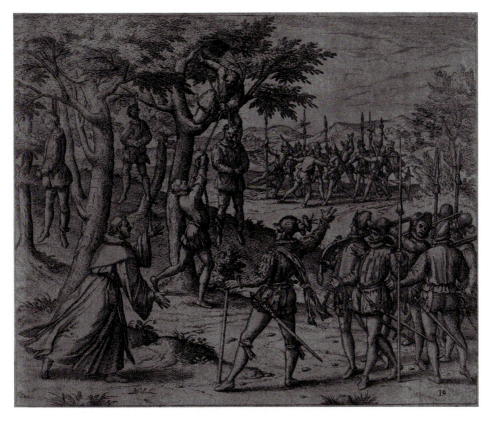

Figure 1.1 A friar attempts to intervene as Columbus orders the hanging of Spanish colonists on Hispaniola, 1500. From Theodore de Bry, *America*, 13 vols. (Frankfurt a. M., 1590–1634). Photo: Special Collections, University of Houston Libraries.

In 1500 Bobadilla concluded that Columbus should be removed from his governorship. His decision—to put Columbus in chains and return him to Spain—has often been portrayed as a tragic injustice, but the investigation's register suggests otherwise. In what seems a comment on Columbus, in the second volume of Cervantes's *Don Quixote*, Sancho Panza is actually awarded an island's governorship: unlike the Genoese Admiral, Sancho turns out fair-minded and competent.[38]

The Later Columbus

It is sometimes assumed that Columbus was neglected or ill-treated by the Spanish monarchy in his last years. This is incorrect. In fact Columbus made good use of the tools still at his disposal. In the eyes of the world he remained the anointed one—God's agent in discovering new lands. And he understood the importance of dramatic gesture. Thus, when the men on the ship returning him to Spain wanted to release him from his irons he pridefully insisted on remaining chained for the duration of the voyage. In a letter to a prominent woman at court that certainly won him sympathy he wrote:

> In Spain they judge me as if I had been sent to govern Sicily or some province or city under settled government, and where the laws can be strictly applied without fear of a complete upheaval. This does me harm. I should be judged as a captain sent from Spain to the Indies to conquer a large and warlike people, with customs and beliefs very different from ours, a people, living in mountains and forests without settled townships, while we have none there either. Here, by God's will, I have brought under the dominion of our sovereigns a new world, whereby Spain, which was called poor, has now become rich.[39]

Immediately upon his return Columbus was released and summoned to the royal court with an allowance for his expenses. Ferdinand and Isabella came to the very reasonable conclusion that Columbus should not serve as Viceroy or governor, but that his considerable seafaring knowledge and skills were still useful. Thus, although they relieved him of his title as Viceroy, he remained "Admiral." And although his monopoly on expeditions to the west no longer obtained—in fact already in May 1499 the monarchs had infringed on the monopoly by licensing other voyages of exploration—Columbus continued to receive significant payments from the court, where his sons, Diego and Fernando, remained as pages. In 1502 Columbus was sent on a last, heroic expedition across the ocean. After exploring the coast of Central America, becoming stranded on Jamaica, courageously facing down a mutiny, calming hostile natives by predicting a lunar eclipse, and finally being rescued by recalcitrant settlers on Hispaniola who thought unkindly of him, he returned to Spain in 1504.

The fact that Columbus spent the years before his death in 1506 gathering documents and pressing the case for the restoration in full, to himself and his heirs, of the privileges granted in the 1492 Capitulations, gave contemporary observers an impression of decline and unfair neglect that Columbus himself certainly encouraged. Still, he undoubtedly died a wealthy man. Columbus moreover never forgot Genoa and the Genoese: a final codicil to his will named a series of Genoese bankers and merchants whose small loans of long ago he wished to repay with bequests.[40] The heirs of this Italian immigrant became prominent Spanish noblemen, with castles and landed estates and a lineage that endured into the late nineteenth century. In the 1890s a wealthy American married one of Columbus's direct female descendants. After she inherited the family estate in Spain, her husband had the interior of its

chapel transported across the ocean, together with the family archive and various furnishings, including a desk known as "the Admiral's." These may be visited nowadays in Boalsburg, Pennsylvania, not far from Penn State University.

Amerigo and "America"

Amerigo Vespucci of Florence was a friend of Columbus. The two met in Santa Fe in 1492, at the time of the drawing up of the Capitulations. Vespucci was there as a representative of the Medici Bank. His mission was to convince the Florentine Giannotto Berardi to become the bank's factor in Seville. Berardi, as we have seen, was the slave trader who invested in Columbus's first voyage. Berardi and Vespucci became partners, and when Berardi died in December 1495 he left it to Vespucci to settle his estate and collect whatever payment was possible on debts that were owed him, including those from Columbus's voyages.[41] Even after Columbus's expeditions failed to generate the expected profits, and even after Columbus's return from the disastrous governorship on Hispaniola, Vespucci continued to support his fellow Italian. In 1510, in a deposition concerning a signature of the late Admiral, Vespucci testified that "this witness [i.e. Vespucci] saw him write and sign on many occasions . . . because he was an officer of the said lord Don Cristóbal Colón and held his books for him."[42] The idea that Vespucci was somehow a rival of Columbus's is an invention. And yet the two continents of the New World were named after Amerigo Vespucci, not Columbus.

The Vespucci family belonged to a social class in Florence well above that of Columbus's family in Genoa. In the thirteenth century the main part of the Vespucci moved to Florence from rural properties outside the city in Peretola (close to Florence's modern airport), although Vespucci relatives continued to live at Peretola throughout the fifteenth and sixteenth centuries. The patronage of the Medici family assisted the Vespucci in rising to a certain prominence during Amerigo's lifetime. Born in 1454, Vespucci was baptized on 18 March.[43] His father, Nastagio, was a notary, and several of Amerigo's relations were employed in the Florentine chancery. An uncle of Amerigo's who was a humanist famous for his learning, Giorgio Antonio Vespucci (1434–1514), became the young man's teacher. An important opportunity for Amerigo developed in 1478, when an older cousin, the jurist Guidantonio Vespucci (1436–1501), invited him to come along on a Florentine embassy to Paris. Guidantonio's prominence in Florentine politics was such that in the 1490s he drew the ire of a contemporary poet who called on him to "go back to Peretola . . . to sell onions by the hundreds!"[44]

It was as a representative of the "Medici Bank" that Amerigo traveled to Seville in late 1491 or 1492, but the bank was a complicated entity. Many of its resources had been transferred to a bank of the Bartolini family in the 1480s to protect the Medici in case of political difficulty or exile. A long-standing fraternal partnership between Cosimo de' Medici (1389–1464) and his brother Lorenzo (1395–1440) resulted first in a continuing but separate role for Lorenzo's son, Pierfrancesco (1430–1476), and then Pierfrancesco's son, Lorenzo (1463–1503), the man who became Amerigo's principal patron.[45] In 1492, shortly after Vespucci arrived in Seville, there was a rupture that forced Lorenzo the son of Pierfrancesco into opposition with the main branch of the Medici family, but Amerigo continued to serve Lorenzo di Pierfrancesco. When other members of the Medici family were exiled from Florence in 1494, Vespucci's patron, Lorenzo, who adopted the surname "Popolano," became in Florence a powerful political figure on account of his hostility toward his now-exiled relatives, and it was with him that Amerigo corresponded from abroad. In Seville Amerigo married a Spaniard called Maria who was possibly the illegitimate daughter of Gonzalo de Córdoba, the general known as *El Gran Capitán* who would later conquer the Kingdom of Naples for Spain.[46] And in Seville

Vespucci worked in partnership with Berardi until the latter's death left him bankrupt and out of work.

We would say today that Vespucci showed a remarkable ability to "reinvent" himself, and that is what he did.[47] In 1499 he took the first step in what would become a career as a navigator and cosmographer when he shipped aboard a westward expedition of Alonso de Ojeda in what was the first infringement on Columbus's monopoly that was authorized by the Spanish monarchs. A strong element in Vespucci's reinvention was his self-promotion through imaginative prose. He described his activities in an engaging way that would attract readers who had no way of knowing the details of his travels. There is never likely to be certainty concerning some of the places visited by Vespucci, and the extent of his nautical accomplishments remains under question. In the nineteenth century there arose a whole school of scoffers who sought to challenge all that Vespucci had written, item by item. That he really did some of the things claimed has since been shown, however, and scholars have slowly been constructing a more balanced account of his career.

It seems clear that Vespucci made only two voyages, not the four that were once alleged. The first, during which Amerigo served an undetermined subordinate role with Hojeda in 1499–1500, seems to have been directed toward pearl beds off the Venezuelan coast that Columbus had reported. During the first voyage Vespucci's ship appears to have become separated from the others, so that he sailed south to the mouth of the Amazon, crossing the equator in the process. Most importantly for his reputation, he claimed to have found a southern equivalent to the Pole Star (so that it has been thought that Vespucci discovered the Southern Cross), and he claimed (falsely) to have calculated longitude on the basis of the movement of the stars, when in fact he had cribbed some figures from Columbus. When Vespucci returned in 1500, Columbus had already undergone his humiliating return and foreigners were moreover temporarily out of favor in Spain. So Vespucci traveled to Lisbon. Lisbon was home to a large colony of Florentines, including Bartolommeo Marchionni, for whom his late partner Berardi had been an agent. In 1501–02 Vespucci was welcomed aboard a Portuguese expedition that sailed southwest from the Cape Verde islands exploring the eastern coastline of what he claimed was a new continent (although Columbus had deduced as much in 1498). These, it seems on reasonably good evidence, were the only two voyages that Vespucci made. And yet he became a famous man. Interestingly, the path Vespucci followed was not that of captain but rather something new. He claimed to have developed a new technical means of navigation that combined astronomy, instruments, and cartography in a more accurate way. Possibly he was ignored albeit tolerated by the experienced captains with whom he sailed. That he really became expert as a cartographer or "pilot" (as he was called) is questionable, although he seems to have made progress by learning on the job—a job he essentially created for himself. What cemented his fame were two small descriptive publications that appeared under his name.

Vespucci was back in Spain from the end of 1502, arriving after Columbus had already left on a fourth and final voyage from which he would return in November 1504. In the first part of 1504, meanwhile, a small Latin pamphlet was published under Vespucci's name with the title *Mundus Novus* or "New World."[48] As announced in the title, the book stated that a new continent had been discovered across the Atlantic south of the equator. Thus Vespucci, not Columbus, came popularly to be believed the discoverer of the "New World" that was South America. The book became an immediate bestseller. Addressed to Vespucci's patron Lorenzo Popolano in Florence—Italy was still the arena that mattered most—the work must have been composed before Lorenzo's death on 20 May 1503. In the past Vespucci's authorship has been denied, but a convincing case has been made that it shares so many

characteristics of Vespucci's earlier manuscripts that, as one scholar writes, "although it is not a veracious work," it is "thoroughly representative of the rest of his authentic oeuvre."[49] Translated into Latin by a Veronese humanist, Fra Giovanni Giocondo, the book was first published in Augsburg.[50] Until now scholars have failed to notice that Vespucci's patron, Lorenzo, was the leader of the Imperial party in a Florence that was divided between partisans of France and the Empire, and it was in Augsburg that the Holy Roman Emperor Maximilian I had been holding court since 1500. It thus made a certain sense for the *Mundus Novus* to be published in that city, although by the time it appeared Lorenzo had died. The report transmitted in a popularizing way a description of the lands and peoples across the ocean that made them objects of great curiosity. Vespucci managed to combine in one brief, readable pamphlet an intriguing geographical account of the new lands while presenting a series of often titillating pseudo-ethnographic details about its inhabitants (nakedness, lustful women, incest, cannibalism) that raised fundamental questions concerning human nature. Clearly he relied on his own observations, but he also drew on Columbus's earlier accounts, and he further borrowed fanciful but well-known motifs from classical and medieval literature.

A second publication appeared in Florence under Vespucci's name in late 1504 or 1505. Written in Italian and continuing the themes of *Mundus Novus*, it is known as the *Soderini Letter* because it was addressed to Pier Soderini, another Florentine politician and the rival of Lorenzo Popolano. Soderini had become the Florentine Republic's titular head of state (*Gonfaloniere di giustizia a vita*) in 1502,[51] and whereas Lorenzo had been the leader of the Imperial party, Soderini was the leader of the French party. The publication deserves to be seen as an attempt to ingratiate Vespucci with Soderini now that his patron Lorenzo was dead. Close study of the text has shown that the *Soderini Letter* was reworked with the addition of material for which Vespucci was not responsible, but there is still a core that was his. As scholar Luciano Formisano puts it, the *Letter* "might best be labelled not pseudo- but rather para-Vespuccian."[52] Who confected the *Soderini Letter*, inserting material that is clearly unauthentic, has been something of a mystery. Clearly it was someone in Florence, and a likely candidate would seem to be Agostino Vespucci, best-known as a friend of Machiavelli's, who was a humanist working in the Florentine chancery under Soderini and thus had an interest in promoting good relations between his employer and Amerigo. Curiously Agostino Vespucci was not related by blood to the Vespucci family. Scholars have recently established that Agostino had a very close relationship with the humanist Giorgio Antonio Vespucci, who, as the *Letter* states, was the teacher of both Amerigo and Soderini. As occasionally happened in humanist circles, the surname Vespucci was conferred on Agostino because of his association with Giorgio Antonio. But his birth-name was "Nettucci," and he came not from Florence but from a tiny provincial village called Terricciola, outside of Pisa. Yet a number of chancery documents refer to him with a different topographical designation as "*Augustinus de Terra Nova*." For many years scholars took this to mean that Agostino came originally from the town of Terranova (now called Terranova Bracciolini) in the Arno valley. But since we now know that Agostino came from Terriciola, and since he had no known connection to Terranova, the sobriquet "*de Terra Nova*" possibly refers to a connection between Agostino Vespucci and the texts of Amerigo concerning the "New Land" (*Terra Nova*).[53] Perhaps the most important underlying point, however, is that, as so often in the first decade of the sixteenth century, the news, to become "real" news, needed an Italian context.

Although Amerigo's treatise applied the term "New World" to the lands across the ocean, he was in no manner responsible for that other name, "America," becoming attached to the same places. This was something that happened more or less by accident. In 1507, in the small town of Saint-Dié-des-Vosges, in the French province of Lorraine, it so happened that

a printer, Martin Waldseemüller, and a humanist, Matthias Ringmann, were engaged in the massive project of publishing a universal geography. It was supposed to combine the classical geography of Ptolemy of Alexandria with what was known about the world from more recent authors as a result of discoveries in the Atlantic and the Indian Oceans. In 1505 the humanist Ringmann had already seen through the press an edition of the *Mundus Novus* through the press in 1505, and at the beginning of 1507 when a copy of the *Soderini Letter* arrived in Saint-Dié the two men believed it to be the latest word on the discoveries in the western ocean. In April 1507 they published an *Introduction* to their cosmography along with a huge map of the world. The map was truly enormous. Printed on twelve separate 18 by 24½-inch sheets, it covers nearly three square meters. The only complete copy of the Waldseemüller Map known to survive is now on permanent display in the Library of Congress. (See Figure 1.2.) At the top of the map there are portraits of Ptolemy and Vespucci, honored as geographers of the Old and New Worlds, and, as stated in the *Introduction*, the continent now known as South America is imagined as representing the fourth part of the known world, along with Europe, Asia and Africa. To this fourth continent they gave the name "America" (Figure 1.3), in honor of Vespucci, although neither Ringmann nor Waldseemüller had had personal contact with him. And the name stuck. Later mapmakers based their work on Waldseemüller's, which was the best available, and, over time, the name was extended in the plural to comprise "the Americas," both South and North.

Columbus, who was already dead, was unable to complain about the credit his friend was receiving. And Ferdinand of Aragon seems meanwhile to have realized that he had a celebrity on his hands. In March 1508 he named Vespucci "Pilot Major" of Spain, appointed him to a post in the House of Commerce (*Casa de Contratación*) and charged him with composing a model map to be printed in copies over which Vespucci would have the monopoly on sales. It is indicative of the unreal quality surrounding Vespucci's fame that, when he died in 1512, the model map had never been drawn up.

In 1986 a will of Vespucci's dating from 1511 was discovered in an archive in Seville. According to its terms, the estate of his former partner, the slaver Giannotto Berardi who had backed Columbus, still owed him 144,000 *maravedis*. Although Amerigo left most of his property to his Spanish wife, and his books and technical material to his nephew Giovanni, what are perhaps most interesting are the affectionate mentions of Florence as he lists his mother and brothers and provides for masses to be said in his memory in Florence's church of Ognissanti.[54] The Vespucci connection to Florence remained strong even after Amerigo's death, as can be seen in the career of his nephew Giovanni, who now assumed the post of "Pilot Major." In the archives of the Florentine government of the 1510s and 1520s there is preserved a thick series of missives from Giovanni Vespucci written in cipher. For years— until he was found out in 1525 and fired by the Spanish Crown—Giovanni worked as a spy in the service of Florence.[55]

North America

Much as in Spain and Portugal, in England and France there were substantial colonies of Italian merchant bankers at the turn of the sixteenth century. And in both England and France there were again Italians who assumed lead roles as explorers of the Atlantic.

In England the resident Italian community had been noteworthy since the end of the thirteenth century.[56] These well-off merchants and bankers sometimes engendered local resentment. In 1517 there was even a May Day riot in London against these foreigners. The riot was in part sparked by one Francesco de' Bardi, a Florentine financier who was a favorite of

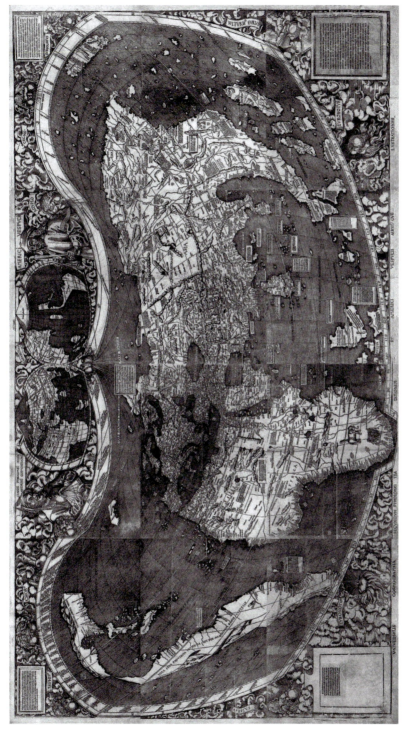

Figure 1.2 The *Universalis Cosmographia* (World Map) printed by Martin Waldseemüller and Matthias Ringmann in 1507, with portraits at top of Amerigo Vespucci (right) and Ptolemy of Alexandria (left) representing modern and ancient geography. Photo: Library of Congress Geography and Map Division, G3200 1507.W3.

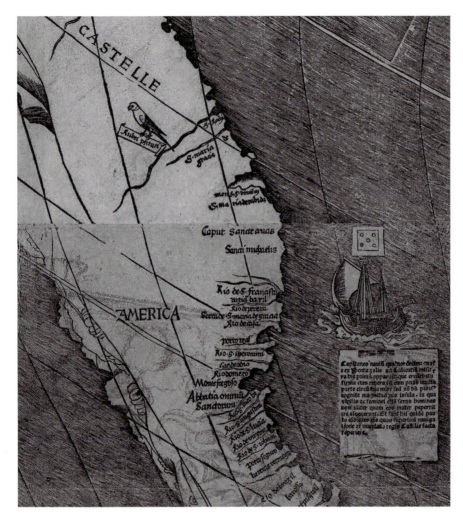

Figure 1.3 Detail of Figure 1.2, in which the name "AMERICA" appeared for the first time. Waldseemüller applied it to the continent now known as South America, which Vespucci had described in his *Mundus Novus* of 1504.

Henry VIII. According to the chronicler Edward Hall, the Florentine enticed a Londoner's wife to move in with him, bringing her silver, too.[57] The English husband brought suit against Bardi, but when he confronted the foreigner in court the husband lost his nerve and dropped the suit—to which Bardi responded by having the husband arrested for payment of his wife's board! There followed soon after a preacher's Easter sermon against "the strangiers (*sic*)." And then, one day in the King's gallery at Greenwich, the Bardi matter came up among a group of Italians that included Bardi himself. They "jested and laughed howe that Fraunces [Bardi] kepte the Englisheman's wyfe, saying that if they had the Mayre's wyfe of London they would kepe her." But, says the chronicler:

> There were diverse Englishe merchauntes by, and harde them laugh, and were not content, insomuche as one William Bolt, a mercer sayd, "Wel you whoreson

Lombardes, you rejoyce and laugh, by the masse we will one daye have a daye at you come when it will!"

As rumor of this spread, "diverse younge men of the citie assau[l]ted the Aliens as they passed by the stretes," leading to a full-scale popular upheaval with talk of murdering the foreigners. Only the intervention of none other than Thomas More, the future saint, calmed the city. More was then serving as under-sheriff of London, although he had already accepted an appointment as counselor to Henry VIII.

Research has now shown that members of the same Bardi family to which the arrogant Francesco belonged had significant ties both to Columbus and to the explorer John Cabot (Giovanni Caboto).[58] Columbus's sister-in-law (the sister of his wife) was married to a Bardi, also named Francesco, who seems to have arrived from Florence in Seville about 1504 and was present at Columbus's deathbed.[59] Earlier still, in 1496, the first expedition of John Cabot received financial backing from the London bank of the heirs of Giovanni Bardi.[60] Like the voyages of Columbus and Vespucci, Cabot's explorations, too, were made possible by the social and financial networks of Italians in the Atlantic world.

Cabot arrived in England in 1495 as an entrepreneurial wanderer. He was fortunate to have survived a series of failures, as for years he bounced about the Mediterranean and up the Atlantic coast. Born about 1450, probably in Genoa, he was an almost exact contemporary of Columbus. His parents seem to have brought him to Venice, where in 1476 he became a citizen. In the 1480s he was active in Crete and in the territory of Mamluk Sultanate, and he later told the Milanese ambassador in London he had once visited Mecca.[61] After a failure to pay debts he fled Venice in 1488, if not earlier, and moved to the city of Valencia in Spain. He appears to have eluded a request from his Venetian creditors that he be arrested. He developed a project to revamp the Valencia harbor that was turned down by the local authorities. In 1494 he began building a bridge over the Guadalquivir in Seville, but at year's end the project was terminated by the city council and the bridge was left unfinished.

Cabot certainly knew of Columbus's first voyage, and a 1498 letter from the Spanish ambassador in England states that prior to coming to England, Cabot had been in Seville and Lisbon seeking support from the Spanish and Portuguese for making a voyage of his own. The important novelty in Cabot's plan was that, given the spherical shape of the earth, the voyage to Asia could be made more quickly if a ship sailed at a northern latitude, where the latitudinal circumferences were so much shorter, as opposed to sailing along the latitudes close to the equator that were then being explored by Columbus.

Additional support for Cabot's plan came from the testimony of cod fishermen who for years had been sailing out into the Atlantic from England, Portugal and the Azores and who occasionally reported seeing distant shores in the West. An interesting factor in the background was climate change. In the period from 1300 to 1850 northern Europe went through a period known as the "Little Ice Age." Historians and climatologists have studied reports of frozen rivers and lakes and charted the progress of glaciers to confirm the phenomenon, which had a serious impact on food supply and the spread of diseases. The north Atlantic, in particular, saw the isolation by frozen ice of the European settlements on Greenland, which lost contact with Europe after 1410. The colder currents also affected the cod population, which moved south and west, thus drawing fishing vessels ever closer to the North American continent.[62]

In 1496, Cabot received a royal patent from Henry VII to make voyages westward from Bristol looking for land that could be claimed for England. But the king provided no financing while also claiming "the fifth part of the whole capital gained."[63] Careful work in account books reveals that, as for Columbus, Cabot's expedition was made possible by Italian

financing—in this case by the Bardi Bank in England.[64] We know little about Cabot's first voyage of 1496, but his second, in 1497, turned him into another explorer-celebrity. The second expedition made landfall in Newfoundland and Nova Scotia (and possibly Maine), and they were claimed for England and the Christian religion. As a Venetian citizen, Cabot is said also to have unfurled a Venetian flag.[65] (Later, in the sixteenth century, there would be Venetians who pondered the possibility of claiming an Atlantic empire for Venice, alleging imaginary expeditions that preceded even that of Columbus.[66]) When Cabot returned to England in 1497 he was feted by the king. Then a larger expedition was outfitted that departed from Bristol in May 1498. . . . But it vanished.[67]

France was slower to reach into the Atlantic, but this nation too made use of an Italian: Giovanni da Verrazzano (1485–1528). Although it used sometimes to be claimed that Verrazzano was born to a branch of the family resident in Lyon, recent research has shown convincingly that he belonged to a major branch that lived in Florence.[68] These Verrazzano belonged to the office-holding class; they had considerable landholdings in the Chianti region; and in the fifteenth century they were linked politically to the Medici family.[69] Early in his career Giovanni worked as a commercial agent in Cairo and he probably learned seamanship in the eastern Mediterranean. In 1522 some Portuguese merchants wrote that Verrazzano was soliciting the support of the King of France, Francis I, for an Atlantic voyage. A French manuscript indicates that in March 1523 a syndicate was formed among a group of Florentine merchants in Lyon, including Verrazzano, to fund the expedition.[70] Four ships were sent out, although a storm soon pushed them back to France. After a further delay, in January 1524, Verrazzano sailed from Madeira in one ship that went directly toward the North American mainland, making landfall at Cape Fear in North Carolina. Verrazzano then proceeded up the coast, becoming the first European to enter New York harbor. Farther up the coast they arrived at Narragansett Bay, Nova Scotia and Newfoundland before sailing back to France. Upon his return, Verrazzano wrote a long and famous letter of 8 July 1524 to King Francis describing the journey and portraying vividly the Native Americans they encountered. His brother Girolamo, who accompanied him on the voyage, was a fine mapmaker who sketched the continent's shoreline and included these discoveries in a world map that he published in 1529. Giovanni, like the other Italians in this first wave of explorers who sailed for the Atlantic kingdoms, was careful to maintain his connections back home. Information from distant lands was always a precious commodity in the world of Italian high finance. Thus the detailed letter that Giovanni wrote to the king was sent in copy to the Florentine merchants with whom he had partnered in Lyon, and also to the partner in Rome of Giovanni's younger brother, Bernardo, who had a prosperous banking business there.[71]

Another voyage was planned in 1526, although its departure was delayed until 1528. Aiming for the Isthmus of Panama, and arriving first in the Lesser Antilles, it was probably on the island of Guadeloupe, visited previously by Columbus and Dr. Chanca in 1493, that Giovanni da Verrazzano went ashore, and—so it was said—in full view of the men aboard ship, including his brother, he was captured, killed, cooked and eaten by the local Caribs.[72]

Aftermath

According to French historian Pierre Chaunu, beginning with Columbus's first voyage, there were more than 500 voyages across the Atlantic before 1520.[73] The traffic would only increase. The consequences, including huge mortalities, the fall of the Aztec and Inca empires, the migration of peoples from Europe, the extraction of gold and silver, a growing commerce in slaves, and the imposition of new modes of governing, landholding and religion,

would be enormous and in some cases catastrophic.[74] And yet a connection between the hemispheres was someday inevitable. Knowing the history and character of the societies that were brought together, it is hard to imagine that it could have happened without catastrophic tragedies, beginning with the exchange of diseases that brought measles, smallpox, influenza and malaria to the western hemisphere, where they killed as many as 90 percent of the people, most of whom never saw a European before they died, and syphilis to Europe, where it brought disfigurement and death to many, especially during the virulent first decades of its transmission.

There were other, happier exchanges as well, however. The potato, the tomato, corn and the sweet potato crossed the Atlantic to Europe, Asia and Africa, as did tobacco, chocolate and peanuts. Thus the tomatoes and cornmeal polenta that today are such staples of Italian cooking arrived relatively late in the long history of Italian civilization. To the New World the Europeans brought livestock (cows, pigs, sheep, horses) and grains (wheat, rice, oats and barley), along with sugar cane, coffee, oranges and lemons, bananas and onions. They also brought honeybees and, to much of North America, where it had died out in the last great Ice Age, the lowly earthworm. Inevitably these exchanges, like those of diseases, would have occurred too. For good and for ill, this was when the world we live in began. For good and for ill, when it happened, there were Italian navigators and Italian financiers—all of them already immigrants living in foreign lands—who played leading parts.

Epilogue: Columbus Day . . .

Now in the storage deposit of the Newark Museum there is a huge and magnificent painting by Albert Bierstadt that portrays *The Landing of Columbus*. (See Color Plate 1.) True to his style as a landscape painter famous for scenes of the Rocky Mountains and Niagara Falls, Bierstadt emphasizes the natural grandeur of the surroundings, not the human actors. A tropical forest opens onto a brilliant beach. The figures of the natives and of Columbus and his men, like the Spanish ships in the background, all appear relatively small.[75] Although Bierstadt painted the canvas expecting to show it at the 1893 exposition in Chicago that celebrated the four hundreth anniversary of Columbus's arrival, he withdrew it when he learned that the jury preferred pictures that emphasized heroic human figures, as in a Spanish painting by Dióscuro Puebla, also depicting the arrival of Columbus, made popular in those years in a print produced by Currier and Ives. (See Color Plate 2.)

It was Bierstadt's particular gift that he knew to show in paint processes of the natural world that lie beyond the grasp of individual human beings. When he pulled his picture from the Chicago exposition, Bierstadt was in effect acknowledging that his contemporaries were looking for heroes in historical figures they believed had mastered nature. In the popular mind of the 1890s Columbus fit the bill.

The adoption of Columbus as a particularly American hero had begun many years before. Already in the colonial period the name "Columbia" was sometimes used as a substitute for "America." During the Revolutionary War, an African American poet, Phillis Wheatley, gave the name "Columbia" patriotic force in several striking poems.[76] After Independence, King's College in New York changed its name to Columbia College; the capital of South Carolina was named Columbia; the capital of the United States became the District of Columbia; and Ohio called its capital Columbus. The tercentenary of Columbus's voyage in 1792 was celebrated with events in Boston and New York.[77] Washington Irving's massive and very popular 1828 biography gave Columbus a romantic treatment that became a standard point of cultural reference.[78]

Although Columbus's Italian origins were of little importance to the general public—and indeed there were multiple mistaken attempts to assign him a different ethnicity (Spanish, Portuguese, Jewish, Greek)—Italian immigrants to the United States latched onto the idea that identifying with the Great Navigator was a way to affirm themselves as bona fide Americans. In 1866 there was a Columbus celebration in New York City sponsored by the Italian Sharpshooters' Association (*Compagnia del Tiro al Bersaglio*). In 1869 a similar tradition began among the Italians of San Francisco, many of whom, like Columbus, had roots in Liguria.[79] The *prominenti* of other cities, including Boston, St. Louis, Cincinnati and Philadelphia, initiated their own commemorations in the following decades.[80]

In American culture at large it was Columbus's role as an explorer, a heroic sea captain, and as the bearer of Christianity to the western hemisphere that spurred the popular devotion, not his *italianità*. The Knights of Columbus, for instance, is a Catholic fraternal organization founded in 1881 by a priest who was Irish American, and for several decades the Knights remained largely Irish, even as Italian immigration was soaring. The four hundredth anniversary celebrations of 1892–1893 that made Columbus central to the national narrative were directed not by Italian Americans but by a WASP elite that wanted to show off to the world the dynamism of the country's industry and the wealth of its natural resources. President Benjamin Harrison urged Americans to celebrate 21 October 1892 as a nationwide holiday, and he expressed the desire that the schools be especially involved in its celebration. An elaborate parade in New York was held in which there were contingents from Italian, Jewish and Native American schools, along with the city's public and parochial schools. The Chicago Columbian Exposition for which Bierstadt originally intended his painting, opened in 1893 and attracted visitors from around world.[81] The pronounced aim of these events was to celebrate diversity in an inclusive and universal way, and, for the times, that was indeed the effect.[82]

The quatercentenary celebrations also happened to take place at a time when immigration from Italy was reaching a peak yet also encountering substantial domestic resistance. It made sense for Italians who were coming to the United States to enhance the public devotion to Columbus, as a hero both with whom they could be identified and, who, in a way, legitimated their presence. Italian benevolent societies, such as the Sons of Columbus Legion (founded in New York in 1897, and the ancestor of today's Columbus Citizens Foundation), mounted annual parades and celebrations. Politicians and organizations like New York City's Tammany Hall that were eager to attract immigrant votes supported measures in many states to make Columbus Day an official holiday. In 1934, a joint resolution of Congress called on the President annually to designate 12 October as "Columbus Day," with local observances as deemed appropriate (including the many state holidays) and flags to be displayed on all public buildings. A series of such annual presidential proclamations, beginning with a proclamation by Franklin Roosevelt, date from that year. Meanwhile, the role of Italian Americans in Columbus Day expanded greatly, especially in the decades after World War II, when its patriotic celebration helped erase the embarrassing memory of Mussolini's declaration of war on the United States in 1941. It was largely a result of Italian American lobbying that, in 1968, in conjunction with the Uniform Monday Holiday Act, Columbus Day was established as a Federal holiday (sometimes called a "national holiday") to be celebrated on the second Monday in October by, among other things, the closing of Federal offices.[83] The Holiday Act came into effect in 1971, when Columbus Day was for the first time marked nationally as an annual federal holiday.

Twenty-one years later, however, at the time of the quincentenary in 1992, Columbus Day became controversial. Historians and scientists were gauging more accurately the demographic losses to indigenous populations that resulted from contact with Europe. Documents uncovered in European archives increasing historical knowledge concerning deeds—ranging

from the unsavory to the indefensible—committed by Columbus and his contemporaries. A greater popular awareness and regret for the harsh treatment of native populations over several centuries became an important factor. Native Americans were learning to press their causes in effective ways before the general public. These were developments that contributed to attempts on the local and state levels, still ongoing, to redefine Columbus Day as Indigenous Peoples Day.[84] And one understands why. Rather than attempt champion heroes and prosecute villains, however, it might stand as a humbling reminder of our common humanity if as we read this history, we interpret it from a perspective more like what we see in Bierstadt's *Landing of Columbus*. The painting underscores how small were the figures who that morning wrought such changes upon the world.

Further Reading

Abulafia, David. *The Discovery of Mankind: Atlantic Encounters in the Age of Columbus*. New Haven: Yale University Press, 2008.

Fernández-Armesto, Felipe. *Columbus* [1991]. London: Duckworth, 1996.

Phillips, William D., Jr. and Carla Rahn Phillips. *The Worlds of Christopher Columbus*. Cambridge: Cambridge University Press, 1992.

Notes

Many thanks to Francesco Guidi Bruscoli, David Harris Sacks and Kirsten Schultz for their careful reading of this chapter, and also to the late María Elena Martínez for some early suggestions.

1 From *The "Diario" of Christopher Columbus's First Voyage to America, 1492–1493*, ed. Oliver Dunn and James E. Kelley, Jr. (Norman: University of Oklahoma Press, 1989), 62–65. For convenient access to this and many of the other texts, see Christopher Columbus, *The Four Voyages*, ed. and trans. John M. Cohen (London: Penguin, 1969), with the quoted passage on 53; and Geoffrey Symcox and Blair Sullivan, eds., *Christopher Columbus and the Enterprise of the Indies: A Brief History with Documents* (Boston: Bedford/St. Martin's, 2005), with this passage on 68.

2 Columbus, *The Four Voyages*, 55–56.

3 Ibid., 72.

4 The crucial Italian contribution is unfortunately ignored in Jack P. Greene and Philip D. Morgan, eds., *Atlantic History: A Critical Appraisal* (Oxford: Oxford University Press, 2009).

5 Giovanni Boccaccio, *De Canaria et insulis reliquis ultra Ispaniam in Oceano noviter repertis*, ed. Manlio Pastore Stocchi, in Boccaccio, *Tutte le opere*, ed. Vittore Branca, 10 vols. in 12 (Milan: Mondadori, 1964–1998), vol. 5, pt. 1, 963–986.

6 In Piacenza the family was known as Pallastrelli; Luisa D'Arienzo, "La famiglia di Bartolomeo Perestrello, suocero di Colombo," *Bollettino della Società Geografica Italiana*, ser. 12, 12 (2007), 649–670.

7 On the rabbits, see Charles C. Mann, *1493: Uncovering the New World Columbus Created* (New York: Knopf, 2011), 291–292.

8 Miguel de Cervantes, *The History and Adventures of the Renowned Don Quixote*, trans. Tobias Smollett (New York: Modern Library, 2001), 85 (1.7).

9 Gabriella Airaldi, *Colombo: Da Genova al Nuovo Mondo* (Rome: Salerno Editrice, 2012), 144, suggests that Columbus, already sailing out of Lisbon by that date, could have received a copy soon after it reached the court. On fifteenth-century geographers, see the catalogue of the exhibition, *Firenze e la scoperta dell'America: Umanesimo e geografia nel '400 fiorentino*, ed. Sebastiano Gentile (Florence: Olschki, 1992).

10 Consuelo Varela, *Colón y los florentinos* (Madrid: Alianza Editorial, 1988), 25–26. See also the Italian translation of this important book: Varela, *Colombo e i fiorentini*, trans. Roberta Pieraccioli (Florence: Vallecchi, 1991).

11 Ruth Pike, *Enterprise and Adventure: The Genoese in Seville and the Opening of the New World* (Ithaca: Cornell University Press, 1966), passim; and Airaldi, *Colombo: Da Genova al Nuovo Mondo*, 67–92. For later developments see Céline Dauverd, *Imperial Ambition in the Early Modern Mediterranean: Genoese Merchants and the Spanish Crown* (New York: Cambridge University Press, 2015).

12 Varela, *Colón y los florentinos*, 19–21.

13 Ibid., 31.

14 Isidoro González Gallego, "El Libro de Privilegios de la Nación Genovesa," in *Historia, Instituciones, Documentos*, 1 (Seville: Universidad de Sevilla, 1974), 277–358; summarized in Helen Nader, "Desperate Men, Questionable Acts: The Moral Dilemma of Italian Merchants in the Spanish Slave Trade," *Sixteenth Century Journal*, 33.2 (2002), 401–422 (402).

15 Charles Verlinden, "Esclaves du Sud-Est et de l'Est européen en Espagne orientale à la fin du moyen âge," *Revue historique du Sud-Est européen*, 19 (1942), 371–406; Domenico Gioffrè, *Il mercato degli schiavi a Genova nel secolo XV* (Genoa: Bozzi, 1971).

16 Pero Tafur, *Travels and Adventures (1435–1439)*, trans. Malcolm Letts (New York: Harper, 1926), 134. Some spellings have been modernized.

17 Nader, "Desperate Men," 408. On Marchionni, see Francesco Guidi Bruscoli, *Bartolomeo Marchionni, "homem de grossa fazenda" (ca. 1450–1530): Un mercante fiorentino a Lisbona e l'impero portoghese* (Florence: Olschki, 2014).

18 Agostino Giustiniani, in his *Polyglot Psalter* of 1516 wrote that Columbus was "vilibus ortus parentibus," and he stated it again in his *Annals* of 1537. See Consuelo Varela and Isabel Aguirre, *La caída de Cristóbal Colón: El juicio de Bobadilla* (Madrid: Marcial Pons, 2006), 137–138; and Airaldi, *Colombo: Da Genova al Nuovo Mondo*, 110.

19 Varela and Aguirre, *La caída*, 137: "Eso que aveys fecho está bien, quequiera que dize mal de nos muerte meresçe, e asy es el derecho."

20 Ricardo Court, "Merchants in Spite of Themselves: The Incidental Building of a Genoese Merchant Network," *Viator*, 33 (2002), 355–376; Court, "'Januensis Ergo Mercator': Trust and Enforcement in the Business Correspondence of the Brignole Family," *Sixteenth Century Journal*, 35 (2004), 987–1003.

21 Airaldi, *Colombo: Da Genova al Nuovo Mondo*, 150–158.

22 Nader, "Desperate Men," 405–406, explains the family's move to Savona and dates it to 1470. Airaldi, *Colombo: Da Genova al Nuovo Mondo*, 131–136, does not explain the move, and she dates it only vaguely ("by 1474"), but she nicely explores its ramifications.

23 Airaldi's proposal, ibid., 142–148, that Columbus sailed with Colón the Elder, explains a period of Columbus's career that was previously little understood.

24 The world was portrayed this way on the Shield of Achilles by Homer, *Iliad*, XVIII. 606. For other ancient flat-earthers, see Jeffrey Burton Russell, *Inventing the Flat Earth: Columbus and Modern Historians* (New York: Praeger, 1991), 23–24.

25 Washington Irving, *The Life and Voyages of Christopher Columbus*, abridged ed. (London: John Murray, 1830), 37–40.

26 William D. Phillips, Jr. and Carla Rahn Phillips, *The Worlds of Christopher Columbus* (Cambridge: Cambridge University Press, 1992), 133–134.

27 Irving, *The Life and Voyages*, 51: "With an enthusiasm worthy of herself and of the cause, she exclaimed, 'I undertake the enterprise for my own crown of Castile, and will pledge my jewels to raise the necessary funds.' This was the proudest moment in the life of Isabella. . . . "

28 Varela, *Colón y los florentinos*, 49–57; Nader, "Desperate Men," 409.

29 Michele da Cuneo "Relación," in *Cartas de particulares a Colón y relaciones coetáneas*, ed. Juan Gil and Consuelo Varela (Madrid: Alianza, 1984), 239–240, translated in Symcox and Sullivan, eds., *Christopher Columbus*, 87–98 (87). On Columbus's old flame, see also note 35 below. Whether there was substance to this claim by da Cuneo, who was an old (and libidinous; ibid., 89–90) friend of Columbus's from Savona, is not known.

30 The letter of Dr. Diego Álvarez Chanca to the city of Seville is translated in Columbus, *The Four Voyages*, 129–157, with the passage quoted on 136–137.

31 David Abulafia, *The Discovery of Mankind: Atlantic Encounters in the Age of Columbus* (New Haven: Yale University Press, 2008), 187–192. It is perhaps worth noting that in 1493, apart from human beings, there were no large-boned land mammals on these Caribbean islands; Chanca, moreover, was a doctor of medicine.

32 Fernández-Armesto, *Columbus*, 128.

33 For a count of the number of slaves transported from the New World on Columbus's order, see Jalil Sued-Badillo, "Cristóbal Colón y la esclavitud de los amerindios en El Caribe," *Revista de Ciencias Sociales*, 30.1–2 (January–June 1993), 111–137 (137).

34 Nader, "Desperate Men," 414–420.

35 See the elegant study of Consuelo Varela and Isabel Aguirre, *La caída* (cited in note 18), also published in Italian as Varela and Aguirre, *Inchiesta su Cristoforo Colombo: Il dossier Bobadilla*, trans. Massimiliano Macconi (Genoa: Fratelli Frilli, 2008). Varela and Aguirre oddly overlook the fact that Beatriz de

Bobadilla—the governor of Gomera in the Canaries as Columbus was leaving on his second voyage—was the cousin of Francesco Bobadilla. Compare Phillips and Phillips, *The Worlds*, 288 n. 22.

36 Varela and Aguirre, *La caída*, 95–120.

37 The engraving shows Columbus himself in command, but if a particular incident was intended, it is more likely to have been one of the several hangings ordered by Columbus's brothers, Bartholomew or Diego.

38 Cervantes, *Don Quixote*, 854 (2.42).

39 Letter from Columbus to the Governess of Don Juan of Castile, 1500, translated (with small adjustments here) in Columbus, *The Four Voyages*, 274.

40 Felipe Fernández-Armesto, *Columbus* [1991] (London: Duckworth, 1996), 182–183.

41 Felipe Fernández-Armesto, *Amerigo: The Man Who Gave His Name to America* (New York: Random House, 2007), 48–56.

42 Ibid., 188.

43 Fernández-Armesto wrongly imagines that Vespucci had a twin brother, Matteo, who supposedly died in infancy (ibid., 14). In practice Florentines gave each child two baptismal names: a principal name and a secondary saint's name that was ordinarily discarded. "Amerigho" and "Matteo" were the two names recorded for Vespucci's baptism in the register in Archivio dell'Opera di Santa Maria dei Fiori, Registri battesimali, Maschi e Femmine, 1, fol. 94r. In this case "Matteo" was only Amerigo's secondary name.

44 Antonio Cammelli, *I sonetti faceti*, ed. Erasmo Pèrcopo (Naples: Jovene, 1908), 519.

45 The account of Raymond de Roover, *The Rise and Decline of the Medici Bank, 1397–1494* (Cambridge: Harvard University Press, 1963), subsequently followed by a popular author like Tim Parks, *Medici Money: Banking, Metaphysics, and Art in Fifteenth-Century Florence* (New York: Norton, 2006), has been substantially corrected for the later decades by Götz-Rüdiger Tewes, *Kampf um Florenz—Die Medici im Exil, 1494–1512* (Cologne: Böhlau, 2011).

46 Fernández-Armesto, *Amerigo*, 51.

47 The theme of "reinvention" is nicely emphasized in Fernández-Armesto's biography.

48 Translated in Luciano Formisano, ed., *Letters from a New World: Amerigo Vespucci's Discovery of America*, trans. David Jacobson (New York: Marsilio, 1992), 45–56. For the original Latin text with an Italian translation see most recently: Amerigo Vespucci, *Cronache epistolari: Lettere 1476–1508*, ed. Leandro Perini (Florence: Firenze University Press, 2013), 120–135.

49 Fernández-Armesto, *Amerigo*, 122–123, follows the excellent work of Luciano Formisano (*Letters from a New World*) with respect to the *Mundus Novus*, although he goes puzzlingly off-track when discussing the *Soderini Letter* (see note 52).

50 Maria Candelora Siliberto, "Il *Mundus Novus* di Amerigo Vespucci fra discipline geografiche, storiche e filologiche," *Rivista geografica italiana*, 105 (1998), 277–309. Romain Descendre, "Il nuovo mondo e l'altro. Augusta 1504. La prima edizione della lettera sul *Mundus novus* di Amerigo Vespucci," in *Atlante della letteratura italiana*, ed. Sergio Luzzatto and Gabriele Pedullà, 3 vols. (Turin: Einaudi, 2010), 1: 679-686, instead asserts (682) the work was translated by a Florentine merchant, Giuliano del Giocondo.

51 Translated in Formisano, *Letters from a New World*, 57–97. See also Vespucci, *Cronache epistolari*, 78–165.

52 Formisano, "Introduction," in *Letters from a New World*, XXXV. Fernández-Armesto, *Amerigo*, 123–132 oddly denies any claim to Vespuccian authenticity in the *Soderini Letter*.

53 Francesca Klein, "Note in margine a/di Agostino Vespucci, cancelliere nella repubblica soderiniana. Una storia prima delle *Istorie*?" in Lorenzo Tanzini, ed., *Il laboratorio del Rinascimento. Studi di storia e cultura per Riccardo Fubini* (Florence: Le Lettere, 2015), 211-238 (219). See also Gerard González Germain, "¿Agostino Nettucci, Alter ego de Agostino Vespucci? Cultura humanística y política en la Florencia de inicios del s. XVI," in *Acta Conventus Neo-Latini Monasteriensis*, 15 (Leiden: Brill, 2015), 237-247. In 1506, on business for Machiavelli, Agostino was engaged directly with the man who earlier printed the Soderini Letter, although he seems not previously to have known him in person: see *Machiavelli and His Friends: Their Personal Correspondence*, trans. James B. Atkinson and David Sices (DeKalb: Northern Illinois University Press, 1996), 121-123 (letter from Vespucci to Machiavelli of 14 March 1506).

54 The testament, dated 9 April 1511, is published in Varela, *Colón y los florentinos*, 142–146.

55 Varela, *Colón y los florentinos*, 78–81.

56 See especially George A. Holmes, "Florentine Merchants in London, 1346–1436," *Economic History Review*, new series, 13.2 (1960), 193–208.

57 For the account that follows, see [Edward Hall], *Hall's Chronicle, Containing the History of England During the Reign of Henry the Fourth, and the Succeeding Monarchs, to the End of the Reign of Henry the Eighth, in Which Are Particularly Described the Manners and Customs of Those Periods*, ed. Henry Ellis, 2 vols. (London: J. Johnson, 1809), 586–588.

58 See Francesco Guidi Bruscoli, "John Cabot and His Italian Financiers," *Historical Research*, 85 (2012), 372–393.

59 Varela, *Colón y los florentinos*, 95–107 (103).

60 Guidi Bruscoli, "John Cabot."

61 Raimondo Soncino to Ludovico Sforza, 18 December 1497, in *Calendar of State Papers, Milan*, ed. Allen B. Hinds, 1 (1912), 337.

62 Brian Fagan, *The Little Ice Age: How Climate Made History, 1300–1850* (New York: Basic Books, 2001), 69–77. In what might be termed a reverse movement from the Atlantic *into* the Mediterranean, these same decades witnessed huge growth in the shipping of Atlantic cod to southern France and Italy.

63 James Alexander Williamson, *The Cabot Voyages and Bristol Discovery Under Henry VII* (Cambridge: Hakluyt Society, 1962), 204–205.

64 Guidi Bruscoli, "John Cabot," 379.

65 Lorenzo Pasqualigo to his brothers in Venice, 23 August 1497, in Henry Percival Biggar, ed., *The Precursors of Jacques Cartier, 1497–1534* (Ottawa: Government Printing Bureau, 1911), 14–15: "the discoverer of these things planted on the land which he has found a large cross with a banner of England and one of St. Mark, as he is a Venetian, so that our flag has been hoisted very far afield."

66 Elizabeth Horodowich, "Venetians in America: Nicolò Zen and the Virtual Exploration of the New World," *Renaissance Quarterly*, 67 (2014), 841–877.

67 An English historian, Alwyn Ruddock, claimed to have found striking evidence of Cabot's return to England after what became a two-year voyage. Cabot allegedly settled a Catholic mission in Newfoundland and extended his exploration to the Chesapeake Bay. Unfortunately, Ruddock failed to publish the evidence, and upon her death in 2005 her notes and drafts were destroyed on her instructions. The effort to reconstruct her material has so far resulted only in the study of Guidi Bruscoli, "John Cabot," 372–374, which confirms a small portion of what Ruddock said she had found. In an essay of 2013, Evan T. Jones ("Bristol, Cabot and the New Found Land, 1496–1500," in *Exploring Atlantic Transitions: Archaeologies of Permanence and Transience in New Found Lands*, ed. Peter E. Pope and Shannon Lewis-Simpson [Woodbridge, U.K.: Boydell and Brewer, 2013], 28–30) stated that he and Margaret Cabot had discovered documents (still unpublished in 2016) that confirm Ruddock's affirmation of Cabot's return.

68 Alessandro Boglione, "Contributo alle biografie di Giovanni e Girolamo da Verrazzano," *Archivio storico italiano*, 157 (1999), 231–267.

69 See Claudia Tripodi, "Mercanti scrittori, mercanti viaggiatori tra città e famiglia: Firenze e le famiglie Vespucci, Da Empoli, Corsali, Da Verrazzano," in *Vespucci, Firenze e le Americhe*, ed. Giuliano Pinto, Leonardo Rombai and Claudia Tripodi (Florence: Olschki, 2014), 123–139 (136–138), which contradicts the speculative hypothesis, stated, e.g., in William F.E. Morley, "Verrazzano, Giovanni da," in *Dictionary of Canadian Biography*, 12 vols. (Toronto: University of Toronto Press, 1966), 1: 657–660, that Verrazzano was a republican who left Florence "to escape the repressive atmosphere" under the Medici.

70 Federigo Melis, "Uno spiraglio di luce sul finanziamento del primo viaggio di Giovanni da Verrazzano," [1970] in *I mercanti italiani nell'Europa medievale e rinascimentale*, ed. Melis and Luciana Frangioni (Florence: Le Monnier, 1990), 287–295; Lawrence C. Wroth, *The Voyages of Giovanni da Verrazzano, 1524–1528* (New Haven: Yale University Press, 1970), 57–66.

71 Published in Wroth, *Voyages*, 133–143. At the bottom of the copy of the letter now in the Morgan Library, Giovanni instructed that it be sent to one of two Florentines in Lyon for forwarding to Buonaccorso Rucellai. Buonaccorso Rucellai and Bernardo da Verrazzano, Giovanni's younger brother, were banking partners in Rome, where they lived in the same palace: Melissa M. Bullard, *Filippo Strozzi and the Medici: Favor and Finance in Sixteenth-Century Florence and Rome* (New York: Cambridge University Press, 1980), 99. Rucellai is mentioned in Rome in 1521 in F.W. Kent, *Household and Lineage in Renaissance Florence: The Family Life of the Capponi, Ginori and Rucellai* (Princeton: Princeton University Press, 1977), 210–211.

72 Wroth, *Voyages*, 237. Verrazzano is known to generations of New Yorkers on account of the bridge connecting Brooklyn and Staten Island that was named in his honor, albeit with a misspelling, as the "Verrazano Narrows Bridge."

73 Pierre Chaunu, *Séville et l'Amérique, XVIe-XVIIe siècle* (Paris: Flammarion, 1977).

74 Alfred W. Crosby, Jr., *The Columbian Exchange: Biological and Cultural Consequences of 1492* [1972] (Westport: Praeger, 2003), initiated what has become a classic discussion among historians, epidemiologists, biologists and anthropologists. For an intelligent, readable overview, see Charles C. Mann, *1493: Uncovering the New World Columbus Created* (New York: Knopf, 2011).

75 Bierstadt painted two other versions of the *Landing* about the same time. One hangs in the Municipal Courthouse of Plainfield, New Jersey. The other, which belonged to the American Museum of Natural History in New York, was destroyed in a fire in 1960.

76 Julian D. Mason, Jr., ed., *The Poems of Phillis Wheatley*, revised and enlarged ed. (Chapel Hill: University of North Carolina Press, 1989), 177: "Where e'er *Columbia* spreads her swelling Sails: / To every Realm shall *Peace* her Charms display, / And Heavenly *Freedom* spread her golden Ray." See also pp. 166–167, 169–171, 175–176.

77 Thomas J. Schlereth, "Columbia, Columbus, and Columbianism," *Journal of American History*, 79.3 (1992), 937–968 (940).

78 Claudia L. Bushman, *America Discovers Columbus: How an Italian Explorer Became an American Hero* (Hanover: University Press of New England, 1992), 107–126.

79 Charles Speroni, "The Development of the Columbus Day Pageant of San Francisco," *Western Folklore*, 7 (1948), 325–335 (328–329). Although the earliest documented celebration found by Speroni took place in 1869, the website www.sfcolumbusday.org (accessed 9 November 2016) dates the celebration from 1868.

80 Marie-Christine Michaud, *Columbus Day et les italiens de New York* (Paris: PUPS, 2011), 12; and Kathleen Loock, *Kolumbus in den USA: Vom Nationalhelden zur ethnischen Identifikationsfigur* (Bielefeld: transcript Verlag, 2014).

81 Erik Larson, *The Devil in the White City: Murder, Magic, and Madness at the Fair That Changed America* (New York: Random House, 2003), offers a well-researched (and gripping) read about the Chicago Exposition.

82 On the inclusive character of the 1892 celebrations, see William J. Connell, "Who's Afraid of Columbus?" *Italian Americana*, 31.2 (2013), 136–147.

83 One very active campaigner was Neil Trama, of Scranton, Pennsylvania, whose family kindly shared a file of his letters and clippings.

84 Berkeley, California, was the first municipality to do so, proclaiming 12 October 1992 as "Indigenous Peoples Day." In 2014 Minneapolis and Seattle passed similar measures. The California state legislature contemplated a bill to replace Columbus Day with Native American Day, but in 2014 chose instead to designate the fourth Friday of September as Native American Day. In 2016, in the Colorado state legislature, a bill to replace Columbus Day with Indigenous Peoples Day was voted down in committee. The president of the National Italian American Foundation recently argued that if local governments decline to celebrate Columbus Day they should replace it with "Italian American Heritage Day": John M. Viola, "A Day About Italians Should be Called Just That," *National Italian American Pensieri Italo-Americani Blog* (10 October 2016).

FROM THE PILGRIM FATHERS TO THE FOUNDING FATHERS

Italy and America

Edoardo Tortarolo

The Theory of American Inferiority

The American continent was discovered by seafaring powers that were looking beyond Europe for new spaces and opportunities for wealth in the second half of the fifteenth century. Spain and Portugal were the protagonists of the construction of empires in America that were linked to settlements in Asia. Competition with the Spanish and Portuguese over these territories came from the French, the English and the Dutch. The colonial struggle became all the more violent because commercial and strategic rivalry was reinforced for England and Holland by the confessional difference created by the Protestant Reformation. Spain and Portugal were the bearers to the New World of a Counter-Reformation Catholicism that was engaged in combat against heretics of all kinds. With the union of the Spanish and Portuguese kingdoms from 1580 to 1640 the American future appeared to lie entirely in the hands of the Spanish monarchy. Although there were voyages of exploration by the French and English throughout the sixteenth century, these resulted in no significant settlements on the Atlantic shore of North America until the beginning of the seventeenth century.

For the Italians of the sixteenth century who were slowly learning the importance of the continents discovered by Christopher Columbus, North America was a place about which very little was known, much of it of a fabulous nature. The most important example is that of Giovanni Botero, from Piedmont, who between 1591 and 1596 wrote what would become the most widely read political-religious geographical text of its time, the *Relationi universali* [Reports on the World].[1] This global history from the end of the sixteenth century included a description of North America that was based on a map by Abraham Ortelius.[2] Botero was a firm upholder of Counter-Reformation Catholicism, a Jesuit and a political adviser to several Catholic rulers. When he described the attempts of Martin Frobisher to find a North-west Passage to Asia in 1578 he attributed the failure to "nature," which opposes heretics. Botero described the native populations of the Americas as devil worshipers who practiced human sacrifice. He believed in the existence of a mythical city known as "Norumbega," lying on the banks of a great river south of Acadia that the French navigator Jean Allefonsce claimed to have visited in 1542. North America, according to Botero, was destined by God to be governed by Spain. Preaching, conversion and political rule would follow armed victory over the locals. The New World could not be left open for English heretics. Botero's sources were, of course, Spanish, especially Acosta.

The Italian states of the sixteenth century were closely bound to the Spanish empire, with the result that Italians participated in the creation of the empire's institutions in America as soldiers, government functionaries, and as members of the religious orders that arrived in the wake of Spanish expansion. There are quite interesting reports concerning some of them.

Marco da Nizza was a Franciscan who took part in the 1539 expedition into Arizona led by Mendoza in search of the legendary city of Cibola. In his report he said that he had seen the city in all its beauty and riches and in the name of the King of Spain he had declared those lands to be the "New Kingdom of Saint Francis."[3] At about the same time there were three Italians from Liguria and Sardinia who were active in the Spanish army led by de Soto that in 1543 reached Arkansas. A "Francesco," one of the Italians, was responsible for building the boats to go down the Mississippi so that the expedition could return to the Gulf of Mexico.[4] Later, in the 1680s, the Italian Jesuit Eusebio Chini accompanied three scientific expeditions to Baja California. In what is today Arizona he is known to have preached to the people of Pima, and at Sonora he introduced the inhabitants to more effective methods of cultivation and animal husbandry.[5]

In the 1600s, however, the Spanish failed to realize their hope of conquering and converting the entire North American continent. The global balance of power favored France, which from Canada launched its commercial and military penetration of the Mississippi Valley, and England, which founded colonies along the Atlantic coastline. These strategic choices of the great monarchies made it possible for certain Italians to start new lives in America.

The best-known case is that of Enrico Tonti, born at Gaeta, who came from a family that was active in the revolt of Naples against the Spanish that had been led by the fisherman Masaniello in 1647. France supported the Neapolitan revolt, and after its failure Tonti and his family fled to that country, where he enlisted in the army of Louis XIV. He accompanied René-Robert de La Salle in his explorations of Lake Ontario and the Mississippi basin down to the Gulf of Mexico. Tonti's experience in dealing with Native Americans enabled him to become a thriving fur trader, and, with the help of a group of Jesuits, he worked to establish a French colony on the Gulf of Mexico, where he died in 1704, fourteen years before the founding of New Orleans in 1718.

In Catholic Italy there existed a small religious minority that traced its roots back to the twelfth century, when a man named Pietro Waldo began a reform movement that by retreating to the mountains of southern Piedmont survived the attempts of ecclesiastical and civil authorities to suppress it as a dangerous heresy. The Waldensians were subject to new persecutions in the sixteenth and seventeenth centuries, and in 1655, during Easter Week, Piedmontese troops were sent in an effort to exterminate them. The Protestant nations, England and Holland in particular, assisted the Waldensians, and John Milton wrote in their defense. In 1656 a group of about 150 Waldensians, with funding from the City of Amsterdam and other Protestant sources, sailed from Holland and landed in Delaware, where they founded a Waldensian colony on land then controlled by the Dutch.[6]

The presence in North America of these Italian soldiers, explorers, preachers, missionaries and religious exiles was assuredly small. Italians made up only a tiny part of the European population that came to America in the seventeenth and eighteenth centuries. Their small numbers found an echo in the ignorance and neglect of Italian learned culture with respect to North America. Italy's great intellectuals and philosophers continued in their fanciful notions, and whatever they knew of America was entirely Spanish America. The proposition that the climate in America was inferior to that of Europe, which Botero had advanced at the end of the sixteenth century, continued to be generally accepted.

Vice versa, it has to be remembered that the first English colonists on the Atlantic coast brought with them the dim view of Italy that had been transmitted to English culture by Calvinist Italian refugees from the Inquisition. Especially representative of Catholic oppression in Italy was the dramatic life of Galeazzo Caracciolo, a military hero from an old Neapolitan family, who died in Geneva in 1586 after fleeing religious persecution. His biography, written by his friend Nicolao Barbani, was translated into English with the title *The Italian*

Convert: News from Italy of a Second Moses. The book became very popular in the English and Anglo-American world, with nine editions in English between 1608 and 1689. The book was cited by Cotton Mather in his *Magnalia Christi Americana* [The Glorious Works of Christ in America] and there were even editions published in New England in 1751 and 1794.[7]

News from America

A genuine change in the way Italy thought about North America took hold at the time of the Seven Years' War. News of the battles being fought in America between English and French troops for the control of the natural resources of the New World was published ever more frequently in Italian gazettes. These were newspapers that were ordinarily published twice a week and drew their notices from the English papers. They were fundamental in reestablishing contact between Italy and Northern Europe and in creating in Italy a public that was informed about current events throughout the world.

With respect to North America, it was in Tuscany that there was the greatest interest. There, after the death of Gian Gastone de' Medici, the last Grand Duke of the Medici family, the government had entered the orbit of the distant Austrian monarchy, resulting in certain cultural freedoms. Florence, moreover, was a preferred goal of English gentlemen on the Grand Tour; while Livorno, as a free port, maintained intense commercial ties with England while supporting a large population of foreigners, many of them English. It should be no surprise that it was in Livorno, in 1762, that there began to be prepared and then published an Italian translation of the *American Gazetteer* of London: the *Gazzettiere Americano.* This was no less than an ongoing encyclopedia of the Americas, with a large share dedicated to the Atlantic colonies, their growing populations and their commerce. In the *Gazzettiere Americano* an Italian public could follow the events of the French–English war with a great deal of accuracy, acquiring even an understanding of the culture of America's native populations, albeit through the lens of European history. In an essay on the Hurons, drawn from the collection of the Jesuit Charlevoix, it was stated that the Hurons made decisions with as much wisdom as the Roman Senate during the best period of the Roman Republic.[8]

At Venice, the capital of the Italian publishing industry in the eighteenth century, William Burke's *An Account of the European Settlements in America* was published in Italian with the title *Storia degli stabilimenti europei in America.* In its seventh "part" the book included numerous reports concerning the Atlantic colonies, stating among other things that the exportation of "choice cod fish" to the Mediterranean resulted in commercial ties between Boston and Italy.[9] Publications in Italian like the *Gazzettiere Americano* and the *Storia degli stabilimenti europei* provided context for the items concerning North America that began appearing frequently in the standard annual news summary known as the *Storia dell'anno.* There, in 1761, Italian readers could learn about the relations of the Iroquois (*Chirochesi*) with the French and English governors during the previous year.[10] In 1764 the terms of the peace treaties that ended the Seven Years' War were published, including the new boundaries that assigned supremacy on the continent to the English and the rules that would govern relations between England and her new subjects in Canada.[11]

There was however a need for a broader understanding of the context in which to situate the news that was coming from America with increasing insistency. The end of the Seven Years' War meant a greater interest in Italy on account both of North America's role in the British Empire and the global crisis in international relations that developed between the 1760s and the 1780s. Gazettes, above all the *Notizie del Mondo* and the *Gazzetta Universale,* both of them published in Florence, offered abundant and precise information on the crisis in relations between London and the American colonies. It was through news from North

America that Italian readers familiarized themselves with such political concepts as the right to be taxed only by one's own representatives and with possible ways for reforming political and fiscal institutions. Words like "despotism" (*dispotismo*) and "resistance" (*resistenza*) came to be used ever more frequently. The sources for these news accounts were English periodicals, some of which reflected the view of Parliament whereas some were with the Opposition: Italian readers had access to both versions of events.[12]

Franklin and Italian Electricity

From the 1760s, when he arrived in London as the representative of the Pennsylvania colony, Benjamin Franklin fired the interest of certain Italians who were interested in him both on account of his diplomatic mission and his scientific achievements.[13] The popularity of Franklin's lifestyle and his way of thinking was something that Italian readers grasped intuitively. His successes in so many areas led to the revision of long-held ideas about the American continent, resulting finally in the discarding of the thesis that "nature" there, with its contrary climate, caused the "degeneration" of intelligence and human vitality. Franklin seemed to demonstrate just the opposite. Already in 1756 the Milanese mathematician and physicist Paolo Frisi wrote a letter to Franklin and he probably visited him in London ten years later.[14] When Alessandro Verri met him in London in 1767 he called him the "Newton of Electricity."[15] The publication in 1774 of a *Scelta di lettere e opuscoli del signor Beniamino Franklin* [Selection of letters and small works. . .], which included *Poor Richard's Almanack*, cemented his popularity.[16] In that same year, interest in Franklin's political point of view was demonstrated by the publication in Milan in the French language of a book titled *Précis de l'état actuel des colonies angloises dans l'Amérique Septentrionale* [Summary of the Present State of the English Colonies in North America], with an appendix containing the speeches made by Franklin in the House of Commons in 1767. The book praised Philadelphia as an experiment in humanity and the respect for natural laws and it reinforced the image of Franklin as a political sage who was able to address Parliament calmly and firmly.[17]

Perhaps Franklin's greatest influence on Italy, however, was in the realm of science. The Piedmontese scientist Giambattista Beccaria was the intermediary by whom the theories of Franklin on electricity became widely known and appreciated.[18] Beccaria's book of 1753, *Elettricismo naturale e artificiale* [Natural and Artificial Electricity], was inspired by Franklin's writings. Its propositions were verified in Bologna by the female scientist, Laura Bassi, and then presented by Giuseppe Toaldo to a larger public, thus becoming instrumental in modernizing scientific endeavor in Italy.[19]

In addition to the studies of electricity that resulted in the invention of the lightning rod, Franklin devoted himself to the problem of the conservation of heat. The Grand Duke of Tuscany learned of the stove that Franklin had invented and he asked a Tuscan in London, Filippo Mazzei, to procure two of them to be shipped to Florence.[20] Franklin's invention stood thus at the beginning of the Mazzei's adventure in America, which became the single most intense intellectual exchange involving an Italian and North America at the end of the 1700s.

Mazzei the Revolutionary Agitator

Within the context of the relations between North America and Italy in the eighteenth century the case of Mazzei (portrayed in Color Plate 3) is truly exceptional. He was the Italian who best understood American geography, American society and American politics, and who inserted himself into American culture at the time of the Revolution with the greatest

success. He arrived in Virginia in 1773 having already gained significant experience in life and in commerce outside of Italy. Born near Florence in 1730, he came into conflict with the Church in Tuscany and moved to Istanbul. From there he went to London where, in the 1760s, he came to know a number of English politicians as well as the representatives of the colonies in North America, Franklin among them. His admiration for English liberty led to an interest in the American colonies, where he imagined it would be possible to live under institutions even more just and equitable than in England and to have financial successes more profitable. Once in Virginia Mazzei bought land at Colle, close to the Monticello of Thomas Jefferson, whose friend and supporter he became. Mazzei brought with him the curiosity and learning that derived from his Tuscan upbringing but also a familiarity with British institutions acquired during the sixteen years of his residence in London (1756–1772). He understood through and through the Whig culture that nourished the resistance to English Parliament of the colonies and he joined a group of the colonists' leaders that included, in addition to Jefferson, James Madison, William Henley and George Washington.

Mazzei was an active entrepreneur and he began to do business in Tuscany, where he shipped tobacco and grain through the port of Livorno. As the conflict between the colonies and England became more acute, his export business dropped off, and Mazzei dedicated himself with a passion to the political struggle. To Grand Duke Pietro Leopoldo he wrote a report on the events of 1774 that was published in four parts in the *Gazzetta Universale* of June 1775. Here Mazzei presented for the first time to Italian readers the political and historical case that had been made by Thomas Jefferson in the latter's *Summary View of the Rights of British America*, composed in July 1774, which had defended the legitimacy of the resistance of the colonists.[21] According to Mazzei, the English affronts derived from a conspiracy against the colonies that aimed to deny them their rights as Englishmen and impose a political and economic despotism through the imposition of new taxes not authorized by the colonies' representatives. The opposition to Parliament was creating among the American colonists a patriotism that could triumph over the English. Thanks to Mazzei in 1775 Italian readers received a clear view of the charges being made by the American colonists that they could contrast with the Parliamentary interpretation then dominant in the Italian gazettes.

Mazzei did not limit himself to propaganda for Italian consumption. He also threw himself into the revolutionary movement in Virginia. He was elected as one of the twelve members of the committee for Albemarle County. In the spring of 1775, at the time of the events in Massachusetts, he volunteered for the independent company of Albemarle. At the same time he wrote articles for the *Virginia Gazette* encouraging the anti-English resistance. These articles are interesting inasmuch as they show that Mazzei understood David Hume and various Enlightenment thinkers and that he appropriated their theories of human nature. They also show him opting for the creation of a new nation already in the spring of 1775. He wrote against Robert Carter Nicholas, who had wished (in the latter's *Considerations on the Present State*) "that Things may return to their old Channel, when we lived a free and happy People."[22] Mazzei on the contrary wanted to create a new state and a new form of government. In May 1776, when Virginia declared its independence and there was debate over the form of the new constitution to adopt, Mazzei circulated a text of *Instructions of the Freeholders of Albemarle County to Their Delegates in Convention* in which he called for a representative democracy based on the notion that

> The people are the Land-Lord, the Representatives are the Steward, & by the persons under the Steward's direction is meant the Members of the executive, & all those, who may be found both convenient & advantagious [*sic*] to the Community,

that they should be chusen [*sic*], their salaries and emoluments appointed, by the Representatives, rather than by the People at large.[23]

At the same time, Mazzei warned against creating an aristocratic government beyond the control of the people and concentrated in a

[. . .] few leading families, their relations, & connections, & Government reduced in substance to a tirannic [*sic*] Aristocracy, & perhaps Oligarchy insolently exercised under the shadow of Liberty.[24]

He therefore urged strong limitations on the government's representatives:

It is incontestable, that the freedom of a Community is reduced in proportion to the power conferred to a small number of its members, & that such reduction of freedom is a necessary evil in an extensive Country, where all the People cannot meet at one place to transact their public concerns. Therefore it would be inconsistent with prudence, and with justice due to our posterity, to delegate any more than what is absolutely necessary to the good Government of a free State.[25]

The goal he declared was

[. . .] to make every body sensible of his consequence, as a member of society equal to any other in his natural rights; to make us more conversant with the Laws, better reconciled with them, & happier under them [. . .].[26]

All the same, Mazzei remained an outsider in Virginia politics. He had brought with him political principles ripened in Europe, in Enlightenment debates that much of the *élite* in the new state found difficult to understand and accept. Foreign affairs, diplomacy and spreading word abroad about the new developments in America proved more congenial to his talents. One fundamental problem for the new American state, in Mazzei's view, was an economic and financial weakness that made it necessary to collaborate with European states that were hostile to English commercial and political monopoly. If the United States received assistance from the European powers they could better arm themselves and more easily defeat the English army. Thomas Jefferson proposed several times that Congress name Mazzei its diplomatic agent in Italy, but without success. Franklin, the new state's ambassador in Paris, was contrary to the requests for military assistance being promoted by Mazzei, and it was he who directly controlled Congress's diplomacy in Europe. The issue was skirted in 1779 when Virginia alone named Mazzei as its agent for obtaining funds and arms in Italy, and in particular from Grand Duke Pietro Leopoldo of Tuscany.[27] Mazzei departed in June 1779, when the military and political situation in Virginia had become especially precarious. Taken prisoner by the English, he was released in September and reached Europe in October 1779.

Making the Case for America

Practical results in terms of funds and arms were minimal. Mazzei remained a loyal supporter of Thomas Jefferson's diplomacy once Jefferson became ambassador in Paris in 1784, whereas his relations with John Adams were cold and sometimes tense. The importance of Mazzei's work in extending European knowledge of the Americans cannot be overvalued.

Apart from his reports to Pietro Leopoldo and articles written for gazettes, Mazzei wrote the most important book about the American experience to be published in Europe in the 1700s: his *Recherches historiques et politiques sur les États-Unis de l'Amérique septentrionale* [Researches Historical and Political on the United States of North America]. Prepared over two years' time, written in French and published in four volumes in Paris in January 1788, it appeared on the eve of the French Revolution.[28] Mazzei was helped by Jefferson, who knew how important it was to win favorable opinion in Europe, and by the French theorist Nicolas de Condorcet, who hoped that the United States would inspire in Europe a politics of renovation and transformation.

Mazzei's *Recherches* targeted in particular two writers he thought were spreading mistaken and damaging ideas about the new American regime. The Abbé de Mably had written his *Observations sur le gouvernement et les loix des États-Unis de l'Amérique* [Remarks Concerning the Government and Laws of the United States of America] (published in 1784) at the request of John Adams. Mably was an anglophile who interpreted the institutions that had been developed in the American Revolution in the light of European republicanism. According to Mazzei, Mably failed to understand the maturity of the American people who were creating a new example for all of humanity to follow. Education and culture stood at the core of American innovation. The stability of the American republic would be guaranteed by the reasonableness of the population, not by an ingrained deference to social superiors (as in England). Most of the population was literate, and since Americans understood honest value they were not likely to fall under the sway of manipulators and demagogues. In this way the Americans would avoid the errors of the direct democracies of antiquity and show that liberty and practical knowledge of the world are supportive of one another.[29] Mazzei furthermore underlined how different American social structure was from Europe's. There were no separate "orders" of men and women, each with rights and specific privileges. All were united in that they had the same possibilities for economic success and political careers. Even the black slaves would be freed as soon as circumstances permitted it. (Mazzei himself possessed slaves on his farm at Colle.)[30]

Mazzei's second target was the Abbé Raynal, the author and editor of an *Histoire philosophique et politique des deux Indes* [History, Philosophical and Political, of the Two Indies], originally published in four volumes in 1770 but revised and augmented over the next decade. Mazzei held that there were two untenable theses in the book. The first was the old canard that the American continent was inferior to Europe—a belief that eighteenth-century naturalists like the Comte de Buffon and Cornelis de Pauw extended to the plant and animal species of the New World. Mazzei wrote that on the contrary plants, animals both wild and domesticated and, of course, human beings, prospered there just as in Europe.[31] Raynal's book also argued, in a passage in fact written by Denis Diderot, that American liberty was exceptional and could not be broadened and applied to the other peoples of the globe. The alliance of the governments of France and the United States was a matter of diplomacy, but it implied no American support for replacing the French absolute monarchy with a republic. Not so for Mazzei, who cited extensive parts of Jefferson's *Notes on the State of Virginia* and Thomas Paine's *Common Sense* in confuting this idea and arguing for the universal qualities of the new American regime.

The *Recherches* of Mazzei were also important in Italy, especially since an Italian wrote them. Most of the Italians who came to North America in the 1700s maintained no contact with their homeland. For example Carlo Bellini, a friend of Mazzei's, came to Virginia and became the first professor in the Italian language in the United States (at the College of William and Mary), but there is no evidence of continuing ties to Italy.[32] Alessandro Scalvini, from Brescia, was one of the few Italians to serve as an officer in the French naval expedition

of Rochambeau to assist the colonists. After three years in America, from 1779 to 1781, he returned home without publishing observations or memoirs. Another subject of the Venetian Republic, Pierantonio Gratarol, visited Baltimore in 1784 and from there left on an expedition to Madagascar, where he died the following year.[33] Diplomatic ties between the Italian states and the new republic were also scarce at the end of the eighteenth century. Popular interest continued to grow, however, as can be seen from a series of "American" novels written by the former Jesuit Pietro Chiari and others in the 1760s, '70s and '80s. A very popular novel published in 1763, once attributed to Chiari but now of uncertain authorship, *L'Americana raminga* [The Wandering American Girl] is representative. The protagonist is a Peruvian girl who moves to Boston and both that city and New England in general are described with a certain amount of detail.[34] But most of the information received in Italy arrived indirectly, through the translation of English or French texts—like the *History of the Two Indies* to which Mazzei objected—or through gazettes and book reviews.[35]

The Italian Enlightenment

While Mazzei was disseminating a new view of America, many Americans were becoming interested in the Italian Enlightenment. As early as 1770 the young John Adams cited the theorist and jurist Cesare Beccaria, whose short treatise *Dei delitti e delle pene* [On Crimes and Punishments] (1764) remains famous today for its condemnation of torture and capital punishment. Mazzei contributed to the success of Beccaria in America by including his work in the cases of Italian books he ordered to be shipped to Virginia. Three copies of *On Crimes and Punishments* (in Italian) were included in a shipment of January 1775; one of the volumes he gave to Jefferson; and Jefferson (who read Italian) copied many of its passages in his *Commonplace Book*. Beccaria's text would then serve as the basis of the philosophical preamble to the *Bill for proportioning crimes and punishments in cases heretofore capital* that Jefferson presented in 1778.[36]

For Jefferson, Italy had a cultural presence that was modern. Jefferson was interested in the ways Italy was contributing to human well-being. When, in the spring of 1787, he traveled from France to northern Italy he was curious about techniques for the growing of rice, the production of white and red wine and cheese manufacture. He wrote to a friend, "Italy is a field where the inhabitants of the Southern states may see much to copy in agriculture." Jefferson became so interested that he exported grains of rice illegally in order to experiment with methods of cultivation.[37] His knowledge of Italy was up-to-date thanks to his correspondence with Giovanni Fabbroni, an economist and scientist who was the second Director of the Gabinetto di Fisica e di Storia Naturale in Florence, where he was inevitably sought out by American visitors.[38] But Jefferson, on account of these concrete and current interests, was something of an exception among the Americans who cared about Italy, since most were instead interested in the older history of Italian republicanism.

Of the American politicians of the Revolutionary generation who studied European republicanism, and Italian republicanism in particular, and who thought that this offered lessons for the new republic, John Adams was certainly the most eminent. His chief work in this area was a three-volume *Defence of the Constitutions of Government of the United States of America* (1787–1789). He conducted meticulous research concerning the institutions of the medieval republics of Florence, Venice, Siena, Bologna, Pistoia, Cremona, Padua, Mantua and Montepulciano. As John Pocock has written, however, the *Defence* is most appropriately seen as the last work in a line of republican writing that began with Italian Renaissance. At the end of the eighteenth century the *Defence* made no connections to modern Italy while its impressive erudition proved of little use for America.[39]

Just as Jefferson journeyed with attention to the realities of northern Italy, similarly, in 1785, a Milanese nobleman, Count Luigi Castiglioni, traveled in America and published a detailed report of what he saw.[40] Castiglioni was a botanist, and his observations reflect a scientific culture that made his book a sober and well-informed source of information on the new country. His firsthand experience with American realities in the years after independence led him to admire many aspects of life both in the large cities (he visited Boston, New York and Philadelphia) and in rural areas. He was impressed by the guarantees of religious freedom, but he also saw and condemned the practice of slavery and the mistreatment of the indigenous population. He was attentive to the demonstrations of social and economic unrest that culminated in Shays's rebellion and he did not close his eyes to the existence of economic and social inequality among the citizens.

The Dream of America

Castiglioni and Mazzei were exceptions. The imprecise and indirect knowledge of America that was possessed by most of the other Italians who wrote about the United States was such that they projected onto the new state wishes and dreams that were far removed from reality. For Italy in the '70s, '80s and '90s of the eighteenth century it is fair to apply the formula advanced sixty years ago with respect to the French view of America by Durand Echeverria in his classic book, *Mirage in the West*.[41] Italians were looking for an ideal of moral justice that had become a political reality. They found it in the United States of America. Moved only by their dreams and the desire to live under a tolerant, just and pacific regime, many Italians wrote to Franklin requesting help in emigrating to America.[42] Late Enlightenment discourse in Italy commonly featured discussions of the American state constitutions and their protection of human rights. The declarations of rights in the preambles of these constitutions became extremely popular. Members of Italian masonic lodges were always seeking to learn more about *Libertas Americana*, and Franklin, who had been very popular in the French lodges inspired them.

The most famous example of an Italian who became passionate about the possibilities now opened by the American Revolution was Gaetano Filangieri, a political philosopher in Naples whose most famous book was *La Scienza della Legislazione* [The Science of Legislation].[43] In a letter to Franklin of 2 December 1782 the Neapolitan described how he wished to come to Philadelphia to live under the new laws there.[44] Franklin dissuaded him, but the two remained in correspondence until Filangieri's death in 1788. Filangieri's main work, the *Science*, reflected the American model throughout. The Revolution, he thought, offered hope of saving Europe from its decadence. Living conditions in America were idealized. Pennsylvania was the "fatherland of heroes, the nursery of liberty and the admiration of the universe." Moral vices were absent, families worked hard and had many children, the women were "sweet, modest, compassionate, generous," and wealth was distributed equitably. Slavery, however, he criticized.[45]

Filangieri is the most apparent case of an Italian interested in the new American state, but in reality there were many Italians who were fascinated by what was happening in the former British colonies. Between 1781 and 1783 the great writer and patriot Vittorio Alfieri penned five odes under the title *L'America libera* [America the Free] that he published in 1784. He claimed to find in the United States the proof that a country really could exist without "tyranny" of any kind, as he had earlier stated in 1777 in his treatise *On Tyranny*.[46] Alfieri projected onto the Americans his ideal of soldier–farmers, of men ennobled by their direct contact with nature and by a way of life that was free and authentic. He thought that Franklin, Lafayette and above all Washington had led a just revolt against English tyranny and they represented the hope of the human race.

With the outbreak of the French Revolution the meaning of American independence changed. In his *Storia della guerra americana* [History of the American War], published in 1809, Carlo Botta reinterpreted the American events in a key that was more moderate when compared with the destructive radicalism of the French Revolution and the need to bring order to its consequences under Napoleon.[47] This was only one of the changes that took place in the passage from the 1700s to the 1800s. Diplomatic relations became more stable and intense. Commercial ties grew. A better understanding of the United States could be found in Italy, and the demand in America for musicians, teachers, painters and sculptors began slowly to change American perceptions. The "myth of Arcadia" attracted elements of the American *élite* to Italy.[48] Most importantly there developed a growing emigration of Italians for political reasons. The result was a perception of the United States by Italians that was more complex, varied, and in some respects contrary to the enthusiasms registered by Filangieri and Alfieri.[49]

Translated by William J. Connell

Further Reading

Buccini, Stefania. *The Americas in Italian Literature and Culture: 1700–1825*. University Park: Pennsylvania State University Press, 1997.

Gerbi, Antonello. *The Dispute of the New World: The History of a Polemic, 1750–1900*. Pittsburgh: University of Pittsburgh Press, 1973.

Venturi, Franco. *The End of the Old Regime in Europe, 1776–1789*, vol. 1: *The Great States of the West*. Princeton: Princeton University Press, 1991.

Notes

1 Giovanni Botero's *Le relationi universali* was first published in Rome in 1591, followed by numerous editions and important supplements; Aldo Albonico, *Il mondo americano di Giovanni Botero* (Rome: Bulzoni, 1990). See the edition: Giovanni Botero, *Le relazioni universali*, ed. Blythe Alice Raviola, 2 vols. (Turin: Aragno, 2015).

2 Norman J. W. Thrower, *Maps and Civilizations: Cartography in Culture and Society* (Chicago: University of Chicago Press, 1996); Jerry Brotton, *A History of the World in Twelve Maps* (London: Allen Lane, 2012).

3 *Scopritori e viaggiatori del Cinquecento*, ed. Ilaria Luzzana Caraci (Milan: Ricciardi, 1996), 617–650. His report was printed in the collections of both Ramusio and Hakluyt.

4 Russell Magnaghi, "Louisiana's Italian Immigrants Prior to 1870," *Louisiana History*, 27 (1986), 43–68 (44).

5 Serena Luzzi, "Il gesuita, la guerra, gli Apaches. Il ruolo diplomatico di Eusebio Francesco Chini, missionario di frontiera," in *Eusebio Francesco Chini e il suo tempo: Una riflessione storica*, ed. Claudio Ferlan (Trent: Fondazione Bruno Kessler, 2012), 103–142. Among the notable missions Chini founded was San Xavier del Bac, in Tucson, Arizona, although the mission's remarkable church dates from the late 1700s.

6 Giorgio Vola, "Cromwell e i Valdesi: una vicenda non del tutto chiarita," *Bollettino Società Storica Valdese*, 149 (1981), 11–37.

7 Emidio Campi, "The Italian Convert: Marquis Galeazzo Caracciolo and the English Puritans," in *Shifting Patterns of Reformed Tradition*, ed. Campi (Göttingen: Vandenhoeck und Ruprecht, 2014), 285–295; William J. Connell, "Darker Aspects of Italian American Prehistory," in *Anti-Italianism: Essays on a Prejudice*, ed. Connell and Fred Gardaphé (New York: Palgrave Macmillan, 2010), 11–22; Giorgio Spini, "The New England Puritans and Italy," *Storia nordamericana*, 3 (1986), 95–105.

8 *Il Gazzettiere Americano, contenente un distinto ragguaglio di tutte le parti del Nuovo mondo*, 3 vols. (Livorno: Coltellini, 1763), 2: 96.

9 William Burke, *An Account of the European Settlements*, 2 vols. (London: Dodsley, 1757), 2: 174. Compare Richard Bourke, *Empire & Revolution. The Political Life of Edmund Burke* (Princeton: Princeton University Press, 2015), 162–176, which attributes the *Account*'s paragraphs on philosophical history and political thought to William's distant "cousin" and collaborator, Edmund Burke.

10 *Storia dell'anno 1760* (Amsterdam [Venezia]: Pitteri, 1761), 184.

11 *Storia dell'anno 1763* (Venice: Pitteri, 1764), 18–22.

12 Franco Venturi, *Settecento riformatore*, 5 vols. in 9 (Turin: Einaudi, 1969–1984), 3: 409–442.

13 Antonio Pace, *Benjamin Franklin and Italy*, Memoirs of the American Philosophical Society, 47 (Philadelphia, 1958).

14 *Illuministi italiani*, vol. 3: *Riformatori lombardi piemontesi e toscani*, ed. Franco Venturi (Milan–Naples: Ricciardi, 1958), 312; Giuseppe Rutto, "La corrispondenza scientifica e letteraria di Paolo Frisi e Domenico Caracciolo," *Rivista storia italiana*, 96 (1984), 172–186. The letter in Latin from Frisi to Franklin does not survive, but Franklin quotes from it in his letter of 5 November 1756 to Peter Collinson.

15 Letter of 27 January 1767 in *Carteggio di Pietro e Alessandro Verri*, ed. Emanuele Greppi and Alessandro Giulini (Milan: Cogliati, 1923), 1 (1): 234.

16 *Scelta di lettere e di opuscoli del signor Beniamino Franklin tradotti dall'inglese* (Milan: Marelli, 1774).

17 Dominique de Blackford, *Précis de l'état actuel des colonies angloises dans l'Amérique Septentrionale* (Milan: Reycends, 1771), with Franklin's remarks at 69–99. On Domenico de Blackford see Franco Venturi, *The End of the Old Regime in Europe, 1776–1789*, vol. 1: *The Great States of the West* (Princeton: Princeton University Press, 1991), 47.

18 Davide Arecco, *Da Newton a Franklin. Giambattista Beccaria e le relazioni scientifiche fra Italia e America nel sec. XVIII. Con una scelta di documenti* (Ovada: Accademia Urbense di Ovada, 2009).

19 Paula Findlen, "Science as a Career in Enlightenment Italy: The Strategies of Laura Bassi," *Isis*, 84 (1993), 441–469.

20 *Descrizione della stufa di Pensilvania inventata dal Signor Franklin americano* (Venice: Graziosi, 1791).

21 *The Papers of Thomas Jefferson*, ed. Julian Boyd, vol. 1 (Princeton: Princeton University Press, 1950), 121–137.

22 Robert Carter Nicholas, *Considerations on the Present State of Virginia Examined* (Williamsburg, 1774), 29.

23 *Philip Mazzei: Selected Writings and Correspondence*, ed. Margherita Marchione, 3 vols. (Prato: Edizioni del Palazzo, 1983), 1: 91.

24 Ibid., 94.

25 Ibid., 97.

26 Ibid.

27 Patrick Henry, "Instructions as Agent for Virginia," ibid., 144–147.

28 Filippo Mazzei, *Recherches historiques et politiques sur les Etats-Unis de l'Amérique septentrionale, où l'on traite des établissemens des treize colonies. Par un citoyen de Virginie. Avec quatre lettres d'un bourgeois de New-Heaven sur l'unité de la législation*, 4 vols. (Colle [Paris]: Froullé, 1788). A selection of chapters from the *Recherches* may be found in Mazzei, *Researches on the United States*, trans. and ed. Constance D. Sherman (Charlottesville: University of Virginia Press, 1976).

29 Mazzei, *Recherches*, 2: 11–12.

30 Ibid., 2: 24, 4: 127–128.

31 Antonello Gerbi, *The Dispute of the New World: The History of a Polemic, 1750–1900* (Pittsburgh: University of Pittsburgh Press, 1973).

32 Frank B. Evans, "Carlo Bellini and His Russian Friend Fedor Karzhavin," *Virginia Magazine of History and Biography*, 88.3 (July 1980), 338–354.

33 Piero Del Negro, *Il mito americano nella Venezia del '700* (Padua: Liviana, 1986), 6; Michela Dal Borgo, "Gratarol, Pierantonio," in *Dizionario biografico degli italiani* (Rome: Istituto dell'Enciclopedia italiana, 1960), 58: 725–731.

34 [Pietro Chiari?], *L'Americana ramminga, cioè memorie di donna Jnnez de Quebrada scritte da lei stessa ed ora pubblicate da M. G. di S. sua confidente amica* (Venice: Pasinelli, 1763). See also Del Negro, *Il mito*, 52; and Alessio Giannanti, "Pietro Chiari's America. Among apocryphal attributions and philosophical considerations," *Rhesis*, Literature, 3.2 (2012), 86–103.

35 Sandro Landi, "Scrivere per il Principe: La carriera di Domenico Stratico in Toscana (1761–1776)," *Rivista storica italiana*, 104 (1990), 86–150; Landi, *Il governo delle opinioni: Censura e formazione del consenso nella Toscana del Settecento* (Bologna: Il Mulino, 2000).

36 *Papers of Thomas Jefferson*, II: 492–507; Gilbert Chinard, *The Commonplace Book of Thomas Jefferson* (Baltimore: Johns Hopkins University Press, 1926), 298–316; Paul Spurlin, "Beccaria's Essay on Crimes and Punishments in Eighteenth-Century America," *Studies on Voltaire and the Eighteenth Century*, 27 (1963), 1489–1504; John D. Bessler, *The Birth of American Law: An Italian Philosopher and the American Revolution* (Durham: Carolina Academic Press, 2014). There were two American editions of *An Essay on Crimes and Punishments*: one published in New York in 1773 and one in Philadelphia in 1778.

37 Letter to Governor Rutledge, 6 August 1787, in *The Writings of Thomas Jefferson*, ed. Henry A. Washington [1853–1854], 9 vols. (Cambridge: Cambridge University Press, 2011), 2: 233.

38 Renato Pasta, *Scienza politica e rivoluzione: L'opera di Giovanni Fabbroni (1752–1822), intellettuale e funzionario al servizio dei Lorena* (Florence: Olschki, 1989).

39 J.G.A. Pocock, *The Machiavellian Moment: Florentine Political Thought and the Atlantic Republican Tradition* (Princeton: Princeton University Press, 1975), 526.

40 Luigi Castiglioni, *Viaggio negli Stati Uniti dell'America settentrionale fatto negli anni 1785, 1786, e 1787* (Milan: Marelli, 1790); *Luigi Castiglioni's "Viaggio": Travels in the United States of North America, 1785–1787*, ed. and trans. Antonio Pace (Syracuse: Syracuse University Press, 1983).

41 Durand Echeverria, *Mirage in the West: A History of the French Image of American Society to 1815* (Princeton: Princeton University Press, 1957).

42 Pace, *Benjamin Franklin and Italy*, 93–165.

43 Gaetano Filangieri, *The Science of Legislation*, trans. William Kendall (London: Robinson and Trewman, 1791).

44 Eugenio Lo Sardo, *Il mondo nuovo e le virtù civili. L'epistolario di Gaetano Filangieri, 1772–1788* (Naples: Fridericiana Editrice Universitaria, 1999), 237.

45 Vincenzo Ferrone, *La società giusta ed equa: Repubblicanesimo e diritti dell'uomo in Gaetano Filangieri* (Bari: Laterza, 2003), 24–29; Alessandro Tuccillo, *Il commercio infame: Antischiavismo e diritti dell'uomo nel Settecento italiano* (Naples: Cliopress, 2013).

46 Stefania Buccini, *The Americas in Italian Literature and Culture 1700–1825* (University Park: Pennsylvania State University Press, 1997), 123–132.

47 Carlo Botta, *Storia della guerra dell'Indipendenza degli Stati Uniti d'America*, ed. Antonella Emina (Soveria Mannelli: Rubbettino, 2010); Daniele Fiorentino, "Il dibattito su Botta e la storia della guerra dell'indipendenza tra Italia e Stati Uniti nel XIX secolo," in *Giacobino pentito: Carlo Botta fra Napoleone e Washington*, ed. Luciano Canfora and Ugo Cardinale (Rome: Laterza, 2010), 169–176; *Tra Washington e Napoleone: Quattro saggi sulla Storia della guerra americana di Carlo Botta*, ed. Antonino De Francesco (Milan: Guerini e Associati, 2014).

48 Van Wyck Brooks, *The Dream of Arcadia: American Writers and Artists in Italy, 1760–1915* (New York: Dutton, 1958).

49 Raymond Grew, "One Nation Barely Visible: The United States as Seen by Nineteenth-Century Italy's Liberal Leaders," in *The American Constitution as a Symbol and Reality for Italy*, ed. Emiliana Noether (Lewiston: Mellen Press, 1989), 119–134; Axel Körner, *America Imagined: Images of the United States in Nineteenth-Century Europe and America* (New York: Palgrave Macmillan, 2012); Körner, "Masked Faces: Verdi, Uncle Tom and the Unification of Italy," *Journal of Modern Italian Studies*, 18.2 (2013), 176–189.

3

WHEN THEY WERE FEW

Italians in America, 1800–1850

John Paul Russo

On 24 April 1799, Vice President Thomas Jefferson wrote to Carlo Bellini, professor of modern languages at the College of William and Mary, about their mutual friends and acquaintances going back before the Revolution. There had been a seven-year gap in their correspondence; Bellini had been seriously ill; his wife had died the previous year. The letter was intended to comfort an old friend. Although Filippo Mazzei "was living in Pisa," other friends had settled permanently in America: "[Y]ou know that Giovanni Strobia has got rich as a grocer in Richmond." Bellini, Mazzei, and Strobia had all enlisted in the Virginia militia. "Vincent [Rossi] is in flourishing circumstances," Jefferson continued. "Anthony Giannini has raised a large family, married several of them, &, after thriving for a while, has become embarrassed, & little esteemed. Francis, his brother in law, & Anthony Molina have done tolerably well. Giovannini da Prato has been constantly sickly & miserably poor. All these are still in this neighborhood"—by which Jefferson meant Charlottesville.[1]

Mazzei, the Florentine physician who was Jefferson's close friend and a financier of the Revolution, had encouraged these mostly Tuscans to emigrate to Virginia in the 1770s. After twenty-five years some were successes, some were failures, and some were doing "tolerably well." Strobia, a tailor and a former member of Jefferson's Williamsburg household, had had the initiative to move on. He even anglicized his name as "John" (as one learns from his obituary in 1809).[2] In a similar vein Jefferson referred to Vincenzo Rossi as "Vincent" and both Antonio Giannini and Antonio Molina were known to him as "Anthony." "Vincent" without the surname suffices to identify a common friend. Writing with the same empirical precision that informs his *Notes on the State of Virginia*, Jefferson testifies to his friendship with these men and also to their Americanization.

One cannot estimate with certainty the number of Italians residing in the United States either in 1800, when the country extended to the Mississippi River with an entire population of 5,309,000, or in 1850, when it reached the Pacific Ocean with a population of 23,191,867. Figures ranging from 3,000 to 12,000 Italians have been suggested. The United States did not track immigration until 1820, and only thirty Italians were recorded as entering in that year. In the decade 1841–1850, an average of 187 Italians entered annually, which was just .11 percent of the total number, a far cry from its 23.26 percent during the heyday of Italian immigration fifty years later. In 1850 there were 3,679 Italian-born immigrants, not including offspring born in America ("second-generation" Italian Americans) or Italians who arrived before 1820 and were living in 1850.[3] On the other side of the ocean, the states that made up the geographical territory of Italy did not keep emigration records until the Kingdom of Sardinia (Savoia-Piemonte) began to do so in 1821. Cesare Correnti did not publish the first *Annuario statistico italiano* [Yearly Italian Statistical Report] until 1857.[4]

With these small numbers of widely scattered Italians in America, the method of examining them cannot reasonably be derived from large-scale immigration studies or micro-histories

of Little Italies. To be certain, there must have been pockets of modest density. Ferry Street in Boston's North End, as described by William Dean Howells in his *Suburban Sketches*, was a Little Italy, but the sketch was first published in 1869.[5] In sum, for 1800–1850, one's conclusions about these Italians in America, mostly bourgeois and professional, arise from piecing together a mosaic of individuals.

The Clerics

In one group are the clerics, with a long history in North America by 1800. In the years from 1800 to 1850 some Italian clerics achieved public status whereas others toiled in obscure parishes or preached along the frontiers as missionaries among the Native Americans, settlers and backwoodsmen. In the former category, Giovanni Antonio Grassi (1775–1849) served as vice president (1811–1812) and ninth president of Georgetown University (1812–1817). A native of Schilpario in the province of Bergamo, Grassi was a Jesuit who, upon ordination, was sent to be rector of a Jesuit college in Russian Poland. His fields of study were mathematics and astronomy. Within a year he was posted to a Russian mission in China, though his departure kept being delayed owing to the disruptions of the Napoleonic Wars. In 1810, after five years of waiting in ports at Copenhagen, London, and Lisbon, he was reassigned to a mission in America, specifically, to Georgetown.

At the time, the university was sorely in need of competent administration. Its founder, Bishop John Carroll, commented that it "has sunk to its lowest degree of discredit." Grassi himself, confronting a mountain of debts, considered himself a "sorrowful spectator of the miserable state of this college." Not mincing his words, he referred to "blackguard" students.[6] Eight presidents in twenty-one years meant a lack of continuity and the goals of the university were confused: Should it be Catholic or secular, pre-seminary or not, local or national? Enrollments had sunk to seventy-five students, while full tuition and board had risen to $220, one of the highest in the nation. Grassi set to work quickly and made significant changes in faculty recruitment, the composition of the student body and the curriculum. He lowered tuition and board to $125 per year, which brought the school within the range of middle-class Catholic families. And he welcomed students of other denominations. Within a year the number of students rose to 120, and by 1815 it stood at 224, thereby wiping out an annual deficit of $3,000. Moreover, he put Georgetown on track to be a national school: in only a few years it went from one-fifth of its students coming from outside the Washington/Maryland area to two-fifths from outside. These long-distance students came mostly from New York and Pennsylvania and many were given scholarships. During the War of 1812, when the British put official Washington to the torch, departing the following day, Grassi offered the government the use of college facilities while also opening the academic year on schedule just five days later. A grateful Congress later granted Georgetown an official charter. Another milestone was reached under Grassi in 1817, when Georgetown awarded its first degree, the Bachelor of Arts.

On a diplomatic mission to Rome in 1817 Grassi fell ill; an inoperable hernia made another transatlantic voyage inadvisable. His presidency came to an abrupt end. From across the ocean, he heard of his accomplishments undone, his plans unravelling, at the hands of less capable administrators and, with six presidents in the next ten years, Georgetown reverted to its earlier plight. "What I had procured with so much labour and patience," he wrote in November 1818, "now I see . . . destroyed."[7] In this year Grassi published *Notizie varie sullo stato presente della repubblica degli Stati Uniti dell'America settentrionale* [Diverse notices on the present state of the republic of the United States of North America], in which his disappointment breaks out: don't leave Italy: "consider the proverb that he who fares well should stay

at home."[8] Edward B. Bunn, Georgetown's forty-fourth president, called Grassi its "second founder," after Bishop Carroll.[9]

As a parish priest—when "parish" is what you make of an endless wilderness—Samuel Charles Mazzuchelli, O.P. has had few equals. Born in Milan in 1806, he studied to be a Dominican at Faenza, interrupting his novitiate to heed a call for missionaries from Edward Fenwick, the first bishop of Cincinnati. Fenwick's diocese stretched from Lake Huron to the Mississippi and from the Ohio River to the Canadian border. It was an area known as the Old Northwest, originally (in 1787) the "Territory Northwest of the River Ohio," out of which were carved Ohio, Indiana, Illinois, Michigan, Wisconsin, and half of Minnesota.

Mazzuchelli's memoirs project his belief that immanental signs were guiding him on a divinely appointed mission at each major step in his career, signs that provided structure to his third-person *Memoirs*. Leaving home, he invokes the injunction of Luke 14:26: "Whoever does not renounce father, mother, brothers, and sisters cannot be my disciple."[10] As his ship approaches North America, in November 1828, a howling gale descends, "bent on destroying man who defied its anger," plunging the ship amid "turbulent foaming waters," as if to warn him of the menace that lies ahead or to test his faith. Mazzuchelli was "clinging to the mainmast," as if beneath the Cross, staring into the "violent, imperious waves venting their wrath," while the "dark and thundering sky denied even the slightest ray of hope," while the wind "whistling constantly among the masts and cordage seemed to prophesy ruin and death."[11] As the modern writer Belden Lane observes in *The Solace of Fierce Landscapes*, the negative sublime entails death but also the possibility of rebirth. The Atlantic, the immigrant's first great hurdle, is spectralized by Mazzuchelli to the degree of apocalyptic ultimacy: "And there will be signs in the sun and moon and stars, and upon the earth distress of nations, bewildered by the roaring of the sea and waves" (Luke 21:25–26).[12]

Mazzuchelli disembarked in a New York that held no Augustinian temptations for him. "Several days of delay . . . convinced the traveler that the splendors of this world are always closely associated with general moral corruption."[13] The journey to Cincinnati, by coach and steamboat, would have been more arduous had he not encountered a kindly American who made all the arrangements, and, at the end, refused reimbursement. Again, Mazzuchelli reads a sign, as if from the Biblical story of Tobias and the Angel: "Father, what wages shall we give him [the Angel Raphael]? Or what can be worthy of his benefits? He conducted me and brought me safe again" (Tobit 12:2–3).[14]

In October 1830, after learning English, and learning to ride a horse and live in the open, and also after completing his novitiate, Father Mazzuchelli traveled 600 miles north by boat, across Lakes Erie and Huron, into the Michigan straits to his headquarters on Mackinac Island, at the opposite end of the diocese of Cincinnati. Then, in November, he boarded a trading vessel to visit Green Bay, which for years had had no priest to offer Mass or give instruction, where "almost all were of Canadian descent and married to the [mainly Menominee] Indians."[15] He then hastened back to Mackinac before the ice froze over. He was 24.

A liberal Catholic in the manner of Manzoni, Mazzuchelli won the respect of Protestant ministers who were as intent upon conversions as was he himself. It was his first lesson in American competitiveness, which he seems to have relished. He appreciated the American separation of Church and State, and he publicly criticized a Protestant Army captain who ordered the soldiers on Mackinac to attend a weekly Calvinist Sunday service despite the fact that many of them were French and Irish Catholics.[16]

In May 1831, after the ice thawed, Mazzuchelli sailed back to Green Bay to establish some semblance of regularity in the mission. In this and the following years he visited Sault Ste. Marie and L'Arbre Croce (Harbor Springs, Michigan) among the Ottawa tribe; turned

westward, traveling by horse and canoe and on foot with snowshoes into the unsettled regions of Wisconsin and Iowa; preached to the Winnebago, Sacs, Sioux, and Fox tribes; stopped over at Prairie du Chien; and crossed into Minnesota territory. Sometimes he followed the tribes: where they wandered, he wandered with them. He translated Latin into Chippewa so that the Indians could sing hymns in their own language. The Mississippi proved a convenient avenue, and he went up and down, founding parishes, erecting churches after his own design. One of them, St. Mathias Church, was constructed upstream at Prairie du Chien, and then, in 1842, floated down the river to Bloomington (now Muscatine, Iowa). His Irish parishioners fondly called him "Father Matthew Kelley." By 1836 he was sufficiently well known to address the Wisconsin legislature as it was entering upon its first steps to statehood. Most often he was alone, riding from one village to another. Getting wind of his coming, the Indians would build him a church of mats and an altar of bark in a matter of hours, or sometimes he would celebrate mass on the "vast prairie."[17] "[T]here was no need of Italian marble for a pavement," he wrote, with almost biblical eloquence, "that was found ready-made of the green grass in summer and hard frozen earth in winter."[18] On one occasion he rode alone through a blizzard "in a sledge, drawn by a single horse, crossing prairies, woods, rivers, and frozen lakes," from Galena, Illinois, to Green Bay and back (400 miles), to retrieve some humble yet precious church furnishings.[19] New York must have seemed far behind, let alone Milan.

He returned to Italy in 1843–44, less for rest than to write his *Memorie istoriche ed edificanti d'un Missionario apostolico dell'Ordine dei Predicatori* [Memoirs, Historical and Edifying, of an Apostolic Missionary of the Order of Preachers], a book of major interest for church history, Christian apologetics, anthropology, and autobiography. Writing in the third person, Mazzuchelli becomes "the Missionary"—"the ideal personality in whom self-will has given way to divine will."[20] As in a saint's life, the facts are selected and arranged in order to fulfill an ideal type. So he recalls his youthful energy and enthusiasm, and, in light of the magnitude of his mission, he prays for courage and endurance:

> [T]he young priest did not lack that abundant zeal that is usually the first fruit of ordination. Would God that he and all priests in the world might persevere and take with them to the tomb the holy fervor that animated them when ordination raised them to the sublime dignity of Christ's ambassadors.[21]

During the second phase of his career in the Old Northwest he founded institutions: Sinsinawa Mound College (1846); the Sinsinawa Dominican Sisters (1847); and St. Clara Academy (now Dominican University). Yet his main duty continued to be pastoral and on the road. In 1863 he died from pneumonia caught tending a sick person in Benton, Wisconsin. So far as I know, his only public memorial is a roadside tablet, one mile west of Benton, lost amid the immense spaces, fitting tribute to the Missionary. In 1993 Pope John Paul II declared Mazzuchelli Venerable, the first step toward sainthood.

The Literati and the Exiles

Every generation has its version of the Wandering Scholar. The first person to occupy a chair in modern languages at a North American college was Carlo Bellini (1735–1804), who taught for twenty-five years at the College of William and Mary. Bellini was a Florentine from a bourgeois business family. His freethinking and Masonic connections put him at odds with municipal authorities, and so he prudently left town and traveled across Europe, exercising his natural gift for languages by learning German, French, Spanish, and English.

He met up with a fellow Florentine Mason, Filippo Mazzei, in London. When the Polizia del Granducato pardoned him, he returned to his native city and took a position in the tax office.

In 1774, however, at the invitation—or rather the instigation—of Mazzei, Bellini and his wife emigrated to Virginia and within months of their arrival they were guests of Jefferson at Monticello. Whether it was his radical politics, his cosmopolitanism, or his genial personality, Bellini impressed Jefferson, who in subsequent years helped him stay afloat by finding him positions as a tutor and interpreter. In his role as a militiaman, Bellini was content with being an "ordinary soldier," which he held a "noble and glorious office." His captain was the future Revolutionary hero Patrick Henry, who addressed him with two other Italian volunteers: "You, Sir, render an important service to this state with your example, because barely arrived in this county, you voluntarily undertake to defend it as a soldier."[22] Surveying his first years in his adopted country in 1778, Bellini wrote an encomiastic letter to his brother in Tuscany that was subsequently published in two Florentine periodicals and widely circulated, which was almost certainly Bellini's intention. He wrote:

> I am at last a free and independent man. As a consequence of liberty and independ-ence in all these vast regions one finds not even a single being so stupid as to have the insolence to believe himself superior to another.[23]

On Jefferson's recommendation, in March 1778, the State of Virginia appointed Bellini to be a foreign correspondent and interpreter, a role that Bellini puffed up among Italian friends to be that of "Secretary of this State of Virginia for Foreign Affairs." In August 1778, on the recommendation of Jefferson and of Patrick Henry (then the state's new gover-nor), Bellini was appointed to the chair in Modern Languages at William and Mary. His sisters in Livorno referred to it as "Saint Mary."[24] During the British invasion and seizure of Williamsburg in 1780, Bellini remained behind while the revolutionaries abandoned the town, and he may have saved the campus by his personal diplomacy.

Bellini's salary depended on the fees of his students, and, in later years, when he suf-fered strokes and was invalid and paralytic, his resources dwindled to near nothing. Living in a run-down house near the campus, he survived on wine and biscuits brought to him by a student. When Bellini's sight declined, Jefferson arranged for a pair of eyeglasses. After Bellini's death in 1804, Jefferson, holding power of attorney, took responsibility for the dis-position of the man's will. The case began while Jefferson was in his first term as President and dragged on for thirteen years after Bellini's death. In the very last of these documents, written from Monticello (1 August 1817), Jefferson made a special request to the consular office in Livorno that testified to his feeling for Italy: "[W]e are erecting a College in my neighborhood"—the future University of Virginia—and "are in want of a stone-cutter . . . capable of cutting an Ionic capital . . . and we suppose we can be better accommodated with one from your place than here, for indeed such workmen are scarcely to be had here at all."[25] Jefferson's biographer, Dumas Malone, wrote that Bellini was the "only man in history" who addressed Jefferson as "My dearest Thomas."[26]

Another Italian, Pietro Bachi (1787–1853) combined the role of Wandering Scholar with that of the Political Exile. In 1814 the Harvard historian George Ticknor had complained of being unable to locate in Boston a single Italian grammar.[27] Ten years later, opening the new program in foreign languages, he interviewed Bachi and offered him the job. Ticknor might not have known at the time that his real name was Ignazio Batolo and that he had a price on his head. Bachi (or Batolo) was a native of Palermo who received his doctorate in law from the University of Palermo. In January 1822 his name was found on a list of Carbonari

conspirators who were plotting to overthrow the Bourbon government in Sicily. He was convicted *in absentia* and sentenced to twenty-four years in chains. Ten others were executed, but somehow Batolo slipped through the roundup and escaped to Malta, thence to London, and finally to Boston, where he turned up as Ticknor's "accomplished Italian exile," reading Italian aloud to him and to the historian William H. Prescott.[28]

Bachi's career at Harvard (1826–1846) was highly productive in its first years. One of his pupils, Theodore Koch, wrote of his teaching that "everybody liked him, not to say loved him.... As a critic of Dante, he had exactly the gift which a good teacher ought to have."[29] When Henry Wadsworth Longfellow needed a French instructor, he wrote that he should be "a youth of spirit and a gentleman, such as I have in German and Italian," referring to Bachi, "the Italian with his charming accent and the shadow upon his life."[30] During these years Bachi published an ambitious series of grammars, anthologies, and a conversation guide, supplying the very lack that Ticknor had lamented. Longfellow praised the revised edition of *A Grammar of the Italian Language* (1838), a project of "immense labor ... at once comprehensive and clear, and wherein every rule is literally *shored up* with good authorities."[31] It was "by far superior to all those already in use in schools."[32] Harvard conferred an honorary MA upon him, and he enjoyed the growing company of Cambridge Italophiles.

If Bellini had a natural gift for languages, Bachi adopted a more scientific approach to pedagogy. "His books were written with great care," they were philologically sound, and they took a student's practical needs into account. His publications in Spanish and Portuguese were "the first studies of comparative philology produced at Harvard."[33] In the preface to *A Comparative View of the Italian and Spanish Languages, or An Easy Method of Learning the Spanish Tongue for Those Who Are Already Acquainted with the Italian*, he pleaded the case for Italian as "indispensable" to a "polite education." He projected his defense of Italian against a centuries-old disparagement of the language and its authors by French and British critics. Bachi could note, quite objectively, that

> Spanish has in some respects a higher claim to attention [than Italian] at the present day in this country—the claim arising from the great extent to which it is spoken on the American continent, and its utility in commercial transaction.[34]

But the fortunes of Italian were about to take a surprising turn.

When Longfellow mentioned a "shadow" upon Bachi's life, he was referring to the latter's life in exile. Even from across the Atlantic Bachi persisted in his political commitments. When Giuseppe Mazzini revived Giovine Italia (Young Italy) in England in 1838, Bachi was appointed Boston's *Ordinatore* (commander) and he instructed its *Congrega* (assembly). How many participated? There must have been a respectable number because Bachi at one point expelled three of them on grounds of poor morals. In the summer of 1844 Bachi joined a group of conspirators on Malta, hoping to invade Sicily. However his movements, like those of the others, had been tracked by Bourbon police, the plot was foiled, and Bachi returned to Harvard without setting foot on the island. The shadow deepened and it exacerbated his alcoholism. Longfellow noted it during the examination period in July 1846: "the Spanish classes did well; the Italian not so well." After twenty years' teaching, and in poor health, Bachi was fired "due to neglect to attend your classes without giving notice."[35] "It was," comments one scholar, "the end of Bachi's career—nay, service at Harvard, for a career it never was."[36] But this is too harsh, for Bachi's record of publication and his teaching up until the early 1840s would be the envy of any scholar.

Bachi returned to Palermo in 1847 in time to participate in the Revolution of 1848. But the younger generation of nationalists treated him like an old-timer, and when, after fifteen

months, the Palermo revolt collapsed, he went back to Boston. He died in bankruptcy in 1853. Bachi was not replaced at Harvard until Luigi Monti, another Sicilian exile, was appointed in 1853.[37] Monti, having become an American citizen, had the satisfaction of returning to Palermo in 1861 as American consul.

Not long before Bachi's death, his daughter commissioned his portrait from Albert Gallatin Hoit, a New England artist noted for his ability "to capture an accurate likeness with frankness, while imbuing it with discretion and 'sweet cordiality.'"[38] In his portrait of Bachi (see Color Plate 5), Hoit's accuracy trumps his discretion and sweetness. The portrait betrays Bachi's anxiety, perplexity, and sense of failure in his final years.

Pietro D'Alessandro (*circa* 1812–1855) was a Sicilian poet and political refugee, whose reading of Carlo Botta's *Storia della guerra d'Indipendenza degli Stati Uniti* [History of the War of Independence of the United States] (1809) led him to American shores.[39] Botta's was a standard history that contributed a fiery idealism to the Italian Risorgimento. In translation it was well received in the United States, remaining on Harvard reading lists through the 1820s until George Bancroft's multivolume history began appearing a decade later.[40] D'Alessandro was a Carbonaro sympathizer and member of the Sicilian secret society known as "*l'ardita falange*" (the bold phalanx). He stayed for nine years in Boston (1833–1842), though he made one or two trips back to Palermo.

D'Alessandro's "Letters of an Italian Exile," a memoir of his first years in America, appeared in the *Southern Literary Messenger* in 1842, translated by Henry Tuckerman, himself a Boston Italophile. A tone of melancholy pervades the "Letters." The writer cannot turn back, yet he does not like what he sees going forward. At the outset he captures the mixed emotions of the immigrant. The weariness of the long voyage vanished entirely upon his sighting land and he felt the thrill of arrival; at length, the recollection of home "awoke in my mind the most painful sense of uncertainty. I felt doubtful of every thing, even my own existence . . . I then felt intensely what it is to be alone." In the end, however, a sense of reintegration and confidence is established: "I stooped reverently to kiss the land sacred to liberty, and felt for the first time that I, too, was a man."[41]

Boston proved uncongenial to D'Alessandro who, without steady work, lived in strained circumstances and relied upon remittances from his family in Sicily. (Fifty years later the remittances of Italians would cross in the other direction!) Though Bachi proved a friend to D'Alessandro, the newcomer had no money and the many responsibilities that come with a growing family. The Bostonians were civil, but they were also cool, distant and "exceedingly wary of foreigners"—not only of Europeans like himself but of non-New Englanders. To be a "stranger" was a kind of "original sin," compounded by the "still less pardonable sin of poverty." Religious metaphor bespeaks the language of the Puritans. Instead of thrift and modesty, which he expected in the city of Mather and the Adamses, he found consumerism and outright extravagance: "their lives are entirely spent in striving after new accumulations," nowhere more apparent than in women's fashion: "gala dresses, all satin and muslin, light feathered bonnets, silk stockings and dancing shoes, with a bit of fur round their necks, of the skirt of their pelisses to *whisper* of *comfort*." Boston women changed outfits several times a day, which Italian women did not do. Rejecting his desire for companionship, they "glide over the ice with a calm indifference." On the other hand, D'Alessandro admired the sense of order (soldiers and police did not roam the streets as in Palermo), the respect for learning, the libraries of Harvard and the Boston Athenaeum, the simplicity of customs forms and official applications in contrast to Italy, the general efficiency: "a quiet population incessantly intent upon industry and commerce, without being retarded by civil restrictions or tyrannical extortions." He earned a decent living by going into the import-export business. Yet if his

decision to return to Italy was marked, again, by mixed emotions, no such emotions inform his ringing advice to Italians: Remain in, and work for Italy. "Live ever in the love of your friends, of letters, of your country."[42]

Aside from translations, D'Alessandro published one book in his lifetime, *Monte Auburno*. It appeared in 1835 with a single eponymous poem of 319 hendecasyllabic lines, inspired by Ugo Foscolo's *I Sepolcri* and by Mount Auburn Cemetery, the first "rural cemetery" in America (1831), which became a noted resting place of writers, artists, Boston Brahmins and Cambridge professors. Like the cemetery itself, *Monte Auburno* reflected the Romantic attitude toward death, which held that the beloved or the friend was not dead but sleeping, having returned to the bosom of nature.[43] As historian Philippe Ariès once explained, starting around 1750, cemeteries that for millennia had been located in town centers were removed—often under a pretense of sanitation and seemliness—and set in landscaped meadows. The tomb site became a kind of family property in which the loved ones were "at home," waiting to be visited, "as one would go to a relative's home, or into one's own home, full of memories."[44] D'Alessandro praised the sheltering

> . . . robusta
> Quercia, che l'arco all'Indian vagante
> Fornì prima co' rami ed or l'incurva
> Pia su le tombe, e le protegge.
> [. . . sturdy oak, that once supplied the wandering Indian with his bow, and now bends its
> pious shape above the graves, protecting them.][45]

The autumnal foliage, New England's "beautiful death" is the appropriate setting for the "*bel soggiorno*" of the dead. Mount Auburn was the most cherished of those "convening places for the literary society of Boston." "[F]riends and colleagues . . . often chose the same cemeteries, and sometimes the same sections of those cemeteries" for their own resting place, because friends and lovers meet again in death as if on earth.[46]

During the late 1830s, D'Alessandro and another exile, Antonio Gallenga, occasionally joined Bachi for supper at his house in Brattle Street, Cambridge. Born in Parma to an upper middle-class family, Gallenga had been imprisoned for his part in a student protest; he would travel far and wide in exile and write a copious memoir, *Episodes of My Second Life* (1885), in which he depicted the flowering of Italophilia in the New England of the 1830s and 1840s. One can imagine the three of them conversing over their literary works, their families, their daily struggles and then, inevitably, turning to the subject of Italy, first with odd bits of news and gossip, then with growing anger at the police, the Pope, the informers, and the corruption in their native country. Why, for the previous two hundred fifty years, had a country with an abundance of human energy and ingenuity squandered its resources so recklessly? Why had its ruling class, with so many models of *buon governo* (good government) before them, been so lacking in vision? Why had it misgoverned the Italians, both economically and politically, so that they fell under foreign rule, forcing the country's best minds into exile? There was practically a tradition in Italy of brilliance denied, a tradition that began with Dante and continued through Marsilius of Padua, Machiavelli, Bruno, Campanella, Galileo, Giannone, Pagano, Cuoco, Foscolo, and Mazzini. It is a conversation one still hears in Italy today.

D'Alessandro returned to Palermo in 1843 to marry and manage his estate. Never abandoning politics, he became a Secretary during the Revolution of 1848, afterwards going into exile on Malta as an aide to Ruggero Settimo, the head of the unofficial government

in exile. There, in 1855, he died of rheumatic fever at the age of 45. Henry Lushington, the Secretary of the English colonial government of Malta, himself to die within months of his friend, wrote a poem to D'Alessandro:

> Rest in thy foreign grave,
> Sicilian! whom our English hearts have loved,
> Italian! Such as Dante had approved—
> An exile—not a slave.[47]

Note how the "Sicilian" blossoms into an "Italian," in the spirit of 1848, "Such as Dante had approved"—and Machiavelli too.

Lorenzo Da Ponte

Perhaps the most famous, and certainly most colorful Italian American of the nineteenth century was Lorenzo Da Ponte (portrayed in Color Plate 4), whose immortality is assured on account of his having been Mozart's favorite librettist, providing the text for *The Marriage of Figaro*, *Don Giovanni*, and *Così fan tutte*. When Da Ponte disembarked at Philadelphia in 1805, he was already 56 years old and his fortunes were at their lowest ebb. Venice had banished him for licentiousness and adultery in 1779; Austria for *lèse-majesté* in 1792; and he was forced to leave England for breach of contract in 1804. His final days in England were spent in hiding aboard a ship. But Da Ponte threw in his lot with America; became a citizen in 1828; never returned to Europe; and lived to his ninetieth year. If the American period of his life would never attain the height of his years with Mozart, it cannot fairly be called a decline, thanks to Da Ponte's unusual ability to match his considerable creative resources to the needs of his new community.

Long ago in a classic essay, Ernesto Masi ranked Da Ponte and Filippo Mazzei among Italy's eighteenth-century "adventurers."[48] Neither man exactly fit the type that was instead fully realized by Casanova and Cagliostro: egoist, amoral, libertine, cosmopolite, living by one's wits, moving from country to country and going from rags to riches—and, often enough, back to rags—in a ceaseless circle. Yet Da Ponte resembled the type more closely than Mazzei, not least in his association with fellow Venetian Giacomo Casanova, who was always ready to offer him a good adventurer's advice. Because Da Ponte did not always follow that advice—he did have scruples of one form or another—he seems more like an *avventuriere galantuomo* (a "gentleman adventurer," similar to Goldoni's self-styled "*Avventuriere Onorato*") rather than an *avventuriere canaglia* (scoundrel).[49] Indeed the naïve, good-natured Da Ponte is perhaps described even better as an adventurer *manqué*, more sinned against than sinning, or, in his case, more duped than duping.

He was born Emanuele Conegliano in the Jewish ghetto of Ceneda (now the city of Vittorio Veneto), 40 miles north of Venice. His mother died when he was five. His father, a leather worker, converted his family to Roman Catholicism when Lorenzo was fourteen, gave the boy the name of the local bishop, and sent him to a religious preparatory school. Financial and domestic problems constrained Lorenzo and his two brothers to become priests. By the time he was ordained in 1773, however, he had already visited Venice on business several times and had fallen in with its libertine circles. The priesthood would be one of Da Ponte's many masks—poet, librettist, bookseller, publisher, gambler, impresario, grocer, tutor, professor. He typically hid the fact that he was a priest, that he was married—or that he was not married, dissimulating according to his advantage.

Let us pass over his golden years in Vienna to his silver ones in New York. It was Casanova who saw Da Ponte floundering as an impresario in London and suggested that he teach Italian. Da Ponte scorned this as "a profession currently practiced by waiters, cobblers, exiles . . . who by way of payment are insulted with a few pennies, or a shilling, or sometimes a measure of beer."[50] One episode in Da Ponte's remarkably entertaining *Memoirs* speaks to the image of Italy in the United States *circa* 1810. Passing a Broadway bookstore, Da Ponte stopped in to ask if there were any Italian books: "I have a few," the clerk replied, "but no one ever asks for them":

> While we stood chatting, an American gentleman approached and joined our conversation. I was soon aware from his remarks that he was admirably read in a variety of literature. Coming by chance to allude to the language and literature of my country I took occasion to ask him why they should be so little studied in a country as enlightened as I believed America to be.
> "Oh sir," he replied, "modern Italy is not unfortunately the Italy of ancient times. She is not that sovereign queen which gave to the ages and to the world emulators, nay rivals, of the supreme Greeks."[51]

The gentleman added that there were "five or at the most six" Italian writers of lasting importance in the previous six centuries, counting out on his fingers Dante, Petrarch, Boccaccio, Ariosto, Tasso, then holding onto that last finger. "To tell the truth, I cannot recall the sixth."

Later in New York, Da Ponte would discover that he was exceptionally good at teaching Italian. But first he tried his hand at opening shops to sell things to support his wife and four children. He sold food, dry goods, and liquor, and he doubted that the Italian language or its literature would sell in a city where "they were about as well known . . . as Turkish or Chinese."[52]

Da Ponte opened groceries first in New York, and then in Pennsylvania in Elizabethtown and Sunbury, each of which failed, mainly on account of his credulity in selling on credit. Yet he never appears to have been unduly depressed by the consequences. His mood is well captured in the picture he paints of himself weighing items in scales and measuring cloth, much like Figaro measuring the size of his bed in *The Marriage of Figaro*.[53]

But Da Ponte returned to New York permanently in 1819 and it was there that he took up the teaching of Italian. One of his students, Clement Clarke Moore, was the son of the president of Columbia College. Moore, who would become a distinguished Hebrew scholar, was a Columbia trustee, although he is known best as the poet who wrote "The Night before Christmas." He recommended Da Ponte to his fellow trustees, and, in September 1825, Da Ponte (at age 76) was appointed its first Professor of Italian literature, with his salary to be paid based on the number of students enrolled.

For the first six or seven years all went well. Da Ponte was a natural teacher, filled with enormous enthusiasm for his subject, as histrionic as it was possible to be within the bounds of good taste, "ordering books from Italy, arranging little plays to be performed by his pupils in his home, and holding weekly receptions at which Italian classics were read and discussed."[54] Though his association with the high culture of late eighteenth-century Vienna enhanced his stature, the secret to his achievement lay in his charismatic charm, optimism, energy and inventiveness, like a character out of his own libretti.

In Da Ponte's first term of teaching, a company of opera singers specializing in the Italian repertoire found its way to New York. It was the Garcia troupe, with its celebrated soprano

Maria Garcia, later Maria Malibran (1808–1836), then 17 years old and at the beginning of an all-too-brief career. Recognizing her talent at once, Da Ponte convinced her father to include "my *Don Giovanni*" in the spring season, with Maria in the role of Zerlina. The tour, which introduced America to Italian opera, was a sensational success, and together with the vogue of studying Italian contributed to a modest change in fortune for the reception of its language and culture. The Garcias moved on but in subsequent years Da Ponte devoted his major effort to establishing Italian opera in New York. Almost on his own he raised sufficient funds to build what he named the "Italian Opera House," the first of its kind in America, which opened in 1833 (Da Ponte was 85). Curiously in that first season, although there were operas by Rossini (6), Cimarosa (1), Pacini (1), and Salvioli (1), there were none by Mozart. Within two seasons Da Ponte's lack of business sense led to ruin. His partner disappeared, leaving him deeply in debt, so that he had to sell the building to pay his expenses. It would burn to the ground in 1836. Yet his efforts stimulated an interest in opera that within another decade would be wildly successful in New York, as Walt Whitman, among others, observed.[55]

Da Ponte's last years were unhappy. His son Giuseppe died suddenly at 21. His wife, 20 years his junior, died in 1831. His opera plans had quite literally gone up in flames. The demands of the role of impresario, successful or otherwise, undoubtedly kept him from his professorial duties, and fewer and fewer students signed up for his courses. He would have understood Robert Frost's lines:

No memory of having starred
Atones for later disregard
Or keeps the end from being hard.[56]

Joseph Rocchietti and the Italian American Novel

Joseph (Giuseppe) Rocchietti has the distinction of writing the earliest known Italian American novel, *Lorenzo and Oonalaska*, which was published in Virginia in 1835.[57] Rocchietti styled himself "Joseph" Rocchietti on the title page, and identified himself as coming from "Casal"—by which he meant Casale Monferrato in Piedmont. A teacher of Italian, he also published a tragedy in Italian, *Ifigenia* (1842); a lengthy essay "Why a National Literature Cannot Flourish in the United States of North America" (1845), arguing that the United States were too insular, imitative and nativist;[58] and a play about the Civil War, *Charles Rovellini, a Drama of the Disunited States of North America* (1875). The facts of Rocchietti's biography are scanty—when and why did he come to America? Where did he live? Why did he publish in Virginia? His bibliography is likely to grow as more items are uncovered in the coming years. According to scholar Francesco Durante, Rocchietti is "perhaps the most prolific among Italian American writers of the early nineteenth century, but certainly the least well-known."[59]

Lorenzo and Oonalaska is a short epistolary novel of 132 pages that draws inspiration from Foscolo's *Ultime lettere di Jacopo Ortis* [Last Letters of Jacopo Ortis] as well as from Goethe's *Sorrows of Young Werther* and Germaine De Staël's *Corinne*. In the novel Lorenzo's parents instill in him the ancient values of the Greek *polis* and the Roman republic. The hero writes that his father "made me swear against every other principle of politics but those of Brutus, Cato, and Washington."[60] These beliefs force him into exile at Geneva, where he teaches Greek, Latin, French and Italian. Oonalaska, a young Englishwomen, is among his pupils in Geneva and they fall in love. After extensive travels in England and America he returns to Switzerland. A series of misunderstandings leads to a duel in which he refuses to kill his rival, while allowing himself to be shot to death.[61] Oonalaska dies upon hearing the news. Most

importantly, the novel expresses Rocchietti's revolutionary republicanism. His hero "longs for Italy to achieve the American political system."[62] To achieve that goal, one must revive a Machiavellian *virtù* that is able "to bear up against adversities with calmness, and heroism."[63]

Other noteworthy Italians established themselves in America in the period from 1800 to 1850. Orazio de Attellis, from a noble family in the Molise, fought in Napoleon's armies in Italy and Russia. Jacobin activities led to his expulsion from the Papal States, Spain, and Mexico. In New York, where he befriended Da Ponte, he opened a girls' boarding school on Broadway and then another in New Orleans, becoming an American citizen in 1828. His twin goals were "to encourage a more assiduous Italian presence in the institutional life of the United States" and "to make Italians acquire in America that national conscience that they did not have in Italy."[64] Having established in New Orleans an Italian guard troop, the Mount Vernon Musketeers, he took up the cause of Texas independence—though not annexation, which he feared would expand slave territory in the West. At age 75 the Revolution of 1848 drew him back to Italy, though amid the intense nationalist fervor his Jacobite ideas were seen as outmoded. He died in 1850 at Civitavecchia on the eve of a planned departure for New York.

In the 1830s Giuseppe Tagliabue emigrated from the environs of Como and set up shop on Pearl Street in New York City, designing and manufacturing scientific instruments such as the hydrometer, lactometer, and thermometer. In the same decade Eugene Grasselli migrated to Cincinnati where he opened a factory for making sulfuric acid; he expanded his business by moving to a site in Cleveland next to Rockefeller's Standard Oil with whom he did business for many years, refusing to be bought out by the oil magnate.[65] Giacomo Beltrami (1790–1855), from Bergamo and in exile for liberal sympathies, explored the upper reaches of the Mississippi and wrote about the discovery of its source in 1824, only to be proven wrong by Henry Schoolcraft eight years later. Eleuterio Felice Foresti, a Carbonaro, was released from Austria's Spielberg prison in an amnesty of 1836 on condition that he "transport" to America. He would succeed Da Ponte in the chair of Italian literature at Columbia.

From 1800 to 1850 the Italians who arrived in the New World encountered long-standing preconceptions. Some belonged to the Renaissance, a period that spread the idea of the Italian as humanist, scientist, courtier or courtesan, but also as the deceitful Machiavel. Yet another Italian profile developed with the advent of Romanticism. Where better to combine both strands of the Italian character, high and low, than in the type of the "noble savage"? Where the Enlightenment treated the child as an imperfect adult needing to be shaped by culture, the Romantics idealized the child as father of the man. Italians were described as unself-conscious children at play, full of candor but with a lack of control, in contrast to Anglo-American maturity, seriousness and work.[66] Closer to nature, the child is in contact with spontaneous life, like the savage—or the naïve artist. Italians were seen as representing the childhood of modernity, to be viewed with fond nostalgia, as in a museum.

The Romantic idealization of the child, which reached its zenith in America in the 1820s and 1830s, improved the general view of Italians. Negative stereotypes remained latent, as immigrants at the turn of the twentieth century would realize;[67] yet, in our period, 1800–1850, with few Italians actually present, and these mostly middle class and professional—a good number of them freedom-loving exiles in a country whose own revolution had inspired them—the ways in which Italians differed from native-born Americans were perceived with fondness and sometimes with wholehearted admiration.

The Time of the Exiles Ends

In July 1850, after the defeat of the Roman Republic of 1849, Giuseppe Garibaldi arrived as a famous refugee in New York City. Typically, he refused the honor of a public reception.

His rheumatism, which incapacitated him from time to time, could not dissuade him from manual labor, and he went to work in a candle factory, mostly hauling barrels of tallow. His name and presence fostered Italian charities in the city (indicating a growing population). He took the first steps toward American citizenship, but then bided his time. Rather than remain in America, after three and a half years, in January 1854, he returned to Europe, stopping over at London to encounter prominent European radicals. As a result of these meetings the exiled Russian intellectual Alexander Herzen was able to write a character portrait of Garibaldi, whom he revered as "a hero of antiquity, a figure out of the *Aeneid*."[68] In one conversation Garibaldi expatiated on the adverse effects of a long exile, a matter with which Herzen was sadly familiar. "What can [the exiles] do now in Europe?" Garibaldi wondered. Then he answered his own question:

> Grow used to slavery and be false to themselves, or go begging in England. . . . Settling in America is worse still—that's the end, that's the land of "forgetting one's own country": it is a new fatherland, there are other interests, everything is different. . .

Many an immigrant would feel the pungency of that remark. Then the man of action turned to the business at hand:

> [M]en who stay in America fall out of the ranks. What is better than my idea, what could be better than gathering together round a few masts and sailing over the ocean, hardening ourselves in the rough life of sailors, in conflict with the elements and with danger? A floating revolution, ready to put in at any shore, independent and unassailable![69]

It was a prophetic statement. A few years later Garibaldi would ship out from a port near Genoa with his volunteer followers—the "Thousand"—and they would "put in" at Marsala to commence the unification of Italy. The time of the exiles was over.

Further Reading

Billington, Ray Allen. *The Protestant Crusade, 1800–1860: A Study of the Origins of American Nativism* [1938]. New York: Rinehart, 1952.

Casillo, Robert and John Paul Russo. *The Italian in Modernity.* Toronto: University of Toronto Press, 2011.

Masi, Ernesto. "Gli avventurieri," in *La vita italiana nel settecento: Conferenze tenute a Firenze nel 1895*. Milan: Treves, 1896, 85–128.

Notes

1 *The Papers of Thomas Jefferson*, ed. Barbara B. Oberg and Julian P. Boyd, 31 (Princeton: Princeton University Press, 2004), 99.

2 Ibid., which cites an obituary in the *Richmond Enquirer* of 17 March 1809.

3 David M. Brownstone and Irene M. Frank, *Facts About American Immigration* (New York: H.W. Wilson, 2001), 210, 211; Diane Portnoy, Barry Portnoy and Charles Riggs, *Immigrant Struggles, Immigrant Gifts* (Fairfax: George Mason University Press, 2012), 60–61.

4 *Annuario statistico italiano per cura di Cesare Correnti and Pietro Maestri* (Turin: Tipografia letteraria, 1858).

5 William Dean Howells's essay, "Doorstep Acquaintance," describing the Italians of Ferry Street, was published in the *Atlantic Monthly* (April 1869), and then reprinted in Howells, *Suburban Sketches* (New York: Hurd and Houghton, 1871), 35–59. For the striking impression in literary circles that it made, see Michael Anesko, *Letters, Fictions, Lives: Henry James and William Dean Howells* (New York: Oxford University Press, 1997), 64.

6 Robert Emmet Curran, *The Bicentennial History of Georgetown University* (Washington DC: Georgetown University Press, 1993), 64.

7 Ibid., 84.

8 Alexander DeConde, *Half Bitter, Half Sweet: An Excursion into Italian-American History* (New York: Scribner, 1971), 10.

9 Edward B. Bunn, S.J., *"Georgetown": First College Charter from the U.S. Congress (1789–1954)* (New York: Newcomen Society in North America, 1954), 6.

10 Samuel Mazzuchelli, O.P., *Memoirs* (Chicago: Priory Press, 1967), 11.

11 Ibid., 14. The translator may have recalled Shakespeare's "rude imperious surge" (*II Henry IV*, Act 3, Scene 1).

12 Ibid., 14–15.

13 Ibid., 15.

14 Ibid., 16.

15 Ibid., 40.

16 Ibid., vii, 80.

17 Ibid., 73.

18 Ibid., 106–107.

19 Ibid., 168.

20 Karl J. Weintraub, *The Value of the Individual: Self and Circumstance in Autobiography* (Chicago: University of Chicago Press, 1978), 54.

21 Mazzuchelli, *Memoirs*, 24.

22 Antonio Pace, "Another Letter of Carlo Bellini," *William and Mary Quarterly*, ser. 3, 4 (1947), 352.

23 Ibid., 351.

24 Earl G. Swem, "Charles Bellini, First Professor of Modern Languages in an American College: Correspondence of Jefferson and Bellini: Settlement of Bellini's Estate," *William and Mary Quarterly*, ser. 2, 5 (1925), 14.

25 Ibid., 27.

26 Dumas Malone, *Jefferson the Virginian* (Boston: Little, Brown, 1948), 285.

27 Angelina La Piana, *Dante's American Pilgrimage: A Historical Survey of Dante Studies in the United States: 1800–1944* (New Haven: Yale University Press, 1948), 9.

28 S. Eugene Scalia, "Figures of the Risorgimento in America: Ignazio Batolo, Alias Pietro Bachi and Pietro D'Alessandro," *Italica*, 42.4 (1965), 311–357 (319). On Prescott, Ticknor and their circle, see Giorgio Spini, "La conquista del Perù," in *Incontri europei e americani col Risorgimento*, ed. Spini (Florence: Vallecchi, 1988), 263–283.

29 Scalia, "Figures," 319.

30 *The Letters of Henry Wadsworth Longfellow*, ed. Andrew Hilen, 6 vols. (Cambridge: Harvard University Press, 1966–1982), 1: 273, 321.

31 *Letters of Henry Wadsworth Longfellow*, 2: 103.

32 Renzo Dionigi, *Antonio Gallenga: An Italian Exile in Brahmin Boston, 1836–1839* (Varese: Insubria University Press, 2006), 25.

33 Ibid., 26.

34 Pietro Bachi, *A Comparative View of the Italian and Spanish Languages, or An Easy Method of Learning the Spanish Tongue for Those Who Are Already Acquainted with the Italian* (Boston: Cottons and Barnard, 1832), vi.

35 Theodore E. Stebbins, Jr. and Melissa Renn, eds., *American Painting at Harvard*, vol. 1, *Paintings, Watercolors, and Pastels by Artists Born before 1826* (Cambridge and New Haven: Harvard Art Museum and Yale University Press, 2014), 264.

36 Scalia, "Figures," 322.

37 Durante, *Italoamericana* [Italian ed.], 1: 447–478.

38 Theodore E. Stebbins, Jr. and Melissa Renn, *American Painting at Harvard*, 264.

39 Scalia, "Figures," 333–334.

40 The first American edition was Charles Botta, *History of the War of Independence of the United States of America*, trans. George Alexander Otis, 3 vols. (Philadelphia: Maxwell, 1820).

41 Pietro D'Alessandro, "Letters of an Italian Exile," trans. Henry T. Tuckerman, *Southern Literary Messenger*, 8.12 (December 1842), 741–748 (741–742).

42 D'Alessandro, "Letters of an Italian Exile," 742, 748.

43 Pietro D'Alessandro, *Monte Auburno* (Cambridge: Torchi di C. Folsom, 1835).

44 Philippe Ariès, *Western Attitudes Toward Death: From the Middle Ages to the Present*, trans. Patricia M. Ranum (Baltimore: Johns Hopkins University Press, 1974), 72–73.

45 D'Alessandro, *Monte Auburno*, 8.

46 Dionigi, *Antonio Gallenga*, 29–30.

47 Henry Lushington, *The Italian War, 1848–9, and the Last Italian Poet: Three Essays* (Cambridge: Macmillan, 1859), lvi.

48 Ernesto Masi, "Gli avventurieri," in *La vita nel settecento: Conferenze tenute a Firenze nel 1895* (Milan: Treves, 1908), 85–128.

49 Masi, "Gli avventurieri," 90.

50 Rodney Bolt, *The Remarkable Life of Lorenzo Da Ponte* (London: Bloomsbury, 2006), 233.

51 Lorenzo Da Ponte, *Memoirs*, trans. Elisabeth Abbott, ed. Arthur Livingston (Philadelphia: Lippincott, 1929), 361.

52 Ibid., 360.

53 Ibid., 357.

54 Joseph Louis Russo, *Lorenzo Da Ponte: Poet and Adventurer* (New York: Columbia University Press, 1922), 111. But see also Sheila Hodges, *Lorenzo Da Ponte: The Life and Times of Mozart's Librettist* (Madison: University of Wisconsin Press, 2002), 198–199.

55 For Whitman's opera going and his strong preference for *belcanto* Italian opera, see Robert D. Faner, *Walt Whitman & Opera* (London: Feffer and Simons, 1951), 4–7, 63, and passim; and Andrea Mariani, *Italian Music in Dakota: The Function of European Musical Theatre in U.S. Culture* (Göttingen: V&R unipress, 2017), 69–101.

56 Robert Frost, "Provide, Provide," in *The Poetry of Robert Frost: The Collected Poems, Complete and Unabridged*, ed. Edward Connery Lathen (New York: Henry Holt, 1979), 307.

57 Carol Bonomo Albright discovered this long-forgotten novel in 1999, following an advertisement for rare books. See Carol Bonomo Albright and Elvira Di Fabio, *Republican Ideals in the Selected Literary Works of Italian-American Joseph Rocchietti, 1835–1845: "Lorenzo and Oonalaska" (1835) and "Why a National Literature Cannot Flourish in the United States of North America" (1845)* (Lewiston: Edwin Mellen Press, 2004).

58 Rocchietti condemns the burning of the Ursuline Convent in Charlestown, Massachusetts, in 1834.

59 Durante, *Italoamericana* [Italian ed.], 1: 327.

60 Joseph Rocchietti, *Lorenzo and Oonlanska* (Winchester: Brooks & Conrad, 1835), 42.

61 The scene anticipates the Naptha-Settembrini duel in Thomas Mann's *The Magic Mountain*.

62 Carol Bonomo Albright, "Earliest Italian American Novel: *Lorenzo and Oonalaska* by Joseph Rocchietti in Virginia, 1835," *Italian Americana*, 18.2 (2000), 129–132.

63 Rocchietti, *Lorenzo and Oonalaska*, 97–98.

64 Durante, *Italoamericana* [Italian ed.], 1: 261.

65 Portnoy, Portnoy and Riggs, *Immigrant Struggles, Immigrant Gifts*, 61–62.

66 Andrew M. Canepa, "From Degenerate Scoundrel to Noble Savage: The Italian Stereotype in 18th-Century British Travel Literature," *English Miscellany*, 22 (1971), 107–146.

67 See William J. Connell, "Darker Aspects of Italian American Prehistory," in *Anti-Italianism: Essays on a Prejudice*, ed. Connell and Fred Gardaphé (New York: Palgrave Macmillan, 2010), 11–22.

68 Jasper Ridley, *Garibaldi* (New York: Viking, 1974), 377. See also the touching essay by Leone Ginzburg, *Garibaldi e Herzen* (Rome: Castelvecchi, 2015), originally published in 1932.

69 Alexander Herzen, *My Past and Thoughts*, trans. Constance Garnett (Berkeley: University of California Press, 1982), 371.

4

AMERICA'S GARIBALDI

The United States and Italian Unification

Don H. Doyle

Between 1848 and 1870, when the United States faced perilous challenges to its survival as a republic, Italy's valiant struggle for independence and unity offered Americans a distant mirror in which to assess their own national aspirations. In 1848, while revolutions were convulsing Italy from Palermo to Rome with a zeal for reform and human progress, the United States was concluding a war of conquest against Mexico. Early in 1848, while Italians were experiencing the "springtime of nations," as contemporaries called it, the U.S. Congress was debating whether to seize "All Mexico" or only the northern half of their defeated neighbor's territory.[1] Twelve years later, in 1860, as the U.S. South threatened to secede from the Union, the American press was fascinated with stories of Giuseppe Garibaldi and his army, "The Thousand" (*I Mille*), as they invaded Sicily and conquered southern Italy in the name of *l'Italia unita*. The next year, even while a newly united Kingdom of Italy was being proclaimed, Abraham Lincoln was inaugurated as president of a nation that, in March 1861, was fast on its way to becoming the dis-United States of America.

Before 1848 the American press published constant reports on affairs in Europe, including Italy, but U.S. journalists barely noticed Garibaldi's exploits in South America between 1834 and 1848. Meanwhile, in Europe, Giuseppe Mazzini and fellow Italian nationalists were publicizing Garibaldi as an iconic transnational hero in exile, a personification of the Italian Risorgimento, or "Resurgence," as the Unification movement was known, who championed the cause of universal emancipation wherever tyranny reigned.[2]

The revolutionary zeal that had ignited the French Revolution of 1789 subsided after the defeat of Napoleon I when the monarchies of Europe met in 1815 at the Congress of Vienna to restore the Old Regime across the continent. The aristocratic ruling classes of Europe viewed the French Revolution as a dangerous experiment that had failed, but whose flame had not yet been extinguished. In league with the Catholic Church, the Old Regime stood ready to repress all demonstrations of sympathy with challenges to the prevailing order of things. Across most of the European continent, even the most basic civil rights of freedom of speech, assembly and political organization were banned, and censorship of journals, publications and instruction in the universities aimed at suppressing public expression of reformist ideas.

Republicans and revolutionaries, for their part, sought to harness their ideals of human equality, personal liberty, and republican self-government (as opposed to monarchy) to nationalist movements for independence from foreign rulers. Giuseppe Mazzini, the founder in 1831 of Young Italy, called on the generation born after 1800 to fulfill the historic mission of the Italian nation and to serve the advancement of human progress. Mazzini believed fervently that the Italian people must realize the Italian nation through a revolutionary process by throwing off the yoke of foreign rule and creating a unified Italian republic that would embody the will of the people. The Italians, Mazzini proclaimed—in language that would

later inspire Abraham Lincoln—must make revolution "in the name of the people, for the people, and by the people."[3]

A vital connection between "nationalism" and "republicanism" took hold in numerous nationalist movements, many of them modeled after Mazzini's Young Italy. There was a Young Europe, a Young Ireland, a Young Germany, a Young Poland, and a Young Switzerland, and there were even Young Turks and a Young America. Mazzini and his followers remained devoted to the idea of a popular republican revolution that would call on the people to rise, cast off their monarchical chains, and create their own republic.

But the Mazzinian nationalist movements were notable more for their repeated failures than their achievements. During the century's first half, the careers of both Mazzini and Garibaldi illustrated the failure of their revolutionary dreams. As a young sailor from Nice, Garibaldi was drawn by Mazzini's vision of a united Italian republic to joining Young Italy in 1833. He also became active in the Carbonari, a secret revolutionary society, and in 1834 was involved in a plot to incite a popular uprising in the Kingdom of Piedmont. Tried *in absentia* and sentenced to death, Garibaldi fled to Brazil later in the year. There he soon took up arms on behalf of the *Farroupilhas* rebellion, a republican independence movement in the province of Rio Grande do Sul that was attempting to break off from the Empire of Brazil. In 1841 Garibaldi and his young Brazilian bride, Anita, removed to Montevideo, Uruguay, where they began a family that soon included four children. When a civil war broke out between the conservative *Blanco* party, which allied itself with the Argentine dictator Juan Manuel de Rosas, Garibaldi and his "Italian Legion" (as his fellow exiled soldiers were known), raised their swords for the liberal *Colorado* party to defend the independence of Uruguay against Argentina. As uniforms, the Italian Legion adopted the bright red smocks of slaughterhouse workers. (See the portrait of Garibaldi in Color Plate 6.) The red shirt, or *camicia rossa*, thus became the emblem of Garibaldi's followers, known as the *Garibaldini*, even though Garibaldi himself more often preferred a poncho and hat in the style of a gaucho—a habit in which he continued after returning to Europe, as though to confirm his transnational appeal.

Mazzini, meanwhile, had also fled Italy in 1834. He was hounded out of Switzerland and France before seeking refuge in London. From Great Britain he continued trying to ignite popular revolutionary uprisings in Italy, periodically leaving his London asylum for Italy in failed attempts, but never abandoning his determination to create an Italian republic through popular revolution.

Many Americans looked upon the Italian struggle for national independence and unification in the light of their country's own revolutionary origins, and they flattered themselves in thinking that the "Great Republic," as admirers called the United States, should become a model for Italy. Of course, the republican experiment had spread throughout the Americas as former Spanish colonies, with the brief exception of Mexico, all having proclaimed independence under republican governments. In Europe, however, apart from a few small city-states, including San Marino, the republican idea survived only as an incendiary revolutionary idea.

The revolutionary fervor about to seize Europe in 1848 arrived at a time when America's historic mission as a model republic was taking a disturbing turn toward imperialism and the expansion of slavery that today seem quite disturbing. In 1846 President James K. Polk, a Southern slaveholder and a bellicose expansionist, provoked war with Mexico to acquire lands that extended from Texas to California. Opponents of the war saw it as part of a "Slave Power" conspiracy that was trying to strengthen its hold on the Federal government by adding more slave states. The Great Republic was transforming itself into an empire for slavery. While U.S. forces were invading Mexico, across the Atlantic, in January 1848, a popular revolt

in Palermo, Sicily, was about to ignite a series of revolutionary uprisings that spread through the Italian peninsula and across Europe.

The Spring Time of Nations, 1848

By the time Garibaldi arrived from South American in the city of Nice—which was then called "Nizza" and was part of Italy—in June 1848, it appeared the European world of kings and popes was on its way out. A new era of popular self-rule and liberal tolerance of ideas about politics and religion seemed to be emerging. Although socialists and "red republicans" committed to violent revolutionary change played important roles in several of the European upheavals of that year, most of the revolutionaries of 1848 were bourgeois reformers who were calling for representative government, the expansion of voting rights and constitutional guarantees of basic civil liberties. For many people, Garibaldi, the red-shirted people's warrior, personified the spirit of 1848 as he gathered recruits and formed an army of volunteers. There were people who expected him to lead a social revolution, but Garibaldi proved to be a pragmatic moderate rather than a red revolutionary. He even offered his sword to Charles Albert, the King of Sardinia, and promised to set aside his republican principles in favor of a war that aimed at ousting Austrian rule in northern Italy and uniting the nation.[4]

The New York *Daily Tribune*, a hugely influential newspaper published by Horace Greeley, was especially interested in the revolutionary events in Europe. Greeley and his editor, Charles Dana, employed dozens of foreign correspondents, many of them intellectuals and reformers who were openly sympathetic with the revolutionary upheavals seizing Europe. Mazzini, with his impressive publicity apparatus, had become familiar to American readers even before 1848 as the leading spokesman for Italian unification, but with rare exceptions even the more cosmopolitan American newspapers took no notice of Garibaldi during the war in northern Italy in 1848.[5]

Ironically, much of the momentum for the revolution that was about to sweep Italy and Europe had its origin in Rome, where the newly elected pope, Pius IX, had promised vast and unprecedented liberal reforms within the Papal States. The Catholic Church had, until then, been an implacable enemy of the revolutionary currents emanating from the Enlightenment and the French Revolution. It had opposed the propagation of ideas concerning human reason and progress, religious tolerance, the separation of church and state and the effort to replace divinely ordained monarchs with popularly elected governments. The new pope, however, soon after his election in the summer of 1846, took steps to align the church with liberal Europe and the Italian nationalist movement. American Protestants, especially New Englanders, had had a deep tradition of anti-Catholicism. Americans saw the Church as a sinister agent of Old World monarchists whose aim it was to bring the American Republic down.[6] Now, astonished Americans hailed the new pope as a harbinger of reform, rather than reaction, whereas Italian nationalists saw it as a signal to advance their cause.

In Palermo, republicans took to the streets to renounce their allegiance to the despotic Bourbon king of the Two Sicilies, Ferdinand II. The king had earlier issued promises of major reforms that were to have begun on his birthday, 12 January 1848. But Ferdinand reneged, and on his birthday the people of Palermo rose in revolt, ousted the Bourbon troops, and seized control of the city. The Palermo uprising was the beginning of the Revolution of 1848. Within a short time, a series of popular uprisings raced up the Italian peninsula. "For the first time in many centuries," one correspondent for the New York *Herald* wrote, "the people of this country have united their sympathies and their efforts on one common point—the achievement of the independence of the peninsula."[7]

When the citizens of Naples rose up, too, Ferdinand II was forced to proclaim new constitutional safeguards for citizen rights, if only to keep Naples from joining the Sicilian rebellion. Other Italian monarchs, including Charles Albert of Sardinia and Piedmont, made similar concessions in March 1848, but such concessions of monarchical authority only encouraged further rebellions.[8]

In Venice and Milan Italians rose against their Austrian rulers and proclaimed republics. Venetian revolutionaries looked to the United States both as a republican model and a potential ally. Marching en masse to the U.S. consulate, a crowd in Venice shouted: "Long live the United States; long live our sister republic." U.S. Consul William Sparks appeared before them, an American flag in one hand and the Italian tricolor in the other, and announced that "the ancient queen of the Adriatic" had thrown off the yoke of foreign rule and that America would rejoice.[9]

King Charles Albert offered to ally his Kingdom of Sardinia with Venice and Milan by making war against the Austrians. Now Italians everywhere spoke of their Risorgimento: of the resurgence of a united Italian nation.[10] Mazzini's dream seemed about to be realized.

Pope Pius IX, watching the explosion of popular discontent throughout Italy and facing fierce opposition to his earlier liberal pronouncements from conservative Jesuits within the Vatican, reversed course and allied with the reactionary wing of the Church. "*Pio Nono*," as Italians called the pope, fled in November 1848 to Gaeta, above Naples, and beseeched Ferdinand II to protect him. In February 1849, an assembly of Roman citizens proclaimed the Republic of Rome and announced the end of the temporal power of the pope. The beleaguered pope called on the major powers of Catholic Europe, France, Austria, Naples and Spain, to march on Rome and restore papal authority.[11] In the winter of 1849, for Americans and Europeans, the Republic of Rome stood as the courageous bastion of republicanism against the forces of monarchy, religion and reaction in the Old World.

Margaret Fuller and the Republic of Rome

Margaret Fuller had already arrived in Rome in the spring of 1847 as special correspondent for the New York *Daily Tribune*, one of those hired by publisher Horace Greeley, who was keen to inform American readers about the revolutionary movements stirring in Europe. While in London earlier, she had met Giuseppe Mazzini and immediately admired his revolutionary vision of a new Italy. At thirty-seven, she had proven herself a brilliant, accomplished intellectual as part of the Transcendentalist group with Ralph Waldo Emerson, Henry David Thoreau, and other New England intellectuals. She edited *The Dial*, a Transcendentalist magazine and authored a book titled *Woman in the Nineteenth Century* (1845) that was a tour de force for women's rights.

For Fuller, America's role in the vanguard of revolutionary change had been betrayed by a "boundless lust of gain," the "horrible cancer of Slavery" and the "wicked War" against Mexico that had resulted:

> My country is at present spoiled by prosperity, stupid with the lust of gain, soiled by crime in its willing perpetuation of slavery, shamed by an unjust war, noble sentiment much forgotten even by individuals, the aims of politicians selfish or petty, the literature frivolous and venal. . . . She is not dead, but in my time she sleepeth, and the spirit of our fathers flames no more, but lies hid beneath the ashes.

In Italy and its revolution she discovered new inspiration for hope. "Here things are before my eyes worth recording, and, if I cannot help this work, I would gladly be its historian."[12]

In February 1849, she saw the birth of the new Roman Republic. One of the deputies of Rome's newly constituted constitutional assembly addressed a crowd from the steps of the Campidoglio announcing the end of the pope's temporal power over Rome and a new government that "will take the glorious name of Roman Republic" and exist as a "pure Democracy." Bells rang, cannons fired and the crowd shouted *Viva la Repubblica! Viva l'Italia!* "The imposing grandeur of the spectacle to me gave new force to the thought that already swelled my heart," Fuller wrote, "I longed to see . . . a little of that soul which made my country what she is." She summoned Americans to support the Italian revolution. "How I wish my country would show some noble sympathy when an experience so like her own is going on." She offered to collect donations from sympathetic Americans "to arm and clothe her troops."[13]

The American press did not always interpret the revolutionary news from Europe with the same enthusiasm. Catholic Bishop John Hughes of New York published articles filled with dire accounts, often false or exaggerated, of priests assaulted and murdered, nuns defiled and dragged naked through the streets and churches desecrated and converted to stables in a general reign of terror against religion.[14] Other Americans were slow to embrace what they feared was another excessive revolutionary tumult in the Old World. Recent immigrants applauded the revolution, however. In June 1849, German immigrants staged several mass meetings in support of liberty throughout Europe, including Italy.[15] Later the same month the friends of Roman liberty in New Orleans held a meeting that resolved that

> the present struggle of the people of Central Italy [is] the struggle of right and justice against brute force and tyranny in their most odious forms. . . [, and] it is our duty as men, as Christians, as American citizens . . . to extend to them in their hour of need all the aid and assistance which we lawfully can.[16]

American sympathizers with the Roman Republic wanted the United States to recognize the new government, but Lewis Cass, Jr., the U.S. chargé d'affaires in Rome, held off taking sides. He was not convinced the revolutionary government would last, and a war between the Republic of Rome and the Catholic countries of Europe was about to commence.[17]

The pope's appeal for aid from neighboring Catholic states yielded quick responses from Spain, Naples, Austria and France. France, meanwhile, had gone through its own revolution in 1848, deposing her King Louis-Philippe, and proclaiming the Second Republic. As President of their new republic, the French elected Louis-Napoleon, the nephew of Napoleon I, largely because of the broad appeal of his family name which they hoped would unify support. Louis-Napoleon, however, proved to be a reluctant republican who wanted nothing more than to return France to the imperial glory of his uncle's regime. To appease his Catholic followers he agreed in 1849 to send troops to Rome, supposedly to preempt the rival Austrians, but it was understood that the French mission was to restore the pope to power and quash the Republic of Rome. In April 1849, therefore, 9,000 French troops landed at Civitavecchia and marched to the western walls of Rome.

Garibaldi and the Defense of Rome

On 27 April Garibaldi, having come from the war against Austria in the North, arrived with his band of legionnaires. Among them were the red-shirted soldiers who had come over from Montevideo, including Aguiar, the former slave who served as the general's aide. Their irregular uniforms and colorful attire made quite a spectacle before the crowd that cheered their procession through the streets of Rome, and Margaret Fuller reported it all for American readers. The Republic placed Garibaldi in command of an army made up of volunteers

who included university students, many with no military experience, some veterans from the north and soldiers with the old Papal Civil Guard who had defected to the Republicans.[18]

Garibaldi was determined not to let the French troops control the heights on the Janiculum, the high hill overlooking Rome from the west, for it would give them an ideal position from which to bombard fortifications and break through the walls at Porta San Pancrazio. On 30 April, as the French approached, Garibaldi's forces fired artillery on them and followed up with a ferocious charge with muskets and bayonets, Garibaldi leading the final assault on horseback with his saber drawn. The French broke ranks and scattered. Garibaldi was wounded in the thigh, his saddle soaked with blood, but he and his small army had repelled an army several times larger.[19]

"I write from barricaded Rome," Fuller told *Tribune* readers in early May 1849. "The Mother of Nations is now at bay against them all." She mused that the reforms in Italy had begun only with the moderate goals of constitutional reform in the existing monarchies, and

> [i]t required King Bomba [King Ferdinand II of Naples], it required the triple treachery of Charles Albert, it required Pio IX . . . and finally the imbecile Louis Bonaparte . . . to convince this people that no transition is possible between the old and the new. *The work is done*; the revolution in Italy is now radical, nor can it stop till Italy become independent and united as a republic.[20]

Garibaldi now emerged as the hero of the defense of Rome, and republican sympathizers everywhere wildly celebrated his victory over the French. But it came at a high political price. Louis-Napoleon blamed Garibaldi for assaulting without cause his peacekeeping forces, and he vowed to vindicate the honor of France by sending reinforcements. By 1 June French forces had swollen to nearly double, and during an absence of Garibaldi's to fight off forces of King Ferdinand II south of Rome nothing had been done to protect the heights of the Janiculum, which had been secured a month earlier. On 3 June, Garibaldi threw his men into a series of failed assaults that, after seventeen hours, left the French in command of the heights. Now his army dug in behind the old Roman wall at Porta San Pancrazio, and the French continued relentless artillery pressure. Anita Garibaldi arrived from Nice to be by her husband's side. New uniforms with red shirts were distributed to Garibaldi's men. But all through June the Republic of Rome, besieged and outnumbered, faced its end while Americans and the whole world watched. Mazzini and Garibaldi became bitterly divided. Mazzini proposed a *levée en masse*: the conscription of all Roman citizens who would then join the army at San Pancrazio and throw themselves into a heroic counteroffensive against the French. Garibaldi thought this was suicidal madness. He wanted to retreat from Rome, set up the government in the mountains, and carry on the fight with guerilla tactics. On 30 June, a day of horrific fighting, the French finally seized Porta San Pancrazio.[21]

On 2 July the Roman National Assembly voted to capitulate. The U.S. chargé d'affaires, Cass, came through the streets to find Garibaldi and offer him safe passage—to America or wherever he wished to go. Garibaldi refused, telling Cass he intended to lead his army out of Rome and make his way to Venice to carry on the fight. He gathered his men in St. Peter's Square and with Anita at his side, both of them on horseback, he addressed them:

> This is what I have to offer to those who wish to follow me: hunger, cold, the heat of the sun; no wages, no barracks, no ammunition; but continual skirmishes, forced marches and bayonet-fights. Those of you who love your country and love glory, follow me.[22]

The speech, in various renderings, spread through the international press and helped launch Garibaldi's career as an international hero, especially in the United States, Britain, and Switzerland where he became the darling of the liberal press as a champion of republican ideals. The New York *Daily Tribune* exclaimed its sorrow for the "martyrs of human liberty" who defended Rome "against the machinations of despotism, the wiles of ambitious hypocrisy and the infernal perfidy of monarchical villains who have stolen power in France by means of hollow professions of that republicanism they mortally hate."[23] At large indignant assemblies that were held during the summer of 1849 Americans denounced Louis-Napoleon as the "Iscariot of liberty, the Benedict Arnold of the old world."[24]

The Revolution of 1848 failed in Italy and nearly everywhere in Europe. The entire Italian peninsula returned to absolute rule, with the exception of the Kingdom of Sardinia, where Charles Albert conceded to demands for a constitutional monarchy. But the revolution would not die: it left behind it a Manichean narrative of beleaguered republicans fighting for liberty, equality and self-rule who were locked in struggle with tyrannical aristocrats, kings and popes firmly committed to defending the Old Regime. For Americans, and for liberals throughout Italy and Europe, Giuseppe Garibaldi and the Italian Risorgimento remained emblematic of the hope for republican ideals in Europe.

Garibaldi's Exile in America

Garibaldi arrived in New York City a full year after he left Rome. He and his men had tried to make their way to Venice, where the uprising against the Austrians was still in progress. Hounded by the armies of France, Spain, Naples, and the Papal States as they made their way across the mountains, they finally disbanded in San Marino. Anita, pregnant and overwhelmed by fever, died tragically during their flight. Garibaldi sought asylum in his homeland, the Kingdom of Sardinia, but the authorities made it clear he was not welcome. He was imprisoned in Genoa for several nights, and although he was then allowed to visit his children in Nice, where they had been staying with his mother, Garibaldi was not granted asylum. A national hero on account of his brave defense of Rome, Garibaldi nonetheless became a man without a country in the postrevolutionary climate of 1849. Great Britain offered him asylum, but Garibaldi suffered painful bouts of rheumatism that paralyzed him for weeks at a time, so he dreaded the cold English winters. He sought asylum in the British colony of Gibraltar, but he was rebuffed by officials there and moved on to Tangier, where he stayed several months writing his memoirs. In June 1850, he left for America.

In contrast with the cold receptions in Liguria and Gibraltar, Garibaldi was welcomed to America with what the New York *Herald* described as "enthusiasm" of the kind that "so peculiarly distinguishes the American character, in the generous and cordial welcome bestowed upon the European republicans, when driven from the land of their fathers by monarchical tyranny."[25] Members of the Italian Committee in New York joined exiled republicans from France and other countries to welcome "the heroic defender of liberty in the Old and New World," and they planned an elaborate public procession through the city to celebrate their hero's arrival in New York.[26]

During the voyage over Garibaldi was stricken by one of his sporadic bouts of rheumatism and had to be carried off the ship. Before entering the city, all arriving immigrants were required to stay for a few days at the quarantine station. There the city health officer ordered that the red, white, and green tricolor flag of the Roman Republic be raised over the quarantine buildings along with the stars and stripes to honor the Italian hero. Unable to walk, he

was restricted to bed while a stream of visitors came to meet him. From Rome, Lewis Cass sent a public letter of welcome:

> I welcome you to this land of freedom. May it always be the land of hospitality to the unfortunate exile, driven by the persecution of arbitrary power to seek refuge in the new world, from the tyranny of the old. . . . The battle of freedom may be lost once and again but it will yet be won, and man restored to the rights which God has given him.[27]

Garibaldi's admirers meanwhile busied themselves making preparations for a grand civic reception at the Astor Hotel. But Garibaldi was ailing and depressed. The defeat of the Roman Republic, the failure of the Italian people to carry on the fight, the cold treatment he received at the hands of Britain and even his native Kingdom of Sardinia, all left him disillusioned. Above all, he was profoundly saddened by the loss of Anita: he left quarantine on 4 August, the anniversary of her tragic death.[28] When the Italian Committee persisted in its plans for a public reception, he declined the invitation in a public letter that left no doubt.

> Though a public manifestation of this feeling might yield much gratification to me, an exile from my native land, severed from my children, and mourning the over-throw of my country's freedom by means of foreign interference, yet believe me that I would rather avoid it, and be permitted, quietly and humbly, to become a citizen of this great Republic of Freemen, to sail under its flag, to engage in business, to earn my livelihood, and await a more favourable opportunity for the redemption of my country from foreign and domestic oppressors.[29]

Garibaldi stayed with Italian friends in New York City for several weeks before retreating to Staten Island to stay at the home of Antonio Meucci, an Italian immigrant who operated a candle-making factory and experimented in various inventions, including a "talking tel-egraph" or telephone.[30] Garibaldi sought a quiet life out of public view. The community of Italian and other European republicans exiled in New York was becoming quarrelsome and divided over ideology and tactics. From exile in London Mazzini continued to plot popular revolution and assassination as the only viable path toward an independent and united Italy, but many had convinced themselves that the revolutionary path was, after Rome, a proven failure. Garibaldi avoided public debate on the subject, but in private he had become disil-lusioned by the unwillingness of Italians to seize their own freedom.

Meanwhile, Charles Albert, the Sardinian king, following his disastrous defeat at the hands of the Austrians, abdicated in favor of his son, Victor Emmanuel II. Many expected the new king to renounce the liberal constitution his father had been forced to accept and to reestablish absolutist government. Instead, Victor Emmanuel II affirmed his commitment to liberal principles of government, while appointing as his prime minister the celebrated artist and author Massimo d'Azeglio, a conservative who opposed republicanism but identified strongly with Italian nationalism.

Though vehemently opposed to Mazzini's revolutionary republicanism, Victor Emma-nuel II and his government openly embraced the Risorgimento. Giuseppe Verdi, the Milan composer who sought to express the soul of Italy in music, became immensely popular as the musical embodiment of Italian aspirations. Throughout the peninsula Italians exclaimed *Viva Verdi!*, which was widely understood to be an endorsement of Victor Emmanuel "Re d'Italia" (V.E.R.D.I.), an expression strictly forbidden outside of Sardinia.[31] The American press hailed the new king of a state that now had a parliamentary government as an example

to the other Italian states, and to all of Europe, showing that the Italian people, abused and derided, were fully capable of representative self-government once the yoke of "theocratic despotism" was lifted.[32]

Garibaldi's arrival in the United States coincided with growing anti-Catholic sentiment, particularly among Protestants in the Northeast and Midwest where so many Irish and German immigrants were settling. Some of this prejudice emanated from Protestant theological disdain for what they considered religious superstition and papist dogma, but much of it was rooted in political ideology, especially the antipathy between republicanism and the Catholic Church. American Protestants saw the Irish and other Catholic immigrants as instruments of a conspiracy hatched in an Old World alliance of church and crown. The plot was to undermine the American republic by its own democratic devices, which involved sending hordes of Catholic immigrants, "voting cattle" as critics referred to them, across the Atlantic to seize control of government, infiltrate the public school system with Catholic priests and nuns, and besmirch the Protestant ideals of sobriety and hard work. Anti-Catholicism was present even in the early years of the republic, but it took a more partisan political turn during the surge of immigration in the late 1840s. Nativist groups, some of them violent urban street gangs, sprang up in various cities to form the basis for the Native American Party, later renamed the American Party, a national organization commonly referred to by its detractors as the "Know Nothings." To the extent that Garibaldi, like the entire Italian nationalist movement, now opposed the newly conservative Pius IX along with the prerogatives of the Church, enthusiasm for Garibaldi gained strength among Protestants in Britain and America.[33]

Many American observers preferred that Italy become a republic, but at the same time, they were increasingly wary of the "red republican" revolutionary program of Mazzini. Under a liberal constitutional monarchy, Italy might achieve unification and independence without the kind of violent social upheaval Mazzini advocated. "Before you can have a republic in Italy, you must have Italy," the New York *Herald* wrote, quoting Italian nationalist Daniel Manin. Many Italian nationalists, including Garibaldi and Manin, began to see King Victor Emmanuel II as the most practical hope for realizing a united Italy. On both sides of the Atlantic, a rift widened between the moderate pragmatists willing to support the Sardinian king and radical republicans wanting to regenerate Italy through popular revolution.[34]

For Americans, the Italian question was the mirror in which they saw alternatives regarding their own future, either as a shining example of virtuous republican liberty and self-rule, or as a failed democracy torn asunder by dangerous ideas of radical egalitarianism and violent revolutionary ideologies being imported by immigrants.[35]

Some conservative American observers were retreating from ideas about a universal human fitness for self-rule toward ideas about national character and "temperament." The recent experience of Latin America and Europe appeared to demonstrate to them that not all peoples were prepared to govern themselves and that some form of elite rule remained necessary, if only as an interim passage on the way toward more democratic practices. Other American observers doubted that Italians, with their long history of fragmentation and cultural diversity, were yet ready to form a nation under one centralized state. Some imagined a federal-style government along the lines of the United States or Switzerland, whereas others envisioned four or five separate nation-states sharing the peninsula. In 1858 the attempted assassination of France's emperor, Napoleon III, by an Italian revolutionary and friend of Mazzini named Felice Orsini, further alienated moderate Americans from the radical Mazzinian path. Many saw Mazzini's hand at work in the violent plot, which involved lobbing bombs under the carriage carrying Napoleon III and his empress as they rode through the streets of Paris en route to the opera.

Yet other Americans defended the attempted assassination as the only recourse of an oppressed people against a tyrant who, in Napoleon III's case, after being elected president, usurped power and then, in 1852, proclaimed himself "emperor." The Orsini affair was covered thoroughly in the American press, and before the would-be assassin was executed, there were large demonstrations in his favor in several American cities.[36] Jessie White Mario, an English writer and strong partisan of the Italian Risorgimento, was invited to deliver a series of lectures in the United States. She had married Alberto Mario, one of Mazzini's followers, and her lectures aimed at promoting the Mazzinian program. She appealed to American support of the Italian struggle for self-rule, defending Mazzini's revolutionary program and denouncing the idea that unification under the Kingdom of Sardinia could provide a more pragmatic path toward Italian unity. The press roundly criticized her, even the *New York Times*, which was sympathetic to the Italian Risorgimento, albeit disillusioned with Mazzini.[37]

Garibaldi himself, meanwhile, was gravitating away from Mazzini and toward Victor Emmanuel II. Many of the people he met in the New York Italian community opposed Mazzini's radical strategies and felt alienated by his dogmatic followers who denounced any other view as unpatriotic. After the failure at Rome, and the failure of the many uprisings that had preceded it, for many Italian nationalists the revolutionary republican path was no longer viable.

Garibaldi, meanwhile, grew restless during his time in New York. He was depressed about his wife's death and his separation from his children, and he had little immediate hope for the future of Italy. He applied for United States citizenship, apparently to enable him to sail his ship under an American flag, rather than to settle permanently there. Beginning in April 1851, Garibaldi set out on a series of commercial expeditions that took him to Latin America and the Far East. By the time he returned to the United States in the fall of 1853 a new government had formed in the Kingdom of Sardinia with Camillo Cavour as the prime minister. The Sardinian consul in New York informed him that the government would not object to him returning to his homeland. Early in 1854 Garibaldi left the United States bound for London and then home to Genoa.[38]

In London Garibaldi and Mazzini met for the first time since a strained farewell in Rome five years earlier. James Buchanan, the United States ambassador to Britain (and future President), hosted a large banquet attended by many of leading European republicans, including Garibaldi and Mazzini. The two were cordial toward one another, but Garibaldi kept his distance, aware of the risk of alienating American and British friends of Italy who wanted nothing to do with the socialist plots associated with Mazzini. He was also concerned that Mazzini's revolutionary ideology might drive Victor Emmanuel II into the arms of reactionaries. With Cavour as prime minister, the Sardinian government appeared to offer the most promising path toward creating a united and independent Italy under a constitutional monarchy on the British model.[39] "Although a born revolutionary," Garibaldi confessed in his memoirs, "I was convinced at that time that Italy should march with Victor Emmanuel to free herself from foreign domination, I thought that I should subject myself to his orders at all costs, and silence my Republican conscience."[40]

He reached Nice in May 1854, saw his children for the first time in nearly five years, and soon resumed the life of a merchant-sailor carrying commercial shipments along the coast between Genoa, Nice and Marseilles. From his earnings he bought property on the tiny island of Caprera, just off the northern tip of Sardinia. On this rocky, windswept island Garibaldi and his companions built a small house with outbuildings in the style of a South American hacienda. There he planned to live the rest of his life, in virtual exile yet within the borders of the Kingdom of Sardinia.

Italy's Second War for Independence, 1859

For almost a decade, even as his global reputation grew, Garibaldi the warrior led a comparatively quiet life, first as an exiled refugee and then as a merchant seaman. Then, in 1859, he was called to Turin, the capital of the Sardinian kingdom, to meet with Cavour about a plan to dislodge the Austrians from Lombardy and unite much of northern Italy. In July 1858, not long after the execution of the Carbonaro Felice Orsini, Napoleon III had arranged a highly secret meeting with Cavour in the French town of Plombières. The plan they agreed on would determine the fate of Italy and prepare the first decisive blow against Austria. By agreement, France would aid Sardinia in making war against Austria in Venetia and Lombardy, whereas Sardinia would cede to France two small border regions: Savoy, the homeland of the Savoy dynasty that ruled Italy, and Nice, the birthplace of Garibaldi.[41] The plan was set in motion when Austria, having learned of the agreement and mistakenly believing they would have British support, declared war on Sardinia. Immediately the French declared war against Austria and the contest was on. Garibaldi was dispatched to attack the Austrian right flank in the lake district north of Milan, capturing Varese and Como, while the French, with only limited support from their Sardinian allies, won a stunning victory against the Austrians at Magenta in early June. Napoleon III and Victor Emmanuel II soon entered Milan in triumph to the cheers of Italians. But at Solferino, east of Milan, a ferocious battle was fought in late June that left thousands of dead and wounded strewn on both sides.[42] The Austrians were forced to retreat, but Napoleon III had no stomach for further assaulting the well-fortified position of the Austrians. He made a separate peace with the Austrian emperor, Franz Joseph, leaving Victor Emmanuel out of the negotiations. The Treaty of Villafranca ended the war with Austria by conferring the Austrian province of Lombardy to France, not Sardinia, leaving it to France to bestow Lombardy on Sardinia in exchange for Savoy and Nice.[43]

There were many Italian nationalists who were furious that Napoleon III had settled the conflict on humiliating terms for the Italians. Cavour resigned as prime minister after a screaming match with his king. Demonstrators in Turin shouted anti-French slogans and brandished posters with the image of Orsini, Napoleon's would-be assassin. Garibaldi instead stoically accepted the terms of peace and publicly acknowledged "the gratitude which we owe to Napoleon and to the heroic French nation," although that was before he learned the disappointing news that his birthplace Nice would be ceded to France in exchange for Lombardy. Most importantly, though, he thought there was sufficient momentum and opportunity for pressing on with the liberation of all Italy.

A masterful publicist, Garibaldi issued an appeal through the international press to gather one million muskets for the pursuit of the Risorgimento. In New York, Italian leaders called on fellow immigrants and "all noble-hearted men" to come to the aid of Garibaldi and the "mother of all nations" in its battle against the "baneful influences of the past—Despotism, Ignorance, and Superstition."[44] The British and American press assisted Garibaldi by portraying him as the popular hero in a story of perfidious monarchs who secretly traded lands and peoples as though they were pawns in a game of chess. An article in the *New York Times* at the end of 1859 was typical in its lavish praise:

> About his name, as about the name of Washington in our own Revolutionary history, had begun to cluster the most passionate hopes and the loftiest aspirations of the patriots of Italy. Hundreds of exiled Italians in every quarter of the civilized world have been looking to Garibaldi, and to the gallant army which the magic of his name had so rapidly evoked from the heart of a population long denied the

use of arms, as the heralds of the great day in which Italy should prove herself once more worthy to stand in the van of the Latin race, and take her ancient rank among the Powers of Europe.[45]

Early in 1860 a meeting of prominent New Yorkers, most of them not Italian immigrants, testified to the tremendous admiration Americans had for Garibaldi and his aspirations. A letter from Charles Sumner, the liberal Republican senator from Massachusetts, was read to the audience: "Surely by her past history and all that Italy has done for human improvement, we are her debtors. Without Italian genius what now would be modern civilization?" Sumner added,

> I confidently look to the day when we may welcome into the fellowship of nations a community, new in external form, but old in its constituent parts . . . constituting the United States of Italy. And may God speed the good time.

After several other speeches the meeting resolved:

> That we tender to the people of Italy our warmest congratulations upon the measures of Independence to which they have already attained, and the assurance of our sympathy and moral support so long as they shall remain true to Order, Justice and Liberty.

The gathering closed with a plea from the women attending, "to send our heartfelt sympathies from the women of America to their sisters and brethren in Italy," and then a call for three cheers for Garibaldi.[46]

When Cavour returned as prime minister in early 1860 the full implications of the pact between France, Austria, and Sardinia had been revealed to the world. Countering its concessions of Nice and Savoy to France, Sardinia garnered major new territories, including Parma, Modena, Romagna, and Tuscany, where plebiscites involving a small segment of the male citizenry were held to ratify the new sovereign boundaries of the kingdom.

Garibaldi had only recently transferred the remains of his wife, Anita, from her grave near Ravenna to Nice, and he was astonished in early 1860 to learn that his homeland was being given away to France. At first, he made plans to travel to Nice to arouse the inhabitants to vote against annexation, but instead, most surprisingly he was persuaded to sail to invade Sicily. It could have seemed another of those Mazzinian plots to ignite a popular revolution, this time against the Bourbon Kingdom of the Two Sicilies, of a kind that Garibaldi had carefully avoided since returning to Italy. But in the spring of 1860, his blood was up, and he felt defiant toward Cavour and King Victor Emmanuel. So he proposed to lead an army of civilian volunteers to join the Sicilians in liberating the Mezzogiorno, as the Italian South was called. The invasion of "*I Mille*" (The Thousand) would become the most sensational episode in Garibaldi's legendary career.

Garibaldi and the Conquest of the Mezzogiorno

Garibaldi and his Thousand departed from Quarto, near Genoa, in early May. They landed in Marsala a few days later, and quickly swept across Sicily, being joined by peasants and revolutionaries wherever they went. "The enemy is flying towards Palermo," he wrote in a widely published letter a few days after landing in Marsala. "The populations are in high spirits, and join my camp by thousands. . . . Tell the Sicilians that the hour is come to put an

end to their slavery, and that we shall do it soon."[47] The *New York Times* compared the "Italian Washington" who "has given his sword, his strength, his hopes and his life to the regeneration of Italy," which it compared favorably to Mazzini who had only "worshipped himself . . . his own philosophy of statecraft."[48]

During the summer of 1860 Americans read about Garibaldi's expedition to conquer the South and unify Italy at the very same time that they were approaching the presidential election of 1860 that would rupture the American Union. It was natural that many American observers should have read their own concerns into the Italian struggle. After Garibaldi entered Naples the *New York Times* hailed the Italian hero:

> Six short months ago nine millions of Italians were chafing madly but silently against the barriers of a brutal despotism which all the policy and diplomacy of the world seemed bound in a common league to fix hopelessly around them. . . . The welfare of all the world beside, so ran the odious sophistry of statesmen, must be fortified and secured by the despair of these unhappy millions. To one man alone the necessity of all this was no necessity, but a hideous mockery and delusion. . . . Master to-day of Sicily and of Naples, only that he may make them, with all Italy, masters of themselves, Garibaldi has taken his place in the foremost rank of men.[49]

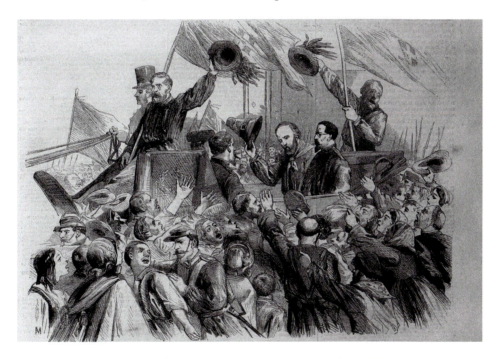

Figure 4.1 "Garibaldi's Entry into Naples—A Sketch in the Strada di Toledo." A drawing by Thomas Nast. Published in the *Illustrated London News* (22 September 1860). World History Archive/Alamy Stock Photo.

The *Times* also published an eyewitness account of Garibaldi's entry into Naples:

> Throughout the journey to Naples, in every village, at every station, the joy and enthusiasm of the people exceeded the power of description. Women and girls presented flags, threw flowers into the carriages, struggled to kiss the hand of the

General. Mayors and syndics ejaculated their gratulations; priests and monks stood, surrounded by their wretched flocks, on the hill side, and shouted their 'Vivas,' and, holding the crucifix in one hand and the sword in the other, waved them in the air, and bawled out their benedictions. As the train passed the King's Guard at Portici the soldiers threw their caps into the air, and joined justly in the 'Viva Garibaldi!'" Inside the city "The shouts of 'Viva Garibaldi,' 'Viva Italia Una!' are deafening, and thousands crowd the staircases and spacious saloons of this beautiful palace. In the evening the whole city is illuminated. Processions block up every street; all men are armed. Thousands of women carry a new poignard [dagger] in their girdles.[50]

The London Illustrated News published an illustration by Thomas Nast of Garibaldi's triumphal entry into Naples, doffing his peasant style hat to the crowds of enthusiastic women and men that thronged his carriage (Figure 4.1).

A month later *Harper's Weekly* republished Nast's drawing of the entry and on the same page printed a cartoon by Nast that showed a stern Garibaldi shooing away a scowling, barefoot priest about to step off a cliff carrying his bogus relics, which included a bottle of the blood of San Gennaro (Saint Januarius) that miraculously liquefied each year in Naples (Figure 4.2).

In America, Garibaldi's reputation as "The Hero of Two Worlds," the champion of universal emancipation and popular government, and the nemesis of the Catholic Church, soared.[51]

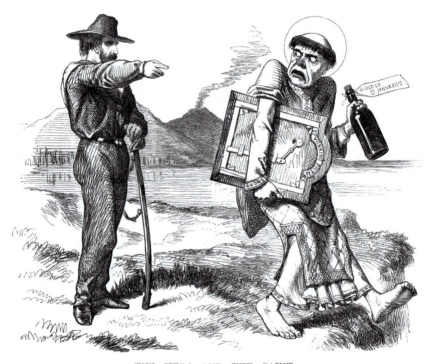

THE HERO AND THE SAINT.

.˙. Garibaldi had expressed his contempt for some of the Popish miracles, and his determination to restrain the power of the priesthood.—*September*, 1860.

Figure 4.2 "The Saint and the Hero—Garibaldi Driving St. Januarius and the Winking Picture Out of Naples." A cartoon by Thomas Nast. Published in *Harper's Weekly* (20 October 1860). Photo: New York Public Library.

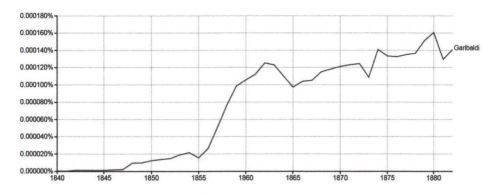

Figure 4.3 Mentions of "Garibaldi" in American English books between 1840 and 1882. Source: Google Books N-Gram Viewer, https://books.google.com/ngrams, accessed 15 August 2015.

The international press covered his every move, and myriad biographical sketches and book-length studies began to appear in English and other languages. The Garibaldi shirt, featuring red puffed-sleeve blouses, crossed the Atlantic to become the hit of the fashion world beginning in 1860. Even children's clothing mimicked the Garibaldi fad. The Google Books N-Gram (see Figure 4.3) charts mentions of the word "Garibaldi" in American publications between 1840 and 1882 (the year of his death) and provides a crude measure of the surge of American interest in him that began during the 1860s. The *New York Times* alone carried more than one thousand articles mentioning Garibaldi between 1859 and 1861. Theodore Dwight, a New England intellectual, in 1859 brought out Garibaldi's autobiography, which he began working on in Gibraltar. It was the first full account of his life available to English readers.[52] Numerous other biographies appeared in English by 1860, as did Alexandre Dumas's French edition of the Garibaldi memoirs.[53] *Harper's Weekly* and *Frank Leslie's Weekly*, two popular illustrated journals, fed a growing American appetite for details on the Italian hero's life. Henry T. Tuckerman, a New England author who knew Italy well, published a lengthy review of English writer William Arthur's *Italy in Transition* in the *North American Review*. Tuckerman viewed Garibaldi not as a self-aggrandizing swashbuckler but as the pragmatic leader of a movement with republican aspirations any American should admire.

> From the hour he first drew breath, on the anniversary of our national independence, July 4, 1807, ... the same motive, spirit, and principles have actuated him. He was never a reckless adventurer, or an aimless champion; but in all he has done ... he has shown himself an Italian patriot soldier.[54]

Coming to America?

Garibaldi's reputation was at its height in the summer of 1861 when rumors began circulating through the international press that the Italian hero was coming to the United States to raise his sword for the cause of American unity and liberty. Most of the rumors traced back to Caprera where Garibaldi and his comrades sent out letters to American friends planting the idea that the general might be willing to serve his beloved "second country" in its hour of need. Garibaldi was trying to bring pressure on King Victor Emmanuel II to complete the unification of Italy, to march on Rome and Venice in the name of *l'Italia unita*. Candido Vecchi, Garibaldi's trusted secretary and publicist, sent a letter to Henry Tuckerman thanking

him for his laudatory article in Garibaldi's name and adding his personal note suggesting that, if invited, Garibaldi might join the Union cause in America. By Vecchi's account, he acted without Garibaldi's knowledge, but that was unlikely. Garibaldi himself inserted the same notion in several letters to old friends in America recalling his "happy sojourn in your great country" and lamenting that while Italy was about to realize its unification, it pained his heart to see America fragmenting. "If I can aid you in any way," he wrote in one letter, "my agent in New York . . . is instructed to take and execute your orders." George Fogg, the U.S. minister to Switzerland, reported that Garibaldi remarked to him: "If your war is for freedom, I am with you with 20,000 men."[55]

As intended, these and other letters from Caprera were widely publicized in the American press, creating a steady drumbeat of speculation, rumor and enthusiasm, along with skepticism about the wisdom of employing a foreign general to fight America's war. On the one hand, the fact of foreign soldiers and officers coming to the Union's aid might be a sensational public diplomacy coup, but on the other hand, it could easily make the Northern cause look desperate. The recruitment of soldiers abroad would also violate the neutrality laws of most foreign countries, so Lincoln's secretary of state, William H. Seward, did little to encourage or discourage the rumors about Garibaldi.

Unbeknownst to Seward, however, an obscure U.S. consul in Antwerp, James W. Quiggle, took it upon himself to write to Garibaldi. "The papers report that you are going to the United States to join the Army of the North in the conflict of my country," his letter of 8 June 1861 began.

> If you do, the name of La Fayette will not surpass yours. There are thousands of Italians and Hungarians who will rush to join your ranks and there are thousands and tens of thousands of Americans who will glory to be under the command of the Washington of Italy.

Quiggle's letter was the first approach from any U.S. official and Garibaldi responded on 27 June. "I should be very happy," he wrote Quiggle, "to be your companion in a war in which I would take part by duty as well as sympathy." By referring to "duty" here, Garibaldi was advancing a claim to American citizenship. During his stay in New York, he had applied for citizenship, but he left before completing the five years of residency required for naturalization. He made a frequent point of this in his correspondence of this period by referring to the United States as his "second country." This may have been an honest mistake, but it suited his purpose by making it appear to government officials in the United States and Italy that he was exempt from a prohibition against recruiting foreign soldiers. The newspaper reports of him coming to America were not "exact," he told Quiggle, adding that should the U.S. government find his services of "some use, I would go to America, if I do not find myself occupied in the defense of my country." Garibaldi then posed a vexing question by asking whether "this agitation is regarding the emancipation of the Negroes or not."[56]

Quiggle, acting still on his own authority, replied on 4 July, explaining that current U.S. policy was to restore the Union, and that it would be a "dreadful calamity" to suddenly emancipate four million slaves. But, he added cleverly, if the war continued "with the bitterness with which it has commenced, I would not be surprised if it result in the extinction of slavery in the United States."[57]

Quiggle forwarded this correspondence to Seward, who received it sometime around the near-disastrous rout of Union troops at the first Battle of Bull Run on 21 July 1861. Six days later, after consulting with Lincoln, Seward wrote to his most trusted diplomat in Europe,

Henry Sanford. In addition to serving as U.S. minister to Belgium, Sanford was in charge of secret service operations in Europe. Go at once to "enter into communication with the distinguished Soldier of Freedom," Seward instructed Sanford.

> Say to him that this government believes his services in the present contest for the unity and liberty of the American People would be exceedingly useful, and that, therefore they are earnestly desired and invited. Tell him that this government believes he will if possible accept this call, because it is too certain that the fall of the American Union . . . would be a disastrous blow to the cause of Human Freedom equally here, in Europe, and throughout the world.

Seward deftly veiled the Union's embarrassing silence on the slavery question in the greater cause of "Human Freedom" for all the world.[58]

Sanford hastened to Turin, where he conferred with U.S. minister George Perkins Marsh about Garibaldi and the political situation in Italy. They were fully aware that Garibaldi was using the rumors of a U.S. offer to bring pressure upon the king to take the Risorgimento to Rome and Venice. They also realized, should the king stand firm, Garibaldi might accept the Union offer, if only to save face. For Garibaldi two issues were at stake: military rank and slavery. He wanted full command of all Union armed forces, explaining that he would be of no use unless he was the "pilot" in full command of the ship during the storm. He also wanted the power to decree the abolition of slavery. If the Union was not fighting for the emancipation of the slaves then it would appear as just another "internal war" over territory and sovereignty, "like any civil war in which the world at large could have little interest or sympathy."[59]

Dodging the press at every step, Sanford, taking care to use an assumed name, chartered a steamer in Genoa and embarked in the dark of night on 7 September. He left the main piazza of Genoa filled with Italians shouting "*Viva Garibaldi!*" and placing candles before a wax effigy of their hero to celebrate the first anniversary of his entry into Naples. "If Garibaldi goes, as I now think probable," he wrote to Seward that night, "it will cause an immense sensation here."[60]

Sanford arrived at Caprera late the next day and made his way by foot to Garibaldi's rustic abode, the Casa Bianca. Garibaldi had been stricken for the previous four months with one of his periodic bouts of crippling rheumatism, and Sanford beheld the aging Italian general, "still an invalid," hobbling toward him. The two men talked late into the night, but Garibaldi expected far more than Sanford could promise. Quiggle, in violation of Sanford's stern instructions, had taken it upon himself to write to Garibaldi announcing that Sanford was on his way "to offer him the highest army commission in the power of the President to confer." Sanford, however, had been authorized only to offer Garibaldi the rank of major general, in charge of a division, but not of commander-in-chief of the Union forces. Seward had been keenly aware of the public diplomacy value Garibaldi's aid might bring to the Union, especially with Britain, which he was terrified was about to recognize the Confederacy as a sovereign nation. The practical value of an aging Italian general who had only a limited knowledge of English and a well-deserved reputation for being headstrong was, however, questionable. Certainly, the appointment of Garibaldi would excite jealousy among the many American officers trained at West Point. By now the Garibaldi affair was also eliciting ridicule in the international press. The *Times* of London, for instance, excoriated the "humiliating character of this proposal" which betrayed America's claim to "native genius" in the area of military leadership.[61]

Upon meeting with Sanford, Garibaldi reiterated his two conditions. "He said the only way in which he could render real service . . . to the cause of the United States, was as commander in chief of its forces," Sanford explained to Seward, and

> that he would only go as such and with the additional contingent power—to be governed by events—of declaring the abolition of Slavery. He would be of little use, he said, without the first, and without the second the war would appear to be like any civil war in which the world at large could have little interest or sympathy.[62]

The two men then discussed Garibaldi coming over as an observer, a role Sanford thought might take full advantage of the Italian hero's moral influence without having to risk having the headstrong general commanding an army. "He knows himself that far and that he could do nothing cooperatively—never has and . . . never can."[63]

Because the Garibaldi affair was becoming public and something of an embarrassment, Sanford did his best to focus attention on the general's insistence on full command of the Union armed forces rather than his vexing question about the moral purpose of the Union's war. Meanwhile, Garibaldi was embarrassed, too, when the king, in effect, called his bluff, telling him he was free to go to America if he wished, but that the Kingdom of Italy was not prepared to march on Rome. From Caprera Garibaldi, nonetheless, continued to express support for the Union, and soon after Sanford left he shrewdly left the door ajar by writing to Quiggle a letter that was then widely circulated in the American and international press:

> I shall not be able to go to the United States at present. I do not doubt of the triumph of the cause of the Union, and that shortly. If the war should unfortunately continue in your beautiful country, I shall overcome all the obstacles which detain me and hasten to the defence of a people who are dear to me.[64]

Garibaldi's most important service to the Union cause came one year later, when the world's attention was focused on him after a failed attempt to march on Rome in apparent defiance of the government. On 29 August 1862, Italian soldiers who were under orders from the king to stop him had wounded Garibaldi at Aspromonte, in Calabria. He was taken to prison at Varignano, and rumors flew that he might die from his wounds, or be tried for treason and executed. Large public demonstrations in support of Garibaldi broke out across Italy and in other parts of Europe. On 28 September and again on 5 October, in Hyde Park, London, Garibaldi demonstrators were assailed by pro-Catholic Irish toughs, tens of thousands of people joined a brawl with clubs, fists, and knives flying.[65] From his hospital prison bed Garibaldi issued an eloquent public letter "to the English Nation" that was widely reprinted. In the letter he called upon Britain, the refuge from tyranny in Europe, to engage France, Switzerland, America and other free nations in leading the world toward peace and liberty. He rebuked France for its foreign conquests, which he called an "emanation of insane minds." Most remarkable was his endorsement of the Union cause:

> Call the great American Republic. She is, after all, your daughter, risen from your bosom; and, however she may go to work, she is struggling to-day for the abolition of Slavery so generously proclaimed by you. Aid her to come out from the terrible struggle in which she is involved by the traffickers in human flesh. Help her, and then make her sit by your side, in the great assembly of nations, the final work of human reason.[66]

What was striking about Garibaldi's embrace of the Union was the remarkable declaration of its abolitionist purpose. The letter, dated at Varignano, 28 September, appeared in London newspapers on 3 October, right between the two massive demonstrations in Hyde Park on successive Sundays, which Garibaldi would not have known about. And the appeal to Britons to defend America's war against the "traffickers in human flesh" came several days before he or anyone in Europe knew of President Lincoln's Emancipation Proclamation on 22 September.[67]

Rumors of an emancipation scheme had been circulating since June when the Union advance toward Richmond was repulsed and the Confederates under Robert E. Lee's command marched north into Maryland. The British and French governments saw their opportunity to intervene in the war, and rumors of Lincoln's emancipation plan only hastened their desire to bring an end to the war before such an edict might ignite racial strife and permanently disrupt the cotton trade. As it happened, Garibaldi's ill-fated march on Rome had the unintended effect of upsetting the Anglo-French scheme to intervene in the Civil War. Because the public uproar over Garibaldi created a crisis in the French government, it derailed the plan for intervention, at least for a while.

Adding to the public excitement over Garibaldi, an obscure U.S. consul in Vienna, Theodore Canisius, taking a page from James Quiggle's book from one year earlier, decided to send a letter to the imprisoned Italian hero. Canisius heaped praise upon the wounded hero for his "great and patriotic work," and invited him "to lend us a helping hand in our present struggle to preserve the liberty and unity of our great Republic." Garibaldi wrote back, explaining to Canisius that "I am a prisoner and I am dangerously wounded," and adding that he hoped to "be able to satisfy my desire to serve the Great American Republic, of which I am a citizen, and which today fights for universal liberty." Canisius went public with the correspondence, and the "news" that the Italian general would fight for America spread through the international press once again like wildfire.[68]

Seward learned about Canisius's self-appointed diplomatic mission when the *New York Times* published the story, and he was furious. Here was an official representing a nation at arms against a treasonous rebellion praising the "great and patriotic work" of an imprisoned rebel possibly facing treason charges. Seward dismissed Canisius summarily, and he explained to the Italian government that the man's actions were entirely unauthorized. For his part, Canisius was completely unapologetic: "I thought the time had come to let the world know what the great Hero of the Castle of Varignano thinks of us and our cause." He reminded Seward of the "great Garibaldi demonstrations in England," and of Garibaldi's astounding letter "To the English Nation," arguing that this endorsement had greatly "strengthened our cause throughout Europe" at a time of peril. Canisius was right, and Seward, with the approval of the Italian government and President Lincoln, soon returned the resourceful consul to his post.

Meanwhile, the king, eager to calm popular unrest, quietly pardoned Garibaldi, who returned to Caprera to recuperate from his wounds. In August of 1863, after Lincoln's emancipation plan had taken effect without the racial mayhem European political leaders had predicted, Garibaldi and his two sons sent a magnificent public letter that was widely published in the American and foreign press:

> Abraham Lincoln, Emancipator of the Slaves in the American Republic:
> In the midst of your titanic struggle, permit me, as one who is also a free child of Columbus, to send you a word of greeting and admiration for the great work you have begun. Posterity will call you a "Great Emancipator," a title to be envied more than any crown, to be valued more than any worldly treasure. You are a true heir of the teaching given us by Christ and by John Brown. If an entire race of human beings, subjugated into slavery by human selfishness, has been restored to human dignity, to

human civilization and human love, this is by your doing and at the price of the most noble lives in America. It is America, the same country which taught liberty to our forefathers, which now opens another solemn epoch of human progress. . . . Greetings to you Abraham Lincoln, the pilot of freedom! Greetings to all of you who fight and die around the lifegiving battle-flag! And greetings to you, the redeemed offspring of Ham! The free men of Italy kiss the glorious fleshmarks from your chains.[69]

The parallel campaigns for national unification in America and Italy permitted Americans to continue to see in distant Italian struggles the value of their own hard-earned unity. The next stages of Italian unification took place in the context of other power struggles on the European continent, and in particular the wars initiated by Otto von Bismarck, the Iron Chancellor of Prussia, to achieve German unification. In 1866 Bismarck won a lightning war against the Austrian empire that had as a side result the cession of Venice to Italy. Four years later, with the outbreak of the Franco-Prussian War, the French troops protecting the Papal States were called back to France and by September 1870 Rome fell to Italian forces with little resistance. The Risorgimento was complete. And the Great Migration of Italians to America was about to begin.

Further Reading

Marraro, Howard R. *American Opinion on the Unification of Italy*. New York: Columbia University Press, 1932.
Riall, Lucy. *Garibaldi: Invention of a Hero*. New Haven: Yale University Press, 2007.
Ridley, Jasper. *Garibaldi*. London: Constable, 1974.

Notes

1 Jonathan Sperber, *The European Revolutions, 1848–1851*, 2nd ed. (Cambridge: Cambridge University Press, 2005), 1.

2 Lucy Riall, *Garibaldi: Invention of a Hero* (New Haven: Yale University Press, 2007); Maurizio Isabella, *Risorgimento in Exile: Italian Émigrés and the Liberal International in the Post-Napoleonic Era* (Oxford and New York: Oxford University Press, 2009).

3 Joseph Rossi, *The Image of America in Mazzini's Writings* (Madison: University of Wisconsin Press, 1954), 134–136.

4 Riall, *Garibaldi*, 69–70.

5 *The Daily Crescent* of New Orleans (4 October 1848) was one exception.

6 Ray Allen Billington, *The Protestant Crusade, 1800–1860: A Study of the Origins of American Nativism* [1938] (repr., Chicago: Quadrangle Books, 1964); Dale T. Knobel, *Paddy and the Republic: Ethnicity and Nationality in Antebellum America* (Middletown: Wesleyan University Press, 1986).

7 *New York Herald* (20 February 1848), quoted in Howard Rosario Marraro, *American Opinion on the Unification of Italy, 1846–1861* (New York: Columbia University Press, 1932), 28.

8 Ibid., 4–14, 28–29.

9 Ibid., 36.

10 Ibid., 37–38.

11 Ibid., 49–52.

12 Margaret Fuller, *These Sad But Glorious Days: Dispatches from Europe, 1846–1850*, ed. Larry Joe Reynolds and Susan Belasco Smith (New Haven: Yale University Press, 1992), 165, 230. In Rome Fuller fell in love and had a child with a young Italian named Giovanni Angelo Ossoli and, whether married or not, went by Margaret Fuller Ossoli. There is a fine essay on her by Helen Barolini, "Ardor and Apocalypse: The Timeless Trajectory of Margaret Fuller," in *Their Other Side: Six American Women & the Lure of Italy*, ed. Barolini (New York: Fordham University Press, 2006), 3–52.

13 Fuller, *These Sad But Glorious Days*, 257, 259.

14 Marraro, *American Opinion*, 66. These reports echoed similar reports propagated by papal sympathizers in Italy.

15 In 1848–49 there were popular protests against the monarchies in Germany and Austria as well.

16 Marraro, *American Opinion*, 68–69.

17 Ibid., 69–72, 78.

18 Jasper Ridley, *Garibaldi* (London: Phoenix Press, 2001), 276–277.

19 Ibid., 278–280.

20 Fuller, *These Sad But Glorious Days*, 274, 278.

21 Ridley, *Garibaldi*, 290–307.

22 Ibid., 306.

23 Marraro, *American Opinion*, 82, quoting *New-York Daily Tribune* (27 July 1849).

24 Ibid., quoting *New York Herald* (9 July 1849).

25 Marraro, *American Opinion*, 167, quoting *New York Herald* (31 July and 1–2 August 1850).

26 *New York Herald* (26 July 1850), quoted in ibid., 167. See also H. Nelson Gay, "Garibaldi's American Contacts and His Claims to American Citizenship," *American Historical Review*, 38 (1932), 1–19.

27 Marraro, *American Opinion*, 168.

28 Ridley, *Garibaldi*, 358–359.

29 Ibid., 359.

30 Meucci patented the invention, which, when the patent was permitted to lapse, was taken up by Alexander Graham Bell. The house where Garibaldi lived, now the Garibaldi-Meucci Museum, may be visited in the Rosebank section of Staten Island.

31 Ridley, *Garibaldi*, 399–400.

32 Marraro, *American Opinion*, 186–187.

33 Paola Gemme, *Domesticating Foreign Struggles the Italian Risorgimento and Antebellum American Identity* (Athens: University of Georgia Press, 2005); Billington, *Protestant Crusade*; Knobel, *Paddy and the Republic*; Tyler Anbinder, *Nativism and Slavery: The Northern Know Nothings and the Politics of the 1850s* (New York: Oxford University Press, 1992).

34 Marraro, *American Opinion*, 186–224.

35 Gemme, *Domesticating Foreign Struggles*.

36 Marraro, *American Opinion*, 215–218.

37 Ibid., 218–221; "Second Lecture on Italy: Signora Mario at Clinton Hall," *New York Times* (9 December 1858); "The Italian Question," *New York Times* (13 December 1858).

38 Ridley, *Garibaldi*, 373–374.

39 Ibid., 375–382.

40 Ibid., 401.

41 Ibid., 397.

42 "The Victory of Magenta and Occupation of Milan," *New York Times* (22 June 1859); "Plan and Particulars of the Battle of Solferino," *New York Times* (20 July 1859).

43 Ridley, *Garibaldi*, 414.

44 "To the United States Press," *New York Times* (17 November 1859); Ridley, *Garibaldi*, 414.

45 "Garibaldi in Retreat," *New York Times* (17 December 1859).

46 "American Sympathy for Italy," *New York Times* (18 February 1860).

47 "Garibaldi's Expedition," *New York Times* (12 June 1860).

48 "The Italian Washington," *New York Times* (27 June 1860).

49 "Garibaldi," *New York Times* (24 September 1860).

50 "Garibaldi at Naples," *New York Times* (4 October 1860).

51 The expression, "Hero of Two Worlds," originated with the Marquis de Lafayette for his exploits in America and France. The earliest reference to Garibaldi as the "Hero of Two Worlds" in U.S. or British online newspaper archives (Chronicling America and British Newspaper Archives) is found in *Dundee Advertiser* (25 August 1862), but the context makes clear this title was already in common use.

52 Giuseppe Garibaldi, *Life of General Garibaldi Written by Himself*, ed. Theodore Dwight (New York: A.S. Barnes and Burr, 1859).

53 Alexandre Dumas, *Mémoires de Garibaldi* (Paris: Lévy, Michel, frères, 1860).

54 [Henry T. Tuckerman], "Giuseppe Garibaldi," *North American Review*, 92.190 (January, 1861), 15–56; William Arthur, *Italy in Transition: Public Scenes and Private Opinions in the Spring of 1860* (Hamilton: Adams, 1860).

55 Candido Augusto Vecchi, *Garibaldi e Caprera* (Napoli: Fibreno, 1862), 52; "Garibaldi on Italy and America," *New York Times* (27 May 1861); Don H. Doyle, *The Cause of All Nations: An International History of the American Civil War* (New York: Basic Books, 2015), 17.

56 Doyle, *Cause of All Nations*, 19–20. See also Harry Nelson Gay, "Lincoln's Offer of a Command to Garibaldi: Light on a Disputed Point of History," *The Century Illustrated Monthly Magazine*, 75.1 (November 1907), 63–74 (66–67).

57 Ibid.

58 Ibid., 20–21.

59 Henry S. Sanford to William H. Seward, Brussels, 18 September 1861, Belgium, RG 59, National Archives II; Doyle, *Cause of All Nations*, 24–25.

60 Sanford to Seward, Genoa, 7 September 1861, RG 59, Belgium, National Archives II.

61 Reprinted in *New York Times* (4 October 1861), 2.

62 Sanford to Seward, Brussels, 18 September 1861, RG 59, Belgium, National Archives II.

63 Ibid.

64 Garibaldi to Quiggle, Caprera, 10 September 1861, enclosed with Quiggle to Seward, Antwerp, 30 September 1861, Antwerp, RG 59; "The Great Rebellion," *New York Times* (29 October 1861); "Garibaldi Again," *New York Times* (30 October 1861). This letter was reprinted repeatedly in the American press.

65 Sheridan Gilley, "The Garibaldi Riots of 1862," *Historical Journal*, 16 (1973), 697–732; Doyle, *Cause of All Nations*, 226–232.

66 "Garibaldi to the English Nation," *London Times* (3 October 1862); "Garibaldi to the English Nation," *New York Times* (18 October 1862).

67 *London Times* (6 October 1862).

68 Garibaldi to Canisius, Varignano, 14 September 1862, Vienna, RG 59; Giuseppe Garibaldi and Domenico Ciampoli, *Scritti politici e militari: Ricordi e pensieri inediti* (Rome: E. Voghera, 1907), 91; Doyle, *Cause of All Nations*, 229–230.

69 Giuseppe Garibaldi, Menotti Garibaldi, and Ricciotti Garibaldi to Abraham Lincoln, Thursday, 6 August 1863, Abraham Lincoln Papers at the Library of Congress, http://memory.loc.gov/ammem/alhtml/malhome.html. My thanks to William Connell for sharing his translation of this letter.

DANTE ALIGHIERI AND THE *DIVINE COMEDY* IN NINETEENTH-CENTURY AMERICA

Dennis Looney

Introduction

Dante Alighieri (1265–1321), the medieval Italian writer and political thinker, author of the *Divine Comedy*, was surprisingly present in nineteenth-century American culture. He emerged as a literary and political touchstone and even assumed an unexpected position as a catalyst for popular entertainment by the century's end. Though the poet's initial reception in the United States in the late eighteenth and early nineteenth centuries depended primarily on how he was read in England and among English expatriates in Italy,[1] after the Civil War interest in Dante burgeoned in the United States independent of English literary tastes. Possibly it was a diminishing of the centrality of mainstream Protestant religion in daily life that encouraged interest in this very Italian and very Catholic (but highly unorthodox) writer.[2] Charles Eliot Norton, professor of art history at Harvard and himself an outstanding Dante scholar, made this point in 1894.[3]

There was also the growing influx of Italian immigrants into the United States over this century, especially in its final decades, and these newcomers—some few aristocrats, the vast majority of them peasants and members of the working class—brought Dante with them to their new country. Lorenzo Da Ponte, after having distinguished himself as Mozart's librettist in Vienna, made his living teaching Italian, including Dante, to New Yorkers in the first decades of the century.[4] And to pick only one of many possible examples from the end of the century: Italian immigrants in California created an association dedicated to Dante, as described by a stunned commenter in *The Dial* magazine in 1897:

> About San Francisco Bay is a settlement of Italian fisherman whose condition is apparently without an aspiration other than to have a supply of the black bread they eat and the sour wine they drink; yet *these people support a society for the study of Dante*.[5]

The commentator appreciates, indeed is mightily impressed by, the people's enthusiasm for the study of Dante. But the people, she implies with her derisive aside about the quality of their bread and wine, are common, simple, and by some measure, probably relatively uneducated: "*yet these people support a society for the study of Dante*." Italians on their way to becoming Italian Americans identified strongly with the cultural significance of the great medieval author.

1865—the end point of the Civil War and an *annus mirabilis* in this history of Dante in America—is an appropriate place to start. Writer George Alfred Townsend depicted the

frightening chaos in the aftermath of Abraham Lincoln's assassination with an allusion to Dante, knowing that his readers would follow:

> Then Mrs. Lincoln screamed, Miss Harris cried for water, and the full ghastly truth broke upon all—"The President is murdered!" The scene that ensued was as tumultuous and terrible as one of Dante's pictures of hell.[6]

The year of Lincoln's death happened to mark the sixth centennial of Dante's birth. Indeed 1865 was a year of celebrations in Italy, with Dante anointed both officially and to popular acclaim as the cultural father of the newly formed country. Henry Wadsworth Longfellow produced a deluxe edition of his translation of *Inferno* in time to send five copies to Florence for its celebration in honor of Dante that year.[7] This was also the inaugural year of the famous Dante Club that met at Longfellow's house in Cambridge, Massachusetts.[8] That same year Vincenzo Botta, an Italian expatriate living in the United States, published with Scribner's in New York *Dante as Philosopher, Patriot and Poet*, a book in which he compares Dante's political philosophy with George Washington's.[9] By 1865 Dante, the foundational figure of Italian culture, was well on his way to becoming Americanized: He was cited in the same breath with the Founding Fathers.

One can study the response to Dante in nineteenth-century America from at least three overlapping perspectives, that of the academy, of politics and of popular culture. Scholars have documented the attention to Dante of writers like Norton who belonged to the educated upper classes of New England.[10] Their "academic" Dante is manifest in the creative literary work of the Transcendentalists and in the collaborative work of the Dante Club, which in addition to Longfellow included Norton and James Russell Lowell. In the wake of this intense regional reception, Thomas Nelson Page, a Dante scholar (and a Virginian) who served as Ambassador to Italy during World War I, would later refer to them as "the Brahmin-class of Intellectuals or would-be Intellectuals."[11]

In addition to *literati*, there were Americans who engaged with Dante for motives best described as "political." Many of the New England intellectual *élite* that promoted the study of Dante's life and works were closely connected with leading abolitionists. They were also interested in Italian unification, and Dante's unflinching criticism of the papacy was easy to interpret as a sign that he would support people everywhere who were striving for self-rule and determination. A politicized interpretation of Dante galvanized American readers as the discourse of abolitionism was refined in the decades leading up to the Civil War in the 1860s and then in the years of Reconstruction that followed. William Lloyd Garrison, the most important American abolitionist, was a friend of Giuseppe Mazzini, the most important Italian nationalist and a Dante admirer; in 1872 Garrison wrote the introduction to the first collection of Mazzini's work published for an Anglo-American audience.[12] Mazzini's political Dante was handed on to Garrison and through him to general readers in English on both sides of the Atlantic.

Dante also began to penetrate popular culture in the nineteenth century, arriving in parts of America far beyond New England. Many Americans did not first learn of Dante through a book or in a classroom or from an erudite written allusion. The wax museum in Cincinnati, Ohio, called "Dante's Hell," which opened in 1828, and the amusement park ride known as "Dante's Inferno," which opened at Coney Island in 1907, exemplify how Dante's *Divine Comedy*, especially the *Inferno*, became a source of entertainment that extended the poet's popularity to a demographic far beyond the halls of academe and the debates of radical politics. In what follows I discuss some examples from each of these three areas.

Dante in the Academy

In the late eighteenth and early nineteenth centuries, academic institutions began to offer courses in Italian that would eventually make it possible for many to gain the skill and opportunity to read Dante. Harvard College was the first to give Dante a place of his own in the curriculum. In 1834, Henry Wadsworth Longfellow (1807–1882) was offered the Smith Professorship of Modern Languages and Literatures at Harvard, where he began teaching two years later. Longfellow took advantage of his position to lecture extensively on the *Divine Comedy*, guiding students through the entire poem over the course of an academic year. His pedagogical approach was to read the poem in Italian, translating and paraphrasing into English, and then to present various contemporary interpretations of it for discussion, focusing on the text as a moral treatise in poetic form with little specific attention to its theological significance. In 1854, after twenty years at Harvard, he was happy to have made enough money from publishing *Evangeline* and other poems to be able to retire from teaching.[13] His last lecture was on *Inferno* XXXIV, with brief comments on *Purgatory* and *Paradise*. He then threw himself into the project of formalizing his working translations of Dante for publication.

While at Harvard, Longfellow worked in tandem with a Sicilian, Pietro Bachi (1787–1853), who taught Italian language to students before they took the advanced course on Dante.[14] Bachi began teaching Italian and Spanish at Harvard soon after arriving in the United States in 1825, continuing until 1844. He prepared basic teaching materials in Italian for his program, which included frequent references to Dante. In the manual on conversation, called *Conversazione italiana, or a Collection of Phrases and Familiar Dialogues in Italian and English*, which was published in 1835, Bachi's textbook created dialogues for travelers as they moved from one Italian city to another.[15] To give one example, at Bologna the leaning tower of Garisenda, which was described by Dante in *Inferno* XXXI. 136–140, is mentioned this way:

> The tower of the Asinelli and the Carisenda so much celebrated by Dante, are truly terrific to look at, on account of their considerable inclination.[16]

There is a blank space on the page for the student to provide a translation of the passage, with a version in proper Italian following on the next page:

> *La torre degli Asinelli e la Carisenda tanto celebrata dal Dante, sono veramente terrífiche a riguardare, a cagione della loro considerábile inclinazione.*[17]

The two adjectives stressed on their antepenultimate syllables are so marked to teach correct pronunciation. Similar examples of sites connected with Dante's life or his poem followed in subsequent dialogues set in Florence and Siena. This pedagogical response to Dante encapsulated a Grand Tour in grammar for New World "literary tourists" who were becoming more interested in Dante.

Earlier in the century, members of the Unitarian community in Boston had conducted a lively conversation on Dante in a variety of journals, including the *Monthly Anthology*, the *North American Review* and the *Christian Examiner*. This group of "writers, ministers, lawyers, and professors" used Dante to express anxieties about the politics of class and religion, especially in the context of tensions between Protestantism and Catholicism.[18] Their tendency to read Dante in connection with political issues established a pattern of what would become an essentially nineteenth-century American response to the poet.

Between 1841 and 1847, a group of Bostonians, some of whom had ties to the Transcendentalist movement, embarked upon a utopian experiment in communal living in West Roxbury, Massachusetts, under the leadership of a Unitarian minister, George Ripley. Members of the collective included Nathaniel Hawthorne, Margaret Fuller, and Theodore Parker—a Unitarian minister who later invited Frederick Douglass to speak from his pulpit.[19] Those signing on purchased shares in the project to buy the land on which they established Brook Farm, which included a school. In his "Reminiscences of Brook Farm," George P. Bradford recalled:

> Various classes were from time to time formed for reading and studying together. One I recollect was a very agreeable opportunity of reading Dante in the original (we read in turn, the whole or nearly the whole) with a number of cultivated, intelligent, and appreciative persons, those of better knowledge of the language helping the others.[20]

Dante was the only author, besides Immanuel Kant, whom Bradford mentioned in his essay, which he concluded with this heady comment:

> And so I cannot but think that this brief and imperfect experiment [Brook Farm], with the thought and discussion that grew out of it, had no small influence in teaching more impressively the relation of universal brotherhood, and the ties that bind all to all, a deeper feeling of the rights and claims of others, and so in diffusing, enlarging—deepening and giving emphasis to—the growing spirit of true democracy.[21]

Dante was an author on the syllabus, as it were, for this course in communal living, or to use Bradford's phrase, in "true democracy." If at the beginning of the century the Unitarians used Dante simply to gloss political issues, by the middle of the nineteenth century these Utopians transformed the author of the *Comedy* into a political touchstone.

But it was not all such highfalutin idealized discourse at Brook Farm. Nathaniel Hawthorne's *The Blithedale Romance* (1852), a fictionalized account of life on the farm, gives us a glimpse into social interaction among the men and women who lived there.[22] The novel presents the narrator, Mr. Coverdale, in a curious position about to eavesdrop on a flirtatious couple from his perch in a natural tree house in the woods. He invokes rather comically the opening of *Inferno* XIII—where Dante the pilgrim enters the Wood of the Suicides—in a way that shows Hawthorne's keen understanding of the original passage. Dante doesn't yet realize that the groans he hears coming from the trees belong to suicides *inside* the trees, believing instead that people hiding behind the trees are making the noises. Hawthorne enfolds Dante's striking image within one of his narrator's most important passages:

> No doubt, however, had it so happened, I should have deemed myself honorably bound to warn them of a listener's presence by flinging down a handful of unripe grapes, or by sending an unearthly groan out of my hiding-place, *as if this were one of the trees of Dante's ghostly forest.* But real life never arranges itself exactly like a romance.[23]

Hawthorne alludes to a key passage where Dante draws attention to the difference between himself as poet and character in the poem (*Inferno* XIII. 22–27). The allusion playfully suggests

that Mr. Coverdale might do anything to avoid revealing himself, that he might even commit suicide. But the narrator quickly reminds the reader of the need to observe the distinction between fact and fiction, that is to say, although he finds himself in a situation analogous to that of souls in Dante's Wood, he is hardly about to end his life. Such a sophisticated rewriting of a complicated passage in Dante shows the extent to which the *Divine Comedy* had become a provocative sounding board for the literary explorations of a self-conscious writer like Hawthorne. By the mid-nineteenth century Dante was firmly ensconced in the literature of the new republic, with most major American authors of the time, and many minor ones, engaging to some degree with the poet's text.[24]

The translation of the *Divine Comedy* by Henry Francis Cary (1772–1844), first published in 1814 and republished frequently thereafter, gained prominence in the United States through Samuel Coleridge's enthusiastic promotion, which established Cary's version as the Dante of record for a generation of American readers.[25] In a review of a reprinted version of Cary's translation that came out in 1845, Margaret Fuller (1810–1850) included critical comments that shed light on the use of Dante in the schoolroom. "We must say," she wrote, "a few words as to the pedantic folly with which this study [the study of Dante] has been prosecuted in this country...."[26] Fuller went on to protest the use of Dante in the elementary classroom as an author too challenging for beginning readers. As for mature readers, they often mistook the commentary that accompanied the text for the poem itself:

> Painfully they study through the book, seeking with anxious attention to know who Signor This is, and who was the cousin of Signora That....[27]

Fuller implied that undue attention to the historical context inevitably distracts the reader from the meaningful beauty of the poetry:

> Shut your books, clear your minds from artificial nonsense, and feel that only by spirit can spirit be discerned.... Would you learn him, go listen in the forest of human passions to all the terrible voices he heard with a tormented but never-to-be-deafened ear....[28]

Here, in what was perhaps a subtle allusion to the very same passage in *Inferno* XIII that caught Hawthorne's attention, Fuller made a plea for what we might call an un-academic reading of Dante that verges on the mystical.

As knowledge of Dante's life, works and times increased over the course of the century, so did the range of possible interpretations of his major and minor works. These new readings, sometimes respectful of academic interpretations of Dante, but often liberated from them, contributed to a growing diversity in the political interpretations of the *Divine Comedy*.

Political Dante between Protestant Appropriation and Catholic "Rescue"

Cordelia Ray (1852–1916), an African American author, refracted her thinking about race, civic activism and freedom through her encounter with Dante's work and life.[29] Her fifty-two line poem, "Dante" (1885), is a superb example of nineteenth-century writing that brought the question of race to the fore in the context of a response to the *Divine Comedy*, while it also reimagines Dante's biography. Ray represented Dante as an abolitionist fighting for the equality of Florentine citizens: a public intellectual who resembled more an activist

constitutional lawyer than the lovesick poet commonly found in nineteenth-century American literature:

> Indignant at the wrongs that Florence bore,
> Florence, thy well-beloved, thy hallowed home,
> With stern denunciation thou didst wage
> Against the law's lax mandates bloody war,
> And all unawed, rebuked the false decrees
> Of kings, of conquerors, popes and cardinals. . . (lines 14–19).[30]

Legal language characterizes Ray's description of Dante: he filed an official accusation, a "denunciation" (16) against the "law's lax mandates" (17) and he "rebuked . . . decrees" (18). This is the vocabulary of the sort of legal and judicial activism associated with the abolitionists. Moreover, Ray sounds an antipapist, anti-ecclesiastical note, creating the image of a Protestant Dante who also would have made sense to activist intellectuals of the nineteenth century.

Ray's image of the poet was in line with many politicized English readings, some of them dating to eighteenth-century Whig traditions, but with roots in the Tudor period. I suspect she knew nothing of these, but her interpretation is nonetheless in dialogue with them due to her Protestant interest in Dante as a critic of the papacy.[31] Whether aware of it or not, Ray was the beneficiary of an interpretive tradition that emphasized Dante's potential for Protestant propaganda.

Beginning around the mid-sixteenth century, intellectuals in England established a pattern of interpreting Dante as a radical political thinker, specifically an authority on antipapal political positions, in the context of Henry VIII's struggle with the Church in Rome and the ongoing cultural turmoil in Elizabethan and Reformation England that followed. These interpretations, needless to say, distort essential features of Dante's Christianity, going so far in some cases as to liken him to Wycliffe or Luther, while at the same time they highlight, even to the point of exaggeration, the specific line of his thinking that was indeed critical of the papacy. This Protestant Dante subsequently influenced Italian nationalists who promoted an idiosyncratic understanding of the poet as a political thinker on the eve of the foundation of Italy. Italians needed a national hero who was critical of the Church in Rome and if he spoke the people's language, all the better. Italian nationalist leaders like Giuseppe Mazzini, in turn, made Anglo-American abolitionists aware of the Italian poet as a political thinker and consequently influenced the way in which the abolitionists understood and used Dante's writings, especially his criticism of the Church.

Frederick Douglass, among many abolitionists, thought of Dante as a radical political reformer. In a revised version of his famous autobiography, he referred to Dante and Savonarola as "great historical personages" of Florentine culture who contribute to the city's "controlling power over mind and heart."[32] When a member of the press visited the elderly Douglass at home in 1889, he reported the following:

> Mr. Douglass invited the reporter into his library, and there the faces of the late Chief Justice Chase, W. Lloyd Garrison, James S. Birney, De Strauss, L. Feuerbach, Dante, Abraham Lincoln, John Brown, and Charles Sumner looked down in smiles and respect on the great negro sage.[33]

By the 1880s and 1890s, Dante had become a fixture in the politics of the liberal world on a par with none less than Lincoln.

In 1897, the Reverend George McDermot, writing on "Dante's Theory of Papal Politics" for the American publication *Catholic World*, provides a striking example of a Catholic need, under pressure from Protestant readings of Dante, to "rescue" the Florentine poet.[34] In the first section of his essay, which McDermot calls pointedly "Dante's Words Misinterpreted," he critiques "the use Protestants and Italian revolutionists have made of his views."[35] From his Catholic perspective, Protestants and Italian revolutionaries are a formidable and lamentable tandem. In a subsequent section, "His Faith Was Sound," the apologist asserts bluntly:

> Those who claim him as a pioneer of the Reformation in the same way that they claim Huss and Wycliffe, those who think he was speculatively allied to the Albigensians or the Waldenses, misunderstand the theory of Dante.[36]

By this moment in the reception of Dante, there was a serious attempt to contest the multiplying Protestant interpretations of his work.

In May 1893, the Columbian Reading Union of New York City reported on a meeting it had organized on "How to Study Dante."[37] Reading groups, sometimes peripherally connected to the academy but often detached from any university or school, were important institutions in fostering the growing popularity of Dante in nineteenth-century America. Some, such as the society organized by fishermen in San Francisco mentioned at the beginning of this essay, were Italian American cultural groups. The leader of this specific group in New York City, a certain Brother Azarias, promised a new way of reading the poet:

> Brother Azarias pointed out the fact that while Dante societies were numerous among Protestants in this country, this was the first Catholic society, to his knowledge, that had taken up the serious study of the immortal Catholic poet. He dwelt on the necessity of an accurate knowledge of the history, literature, politics, and art of Dante's age in order to appreciate in any degree the poem.[38]

For "accurate" knowledge, read "Catholic." Brother Azarias and his fellow readers felt compelled to reclaim Dante from what they perceived to be the distorted exegesis of Protestantism. This Counter-Reformation, as it were, in the interpretation of Dante would eventually be absorbed into the ongoing scholarly work of academia devoted to an accurate exegesis of the poet's work.

In response to these various attempts to claim Dante as one sort of a thinker or another, a new kind of work began to be published of which Gauntlett Chaplin's *Dante for the People* is exemplary.[39] In the introduction to this popularizing version of chestnuts from the *Divine Comedy*, the editor states unashamedly that the book's "design is to disentangle the poet, in a degree, from the theologian and the politician."[40] That is, by the beginning of the twentieth century, there was the sense that overtly politicized translations, commentaries, and appropriations had lost sight of the real Dante and his poem. A new need emerged to claim Dante not as a Catholic or Protestant writer but as a poet for the people. Though this popular Dante overlapped to some extent with the academic/literary Dante and with the political Dante, it originated at the beginning of the nineteenth century in the most unexpected place: the wax museum.

Dante in Popular Culture: From the Wax Museum to Fairgrounds

Throughout the nineteenth century an animated discussion of contemporary Italian politics and Italian cultural figures—Dante first among them—was carried out in the popular press.

The first published American translation of a passage from Dante appeared in 1791 in *The New-York Magazine*, with the translator, William Dunlap, tackling a section from the Ugolino episode in *Inferno* XXXIII.[41] An active figure on the New York cultural scene, Dunlap's interest in Dante indicates the extent to which the reception of the poet developed in popular culture alongside his reception among academics and literary scholars.[42] Americans would respond to Dante in different ways—academic/literary, political, and popular—none more unusual than that guided by the English author, Frances Trollope, the mother of the novelist Anthony Trollope.[43]

In the opening chapter of her *Domestic Manners of the Americans*, Trollope alluded to Dante's *Inferno* to describe her arrival at the mouth of the Mississippi River on Christmas day, 1827, after a seven-week voyage from London.

> I never beheld a scene so utterly desolate as this entrance of the Mississippi. Had Dante seen it, he might have drawn images of another Bolgia from its horrors. One only object rears itself above the eddying waters; this is the mast of a vessel long since wrecked in attempting to cross the bar, and it still stands, a dismal witness of the destruction that has been, and a boding prophet of that which is to come.[44]

Although the greater part of Trollope's journey was over, her literary allusion suggests that she was about to enter upon the most challenging stretch of her trip. Her comparison invited the reader to imagine the bleak panorama as if deep in Dante's hell among the "bolgias" or "pouches" of the eighth circle, where fraudulent sinners are punished. Her description of a wrecked ship recalls the first simile in the *Inferno*, which likens the protagonist of Dante's poem to a shipwrecked sailor who has barely escaped death. I cite the simile in Cary's version, *Inferno* I. 22–27.

> And as a man, with difficult short breath,
> Forespent with toiling, 'scaped from sea to shore,
> Turns to the perilous wide waste, and stands
> At gaze; e'en so my spirit, that yet fail'd,
> Struggling with terror, turn'd to view the straits
> That none hath passed and lived.[45]

Trollope depicts herself in an analogous position to Dante's pilgrim as she sails into the Mississippi delta. Having survived the crossing of the Atlantic, catching sight of the shipwreck gives her pause to consider "the destruction that has been" for other less fortunate travelers. Like the sailor in Dante's simile she is safe for the time being, but like Dante the pilgrim she is about to embark on a voyage of even greater danger, for which the eerie mast can be interpreted as "a boding prophet of that which is to come." She knows Dante's poem well enough to use this allusion at the beginning of her book to suggest that the new world she is about to enter has things in common with an inferno.

After a brief stay in New Orleans, Trollope sailed up river to Cincinnati, the new boomtown in what was then called Western America, arriving on 10 February 1828. The growing population of Cincinnati became her laboratory for studying the locals. *Domestic Manners of the Americans*, written for an English audience back home and peppered with citations from Dante, is part travel guide, part literary essay, part sociological study.[46] With its depiction of U.S. citizens as tobacco-spitting hayseeds, the book proved to be a financial success soon after its publication in 1832, going into a fifth revised edition by 1839.

Trollope left Cincinnati after two years but not before she had established a successful commercial venture, which she advertised as "Dante's Hell." Readers of Cincinnati's *Saturday Evening Chronicle of General Literature, Morals, and the Arts*, found this advertisement on the back sheet of their newspaper, 30 August 1828:

> The proprietor of the *Western Museum* always anxious to oblige his subscribers and the public and to render his Museum as attractive to them as possible, begs to announce, that in future the entrance to the Museum will admit to the splendid scenic exhibition of Dante's Hell, purgatory and paradise without additional charge.[47]

Frances Trollope knew her Dante and once she had learned enough about the citizens of this city on the edges of western civilization, she knew that Dante would be right for them. Joining forces with the owner of a local collection of natural historical oddities at the Western Museum, and a young artist, Hiram Powers, she created a chamber of horrors, which was open to the public in the evening. Trollope's eldest son, Thomas, who later spent much of his life in Italy, recalled the creative collaboration between his mother and Powers in his memoir *What I Remember*:

> And it occurred to her to suggest to him to get up a representation of one of Dante's *bolgias* as described in the *Inferno*. The nascent sculptor, with his imaginative brain, artistic eye, and clever fingers, caught at the idea on the instant. And forthwith they set to work, my mother explaining the poet's conceptions, suggesting the composition of *tableaux*, and supplying details, while Powers designed and executed the figures and the necessary *mise en scène*.[48]

Actors playing the part of infernal greeters roamed the dark as frightened visitors gingerly made their way from one scene of the spectacle to the next. Powers mechanized much of the exhibit, adding a "metal rod as a barrier between the show and the spectators, and [he] contrived to charge it with electricity."[49] By the end of 1829, the exhibit had grown, according to the *Cincinnati Adviser and Ohio Phoenix*, to include:

> Upwards of 50 wax figures (size of life) consisting of phantoms, imps, monsters, devils among which Belzebub & Lucifer are conspicuous, with a variety of human sufferers in every stage of torment.[50]

"Dante's Hell" quickly "became the most celebrated single attraction staged by an American museum in the pre-Civil War era."[51] Trollope's version of Dante was the first commercial (nonpublishing) enterprise to capitalize so directly on the original, a model that would be imitated many times over in the coming decades and into the twentieth century with Dante's vision of hell becoming a standard source of inspiration for haunted houses on the midways of carnivals and fairs around America. Of the many derivations, here was a striking one from the end of the nineteenth century.

In 1896, in celebration of the centennial of the state of Tennessee, an exposition was organized in Nashville, which ran from late spring to early fall. Though the fair focused on commerce, industry, agriculture, and art, with large pavilions dedicated to these broad themes, there was a section of the fairgrounds, Vanity Fair, given over to what one might call educational entertainment. It included the cabins where Lincoln and his counterpart, Jefferson Davis, had been born, the recreation of a Colorado gold mine, Edison's Mirage, which

introduced Nashvillians to motion pictures, a cyclorama of the Battle of Gettysburg and a simulated "Old Plantation," with African Americans tending crops under the watchful eyes of white overseers.[52]

There were other venues, among them a haunted house, which visitors walked through with a guide:

> After this the journey was resumed, and the party taken through a grotto past the infernal regions. Dante's *Inferno* is illustrated with pictures and scenes, and through the grotto lined with skulls and peopled with uncanny things the road went. Then, at the darkest and most doleful part of the journey, the end of "Night" was reached, and there was a sudden change. A door opened, and a flash of light almost blinded the party in the lead.[53]

The haunted house recreated Dante's journey through hell leading the "reader" to the last passage in *Inferno* XXXIV, in imitation of the pilgrim's journey as he emerged from the blackness of hell to see the light. We don't have a full description of what participants actually experienced in the Tennessee centennial's version of hell, but similar versions of Dante's *Inferno* at other fairs of the same time mention mirrors, archways, corridors, rivers, "the throne room of Satan himself," amid other "[c]reative scenic and mechanical effects for those willing to pay the twenty-five cent admission fee."[54] Although Nashville was a Southern city of some sophistication, even dubbed the "Athens of the South," it could not boast of an academic tradition of reading Dante as did Boston and New York. Where, then, did this interest in Dante come from?

The version of Dante's *Inferno* at the Tennessee centennial exposition derived from the wax museum in Cincinnati and it represented the permutation of that popular Dante deeper into the provinces of the people. The 1935 Fox film, *Dante's Inferno*, starring Spencer Tracy and debuting Rita Hayworth in a minor role, can serve as a final witness to the widespread popularity of this carnival version of Dante. Tracy's character enlarges the Dante's *Inferno* haunted house he operates at the fair without concern for visitors' safety, bribing the inspectors who try to block him. A ten-minute vision of hell proper, cleverly cited from a previous silent version of Dante's *Inferno* (Fox, 1924), can't deter the man's greed, and the film ends in tragedy. The moral of the story: even this popular Dante should be able to teach you the difference between right and wrong.

Conclusion: Sailing with Dante from the Old to the New World

With the onset of mass immigration and a growing Italian presence in the United States at the end of the nineteenth century, Dante took on new meanings. As immigrants from Italy streamed into the United States, a great many of them passed through the harbor of New York City, where the Statue of Liberty greeted them with her famous welcome: "Give me your tired, your poor, / Your huddled masses yearning to breathe free...." Taken from a poem by Emma Lazarus (1849–1887), these lines were composed in 1883 as part of a campaign to raise money for the construction of the statue's pedestal. Eventually they were inscribed on a plaque inside the pedestal in 1903. The poem effectively transformed the neoclassical symbol of republican liberty into an image of the immigrant's newfound freedom in the land of opportunity. After landing, however, the immigrants entered holding rooms, first at Castle Garden, and then, after 1892, at Ellis Island, where they began dealing with their new state's bureaucracy. They quickly discovered that the streets of America were not paved with gold.

In 1881 the cartoonist Thomas Nast sought to warn immigrants about the perils of life in their new country with a striking cartoon adaptation of the Statue of Liberty (which was then under construction) that appeared in *Harper's Weekly* with this caption: "A warning light. Will it be necessary to erect an admonition of pestilence and death in our harbor? A question which our citizens must decide."[55] The drawing (Figure 5.1) provides visual commentary on the issue's editorial column about New Yorkers' growing protests on the unsanitary quality of life in their city.[56] Although the editorial doesn't mention immigration specifically, it could have. Immigrants were contracting illnesses in passage to their new country and growing more ill in holding areas on the island as they waited to gain entrance to the United States. Nast's image transforms Lady Liberty into a macabre skeletal figure of Death, with a "Roll of Death" in place of the Declaration of Independence in one arm and the lamp of liberty upside down in the other. An inscription on the base of the pedestal proclaims: "NEW YORK/LEAVE ALL/HOPE/YE THAT ENTER." The allusion to the Gates of Hell in Dante's *Inferno*, translates the famous verse, "Lasciate ogni speranza, voi ch'entrate" (*Inferno* III. 9), on the inscription.

This final example of Dante in nineteenth-century America brings together all three of the ways in which the poet was used during the century: academic/literary, political and popular. Knowing the literary source of the quote is not necessary to understanding part of its message, but some academic knowledge of Dante's *Inferno*, however basic, enriches one's response to the image. With that additional knowledge, New York becomes not merely a place that is hopeless: the fullness of the allusion leads the reader to compare the city with hell itself.

The political implications of such a comparison are vast, as the editorial column in *Harper's Weekly* makes clear. To be sure, this is not specifically an example of a political Dante as an idiosyncratic voice of liberty caught between contending interpretations of the poet's work, Protestant and Catholic. But it does show how a politicizing interpreter, Thomas Nast in this case, can utilize Dante to make a powerful point. Political will is needed to clean up New York City, the editorial accompanying the cartoon opines. The gargantuan figure of Death could be, for all we know, inspired by one of the ghouls in the Dante carnival shows running across America. In any case, the combination of skeleton, Death and Dante, as terrifying as it appears here, is, as we have seen, a common feature of entertainment in the nineteenth century.

If Nast demonized the experience of Italians sailing into their new country, the Italian poet Giovanni Pascoli (1855–1912) romanticized it in a late poem written from the perspective of those very Italians who sailed past the Statue of Liberty. His "Hymn to Dante from the Italian Emigrants,"[57] composed in 1911, was intended to be set to music and sung at the celebration in honor of the unveiling of the statue of Dante now in front of Lincoln Center in New York City. In its opening sections the poem invoked the two greatest sailors of the Italian tradition, the legendary Ulysses and the historical Columbus. In its third and final section, the poem called Dante the "eternal helmsman of Italy" (line 21) and asked him to guide the young country forward into the waters of the future.

In Pascoli's fiction, it was the Tuscan poet who steered Columbus to America, as if to say that the real discoverer of the New World was none other than Dante! Now, at the urging of Italian expatriates in America, the great poet can help Italy to right its course. Pascoli's poem reverses Nast's image of immigrants sailing into New York harbor past an infernal Statue of Liberty. Here is a saintly Dante whom Italians in America could invoke and take pride in. Pascoli's thinking was, alas, wishful. In the coming decades Italy and Dante would fall into the hands of those Fascists who would misread the poet—and sink the ship of state.

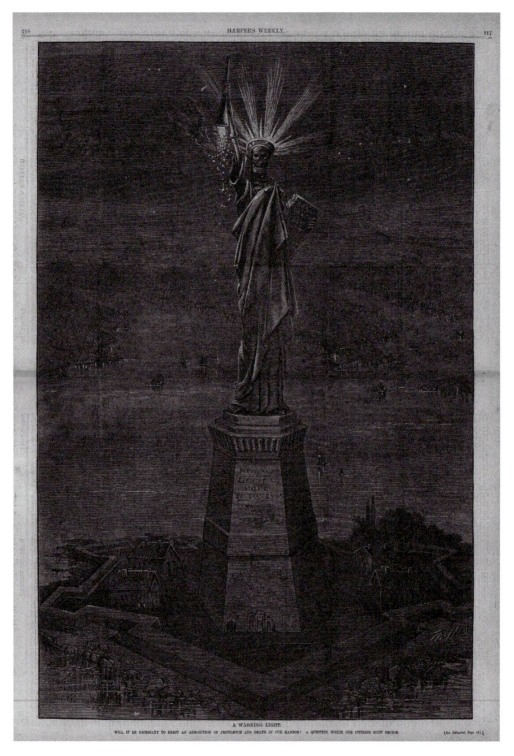

A WARNING LIGHT.
WILL IT BE NECESSARY TO ERECT AN ADMONITION OF PESTILENCE AND DEATH IN OUR HARBOR? A QUESTION WHICH OUR CITIZENS MUST DECIDE.

Figure 5.1 "A Warning Light." A cartoon by Thomas Nast. Published in *Harper's Weekly* (2 April 1881). Collection of William J. Connell.

Further Reading

Audeh, Aida and Nick Havely. *Dante in the Long Nineteenth Century: Nationality, Identity, and Appropriation.* Oxford: Oxford University Press, 2012.

Dupont, Christian. "Reading and Collecting Dante in America: Harvard College Library and the Dante Society," *Harvard Library Bulletin*, 22 (2011), 1–57.

Havely, Nick, ed. *Dante in the Nineteenth Century: Reception, Canonicity, Popularization.* Bern: Peter Lang, 2011.

Mazzotta, Giuseppe and Arielle Saiber, eds. "Longfellow and Dante," special issue of *Dante Studies*, 128 (2010).

Notes

1 Theodore W. Koch, *Dante in America: A Historical and Bibliographical Study* (Boston: Ginn, 1896), 9.

2 Kathleen Verduin, "Dante in America: The First Hundred Years," in *Reading Books: Essays on the Material Text and Literature in America*, ed. Michele Moylan and Lane Stiles (Amherst: University of Massachusetts Press, 1996), 40, 50.

3 James Turner, *The Liberal Education of Charles Eliot Norton* (Baltimore: Johns Hopkins University Press, 1999), 335. The original speech is catalogued as "Dante, Lecture I," 458, n. 35.

4 On Da Ponte, see Chapter 3.

5 Katherine Merrill Graydon, "A Dante Society among Fishermen," *The Dial*, 23 (1 September 1897), 110.

6 George Alfred Townsend, *The Life, Crime, and Capture of John Wilkes Booth* (New York: Dick and Fitzgerald, 1865), 10.

7 Edward Wagenknecht, *Henry Wadsworth Longfellow: His Poetry and His Prose* (New York: Ungar, 1986), 221–222. The copies, wrapped in scarlet cloth, were delivered by Longfellow's friend, Charles Sumner; see Kathleen Verduin, "Grace of Action: Dante in the Life of Longfellow," *Dante Studies*, 128 (2010), 35.

8 Verduin, "Grace of Action," 34. Matthew Pearl's popular mystery, *The Dante Club: A Novel* (New York: Random House, 2003), is set in 1865.

9 Vincenzo Botta, *Introduction to the Study of Dante Being a New Edition of Dante as Philosopher . . .* (New York: Scribner's, 1886), 57–58.

10 Koch, Turner and Verduin, among others.

11 Thomas Nelson Page, *Dante and His Influence* (New York: Scribner's, 1922), 7. Page's lectures were delivered at the University of Virginia.

12 *Joseph Mazzini: His Life, Writings and Political Principles*, compiled by Emily Ashurst Venturi, intro. William Lloyd Garrison (New York: Hurd and Houghton, 1872). See also Enrico Del Lago, *William Lloyd Garrison and Giuseppe Mazzini: Abolition, Democracy and Radical Reform* (Baton Rouge: Louisiana State University Press, 2013), esp. 228 n. 5.

13 Verduin, "Grace of Action," 25.

14 Koch, *Dante in America*, 38. On Bachi, see also Chapter 3.

15 Pietro Bachi, *Conversazione italiana, or a Collection of Phrases and Familiar Dialogues in Italian and English* (Cambridge: Munroe, 1835).

16 Ibid., 168.

17 Ibid., 169. Bachi uses the definite article with Dante's name.

18 Kevin P. Van Anglen, "Before Longfellow: Dante and the Polarization of New England," *Dante Studies*, 119 (2001), 155–186, citation on 178.

19 See the entry on Parker in Mason Lowance, *Against Slavery: An Abolitionist Reader* (New York: Penguin, 2000), 273–290. Ralph Waldo Emerson declined to join the group.

20 George P. Bradford, "Reminiscences of Brook Farm," *The Century*, 45.1 (1892), 141–148 (147).

21 Ibid., 148.

22 *The Blithedale Romance* (Boston: Ticknor, Reed, and Fields, 1852).

23 Ibid., 124. Italics added.

24 According to J. Chesley Mathews, James Fenimore Cooper was the only major exception: "The Interest in Dante Shown by Nineteenth-Century American Men of Letters," in Mathews et al., *Dante Alighieri: Three Lectures* (Washington DC: Library of Congress, 1965), 1–22.

25 Angelina La Piana, *Dante's American Pilgrimage* (New Haven: Yale University Press, 1948), 24.

26 Margaret Fuller Ossoli, "Italy: Cary's Dante," in her *Life Without and Life Within, or Reviews, Narratives, Essays, and Poems* (Boston: Brown, Taggard and Chase, 1859), 102–107 (103). On Fuller, see especially

Helen Barolini, *Their Other Side: Six American Women and the Lure of Italy* (New York: Fordham University Press, 2006), 3–52.

27 Ibid., 104.

28 Ibid., 104–105.

29 For a more complete discussion of Ray, see Dennis Looney, *Freedom Readers* (Notre Dame: University of Notre Dame Press, 2011), 50–62.

30 First published in the *AME Church Review*, 1.3 (1885), 251, Ray's poem was reprinted in 1910 in a collection of her work called simply *Poems*, republished in *Collected Black Women's Poetry*.

31 For the Whig appropriation of Dante, see Edoardo Crisafulli, *The Vision of Dante: Cary's Translation of the Divine Comedy* (Leicester: Troubadour, 2003), 265–325; for a general orientation to the topic of Dante in Reformation England, see Nick Havely, "'An Italian Writer Against the Pope?' Dante in Reformation England, *ca.* 1560–*ca.* 1640," in *Dante Metamorphoses*, ed. Eric G. Haywood (Dublin: Four Courts Press, 2003), 127–149.

32 *Life and Times of Frederick Douglass*, intro. Rayford W. Logan (Toronto: Collier-Macmillan, 1962), 589.

33 The passage from the *Washington Press*, dated 11 January 1889, is in *The Frederick Douglass Papers*, ed. John V. Blassingame, 5 vols. (New Haven: Yale University Press, 1979–92), 5: 399.

34 *Catholic World*, 65 (1897), 356–365 (363).

35 Ibid., 356.

36 Ibid., 363.

37 "Columbian Reading Union," *Catholic World*, 57 (1893), 294–296.

38 "Columbian Reading Union," 294.

39 Gauntlett Chaplin, *Dante for the People* (Boston: Pilgrim Press, 1913).

40 Ibid., 5.

41 "A Passage from Dante's *Inferno* Thrown into English Heroic Verse," *The New-York Magazine; or, Literary Repository*, 2.5 (May 1791), 297.

42 La Piana, *Dante's American Pilgrimage*, 24.

43 For more detailed discussion of Trollope's Dante exhibit, see Looney, *Freedom Readers*, 15–22.

44 Frances Trollope, *Domestic Manners of the Americans*, ed. Donald Smalley [1949] (rpt., Gloucester: Peter Smith, 1974), 4.

45 *The Vision; or Hell, Purgatory, & Paradise of Dante Alighieri*, trans. Henry Francis Cary (New York: Hurst, 1844).

46 There are at least four references to Dante in Trollope's book: 4, 44, 172, and 312.

47 *Saturday Evening Chronicle of General Literature, Morals, and the Arts* [Cincinnati] (30 August 1828), 2: 35, p. 4, column 2.

48 Thomas Adolphus Trollope, *What I Remember* (New York: Harper, 1888), 123.

49 Trollope, *What I Remember*, 123.

50 *Cincinnati Advertiser and Ohio Phoenix* (19 December 1829).

51 Louis Leonard Tucker, *A Cabinet of Curiosities: Five Episodes in the Evolution of American Museums* (Charlottesville: University of Virginia Press, 1967), 90.

52 For a photograph of the "cotton patch and cotton pickers," see Herman Justi, ed., *Official History of the Tennessee Centennial Exposition* (Nashville: Brandon Printing Company, 1898), 368; for the image of worker and overseer, see 379.

53 Justi, *Official History*, 208.

54 From the guide to the exposition celebrating the Louisiana Purchase in St. Louis in 1904, http:// exhibits.slpl.lib.mo.us/lpe/data/lpe240039979.asp (accessed 15 March 2015).

55 *Harper's Weekly*, 25.1266 (2 April 1881), 216–217. Nast was infamous for his caricatures of Irish Catholics and also Italians, Chinese and African Americans, despite the sympathy he sometimes showed for these latter three groups. His notoriety as a caricaturist prompted an outcry from some Italian Americans (e.g., Italian American One Voice Coalition), when the Morristown native was nominated to be inducted into the New Jersey Hall of Fame in 2011. The bid failed. See http://thomasnastcartoons. com/2014/03/02/thomas-nast-and-the-new-jersey-hall-of-fame/ (accessed 23 July 2015).

56 "The People and the Streets," ibid., 211.

57 Giovanni Pascoli, "Inno degli emigrati italiani a Dante," in *Odi et Inni, MDCCCXCVI–MCMXI*, ed. Pascoli, 6th ed. (Bologna: Zanichelli, 1923), 196–197. I am indebted to Martino Marazzi's reading of this poem, *Danteum: Studi sul Dante Imperiale del Novecento* (Florence: Franco Cesati, 2015), 91–94.

PHOTO ESSAY: LIFE IN ITALIAN AMERICA

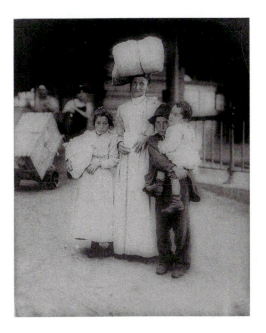

Photo 1 Italian immigrant family at Ellis Island, *circa* 1910. Photo: Library of Congress Prints and Photographs Division, 3b15378u.

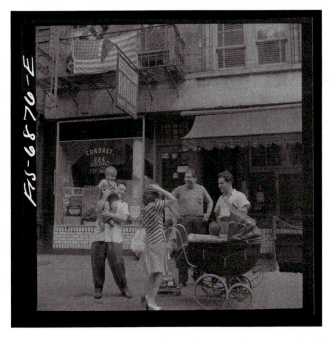

Photo 2 Italian Americans on MacDougal Street, New York City, relaxing on a Sunday in August 1942. Photo by Marjory Collins. FSA/OWI Collection, Library of Congress Prints and Photographs Division, 8d21706u.

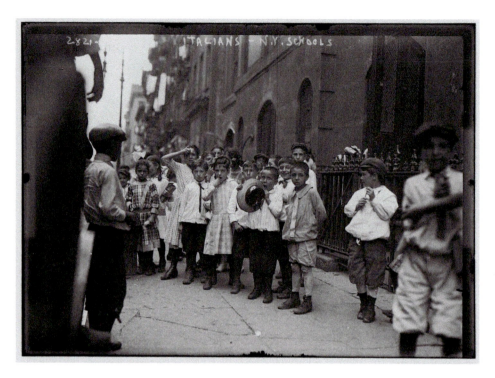

Photo 3 Italian schoolchildren, New York City, *circa* 1910–1915. Photo: George Grantham Bain Collection, Library of Congress.

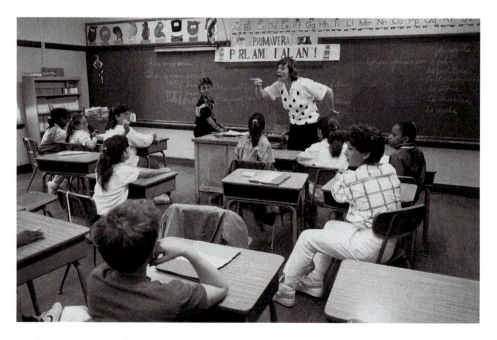

Photo 4 Italian Language class, Chicago, *circa* 1980s. Photo courtesy of Dominic Candeloro.

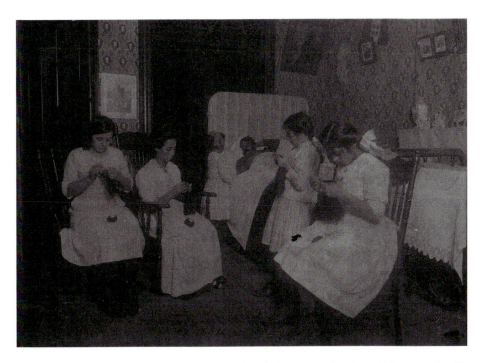

Photo 5 Italian family crocheting bags, with father sick in bed. Note on the photo: "Not contagious." New York City, November 1912. Photo by Lewis Hine. Library of Congress LC-DIG-nclc-04276.

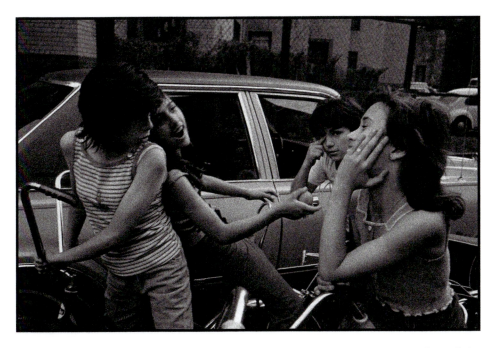

Photo 6 Dee, Jojo, Frankie and Lisa after school on Prince Street, New York City, 1976. Photo: © Susan Meiselas/Magnum Photos.

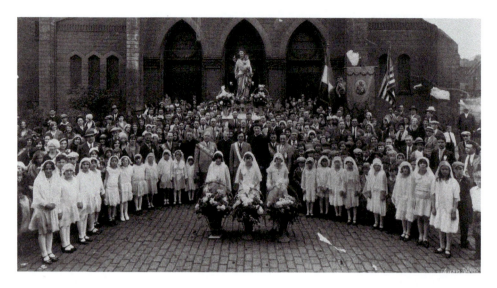

Photo 7 St. Joseph's Club members and First Communion class gather for the Feast of Saint Joseph, March 1929, at All Saints Church, Bridgeport, Chicago. Photo courtesy of Dominic Candeloro. Italians in Chicago Project, Italian American Collection, University of Illinois, Chicago.

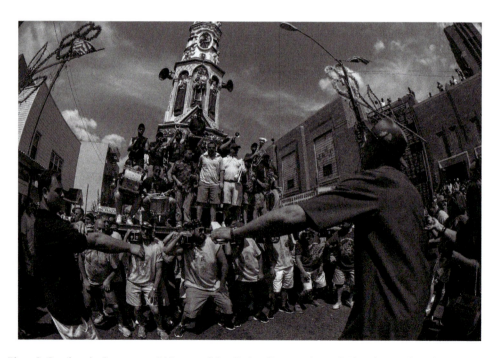

Photo 8 One hundred twenty parishioners of Our Lady of Mount Carmel Church in Williamsburg, Brooklyn, NY, carry the Giglio Tower in the 128th annual Giglio Festival, 12 July 2015. Photo: © Stacy Walsh Rosenstock/Alamy Stock Photo.

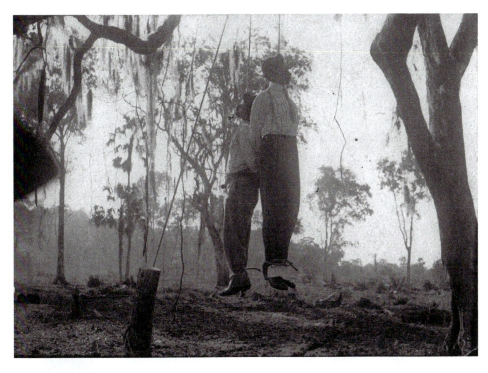

Photo 9 The hanging of Castenge Ficarrotta (pipe in mouth) and Angelo Albano, Tampa, Florida, 1910. Photo: © Cigar City Magazine.

Photo 10 Residents of Bensonhurst, Brooklyn, NY, jeering during a protest march of African Americans after the murder of Yusuf Hawkins in 1989. Photo: © Eli Reed/Magnum Photos.

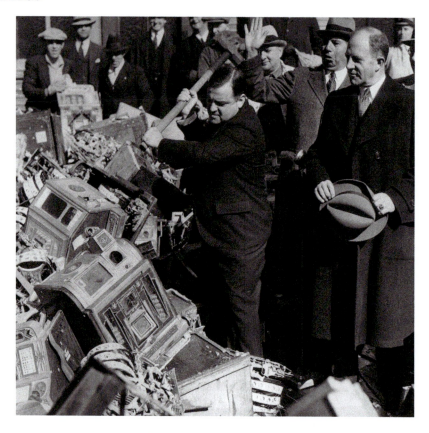

Photo 11 New York City Mayor Fiorello La Guardia smashes slot machines confiscated in gambling raids, 1935. Photo: Hulton Archive/Getty Images.

Photo 12 Nancy Pelosi (with her grandchildren and the children of other members of Congress) wields the gavel as she becomes the first woman Speaker of the U.S. House of Representatives, Washington DC, 4 January 2007. Photo: Chip Somodevilla/Getty Images.

Photo 13 Italian fishermen drying nets, Boston area, *circa* 1917–1934. Photo by Leslie Jones. Leslie Jones Collection, Boston Public Library.

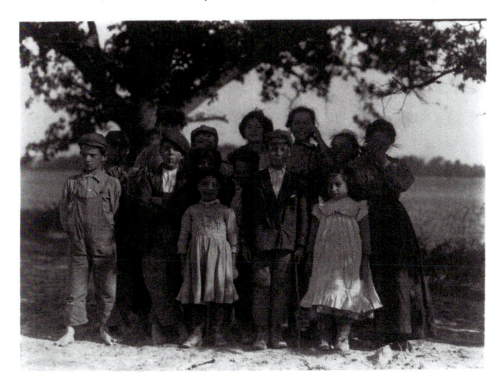

Photo 14 A group of berry pickers from Philadelphia on Giles Farm, Seaford, Delaware in May 1910. A note on the photo: "The children came before school vacation. They are all Italians. The boy who is smoking is confined in a Truant School of Philadelphia. He smokes 15 cigarettes a day." Photo: Library of Congress, LC-DIG-nclc-00094.

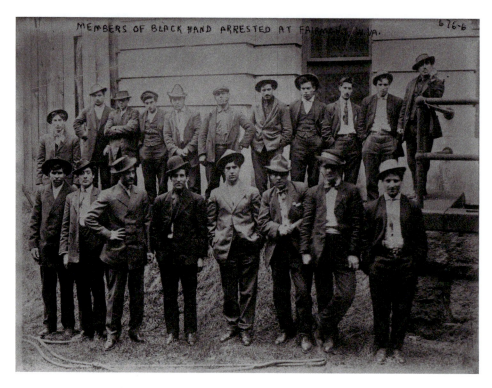

Photo 15 Black Hand members arrested in Fairmont, West Virginia, *circa* 1908. Photo: George Grantham Bain Collection, Library of Congress LC-DIG-ggbain-03246.

Photo 16 U.S. Attorney Rudolph Giuliani announces indictment of the former deputy director of the New York City Parking Violations Bureau on Federal racketeering charges, 1986. Photo: Bettmann/ Getty Images.

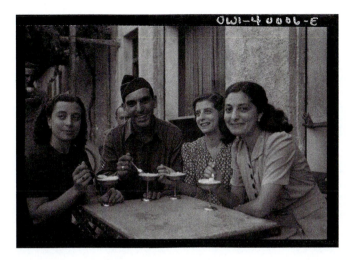

Photo 17 After the Allied invasion of Sicily, U.S. Army Sergeant Vincent J. Crivello, of Milwaukee, Wisconsin, found three cousins in Palermo, 1943. Photo by Nick Parrino. FSA/OWI Collection, Library of Congress LC-DIG-fsa-8d34225.

Photo 18 Father Vincent Capodanno of the Navy Chaplain Corps, leads field prayer services in Vietnam for Marines of A Company, 1st Battalion, 7th Marines, 11 September 1966. He was killed in 1967 while administering last rites in battle to dying Marines and posthumously awarded the Medal of Honor. Photo by Marine Corps Archives and Special Collections on Flickr.

Photo 19 Midnight mass at an Italian parish during World War II. New York City, Christmas Eve, 1942. Photo by Marjory Collins. FSA/OWI Collection, Library of Congress.

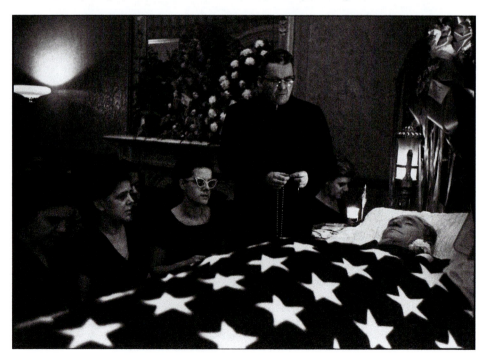

Photo 20 Daughters and priest at bier, Hoboken, New Jersey, 1958. Photo: © Eve Arnold/Magnum Photos.

Part II

THE GREAT MIGRATION AND CREATING LITTLE ITALIES

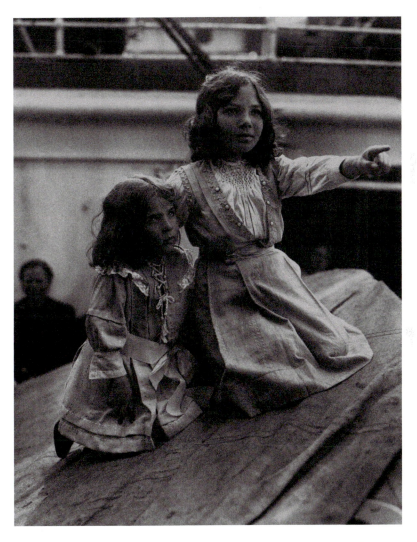

Frontispiece II Two Italian immigrant girls aboard ship, 1919. Photo: Bettmann/Getty Images.

6

WHY ITALIANS LEFT ITALY

The Physics and Politics of Migration, 1870–1920

Maddalena Tirabassi

More than twenty-nine million Italians left their homeland in the years between 1860 and 2011. Of these, 5,800,706 came to the United States between 1876 and 2005, and over 4.5 million (4,668,665) arrived in the United States between 1881 and 1920. This chapter explores the reasons that inspired so many Italians to leave Italy in the decades after their country's Unification in 1860–61 and before the immigration quotas that the United States imposed in the 1920s. Economic hardship is usually cited, and of course it played the major role, but other notable factors that encouraged Italians to leave their country should not be overlooked. These other factors included an older tradition of mobility and persecution for political reasons.

People living in certain areas of the Italian peninsula were accustomed to a degree of mobility since ancient times. In mountainous areas, especially, migrants would descend regularly to the major Italian cities: men in order to run businesses, women to work as wet nurses, servants and textile workers.[1] Peasants and shepherds practiced a seasonal mobility that involved travel between the mountains and the plains in order to work in rice weeding, wheat and grape harvesting and the raising of livestock. Similarly, the poorest part of the rural population—woodcarvers, peddlers, cripples, street musicians, beggars—often spent time in the major cities not only of Italy but of Europe and the United States.[2] Such temporary migrations were a not unfamiliar aspect of the domestic economy.[3]

The struggle for political unification, the Risorgimento, created a new wave of emigrants: the political exiles. It is only recently that the exiles have been linked to the history of Italian migrations.[4] New research has shown that approximately 3,000 individuals escaped between 1815 and 1830 heading mainly to Great Britain.[5] They also crossed the Atlantic to fight in the independence war of the Rio de la Plata in South America.[6] The best known participant to this experience was Giuseppe Garibaldi, who in the defence of Montevideo in 1843 gained the name of "Hero of the Two Worlds."[7]

Population movements both within and beyond the Italian peninsula took place throughout Italian history, but after Unification, migration registered a huge increase that was due principally to the impoverishment of the rural population.[8] In many areas common lands were enclosed, with the result that traditional benefits—such as the right to pasture or to collect firewood—were suppressed. With rising taxation, higher mortgage rates, and compulsory military service to contend with, *contadini* (peasants) were forced to resort to loans that led to increasing debt.[9]

In the aftermath of Unification, Italy became a differentiated country. With respect to the economy, 75 percent of the national income was generated in the territories of Liguria, Piedmont, Lombardy and the Veneto, with only a third of the population of Italy.[10] In the south, the farmers' conditions were precarious because of a regime of small properties, totally

inadequate to maintain the farmers' families, alongside large estates known as *latifondi* that were over 1 square kilometer. The land market was usurious, and the long economic crisis between 1888 and 1896 brought about the collapse of the manufacturing sector, aggravating the effects of an agrarian crisis in the 1880s in the northern region of Piedmont and Lombardy.[11] The crisis drastically reduced farm incomes, depressed the demand for artisanal work, and transformed the distribution of farm work. With farmers no longer able to obtain added income through the spinning and weaving of wool and silk, new sources of income had to be sought elsewhere.[12]

Most importantly, throughout the agricultural areas of the entire peninsula—in southern territories characterized by large estates, in northern areas where agricultural leasing was practiced on a massive scale and in central areas where sharecropping predominated—migration became a means of controlling and reducing the population pressure on the land. As historians have noted, the expulsion of the excess population became for the dominant elites a kind of survival tactic that permitted them to maintain paternalist patterns of control and resist the challenges of capitalistic transformation.

In Sicily at the end of the nineteenth century the peasants organized themselves into *Fasci dei lavoratori* ("bands" of rural workers), but the defeat and suppression of their organizations induced them to cross the ocean. Almost one million Sicilians left Italy between 1896 and 1914, bringing their ideologies with them: from socialism to anarchism to revolutionary syndicalism.[13] As historian Rudolph Vecoli pointed out, "Emigration and subversion were, for the Italian workers and *contadini* that came to America, two interlinked ways to react to the oppressive conditions of Italy at the end of the nineteenth century."[14]

Agricultural Crisis

There was a great collapse in global grain prices in the 1870s, thanks to railroads and steamships, and to the peace that prevailed in the grain-producing areas of Eastern Europe (after the Crimean War) and the United States (after the Civil War). The effects of a reduced demand for Italian grain were particularly destructive in the Italian South. Other industries, like the silk and cotton industries of central and southern Italy, since they were less innovative, declined after customs' unification in 1876–77. The silk industry, in addition, in the years from 1888 to 1896, was struck hard by pébrine, a contagious disease of the silkworm that leaves the worms unable to produce thread, so that young women found themselves without work and men were forced to migrate in search of income.[15] In addition, the conclusion of many of the great public works projects of the new nation-state meant that many thousands were put out of work.

As Donna Gabaccia properly observes, "the exact nature of rural economic change is still to be fully explored, since Italy was not 'a land forgotten by time' or a last bastion of feudalism and subsistence production. Most recent studies in immigration history acknowledge that migrants left a country in economic ferment."[16] In the South, small properties were by themselves unable to support the family of a *contadino*, but daily wageworkers were bound by contractual relationships that depressed their income. In some areas, the maximum number of working days per year grew from 60 to 160.[17]

Population increase in the South, which took off in the 1870s, instead of becoming a driving force for the economy, hindered growth and made people leave. Emigration was the instrument through which a tenuous integration of the various Italies existing before Unification was realized in the new market economy. Rural society, with its traditional elites and hierarchies, survived thanks largely to this "safety valve."[18]

Rural Living Conditions

Study of the living conditions of the Italian rural population over the long-term suggests that the choice to emigrate was often not a direct response to a crisis, but rather a hopeful venture aimed at seeking a better life, especially for the next generation. The life of the peasantry in Italy was examined in exhaustive detail in two agrarian surveys commissioned by the Italian Parliament that historians have found especially illustrative. Named after the members of Parliament who led these investigations, Stefano Jacini and Eugenio Faina, the *Inchiesta Jacini* (1877–1886, with its report published in 1884) encompassed agricultural conditions throughout the entire peninsula,[19] whereas the *Inchiesta Faina* (1906–1911) covered Southern Italy and Sicily.[20] Both *inchieste* show that regional variations were far more complex than those assumed in the usual "North/South" distinction.

According to the descriptions of housing, for instance, in Sicily, houses were very often composed of one room of 25 square meters without flooring, with unplastered walls, and with a single opening that served as door, window and chimney.[21] A way of living portrayed as picturesque by some foreign painters—or a German photographer like Wilhelm von Gloeden (see Figure 6.1)—was deplorable for those who actually lived it. In Abruzzo

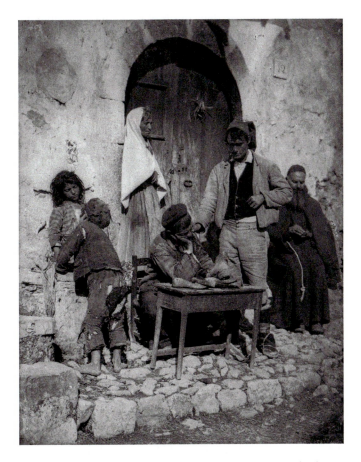

Figure 6.1 A Sicilian family with a friar, *circa* 1895. Photo by Wilhelm von Gloeden. Courtesy of Alinari Archives.

there was only one room for the whole family and frequently for the animals too—pigs and chickens—with a pile of straw as a bed. In Puglia housing conditions were considered by the *relatore* (inspector) as the worst in the country: The houses were dirty and there were communal beds for several members of the family, and when *contadini* lived in towns and cities their rooms had little light or air and moist sacks of straw or mouldy flax served for their beds. In Gallipoli, in the province of Lecce, the peasants lived in hovels rather than houses. In Altamura the circumstances were comparable: dirty houses, communal beds for many, with "the pigs almost always in the same environment." The state of peasants' houses in the cities and large towns were more deplorable than those in smaller rural municipalities.[22] The situation was the same in Campania, and in the province of Salerno, the *contadini* sometimes lived in haystacks.[23] In Calabria, in the one or two rooms in which livestock also lived, the same bed was shared by parents and children.[24]

In mountainous areas of northern Italy living conditions were not much better. In some parts of Lombardy, for instance, people lived in stables during the winter because the animals would keep them warm. The best room of the house was used to grow silk worms that were attended to by women and children who, according to the *Inchiesta Jacini*, did not sleep for eight to ten days in a row.[25]

The *contadino*'s diet at the end of the century was very poor. Working men ate three times a day and at breakfast and lunch took their meals of bread and vegetables in the fields (with wine sometimes being a part of the diet). These meals were considered a portion of the pay of the *giornaliero*, or daily worker. Dinner usually consisted of a vegetable soup. In Calabria the peasant's diet consisted of bread, olive oil, and vegetables at noon, and *polenta* or beans or potatoes, at dinner; meat was only eaten at big festivities. When the harvest was bad, a "bread" made from lentil flour and wild weeds, with no oil, became the daily diet for the poorest.[26] The following is a list of the foods consumed by a Sicilian farmer over the course of a year: 4 hectoliters (approximately 11 bushels) of wheat; 360 liters of wine; 40 kilograms of cheese, usually ricotta cheese (the poorest in terms of calories); 80 kilograms of pasta; 15 kilograms of rice and 1 kilogram of meat.[27] In Puglia, too, the diet was composed of cereals and bread, plus olive oil, beans, maize and carobs. Since salt was expensive, sea water was used to season foods. In Campania inspectors tried to evaluate the caloric content of the *contadino* diet: They calculated a daily average of 130 grams of protein, which was considered satisfactory.[28] The daily diet of a *giornaliero* in Monteleone, Calabria, consisted of 1.2 kilograms of maize bread, 1 salted sardine, 0.9 kilograms of potatoes or boiled vegetables, one *soldo*'s worth of salt, and oil.[29] Men usually ate better than women and children since they worked far from home and received meals with wine as part of the pay.

In northern regions the living conditions of *contadini* were also bad. In Lombardy, notwithstanding the presence of some protein—milk, lard and cheese—the *Inchiesta Jacini* denounced the inadequacy of the *contadino*'s diet based on vegetables, polenta and rice.[30] In the northern province of Lecco cases of pellagra were reported. At Gallarate, bad housing conditions and diet deficiencies resulted in an unusually low life expectancy of 25–34 years for peasants.

These harsh living conditions deeply affected the families of these agricultural workers.[31] To give birth, the women interrupted work only for a few days, two weeks at most. At the end of the nineteenth century, 11 percent of rural women continued to breast-feed up till 31 months of age.[32] Babies were usually taken to the fields by their mothers. In the *Inchiesta Faina* the inspector of Campania in 1909 observed that "Sometimes children are left unguarded, and for this reason we have accidental homicides caused by fire, hot water

burnings, falls, pig bites and so on, and every day the newspapers reported accidents like these."[33] Domestic accidents were one of the main causes of child mortality.[34]

Twenty-five years later, in the *Inchiesta Faina*, we find attempts to determine the motivations for emigration. When asked, "Why do you want to go to America?" one migrant was reported to answer: "*Perché qui non si può vivere, perché in America si sta meglio, perché a casa si sta come bestie.*" ("Because here you cannot live, because in America things are better, and because at home we live like animals.") The comment of the *relatore* was: "*Emulazione, lettere rozze ma suggestive, descrivono l'America come il paese della cuccagna.*" ("The bragging in the crude but evocative letters [they receive] describes America as the land of plenty.") He also noticed a decline in the role of emigration agents, which he attributed to stronger forces in the call from relatives and friends and in the low wages in Italy.[35] In the following passage we find a more sophisticated analysis of the choice to leave:

> Was emigration motivated more by a desire to enrich themselves or by necessity? There was little influence from the lure of foreign governments. In fact when they go to the U.S. there are many obstacles to immigration and a rigorous selection is conducted among those who disembark. And they don't go to Argentina because *contadini* are needed there, but instead the *contadino* or laborer who emigrates . . . does not want to go back to that life.[36]

In the *Inchiesta Faina* there was an effort to define the general traits of those who emigrated. These were "*contadini* of different classes, more smallholders; predominantly male adults. A reverse selection of the population was also noticed: women and the elderly are left behind."[37]

A closer look at the migrants shows a heterogeneous population made up of mostly illiterate men leaving from every corner of the country, heading toward every country of the world. (See Tables 6.1 and 6.2.) Indeed an earlier parliamentary *inchiesta* on education, directed by Carlo Matteucci in 1864, had shown the presence in Italy of 17 million illiterates out of a population of 26 million, with illiteracy especially a rural problem, particularly in southern regions.[38] When children attended school, they did so only in winter when work in the fields was suspended. Illiteracy rates for women were always higher than for men, since the latter were taught to read during their compulsory military service. Furthermore, since writing was only taught from the third grade on, being literate in nineteenth-century Italy often meant only being able to read: in 1861, 28.8 percent of educated females could read, but not write; the law only changed in 1888.[39]

Table 6.1 Illiteracy rates (%) in Italy by sex, 1861–1921. Istat—Istituto Centrale di Statistica, *Sommario di statistiche storiche dell'Italia 1861–1965* (Rome, 1968).

Year	Male	Female
1861	68	81
1871	62	76
1881	55	69
1891	—	—
1901	42	54
1911	33	42
1921	25	31

Table 6.2 Illiteracy rates (%) in southern Italian regions, 1871–1881. *Inchiesta Jacini*, 13 (1884), 132–133.

Region	Total Population		Male		Female	
	1871	1881	1871	1881	1871	1881
Abruzzo and Molise	86.83	83.3	79.69	74.82	93.63	91.26
Campania	82.4	78.41	76.4	71.61	88.82	85.05
Puglia	86.52	83.11	81.64	77.63	91.24	88.41
Basilicata	89.62	8732	83.62	80.67	95.33	93.56
Calabria	88.77	87.02	82.06	79.79	95.44	93.96
Sicily	87.22	83.97	83.03	78.85	92.21	89.53

Regional Diversity

Illiteracy was not the only problem faced by the new Italian State in the effort to "*fare gli Italiani*" ("make Italians"). Many writers and social observers of the time noticed that the majority of the Italian population was not able to speak the Italian language but instead spoke hundreds of local dialects. Consequently, once they emigrated, this babble of tongues prevented even basic exchange and dialogue among the new arrivals.[40] Edmondo De Amicis, the author of the most famous novel about the great Italian migration, *On the Ocean*, included a chapter entitled "L'Italia a bordo" (Italy aboard ship) that amusingly illustrated the difficulties in communication among the many regional components of Italian migrations.[41]

The fact that the Italian State had been constructed only recently meant that a strong tradition of local autonomy persisted not only as a social reality but also even among the ideals of the Risorgimento.[42] What characterizes Italy's development as a nation, and differentiates it from other European countries, is that modern Italy witnessed neither a progressive one-by-one extinction of local cultures, nor the colonization of the national territory by a single region—neither by Piedmont nor by Rome. In many areas regional government developed out of a pattern established at the turn of the eighteenth century by the French administration in the Napoleonic period. At the time this was done in order to overcome the hundreds of municipalities that in some cases had behaved as states of their own up to the end of the 1700s. Whereas some regions, such as Piedmont and the Veneto, heirs respectively of the Kingdom of Sardinia and the Republic of Venice, were characterized by as strong pre-Unification administrative tradition, others had been formed from the aggregation of territories belonging to different states. Lazio, for instance, brought together parts of the Papal State and the Kingdom of Naples. A vernacular culture rooted in the "locus of origin," as Donna Gabaccia calls it, "continued to be the focus of the sense of belonging in Italian emigrants. Emigration therefore contributed to keeping alive the localism that the proponents of the Italian nation were trying to overcome."[43]

However localism and national culture were perceived in different ways according to social class. Whereas Italy's upper classes generally embraced both national and local cultures with a degree of comfort, the lower classes preserved longer the traditions associated with the local dimensions of neighborhood, village and craft.[44] Only over time, as historians have shown, did the Great Migration help also to develop a national identity among Italians of the lower classes. A continuous confrontation with "the other" gradually brought them to recognize in themselves an Italian identity. It was in foreign lands that for the first time they were called "Italians."

Departures

The widespread cliché according to which Italian emigration was a phenomenon confined to the southern part of the country is immediately debunked by territorial data and regional emigration estimates available beginning from 1876.

The exodus from Italy affected all regions (see Table 6.3), starting from a concentrated northern out-migration that occurred between 1876 and 1900, in which three regions alone provided 47.5 percent of the migration quota: Veneto (17.9 percent), Friuli-Venezia Giulia (16.1 percent) and Piedmont-Valle d'Aosta (13.5 percent). These circumstances were reversed in the following two decades, between 1900 and 1920, when out-migration came mainly from the southern regions, with Sicily providing the greatest contribution, 12.8 percent with 1,126,513 emigrants, followed by Campania with 955,1889 (10.9 percent).[45]

Much of the migration, particularly from northern Italy, was to other European countries. (See Table 6.4.) The United States, however, was the most common destination for transoceanic migrations, and the most frequent goal of emigrants from the southern parts of Italy. (See Tables 6.5 and 6.6.)

Between 1876 and 2005, 5,800,706 Italians left for the United States, with over four and one half million departing prior to 1920.

Especially important in the first decades of the Great Migration was an influx of agents and subagents who traveled throughout the country recruiting young men on behalf of the shipping companies. In 1901, when a law was passed to prohibit it, there were more than 10,000 agents.[46] From that point on the most likely source of information directing migrants toward the Americas came from the persons who wrote or returned with their stories. Contact was maintained through letters and photographs. Since much of this population was illiterate, emigrants and their families back home required the help of people like priests or

Table 6.3 Italian emigration by region of origin, 1876–1915. Author's compilation from Istat data: *Sommario di statistiche storiche italiane*, selected years.

Region	1876–1900	1901–1915
Piedmont and Valle d'Aosta	709,076	831,088
Lombardia	519,100	823,659
Veneto	940,711	882,082
Trentino	—	—
Friuli and Venezia Giulia	847,072	560,721
Liguria	117,941	105,215
Emilia	220,745	469,430
Tuscany	290,111	473,045
Umbria	8,866	155,654
Marche	70,050	320,107
Lazio	15,830	189,125
Abruzzo	109,038	486,518
Molise	136,355	171,680
Campania	520,791	955,188
Puglia	50,282	332,615
Basilicata	191,433	190,260
Calabria	275,926	603,105
Sicily	226,449	1,126,500
Sardinia	8,135	89,624
Total	5,257,911	8,765,616
Average/period	210,316	584,374

Table 6.4 Italian emigration within Europe, selected countries, 1876–1915. Author's compilation from Istat data: *Sommario di statistiche storiche italiane*, selected years.

Year	France	Switzerland	Germany	Benelux	Great Britain	Five-Country Total	European Total
1876–85	406,780	101,571	71,208	3,524	5,419	588,502	850,219
1886–95	286,054	96,843	127,986	2,053	5,891	518,827	970,133
1896–1905	396,292	397,374	434,748	8,221	23,527	1,260,162	1,890,943
1906–15	569,577	744,504	591,905	23,691	34,646	1,964,323	2,426,091
Total	1,658,703	1,340,292	1,225,847	37,489	69,483	4,331,814	6,137,386

Table 6.5 Italian emigration overseas, 1876–1915. Author's compilation from Istat data: *Sommario di statistiche storiche italiane*, selected years.

Year	United States	Canada	Argentina	Brazil	Australia	Total
1876–85	83,583	1,198	157,860	55,936	460	299,037
1886–95	377,068	7,557	414,426	503,599	1,590	1,304,240
1896–1905	1,306,083	23,225	489,748	450,423	3,440	2,272,919
1906–15	2,385,800	116,585	716,043	196,669	7,540	3,422,637
Total	4,152,534	148,565	1,778,077	1,206,627	13,030	7,298,833

Table 6.6 Italian emigration to the United States, 1876–1920. Author's compilation from Istat data: *Sommario di statistiche storiche italiane*, selected years.

Year	Emigration to the United States from Italy	Total Emigration from Italy	Percentage
1876–1880	13,235	543,984	2.43
1881–1890	244,870	1,879,200	13.03
1891–1900	514,330	2,834,730	18.14
1901–1910	2,329,450	6,026,690	38.65
1911–1920	1,566,780	3,828,070	40.93
Total	4,668,665	15,112,674	30.89

pharmacists for the writing and reading of letters.[47] The letters themselves had a great impact on migration. They influenced the choice of destinations; they were often published in local newspapers; and, as we have seen, they were even used by the Italian State in its investigations of the phenomenon of migration.

Emigrants were mostly young men who migrated in groups from the same town, usually under the guidance of someone who had made the journey previously. Migrants intended to return after having earned a decent amount of money. They sent remittances home, in order to pay debts or to buy a house and land in Italy. The typical period of stay in the United States lasted a few years but many crossed the Atlantic several times during this period. It was rare for families to move together all at once: Women and children followed the man only if he decided to remain. In the years of the Great Migration, and often even after, the "commuting" of these men required that the women remaining in Italy take on the chores of the man who had emigrated, as well as new responsibilities, including the administration of the remittances that arrived.

Migratory movements greatly affected community demographics. In mountainous areas that were mainly characterized by the commuting of men, marriages and births occurred

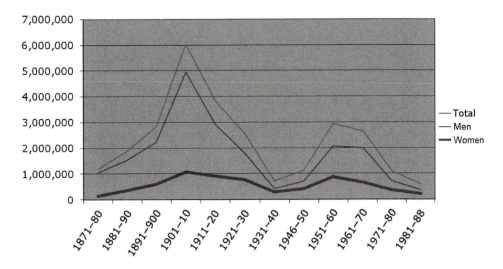

Figure 6.2 Italian emigration by sex, 1871–1990. Istituto Centrale di Statistica, *Sommario di statistiche storiche italiane 1861–1965, 1861–1975*, selected years.

in accordance to the seasonal pattern of departures and returns.[48] In the South, at the time of the Great Migration, one speaker in the *inchiesta* directed by Faina observed: "[B]efore leaving, the man would marry the woman of his heart, only then to leave after no more than a week of married life." Another stated, "The *contadino*, having already decided to leave the woman behind at home, marries her, on the one hand, to make sure she is now in his possession, and, on the other, to have someone who would look after the gradually accumulated savings back home, preventing them from being spent away by the father's family."[49] After two or three years, sometimes five or more, but rarely more than ten, emigrants would return, often only again to emigrate after a year or two.

One focus of research in recent years regards women who migrated for marriage purposes because it was easier to marry abroad. (See Figure 6.2.) We can find traces of this even from the beginning of the Great Migration, when it was more common for men to go back to Italy to marry women from their *paesi* of origin.

Migration Legislation and the Transatlantic Journey

Beginning in 1868 the Italian Parliament, concerned with emigration, tried to alleviate what appeared to be a cause of the phenomenon, by inviting landowners and industrialists to provide fair wages, while also passing legislation restricting permission to emigrate. In reality both the country's ruling class and its Parliament were divided in their evaluation of migration, with the result that the proposed solutions differed widely.[50] Some entrepreneurs saw benefits in a more general labor mobility and in the economic gains that the working classes might achieve through temporary migration. On the opposite side, great landowners, not only in the South, but also in the Veneto and Piedmont, viewed with concern a weakening of the labor force produced by departures. They feared that it would give *contadini* greater bargaining power. Union organizers and the Workers' Party, too, also harbored doubts about encouraging emigration, which they thought threatened to undermine the formation of structures organized on the principle of class interest.[51]

In 1873 it was concern with depopulation that led to the approval of the first explicit parliamentary legislation against emigration, the "Lanza Circular." Departure for Algeria or the Americas was prohibited to those who did not have jobs or adequate means of subsistence in the place of destination, to youths subject to conscription, to the handicapped, and to children. Then, in 1876, the first draft of a law attempted to liberalize emigration while also protecting migrants by requiring, among other things, that shipping agents be insured against cases of fraud or damage to passengers, and that they clearly specify the dates of departure and arrival. The plan was never approved, however, and the law of 1873 remained in force. But then, as the agrarian crisis of the late 1870s set in, the idea of a full liberalization gained momentum. Emigration began to be considered to be a "real social safety valve, able to lift the threat of overpopulation, while opening new avenues for commerce and industry, blending and perfecting Italian (and European) civilization, and broadening the concept of Motherland beyond concrete borders."[52] On 15 December 1887, Francesco Crispi, who succeeded Agostino Depretis as Prime Minister, introduced a bill by which the government intended to transform emigrants from objects to be controlled into subjects to be protected.[53] The law was approved in 1888, but it did not improve the situation for migrants because it did not limit the enrollment of volunteers: from the hands of the agents, reshaped by the law, to those of subagents who perpetrated a savage recruitment policy. The law on emigration passed by the Crispi administration was the result of a compromise that tried to limit departures with a series of constraints, but also established for the first time the freedom to emigrate and banished prepaid transportation. For the first time in 1901, new legislation, known as the *Legge Luzzatti* (the Luzzatti Law), arranged a plan of assistance and protection of emigrants and established a new Commissariato Generale dell'Emigrazione (General Commissariat for Emigration) under the Ministry of Foreign Affairs.

Complaints regarding the quality of life of the Italian emigrants began with the trip overseas. With the growth of transoceanic migration, the passenger transport market expanded and exploitation by shipping companies also escalated. Steam navigation, introduced in 1860, replaced sailing, reducing transport times dramatically, as well as the cost to the companies. Historian Augusta Molinari comments on the migratory experience of Andrea Gagliardo who, over a period of more than fifteen years, crossed the Atlantic fourteen times. It took Gagliardo fifty-seven days to go from Genoa to New York in 1847 with the brigantine *Bettuglia*, but only seventeen days in 1861 to travel by steamship from Liverpool to New York.[54] Whereas the norm had been forty-four days by sail, it would be reduced to fourteen under steam power by the end of the century. From 1860 emigrants could leave via steamship from Genoa, whose port, from 1876 to 1901, saw 60 percent of Italy's transoceanic emigration, and 34 percent of the emigration between 1902 and 1924. There was only one Italian shipping company, the Navigazione Generale Italia—formed from the merging of the Florio and Rubattino companies in 1881—and in the first decade of the twentieth century it transported only half of the migrants, whereas the others left from Marseille, Le Havre, Bremen, Hamburg and Liverpool. Only at the beginning of the twentieth century, with the strengthening of southern migration, did Naples start taking on a leading role as a port of departure, with Palermo and Trieste also entering the system.[55]

Shipowners operated as emigration agents, through the mass network of representatives and carrier agents who recruited emigrants to South America, and also controlled the transfer of remittances through intermediaries and agencies, "marking—as economist Ercole Sori observed—the blackest page of European emigration."[56] There were many

ways of funding travel: there was the self-financed journey, the journey paid for by relatives who had already emigrated, but also journeys funded by bankers, or "masters," who would then force the migrants into a situation of subordination, working until the debt was paid off. This last option was an arrangement accepted by more than 30 percent of those who left Italy in the second half of the nineteenth century.[57] In 1870 Pasquale Antonibon, a deputy in the Italian Parliament, began presenting facts and figures concerning the appalling living conditions of the migrants who left with prepaid tickets: According to the migrants themselves, they were desperate people who for the most part were dying "*di passione e di fame*" (of passion and of hunger).[58] The ships often turned out to be inadequate, with the available space on board being overloaded. In 1899, on a steamship headed toward Brazil, there were twenty-seven deaths caused by asphyxiation. In another case, thirty-four victims died of starvation or diseases that developed on board as a result of poor hygiene.[59]

Until a law of 1901 improved conditions by establishing a minimum space requirement per person, laying down rules of hygiene and requiring the presence of a medical officer, shipowners profited by transporting emigrants on ships that had been built for other purposes. They even opted to use a fleet of old steamers that were called "wrecks of the sea."[60] It was only after 1907 that it became necessary for the transatlantics sailing to the United States to adhere to genuinely strict standards of safety and hygiene for the third-class passengers who disembarked at Ellis Island. And it was not until the eve of World War I that an actual modernization of the fleet gradually developed.[61]

With regard to living conditions on board the transatlantics, we have a wide range of literature.[62] Professional writers, medical officers, and migrants themselves left vivid accounts of the journey. Apart from descriptions of the stench and lack of air, in these descriptions we regularly read of fatalities and of infectious diseases contracted on board that led either to death or to rejection at the port of entry.[63] In the first two decades of the century tens of thousands were refused entry due to illness. The magazine *Italica Gens* reported that in the period from 1 July 1910 to 30 June 1911 more than 10,315 out of 223,453 immigrants were rejected. Though the most common reason was "They could become a burden to the community," the second was "trachoma."[64]

Return Migrations

History teaches us that migration is rarely a one-way event; the circularity nature of migration has been emphasized by numerous studies.[65] Return journeys have been insufficiently examined.

There are some statistics, of course (see Table 6.7 and Figure 6.3), but these do not take into account either commuting or circularity and they exclude illegal migration. Complete statistics regarding Italians returning from European countries exist only from 1921. From the numbers we do have, however, it appears that 11,045,704 out of 29,350,991 emigrants (between 1861 and 2005), returned to Italy, with more than a third following a variable flow, and with over 100,000 annual returns in the 1950s and just under 200,000 in the 1960s. There were various types of returns: those who leave but come back, leaving the family to guard the property, those who return defeated and those who have achieved their objectives (earned enough money to pay debts, build a house, buy land, get married). Beyond personal choices, return migrations were dictated also by political and economic pressure, as shown in the peaks in Figure 6.3 during the Panic of 1907 and World War I.

Table 6.7 Emigration and return migration, 1876–1976. Francesco Paolo Cerase, "L'onda di ritorno: i rimpatri," in *Storia dell'emigrazione*, 1:113–125 (116).

Years	Emigration	Return Migration	Percentage
1876–1915	14,031,567	—	
1906–1915	5,848,728	1,964,647	34
1916–1942	4,355,222	2,267,873	52
1946–1976	7,447,175	4,319,586	58

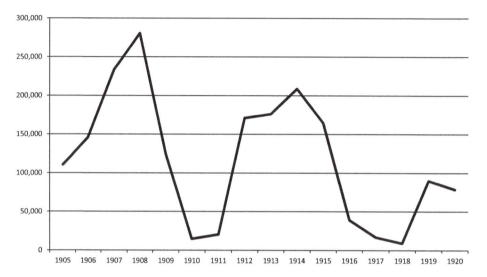

Figure 6.3 Return migration from the United States, 1905–1920. Istat, selected years.

The impressive return exodus to Italy in the winter of 1907–1908, caused by the contemporary American economic crisis, was described by a social observer of the time, Amy Bernardy:

> Entire docks in Boston and New York were full of expectant crowds, day and night. The liners anchored, two to three on their respective piers, gobbling people up in streams. We started the evening at eight o'clock and embarking lasted all night; Dawn seemed to never come. Besides the people who had a secure place on board, many came from their homes nearby ready to leave the country, hoping to take the place of someone who was denied boarding.[66]

For Bernardy there seemed to be little difference between the winners and losers in the "return" process:

> On these journeys going back home you see the "fortunate ones" who, in America, for the price of an eye or a leg or a less visible but more fatal injury, return home as *signori*; the most fortunate ones return with a square suitcase and diamond brooch, with shiny shoes and a gold chain, and have enough money spare to buy a house or the land they've had their eye on, on which they will build something very modern to flaunt.[67]

Conclusion

The traditional Italian migration experience shows that there was no single reason to migrate but an intermingling of factors in which economic reasons nonetheless dominated. A population, familiar with migrations since ancient times, was prone in times of crisis to resort to this safety valve. The United States has always been the first choice in transoceanic migrations and even today it is the country of choice for Italian migrants going overseas.

Further Reading

Choate, Mark. *Emigrant Nation: The Making of Italy Abroad*. Cambridge: Harvard University Press, 2008.

Cinotto, Simone, ed. *Making Italian America: Consumer Culture and the Production of Ethnic Identities*. New York: Fordham University Press, 2014.

Gabaccia, Donna R. *Italy's Many Diasporas*. Seattle: University of Washington Press, 2000.

Notes

1 Pier Paolo Viazzo, *Upland Communities: Environment, Population and Social Structure in the Alps since the Sixteenth Century* (Cambridge: Cambridge University Press, 1989); Adriana Dadà, "Balie, serve e tessitrici," in *Migrazioni: Storia d'Italia*, ed. Paola Corti and Matteo Sanfilippo, Annali 24 (Turin: Einaudi, 2009), 107–122.

2 John Zucchi, *The Little Slaves of the Harp: Italian Child Street Musicians in Nineteenth-Century Paris, London and New York* (Montreal and Kingston: McGill-Queen's University Press, 1992).

3 Franco Ramella, *Terra e telai: sistemi di parentela e manifattura nel biellese dell'Ottocento* (Turin: Einaudi, 1981).

4 Donna R. Gabaccia, *Italy's Many Diasporas* (Seattle: University of Washington Press, 2000); Patrizia Audenino and Antonio Bechelloni, "L'esilio politico fra Otto e Novecento," in *Migrazioni*, ed. Corti and Sanfilippo, 343–369.

5 Agostino Bistarelli, *Gli esuli del Risorgimento* (Bologna: Il Mulino, 2011).

6 Maurizio Isabella, *Risorgimento in Exile: Italian Emigrés and the Liberal International in the Post-Napoleonic Era* (Oxford: Oxford University Press, 2009).

7 Lucy Riall, *Garibaldi: Invention of a Hero* (New Haven: Yale University Press, 2007).

8 Patrizia Audenino and Maddalena Tirabassi, "Italy on the Move: From Unification to the Great Migration," forthcoming in a volume edited by Elizabeth Messina. Historical research has increasingly considered Italy's Unification of limited relevance in explaining both external and internal Italian migration. See Paola Corti and Matteo Sanfilippo, *L'Italia e le migrazioni* (Rome-Bari: Laterza, 2012); Patrizia Audenino and Maddalena Tirabassi, *Migrazioni italiane: Storia e storie dall'Ancien régime a oggi* (Milan: Bruno Mondadori, 2008); Angelina Arru, Daniela Caglioti and Franco Ramella, eds., *Donne e uomini migranti: Storie e geografie tra breve e lunga distanza* (Rome: Donzelli, 2008).

9 Ercole Sori, *L'emigrazione italiana dall'Unità alla seconda guerra mondiale* (Bologna: Il Mulino, 1979), 69.

10 Alberto Caracciolo, "Le 'Italie economiche' alla vigilia dell'Unità nazionale," in *Storia d'Italia*, dir. Ruggiero Romano and Corrado Vivanti, 6 vols. in 10, (Turin: Einaudi, 1972–1976), 5: 621–693 (686).

11 Sori, *L'emigrazione*, 115.

12 Ibid., 92–100.

13 Lucy Riall, *Under the Volcano: Revolution in a Sicilian Town* (Oxford: Oxford University Press, 2013), 178.

14 Rudolph Vecoli, "Negli Stati Uniti," in *Storia dell'emigrazione*, 2: 55–88 (68).

15 Sori, *L'emigrazione*, 115.

16 Donna R. Gabaccia, *Militants and Migrants: Rural Sicilians Become American Workers* (New Brunswick: Rutgers University Press, 1998), 8.

17 Sori, *L'emigrazione*, 102.

18 Ibid.

19 Stefano Jacini, *Atti della giunta per l'inchiesta sulle condizioni della classe agraria*, 15 vols. in 26 (Rome: Forzani, 1881–85). [Henceforth: *Inchiesta Jacini*]. The entire *inchiesta* was reprinted by Forni Editore of Bologna over the decade 1978–1988.

20 Eugenio Faina, *Inchiesta parlamentare sulle condizioni dei contadini nelle province meridionali e nella Sicilia*, 8 vols. (Rome: Tipografia Nazionale Bertero, 1909–11). [Henceforth: *Inchiesta Faina*]. Extended excerpts

from the *inchiesta* are published in Sandro Rogari, *Mezzogiorno ed emigrazione: l'inchiesta Faina sulle condizioni dei contadini nelle province meridionali e nella Sicilia: 1906–1911* (Florence: Centro Editoriale Toscano, 2002).

21 *Inchiesta Jacini*, 13 (1884), 56–57; descriptions of some types of Sicilian farmers' houses are in Donna R. Gabaccia, *From Sicily to Elizabeth Street: Housing and Social Change Among Italian Immigrants, 1880–1930* (Albany: SUNY Press, 1984), 16–21.

22 *Inchiesta Jacini*, 12 (1885), 469–471.

23 *Inchiesta Jacini*, 7 (1882), 194.

24 *Inchiesta Jacini*, 9 (1883), 63.

25 *Inchiesta Jacini*, 6.1 (1882), 372.

26 *Inchiesta Jacini*, 9 (1883), 326.

27 *Inchiesta Jacini*, 13 (1884), 668.

28 *Inchiesta Jacini*, 7 (1882), 335.

29 *Inchiesta Jacini*, 9 (1883), 422.

30 *Inchiesta Jacini*, 6.1 (1882), 175, 187.

31 Maddalena Tirabassi, "Making Space for Domesticity: Household Goods in Working-Class Italian American Homes, 1900–1940," in *Making Italian America: Consumer Culture and the Production of Ethnic Identities*, ed. Simone Cinotto (New York: Fordham University Press, 2014), 57–70.

32 Massimo Livi Bacci, *Donna, fecondità e figli: Due secoli di storia demografica italiana* (Bologna: Il Mulino, 1980); and Barbagli, *Provando e riprovando: Matrimonio, famiglia e divorzio in Italia e in altri paesi occidentali* (Bologna: Il Mulino, 1990), 366.

33 *Inchiesta Faina*, 4 (1909), 264.

34 Massimo Livi Bacci, *L'immigrazione e l'assimilazione degli immigrati italiani negli Stati Uniti* (Milan: Giuffré, 1961), 86.

35 *Inchiesta Faina*, 5 (1909), 711.

36 *Inchiesta Faina*, 4 (1909), 608.

37 Ibid.

38 Ernesto Ragionieri, "I problemi dell'unificazione," in *Storia d'Italia*, dir. Ruggiero Romano and Corrado Vivanti, 6 vols. in 10 (Turin: Einaudi, 1972–1976), 4: 1678–1743 (1714); Istituto Centrale di Statistica, *Sommario di statistiche storiche dell'Italia 1861–1965* (Rome: L'Istituto, 1968).

39 Michela De Giorgio, *Le italiane dall'Unità ad oggi* (Bari: Laterza, 1992), 437; Vito Cappelli, "Le donne in Calabria nelle società di mutuo soccorso (1875–1900)," *Movimento operaio e socialista*, n.s., 3.4 (1981), 287–297.

40 Marie Hall Ets, *Rosa: The Life of an Italian Emigrant* (Minneapolis: University of Minnesota Press, 1970).

41 Edmondo De Amicis, *Sull'oceano* (Milan: Fratelli Treves, 1889); published in English as *On Blue Water*, trans. Jacob B. Brown (London: Putnam, 1897).

42 Lucio Gambi, "Le 'regioni' italiane come problema storico," *Quaderni storici*, 34 (1977), 275–298; Maddalena Tirabassi, "Global Identity and Regionalism in Italian Migration from 1911 to the 1930s," unpublished paper, forthcoming, presented in Philadelphia 23 October 2011.

43 In Audenino and Tirabassi, "Italy on the Move."

44 Giovanni Levi, "Regioni e cultura delle classi popolari," *Quaderni storici*, 41 (1979), 720–731 (728).

45 Rudolph Vecoli, "The Italian Diaspora, 1876–1976," in *Cambridge Survey of World Migration*, ed. Robin Cohen (Cambridge: Cambridge University Press, 1995); Gianfausto Rosoli, ed., *Un secolo di emigrazione italiana: 1876–1976* (Rome: Centro Studi Emigrazione, 1978); George E. Pozzetta and Bruno Ramirez, eds., *The Italian Diaspora: Migration Across the Globe* (Toronto: Multicultural History Society of Ontario, 1992).

46 Amoreno Martellini, "Il commercio dell'emigrazione: intermediari e agenti," in *Storia dell'emigrazione*, 1: 293–308 (297).

47 See Antonio Gibelli and Fabio Caffarena, "Le lettere degli emigranti," ibid., 563–574; Emilio Franzina, *Merica, Merica: Emigrazione e colonizzazione nelle lettere dei contadini veneti in America Latina 1876–1902* (Milan: Feltrinelli, 1979); Samuel L. Baily and Franco Ramella, *One Family, Two Worlds: An Italian Family Correspondence Across the Atlantic, 1901–1922* (New Brunswick: Rutgers University Press, 1988). On photographs, see Peppino Ortoleva, "Una fonte difficile. La fotografia e la storia dell'emigrazione," *Altreitalie*, 3.5 (1991), 120–131; and Paola Corti, *Emigranti e immigrati nelle rappresentazioni di fotografi e fotogiornalisti* (Foligno: Editoriale Umbra, 2010).

48 Audenino and Tirabassi, *Migrazioni italiane*, 13.

49 *Inchiesta Faina*, 2: 244.

50 Gianfausto Rosoli, *Un secolo di emigrazione italiana, 1876–1976* (Rome: Cser, 1978); Fernando Manzotti, *La polemica sull'emigrazione nell'Italia unita* (Milan-Città di Castello: Società Editrice Dante Alighieri, 1969), 111–168; Zeffiro Ciuffoletti and Maurizio Degli Innocenti, *L'emigrazione nella storia d'Italia 1868–1975* (Florence: Vallecchi, 1978); Maria Rosaria Ostuni, "Leggi e politiche di governo nell'Italia liberale e fascista," in *Storia dell'emigrazione*, 1: 309–319.

51 Audenino and Tirabassi, *Migrazioni italiane*, 40.

52 The concept originated with the economist Luigi Einaudi (later the second President of the Republic of Italy) who thought there would be economic benefits derived from the growth of "colonies" of Italians who settled abroad. Italian populations in foreign countries would create markets for Italian goods as well as bridgeheads for international trade with the mother country, constructing, ultimately, a "greater Italy." Ibid.

53 Ibid., 41.

54 Augusta Molinari, "Porti, trasporti, compagnie," in *Storia dell'emigrazione*, 1: 237–255 (237); Molinari, *Le navi di Lazzaro. Aspetti sanitari dell'emigrazione transoceanica italiana: il viaggio per mare* (Milan: Franco Angeli, 1988).

55 Over the course of 150 years about thirteen million migrants went to Africa, North and South America, and Australia by ship, not counting illegal immigrants.

56 Sori, *L'emigrazione italiana*, 300.

57 Ibid., 297.

58 Silvano Tomasi and Gian Fausto Rosoli, *L'intuizione dei fatti avvenire . . . Mons. Scalabrini e la pastorale delle migrazioni moderne* (Piacenza: Tip. dell'Amico del Popolo, 1987), 23–24.

59 Gian Antonio Stella, *Odissee: italiani sulle rotte del sogno e del dolore* (Milan: Rizzoli, 2004), 74–75.

60 Molinari, "Porti, trasporti, compagnie," 241.

61 Ibid., 245.

62 The literature on the voyage to America is huge. See, however, Emilio Franzina, *Dall'Arcadia in America: Attività letteraria ed emigrazione transoceanica in Italia (1850–1940)* (Turin: Edizioni della Fondazione Giovanni Agnelli, 1996); Stelio Fongaro, *Lo straniero: antologia della letteratura classica italiana* (Basel: CSERPE, 1985); and Fernando Manzotti, *La polemica sull'emigrazione nell'Italia unita* (Milan-Rome: Società editrice Dante Alighieri, 1969).

63 Stella, *Odissee*, 74–75.

64 *Italica Gens* (5 May 1912), 143–144.

65 See Luigi De Rosa, *Emigranti, capitali e banche (1896–1906)* (Naples: Edizioni del Banco di Napoli, 1980); Sori, *L'emigrazione italiana*.

66 Amy A. Bernardy, "Navigazioni di lungo corso," in her *Passione italiana sotto cieli stranieri*, (Florence: Le Monnier, 1931), 107–120, an essay that reprises passages from her essay of 1907, "Emigrazioni di lungo corso." See also Maddalena Tirabassi, *Ripensare la patria grande: Amy Bernardy e le migrazioni italiane* (Isernia: Cosmo Iannone, 2005), 90. On Bernardy, see my contribution in Chapter 8.

67 Tirabassi, *Ripensare la patria*, 92.

7

THE SILENCE OF THE ATLANTIANS

Contact, Conflict, Consolidation (1880–1913)

Peter Carravetta

From Emigrant to Immigrant: The Sense of the Passage

The number of difficulties and real chances for disasters large and small being endless, one wonders how the Italian immigrants to the Americas withstood whatever life threw at them during their journey and resettlement, and moved on to forge themselves a new life. Perhaps, as befits the etymon of *migrare*, which from the Latin means simply "to move (on)," to go off somewhere or on to something else, their condition as migrants suggests two possible approaches, one literal: moving to another country; and the other metaphorical: engaging in activities such that the immigrant becomes somehow and perhaps inevitably someone else. We have seen the reasons why they left.[1] We know so many never completely severed the overstretched umbilical cord with their provenance, preferring to return, whether periodically owing to the seasonal ebb and flow of particular sectors, such as farming or construction, or maybe permanently for more complex reasons or even simply because they just "couldn't take it."

Now we must ask: What was it that pulled them through the trans-formation into functioning members of a different nationality, cobbling a different public self not at all in harmony with the basic cultural brick and mortar of the first self, the one rooted in and shaped by a "fatherland," or the "mother tongue," or the very *idea* of Italy? And to what level or degree did they achieve the transformation required eventually to become American? Or did they ever? I am provisionally using "American" as an uncontested umbrella word, which it is not, since the Italians experienced a variety of often contradictory if not paradoxical aspects of the new country, as we will see later. For we must ask: Which Americans spoke for which Italians? With what purpose?

Now that present-day Italian Americans are four or five generations removed from these humble trailblazers, do they configure a distant model, an *arché*, and inscribe a "founding" rhetoric for what has emerged over the same period of time as a constantly challenged sense of social identity? Furthermore, can the experience of the first generation of the great exodus teach us anything about broader sociohistorical shifts that impact on the very essence of what a national identity is, on what modern Western history itself is supposed to consist of?

The physical journey over the Atlantic has already disrupted many "natural" attachments to the earth, their roots. No doubt this affects how the immigrants will see, relate to, and live in the "world"—quite appropriately *here*, the "*New* World." To grasp the symbolic and existential ramifications of what the journey meant, recall the scene in Emanuele Crialese's film *The Golden Door* (2006/2007), when the ship loaded with emigrants edges out from the dock (probably Palermo) to the tune of a gloomy, bone-rattling fog horn. What at first sight appears to be a normal teeming period crowd literally filling the screen, seen from a strategic overhead shot, is slowly but inexorably separated into two: those who stay behind, on land, in

Sicily, and those who, with Salvatore and his family, depart toward the United States. Those on the ship experience the growing spatial void being filled by an indifferent dark-brown sea, with the actual tearing away foregrounded in a swirl of kerchiefs. The scene makes the viewer think of what the individual self must have felt at the moment: that this was going to be an epochal, life-altering, unidirectional event, like a death in the family, or going to war or dissolving a marriage: the separation will scar the self forever.

Immediately afterward: the real drama of the journey. Making it through between ten and twenty days at sea, depending on the number of ports ... to pick up more emigrants. This was no tourist cruise. The same Crialese film shows what a nightmare it was, especially for people who had never even seen the sea, as the great majority came from hinterland mountainous regions. That *terra firma* has symbolic affirming power did not need to be explained to them. The majority of emigrants, even those who made their living at sea, like tuna fishers and maritime workers, had a bone-sure sense of what land was like: governments come and go, harsh winters and dry seasons occur periodically, and, yes, the sea is dangerous, but one knows where one plants one's feet. These people, this avalanche of humanity, setting out to sea, consisted, as is well known, mostly of underemployed or unemployed laborers, *contadini*. They were exploited, undereducated and largely unskilled country folk who knew only their immediate region, only their fields and rivers and woods, and were imbued with various fatalistic beliefs.

Still, among them, something snapped and they decided to leave.

Upon uprooting they were identified by society as "labor migrants," though the claim being made here is to recall that they need to be considered "dispersed" souls wandering in search of security, freedom, and *a* home (since they no longer had *the* home).

In the old country this class of people, the largest numerically, coming mostly from the South (see Table 7.1), did not enjoy the advantages of the urbanized middle class, which had

Table 7.1 Emigration from Italy by region, 1905 and 1906. Source: Gianfausto Rosoli, ed., *Un secolo di emigrazione italiana 1878–1976* (Rome: Centro studi emigrazione, 1978), 229; taken from Antonio Mangano, "The Effect of Emigration Upon Italy," *Charities and the Commons: A Weekly Journal of Philanthropy*, 19 (4 January 1908), 1329–1338 (1331), here corrected for small computation errors.

Region in Italy	1905			1906		
	Europe and Africa	North and South America	Total	Europe and Africa	North and South America	Total
Piedmont	37,409	30,987	68,396	38,305	33,885	72,190
Liguria	1,908	6,324	8,232	2,304	6,630	8,934
Lombardy	45,845	16,211	62,056	43,586	20,046	63,632
Veneto	95,453	12,571	108,024	88,547	16,338	104,885
Emilia	28,659	9,921	38,580	29,989	12,692	42,681
Tuscany	21,123	10,497	31,620	23,151	13,690	36,841
Marche	10,788	21,131	31,919	10,690	23,811	34,501
Umbria	7,435	2,464	9,899	10,828	3,958	14,786
Lazio	1,586	13,116	14,702	2,181	16,326	18,507
Abruzzo and Molise	6,909	52,020	58,929	6,030	52,002	58,032
Campania	4,588	79,728	84,316	4,332	85,437	89,769
Puglia	4,809	16,541	21,350	3,963	29,799	33,762
Basilicata	534	16,475	17,009	310	17,788	18,098
Calabria	1,513	60,777	62,290	1,507	55,577	57,084
Sicily	8,329	97,879	106,208	5,934	121,669	127,603
Sardinia	2,360	441	2,801	4,655	2,017	6,672
Total	279,248	447,083	726,331	276,042	511,935	787,977

greater autonomy and could rely in various degrees on existing government agencies and private institutions. Immigrants from this latter sector should properly be called "expatriates" or "exiles."[2] They were typically more "worldly" in their outlook on life and society, were well educated and, significantly, most did not travel in steerage.[3] Interpreting the role of those who were employed in still other sectors, from business to government, from transportation to specialized labor, requires a more nuanced approach toward the migration progress, based on the different socio-ideological spaces they navigated.[4] Here we would see a heterogeneous group which, in general, was less fatalistic or apocalyptic about leaving the land, and was better equipped to enter and explore the "New World." And finally there were also, albeit in a restricted number, some professionals, intellectuals and artists in their midst. Accounting for these groupings one can begin to study the variety of Italian *diasporas* that participated in the historic demographic flow.[5] But it becomes all the more important and more difficult to imagine the experience of the veritable "silent majority" among those who did not go back to Italy, about three million people.

A paradox emerges in the historical reconstruction of this "silent majority." These emigrants did not speak about themselves, left few traces and, over a thirty-year period they were *not* truly represented in American society, though they had become very visible to the host.[6] This was not because they chose not to speak out in exchange for some minimal guarantees, protection and civil status. Instead, to repurpose an expression from the 1980s–1990s, this "subaltern" underclass[7] did not speak out *because they could not*: I am arguing for those two-plus million people (out of the three million who remained in North America) with no language skills, education, no access to effective social discourse, no access not only to the means of production (obviously, though of course some managed to start their own in-house businesses),[8] but also to *the very possibility of communication*. In this perspective, what we have to work with is how they were perceived by denizens of the host country, how they were described and labeled, how *their social and cultural identities were being constructed from the outside*, as it were, once in America. And yet we can only infer or guess what, at the same time, they must have been experiencing on the inside, in their minds, their guts, their hearts. For this aspect we usually turn to literature, theater and the other arts, as our last limited yet ever-revealing passageway into the psyche of the immigrant.[9]

In some way the sea crossing washed the soil from under their feet. It made for an awareness that reality is an unstable dimension. From the time they landed, they were ever conscious of where they walked. There is a tradition of scholarship that interpreted the role of the individual migrants as passive: fearful and ignorant, they were unequipped to realize what forces and dynamics were at work in their lives.[10] Many did not know they were even "Italians" until they got to Ellis Island.[11] Many found that their most basic sense of identity was threatened; their own names were changed almost arbitrarily before being approved and released to land.

A Patchwork of Italianess

The Italians by and large spoke provincial or regional dialects, and upon aggregating into communities even their dialects changed, especially during the first decades, as they borrowed words from *compaesani*, pulling in whatever Italian they knew, coining new words, and inventing a new morphology, as the presence of English encroached and became steadily dominant.[12] Though highly uneven, this can still serve as a *koiné*, or common language, for interpersonal, interregional exchanges and affiliations. Looking closer, we find other aspects that demand *realignments* of practices and strategies to connect and exchange with specific groupings. In finding themselves members of small dedicated groups—such as when

hired for work gangs, joining neighborhood political activists, partaking in parochial organ-izations, or becoming educators[13]—these immigrants, strangers and babbling aliens, were nevertheless forced to interact *across* national language barriers and religious and ritualistic differences. A few scholars have recently conjectured that, unbeknownst to themselves, the first-generation emigrants/immigrants were participating in the larger political economy of the North Atlantic trade triangle, and as such their interpretation requires a transnational perspective. Moreover, whenever and wherever they found work, except in the cases of older family members working in the back of a small storefront business, these Italian immigrants had to deal with people from all sorts of backgrounds, some also immigrants, but most oth-ers already established on the territory: blacks and Jews, Europeans and Asians, Latinos and WASPS, the wealthy and the paupers, urbanites and local boors.

This fluid and shifting social reality would have made unexpected demands on the immi-grant, as it required engaging this panoply of humanity at work or in the street in order to figure out, or "decode," how best to coexist with the (very different!) locals. The juxtaposi-tion forced them to constantly self-check, and constantly look for ways to rearrange their own homes, work, and living habits. If the *koiné* was the main vehicle for regrouping locally while re-elaborating a now swelling imaginary past, the anxiety-filled and ever uncertain relations of the present, whether recurring or isolated, had to be experienced and experi-mented with anew, on the spot, on their skin. The immigrant, in negotiating his "belong-ing" to the broader "American" paradigm, had to become malleable, inventive, with sharper reflexes, essentially a "survivalist." Connecting civilly at any specific point proved a day-to-day campaign: too many the opportunities for swindlers and profiteers to set them back in multiple ways. When local opportunities for growth diminished, or authorities failed them, they retrenched in their neighborhoods. A redoubling or splitting of the self informed one's psychosocial worldview. Immigrants developed a stereoscopic vision of things: Everything could be looked at in two ways, the Italian way (or their understanding of what was thought to be Italian) and the American way (or their understanding of what this America was turn-ing out to be).

That migrants in general must be adaptive is a safe generalization, but many of them, not only Italians but also Hungarians, Czech, Germans and Jews, displayed a clearly pragmatic approach to dealing with a new environment. This became a positive predisposition when beginning the process of incorporation and assimilation in the United States, where a Prot-estant ethic in principle favored individualism, self-reliance and initiative. If not before the journey, then decisively after relocating, one became pragmatic.[14] An immigrant quickly realized, moreover, that one did not have to be "100 percent American" all the time in order to live and work in America. The immigrants could adapt to and interact with the *necessary interfaces* (landlords, schools, the police, employers) and still have psychological space suffi-cient for recreating an interior world that was familiar, local and full of symbols of belonging. The great number of local clubs and religious feasts attest to this. Yet this personal-familiar world had the peculiarity of constituting a de-territorialized minor culture, one that alter-natively loved and resented the grander paradigm called "Italy" that to them was inexorably turning into a fuzzy past, maybe a myth, as old as Jesus or Rome.

Furthermore, what is often not included or thematized sufficiently, in the discussion about migration, is the role of class, both with respect to the immigrant him/herself, and with respect to the existing social classes or groups in America that were empowered to assess and pass judgment on the newcomer. Who, and from what stump or editorial office or govern-ment agency, could contribute to creating an identity for the newcomer? To return to the most physical of levels, social psychologists tell us that a standard reaction upon being thrown into a different environment is that the subject sharpens her focus and searches spontaneously

for what, in the new habitat, is recognizable, constituting a safe reference point or locus of primary orientation with respect to the basics of life: streets, houses, clothing, iconic images, time schedules, sounds. But did the immigrants all negotiate the transition, which effectively meant going through the complex stages of culture shock, in the same way? And how did it come about that the immigrants were assigned by the American public a repertoire of semantic/symbolic markers that made rabble-rousing discriminatory statements not only acceptable but quick and effective? What agencies or communities contributed to creating public resentment toward the Italians, a resentment that was bolstered by scientific and juridical authorities, as we will see, and then edged into and complicated the bond between first and second generation Italians?

In order to find further links among these larger concerns, we need to turn to some more circumscribed issues. I would like to begin with a "culture-scape":[15] a sketch of what America was like at the end of the nineteenth century that illustrates the complex dynamics into which the immigrant walked unawares. Then I shall treat the changing *perception* of Italian immigrants between 1880 and 1913: a treatment that requires identifying further discursive subsets that impacted the lives of this first generation. Finally, and in conclusion, I shall examine the broadly philosophical implications of this sketch and of the role of migrations in history.

The Changing Culture-Scape of America from 1880 to World War I

One must consider some general aspects of the host society into which the immigrants arrived. The Gay Nineties have also been called the "Grey Nineties."[16] Jim Crow policies[17] had sealed the fate of African American social integration and advancement for another seven decades.[18] In the same decades the Amerindian genocide ended with the total submission of the Native Americans.[19] During these years the Frontier Hypothesis anchored to the Grand Scheme of an American "Manifest Destiny"—which originates in the early 1840s—came to fruition: The country was ripe now for the unprecedented exploitation, coast to coast, of its vast land. These are the post–Civil War decades of the rapid growth and expansion of major industries, such as coal and steel, of the manufacturing and shipping tycoons, and the decades of struggle of the farmers, the "agrarian revolt," against the North-East moguls, the railroad barons.[20] Significantly, America began to take a peek at the rest of the world.[21]

One major concern that loomed large in public discourse concerned the millions of foreigners "flooding our shores" who were becoming front-page news, starting by the early 1880s. An occasional optimistic entreaty by the likes of William Lloyd Garrison—the son of the famous abolitionist—to the effect that "Uncle Sam Is Rich Enough to Give Them All a Farm,"[22] would be countered soon by an avalanche of discriminatory, racist articles by resurgent nativists representing allegedly "threatened" communities in a number of states. As late as 1896, Garrison could still write "Let them come . . ." with ecumenical fervor, but the times they had a-changed, for, unfortunately, there were no welcoming committees to greet them—notwithstanding the good intentions of Emma Lazarus![23] Indeed, early on some Italians were treated worse than slaves and denied their very humanity by being assigned numbers, as reported by an article that the *New York Times* headlined "ONE ITALIAN PROBLEM SOLVED":

A fundamental improvement is reported from the works of the West Shore Railroad. . . . We refer to the ingenious way by means of which the contractors on the

lines named identify the Italians in their employment. The "linked sweetness long drawn out" of Italian patronymics, so suggestive of Southern indolence and leisure, possesses no such charms in the ears of said contractors as leads them to master the difficulties presented in their memorizing and pronunciation. They therefore substitute numbers for names in their identification of the Italians in their employment, these numbers being conspicuously painted on the most spacious portion of the trousers worn by the men. . . .[24]

But these were the years of Wild West capitalism, which demanded government policies that were supposed to protect American manufacturers and contractors, not the workers.[25] Although the Sherman Act, effectively the first antitrust law, was passed in 1890, there were Supreme Court decisions that, though curbing monopolies to some degree, explicitly supported industry in the face of growing claims against workforce abuses and the labor disputes that were connected with immigration.[26] This would have important ramifications when the intellectual component of the Italian migration took a leading role in early struggles to build unions, improve labor conditions, raise wages and advance other social issues.[27]

A tacit, selective anti-immigration sentiment in American social history goes back to the founding of the Republic,[28] becomes more vocal during the Jacksonian era and reached an early peak with the anti-Catholic Know Nothings of the 1840s and 1850s. Until the Civil War, the largest number of immigrants came from Sweden, Germany, England and Ireland. After the conflicted results of the Reconstruction Era, more attention was focused on the foreigners, and the passing of the Chinese Exclusion Act in 1882 signaled a paradigm change in American immigration history. The American government could legitimately now decide who would be barred from its sovereign territory.[29] During the 1880s the American Protection Association became influential in public debate, and it reached a membership of over two million by the mid-1890s. In 1894 the Immigration Restriction League (IRL) championed an "Ideal American" who was juxtaposed against the "hordes" that were arriving. One of the co-founders of the IRL, Prescott Farnsworth Paul, argued that Americans would soon have to decide whether they wanted a nation

> peopled by British, German, and Scandinavian stock, historically free, energetic, and progressive, or by Slav, Latin, and Asiatic races, historically downtrodden, atavistic, and stagnant.[30]

An "Anglo-Saxon complex" was slowly being forged in the American collective unconscious. The conviction that the unchecked daily disembarkation of thousands upon thousands of foreigners could not continue—the harbinger of a cultural identity crisis—soon demanded that certain distinctions be made:

> Upon the whole, however, the contributions to our population from the Teutonic and Scandinavian countries have been assimilable, useful, and even needful . . . objectionable immigration is immigration of a people so alien to us that they cannot become Americanized, either in the first or in the second generation, and that threaten to remain here, so long as they remain at all, as foreign colonists. Such is the emigration from Italy, from Russia, from Poland, from Bohemia, and from Hungary. Immigrants from some of these nationalities are found convenient and available, on account of their cheapness, due to a low standard of living, by capitalists in Pennsylvania and elsewhere who are actively engaged in the good work of protecting American labor against the pauper labor of Europe.[31]

One strategy that attempted to stem the tide involved legislation to impose a literacy test on immigrants: Such legislation was passed five times in the House of Representatives, although it was vetoed by a succession of presidents.[32] Another strategy involved reporting constantly on the repulsive, unhealthy and uncouth ways of living of the immigrants: the tenements and slums of New York, Boston, Philadelphia and other urban enclaves. Well-meaning, upstanding middle-class white (North European) Americans were "shocked" at the way the majority of first-generation immigrants, and Italians foremost among them, were living in "their" America. And justifiably so![33]

But there is a difference between a generic, moralizing indignation, and concrete, effective intervention to improve matters. Improvement, ultimately, came about thanks largely to the initiative of the immigrants themselves, through a growing number of neighborhood and fraternal associations, parochial councils, and social clubs.[34] And the publication of periodicals and local newspapers.[35] Fundamental in this context remains the famous book by Jacob Riis, *How the Other Half Lives*, which was published in 1890. Summing up by then current opinion, but with the verve of the committed reporter, here we read that these Italians in lower Manhattan are undesirables, riff-raffs ("lazzaroni"), unassimilable paupers, thieves; they were deemed collectively uncouth, unclean, archaic and backward:[36]

> In the slums he [the Italian] is welcomed as a tenant who "makes less trouble" than the contentious Irishman or the order-loving German, that is to say: is content to live in a pig-sty and submits to robbery at the hands of the rent-collector without murmur. . . . Like the Chinese, the Italian is a born gambler. His soul is in the game from the moment the cards are on the table, and very frequently his knife is in it too before the game is ended. No Sunday has passed in New York since "the Bend" became a suburb of Naples without one or more of these murderous affrays coming to the notice of the police.

However, Riis also points out that these new unkempt and slick tenants have some positive qualities:

> With all his conspicuous faults, the swarthy Italian immigrant has his redeeming traits. He is as honest as he is hot-headed. There are no Italian burglars in the Rogues' Gallery; the ex-brigand toils peacefully with pickaxe and shovel on American ground. . . . The women are faithful wives and devoted mothers. Their vivid and picturesque costumes lend a tinge of color to the otherwise dull monotony of the slums they inhabit. The Italian is gay, lighthearted and, if his fur is not stroked the wrong way, inoffensive as a child.

And finally he zooms in on the real culprit behind this deplorable state of affairs:

> An inspector of the Health Department found an Italian family paying a man with a Celtic name twenty-five dollars a month for three small rooms in a ramshackle rear tenement—more than twice what they were worth—and expressed his astonishment to the tenant, an ignorant Sicilian laborer. He replied that he had once asked the landlord to reduce the rent, but he would not do it. "Well! What did he say?" asked the inspector. "'Damma, man!' he said; 'if you speaka thata way to me, I fira you and your things in the streeta.'" And the frightened Italian paid the rent.

It's the greed of the landlords that's the problem, and before we point the finger across the ethnic-national divide, it isn't just the Irish, who are now up on the pecking order having arrived *en masse* half a century earlier, who exploit the ignorant immigrant: what's often overlooked is that it is also the Italian "padrone" who enslaves his helpless charge:

> The padrone—the "banker," is nothing else— ... receives him at the landing and turns him to double account as a wage-earner and a rent-payer. In each of these roles he is made to yield a profit to his unscrupulous countryman, whom he trusts implicitly with the instinct of utter helplessness. The man is so ignorant that, as one of the sharpers who prey upon him put it once, it "would be downright sinful not to take him in."[37]

Reading the entire tract, and coming to terms with the fact that more than half of the population of New York City lived in slums, it is too easy to say that Riis used what today appear to be some politically incorrect qualifiers when describing the Chinese, the Jews, the Czech, the Hungarians and so on. At bottom he was trying, perhaps in the spirit of the many other social crusaders at the time, to offer a spectrum of an urban underclass that hardly reflected the lofty ideals of a country where the streets were paved with gold: *that* myth, it might now be argued, proved to be a farce! Exploitation reigned, demoralization and abuse were the norm, and being blamed for this condition was thrust back upon the hapless immigrant:

> Pauperdom is to blame for the unjust yoking of poverty with punishment, "charities" with "correction," in our municipal ministering to the needs of the Nether Half.[38]

The major press in English from various cities furnishes a great observatory to gauge dominant public opinion and corroborate this assessment. Although patterns emerge, they are not necessarily transhistorical or atemporal, and are perhaps better understood as interclass and trans-ethnic. However, in tracking an increasingly negative view of the Italian arrivals it is possible in the press to mark out a period that began with the widely discussed 1891 lynching of eleven Sicilians in New Orleans,[39] and continued over the years with reportage that concerned the insidious Italian "Black Hand," or that emphasized Italians who got into violent scuffles.[40] Such articles appeared about as frequently as others that concerned the hunting down of a stray Sioux or Comanche in the Far West, or about the lynching of a Negro in the South. Matters get more complicated when we add reports of the growing presence of Italian immigrants among the anarchists, socialists, union organizers, labor disputes, strikes, demonstrations and riots that were the source of so much middle-class and government anxiety in the first fifteen years of the twentieth century.[41] The tenor and ideological depth of popular prejudice against Italians would continue to grow in this manner until it culminated, in the post–World War I decade, in the case against Sacco and Vanzetti.[42]

Making Italian Americans

It is difficult today to comprehend how a national government and, by reflection, the people it presumably represented as "Americans," could come up with and endorse blatantly racist and exclusivist policies against Italians (and other groups as well) to the point of making them a widely accepted background scapegoat and despicable social value or frame of reference. But if we recall briefly the role played by the Dillingham Commission (1907–1911) in

the fate of all immigrants, not just Italians, things become clearer. The Commission's work was a crucial sociohistorical event where identities were shaped from the outside, and measured and pinned on the body of the immigrant, both metaphorically and literally.

According to Desmond King, in 1882, out of 650,000 European immigrants who arrived in the United States, 13.1 percent came from southern and eastern European countries comprising Austria-Hungary, Greece, Italy, Montenegro, Poland, Portugal, Romania, Russia, Serbia, Spain and Turkey. Twenty-five years later, in 1907, which was an all-time peak year for immigration, we notice an epochal change: Of 1,207,000 immigrants who arrived in the United States, 81 percent came from these same southern and eastern European countries.[43]

The predominance of the southern Europeans figures even more starkly in a table (see Table 7.2) that compares the sources of immigration in the three periods 1820–1860, 1861–1900 and 1901–1920. Among the general public there was cause for alarm.

A growing chorus that something be done about this "invasion" eventually forced government officials to take action.[44] It was not that there weren't Italian immigrants who had already incorporated and assimilated by the beginning of the century, and distinguished themselves in various sectors of society. There were successful bankers, politicians, wine growers, artists and political activists on the scene.[45] It was that great mass at the bottom of the socioeconomic hierarchy that, together with their *confreres* from other countries, represented a veritable human tsunami arriving at the various ports, from Boston to New Orleans, from San Francisco to Los Angeles, with New York being the major hub. In 1907 the numbers peaked at nearly 300,000! (See Table 7.3.)

Table 7.2 Immigration to the United States, percent by global region of origin, 1820–1920. Source: Roger Daniels, *Not Like Us: Immigrants and Minorities in America, 1890–1924* (Chicago: Ivan R. Dee, 1997), 63, using INS data.

Region	1820–1860	1861–1900	1901–1920
Northwestern Europe	95	68	41
Southeastern Europe	—	22	44
North America	3	7	6
Asia	—	2	4
Latin America	—	—	4
Other	2	1	1

Table 7.3 Annual totals of immigrants to the United States, 1906–1916. Source: Robert F. Foerster, *The Italian Emigration of Our Times* (Cambridge: Harvard University Press, 1919), 15.

Year	Number of Immigrants (All Countries)
1906	286,814
1907	294,061
1908	135,247
1909	190,398
1910	223,453
1911	189,950
1912	162,273
1913	274,147
1914	296,414
1915	57,217
1916	38,814

As a result, President Theodore Roosevelt was lobbied heavily to take action, and in 1907 Congress approved the creation of a U.S. Immigration Commission, known by the name of the Vermont Senator who chaired it, William P. Dillingham. What was perhaps most remarkable about this gargantuan undertaking was the coordination and collaboration of hundreds of scientists, demographers, anthropologists, sociologists, medical researchers and criminologists who went on to conduct interviews, collect recordings and photographs, draw conclusions, and eventually testify before other experts and officials about the most diverse aspects of the nature of the European mass exodus to the United States.

Lasting nearly three years, the investigation's results were delivered in 1911, in forty-two volumes. It is by far the most exhaustive, thorough, and we might even say scientifically "accurate" investigation of such a huge topic to date.[46] Paradoxically, the Italian intelligentsia contributed to strengthen the Commission's conclusions that southern Europeans and east Europeans were "inferior," relying among scientific authorities on the work of the Italian criminologist Cesare Lombroso, and of his younger peer, Alfredo Niceforo. The latter made a case for "two Italies standing in stark contrast," and whereas

> The Aryans, northern Italians, have a more developed sense of social organization rare among Mediterraneans, southern Italians [. . .] have by contrast a more developed individualistic sentiment.[47]

By the time they got through the hearings and testimony, the Commission had adopted this assessment as scientific, factual truth.

We recall how, in official immigration statistics, "Italians" were listed next to other nationalities and "races" in the late-nineteenth century as "undesirables" and "unamericanizable," but by the early 1900s a further distinction was introduced between "Northern" and "Southern" Italians. The Commission thus legitimated as unvarnished truth a distinction between more bourgeois northern Italians and more rustic, Arab-looking southerners. In other words, the Commission confirmed and reified a descriptive characterization that had already become popular belief and would remain the basis of stereotyping until only a few decades ago.[48] The impact was felt by the immigrants not only on arrival, but also in the course of these early decades of constant negotiation with the social reality with which they and their children interacted and competed with other groups for a seat at the table.

One area of investigation and reflection that is often overlooked is the complex relationship between newly arrived Italians and the African Americans who were already here. Though both groups were seen with suspicion in the early 1900s, Italian immigrants were grouped with an increasing frequency with the "whites": disgusting as they might be, the opinion went,[49] they were at least "*not* black."[50] Things such as feeling or "being Italian," and feeling and "being American," though still pressing concerns at this stage, made room for an overarching concern: passing for or "being white."

And in terms of society at large, moreover, what we register is the emergence of a conceptual distinction, adopted even by the highbrow intellectuals and labor reformers, among those from the "new immigration" whom they thought acceptable or at least "Americanizable," and those whose basic set of qualities were "unwanted," "dangerous," and "unassimilable."[51] The nation's founders and their descendants up to about the period of the Civil War were clearly constitutive of what then was referred to as the "old" immigration, so there was no stigma attached to the fact that, if we pursued it far enough, they also could trace their origins back to Europe, specifically to Holland, England, Scotland, Germany, the Scandinavian countries. The issue became who, among the *new* immigrants, was acceptable.

I have argued elsewhere that after four or five generations, it seems that wherever they replanted roots, resettled, people feel they *own* the land and, with it, its history, and are therefore entitled to calling themselves natives.[52] Therefore, as the great majority of the new immigrants—Italians, Croats, Slovaks, Greeks, Bohemians (Czechs), Turks, Romanians, Poles, Russians and Polish and Russian Jews—had physically just arrived from different lands, they had no right to the claim of "belonging" to the new country and calling it "theirs" as well. In fact, the Commission concluded that the great majority of them, the "refuse" of other nations, worshipped in Orthodox churches and synagogues, that they were heavily illiterate and impoverished, that they now lived together in "Little Italies" and "Little Polands" and "Jewtowns" and "Chinatowns" in the jam-packed and unhealthy and dangerous inner cities, and implicitly had no desire to "Americanize."[53] Moreover, whereas the old immigration movement was conceived as being essentially one of permanence, as entire families settled the land, the new immigration, the report continued, was made up largely of individuals, a considerable proportion of whom apparently had no intention of establishing a permanent domicile, their only purpose in coming to America being to temporarily take advantage of the greater wages paid for industrial labor in this country. This claim has been contested, since as we glean from other sources (including worsening conditions in the sending country), by early 1900 the majority came to stay, no matter what the odds.

The Dillingham Commission was important for another more theoretical reason. Two of the most important and powerful discursive formations of the country, science and jurisprudence, had joined their authority and created a *de facto* legitimate stereotype. In principle, science seeks to find what is called knowledge, whereas the law seeks what is the truth of a particular state of affairs in social interactions in view of what is legitimate. Thus we witness, on a grand scale, how institutions of higher learning and the professions (the scientific community comprising some ten different specific disciplines) present their research and findings, and another fundamental body (rooted in ethics, the law, and setting norms for moral compass), meaning the Congress of the United States, have now proved *and* approved beyond the shadow of a doubt that some groups or races or nationalities were inferior to others: Stereotyping is legitimated! Historians of the period corroborated the conviction.[54] And the then-dominant field of geography also supplied further ammunition.[55] One need only consider the representation of Italians in the early silent era movies to get a glimpse.[56] Thus by the time World War I broke out intellectual and political élites could state that what had made America great were the values of the legitimate heirs of the immigrants hailing from northwestern Europe, an idealized white Anglo-Saxon Protestant Europe, and that it was scientifically accurate, politically advantageous, and socially acceptable to discriminate against people coming from Mediterranean and eastern European countries.[57] As historian Oscar Handlin concluded in his path-breaking work, the Commission only proved what everyone believed even before it started its lengthy, laborious, "scientific" research, and its equally lengthy committee work.[58]

A number of people and associations protested the misuse of the results of the Dillingham Commission.[59] But once the Commission's report was circulated, overt xenophobia became standard fare in the press. Patriotic groups and associations began to craft rules and procedures for Americanizing the immigrants. As had been done with the Amerindians, the pressure was on to forget the ways of the old world, of the immigrant parents, and learn "the proper way we do things in America." Patterns also began to emerge in the ways in which Americans undertook to think about assimilating the immigrants. Historian Desmond King has drawn attention to three competing models of assimilation: (1) an *Anglo Conformity Model* under which assimilation means instilling all members of the polity with Anglo-Saxon values and interests; (2) a *Melting Pot Model* in which the group that is longest present or most

dominant does not determine an overall national identity, which instead remains open to negotiation; and (3) a *Salad Bowl Model* that views assimilation as a form of cultural pluralism in which a multiplicity of ethnic groups and identities coexist.[60]

An interesting point here is the growing popularity of the melting-pot ideology, as per the title of the influential play by Israel Zangwill, which premiered in 1908. This was to create a narrative for large sectors of popular opinion, as some lines seemed to be perfectly etched:

> America is God's Crucible, the great melting-Pot where all races of Europe are melting and reforming . . . Germans and Frenchmen, Irishmen and Englishmen, Jews and Russians—into the crucible with you all! God is making the American.[61]

This ideology was viewed quite positively by the assimilationists and the pro-immigration leagues, notwithstanding that it was an immigrant Jew who advocated it: He all but wanted to cast off his origin and literally start anew, construct the new citizen of this exceptional country. And it would be another immigrant, this time an Italian, Frank Capra, who a generation later would shape for common consumption the American Dream.

The paradox for historians, social and literary alike, is that, broadly speaking, *at the same time* that Americans were vouching for *both* the conformity model *and* the melting-pot assimilation schemes, they were also "deliberately controlling who was to be eligible to assimilate."[62] The fact that some of these groups found solace or validation or security within their own enclaves only heightened the discrimination and racism against them. The process of a coercive, warped or incoherent assimilation into America had also political and economic aspects to it, because lots of funds were made available from private foundations as well as government agencies and school districts, to educate the immigrants themselves and/or their children into the American way of life, often in traumatic ways.[63] Schools were set up even in factories and offices, so that everyone spoke English, learned white Protestant mores, and by and large tried to live up to the values of the dominant Anglo conformity model. Multiculturalism was far in the future. Second generation Italian Americans learned to love sliced bread and peanut butter and jelly. Some, following the entreaties of people like Gino Speranza and his newspaper *Il Progresso Italo-Americano* [The Italian-American Progress] thought it best to cut off their cultural and linguistic roots and become champions of the American way of life.

Conclusions

In closing one might reasonably ask: Why did they stay? Of those three million who did not go back, given the culture-scape we just sketched, what motivated the immigrant to remain? Perhaps the experience of migrating brings one closer not only to what is essential to human survival, but also to the instincts necessary for coexistence, instincts that may actually predate the construction of our social identities that now seem so important to us. Identification with a country of provenance—with its many language-and-history marked social worlds—dies when the migrant dies. Contrary to some accounts, I do not think of the Great Migration of the Italians who came to American in the years from 1880 to 1920 as a wave of people who arrived bearing a sword or a torch like Aeneas, who arrived foreordained on the shores of Latium. This was instead a transitory historical generation that was disseminated almost at random in the most varied environments—farming, railroads, construction, fisheries, mills and so on. They planted the seeds of a generation that, in growing up American, would carry a complex symbolic load, or "charge" or field of expression. But their parents were *no longer* "*Italian*" and *not yet* "*American*." They might be called "Atlantians."

Many are the writers who have tried so valiantly to "reconstruct" or "reimagine" or "reclaim" what the lives of these people, the first generation of immigrants, were like.[64] But in these texts one often hears an echo chamber, a hollow space that is approached, tasted, teased and yes, given a voice, but one which somehow sounds distant and, as it were, from the "outside." In an effort to regain some authenticity, some contemporary researchers have turned to the eloquent few of the period, to persons who claimed to represent "their own people" and who furnished partial mirrors, "in their own language," of their living conditions and of the profound social problems they faced. I am thinking of the radical organizer and writer Arturo Giovannitti, and popular writers such as Bernardino Ciambelli, Riccardo Cordiferro and others,[65] and the plethora of activists and well-meaning "patriots" who peopled the pages of the very active Italian language press.[66] Still, like veteran actors on the stage of Italian American history, these persons end up as "figures" or "characters," not as real people.[67] Their stories are destined to be recounted a generation later—maybe two or three generations later—when the net results risk romanticizing and idealizing our stoic, self-less, impenetrable grandmothers and grandfathers.

The experience of the first generation of immigrants has been by and large safely labeled either as an epiphenomenon in the lives of nations or as a preliminary, indeed transitory, step *toward* becoming Italian American. It is quickly subsumed as a "natural" thing, complicated and dramatic of course, but subject to laws of economics and ultimately not the stuff that makes history and civilizations. Yet the magnitude of the tidal wave of Europeans to the Americas, and of Italians in particular, touched on a greater set of social institutions and cultural mores than could ever be contained within any one national discourse. It involved the entire world of the Euroamerican *oecumene*, the North Atlantic trade and development, ultimately the troubled when not diabolic relationship between capitalism and democracy. Survival, labor, dignity and the desires for a functional justice system and the improvement of one's family, were predominant among the culture-shocked immigrant arrivals, and these were matters that cut right through the epistemological grids of race, gender, language and identity affiliation that modern scholars have created for them.

Considered historically, the silent majority to which I have been referring seems to puncture rather than reinforce the cultural structures we normally work with, such as pride of flag, or descent, or place, or religion, or language. Here the crucial components of what makes a culture were experienced at their base value, at their lowest possible denominator, so to speak, at the locus where a belief system—the value of certain rituals, the reassurance of origin, the identity of names, a memory which was not that of the grand paradigm called Italy, that of the high culture or *alta cultura*—was still anchored to a material, life-sustaining process, implying above all concerns for a real job, a safe family or loved one, a peculiar often illogical network of habits and social dynamics. These people knew, in their inability to get a hearing in the host society, that there was no going back, for migration is truly a one-way trip, and all the romanticizing about their "having made it" in the host country will never cauterize the wound of being forever in-between. The new credo that now, in this country, if wrong was done there would be an authority to which one could turn—a democratic government (!), bad apples notwithstanding—was just that, a credo, a hope, a force pulling them onward into the unknown, chart it, dig the ditches, lay the rails, erect the buildings, stitch the garments, sell the newspapers, hawk their meager products somehow.

It is only with the American-born that the question "What is an Italian American?" truly arises. But the Atlantians, those who "came before," were locked in the silent and unutterable effort of making do, of living, and of clearing new pathways for themselves, true explorers without maps and compass. Still, they managed to draft blueprints for survival, they found self-determination in the face of a stripped self, they offered models of adaptability to new

mores and devised ingenious ways of resolving problems, and undoubtedly all of them contributed to the process of planting new seeds and grafting where possible different shoots, premises for seeding ever-new gardens.

This silent crowd of misunderstood and maligned individuals on opposing shores of the ocean sea called the Atlantic existed in a twilight world. They never fully entered and partook in the much touted and dreamed of New World. When the next generation finally came of age, and aspired to validate its own past, it could obviously see the remains of what had taken place, but their interlocutors, if they spoke at all, spoke a different idiom, and I don't mean just English. These ocean-crossers, these lower-case explorers and pioneers, this transient generation present formidable problems of interpretation, being more a *translatio* (literally "a carrying across") between and among contrasting and conflictual worldviews. Today's Italian Americans are in this sense the heirs to an origin that is fundamentally a translation from a non-language to a non-place, from a powerful silence to a Babel of possibilities. Theirs is the task to give voice and relevance to the silence.

Further Reading

Carravetta, Peter. *After Identity: Migration, Critique, Italian American Culture*. New York: Bordighera, 2016.

Gabaccia, Donna R. *Italy's Many Diasporas*. Abingdon: Routledge, 2003.

Tomasi, Lydio F., ed. *The Italian in America: The Progressive View 1891–1914*. New York: Center for Migration Studies, 1978.

Notes

1 See Chapter 6 by Maddalena Tirabassi.

2 I have developed a critical model for the proper interpretation of the different kinds of migrants in Carravetta, "Migration, History, Existence," in *Migrants and Refugees* [Olympia IV: Human Rights in the 21st Century], ed. Vangelis Kyriakopoulos (Athens: Komotini, 2004), 19–50; reprinted with emendations in Carravetta, *After Identity: Migration, Critique, Italian American Culture* (New York: Bordighera, 2016), 11–20.

3 This group includes those who arrived with strong intellectual and political motivations and joined the ongoing struggle for labor reform, immigrants, children and women's rights, becoming activists and ideologues. See Philip Cannistraro and Gerald Meyer, eds., *The Lost World of Italian American Radicalism* (Westport: Praeger, 2003); and Rudolph J. Vecoli, "The Italian Immigrants in the United States' Labor Movement from 1880 to 1920," in *Gli italiani fuori d'Italia: gli emigrati italiani nei movimenti operai dei paesi d'adozione, 1880–1940*, ed. Bruno Bezza (Milan: Franco Angeli, 1983), 258–306.

4 We would have to include in this group professionals associated with the Italian diplomatic corps or consular offices, shipping and navigation personnel, medics and religious representatives and highly specialized artisans who arrived with a labor contract already.

5 See Donna Gabaccia, *Italy's Many Diasporas* (Abingdon: Routledge, 2003). The concept of diaspora introduces a dynamic element in the otherwise static notions of identity, ethnicity and migrant. For a fuller theory, see Robin Cohen, *Global Diasporas: An Introduction* (Seattle: University of Washington Press, 1997). Though economic need is traditionally considered the prime mover for the great exodus, diasporas are much more complex and witness a variety of forces intersecting and stitching a web of motives, creating "endogenous patterns" owed to peculiar historical conjuncture and remote chance events; see on this Enrico Moretti, "Social Networks and Migrations: Italy 1876–1913," *International Migration Review*, 33.13 (1999), 640–657.

6 Of course this changes over time. By the early 1900s there were over 250 Mutual Aid Societies and other local organizations. See Antonio Mangano, "The Associated Life of the Italians in New York City," in *Charities*, 12 (7 May 1904), 476–482, reprinted in Lydio F. Tomasi, ed., *The Italian in America: The Progressive View 1891–1914* (New York: Center for Migration Studies, 1978), 153–161. Some were religious and marked by their parishes; see "The American Mission of Frances Xavier Cabrini," *The Catholic World* (April 1918), reprinted in Wayne Moquin and Charles Van Doren, eds., *A Documentary History of Italian Americans* (New York: Praeger, 1974), 338–342. Two monographs give an idea of the

cruciality of religion among the newly arrived: Robert A. Orsi, *The Madonna of 115th Street: Faith and Community in Italian Harlem, 1880–1950* [1985], 3rd ed. (New Haven: Yale University Press, 2010) and Marco Callaro and Mario Francesconi, *John Baptist Scalabrini: Apostle to Emigrants* (New York: Center for Migration Studies, 1977). In a sense, this also contributed to the immigrant beginning to feel "Italian" (as opposed to solely Neapolitan or from a small Sicilian or Calabrian town) whether in Harlem or the North End, creating a social identification bond that did not exist among them prior to embarking for America.

7 Cf. Gayatri Spivak, "Can the Subaltern Speak?" in *Marxism and the Interpretation of Culture*, ed. Cary Nelson and Lawrence Grossberg (Basingstoke: Macmillan Education, 1988), 271–313.

8 Much of the early historical research on Italian Americans, beginning in the 1950s, focused on rediscovering the exemplary lives of the entrepreneurs, small-business owners and artisans who had left a positive mark on American society. See, for example, various early volumes of the proceedings of the American Italian Historical Association.

9 On the literature of the pre–World War I period written by and large in Italian, again, by that small percentage that could, see Martino Marazzi, *Voices of Italian America: A History of Early Italian-American Literature with a Critical Anthology* (New York: Fordham University Press, 2012) and Durante, *Italoamericana* [American ed.]. For the theater, see Emelise Aleandri, *The Italian-American Immigrant Theatre of New York City, 1746–1899* (Lewiston: Mellen Press, 2006), a multivolume work. For a shorter article on the subject of theater for high versus low culture, see Esther Romeyn, "Performing High, Performing Low: Enrico Caruso and Eduardo Migliaccio," *Differentia*, 6–7 (1994), 165–175.

10 This reminds us of the then ongoing struggle, on both sides of the Atlantic, that functioned as background to Antonio Gramsci's work and ideas. A burgeoning underclass of farmers and a growing cadre of industrial laborers needed to be educated and made aware (so as to "acquire class self-consciousness") of their status as an exploited group or class that had or ought to have "rights" as a first step toward an emancipation and change that might end what was a millennial subjugation. Italian *émigré* intellectuals at the beginning of the twentieth century did much to carry on this work among the Little Italies, vying for better representation and working conditions. See notes 3 and 27 for bibliography.

11 Donna Gabaccia, "Is Everywhere Nowhere? Nomads, Nations, and the Immigrant Paradigm of United States History," *Journal of American History*, 86 (1999), 1115–1134. This pioneering article alerts us that hitherto historians have operated under "the tyranny of the national" (1116), thus working within a model that imposes homogeneities and sets up an in/out paradigm, while being blind to specific international and transnational flows and relations that reveal migration to be more complex, stratified and heterogeneous, with unsuspected networks or kinships. Drawing on this and related studies, there is need now for Italian American social and cultural history to situate itself within the broader and more flexible paradigm of an "Atlantic, capitalist, and world economy" (1118).

12 Hermann Haller, *Una lingua perduta e ritrovata* (Florence: La Nuova Italia, 1993).

13 To get a sense of the variety of occupations of this first major wave of Italian immigrants, still useful is the monumental (and thorough for the period) work of Robert F. Foerster, *The Italian Emigration of Our Times* (Cambridge: Harvard University Press, 1919), in particular Book II, "Causes," 47–126, and the chapters from Book III, 320–411. Though terminology and social concerns are peculiar to the decades in question, 1880–1915, the book is illuminating in placing emigration within a broader Euro-American dynamic, and compares the immigration to the United States to that going on at the same time in Argentina, Brazil, France, Switzerland, Austria-Hungary and even North Africa.

14 John Bodnar, *The Transplanted: A History of Immigrants in Urban America* (Bloomington: Indiana University Press, 1985), 46, 52.

15 I am loosely adapting the notion, first developed by Arjun Appadurai, in his article "Disjuncture and Difference in the Global Cultural Economy," *Theory Culture Society*, 7 (1990), 295–310.

16 An alternate well-known moniker for that decade is the "Progressive Era," on account of reactions to financial liberalization, and explosion of social activism and calls for social reform. But historians recently have seen how it could also be called the "Regressive Era." For period documents and commentary, see Richard M. Abrams, ed., *The Issues of the Populist and Progressive Eras 1892–1912* (Columbia: University of South Carolina Press, 1969). See also Jackson Lears, *Rebirth of a Nation: The Making of Modern America, 1877–1920* (New York: Harper, 2009).

17 The second Morrill Act of 1890 continued this "Separate but Equal" policy by permitting states to divide federal funds, nominally in support of agricultural and mechanical arts colleges, between separate institutions for white and black students. In another important landmark case, *Plessy v. Ferguson* (1896), the Supreme Court voted 8–1 that "governments could enforce segregation by statute." See Williamjames Hull Hoffer, *Plessy v. Ferguson: Race and Inequality in Jim Crow America* (Lawrence: University Press of Kansas, 2012).

18 In fact, matters had gotten so bad with the treatment of African Americans that between 1910 and 1960 some six million African Americans left the rural South for the urban Northeast and Midwest, representing one of the greatest domestic or *intra*-national demographic shifts of modern times. Steven Reich, ed., *The Great Black Migration: A Historical Encyclopedia of the American Mosaic* (Santa Barbara: ABC/CLIO/Greenwood, 2014); Roger Daniels, *Not Like Us: Immigrants and Minorities in America, 1890–1924* (Chicago: Ivan R. Dee, 1997), 35–37.

19 After the massacre at Wounded Knee, in the Dakota territories, in 1880, Black Elk pronounced it "The Death of a People's Dream." See Dee Brown, *Bury My Heart at Wounded Knee* (New York: Holt, Rinehart & Winston, 1970). William J. Connell, "Who's Afraid of Columbus?" *Italian Americana*, 31.2 (2013), 136–147 noted similarities in what happened at Wounded Knee with the contemporary lynching of Italians in New Orleans. The Dawes Act of 1887, www.ourdocuments.gov/doc.php?flash=true&doc=50, was meant to apportion 160 acres to individual Native Americans, but it turned out to be an administrative and political disaster with unscrupulous whites buying off the land. The Curtis Act of 1898 mandated the dissolution of the right to incorporation by tribal governments by 1906. There was thus an uncanny parallel with what happened in Italy after Unification, when lands were expropriated from the Church and the Bourbon dynasty.

20 See Lawrence Goodwyn, *The Populist Moment: A Short History of the Agrarian Revolt in America* (Oxford: Oxford University Press, 1978).

21 In the periodicals of the era—*Atlantic Monthly, North American Review, Harper's Weekly, Charities of the Commons*—there are many articles that comment critically upon what is going on in Europe in political, economic, military and other affairs. It is easy to perceive a growing interest in "internationalism" as a relevant and timely component of American social and political discourse. It will come to a head in 1898, a date scholars consider the birth of American imperialism.

22 *Boston Daily Globe* (22 October 1881), 5. The headline reworked a folksong about the Homestead Act that went: "Uncle Sam is rich enough to give *us* all a farm."

23 For Garrison's "Let them come," see *Boston Daily Globe* (11 April 1896), 6. Emma Lazarus's poem, "The New Colossus," with its famous lines, "Give me your tired, your poor, / Your huddled masses yearning to breathe free. . . ," was originally published in 1883 to raise funds for the Statue of Liberty's pedestal. It was rediscovered after her death and in 1903 it was inscribed on the plaque inside the statue's base. Because Liberty is said to challenge the Old World to "Keep, ancient lands, your storied pomp," with "*silent* lips," and because the immigrants are called "wretched refuse," commentators and cultural critics have remarked upon the poem's ambiguity and the potential for a deconstructive reading.

24 *New York Times* (26 August 1883). The article goes on to say that this "ignominy" should and will end "at such a time as the said Italian has developed a proper appreciation of his dignity as one of the sovereigns of the United States."

25 In February 1886, Congress passed the "Assisted Immigration Act," which regulated the degree to which corporations could contract labor abroad, and protected against undesirables, as laws in 1875 and 1882 had done. The law was challenged in *United States v. Craig*, 11 October 1886, on the grounds that it interfered with the free operation of commerce, and, as free trade was sustained by Congress, the restriction was deemed unconstitutional. No challenge was made to the immigration of persons, meaning labor, in itself. See *New York Times* (12 October 1886), 1. Interestingly, in arguing for the constitutionality of the Act, Judge Brown spells out the motives for challenge: "It had become the practice for large capitalists in this country to contract with their agents abroad for the shipment of great numbers of an ignorant and servile class of foreign laborers, under contracts, by which the employed agreed, upon the one hand, to prepay their passage, while, upon the other hand, the laborers agreed to work after their arrival for a certain time at a low rate of wage. *The effect of this was to break down the labor market, and to reduce other laborers engaged in like occupations to the level of the assisted immigrant.*" [emphasis added] *The Federal Reporter*, 28 [Cases Argued and Determined in the Circuit and District Courts of the United States, August–December, 1896], 798. In the opinion, however, the legal reasoning gets murky: "a careful perusal of the section will demonstrate that the penalty is attached, not to the making of the illegal contract, but to assisting, encouraging, or soliciting the migration of the alien to perform labor or services here, knowing that such illegal contract or agreement had been made." In the end the issue is raised that there are local statutes that interpret parts of the law, especially concerning what "assisting" or "soliciting" mean. One consequence was that, as foreign labor was lured to the United States with (basically false) contracts, upon arriving at Castle Garden Immigration Depot in lower Manhattan (after 1892, arrivals disembarked on Ellis Island), a condition for the immigrant laborer to remain on U.S. soil was that he, on the one hand, be not "feeble minded," ill in any way, a pauper or anarchist, and become a charge to the public, a vagrant, and on the other that he did not violate the law by declaring that some firm had actually solicited his arrival with a contract. But the premises for "selective" or "preferential" immigration were already laid out.

26 Abrams, ed., *The Issues*, 125 et infra. For some period texts, see John A. Garraty, ed., *Labor and Capital in the Gilded Age* (Boston: Little, Brown and Co., 1968). For the broader context, Susan H. Smith and Melanie Dawson, eds., *The American 1890s: A Cultural Reader* (Durham: Duke University Press, 2000).

27 On this major chapter in Italian American social history, see especially Philip V. Cannistraro and Gerald Meyer, eds., *The Lost World of Italian American Radicalism*; Donna A. Gabaccia and Fraser M. Ottanelli, eds., *Italian Workers of the World: Labor Migration and the Formation of States* (Carbondale: University of Illinois Press, 2001); and Marcella Bencivenna, *Italian Immigrant Radical Culture: The Idealism of the "Sovversivi" in the United States, 1890–1940* (New York: New York University Press, 2011).

28 This is the thesis, to some degree controversial, of Aristide R. Zolberg, *A Nation by Design: Immigration Policy in the Fashioning of America* (New York: Russell Sage Foundation, 2006).

29 For the text of the series of statutes and progressively more restrictive immigration laws, between 1875 and 1907, see *Immigration Laws and Regulations of July 1, 1907*, Washington DC, Department of Commerce and Labor, Bureau of Immigration and Naturalization, 4th ed., 15 February 1908. The list contains seventeen acts. As we will see later, with the publication of the Dillingham Commission report in 1911, there will be a qualitative change in sections regarding who might be excluded from admission to the United States.

30 As quoted in Daniels, *Not Like Us*, 43.

31 *New York Times* (26 July 1888), 4. The complexity of the forces interacting in determining whether immigrants were good or bad for the country is borne out by the history of labor, where even the well-meaning patriotic capitalists could not ignore the advantage of unprotected cheap labor, and obstruct the path of the fledgling labor organizations. Immigrants typically got caught in the cross fire. See Bodnar, *The Transplanted*, chapter 3, 85–116.

32 Sample articles: the *Boston Daily Globe* (3 January 1896), 9: Representatives of the [immigration restriction] league . . . last month spent three days at Ellis Island . . . for the purpose of investigating the class of immigrants that arrive in this country under the present immigration laws. The main point that they sought light upon was the illiteracy [in English or some other language] of arriving immigrants. . . . A great proportion of the illiterate immigrants are Hungarians, Galicians, Austrians, Italians, Poles, Syrians, Arabians and Asiatic Turks." Later the same year, the *Boston Daily Globe* (25 April 1896), 9, reports: "Half Are Illiterate. Influx of Immigration from Southern Italy Claimed to Be Seriously Bad . . . Prescott F. Hall, secretary of the Immigration Restriction League" went to Ellis Island to see for himself and his finding that 7,000 out of 11,000 that landed in a three-month period could neither read nor write added ammunition to his claim that "the great efficiency of the reading and writing tests [are] a means of further restricting immigration." The House of Representatives passed versions of an Immigration Literacy Test law—which basically meant to test whether the immigrants had any basic reading skills even in their native tongues—in 1895, 1897, 1913, 1915 and 1917. Each time it was vetoed by a different president, some say for the sake of political opportunism. It finally was passed by Congress, even after President Woodrow Wilson had vetoed it twice, and became law in May 1917, during the years of World War I, when anti-immigrant feeling peaked.

33 See various articles in the *New York Times*: "Improved Tenements" (2 June 1887), 2; "Inspection of Tenements" (25 November 1888), 9; "An Unhealthy District" (18 June 1890), 8; and so on through the 1890s, with other articles bearing such titles as "Tenement House Evils," "Slavery in Tenements," "Unsafe Tenements." New York City was the epicenter of this urban blight. The Tenement House Act, enacted in Albany in 1867, expanded the authority of New York City's Board of Health to oversee construction of tenement housing in 1878. Architect James E. Ware won the competition for a standard model, measuring 100 feet by 25 feet, called the "dumbbell": "Five to seven stories high, the tenement will have 14 rooms per floor, with two four-room apartments in front, two three-room apartments in back, and two toilets near the center of each floor to be shared by the tenants. The bedrooms all have windows, but 10 of the 14 rooms open onto air shafts only three to five feet wide, created by indenting the hallway sections of abutting tenements; little light or air reaches the apartments, the air shafts often become filled with refuse, and they become fire hazards." From James Trager, ed., *The New York Chronology* (New York: HarperResource, 2003), 190. For living conditions in nearby Philadelphia, see Emily Wayland Dinwiddie, "Some Aspects of Italian Housing and Social Conditions in Philadelphia," *Charities*, 12 (1904), 490–493, reprinted in Lydio Tomasi, ed., *The Italian in America*, 175–179. For conditions in a smaller city, see for example "Expert Speaks of Tenement Houses," *Hartford Courant* (16 November 1905), 12, about "sanitary inspection"; and, two years later, "Calls Tenement Loathsome Dirty," ibid. (14 January 1907), 6. In 1912 we read of "Poor People Who Live Underground. . . [in] Some Vile Basement Tenements on Pleasant St. Park Street Family Has No Sunlight All Day Long. Children Living Like Moles, Must Wear Glasses," ibid. (23 February 1912), 5. See especially the Introduction and chapter 4 of Jacob A.

Riis's 1890 classic *How the Other Half Lives: Studies Among the Tenements of New York* (New York: Dover Publications, 1970), reissued in 2010 by Harvard University Press.

34 See Silvano Tomasi, "Militantism and Italian-American Unity," in Francis X. Femminella, ed., *Power and Class: The Italian-American Experience Today* (Staten Island, NY: AIHA, 1973), 20–28.

35 See Peter A. Vellon, *A Great Conspiracy Against Our Race. Italian Immigrant Newspapers and the Construction of Whiteness in the Early 20th Century* (New York: New York University Press, 2014); Joseph Velikonja, "Family and Community: The Periodical Press and Italian Communities," in Richard N. Juliani, ed., *The Family and Community Life of Italian Americans* (Staten Island, NY: AIHA, 1983), 47–60; and the beautifully edited and commented catalogue by James Periconi, *Strangers in a Strange Land: A Catalogue of an Exhibition on the History of Italian-Language American Imprints (1830–1945)* (New York: Grolier Club, 2012).

36 Jacob A. Riis (1849–1914) was an immigrant from Ribe, Denmark, who arrived in New York in 1870. He became a journalist, photographer and reformer. In his book, he traces the origin of the tenements as the result of the population explosion of New York City first in the 1820s to the '40s, then again after the Civil War, where the "new" popular housing model debuted. More than half the population of the city lived in what became veritable slums, and the majority was foreign-born: "The one thing you shall vainly ask for in the chief city of America is a distinctively American community. There is none; certainly not among the tenements." "A map of the city, colored to designate nationalities, would show more stripes than on the skin of a zebra, and more colors than any rainbow." See James P. Cosco's rich, in-depth study, *Imagining Italians: The Clash of Romance and Race in American Perceptions, 1880–1910* (New York: SUNY Press, 2003), especially chapter 1; and Ilaria Serra, *The Imagined Immigrant: Images of Italian Emigration to the United States between 1890 and 1924* (Madison & Teaneck: Fairleigh Dickinson University Press, 2009). The latter uses, besides the *New York Times*, the *San Francisco Chronicle*. Although these two studies devote space to how the Italians were perceived, a comparison with how other groups were described by Riis, in particular the Chinese, the Jews and the Czech (and as nonimmigrants, the African Americans, and the pestiferous hordes of homeless children and teenage gangs, called "Arabs"), shows that some of the adjectives used for these latter were even more stirring, and by today's standards, almost insulting. To Riis's credit, however, it must be said that his object was to show the average Americans, and denounce to policy makers in particular, that it was the tenements that bred such unfathomable conditions, and he was merely using the accepted public language of his day.

37 Elsewhere Riis wrote about "the dreadful padrone system, a real slave system in Italian children, who were bought of poor parents across the sea and made to beg their way through France to the port whence they were shipped to this city, to be beaten and starved by their cruel masters and sent out to beg." For sample reporting on the issue, see "Padrone Slavery. An Evil Which, to a Certain Extent, Exists in Boston. Methods Adopted to Keep Many Ignorant Italians Under Subjection. How Immigrants Are Bound Out to Unscrupulous Taskmasters," *Boston Daily Globe*, (4 July 1884), 5; "Deluded Immigrants. An Italian and Family of 13 at the Mercy of a Usurer ["one Ciroceni"]—Stonecutter Here Under Contract," ibid. (1 July 1888); and "Padrones and Laborers. Why Italian Immigrants Come to America. Testimony Heard by the Congressional Investigating Committee. Leaving Ten Cents a Day for a Mythical Dollar and a Half," ibid., (28 July 1888).

38 Riis, *How the Other Half*, 152.

39 The entire story is told by Richard Gambino, *Vendetta* [1977], 2nd ed. (Toronto: Guernica, 2000). An HBO teleplay version with the same title, starring Christopher Walken, was directed by Nicholas Meyer and released in 1999, with a DVD issued in 2004.

40 For a representative selection of articles, see the collection in Salvatore J. LaGumina, *WOP! A Documentary History of Anti-Italian Discrimination* [1973] (Toronto: Guernica, 1999); Moquin and Van Doren, eds., *A Documentary History of the Italian Americans*; Francesco Cordasco and Eugene Bucchioni, eds., *The Italians: Social Backgrounds of an American Group* (Clifton: Augustus M. Kelley Publishers, 1974); commentary throughout Richard Gambino, *Blood of My Blood* [1974] (Toronto: Guernica, 2003); Lydio Tomasi, ed., *The Italian in America*; and various pages in Jerre Mangione and Ben Morreale, *La Storia: Five Centuries of the Italian American Experience* (New York: Harper Perennial, 1992). See also William J. Connell and Fred Gardaphé, eds., *Anti-Italianism: Essays on a Prejudice* (New York: Palgrave Macmillan, 2010). Considering that Italian American studies have grown considerably in the past thirty years, it is remarkable that there have not been further collections of materials of this kind. The dearth of original documentation is what prompted the D'Amato Chair at Stony Brook to launch the Italian American Archive Project.

41 See Cannistraro and Meyer, eds., *Lost World*; and Bencivenna, *Italian Immigrant Radical Culture*, and the sources cited in those books.

42 Herbert Ehrmann, *The Case That Will Not Die: Commonwealth vs Sacco and Vanzetti* (Boston: Little & Brown, 1969).

43 Desmond King, *Making Americans: Immigration, Race and Origins of the Diverse Democracy* (Cambridge: Harvard University Press, 2002), 51.

44 In my research I have plied the pages of major dailies, such as the *New York Times, Los Angeles Times, Boston Daily Globe, Hartford Courant, Chicago Tribune* and others for the years 1880–1914.

45 See for instance, "Lots of Italian Banks. North End of Boston Full of Them. How They Do Business Without Any Legal Restraint. American Banks Patronized Only by the Educated Minority," *Boston Daily Globe* (28 January 1894), 11.

46 This remains a problematic issue because the Commission allegedly employed the top scientists of the day, though in retrospect scholars have identified two kinds of problems. One is intrinsic to the nature of scientific discourse, especially concerning the typologies of race and intelligence, which existed at the time and dovetail into the question whether these have (or according to some, have not) been superseded by later and contemporary research (just think of recent publications in sociobiology and the genome project). The second problem is extrinsic to science, in the sense that the results were appropriated by ideologues and politicians to make the case that certain people are naturally inferior, unteachable, unadaptable and so on, and who could therefore be justifiably excluded from entering the country. See on this Oscar Handlin, *Race and Nationality in American Life* (Garden City: Doubleday, 1957); King, *Making Americans*; Jon Gjerde, ed., *Major Problems in American Immigration and Ethnic History: Documents and Essays* (New York: Houghton Mifflin, 1998); and the monograph by Robert Zeidel, *Immigrants, Progressives, and Exclusion Politics: The Dillingham Commission, 1900–1927* (De Kalb: Northern Illinois University Press, 2004).

47 See the detailed analysis in Peter D'Agostino, "Craniums, Criminals, and the 'Cursed Race': Italian Anthropology in American Racial Thought 1861–1924," *Comparative Studies in Society and History*, 44 (2001), 319–342. On Lombroso and his theory, see the thorough study by Mary Gibson, *Born to Crime: Cesare Lombroso and the Origins of Biological Criminology* (New York: Praeger, 2002).

48 See, for instance, the contested thesis of Edward Banfield, *The Moral Basis of a Backward Society* (New York: Free Press, 1958), which argued that the Southerner's allegiance primarily if not solely to the family, at the expense of social investment in a broader "civil" society, was "amoral." The problem with this book is that it is ahistorical, and the fact that the sample population had been oppressed for centuries was immaterial to his point, which was to prove that the poor are morally inferior and don't behave like middle-class suburbanites. Less prejudicial in its premises was Eric Hobsbawn, *Primitive Rebels* (New York: Norton, 1965), which shifted the emphasis from the moralistic to the anthropological, with reference to the same areas studied by Banfield. For an Italian history of how the "inferior" Southerner was "constructed" over time, see Vito Teti, *La razza maledetta: origini del pregiudizio antimeridionale* (Rome: Manifesto libri, 1993).

49 Implied in the exhortations to be "good Americans" by the likes of Gino Speranza, the owner of *Il Progresso Italo-Americano*, and the Italian consular personnel.

50 Revealing work has been done on this topic, often seen as problematic in Italian America, by Thomas Guglielmo, "'No Color Barrier': Italians, Race, and Power in the United States," in *Are Italians White? How Race Is Made in America*, ed. Jennifer Guglielmo and Salvatore Salerno (New York: Routledge, 2003), 29–43. On the role the Italian language press played in this scenario, see Vellon, *A Great Conspiracy*.

51 Compare Handlin, *Race and Nationality*; King, *Making Americans*.

52 See my paper "Migration, History, Existence." See also the beautiful essay by Hans Magnus Enzensberger, "The Great Migration," in his *Civil Wars: From L.A. to Bosnia*, trans. Piers Spence and Martin Chalmers (New York: The New Press, 1994). His analogy with the attitudes of passengers in a train compartment, who treat each new passenger as an "intruder" but who in turn, after establishing community with those already there, will perceive a new later passenger entering the compartment as an intrusion, is very instructive.

53 This can be followed as ongoing topic for years in *Harper's Magazine*, setting the prejudgment that Italians were to be distrusted and in general were not good people.

54 While he was president of Princeton University, Woodrow Wilson, later to become the twenty-eighth President of the United States (1913–1921), wrote a five-volume *History of the American People* (New York: Harper & Brothers Publishers, 1903), where we can read the following assessment (5, 212–213): "The census of 1890 showed the population of the country increased to 62,622,250, an addition of 12,466,467 within the decade. Immigrants poured steadily in as before, but with an alteration of stock which students of affairs marked with uneasiness. Throughout the century men of sturdy stocks of the north of Europe had made up the main strain of foreign blood which was every year added to the vital working force of the country, or else men of the Latin-Gallic stocks of France and northern Italy; but now there came multitudes of men of the lowest class from the south of Italy and men of the meaner

sort out of Hungary and Poland, men out of the ranks where there was neither skill nor energy nor any initiative of quick intelligence; and they came in numbers which increased from year to year, as if the countries of the south of Europe were disburdening themselves of the more sordid and hapless elements of their population, the men whose standards of life and of work were such as American workmen had never dreamed of hitherto."

55 See Ernst Georg Ravenstein, "The Laws of Migration," *Journal of the Statistical Society of London*, 48.2 (June 1885), 167–235, cited in Zolberg, *A Nation by Design*, 202. In the age of positivism, there was a broad application of theories and methods derived from geography, biology and the recent science of evolution. Leading anthropologist Franz Boas, who edited volume 38 of the Final Report, wrote on "Changes in bodily form of descendants of immigrants," deploying the tools of the new science of anthropometry.

56 I am thinking of films like *The Black Hand* (1906), *The Organ Grinder* (1912), *The Italian* (1915) and *Tony America* (1918). See Carlos E. Cortes, "The Hollywood Curriculum on Italian Americans: Evolution of an Icon of Ethnicity," in *The Columbus People*, ed. Lydio F. Tomasi and Piero Gastaldo (New York: Center for Migration Studies, 1994), 90–92; and Giorgio Bertellini, *Italy in Early American Cinema* (Bloomington: Indiana University Press, 2009).

57 The actual documents can easily be retrieved online by going to the Open Collection Program, Immigration to the United States, 1789–1930, at Harvard University.

58 See Oscar Handlin, *Race and Nationality*. The theses of Handlin's most famous book, *The Uprooted* (New York: Grosset & Dunlap, 1951), were critiqued by later scholars, and, concerning Italian Americans, by Rudolph Vecoli, for generalizing about, and minimizing the relevance of, the places of origin of the immigrants. But in this sense he was already pointing to the necessity, recently underscored by Gabaccia, of breaking beyond the restrictive "national" paradigm for interpreting migrations.

59 For one thing, people started differentiating between culture and race. The Immigrants Protective League made it known to congressmen that they meant to "aid in the Americanization of immigrants." Its director, Grace Abbott, "threw cold water on the non-historical notion that the older immigrants had been perceived at their time of their arrival as any less assimilable than the new immigrants were now judged in 1912." Abbott reported that "when you come in close daily contact with the newer arrivals, you find that they are men and women just like the rest of us, some good and some bad, and it is impossible to discriminate against them as a whole." (King, *Making Americans*, 63).

60 Ibid., 85.

61 Israel Zangwill, *The Melting Pot* (Charleston: Bibliobazaar, 2009), 35.

62 This recalls the thesis, already mentioned earlier, advanced by Zolberg, *A Nation by Design*, according to which there has never been a moment in our national history when our leaders and representatives did not explicitly, or tacitly, promote a selection process that favored certain incoming groups over others.

63 See Gary Gerstle, "Liberty, Coercion, and the Making of Americans," *Journal of American History*, 48.2 (1997), 524–558.

64 I am thinking of fictional or family-autobiographical works produced by writers who were the children of the immigrants, and who by expressing themselves in English, make up what is really the "first" generation of Italian American literature. See, for instance, the writings of Garibaldi La Polla, John Fante, John Ciardi, Jerre Mangione, Pietro di Donato and Helen Barolini. In scholarship, see also Barolini, ed., *The Dream Book: An Anthology of Writings by Italian American Women* [1985], rev. ed. (Syracuse: Syracuse University Press, 2000); Mary Jo Bona, *Claiming a Tradition: Italian American Women Writers* (Carbondale: Southern Illinois University Press, 1999); and Fred Gardaphé, *Italian Signs, American Streets: The Evolution of Italian American Narrative* (Durham: Duke University Press, 1996). Of special importance is the Ellis Island Oral Histories project (1892–1976), which recorded, to the degree that it was still possible with an aging and disappearing generation, the accounts, and songs, of the first Italian immigrants.

65 See Durante, *Italoamericana* [American ed.].

66 See Vellon, *A Great Conspiracy*.

67 See Serra, *The Value of Worthless Lives*.

8

THE LITTLE ITALIES OF
THE EARLY 1900s

From the Reports of Amy Bernardy

Maddalena Tirabassi

"Little Italies never die." So writes the urban sociologist Jerome Krase, who has dedicated years of research and numerous publications to this theme.[1] The first question that I would like to pose in this context is why Little Italies endured in such an iconic way, while the other ethnic neighborhoods born of the Great Migration proved so short-lived.

A second question, more complex, regards how to interpret them. Ethnic neighborhoods can be seen in two very different ways. Are they places of exclusion, of marginalization, and of social blight—ghettoes and slums? Or are they built with the future in mind, as places where a culture will be maintained?[2] A dichotomy of this kind has always been present in the literary production of Italian Americans, even if the prevailing mode of interpretation, connecting space with time, sees the Little Italies in the second manner, so that Little Italy becomes "the foundational site" or the "scene of the beginning."[3] They were seen either as a ghetto or as a source of culture, therefore, with an emphasis on one or the other aspect depending on differing geographical and historical contexts. The history of the Italian American Little Italies is in fact a lengthy one that begins even before the Great Migration, that then develops during the last decades of the nineteenth century, and that reaches down to our own time. How they are interpreted depends moreover on the perspective of the observer.[4] Whether they are being described by the inhabitants of the Little Italies or by external witnesses matters a great deal, and, in addition, the external witnesses can be either Italian or American, with each distinction resulting in a different image.[5] It is especially when these conditions are considered that the writings of one Italian observer, Amy Allemand Bernardy, assume great value, for she was a writer who focused her attention on the neighborhoods of the Italian immigrant community precisely at the time of their greatest expansion, in the first decade of the twentieth century. Her observations, while reflecting deeply the political and cultural context in which she lived, offer one of the first and most well-defined cross-sectional portrayals of the Italian American world at the beginning of the century.

Amy Allemand Bernardy was born in 1880 in Florence, where her father, an American, was Consul for the United States, whereas her mother came from Savoy. Bernardy became interested in the issue of emigration during her studies at the University of Florence, when she became vice president of the university committee of the Società Dante Alighieri.[6]

In 1903 Bernardy was hired as a lecturer in Italian at Smith College in Northampton, Massachusetts, where she directed the language program until 1910. Over the next two decades the United States became her adoptive country. Decisive in this regard was the assignment she received in 1908 from the Italian government's Commissariat for Emigration to investigate the material and moral conditions of Italian women and children in the industrial cities of the eastern United States, an assignment that was later expanded to include the

western states. This experience, which resulted in dozens of essays, turned her into the most knowledgeable expert in the world on the communities of Italian emigrants. Her duties involved the inspection of their workplaces and homes, in addition to promoting the teaching of the Italian language.[7]

Bernardy's analyses took into consideration the economic potential of the Italian communities throughout the world as a tool for the peaceful conquest of new markets, as may be seen in her observations concerning the diet of the Italian emigrants. She noted

> the great interest and value pertaining to family cuisine as a bond and patriotic reminder of Italy. Note how the Genoese tradition of trenette with pesto, and the tradition of cooking with garlic and olive oil, have a worth and a significance that transcend by far their immediate dietary function; and how, on the other hand, the memory of the immigrant, especially his gastronomic memory, has served to spread a taste for certain imported goods among people of other cultures, thus, both directly and indirectly, doing a great service with respect to our trade and exports.[8]

Bernardy declared herself favorable to "Americanization" in a political sense, maintaining that it was both indispensable and providential, since "the fatherland is defended better by a 'citizen' than by a 'dago.'"[9] "This is the thing," she wrote:

> In America the Italian worker who remains true to his language or his dialect, and to his manners, under the sway of ancestral and paternal rules, who eats little and saves a great deal, remains, for the American, a "dago" and not a "citizen." And so long as he stays a "dago," Fortune, who in America is nationalist and protects her "citizens," won't smile on him. Transform the "dago," teach him—as they have done with the Irishman, the Swede and the German—to speak, to dress, to eat, and to wash himself in the American way, to read and write in English, to understand the Fahrenheit thermometer and the electoral machinery, like a self-respecting "citizen." Make him an American and he will be equal with the others and the doors will open for him that open for the others. If not, they won't.
>
> It is useless to try to Italianize and infinitesimal part of this enormous America. It is Little Italy that has to be Americanized. Speaking in simple and honest language, without metaphors or similes, it can be reduced to the dilemma that America imposes on us, since the Italian wants or needs to emigrate. Do you want him to be Italian? He will be unhappy. Do you want him to be happy? He should be an able-bodied American, since, regardless, his children, through their schooling, "leave Little Italy behind to follow the paths of Americanization."[10]

Little Italy: A Place or a People?

Let's look more closely at Bernardy's analysis of the Little Italies. With respect to vocabulary, she employs in an undifferentiated way in Italian the term *piccola Italia* (little Italy), along with the words *colonia* (colony) and *quartiere* (quarter), and the English term "Little Italy," with a propensity for *piccola Italia*—a term that appears as the title of a chapter in her book, *America vissuta* [America as Lived] of 1911.[11] In an exaggerated literary flourish she claims that the phrase "Little Italy" derives from the term "Little Troy" (*parvam Troiam*) used by Andromache to refer to Rome in Virgil's *Aeneid* (3.349), the point being to exalt the Latinity and Italian origins of the Little Italies of her own day. The term "Little Italy" thus stems from a custom in the founding of colonies, "already thousands of years old at the time of Virgil," of naming

them so as to keep alive a feeling for one's homeland. A fervent nationalist, Bernardy believes wholeheartedly in the idea of Italy, and she observes with some bitterness the fragmentation of the "great fatherland" along regional and municipal lines:

> In general, the Italian emigrant, whether northern or southern, always retains more memory of his small fatherland than of his great one. Having perceived only particular elements of his homeland—his family, the bell tower, his small piece of land—he has a nostalgia for regional and domestic things that is therefore elegiac, sentimental and limited, with no national aspiration of a higher and collective order beyond these very few particulars.
> "Little Venice," "Little Naples," "Little Palermo." There is a "Little Naples" in Marseilles just as there is in New York, while "Little Palermo" is found throughout the agricultural areas farmed by Sicilians in the United States. Other small fatherlands, including Friulian ones, are spread across South America or found somewhat unexpectedly, for example, in Australia. . . .[12]

Her study of the Little Italy of the North End in Boston demonstrates her understanding of the ethnic stratigraphy of the neighborhood:

> The Irish were here first; around it were created streets that were Chinese, Jewish and Negro, then Greek groups, and, more recently, nuclei of Portuguese and Syrian communities. But the center passed to the Italians, who invaded it and extended themselves there.[13]

But she also notes the dynamic quality and the mobility of Italians.

> And today it is not big enough. Italian groups are invading the South End and suburban villages where the immigrant sooner transforms himself into a citizen and lives a bit more hygienically. . . . The grandmothers are the keepers of the flame; the granddaughters are the iconoclasts who destroy native customs. And the latest women to arrive become keepers or iconoclasts, too, according to their age and economic necessity. But by the time the kerchief of one immigrant woman is replaced, either by rags or by the fashionable feathers of the milliner, we hardly notice, for another immigrant has arrived in the meantime. . . .[14]

But what, according to Bernardy, sets the Little Italies apart? It is not so much the buildings, which the Italians found already there, but rather a complex of suggestions that she studies by means of a semiotic analysis that surprisingly meets modern standards. She thus pushes herself into that "archive of space," to use the words of literary scholar William Boelhower, "in which everything speaks: the streets, the buildings, the market stalls, the shop signs, people's clothing, the color of their eyes, and everything else."[15] Her prose imparts sound, motion and above all meaning to scenes like the one captured by Lewis Hine in a famous photograph of Mulberry Street (Figure 8.1).

Bernardy writes:

> That you are in a "colony" you sense immediately: from the character types, from the accents, from the general intonation of an environment in which an American face and voice is an exception; from certain facial creases or poses common to the race that are not yet forgotten and perhaps impossible to forget, that leap out from

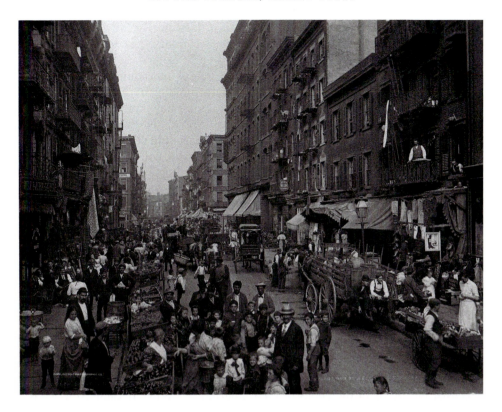

Figure 8.1 Mulberry Street, New York City, *circa* 1910. Photo by Lewis Hine. Library of Congress Prints and Photographs Division, LC-D401–12683.

an unfortunately American canvas with a Latin style that at the same time offers joy and pain, like an harmonious musical phrase that tries to lift itself imprudently above the discord of an ill-suited accompaniment.[16]

These intangible sounds and attitudes alternate with more fixed, visible symbols that Bernardy believes are worthy of being captured photographically.

For an explorer, armed with curiosity, intelligence, and perhaps with a Kodak, who proposes to study the streets of the North End, and to enjoy for its charming artistic quality, without too much sociopsychological refinement, this Latin acclimatization on American soil, Little Italy has many attractions to offer. Inexhaustible material, in fact, for the intelligent Kodak. . . . Scattered in all directions within its boundaries, along Hanover Street, around North Square, from Richmond to North Bennet, the colony has its churches, its banks, its charitable institutions, even its theaters, and, of course, its trattorias.[17]

But her attention returns to its "racial" features:

The little shops selling fruit and vegetables stretch their goods, slightly damaged perhaps by the cold or by the dusty air, and the fact that the price is written in American "cents" doesn't mean that the surrounding gossip won't be in dialect

155

from Avellino or Termini Imerese. And even if the voices went silent it would be unmistakable: they are so Southern, those deep, lidded eyes, here in the land of hard looks and thin lips. Cast all too apparently in Siracusa or Cosenza are certain heads that seem made of fine bronze, round and compact, which only now, when compared with the crude and angular molding of the American head (which betrays a hasty mingling of races), reveal to us how much the silent labor of centuries spent in the fatherland, on their own soil, has left its traces upon them. All too authentic are the inherited coins that still shine on the neck of some young bride from Abruzzo or Calabria who, alas, will willingly take them off in homage to local fashion, or, worse, will sell them to some second-hand dealer of North or Salem Street to buy kerosene or American coal. On Sunday, when they leave mass, it is an entirely rural Italy that invades their memory and their longings. . . .[18]

The restaurants, the most tangible and enduring symbol of the Italian presence abroad, are described at an initial stage, one in which an Italian culture of freedom with respect to alcohol mattered more than gastronomy.

Or rather, if instead of the well-being of the soul, you consider their material well-being, you could, in a room reminiscent of any typical provincial hotel in Italy, have prepared for you by a waiter who is more or less a co-national a vermouth from the fatherland and dine *all'italiana* without noticing any very evident Americanizations, raising your glass to the health of all non-drinkers and the eternal infamy of all the cooks of New England. . . . Why? Because America is ostensibly a country of non-drinkers, and the license costs much more than the revenue from a modest trattoria. Were it not that, having learned about Puritan legislation and, hence how keep up appearances, from a nearby grocery, or another store so supplied, you bring to the host a bottle that you declare to him as your own property, and that you uncork with your own hands. In this way the conscience of the proprietor and the letter of the Puritan law accommodate one another in a perfect and auspicious manner, so that absolving the legislators in this Christian way, you finally drink to the greater glory of Italy, in the coffee cups that the host necessarily provides, that prohibited liquor which, on account of that always necessary respect for legality, you will call only "Moka." But . . . what excellent Moka from Barletta or from Castellina in Chianti one may drink even in the most modest osterias of Little Italy![19]

Culture and Customs

Bernardy shows moreover that she is perfectly aware of the phenomenon, the subject of much study today, that involves the preservation or freezing in time by the immigrants of the cultural practices of their place of origin. She writes:

I am sure that with respect to certain folkloristic customs and traditions of the villages there could be found, or at least up until a few years ago there could be found, more direct and evident traces in the colony than in the fatherland, insofar as their essence and intimate observance. Certain old forms of Sulmona almond candies, to cite an obvious example, are still found in Five Points in New York, while in

Sulmona they don't have them anymore. This is logical, since the New York confectioner had grown up from childhood making them under the instruction of an elder in the trade, and remaining isolated, with a small enterprise, in a world that was completely foreign, he perpetuated the old models. At Sulmona, instead, where the producers were in contact with the novelties of the day, with a desire to compete with them, they changed. In Sulmona what counted was newness, while in New York what attracted was instead the unchanging quality of the model, so that each, with his new "crown" [a cake prepared for Easter] could find an exact copy of one that he had had as a child.[20]

In addition to the shops, the churches and restaurants, she cites the theaters as a marker of the ethnic quarter, although the plays that were put on were mostly French chivalric romances.

And within the theater you will see the emigrant audience. . . . And there will not be a person who does not entirely abandon his poor exiled soul for the enchantment of the ancient stories, just as when, on the Etruscan or Sicilian seashore "he would tell tales with his family."[21]

Another marker of the Little Italies consists in its language, which she renames "la lingua dell'*iesse*,"—the language of "yes":

Because the "*sì*" that resounds in the *bel paese* [Italy] is the very first word that the newly disembarked immigrant—in "*Cialiston* (Charleston) to go to *sciabolare* (shovel) in *Ricciomondo* (Richmond)," or "get off *u dorte int'u diccio* (and work in the ditch) on the *tracche* (tracks) of *Portolante* (Portland)," or simply "to *sciainare* (shine shoes) in Boston"—eliminates from his vocabulary in the colony.[22]

The Powerful

Bernardy condemned Little Italy for multiple reasons. In addition to its regionalism, she thought it provided fertile soil for Italian American bosses and bankers, the so-called *banchisti*, whom she denounced in numerous articles in American newspapers:

The *paesano* who keeps [the immigrant's] money is his confidant, his legal adviser, his private counselor (*consigliere*), his great protector, his general agent. When a *paesano* flees or fails, the injured party complains, curses or resigns himself to it according to his character; and then he returns to working and saving. If even here in the North End, [Italy's] colonialist obsession continues to stir up and send over such human waves, what will become of these uncertain Italian spirits, fluctuating between American slums and the Italian coast, between poverty and corruption, between priest and anarchist, prey to bosses and brokers, to discredited politicians and dishonest bankers, to professionless meddlers and shameless parasites? All too often they are poor and conscious of their poverty, but unable to lift themselves up. What can we do with these Italian spirits?[23]

In a similar way, the novelists who situated their romances in the Little Italies denounced their double-sided character. Bernardino Ciambelli, in the preface to one of the most famous

of the Italian-language novels with its plot in the Italian quarter of New York, published in 1893, *I misteri di Mulberry Street* [The Mysteries of Mulberry Street], wrote:

> [T]o display the wounds that can infect a colony is not to cast insults at it, but rather an exhortation to do what is needed that the wounds may disappear. For no one can deny that even on Mulberry Street, amid a population of honest and good workers, of the most upright wives and innocent girls, there grows the arrogant plant of vice … the gambling house next to the storefront.[24]

Bernardy, because she lumped together the bosses and the *prominenti*, the *banchisti*, priests, professionals, notaries, pharmacists and so forth, was unable to discern the social stratification that these persons represented within the Little Italies. As was noted by the Canadian scholar, Robert Harney, in many cases these people were the descendants of Italians who had immigrated prior to 1890, so that within the ethnic group they represented the possibility of upward social mobility, while also functioning as mediators with the outside world.[25] They thus constituted, at least in the medium term, the community's major conduit for escape from the ghetto.

Living Conditions

Where Bernardy's analysis remains most helpfully accurate today is in her detailed discussions of the material living conditions of the ethnic quarter. This can be seen, for instance, in her description of conditions in the tenements forming the skeletal structure of the Little Italies in the cities of the eastern United States that were judged the darkest aspect of Italian emigration—conditions that are confirmed in contemporary photographs. (See Figure 8.2.)

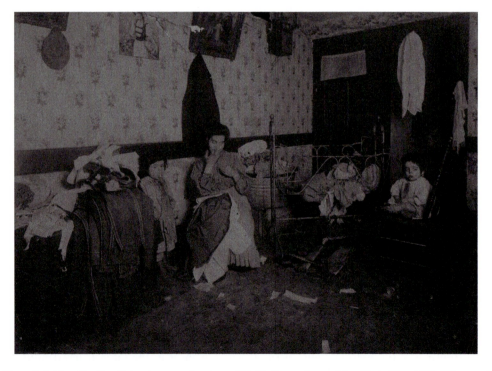

Figure 8.2 Mrs. Guadina living in a rear house at 231 Mulberry Street, New York City, 1912. Library of Congress Prints and Photographs Division, LC-DIG-nclc-04144.

Thirty-two tenements, with more or less twenty-eight apartments in each, constitute a "block," in which there pulses what is sometimes the population of an entire Italian village of 1200 souls or more. In New York and Boston domestic animals are not permitted, but in the courtyards and basements frequently there are wretched cats that are lame, blind, without tails, or scabby. The "physiognomy of the tenement" is thus evident even in these poor animals. . . . On the other hand, the rats, mice and moles are a genuine affliction. I remember an apartment in which they were so large and unembarrassed that the children poked at them calling them "pussy" (*micio*). And in the children what we have called the physiognomy of the tenement is awful indeed. The dirtiness among a group of peasants that is tolerable without complete disgust when in the open air and where there is sunlight, in the tenement literally rots on their backs. Conditions that in a hut in Calabria can be either painful or picturesque here become tragic and lurid. In the tenement they cook on a small metal stove or oven with coal, gas and sometimes kerosene. When the stove is extinguished and remains warm, the littlest children are put beneath it so they won't complain of the cold. If they lift their noses or their little hands they burn them on the bottom. . . [26]

In the tenements then there are also the boarders, the *bordanti* in the slang of the Little Italies.

As for the boarders, all that could ever be said would still fail to capture the reality. They are, it is true, a source of income, but they are also the principal factor in the crowding, the filth and the degeneration of the domestic life of the family that has emigrated.

All of us who have seen "how the other half lives" in the large American cities know about these caves of pain and misery in which either force or flattery quickly overcomes whatsoever woman who lives there who is not a repugnant shrew. Or the women themselves confess it with a cynical and resigned ingenuousness: "What do you expect, Lady? They are men and we live here like animals. Not even the little girls are spared." In dirty holes like these I have seen young girls who are undernourished, deflowered, exhausted from pregnancies that are precocious and frequent, and, worse, that are frequently terminated before completion.[27]

She lamented also that paid work was being done in the home. (Compare the scene in no. 5 of the Photo Essay.)

It used to be only the Jewish families that did this; but with the growth in immigration of Italian families it has become the sad boast of our women and aggravates the crowding problem. It is favored, as might be expected, by the sedentary and reclusive habits of the Italian emigrant woman and by the number of her children. For without the hands of the children, who sew, who unthread, who hook, who stitch, who help, who hold, and who, loaded with boxes or with cloth, carry them back and forth between the home and the warehouse, it would be impossible for an adult to do the mass of work that she accomplishes in a day at a very low price.[28]

Such considerations later prompted her to write, in 1931:

Maybe it is necessary and a good thing too, that the Little Italies should die. For their role as a protective funnel, whether for good or for ill, for an immigrant who

was illiterate, unable to live alone and to defend himself in a hostile world, is either finished or about to come to an end. Italy has become something different. The world after the war has changed. The Little Italies need to become something new too. They have held back too many tears, nourished and hidden too many sores, tempted and offered pretexts for too many accusations, both just and unjust. Yet, for they who lived in them and knew them up close, not only from the perspective of the Americans, but in their most intimate and misunderstood aspects, their memory will be tinted inevitably with a kind of remorse and nostalgia.[29]

Little Italies Never Die

Yet, Bernardy's elegy notwithstanding, the Little Italies managed to survive even after the majority of Italian Americans had abandoned them.[30] Other "Euroamerican" ethnic neighborhoods, the German, Jewish and Polish Towns that were created during the Great Migration, disappeared. But the Little Italies of the Italian immigrants endured. They outlasted the New Deal, the great uprooting of the post–World War II years, urban renewal under the Great Society programs and then gentrification. Seen in this historical perspective they offer a contribution to contemporary debate over the role of neighborhoods in discussions of the marginalization of ethnic groups. The most important point regards the possibility of change in their permeability, both internally and externally. If at the beginning they were ghettos, they were nonetheless ghettos with gates that were open to persons who had experienced the culture of modernity, a necessary condition for integration in American society—a society which, even while it underwent dramatic changes, allowed sufficient space for those ethnic groups that wished to maintain their cultures, and in this respect the Italians stand out.

Another hypothesis perhaps may be found in a continual game of mirrors that has been played with American public opinion in the construction of an Italian identity. In the 1950s—the years when Italian ethnic identity reached maximum visibility in the United States—there took place simultaneously an enormous growth in mass tourism from the United States in Italy. From that point on, there existed among Americans a tendency to look for the "Italian lifestyle" even in their own Little Italies.

The migration of Americans of Italian origin to the suburbs, thanks at last to the wealth acquired in the postwar years, witnessed the transformation, but not the extinction of the Little Italies. They became places to visit, to find restaurants, shops, churches. The ethnic revival of the 1970s did the rest, tilting the needle away from the defensive isolation that characterized the first years of the twentieth century and toward the preservation of a symbolic, voluntary ethnic identity, of a cultural nature, for which today's Little Italies remain important markers. It remains to be seen whether they will be able to resist the sort of commercialization that can tend to turn ethnic neighborhoods into ethnic Disneylands.[31]

Translated by William J. Connell

Further Reading

Gabaccia, Donna R. *From Sicily to Elizabeth Street: Housing and Social Change Among Italian Immigrants, 1880–1930.* Albany: SUNY Press, 1984.

Gans, Herbert. *Urban Villagers: Group and Class in the Life of Italian-Americans* [1962]. 2nd ed. New York: Free Press, 1982.

Puzo, Mario. *The Fortunate Pilgrim* [1965]. New York: Random House, 1997.

Riis, Jacob A. *How the Other Half Lives: Studies Among the Tenements of New York*. Edited by Luc Sante. New York: Penguin, 1997.

Notes

An earlier version of this chapter appeared in French as "Amy Bernardy et les Petites Italies," in *Les petites italies dans le monde*, ed. Marie-Claude Blanc-Chaléard, Antonio Bechelloni, Bénédicte Deschamps, Michel Dreyfus and Eric Vial (Rennes: Presses Universitaires de Rennes, 2007), 353–365.

1 Jerome Krase, "America's Little Italies: Past, Present and Future," in *Italian Ethnics: Their Languages, Literature and Lives*, ed. Dominic Candeloro, Fred Gardaphé and Paul Giordano (Staten Island: AIHA, 1990), 167–184 (179).

2 Krase's approach helps greatly in better understanding the view of Bernardy. In his essay, "Italian American Urban Landscapes, Images of Social and Cultural Capital," *Italian Americana*, 22.1 (2003), 17–44, he argues that people living in slums can be seen either as victims or as the keepers of a cultural tradition. See also James Dickinson, "Entropic Zones: Buildings and Structures of the Contemporary City," *Capitalism, Nature, Socialism*, 7.3 (September 1996), 81–95.

3 William Boelhower, "Introduction," to Boelhower and Rocco Pallone, eds., *Adjusting Sites: New Essays in Italian American Studies* (Stony Brook: Forum Italicum, 1999), vii. Tina De Rosa's novel, *Paper Fish* [1980] (New York: Feminist Press, 1996), set in the Italian section of Chicago during the 1940s, includes in its second edition an afterword by Edvige Giunta titled, "A Song from the Ghetto."

4 Among the studies of Italian settlements before the Great Migration, see Richard N. Juliani, *Building Little Italy: Philadelphia's Italians Before Migration* (University Park: Penn State University Press, 1998); Rudolph Vecoli, "Chicago's Italians Prior to World War I: A Study of Their Social and Economical Adjustment" (Ph.D. diss., University of Wisconsin, Madison, 1963); Vecoli, "The Formation of Chicago's Little Italies," *Journal of American Ethnic History*, 2 (Spring 1983), 5–20.

5 As Krase argues, these communities have always been seen positively by the people who lived there, but negatively, as places of voluntary segregation, by outside observers. See Krase, "America's Little Italies." See also Louis Wirth, *The Ghetto* (Chicago: University of Chicago Press, 1928); Herbert Gans, *The Urban Villagers: Group and Class in the Life of Italian-Americans* [1962] (New York: Free Press, 1982); William Foote Whyte, *Street Corner Society* (Chicago: University of Chicago Press, 1943).

6 See my book, Maddalena Tirabassi, *Ripensare la patria grande: Amy Allemand Bernardy e l'emigrazione italiana* (Isernia: Cosmo Iannone, 2005). The complicated history of the Dante Society parallels in certain aspects the changing political views of Bernardy, who passed from nationalism to Fascism; compare Beatrice Pisa, *Nazione e politica nella "Società Dante Alighieri"* (Rome: Bonacci, 1995), 87–88 (274).

7 Amy A. Bernardy, "L'emigrazione delle donne e dei fanciulli nella North Atlantic Division, Stati Uniti d'America," in *Bollettino dell'emigrazione* (1909, no. 1); Bernardy "L'emigrazione delle donne e dei fanciulli negli stati del Centro e dell'Ovest della Confederazione americana," in *Bollettino dell'emigrazione* (1911, no. 1).

8 Amy Allemand Bernardy, *Passione italiana sotto cieli stranieri* (Florence: Le Monnier, 1931), 186.

9 Amy Allemand Bernardy, *Italia randagia, attraverso gli Stati Uniti* (Turin: Bocca, 1913), 234–235.

10 Ibid., 147.

11 She uses the term again, in the plural, in her 1931 book, *Passione italiana*, where she writes of "Il cuore delle piccole italie" (The heart of the Little Italies).

12 Ibid., 182, 183 (Tirabassi, *Ripensare*, 107).

13 Bernardy, *America vissuta* (Turin: Bocca, 1911), 305 (Tirabassi, *Ripensare*, 93).

14 Ibid. See also Maria Susanna Garroni, "Little Italies," in *Storia dell'emigrazione, Arrivi*, 207–233.

15 Boelhower, "Introduction," vii.

16 Bernardy, *America vissuta*, 306–307 (Tirabassi, *Ripensare*, 93).

17 Ibid., 308–309 (Tirabassi, *Ripensare*, 95).

18 Ibid. (Tirabassi, *Ripensare*, 95).

19 Ibid., 312 (Tirabassi, *Ripensare*, 95).

20 Bernardy, "Il cuore delle Piccole Italie," 189.

21 Bernardy, *America vissuta*, 313 (Tirabassi, *Ripensare*, 132). Here Bernardy quotes Cacciaguida from Dante, *Paradiso*, 15.125: "favoleggiava con la sua famiglia."

22 Ibid., 318–319 (Tirabassi, *Ripensare*, 99).

23 Ibid., 323 (Tirabassi, *Ripensare*, 104).

24 Durante, *Italoamericana* [Italian ed.], 2: 150. See also Durante, *Italoamericana* [American ed.], 173.

25 Robert F. Harney, *Dalla frontiera alle Little Italies: Gli italiani in Canada 1800–1945* (Rome: Bonacci, 1984), 197–208; George Pozzetta, "The Mulberry District of New York City: The Years Before World War One," in *Little Italies in North America*, ed. Harney and Vincenza J. Scarpaci (Toronto: Multicultural History Society of Ontario, 1981), 7–40 (11–13).

26 Bernardy, *Italia randagia*, 206–208.

27 Ibid., 212–213.

28 Bernardy, "L'emigrazione delle donne ... nella North Atlantic Division," 18–37; Bernardy, "L'emigrazione delle donne ... negli stati del Centro e dell'Ovest," 4.

29 Bernardy, *Passione italiana*, 138.

30 Jerome Krase, "Little Italies in New York City: A Semiotic Approach," *Italian American Review*, ser. 1, 5.1 (Spring 1996), 103–116.

31 Krase, "America's Little Italies: Past, Present and Future," 180.

9

INTERPRETING LITTLE ITALIES

Ethnicity as an Accident of Geography

Maria Susanna Garroni

"Little Italies exist no more." So say some people. But others say they never really existed. And others, instead, claim that that they still exist; that they have reemerged with more life than ever, although in a different form. (See Color Plates 22 and 23.) Some say that Italian Americans used to be embarrassed by Little Italies. Yet it is also probably true that the continuing existence of Little Italies was reassuring, not only for the Italian immigrants of the first generation who lived there, but also for the successive generations that abandoned them for more comfortable surroundings. Indeed there are people today who are proud to promote their survival.

A great number of historians, literary scholars, anthropologists and sociologists have made "Little Italy" the focus of their research, but what does the phrase really mean? Historian Donna Gabaccia, writing in 2006, emphasized how Italian immigrants did not themselves refer to their districts as Little Italies. Instead they preferred to use the name or nickname of the area where they lived. Thus in St. Louis, for example, they called it "The Hill." She also points out that many Italian American scholars and activists prefer to avoid the term "Little Italy."[1] So is it still possible to use "Little Italy" as a category that actually illuminates important parts of the history of the Italians who came to the United States and who, by remaining, became Italian Americans?

Looking for Roots

In her autobiography, the well-known Italian American writer Maria Laurino feels the need from time to time to "keep returning" to Bensonhurst, Brooklyn, a "Little Italy" almost by definition, a "nationally known Italian-American community," described as such not only in newspaper reports of racial disturbances targeting blacks, but also in the cinema of Spike Lee and in many surviving essays and memoirs.[2] It is not her childhood neighborhood. She grew up in a neighborhood and in schools that she considered integrated. And her ethnicity has largely disappeared, pushed aside by her taking on a specific professional role, as a journalist, and a social status, as a member of a "middle class," that are both by now consolidated and no longer defined in terms of ethnicity. All the same, the impulse to recognize and decode the traces of a culture she has apparently canceled out, but that constantly reemerge, attract her almost unconsciously, and it would seem, inevitably, to Bensonhurst's Little Italy. The observation and experience of a geographic place appeals to her origins, to her roots, it illustrates aspects of her own personality, and, in part, the reasons for her own way of doing things, but, above all, her way of feeling irremediably Italian American: "Identity as a pact of unity; ethnicity as an accident of geography."[3]

Bensonhurst is thus a virtual nexus, a projection of all of the possible Little Italies that the immigrants themselves preferred to call their "communities." Maria Laurino describes

well the existential impulse that seems to characterize children of the third and fourth generations of the Italian immigrants, and perhaps of immigrants in general, to seek out the physical coordinates of the neighborhood in which they lived their early years, of the spaces in which their first memories of childhood are situated. These are twinned elements—neighborhood and ethnicity—that continually reappear in the conversations, memories and worldview of Italian Americans. It is a worldview in whose depths there remains an indefinite and indefinable sense of exclusion, that distant memory of a subtle feeling of shame. But these memories also express pride in the successes achieved through many difficulties, an understanding of the worth of a cultural tradition, of the dignity, loyalty and hard work that have made it possible for the Italian immigrants and their descendants legitimately to become and to be considered American.[4] Still today, therefore, it makes sense when wondering about the ethnic affiliations of the descendants of immigrants, to ask what the Little Italies really represented both for their inhabitants and for the cities in which they were situated, and to ask whether it is true that they are returning to life in ways that are both urbanistic and metaphorical.

Many of the mostly impoverished neighborhoods where there were once dense populations of Italians—if they were not hollowed out by the succession of urban renewal campaigns in North America—are now experiencing a kind of springtime. They are blossoming with cafés and restaurants after having been restructured with respect to living quarters and open spaces and repopulated by a class of persons attracted by an aroma of tradition combined with a touch of acceptable nonconformity and transgressivity; whereas financially they have experienced rising real estate prices, as they become a source of touristic and commercial value. On a metaphorical plane, instead, there is a ferment of initiatives that seeks to bring together these "hyphenated" Italians (who no longer use a hyphen for "Italian American") so as to reinforce the unifying elements that can serve as cultural, economic, legal and political resources.

The Little Italies appear, therefore, to be rediscovering an internal vitality. At the same time, however, the external world is rediscovering the Little Italies—or at least the virtual, post-modern communities of the fifty to sixty million people of Italian ancestry who now live outside of Italy and are scattered throughout the world. The globalization of markets offers new cultural and economic opportunities for Italy herself in connecting with these Little Italies, whether real or imagined, geographically concrete or instead made vital and practicable thanks to new forms of communication. In this way the Little Italies around the world still play an important role.

One common feature in the behavior of Italian immigrants throughout the world, noticed by contemporary observers and researchers alike, was a tendency, at least initially, to gather in a geographic space that was sufficiently compact to permit the practices of collaboration, solidarity and the maximization of resources on a daily basis. But the explanations that were given for this kind of gathering varied; the areas contained within the Little Italies and their population densities varied; the length of time it took for them to come into being varied; and the duration of Italian ethnic characteristics of these communities varied. Italians in the United States did not settle in the patterns as elsewhere in the world (Argentina, Brazil, Australia, Canada. . .), and there were differences within the United States as well. Often the histories of the countries to which Italians emigrated have been written from a national perspective, so that the local histories of the immigrant communities in their cities escaped attention.[5] The study of Little Italies has developed according to such different methodologies, and in such differing contexts, that it makes sense to try to describe what went into the creation of the concept of a Little Italy, when they first began to attract the attention of observers, what forms they took in the United States, how they influenced the

transformation of the immigrants into an "ethnic group" and, finally, what role they may hope to play in the future.

Little Italies as a "Problem"

Perhaps it was the photographs and writings of Jacob Riis published in 1890, or plays like *Little Italy: A Tragedy in One Act*, by Horace B. Fry which appeared in 1902, or *The Heart of a Stranger: A Story of Little Italy*, written by Anne Christian Ruddy (under the name of Christian McLeod), which came out in 1908, that gave Little Italy its fixed characteristics in American culture and society.[6] For many years, speaking of the Italian neighborhoods in the United States meant speaking of the infamous "tenements": rented apartments, in the shape of handlebars or parallelograms, with the tiniest of rooms, often without access to air and sunlight, where there were often shared bathrooms in the courtyards or in atriums and the entrances were at times in the rear of other buildings, in narrow alleys that were also dark, dirty and smelly. The often run-down structures were crowded with many single men, children, old people and women—the fathers and the married men of working age often absent, away on distant jobs.

They overlooked packed streets that were clogged with carts and street peddlers whose cries mixed with those of old and young folk, poorly dressed, often in peasant clothes, the women in long, shapeless dark dresses, with scarves on their proud upright heads, the children wearing what seemed rags rather than proper clothes. These neighborhoods were also considered receptacles of the criminal activities of the Black Hand, of the violent manifestations of Mediterranean jealousies, of the cruel mistreatment and abuse of children by adults, and of women by men. They were neighborhoods portrayed as being immersed in disease, wickedness and noise, places in the great industrial cities where only Italians were willing to live.

In other countries—the United Kingdom,[7] France,[8] Latin America[9]—the people who emigrated from the peninsula called "Italia," better known at the beginning of the previous century on account of her geographical position rather than for her social, political and cultural complexities, came to be recognized as weaving together small, mobile communities, swarming with inhabitants but with certain landmarks of stability and of social gathering. These communities of Italian immigrants were seen as centrifugal and centripetal at the same time, long before these phenomena were recorded and became codified in the press in the United States. Already at the time of the early Italian emigration, labeled as "precocious" by the Argentine historian Fernando Devoto since it preceded the Great Migration that began in the 1880s, observers in these countries noted those characteristics in the arriving Italian immigrants as well as the urban problems for which they were judged responsible. In Europe and Latin America, however, the Italian immigrants integrated themselves and spread out fairly rapidly into the surrounding urban areas and the productive sectors of the economy.[10]

It was in the United States, in all truth, that the crowding of Italian immigrants into specific parts of cities that were clearly delineated and populated by the most downtrodden inhabitants began to be seen as an ethnic characteristic, thus becoming an object of attention, categorization and concern. In a society accustomed to receiving immigrants from various European countries, and thus periodically subject to xenophobic currents, the Italians in fact constituted the first European group of a noteworthy consistency to seem resistant to quick assimilation. They presented instead aspects of alterity that were perceived as menacing the stability and harmony of American society. Encouraged by what Robert Harney called the "Italophobia" of Anglo-Saxon culture, and sustained by the scientific racism that was widespread in the second half of the nineteenth century, the definition of Little Italy as a place with negative and worrying connotations emerges with insistence in the North American

press and in the literature of the last years of the 1800s. However, as Gabaccia observes, refer-ring to recent academic studies of the concept of "whiteness," the term also helped to con-solidate the ongoing process of the construction of a national identity in the United States that was based on racial hierarchy and exclusion. In a study of 1985 by Robert Freemen it was shown that one of the reasons for the creation of Little Italies in certain sections of major American cities was "discrimination on the part of landlords in other sections."[11] Meanwhile the emigration of Italians to other parts of Europe in the same period (between 1876 and 1914, 44 percent of the total of Italian emigration went to Europe, as opposed to 31 percent to North America) took place in a manner that progressively integrated them, albeit not without tension, within the national landscape. In European and Latin American countries terms like "Italian streets" or "Italian quarters" were used to describe the places where Italian constituted a visible majority, but not "Little Italies."[12]

To these general observations Gabaccia adds the results of a specific study that she made of New York City. The Little Italy of this city came to be intentionally and repeatedly described and identified as such in the press of the early twentieth century with an area where Italians at that point were no longer the prevalent part of the population. To present the district to their readers as a "Little Italy" became a way of encouraging a kind of urban tourism that offered emotion and adventure, but "without the risks." It was a kind of experience that was becoming fashionable among the better-off classes of the period.[13]

The statistics published by the Dillingham Immigration Research Commission in 1911 only stimulated further real and imagined fears that had been accumulating over several decades. Among the peoples considered by the Commission as part of the "new immigra-tion," the Italians were the most numerous. They made up 16.9 percent of the perma-nent immigration between 1899 and 1924, followed by Jews from the countries of Eastern Europe (14.3 percent), Germans (9.2 percent) and Poles (7.6 percent).[14] Yet the Italians had the lowest rate of naturalization. In 1910 only 17.7 percent of the Italian immigrants had been naturalized. Even in 1930 barely 50 percent of those born in Italy had at last taken up American citizenship, thus remaining a few points below the percentages of the immigrants from Slavic countries, and also below the groups that came in the early nineteenth century from such countries as England, Germany and Ireland, comprising what was called the "old" immigration. (Many of the old immigrants were Protestant, they were more literate and not so destitute, and thus were considered less dangerous and more capable of integrating into American society.)[15]

This reluctance to become American, interpreted as a lack of interest in the "polity" and the sign of a weak feeling of civic responsibility, seemed to find proof in the high percentage of Italians who returned to their homeland. In the eyes of American society the Italian rep-resented "birds of passage" who remained only for a brief period, temporarily profiting from a place's resources only to pass on afterward to more favorable shores, whether according to the season or to convenience. Roughly forty-six Italians out of a hundred returned to their country between 1899 and 1925. The Poles and Slovaks also had high rates of return, but they were measurably lower at 33 percent and 36 percent respectively.[16]

In addition to these statistically quantifiable aspects, there were others that from a social and cultural point of view could be seen in negative terms by American society. The Ital-ians, in addition to failing to speak English, and in keeping their children from school to a greater extent than other ethnic groups, came from a country where Church, monarchy and the aristocracy had deprived them of political skills. Their Catholic faith, so it was under-stood, had rendered them prejudiced, superstitious and incapable of self-determination and independence in a manner quite unlike the (also despised) Irish, who at least, thanks to their struggles with the English, had learned to develop self-reliance and the capability to

organize themselves. Instead of the well-ordered nuclear families of the Germans, the Italians lived in large extended families, in what seemed like a poorly concealed promiscuity among so many boarders, in urban communities where the visible outnumbering of the women by the men seemed necessarily to feed a traffic in sex that was morally inexcusable. Thus the concentration of Italians in specific urban areas came to be defined as the "Italian problem," on the one hand by reformers who wanted to correct it, and, on the other, by the citizenry at large, who wanted to strengthen and define their own national culture in opposition to it.[17]

Together with more general problems like the assimilation of the immigrants, the improvement of their living conditions and the renewal of urban zones that had deteriorated as a result of unplanned industrialization, American society, influenced as it was by reform movements, at the turn of the century saw as one of its chief problems the need to establish a more detailed knowledge concerning the lives of Italian immigrants.

Little Italies as a Subject of Research

The manner of looking at Little Italies as "communities"—which is to say as social formations with an internal form of organization linked to a spatial or geographic dimension, in which this spatial dimension is not only descriptive but plays an autonomous role in characterizing the entire group that adheres to it—was developed in the early twentieth century by sociologists who worked at the University of Chicago. The Department of Sociology, which was established in 1892, was formed with the goal of studying the by-then startling urban problems that Chicago was facing, and of proposing reforms to address them.[18]

This project, together with the concern in American society about the ways in which the "new immigrants" were different, about the possible threat they posed to the established order and to the stability of the country's socioeconomic relations, directed the Chicago sociologists toward the development of plans for a new approach intended to analyze the forms of integration, assimilation and modernization of ethnic groups in the United States under the assumption that these were conditioned by their location. Thus the immigrants and, even more specifically, the environments in which they lived, became objects of public attention. The reason for looking carefully at their neighborhoods was explained with clarity by Robert E. Park:

> Proximity and neighborly contact are the basis for the simplest and most elementary form of association with which we have to do in the organization of the city life. Local interests and associations breed local sentiment, and, under a system which makes residence the basis for participation in the government, the neighborhood becomes the basis of political control. In the social and political organization of the city it is the smallest local unit.

It was necessary, in other words, to study the "community," the smallest of political units, to understand how to intervene in the acculturation of the immigrants. Park subsequently explained what he meant by the term "community":

> The simplest possible description of a community is this: a collection of people occupying a more or less clearly defined area. But a community is more than that. A community is not only a collection of people, but it is a collection of institutions. Not people, but institutions, are final and decisive in distinguishing the community from other social constellations.[19]

Then, enumerating the functions fulfilled by the community, or, better, the reasons for which it is formed, Park adopted the approach of fellow sociologist William I. Thomas: immigrant communities existed to give the immigrants the conditions necessary for life. Man—Park explained, using the term to refer to the human race, women included—requires not only material support, but also hopes, dreams and relationships with other men. He lives with desires, and these desires are fundamentally four in number: to have a house, or at least a place of shelter; to have new experiences and entertainments; to obtain some form of social recognition; and to express affection toward things or persons that reciprocate this affection. When the community offers a physical space for the fulfillment of these desires, at least in some degree, it performs its function and it helps the immigrant to adapt to the American environment.[20]

The Chicago School thus localized in the residential neighborhood of the immigrants the possible engine for their "nationalization." It would be through the neighborhood that they would absorb the lessons of fellowship and political participation that stood as the pillars of American citizenship.

But was this really the way things were for the Italian immigrants in the United States? Was the residential neighborhood known as "Little Italy" truly a launch area for entrance into American society?

What Characterized Little Italy?

Without question, because these were the earliest studies and because they were so substantial, the research done in North America became the model to which all later attempts to reconstruct the characteristics of Little Italies would necessarily refer.

The first studies, more sociological than historical, tended to describe the Little Italies as places that witnessed the progressive dissolution of the social forms imported from the land of origin, difficulties in adapting a premodern peasant civilization to modern American society, the crumbling of customary hierarchies, and anxiety and isolation for immigrants of the second generation, while also serving as milieux for a rapid and inevitable assimilation to American culture.

Hints of an approach that would become more complex began to appear in the 1940s. In *Street Corner Society: The Social Structure of an Italian Slum*, about the Italian community of Boston, which was published in 1943, the sociologist William Foote Whyte argued that what seemed to be a neighborhood defined by Italian immigration was in fact a permeable space characterized by organizational forms and relationships of interaction and dependence determined by the neighborhoods broader urban surroundings. Jerre Mangione's influential *Mount Allegro: A Memoir of Italian American Life*, a book about the life of the Sicilian immigrants in a neighborhood of Rochester, New York, had appeared one year earlier, and it documented the desire of the author, a second generation Italian American, to escape from the confines of his neighborhood. Still, at the end of the 1950s, sociologist Herbert Gans was able to argue that America's Little Italies were even more closed and self-referential than in the model that had emerged from the Chicago School. Published in 1962, based on his study of Boston's West End, Gans's *The Urban Villagers* described a society that was so attentive to itself, so resistant to the values of individualism and competitiveness of American society, and so bound up in its own emotive forms as to render it incapable of interacting in a constructive way with its host society. The peasant culture of origin would have to be superseded if the Italian immigrants were to have any possibility of entering the mainstream of modern American civilization.[21]

A decisive turn in the argument took place with the publication in 1964 of an essay by Rudolph Vecoli. In opposition to a general tendency to deprecate Italian peasant culture, Vecoli argued that for immigrants their culture of origin often became a valuable resource in confronting living conditions replete with unknowns and situations that were difficult to decipher, although at the same time he acknowledged that it could have the negative effect of keeping the immigrant enclosed within the coordinates of an agrarian culture or of a primitive transgressiveness that was opposed to the values of industrial society.[22] Another study, published in the same year, further advanced the field by introducing in the American context the concept of "chain migration" that had previously been advanced by researchers studying immigration to Australia. The authors, John and Leatrice MacDonald, pointed to the role of personal connections within the immigrants' particular communities of origin as providing the information that would induce a group of emigrants to settle in a specific place. It was this chain migration that resulted in the creation of ethnic groupings characterized by strong elements of local attachment (*campanilismo*) and regionalism that remained homogenous both in class membership and in productive capacity.[23]

Then, in the 1970s, influenced both by the ethnic revival that followed on the Civil Rights movement, and the rise of a new social history that underlined the active and participatory role of the lower classes in making life choices, there appeared a series of studies that attempted to overturn or to create a new synthesis of the earlier views of the Italian communities.

One of the first studies to analyze the phases of Italian settlement in an urban area was the work of Humbert Nelli on the immigration of Italians to Chicago, showing that there were successive stages of settlement. The first to arrive were northern Italians who came in limited numbers together with their families and created the first community structures, such as the food stores and saloons, and also the first social networks. They started to live in the poorer areas of the downtown, yet in the 1870s Italians could be found scattered in most of the city districts. Southerners then followed, and since they were overwhelmingly male, they changed the character of the community. The growth or decline of the Italian neighborhoods seemed to depend on the changing urban features of the city. Rising land values and the opening of a rail station in another part of the city caused the Italians to abandon the center. Economic success encouraged the Italians to leave their initial places of residence and to move to more preferable areas. But the neighborhood around Dearborn Station maintained its character as an Italian quarter that was a place for welcoming and assisting successive waves of immigrants in their transition. Ethnic churches developed in those areas where the community seemed to have assumed features of stability. Although they had been considered little able to acquire at the same speed the socioeconomic successes of their predecessors of the old immigration, the Italians were in reality quite "socially mobile" even before 1920. Nelli thus described an ethnic community that was in continual motion, not excessively concentrated, whose spaces were shared with other ethnic groups.[24] It would be in fact difficult if not improper to use a term like "Little Italy" to describe a community as fluid and differentiated as the one analyzed by Nelli.

Another characteristic feature of the studies of the 1970s was a greater attention to the culture of origin of the immigrants: their values, their goals, their choices.

Two aspects of these studies should be underlined. To begin with, there were some scholars who saw the behavior of the Italians, enclosed in their communities during the first stage of immigration, as consciously directed from the beginning toward using the immigrant neighborhood as a means to social mobility. John W. Briggs was the author of a study of the Italian communities of Rochester and Utica, New York, and of Kansas City, Missouri, where this

approach seemed evident. Above all, Briggs arrived at the conclusion that the model of chain migration neglected the extent to which migratory choices were self-determined. Emigrants from the Sicilian town of Termini Imerese, for example, though welcoming information and assistance from relatives and friends of the same hometown, nevertheless went off in different directions. Briggs furthermore saw the immigrants as individuals motivated by the bourgeois ethic, which is to say by an aspiration to social mobility that derived from their belonging, in the places they had left, to the class of artisans and small proprietors rather than to the peasant class. Little Italies, from this perspective, became launching pads toward better living conditions and places of transition from traditional to modern society.[25]

A second aspect of life in Little Italies that was brought into high relief during the 1970s was the role of the family. In a book that remains a watershed in the historiography of the Little Italies, Virginia Yans-McLaughlin, who was influenced by the studies of the African American family of Herbert Gutman, wrote about the Italian community of Buffalo specifically with a view to family structure and family life. Her conclusions remained somewhat ambivalent. On the one hand, the power of the patriarchal family structure and the fundamental role of women in cementing and reproducing the values attached to it helped the Italian immigrants to overcome the difficulties of dislocation. On the other hand, agreeing in part with the "familistic" interpretation of Edward Banfield, she argued that this rigid structure impeded the access of women to the labor market, that it blocked certain forms of cooperation within the community, and that it served as an obstacle to the acquisition of any kind of class consciousness.[26]

Yans-McLaughlin's methodology had the advantage of zooming in on the ethnic community *per se*, and its internal culture. Structural elements, both those in the larger society that Whyte had previously indicated as well as the internal mechanisms of the Little Italies themselves, ceded place to an interest in the "superstructural" features of culture. The mass of studies that followed was described and summarized from a critical perspective in a Vecoli essay of 1983. Looking closely again at a group of Italian immigrants in Chicago, he enumerated the characteristics that seemed to inform the Little Italies of North America.

Above all there emerged a lack of homogeneity in the urban patterns of Italian immigration. Chicago had not fewer than sixteen different residential areas of Italian settlement. There was thus no "concentric model" such as the Chicago School had hypothesized, nor were there successive "phases," as Nelli had proposed. Instead, groups originating from the same regions in Italy were collected along avenues or streets in determined areas. The choice, moreover, depended on the geographic and productive opportunities offered by the city itself. If it was true, as shown in previous studies, that focal points for these communities were the Italian churches, it was also true that in addition to the churches Italians belonged to and created different social organizations that were based on their common places of origin. Employment, along with the migratory chain, was the major factor in determining the residence of a group. Italians from Genoa who sold pastries and ran restaurants and delis, became rooted in the busy downtown. Also downtown was a group from Ricigliano (in the province of Salerno), who sold newspapers, shined shoes and worked as street sweepers. A group of Tuscans was hired by the McCormick Reaper Works and so they settled in the streets around the factory in the Twelfth Ward. When another group of Tuscans was taken on by the Northwestern Terracotta Works after a man from Lucca became hiring chief, they settled around that factory in the Twenty-Fourth Ward. Other Tuscans, employed since the late 1890s at the National Malleable and Casting Works, moved to Cicero when, in 1910, their factory opened a branch there. And the reasons why Italians left the Little Italies were not necessarily determined by economic betterment but rather by the transformation of the available employment opportunities.

In his essay Vecoli also remarked on the importance of tracking the history and motivations of the people he called "pathfinders" or "trailblazers": the persons who had the initiative to lead migratory flows from places of origin toward specific destinations. Francesco Ligorio, a Genoese, opened a restaurant in the mid-1800s and brought friends and relatives to work there. The result was a colony of Genoese in a particular area of the Near North Side. The *padrone* Luigi Spizziri, who arrived in Chicago from Calabria at the start of the 1870s, brought a large number of his fellow Calabresi to the area around South Clark Street where his business was centered. From the history of these communities it becomes clear how relevant was the solidarity network that connected people coming from the same place. The stronger their regional ties were, the longer the Little Italies lasted. In the 1930s many of these same communities were still alive, and even in the 1950s and 1960s some of them retained the distinctive features of Little Italies.[27]

Such were the characteristics that have emerged from the study of immigrant settlements in large industrial cities. But the 1980s and 1990s also witnessed a growing interest in Italian settlements in the American West, in mining and agricultural zones, and in areas with dispersed agrarian settlement patterns rather than urban ones. These studies have an importance that is noteworthy because they bring to the fore questions of intentionality and expectation of the Italian immigrants themselves that had escaped earlier observers who were focused on the functionality of the ethnic communities.

Ryan Rudnicki counted at least 281 places where there were significant settlements of Italian ethnics that developed in the agricultural and mining areas of the Midwest in the years between 1880 and 1930. The interests of the employers—most of them mining or drilling firms—and of real estate speculators were often what gave rise to these settlements of Italians. Labor shortages or projects to extract the resources of a particular areas were what attracted the immigrants. This is what happened in certain communities of Texas,[28] and, for instance, in Rosati, Missouri, where a whole group of Italians chose to settle after leaving their original "colony" in Sunnyside, New Jersey.[29]

A number of writers argue that these Little Italies in isolated areas of low population density spared the Italians who lived there from the trauma of the forced modernization that took place in areas of rapid urban transformation. Moreover, it was precisely their isolation and the fact that they occupied specialized niches in the market economy that allowed these communities to retain a more stable cultural and economic autonomy. And indeed these communities were subject to much less aggressive forms of discrimination and prejudice. These Little Italies enjoyed a greater homogeneity and stability because once they were established they tended, to a much greater extent than in the big cities, to depend for their growth on the chain migration that relied on networks of relatives and of people from their hometowns in Italy, so that linguistic and cultural traditions were preserved much longer.

The Little Italies scattered across Long Island were created instead in response to a two-fold need. On the one hand, the speculative passion that overtook the United States in the 1920s infected the Italian community too. A number of the Italian *prominenti* saw in their own community a reservoir of customers for real estate projects that they were undertaking beyond the boundaries of the community itself. On the other hand, these initiatives were answering a real need of many Italian immigrants who wanted their own plots of land where they could build a house and plant a garden. A desire for land was probably always present. Mangione himself speaks of it as a recurring theme in the conversations of his Rochester community.[30]

Leonardo De Paola, who belonged to many Italian American associations in New York, noticed that many of them desired to find sites outside the city at which to celebrate the feasts of their saints. De Paola purchased twelve acres of land at Dutch Broadway in Elmont,

New York. In 1938, with a partner, he opened a small bar and restaurant, set out picnic tables in the surrounding area, and built a chapel where masses could be held on saints' days as needed. For a while De Paola's own family lived in six rooms above the chapel. He would rent out the whole property to Italian American organizations from Brooklyn, Manhattan and the Bronx. Many of the Italians who went to Elmont to celebrate the saints' feasts ended by living there. In the 1980s Elmont, which was originally inhabited by Germans, had one of the largest Italian American populations on Long Island.[31]

In the years between 1980 and 1990 suggestions originating in the broader culture had an impact on the study of Little Italies. Thus the attempt in English language historiography to speak more "scientifically" and less "impressionistically" about family structures, the conditions and opportunities for work, and gender relations opened new perspectives on Little Italy. One of the books that answered this call in a particularly original way, linking family history, women's history and urban history, was the study by Donna Gabaccia of the community of Sicilians that settled around New York's Elizabeth Street. Gabaccia wrote what in reality might be described as an intellectual history of the lower classes. She reconstructed the ideals, the hopes, the ethical meaning of the behavior of the Sicilians in their home village. She identified in the *casa*, which is to say the extended family, bonds of loyalty and belonging that informed the choices of the various components of the *casa* with respect to inheritance and occupation. Contrary to what Banfield had asserted, and also Yans-McLaughlin, Gabaccia denied that the *casa* induced an "amoral familism" in the Sicilians. It was precisely to maintain the honor and well-being of the *casa*, in fact, that the Sicilians established relationships of reciprocal advantage with neighboring *case*, with friends and acquaintances. Once they had emigrated to a new social context, it was the context, Gabaccia argued, that determined choices and behaviors that were different from those in their culture of origin. The narrow environment, the different layout of the domestic space, the different economic relations between parents and children—and also between employers and their workers (who, no longer peasants, assumed a new social respectability closer to that of the artisan thanks to the monetization of their salaries)—resulted in an entirely new family culture. A Sicilian woman in the tenements, for example, might help her husband in the morning to set up shop, then meet her *comari* (her fellow godmothers, or, by extension, women from the same ancestral village) in the afternoon to do the needlework that was hired out to them by a female acquaintance who picked it up from a nearby clothing factory, then have coffee with a neighbor who lived on the floor below while looking after her own children and the children of the other families, and then have dinner with her family and its boarders. A woman who had previously been isolated in an agricultural village in Sicily thus found herself at the center of a new network of social and economic relations. If it was true that the Italian immigrants maintained certain Sicilian traditions, it was also true that they adapted them to the new environment that, in turn, partly determined their development.[32]

The urban context, therefore, transformed the original culture, redefining social roles, even as the older culture was being used to address the new context. From this perspective, if one can speak of a genuine Little Italy it is because a transitory and prevalently male immigration became interwoven with territorial networks that were constructed to a significant degree by Italian immigrant women. Many of them knew how to employ their home culture so as to reinforce, direct and manage the family's resources. At the same time, they knew how to grasp the opportunities afforded by life in the United States. Contrary to the old stereotype, embedded in the scholarly literature, of the passivity of the Italian immigrant woman who was largely encapsulated within her family, most recent studies conclude that whenever the context made it possible, the Italian immigrant woman took up occupations that would have been forbidden in her home village, and it was with some frequency that

she ventured out into public space. Immigrant women went out with their children to work on farms to harvest and can agricultural products. They worked in clothing factories and in laundries, and they carried on their heads the packages of cloth that they took home to sew. It was with their assistance that the small ethnic businesses of the neighborhood were able to survive and sometimes to flourish. They found employment in pasta factories, in shops that sold sweets and caramels, they were partners in opening saloons, they ran and even established small businesses, they hosted boarders, and they managed vegetable gardens and orchards. Within their community they became social aides, teachers, nurses, midwives, actresses, opera singers, businesswomen. Even their sometimes humble employment helped to fill in where the salaries of their husbands were often irregular, so that they contributed in a substantial measure to the accumulation of capital by the family group.[33] The participation of women in electoral politics was in certain cases proportionally greater than for men, as the work of Stefano Luconi has shown for Philadelphia, where women played a significant role in electoral campaigns and in union organizing, winning respect and an acknowledgment of a value they would never have found at home in Sicily.[34]

A historiography skewed according to gender has meant that for a long time scholars have neglected the role of the nuns who emigrated to the United States. In the Italian parochial schools, which numbered eighty in 1917 according to the Scalabrini Father Manlio Ciufoletti, the teachers were overwhelmingly Italian immigrant nuns: 518 out of a total of 621 schoolteachers. They came in larger numbers than the Italian priests who emigrated, and by the 1930s there were nine Italian congregations in the United States with a total of about 1,050 sisters. As recent studies have shown, Mother Cabrini and her congregation were hardly the only ones to work among the communities of Italian immigrants. Other Italian nuns who emigrated to the United States became social workers, nurses and managers of charitable institutions, and they founded schools and hospitals. They also worked to democratize relations with the Church hierarchy. Their numbers were small, but their activity helped in part to weave the threads of the Little Italies.[35]

Italian immigrant women, whether in roles that were new or traditional, some imported from their places of origin, others learned in new contexts, contributed in important ways to the formation of a new middle class in the Little Italies and to building the networks of what can be defined, at least for a certain period, as "homogenous communities."[36]

An accent on the *casa* and on the *famiglia* constitutes one of the guiding threads of the research of Robert Orsi on the Italian residents who congregated around the church of Our Lady of Mount Carmel on East 115th Street in Manhattan. His book, published in 1985, opened the way toward what might be called a "dramaturgical" interpretation of the spaces that the Little Italies afforded to Italian immigrants. It was a way of looking at the neighborhood as a place not just for maintaining traditions but also for manifesting beliefs, feelings and emotions that still today seem to remain characteristic of Italian American ethnicity.

From 1884 Italian immigrants from Campania, Basilicata and Calabria had been populating the area around 115th Street. A continual influx of new arrivals kept alive the values and knowledge of their places of origin and thus helped to suture the gap between the first generation of immigrants and the generation that had been born in the United States. Common observance of the religious devotions tied to the Madonna of Mount Carmel—practices that deviated somewhat with respect to Catholicism as it was institutionalized in America—built bridges among the different regionalisms so that a sense of commonality coalesced around the church, transforming Harlem into "*cara Harlem*."

These Italians of Harlem, according to Orsi, based their distinction of good from evil and their moral judgments on what the French historian Emmanuel LeRoy Ladurie, in his studies of small communities, called the *domus*, the Latin word for "home." Here the domus

became a unifying principle that combined place of habitation and family, and both the individual and what he or she possessed, both materially and immaterially. According to Le Roy Ladurie the domus constituted the principal component for constructing social relations and for transmitting cultural values. Employing this concept (whose similarity to the *casa* of Gabaccia's Sicilians is self-evident), Orsi saw the community as something like a theatrical stage on which the impulses of the domus were manifested, while the Madonna became the religious symbol charged with protecting it. Although she had been brought over from Italy, "the Madonna . . . was truly of 115th Street," a genuine result of the hybridization of its culture of origin.[37]

In the years that followed, the books about the Little Italies that appeared became ever more descriptive and nostalgic, as, for example, in Michael Immerso's *Newark's Little Italy: The Vanished First Ward*, which was published in 1997, or in Anthony V. Riccio's 1998 collection of oral histories and photographs in his *Portrait of an Italian-American Neighborhood: The North End of Boston*.[38] They recount a world as it once was, they observe recent transformations, they remark on what no longer exists. But a problem remains. For those who lived in them, what role do these Little Italies still play in their memories and what did they count for in shaping the identity of these people? As Laurino puts it, "You may take the girl out of Bensonhurst . . . but you may not be able to take Bensonhurst out of the girl."[39]

Andreina De Clementi has noticed that in many of her conversations with contemporary Italian Americans there emerges a preoccupation today with "the absence of an ethnic community," now that its basic foundation in residential segregation has disappeared. As Micaela Di Leonardo argues, if one is to speak of a community, one has to be able to describe its ongoing mutations, the exchanges among its components and its evolving relations with the external world—things that not even the most recent studies of contemporary Italian Americans have been able to do.[40] It is true that most of the immigrants ended up elsewhere. But though they left these physical communities, they did not necessarily leave the metaphorical ones—the Little Italies that live on in the literature and the memoirs of the Italian Americans.

There Is Still Work to Be Done

By looking with greater care at what remains of these enclaves, at what the people in them worry about, and at what has disappeared, new perspectives continue to open up. There are many general themes that, when explored in the context of the Little Italies, can deepen our understanding of the ways in which immigrants are integrated into a new society while also assuming a cultural identity in a new place. A more precise examination of the periodization of the Italian immigrant experience could very well sharpen this understanding. Stefano Luconi, for example, in his study of the community of Philadelphia, argues that it was in the 1930s, with the emergence of Italian nationalism under the Fascist regime, that the Little Italies began to take leave of their regionalist or campanilistic spirit and to develop a stronger sense of *italianità*.[41] The argument makes a certain sense, but its impact on our interpreting the Little Italies of the 1930s remains to be seen, since this was a later stage in their history, when many Italian immigrants had already moved out to other urban neighborhoods.

The impact of war on Italian ethnic communities affords possibilities for demonstrating both similarities and differences. The English, Brazilian, American, Australian, French and Canadian communities of Italians all experienced difficulties during World War II. Their associations with Italy and everything Italian became problematic to varying degrees, while their new identities suddenly became questionable. Yet certain communities, for instance in the United States, came out of World War II having achieved a much higher degree of

integration. Thanks to military service, educational opportunities, changing markets, employment opportunities, interethnic marriages and the necessity of many Italian Americans to forge lives outside their ethnic communities, the Little Italians began to dissolve within the broader North American context and to lose many of their ethnic characteristics.

We still know very little about the role of Little Italies as places for the elaboration of the plural identities characteristic of modernity. Often layered the one on top of the other, these identities, be they those of hometown, province, nation, religion or political party, were accepted and expressed in times and places that differed in ways that remain to be explored.

Little Italies can also be studied as places where political cultures matured. The circumscribed space, the sites for socialization from the "corner" to the street, from the saloon to the cooperative, permitted exchanges of ideas, rehearsals for protests, and encounters with a modern politics that was quite different from the politics they knew in their home country. But these experiences were all filtered by the relationship with the host society. The festivities for May Day, for example, allowed for the creation of a political identity that was very "Italian" and tied to the forms of socialism and anarchism prevalent back in Italy, yet they were always accompanied by consideration of the opportunities offered by the workers' movements and by union organizing in the United States, and by the political freedoms that they discovered there. On the other hand, the years in which radicals were persecuted had the effect of erasing the historical memory of these political outbursts and causing Italian Americans to embrace instead the political movements and ideologies that the nation considered acceptable. The American Little Italies thus came under the wing of the Republican and Democratic parties, but in ways and on timetables that were determined by the host society.[42] In this way, both in the United States and elsewhere, the Italian neighborhoods became a place of political acculturation that led to citizenship in the new country, but always in accordance with local political forms, values and concepts, rather than those of the country from which they came.[43]

One of the more interesting features of America's Little Italies has to do with the way they witnessed the emergence of a kind of racism among the Italian immigrants. The Italians of Baltimore, for instance, after an initial attempt at an alliance with the city's black residents, embraced the positions of the whites. Much the same pattern emerged in Philadelphia, as Luconi's work has shown. Food and the family table was used as a discriminating factor when the Italian Americans in Harlem in the 1930s distinguished themselves from African Americans and Puerto Ricans: They said that these other groups did not eat together "like a family." It was an implicit acceptance of the idea that racial inferiority and nutritional inferiority went hand in hand—an idea that had often been used in public criticism of the Italians themselves.[44] This development of a racial culture among Italian Americans seems to confirm the suggestion that emerged at a 2003 conference held at the University of Western Australia: in order to understand the internal dynamics of Little Italies it is crucial to understand the political culture and the socioeconomic direction of the society of destination.[45]

There is one last feature that deserves to be put on the table. In the book that collects the correspondence of the Sola family, some of whose members emigrated to Argentina from the town of Valdengo, near Biella in Piedmont, there emerge several new directions for possible research. To begin with, there is the experience of the traveler who is simply exploring opportunities and therefore sees the ethnic communities as support structures to be used instrumentally. Furthermore, it becomes clear from the letters that the bond between Valdengo and the community of the Biellesi in Argentina endured quite a long time, generating reciprocal expectations and answering reciprocal needs. And whereas many studies have emphasized the role of the funds sent back to Italy by the emigrants, here, instead, one discovers that funds from the community of origin were being sent to Buenos Aires to support

the enterprises of the Biellese community. Concerning the temporal and economic nexuses that linked the Little Italies with their hometowns we still know very little.[46]

Perhaps what would be most meaningful as these studies move forward would be if we could unmoor the category of Little Italy from its spatial and geographic dimensions and instead consider the Little Italies as networks of relationships, identifying their nodes and their extent, rather than thinking of them as communities or neighborhoods. Seen in this way, Little Italy represented an accumulation of social capital whose growth and development, and the direction it offered to its members, remain to be examined. It is easy to see how this might open a vast field for new investigations. As the written testimony of so many Italian American writers informs us, Little Italies that were real or imagined continue to play a fundamental role in the construction of the identities of large sectors of the Italian ethnic group.[47] Moreover their resurgence as places for cultural tourism and their role in the commercialization of ethnicity reveal how Little Italies seem to respond to the profound need for identification in the collective imagination that even transcends the boundaries of the particular ethnic group itself. What is happening now in the Little Italies does not seem to be happening among other ethnic groups. Evidently the Little Italies are places where even people who do not have Italian ancestry are able to see or to imagine, whether staged or lived, that emotionalism, that sensuality, the power of the hopeful and profound feelings of loyalty to the blood ties that we all harbor. Yet these feelings in many of us have been repressed by the rationality and efficiency of the industrial and technological economy, by the emotional sterility and by the suspension or parceling out of individual responsibility that managerial careerism induces. Little Italy is thus "a theater of extremes."[48] It needs to survive so that postmodern society may remember the existence of a part in us that tends to be suffocated.

Translated by William J. Connell

Further Reading

Cinotto, Simone, ed. *Making Italian America: Consumer Culture and the Production of Ethnic Identities.* New York: Fordham University Press, 2014.

DeMarco, William M. *Ethnics and Enclaves: Boston's Italian North End.* Ann Arbor: UMI Research Press, 1981.

McKibben, Carol Lynn. *Beyond Cannery Row: Sicilian Women, Immigration, and Community in Monterey, California.* Urbana: University of Illinois Press, 2006.

Notes

Writing about Italian Americans has been one of my main passions ever since my years at university. Along the way I met Stefano Luconi who has become a lifelong friend and an irreplaceable cultural reference. This chapter would not have been written without his suggestions and comments. Special thanks to William J. Connell, whose patience and careful translation made this chapter possible. An earlier version of this chapter was published in Italian in *Storia dell'emigrazione*, 2: 207–233.

1 Donna Gabaccia, "Global Geography of 'Little Italy': Italian Neighbourhoods in Comparative Perspective," *Modern Italy*, 11 (2006), 17.

2 Maria Laurino, *Were You Always an Italian? Ancestors and Other Icons of Italian America* (New York: Norton, 2000), 121–155.

3 Ibid., 121.

4 Gianfranco Zucca and Danilo Catania, "Dove il grattacielo incontra il cielo: Tempo biografico e commemorazione storica nei giovani di origine italiana di New York e San Francisco," *Altreitalie*, 36/37 (2008), 290–300.

5 Marie-Claude Blanc-Chaléard, "Introduction," in *Les Petites Italies dans le monde*, ed. Marie-Claude Blanc-Chaléard, Antonio Bechelloni, Bénédicte Deschamps, Michel Dreyfus and Éric Vial (Rennes: Presses Universitaire de Rennes, 2007), 18–20.

6 Rudolph Vecoli, "Immigration, Naturalization and the Constitution," *Studi Emigrazione*, 85 (1987), 75–101.

7 Russell King, "Work and Resident Patterns of Italian Immigrants in Great Britain," *Studi Emigrazione*, 16 (1978), 74–81; Terri Colpi, "Origins and 'Campanilismo' in Bedford's Italian Community," in *A Century of Italian Emigration to Britain, 1880–1980s* [=supplement to *The Italianist*, 13 (1993)], ed. Lucio Sponza and Arturo Tosi, 59–77.

8 John Zucchi, "Les 'petits Italiens': Italian Child Street Musicians in Paris, 1815–1875," *Studi Emigrazione*, 97 (1990), 27–52.

9 Angelo Trento, "L'assimilazione degli italiani in Brasile," in *Nascita di una identità: la formazione delle nazionalità americane*, ed. Vanni Blengino (Rome: Edizioni Associate, 1990), 242–53; Fernando J. Devoto, "L'emigrazione ligure e le origini di un quartiere italiano a Buenos Aires (1830–1870)," in *Popolazione, società e ambiente: Temi di demografia storica italiana (secc. XVII–XX)*, ed. Società Italiana di Demografia Storica (Bologna: Clueb, 1990), 477–498 (478–479).

10 Donna Gabaccia, "Global Geography of 'Little Italy': Italian Neighbourhoods in Comparative Perspective," *Modern Italy*, 11 (2006), 9–24.

11 Robert C. Freeman, "The Development and Maintenance of New York City's Italian American Neighborhoods," in *The Melting Pot and Beyond: Italian Americano in the Year 2000*, ed. Jerome Krase and William Egelman (Staten Island: AIHA, 1987), 226.

12 Gabaccia, "Global Geography," 11, 18–22.

13 Gabaccia, "L'invention de la 'Petite Italie' de New York," in *Les Petites Italies*, ed. Marie-Claude Blanc-Chaléard, Antonio Bechelloni, Bénédicte Deschamps, Michel Dreyfus and Éric Vial (Rennes: Presses Universitaires de Rennes, 2007), 27–43.

14 Thomas J. Archdeacon, *Becoming American: An Ethnic History* (New York: Free Press, 1983), 116–122.

15 Reed Ueda, "Naturalization and Citizenship," in *Immigration*, ed. Richard A. Easterlin, David Ward, William S. Bernard and Reed Ueda (Cambridge: Harvard University Press, 1982), 106–144.

16 Archdeacon, *Becoming*, 118–119, 139. The data are obviously only an indication, since it is not clear how many Italians made the voyage more than once.

17 Rudolph J. Vecoli, "Prelates and Peasants: Italian Immigrants and the Catholic Church," *Journal of Social History*, 2 (1969), 217–268.

18 Lester R. Kurtz, *Evaluating Chicago Sociology: A Guide to the Literature with an Annotated Bibliography* [1984] (Chicago: University of Chicago Press, 1986), 1–11; Stow Parson, *Ethnic Studies at Chicago, 1905–45* (Urbana: University of Illinois Press, 1987).

19 Robert E. Park, Ernest W. Burgess and Roderick D. McKenzie, *The City* [1925] (Chicago: University of Chicago Press, 2012), 7.

20 Ibid., 115–119.

21 William Foote Whyte, *Street Corner Society: The Social Structure of an Italian Slum* (Chicago: University of Chicago Press, 1943); Jerre Mangione, *Mount Allegro: A Memoir of Italian American Life* [1942] (Syracuse: Syracuse University Press, 1998); Herbert Gans, *The Urban Villagers: Group and Class in the Life of Italian-Americans* [1962] (New York: Free Press, 1982).

22 Rudolph J. Vecoli, "*Contadini* in Chicago: A Critique of *the Uprooted*," *Journal of American History*, 54 (1964), 404–417.

23 John S. MacDonald and Leatrice D. MacDonald, "Chain Migration, Ethnic Neighborhood Formation, and Social Networks," *The Milbank Memorial Fund Quarterly*, 42 (1964), 82–97.

24 Humbert S. Nelli, *The Italians in Chicago, 1880–1930: A Study in Ethnic Mobility* (New York: Oxford University Press, 1970), 22–55.

25 John W. Briggs, *An Italian Passage: Immigrants to Three American Cities, 1890–1930* (New Haven: Yale University Press, 1978).

26 Virginia Yans-McLaughlin, *Family and Community: Italian Immigrants in Buffalo, 1880–1930* (Ithaca: Cornell University Press, 1977).

27 Rudolph Vecoli, "The Formation of Chicago's Little Italies," *Journal of American Ethnic History*, 2 (Spring 1983), 5–20.

28 See the essays by Valentine J. Belfiglio ("Italians in Small Town and Rural Texas"), Ryan Rudnicki ("Migration Networks and Settlement Patterns: Patterns of Italian Immigrant Settlement"), and Ernesto Milani ("Marchigiani and Veneti on Sunny Side Plantation") in Rudolph J. Vecoli, ed., *Italian Americans in Rural and Small Town America* (New York: AIHA, 1987).

29 Milani, "Marchigiani and Veneti," 27.

30 Mangione, *Mount Allegro*, passim.

31 Salvatore LaGumina, "Gli italo-americani a Long Island: gli anni della fondazione," in *Euroamericani*, vol. 1, *La popolazione di origine italiana negli Stati Uniti*, ed. Marcello Pacini, Rudolf J. Vecoli and Domenic Candeloro (Turin: Fondazione Agnelli, 1987), 269–279.

32 Donna Gabaccia, *From Sicily to Elizabeth Street: Housing and Social Change Among Italian Immigrants, 1880–1930* (Albany: SUNY Press, 1984).

33 Diane C. Vecchio, *Merchants, Midwives, and Laboring Women: Italian Migrants in Urban America* (Urbana: University of Illinois Press, 2006); Carol Lynn McKibben, *Beyond Cannery Row: Sicilian Women, Immigration, and Community in Monterey, California* (Urbana: University of Illinois Press, 2006); Dominic Candeloro, Kathy Catambrone and Gloria Nardini, eds., *Italian Women in Chicago: Madonna mia!! Qui debbo vivere?* (Stone Park: Casa Italia, 2013). Historical writing on this subject has grown in recent years. Among the most useful studies is Stefano Luconi and Mario Varricchio, eds., *Lontane da casa: Donne italiane e diaspora globale dall'inizio del Novecento a oggi* (Turin: Accademia University Press, 2015).

34 Stefano Luconi, *Little Italies e New Deal: La coalizione rooseveltiana e il voto italo-americano a Filadelfia e Pittsburgh* (Milan: Franco Angeli, 2002), 241–244.

35 Maria Susanna Garroni, ed., *Sorelle d'oltreoceano: Religiose italiane ed emigrazione negli Stati Uniti: una storia da scoprire* (Rome: Carocci, 2008); Stefania Bartoloni, ed., *Per le strade del mondo: Laiche e Religiose fra Ottocento e Novecento* (Bologna: Il Mulino, 2007). The role of the Church in the Little Italies needs further study, as indicated in Massimo di Giocchino, "Religione e società nelle Little Italies statunitensi (1876–1915): Una rassegna tra studi e fonti," *Archivio Storico dell'Emigrazione Italiana* (May 2016), www.asei.eu/it/2016/05/.

36 Vecchio, *Merchants*, 61.

37 Robert A. Orsi, *The Madonna of 115th Street: Faith and Community in Italian Harlem, 1880–1950* [1985], 3rd ed. (New Haven: Yale University Press, 2010).

38 Michael Immerso, *Newark's Little Italy: The Vanished First Ward* (New Brunswick: Rutgers University Press, 1997); Anthony V. Riccio, *Portrait of an Italian-American Neighborhood: The North End of Boston* (New York: Center for Migration Studies, 1998).

39 Marianna De Marco Torgovnick, "On Being White, Female, and Born in Bensonhurst," in *Beyond the Godfather: Italian American Writers on the Real Italian American Experience*, ed. A. Kenneth Ciongoli and Jay Parini (Hanover: University Press of New England, 1997), 158.

40 Andreina De Clementi, "La sfida dell'insularità. Generazioni e differenze etniche tra gli emigrati meridionali italiani negli Stati Uniti," *Memoria e Ricerca*, 8 (1996), 99–114; Micaela di Leonardo, *The Varieties of the Ethnic Experience: Kinship, Class and Gender Among California Italian-Americans* (Ithaca: Cornell University Press, 1984), 131–135.

41 Stefano Luconi, *From Paesani to White Ethnics: The Italian Experience in Philadelphia* (Albany: SUNY Press, 2001).

42 Luconi, *Little Italies e New Deal*; see also the essays of Garroni, Elisabetta Vezzosi and Vecoli in Andrea Panaccione, eds., *May Day Celebration* (Venice: Marsilio, 1988).

43 Nicholas DeMaria Harney, "Italian Diasporas Share the Neighborhood (in the English-Speaking World)," *Modern Italy*, 11 (2006), 3–7.

44 Gordon Shufelt, "Jim Crow Among Strangers: The Growth of Baltimore's Little Italy and Maryland's Disfranchisement Campaigns," *Journal of American Ethnic History*, 19.4 (2000), 49–78; Luconi, *From Paesani*, 125–146; Simone Cinotto, *Una famiglia che mangia insieme: Cibo ed etnicità nella comunità italoamericana di New York, 1920–1940* (Turin: Otto editore, 2001), 149–157.

45 Harney, "Italian Diasporas," 3-7.

46 Samuel L. Baily and Franco Ramella, eds., *One Family, Two Worlds: An Italian Immigrant Family's Correspondence Across the Atlantic, 1901–1920*, trans. John Lenaghan (New Brunswick: Rutgers University Press, 1988).

47 Dan Ashyk, Fred L. Gardaphé and Anthony Julian Tamburri, eds., *Shades of Black and White: Conflict and Collaboration Between Two Communities* (Cleveland and Staten Island: AIHA, 1999).

48 Orsi, *The Madonna*, 48.

10

CULTURE AND IDENTITY
ON THE TABLE

Italian American Food as Social History

Simone Cinotto

Novelist Mario Puzo (1920–1999) was once asked what he felt was at the core of his Italian American identity. With no hesitation, the author of *The Godfather* (1969) and *The Fortunate Pilgrim* (1965) confessed:

> I had every desire to go wrong but I never had a chance. The Italian family structure was too formidable. I never came home to an empty house; there was always the smell of supper cooking. My mother was always there to greet me. [. . .] During the great Depression of the 1930s, though we were the poorest of the poor, I never remember not dining well. Many years later as a guest of a millionaire's club, I realized that our poor family on home relief ate better than some of the richest people in America. My mother would never dream of using anything but the finest imported olive oil, the best Italian cheeses. My father had access to the fruits coming off ships, the produce from railroad cars, all before it went through the stale process of middlemen; and my mother, like most Italian women, was a fine cook in the peasant style.[1]

Puzo's memory vividly frames the reasons that made food a vital marker of Italian American identity, deeply embedded into and revealing the social and cultural history of Italians in the United States; in the Hell's Kitchen district of Manhattan where the young Mario grew up, as well in the many other places reached by Italian immigrants. First, for the Puzos as well as many other Italians in the United States in the early twentieth century, food became culturally entrenched with "family," sentiments expressed, for instance, in Ralph Fasanella's classic painting, *Family Supper*. (See Color Plate 17.) The family was at one time the social unit many of them relied upon the most as they navigated the difficulties and sorrows of migration and settlement, and the special ethos and distinctive notions of intimacy and domesticity, which they thought best identified them in the eyes of other Americans. Puzo's Proustian "smell of supper cooking" sensually evokes in memory the values and behaviors that made the Italian family structure "formidable"—which comprised some forms of resistance to individual social mobility, seen as a disintegrating force. Many among the more than three million turn-of-the-twentieth-century Italian immigrants to the United States, and their children and grandchildren after them, believed in the power of food to create and support family and community in a world of cultural and material stress. The culture-building process was heavily gendered. Placing food as the center of ethnic domesticity and identity resulted in the significant feminization of the immigrant private sphere: Italian immigrant women were invested of the role of family and homemakers through their culinary skills;

tradition-keeping specialists who, like Puzo's mother, were, or had to learn to be, "fine cooks in the peasant style." The centrality of mothers as nurturing saints holding the real power in Italian American family culture was widely amplified by their social importance as managers of food consumption and rituals in the immigrant home.[2]

The fact that before World War I a disproportionate number of migrants were single men, and sometimes single women, who had left their family in Italy and lived together in work camps and communities, certainly played a role in making food a pivotal factor in the Italian American experience. On the one hand, distance and uncertainty about spouses and children across the ocean fostered the idealization of family togetherness as a central "Italian" social value to be attained as soon as possible, at the same time as even members of the extended family who were already in the United States had become more important as sources of support than they had ever been in Italy.[3] The bountiful Italian Sunday dinner opened to aunts, uncles and cousins, which, once families had finally reunited in America, developed into the quintessential festive ritual for Italian Americans, celebrated family solidarity and cohesiveness through a comprehensive meaning of family—and food sharing as its cement. On the other hand, single men and women living together in labor camps and boardinghouses, and sticking to their food preferences, often catered to by a *padrone* (ethnic broker) who supplied them with Italian food, helped Italian food habits to persist in the United States even in the transiency of early phases of migration.[4] Migrant men and women without families needed some public or semipublic institutions that fed them. After the end of mass migration, some of the boardinghouses where the single immigrants lived eventually evolved into early Italian restaurants, gradually discovered and patronized also by non-Italians. Together with Chinese and Mexicans—the other two major immigrant groups that in an earlier migration stage had been overwhelmingly male—Italians created the strongest public cuisine and most popular restaurants in the United States.[5]

In fact, the second reason why food has been at the center of the Italian American experience is the importance of the food trade (Puzo's mother's "finest imported olive oil and best Italian cheeses" and his father's "fruits coming off ships and produce from railroad cars") in the Italian immigrant economy. Merchants importing food from Italy to the United States were some of the most numerous category among earlier migrants, so that when the great migration wave hit U.S. large cities a system of supply of Italian food to Italian immigrant consumers already existed. Supported by the Italian state, which looked at the immigrant "colonies" overseas as crucial markets for Italian products and beachheads for Italian diplomacy, immigrant importers purveyed immigrant communities with genuine Italian food, before a domestic industry of Italian food, for the most part in the hands of other Italian Americans, emerged and took over most of the ethnic market after World War I. Both Italian food importers and domestic producers of Italian-style food, which as wealthy businessmen providing jobs to other Italian immigrants surged as some of the *prominenti* (ethnic leaders) in their respective communities, were able to promote the consumption of their products as the best way immigrant consumers could articulate their new identity of Italians in America. As such, they should be counted among the most effective diasporic nation builders. Since the interwar years, Italian restaurants attracted a growing clientele of non-Italian eaters, including middle-class Americans, thus successfully popularizing food as a vital part of Italian American life, culture and identity. By the 1920s, Italian immigrants were represented at every link of the American food chain and at every occupational level: from the blueberry pickers of New Jersey to the sugarcane sharecroppers of Louisiana, to the vineyardists of California, to the itinerant fish peddlers of Philadelphia and Boston, to the waiters and staffs of New York's Greenwich Village and Theater District Italian restaurants. Some of them became tycoons, or "kings," in their own trade, and their names are still popular today as well-known brands.[6]

The role of the food trade in Italian American economy and as a material and cultural bond between Italy and the United States was and has never since ceased to be fundamental.

Thirdly and finally, the mutually fueling cycle of production and consumption of Italian food in America, and the inextricable entrenchedness of the material, nutritional and economic nature of food with its cultural, symbolical and imaginative dimension, not only made the consumption and sharing of familiar food a common language that all Italians in the United States understood and valued, but actively translated identity into *taste*. The food preferences of Italians in America became representations of their vision of the world, of who they were, and who they aspired to be. As Puzo insisted, even "though we were the poorest of the poor, I never remember not dining well." The relative abundance of food the immigrants enjoyed in the United States seemed to them the promise their migration project had fulfilled most completely. As working people, the opportunity of "dining well" was revolutionary, as the high levels of consumption of the food of choice dismantled barriers of social inferiority that were inscribed in their often short and rickety bodies as well as—in reverse—in the bigger and healthier bodies of their American-born children. For immigrants, being able to be hospitable and offer rich and nutritious food to family and guests meant achieving a long-denied respectability. Their self-described superior taste for food, regardless of their limited economic means ("our poor family on home relief ate better than some of the richest people in America"), provided Italian immigrants with a sense of distinction rooted in a valuable ancestral heritage and a distinctive cultural citizenship in the American multiethnic landscape.

Food and Migration: Social Landscapes and Geographies of Italian American Food

Any chronological discussion of Italian American food and cuisine must start from what immigrants ate, and most often wanted to eat but couldn't, in their native country. The *Inchiesta Agraria e sulle Condizioni della Classe Agricola* [Survey of Rural Areas and the Living Conditions of Rural Workers, 1881–1890], better known as *Inchiesta Jacini* from the senator of the Kingdom of Italy, Stefano Jacini, who initiated it, documents in fine detail the diet of the vast majority of the Italian population, from North to South, who lived on the land, including most of those who were joining the migration flow to the United States. Italian migrants to the United States brought with them neither a sense of nation (they reserved their feelings of affiliation to their families and villages), nor the concepts and practices of a national cuisine. The first edition of Pellegrino Artusi's *The Science in the Kitchen and the Art of Eating Well*—the first and most famous effort to provide the new Italian bourgeoisie with a tool of collective identity that connected the table and the nation—had just been published (1891) and remained obviously out of reach for a highly illiterate population. Even Artusi, after all, limited himself to collect and assemble specialty dishes of the regions he knew best, Tuscany and Emilia-Romagna, and of the principal cities. In the countryside, among the peasant majority, a patchwork of local food habits prevailed. The *Inchiesta Jacini* noted that the staples of the *contadino* (peasant) diet were corn polenta and chestnuts in the North, and black bread and vegetable soup in the South. These foods were complemented with small amounts of durable proteins—cured pork, cheese, dried cod and salted sardines—and cooking fats, mostly lard, rarely butter (in the North) or olive oil (in some coastal areas).[7] As the wide use of American plants like corn, potatoes, tomatoes and red chili peppers, imported into Europe as part of the Columbian Exchange, clearly witnessed, Italian regional cuisines were themselves recent inventions, the best of the special-occasion, festive gastronomies of the poor that the local middle classes had merged into their cookery.[8] Industrially produced

durum-wheat pasta was a fairly rare commodity at the turn of the twentieth century, if not in the production areas of Naples, Genoa and Western Sicily, and even Neapolitans, by far the world's largest consumers of pasta at the time, had only in the 1830s begun to sauce their macaroni with tomatoes.[9] Pizza, a Neapolitan street food delicacy that intrigued *belle époque* travelers, was virtually unknown outside the city.[10]

Leaving behind the scarcity of lands impoverished by rural crisis and overpopulation, mobile peasants experienced dietary change as soon as they boarded the ship that would take them to America: The Italian state and the religious associations that provided assistance to migrants prescribed shipping lines to provide steerage passengers with nutritious meals. Being served beef—the most dreamt of and least consumed food in the Italian peasant food-scape—was a pleasant surprise for them.[11] Because of the U.S. precocious industrialization of food production and distribution and, consequently, the falling prices of most foodstuffs by the end of the nineteenth century, Italian immigrants almost everywhere in the United States enjoyed a vast availability of food at much cheaper costs than in Italy. In 1909, a report of the Italian Ministry of Foreign Affairs stated that the immigrant diet was overall "much more abundant, varied, and nutritious in the United States than in the homeland."[12] Immigrant cooks—especially in cities—had to face the lack of familiar ingredients, but had access to an unprecedented variety of foods, including those brought to American tables by U.S. imperial expansion in equatorial Latin America. The technical conditions of prepara-tion—in an urban rather than rural environment; on a gas stove rather than the open fire typical of many Italian peasant homes—also encouraged change, creativity and innovation. Furthermore, interaction with Italians from different parts of the country stimulated culinary hybridization in a diasporic-national dimension. In one of the very few autobiographies of Italian women in the great migration of the turn of the twentieth century, the Lombard migrant Rosa Cavalleri remembered that her daily chore in the iron mining camp in Mis-souri, where her husband worked, consisted of cooking for twelve men:

> Never in my life had I made coffee, and I would have to learn if I was going to cook for these men in America. "But it is easy, Rosa," Gionin [one of the immigrant men] said. "Just make the water boil and grind the coffee and put it in like this. And always we have plenty of sugar and cream to go in. [...] Angelina [a Sicilian woman] will teach you everything—even to make the spaghetti and ravioli like the people in South Italy."[13]

Puzo's mother might have learned to be "a fine cook in the peasant style" in similar circumstances. In America, immigrant cooks created new dishes out of their memories of recipes and practices handed down by imitation and oral transmission in their original homes and local communities, so that invention and hybridization were mantled with tradition and authenticity. In the urban East, where immigrants from the Italian South widely pre-dominated, and many of the early Italian food merchants were Neapolitan and Sicilian, there did emerge a "red sauce" cuisine, based on tomato sauce, olive oil, garlic, macaroni and melted cheese, which became, in effect, the first real, globally recognized and popular, Italian national cuisine. Popular elaborations of southern Italian dishes that became Italian American classics—while remaining for the most part unknown in Italy—included spaghetti and meatballs, lasagna, baked ziti and manicotti, veal and chicken parmigiana, sausage and peppers or broccoli rabe and Italian cheesecake. These recipes articulated the social mean-ing of Italian American gastronomy: the generous use of ingredients (meat, durum-wheat pasta, canned tomato products, olive oil, sugar, coffee) that in rural Italy had been highly valued, but remained mostly out of reach because they had to be purchased for money on

the market, and the substitution of these richer ingredients for poorer originals (e.g., the slices of veal or chicken for eggplants or zucchini in the *parmigiana*), translated festive food into the everyday and imitated the food immigrants had jealously seen the elite of their *paese* (hometown) consuming. Italian American foodways signified a newly attained social status, respectability and even full humanity on the part of the immigrants who cooked and consumed them. Southern Italian rural immigrants, who by the end of the nineteenth century in their home country had been racialized as short, weak, lazy, poor workers, poor soldiers, and poor mothers, specifically because of their exceedingly low-protein diet, could see the effect of the dietary transformation in anthropological terms by looking at their own, and especially their children's, bodies.[14] In 1937, a correspondent from New York for the Italian newspaper *La Stampa*, aware of the racial structure that regulated access to full American citizenship, linked dietary improvements to skin color:

> Our immigrants and their children, especially those from Southern Italy, suffered from dietary defects different from those that afflicted Americans. While the latter ate too much meat and little or no vegetables, fruits, and legumes, for our people it was the opposite. They ate abundant fruit and vegetables, but only every now and then meat, milk, and butter. Over here as well [as in Italy,] vitamin deficiency frequently produced rickets. One had to feel the mortification of seeing in American scientific texts Italians ranking along with Negroes in rates of rickets. In immigrants' hometowns, dietary deficiencies influenced profoundly the skeletal development producing the low height of those populations, and the miserable appearance which disturbed Americans so much that they came to consider us a degenerate race, [. . .] but it was right here in America that the fact that height deficiency is not a fixed character of our race was brilliantly proved. [. . .] From rickety, dwarf-like, and simian-paced parents, a spawn of giants is born. When you enter some Italian homes, and mother and father introduce you to their children, you are immediately prompted to ask: "Are they really your children?" [. . .] Another feature that tends to fade away in America is the dark complexion of southern Italians. It is apparent that this, too, is not a fixed character and distinctive of race, but a consequence of climatic conditions. The children born in America are far more light-skinned than their ancestors.[15]

The socially revolutionary character of Italian American gastronomy is further witnessed by the general manifestations of disgust that middle-class travelers from Italy reserved to the food that was served to them when they visited U.S. Little Italies. Whereas immigrants were developing a taste for their diasporic cuisine and adopting its hybrid flavors as distinctive signs of an emerging identity, middle-class visitors found Italian American food to be too spicy, too garlicky, and too greasy; a vulgar and vilifying mockery of "Italian cuisine" that betrayed the lack of taste of stranded rural people who had encountered the mass consumerism of the American marketplace (which they also viewed with suspicion).[16]

Alongside class, geography and the regional distribution of Italian immigrants in the United States played an important part. Turn-of-the-twentieth-century Italian immigration to the Western United States was demographically and socially quite different from that of the urban East. Many California Italians were Northerners from Tuscany, Liguria and Piedmont; they first entered a racialized society and labor market in which not they but Chinese, Mexicans and other non-European immigrants were the most disadvantaged ethnic groups; and they were disproportionately represented in agriculture, winemaking and other food-related occupations and businesses (as opposed to the construction work and

garment-industry jobs landed by many Italian immigrants to New York or Chicago). As a result, not only was Italian American food culture different in California—"Northern Italian" foods like *pesto, focaccia* and *cioppino* (a reinvented Genoese fish soup) were commonplace there while virtually unknown in the East as well as in most of Italy—but much of the fruit, produce and wine that Italian Americans ate and drank throughout the United States was raised, marketed and shipped by Italian immigrants in the West.[17]

It was especially in the industrial East and Midwest, where Italian immigrants congregated in close-knit urban enclaves, that early in the twentieth century middle-class social workers, philanthropists and reformers, armed with the discoveries of emerging modern food science, actively mobilized to reform Italian immigrant foodways, which they, much like their visiting Italian counterparts, saw as unhealthy, stimulating the consumption of alcohol and wasteful.[18] These efforts waned in the interwar years when further immigration from Italy was halted by law, Southern Italian immigration ceased to be a U.S. national emergency, and other migrants—blacks from the American South, Mexicans and Puerto Ricans—replaced Italians as "problem" groups. What did not change over time was the centrality of food in Italian American family life—as highlighted by Puzo. In fact, the durability of the culture that made food the Eucharist that sanctioned the family communion, and defined gender and generational identities in the family, needs to be explained in the face of second generation Italian immigrants' widespread rejection of features of the immigrant culture as marks of social inferiority and shame in the interwar years.[19] Some American-born Italian schoolchildren felt that the food habits of their parents were a source of shame, as un-American, anti-modern and at odds with the mass popular culture they were so attracted to:

> "To have a bite I either stole some money from home or took it from my shoe shining on Saturdays and Sundays," confessed one of them. "With this money I would buy the same stuff that non-Italian boys were eating. To be sure, my mother gave me each day an Italian sandwich; that is half a loaf of bread filled with fried peppers and onions, or with one half dipped into oil and some minced garlic on it. Such a sandwich would certainly ruin my reputation; I could not take it to school. My God, what a problem it was to dispose of it, for I was taught never to throw away bread."[20]

The social resolution of this cultural clash accounts for the persistence of the Italian American gastronomic model through the generations. As Puzo's memory suggests, the success of the ideology of the "Italian family," shaped and transmitted through food-sharing rituals, was largely rooted in class. Immigrant parents were able to carve a space for food as the mobilizing force for the "Italian family" narrative, and by that means building solidarity and controlling the desire of younger members for freedom and mobility. As they gradually allowed their children to act autonomously in the public world of "American society," (there actually was no viable alternative to that) immigrants constructed a domestic and intimate "traditional" space in which everybody was asked to act "Italian," i.e., relinquish their individualism to the group's collective project and participate in its ceremonials.[21] Family food rituals incorporated and nonverbally articulated the entire narrative. The latter, however, would have been ineffective if it were not grounded in the fact that family ties remained critical to the survival of members of the urban working class, especially during the Depression. In the end, although rooted in a working-class immigrant culture, the development of Italian American versions of such concepts as home, domesticity and privacy signaled an early move by Italian Americans toward middle-class values and behaviors, especially notable as a statement of distinction from the African American migrants who increasingly, since the 1920s, arrived in the inner-city sections that had been Italian immigrant first-settlement

areas. Italian American foodways sanctioned the notion of Italians as a family people hold-ing a superior family culture also in opposition to the family (and food) cultures of these disadvantaged newcomers.[22]

Finally, the increasingly positive perception of Italian food by and even popularity among non-Italian Americans since the 1930s significantly helped Italian immigrant food's process of intergenerational cultural transmission and identification. That was, in turn, for a large part the result of the successes of the Italian food industry in the United States.

Italian American Food Business: Social Mobility, Cultural Cohesion, Transnational Politics

Since the turn of the twentieth century, the attachment of Italians in America to their dis-tinctive foodways has been at once the cause and the consequence of the disproportionate Italian presence in virtually every kind of food business, from pushcart peddlers and gro-cers to manufacturers, importers and restaurateurs. While providing material for community self-sufficiency in the form of food and jobs, the ethnic food industry effectively linked its interests to Italian cultural nationalism in the United States, thus dramatically fostering the symbolic connection between food and Italian American identity.

A decisive early impulse to the development of food businesses among Italian immigrants in America was provided by immigrants' articulation of the diasporic nostalgia of home into consumption: The economy of Italian immigrant food was always also an economy of emo-tions. A lively food trade existed in the early years of the twentieth century among immi-grants from Cinisi, Sicily, to New York:

> Someone takes his chances in the business world. He writes to his relatives in Cinisi, has olive oil, wine, and figs, lemons, nuts, etc., sent to him, and then he goes from house to house. He does not enter in a business way, but goes to visit some family, talks about Cinisi, then informs them that he has received some produce from the hometown. And sure enough, the people will say, "You will let us get some, eh?" "Of course. Tell your relatives. I can get all you want." In this way the business man makes his sales.[23]

The presence in many states of the Union of large markets of Italian food consumers like those from Cinisi allowed Italian immigrant entrepreneurs in the food business to benefit from their exclusive social and cultural capital in a nearly monopoly regime, making the most of the network of privileged relations they could build in the communities and profit-ing from their knowledge of the tastes of their Italian customers. Further attractive factors for the concentration of Italian immigrants in the food business were the low capital required at level entry in independent occupations, like—at the most basic—in the street peddling business, and the insecure and demanding nature of many trades in agriculture and the food processing industry, which discouraged many other potential competing groups from the field. Finally, food trade accounted for most of the economic relations between the United States and Italy, and is still to this day among the most valuable items in the Italian exports to the United States.[24] This created jobs and wealth for Italian Americans as well as continued the circulation of foods, culinary ideas and gastronomic imaginaries between the two sides of the Atlantic.

New York-based Italian importers of citrus fruit and Marsala wine from Sicily, canned tomato products and pasta from Naples and olive oil and hard cheese from Genoa were already overrepresented in the city among the immigrant mercantile class before the arrival

of the mass proletarian immigration of the end of the nineteenth century. These merchants were early on ready to supply recent immigrants with food they could recognize as theirs.[25] The preference of immigrants for food that was familiar and authentic led them to support Italian food imports with great loyalty, which resulted in making food vital for Italy's export economy and food importers some of the most effective representatives of Italian economic interests in the United States, before, under and after Fascism. In Italy, the demand from the large communities of Italian immigrant eaters in New York, Chicago and San Francisco resulted in a boom of the predominantly small-scale local food industry early in the twentieth century.[26] Under the aegis of the Italian Chambers of Commerce established in New York, Chicago and San Francisco, immigrant food businessmen kept relations with Italy alive in the interwar years and beyond, and had a most active role, using modern means like advertising in the Italian-language press and sponsoring Italian radio shows, in promoting ethnic consumerism and placing food at the core of Italian American identity discourses.[27] The most aggressive effort at linking diasporic nationalism and the table was the "buy Italian" campaign launched by the Italian Chamber of Commerce and the pro-Fascist Italian press in 1935, which asked immigrants in America to support Italy, the homeland "strangled" by the embargo declared by Great Britain and France in retaliation for the Italian invasion of Ethiopia, by purchasing Italian imported foods.[28]

Such pressing pleas to the diasporic nationalism of immigrant consumers reflected the increasingly significant competition brought to Italian food imports by domestic production, also in the hands of other Italian immigrants. After World War I, when the conflict temporarily cut off imports from Italy, mass immigration waned, and new protectionist tariff policies heavily penalized Italy's exports, local productions and systems of supply of Italian-style food to the immigrant communities (and the general market) mushroomed in every angle of the United States reached by sizeable Italian contingents. Italian immigrant farmers introduced many vegetables to American fields—eggplants, zucchini, broccoli, fennel, endive, escarole and many others—and dramatically expanded the production of the return migrant, the tomato. Domestic food processing plants and farms supplied Little Italies and Italian immigrant homes with Italian sausages, Italian cheeses, Italian canned tomatoes and Italian pasta, all made in the United States from American ingredients.[29] Every U.S. city with a more than negligible Italian population had its pasta company by 1930. In California, Italian wine makers supplanted previous immigrants from Germany, France and Scandinavia to become leaders of the market, before and after the Volstead Act (they turned into homemade wine grape growers during Prohibition). The near totality of the wine Italian immigrants drank in their urban enclaves of the East came from across the continent, and was made by other Italians.[30] In fact, some of the most notable success stories in Italian immigrant business history belong to the food trade: the founder of Chef Boy-Ar-Dee canned pasta products, Hector Boiardi; Planters Nut's founder Amedeo Obici; the founder of the American Canning Co. (later Del Monte Corporation), Mark Fontana; the brothers Ernest and Julio Gallo of the E. & J. Gallo Winery; and Joseph DiGiorgio, the Sicilian produce sale middleman who established the DiGiorgio Corporation, to cite a few. In many of these companies the bulk of the labor was Italian: the Italian-Swiss Colony of Asti, California, employed only Italian immigrants by statute; the overwhelming majority of the workers in the American Canning Co. of Monterey were Sicilian and other Italian women.[31] As Italian immigrants dominated the industry, both as workers and entrepreneurs, their ethnicity was fundamental in guaranteeing immigrant consumers about the authentic *italianità* of their Italian American food products, which created strong bonds, colored in green, white and red, between producers and consumers.

These bonds also actively created *place*. Even if Italian immigrants were never the absolute majority of the population, not even in the city enclaves called Little Italies, but shared the urban space with other groups, the proliferation of Italian grocery stores, bakeries, butcher shops and fruit and vegetable open markets emanating the flavors, smells, colors and names of Italian food, conferred the areas where they concentrated a distinct Italian character, both for the Italian residents themselves and outsiders, donning otherwise anonymous neighborhoods with a clear Italian identity. "There was the reassuring fragrance of warm bread," a recent immigrant recalled about the first the street where he lived in America, "the heady aroma of roasting coffee, the musty smell of wooden barrels filled with wine, the pungent odors of ripe olives and anchovies in brine, of gorgonzola and provolone cheese and hanging salami."[32] Italian immigrants used different strategies to reclaim the space of the neighborhoods where they lived as "theirs." One of these was street *feste*, involving the sacred dimension of the Mass, blessings and procession of the Madonna or patron saints. Food from stalls and restaurants run by other Italian immigrants was invariably the most powerful sensual media of the participants' sharing in Italian American identity.[33] Finally, Italian food stores and markets performed important collateral social functions in Italian urban communities: They may have offered food on credit to needy neighbors, served as meeting places and call centers when few working people had private telephones, and surveilled the streets for the local community. In her famous book-length attack against modernist urban renewal, Jane Jacobs praised at length two Italian immigrant neighborhoods in New York City, East Harlem and Greenwich Village, as examples of the instrumentality of independent food stores in catering to the distinctive needs of local residents and providing them with the sense of safety of an urban village.[34]

A specific division of the Italian American food industry—restaurants—was critical in articulating the connection between Italians and their food, and popularizing correlated images of pleasure and exoticism, for non-Italian American consumers. Such narration was so successful, indeed, to eventually propagate from the Little Italies of North America, via American popular culture, to the rest of the world. Many imaginaries about Italian immigrants were negative, in early-twentieth-century urban America. Yet others were positive, if seen through the lens of the consumption of cultural difference, at a moment when ethnic tourism, or "slumming," as it was sometimes called, was nascent. To outsiders, Italian immigrants in U.S. cities seemed to conduct most of their lives in public, on the streets; the contrary of what was prescribed by Victorian middle-class culture, which restricted the expression of authentic feelings and emotions to the domestic intimacy of the home.[35] Early tourist guidebooks to New York did not deny the poverty and chaos that the visitor (imagined as Anglo-Saxon and middle-class, male and female) would have met on the streets of the Italian quarters, but insisted more on picturesque details, such as the religious processions, the straggled mothers with children, the gestures of street vendors and the singing barbers, "Each one a cousin of Caruso and a nephew of Verdi."[36] Prohibition, and the consequent failure of competing Irish and German American saloons and high-end restaurants, helped Italian restaurants to enter the diversifying panorama of eating places in urban America. Since the 1920s, restaurants in Boston's North End or San Francisco's North Beach emerged like the safe places where middle-class Americans could experience the Italian culture toward which they felt such an intense mix of suspicion and attraction. Italian immigrant restaurateurs, in turn, understood that it was vital to serve a tourist experience, along with food, to their non-Italian patrons. The daughter of the owner of the Italian restaurant Gonfarone's in New York's Greenwich Village, for example, wondering about the reason for the place's popularity, came to the conclusion that it resided in its economy of production and consumption

of images; images of Italians as a naturally exuberant people, blessed with an innate taste for beauty, and family-loving:

> Whatever "atmosphere" existed sprang from the fact that papa, and Madama Gonfarone, his partner, and the waiters and bus boys and cooks, and the bartender and the dishwashers, and musicians, spoke and thought and acted "Italian." This little Italian world was friendly, pleasant and gay.[37]

Italian immigrants to urban United States, in other words, re-elaborated the stereotypes that an Anglo-Protestant culture fashioned for them; reversed them upon an equally stereotyped racialization of the Anglo-other, and, within this game of distorted mirrors, they sold, with their cuisine, a diasporic image of Italy and the Italians as places of evasion from post-Victorian middle-class self-control and emotional restraint. The production of cultural difference fashioned in a recognizable and replicable tourist package had to correspond to some codification and standardization of Italian American cuisine; a process that could never have happened in Italy, with all its loyally observed local and regional traditions and specificities. In the late 1910s, a typical Gonfarone's menu included

> Assorted Antipasto; Minestrone; Spaghetti with Meat or Tomato Sauce; Boiled Salmon with Caper Sauce; Sweetbread with Mushroom Patty; Broiled Spring Chicken or Roast Prime Ribs of Beef; Brussels Sprouts, Spinach; Boiled or Mashed Potatoes; Green Salad; Biscuit Tortoni or Spumoni; Fresh Fruit, Assorted Cheese; Demi-tasse.

"This formidable list represented not a choice of items, but a list of all the food a customer could have on a weekday night for fifty cents, including a pint of California red wine."[38] Diasporic restaurants like Gonfarone's syncretically merged the culinary elaborations of early-twentieth-century Italian immigrant cooks to America, eventually producing a familiar and identifiable Italian cuisine, which, if it shied away some of its originators, it gave way to an immensely popular consumable representation of Italian American identity, set to please millions of multiethnic consumers in America, and later worldwide.

Generations of Italian American Food

Italian American foodways evolved after World War II, enabling their power to represent Italian American identities survive the dissolution of the first-settlement communities in which the Puzos and many other immigrants from Italy had lived in the first half of the twentieth century and the passing of generations after turn-of-the-twentieth-century mass migration. Yet, the evolution of Italian American food culture navigated through significant tensions. In the 1950s and 1960s, the tension was between the suburbanization of second generation Italian America, which seemed to lead to severing ties with immigrant food culture, both in terms of the oral transmission of culinary knowledge most forcefully represented by grandmothers, aunts and mothers, and the provision of "authentic" Italian food from Italian food shops, on the one hand, and, on the other, the completion of the industrial standardization of the Italian foods that had made it to the general market, like pizza and pasta (including its canned version).

Anthropological studies show that at the time many recipes and practices from immigrant food culture were actually falling into oblivion, or retreating to very special occasions, whereas a meal pattern that alternated "American" meals on weekdays with "Italian" meals

on weekends was emerging as most common.[39] Writer Helen Barolini remembered how the transition happened in her suburbanized family:

> In adopting American ways [. . .] both my parents lost the old-world family cohesiveness and unity of their parents. They had discovered a whole world outside family—family was no longer the fortress one stayed immured in; there were other attractions like business and social success, a country club and Corinthian club, material possessions. We girls learned to sew and cook in home-economics class. I remember learning to make Welsh rarebit, tuna fish casserole, prune whip, tomato aspic, chipped beef on toast—all things we'd never eat at home, but which I told my mother about. It turned out that she herself, once, had attempted to go Wasp in her early days of marriage by serving my father creamed chicken on waffles. Once and never more; he had certain rules: Sunday was for spaghetti with meatballs (the word pasta was not used and no other form of it ever appeared) and he could get testy about the tomato sauce if it was too bitter, too thin, too thick, too cooked; a chunk of iceberg lettuce to munch on was all he wanted—no mixed salad; white fish or kidney beans were served in a broth of oil and garlic; strawberries were never to be crushed as a topping for ice cream and fruit in general was not to be promiscuously mingled in a "fruit cocktail"; and only Italian bread was ever to be placed on his table. American bread, which pop disparaged as cotton batting, was reserved for our school sandwiches. "Take out the soft part," he'd command us children about Italian bread, "eat the crust, the soft part's no good."[40]

Meanwhile, though, the distinctive identity and taste of Italian American food seemed threatened to be dissolved in the process of mass production, as many of the companies that immigrants had started before World War II were being acquired, with their networks of suppliers, distributors and consumers, by big corporations. After it made the crossing from Naples early in the century with the sizeable Neapolitan contingent of Italian immigrants, been baked in the basement of bakeries, and sold by the slice on the streets of Little Italies, pizza had remained unknown to other Americans until World War II. In the 1950s, as GIs returning from occupied Italy may also have helped popularizing it, a market for pizza was created almost overnight by inventive cooks and entrepreneurs who opened modernized pizza parlors first in the outer neighborhoods of New York, New Haven, Boston, Philadelphia and Chicago, where second generation Italian Americans had relocated, and then all over these cities. The deep frozen version of pizza, made by the millions in industrial plants in New Jersey and aimed at suburban supermarket shelves throughout the nation, followed suit. The quintessential Italian American dish, spaghetti with meatballs, was such an innocuous symbol of identity as to be featured in the most popular scene of the Disney's film, *The Lady and the Tramp* (1955). A decade later (1969), an equally popular TV commercial for Prince Spaghetti introduced for the first time elements of nostalgia for the bygone era of homogeneous Italian urban communities and traditional rich family life for the consumption of Italian and non-Italian Americans alike.

A new kind of tension emerged in fact in the 1970s and 1980s, as on the one hand, the ethnic revival movement endorsed food to be the most meaningful heritage of the immigrant culture third-generation Italian Americans strived to rediscover and celebrate, and on the other new middle-class discourses, closely reminiscing the critiques of Italian American food expressed by Italian travelers to America of the early twentieth century, were emerging, promoting the notion that Italian American food was an unfortunate bastardization of "real" Italian cuisine, which was only that of Italians in Italy. Italian American revivalists

indulged in the production and consumption of community cookbooks celebrating the culinary legacies of Little Italies everywhere in the United States and Italian American food continued to be the most pleasurable part of the immigrant heritage to share and enjoy at ethnic street fairs and official gatherings of Italian American associations. At the very same time, a tiny group of middle-class northern Italian immigrants in New York City, many of whom had never cooked in Italy, reshaped Italian food in America by detaching it from its immigrant origins and relocating it within the "authentic" traditions of Italian regional cooking. Cookbook writers and cooking instructors Marcella Hazan, Giuliano Bugialli, Franco Romagnoli and Lidia Bastianich were welcomed by a culture industry eager to let them promote real Italian food among a growing cosmopolitan class of professional Americans who were avid consumers of foreign and ethnic cuisines. Recent immigrant, Italian-born and trained chefs opened upscale restaurants serving Tuscan and other regional cuisines on the Upper East Side of New York or in the Chicago Loop. Sometimes called "northern Italian cuisine" to differentiate it from the down-market red-sauce clichés of early twentieth-century immigrants, this new template for Italian eating first popularized dishes like creamy risotto, gnocchi, pesto, osso buco and tiramisù, and then formerly little-known foodstuff like sun-dried tomatoes, Treviso radicchio and balsamic vinegar, which became popular in Italy outside their local places of production at the same time they were being adopted by New York's and Los Angeles' "food scenes." So thorough was the transnational alignment of taste and culinary culture, and so wide the audience of this discourse, that by 1996 Hollywood was able to present the character played by Tony Shalhoub in the movie *Big Night*—an Abruzzese immigrant cook to New Jersey in the 1950s who refuses to serve his ignorant American customers the inauthentic Italian ("red sauce" immigrant) food they like—as the hero of the story. Third-generation Italian Americans willing to research and reconsider their identity starting from their larders and gas stoves were left with the intellectual and gastronomic task to reconcile two different transnational discourses rooted in different times and places, and articulating contrasting ideas about class and distinction.[41]

As Italian American food culture entered the twenty-first century, and the new postindustrial consumer landscape, this reconciliation seemed to have, for the most part, happened. In the current consumer culture promoted both in Italy and the United States by Slow Food and the many other actors in the American food revolution, authenticity, artisanality, craft, creativity, time-blessed popular traditions—of which Italian American food culture is rich—are adding-value factors in the evaluation of food and cuisines. Eataly, the Italian food megastore chain co-owned by the Italian businessman Oscar Farinetti, Lidia and Joe Bastianich and Mario Batali, which opened its first, very successful U.S. branch in front of Manhattan's Flatiron Building in 2010, functions as an archive of the good-to-eat and good-to-think Italian food (the kind Slow Food supports, produced by small-scale independent farmers) for the convenience of upper- and middle-class consumers. (See Color Plate 28.) In this cultural climate, the "low-brow" diasporic Italian cuisine that turn-of-twentieth-century immigrants to the United States first envisioned and practiced stands on the same par of dignity of the "high-brow" cuisine of famed chefs, from Mario Batali to Michael White, who in fact very often declare to be inspired by it. The Slow Food-promoted concepts of preferring to shop for natural, unprocessed, fresh and local food, thus supporting local and familiar vendors and producers, had already been explored in everyday practice by humble Italian American immigrant women in their overcrowded neighborhoods more than one hundred years ago. The legacy of Italian American foodways and its power to represent Italian American culture and life continue in the present.

Further Reading

Cinotto, Simone. *The Italian American Table: Food, Family, and Community in New York City*. Urbana: University of Illinois Press, 2013.

Diner, Hasia. *Hungering for America: Italian, Irish, and Jewish Foodways in the Age of Migration*. Cambridge: Harvard University Press, 2003.

Gabaccia, Donna R. *We Are What We Eat: Ethnic Food and the Making of Americans*. Cambridge: Harvard University Press, 1998.

Notes

1 Mario Puzo, "Choosing a Dream," in *The Immigrant Experience: The Anguish of Becoming American*, ed. Thomas C. Wheeler (New York: Dial Press, 1971), 39.

2 Simone Cinotto, *The Italian American Table: Food, Family, and Community in New York City* (Urbana: University of Illinois Press, 2013), 47–71.

3 Donna R. Gabaccia, *From Sicily to Elizabeth Street: Housing and Social Change Among Italian Immigrants, 1880–1930* (Albany: State University of New York Press, 1984).

4 Luciano J. Iorizzo, *Italian Immigration and the Impact of the Padrone System* (New York: Arno Press, 1980).

5 Donna R. Gabaccia, *We Are What We Eat: Ethnic Food and the Making of Americans* (Cambridge: Harvard University Press, 1998).

6 Donna R. Gabaccia, "Ethnicity in the Business World: Italians in American Food Industries," *Italian American Review*, 6.2 (1997/1998), 1–19.

7 Stefano Somogyi, "L'alimentazione nell'Italia unita," in *Storia d'Italia*, dir. Ruggiero Romano and Corrado Vivanti, 6 vols. in 10 (Turin: Einaudi, 1972–1976), 5: 839–887.

8 Piero Meldini, "L'emergere delle cucine regionali: L'Italia," in *Storia dell'Alimentazione*, ed. Jean-Louis Flandrin and Massimo Montanari (Rome: Laterza, 1992), 658–664.

9 David Gentilcore, *Pomodoro! A History of the Tomato in Italy* (New York: Columbia University Press, 2010).

10 Zachary Nowak, "Folklore, Fakelore, History: The Origins of the Pizza Margherita," *Food, Culture, and Society*, 17.1 (2014), 103–124.

11 Piero Bevilacqua, "Emigrazione transoceanica e mutamenti dell'alimentazione contadina calabrese fra Otto e Novecento," *Quaderni storici*, 47 (1981), 520–555.

12 Ministero degli Affari Esteri. Commissariato dell'Emigrazione, *Emigrazione e Colonie: Raccolta di Rapporti dei Regi Agenti Diplomatici e Consolari. Vol. III, America. Parte III, Stati Uniti* (Rome: Editrice Manuzio, 1909), 122–123.

13 Marie Hall Ets, *Rosa: The Life of an Italian Immigrant* (Madison: University of Wisconsin Press, 1999), 172.

14 Paolo Sorcinelli, "Identification Process at Work: Virtues of the Italian Working-Class Diet in the First Half of the Twentieth Century," in *Cooking, Eating and Drinking in Europe since the Middle Ages*, ed. Peter Scholliers (New York: Berg, 2009), 81–97.

15 Amerigo Ruggiero, *Italiani in America* (Milan: Fratelli Treves, 1937), 148–150.

16 Cinotto, *The Italian American Table*, 206–207.

17 Simone Cinotto, *Soft Soil, Black Grapes: The Birth of Italian Winemaking in California* (New York: New York University Press, 2012).

18 Harvey A. Levenstein, "The American Response to Italian Food," *Food and Foodways*, 1.1 (1985), 1–30.

19 Leonard Covello, *The Social Background of the Italo-American School Child: A Study of the Southern Italian Family Mores and Their Effect on the School Situation in Italy and America* (Leiden: Brill, 1967); Irvin L. Child, *Italian or American? The Second Generation in Conflict* (New Haven: Yale University Press, 1943); William Foote Whyte, *Street Corner Society: The Social Structure of an Italian Slum* (Chicago: University of Chicago Press, 1943).

20 Quoted in Covello, *The Social Background*, 271.

21 In early-twentieth-century New York, the principal Italian immigrant goal was achieving homeownership (at an earlier stage in Italy, then in some of the city's outer boroughs) as soon as possible, which required the mobilization of all family resources, and was pursued even at expenses of other forms of social mobility, such as children's education. Thomas Kessner, *The Golden Door: Italian and Jewish Immigrant Mobility in New York City, 1880–1915* (New York: Oxford University Press, 1977).

22 Cinotto, *The Italian American Table*, 72–101. For the broader context, see Thomas Guglielmo, *White on Arrival: Italians, Race, Color, and Power in Chicago, 1890–1945* (New York: Oxford University Press, 2003);

Jonathan Rieder, *Canarsie: The Jews and Italians of Brooklyn Against Liberalism* (Cambridge: Harvard University Press, 1985); Jennifer Guglielmo and Salvatore Salerno, eds., *Are Italians White? How Race Is Made in America* (New York: Routledge, 2003).

23 Robert E. Park and Herbert A. Miller, *Old World Traits Transplanted* (New York: Henry Holt, 1921), 149.

24 Istituto Nazionale per il Commercio Estero, *L'America a Tavola: Consumi, Tendenze e Prospettive: Il Mercato USA dei Prodotti Agroalimentari Autentici Italiani* (New York: Istituto Nazionale per il Commercio Estero, 2011), 30–31.

25 Robert F. Foerster, *The Italian Emigration of Our Times* (Cambridge: Harvard University Press, 1919), 337–340, 467–468.

26 Francesco Chiapparino and Renato Covino, *Consumi e Industria Alimentare in Italia: Lineamenti per una Storia* (Narni, TR: Giada, 2002).

27 Elizabeth Zanoni, "'In Italy Everyone Enjoys It—Why Not in America?': Italian Americans and Consumption in Transnational Perspective during the Early Twentieth Century," in *Making Italian America: Consumer Culture and the Production of Ethnic Identities*, ed. Simone Cinotto (New York: Fordham University Press, 2014), 71–82. See also Mark I. Choate, *Emigrant Nation: The Making of Italy Abroad* (Cambridge: Harvard University Press, 2008).

28 Cinotto, *The Italian American Table*, 155–179.

29 Ibid., 105–154.

30 Cinotto, *Soft Soil, Black Grapes*.

31 Carol Lynn McKibben, *Beyond Cannery Row: Sicilian Women, Immigration, and Community in Monterey, California, 1915–99* (Urbana: University of Illinois Press, 2006).

32 Maria Sermolino, *Papa's Table d'Hote* (Philadelphia: Lippincott Co, 1952), 25.

33 Robert A. Orsi, *The Madonna of 115th Street: Faith and Community in Italian Harlem, 1880–1950* [1985], 3rd ed. (New Haven: Yale University Press, 2010).

34 Jane Jacobs, *The Death and Life of Great American Cities* (New York: Vintage, 1975).

35 Joseph P. Cosco, *Imagining Italians: Race, Romance, and Reality in American Perception, 1880–1910* (Albany: State University of New York Press, 2003).

36 Konrad Bercovici, *Around the World in New York* (New York: The Century Co., 1924), 129.

37 Sermolino, *Papa's Table d'Hote*, 15.

38 Ibid., 125–126.

39 Judith Goode, Janet Theophano and Karen Curtis, "A Framework for the Analysis of Continuity and Change in Shared Sociocultural Rules for Food Use: The Italian-American Pattern," in *Ethnic and Regional Foodways in the United States: The Performance of Group Identity*, eds. Linda Keller Brown and Kay Mussell (Knoxville: University of Tennessee Press, 1984), 19–30.

40 Helen Barolini, *A Circular Journey* (New York: Fordham University Press, 2006), 24–25.

41 Cinotto, *The Italian American Table*, 211–218.

11

ITALIAN AMERICANS AND THEIR RELIGIOUS EXPERIENCE

Richard N. Juliani

In a sparsely appointed room in the small house that served as a rectory, Father Gaetano Mariani entered a note in his diary, which, translated from his native language, read

> The 23rd of the month of October 1853 was the beginning of the little Italian chapel dedicated to St. Mary Magdalen de Pazzi, established in the city of Philadelphia between 8th and 7th Streets through the kindness of the Most Reverend Monsignor Neumann, worthy Roman Catholic Bishop of the city and diocese of Philadelphia

—before adding that he himself had been named as its pastor and given the authority to bless the chapel on the same day. At the moment of this vignette, the first church to be designated as being for the exclusive use of Italians as Catholics was formally acknowledged by the priest who would lead its congregation during the next twelve years. First as the "Italian Mission," then as a parish, it would remain over the next 150 years as an important site for events, both sacred and secular, for Italians who settled in Philadelphia, as well as a template in their wider history as Catholics throughout America. Although the founding of St. Mary Magdalen de Pazzi was a pivotal moment, it represented only one part within a larger, more complicated context.[1]

The history of Italian American religious life is also partly enmeshed in the struggle for Italian sovereignty, especially after its final stage culminated in triumph against the Papal States. Subsequent sanctions by the Holy See which banned participation in the politics of Italy fueled the hostility of many Italians toward the Church. The widespread departure of emigrants, which began not long after the founding of the kingdom, reflected lingering tensions, but went beyond the boundaries of their relationship to the Church of Rome. Contrary to popular impression, not all Italians who emigrated were Catholic, but included agnostics, or even atheists, or persons simply indifferent to organized religion. Other Italians were already Protestants, or destined to become members of various Protestant denominations after their arrival in America. An early group of Waldensians, a denomination that had been established in northern Italy during the Reformation, had settled in 1607 near what would later become Wilmington, Delaware. And even a handful of Italian Jews joined into the immigration that crossed the ocean in search of a new life. But Italians who were at least nominal Catholics, nevertheless, were conspicuously represented in the population movement toward America and issues related to their spiritual care would assume great prominence.

The experience of Italian Catholics was also complicated by the new setting in which they found themselves as immigrants. Despite the serious conflict and lingering tensions that its recent history had engendered, Italy remained a society, if not a state, in which the great

resonance of Catholicism in the daily life of many Italians provided the Church of Rome with a considerable degree of influence and control over much of the population. In contrast, America, as an undeniably Protestant nation and culture, required Catholicism, if it were to survive, to defend itself against a less hospitable climate. Italian Catholics, along with their co-religionists, had to adjust, therefore, not merely to America, but to Protestant America and to the vulnerabilities of Catholicism as a minority religion. It also meant that American Catholicism had to protect itself from threats to its fragile security which emanated from its own ethnic diversity—and Italians would find themselves, as German Catholics already had, in the midst of that dilemma.

Early Initiatives from Rome

Some scholars find the origins of Catholic policy toward immigrant Italians in the visit of Archbishop Gaetano Bedini, Papal Nuncio, which was intended to promote diplomatic relations with the United States and to allow discussion with clergy of problems facing the Church in North America in 1853. But after another Italian, Alessandro Gavazzi, an ex-Barnabite priest and participant in the struggle to become an independent nation, accused him of supporting Austria and being responsible for executions of patriots, affirming the prelate's role as "the bloody butcher of Bologna," subsequent events would be greatly altered. After failing to sway lay trustees at Philadelphia's Holy Trinity, a German-speaking congregation, to cede control of their disputed parish to diocesan authorities, Bedini's mission rapidly deteriorated. Blocked by protesters from entering the church, when he sought to maintain credibility with them by refusing an offer of lodging from Bishop John Neumann, it only offended the latter. But after Bedini fled his untenable situation in Philadelphia, he encountered even more serious troubles.[2]

By late 1853, newspapers, debating Gavazzi's allegations, incited protests in other cities. In December, when nearly 1,000 demonstrators, searching for Bedini, converged on the archbishop's residence in Cincinnati, violence escalated, with sixty of them arrested, nine others wounded by police fire, and one killed. In January 1854, the opposition, after distributing notices with Gavazzi's charges, smashed windows of the cathedral in Wheeling, West Virginia. After being burned in effigy in Midwestern cities, another crowd rioted against him in Baltimore. In defense of Bedini, Senator Lewis Cass, father of the U.S. Ambassador to Italy, asked the Senate to clarify Bedini's diplomatic status and provide government protection. Although the effort failed, the Bedini affair had been placed before the entire nation.

In late January, as Bedini's visit neared its conclusion, Italian and German exiles in New York planned a mass meeting with a mock trial based on Gavazzi's indictments. From his place of hiding, Bedini sought to return to Philadelphia, where Neumann, after consulting with his priests, promised what he hoped would be a long and safe visit. But without replying, Bedini, evading another angry mob, furtively left Staten Island on a ship bound for England. And in Philadelphia, the final public protest against Bedini condemned the members of the Senate who had recently supported him.

The intent of Bedini's visit became more evident from his report written after returning to Rome. In his assessment of conditions facing American Catholicism, he feared that as many as two-thirds of its immigrant members might abandon their faith as a result of the absence of their own clergy. Despite the defiance encountered at Holy Trinity, and perhaps mindful of what had already been accomplished at the Italian Mission of St. Mary Magdalen de Pazzi, Bedini identified the ethnic parish as a possible solution. In a moment which would reverberate in later years, he had anticipated the antinomy of saving the faith of immigrants while separating them with reduced status within a largely Anglo Saxon population. But the

impact of Bedini's visit is easily conflated. Even before his arrival, the American hierarchy had already shown concern over immigration, but a long lapse would precede any serious pastoral efforts. For Italians, it was not Bedini, but migration itself that would invoke response. And it was only after the flow of immigrants became a mass movement, a generation after Bedini's visit, that the principal issues of their religious situation would be fully discerned.

Early attempts to establish places of worship for Italians did not easily meet with success. In New York City, Father Antonio Sanguinetti who, after finding Italians without their own churches on his arrival in October 1857, sought to organize St. Anthony of Padua at the site of a former French church on Canal Street. But Sanguinetti and his supporters, after struggling against Archbishop John Hughes's opposition to attempts to obtain the aid of Irish benefactors, gave up their effort only a year later. Despite subsequent petitions from parishioners to Pope Pius IX and to Hughes that failed to gain support, the parish was reopened in 1866. Meanwhile in Philadelphia, after Mariani's death, a series of "temporary pastors" sought to keep the struggling Italian Mission open during a period of turmoil, which culminated with its temporary closing under an interdict issued by Bishop James A. Wood in 1867. In contrast to New York, Father Antonio Isoleri, appointed as rector in 1870, despite difficulties with Wood and a devastating fire that destroyed much of the main chapel, secured support from the "buon Irlandesi," who shared the parish and neighborhood with Italians, which not only enabled his church to survive, but his pastorate to thrive over a remarkable tenure of fifty-six years. It also augured the oscillating kinship between Italians and Irish that would remain an important aspect of American Catholic history.[3]

The "Italian Problem"

With the massive immigration of Italians in the late nineteenth century, American Catholicism assumed the urgent priority of preserving their faith—soon defined by three major dimensions of what would be called the "Italian Problem." First, it was argued, sometimes with the support of specious data, that many Italians, responding to Protestant proselytizers and the allure of material life in America, had been defecting from Catholicism; second, that Italians who remained as Catholics failed to provide adequate financial support to their parishes; and third, that their popular piety, as expressed in the veneration of saints in public processions on the streets of "Little Italy," reflected vestiges of pre-Christian cults and exceeded the limits of conventional Catholicism.[4]

Some early observers deftly depicted Italians as Catholics. In 1888, Bernard J. Lynch, writing in the *Catholic World*, the influential Paulist publication, offered an appraisal of New York's Italians, which easily applied to other places of settlement and community formation. His ambivalent amalgam of information and ideas, sometimes devolving into exaggeration and stereotype, would reach what he called the "delicate question of religion." Based on his observations of Italians within the jurisdiction of Transfiguration parish, who neither knew the Apostles' Creed nor such basic truths as the Trinity, the Incarnation and the Redemption, he termed them as perhaps "the worst off in religious equipment" of any immigrant group. But whereas Northern Italians were "a fairly instructed people," immigrants from the former Neapolitan states were "not well enough instructed to receive the sacraments," which if administered would be invalid. And spiritual life within their homes, consisted mainly of devotions, icons, shrines and indulgences, which fed "on the luxuries of religion without its substantials."[5]

Lynch largely blamed political and civil factors, along with the disorganized state of the clergy, for the sorry condition of religion in southern Italy. He saw the poverty, isolation and landlord system as worse than in Ireland. As for deficiencies in matters of faith, the apathy of

the clergy, which was due to a system of fixed tenure and salary, had caused them to fail to properly instruct their flock. But rejecting any belief that the climate of the Mezzogiorno had induced a shiftless, ignorant personal character, Lynch defended Italian immigrants as the busiest people in America with a memorable metaphor: "There isn't a drone in their hive."[6]

To meet pastoral needs of immigrants, Lynch proposed well-trained Italian priests, offering services in basement chapels of annex congregations. Despite objections of Genoese and Lombards who preferred to join the Irish upstairs, most Italians, he believed, were willing to accept such arrangements. Every initially Italian parish, after failing to secure sufficient financial support, he asserted, had found it necessary to become Irish. Ignoring the demeaning implications of his words, Lynch declared "The Italians as a body are not humiliated by humiliation." And lacking any aid from Italy as a nation, "the Catholic Church in America is to the mass of the Italians almost like a new religion." Further aggravating matters, Irish families, seeing Italians as "almost of a different civilization," fled when they moved into their tenement houses or enrolled children in the same schools. But children provided hope that the Church might still be able to solve the pastoral problem. And in Lynch's view, the recently announced plan of Bishop Giovanni Scalabrini of Piacenza held great promise. Despite other deficiencies, more apparent in retrospect, Lynch had well articulated the "Italian Problem" as it was widely seen at the time.[7]

The American hierarchy first recognized the value of priests of the same ethnicity as their congregations at the Fourth Provincial Council of Baltimore in 1840. Some forty-four years later, they placed the issue of defection on their agenda in preparation for the Third Plenary Council in Rome in 1884. Although deliberations included the protection of emigrants at ports of departure as well as on the transoceanic passage, the focus centered on their spiritual welfare after arrival in America. But the council failed to reach unanimity over the solution—whether to organize special parishes with Italian priests or to assign specially trained priests to larger, more inclusive ones to care for them. Despite the urgency ascribed by the Office of Propaganda Fide, convinced that Italians suffered more than other immigrant groups, the inability of American bishops to find answers at the council only intensified their relationship with Rome.[8]

Other sources further confused the search for a solution to the "Italian Problem." While his American counterparts remained stymied in disagreement on a course of action, Bishop Scalabrini organized the Congregation of St. Charles Borromeo, a missionary order, with a college in Piacenza to prepare priests for the spiritual care of Italian immigrants in the Americas. Among Italian clergy already in America who offered their own plans, few of them were as highly regarded as Monsignor Gennaro De Concilio, a native of Naples, professor at Seton Hall University, theologian at the Third Plenary Council of Baltimore, founder of two Italian churches in Jersey City, treasurer of the St. Raphael Society and author of the Baltimore Catechism. In his widely distributed pamphlet of 1888, De Concilio's proposal for a "Mother Church" included social services in any city with a large Italian population, chapels in smaller cities, staffed by Italian priests and funded by Propaganda Fide. In December of the same year, Pope Leo XIII, in a special message, decrying the poverty, dehumanization and exploitation accompanying immigrant life, endorsed the Scalabrini program and urged the recruitment of sons from immigrant families for the priesthood. Expanding the Abbelen petition of 1886, which had proposed separate parishes, the Lucerne Memorial of 1891, delivered to the Holy Father by Peter Paul Cahensly, founder of the St. Raphael Society, offered a broader plan, designed by Scalabrini supporters, for immigrants to have their own parishes, priests and bishops. But newspapers, distorting its message, claimed that it espoused a double jurisdiction, with American bishops for American Catholics and foreign bishops for immigrant Catholics. With "Cahenslyism" seen as separating Catholicism into parallel

structures, Scalabrini and his followers protested that their intention had been nothing more than to preserve the faith among immigrants by promoting their own ethnic culture. And as the Italians, hoping to emulate their German predecessors in resisting assimilation, met strong opposition from those bishops who rejected any pluralistic initiatives, the American hierarchy itself remained divided over the "Italian Problem."[9]

The hierarchy, while struggling with the Nativist perception that Catholicism was a foreign institution, also feared that many immigrants had defected from a church that they had found to be too different from what had been left in their native lands. Striking some balance between assimilation and pluralism was essential to solving the "Italian problem," which had become "the great Catholic question in this country." It would require integrating Italians into parish and practice in a manner that was meaningful to them but acceptable to other Americans. In forging an answer, three types of parish structure, each distinctively attempting to reconcile diversity with unity, emerged. The "duplex" or "annex" church placed Italians and their religious services into a basement chapel of an established parish, dominated by another ethnic group, usually Irish Catholics. It palpably offered "second-class citizenship" to Italians who were spiritually tolerated, but sometimes disdainfully at a distance by their co-religionists. The canonical or territorial parish, a more benign alternative, eschewed separation, allowing Italian born or Italian speaking priests to minister to immigrants in their own services, but in the same "upper church" (without any basement chapel) of a single congregation. It sought to soften ethnic differences and encourage the assimilation of Italians as Catholic Americans. In contrast to both of these "shared" models, the "nationality parish" granted Italians their own church, with an Italian pastor and priests, and defending the spiritual and secular integrity of Italian life. Though initially representing self-segregation and cultural preservation, it too would eventually become another avenue of assimilation. But as fear of foreign influences eased, the "nationality parish" persisted over several decades in response to the "Italian problem."[10]

In *The Catholic Encyclopedia* of 1913, Father John De Ville surveyed the religious condition of Italians in America in the early twentieth century. Well-qualified for the task, he had migrated from the Austrian Tyrol, attended St. Bonaventure Seminary in Allegany, New York, before being ordained in 1897. After serving as first pastor of St. Anthony of Padua in Walston, Pennsylvania, he founded other Italian parishes in the Diocese of Erie. Praised for opposing Black Hand activities in Jefferson County, he had also administered last rites to Italian miners. By 1912, the erudite De Ville, having relocated in Chicago, then in Gary, Indiana, was an assistant editor of the newly founded *Our Sunday Visitor.*[11]

After describing secular aspects of immigration, De Ville, like Lynch twenty-five years before, took up the religious dimension of Italian life in America. Commending early Franciscans for having been "indefatigable in their work in the new vineyard of the Lord," he noted the Jesuits, Scalabrinians, Salesians, Passionists and Augustinians who followed them in ministering to Italians. Although the hierarchy had sought Italian priests to administer spiritual care, it had been less successful in persuading Italians to support them. Parochial schools, where both English and Italian languages were taught, offered some promise, especially in enabling children to draw parents to the Church. De Ville cited the San Raffaele Society for protecting Italians, along with two weekly newspapers published under Catholic auspices. He found strong evidence for a "religious disposition" in the many benevolent societies that carried the names of patron saints of Italian towns. Their yearly festivals and parades, despite giving outsiders an unfavorable impression of popular piety from the cult of saints being misunderstood and overemphasized, similarly attested to the strong attachment and religious feelings associated with native places. His statistics, taken from *The Official Catholic Directory*, included 219 Italian churches, a miscount that later writers would not notice. Though De

Ville himself would pursue a sometimes controversial career in the Catholic Americaniza-
tion Movement and as Cardinal Désiré Mercier's spokesman on behalf of Belgian children
victimized by World War I, his early contribution to Italian American history waits to be
revisited and rediscovered.[12]

Women Religious: Cabrini and Others

The story of Catholic efforts among Italian immigrants, however, was not found in the work
of priests alone, but also notably contained in the ardent labor of women in religious orders
whose contributions are too easily overlooked. In September 1872, four Franciscan sisters of
Allegany, a congregation organized by Father Pamfilo da Magliano, an Abruzzo native and
member of the Friars Minor, began teaching Irish and Italian children at the newly opened
school at St. Anthony of Padua which had been reestablished as a parish in New York City six
years earlier. In Philadelphia, where Father Isoleri had sought to open his own school, it only
became a reality when Sister Lucrezia, an Austrian member of the Third Order Missionary
Sisters of St. Francis, left the motherhouse of her order in Gemona del Friuli in Italy and
along with three other sisters, trained at Peekskill, New York, and founded the school and
asylum for orphan girls at St. Mary Magdalen de Pazzi in 1874. These intrepid sisters had not
only introduced the first schools in their respective locations but also laid the foundation of
parochial education for Italian children everywhere.[13]

In subsequent years, similar efforts saw the opening of parish schools wherever Italian
immigrants settled and formed communities in cities throughout America. By 1920, in the
Catholic version of the spreading consciousness that brought women into careers that con-
tributed to the development of social welfare as a profession, members of various religious
orders, some of them immigrants themselves and others American born, increasingly turned
to the needs of Italians. They taught in parish schools and private academies, but also found
their calling in orphanages, hospitals, settlement houses and other agencies of human ser-
vice. They were members of orders—Franciscans, Dominicans, Ursulines, School Sisters of
Notre Dame, Sisters of St. Joseph, Sisters of Charity, Sisters of Mercy, Sisters of the Holy
Cross and Sisters of the Immaculate Heart of Mary—whose presence was felt by Catholics
of all backgrounds. But they also included the Daughters of Mary Help of Christians, the
Apostles of the Sacred Heart of Jesus, the Missionary Sisters of the Catholic Apostolate (or
Pallottines), the Maestre Pie Filippini (or Religious Teachers Filippini) and the Missionary
Sisters of the Sacred Heart of Jesus—orders that had a special resonance for Italians, having
been founded in Italy and having embraced, in some cases from their beginning, the mission
to serve immigrants in America.[14]

Whereas most sisters who worked among Italians would pass their lives in relative obscurity,
some of them deserve to be remembered prominently in the history of American Catholi-
cism, none more so than Mother Frances Xavier Cabrini, who would be eventually canon-
ized as a saint. Born in July 1850 in Sant'Angelo Lodigiano in the province of Lombardy,
then a part of the Austro Hungarian Empire, Francesca Saveria Cabrini was the youngest of
eleven children, among whom only four would survive to adulthood. After being admitted
to the religious order that had provided her early education, despite frail health, she began
teaching and working among the poor. In 1874, diocesan authorities asked her to reorganize
a girls' orphanage as a religious institute, where she, having taken her own religious vows in
1877, became the director of five novices who aspired to form a religious community under
her leadership. In 1880, the local bishop granted permission for the 30-year-old Cabrini and
her companions to establish the Institute of the Missionaries of the Sacred Heart of Jesus.
Although at first expected to serve only Lombardy, Mother Cabrini sought the approval of

ecclesiastical authorities in Rome for a mission intended for China in 1887. In the following year, Bishop Scalabrini, who had recently founded his own institute to minister to Italian immigrants, convinced Cabrini to redirect her program to America.[15]

Second-class passenger Madame Saveria Cabrini, as she was listed on the Compagnie Générale Transatlantique's *La Bourgogne* out of Le Havre, arrived at Castle Garden on 1 April 1889. A large number of Italians and other immigrants who had shared the voyage in steerage class, which accommodated as many as 600 passengers, dispersed to an uncertain future. But Mother Cabrini, having reclaimed her proper identity, confronted her own challenges. Despite a letter from Archbishop Corrigan, which Bishop Scalabrini had shown Cabrini, formally requesting that sisters be sent to New York, the American prelate did not initially welcome her arrival. Ignoring his early ambivalence, the undaunted Cabrini pursued her mission. After briefly sharing the hospitality of the Sisters of Charity, she opened an orphanage that served her small group of companions as their own first convent on Palm Sunday in April 1890. With the founding of a school, they also offered religious instruction at St. Joachim's, a Scalabrini parish in lower Manhattan. But as they attempted to provide for the spiritual welfare of immigrant families, the sisters also discovered the need to solicit financial aid as mendicants on the streets of the city. And only three years after arrival, their abrupt departure from St. Joachim's showed that their work would not always reach unmitigated success, but continue to challenge them. But a brighter future lay ahead.

Despite their early difficulties, the Missionary Sisters of the Sacred Heart would quickly show the results of their efforts. In 1890, when the charismatic Mother Cabrini returned to Rome for an audience with Pope Leo XIII, she also escorted the first North America postulants seeking to enter her order to the motherhouse in Italy. On her return to New York in 1891, she established an enlarged orphanage and a new novitiate. In the next year, the Missionary Sisters opened an orphanage and school for the largely Sicilian population of immigrants in New Orleans, Louisiana. Meanwhile, at the behest of the now supportive Corrigan, they expanded their work by opening a hospital in New York City. Before the decade had ended, their work had spread to Buenos Aires, Paris and Madrid and included plans for London. But it would gain even more momentum and leave its greatest impact in the United States in a new century.

As the twentieth century opened, Cabrini and the Missionary sisters, like other newcomers, followed the paths of earlier immigrants to where they were needed as workers. They opened schools and orphanages for Italians in such industrial cities as Scranton, Newark and Chicago but also in the mining areas of Colorado. By 1903, with the founding of a school and orphanage in Seattle, the efforts of the intrepid Cabrini spanned the entire continent of North America, but her plans were beckoning even further. In 1905, she extended her work by schools and orphanages that served Mexican as well as Italian children in California, along with a later facility for young victims of tuberculosis. In June 1909, Cabrini attained a more personal goal, becoming an American citizen, with a petition for naturalization on which she listed herself as a "teacher" residing in Seattle. She lived only eight more years before her death at the age of 67 in December 1917 at Columbus Hospital, one of the two hospitals founded by her efforts in Chicago. For twenty-eight years, the diminutive but indefatigable and charismatic Cabrini had established sixty-seven missions of education, health care and religious instruction in Europe and the Americas. Her remarkable life was duly recognized by her canonization, the first immigrant to be elevated to sainthood, by the Vatican in 1946. It is also reflected in the shrines dedicated to her, which have become pilgrimage sites for the multitude of devoted supplicants who still seek her intercession in the cities in which she served.

Mother Cabrini, however, was not alone. Of less acclaim, but similarly instrumental in building Catholicism in America, Sister Ninetta Ionata also deserves recognition for her labor

among immigrant Italians. Born in Guglionesi, in the Campobasso province of the present day region of Molise, in November 1887, she had applied at an early age to several religious orders with the intention of joining the first one that accepted her. When the Pontifical Institute of the Religious Teachers Filippini replied, she eagerly seized the opportunity to enter its motherhouse in Rome in 1906. Two years later, Sister Ninetta took her final vows as a member of the order, but while continuing her own religious formation, she was soon to enter into the struggle to maintain and nourish the faith of immigrant Italians in America. Meanwhile, far off in New Jersey, a former Barnabite priest who had arrived to America in 1897, Father Aloysius Pozzi, more recently transferred from rural Vineland, toiled as founding pastor of St. Joachim's, generally regarded as the first parish for Italian workers in the steel, rubber and pottery factories and their families in the Chambersburg section of industrial Trenton in 1901. After nearly nine years of ministering to the Italians of the city, which sometimes included eloquently disputing Protestant efforts among them, Pozzi left for Italy with a double purpose in May 1910. Though hoping to recover from recent illness in the fair clime of his native land, he also intended to recruit Italian sisters to nurture the health of his parish. In Rome, after unsuccessful overtures to several religious communities, he placed his request before the Religious Teachers Filippini, along with soliciting support from Pope Pius X. Good fortune finally rewarded Pozzi's efforts when the Filippini, in obedience to the mandate of the Holy Father, agreed to become missionaries in the vineyard of immigration.[16]

In early August 1910, Pozzi and five members of the Filippini order, among them the 24-year-old Sister Ninetta Ionata, left Naples on the *Sant'Anna* of the Fabbre Line, bound for the port of New York. After the Atlantic crossing, when their train reached Trenton, a crowd of several hundred Italians accompanied by a military band met their pastor and his companions at the Clinton Street Station of the Pennsylvania Railroad. And as priest and sisters emerged from automobiles that had brought them to the parish hall, more Italians greeted them. But the enthusiastic reception was probably especially aimed at welcoming the Italian sisters who would replace the two French Dominicans assigned to inaugurate the parish school in the previous year. It was a memorably fitting and auspicious welcome to the Filippini Sisters who would repay them by their devoted and diligent service in the years to come.

Despite harsh conditions that they found in their accommodations, the Filippini began their work in Trenton, which entailed much more than teaching the children of immigrant families, but visiting and caring for the less fortunate of the community as well. Six years after arrival, when their superior was called back to Rome, Sister Ninetta assumed charge of the sisters. With the great influenza epidemic of 1917–18, their work shifted even more toward tending the sick and dying, along with comforting grieving families. Over their first half-century, the Filippini grew to 500 sisters teaching and ministering to more than 50,000 Italians throughout the Americas. In 1954, Sister Ninetta, after being elected Mother Superior of the order in Rome, recognized that her work was far from done. Under her direction, the Filippini opened a new foundation in England, then in Brazil, Ireland and Switzerland, and continued their efforts, even after her death in São Paulo in 1976, by founding missions in Eritrea, Ethiopia, India and Albania. But on a bridge over the Delaware River, the words still visible to anyone arriving to the place that provided their first site "Trenton makes; the world takes" prophetically recognized the seeds sowed by the Filippini in 1910.

The "bricks and mortar" record, however, does not convey the real significance of the sisters who served immigrant communities. A priest memorably recognized Sister Ninetta's efforts at the time of her death:

> we must not forget or underestimate what burned within her and gave content
> and form, impetus and color to her ideas, her words, her actions: a clear, staunch

faith that "moved mountains" and let her pass untangled "per ignem et acquam," an unshakable confidence in God—and indirectly, in the potential goodness of every human being—which alone can explain such daring and resolution in a woman absolutely indifferent to earthly ambitions and greed.

It was a salute that could have been directed at many of the sisters who not only ministered to the needs, but altered the lives of countless immigrants.[17] The accounts of Mother Cabrini and Sister Ninetta Ionata represent vignettes that do not convey the fuller record of the many sisters who helped to transport Catholicism to America while they also served as the midwives of assimilation who facilitated the adjustment of immigrants and their families to life in a new land. But though the work of religious sisters must be remembered, another initiative among Italians also deserves recognition.

Protestant Efforts among Italians

Amid Catholic concerns, Protestant efforts to address the spiritual and social problems of Italian migration should not be overlooked. Often embedded in the fledgling field of social work and the Settlement House Movement, Protestants had recognized and responded to the material plight of Italians and their families—unemployment and poverty, housing congestion, public health and disease, opportunities for recreation and the reduction of illiteracy. With compassion for new arrivals, various denominations provided temporal and spiritual assistance to Italians in adjusting to urban America. The Protestant program, often based on the premise that Catholicism was a liability at the root of problems for Italians, also encouraged conversion. Though American Catholicism saw such efforts as contributing to the widely believed apostasy of Italians, Protestants replied that Italians were often not practicing Catholicism any longer, if they ever had been, and denied accusations that they were proselytizing. With disagreement raging, tensions between Catholic and Protestant leadership mounted.

In 1918, F. Aurelio Palmieri, an Augustinian priest, indefatigable scholar and prolific writer, offered an assessment of Protestant efforts that remains a valuable source of information even today. Although almost all Italian immigrants were likely to be either "practically or nominally Catholics," he argued that it was

> a recognizable fact that as soon as they establish themselves in the United States, they are looked upon by some Protestant denominations as virgin soil to be exploited for the profit of their own religious aims,

and soon subjected, with the aid of Italian ministers, to a program of wide propaganda among them. In seeking to determine the results, Palmieri, after noting the contradictory views of previous observers, offered his own findings. He noted the early presence of the Waldensians, then later efforts of Baptists and Methodists in Italy after 1870, with only scant success from large expenditures and the number of missionaries, before returning to Protestant evangelization in America.[18]

Palmieri saw the threat of Italian immigration to the Protestant majority as providing the underlying motive for proselytization. Citing others with similar views on Catholics and Jews displacing Protestants from neighborhoods, he offered a comprehensive profile of efforts and results for each denomination among Italians. Though hesitant about their accuracy, he reported totals that showed 326 churches and chapels, 13,774 members, 42 schools, 13,927 pupils in Sunday Schools, 201 Italian pastors, and an expenditure of $227,309, along

with $31,571 from Italian donors. Palmieri asked: "Is it true that in fifty years the above quoted denominations have been able to associate to their bodies 14,000 Italians who have left the Catholic Church?" His answer, stated even more clearly than his question, that "we are firmly convinced that there is exaggeration, and much exaggeration, in the figures just given," rested upon two points. First, Waldensians, found in their own churches or within congregations of other denominations as "native Protestants of Italy," should not be included as converts to American Protestantism. Second, membership was generally exaggerated. Citing Constantine Panunzio, a sociologist and minister, Palmieri noted the tendency of pastors to inflate the size of their congregations, as well as to redundantly report the same children as "attending at least three Sunday-schools; at the proper season, they went to three Christmas trees, three picnics, three entertainments, three outings, three everything." As one minister had even declared, "The Italian work in this city is a big farce." And with less than 6,000 converts from all efforts, another Italian minister concluded that a half-century of "evangelical work" had ended in complete failure.[19]

With his analysis having become a polemic, Palmieri refocused on the "Italian problem" of American Catholicism. He asked why the scant population of Italian Protestants had the freedom and means of supporting their 326 churches and missions, as well as more than 200 pastors, while four million Italian Catholics had only 250 churches and an insignificant number of priests "of their own race." With such inquiry as the first and most necessary step, Palmieri had described Protestant efforts in order to argue for national parishes under Italian speaking priests as the answer to the "Italian problem."[20]

The Nationality Parish

Whether the actual level of apostasy among Italians was great or had only been exaggerated, the "Italian Problem" demanded an answer. And whether defection was due more to anti-clericalism resulting from recent Italian history and brought by immigrants as "cultural baggage," or more to the seductive charms found in America, or even more to the solicitations of Protestants did not essentially matter. After the opening of St. Mary Magdalen de Pazzi in Philadelphia in 1853, nearly thirteen more years lapsed before St. Anthony of Padua, originally founded as a territorial parish in 1859, was reorganized as the first Italian parish in New York City in 1866. Six years later, St. Bonaventure was opened as an Italian parish in St. Louis, but neither well organized or located, only to be closed in 1883. In Chicago, the Church of the Assumption was founded in 1881, the first of twelve Italian parishes to be established in the archdiocese by 1919. By 1913, when De Ville reported on Italian parishes, the Archdiocese of New York already had twenty-six Italian parishes; and similarly Newark had nineteen, Philadelphia and Pittsburgh each had thirteen, Scranton and Trenton each had twelve and Brooklyn had eleven of them. But as Italian parishes continued to proliferate, their actual number, like the size of the Italian Catholic population itself, became an elusive figure, and even "official" sources did not provide reliable information. When the 1922 edition of *The Official Catholic Directory*, for instance, listed numerous Italian parishes and missions in nine archdioceses and twenty-eight dioceses, it failed to identify and include others, which were clearly known from other sources as being "Italian."[21]

At almost the same time, the assessment of the role of the nationality parish cannot be easily separated from claims, as Palmieri asserted, that Italians had remained relatively staunchly affiliated with Catholicism. As early as 1912, Bishop Regis Canevin of Pittsburgh presented demographic data that supported his conclusion that the "leakage" of immigrants from Catholicism had been greatly exaggerated. In 1925, Bishop Gerald Shaughnessy similarly argued that despite some success by Protestants, who had used architectural design

and interior adornment in their churches to simulate the appearance of Catholicism, relatively few Italians had abandoned their original faith. It is difficult to deny the influence of the nationality parish that would endure long after discussion of the "Italian problem" had ended.[22]

The significance of the nationality parish, however, was not to be measured in numbers, but rather in its spiritual and temporal role. On the spiritual level, it allowed immigrants to hear the message of faith in some version of their own language. The sermons, confessions, hymns and even conversations with a priest, as important as anything else, provided guidance, consolation and hope. Whereas no historian or social scientist can know the ultimate results of the supernatural objectives of such forms of communication, it is on the temporal level that religious experience becomes accessible to empirical assessment—and reveals that the nationality parish, wherever established, quickly became much more than simply a house of worship for immigrants. From its inception, whereas denoting that some early residential gathering of Italians had already occurred, other functions can be discerned. For the individual, it undoubtedly facilitated adjustment to a new society by providing continuity with the traditional culture of the Old World. But as a major institutional agency of group life, it anchored and facilitated the growth and transformation of an inchoate population into a more recognizable community. Not within a single Little Italy, but within a network of Little Italies, initially distinct and separated by differences of language and geographical origins, it responded to the exigencies of survival in a hostile environment, as intermarriage, friendship and other forms of association produced a more nationalistic level of cohesion. And not only within the fraternal association, where Ligurian became a "brother" to a native of Molise, or at the bakery where Lucanian bought pastry from the Sicilian, or in the shop where Tuscan sold imported Chianti wine to a Pugliese, but also in the pews of a church shared by all of them together, "*paesani*" redefined and reconstituted themselves more comprehensively in the "urban villages" of American cities than they had in the native towns of their homeland what it meant to be "Italian." And when their priests urged them to rise above regional identities, they were not expressing a wishful fantasy, but a process that had already begun. As intermarriage data in sacramental ledgers unequivocally show, the nationality parish, even when dominated by natives of a particular region, not only reflected this ongoing reality, but served as a catalyst for what would accelerate even more in the future.[23]

Though mediating transition, the nationality parish also signaled the presence of a people who had sought to stake their place to a particular area of a city—as well as within the social structure of a society. By its physical architecture and social life, and even more emphatically its street processions, the nationality parish gave Italians a device by which they marked their boundaries as Catholics and residents of urban America. In short, the Italian parish legitimized a claim that may, at times, have intruded on the space and sensibilities of others. And although giving Italians a church of their own, it also separated them from the Irish who had not especially welcomed them as newcomers, but perhaps providing something that both groups had sought. It was not, however, the only problem that Italians represented.[24]

Popular Piety and Practice

Even when occurring within the confines of their own parish and community, some religious practices of Italians disturbed others who saw themselves as more "proper" Catholics. When Benedictine monks left their monasteries and carried Christianity to the more remote villages of Southern Italy, it had been grafted onto previously existing religions, producing a result in which the veneration of saints disguised earlier polytheism. It has been succinctly noted that "Their folk religion was a syncretic melding of ancient pagan beliefs,

magical practices, and Christian liturgy." When immigrant Italians honored patron saints by fusing cult and occult in colorful street processions and other practices, often with a lingering sense of *campanilismo* that linked them to hometowns, they continued to reflect those origins. But such ceremonies, which appeared to elevate the chosen saint above a Supreme God, were easily perceived as being questionable, if not more pagan, as a Christian act. Practices that seemed to have little connection to the dogmas or polity of "official" Catholicism, but which were deeply rooted in personal psyches and collective history, brought the "cult of the saints," along with its powers of miraculous intercession to the New World. In relocating these traditions from ancestral villages and towns to the streets of American cities, which *paesani* defined as acts of piety, other Catholics saw scandalous displays of superstition.[25]

Another aspect of consciousness—the disdain for the institutional Church and a clergy seen as allied with a ruling class of landlords—allegedly encouraged southern peasants to regard priests, even when relatives or *paesani* of their own village, with familiarity and contempt. But despite being celibates clad in women's garb, making them anomalous in a culture that prized virility, they were respected and feared for their power to exorcize evil spirits and their more routine but indispensable role in administering the sacraments. Such perceptions also accounted for the failure of the *contadini* to regularly meet their obligations—Mass, confession and Holy Communion—so highly regarded by American Catholicism, along with the disparity between men and women in such matters.[26]

The beliefs and practices of immigrants, as Robert Orsi recognized among Italians on the Upper East Side of New York City, had their own legitimacy. Distinguishing the "official" church from their kind of faith, based on deeply held ultimate values and ethical convictions, popular religion gave adherents their own "ground of being," or what really mattered to them. In the *festa* by which their faith was openly expressed rather than enclosed and obscured within a building, Italians challenged priestly control over religion. In the ensuing struggle over an iconic statue and its public celebration, the cult of the Madonna of Mount Carmel emerged as a new source of personal identity and social solidarity, as well as the decisive force in establishing Italian Harlem, while the shrine became more important than the parish.[27]

Irish-Italian conflict was also being recast from an exclusively American setting to a more international context, as Pope Leo XIII, among other motives for granting official recognition to the shrine of Mount Carmel, sought to convince southern Italians that the Vatican cared more about them than the Italian government did. The Holy Father had seized the opportunity to strike against not only against Modernism but an American hierarchy that was not favorably disposed toward Italian immigrants. Further issues also previously ignored—such as the internal anxieties of immigrants and the role of the "domus" as the principal mechanism of control over their lives—have also broadened the perspective on immigrant religious life.[28]

The homage paid to saints by street processions (see Color Plate 27) often created an assumption that southern Italians differed from other immigrants, supposedly reflected by sometimes garish expressions of faith and confirmed by their underdeveloped formation as Catholics. But similar devotions, often manifested in public events, have long been found in northern Italy as well as the Mezzogiorno. And even the Irish practice of faith, the standard to which Italians had been unfavorably compared, had been exaggerated. The work of the Church was often not merely to preserve the faith of immigrants, but often to convert nominal Catholics, which included the Irish, into practicing believers. Whereas what was singularly presented in describing Italians was more of a stereotype than a valid profile of cultural character, it encouraged a faulty comparison that was used to indict them about their alleged failures as Catholics.[29]

Fascism and Faith

The impact of foreign influences upon Italian American Catholicism has also been recognized at a "higher" institutional level in transnational aspects of the "ideology of the Roman Question," that is, the sequestration and loss of temporal power imposed upon the Holy See by victorious nationalist forces in 1870, then the Law of Guarantees in 1871, and maintained until the Lateran Pacts established the Vatican State in 1929. As the Order Sons of Italy in America (OSIA) evolved from what was first feared as a form of Freemasonry at its founding in 1905, the Church, facing an exploding OSIA membership, recognized the organization in 1919, allowed priests to join lodges and embraced it as a "mediating ideology" among immigrants. The rapprochement of Church and state in Italy enabled Fascism to penetrate Italian American Catholicism. Consulate programs supported parishes, schools, hospitals, mass media and religious orders, ostensibly celebrating ethnic nationalism, while co-opting members of the American hierarchy to willingly, conspicuously and enthusiastically salute the movement at public events.[30]

On a more secular level, Italian Fascism used ideology and institutions that promoted ethnic identity and cohesion to implement a policy of "emigrant colonialism" as a means of maintaining influence and control over a far flung people found in ethnic enclaves in distant destinations. The "practical reconciliation," which resolved a previously bitter separation, created a symbiotic relationship first between Liberal Italy, then Fascism, and the Catholic Church. Within this context of collusion, emigration became a missionary field in which *italianità* was manipulated not only to cement fidelity to the Church, but also loyalty to the state. Whether viewed as a matter of religious identity or citizenship, or in terms of immigrants as temporary sojourners who would retain their self-consciousness as Italians in some sense and eventually return to Italy, or as permanent settlers who sought assimilation as Americans, the issue remained unresolved. And the tension between Italian priests who sought a more pluralistic agenda for their congregants and the mainly Irish American clergy who saw cultural assimilation as the only acceptable prescription for immigrants similarly persisted.[31]

But even with its transnational attributes, the arena for the unfolding of Italian American Catholicism in the early twentieth century remained its "nationality parishes." And for the people who found their way to the pews and altars of these churches, it became a time of great transformation. Within their families, a new generation, born in America, increasingly found itself in classrooms, at places of work and in neighborhoods, which inevitably and decisively altered Italians into Americans. At the same time, the Little Italies, which as foreign colonies in urban America had previously disturbed other Americans, were becoming Italian American communities, where physical and social space was often shared with other peoples no longer threatened by their presence. And Italian Fascism, although casting a new shadow of suspicion on churches, under the care of religious orders with headquarters in Rome, which could also serve as conduits of political ideology and influence among Italian Americans, only momentarily interrupted the process. Despite older members of immigrant families stigmatized as "enemy aliens," the massive participation of sons and grandsons in the military forces of the United States during World War II, which confirmed the loyalty of Italian Americans, enabled the matter to be fully resolved and forgotten. Finding opportunities that had formerly moved more gradually, before accelerating during a time of postwar peace and prosperity, Italian Americans reached new levels of educational and occupational achievement that elevated their lifestyles and inducted them into an expanding middle class. But the same mobility threatened to separate them from their earlier sources of Catholic identity and practice.

Religion and Assimilation

Meanwhile, if Italian Protestants, maligned by Catholic newspapers, omitted by a dichotomy that saw only Catholic and anticlerical Italians, and marginalized, if not ignored, their distinctive chapter in Italian American history enhances our understanding of assimilation. Their conversion, more in response to Irish-Italian conflict within Catholicism rather than to Protestant persuasion, required a major alteration of cultural self-understanding. Held with a disdain by Italians themselves that even penetrated the rhetoric of religion, it encouraged the substituting of "evangelical" to assuage the aversion to all things Protestant. Yet, Protestants themselves did not always welcome the results of their efforts, but preferred that converted Italians form their own congregations or even establish new denominations. Identifying and counting Italians as Protestants, especially after entering larger congregations, consequently became difficult. Including Waldensians and other non-Catholics with conversions made after arrival in America, the total appears to have been under-enumerated. Against estimates that never exceeded 21,000 members, Italian Protestants, with 300 churches and missions, reportedly numbered more than 100,000 shortly after World War II.[32]

Despite a diversity that discourages generalizations, Italian Protestantism appears to have encouraged assimilation. By teaching the same hymns first in Italian, then in English, it facilitated literacy so crucial for Americanization. While seeking to retain aspects of traditional culture, except elements of Catholicism, it offered a gradual, balanced course that Charles J. Scalise, himself an Italian Baptist minister as well as a scholar, calls "integrated assimilation." It was emphatically expressed at an early moment by Reverend Charles Brooks, a prominent Baptist:

> While we expect and desire the Americanization of these groups, we do not desire the obliteration or destruction of their unique racial heritage, but invite them to share these gifts with us, as we seek to make our contribution to them.

Protestant efforts also rested on a revision of history that linked immigration to Biblical Christianity, transformed Italians into Puritans, and allowed them to appropriate their own mythology. By negating both traditional Catholicism and atheistic anarchism, Protestant patriotism became a more effective vehicle for cultural and structural assimilation. But Scalise's interpretation ironically provides another sense of how Italian Protestants have become less visible, if not "invisible," by their assimilation as Americans.[33]

Reflecting the course of his own life and career as a distinguished sociologist, William J. Form clarifies how Protestantism encourages assimilation by his research on several denominations. By rejecting Catholicism, the first generation had not only diminished its own bonds with the Italian community but weakened the linkage between ethnicity and religion for the next generation. As Italian Protestants, with their ethnicity subordinated to religion, moved further away from traditional culture and toward more American ways, their assimilation and social mobility accelerated. After sensing the demise of Italian churches as early as 1935, in another decade pastors could redefine their collective failure to "save the second generation" to be a byproduct of individual success.[34]

Though the Protestant part cannot be omitted in the "larger story" of Italian American history, that effort remains in an early stage. Despite recent work by several scholars, the major contribution that would correct this omission has yet to appear. That deficiency stands out when seen against the longer historiography of the Italian American experience. Any attempt to measure the impact of Protestant efforts must reach beyond the record of churches, missions and settlement houses, and even past the assessment of their impact on

assimilation. It should include the often overlooked work of such early writers as Sarah Gertrude Pomeroy, Antonio Mangano, Enrico Sartorio, Constantine M. Panunzio, Philip M. Rose and others who, as ministers of various denominations and social workers, defined immigrant Italians as a special concern of pastoral responsibility and civic action, while also placing them on the agenda of scholarly inquiry. Although each of them recognized the subject in his or her own way, Pomeroy expressed it most directly by her introductory words: "Of all the vast army of aliens who daily pass through the portals of our United States, no one nationality deserves more attention and study than does the Italian."[35]

From seeds planted by earlier writers, more empirically oriented later scholars, such as Form, continued to explore the role of religion in the integration of Italians into American society. For the Catholics who comprise the bulk of that population, though a historical focus may still ask whether the nationality parish facilitated assimilation and social mobility or acted as a hindrance to it, that concern has largely become a moot question. Under the impact of a change with a larger society, the nationality parish could not remain a sufficient reservoir of traditional culture to prevent the assimilation of Italians as Americans. With educational and occupational achievement, social mobility has encouraged later generations of Italian Americans to leave their old neighborhoods and relocate themselves with other Americans in suburbia. At the same time, the social ecology of neighborhoods, once so heavily Italian in residential composition and manifest character, have been altered by the arrival and settlement of other ethnic groups, leaving them far more diverse than they once were. And in some highly disputed cases, public policies that promised the renewal of what were viewed from the outside as deteriorated urban areas, though cherished by residents as their neighborhood, have not served to retain but to displace Italian Americans. Such "progressive" initiatives, which have erased its ecological and cultural base, have also rendered the Italian nationality parish as an expendable entity to ecclesiastical officials.

The Persistence of Tradition

But even while being undermined by assimilation and mobility, as well as by changes to the ecology of neighborhoods, the nationality parish has still not yet become entirely extinct. In the Archdiocese of Philadelphia, where the Italian Mission of St. Mary Magdalen de Pazzi served as the flagship, the pattern among parishes, in contrast to any singular, monolithic trajectory, reflects the diversity that unfolded over the years and persists even at the present time. It includes Our Lady of Good Counsel, arguably the largest of all Italian parishes, which was suppressed, or "dismembered," as it was euphemistically termed by archdiocesan officials, by the controversial and still puzzling action of Cardinal Dennis J. Dougherty in 1933. And after being vigorously protested, first on the streets by indignant demonstrators and then in the courts by earnest but unsuccessful litigants, it lingered as a painful reminder in hearts and minds of devoted members who protested that "He took our church away from us." After another sixty-seven years, it was followed by the termination of St. Mary Magdalen de Pazzi, that venerable pioneer, as a result of neighborhood changes that vitiated its financial viability in 2000. This profile also contains St. Nicholas of Tolentine founded merely to serve as an auxiliary chapel for Our Lady of Good Counsel, which not only survived its "mother church," but now thrives as a vibrant, solvent parish—the last Italian one offering the Italian language at its services, within the city itself. And in an even more surprisingly variation, Our Lady of the Assumption, originally established to serve quarry workers, railroad laborers and estate gardeners and their families, in Strafford, a suburb of the upper Main Line, can also be found. Founded as the eighth Italian parish in the Archdiocese in 1908, the church, redesignated as a territorial parish some forty-seven years later in 1955, also reasserted its

coterminous status as a nationality parish that it continues to exuberantly retain and express at the present time. In some sense, this array of varying outcomes at the organizational level suggests the options that Italian Americans can find at the personal level. Whereas some remaining parishes may be considered equally Catholic, they are clearly no longer, if they ever were, equally "Italian."[36]

Such considerations raise another question: What does it mean to be an Italian American Catholic today? What remains of the doctrinal creed that they held, the cult by which they expressed their faith and the moral code by which they conducted themselves in everyday life—the very matters that once attracted so much concern from ecclesiastical authorities and co-religionists? A previous reflection on this question asked what had become of the religious culture of the *contadini*—or was there any such thing as a distinctive Italian American Catholicism. The so-called Hibernization thesis, offered by some scholars, argued that Italian Americans had become increasingly indistinguishable from Irish Catholics, whereas a dissenting view proposed that they had become rather indifferent toward Catholicism. And as other scholars held that the "cult of the saints," as reflected in the *feste*, had actually persisted with renewed vitality, ethnographic research showed the steady decline of traditional cult beliefs and practices. And other attempts to answer the basic question were similarly contradictory and inconclusive. But that debate was forty years ago.[37]

A more recent effort, drawing upon studies that explored such issues, proposes six principal elements as an answer: (1) the rejection of any sharp distinction between the "sacred" and the profane; (2) an emphasis upon the existential and experiential rather than upon more abstract matters of doctrine; (3) the contouring of religion to the demands, values and relationships of the family; (4) the mediation of religion by personal, concrete, immediate and situational "vehicles"; by affective, spiritual and "of the heart" values; by communal/parochial considerations; and by being lay-centered; (5) a pragmatic and "this-worldly" orientation that lacks any "surrender" to the transcendent; and (6) a view of human nature and social institutions that ranges from anti-utopian realism to an overt cynicism. Beyond a need for clarification, this answer deliberately limits itself as sociology by including a critique from a Catholic perspective, that is, how Italian American Catholicism measures up against the magisterium of "official" Catholicism. For addressing a neglected matter, the effort deserves commendation as an attempt to delineate some sense, even if only offered as hypotheses, of how Italian Americans have appropriated their own form of faith—and how that impinges upon their acceptance and place within institutional Catholicism at the present time.[38]

Attempting to delineate Italian American Catholicism is fraught with the risk of constructing something that becomes a caricature under the guise of a valid sociological profile. And even usually astute observers who draw attention to a prolific presence of candles and statues ignore the fact that such artifacts are generally found in not only Italian but almost all Catholic churches. But what is even more fundamental is that a single, comprehensive and all-encompassing answer may be the wrong goal for scholarly investigation. Religious behavior, as other aspects of Italian American history, is not entirely amenable to generalizations that depict an entire population as a phalanx of simultaneous experience. And as we construct generalizations about human conduct, it remains essential to find the variations that temper and enrich the understanding of our subject.

The limitations of the study of religious behavior and identity, moreover, even more than most areas of human existence, are often reflections of a covert "interior life" that remain largely inaccessible to scholarly efforts. Though we may be able to enumerate how many people claim a certain faith, or to count the number of parishes that are identified with its adherents, or even to measure their frequency of participation in overt ceremonies, religion, like ethnicity itself, remains somewhat elusive to materialist approaches of history and the

social sciences. It is now more than thirty years since an influential sociologist declared that Italian Americans had entered the "twilight of ethnicity," swallowed by assimilation, especially by intermarriage which eradicated their self-identity as well as erased their visibility to other Americans. Other scholars concurred that merely "symbolic ethnicity," the expressing of vestigial traces at family gatherings was all that remained of their almost totally extinguished traditional culture. With heirs of the historic immigration now absorbed within American society, and Catholics among them similarly distributed within mainstream parishes, the "Italian Problem" of the past no longer exists. And today's greatly lessened migration of transnationals, with its core of scientists, scholars and businesspeople, by which America no longer finds itself threatened, is far more likely to be welcomed as contributors to both societies. Yet, efforts to explore Italian American life have not been exhausted. And religious experience, despite its deeply embedded locus, or perhaps because of it, whether as an aspect of a historical past or a persistent part of the present, remains an eminently pursuable challenge.[39]

Further Reading

D'Agostino, Peter R. *Rome in America: Transnational Catholic Ideology from the Risorgimento to Fascism*. Chapel Hill: University of North Carolina Press, 2004.

Juliani, Richard N. *Priest, Parish and People: Saving the Faith in Philadelphia's Little Italy*. Notre Dame: University of Notre Dame Press, 2007.

Orsi, Robert A. *The Madonna of 115th Street: Faith and Community in Italian Harlem, 1880–1950* [1985]. 3rd ed. New Haven: Yale University Press, 2010.

Notes

1 For the history of St. Mary Magdalen de Pazzi, see Richard N. Juliani, *Priest, Parish and People: Saving the Faith in Philadelphia's Little Italy* (Notre Dame: University of Notre Dame Press, 2007).

2 For a more detailed examination of the visit of Archbishop Gaetano Bedini, as well as its significance, see Juliani, *Priest, Parish and People*, 13–15; as well as the same author's earlier work, *Building Little Italy: Philadelphia's Italians before Mass Migration* (University Park: The Pennsylvania State University Press, 1998), 156–164.

3 For Sanguinetti's efforts in New York City, see Jay P. Dolan, *The Immigrant Church: New York's Irish and German Catholics 1815–1865* (Notre Dame: University of Notre Dame Press, 1983), 22–25; and Luciano J. Iorizzo and Salvatore Mondello, *The Italian Americans*, rev. ed. (Boston: Twayne Publishers, 1980), especially, chapter 12, "The Role of the Church in the Lives of Italian Americans," 216–247. For a recent examination of Irish and Italian conflict within Catholicism from 1848–1920, see Paul Moses, *An Unlikely Union: The Love-Hate Story of New York's Irish and Italians* (New York: New York University Press, 2015), particularly 11–70. For the "Buon Irlandesi" in support of the Italian church in Philadelphia, see Juliani, *Priest, Parish and People*, 74–80.

4 The study of the "Italian Problem" begins with Henry J. Browne, "The 'Italian Problem' in the Catholic Church of the United States, 1880–1900," *Historical Records and Studies, United States Catholic Historical Society*, 35 (1946), 46–75. It remains a key source.

5 Bernard J. Lynch, "The Italians in New York," *Catholic World*, 47.277 (April 1888), 67–73.

6 Ibid., 70–1.

7 Ibid., 71–3.

8 Juliani, *Priest, Parish and People*, 166–168.

9 Ibid., 168–171.

10 Ibid., 170–171. For the original formulation of this scheme of parish types, see Silvano Tomasi, *Piety and Power: The Role of the Italian Parishes in the New York Metropolitan Area, 1880–1930* (Staten Island: Center for Migration Studies, 1975).

11 John De Ville, "Italians in the United States," in *The Catholic Encyclopedia*, ed. Charles George Herbermann, 15 vols. (New York: The Encyclopedia Press, 1913), 8: 202–206. Though the details on his life have been gathered from a variety of sources, the most comprehensive summary is provided by Ruth Hutchinson Crocker, *Social Work and Social Order: The Settlement Movement in Two Industrial Cities, 1889–1930* (Urbana: University of Illinois Press, 1992), 171–182.

12 De Ville, "Italians in the United States," 205–206.

13 For a comprehensive study of the work of religious sisters among immigrants and native born Catholics, see Margaret M. McGuinness, *Called to Serve: A History of Nuns in America* (New York: New York University Press, 2013).

14 The list of religious orders that were present and serving at this time is reconstructed from annually published information provided for archdioceses and dioceses. For one such volume, see for example, *The Official Catholic Directory* (New York: P.J. Kenedy & Sons, 1922).

15 For an introduction to the life of Mother Francis Xavier Cabrini, see the website of her order: www.mothercabrini.org/who-we-are/mother-cabrini/. Among several biographies, for a relatively recent one, see Sister Mary Louise Sullivan, *Mother Cabrini: Italian Immigrant of the Century* (New York: Center for Migration Studies, 1993).

16 For an introduction to Mother Ninetta Ionata, see "American Pioneers" under the history tab at the website: www.filippiniusa.org/. For more detailed information, see Sister Margherita Marchione, *The Religious Teachers Filippini in America—Centennial 1910–2010* (Mahwah: The Paulist Press, 2010). For the life and work of Father Aloysius Pozzi and the early history of St. Joachim's Church in Trenton, New Jersey, see the *Trenton (N.J.) Evening Times* for January–September 1910.

17 The quoted tribute to Mother Ninetta at the time of her death is found at the Filippini website.

18 F. Aurelio Palmieri, "Italian Protestantism in the United States," *Catholic World*, 107.638 (May 1918), 177–189.

19 Ibid., 180, 188–189.

20 Ibid., 189.

21 Dolan, *The Immigrant Church*, 22–23; John Rothensteiner, "Catholics from Italy and the Near East," in his *History of the Archdiocese of St. Louis in Its Various Stages of Development from A.D. 1673 to A.D. 1928*, 2 vols. (St. Louis: Blackwell Wielandy, 1928), 2: 681–683; Humbert S. Nelli, *Italians in Chicago 1880–1930: A Study in Ethnic Mobility* (New York: Oxford University Press, 1970), 29–31, 189–191; De Ville, "Italians in the United States," 205–6; *The Official Catholic Directory* (New York: P.J. Kenedy & Sons, 1922).

22 Rt. Rev. Regis Canevin, *An Examination, Historical and Statistical, into Losses and Gains of the Catholic Church in the United States from 1790 to 1910* ([Pittsburgh]: n. pub., 1912), 13–19; Gerald Shaughnessy, *Has the Immigrant Kept the Faith* (New York: MacMillan, 1925). See also the invaluable examination by Rudolph J. Vecoli, "Prelates and Peasants: Italian Immigrants and the Catholic Church," *Journal of Social History*, 2 (Spring 1969), 217–268.

23 For the functions of a parish for an immigrant people, see Juliani, *Priest, Parish and People*, 309–324. For the fusion of immigrants, and transformation of the "*paesani*" concept, from localistic identity and cohesion to a more nationalistic level, see Richard N. Juliani, *The Social Organization of Immigration: The Italians in Philadelphia* (New York: Arno Press, 1980). This process, earlier described in the author's doctoral dissertation in 1971, has been reaffirmed by its "rediscovery" by later writers who, conveniently forgetting where it was first found, fail to observe scholarly protocols of attribution to the original source. For intermarriages uniting partners from different parts of Italy, but for a later period, see Nelli, *Italians in Chicago*, 195–196.

24 Juliani, *Priest, Parish and People*, 311–313.

25 Rudolph J. Vecoli, "Cult and Occult in Italian American Culture: The Persistence of a Religious Heritage," in *Immigrants and Religion in Urban America*, ed. Randall M. Miller and Thomas D. Marzik (Philadelphia: Temple University Press, 1980), 26–27.

26 Vecoli, "Cult and Occult," 27.

27 Robert A. Orsi, *The Madonna of 115th Street: Faith and Community in Italian Harlem, 1880–1950* [1985], 3rd ed. (New Haven: Yale University Press, 2010).

28 Orsi, *The Madonna*, 62–64, 75–149, 150–162. See also Joseph Sciorra, *Built with Faith: Italian American Imagination and Catholic Material Culture in New York City* (Knoxville: University of Tennessee Press, 2015).

29 Michael P. Carroll, *Madonnas That Maim: Popular Catholicism in Italy since the Fifthteenth Century* (Baltimore: Johns Hopkins University Press, 1992); and Carroll, *Veiled Threats: The Logic of Popular Catholicism in Italy* (Baltimore: Johns Hopkins University Press, 1996). For an authoritative Italian source and perspective on the same issues, see Gabriele De Rosa, *Chiesa e religione popolare nel Mezzogiorno* (Rome-Bari: Laterza, 1978).

30 Peter R. D'Agostino, *Rome in America: Transnational Catholic Ideology from the Risorgimento to Fascism* (Chapel Hill: University of North Carolina Press, 2004).

31 Mark I. Choate, *Emigrant Nation: The Making of Italy Abroad* (Cambridge: Harvard University Press, 2008), especially chapter 5, "For Religion and the Fatherland," 129–146.

32 Charles J. Scalise, "Retrieving the 'WIPS': Exploring the Assimilation of White Italian Protestants in America," *Italian Americana*, 24.2 (Summer 2006), 133–146.

33 Ibid., 142.

34 William Form, "Italian Protestants: Religion, Ethnicity, and Assimilation," *Journal for the Scientific Study of Religion*, 39.3 (September 2000), 307–320.

35 Antonio Mangano, *Sons of Italy: A Social and Religious Study of the Italians in America* (New York: Missionary Education Movement of the United States and Canada, 1917); Enrico C. Sartorio, *Social and Religious Life of Italians in America* (Boston: Christopher Publishing House, 1918); Philip M. Rose, *The Italians in America* (New York: George H. Doran Company, 1922); Constantine M. Panunzio, *The Soul of an Immigrant* (New York: The Macmillan Company, 1924); and Sarah Gertrude Pomeroy, *The Italians: A Study of the Countrymen of Columbus, Dante and Michael Angelo* (New York: Fleming H. Revell Company, 1914). Pomeroy's remark is found on page 9.

36 Juliani, *Priest, Parish and People*, 317–324.

37 Vecoli, "Cult and Occult," 37–41.

38 Joseph A. Varacalli, "Catholicism, Italian Style: A Reflection on the Relationship Between the Catholic and Italian Worldviews," in *Models and Images of Catholicism in Italian Americana: Academy and Society*, eds. Varacalli, Salvatore Primeggia, Salvatore LaGumina and Donald J. D'Elia (Stony Brook: Forum Italicum, 2004), 110–124.

39 For his important argument, cited here, see: Richard D. Alba, *Italian Americans: Into the Twilight of Ethnicity* (Englewood Cliffs: Prentice-Hall, Inc., 1985).

12

ITALIAN AMERICANS AND RACE DURING THE ERA OF MASS IMMIGRATION

Peter G. Vellon

In April 1924, A.L. Adee, a successful furniture maker located in Vancouver, Washington, wrote Congressman Albert Johnson, cosponsor, along with Senator David Reed, of the Immigration Act of 1924. In a brief letter of support for Johnson's restrictive efforts, Mr. Adee declared that the United States had "acted as a garbage Dump for Europe long enough I should think" and "I say let's quit." Adee concluded his diatribe by warning that if unfettered immigration should continue, southern Italians, in particular, posed the most dangerous threat to America. Imagining an America with increasing numbers of southern Italian immigrants, Adee resentfully exclaimed he would have "to take orders from a Dago."[1] During the late nineteenth and early twentieth centuries fear, mistrust and downright scorn of the southern Italian immigrant remained prevalent throughout the United States. During this period, the issue of mass immigration, predominantly from southern and eastern Europe, provoked consistent debate and exasperation over what kind of country America should strive to be. Although immigrants received support from many who felt their contributions outweighed their shortcomings, by 1924 longtime advocates of immigration restriction would eventually win the day. A primary factor in the push to halt the continued influx of southern Italians revolved around race.

In an article published in the influential *North American Review*, under the title, "The Future of American Ideals," Prescott Hall, one of the leading voices for immigration restriction and, along with fellow Harvard graduates Robert Ward and Charles Warren, one of the founders in 1894 of the Immigration Restriction league, worriedly asked "is there, indeed, a danger that the race which has made our country great will pass away...?"[2] With the influx of hundreds of thousands of Italian immigrants, predominantly from southern Italy, arriving each year at the turn of the twentieth century, the nature of how Americans discussed immigration and race was transformed. This very public debate initiated an often intense and impassioned discussion of, not only *who* could be an American, but for many, *whether* the United States would cease to exist as a racially pure society. During this period, the category of "race" assumed myriad cultural and biological undertones that today one might file instead under the heading of ethnicity or nationality. As one historian has noted, "in the early twentieth century race and ethnicity were not firmly separated into distinct concepts, and indeed the latter term was scarcely used."[3] Historians, specifically those working within the field of whiteness studies in the past thirty years have increasingly focused upon how race and color proved instrumental in the process of immigration to the United States. Their work reminds us "that the history of European immigration has a central place in the story of how race and white supremacy survived US history."[4] The category of race cannot be viewed through our current concept of race, but must be analyzed as a social construct that has changed, mutated

and been reworked over time. One influential historical work asserts that the immigration saga has to be "recast as a racial odyssey" and delineates how whiteness became fractured into a hierarchy of scientifically and sociopolitically determined white "races" during the period of mass immigration in the mid to late nineteenth and early twentieth century.

Further, the author argues that contemporaries did not see "ethnicity" when discussing official categories such as Anglo-Saxons, Celts, Mediterraneans, Hebrews, Slavs, Alpines and Nordics, but rather distinct "races" ranked according to their perceived proximity to whiteness. Therefore, an immigrant might be considered white, yet at the same time be perceived as racially distinct from other whites.[5] Complicating the simple "white-black" dichotomy of some whiteness studies, this particular work cautions that to "miss the fluidity of race itself in the process of becoming Caucasian is to reify a monolithic whiteness, and, further, to cordon that whiteness off from other racial groupings along lines that are silently presumed to be more genuine."[6]

Italian Immigrant "In-betweenness"

For contemporaries, what set southern and eastern Europeans apart from those Europeans who had preceded them had to do with their biological traits; physical features, including skin hue; cultural mores; religious customs; economic position; political values and more. Often this messy hodgepodge of characteristics came under the catchall heading of race. With the spreading influence of eugenics in the post–Civil War period, everyone from scholars, anthropologists, politicians and armchair classificationists traded in the currency of racially distinct hierarchies of classification. For Italian immigrants coming from post-unification Italy, the stigma of separate and inferior racial status already dogged those from the Mezzogiorno—the Italian "South." Perceived as a pressing social and political "problem" in Italy, the southern regions, including Sicily, occupied an image of "otherness" that stood in perceptual contrast to the more modern, industrializing northern regions. Northerners came to perceive Southerners as primitive, indolent and habitually inclined to crime and vice. Furthering this perception was the history of racial intermixing with nearby Africa. For example, writing in 1806, French author, Creuze de Lesser stated that "Europe ends at Naples and ends badly. Calabria, Sicily and all the rest belong to Africa."[7] In addition, the work of noted anthropologists and criminologists such as Cesare Lombroso, Giuseppe Sergi and Alfredo Niceforo gave the imprimatur of scientific and scholarly support to racial and biological explanations for alleged southern Italian savagery and backwardness.

Indeed, the impact of the new nation-state's construction of Southerners greatly impacted and neatly aligned with concurrent racial classifications in the United States. During the late nineteenth and early twentieth centuries, a period often defined as the era of mass immigration, approximately twenty-six million immigrants entered the United States. Coming from all over the world, eastern, central and southern Europeans comprised a major proportion of those who arrived. Fleeing religious and economic persecution, immigrants from Russia, Poland and Italy, entered the country in droves, settled predominantly in expanding urban areas, and, in the age of flash photography, became highly visible symbols of a rapidly changing American society.

Perceived by many Americans as vastly different, and inferior, to those immigrants who hailed from more northern and western European countries, southern and eastern Europeans arrived with different languages, religions and political ideologies, and often slid into the most menial, stigmatized jobs in the expanding industrial economy. By 1907 the United States Congress funded an investigation and commissioned an inquiry more commonly

known as the Dillingham Commission. Chaired by Senator William Dillingham of Vermont, the Commission did work that cost taxpayers nearly one million dollars, publishing its findings in 1911 in forty-one volumes. The Commission delineated stark differences between northern and western Europeans (labeled old immigrants) and southern and eastern Europeans (labeled new immigrants). Its conclusions were clear: This "new" stream of immigrant would prove more difficult to assimilate than the "old" immigrant stock contemporaneously labeled as Nordic, Anglo-Saxon, Teutonic and, by 1911, even Celt. According to the Commission, "The new immigration, coming in such large numbers, has provoked a widespread feeling of apprehension as to its effects on the economic and social welfare of the country."[8] Embodying the prevailing scientific consensus of the period, the Commission delineated some forty-five different races or peoples then immigrating to the United States and produced a volume admittedly aimed at the "student of immigration," rather than the ethnologist.[9] In other words, the Commission's findings did not purport to offer new scientific information or analysis, but rather they summarized the science of race as it existed at the time, replete with contemporary biases and stereotypes. The commission thus followed a classification system developed in the 1790s by the German physiologist, Johann Friedrich Blumenbach, common in the American "school geographies" of the 1800s, that distinguished among five "great races": "the Caucasian, Ethiopian, Mongolian, Malay, and American, or, as familiarly called, the white, black, yellow, brown, and red races."[10] The Commission's conflation of "race" and "color" spoke to the intimate connection between those two categories, as well as the facile, and often sloppy, manner in which people constructed race during this period.

Although Italians benefited from a 1790 immigration law allowing "free white persons" to legally enter the United States and naturalize, as citizens, southern Italian immigrants often occupied an in-between racial position during this period. Racially set apart, and deemed inferior, from northern and western European immigrants, Americans consistently questioned southern Italian racial and color status. Relying upon the Italian anthropologists Sergi and Niceforo, the Dillingham Commission neatly separated the Italian "race" into "northern" and "southern," declaring that "these two groups differ from each other materially in language, physique, and character."[11] Owing to the transnational nature of these racial ideas, the Commission tapped into the "southern problem" and detailed the many inherent physical and emotional racial differences separating the north and south Italian. In its "Dictionary of Races or Peoples," it explicitly maintained that the Italian race was not homogenous:

> The North is inhabited by a very broad-headed ("alpine") and tallish race. . .; all of Italy South of the Apennines and all of the adjacent islands are occupied by a long-headed, dark, "Mediterranean" race of short stature. This is the South Italian supposed to be descended from the ancient Ligurians of Italy, and closely related to the Iberians of Spain and Berbers of northern Africa.[12]

Instrumental in maintaining that southern Italians possessed unique racial attributes separating them from their northern counterparts was demonstrating a blood connection to Africa. The Dillingham Commission report quoted "the foremost Italian ethnologist" Giuseppe Sergi who theorized that southern Italians owed their origin to the Hamitic stock of northern Africa. (The term "Hamitic" was adapted from the Biblical story [Genesis 9:20–27, 10:6–14] of Noah's son, Ham, some of whose descendants settled in Africa). "It must be remembered," wrote Sergi, "that the Hamites are not Negritic or true African, although

there may be some traces of an infusion of African blood in this stock in certain communities of Sicily and Sardinia, as well as in northern Africa. However, the report maintained that members of the Hamitic stock "would be taken by travelers to be Negroes."[13]

In his *North American Review* article of 1912, Prescott Hall lamented the arrival of so many immigrants who, in terms of racial makeup, radically deviated from what he described as a "fairly definite American type" embodied by "English civilization," the "Teutonic race," and "Northern Europe." Southern Italians, in particular, explained Hall, possessed so many of the racial attributes that hindered their assimilation into society and, by virtue of their increasing immigration, threatened the very fabric of American society. Hall warned that "the South Italian, which constitutes the largest element in our present immigration, is one of the most mixed races in Europe, and is partly African, owing to the Negroid migration from Carthage to Italy." Informing this threat, according to Hall, was the fear that the "American" race would become mongrelized by the possible miscegenation between lesser, darker races. Unlike "old" immigrants who comprised Hall's preferred American type, this influx of "darker races" would not abide by existing racial norms. Only due to "insurmountable prejudice" against the "black races" have the Teutonics managed to keep intact and pure the dominant race, Hall argued. However, unlike the past,

> [W]hat would happen if a large Mediterranean population should be colonized in our southern states and should interbreed with the negro population. . .? will the descendants of the emotional, fiery Italians submit to the social judgment that a man with a sixteenth or a thirty-second part of negro blood is a colored man who must occupy a position socially, if not politically, inferior?[14]

For many Americans, southern Italians posed a threat to American society specifically due to their questionable race and color, or more broadly, because of their ascribed in-between status. Although their marked difference from northern Europeans in language, culture, religion and economic status remained integral to their debased status, much of these categories often fell within the complicated, fluid and messy category of race and color. Examining illustrations in contemporary journals, one can discern the popular perception of Italian immigrants during this period.

For example, a cartoon captioned "Where the Blame Lies," from *Judge* magazine in 1891, shows swarthy, bearded immigrants who bring with them "Anarchism, Socialism, the Mafia and such kindred evils." (See Figure 12.1.) Eighteen years later, when a similar cartoon titled "Fooled Pied Piper" was published in *Puck* magazine, Italian immigrants were still being targeted as rats: subhuman, undesirable, dangerous and subversive. (See Color Plate 8.)

Although recent scholars have grown accustomed to using the term "in-between" to describe Italian racial status in America, the concept was already being used in the contemporary press of the 1890s.[15] An 1899 headline in a New York newspaper read: "Italians in Louisiana: Lynch Law Applied to Italians Alone Among White Men Because They Are Classed Somewhere Between White Men and Negroes." The newspaper theorized that the southern Italian "is as it were a link connecting the white and black races. Swarthy in color the Sicilians are darker than the griffes and quadroons, the Negro half-breeds of southern Louisiana."[16] A popular contemporary work of fiction, revolving around the 1891 lynching of Italians in New Orleans, offered its observation about the essential racial character of Sicilians: "the Sicilian have always been the most bloody-minded and revengeful of the Mediterranean races. . . . These traits are probably owing to their saracen origin."[17]

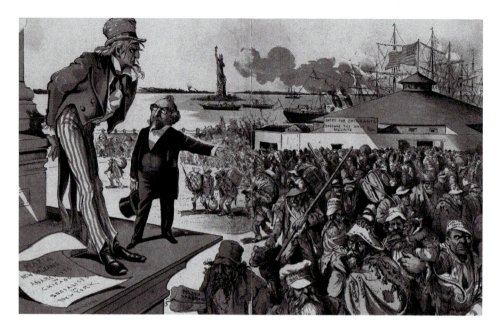

Figure 12.1 "Where the Blame Lies." A cartoon by Grant E. Hamilton, published in the magazine *Judge* (4 April 1891), 458–459. Courtesy of Library of Congress Prints and Photographs Division, LC-USZC4–5739.

Lynching and Italian Immigrants

Perhaps no greater example of the precarious racial position occupied by southern Italians was their victimization at the hands of lynch mobs, most notably in the American South. In the eyes of native whites, the Italian immigrant in the South was a racial enigma. In many cases recruited to "replace" black labor because of "superior" skills, Italians were looked upon with suspicion because of their apparent racial characteristics. Perceived as nonwhite, or "in-between" white and black, Italian immigrants strengthened this perception by their social and economic association with African Americans. It was this nonwhite status that would, at times "license" white Southerners to utilize the racial tool of lynching as they had so often with African Americans. The presence of lynching as an extralegal form of summary justice did not reside solely in the South however, but its proportion and significance remained unmatched outside of the South. The percentage of lynching that occurred in the South as compared with other regions increased with each decade after the Civil War, from 82 percent of all lynching during the 1880s to more than 95 percent during the 1920s. Since lynching deaths were initially recorded in 1882, 85 percent of all victims in the South were black. These percentages are certainly higher in light of all the lynching that went unreported.[18]

The most notorious lynching of Italians occurred in New Orleans, Louisiana, on 14 March 1891. Labeled by one scholar as the largest mass lynching in U.S. history, the killings occurred after nine of the nineteen Italians indicted for the murder of New Orleans Police Chief, David Hennessy, had faced trial and been found not guilty through acquittal or mistrial.[19] Occurring amidst an ongoing business rivalry between the Mantranga and Provenzano families, Hennessy was shot on 15 October 1890 by unknown assailants and died the next day. When asked who had shot him Hennessy reportedly stated it was the "dagoes." With fears of Italian organized crime rampant, local authorities rounded up suspects simply

for being Italian. Eventually nineteen Italians would be indicted for Hennessy's murder with the first nine standing trial in February 1891. By mid-March 1891, a jury acquitted six and declared a mistrial for three prompting feelings of revenge across the city of New Orleans. Incited by local newspapers, as well as local leaders, a mob gathered and headed toward the jail where the Italians, including the nine declared not guilty, were being held. In a horrific display of organized vigilantism, on 14 March the mob stormed the jail and proceeded to shoot, beat, and hang eleven of the nineteen Italians. Despite this gross miscarriage of justice and law, local New Orleans newspapers responded with outright approval. Even *The New York Times* responded to the murders with grudging acceptance stating that there could be no doubt "that the mob's victims were desperate ruffians and murderers" and referred to the victims as "sneaking and cowardly Sicilians, the descendants of bandits and assassins." The editorial concluded "lynch law was the only course open to the people of New-Orleans to stay the issue of a new license to the Mafia to continue its bloody practices."[20]

Aside from the lynching of eleven Italian immigrants in New Orleans in 1891, there was a long pattern of violence against Italians. In the 1890s alone, five other lynchings of Italian immigrants occurred in various states. Including 1891, there were three in Louisiana, one in West Virginia and two in Colorado; in Mississippi there were lynchings in 1886 and 1901; one in Arkansas in 1901; one in Florida in 1910; and two in Illinois in 1914 and 1915. In total, forty-six Italians were murdered at the hands of lynch mobs. When Castenge Ficarrotta and Angelo Albano were lynched in Tampa in 1910, a pipe was stuck in Ficarrotta's mouth. (See Photo Essay no. 9.)[21]

Italian immigrants reacted harshly to the sight of their *connazionali* murdered in cold blood. Italian language newspapers gave front-page coverage, not only to the notorious 1891 New Orleans lynching, but also to those that followed in Louisiana, Mississippi and elsewhere. Newspapers, such as New York's *Il Progresso Italo-Americano* [The Italian-American Progress], wondered how a country that pretended to be at the vanguard of civilization could act so barbarously. Italian immigrants must have been horrified to see Italians suffering a form of racial murder usually reserved for African Americans. Writing to *Il Progresso* in response to the New Orleans lynching of eleven Italian immigrants, a person by the name of Marchese from Massachusetts wondered how such an atrocity could occur in an allegedly civilized nation. Another Italian, Alberto Dini, wrote to the *Cristoforo Colombo*, another Italian language daily in New York City, to declare "not even the savage population of Central Africa would approve of such a disgraceful action."[22]

Frequent comparisons to African Americans and observations of a swarthy skin color meant to stigmatize southern Italian immigrants permeated American society during this period. Although Italian immigrants suffered discrimination, they did not fall victim to the rigid, institutional, and legal forms of racism suffered by African Americans. To that end, there never existed a policy of Jim Crow segregation directed toward Italians.[23] Nevertheless, because of the American racial dynamic of white over black, comparisons to African Americans, with respect to the type of labor or where one lived, often served as a temporary scar on the status of "in-between" immigrants. For Italian immigrants, the horrific act of lynching became the most graphic manifestation of how the lines between white and black often became blurred for those deemed "not quite white."

The Racial Foundations of Immigration Restriction

Notwithstanding these horrific acts of violence, Italian immigrants continued arriving in record numbers, with as many as 285,731 Italians immigrating to the United States in 1907 alone. However, with the increasing number of southern and eastern European immigrants,

restrictionist voices grew louder. Opposed to immigrants perceived as unfit to assimilate successfully into their version of a WASP worldview, increasing attempts to disrupt the flow of Italians, in particular, echoed throughout the country. Buoyed by the work of the Dillingham Commission, whose report concluded there existed a distinct cultural and racial difference between what they described as the new immigrants and old immigrants, restrictionists ramped up their effort to cut off the flow of undesirables. For instance, a letter from Samuel High, president of the Patriotic Order Sons of America in New Jersey, to his congressman, Representative Walter McCoy in 1912, emphatically addressed this viewpoint. High explained that "the majority of them (immigrants) do not know how to read or write even their own name in the language of the country in which they were born," and "do not come here with the same purpose in view as did the good immigrant, [the] Germans, Irish, Scotch and Danes of twenty or thirty years ago."[24]

However, with the Dillingham Commission reports published in 1911, followed shortly thereafter by the hyper-nationalism and patriotism unleashed by American entry into World War I, the existing suspicions of hyphenated Americans only intensified. At times resembling a crusade, "Americanization" campaigns professed to coin Americans rapidly by eliminating hints of foreignness. On the federal level, a director of Americanization was appointed in the Bureau of Education at the Department of the Interior, and in 1914 the Bureau began its work of providing English language classes for immigrants. The new department for Americanization appointed racial advisers in order to more fully understand the immigrant races, to foster a better relationship among them and to further the educational aspects of Americanization. The Bureau issued a monthly bulletin—*Americanization*—targeted to an audience labeled "the workers of the country." In a memorandum entitled "What Is Americanization?" in 1917, Philander P. Claxton, the commissioner of education, stressed the importance of schooling as the vehicle through which the tenets of Americanization could be channeled to the immigrant masses:

> Americanization is a process of education, of winning the mind and heart through instruction and enlightenment. From the very nature of the thing it can make little or no use of force. It must depend rather on the attractive power and the sweet reasonableness of the thing itself.[25]

With American entry into the war in 1917, President Wilson officially sanctioned patriotic vigilance by signing into law the Espionage and Sedition Acts—the most repressive legislation with respect to civil rights since the Alien and Sedition Acts of 1798. Heightened by fear of the revolution in Russia, the Espionage and Sedition Acts provided the context for the ensuing government sponsored Red Scare of 1919 and 1920.[26] World War I became the catalyst for accelerating longstanding nativist and anti-hyphenate feelings into a tangible attempt to alter what was perceived as the changing "fabric and texture" of American society.[27] According to one scholar, Americans conflated conceptions of democratic society and Anglicization:

> The country which had received all the European nationalities, as well as the Chinese, Japanese, and Negroes, was offered another, higher image of the American: Anglo-Saxon in coloring, lineaments, and physique; Protestant in religion; masterly in nation-building.[28]

Frances Kellor, the editor of the New York magazine, *The Immigrants in America Review*, summarized the central goal of the Americanization movement as the creation of "one people in

ideals, rights and privileges." Throughout 1917 and 1918, city and state governments organized and initiated campaigns to further the process of Americanization for new immigrants. Many Americans, such as A.L. Sanders of Brooklyn, New York, a self-described "wife and mother of good American men" intensified their support for immigration restriction, writing that the "country must be kept clean which it cannot be if we allow the riff raff of other countries to come here."[29] One contemporary observer commented that World War I

> awakened Americans to the danger that threatened our country in the existence here of a group of citizens whose allegiance is divided, or at least not thoroughly "Americanized." . . . We took it for granted that that the newcomers were being assimilated, that they were rapidly being converted into loyal Americans. The war, however, taught us that they were not.[30]

Americans began to demand "100 percent Americanism" from residents and noncitizens, as well as an unyielding loyalty and patriotism to the American cause in the war. In 1915, for instance, Kellor stressed the need for a conscientious effort to "forge the people in this country into an American race" that would be loyal to the United States in times of war and peace. Given the heterogeneity of races delineated at this time, the use of the term "American race" speaks to a narrow construction of who could become American. Resembling a crusade, Americanization drives and policy resounded from grassroots organizations all the way up to the federal government. Patriot leagues and organizations reminiscent to the Sons of Liberty during the Revolutionary period enforced and maintained loyalty to the cause. Groups such as the National Security League, the American Defense Society and the American Protective League sought to root out subversives and radical agitators and anyone else who spoke out against the American role in the war.

In many ways, English literacy drives were the centerpiece of these campaigns. Literacy tests aimed at stemming the flow of "new" immigrants had been a staple of those nativists intent at restriction. Alarmed by millions of foreign language speakers flooding American cities and concomitant images of seemingly foreign oases like the Lower East Side of Manhattan, language became an important marker stigmatizing those deemed incapable of assimilating. Although Congress passed literacy test legislation in 1896, 1909, 1913, 1915 and 1917, various presidents vetoed each bill. By 1917, however, gripped by wartime hysteria and informed by data revealing that immigrants overwhelmingly comprised a majority of the 700,000 illiterate [in English] draftees, Congress overrode President Woodrow Wilson's veto and enacted the first Literacy Test exclusion.[31]

During the height of the postwar recession, massive strike waves swept through the country. Sensationalized by business leaders and newspapers as the work of Bolsheviks subversively working to destroy American society, many immigrants, Italians in particular, came under even more intense scrutiny. For Italian immigrants with radical political leanings, the message of persecution, detention and deportation—even execution—made it stridently clear that continued agitation would be met by the full weight of the American government. The suppression of radical newspapers and journals, the deportation of prominent anarchists such as Luigi Galleani, and the mysterious death of anarchist Alfredo Salsedo—charged with the Wall Street bombing of 1920—marked the height of the Red Scare. Indeed, the suspicion and suppression of those with radical sympathies and ideologies continued past the Red Scare of 1919–1920 with the "legal" execution of Sacco and Vanzetti in 1927. Italian immigrants's connection to radical working-class movements and worker militancy during the postwar period served to taper the support of many progressives and pro-capitalists who, for their own motives, had not vocally supported immigration restriction.

By the early 1920s, efforts intent on fulfilling the goals of restrictionists, as well as the recommendations of the Dillingham Commission, would soon emerge as national-origins-based immigration legislation found an opportune political environment. At the core of the Immigration Act of 1924, more commonly known as the Johnson-Reed Act, named after the bill's sponsors in the House and Senate, Albert Johnson and David Reed, remained the explicit role of race. One of the leading advocates of immigration restriction based upon national origins was prominent eugenicist Dr. Harry Laughlin who served as an expert adviser to the House Committee on Immigration. Laughlin explained the racial premise behind the law when he stated,

> after we determine what the American race is, and the biological components of it in the proper proportion, then our immigration policy should be to recruit each element of these races, and only to bring in such individuals of personal qualities and good family stock qualities whose progeny will improve the natural talents, the emotions, instinct, quality of the American people.[32]

Passed in 1921 and amended in 1924, quotas based upon national origins effectively cut off the flow of "new" immigrants from eastern and southern Europe. In addition, the legislation barred the admission of any alien who, according to existing law, was ineligible for citizenship, effectively banning immigration from Japan. And, despite the arrival of Italian immigrants for more than three decades, the debate over the proposed restrictions reflected the ongoing deliberation about southern Italian racial status. Both supporters and opponents of the quota laws maintained the intimate connection between race, color and national origins.

Writing to his local Congressman in New York, Joseph Gladstone expressed his opposition to the bill because "such racial legislation" was a "sacred violation of the divine spirit of America." Gladstone continued that the legislation "is a false declaration of racial propaganda and can only result in a racial consciousness in this country that means a repetition of the centuries of European racial hatreds."[33]

The reaction of many Italian immigrants living in the United States to the national origins quotas revealed an evolving consciousness informed by American racial socialization. By the 1920s, Italian immigrant opposition to immigration restriction was not so much directed at restriction in particular, but rather that southern Italians became profiled and targeted. For example, according to the editor of *Il Popolo*, an Italian language daily newspaper in New York City, immigration needed to be restricted to some degree. However, outraged that the legislation explicitly turned on the alleged racial differences between northern and southern Italians, the editor stated that "there should be formulated an adequate method for the selection of new-comers," but it should not be based upon "race discrimination."[34] It has been argued that "the form taken by implementation of the 1924 legislation ensured that the racially excluded 'new immigrant' groups would remain in some sense 'inbetween'. . . . Even at the low point of their racialization, the new immigrants remained inbetween, or 'conditionally white.'"[35]

Over time, the quota laws, along with the arriving global economic depression and World War II, effectively closed the doors to mass immigration from Italy. As a consequence, by the 1930s, the racial in-betweeness of once questionable southern Italians began to give way to a more inclusive ethnic difference. To that end, changing notions of race and color, along with evolving historical events, placed Italians as part of a newly defined and celebrated white, ethnic backbone of America. Despite the attractiveness of this version of Italian immigrant history to many, it is a version that cannot be recounted without including the vital, and

often, uncomfortable, role of race and color in the lives of southern Italian immigrants and their children during the era of mass immigration.

Further Reading

Guglielmo, Thomas A. *White on Arrival: Italians, Race, Color, and Power in Chicago, 1890–1945*. New York: Oxford University Press, 2003.

Jacobson, Matthew Frye. *Whiteness of a Different Color: European Immigrants and the Alchemy of Race*. Cambridge: Harvard University Press, 1998.

Roediger, David. *Working Toward Whiteness: How America's Immigrants Became White*. New York: Basic Books, 2005.

Vellon, Peter G. *A Great Conspiracy Against Our Race: Italian Immigrant Newspapers and the Construction of Whiteness in the Early 20th Century*. New York: New York University Press, 2014.

Notes

1 Letter from A.L. Adee to Albert Johnson, 1 April 1924, in National Archives, Washington DC, RG 233, 68th Congress. Petitions and Memorials. Committee on Immigration and Naturalization. HR 68A-H6.1. HR 6540-101. Box 376, HM FY95.

2 Prescott F. Hall, "The Future of American Ideals," *The North American Review*, 195.674 (January 1912), 94–102.

3 David R. Roediger, *How Race Survived U.S. History: From Settlement and Slavery to the Obama Phenomenon* (London: Verso, 2008), 138.

4 Ibid., 139.

5 Matthew Frye Jacobson, *Whiteness of a Different Color: European Immigrants and the Alchemy of Race* (Cambridge: Harvard University Press, 1998), 13.

6 Ibid., 6–7.

7 M. Creuze de Lesser, *Voyage en Italie et en Sicile* (Paris: L'Imprimerie de P. Didot L'Aíné, 1806).

8 The United States Immigration Commission: Brief Statement of the Conclusions and Recommendations of the Immigration Commission, with Views of the Minority, Senate, 61st Congress, 3rd Session, Document No. 783 (Washington DC: Government Printing Office, 1911), 16.

9 United States Immigration Commission: Dictionary of Races or Peoples, prepared for the Commission by Daniel Folkmar, assisted by Elnora C. Folkmar. Senate document—United States Congress, 61st, 3rd Session (Washington DC: Government Printing Office, 1911), 3.

10 Ibid.

11 Ibid., 81.

12 Ibid., 82.

13 Ibid.

14 Hall, "The Future," 94, 95, 99.

15 For work that focuses upon the "in-betweenness" of European immigrants see David R. Roediger and James Barrett, "Inbetween Peoples: Race, Nationality and the 'New Immigrant' Working Class," *Journal of American Ethnic History*, 16 (1997), 3–44; George E. Cunningham, "The Italian, A Hindrance to White Solidarity. 1890–1898," *Journal of Negro History*, 50 (1965), 22–36; Jean A. Scarpaci, *Italian Immigration in Louisiana's Sugar Parishes: Recruitment, Labor Conditions and Community Relations, 1880–1910* (New York: Arno Press, 1980); Scarpaci, "A Tale of Selective Accommodation: Sicilians and Native Whites in Louisiana," *Journal of Ethnic Studies*, 5 (1997), 37–50; Robert Orsi, "The Religious Boundaries of an Inbetween People: Street Feste and the Problem of the Dark-Skinned Other in Italian Harlem, 1920–1990," *American Quarterly*, 44 (1992), 313–347; John Higham, *Strangers in the Land: Patterns of American Nativism, 1860–1925* [1955], rev. ed. (New Brunswick: Rutgers University Press, 2002), especially 169; Ernesto Milani, "Marchigiani and Veneti on Sunny Side Plantation," in *Italian Immigrants in Rural and Small Town America*, ed. Rudolph Vecoli (New York: AIHA, 1987), 18–30; Vecoli, "Are Italian Americans Just White Folks?" *Italian Americana*, 13 (1995), 149–161.

16 *The New York Sun* (4 August 1899).

17 Jacobson, *Whiteness*, 61.

18 Colin A. Palmer, *Passageways: An Interpretive History of Black America*, 2 vols. (New York: Harcourt Brace, 1998), 1: 109–110.

19 See Richard Gambino, *Vendetta: A True Story of the Worst Lynching in America, the Mass Murder of Italian-Americans in New Orleans in 1891, the Vicious Motivations Behind It, and the Tragic Repercussions that Linger to this Day* (New York: Doubleday, 1977).

20 *New York Times* (16 March 1891).

21 Stefano Luconi, "Tampa's 1910 Lynching: The Italian-American Perspective and Its Implications," *Florida Historical Quarterly*, 88.1 (Summer 2009), 30–53. "Castenge" was probably a form of Castenzio or Costanzo.

22 *Il Progresso* (16 March 1891); *Cristoforo Colombo* (18 March 1891).

23 See Thomas A. Guglielmo, *White on Arrival: Italians, Race, Color, and Power in Chicago, 1890–1945* (New York: Oxford University Press, 2003).

24 Samuel W. High to Representative Walter McCoy, 8 June 1912. HR 62A-H10.2, Box 619, "New Jersey," NARA.

25 Quoted from Desmond King, *Making Americans: Immigration, Race, and the Origins of the Diverse Democracy* (Cambridge: Harvard University Press, 2000), 91–92.

26 Paul Avrich, *Sacco and Vanzetti: The Anarchist Background* (Princeton: Princeton University Press, 1996), 93–95. See also Robert K. Murray, *Red Scare: A Study in National Hysteria, 1919–1920* (New York: McGraw-Hill, 1955).

27 King, *Making Americans*, 97. For other studies dealing with aspects of the effects of World War I and Americanization drives on immigrants in America, see David Montgomery, "Nationalism, American Patriotism, and Class Consciousness among Immigrant Workers in the United States in the Epoch of World War I," in *"Struggle a Hard Battle": Essays on Working-Class Immigrants*, ed. Dirk Hoerder (DeKalb: Northern Illinois University Press, 1986), 327–354; James H. Barrett, "Americanization from the Bottom Up: Immigration and the Remaking of the Working Class in the United States, 1880–1930," *Journal of American History*, 79 (1992), 996–1020; Lizbeth Cohen, *Making a New Deal: Industrial Workers in Chicago, 1919–1939* (New York: Cambridge University Press, 1990).

28 Solomon as quoted in King, *Making Americans*, 19–20.

29 Letter from A.L. Sanders to Congressman Frederick W. Rowe, RG 233, 64th Congress, Petitions & Memorials, Committee on Immigration and Naturalization, HR 64A-H8.1, Immigration, Box 426, NARA.

30 Gregory Mason, "An Americanization Factory: An Account of What the Public Schools of Rochester Are Doing to Make Americans of Foreigners," *The Outlook* (23 February 1916), 439–448.

31 King, *Making Americans*, 97.

32 Laughlin as quoted ibid., 135.

33 Letter from Joseph Gladstone to Congressman Ogden L. Mills, 29 March 1924, RG 233, 68th Congress, Petitions & Memorials, Committee on Immigration and Naturalization, HR 64A-H8.1, Immigration, Box 426, NARA.

34 Letter from Editor of *Il Popolo* to Congress, 29 December 1923, RG 233, 68th Congress, Petitions & Memorials, Committee on Immigration and Naturalization, HR 64A-H8.1, Immigration, Box 426, NARA.

35 David R. Roediger, *Working Towards Whiteness: How America's Immigrants Became White. The Strange Journey from Ellis Island to the Suburbs* (New York: Basic Books, 2005), 144.

DISCRIMINATION, PREJUDICE AND ITALIAN AMERICAN HISTORY

Salvatore J. LaGumina

It has been the unhappy lot of virtually every immigrant group in the United States to encounter discrimination and to be treated in a prejudiced manner based on perceived affiliation with a particular cohort. For newcomers whose background and culture approximated the prevailing Anglo-Saxon model, victimization of discriminatory practices was minor. For those who adhered to different and contrasting value systems regarding religion, language, cuisine, customs and philosophy, however, the bias and prejudice experienced could not only be severe but also of a duration that extended into second and third generations. Much depended on particular historical circumstances as, for example, the altered political status of the nations from which immigrants originated or the relations of those nations with the United States. Such circumstances were highly relevant when it came to the massive Italian immigration that accounted for one of the largest influxes of newcomers into this country and continues to represent a major identifiable ethnic bloc.

Sources of Discrimination

Although the discrimination visited upon Italians was in many respects similar to that experienced by all immigrants, it nevertheless was distinctive in that it was preceded by a virtual avalanche of negativity and pessimism. In articulating his call for immigration restriction in 1891, Senator Henry Cabot Lodge differentiated between northern and southern Italians, maintaining that whereas Italians from northern and central Italy were sober and industrious and therefore desirable, the absence of these attractive virtues among southern Italians and Sicilians rendered them detrimental:

> A less favorable view may be taken of the immigrants from southern districts and Sicily. These are the most illiterate parts of Italy, and in these districts brigandage was for many years extremely prevalent.[1]

The north/south differentiation endured in the public mind and could readily be found in the popular press, as in this statement published in 1916 in the *Brooklyn Eagle*.

> The Italian is separated into two classes of stomachs. The tall, cultured Northern Italian, from Venice, Milan or Tuscany, does not eat what the little swarthy Calabrian, Sicilian, or Neapolitan will feast upon. The cooking is different, the tastes are different, and the homes are different.[2]

Contemporary media, abetted by the American intelligentsia, created a portrait of Italy as a land so chronically plagued by beggars and criminals as to render its immigrants

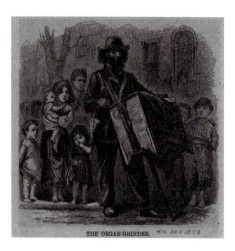

Figure 13.1 "The Organ-Grinder." A drawing by Charles Stanley Reinhart, *Harper's Magazine* (December 1873), 34. Photo: New York Public Library.

objectionable. Americans read a steady flow of outrageous accounts about a country where innocent travelers were regularly assaulted on lonely Italian roads. Even before the onset of mass Italian emigration there were patronizing depictions of Italians that helped engender persisting stereotypes. A campaign against organ grinders (see Figure 13.1), present in New York City from the 1850s, and almost all of them Italian, led to an attempt to ban them as a public nuisance.[3]

These depictions initiated in American popular culture a stream of humiliating ridicule. There was, for instance, a hit song in 1908 called "Wop, Wop, Wop!" (see Color Plate 9). Written by famed songwriter James Brockman, it contained verses like these:

> When first I came to dees-a coun-ti-ree,
> All people call me "dago man";
> And you can bet dot was no fun to me,
> Den dey change and call me Guinie.
> Twice as bad a name dey gimmie. . . .
> Dey call me a nick-name,
> Dey shout-a "Toney,
> You're a phoney,
> Look-a like-a Macaroni!"
> Wop! Wop! Wop![4]

A cartoon from 1912 (see Figure 13.2) portrayed "a Wop" as a spaghetti- and garlic-eating shoe polisher who wore a corduroy suit with a red bandana and carried a stiletto. The insulting terms and the demeaning images proved remarkably long lasting.

As is so often the case, derision was accompanied by fear: even the shoe-shining Wop possessed a stiletto. American nativists not surprisingly drew on negative images of Italian brigands to warn Americans about the danger the immigrants represented. To give a typical example, in a lengthy article the *New York Times* feigned surprise that

> a genuine Italian bandit, black-eyed, swarthy and wicked, with rings in his ears, a
> fellow who has actually robbed and murdered, held travelers for ransom, and cut

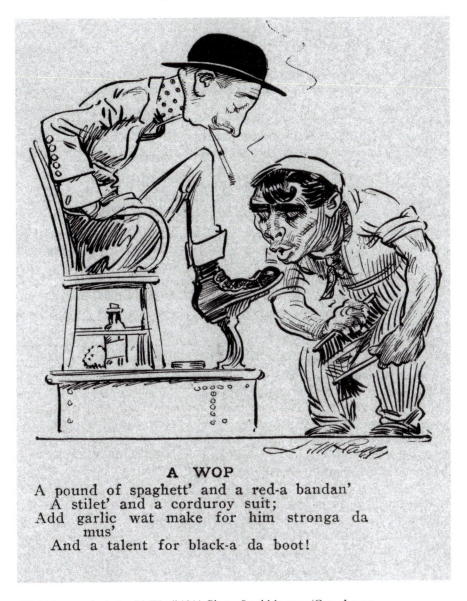

Figure 13.2 Cartoon depicting "A Wop." 1911. Photo: StockMontage/Getty Images.

off their ears when the ransom was not forthcoming, should be captured by a New York detective on a peaceful Mississippi River watermelon sloop.[5]

Journalists wrote article after article about Italian "Black Hand" scoundrels committing heinous crimes. (See Photo Essay no. 15.) The lurid accounts and explicit sketches of muckraking newspapers alerted Americans to certain blemishes and failings that supposedly characterized Italians thereby highlighting their evident inclination to crime, their ignorance, their striking indolence and their penchant for mendicancy as opposed to honest labor.

Thus, if we cast our eyes upon Italy, we discover a state of things before which our rings, bribes, and jobs pale with conscious inferiority of villainy. By as much as the

Italian is lazier, more gossiping, and fitter for intrigue than the American, by so much is he more of an artist in "managing things."[6]

Negative impressions about Italian American immigrants could also be found among major American writers who, although not as censorious, proffered an unattractive picture. Maintaining he personally witnessed their violent "love feuds" culminating in stabbings and shootings, novelist and journalist Theodore Dreiser, wrote a descriptive sketch titled "The Love Affairs of Little Italy" in 1904 that gave a stark portrayal of the temperamental, impassioned and violence-prone ethnic group residing in East Harlem:

Vigorous and often attractive maidens in orange and green skirts, with a wealth of black hair fluffed back from their foreheads, and yellow shawls and coral necklaces fastened about their neck; dark, somber-faced Italian men, a world of moods and passions sleeping in their shadowy eyes, decked out in bright Garibaldian shirts and soft slouch hats, their tight fitting corduroy trousers drawn closely about their waists with a leather belt; quaint, cameo-like old men with rings in their ears and hands like claws and faces with strongest and most sinister lines, and yet with eyes that flash or beam with tenderness; and old women in all forms of color and clothing, who chatter and gesticulate and make the pavements resound with the excitement of their everyday bargaining. This, truly, in so far as New York is concerned, is the region of the love feud and the balcony. . . . Dark, poetic-looking Italians lean against doorjambs and open gateways and survey the surrounding neighborhood with an indolent and romantic eye. Plump Italian mothers gaze comfortably out of open windows before which they sit and sew and watch their chubby little children romp and play in the streets. . . . And from out these windows and within these doors hang or lounge those same maidens, over whom many a boldly feud has been waged and for whom (a glance of the eyes or the shrug of a shoulder) many of these moody-faced, somber-eyed, love-brooding Romeos have whipped out their glistening steel and buried it in the heart of a hated rival.[7]

The religious background of the majority of Italians—Roman Catholicism—provided another basis for discrimination. There were even Italian Americans who became Protestant clergymen and denounced Italian Catholics as either suspicious or religiously indifferent. As Albert Pecorino of Montclair, New Jersey, put it:

The chief conviction of the Italian is that religion is not his business, the priest has care of it and he has been taught to submit absolutely to the teachings of the church even if he does not understand them. . . . The word religion means nothing more to them than ceremonies and rites. . . . God is not known by them; Christ as a living power in the heart of man is unknown.[8]

Naysayers were not confined to the rude and the ignorant: distinguished patrician voices, like that of the noted Harvard University paleontologist Nathaniel S. Shaler, joined in disparagement on account of religion. He argued that non-Aryans and non-Germanic European peasants

pauperized by their armies and the (Catholic) Church were wholly different from Americans in motives and aspirations, and represented a hardened social caste that was nearly innately impossible to Americanize on the civic front.[9]

Much of the animus can be explained by the growth of American xenophobia in a period in which Social Darwinism promoted the concept that certain national groups were naturally selected to lead human societies. Because Italians, especially those from southern Italy, fell short with respect to preferred characteristics, and because they constituted the largest group of new immigrants, their entry was doubly deplored. The influx drew the ire even of organized labor, especially during times of economic hardship, such as the recessions that followed the Panics of 1883 and 1907. This atmosphere became the backdrop for some of the ugliest instances of anti-Italianism, including the 1891 New Orleans lynching—the largest mass lynching in American history—which was launched by Louisiana men said to have been of good standing.

News of such episodes was reported back to Italy. In 1908 the cover of Italy's principal Sunday newspaper, *La Domenica del Corriere* [The Sunday Courier], featured a lurid scene in which Night Riders were shooting up a wooden building in Damascus, Virginia, where a crew of Italian laborers were living while building a nearby sawmill. (See Color Plate 7.) The reporter who filed the story from New York, Luigi Barzini Sr., explained the attack as a consequence of the shortage of work after the Panic of 1907. In this incident, fortunately, the workers were able to sneak out of the building one by one, and the authorities later charged twenty-nine men with the assault.[10]

The prevailing contract labor practice, otherwise known as the *padrone* system, was often criticized by labor organizers because it fostered a network of relationships whereby bosses within the ethnic community supplied immigrant workers for labor-intensive jobs in American businesses. Although some *padroni* were scrupulous and fair, too many were inclined to enjoy their powerful position by abusing immigrants. One unsurprising consequence was a strengthening of the image of Italian newcomers as docile, ignorant and uneducated, and thus a threat to organized labor's aspirations for a higher American standard of living. Since the perceived menace to American ways dovetailed with a widespread view that immigration should be curtailed, immigration restriction became a dominant issue for decades, ever-present in the popular press (see, for example, Color Plate 8), and often a determining factor in national elections. With the passage of the Emergency Quota Act of 1921, which imposed quotas on the basis of national origin, followed by the Immigration Act of 1924, which imposed much stricter quotas, severe restrictions applicable to immigration from southern and eastern Europe became a reality.

Yet diminution of immigration due to the quota system did not lead to a relaxation of prejudice against Italian immigrants, as evidenced by the controversial Sacco and Vanzetti trial, in which anti-Italian prejudice played a role in the conviction of the Italian-born anarchists Nicola Sacco and Bartolomeo Vanzetti for the murder of two men during the robbery of a shoe factory in 1920. According to the noted jurist Michael A. Musmanno, one of their defense lawyers:

> it must remain as a source of everlasting shame that Henry H. Ripley, the foreman of the jury which passed upon the fate of those two Italians, always referred to Italians as dagoes. He also made the remark, which was never refuted, that "if he had the power" he would "keep them out of the country."[11]

It was also eloquently expressed by Vanzetti who stated, "I am suffering because I am a radical and indeed I am a radical. I have suffered because I am Italian, and indeed I am Italian."[12] In 1977 Massachusetts Governor Dukakis issued a proclamation stating they were indeed treated unfairly because of their nationality: "The atmosphere of their trial and appeals was permeated by prejudice against foreigners and hostility toward unorthodox political views."[13]

The 1920s were a time of renewed nativism, seen, for instance, in the revival of the Ku Klux Klan (KKK) originally founded in the South in 1866 to keep former slaves in a subservient position by use of terrorism and intimidation. It wielded such enormous influence that it was able to withstand Congressional legislation designed to curb it. In the 1920s it extended its nasty focus into northern states where it denounced not only blacks but also Jews, Catholics and immigrants. In this venomous atmosphere Italian Americans became yet another target. One Klan leader in Patchogue, New York, announced:

> The last of the Klan ideas is national religion—whether it shall be Judaism, Roman Catholicism or Christianity modeled after the teachings of Christ. A Dago Pope is trying to dictate the ecclesiastical policy of America. Catholic teachers are pushing their way into our schools, which the Catholic authorities hate like the devil. No Catholic should be allowed on any school board, and not until they will let me teach in their parochial schools should any Catholic be allowed to teach in the public schools.[14]

The immigrants' status became even more vulnerable when dozens of Congressional members, wrestling with the severe impact of the Great Depression, co-signed a simplistic and inhumane bill that would have deported approximately sixteen million legal resident aliens. Although the proposal was not adopted as law, the widespread support for it demonstrated the extent to which immigrants were viewed as expendable.

Discrimination in Education

Discrimination during the interwar years surfaced in numerous walks of life including education, even though education had long been understood as a fundamental tool in assimilation and upward mobility. However, in reaction to involvement in the World War, the postwar period found the nation seething with chauvinism and unreceptive to proposals to foster studying additional languages like Italian—notwithstanding the then prevalent school offerings in Latin, German and French.

Within the ethnic community there were pioneer Italian American educators like Leonard Covello (1887–1982) who sought to counter the prevailing educational practice wherein young Italian American students were being separated from their culture, language and families. He movingly expressed his thinking in his autobiography:

> throughout my whole elementary school career, I do not recall one mention of Italy or the Italian language or what famous Italians there were in the world, with the possible exception of Columbus. . . . We soon got the idea that "Italian" meant something inferior, and a barrier was erected between children of Italian origin and their parents. . . . We were becoming Americans by learning how to be ashamed of our parents.[15]

A language teacher in DeWitt Clinton High School, in 1922 Covello introduced the teaching of Italian. As the first principal of Benjamin Franklin High School in 1934 he developed an educational establishment that effectively interfaced with the Italian East Harlem neighborhood becoming involved with almost every aspect of the activities of the ethnic community. It became a model for cultural pluralism.

A particular instance of the general educational insensitivity was evident in the actions of the Board of Education in Port Washington, New York, a Long Island community where

thousands of Italians worked in sand mines that produced the mineral that was critical to New York City's extraordinary construction development. In 1935, as this emerging Italian enclave became the nucleus of a major and vibrant community, replete with panoply of ethnic institutions, it petitioned the school board to introduce Italian language study simultaneously expressing support for a school tax increase for the purpose. Concurring with the views of a myopic school board spokesman, who conveniently overlooked the fact that the district was then offering other foreign languages, the school board resolutely denied the request as non-essential: "If these people [Italians] adopt this country they should be taught our language, and if they desire another language, it should be learned at their own expense."[16] It was not until the 1970s that Port Washington offered the study of Italian in its curriculum.

There was something ironic about the educational package offered to Italian Americans since on the one hand it was a commendable effort to provide education for immigrant children rendering them better educated and better prepared for the job market while simultaneously discouraging formal study of the rich Italian language. The discriminating atmosphere was so insidious that many Italian Americans avoided studying Italian for fear that it might be overheard and result in discrimination.[17]

The outbreak of World War II, especially after Mussolini declared war on the United States in the wake of Pearl Harbor, produced a worrisome atmosphere for Italian Americans. The land in which they or their parents were born was now the enemy—a sure breeding ground for discrimination that once again displayed itself against an educational background wherein an Italian name was sufficient grounds for prejudice. When an elated and college-educated John Pedrotti came away from an interview for the position of headmaster of a private school certain the job would be his, he soon came to the bitter realization that his name was held against him.

> It seems there was the "little problem" of my last name. Could I change Pedrotti to Peters or something similar? If I did that, "the appointment was mine," he was told. Additional information further underscored the discrimination he was up against in the prevailing educational establishment. "I am sure you will agree that although they distinguished themselves in many other fields, the Italians have not done so well in education."[18]

The wartime hostile environment even was experienced by Italian American volunteers who served in dangerous actions to topple the Italian Fascist government. Max Corvo, who oversaw the Office of Strategic Services (OSS) operations in Italy, clearly felt it.

> There was also a feeling within the organization that there were too many Italo-Americans in the Italian SI Section. This ran against the grain of some people who genuinely believed that first-generation Americans and foreigners should not be entrusted with highly classified secrets.[19]

Corvo also cited OSS interdepartmental correspondence that referred to Italian Americans within SI disparagingly because they were "largely of Sicilian origin," harboring "peculiar group loyalty," and that they were "both despised and laughed at" by northern Italians.[20]

In the 1970s charges that severe under-representation of Italian Americans among faculty in the City University of New York (CUNY) was tantamount to discrimination led to an investigation validating the accusations. It led to a decree verifying under-representation and designating Italian Americans as an affirmative action category for the University and a New York State Senate report titled *A History of Italian American Discrimination at CUNY*, as well as

a state law that created the John D. Calandra Italian American Institute as part of the CUNY system. The Institute was charged with heightening awareness, fostering higher education, and conducting research to deepen understanding of Italian American culture and heritage, and its mission was bolstered by a Federal Judge's order that affirmed Italian Americans as a cognizable group entitled to Affirmative Action protection. More than thirty years later the issue still surfaces, with some parties maintaining continued Italian American under-representation.[21]

The status of Italian language study in recent decades continues to be provocative and provides much food for thought regarding the dubious degree to which society values Italian culture. The days of blatant discrimination may be over; nevertheless intolerance persists in understated ways including oversight and non-inclusion. Admittedly it is debatable as to whether or not discrimination is involved; however, if we accept the meaning of *culture* as a system of beliefs, values, images, lifestyles and customary practices including language, then the extent to which language study is supported tells us much about how highly it is valued. On the one hand there has been an impressive growth in the number of students studying Italian on a college level, yet on the other hand promoters of Italian language are constantly faced with a struggle to maintain its position as a vital component of language arts—a struggle revealed in the current debate over losing its AP (Advanced Placement) position in high schools. After years of effort Italian classes gained AP inclusion in 2006, only to be dropped from that status in 2009. When it was announced in December 2012 that Mandarin Chinese would replace Italian to fulfill New York State's World Language requirement in a Long Island school district, many Italian Americans interpreted this as a disparagement of their culture. The explanation that the step was dictated by demographic changes and the need to meet global challenges did not satisfy them. As one spokesman stated, "I dare say that your actions smack of discrimination and are insulting to the Italian-American community."[22]

Politics

Whether through insinuation, omission or non-inclusion, Italian Americans have dealt with stereotyping and discrimination in politics. This is clear when we look at the rate of participation following the 1880s onset of mass immigration during which they played inconsequential and peripheral roles at first—understandable given their preoccupation with the full-time task of earning a living, learning a new language and acquiring citizenship. These were the priorities of newcomers, and it should be remembered that many were "birds of passage" who planned to return to Italy. Their foray into politics occurred in the insular loci of ethnic neighborhoods where the majority of inhabitants were of their own background. It would be a different story when they ventured beyond their ethnic enclaves. There they were often vilified with criminal associations, albeit in the absence of verifiable proof—allegations were sufficient to tarnish their careers as illustrated in a series of dramatic cases, to be mentioned here, all of which occurred within the past two generations.

Following a highly successful career as a lawyer, the popular San Francisco Mayor Joseph Alioto (1916–1988), who served as mayor from 1968 to 1976, won national attention thanks to his nominating speech for Hubert Humphrey at the 1968 Democratic National Convention. This immediately led to widespread speculation that Alioto had become the leading vice-presidential contender for the ticket, an event that brought great elation to Italian Americans. The euphoria would be short-lived due to quickly surfacing rumors reported in *LOOK* magazine that Alioto had connections with criminal mob figures:

> Mayor Joseph L. Alioto of San Francisco, the rising politician who came close to the Democratic nomination for the Vice Presidency in 1968, is enmeshed in a web

of alliances with at least six leaders of La Cosa Nostra. He has provided them with bank loans, legal services, business counsel and opportunities, and the protective mantle of his respectability. In return, he has earned fees, profits, political support and campaign contributions. A lengthy investigation by *LOOK* reveals that some of these links between Alioto and the underworld go back almost a quarter of a century. They have not been broken.[23]

Alioto sued *LOOK* for libel and alleged the use of ethnic "guilt by association" in his rebuke of the allegations, maintaining he was particularly vulnerable for two reasons:

> First, because of his Italian descent, plaintiff was susceptible to being associated in the public mind with what the article liberally refers to as the Cosa Nostra and the Mafia and those of their alleged members who also bear Italian names. Second, because having represented persons charged with crimes, some of whom also had alleged connections with organized crime, he suffered the lawyer's vulnerability to that public sentiment which often tends to identify the lawyer invidiously with his client. The article in fact invites the reader to make that very identification.[24]

Although he eventually won the lawsuit, Alioto's chances for a place on the national ticket were killed as was a plan to run for governor of California.

Another such case occurred in 1969 involving an up-and-coming and highly regarded New York State Senator Edward Speno (1920–1971) of East Meadow, Long Island. Speno became another Italian American whose ascendancy was impacted by allegations of criminal activity when he challenged Charles Goodell for the Republican Party's nomination for United States Senate; it meant bucking incumbent Governor Nelson Rockefeller, who had appointed Goodell to the Senate. Speno continued his quest within his party but was now faced with insinuations of a criminal nature in a series of *Newsday* articles attacking him for alleged financial manipulations. Speno struck back charging that the allegations were totally unfounded and devised for political reasons by *Newsday* editor, Democrat Bill Moyers. The result proved to be a serious diversion that destroyed Speno's chances for higher office.

Mario Cuomo (1932–2015), the Governor of New York from 1983 to 1995, was one of the most conspicuous Italian American politicians. His long career elicited considerable positive attention, although many observers noted its quirky political steps—passages that perhaps can be understood because of Cuomo's position as an ethnic outsider. As one writer put it in the *New York Times*:

> Most of his political life, Cuomo has been on the outside fighting to survive. In his unsuccessful run for Mayor of New York, in 1977, he was opposed by the regular Democratic organizations. He felt he was particularly discriminated against as an Italian-American, but more generally, the political mainstream viewed him as an intruder, a lawyer who had not cut his teeth on political issues but on legal ones.[25]

Political discrimination was widely believed to be at play during the 1980s when New York Governor Cuomo's oratorical skills brought him such national prominence that he emerged as the Democratic Party's leading prospective presidential nominee in 1987. This was followed by the surfacing of press stories insinuating a background associating him as well as his father-in-law Charles Raffa, with criminal elements. Cuomo was disgusted that unfounded criminal allegations and rumors were believed so readily. He responded that if to be smeared with criminal charges and suffer discrimination was the price Italian American

Catholics in the public arena were forced to pay, it might even encourage him to fight for the nomination: "If anything could make me change my mind about running for the presidency, it's people talking about 'an Italian can't do it, a Catholic can't do it.'"[26] However, despite being defended by many experts in the field of criminal investigation, and despite receiving encouragement from many Democratic Party leaders Cuomo became convinced that the public would not vote for an Italian American for president. He did not actively seek the 1988 nomination and did not become the party's candidate.

In yet another instance, in 1984, Geraldine Ferraro (1935–2011) made history when she became the first woman to run as the official candidate of a major party (Democrat) for vice president. The daughter of an Italian immigrant who grew up in blue-collar working-class district, a Catholic who was pro-choice, an elementary school teacher, lawyer, assistant district attorney, a feminist leader and a member of Congress, she would enter history books as the first of her gender to achieve that vaunted political position. Unfortunately Ferraro also was confronted with prejudice and discrimination in the wake of intense press scrutiny that raised questions about not only her financial dealings but also those of her businessman husband John Zaccaro. Reports circulated that Zaccaro was said to have rented property to a pornography distribution firm and that he failed to pay back taxes. Subsequently he was convicted of "scheming to defraud" on a loan application by grossly overstating his wealth. The welter of criminal imputations put Ferraro on the defensive as she tried to dismiss them as examples of blatant anti-Italian discrimination and also were said to have caused Walter Mondale, the Democratic presidential candidate to consider replacing her on the ticket. The defeat of the Mondale/Ferraro ticket could hardly be attributed to these criminal allegations, but surely they were not helpful. How damaging they were was evident in 1992 when she was vying for the Democratic nomination for a seat in the United States Senate seat against Robert Abrams and Elizabeth Holtzman, both of whom resurrected the same charges about ethics and associations with mob-connected figures that dogged Ferraro when she was Mondale's running mate. Although at one point leading Abrams and Holtzman in polls, Ferraro withdrew from the contest.

One can also make a case that innuendo-laden and defamatory newspaper articles and television ads smeared Philadelphia Mayor Frank Rizzo (1920–1991; Mayor 1972–1980). Controversial in life and in death, Rizzo served as Philadelphia Police Chief and two terms as Philadelphia mayor. A law-and-order advocate, blustery and tough and the only Italian American ever to head the city, Philadelphia-born Rizzo embodied the resentments and aspirations of white working-class voters. In 1987, when he attempted to return to office, local Italian Americans responded to a description of Rizzo's supporters in the *Philadelphia Daily News* as "a group of middle-aged men in dark suits" as a discriminatory, essentially poorly veiled anti-Italian canard. The local Sons of Italy president denounced the newspaper for its outrageous coverage.

> The *Daily News* probably decided to zero in on the Italian-American segment of the parade because of the participation of one notable marcher—mayoral candidate Frank Rizzo. The offense Italian-Americans took was the demeaning reference to "a group of middle-aged men in dark suits."[27]

Guilt by association and innuendo also impacted the political career of Catherine Abate (1927–2014), who came to public attention in 1992 when New York City Mayor David Dinkins appointed her City Commissioner of Corrections. Brought up in an Italian American family, a graduate of Vassar College and a lawyer who had compiled a twenty-year career in managerial positions in city agencies, when she was appointed Corrections Commissioner

there were press reports about mobster connections of her 89-year-old father, Joseph F. Abate. Catherine vehemently rebuked the charges: "There is no way I can even approach him to cite these allegations. They have to be completely false. What are they based on? They are saying he has associations. That's not the man I know."[28] Furthermore, she stated, "It is unfortunate that Italian-Americans and other ethnic groups sometimes are the target of this kind of abuse."[29] Having personally experienced the sting of discrimination because of his ethnic heritage, Governor Mario Cuomo came to Abate's defense, questioning the decision of the *New York Times* to publish an article about Abate's father and stating that people "should be judged on their merits and not by the accident of ethnicity, race, sex or birth."[30] After her tenure as Corrections Commissioner, and following two terms as a New York State Senator, in 1998 Abate contested Oliver Koppell and Eliot Spitzer to become the Democratic Party nominee for New York Attorney General. As the only woman, and as an Italian American with strong labor support, she was said to be an early favorite—only to once again be soiled with charges about her father's mob connections, accusations that were bolstered by additional evidence unearthed by law enforcement agencies. Though she now accepted the reality of the evidence and sought to quiet the issue, Abate continued to insist that she had no knowledge or suspicion of her father's background. With massive funds at his disposal, Spitzer jumped at the opportunity to further sink her candidacy by producing campaign literature that pointed at her father's background and supposedly tainted her. The result was that she lost the race and Spitzer won.[31]

A major political figure in Washington State and a former state senator, Dino Rossi was the Republican candidate for governor twice, seemingly winning the race in 2004 only to lose it on a recount. During his 2008 race for the position he was confronted with innuendo-loaded campaign material in the form of a Democratic Party television ad set against a background of a photograph of Rossi accompanied by the soundtrack of *The Sopranos* television series. Because it served to remind audiences about Italian American mobsters many disturbed Italian Americans led by the president of the Italian Club of Seattle denounced the obvious innuendo that connected Rossi with building industry leaders since it "aims to link Italian-American gubernatorial candidate Dino Rossi to Italian-American criminals through the use of the theme song to *The Sopranos*."[32] Although Democratic Party leaders denied the allegation, the song was removed from the ad. It might be added that this was not the first time in Washington State that Italian American politicians were attacked in this way. Former Governor Albert Rosellini (1910–2011; governor of Washington, 1957–1965) faced "Mafia-tie" rumors in his time.[33] Whether this type of slur made a difference in the outcome of Rossi's 2008 quest is debatable. What is certain is that Rossi lost the election.

The use of the criminal association stereotype continued in Long Island's contest for Nassau County Executive in 2013. It came to the fore during the Democratic Party primary in which Adam Haber, vying with former County Executive Thomas Suozzi for the nomination, produced a troubling and widely distributed television ad featuring red wine–drinking "hacks" proclaiming the good old days of Suozzi while intimidating anyone who opposed them. The Order Sons of Italy swiftly condemned the depiction as demeaning to Italian Americans: "Suozzi . . . has done nothing in his political career to warrant the unfair, unjust and defamatory television ad that insults not only Suozzi, but millions of Italian-Americans."[34] The strong reproach compelled Haber to apologize and pull the ad.

Popular Perceptions

Despite the widely professed belief that aptitude and ability, not bigotry or bias, governs the field of sports, reality has shown it to be otherwise. *Racial* prejudice, for example, has been a

facet of American life throughout most of its history. Of lesser degree but nonetheless present, prejudice based on ethnicity was an issue with which Italian Americans, among others, had to contend. It is appropriate therefore to provide a few examples. It is a matter of record that gifted Italian American youngsters changed their names so as to be inconspicuous in the realm of sports and filmdom. The first of his nationality to gain baseball stardom, Francesco Pizzolo, born of Italian immigrant parents and much to their chagrin, changed his name to the nonethnic appellation of "Ping Bodie" when he became a professional baseball player.[35] Those who kept their Italian birth names frequently endured humiliation in the pre–World War II period. Joe DiMaggio, arguably the greatest of all Italian American baseball players began his baseball career in a minor league in 1933 and quickly became a brilliant star enjoying a banner year in 1936, his first as a New York Yankee and followed it with an even more sensational 1937 season that launched the DiMaggio legacy that established him as a national folk hero. Referred to as the "Big Dago" by his teammates, he became the subject of a profile in the popular weekly *LIFE* magazine.

> Although he learned Italian at first, Joe, now twenty-four, speaks English without an accent, and is otherwise adapted to most United States mores. Instead of olive oil or smelly bear grease he keeps his hair slick with water. He never reeks of garlic and prefers chicken chow mein to spaghetti.[36]

Whether or not the author meant to ridicule him, the depiction helped firm up a hackneyed stereotype image.

Name changing was common in the pre–World War I boxing field in which Irish Americans predominated. Many a prospect altered his name to gain entry into the lucrative sport field that opened doors to local economic and political influence. Before he became a powerful political leader in New York's Tammany Hall, Paolo Antonio Vaccarelli gained fame as a bantamweight boxer under the name of Paul Kelly, since an Irish *nom de plume* was virtually a prerequisite to attract a local following.[37] As scholar Gerald Gems notes, "The prescribed aliases denote the affectation of pseudo identities to gain acceptances and the power relationships with the boxing hierarchy."[38] Others who fought under ethnic aliases were Pat Moran (Paul Maiorana), Benny Frankie Conley (Conte), Pete Herman (Pete Gulotta), Marty O'Brien (Anthony Martin Sinatra—Frank Sinatra's father) and Johnny Dundee (Giuseppe Curreri). Boxers of a later generation who retained their Italian names were frequently demeaned by journalistic portraits of brutally rough, semi-illiterate men. Jake LaMotta, for instance, was described as a small-time hoodlum who had spent time in prison, and thereby acquired a reputation as an aggressively crude and vicious pugilist who depended upon toughness and utter power rather than basic skills and athletic ability to defeat ring opponents; while Rocky Graziano (Thomas Rocco Barbella), the beneficiary of limited formal education who also spent time in jail, relied on street smarts to rise in the boxing world.

With numerous articles, books, videos, a Broadway play, a Sons of Italy lodge, and video documentaries about his career, along with the Super Bowl trophy, Vincent Lombardi (Color Plate 21) is arguably the most storied Italian American name associated with professional football. Born of second generation Italian American parents in Brooklyn's Sheepshead Bay in 1913, the dark-skinned son of a tight-knit and faithful Catholic family of modest economic means grew up in a mixed Irish/Italian neighborhood. He also became familiar with his grandmother's adjoining heavily Italian neighborhood, one that was crowded with sidewalk markets displaying green vegetables and pasta shops that sold ravioli, spaghetti and Italian bread. He attended public schools, a seminary, and Brooklyn's St. Francis Preparatory School. Like others of his background he was subjected to invective ethnic epithets like

"guinea" and "wop," not hesitating to respond physically to those who taunted him. Nevertheless Vincent showed no interest in learning Italian; he was "ambivalent about his heritage because he knew that many Americans held contempt for southern Italians."[39]

Nor was Lombardi interested in following his father's career as a butcher, opting instead to play sports, especially football, at every opportunity. Winning a Fordham University football scholarship, he achieved fame as one of the Seven Blocks of Granite and upon graduation began coaching football at St. Cecilia High School, which became recognized as a national power, all the while teaching major academic subjects. For several years Lombardi served as assistant football coach at Fordham University and the West Point Military Academy, hoping that background would land him a job as a college head coach only to realize that his nationality was an obstacle. "Here I am, an Italian, forty-two years old, and nobody wants me. Nobody will take me."[40] Simply put, it was believed that ethnic discrimination was the cause of his failure to win the coveted position at Wake Forest University and other southern colleges. Lombardi definitely thought anti-Italian discrimination was involved. "I know I lost some jobs because of my Italian heritage."[41]

Against this background in 1959 Lombardi became head coach of the Green Bay Packers leading them to nine victorious seasons, five NFL championships and two Super Bowl triumphs. He became a foremost national icon second to none, noted and respected not only for his strict discipline, hard work ethic, and conservative philosophy, but also for his adamant promotion of equality for all regardless of race that earned the gratitude of black players.

For contemporary Italian Americans stereotyping and discrimination seem to be realities largely of earlier times. Though negativity has been clearly and thankfully attenuated it is useful to realize that to some degree prejudice persists especially with regard to a mindset about crime and Italian Americans, a notion so pervasive in the public notice that journalists readily, if unconsciously, resort to utilize stereotypical linkage in their writings. For instance, although he was writing about college basketball, in March 1991, a sports reporter could not resist making a discriminatory comment about Creighton University basketball coach Tony Barone, as having a "face out of *Goodfellas*," invoking the images of Italian American hoodlums featured in Martin Scorsese's film that was then enjoying popularity.[42]

In recent years extant Italian organizations have joined others to form auxiliary bodies to fight discrimination. While recognizing that overt discrimination is less apparent in today's society, there is awareness that prejudice and bias continue to surface in a variety of ways and that combating negative stereotypes requires an ongoing commitment. That persistent stereotyping is closely associated with discrimination is readily evident as the following example demonstrates. In 2006 *Sports Illustrated Magazine* described National Football Commissioner Paul Tagliabue as having previously been a "consigliere," an Italian term for adviser, associated with criminal activities popularized in *The Godfather* movie.[43] It prompted the *Baltimore Sun* to state:

> At issue here is consigliere. Anybody who has seen the movie *The Godfather* or read the novel knows what the term means: a counselor or adviser to the head of an organized crime family. In the movie and novel, all those families were Italian-American.[44]

To be sure not all completely agree that discrimination continues to be a problem—even among Americans of Italian descent—some of who are among the producers of the most egregious and offensive examples of anti-Italian denigrations. Whereas such television series as *The Sopranos* (1999–2007) and *Jersey Shore* (2009–2012) elicited criticism from many Italian American organizations, a number of well-known ethnic group members stated that they

enjoyed the shows and did not take offense. The 2004 animated film production of *Shark Tale* was one of the few times in which major Italian organizations demonstrated a degree of solidarity in denouncing the production because it cast vicious sharks bearing Italian names as defamatory thus encouraging the assumption that Italians are connected with crime. Objections notwithstanding, the film was widely distributed.[45]

Occasionally antidiscrimination attention has focused on issues of local impact, as in a suburban Chicago school play titled "A Little Mobster Comedy," performed by the Bada Bing Players that upset local Italian Americans because of gangster portrayals of nationality group members. The protesters lost their 2006 federal court bid to halt the production. Another production that raised the ire of many Italian Americans for its stereotypical representations was "The Guineas Show," an animated web series developed for blip.tv that revolved around the activities of immigrant Salvatore Guinea and his mother Nanna Guinea who diligently ran their family-owned pizzeria in Hollywood. While the creator and animator of the show claimed Italian ancestry, and though it received praise by some in the industry, a significant number of Italian Americans denounced its slanderous nature and insisted that it be taken off the air.[46]

It is a truism that society tends to look at minority groups who differ from the mainstream in fundamental ways as inferior—an attitude that easily leads to discrimination. This overview has focused on the issue of discrimination and Italian Americans in various fields of endeavor in an attempt to demonstrate its impact on the ethnic community. Hopefully it has helped to illuminate how discrimination, prejudice and bias has impacted the community historically and suggests that, though less significant, it nevertheless continues to impinge on Italian American life. Initially experienced in overt forms in the earliest days of Italian immigration, contemporary practices are manifestly less severe, less flagrant and less obvious, but not altogether gone.

Further Reading

Connell, William J. and Fred Gardaphé, eds. *Anti-Italianism: Essays on a Prejudice*. New York: Palgrave Macmillan, 2010.

LaGumina, Salvatore J. *WOP! A Documentary History of Anti-Italian Discrimination*. Toronto: Guernica Editions, 1999.

Notes

1 Henry Cabot Lodge, "The Restriction of Immigration," *North American Review*, 152 (1891), 27–38 (31).
2 "Lights and Shadows in Brooklyn's Italian Colonies," *Brooklyn Eagle* (20 February 1916), 3.
3 John E. Zucchi, *The Little Slaves of the Harp: Italian Child Street Musicians in Nineteenth-Century Paris, London, and New York* (Montreal and Kingston: McGill and Queen's University Press, 1998), 111–144. Much later, in 1936, Mayor Fiorello La Guardia banned organ-grinding entirely. In his autobiography (as quoted by Sam Roberts in the *New York Times* [2 August 2010]) La Guardia wrote that as a boy living in Arizona, "I must have been about 10 when a street organ-grinder with a monkey blew into town. He, and particularly the monkey, attracted a great deal of attention. I can still hear the cries of the kids: 'A dago with a monkey! Hey, Fiorello, you're a dago too. Where's your monkey?' It hurt. And what made it worse, along came Dad, and he started to chatter Neapolitan with the organ-grinder. . . . He promptly invited him to our house for a macaroni dinner. The kids taunted me for a long time after that. I couldn't understand it. What difference was there between us? Some of their families hadn't been in the country any longer than mine."
4 James Brockman, *Wop, Wop, Wop! Italian Novelty Song* (New York: M. Witmark and Sons, 1908).
5 *New York Times* (9 July 1881), 4.
6 "Rings in Italy," *New York Times* (16 April 1876).
7 Theodore Dreiser, "The Love Affairs of Little Italy," in *The Color of a Great City*, ed. Dreiser (Syracuse: Syracuse University Press, 1996), 268–269.

8 Albert Pecorino, "The Italian Problem," *First Annual Report of the Montclair Italian Missionary Society* (10 November 1903), 10–11.

9 Joseph P. Cosco, *Imagining Italians: The Clash of Romance and Race in American Perceptions, 1880–1910* (Albany: SUNY Press, 2003), 183.

10 Luigi Barzini [Sr.], "I 'cavalieri della notte' alla caccia degli italiani," *La Domenica del Corriere*, 5 July 1908, 5. Barzini's son Luigi Jr., would become a well-known journalist who also wrote from the United States. The indictment of the twenty-nine Night Riders was reported in the *Sylvan Valley News* [Brevard, North Carolina], 17 July 1908, 8.

11 Michael A. Musmanno, *The Story of the Italians in America* (Garden City: Doubleday, 1965), 143.

12 Nicola Sacco and Bartolomeo Vanzetti, *The Letters of Sacco and Vanzetti*, ed. Marion Denman Frankfurter and Gardner Jackson, intro. Richard Polenberg (New York: Penguin, 1997), 377, from Vanzetti's last speech to the court, 9 April 1927.

13 Quoted in Paul Avrich, *Sacco and Vanzetti: The Anarchist Background* (Princeton: Princeton University Press, 1996), 5.

14 *Patchogue Advance* (16 March 1923).

15 Leonard Covello, *The Heart Is the Teacher* (New York: McGraw-Hill Book Company, New York, 1958), 43.

16 *Port Washington News* (15 March 1935).

17 See Salvatore J. LaGumina, *The Humble and the Heroic: Wartime Italian Americans* (Youngstown: Cambria Press, 2006), 9.

18 LaGumina, *The Humble and the Heroic*, 113–114.

19 Max Corvo, *The OSS in Italy 1942–1945* (New York: Praeger, 1990), 273.

20 Ibid., 281.

21 See Joseph Scelsa, "Affirmative Action for Italian Americans: The City University of New York Story," in *Anti-Italianism: Essays on a Prejudice*, ed. William J. Connell and Fred Gardaphé (New York: Palgrave Macmillan, 2010), 87–93.

22 Joie Tyrrell and Scott Eidler, "District to Phase Out Italian, Replace It with Mandarin," *Newsday* (13 December 2012); and *Justice* [Newspaper of the Commission on Social Justice, Order Sons of Italy in America] (January–March 2013).

23 Richard Carlson and Lance Brisson, "The Web that Links San Francisco's Mayor Alioto and the Mafia," *Look*, 33.19 (23 September 1969), 17–21.

24 Alioto v. Cowles Communications Inc. 430 F. Supp. 1363 (1977) Joseph L. Alioto, Plaintiff. Cowles Communications Inc. Defendant, U.S. District Court, N.D. California, 3 May 1977.

25 Jeffrey Schmalz, "The Mystery of Mario Cuomo," *New York Times* (15 May 1988).

26 Jeffrey Schmalz, "Cuomo Asserts He Is Victim of Ethnic Bias by Columnists," *New York Times* (19 January 1986).

27 Gabriel L.I. Bevilacqua and Nicholas DeBenedictis, "Italian Paraders Misrepresented," *Philadelphia Daily News* (16 October 1987), Letters to the Editor, responding to Tom Cooney, "Scene & Heard: They Love a Parade Anyway," ibid. (18 September 1987), B3.

28 Selwyn Raab, "Correction Head's Father Tied to Mafia," *New York Times* (21 April 1992), B3.

29 Selwyn Raab, "Officials Defend Jails Chief," *New York Times* (22 April 1992), B3.

30 Ibid., quoting Mario Cuomo.

31 Peter Elkind, *Rough Justice: The Rise and Fall of Eliot Spitzer* (New York: Penguin, 2010), 33–34.

32 Richard Roesler, "*Sopranos* Theme Will Be Pulled from Anti-Rossi Ad," *Seattle Times* (26 June 2008), B3.

33 On Rosellini, see Mike Baker, "FBI Didn't Think Much of Washington's Gov. Rosellini, Files Show," *Seattle Times* (14 June 2013): "Rosellini's chief Republican political rival, former Gov. Dan Evans, said in an interview with the AP that he didn't agree with the portrayal of Rosellini as unethical. 'The trouble with the FBI files is that if you accept all the accusations at face value, you can make quite a case,' Evans said. 'A lot of the stuff is just that: accusations.'"

34 Celeste Katz, "Adam Haber Pulls Sopranos-Style Attack Ad," *New York Daily News* (26 June 2013), quoting a letter by Santina Haemmerle of the Sons of Italy.

35 Gerald R. Gems, *Sport and the Shaping of Italian American Identity* (Syracuse: Syracuse University Press, 2013), 46–47.

36 Neil J. Busch, "Joe DiMaggio," *LIFE* (1 May 1939), 63–69.

37 LaGumina, "March and Vaccarelli: Turn-of-the-Century Political Bosses," in *Italian Americans in a Multi-Cultural Society*, ed. Jerome Krase and Judith N. DeSena, AIHA (Stony Brook: Forum Italicum, 1994), 200–216.

38 Gems, *Sport*, 22.

39 Michael O'Brien, *Vince: A Personal Biography of Vince Lombardi* (New York: William Morrow and Co., 1987), 23.

40 David Maraniss, *When Pride Still Mattered* (New York: Simon and Schuster, 1999), 165.

41 O'Brien, *Vince*, 104.

42 Vincent S. Romano, "Italian-Americans Fouled," *Newsday* (29 March 1991), 52.

43 Karl Taro Greenfeld, "The Big Man," *Sports Illustrated* (23 January 2006).

44 Gregory Kane, "Ethnic Jabs Leave Jabber with a Bad Bruise," *Baltimore Sun* (25 January 2006), 1B: "Adviser is clearly what the caption writer at *Sports Illustrated* meant. Adviser, not some term linked to the Mafia, is precisely what this character should have used. And SI editors should have called him or her on it. 'They want to show they're so sophisticated because they know Mafia-speak,' said Dona De Sanctis, the deputy executive director of the Washington DC-based Order Sons of Italy in America. 'Once again, an Italian-American who has nothing to do with criminal activity is associated with the Mafia simply because of his last name.'"

45 Jerome Krase, "*Shark Tale*—'*Puzza da cap*': An Attempt at Ethnic Activism," in *Anti-Italianism*, ed. Connell and Gardaphé, 137–150.

46 "The Guineas Show: They Have What It Takes on Blip.tv," *PRLog* (27 January 2012).

THE LANGUAGES OF ITALIAN AMERICANS

Nancy C. Carnevale

The plural in the title of this chapter refers to the multiple languages Italian migrants have encountered and created, from their place of origin in Italy through settlement in the United States, continuing at least into the second generation. The reverberations of those languages can still be felt. This is true for postwar immigrants and their families no less than for those who arrived during the era of mass migration at the turn of the twentieth century. Whereas it is readily understood that non-English-speaking immigrants past and present face difficulties with communication in American society and that language can be a barrier to full inclusion, there are multiple dimensions to consider in any examination of immigrants or ethnics and their languages. In the Italian case, one can begin with the fact that most of those who came to the United States spoke a regional or local dialect rather than standard Italian. Their American-born children ensured that English was also spoken in the home, even if not always by the parents. The fusion of dialect with English that the immigrant generation often employed further complicated the language environment within the Italian American household. This linguistic background influenced subsequent generations, even if not conversant in Italian, a dialect or the hybrid idiom. A central issue raised by an examination of language and Italian Americans regards ethnic identity. Within the home, generational divides fostered by vast differences in lived experience could be exacerbated by and reflected in language use. Joseph Luzzi, a second generation Italian American and professor of Italian literature, whose parents emigrated from Calabria in the late 1950s, reflects on the absence of a common language between father and son. After the death of his father in 1995, Luzzi recalls:

> I would hear my father's voice but didn't know how to respond. . . . English . . . sounded pedantic and prissy. Answering in Italian was no less stilted, either when I tried to revive my Calabrian or when I used the textbook grammar that was unnatural to both of us. I had so much to tell him but no way to say it. . . . Without his words, I was losing a way to describe the world. Memories suddenly mattered more than ever before, and I didn't know if I could find the language to keep them alive.[1]

As Luzzi's experience illustrates, the divergence in language use within the Italian American family had consequences beyond those of communication in the present moment. The inability to fully transmit memories of events, people and customs experienced in dialects, many of which are dead languages no longer spoken in Italy—"frozen in time by exile" as Luzzi puts it[2]—raises the question of cultural transmission. How has Italian American identity been passed on to subsequent generations in the absence of a language to do so? To what degree is knowledge of Italian or of an Italian dialect necessary to maintain and perpetuate ethnic identity?

Additionally, we need to consider how Italian American languages were shaped and experienced within a larger context. The questions of language that Italian migrants and their families faced developed in relation to the world outside of the home, both in Italy and in the United States. In turn, the languages spoken (and not spoken) by the migrants would affect how others perceived them. None of these aspects of language are unique to any one immigrant/ethnic group, but they played out in particular ways within Italian American households and communities, and in relations with the larger society.

Italian and the Dialects

In order to understand more fully the linguistic experience of Italian Americans, it is necessary to begin with the history of standard Italian and the dialects in Italy. Even though Italian immigrants traveled thousands of miles to reach the United States, they could not escape their native country's complicated linguistic history that continued to influence them and their descendants. The largely southern Italian migrants who came to the United States brought with them a host of dialects. These varied widely in terms of their intelligibility to other dialect speakers as well as to speakers of what would become standard Italian. The following proverbs give some indication of the difference between even the two most widely spoken southern dialects:

Neapolitan:
Male non fa' e paura nun ave'.
[Don't treat others badly and you will have nothing to fear.]

'O core nun se fa maje viecchio.
[The heart never gets old.]

Sicilian:
Lu poviru e' 'n amicu pirdutu.
[A poor person is a lost (i.e., worthless) friend.]

E doppu cuntintizza veni morti.
[And after contentment comes death.]

Given the divergence between dialects, communication within the peninsula was a recognized problem well before Italy became a nation. Indeed, language was such a fraught subject in Italy for centuries that it earned its own appellation: "*la questione della lingua*" (the "language question").

Though commonly considered corruptions of standard Italian, each dialect evolved directly from the Latin much like the Florentine dialect of the fourteenth century that would eventually constitute the basis of standard Italian. Linguistically speaking, there is no difference between a language and a dialect. The establishment of the standard in the 1880s, two decades after Italy was united through the Risorgimento, was the outcome of centuries of debate. The influence of Dante Alighieri's *Divine Comedy*, written in the fourteenth-century Florentine vernacular, the economic power of the city-state from the fourteenth through the sixteenth centuries, and the greater intelligibility of the dialect to the elites already literate in Latin were some of the reasons that Florentine emerged early on as the frontrunner for a common language.

Language North and South

At the birth of the Republic in 1861, only a small fraction of the newly conceived Italian citizenry spoke Italian. The poverty and historic neglect of the South by the more prosperous North ensured that Southerners, with fewer opportunities for schooling, would learn the language at a slower rate. Even well into the early decades of the twentieth century, few Southerners would receive the high school education needed to learn standard Italian. The dialects remained intact, resisting even the Fascist government's attempts to stamp them out as part of Mussolini's nationalist ambitions for Italy. It was not until the mid-twentieth century that a majority of Southerners adopted the standard Italian that was widely heard on radio and television. Many, however, remained bilingual, employing their dialects on a daily basis with intimates. Some, such as the elderly, remained largely monolingual, speaking only dialect.[3]

Even though there were very real obstacles to the diffusion of standard Italian throughout the South, beginning in the late nineteenth century the delayed acquisition of the language and the persistence of the dialects were attributed to southern ignorance. This was of a piece with the long-standing general devaluation of southern Italians that gained traction with Unification. The significant socioeconomic challenges southern Italy faced, exacerbated by policies established in the north, were collectively identified as a national problem, the so-called Southern Question. The pejorative view of the Mezzogiorno took on a heightened racial dimension with the newly emerging field of criminal anthropology led by Cesare Lombroso and his followers. They propagated the idea that Southerners were more prone to violent criminal behavior than their northern counterparts because they were biologically inferior, the result of their supposed mixing with other groups, including Africans. They saw the use of dialects, along with certain physical features such as darker skin tone, as expressions of an innate inferiority.[4] The beliefs of the Italian criminal anthropologists were uncritically accepted by American government officials, social scientists and others in large part because they fit in with then-popular notions of racial hierarchy in the United States that placed southern and eastern Europeans who were immigrating *en masse* below northern and western Europeans. Southern Italians were distinguished from northern Italians and ranked low, if not last, among European groups. In the early decades of mass migration the prevalence of illiteracy among southern Italians and their low rate of English language acquisition were considered evidence of inferiority. This at a time when the ability to speak the English language was understood to be a sign of fitness for full inclusion in American society.

Migrating Languages

For the most part, the immigrants arrived in the United States unable to speak standard Italian, though they may have had a passive knowledge that enabled them to understand at least some of it.[5] They likely brought with them a heightened awareness of language as a social marker that colored their experiences with the English language. Despite the avowals of many in the later generations of Italian Americans concerning the willingness and ease with which their ancestors learned English, this experience was far from universal, at least in the era of mass migration. Southern Italians found themselves near the bottom of the employment ladder, working long hours for low pay as unskilled labor, leaving little time for night school. In any case, in the early years, Italians had one of the highest rates of return migrations providing scant incentive to learn English. The focus on Americanization in the night schools may also have been a deterrent. The low levels of education and high rates of illiteracy previously noted, along with a propensity for living in ethnic enclaves, also worked

against the acquisition of English, although in recent years scholars have questioned the illiteracy rate.[6] Italian immigrant women, who generally worked within the home and so had less contact with non-Italians, learned English at even lower rates than Italian immigrant men. Italian children who immigrated with their parents as well as the American-born were often penalized at school for their imperfect use of English that was seen as a reflection of an inherently low intelligence rather than the result of limited exposure to English at home.

Though English language acquisition by immigrants in the early years was delayed—sometimes indefinitely—the problem of communication between dialect-speaking Italians was resolved through the creation of a hybrid form of speech. This development was not unique to Italians, but it figured prominently in caricatures of Italian immigrants, perhaps reflecting their slow rates of English language acquisition. Like the better-known Spanglish, "Italglish" combined elements of English with the immigrant language(s). More than just the stereotypical heavy accent and pidgin English, this fusion with dialect (often Neapolitan) and standard Italian became a widely recognized if unstable idiom. Variations existed based on the region of Italy from which the migrants came, as well as their place of settlement in the United States, and their degree of fluency in English. Words were created for place names, objects or actions that were unique to the United States or to the immigrant experience. Examples include "Nevarca" (Newark), "Bruccolino" (Brooklyn), "gallone" (gallon) and "parcare" (to park). Even when Italian or dialect words existed, ubiquitous features of everyday life in America were often expressed in the immigrant idiom—"la giobba" (job) rather than the Italian "un lavoro," is a classic example. Colloquial American expressions were Italianized as with "sanemagogna" (son-of-a-gun). Beyond its import as a means of intraethnic communication, this hybrid form of speech illustrates the identity transformations the migrants underwent as they lived in the United States. This transformation was abundantly clear when migrants returned to Italy to visit or to stay, bringing with them a language form that was unfamiliar to Italians in Italy. Nor was this idiom unique to the early immigrants. Postwar immigrants, including the wave following the loosened restrictions of the Immigration and Nationality Act of 1965, used similar speech forms.

The Second Generation

The first spoken language of the children of the immigrants, whether raised in the United States or recent migrants themselves, was often the dialect of their parents with varying degrees of influence from English. This was most likely the case if there were no older siblings to introduce English into the household. As children began to attend school, they learned the English equivalents for the mixed language words of their parents and introduced them into the home, thus facilitating the switch to English from the dialect, at least among the children. It was not unusual in any era for the children of immigrants to understand the dialect spoken by their parents but to answer them in English, reflecting the passive knowledge each generation had of the other's primary language. Their facility with English gave the second generation a certain authority in the family even as children that they would not otherwise have had in Italy. This could contribute to generational tensions, a common issue in immigrant households in the United States.[7]

As children came to understand that the languages of the home and outside of the home—along with the realities they each represented—were distinct, they could experience internal conflicts. This was the result of the privileged status of English in the United States and the low status of southern Italian migrants and their dialects even among the immigrants themselves. Among English-speaking countries, the United States historically has been a particularly unwelcoming country for immigrant language maintenance. This was not, however, a

feature of all English-speaking countries at all times. Second generation children growing up in Anglophone countries that had more tolerance for dual identities and a greater appreciation of the needs of dialect-speaking children in the schools fared better.[8]

Language as Performance

Italian, the dialects and Italian American idioms flourished in the United States beyond their use at home or in daily interactions with other immigrant Italians. Italian could be heard on the radio in the form of songs as well as dramas and comedic skits. Opera, whether through the radio or records, was another source of Italian language entertainment. Enrico Caruso was appreciated by immigrant Italian laborers as much as by American highbrow opera aficionados. The Neapolitan dialect was the language of many popular songs that immigrant families enjoyed on 78 rpm records or in live performances.[9] Italian-language dramas and Sicilian puppet ("pupi") theater were staples of the Italian American stage. These were performed in standard Italian.

The variety performer, Eduardo Migliaccio (1892–1946), who went by the stage name, "Farfariello" was unique for performing in the Italo-American idiom. Based in New York City but widely known, he was very popular with Italian immigrants for his amiable portrayals of familiar figures within America's Little Italies. (See Figure 14.1.) By using the hybridized language the immigrants were speaking at the time, rather than relying on standard Italian or even a dialect, his one-person "*macchiette coloniali*" (sketches of immigrant types) captured Italian immigrant life in the United States.[10] In later years, Italian Americans could listen to Farfariello on the radio. The excerpts that follow, combining dialect with Italianized English (printed in bold), are taken from Farfariello's song lyrics. In addition to illustrating Italian immigrant speech, they suggest the flavor of his performances, which often dealt with changes wrought by immigration in social status and in relations between the sexes.

Here, Tony the barber shows off his purported life in New York:

> Me chiamano **Tony de barbe gaie** [They call me Tony the barber guy.]
> Faccio 'a **laife** 'a sera a **Brodue**' [I have the life at night on Broadway.]
> E lla' me vide: "**Alo'** . . . **Auaie**" [And there you can see me: "Hello, how are you?"]
> 'E mmeglie **ghelle** tutte appriesso a mme [And the best girls are all after me.][11]

In this dialogue, a couple discusses a trip to "Cunailando" (Coney Island):

> **Se uar' iu' uante Nik**?—**Meri' dress oppo** [Say, what do you want Nick?—Mary, dress up.]
> Te porto a **Cunailando**, iammo **orrioppo** [I'll bring you to Coney Island, let's go, hurry up!]
> **Mai matera no uante**—**Ezze natingo** [My mother doesn't want. . .—That's nothing.]
> **Iu' come giuste seme** [You come just the same.][12]

Farfariello often found comedic inspiration in the miscommunications, both linguistic and cultural, that occurred in the confrontations between Italian (or dialect) and English. In the following exchange, for example, the English "shame" is mistaken for the Italian "scemo" for "stupid":

> **O dezze sceme**. Sceme—Eh pare a vuie ca so sceme.
> [Oh that's a shame. Stupid?—And do I look stupid to you?][13]

Figure 14.1 "Farfariello" (Eduardo Migliaccio), here photographed *circa* 1910, portrayed women as well as men in his *macchiette coloniali*, comic character sketches of Italian immigrant life. Courtesy of the John D. Calandra Italian American Institute of Queens College, CUNY.

The Languages in Print

The immigrants also had access to a wide variety of Italian language newspapers, from influential commercial newspapers such as *Il Progresso Italo-Americano* [The Italian-American Progress] to a vibrant radical press. Nationally, from 1884 to 1920, well over three hundred

Italian language newspapers were published, although many of them were short-lived. Circulation rates were robust. In New York City, the daily circulation ratio in 1920 was one newspaper for every 3.3 Italians, which was a proportionally higher rate of readership than for the Yiddish press. The impact of the Italian press was augmented by the practice of passing daily or weekly publications from person to person, the availability of Italian language newspapers in libraries, and the tradition of the immigrant reader who read aloud on the job.[14] The quality of the Italian used in these publications varied, reflecting the low levels of migration by the well-educated. Like the Italian stage, some Italian language publications were inflected with English and the hybridized English of the immigrants. Over time, English came to predominate.

As a recent landmark collection affirms, a good deal of writing in Italian and in dialect beyond journalism was produced in the United States during the period from the beginning of mass migration in the 1880s through the Second World War.[15] The editor found numerous and diverse forms of writings by the immigrant generation. Moreover, as noted previously, there is also evidence that Italian immigrants read as well as wrote in larger numbers than illiteracy rates suggest. But the history of writing and reading in Italian has remained largely invisible over the years, contributing to a view of Italian Americans as a particularly unlettered group that has endured well beyond the era of mass migration.[16]

Language in Wartime

At every turn the historical moment conditioned the experiences of language for the migrants. The World War I years ushered in an era of hyper-nationalism that required immigrants to demonstrate their allegiance to their new country in large part by shedding all vestiges of their pre-migration cultures, including language. Although many immigrants claim that their names were changed by immigration officials at Ellis Island, name changes were more likely the result of encounters with teachers and other authority figures in these early years or by choice in an effort to fit in. Whereas German immigrants bore the brunt of this wartime xenophobia, other immigrant groups also received the message in this period and continuing into the 1920s through a zealous Americanization movement. The ability to speak English—and English alone—would become a defining characteristic of a "real" American.[17]

Language use and attitudes about language on the part of the Italian immigrants and their descendants were most deeply impacted by the Second World War. With the United States at war with Italy, Italians who had not naturalized were scrutinized. Over 600,000 were declared "enemy aliens" and forced to register with the government; a few were interned. In California, thousands were relocated away from the coast and placed under curfew. Throughout the country, various restrictions were placed on Italian enemy aliens. English language use became a measure of loyalty. Italian language radio broadcasts and newspapers were suspect. Government officials sometimes saw the use of Italian names for fraternal and other organizations as well as personal letters written in Italian as evidence of disloyalty. Although the Italian language was not proscribed, the heightened suspicion of Italians created anxiety about the use of the language even in private and by American citizens of Italian descent. That the use of dialect in the playful novelty songs of Louis Prima occasioned concern gives some idea of the atmosphere. It is no wonder that many second generation Italian Americans cite the war years as the time their families stopped speaking Italian/dialect at home. Ironically, native fluency in Italian/dialect became a vehicle for some Italian Americans to distinguish themselves in the military by participating in secret operations across enemy lines in Italy. Although the war ultimately led to greater acceptance of Italian Americans and

other southern and eastern European ethnics, this did not necessarily include overt cultural expressions such as public use of immigrant/ethnic languages. Not surprisingly, the number of Italian language periodicals and radio broadcasts shrank dramatically in this period.[18]

Language Maintenance and Loss

Language maintenance has been a challenge for most if not all groups in the United States, but it may have been particularly difficult for Italian Americans. The number and diversity of southern dialects that the immigrants brought with them mitigated against the "maintenance" of the standard. This absence of a common language may help explain how food, and family, as opposed to the spoken word, became such prominent ethnic signifiers for Italian Americans. With little attachment to the Italian nation-state and its official language, the immigrants arrived with identities rooted in their villages, often expressed through a love of local foods. Over time, a distinctive Italian American cuisine developed that was embedded in familial rituals. As historian Simone Cinotto writes regarding Italian Americans and food in East Harlem, "food and the family became in fact their diasporic national language."[19]

The largely negative connotations associated with the dialects meant that parents may not have been particularly concerned to pass them on to their children. In any case, the immigrants viewed the dialects as languages of the home and the immediate community, with little intrinsic value. Since standard Italian was generally not spoken at home, acquiring it necessitated formal study; yet, from the era of mass migration to today, Italian has not been widely offered in secondary schools. With few exceptions, there was little institutional support for the study of Italian, nor, as already noted, did the early decades of the twentieth century provide an environment conducive to the maintenance of immigrant languages.

Though there was some momentum within Italian American communities during the interwar years to promote Italian language study in the public junior and high schools, World War II brought these efforts to an abrupt halt. Although intended to benefit Spanish speakers, the 1968 Bilingual Education Act did lead to the establishment of some bilingual Italian school programs during the 1970s in places with significant immigrant populations from the postwar wave, such as New York City and Chicago. On the West Coast, the San Francisco Bay Area Scuola di Lingua e Cultura Italiana, formed in 1970, was originally geared toward Italian American children. Despite these and other sporadic local efforts to teach Italian at the elementary and secondary level up to the present day, standard Italian language instruction geared toward Italian American children has been limited. Only in 2015 did New York City's first dual language preschool program in Italian and English open—in Bensonhurst, an Italian American neighborhood for many years which today is home to an ethnically diverse population.[20]

Recent years have witnessed something of a revival in language maintenance efforts reflecting changes within both Italy and the United States. Italy and the Italian language are no longer associated with a devalued immigrant population in the United States. Rather, Italy has become positively identified with food, fashion, art, and design. There is a certain cachet for Italian American youth today to publicly identify as Italian language speakers. This is occurring within the context of a greater appreciation of ethnic diversity in the United States in recent decades. The "brain drain" Italy has been experiencing due to high unemployment among the professional classes has resulted in Italian immigrants who are more likely to be highly educated and well-employed. They are also less likely to live in ethnic

clusters.[21] The presence of Italian women in greater proportions than in the past facilitates language maintenance given the historical role of migrant mothers in perpetuating the cultures of origin.[22] Even dialect usage has been reclaimed by some Italian Americans whose parents arrived in the later twentieth century, just as Italy has begun to place new value on its dialects that are now fast disappearing.[23]

Italian American educators and others have organized in recent years to encourage more students (including heritage students) to take Italian at the high school level. They successfully lobbied the Educational Testing Service (ETS) to institute an Italian language Advanced Placement (AP) test. The effort is showing results. The number of students enrolled grew from 49,287 in 1998 to 80,752 in 2009 with a 20 percent increase between 2002 and 2006. Since 2009, Italian is the fifth most studied language in the country.[24] Despite the growing numbers of students of Italian, in 2008 ETS suspended the AP exam in Italian citing lack of demand. Such a move threatened to depress the number of students studying Italian at the secondary school level. Prominent figures in the Italian American community joined forces with the Italian Ambassador's office and major Italian American organizations such as National Italian American Foundation (NIAF), Order Sons of Italy in America (OSIA), and UNICO National to reinstate the exam.[25] This episode reveals the ability of language to mobilize Italian Americans up to the present day.

When Italian has been offered at the secondary school level, heritage students past and present have faced obstacles based on misconceptions about dialect speakers. In a recent study, second generation Italian American college students in New York City reported that their high school Italian teachers were critical of dialect usage, reinforcing negative views about dialects as incorrect versions of the standard and thus a sign of a lack of education. As college students, the same cohort of students exhibited a range of emotions about the dialect including pride, suggesting a greater acceptance of the dialects among Italian Americans in a multilingual, urban setting.[26] Clearly, language maintenance for Italians has been affected by the history of Italian and dialect in Italy as well as by the American context.

The increase in the Italian population in the United States in the latter decades of the twentieth century due to the more open policy of the Immigration and Nationality Act of 1965 resulted in an influx to Italian American neighborhoods. These newer Italian/dialect speaking arrivals sometimes found themselves at odds with Italian Americans of the second and later generations, many of whom had not retained fluency in Italian or in a dialect. Organizational life, for example, could be challenging to coordinate: In what language should meetings be conducted or newsletters published? The following incident, which occurred in Williamsburg, Brooklyn, presents a contentious example:

> This linguistic disagreement between Italian immigrants and American-born Italian Americans made itself felt in the local initiative in 1988 to officially rechristen a stretch of Graham Avenue "Via Vespucci," which was delayed for twelve years, according to Anthony Pastena ... in part because of a dispute among Italian Americans about whether to use the Italian "via" or the English "street."[27]

Despite the attempts to increase the level of Italian language instruction in the schools and various language maintenance efforts, Italian usage in all of its forms continues to decline in the United States. This decrease reflects a common pattern of language loss in the United States, along with the smaller percentage of new immigration from Italy.

Although with 725,223 speakers, Italian ranked ninth among the second languages spoken in the United States in 2010, it is also the language that since 1980 has shown the greatest

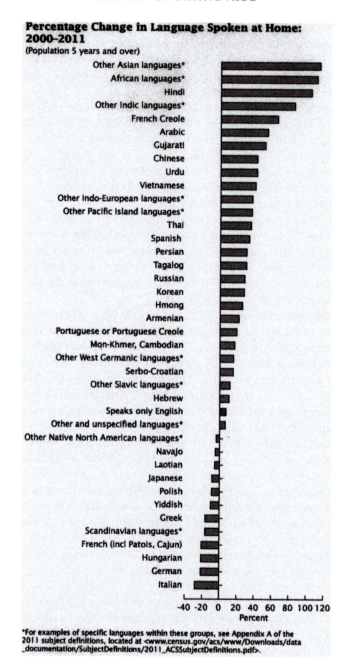

Percentage Change in Language Spoken at Home: 2000–2011
(Population 5 years and over)

*For examples of specific languages within these groups, see Appendix A of the 2011 subject definitions, located at <www.census.gov/acs/www/Downloads/data _documentation/SubjectDefinitions/2011_ACSSubjectDefinitions.pdf>.

Figure 14.2 Increase/decrease in languages spoken in the home, 2000–2011. Camille Ryan, "Language Use in the United States, 2011," American Community Survey Reports, August 2013, 8, from U.S. Census 2000 data and ACS Survey of 2011.

drop (-55 percent) among second languages spoken at home, with a precipitous decline registered in the most recent period, as can be seen in Figure 14.2, which shows Italian at home declining at a faster rate than any other language.[28] In terms of Italian in the public realm, little remains of the Italian language press, although there is still an Italian language readership

sufficient to maintain the daily newspaper *America Oggi* [America Today] (formerly *Il Progresso Italo-Americano*). The bilingual website of the Italian/American Digital Project (IADP), i-Italy, established in 2007, along with its magazine, represents a recent Italian language media venture aimed at "Italophiles in North America, Americans of Italian descent, and Italians living in the U.S."[29] An online newspaper, *La Voce di New York* [The Voice of New York], has been publishing since 2010.[30] Spoken Italian continues to be heard on RAI television broadcasts and ICN radio.[31]

Returning to the question of cultural transmission, sociolinguists have shown that loss of language does not necessarily correlate with loss of ethnic identity. Knowledge of even a few words—whether in Italian, dialect or hybrid language forms—can be used to signal an Italian American identity. Italian Americans may retain a knowledge of Italian/dialect words and phrases to a greater degree than other people of European ancestry, an observation that is supported by contemporary popular representations of Italians engaging in such "code-switching" in film and television. Even nominal use of Italian words can stimulate an interest in younger generations in learning the language. In any case, Italian American identity can be passed on through the English language. Family stories and anecdotes recounted in English can "transmit family values and beliefs," create opportunities for "reflections on the heritage that immigrant relatives such as parents and grandparents had left," and reinforce in-group status.[32]

Even in the absence of fluency in Italian or dialect, some Italian Americans continue to evince a distinctive speech style. Sociologist Donald Tricarico's study of an Italian American youth culture that emerged in the 1980s describes the use of "a jargon formed by the collision of Italian peasant dialects and lower class New York City 'street' English."[33] It includes such Italian phrases as "*Che brutto!*" (How awful!) as well as phonetic Anglicized versions of dialect—"goombah," for the dialect, "cumpà" ("compare" in Italian, "godfather"[34] in English). Nor are Italian American speech styles limited to urban youths; examples from popular culture abound. These speech styles demonstrate the dynamism of language that changes to reflect contemporary hybrid identities as well as the continued ability of language to signal Italian American ethnicity even when used in a fragmentary, idiosyncratic manner.

Further Reading

Carnevale, Nancy C. "*Lingua/Lenga'/Language*: 'The Language Question' in the Life and Work of an Italian American Woman," *Frontiers: A Journal of Women's Studies*, 27.2 (Winter 2006), 3–33.

Carnevale, Nancy C. *A New Language, a New World: Italian Immigrants in the United States, 1890–1945*. Statue of Liberty/Ellis Island Centennial Series. Urbana: University of Illinois Press, 2009.

De Fina, Anna and Luciana Fellin. "Italian in the US," in *Language Diversity in the USA*, edited by Kim Potowski. Cambridge: Cambridge University Press, 2010, 195–205.

Haller, Hermann W. *Una lingua perduta e ritrovata*. Florence: La Nuova Italia, 1993.

Notes

1 Joseph Luzzi, "My Father's Dead Dialect," *New York Times* (29 July 2014).

2 Ibid.

3 The standard sociolinguistic work on the Italian language is Tullio De Mauro's *Storia linguistica dell'Italia unita* (Rome: Laterza, 2015), originally published in 1963. For a study in English, see Martin Maiden, *A Linguistic History of Italian* (London: Longman, 1995). On the Italian language and emigration, see Massimo Vedovelli, ed., *Storia linguistica dell'emigrazione italiana nel mondo* (Rome: Carocci Editore, 2011).

4 While northern Italian dialects could also be stigmatized, the generalized negative view of the South and the significantly lower rates of standard Italian spoken there ensured that the use of southern Italian dialects had more pejorative connotations.

5 Northern Italians, who generally settled in California, were more likely to be trilingual than their southern Italian counterparts to the East and Midwest, fluent in English, standard Italian and a northern dialect.

6 Although certain regions of the South, such as Calabria and Sicily, had illiteracy rates as high as 80 percent, over half (54.2 percent) of the southern Italian immigrants to the United States overall were literate. The rate of illiteracy is still substantial, however, when compared to other groups such as Jewish immigrants who arrived in the same period with an illiteracy rate of 26 percent. See Peter Vellon, *A Great Conspiracy Against Our Race: Italian Immigrant Newspapers and the Construction of Whiteness* (New York: New York University Press, 2014), 10.

7 Nancy C. Carnevale, "Language in American Immigrant Life," in *A Companion to American Immigration*, ed. Reed Ueda (Oxford: Blackwell, 2006), 473.

8 On how changing contexts and teaching methods have led to more positive outcomes for bilingual children of Italian parents in English-speaking countries, see Arturo Tosi, *Language and Society in a Changing Italy* (Clevedon: Multilingual Matters, 1991), 235–242.

9 For more on Caruso and other Neapolitan born singers, see Simona Frasca, *Italian Birds of Passage: The Diaspora of Neapolitan Musicians in New York* (New York: Palgrave Macmillan, 2014).

10 For the Italian American stage, see Emelise Aleandri, *The Italian American Theatre of New York City* (Charleston: Arcadia Publishing, 1999).

11 "Tony 'o Barbiere," Eduardo Migliaccio Collection, box 8, Immigration History Research Center, Minneapolis, Minnesota (IHRC). For each of these examples, I have maintained Farfariello's punctuation and lineation. The translations (with added punctuation) are mine. On Farfariello in film, see Giuliana Muscio's Chapter 26 below.

12 "Cunailando," Eduardo Migliaccio Collection, box 3, IHRC.

13 "O' Cucchiere Napulitano," Eduardo Migliaccio Collection, box 8, IHRC.

14 Vellon, *A Great Conspiracy,* 10.

15 Durante, *Italoamericana* [American ed.].

16 For a discussion of reading in the era of mass migration, see Alexandre de Luis, "The Italian Immigrant Reads: Evidence of Reading for Learning and Reading for Pleasure, 1880s–1920s," *Italian Americana*, 30 (Winter 2012), 33–43. On book publishing in the Italian language, see James Periconi's Chapter 15. Postwar Italian migrants also produced works in Italian and dialect. See, for example, Vincenzo Ancona, *Malidittu La Lingua/Damned Language*, eds. Anna L. Chairetakis and Joseph Sciorra (New York: Legas, 1990). The invisibility of Italian American writing has extended to the substantial body of English language works from the early twentieth century on. Author and journalist Gay Talese antagonized many Italian American writers (and readers of their works) with his essay, "Where are the Italian American Novelists?" *New York Times Book Review* (14 March 1993).

17 Nancy C. Carnevale, "Language, Race, and the New Immigrants: The Example of Southern Italians in the U.S.," in *Immigration Research for a New Century: Multidisciplinary Perspectives*, eds. Nancy Foner, Rubén G. Rumbaut and Steven J. Gold (New York: Russell Sage Publications, 2000), 409–422.

18 Nancy Carnevale, "'No Italian Spoken for the Duration of the War': Language, Italian American Identity, and Cultural Pluralism in the World War II Years," *Journal of American Ethnic History*, 22.2 (Spring 2003), 3–33. For more on Italian Americans during the war years, see Lawrence DiStasi, ed., *Una Storia Segreta: The Secret History of Italian American Evacuation and Internment During World War II* (Berkeley: Heyday Books, 2001); DiStasi, *Branded: How Italian Immigrants Became "Enemies" During World War II* (Acworth: Sanniti Publications, 2016); and also Chapter 22 by Dominic Candeloro.

19 Simone Cinotto, *The Italian American Table: Food, Family, and Community in New York City* (Urbana: University of Illinois Press, 2013), 60. See also his Chapter 10 in this book.

20 Yole Correa-Zoli, "The Language of Italian Americans," in Charles A. Ferguson and Shirley Brice Heath, eds., *Language in the USA* (Cambridge: Cambridge University Press, 1981), 239–256; Rachel Silberstein, "New York's First Italian Dual Language Preschool Coming to Bensonhurst," *BKLYNER* (30 January 2015).

21 See Chapter 36 by Teresa Fiore.

22 Luciana Fellin, "The Italian New Wave: Identity Work and Socialization Practices in a Community of New Italian Immigrants in America," *Forum Italicum*, 48 (2014), 292–310 (299).

23 Luciana Fellin, "The Question of Language in the Italian American Experience," in *L'Italia allo specchio: Linguaggi e identità italiane nel mondo*, ed. Fabio Finotti and Marina Johnston (Venice: Marsilio, 2009), 465–478.

24 Anna De Fina, "Language and Identities in US Communities of Italian Origin," *Forum Italicum*, 48.2 (2014), 253–267 (266).

25 Anthony J. Tamburri, personal communication, 10 March 2015.

26 Hermann W. Haller, "Evolving Linguistic Identities Among the Italian-American Youth: Perceptions from Linguistic Autobiographies," *Forum Italicum*, 48 (2014), 245–249.

27 Joseph Sciorra, *Built with Faith: Italian American Imagination and Catholic Material Culture in New York City* (Knoxville: University of Tennessee Press, 2015), 173 note 21 (based on a personal communication from Anthony Pastena, 10 April 1985).

28 *Languages Spoken at Home for the Populations 5 Years and Over: 1980, 1990, 2000, and 2010*, www.census.gov/prod/2013pubs/acc-22.pdf (accessed 13 May 2015).

29 www.iitaly.org/166/about-us

30 www.lavocedinewyork.com/

31 See www.iitaly.org. Italian language readers also have access to publications from Italy through the Internet.

32 De Fina, "Language and Identities," 262.

33 Donald J. Tricarico, "Guido: Fashioning an Italian American Youth Identity," *Journal of American Ethnic Studies*, 19 (Spring 1991), 41–66 (46); Tricarico, "Bellas and Fellas in Cyberspace: Mobilizing Italian Ethnicity for Online Youth Culture," *Italian American Review*, new series, 1.1 (2011), 1–34 (15). For evidence of awareness on the part of Italian Americans of distinctive speech styles, see the "Stevie B Italian American Slang Word of the Day" videos on Youtube. For a consideration of tensions within the Italian American community on the use of such speech, see Johnny De Carlo, "Hey, Goomba! Exploring Formal Italian Language, Dialects & Slang Terminology," www.i-italy.org/bloggers/15974/hey-goomba-exploring-formal-italian-language-dialects-slang-terminology (accessed 14 May 2015).

34 Although in Italian the word *compare* (or "co-father") has a more expansive connotation than suggested by the English equivalent "godfather." See this book's glossary.

ITALIAN AMERICAN BOOK PUBLISHING AND BOOKSELLING

James J. Periconi

What does a study of immigrant foreign-language book culture teach us about the social reality of Italian immigrants to the United States at the turn of the twentieth century? We ask this from a bibliographic perspective, broadly conceived, that is, from examining the economic and social conditions of Italian-language book authorship, production, advertising, distribution, reception, selling at retail, and the evolution of this business from beginnings in the late nineteenth century until after World War II—in effect, bibliography as the sociology of texts.[1] We focus on New York City book publishers/importers and booksellers because of their predominance, but also discuss the most important city outside of New York that reflected a nationwide business competition, namely, San Francisco. Do the popular grammars, "encyclopedias," book catalogues, "secretaries" (books of model business and social letters) and directories, as well as the imaginative works and histories the community's writers produced, help us understand how these immigrants presented themselves to the world, revealed who they were and who they were becoming, intentionally or otherwise?

In recent decades American historians have encouraged the study of immigrant print culture—newspapers, magazines and books—not so much as mere sources of "facts" about those immigrants, but, more interestingly, as a window through which to illuminate the "*mentalités* and psychic maps" of immigrants in America.[2] A few such efforts have been made into the periodical literature (newspapers[3] and magazines) of Italian immigrants, but with the exception of one major work there have been only glancing references to the corpus of books produced by immigrants in Italian America during the Great Migration.[4] In my prior work, I surveyed Italian-language immigrant books in America as a possible yet unexplored key to making sense of Italian American history.[5] This essay now asks several more focused questions about book publishing in pursuit of the same objective, looking more closely at some of the major businesses and actors who made publication possible, that is, the publishers and booksellers themselves, the economic and social conditions under which they worked, and a close look at the most popular publications as a key to understanding their goals and why they enjoyed some economic success.

What drove these book publishers? Were they just trying to make a buck, as entrepreneurs not all that different from those who started construction businesses, fruit stands or asphalt or cement plants? Or, worse, were they developing a compliant and complacent identity for Italian immigrants that was designed only to serve their own economic and political goals, as has often been charged about the publishers of Italian American newspapers?[6] Can a case be made that the people in the book trade were at least in part trying to meet an existing need of their customers? Or, more interestingly, in accordance with American-style capitalism, were they trying to *create* a need (and thus a market) and then make products to supply it? Whatever their motivation, they used the capitalist tool of advertising, especially in their catalogues, grammars, "encyclopedias" and directories, to sell their wares, not only those

works but also the fiction, poetry, histories and other works they produced, for entertainment, and for the instruction of fearful immigrants on how to navigate a stressful and pressured environment.[7]

Beginnings I: From Bookstalls and Peddlers to Real Bookstores

Before discussing book publishers, let us review how Italian books were first sold by book importers, or actually, rented in New York (mostly before the book publishers).[8] We start with book peddlers: A *New York Sun* newspaper story reports this phenomenon:

> One book peddler told the reporter that for the first privilege of reading an uncut book he charged about a third of the market price. The next half dozen readers paid about 20 cents on the dollar. Finally it ran down by stages as low as 10 cents or even 5 for a week's use, and then the boys on the ferry boats and the like get their turn at it. "And where do you get your books," the walking library was asked.

> "At the banker's," was the reply.
> Nobody can tell just why all the Italian booksellers in New York except the newspaper publishers are bankers, but they are. Not all the Italian bankers are booksellers, but every bookseller is a banker.[9]
> There are from a dozen to twenty of them, at least one or two in each Italian center, and some of them do a very large trade. Many thousands of volumes are imported by them every year, chiefly from Milan, Florence and Rome, and besides their local sales one or two of them send out consignments of books to other parts of the country where there are large Italian settlements. Some idea of the extent of the Italian book trade in New York can be formed from the fact that one banker-bookseller, one of the largest, publishes a copiously illustrated book catalogue of 176 pages, with a fancy cover.[10]

A *New York Times* story of 1906 colorfully describes what appears to be a somewhat different phenomenon of fixed, open-air bookstalls:

> To see the American Italian at home it is necessary to seek him in the vicinity of Mulberry Bend. After pushing through a mass of shoppers, after just barely escaping a collision with a dozen maidens freighted down with bread, after stuffing up your nostrils to keep out the odor of macaroni and cheese, you will be able to reach the vendors of books.
> What a large assortment, and nearly all of them published with the intent and purpose of being disposed of at a low figure to the populace! No de luxe editions to be seen here; nothing limited about their circulation; no numbered copies; no deckled edges; but all got up in a common paper or a cheap muslin binding. But these books are not intended for exhibition purposes; they are to be read. A single reading in "little Italy" does not impair its usefulness; it is passed on to someone else, and as long as the binding lasts on and on it goes.[11]
> Hurry to one of the bookstalls. Some old friends greet us. Here is "Quo Vadis," there "Resurrection," a bit beyond "Gil Blas," and right alongside of it is "Decameron." Strain your eyes a mite to catch a glimpse of [other works]. . . . [O]f course, all these books are printed in their language. No bookseller's stock would be complete without a dozen or two works on that great subject of love. . . . Added to these is

a large list of novels, exciting enough, and thrilling withal. . . . Italy's daughters and sons are by birth of a literary temperament, and it's reasonable to allow that some of their native desire is transplanted here. . . .

There is a world of information here about bookselling and renting in Little Italy in this era, as well as about the significance of reading for Italian immigrants. For starters, book peddlers were, in effect, marketing their wares, hawking books they obtained from "banker-booksellers," who were presumably in offices or shops, rather than in dedicated bookstores. The peddlers (with or without encouragement) applied variable rental prices to fit all pocket books. The bookstalls in the *New York Times* story may or may not have participated in the same method of bookselling described in the first story from the *New York Sun*. The backdrop to this is that the illiteracy level of the Italian populace at home, some of whom emigrated, was steadily declining from 1871 to 1911. In Campania, whence many immigrants came, it declined from 85 percent to 54 percent. One factor may have been precisely a belief of many Italians that a literacy test for entry into the United States was imminent.[12] Although they often lacked money (or the desire) to *purchase* books, the immigrants were reading rented works of classical literature—Boccaccio, and Tolstoy and Lesage in Italian—as well as the romantic (if not "trashy") novels of Carolina Invernizio, that were then very popular in Italy.

Booksellers were clearly plentiful in this world: the reporter's quick count—"from a dozen to 20"—in New York, with "at least one or two in each Italian center," doing "a very large trade," suggests both popularity and the competition that went with there being so many purveyors of the same types of materials. There was also a beneficial effect in having proximate bookstalls that would cause shoppers to linger. The likely reason that all the booksellers "are also" bankers is a simple one. It took capital to buy "thousands" of volumes from what were probably Milanese, Roman or Florentine booksellers somewhat skeptical of the business reliability of Mezzogiorno Italians. And it would take capital—at least, for those of the booksellers who were, or would soon become, publishers as well, and thus usually also printers of their own works—to purchase printing presses and boxes of typeface, and rent quarters spacious enough to do such work.[13]

The rental of books, as well, suggests collateral facts: the immigrant could stretch his limited entertainment pennies on these cheaply printed books that were read and reread by immigrants who probably saw little reason to retain copies of them, but preferred rental (or borrowing from the library) to purchase.[14] Middlemen peddlers could also earn a living in this business, along with writers and publishers. Above all, the selling of books in bookstalls—one of which was that of a major player in our story, Antonio De Martino, before he owned a bookstore and household goods emporium—mixed with the "odor of macaroni and cheese" suggests strongly that books were needed, purchased and consumed *much like other daily household goods.*

Indeed, this is a recurrent theme: books as just another "commodity" of the Italian immigrant household.[15] One sees it in the "emporia" of Francesco Tocci and Antonio De Martino, discussed later, that would define the successful capitalist enterprise of book publishing, bookselling, including, along with the American products, imported works bearing the logo of the New York booksellers as "unique repository in the U.S."[16] These imported works made up the bulk of their stock in the early years, but were then supplemented by the generation and sale of American Italian works. For the bankers, as well, book reading would help encourage assimilation into American ways, including that American habit of saving regularly with deposits made at the local Italian bank.

Beginnings II: Early Booksellers and Bookstores

In addition to the outdoor bookstalls, which seemingly were not advertised in newspapers any more than would fruit or vegetable stalls, bookseller advertisements identifying actual bookstores (with addresses), only occasionally associated with bankers, abounded surprisingly early in newspapers; and, as with the outdoor bookstalls, much of their stock was imported from Italy. One page of *L'Eco d'Italia* [The Echo of Italy] in 1891 contained advertisements from no fewer than three different booksellers, including Giovanni Cereghino's Libreria Italiana [Italian Bookstore], which offered school books, grammars, novels, and the opera *libretti* of Meschino, among other categories, both for sale and for "rent" (actually referred to as a "'temporary' deposit") at 50 cents per month. Cereghino's advertisement also listed various devotional works, the (John) Milhouse Italian-English dictionary produced in England, books to learn English, and the Bible.[17] The other two booksellers on this page of the *Eco* were Libri d'Oro [Golden Books], at 401 Hudson Street "and other locations," run by Augusto Bassetti; and the newspaper's own Libreria dell' *Eco d'Italia* [Echo of Italy Bookstore], then located at 22 Centre Street. All of the works on offer appear to have been imports. By 1896, however, by which time novels had written in America and published by Italian American publishers, the bookstore of *Il Progresso Italo-Americano* [The Italian-American Progress] carried the eight novels of Bernardino Ciambelli that had been published in the United States since 1891.[18]

By 1919, about twenty-eight or twenty-nine years after the 1891 advertisement, the *Catalogo Almanacco della Libreria Banca Tocci* [Catalogue-Almanac of the Tocci Bank Bookstore], located at 89 Park Street, New York, had become the successor to the catalogue of the earlier Libreria dell'*Eco d'Italia* [Bookstore of the *Eco d'Italia*]. (See Figure 15.1.) Bookseller catalogues are, at least nowadays, considered a tool for a segment of a larger class of readers, namely, moneyed, well-educated ones. It seems surprising that late nineteenth and early twentieth-century Italian immigrants would have had the leisure and interest sufficient to peruse a lengthy catalogue, a fairly rich variety of tastes in reading, and the discretionary funds needed to satisfy desires beyond the necessities of life. The gracious air of the prefatory note, "To our Readers," which proclaimed the wish "to be able to be useful to you as we have been for a half-century," despite restrictions caused by World War I, assumes as much. The 1919 catalogue contains 165 pages of advertisements, mostly for books in categories that were quite diverse. There were "marvelous novels," and books that belonged to a "historical library." A "social library" included translated works by Tolstoy and Gorky. Among the "rare editions" were *I misteri di Parigi* [The Mysteries of Paris] written by the popular Frenchman Eugène Sue, which are thought to be the forerunner of the "I misteri" series of greatest of the American Italian novelists, Bernardino Ciambelli.[19] The catalogue included a "practical scientific library," a list of "stories and popular novellas" and also such classics as Dante's *Divine Comedy* and the poetry of Giosuè Carducci, alongside a healthy selection of dictionaries for French, German, Latin and Greek in addition to Italian and English.

Though the publishing provenance of these works (i.e., whether in Italy or the United States) is not stated in the catalogue, it appears that many of them were still being imported from (and published in) Italy. Yet an increasing number were clearly being published by (or, in some cases, imported from Italy but as sole distributors) the Italian Book Company, which will be discussed later. In the latter regard, the catalogue included sheet music, chromolithographs (and other art work), among which are two rather stunning works reflecting the war raging in Europe at that time, published by the Italian Book Company of New York, to which we now turn our attention.

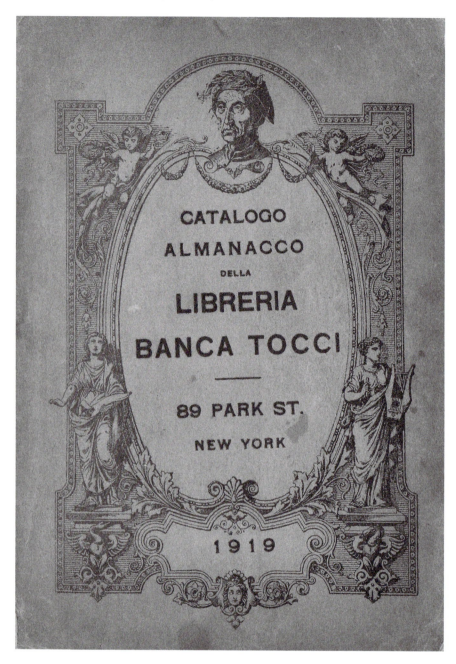

Figure 15.1 Catalogo Almanacco della Libreria Banca Tocci, 1919. Collection of James J. Periconi. Photo: Robert Lorenzson.

Arrival: Francesco Tocci, Antonio De Martino, and the Società Libraria Italiana, the Italian Book Company

It was in this late-nineteenth-century/early-twentieth-century atmosphere in New York that there arrived several commercial Italian book publishers.[20] The first major Italian-language

book publisher of the first half of the twentieth century was the Società Libraria Italiana or Italian Book Company of New York (IBC), founded by Francesco Tocci and Antonio De Martino.

The first of these co-founders, Tocci was one of the bankers referenced in the early-twentieth-century news articles. His venture into book publishing, as opposed to bookselling, had begun with the acquisition in 1891 by his uncle Felice Tocci (owner of the Banca Tocci) of the *Eco d'Italia*, the very first Italian-language newspaper in the United States, founded in 1850. Francesco had worked in the 1890s at his uncle Felice's Libreria dell'*Eco d'Italia* and also at the Libreria Banca Tocci. Before Francesco started the IBC, he published several language teacher/authors under the imprint of the IBC's progenitor, Francesco Tocci Editore, also known as The Emporium Press. "The Emporium Press/F. Tocci" published books as early as 1901,[21] and its authors included (in 1906, 1909, 1910) Giuseppe Cadicamo, an editor of the *Eco d'Italia* and founder of an Italian boarding school in Queens to teach immigrants Italian; and, more significantly, Alfonso Arbib-Costa, a City College professor. Arbib-Costa wrote a popular lesson book for Italians learning the English language called *Lezioni graduate di lingua inglese* [Step-by-Step Lessons in the English Language], copyrighted in 1906. Arbib-Costa's equally popular *Italian Lessons* for English speakers states that it was first published in 1908 by "Francesco Tocci ed.," and copyrighted by Tocci in 1909. In 1910 the copyright to Arbib-Costa's *Italian Lessons* was assigned to Tocci's second, more enduring publishing company, the IBC.[22] With the IBC, *Italian Lessons* went through an eighth "revised" edition in 1933.

An even shrewder capitalist than Francesco Tocci was the other IBC co-founder, Antonio De Martino. With Tocci, De Martino created the IBC in 1901,[23] having started before then in his case with a bookstall on Mulberry Street.[24] That De Martino was a shrewd business-man is evident from the way the company soon boasted, on its letterhead, a capitalization of $250,000—a boast that was no doubt critical for importing works, as well as required by Italian law, especially since as an importer of Italian titles De Martino often sought exclusive U.S. rights. De Martino was the first treasurer of the IBC, while Tocci was the first president. The younger De Martino, after Tocci's death, became its proprietor and possibly sole owner for decades, well into the 1950s, when the "Libreria [bookstore] De Martino, Inc. (Italian Book Company)" seemed to have displaced the former bookseller/publisher IBC.

What Made Money for the IBC?

Besides the Arbib-Costa books, the IBC's most popular works in Italian, to judge by the many editions and printings they went through, and the many copies of the work that have survived, were Angelo De Gaudenzi's *Nuovissima Grammatica Accelerata* [Newest Accelerated Grammar] and Giuseppe Molinari's 1917 *Raccolta di discorsi per ogni occasione* [Collection of Speeches for All Occasions], bound together with Riccardo Cordiferro's *Brindisi ed augurii* [Toasts and Greetings].

De Gaudenzi's book was copyrighted by him personally in 1896 and 1900, after which he sold its copyright to the IBC. (See Figure 15.2.) Unlike most of the IBC's works, which were bound inexpensively in wrappers and printed on inexpensive paper, this work was (like Arbib-Costa's grammar books) bound in boards. On the front cover of a 1914 edition printed for a bank in Cleveland (as on the cover of earlier editions), it even promised to be a "complete course for learning to write, speak and understand the English language in a brief time without a teacher." The ability of, and importance for, Italian immigrants with suffi-cient Italian language reading skills to teach themselves American English in America "with-out a teacher" cannot be overstated.[25] They could improve their Italian—not only because the work is largely in Italian, but also because the bilingual model correspondence contained

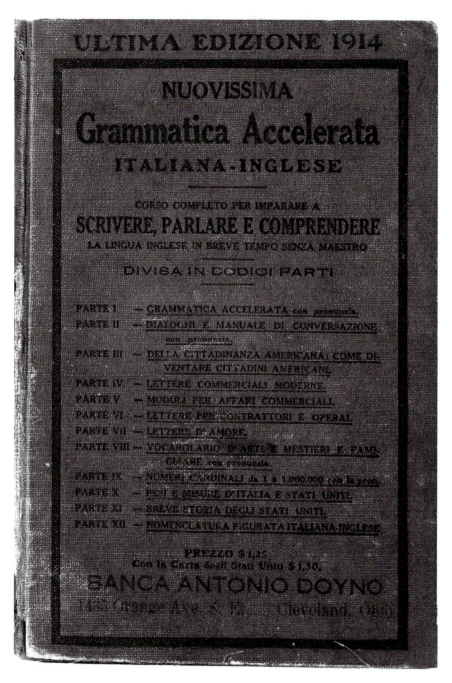

Figure 15.2 Angelo De Gaudenzi, *Nuovissima Grammatica Accelerata*. Edition of 1914 published by the Italian Book Company on behalf of the Banca Antonio Doyno of Cleveland. Collection of James J. Periconi. Photo: Robert Lorenzson.

therein promoted improvement—and thereby to become book readers in America (as they were not in Italy). The front cover self-description (if not out-and-out advertisement) noted that this 1914 IBC edition had grown into twelve parts, having added a brief history of the United States, and updated contemporary events, as if to counter the oft-made criticisms of the Italian periodical press that it failed to educate readers about their adopted country.[26]

Indeed, the *Nuovissima Grammatica Accelerata* became something of a publishing phenomenon, enduring at least seventy years (from 1896 to the mid-1960s), most of which were with the IBC, of which De Gaudenzi was the Corporate Secretary. In the post-IBC bookstore years it was sold by the Libreria De Martino, Inc., which was reportedly directed in the 1950s and 1960s by De Martino and then his daughter.[27] The most recent edition so far to have been located of the *Nuovissima Grammatica Accelerata*, published in 1963, states that the copyright is held by the IBC as publisher, although the bookseller is listed as the Libreria De Martino at the IBC's Mulberry Street shop. This later (perhaps final) edition mentioned the death of Pope John XXIII on 3 June 1963. There were still multiple sections, including an Italian-English vocabulary for a variety of situations, model letters in Italian and English for business and personal affairs; and, as in earlier editions, this one provided advice in Italian about American citizenship and the right to vote, adding a section on the U.S. Constitution.

Astonishingly, as if neither reading tastes nor anything else had changed from the late nineteenth and early twentieth centuries, this 1960s edition of *Nuovissima Grammatica* also contained seven pages of advertisements for Italian books, printed at the beginning and end of the volume. The books included a large selection of Italian-English dictionaries and grammars, many of them imported works that had been on sale already in the 1880s and 1890s. The books advertised even included the *Nuovissima Grammatica* itself, as well as an abbreviated version. Also advertised were conversation manuals and the ever-present "segretario"[28] with model social and business letters,[29] as well as an Italian-Spanish dictionary, Italian-French conversation manuals, and religious and spiritual books. There is something poignant here in the advertising plea (in Italian), utterly unnecessary in the earlier years, to "give the opportunity to your children to learn the Mother Tongue, Italian." One imagines De Martino's daughter holding onto a still sizeable stock of imported works no longer of use or interest in the 1960s to the non-Italian-speaking children and grandchildren of the immigrant generation.

One of the other advertisements was for the other highly popular IBC work—again judging from the relatively large number of copies that survive—Molinari's *Raccolta di discorsi*, which was first printed and marketed by the IBC in 1917, when it was bound together with Cordiferro's *Brindisi ed augurii* Some copies were printed in Italy, and some in the United States. The editors of the Molinari/Cordiferro work professed their desire to provide speeches, toasts and greetings that could be read and used by "every class within the [Italian] Colony." The editors preface the work with constant references to what is needed and useful in "the Colony" of about 600,000 Italian immigrants, so as to be "accessible to every [level of] intelligence . . . that deals with material that is so different and subjects so disparate." In a slightly defensive tone, Molinari declares that the Colony is unfairly attacked for having so many balls, banquets, picnics, parades and "similar foolish things," when the six hundred or so associations that hold these events are part of the greatness of this—one of the largest Italian cities—in demonstrating love of the Fatherland. Thus, he provides a model speech in honor of King Victor Emmanuel II, one for Garibaldi, and several speeches in honor of the Italian flag, but also for Decoration Day, Thanksgiving and a few other American holidays. Elsewhere in this three-author work there are speeches for a variety of organizations, and for family gatherings. In a later version printed in Italy there would be an eleven-page section entitled "The New Fascist Italy," celebrating the 1922 March on Rome and the entry of Italy in World War I, although this would be omitted from the American edition.

Competition

There was one significant competitor of De Gaudenzi's *Nuovissima Grammatica*: Alberto Pecorini's *Grammatica-enciclopedia italiana-inglese per gli italiani degli Stati Uniti* [Italian English Grammar-Encyclopedia for Italians in the United States].[30] For the Nicoletti Bros. press, which published it for forty years, the *Grammatica-enciclopedia* probably served the same purposes De Gaudenzi's *Nuovissima Grammatica* for the IBC. The book's cover declares the aim of the work is to help the reader "learn the English language without a teacher," much as De Gaudenzi's previous work had claimed in its early editions. The "encyclopedia" part of the work put language acquisition into action, with instruction on how to navigate the difficulties of this foreign land. First published in 1911, reprinted in 1912, taken over by the Libreria Nuova Italia Editore, by 1919 according to the title page (on the verso of which it was stated that the copyright was held by the New Italy Book Co. of New York), it was reprinted in 1935 and as late as 1949, also by the Libreria Nuova Italia. Like De Gaudenzi's work, Pecorini's contained sections on American citizenship as well as the expected pronunciation and rules of grammar section, model letters for business and family, Italian-English dialogues and ads for both Italian-English and English-Italian dictionaries. Pecorini had earlier observed the problem of Italians in America not knowing their own language.[31] As Pecorini carefully explained in his preface, his own, made-in-America grammar/encyclopedia could be the mechanism for semiliterate Italians "of the middle class" who had not achieved the upper levels of elementary schooling in Italy, "but who nevertheless had a knowledge of the Italian language that made them able to appreciate a good and practical grammar," and thereby gain confidence to navigate in the New World.[32]

Booksellers and the Capitalist Spirit

Business records reveal that De Martino was a savvy businessman who used the capital he somehow obtained—perhaps through Tocci and his uncle's bank, although no firm evidence has been found—for a variety of useful purposes.[33] One important purpose was to get copyright protections wherever he could; nor did he hesitate to sue those who, in his view, infringed on the IBC's copyright or exclusive rights to distribute imported works. From a review of the litigation files, it appears that the scope of copyright protection or exclusive rights that De Martino seems to have bargained for was never as clear as he claimed: De Martino sometimes lost on his claims of expansive rights. He also vigorously defended copyright infringement charges against the IBC.

As with twentieth-century publishers, key to the economic success of the venture was having at least a couple of repeat sellers as a base to permit the venture's survival, and even experimentation and expansion. On the basis of survival rates, De Gaudenzi's *Grammatica Accelerata*, Molinari/Cordiferro's *Raccolta di discorsi / Brindisi e augurii* and Arbib-Costa's works were good sellers, if not blockbusters, and not far behind were the various "secretaries" that seemed to emanate periodically from the IBC in many varieties, as noted.

As well as serving a crucial social function (to help immigrants learn English through using their nascent Italian), these grammars, "encyclopedias," secretaries and similar works served a crucial business function beyond the income generated in their decades of sales for the publishers: these works helped create a marketplace[34] of book-buying readers. It started by their importing Italian-English dictionaries, readers and grammars, but then advanced to the writing and publishing their own, grammars and the like. But they also helped create a class of readers eager to learn not only English in general, but who also needed to learn Italian, with De Gaudenzi's *Grammatica Accelerata*, for example, providing both Italian and

English vocabulary (with pictures) for mechanics, gardeners, metalsmiths, stonecutters, tailors, electricians and carpenters, among others. And immigrants could learn how to become more Italian (than Neapolitan, Sicilian, etc.) than they could become in the old country, by developing a taste for literature as perhaps never before. These works built on the preparation immigrants made in Italy for their journey to America, as Pecorini had declared his intentions in the preface to his *Grammatica-Enciclopedia*: to build on the knowledge the average Italian worker in the United States had of Italian, even without having achieved the higher grades of elementary school in Italy, to be able to use a practical grammar for an Italian to learn English "without a teacher," but also to improve their Italian language skills.[35]

Directories and the Capitalist Spirit

Before turning to the literature that Italians created, and then craved reading, in America, one further class of evidence informs us about full participation by the Italian-language book industry in the American capitalist spirit: the directories. These contain much useful information about booksellers[36] and publishers[37] in New York in the early twentieth century. For example, Angelo De Gaudenzi took out a full-page ad in Italian in the 1905 *Italian American Directory*, as both "publisher and bookseller," importer of books of all the leading Italian publishers, indeed, calling his shop "the greatest Italian Bookstore in the United States." He pitched his ability to help setup of bookstores "in whatever part of the United States." Upon request, he would send a "prospectus" for doing this "at the cheapest prices." He also trumpeted his *Nuovissima Grammatica Accelerata*, discussed earlier.

Handsomely bound (like the grammars) in boards (not wrappers), the Italian directories served a unique function of taking occasional stock of the progress of Italians in America, measuring the numbers and breadth of the Italian colony throughout the country at various times, by state and often by occupation, a kind of declaration of how far the Italian colony had advanced in business. Despite their issuance typically in Italian, they formed a critical measure of just how much Italians believed themselves to have been assimilated, integrated into American society; and thus they merit our special attention.

The first directory or almanac to be found in the East, according to Pietro Russo, was published in January 1862, followed by others.[38] Another nineteenth-century directory was the *Guida degli italiani in America: strenna 1893 dell'Eco d'Italia, il più antico ed il più diffuso giornale italiano in America* [Guide of the Italians in America: Gift for 1893 of the *Eco d'Italia*, the Oldest and Most Widely Distributed Italian Newspaper in America]. In the West, there were the Italian-Swiss catalogs, such as the *Primo Almanacco Italosvizzero Americano*, published by J. F. Fugazi in 1881; and the *Almanacco Illustrato Dell'Elvezia* published in 1895 by the Libreria e Tipografia del Giornale *L'Elvezia* [Bookstore and Press of the Newspaper *The Elvezia*]. Later in New York, the 1905 *Italian American Directory: Guida generale per il commercio italo-americano/ General guide for the Italian American trade* [New York: Italian American Directory Co.]; the 1906 *Gli Italiani negli Stati Uniti d'America*, by the same publisher; and the biographical almanac, *Italiani di America* of Ario Flamma (editions of 1936, 1941, 1949).

In its very physical makeup, the 1905 *Italian American Directory* reflects this jostling and jockeying for position in the New World: the cover is crowded with multicolored pictorial as well as textual advertisements for sellers of wine and olive oil (with handsome bottles of each stamped on the cloth cover) and real estate, with an ad for The Atlantic Macaroni Company very close to one for the Banca Cuneo. (See Color Plate 10.) Even the fore-edge of the book has a stamped advertisement: Maffei & Co., a Manhattan importer of and agent for food products and wines. Attempting to fill the same need that American city directories had since the early nineteenth century filled before there were telephone books, this directory

is notable for its national (and international) scope. Names and addresses of Italians in the directory were organized by borough (within New York City) and then by trade. Italians in forty-four of the then forty-eight states, as well as Washington, DC, were listed by name, and organized by city or county and trade. A demographic map of the United States shows the distribution of Italians across the country, and population in each state. The directories also provide information about publishers and booksellers nationwide. Besides five San Francisco publishers and one bookseller, four publishers were listed in Philadelphia; in Chicago, four publishers though no Italian booksellers; and in Newark, two publishers but no booksellers.

The 1906 *Gli Italiani negli Stati Uniti d'America* was the result of the organizing committee of the 1906 Milan Exposition directing Italian chambers of commerce around the world to prepare a volume in a series about Italians abroad.[39] This ambitious work, in an impressive, large folio format, measuring 15 7/8 inches long by 11 1/8 inches wide, on thick, glossy stock, contains essays in the first part by an all-star cast of Italian writers, from then inspector of immigration, Adolfo Rossi on Italian manpower in the United States, Italian-language teacher Arbib-Costa on Italians in public schools, Alfredo Bosi on the failure of the Italian colony in New York to establish a true Italian school there, Bernardino Ciambelli on Columbus Day and others. The second part, comprising 290 of the 473-page total, is a directory of advertisements and summaries of Italian American businesses that undoubtedly paid for the privilege. It is here that Francesco Tocci set out on his ambitious book publishing program described next.

National Competition among Booksellers

Competition was not only for local business or consumer customers. Tocci in his Emporium Press in the 1906 directory, and Angelo De Gaudenzi in the 1905 directory, like Giovanni Cereghino before them, advertised that they sold books both at wholesale and retail. Other documents reflect that competition abounded, especially from San Francisco: as early as 1881 there, an ad for M.G. Tonini's Libreria Italiana, at 26 Montgomery Street, "Importer and Dealer in Foreign and Domestic Books and Stationery," appeared in the *Primo Almanacco Italosvizzero Americano*, as did others. In an 1895 *Almanacco Illustrato Dell'Elvezia*, published by the Libreria e Tipografia del Giornale *L'Elvezia*, the Libreria Italiana of George F. Cavalli, at the offices of the newspaper itself, was the "only Italian bookstore in California," perhaps having replaced Tonini's, with a great assortment of books of all types, especially school books. Cavalli's *Libreria Italiana* claimed its book prices were "lower than those of Italian bookstores of New York."

What Else Did the IBC Publish?

In creating a market for the reading of Italian by immigrants to serve other than purely practical needs, what body of work did the IBC generate? The approximately forty original works published by the IBC (i.e., not including the several hundred imported works, or scores of sheet music,[40] music rolls and the like) may seem modest, but the work of finding them is hardly over. Numbers increase any time a new search engine permits a broader or deeper search by publisher; I have examined copies of about twenty of them. Virtually all were printed in the United States, as well as being published here; a few were not. Over the years since the founding of the company, as if running the business were not enough, De Martino himself became an author of several IBC best sellers.[41]

Other titles include fiction, such as three novels by Ciambelli, and non-fiction, such as Pallavicini's *La guerra italo-austriaca (1915–1919)* [The Italo-Austrian War, 1915–1919]

(published in 1919), as well as (in the "memoir" category) *Casanova: memorie d'avventure amorose* [Casanova: Memoirs of Amorous Adventures] (published in 1944), and perhaps more famously,[42] De Martino's own *L'assassinio della contessa Trigona* [The Assassination of Countess Trigona] (published in 1919 and again in 1944). As for the imported works, under the name of the actual publisher there was printed in Italian a statement to the effect that the IBC (address) is "the only distributor in the U.S"; or in English, after the IBC's name and address, the declaration "This copy can be imported in the U.S. of A. only by Italian Book Co. of New-York." Nothing written by immigrants in English quite captured the gritty world of the ghetto, the class separation of immigrants from world of Americans or the conflict between American-born children and their Italian parents, as the novels of Bernardino Ciambelli; or the despair experienced by many of immigrants in being excluded from American society as the reportage of Adolfo Rossi of the Five Points in Manhattan and other aspects of his life in America.

The most important of these was Ciambelli, the most prolific and probably most significant chronicler in fiction of the life of the *colonie italiane* in New York and in the larger world of New York for more than thirty years in about twenty novels.[43] The IBC published three of them. Most began life as appendix literature in newspapers or magazines such as *La Follia* [Folly].[44]

At the same time, perhaps borrowing the most important lesson from the sales of books at outdoor bookstalls that characterize the earliest period, the two major booksellers in New York integrated the sales of books in their emporia, such as Tocci's and IBC's, for decades so that book buying became as ordinary, as integrated into regular purchases, as buying kitchen utensils. The IBC also imported manuals for gardening and other useful domestic occupations, where there was less need to create an American version, but generated immigrant novels and books of poetry, in Italian, to reflect and, as one of the major scholars[45] has noted about the literature, negotiate the terrifying and stressful experience of the New World.

What Drove De Martino (and the Italian Book Company) and Tocci?

How important was the IBC in the Italian colony? Can we glean anything from the record reflecting how the colony viewed the publishers? Others did in fact recognize the importance of the IBC: Among the least chauvinistic, the Federal Writers Project *The Italians of New York* called the IBC "one of the most important wholesale and retail Italian book shops in the city,"[46] pointing out in the Italian edition published later that the prominence of the IBC as wholesale and retail bookseller extended throughout the country, consistent with De Martino's self-promotion.[47]

Years afterward, Italo Stanco, a successful and sophisticated novelist, praised De Martino in *Divagando* [Roaming],[48] a large-circulation Italophone weekly cultural journal, as someone who was a "pioneer" who "refined the crude minds of the humbler Italian immigrants of more than a half-century ago," immigrants who lived "in the mean dens of the Five Points, of Mott, Mulberry and Elizabeth Streets." Starting in one of the small bookstalls on Mulberry Street about which we heard earlier, squeezed between many others, De Martino took the IBC to the glory of the large "emporium" it occupied at 145–47 Mulberry Street. The "indefatigable bookseller-editor" De Martino possessed literary and artistic properties of "thousands" of works of every type, from novels to songs. To obtain many of these "properties," as Stanco calls them, De Martino "commuted" between New York and his beloved native Naples—where he stayed anywhere from two to thirteen months.

Finally, *Il Progresso Italo-Americano*,[49] in 1956, celebrated the sailing of De Martino's ship from New York, his fifty-third Atlantic crossing to his native Italy "to enrich this bookstore with all the newest and most interesting publications that see the light of day in Italy" in order to develop an unrivaled selection for his American public, and to be able to offer the most complete and varied collection, "all in Italian."[50] His trips, the article emphasizes, were not pleasure trips, but excursions of "bibliographic research" that enhanced his flourishing book business. The IBC's business records show that De Martino arranged book deals and translation deals with leading Italian authors, or, alternatively, he developed book distribution arrangements with Italian publishers such as Fratelli Bocca of Torino.[51] This insured that, much as Lorenzo Da Ponte had done a century before in importing into, and distributing Italian imprints in, the United States, new political, economic, social and literary ideas from Italy were made available to Italians here as well as that part of the American public who could read Italian.

As for Tocci, he described his own goals at a much earlier time in a four-page spread in the 1906 directory (*Gli Italiani negli Stati Uniti d'America*, noted previously) in terms similar to those that would be used about De Martino retrospectively in the 1950s. The goals for his publishing venture (The Emporium Press, also known as Francesco Tocci, ed.) that immediately preceded the Società Libraria Italiana, harked back to its beginnings in 1895, when he separated from his uncle, Felice, whose Libreria dell' *Eco d'Italia* had become in time the Libreria Banca Tocci [Tocci Bank Bookstore] on Park Street in New York. Francesco wrote there had been in 1895 "several Italian booksellers in New York, whose stock consisted principally of popular literature, sold at high prices."[52] (Among these several booksellers was Giovanni Cereghino, discussed earlier). Tocci's idea for his Emporium, however, included the "largest possible deposit of Italian books of all types, excelling certainly in works of easygoing tales of chivalry, which are the works most highly sought by our people," but where could be found as well a "varied assortment of literary and modern works."

His shop, he continued, ordered crates of books from Italy of all types, and offered to send packages of books throughout North America. Though many of them were "school books or works of amusing literature," like the popular novels written by Carolina Invernizio or tales of chivalry, Tocci noted with evident pride that one could also find in his shop works of the "best modern literature," like those by Gabriele D'Annunzio and Giosuè Carducci. Noting that he is a cultured man with good taste, he promised one day to make a gift of such modern literary works, "good Italian books," to the Italian colony, but also for "studious Americans," "quite a few of whom know our language."[53] Six large photos are spread over three pages following this page of text (which itself contained a photo of the dashing Tocci), including one of the printing operation's composition room and printing press room.

Conclusions

The major Italian immigrant book publishers were advanced practitioners of capitalism, but they also sought to educate and raise the fortunes of immigrants. The readers of the books in the Italian community, for their part, were clearly the strivers and dreamers: colonsufficiently literate in Italian in preparing to emigrate, they found a way in the New World to read a wide variety works in Italian, including along with Italian originals, French and Russian novels and stories in translation. At the same time, they used their modest skills in Italian to teach themselves English, at their own pace, "without a teacher." They consumed books as they consumed other commodities, to survive and to thrive in the often hostile environment of the New World, to learn written communication from model letters in both languages. And the process evolved over time: from the impulse rentals, if not purchases, from crowded, competing bookstalls among the food stalls on Mulberry Street in the early years,

to handsomely designed catalogues selling the widest variety of books imaginable both for instruction and for entertainment, in order to satisfy their cravings; from there to the grand emporia with bookstores that became more prevalent in the course of the first decades of the twentieth century. Despite the many gaps in the record—no records have been found to date to suggest the actual numbers of copies printed of any of these books—the multiple editions and printings of the major works in Italian, some lasting four decades and some as long as seven decades, suggest the popularity and great importance of the major tools of self-education and self-advancement: grammars and "encyclopedias," with dictionaries and bilingual model letters, and belie the popular image of illiterate peasants poorly equipped for life in twentieth-century America.

Further Reading

Durante, Francesco. *Italoamericana: The Literature of the Great Migration, 1880–1943*. Edited by Robert Viscusi (New York: Fordham University Press, 2014).

Periconi, James J. *Strangers in a Strange Land: A Catalogue of an Exhibition on the History of Italian-Language American Imprints (1830–1945)* (New York: Grolier Club, 2012).

Notes

1 The phrase was invented by Donald F. McKenzie, *Bibliography and the Sociology of Texts* (Cambridge: Cambridge University Press, 1999). See also G. Thomas Tanselle, "Introduction," and Robert Darnton, "What Is the History of Books?" both in *Books and Society in History*, ed. Kenneth E. Carpenter (New York: Bowker, 1983), xvii–xxiii and 3–26, for succinct descriptions of somewhat different conceptions of *histoire du livre*, each departing from the traditional understanding of bibliography.

2 Joshua A. Fishman, *Language Loyalty in the United States: The Maintenance and Perpetuation of Non-English Mother Tongues by American Ethnic and Religious Groups* (The Hague: Mouton, 1966), as cited by Rudolph J. Vecoli, "The Italian Immigrant Press and the Construction of Social Reality, 1850–1920," in *Print Culture in a Diverse America*, eds. James P. Danky and Wayne A. Wiegard (Urbana: University of Illinois Press, 1998), 17–33. The quote is from Robert Harney, "The Ethnic Press in Ontario," *Polyphony: The Bulletin of the Multicultural Historical Society of Ontario*, 4 (Spring/Summer 1982), 7.

3 On the *prominenti* press, by far the most significant such work is that of Durante, *Italoamericana* [American ed.], 81–365. See also, Vecoli, "The Italian Immigrant Press," 18–24; and Peter G. Vellon, *A Great Conspiracy Against Our Race: Italian Immigrant Newspapers and the Construction of Whiteness in the Early 20th Century* (New York: New York University Press, 2014). Much more has been written on the radical press: see Durante, *Italoamericana* [American ed.], 551–788; Vecoli, "The Italian Immigrant Press," 24–28; Marcella Bencivenni, *Italian Immigrant Radical Culture: The Idealism of the Sovversivi in the United States, 1890–1940* (New York: New York University Press, 2011), 67–98; and Bénédicte Deschamps, "De la presse 'coloniale' à la presse italo-américaine: le parcours de six périodiques italiens aux États-Unis (1910–1935)," PhD thesis, Université de Paris 7, (1996).

4 See Vecoli, "The Italian Immigrant Press," 18, 26.

5 See James J. Periconi, *Strangers in a Strange Land: A Catalogue of an Exhibition on the History of Italian-Language American Imprints (1830–1945)* (New York: Grolier Club, 2012).

6 See, e.g., George E. Pozzetta, "The Italian Immigrant Press of New York City: The Early Years, 1880–1925," *Journal of Ethnic Studies*, 1.3 (Fall 1973), 32–46; Vecoli, "The Italian Immigrant Press," 24. For a contemporary's charge of this kind, see Carlo Tresca, "Il fascista Gene Pope è un uomo di paglia," *Il Martello* (14 November 1934), translated in Durante, *Italoamericana* [American ed.], 775–778: "The fascist Gene Pope is a man of straw."

7 See Martino Marazzi, *A occhi aperti: letteratura dell'emigrazione e mito americano* (Milan: Franco Angeli, 2011), passim, for this view of the function of the literature of Italians in America.

8 By "first sold," I mean during the mass migration in the late nineteenth century, skipping the *sui generis* early nineteenth-century Italian book importing and bookselling efforts of Lorenzo Da Ponte in New York (mentioned in Chapter 3). See also Periconi, *Strangers*, 45.

9 Though some of the booksellers were indeed also bankers, such as the Tocci's, by no means were all or even the majority of booksellers also bankers. One theory of how the reporter came to be confused may

have been playfulness by the young book-hawkers, who had some awareness that historically, in Italy, street bookdealers are called "bancarellieri," selling their wares from "bancarelle."

10 Quoted in Eliot Lord, John Trenor and Samuel Barrows, *The Italian in America* (New York: R. F. Buck, 1905), 246–247. The "176-page catalogue" is possibly an early catalogue for the bookseller-banker, Felice Tocci, advertised in *L'Eco d'Italia* in 1891. A later (1919) edition of this catalogue is discussed later.

11 *New York Times Saturday Review of Books* (31 March 1906), BR201.

12 Carlo M. Cipolla, *Literacy and Development in the West* (Baltimore: Johns Hopkins University Press, 1969), 19, 94–97, 127, and Ercole Sori, *L'emigrazione italiana dall'unità alla seconda guerra mondiale* (Bologna: il Mulino, 1979), 205–211, cited in Vecoli, "The Italian Immigrant Press," 17.

13 That banks have historically been critical in the development of printing and publishing is well known among book historians. See, e.g., the "Introduction," (especially 25 *et seq.*) to *The Cambridge History of the Book in Britain*, vol. 5, *1695–1830*, eds. Michael F. Suarez, S. J. and Michael L. Turner (Cambridge: Cambridge University Press, 2009), especially 25ff.

14 As early as 1894 the Anson Phelps Stokes Italian Free Library at 149 Mulberry Street in Manhattan made most of the same works available for free. See Alexandra de Luise, "The Italian Immigrant Reads: Evidence of Reading for Learning and Reading for Pleasure, 1890s–1920s," *Italian Americana*, 30.1 (Winter 2013), 33–43.

15 This idea, too, is canonical in the study of book history; see, e.g., James Raven, "The Book as Commodity," in *The Cambridge History of the Book in England*, eds. Suarez and Turner, 5: 85–117.

16 See, e.g., William Galt (pseud. Luigi Natoli), *Mastro Bertuchello e il Tesoro dei ventimiglia* (Milan: La Madonnina, 1951).

17 *L'Eco d'Italia* (31 January 1891), 2.

18 *Il Progresso Italo-Americano* (5 July 1896), S4.

19 Franca Bernabei's "Little Italy's Eugène Sue: The Novels of Bernardino Ciambelli," in *Adjusting Sites: New Essays in Italian American Studies*, ed. William Boelhower and Rocco Pallone (Stony Brook: Forum Italicum, 1999), 3–56.

20 This essay excludes discussion of the radical book press, a topic that merits its own full, and rather different discussion.

21 Located at 145 Spring Street, as late as 1915, as a printer it boasted that though its prices were no higher than those of other printers, its high quality work could be compared only with that of the "best of American establishments." From an advertisement in *Il Carroccio*, 2.10 (November 1915), IV.

22 "The Emporium Press (Francesco Tocci)" was listed in 1901, and still listed in 1910, in *The Trow Copartnership and Corporation Directory for the Boroughs of Manhattan and the Bronx*, at 209 Grand Street in the earlier edition and at 520 Broadway in the later one.

23 According to *Gli italiani di New York: versione italiana, riveduta ed ampliata da Alberto Cupelli*, "a cura degli scrittori del Federal Writers' Project della Work Projects Administration di New York City" (New York: Labor Press, 1939), 87.

24 See, later, discussion in a 1953 story in the magazine *Divagando* by Italo Stanco.

25 See Vecoli, "The Italian Immigrant Press."

26 Pozzetta, "The Italian Immigrant Press," 32.

27 Private conversation (2012) with Ernie Rossi, grandson of the founder of Rossi & Co. books.

28 The most thorough treatment of such manuals or "secretaries," placing the origins of such works firmly in Italy, is Mary Anne Trasciatti, "Letter Writing in an Italian Immigrant Community: A Transatlantic Tradition," *Rhetoric Society Quarterly*, 39.1 (January 2009), 73–94.

29 Examples include Antonio De Martino, *Segretario amoroso: italiano-inglese* (New York: Italian Book Co., 1945); and De Martino (with Violetta Sironi), *Segretario speciale per la corrispondenza delle madri, spose, fidanzati con i figli, mariti, fidanzati in italiano* (New York: Italian Book Company, [1945?]).

30 Alberto Pecorini, *Grammatica-enciclopedia italiana-inglese per gli italiani degli Stati Uniti* (New York: Nicoletti Bros., 1911).

31 *Gli americani nella vita moderna osservati da un italiano* (Milan: Fratelli Treves, 1909), 397–398.

32 Pecorini, *Grammatica-enciclopedia*, "Preface."

33 The Immigration History Research Center, University of Minnesota, contains about 150–200 pages of records of the IBC.

34 I thank G. Scott Clemons, a major collector of the great Venetian printer, Aldus Manutius (1449–1515), for this insight into how Aldus, by publishing grammars and dictionaries in ancient Greek, which was nearly a lost language, created a marketplace for the Greek playwrights and other writers he published.

35 Pecorini, *Grammatica-enciclopedia*, "Preface."

36 As of 1906, there were at least a half-dozen others besides De Gaudenzi, the Tocci's and De Martino, consistent with the newspaper account of the same time discussed earlier.

37 There were about twenty other book publishers at this same time.

38 See *L'Eco d'Italia* (9 January 1862), cited in Pietro Russo, "La stampa periodica italo-americana," in *Gli italiani negli Stati Uniti. L'emigrazione e l'opera degli italiani negli Stati Uniti d'America* (Florence: Istituto di studi americani, 1972), 493–546. Russo also cites an *Almanacco della Pace, Almanacco enciclopedico Italo-Americano, Almanacco Per l'anno, Il vero Barbanera contenene le principali leggi e informazioni utili agli italiani stabiliti in America*, all edited in New York. Russo, "La Stampa," 536 n. 94.

39 For a thorough explanation of this background, as well as an analytic *tour de force* on the several layers of functioning of this directory, see Robert Viscusi, "The Universal Exposition," in Periconi, *Strangers*, 30–41.

40 As late as 1949, the IBC held copyright on over 1,000 Italian songs, and threatened to sue foreign language radio broadcasters that refused to pay IBC a licensing fee for every song played: *The Billboard* (9 July 1949), 16.

41 See the works cited in note 29 above; and Antonio De Martino, *Tripoli italiana: la guerra italo-turca* (New York: Italian Book Company, 1911); De Martino, *L'assassinio della Contessa Trigona* (New York: Italian Book Company, 1919, 1941); De Martino, *Collection of Italian and Neapolitan Songs* (New York: Italian Book Company, 1934); De Martino, *Libro del sapere* (New York: Italian Book Company, 1941); and De Martino and Umberto Fragasso, *Il libro delle erbe: medicinali e magiche* (New York: Italian Book Company, 1946).

42 This is the slightly fictionalized story of the famous murder of the Contessa Trigona by her lover when she ended their love affair, an event that marked the beginning of the decline of the Sicilian nobility.

43 Durante, *Italoamericana* [American ed.], 145–182; Marazzi, *A occhi aperti*, 52–65; and see Rose Basile Green, *The Italian-American Novel: A Document of the Interaction of Two Cultures* (Cranbury: Associated University Presses, 1974), 64–65; and Alfredo Bosi, *Cinquant'annni di vita italiana in America* (New York: Bagnasco Press, 1921), 408.

44 Bénédicte Deschamps, "La letteratura d'appendice nei periodici italo-americani (1910–1935)" in *Il sogno italo-americano: realtà e immaginario dell'emigrazione negli Stati Uniti*, ed. Sebastiano Martelli, Acts of the Conference of the Istituto "Suor Orsola Benincasa," Naples, 28–30 November 1996 (Naples: Cuen, 1998), 279–294.

45 Marazzi, *A occhi aperti*, passim.

46 Works Progress Administration, *The Italians of New York: A Survey Prepared by the Workers of the Federal Writers' Project* (New York: Random House, 1938), 132.

47 *Gli Italiani di New York*, 87. The Italian edition is cited at note 23.

48 *Divagando* (16 September 1953), 26.

49 *Il Progresso Italo-Americano* (10 February 1956), 7.

50 While the imported books were mostly published in Italian, the IBC also published a very small number of English-language translations, such as Maria Gentile, *The Italian Cook Book: The Art of Eating Well* (New York: Italian Book Company, 1919); and Benito Mussolini, *John Huss the Veracious* (New York: Italian Book Company, 1939).

51 See note 33 and discussion in text.

52 *Gli Italiani negli Stati Uniti d'America*, 452.

53 Ibid. In this latter regard Tocci published and sold Arbib-Costa's Italian-language instruction books, which appear to be designed mostly for non-Italians, each of which works went through many editions in the decades they were published by the IBC. In addition to the previously noted *Italian Lessons*, Arbib-Costa's *Advanced Italian Lessons* (New York: Italian Book Company, 1912 [1st ed.]) appears to have also sold well in its 1914 [2nd] and 1924 [3rd] editions.

FROM MARGINS TO VANGUARD TO MAINSTREAM

Italian Americans and the Labor Movement

Marcella Bencivenni

On 27 March 1874, the *New York Times*, covering a strike of the Erie Railroad workers, reported that the company was hiring Italian immigrants directly from the steamships at Castle Garden.[1] On the same day the newspaper reported that "between 100 and 200 Italians" had been hired to replace striking tunnel builders on a Delaware, Lackawanna and Western Railroad project near Hoboken, New Jersey.

> The men had scarcely begun their labors before they were attacked by a band of the strikers. A riot, during which stones and clubs were freely used, ensued. The Italians, finding themselves worsted, retreated, not, however, until several of them had been severely hurt and fled, many of them into neighboring houses. One of them, however, had been rendered unconscious by a blow upon the head with a stone, and the infuriated strikers beat him almost to death.[2]

Indeed, gangs of Italian newcomers (as well as Hungarians, Japanese, and blacks) were used extensively, often under false contracts and without their knowing, to break strikes during the 1870s and 1880s.[3]

Ironically, though widely denounced as "scabs," early Italian immigrants also earned a reputation for extreme violence and insubordination. Stories of "spontaneous revolts" led by "uncontrollable" Italians rising up and attacking their employers filled the press during the nineteenth century. Over and over Italian workers were described as exploding in furious outbursts over a particular abuse, marching and parading through streets with red flags, destroying property, instigating resistance and vowing vengeance against their contractors and the police. Most of these strikes were said to have begun without planning and almost without warning, and they were attributed to the "barbarous tactics" that the Italians had brought with them.[4]

For years, these two almost opposite images—the "padrone slave" and the "primitive rebel"—dominated popular perceptions and scholarly views of Italian immigrant workers.[5] Today, however, it is clear that the experience of Italian workers in the United States was far more complex than these stereotypes suggest. As a large body of revisionist studies has uncovered, not only were Italians organizable and capable of collective class-based action, but they also played a major role in the American labor movement, putting their distinctive stamp on industrial unionism in particular.[6]

Far from passive and acquiescent, Italian immigrants fought intensely to improve their working and living conditions—and to change their world. Particularly in the period before World War I, they mobilized in large numbers, participating in, and often leading, some of

the most important labor strikes in the nation's history. Their struggle typically began outside of formal political spaces, such as trade unions or parties (a fact that made their activism invisible to American eyes); yet it was precisely this kind of informal organization that spurred their class consciousness and labor militancy. Their radicalism becomes fully visible only when we extend our analysis of working-class activism beyond traditional forms of political participation (such as union and party membership or voting) to include both less formal, often hidden, strategies of resistance and also non-English language sources.

It is also now clear that Italian immigrant labor organizing was not a direct result of Americanization, as suggested by early histories, but rather a compound of old world ideologies and new world experiences—rooted in Europe and fueled by American indignities.[7] The key for studying and understanding Italian responses to industrial America lies in the transnational connections that tied Italian migration, European politics and American developments.

Emphasizing these transatlantic links, this chapter begins with a brief overview of the emergence of labor militancy in Italy and then moves to the American context, discussing the challenges faced by Italian immigrant workers and their responses. Relying on the rich literature that has emerged in recent years on the "lost world of Italian American radicalism," it delves into the political culture and circumstances out of which a distinctive Italian labor movement emerged in the United States and the many forms it took—from spontaneous revolts, revolutionary syndicalism, to trade unionism.[8] Along with much of the American Left, Italian American organized labor, at least in the political sense of a counter-ideology to capitalism, gradually vanished as a result of specific historical conditions and circumstances, both internal and external to the movement. Yet, the struggles and mobilization of Italian workers, particularly between 1909 and 1919, revealed surprising strength, reminding us how "marginal" immigrants have shaped and continue to shape the American labor movement.

Origins of Labor Militancy in Italy

In Italy, when compared with other European nations, the labor movement arrived relatively late.[9] Prior to Italian unification in 1861, only a handful of workers' associations existed and they were largely isolated and ineffectual. The only conspicuous organizations were mutual aid societies—self-help organizations that provided workers with medical, legal and financial assistance, such as benefits for illness, old age and burial. In the 1860s, however, inspired by the Risorgimento, new forms of workers' societies began to form whose structure and tactics presaged those of modern trade unions.[10]

Ideologically, this transformation began with Giuseppe Mazzini's political aspirations for a *Giovine Italia*—a "Young Italy" founded on republican, democratic, and secular values. The mastermind of Italy's independence, Mazzini was also the first Italian intellectual to concern himself with the social question. His faith in the brotherhood of all men, his opposition to caste and privilege, and his emphasis on universal suffrage and education inflamed the hearts of thousands of hungry and dissatisfied workers, helping to plant the seed of organized labor.[11]

The agrarian crisis of the 1870s and the failure of the newly formed Italian state to implement badly needed political, economic, and social reforms further radicalized Italian workers. An 1868 tax on flour, in particular, unleashed a violent resistance that spread "with lightning-like rapidity" from the province of Verona to "almost every part of the country."[12] It took military troops three months to restore order: 275 demonstrators were killed, 1,000 wounded and 3,788 arrested. *Leghe di resistenza* ("leagues of resistance") began to quickly replace mutual aid societies; rebellions and protests became also more frequent. By 1870 the numbers of workers' associations rose to 878, and in the following decade Italian workers carried out 465 strikes to demand wage increases and better working conditions.[13]

The gradual rise of literacy contributed to this mounting militancy. But the most important event in the rise of the Italian labor movement was the spreading of socialist ideas following the founding of the International Workingmen's Association (the First International) by Karl Marx in 1864. An Italian Federation of the IWA, largely dominated by anarchists, was founded in 1872, counting more than 30,000 members two years later. Internal dissent and government persecution destroyed the International by 1880, but the anarchists, like Mazzini earlier, played an instrumental role in awakening the Italian workers.[14]

As industrialization began accelerating in the North organized labor grew further. In 1882, the Italian Workers' Party was founded in Milan, followed by "chambers of labor" (central coordinating bodies created as rivals to local "chambers of commerce") and the Italian Socialist Party. Setting up a broad agenda calling for sweeping political, economic and social reforms, the new party, led by Filippo Turati, made rapid gains. After just a year, it had 131,000 members and 270 affiliated workers' associations. By 1894 there were sixteen chambers of labor with more than two hundred sections and 40,000 members.[15]

Contrary to popular perceptions, the advances made by the labor movement were not confined to the Northern industrial section but reached into agricultural districts. *Braccianti* (day laborers), small-tenant farmers and peasants launched countless strikes during the 1880s and 1890s, and were an integral part of the movement. By 1901 the agricultural sector made up 23 percent of the 661,478 official members of unions and local chambers of labor—the highest percentage of organized farm workers in Europe.[16] Perhaps the most evident manifestation of labor's growing muscle was the organization of the *Fasci dei lavoratori* (literally "bundles of workers") in Sicily in the early 1890s. Led by local socialist intellectuals, the *Fasci* were particularly successful in organizing bricklayers, sulfur miners, agrarian workers, and, for the first time, women, eventually reaching a membership of 300,000.[17]

Such revolutionary efforts, however, were systematically (and often effectively), crushed by the Italian government. Party leaders, labor organizers and even rank and file workers were arrested by the thousands and sentenced to what was known as *domicilio coatto*, house arrest on designated islands. A second reactionary wave followed in 1898 after a series of violent upheavals in Milan (known as the "May events"). More extensive than the previous one, it resulted in further arrests, the suspension of radical papers and the dissolution of all working class, socialist, republican and anticlerical associations.[18]

Despite systematic repression, the labor movement not only survived but continued to grow. Indeed, with the establishment of Giovanni Giolitti's liberal government in 1901, Italian labor reached its "golden era": The chambers increased to sixty, and by mid-1902 there were twenty-seven national federations representing almost half a million workers. Eventually, in 1906 unions coalesced in the creation of a national confederation of labor: the *Confederazione Generale del Lavoro* (CGL).[19]

Influenced by events in France and Germany, particularly the development of the *bourses du travail* (small, local and self-governing labor organizations functioning as generators of revolutionary class consciousness), the Italian labor movement was, however, deeply divided between reformists on the one hand and the revolutionaries on the other hand, particularly the syndicalists, who stressed the primacy of working-class action as an instrument of revolutionary struggle.[20]

It was in this turbulent political, social and economic climate—as Italy simultaneously underwent the processes of industrialization, modernization, nationalism, and growing class militancy—that Italians began to abandon their homeland in record numbers. Lured by the expanding world economy and the availability of waged labor, as many as twenty million migrated in search of "bread and work." As a result of this proletarian diaspora, the Italian

labor movement assumed international proportions transforming Italians into "workers of the world." The story of the five millions of them who settled in the United States is only a chapter of this larger diasporic history.[21]

Work and Reception in America

Along with the "new immigrants" of the late nineteenth-early twentieth century, migrant Italians provided essential manpower for the expanding world economy. But, unlike other nations such as Argentina or France where the Italians were quickly absorbed into the industrial labor force, in the United States they were initially largely excluded from manufacturing and relegated to unskilled and manual jobs. This status reflected both the particular character of Italian immigration and the prejudices of American employers. Both shaped Italian responses to American labor.[22]

Mostly from the Mezzogiorno, over two thirds of the Italian newcomers who arrived at Ellis Island were *contadini*: landless peasants, predominantly male, with no experience of mass production industries. Unlike other immigrants, they did not plan to stay but intended to go back to Italy as soon as they accumulated enough money to buy some land in their home country. As many as one half of them did return. Willing to make extreme sacrifices to fulfill their dream, they constituted a highly mobile, malleable, and cheap labor force.[23]

Akin to the Irish immigrants of the antebellum years, Italians' hope for a better life typically began with "a pick and shovel"—digging canals, paving streets, installing gas lines, building bridges and skyscrapers, excavating tunnels and laying tracks. In 1890, nearly 90 percent of the laborers in New York's Department of Public Works were Italian immigrants. It would not be an exaggeration to say that Italians built modern-day New York.[24] Italians were excluded from better jobs, however, not only because of their lack of skills or their alleged "love of outdoors" but because of racial prejudices.[25]

American employers made no secret of their disdain for Italian workers, referring to them as "black labor" (a bias reinforced by Italian immigrants' willingness to work with blacks) and "the Chinese of Europe," or as guineas and dagos. American labor organizers shared and reinforced these nativist prejudices, accusing Italian workers, like the Chinese and Irish before them, of depressing wages and downgrading standards of living for American workers. Ironically, they also deemed Italians by nature un-organizable because of their proclivity to violent reaction in the face of extreme exploitation or abuse. Both Terence W. Powderly of the Knights of Labor and Samuel Gompers of the American Federation of Labor supported restrictive immigration laws against them—a campaign that eventually culminated in the discriminatory Emergency Quota Act of 1921 and the Immigration Act of 1924, effectively halting Italian emigration to the United States.[26]

Alienated and estranged, almost everywhere Italians worked in gangs under labor agents called *padroni*, or bosses. Functioning as intermediaries between the old and new world, the *padroni* recruited Italian immigrants, often their own *paesani*, for American employers and then acted as overseers on the work site. The system was open to flagrant abuses: a *padrone* controlled the wages, contracts, and food supply of the immigrants under his authority and could keep workers on the job for weeks or months beyond their contracts in locked camps patrolled by armed guards. He charged the workers a fee (known as the *bossatura*) for all his services—jobs, accommodations, transportations and food as well as other necessities such as currency exchange and mailing. Sometimes workers were sent hundreds of miles away to nonexisting jobs or to break strikes, facing intimidation, violence and even death. But, for all its abuses, the *padrone* system satisfied two essential needs: it provided early immigrants, who

did not speak English and did not know the country, with guidance and services that were otherwise unavailable, and, above all, it served the interests of American capitalists by finding them cheap labor.[27]

But Italian workers' experiences in America were far more varied and complex than the classic sojourner characterization suggests. Italian immigrants embodied a wide assortment of labor experiences, traditions and ideologies. Migratory flows were also intricate and ambiguous, characterized by many directions, high mobility and circular journeys within a vast territory.[28] Although the overwhelming majority of Italian immigrants found work in cities as temporary laborers, many pursued a different path in faraway destinations. In San Francisco, for instance, they worked as fishermen and stevedores. In Kansas, northwestern Pennsylvania, Minnesota, Colorado and Michigan they mined coal and ore from the earth. Italians also labored on farms and ranches throughout the country, raising crops such as cotton, grapes, vegetable and berries. A few also became successful entrepreneurs in viticulture and the food industry.[29]

Perhaps more importantly, a substantial minority of Italian immigrants—between 15 and 20 percent—were skilled workers and artisans such as barbers, tailors, bricklayers and stonemasons. Unlike the *contadini*, these workers had a high rate of literacy and were more likely to have been involved in nascent labor organizations in Italy before they immigrated. Following distinct "chain occupations," these migrants settled in cities where they could pursue their trades. Granite workers, for example, went to quarries in Vermont, Rhode Island, and Maine; silk weavers to mills in New Jersey and Massachusetts, while barbers and tailors settled for the most part in New York City. As they adjusted to their new worlds, they transplanted not only their crafts but also their political ideas and labor experiences, creating a number of distinctive and enduring Italian immigrant radical communities.

After 1900, as Italian settlements became larger and more stable, Italian immigrants began gradually to enter industrial jobs as unskilled and semiskilled machine operators. Women, who had begun to arrive in larger numbers after 1900, quickly came to dominate "light" industries such as canning, garment and cigar manufacturing. Far from supplemental, their labor became critical to the family economy, as men's salaries were generally too low to ensure the family's survival.[30] In addition to taking manufacturing jobs, some women earned money by providing services to their community, such as midwifery, lodging and boarding, cooking and cleaning. Wives of artisans, craftsmen or grocers typically worked alongside their husbands in the shops, managing small retail businesses catering to Italian and American consumers.[31] Constrained by childbearing and child-rearing, most Italian women, however, worked from home or in small tenement workshops doing embroidery, lace making or piece work—work that paid them by the piece, such as stitching together garments or hand-assembling artificial flowers or jewelry, often assisted by their children. By 1920, close to 80 percent of hand embroiderers in New York were Italian women who worked for the most part from home. Although highly exploitative, homework became Italian women's preferred option because it allowed them to care for their children and to set their own production pace.[32]

The gradual inclusion of Italian workers in small and mass production industries did not necessarily translate into their participation into American labor organizations. Removed from mainstream American society, Italian immigrants built a world all their own, clustering together in small enclaves along regional lines that replicated familiar social patterns, values and institutions. Though many historians have underscored the conservative implications of such insularity, the creation of distinctive Little Italies also favored the reproduction and maintenance of native radical traditions, as well as conversion to radicalism. In the face of mounting hardship, exploitation and discrimination, class and ethnicity became in effect congruent sources of solidarity.[33]

Inspired by charismatic radical leaders or *sovversivi* (subversives)—as anarchists, socialists, syndicalists and communists were collectively known—Italian immigrants formed mutual aid societies, workers' cooperatives, cultural organizations and trade unions almost immediately upon arrival. The first consumers' cooperative among Italians opened on Mulberry Street in lower Manhattan in 1879. More followed in the next years in radical strongholds such as Philadelphia, Paterson (New Jersey), Barre (Vermont), San Francisco, and Ybor City (Florida). Between 1882 and 1896 in New York City, Italian pastry cooks, barbers, garment workers, masons, shoe workers, musicians and woodworkers in New York City each established a mutual aid society affiliated with the Socialist Party, and similar ones were formed in other cities.

Contrary to the perceptions of American union organizers, the *sovversivi* worked from the earliest times to organize Italian workers despite overwhelming odds. The first Italian Workers' Union was established in 1886 and other attempts to unite Italian immigrants immediately followed. These early initiatives quickly collapsed in the face of mounting opposition by local *padroni* and *prominenti*—powerful men, typically corrupt and opportunistic, who controlled the political and social life of the Little Italies. But eventually the Italian Socialist Federation established in 1902 was able to attain a relative degree of organizational stability and unity, leading hundreds of thousands of Italians into the labor struggle.[34]

Several trade unions and locals affiliated to the Knights of Labor were also organized during the late nineteenth century among skilled workers, such as the Italian Freight Handlers' Union (1886) and the Italian Masons' Protective Union (1890).[35] In Chicago around the same time Italians helped create the Marble, Enamel and Glass Mosaic Workers' Union and ten years later Giuseppe D'Andrea, an immigrant from Abruzzo, organized Italian laborers there into the Sewer and Tunnel Miners' Association. Meanwhile in Boston, Dominic D'Alessandro, who had arrived from a village near Rome in 1898, launched a local branch of the Laborers' and Excavators' Union in 1904, which attracted over 1,000 members and won a pay of two dollars a day for all its workers.[36] D'Alessandro soon distinguished himself as one of the best Italian organizers for the American Federation of Labor (AFL) and eventually became the president of the International Hod Carriers and Building Laborers' Union in 1908, a post he served with great success until his death in 1926.[37]

Although mostly short-lived, these associations demonstrated the ability and willingness of Italians to organize and to also join American trade unions when offered the opportunity, as in the case of the Knights of Labor or the United Mine Workers. Founded in 1869 as a fraternal organization embracing all workers and promoting a wide variety of political reforms—the eight-hour day, abolition of child labor, equal pay for equal work—the Knights were especially attractive to Italians. However, after the Haymarket riots in Chicago in 1886 the Knights suffered a precipitous decline, and, as American labor reorganized along the more conservative lines of the AFL, Italians began to withdraw from American unions.[38]

Indeed, the AFL did not welcome or seek to organize the new immigrants. In addition to discrimination and lack of information, it often created impossible obstacles, such as prohibitively high initiation fees, apprenticeship requirements, and citizenship or naturalization papers. But the growth of separate Italian organizations eventually forced the AFL to increasingly accept Italian craft workers into its organization or to form language locals. Thousands of skilled Italian workers eventually joined the AFL. But even when offered membership, Italians found themselves systematically relegated into subordinate positions and largely excluded from union jobs. Imbued with more radical ideas, they also found the culture and discipline of the AFL, which held meetings only in English, oppressive and alienating. Unlike unions in Italy, the AFL embraced a policy of "pure and simple" unionism, focusing on the defense of the narrow economic interests of their members, rather than broader social

and class struggles. Italians resented also the AFL's restrictive policies—particularly its high initiation fees and dues—and objected to craft organization that divided workers and undermined solidarity. Consequentially their commitment and contributions to these unions were minimal: only when "given sufficient bargaining power" did Italian immigrants successfully participate.[39]

But trade unions were not the only, or for that matter the most important, organizational expression of working-class life in America. As in Italy, class solidarity and action among Italian immigrant workers were deeply embedded in community spaces, traditions, and family and kin networks. Lacking a central party or organization, the cornerstones of the Italian American labor movement were small, autonomous socialist and anarchist groups, or *circoli* ("circles" or clubs). Announcements in the Italian language radical newspapers show hundreds of such circles being formed throughout the nation—in large cities in the Northeast as well as in remote towns in Montana, West Virginia, Iowa and Wyoming. Similar to the Workmen's Circles of the First International, they served as centers of political organizing, intellectual debate, social gathering and recruitment.[40]

Typically, most of these groups centered on male activism, but women made important contributions to the labor movement and even organized separate feminist groups to promote economic equality and women's liberation. Questioning the power relations that relegated them to subordinate roles, Italian radical women hosted lectures and published provocative articles on the "woman's question" and feminism. They sustained family cultures that nurtured and perpetuated radicalism and played important roles at the local level, particularly as community organizers and fundraisers. Italian women also made major contributions to the clothing, textile and cigar-making trades of the late 1910s where they often outnumbered men. Though marginalized by their male comrades, they often distinguished themselves as "the most passionate" and "fiery" in the struggle, and some, like Maria Roda, Bellalma Forzato-Spezia, Angela Bambace, Tina Cacici and Virgilia D'Andrea rose to prominent leadership roles and notoriety.[41]

The Formative Years

The growth of radicalism in the Little Italies coincided with the arrival of anarchists and socialists driven into exile by the violent antiradical repressions of late-nineteenth-century Italy. Virtually all the most prominent Italian anarchists—Francesco Saverio Merlino, Pietro Gori, Giuseppe Ciancabilla, Errico Malatesta and Luigi Galleani—visited the United States at the turn of the century.[42] Although most of them stayed in the United States only temporarily, their reputations and exceptional oratorical skills won many converts among Italian immigrants, particularly among miners and quarry workers.

Luigi Galleani, in particular, inspired thousands of immigrants through his lecture tours and the pages of his world-renowned newspaper, *Cronaca Sovversiva* [Subversive Chronicle]. From 1901 until his deportation in 1919, he led one of the most militant and dedicated anarchist groups, which included, among others, the anarchists Nicola Sacco and Bartolomeo Vanzetti, who were executed in 1927. But Galleani's intransigence and his categorical opposition to any form of organizations, including labor unions, limited his contributions to the labor movement considerably.[43] Other organizational anarchists like Errico Malatesta, Pietro Gori, and later, Carlo Tresca, however, urged Italian immigrants to organize and cooperate with labor unions. Their position was enormously influential among Italian workers and their tactics were also very close to those adopted later by the Industrial Workers of the World (IWW), the revolutionary union established in 1905.[44]

By the late nineteenth century, Italian socialist leaders also began to arrive in America. Paolo Mazzoli, the editor of a socialist newspaper in Modena, helped to establish the Italian Socialist Party of Pennsylvania in 1893; Giusto Calvi, a socialist from Liguria, launched the newspaper *Avanti!* [Forward!] in Philadelphia in 1895; and Bernardino Verro and Nicola Barbato, two of the most renowned heroes of the Sicilian *Fasci*, came to the United States in 1898 to organize Italian workers in Buffalo, New York, and nearby towns.[45]

These pioneering leaders, however, brought with them not only their talents and experiences, but also their disputes. As in Italy, the Italian American Left, to a far greater extent than other ethnic groups, covered the entire spectrum of radical ideologies and was deeply divided. Ferocious polemics raged not only between anarchists and socialists, but also between organizational and anti-organizational anarchists, and reformist and revolutionary socialists. The history of the *Federazione Socialista Italiana* (FSI), Italian Socialist Federation, offers perhaps the best example of the internecine divisions that weakened the movement.[46]

The FSI was formed in 1902 under initiative of the socialist Giacinto Menotti Serrati, who had been called from Switzerland where he was in exile, to assume the editorship of *Il Proletario* [The Proletarian], a newspaper launched by socialists in Pittsburgh in 1896 which became one the most important voices of Italian labor for several decades. Serrati envisioned the FSI as the aggregating force for all Italian socialists in the United States, independent from American leftist parties which he considered politically too timid and xenophobic. After a year, the Federation had one hundred official members and many unofficial supporters. But despite efforts to foster unity, from the start the FSI was torn between reformists and syndicalists—a struggle that echoed that of the Socialist Party in Italy.

The founding of the IWW, however, bolstered the revolutionary current within the FSI. Repudiating the conservative orientation and restrictive policies of the AFL, the IWW endorsed the class struggle and sought to unite all industrial workers, regardless of their trade, in one big union. Its policies and tactics mirrored those of many Italian labor organizations and at its second congress the FSI voted to adhere to the newly formed American union. The driving force behind the consolidation of the syndicalist position was a recent arrival from the Abruzzo: Carlo Tresca. Though only twenty-five when he landed in the United States in 1904, Tresca had already many years of experience in the labor movement in Italy, having served as secretary of the Italian Railroad Workers Union and as editor of the socialist newspaper *Il Germe* [The Seed]. In fact, like other *sovversivi*, it was his political activism that led him to migrate to avoid a jail sentence.

Although Carlo Tresca began his political career as a socialist, by the time he arrived in the United States he had shifted toward revolutionary syndicalism and anarchism, believing that the fight against capitalism was to be waged by direct action of the workers organized into revolutionary unions. The FSI immediately offered him the directorship of *Il Proletario*, and within two years he managed to add nearly two thousands subscribers to the paper reaching a total circulation of 5,600. Tresca also did much to reinvigorate the FSI, increasing the number of active sections from thirty to eighty with more than a thousand members from the mere one hundred of the founding year.

A "rebel without uniforms," Tresca, however, desired more independence and in 1906 resigned the directorship of *Il Proletario* and also quit the FSI. Although he continued to support Italian labor unions and the IWW in the future, he never again joined a political organization. For the next forty years until his unsolved murder in 1943, he stood out as a "free-lance revolutionary" waging a one-man unrelenting war against capitalism, Fascism, and the "colonial mafia" of the Little Italies—the collective term he used for the *prominenti*, *padroni*, priests and consular officers who exploited the Italian immigrants.[47]

Tresca's departure unfortunately reopened the internecine struggle over the FSI's ideological identity. The man sent to replace him as editor of *Il Proletario*, Giuseppe Bertelli, took a very different approach. A reformist socialist, Bertelli insisted that Italian workers should integrate into the American socialist movement and work through the established trade unions. But his efforts to bring the FSI toward mainstream labor were ultimately futile. The bulk of FSI members remained in fact deeply skeptical of institutionalized parties and electoral politics.

Frustrated, several groups of reformist socialists seceded. Members in Chicago launched *La Parola dei Socialisti* [The Socialists' Word] and others in Pennsylvania published the short-lived *L'Ascesa del Proletario* [The Rise of the Proletarian]. Bertelli officially left the FSI in 1908 and moved to Chicago, where he and his supporters formed another Italian Socialist Federation as a section of the Socialist Party of America. Though relatively small, this federation included some of the most important Italian labor leaders who helped organize and lead a number of important strikes in the 1910s.[48]

Meanwhile the withdrawal of the reformists allowed the syndicalists to assume full leadership of the FSI, and at the Utica convention of 1911 the federation's members voted to make revolutionary syndicalism its official ideology, mandating membership in the IWW. The triumph of syndicalism resulted from several reasons: First it reflected the influence of transnational events, coinciding with the ascendancy of syndicalism in Italy and the formation of the *Unione Sindacale Italiana* in 1912. Second, syndicalist ideas, which rejected electoral politics and emphasized the role of revolutionary unions as the real instrument for change, were more congenial to the situation of Italian immigrants, who for the most part were not naturalized and could therefore not vote. Finally, syndicalist methods of direct action—sabotage, boycotts and strikes—were closer to the traditions of resistance of the Italian immigrants and better suited to their marginal position in the American economy.[49]

The new ties to the IWW finally broke the isolation of the FSI and launched a period of intense activism, which catapulted Italian workers and syndicalist leaders such as Tresca, Arturo Giovannitti and Joseph Ettor to the forefront of the labor struggle and into national prominence. Long vilified as "servile wage cutters" and strikebreakers, by the early 1910s Italian workers had become the revolutionary vanguard of the American proletariat. The appeal that a radical critique of the capitalist structure of American society might have had for ordinary Italian immigrants was brilliantly illustrated in the Italian language version of a famous cartoon image printed on a postcard by the International Publishing Company of Cleveland in 1913.[50] (See Color Plate 12.) Portraying "The Pyramid of the Capitalist System," a swelling money bag is held up at the top by a small class of rulers (*Noi comandiamo voialtri*—We rule you), then a layer of priests (*Noi coglioniamo voialtri*—We fool you), then a layer of soldiers (*Noi facciamo fuoco su voialtri*—We shoot at you), then a layer of dining socialites (*Noi mangiamo per voi*—We eat for you). But supporting the whole structure is the large working class (*Noi lavoriamo per tutti*—We work for all; *Noi diamo da mangiare a tutti*—We feed all).

The Strike Wave of 1909–1919

Evidence of Italian participation in strikes can be found since the inception of the great migration throughout the industries where Italians worked. Lacking bargaining power and union representation, until the founding of the IWW Italian workers challenged capitalism for the most part from within their ranks, resorting to spontaneous protests against their oppressive conditions. On May Day of 1903, for example, Italians employed to build the New York City subway walked out demanding wage increases and a reduction of the workday to eight hours. Defying the orders of American unions and the advice of their own

conservative labor leader, Tito Pacelli, the Italian strikers refused to accept arbitration and stuck together to the end, despite the aggressive tactics the police used to deter them. After five weeks, they finally got a raise of twenty-five cents a day and, more importantly, won recognition from the AFL, gaining their own locals in the excavators and rockmen's unions.[51]

Italians were also among the most tenacious fighters in the mining industry, in which they were employed in large numbers. They led, for instance, among many other miners' struggles, the coal strikes of 1903–4 in southern Colorado and Utah. As in other demonstrations, they were eventually crushed under the use of scabs, evictions, police force and deportations of "undesirable" radicals. Fifty-two men, mostly Italians, were taken to the state line during the strike in Colorado. Among them were the main leaders, Charles Demolli and Adolfo Bartoli, who had also founded the labor paper *Il Lavoratore Italiano* [The Italian Worker] in Trinidad in 1902. An additional 120 Italians were apprehended and loaded into boxcars after they successfully thwarted the arrest of Mother Jones—"the most dangerous woman in America"—who had arrived to support the miners. At the end, the strike was lost but Italian miners participated vigorously in the struggles that followed, as evident in the Ludlow Massacre in Colorado in which nineteen strikers, nine of them Italian, were killed by state militia.[52]

Italian workers also distinguished themselves from the earliest times for their activism in the silk industry, particularly in Paterson, New Jersey, which was home to one of the most important and vibrant radical communities. Largely composed of highly politicized weavers from northern Italy, Paterson Italians gathered around the "Right to Existence" group, which embraced anarcho-syndicalism and published *La Questione Sociale* [The Social Question] (1895–1908) and *L'Era Nuova* [The New Era] (1908–1915), two of the most influential anarchist newspapers in the world. Between 1884 and 1905 Italians were involved in at least five strikes in Paterson. All were marked by the same tactics later exploited by the IWW and used aggressively by Italian strikers in the following years: spontaneous uprisings, parades, mass picketing and violence.[53]

The Italian longshoremen in Brooklyn offer additional evidence of the intense organizing drive that took place among Italian immigrant workers in the early twentieth century. Although Italians had initially entered the waterfront workforce as strikebreakers in 1887, twenty years later they were the backbone of the city harbor's labor movement. On May Day 1907, they launched a strike to win wage increases that united 30,000 longshoremen, blacks as well as other ethnic groups. Longshoremen rebelled again, on a larger scale, in 1919. Defying union leaders who had opposed striking, 150,000 workers shut down New York's harbor, in what became the largest waterfront strike in U.S. history. As in 1907, the protest was said to have been started and led by the Italians, who were depicted in the press as the most "dynamic" group.[54]

Following a course similar to other protests of this period, most of these early strikes were defeated. Yet, Italian immigrants participated with increasing enthusiasm in other labor struggles as time went on: in the Mesabi iron range (Minnesota) in 1907 and 1916; the Westmoreland mines of Pennsylvania in 1910; the cigar industries of South Florida in 1910; the mills of Lawrence and Paterson in 1912 and 1913 respectively; the barbers' general strike of 1913 in the New York metropolitan area; Ludlow, Colorado in 1914; the anthracite and coal towns of eastern Pennsylvania in 1916; and the general strikes of 1919.

In fact, the Italians became the mainstay of industrial unionism, leading some of the most important IWW strikes in the northeast and also forging important multiethnic alliances. In San Francisco, for example, during the early 1910 they formed a Latin branch of the IWW with Hispanic and French radicals that propelled a series of labor agitations among the city's bakers, cannery workers and *salumieri* (sausage makers).[55] Similarly, in Ybor City, Florida, Italians organized with Cubans and Spaniards in the cigar factories producing a distinct Latin

radical subculture around commonly held values: working class solidarity, distrust of centralized power and anticlericalism.[56]

But Italians' greatest contribution to American labor was without a doubt the Lawrence strike of 1912. The strike began over a wage cut; it lasted three months and ended with an historic victory for industrial workers and a congressional investigation of working conditions in the textile mills. As many scholars have documented, Italians were the largest and most militant group of the nearly 25,000 strikers representing over twenty different nationalities. From the beginning they dominated the strike, providing leadership, mass militancy and strategies that drew on familiar homeland tactics of resistance, forming, for instance, the first moving picket line in U.S. history and organizing a "children exodus" to other cities during the strike.[57]

The Lawrence strike was the culmination of the FSI's unionizing efforts, providing stigmatized Italian immigrant workers with a sense of pride and dignity that inspired unprecedented unity and solidarity. It was a committee of Italians, led by the IWW organizer Angelo Rocco, which instigated the strike. Rocco then urged Joseph Ettor, a second-generation Italian and well known IWW organizer in the west, to join the battle. Realizing the importance of Italian workers to the strike's success, Ettor invited in his turn Arturo Giovannitti, the then-editor of *Il Proletario* and one of the most charismatic Italian radicals. Their arrest (and eventual acquittal) on fabricated murder charges further dramatized the strike, stirring the Italian community to its depth and making Giovannitti into a folk hero and internationally known poet.[58] The strike, as many commented, marked the beginning of a new era for Italians immigrants, spawning a series of strikes in nearby mills and other industries that reverberated throughout the industrial world.

Lawrence was followed a year later by another epic labor battle in Paterson. This too was mainly an "Italian" strike: it was the Italians who began the walk off; half of the strikers who were arrested (estimated at 1,800) were Italians; and two well-known Italian syndicalists, Edmondo Rossoni and Carlo Tresca, arrived early at the scene. Like Lawrence it assumed a strong anarchistic and confrontational bend. The struggle lasted six months and generated enormous support from both the American Left and the wider Italian American community, culminating in the staging of a pageant at Madison Square Garden to raise money for the strike. But despite the strikers' heroic resilience, the mill owners, supported by city officials and the police, outlasted the workers. In doing so they not only defeated the strike but also effectively shook the credibility of the IWW and the FSI. Indeed, after the Paterson fiasco, both the FSI and the IWW began to lose their holds on the workers. Victimized by wartime dissent and repression, *Il Proletario* was forced to suspend publications in November 1918, and although it was eventually replaced by *Il Nuovo Proletario* [The New Proletarian] it never regained its prominence among Italian American workers. Lapsing into a permanent state of crisis, the FSI disbanded in 1921.

The New Unionism

The triumph of the Bolsheviks in Russia briefly galvanized revolutionary hopes and many former FSI members—most notably Antonino Capraro, Ignazio Camarda, Antonio Presi, Raimondo Fazio, Flavio Venanzi and briefly Arturo Giovannitti—embraced communism. On 6 November 1921, under the aegis of the American Communist Party, they organized the Federation of Italian Workers of America in New York City which sponsored two important newspapers: *Alba Nuova* [New Dawn] (1921–24) and *Il Lavoratore* [The Worker] (1924–31). Led by Vittorio Vidali (alias Enea Sormenti), an Italian communist who had arrived clandestinely in the United States after the rise of Fascism in Italy, by 1928 the

federation numbered about 1,000 members and played an important role in organizing Italian workers and fighting Fascism.[59]

But after the decline of the syndicalists, the Italian immigrant Left began to move away from revolutionary doctrines toward a "new unionism" shaped by more pragmatic concerns and a middle-ground ideological position between the conservativism of the AFL and the syndicalism of the IWW. The history of the Italian garment unions offers perhaps the best examples of this new labor culture.[60] The garment industry was initially dominated by Jewish immigrants who also largely controlled the International Ladies' Garment Workers' Union (ILGWU), established in 1900 in opposition to the more conservative United Garment Workers union. By the mid-1910s, however, Italians accounted for more than 35 percent of the industry, and eventually outnumbered the Jewish workers. After the waist and dressmakers' strike of 1909, also known as the "Uprising of the Twenty-Thousand," they began unionizing in significant numbers, participating enthusiastically in the general strikes that took place between 1910 and 1913. During this period they also began publishing the labor newspaper *L'Operaia* [The Working Woman] and *Il Lavoro* [The Job]. A particularly important factor contributing to their increased union involvement was the infamous Triangle Shirtwaist Factory fire of 1911 in which 146 workers died (forty-six of them Italian women).

A vigorous movement emerged from this growing class militancy that led to the establishment of the Amalgamated Clothing Workers of America in 1914, which finally gave Italians a foothold in the industry. But in spite of their successful efforts to unionize, Italian labor organizers remained largely excluded from leadership positions in the ILGWU. Demanding an equal stand, they launched a fierce battle to establish their own locals and after years of negotiations they secured Locals 48 and 89 of the ILGWU, representing cloak makers and dressmakers respectively.[61]

Local 48 was created in 1916 under the leadership of Salvatore Ninfo, a Sicilian immigrant who had arrived in New York in 1899. Local 89 was formed in 1919 and run by the imperious Luigi Antonini (1883–1968) who had arrived in New York in 1908. A dress presser, Antonini knew firsthand the poor working conditions of the garment workers and fought intensely to organize them. A talented organizer, he eventually became vice president of the ILGWU.[62]

By the 1930s, Local 63 of Italian coat makers had 7,000 members; Local 48 had 9,000 members; and with 45,000 members, Local 89 was the nation's largest garment union. Italians were well represented in other industries as well, often constituting the entire membership or a considerable majority of the locals in which they were organized, as in the case of the building trades, longshoremen, musicians, barbers and shoe workers.

Their success rested largely on the charismatic influence and talents of their socialist leaders: Emilio Grandinetti, August and Frank Bellanca, Luigi Antonini, Arturo Caroti, Fort Velona, Francesco Procopio, Giovanni Sala and Girolamo Valenti. Mostly from the Mezzogiorno, these leaders were acutely aware of the distinct sensibilities and values of their fellow workers and appealed to a shared sense of Italian ethnic identity to convince them to join the unions. For example, they made use of village ties to foster class solidarity, overlapping class consciousness with ethnic consciousness. Similarly, they played on family values and respect to promote loyalty toward the union, urging workers "not to dishonor your name and that of your family by committing treason against your fellow workers" and warning them of "the social ostracism that awaited any Italian scab."[63] Indeed, Italian union organizers won the trust of Italian immigrant workers and bound them to the unions by cultivating *personalismo* ("personalism"), a brand of politics based on informal patronage and one-on-one relationships with the workers.[64]

At first ethnic divisions, language barriers and competition made it difficult for Italian and Jewish leaders to cooperate, but garment unions eventually emerged as a model of interethnic alliance. Another major achievement of these new unions was the radicalization of women, who represented 84 percent of the workers in the dress and shirtwaist industries by 1913. Starting in 1909, Italian American unionists created institutions specifically devoted to organizing Italian women—such as the Women's Mutual Benefit Association, which offered girls medical benefits but required that they attend a monthly meeting, or the Italian Girls' Industrial League, which educated its members about trade unionism. To attract more Italian American women to the labor movement, in 1913 Luigi Antonini and Alfredo Coniglio also launched *L'Operaia*. The union's consistent efforts eventually paid off. By 1914, some 76,522 Italian women had joined the unions in New York. Thousands of them participated in the strikes of the late 1910s, distinguishing themselves on picket lines, at strikers' meetings, and on committees.[65]

Angela Bambace is probably the best known of these female organizers. Her involvement with the labor movement began in 1917 as a young sewing machine operator, when she joined, along with her sister Maria, Local 89 of ILGWU. Both sisters helped to organize the strike of the waist-maker workers in 1919, drawing into the struggle many coworkers through workplace committees, house visits and educational programs. By 1927, Angela Bambace had become one of the most active garment union organizers and an outspoken communist. Demonstrating great ability and leadership, in 1956 she was elected vice president and member of the general executive board of the ILGWU. She was the first woman to reach such a position.[66]

The "new unionism" also helped to reduce the factionalism among the various groups and provide a common ground for cooperation and interaction. Anarcho-syndicalist Carlo Tresca, revolutionary socialist Arturo Giovannitti, and communist Antonino Capraro, for example, all initially endorsed the new unions and helped them to thrive. A testimonial to their growing spirit of cooperation, in 1919 Italian radicals established in New York City the Chamber of Labor. Modeled after the older *camere del lavoro* in Italy, it aspired to mobilize and educate Italian workers and promote more cooperation among Italian radical groups.[67] Soon however, domestic and transnational events—postwar depression, the rise of Fascism, political repression, internecine struggle between communists and socialists—disrupted unity and "dashed these high expectations."[68]

Labor and Radical Decline

The outbreak of World War I constituted the first blow to the socialist dream of working class internationalism. As soon as the war broke out in 1914, Italian radicals engaged in a fierce debate about whether or not Italy should enter the war. Like other historic Italian events, the interventionist crisis, as it became known, had significant transnational repercussions. Following the example of eminent renegade socialists like Benito Mussolini, many Italian immigrant radicals advocated Italian intervention.[69] Intoxicated by the nationalist propaganda of the Italian-language mainstream press first, and the coercive patriotism of the American government later, Italian immigrants overwhelmingly supported the war. Anarchist Erasmo Abbate (Hugo Rolland) recalled that Italian workers, who had previously followed him in a strike, later beat him up for his opposition to the war. Italians in the Minnesota iron range similarly deserted the IWW because of its antiwar position.[70]

More significantly, in the wave of the postwar strikes and the Red Scare generated by the Russian Revolution, Italian radicals were the subject of a repressive campaign by the United States government. Anarchists, syndicalists, and even more moderate socialists were hunted down,

imprisoned and in some cases deported. Radical groups were infiltrated and dismantled—their meeting places shuttered, their newspapers banned, and their printing machinery destroyed.[71]

The 1920s further eroded the ethnic and working class solidarity of Italian Americans. Italian immigrant radical activities, like American radicalism in general, sharply declined in the face of rising standards of living, the explosive growth of mass culture, the "open shop" adopted by American employers, and the nation's continued obsession with "100 percent Americanism." The arrest and eventual execution of Sacco and Vanzetti along with the resurgence of nativist sentiments and the Ku Klux Klan, which began attacking not just blacks but also immigrants (especially Jews and Catholics), further compelled Italian workers to quietly distance themselves from "un-American" values and lifestyles. Simultaneously, the enactment of the new immigration quota laws in 1924 ended Italian emigration to the United States, depriving the movement of new blood and radical exchanges.

The Great Depression temporarily revitalized Italian efforts to ameliorate capitalism through both past and new radical affiliations. A small but steady contingent of Italian American communists—including most notably elected politicians like Peter Cacchione and Vito Marcantonio—contributed significantly to the Popular Front culture and activism. Their main newspapers, *L'Unità Operaia* [Workers' Unity] (1932–8) and *L'Unità del Popolo* [The Unity of the People] (1939–51), reached a circulation of about 10,000 copies in 1940 whereas their main cultural organization, the Garibaldi-American Fraternal Society, had over 11,000 members organized into 130 lodges.[72]

But although Italian Americans participated in the labor struggles of the 1930s in higher numbers than ever before, they no longer comprised a distinctive Italian labor movement. By then they had become part of a multiethnic American working class. This transformation, however, did not simply result from Americanization, as often suggested, but also reflected transnational influences. The rise of Fascism in particular, and the ideological struggle that came with it, had a powerful effect on the Little Italies, forever altering the political character of Italian Americans. As has been amply documented, Italian Americans overwhelmingly supported Fascism. The reason for their enthusiastic endorsement, however, stemmed more from ethnic injury than political convictions.[73]

Ironically, the threat of Fascism also helped galvanize the Italian American Left. For more than two decades, until the outbreak of World War II, fighting Fascism became the main *raison d'être* of Italian American radicals and labor leaders. From the *galleanisti* anarchists who had gone underground, veterans from the socialist, syndicalist and communist guards, to newly arrived *fuorusciti* (political exiles)—all poured their energy in the fight against Fascism. Several attempts were also made to put ideological divisions aside for democracy and liberty's sake. Most notably, in 1923 the Anti-Fascist Alliance of North America (AFANA) was established in New York. For years it published a daily newspaper, *Il Nuovo Mondo* [The New World] (1925–1931), later replaced by *La Stampa Libera* [The Free Press] (1931–1938), which sold between 25,000 and 35,000 copies.

Italian unions, particularly Locals 48 and 89 of the ILGWU, became the mainstay of the opposition to Mussolini, subsidizing scores of the anti-Fascist activities and publications. Luigi Antonini, in particular, effectively turned thousands of garment workers away from the spell of Fascism through his fiery speeches on the radio and union meetings.[74] But rank-and-file members did not necessarily share the anti-Fascism of their leaders. Evidence indeed suggests that Fascism successfully infiltrated many unions and won the allegiance of their members, by establishing after work clubs that promoted cultural events, such as films, plays, sports, and music with obvious Fascist propaganda overtones. Eventually, the forces against the Italian American Left were too great and their own movement too divided and weak to break Mussolini's grip.[75]

The last offspring of the Italian American labor movement was the creation of the Italian Labor Education Bureau in 1934. Founded by Arturo Giovannitti, Vincenzo Vacirca, Serafino Romualdi and Felice Guadagni, it sought to provide Italian workers with a deeper understanding of socioeconomic problems. Its activities included labor propaganda, radio broadcasts, lectures and publications of pamphlets. But like other surviving radical organizations and publications, it was a desperate attempt to keep alive a movement that was dying out.

A few incorrigibles and some of their children, mostly anarchists, continued to sustain the subculture created decades earlier by the *sovversivi* well into the 1960s and 1970s. As oral interviews attest, they still went to plays, picnics and lectures; they still read and contributed to radical newspapers published in Italy and the United States. But these gestures "could not turn back the biological clock. The Italian American Left failed to reproduce itself," and with its demise "a unique breed of dreamers and rebels also passed into extinction."[76]

Further Reading

Bencivenni, Marcella. *Italian Immigrant Radical Culture: The Idealism of the* Sovversivi, *1890–1940*. New York: New York University Press, 2011.

Cannistraro, Philip and Gerald Meyer, eds. *The Lost World of Italian American Radicalism: Politics, Labor and Culture*. Westport: Praeger, 2003.

Fenton, Edwin. *Immigrants and Unions: A Case Study: Italians and American Labor, 1870–1920*. New York: Arno Press, 1975.

Notes

1 "Castle Garden Affairs," *New York Times* (27 March 1874), 8.
2 "Labor Troubles in Jersey City," ibid.
3 Edwin Fenton, *Immigrants and Unions: A Case Study* (New York: Arno Press, 1975), 79–84, 203–204.
4 Ibid., 197–201.
5 See for example, John Rogers Commons et al., *History of Labor in the United States*, 4 vols. (New York: Macmillan, 1918–1935); Gerard Rosenblum, *Immigrant Workers: Their Impact on American Labor Radicalism* (New York: Basic Books, 1973); John Laslett, *Labor and the Left: A Study of Socialist and Radical Influences in the American Labor Movement, 1881–1924* (New York: Basic Books, 1971); and Eric J. Hobsbawm, *Primitive Rebels* (New York: W.W. Norton, 1959). Stereotypes of Italians as un-organizable were reinforced by Edward Banfield's influential book, *The Moral Basis of a Backward Society* (New York: Macmillan, 1958).
6 For an early criticism of such views see Rudolph Vecoli, "Italian American Workers, 1880–1920: *Padrone* Slaves or Primitive Rebels?" in *Perspectives in Italian Immigration and Ethnicity*, ed. Silvano M. Tomasi (New York: Center for Migration Studies, 1977), 25–43, and Donna Gabaccia, "Neither Padrone Slaves Nor Primitive Rebels: Sicilians on Two Continents," in *"Struggle a Hard Battle": Essays on Working Class Immigrants*, ed. Dick Hoerder (DeKalb: Northern Illinois University Press, 1986), 95–117.
7 For example, Fenton, *Immigrants and Unions*; and Humbert Nelli, *From Immigrants to Ethnics: The Italian Americans* (Oxford: Oxford University Press, 1983).
8 See Philip V. Cannistraro and Gerald Meyer, eds., *The Lost World of Italian American Radicalism: Politics, Labor and Culture* (Westport: Praeger, 2003).
9 Three main factors accounted for such delay: the political partition of Italy into separate states ruled by foreign powers that effectively suppressed many political and civil liberties while further dividing Italians, widespread illiteracy and, finally, the semi-feudal state of much of the Italian economy, which was not affected by industrialization until the very end of the nineteenth century.
10 Nunzio Pernicone, "The Italian Labor Movement," in *Modern Italy: A Topical History Since 1861*, ed. Edward Tannenbaum and Emiliana Noether (New York: New York University Press, 1974), 198.
11 See Denis Mack Smith, *Mazzini* (New Haven: Yale University Press, 1996).
12 Humbert L. Gualtieri, *The Labor Movement in Italy* (New York: S.F. Vanni Publishers, 1946), 75.
13 Ibid., 76–79.
14 Pernicone, "The Italian Labor Movement," 199.
15 Alexander De Grand, *The Italian Left in the Twentieth Century: A History of the Socialist and Communist Party* (Bloomington: Indiana University Press, 1989), chapter 1.

16 Denis Mack Smith, *Modern Italy: A Political History* [1959] (Ann Arbor: University of Michigan Press, 1997), 157.

17 Women participated in eighty-seven stoppages and constituted 34 percent of the total number of strikers. Gualtieri, *The Italian Labor Movement*, 172–183, 218; and Jennifer Guglielmo, *Living the Revolution: Italian Women's Resistance and Radicalism in New York City* (Chapel Hill: University of North Carolina Press, 2010), 32–40. For a detailed history of the Sicilian *Fasci*, see Francesco Renda, *I Fasci Siciliani, 1892–94* (Turin: Einaudi, 1977).

18 Louise Tilly, "I Fatti di Maggio: The Working Class of Milan and the Rebellion of 1898," in *Modern European Social History*, ed. Robert J. Bezucha (Lexington: D. C. Heath, 1972), 124–158.

19 Pernicone, "The Italian Labor Movement," 205.

20 Carl Levy, "Currents of Italian Syndicalism before 1926," *International Review of Social History*, 45 (2000), 209–250.

21 Ernesto Ragionieri, "Italiani all'estero ed emigrazione di lavoratori italiani: un tema di storia del movimento operaio," *Belfagor*, 17 (1962), 641–69; Donna Gabaccia and Fraser Ottanelli, eds., *Italian Workers of the World: Labor Migration and the Formation of Multiethnic States* (Urbana: University of Illinois Press, 2001); Donna Gabaccia, *Italy's Many Diasporas* (Seattle: University of Washington Press, 2000), chapter 3.

22 Rudolph Vecoli, "The Italian Immigrants in the United States Labor Movement from 1880 to 1929," in *Gli Italiani fuori d'Italia: Gli emigrati italiani nei movimenti operai dei paesi d'adozione 1880–1940*, ed. Bruno Bezza (Milan: Franco Angeli, 1983), 257–258. For a comparative analysis see Samuel Baily, "The Italians and the Development of Organized Labor in Argentina, Brazil and the United States, 180–1914," *Journal of Social History*, 3 (1969–70), 123–134, and Samuel L. Baily, *Immigrants in the Land of Promise: Italians in Buenos Aires and New York City* (Ithaca: Cornell University Press, 1999).

23 For the general contours of emigration see Maddalena Tirabassi's Chapter 6.

24 Philip V. Cannistraro, "The Italians of New York: An Historical Overview," in *The Italians of New York*, ed. Cannistraro (New York: The New-York Historical Society, 1999), 7.

25 Peter G. Vellon, *A Great Conspiracy Against Our Race: Italian Immigrant Newspapers and the Construction of Whiteness in the Early Twentieth Century* (New York: New York University Press, 2014). See also Thomas A. Guglielmo, *White on Arrival: Italians, Race, Color, and Power in Chicago, 1890–1945* (New York: Oxford University Press, 2003); and Jennifer Guglielmo and Salvatore Salerno, eds., *Are Italians White? How Race Is Made in America* (New York: Routledge, 2003).

26 For a more detailed study of nativism within the AFL see Robert Asher, "Union Nativism and the Immigrant Response," *Labor History*, 23 (1982), 325–348. On discrimination and prejudice against Italian immigrants see also the essays by Peter Vellon and Salvatore LaGumina in Chapters 12 and 13 of this volume.

27 Vecoli, "The Italian Immigrants in the United States," 261; and Fenton, *Immigrants and Unions*, 71–94. For a discussion of the padrone system across nationalities see Gunther Peck, *Reinventing Free Labor: Padrones and Immigrant Workers in the North American West, 1880–1930* (New York: Cambridge University Press, 2000).

28 Thierry Rinaldetti, "Italian Migrants in the Atlantic Economies: From the Circular Migrations of the Birds of Passage to the Rise of a Dispersed Community," *Journal of American Ethnic History*, 34.1 (Fall 2014), 5–30.

29 Simone Cinotto, *Soft Soil, Black Grapes: The Birth of Italian Winemaking in California* (New York: New York University Press, 2014).

30 See Jennifer Guglielmo, *Living the Revolution: Italian Women's Resistance and Radicalism in New York City, 1880–1945* (Chapel Hill: University of North Carolina Press, 2010); Colomba M. Furio, "Immigrant Women and Industry: A Case Study, Italian Immigrant Women and the Garment Industry, 1880–1950" (unpublished dissertation, New York University, 1979); and Carol Lynn McKibben, *Beyond Cannery Row: Sicilian Women, Immigration, and Community in Monterey, California, 1915–99* (Urbana: University of Illinois Press, 2006).

31 Diane Vecchio, *Merchants, Midwives and Laboring Women: Italian Migrants in Urban America* (Urbana: University of Illinois Press, 2006); and Judith E. Smith, "Italian Mothers, American Daughters: Changes in Work and Family Roles," in *The Italian Immigrant Woman in North America*, ed. Betty Boyd Caroli (Toronto: The Multicultural History Society of Ontario, 1978), 206–221.

32 Guglielmo, *Living the Revolution*, 69–78.

33 Cannistraro and Meyer, "Introduction," in *The Lost World*, 12.

34 Fenton, *Immigrants and Unions*, 205–208.

35 Ibid., 257–269.

36 Vecoli, "The Italian Immigrants," 266–268; Fenton, *Immigrants and Unions*, 50–54, 160–162.

37 Fenton, *Immigrants and Unions*, 219–242. See also Laborers' International Union of North America, "The Laborers' Early Years," http://nwlaborerstraining.org/LIUNA%20-%20The%20Laborers'%20 Early%20Years.pdf

38 Fenton, *Immigrants and Unions*, 136–139.

39 Vecoli, "The Italian Immigrants," 266; Fenton, *Immigrants and Unions*, 142–146.

40 For a detailed discussion see Marcella Bencivenni, *Italian Immigrant Radical Culture: The Idealism of the Sovversivi in the United States, 1890–1940* (New York: New York University Press, 2011).

41 Guglielmo, *Living the Revolution*, 150–160; Bencivenni, *Italian Immigrant Radical Culture*, 85–94; Donna Gabaccia and Franca Iacovetta, eds., *Women, Gender, and Transnational Lives: Italian Workers of the World* (Toronto: University of Toronto Press, 2002).

42 Gino Cerrito, "Sull'emigrazione anarchica negli Stati Uniti," *Volontà*, 22 (July–August 1969), 269–276.

43 Nunzio Pernicone, "Luigi Galleani and Italian Anarchist Terrorism in the United States," *Studi Emigrazione*, 30.111 (September 1993), 469–488. For a full biography see Ugo Fedeli, *Luigi Galleani: Quarant'anni di lotte rivoluzionarie* (Cesena: Edizioni L'Antistato, 1956).

44 Salvatore Salerno, "No God, No Master: Italian Anarchists and the Industrial Workers of the World," in *The Lost World*, ed. Cannistraro and Meyer, 171–188.

45 Mario De Ciampis, "Storia del movimento socialista rivoluzionario italiano," *La Parola del Popolo* (December 1958–January 1959), 136.

46 Michael M. Topp, *Those Without a Country: The Political Culture of Italian American Syndicalists* (Minneapolis: University of Minnesota Press, 2001).

47 Nunzio Pernicone, *Carlo Tresca: Portrait of a Rebel* (New York: Palgrave, 2005).

48 Elisabetta Vezzosi, *Il socialismo indifferente: immigrati italiani e il partito socialista negli Stati Uniti* (Rome: Edizioni Lavoro, 1991), 39–41, 80–83, 110–13; and Vezzosi, "Radical Ethnic Brokers: Immigrant Socialist Leaders in the United States Between Ethnic Community and the Larger Society," in *Italian Workers of the World*, ed. Gabaccia and Ottanelli, 124–125.

49 Bruno Cartosio, "Gli emigrati italiani e l'Industrial Workers of the World," in *Gli italiani fuori d'Italia*, ed. Bezza, 371; Salerno, "No God No Master," in *The Lost World*, ed. Cannistraro and Meyer; and Topp, *Those Without a Country*, 41 and 44.

50 Based on a Russian cartoon of 1900, a finer American version (in English) first appeared in the IWW newspaper *Industrial Worker* in 1911. An Italian and English version in the form of a poster is preserved on a postcard printed in Cleveland now in the Biblioteca Franco Serantini in Pisa, Italy, while a poster version in Italian and English survives in the archives of the Immigration History Research Center of the University of Minnesota. Color Plate 12 shows a 1913 postcard of the image now in the Biblioteca Franco Serantini in Pisa.

51 Fenton, *Immigrants and Unions*, 209–219. The strike was also extensively covered in the *New York Times*. See, for instance the papers of 2, 4, 14 and 17 May and 7 June 1903.

52 Philip F. Notarianni, "Italian Involvement in the 1903–04 Coal Miners' Strike in Southern Colorado and Utah," in *Pane e Lavoro: The Italian American Working Class*, ed. George Pozzetta (Toronto: The Multicultural History Society of Ontario, 1980), 47–65.

53 There are many studies of Paterson anarchists. See above all, Kenyon Zimmer, *Immigrants Against the State: Yiddish and Italian Anarchism in America* (Champagne: University of Illinois Press, 2015), 49–87, and Salerno, "No God, No Master."

54 Fenton, *Immigrants and Unions*, 250–6; and Calvin Winslow, "Italian Workers on the Waterfront: The New York Harbor Strikes of 1907 and 1919," in *The Lost World*, ed. Cannistraro and Meyer, 99–111.

55 Paola A. Sensi-Isolani, "Italian Radicals and Union Activists in San Francisco, 1900–1920," ibid., 189–203.

56 Gary Mormino and George Pozzetta, *The Immigrant World of Ybor City: Italians and Their Latin Neighbors in Tampa, 1885–1995* (Gainesville: University Press of Florida, 1998).

57 See above all Topp, *Those Without a Country*, chapter 3; and Topp, "The Transnationalism of the Italian American Left: The Lawrence Strike of 1912 and the Italian Chamber of Labor of New York City," *Journal of American Ethnic History*, 17.1 (Fall 1997), 39–64.

58 On Giovannitti see above all, Bencivenni, *Italian Immigrant Radical Culture*, chapter 6; and the anthology *Il bardo della libertà: Arturo Giovannitti, 1884–1959*, ed. Norberto Lombardi (Isernia: Cosmo Iannone Editore, 2011).

59 Nunzio Pernicone, "Italian Immigrant Radicalism in New York," in *The Italians of New York*, ed. Cannistraro, 81.

60 See Charles Zappia, "Unionism and the Italian American Worker: A History of the New York City 'Italian Locals' in the International Ladies' Garment Workers' Union, 1900–1934" (PhD Dissertation,

University of Berkeley, 1994); and Zappia, "From Working-Class Radicalism to Cold War Anti-Communism," in *The Lost World*, ed. Cannistraro and Meyer, 189–190.

61 For a general history of garment workers see Louis Levine, *The Women's Garment Workers* (New York: B. W. Huebsch, 1924).

62 For a history of Local 89 see Serafino Romualdi, "Storia della locale 89," Fifteenth Anniversary pamphlet, 1934. In Antonino Crivello Papers, IHRC479, Box 1, Immigration History Research Center, University of Minnesota.

63 Steve Fraser, "Landslayyt and Paesani: Ethnic Conflict and Cooperation in the Amalgamated Clothing Workers of America," in *Struggle a Hard Battle*, ed. Hoerder, 291–292.

64 Ibid.

65 Colomba M. Furio, "The Cultural Background of the Italian Immigrant Woman and Its Impact on Her Unionization in the New York City Garment Industry, 1880–1919," in *Pane e Lavoro*, ed. Pozzetta, 81–98; and Jennifer Guglielmo, "*Donne Ribelli*: Recovering the History of Italian Women's Radicalism in the United States," in *The Lost World*, ed. Cannistraro and Meyer, 113–114.

66 Jean Scarpaci, "Angela Bambace and the International Ladies Garment Workers Union," in *Pane e Lavoro*, ed. Pozzetta, 99–118.

67 Topp, *Those Without a Country*, 234–244.

68 Rudolph Vecoli, "The Making and Unmaking of the Italian American Working Class," in *The Lost World*, ed. Cannistraro and Meyer, 52.

69 Stefano Luconi, "From Left to Right: The Not so Strange Career of Filippo Bocchini and Other Italian American Radicals," *Italian American Review*, 1st series, 6 (Autumn/Winter 1997), 59–79.

70 Topp, *Those Without a Country*, 135–173.

71 Paul Avrich, *Sacco and Vanzetti* (Princeton: Princeton University Press, 1991), 93–94. For further information on governmental repression during the Red Scare, see William Preston, *Aliens and Dissenters: Federal Suppression of Radicals, 1903–1933* (New York: Harper, 1963); and Robert Justin Goldstein, *Political Repression in Modern America: 1870 to the Present* (Cambridge: Schenkman Publishing, 1978), chapter 5.

72 See Gerald Meyer, "Italian Americans and the American Communist Party," in *The Lost World*, ed. Cannistraro and Meyer, 205–227; and Meyer, "*L'Unità del Popolo*: The Voice of Italian American Communism, 1939–1951," *Italian American Review*, 1st series, 8.1 (Spring/Summer 2001), 121–155.

73 John Patrick Diggins, *Mussolini and Fascism: The View from America* (Princeton: Princeton University Press, 1972).

74 Vecoli, "The Making and Un-Making," 55–56.

75 On Fascist propaganda in the Little Italies see Gaetano Salvemini, *Italian Fascist Activities in the United States*, ed. Philip V. Cannistraro (New York: Center for Migration Studies, 1977); Stefano Luconi, *La Diplomazia Parallela: il regime fascista e la mobilitazione politica degli italo-americani* (Milan: Franco Angeli, 2000), and Matteo Pretelli, *La via fascista alla democrazia americana* (Viterbo: Edizioni Sette Città, 2012).

76 Pernicone, "Italian Immigrant Radicalism," 89.

17

THE SACCO AND VANZETTI CASE AND THE PSYCHOLOGY OF POLITICAL VIOLENCE

Michael Topp

What began as a simple, if brutal, robbery became one of the most notorious and important trials in American history. Payday was 15 April 1920 at the Slater and Morrill shoe factory in South Braintree, Massachusetts. Just after 3:00 PM that day, paymaster Frederick Parmenter and his guard Alessandro Berardelli left the company's offices and headed toward its nearby factory. They never arrived at their destination. Two men waiting by a fence outside the nearby Rice and Hutchins factory robbed them of boxes containing $15,776 and shot them both. Berardelli was killed instantly, and Parmenter died soon after the robbery. The two shooters fired into the air, and at nearby factory windows and a bystander, then jumped into an approaching car with two or three other people in it and drove quickly out of town. The crime took less than a minute; the trial would last seven years, and its implications are in many ways still with us today.[1]

The Trial and the Appeals

Nicola Sacco and Bartolomeo Vanzetti were arrested, really by accident, on 5 May 1920. Both were armed; Vanzetti had three or four shotgun shells in one of his pockets, and Sacco had about twenty-three shells of various makes on him. Both were Italian immigrants and followers of the anarchist Luigi Galleani. Federal authorities were pursuing Galleani's adherents at the time for their suspected involvement in a nationwide series of bombings. Sacco and Vanzetti, thinking they had been arrested in connection with these bombings rather than a robbery, both told several lies about their activities and their beliefs to the police.

Local authorities were convinced that the two anarchists and their compatriots were responsible for a series of payroll robberies that had plagued the area. Vanzetti was quickly indicted for an earlier failed robbery attempt in Plymouth on 24 December 1919. Sacco had an unimpeachable alibi for this earlier robbery, but Vanzetti was convicted under circumstances at least as troubling as the more famous trial. This first trial was marred by relentless prejudice against Italian immigrants. One witness said he could identify Vanzetti because "the way he ran I would tell he was a foreigner."[2] Over a dozen witnesses swore Vanzetti had sold them eels, a traditional Italian Christmas Eve dinner, on the day of the robbery, including Beltrando Brini, Vanzetti's thirteen year old neighbor who helped him that day. Prosecutor William Katzmann dismantled their testimony, mocking their poor English and accusing them of fabricating the story to protect a fellow immigrant.

Sacco and Vanzetti were indicted, Vanzetti as a convicted felon, for the 15 April robbery in September 1920. Their trial began on 31 May 1921 and lasted more than thirty days. (See Figure 14.1). The prosecutor was again William Katzmann. Sacco was defended by Fred Moore, well known for defending radicals, and by William Callahan. Two local lawyers,

Jeremiah and Thomas McAnarney, represented Vanzetti. Moore was the driving force during the trial and most of the appeals, and his perceived lack of decorum antagonized Judge Webster Thayer throughout the proceedings. After more than 150 witnesses were heard from, Sacco and Vanzetti were found guilty on 14 July 1921. Seven appeals stretched over the next six years, during which the two anarchists' representation changed several times. In October 1924, William Thompson, a highly respected Boston lawyer, took over their case. Herbert Ehrmann joined him in November 1925. Ehrmann would argue their innocence until his death in the 1960s. Arthur Hill stepped in briefly just after their last appeal was denied on 6 August 1927. After seven long years, Sacco and Vanzetti were executed just past midnight on 23 August 1927.

Because the crime occurred in broad daylight, there were dozens of witnesses. Eyewitness testimony against Sacco and Vanzetti has been maligned, even dismantled, by scholars in the years since the crime. But at the time, this testimony was very damaging. There were several key witnesses against Vanzetti, none of whose accusations held up under scrutiny. Harry Dolbeare, a potential juror for the trial, saw Vanzetti at the *voir dire* and claimed that he had seen him with a "tough looking bunch" of men the morning of 15 April in South Braintree. But he couldn't identify any of the other men, or explain why he could identify only Vanzetti months later. Austin Reed, a railroad crossing tender in a nearby town, claimed Vanzetti yelled at him from a car crossing the tracks as he attempted to close the gate for an oncoming train. But he testified that the defendant shouted at him in "clear unmistakable English"; Vanzetti spoke with a heavy accent. John Faulkner said that Vanzetti was a fellow passenger on a train heading toward South Braintree the morning of the crime. But no one else on the train identified Vanzetti, and no tickets were sold that day for the destination Faulkner described. Only one person put Vanzetti in the getaway car at the time of the crime. Michael Levangie, a railroad crossing tender in South Braintree, testified that he saw Vanzetti driving the car after the robbery. But Vanzetti couldn't drive.[3]

More people claimed to have seen Sacco, seven in all, but four provided the most damaging accounts in court. Mary Splaine, a Slater and Morrill bookkeeper, gave an exacting description of Sacco, even down to the size of his hand. But she admitted she saw the man she described from a distance of sixty to eighty feet. Felix Frankfurter, a future Supreme Court judge who argued the defendants' innocence, calculated that given the speed of the car, she would have seen him for between 1½ and 3 seconds. (Marion Denman Frankfurter would publish a collection of Sacco and Vanzetti's letters in 1928.) Louis Pelser, a shoe cutter at Rice and Hutchins, stated in court that he had seen both the license number of the car and Sacco. But two men he worked with testified that he dove under a bench once the shooting began, and told them he hadn't seen anything. Carlos Goodridge, a traveling salesman who had been in a local pool hall, identified Sacco as the man who pointed a gun at him as he drove by. But four other witnesses testified that he'd told them at the time that he hadn't seen enough to identify anyone. Lola Andrews had been in South Braintree that day looking for work. She claimed that she and a friend had walked by two men, one standing by a car and one underneath it, who she identified as Sacco. But her friend rebutted her testimony, saying it was the man standing by the car to whom they'd spoken.[4]

Not only was the testimony of all four of these witnesses disputed, they were each in their own way unreliable. Splaine had first accused a fellow employee at Slater and Morrill of the crime. Her boss told a Pinkerton agent investigating for the insurance company not to take anything she said seriously, that she was "one of the most irresponsible persons he ever came in contact with."[5] Pelser told different stories to the prosecution and defense before the trial, and a new one at the trial itself. Goodridge was an utterly disreputable man. His real name was Erastus Corning; as part of his lengthy criminal past, he committed perjury for a

marriage license so he could commit bigamy. Both sides in the case harassed Andrews about her identification. She said at one point a government agent was "bothering the life out of her" to identify Sacco.[6]

The defense was culpable of wrongdoing as well. Fred Moore tried to get Lola Andrew's estranged son to pressure her to change her testimony. He sought, unsuccessfully, a criminal indictment against Goodridge to coerce him. He got Pelser drunk and had him sign a deposition negating his identification of Sacco; Pelser sobered up and changed his story back again. There is even evidence that Moore tried to create an alibi for Sacco. Sacco and Vanzetti's defenders argued, then and more recently, that these steps reflected distrust of the justice system. Because they were Italian immigrants, and radicals, they didn't expect to be treated justly by the courts.

This distrust was clearly warranted. Prosecutor Katzmann defended his shaky witnesses, at times beyond logic or reason. He made the empty claim to the jury that Levangie "honestly meant to tell the truth," arguing he must have seen the man *behind* the driver since Vanzetti couldn't drive. He complimented Pelser for admitting he had changed his story several times, though this admission seemed unavoidable. He said of Lola Andrews, whose identification was utterly implausible, that he had never "laid eye or given ear to so convincing a witness."[7] If this could be explained away as prosecutorial vigor, the reports filed by Pinkerton agent Henry Hellyer had darker implications. Katzmann had access to Hellyer's materials, and used them during the trial. The defense didn't see them until May 1926. Sacco and Vanzetti's lawyers didn't know until then that several witnesses, including Splaine and Levangie, had given very different accounts of what they'd seen to Hellyer.[8] These changes in witness testimony point strongly to prosecutorial manipulation.

There was clearly misdoing on both sides. But with two lives at stake, the larger conclusion is that the eyewitness testimony, which is always shaky, especially across ethnic and racial lines, simply did not hold up. Of the forty-five witnesses who claimed to have seen one or more men committing the crime, thirty-four identified neither Sacco nor Vanzetti. Of the eleven who did—four identified Vanzetti, and seven Sacco—their testimony was faulty, contradictory and/or manipulated.

Nor has the material evidence against the two anarchists withstood the weight of historical scrutiny. There were two main pieces of evidence the prosecution emphasized: a cap they claimed belonged to Sacco, and a gun they claimed was Vanzetti's. Katzmann argued that the cap found near Berardelli's body was Sacco's. It was an important piece of evidence. Katzmann brought it up in his closing, and Judge Thayer referred to it on three separate occasions in denying appeals. But there was no clear evidence that the cap belonged to Sacco, and it was mishandled by authorities. Police didn't pick it up until a day after the crime, which deeply damaged any claim it was connected to the robbery. There was a hole in the back of it that the prosecution claimed came from Sacco hanging it up at work. Jerome Gallivant, the Police Chief in Braintree, later admitted he had had it in his car for weeks, and had made the hole himself looking for evidence of who owned it. It didn't even fit Sacco, who tried it on during the trial.

The story of the gun that prosecutors claimed belonged to Vanzetti was even more troubling, and more damaging to the defendant. Katzmann argued that the gun had belonged to Berardelli, and that Vanzetti had picked it up during the robbery. It was the single piece of material evidence tying Vanzetti to the crime. As Thayer stated, if the evidence connecting him to the gun was accurate, Vanzetti was guilty.[9] Testimony concerning this gun from Berardelli's wife and from employees at the shop where the payroll guard had had the gun repaired was very confusing. The prosecution never established that Berardelli even had the

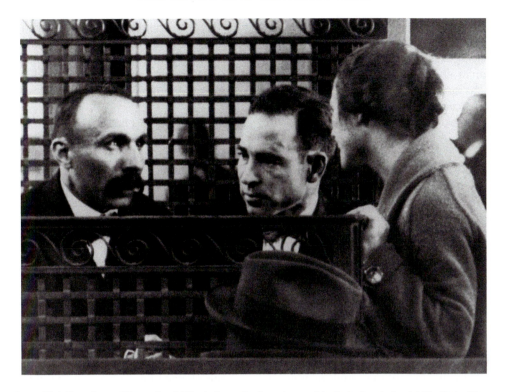

Figure 17.1 Bartolomeo Vanzetti and Nicola Sacco in the prisoners' dock during their trial. Dedham, Massachusetts, 12 July 1921 (two days before they were declared guilty). Boston Globe/Getty Images.

gun with him the day he was killed. Nonetheless, it emerged as damning evidence against Vanzetti.

Once again, prosecutorial misconduct determined the outcome of the trial. Two scholars investigating Massachusetts police reports related to the trial released in 1978 found evidence that the gun found on Vanzetti had not been Berardelli's. They weren't even the same caliber; Berardelli's was a .32, whereas Vanzetti's was a .38. The police knew this going into trial. Michael Stewart, the Chief of Police in Bridgewater who oversaw the Sacco and Vanzetti investigation, acknowledged it in a memo early in 1921.[10]

There were also troubling absences in terms of material evidence. Police found the first getaway car (the robbers switched cars soon after the crime), but prosecutors didn't introduce fingerprints found on the car into evidence. Some scholars argue they couldn't because the fingerprints didn't match the defendants'. Authorities tracked Sacco and Vanzetti's anarchist allies throughout the United States and to Italy, but never found the money. Of six bullets taken from the bodies of the two men, prosecutors couldn't determine the origin of five of them.

The one bullet that prosecutors did connect to the defendants remains at the center of the irresolvable controversy concerning their guilt or innocence. Again, the chain of evidence was broken at the start. The police marked neither the bullets they found on Sacco when he was arrested nor the shells they found at the scene. The testimony by ballistics experts was marred by error and manipulation. One expert said he was "inclined to believe" that the bullet, marked "bullet III" in evidence, had come from Sacco's gun. Both Katzmann and,

289

unforgivably, one of Sacco's lawyers, misinterpreted this as a definitive argument connecting the bullet to Sacco's gun. Another ballistics expert, Massachusetts State Police Chief William Proctor, argued the bullet was "consistent with" one fired through Sacco's gun. Unable to definitively tie the bullet to Sacco's gun, Proctor arranged this vague wording with Katzmann instead.[11] The defense never challenged it, and this testimony stood as condemning evidence against Sacco.

The ballistics evidence during the trial in any case was suspect. The science of ballistics was relatively new, and testimony presented by both sides was contradictory and confusing. Two experts writing in the 1930s asserted that none of this testimony, from either side, was worth the time and effort it took to explain it. The prosecution claimed, too, that bullet III and several of the shells found on Sacco were obsolete, an argument that tied the crime more closely to the anarchist. Jurors later referred to this as definitive. Sacco and Vanzetti's detractors continued to refer to the obsolete bullets for decades. But they weren't obsolete. Herbert Ehrmann found them easily in 1927. A firearms expert found them again as late as 1962.[12]

The prosecution misinterpreted and manipulated evidence, but even Sacco and Vanzetti defenders have argued that bullet III is "the only prosecution evidence that has grown stronger, not weaker, since the trial."[13] Tests conducted on Sacco's gun in the 1970s by James Starrs conclusively tie a shell casing found at the scene to the anarchist's weapon. Although this might convince some at least of Sacco's guilt, given the lack of care police took with the evidence, repeated instances of prosecutorial misconduct, and the seeming determination to convict Sacco and Vanzetti at all costs, it is not inconceivable that this evidence too was manufactured or manipulated (Figure 17.1).[14]

If the question of their guilt or innocence remains clouded by controversy, the unfairness of their trial is indisputable. Although Sacco and Vanzetti were purportedly being tried for robbery and murder, it was their political beliefs that were on trial. Much of the case against the two anarchists hinged on the fact that they told lies to the police the night of their arrest. Katzmann focused enormous attention on their "consciousness of guilt," claiming they had lied to cover up their involvement in the South Braintree crimes. Thayer spent a huge amount of time on this issue in his instructions to the jurors. (In the transcript, this stretched to seven of the twenty-six pages of his address; by contrast, bullet III got one paragraph). Katzmann's argument compelled Sacco and Vanzetti to explain that they lied because they feared being identified as anarchists rather than because of their involvement in a crime. Because the prosecution maneuvered them into discussing their anarchist ideals, Katzmann was able to attack their radical beliefs *and* point out that they raised the issue themselves. Sacco and Vanzetti each explained that they were moving anarchist literature the night of their arrest, and Katzmann cajoled Sacco into making an impassioned and self-destructive speech from the stand defending anarchism.[15]

Judge Thayer's conduct made the implications of their identity as anarchists even more dire. His antiradicalism was evident even before their trial. He had been the judge in Vanzetti's trial for the unsuccessful robbery on Christmas Eve in Plymouth. Though Vanzetti had never been convicted of a crime, Thayer handed down an unusually long sentence, arguing, "the defendant's ideals are cognate with the crime."[16] Thayer wasn't assigned to the Sacco and Vanzetti trial, but he called in a favor from an old friend to get the case.[17]

Thayer's conduct during the trial was reprehensible. He granted Katzmann enormous leeway when he questioned the defendants, at one point allowing him to badger Sacco about having left the United States in 1917 to avoid the draft, and demanding to know whether Sacco could defend his claim that he "loved a free country." During this cross examination, Thayer interjected in remarkable and seemingly illogical ways, asserting eight separate times that the defendants were saying they had been hiding anarchist literature to protect the

interests of the United States. It is difficult to believe that this confusing assertion was any-thing but willful manipulation—Thayer was compelling the defendants to argue eight times that hiding this literature was for their own well-being, not to protect the United States.[18]

Thayer's behavior outside the courtroom was even more disturbing. He discussed the case with numerous people, attacking Sacco and Vanzetti's beliefs. Journalists, a head of the Bos-ton Federation of Churches, a former Boston city treasurer, and essayist Robert Benchley all testified Thayer had assured them that the anarchists wouldn't get away with anything in his court. Thayer's outlandish behavior culminated in his boast to a faculty member of his alma mater, "Did you see what I did with those anarchist bastards the other day?" after he had rejected four appeals in a single day.[19] Thayer was fixated on Sacco and Vanzetti's anarchism, and he was not alone.

The Federal Bureau of Investigation involved itself in the case in multiple ways, again belying the notion that this was a simple criminal trial. Sacco and Vanzetti were arrested at the height of the post–World War I Red Scare, when the Department of Justice and the newly formed FBI were tracking radicals across the United States. In January 1920 Attor-ney General A. Mitchell Palmer had overseen raids in thirty-three cities, leading to thou-sands of arrests. Federal authorities arrested about five hundred suspected radicals in Boston and surrounding towns, marching many through the streets in chains.[20] Sacco and Vanzetti's defense team tried repeatedly to get the Department of Justice to release information about its involvement in the trial. They didn't succeed until they convinced two former Justice Department employees to file affidavits during the appeals process. Lawrence Letherman and Fred Weyand both stated that the Department got involved in the case early, that it was determined to deport Sacco and Vanzetti if they were acquitted, and that most Justice offi-cials believed the crime had been committed by professionals.[21] Although scholars disagree about how much the Justice Department interacted with the prosecution, at the very least it placed a spy in the cell next to Sacco's, and attempted to place one in Rosa Sacco's house while her husband was imprisoned; it tracked radical groups' finances looking for the sto-len payroll; and it provided translated articles from radical newspapers to Katzmann. Justice officials tracked the Sacco-Vanzetti Defense Committee carefully as well. It placed an agent named Harold Zorian on the committee. Zorian collected information and defense funds, and eventually absconded with both.

It was impossible for Sacco and Vanzetti to receive a fair trial. The prosecution intention-ally misidentified Berardelli's gun and manipulated eyewitness testimony. Certain scholars speculate that they may even have substituted bullet III. Judge Thayer repeatedly took actions in and out of his courtroom that were damaging to the defendants. The Department of Jus-tice and the prosecution cooperated in ways that revealed the true purpose of the trial—to condemn two anarchists rather than to try two alleged robbers and murderers.

After Sacco and Vanzetti's conviction in July 1921, the defense filed seven appeals. Three concerned the manipulation of eyewitness testimony; one possible prejudicial behavior of the jury foreman; one Proctor's manufactured ballistics testimony; one accused Thayer himself of misconduct. All of these appeals were denied. The Massachusetts State Supreme Court at the time could only rule on issues of law, not issues of contested fact. That limited the possibility of any of the appeals' success. Moreover, due to a quirk in Massachusetts law corrected soon after because of this trial, Thayer himself ruled on the appeals. This included the one based on his own behavior. The judge "showed the anarchist bastards" by rejecting each and every one. The most wrenching denial was of the appeal based on a confession made by Celestino Madeiros. Madeiros, a Portuguese immigrant, was in prison for robbery and murder when he slipped a note to Sacco confessing to the South Braintree crime. He implicated the Morelli gang, a group of criminals who operated out

of Providence, Rhode Island. His confession was plausible—Ehrmann wrote a book titled *The Untried Case* laying out this alternative version of the crime—but Thayer rejected this appeal as well.[22]

Though few people had ever heard of Sacco or Vanzetti when they were arrested, by the time their appeals were winding down they were, one writer declared, "the two most famous prisoners in the world."[23] Fellow radicals were the only ones who raised the alarm quickly when the two anarchists were arrested. Carlo Tresca, an anarcho-syndicalist and briefly a member of the Industrial Workers of the World (IWW), was known among his compatriots as the "fixer" of the Italian anarchist movement. Tresca asked Elizabeth Gurley Flynn, an IWW member and an inspiring speaker, to help him spread the word about Sacco and Vanzetti's situation; her connections with the English-speaking Left were invaluable. The Sacco-Vanzetti Defense Committee, initially composed solely of Galleani's followers, soon included Leftists and leading liberals. Eugene Debs, the perennial Socialist candidate for president, was in jail for protesting World War I when Sacco and Vanzetti were arrested. The first thing he did when freed in 1921 was to send them his prison release money. In 1924, the notoriously redbaiting American Federation of Labor protested the unfairness of the trial. Sacco and Vanzetti also benefited from the backing of some of Boston's wealthiest and most elite liberals. Boston Brahmin Elizabeth Glendower Evans and several of her friends began visiting Sacco and Vanzetti soon after their arrests. They brought them food, books and flowers regularly, and taught the two men English.

Protests against the injustice of the trial grew slowly until late in the appeal process, but by then critically important liberal and even conservative voices began to voice their objections. At the end of 1926, just after Thayer rejected the Madeiros appeal, the staunchly conservative *Boston Herald* published an editorial titled "We Submit." The piece, which won a Pulitzer Prize, attacked the defendants' anarchism but argued a new trial was necessary.[24] Just months later future Supreme Court Justice Felix Frankfurter published a lengthy and vehement assault on the trial in the *Atlantic Monthly*. An attempted rebuttal by Northeastern Law School Dean J. H. Wigmore fell flat. A. Lawrence Lowell, the President of Harvard University, lamented "Wigmore's ridiculous article looked as if there was nothing serious to be said on the side of the courts."[25]

Facing protests from all corners, Massachusetts Governor Alvan Fuller made an unprecedented move. He put together a committee of prominent citizens to review the case, and agreed to abide by their decision. Whereas this appeared to offer the defendants a tremendous opportunity to reassert their innocence, their supporters were justifiably wary. One committee member was former Probate Court judge Robert Grant, who had published work dismissing Italian immigrants as inferior peoples.[26] A. Lawrence Lowell, the unquestioned leader of elite Boston who had recently bemoaned Wigmore's ineffective effort to legitimate the verdict, led the committee. His influence was so great that the committee bore his name.

Though the committee appeared to conduct a thorough investigation, its findings were a foregone conclusion. The Lowell Committee was appointed on 1 June 1927 and reported to Governor Fuller on 27 July. It reviewed the trial transcripts, and interviewed old and new witnesses, jury members, attorneys, and Judge Thayer. But the tone of the committee's investigation was clear from the beginning. For example, Lowell was triumphant when he thought he'd caught a member of the Defense Committee who provided Sacco with an alibi in a lie. When the man provided indisputable evidence that he had told the truth, the correction never made it into the committee's final report. Committee members argued, at times combatively, with defense witnesses. Ultimately the committee offered only the illusion of an investigation. Lowell drafted the committee's final report before the defense made its closing

arguments. The report concluded that Sacco was guilty, and that Vanzetti was "on the whole" guilty, an ambiguous turn of phrase that has tormented the defendants' advocates ever since.[27]

By the time the Lowell Committee made its findings public, furious protests had spread across the country and the globe. In the United States, strikes and demonstrations erupted in cities large and small, from New York to Chicago to San Francisco to Tampa. People marched in the streets every day in Boston, where even notoriously apolitical people like poets Edna St. Vincent Millay and Dorothy Parker were arrested for protesting. Communist parties in Europe and Latin America especially had used the case, often cynically, to attack American capitalism and its judicial props. Protests by the summer of 1927 expanded far beyond the Communists' efforts. People marched by the thousands in every major capital in Europe, and in cities across Latin America, Asia and Africa. These protests at home and abroad often turned violent as angry men and women clashed with police. Governor Fuller received a petition with a half million signatures collected worldwide demanding justice for Sacco and Vanzetti. Renowned intellectuals and political leaders throughout the world voiced their indignation, among them Albert Einstein, H. G. Wells, Marie Curie, H. L. Mencken and Jane Addams. Even Benito Mussolini, the Fascist leader of Italy and hardly a fan of anarchism, contacted Fuller to express his concern.[28]

It was all for naught. Sacco and Vanzetti's defense team reached out unsuccessfully to liberal Supreme Court Justices Oliver Wendell Holmes and Louis Brandeis for a stay of execution. Scheduled to be electrocuted on 10 August, the two men, already shaved for the death chamber, got a brief reprieve hours before they were to be killed. Vanzetti was able to visit with his sister, who arrived from Italy on 19 August. But just after midnight, on 23 August 1927, Sacco and then Vanzetti were executed, having followed Celestino Madeiros to the electric chair.

Their executions ended the trial, but the legacy of the Sacco and Vanzetti case has occupied artists and activists to the present day. Their defenders continued to argue their innocence for decades. Due largely to their urging, on 23 August 1977, fifty years after their execution, Massachusetts Governor Michael Dukakis issued a proclamation declaring that Sacco and Vanzetti had not received a fair trial, and declaring the day "Nicola Sacco and Bartolomeo Vanzetti Memorial Day." The case has inspired a remarkable number and range of creative efforts on behalf of the two anarchists. There were novels and other literary productions from the first. There have been artistic portrayals, most notably the murals created by artist Ben Shahn in 1931 and 1932. (See Color Plate 11.) A number of musicians after their executions have also drawn inspiration from the two men. For example, Anton Coppola, uncle of director Francis Ford Coppola, created an opera titled "Sacco and Vanzetti," which premiered in Tampa, Florida in 2001. In more recent years, there have been movies, documentaries, and by now dozens of websites on the anarchists and their trial.

Anarchism and the Psychology of Political Violence

Sacco and Vanzetti's images as gentle anarchists, built by those fighting for their freedom, grew stronger in the years after their deaths. Once their case became a cause célèbre, prominent liberals presented them in ways that would appeal broadly to the public. John Dos Passos published a pamphlet titled *Facing the Chair*, famously describing the two men simply as "the shoemaker and the fish peddler." He denied that their anarchist beliefs had led them to violence, writing, "Good people generally have contended that anarchism and terrorism were the same thing, a silly and usually malicious error fostered by private detectives and the

police bomb squads."[29] Elizabeth Glendower Evans, the wealthy woman who visited regularly with both men, published a pamphlet which presented Vanzetti in glowing, if racialized, terms. She wrote that he exhibited the "exquisite courtesy characteristic of the South Latin race, and his interests are philosophical and humanitarian," noting that he was "much esteemed among his fellows as a thinker."[30]

The images of these men as gentle souls were exaggerated, but they were not fabrications. Sacco was a loving family man who took solace and comfort in the outdoors, and an able and trustworthy worker. He was devoted to his wife Rosa, and to his son Dante, and eventually to his daughter Ines, born while he was imprisoned. He referred to how much he missed them, to memories of being with them, time after time in his letters. In his last letter to Dante, he beseeched his son to care for his mother after the execution. "Instead of crying," he wrote, "be strong, so as to be able to comfort your mother, and when you want to distract your mother from the discouraging soulness, I will tell you what I used to do. To take her for a long walk in the quiet country, gathering wild flowers here and there, resting under the shade of trees, between the harmony of the vivid stream and the gentle tranquility of mother nature, and I'm sure she will enjoy this very much, as you surely would be happy for it."[31] He had found work at a shoe company and had taken an unpaid six-month course to become a skilled edge trimmer. He earned a good wage and had over $1,500 in savings when he was arrested. His employer gave Sacco the keys to the factory where he worked; he frequently opened and closed the factory on workdays. He was generous as well. He distributed extra produce from his garden to his neighbors and to those in need. He was, by all appearances, little different than the fellow Italian immigrants he lived and worked among, and even more successful than most.

Vanzetti's life was much less structured, but no less praiseworthy. He had had a series of jobs since his arrival in the United States. He'd had a rougher time of it than Sacco, enduring harsh working conditions especially in the restaurants where he worked, and going without work or even a place to stay at times. When he was arrested he was indeed a fish peddler, selling fish he bought fresh in Boston or caught himself, and digging for clams to sell. Living such an unstructured life, he embodied many of the negative stereotypes of Italian immigrants so scorned in the country at this time. He didn't practice his skill—he was trained as a pastry maker—and he lived unencumbered by factory whistles or time clocks. But he was also one of many working class autodidacts, a voracious reader bent on improving himself and his mind. He didn't smoke or drink, or cavort. There's no evidence he ever even had a romantic attachment, but he cared deeply for those around him. He was famously a father figure to his landlord's son, Beltrando Brini, whose testimony that he was selling eels on Christmas Eve day in 1919 Katzmann so efficiently discredited. Beltrando's father worked a great deal, and Vanzetti called Beltrando his "spiritual son," encouraged him to pursue his interest in music and counseled him when he misbehaved.[32] Brini, who became the conductor of the Plymouth Philharmonic Orchestra, recalled the last time he saw Vanzetti as a free man. He was almost 13, and he had just taunted a neighbor who was taking him to task for inadvertently trampling his garden. Vanzetti witnessed the encounter, and quietly exhorted Brini to treat those around him with respect. "Vanzetti was like a father to me," Brini later reflected. "He established in my mind, with his conversation and actions, values and virtues that have remained with me ever since."[33]

Both men were deeply sensitive human beings, and many who knew them thought them incapable of violence. One friend recounted that Sacco was unable to kill the chickens he raised when they were needed for dinner. He had to have his wife do it. Vanzetti once found an injured kitten and spent weeks nursing it back to health. William Thompson, the esteemed Boston lawyer who took over their case during the appeal process, grew to respect

the two men immensely. Though he tried to dodge the case initially, Thompson became convinced that the two men were innocent. He spent considerable time particularly with Vanzetti, and insisted that he was incapable of having killed anyone. Those close to Sacco and Vanzetti, and many who came to know them during their imprisonment, were convinced that these were gentle and compassionate men. In many ways they were.

But there was another side to each of these men, nowhere evident in the literature produced by their liberal supporters, and not readily visible in their day-to-day lives. They were followers of Luigi Galleani, an anti-organizational anarchist who insisted that the existing society would have to be destroyed before a more benevolent and peaceful one could be built. By the time Sacco and Vanzetti encountered Galleani's ideology, soon after each arrived in the United States in 1908, he was one of the most important and most radical anarchists in the country.

Galleani's political beliefs, though, took root in the country of his birth.[34] His version of anarchism was the product of the evolution of radical politics in Italy, where he lived and agitated until 1900. The anarchist movement had reached the height of its power in Italy in the 1860s and 1870s, and anarchists led insurrections in 1874 and 1877. But the rebellions collapsed, and the Italian government arrested anarchists and sentenced them as *malfattori*, or common criminals. In response, many Italian anarchists became increasingly secretive and even paranoid. A strain of anarchism emerged that rejected all organizations as inherently authoritarian and vulnerable to penetration by government spies.

Galleani came of age politically just as anarchism in Italy was making this turn. During the 1880s he became an able and notorious strike leader and agitator, and had to leave Italy in 1889 to avoid arrest. He worked as a secretary in Paris for Ettore Molinari, an Italian anarchist chemist who inspired [and probably authored] the bomb manual Galleani eventually circulated.[35] Galleani traveled next to Geneva, living briefly with Elisée Reclus, an advocate of revolutionary violence. Returning to Italy, Galleani was arrested again, and sentenced to five years in prison. He eventually escaped, making his way to the United States in 1900.[36]

By the time he arrived in Paterson, New Jersey, he had experienced imprisonment and exile, and encountered the staunchest advocates of violence in the anarchist movement. Shot in the face during a strike and facing arrest, he left for Canada in 1902, slipping back into the country to join an enclave of Italian immigrant anarchists in Barre, Vermont. He spent the next two decades in the United States working to organize fellow Italian immigrants around a set of unyielding principles, advocating individual acts of bravery and rebellion, and violence, to incite revolution.[37] He edited the weekly *Cronaca Sovversiva* [Subversive Chronicle], and wrote many of its most incendiary articles. He published a pamphlet around 1905 titled *La salute è in voi!* [Health is Within You!] that contained instructions for assembling and detonating bombs (see Figure 17.2). "The manufacture of explosives is not difficult," the pamphlet assured its readers, "but to be able to make them effectively and without danger it is necessary to follow closely all of the instructions which will follow."[38] He had provided a tool for his adherents to put their philosophy into action.

As archaic as this philosophy seemed, even at the time, Galleani attracted fiercely loyal adherents in Italian immigrant colonies across the country. *Cronaca Sovversiva*, its subscriber list in the thousands, was the leading Italian anarchist journal in the country in the early twentieth century. In its pages he berated his foes [often on the Left] and exhorted his followers: "We do not argue about whether property is greedy or not, if masters are good or bad, if the State is paternal or despotic, if laws are just or unjust, if courts are fair or unfair, if police are merciful or brutal. When we talk about property, State, masters, government, laws, courts, and police, we say only that *we don't want any of them*."[39] He published a collection of biographies of anarchist assassins and practitioners of revolutionary

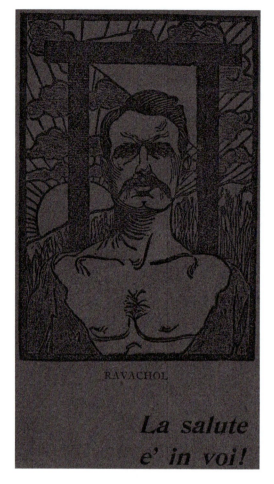

Figure 17.2 Luigi Galleani's anarchist bomb-making manual, *La salute è in voi!* [Health is Within You!], published *circa* 1905. The portrait on the cover is of the French anarchist Ravachol. Photo courtesy of Library of Congress Prints and Photographs Division, Rare Books/Special Collections.

violence titled *Faccia a faccia col nemico* [Face to Face with the Enemy]. He drew people to him with his ferocious eloquence, with his relentless assaults on a society he deemed hopelessly corrupt.

In a way, the fact that he was able to attract a following was deeply paradoxical. He and his adherents rejected any form of leadership or authority as inherently oppressive. Frustrated with the often comically anarchistic Sacco-Vanzetti Defense Committee, non radical members complained that meetings rarely yielded decisions, and even more rarely followed them. But his fellow anarchists looked to Galleani, the austere father figure they called their teacher, for guidance and inspiration. Federal agents who arrested and deported him called Galleani's newspaper "the most rabid, seditious, and anarchistic sheet ever published in this country."[40] But after they questioned him, they understood why people followed him.

Sacco and Vanzetti were two of Galleani's most loyal adherents, and among those most willing to involve themselves in the revolutionary violence he encouraged. In 1917, once

the United States entered World War I, a small group of Galleanisti made their way through El Paso, Texas, to Mexico. They were concerned about being drafted, though as noncitizens they were ineligible. They were also preparing themselves for what they hoped was an impending revolution in Italy. They were ultra militants, principally from Chicago, Youngstown, Philadelphia and a few small towns surrounding Boston. Sacco and Vanzetti met for the first time at a meeting of potential participants in Boston, and became two of about sixty anarchists who made the trip.[41]

In Mexico they lived communally, complained about the food, and waited in vain for a left-wing revolution in Italy. Faced with a war they considered murderously unjust and the beginning of relentless repression of their movement, they also discussed how to engage in more meaningful revolutionary activity back in the United States. While they were in Mexico, Galleani was arrested in June 1917 for obstructing the draft. Though he was quickly fined and released, his followers vowed to retaliate.

They apparently began to implement their plans almost immediately as they slipped back into the United States in fall 1917, and they began almost as quickly to attract the attention of law enforcement. Certain of them may have been involved in a series of bombings in the Midwest, including one that killed ten police officers in Youngstown, Ohio. In January 1918, Ella Antolini, one of the few women among Galleani's adherents, was arrested on a train in Chicago for attempting to transport dynamite to the east coast. In May 1918, authorities rounded up about eighty Galleanisti, including Galleani himself. But Federal agents couldn't justify his deportation, ironically, precisely because he was so anti-organizational. He belonged to no organizations considered anarchistic. An immigration law outlawing anarchism of all stripes, passed in October 1918, took care of this problem, and Galleani was deported in June 1919 with eight of his supporters.

As he left, Galleani called for vengeance, and his fellow anarchists responded. In February 1919 they circulated a flier titled, "Go-Head!" which threatened, "deportation will not stop the storm from reaching these shores. The storm is within and very soon will leap and crash and annihilate you in blood and fire . . . deport us! *We will dynamite you!*"[42] Weeks later, thirty packages were mailed to prominent government and business leaders, scheduled to arrive on May Day, each containing iron slugs wrapped around dynamite and designed to explode when they were opened. None reached their intended targets, held up at the post office for insufficient postage. Soon after, a series of bombs were hand-delivered to the homes of business and government leaders in seven cities. One detonated on the porch of Attorney General A. Mitchell Palmer, the man responsible for the roundup of anarchists and other radicals. The man delivering the bomb was blown to pieces, but Federal agents found enough of his remains to identify him as Carlo Valdinoci, a Galleanisti who was in Mexico in 1917 and who had been on the train with Ella Antolini just before she was arrested.

Federal authorities found copies of a flier titled "Plain Words" signed by the "anarchist fighters" at the scene of the explosion. Like the earlier flier, it promised revenge. "You have jailed, deported, and murdered us. We accept the challenge. There will be bloodshed; we will not dodge; there will have to be murder; we will kill, because it is necessary; there will have to be destruction; we will destroy to rid the world of your tyrannical institutions."[43] Federal agents tracked the flier to a New Jersey print shop. In late February, they arrested two more Galleanisti, Andrea Salsedo and Roberto Elia, who worked at the shop. The two men were questioned for eight weeks in a Federal building in New York City. Salsedo was beaten repeatedly, and finally confessed he had helped print the fliers and apparently named others involved in the bombing conspiracy. Despondent about his confession and disoriented by his confinement, Salsedo leapt out a fourteen story window to his death on 3 May, just two days before Sacco and Vanzetti were arrested. Clearly the Galleanisti were using bombs to try

to destroy their enemies. Nor, apparently, were these bombs their first efforts. Historian Paul Avrich has suggested that they may have been using bombs as early as 1914. Galleani all but boasted to his captors that a bombing in New York in 1914 was the work of his group, and even hinted the 1916 bombing in San Francisco for which labor organizers Thomas Mooney and Warren Billings were framed was his work as well.[44]

No concrete evidence has ever linked Sacco or Vanzetti directly to building or placing any explosives. But they were not the peaceful, philosophical radicals their liberal defenders described. They had both been in Mexico among Galleani's ultra militants. Although their movements were not always easy to trace, Vanzetti was in Youngstown at the time of the bombing there, and left soon after. And the two men remained closely connected to people directly involved in the bombings. After Salsedo and Elia were arrested, Sacco and Vanzetti's anarchist group in East Boston met to decide how to respond. The group sent Vanzetti to New York to see what they could do to help their comrades and to assess the danger to themselves. When Valdonoci—who Rosa Sacco referred to as "a great anarchist"—was killed, his wife Assunta moved in with the Sacco family. She was still living with them in November 1922, by which time Sacco and Vanzetti had already begun their appeals. Historians Nunzio Pernicone and Avrich even speculated that Sacco and Vanzetti may have been moving dynamite the night they were arrested; that that was why they lied to the police about their activities.[45] Even if evidence suggests their most significant involvement was ideological rather than physical, this involvement at least was indisputable.

They certainly articulated the ideals and tactics of their anarchism, even when imprisoned, even when writing to their wealthy boosters. They each wrote extensively in prison, Vanzetti more than Sacco. An edited collection of their letters published soon after their execution, designed to evoke sympathy for their plight, revealed them as sensitive and often eloquent. It also evidenced men who were ardent anarchists, angry and dreaming of revenge and martyrdom. Vanzetti declared in one letter, "Both Nick and I are anarchists—the radical of the radical—the black cats, the terrors of many, of all the bigots, exploitators, charlatans, fakers and oppressors."[46] Sacco wrote about a dream he had in which he was leading a strike, urging the strikers on until, "while I was finish to say the last word one of the soldiers fire towards me and the ball past through my heart, and while I was fall on the ground with my right hand close to my heart I awake up with sweet dream!"[47] Just before his execution, he wrote to Gardner Jackson, a reporter and member of the Defense Committee, "we represent two opposite class; the first want to live at any cost and the second fight for freedom, and when it come to take away from him he rebel; although he know that the power of the first, of the opposite, class will crucify his holy rebellion."[48] Jackson later reflected about Sacco, "He loved flowers. He loved birds. He was also a terrific hater."[49]

Sacco has always been regarded as the angrier and more militant of the two. Vanzetti described him as more prone to action, even a better anarchist, than he had been. Asked to write a political testament before his execution, he responded, "I have wrote all of that with 15 years of militancy; Sacco did better than I. Babblers count for naught."[50] He insisted repeatedly that he had never killed or hurt anyone. "I have not stole a cent nor spilt a drop of human's blood," he insisted to Lucy Stone Blackwell, a feminist leader to whom he wrote most often, and most unreservedly, about political matters.[51]

But Vanzetti's letters often echoed Galleani's ferocity. "We must be heroic with the truth, the only Liberator," he wrote to Blackwell. The truth, the foundation of Galleani's and Vanzetti's anarchism, was that wholesale destruction was necessary before a just world could be built.[52] Vanzetti declared, again to Blackwell, "To progress, even a little . . . we have to destroy a world."[53] He called repeatedly for revenge against his enemies, arguing that violent opposition to the existing system and its defenders was unfortunate but necessary. "If I make them

pay dear for my life," he wrote in 1925, "I will choose to die beautifully in an open and heroic rebellion."[54]

As their executions approached, both men called for their comrades to avenge their deaths. In the June 1926 issue of *Protesta Umana* [Humane Protest], the Defense Committee's publication, a letter signed by Sacco and Vanzetti evoked the title of Galleani's bomb manual: "Remember. . . *La salute è in voi!*"[55] Their fellow anarchists took their call to heart. That month, a bomb exploded at the home of Samuel Johnson. The bomber apparently mistook his house for his brother Simon's. (Sacco and Vanzetti and two other anarchists had tried to retrieve their car from Simon's garage the night the police picked them up. Simon's suspicious wife called the police, which led to Sacco and Vanzetti's arrest.) In May 1927 a bomb addressed to Governor Fuller was intercepted at the post office. In August, four more bombs detonated, one at the home of a juror at the trial. After the executions, two more bombs were planted—one at the home of Sacco and Vanzetti's executioner, and one at the home of Judge Webster Thayer. Neither was hurt in the explosions.[56]

One has to wonder what drove these two very different men—both very sensitive, but with very different temperaments—to advocate and possibly even take active part in political violence. It's a compelling question because both Sacco and Vanzetti, lauded by an immense number and range of individuals for the quality of their characters, would be considered terrorists in today's terms. Many scholars discuss political violence and terrorism in terms of social rather than individual psychology, one arguing that it is necessary to understand them "as cultural and collective rather than dispositional and individualistic."[57] Despite popular perceptions of the illogic and madness of such acts, there is common agreement that those who engage in political violence are not insane, or maladjusted, or even distinguishable from the general population in terms of individual traits.[58]

One scholar, Nehemia Friedland, argued that a person's individual disposition to violence is relatively unimportant if there is a clearly articulated and ideologized discontent and a clearly established group identity.[59] Both were true of Galleani's adherents, and especially of the group who traveled to Mexico. There is consensus as well among scholars that if a group functions in isolation—if it prioritizes separatism and secrecy—its predilections to violence may be enhanced. Again, this was characteristic of the Galleani group. As Italian immigrants, as radicals, and as anarchists (the "radicals of the radicals," in Vanzetti's words) they were an enclave in an enclave in an enclave. Though Sacco interacted with fellow workers and with his neighbors, and Vanzetti was well known in the community in which he sold fish, their most meaningful interactions before their arrests were with fellow anarchists. Outsiders, like Sacco's former lawyer Fred Moore and novelist Upton Sinclair, whose work *Boston* depicted the anarchist community, spoke of their guardedness and self-seclusion.[60] They even regarded Carlo Tresca, the Italian immigrant anarchist of a less radical stripe, warily. They relied on his help at critical moments. It was Tresca who Vanzetti visited in New York soon after Elia and Salsedo's arrest. He was the first to draw attention to their perilous situation when Sacco and Vanzetti went to trial. Yet in part due to the fact that he had recommended that they hire Moore, whose counsel Sacco eventually angrily rejected, by the end of the trial Galleani's adherents had turned on Tresca. They launched a campaign against him that lasted for the next decade and more.[61]

Galleani and his followers were a closely guarded community. Many of them, including Sacco and Vanzetti, engaged with others at their work and in their communities in meaningful and even inspiring ways. Sacco and especially Vanzetti formed genuine friendships with several of their wealthy defenders during their imprisonment. But Galleani and his fellow anarchists were also secretive individuals, deeply suspicious of those they considered outsiders. The political enclave they formed, and what they saw as they peered out from it, formed in many of them a mindset ready to embrace violence and violent acts.

Though Friedland argued that group identity was far more important than an individual's penchant for violence, individual mentalities were certainly relevant. Perhaps the best explanation of Sacco and Vanzetti's turn to political violence in terms of individual psychology came from a fellow anarchist. Emma Goldman had firsthand knowledge of anarchist violence. She had planned with fellow anarchist Alexander Berkman to assassinate Henry Frick, who ran Carnegie's steel mills, during the Homestead strike in 1892. She had been accused of inspiring Leon Czolgosz, who assassinated President William McKinley in 1901. In an essay titled, "The Psychology of Political Violence," Goldman argued that such violence was the product of sensitive minds molded by deprivation and by violent environments.

> The ignorant mass looks upon the man who makes a violent protest against our social and economic inequities as upon a wild beast, a cruel, heartless monster, whose joy it is to destroy life and bathe in blood; or at best, as upon an irresponsible lunatic. Yet nothing is further from the truth . . . those who have studied the character and personality of these men, or who have come in close contact with them, are agreed that it is their super sensitiveness to the wrong and injustice surrounding them which compels them to pay the toll of our social crimes.[62]

Sacco and Vanzetti's advocates continually defended them as kind and sensitive men, and Goldman spoke to what happened when sensitive human beings were introduced to ideas—like Galleani's—that confronted the perceived wrongs of the world: "[W]hat happens to a man," Goldman asked,

> with his brain working actively with a new ferment of ideas, with a vision before his eyes of a new hope dawning for toiling and agonizing men, with the knowledge that this suffering and that of his fellows in misery is not caused by the cruelty of fate, but by the injustice of other human beings—what happens to such a man when he sees those dear to him starving, when he himself is starved? Some natures in such a plight, and those by no means the least social or the least sensitive, will become violent.[63]

Sacco and Vanzetti were both profoundly empathetic men, and in Goldman's terms, they were shaped by a world marked by violence and injustice.

There is no question that Sacco and Vanzetti lived in a profoundly violent world—both in abstract and concrete terms. In Italy, not just anarchists, but rebels and reformers of all stripes had used force to alter society. The Risorgimento, the unification of Italy completed in 1861, led by Italian heroes like Giuseppe Mazzini and Giuseppe Garibaldi, had been an armed insurrection. Errico Malatesta, who had led anarchist revolts in Italy in the 1870s, explained, "Even if we had not become anarchists with the First International, it would have been enough for us to be democrats to adopt armed revolt against oppression. . . . When [the Italian Anarchists] passed over to the International, they taught us nothing in that camp that had not been learned from Mazzini and Garibaldi."[64]

World War I, ending just two years before Sacco and Vanzetti's arrest, had been a bloodbath. Almost fourteen million people were killed and over thirty-four million were wounded. This was the war Galleani [and many other leftists] saw as a conflict between various nations' capitalists, bent on widening their access to international markets. As far as they were concerned it was a wholesale and inhuman slaughter of working people to bolster the fortunes of the wealthy of their nations.

The United States, where Sacco and Vanzetti embraced anarchism, was a violent and dangerous place for its largely immigrant workforce. It led the world in the early twentieth century in industrial accidents, which by one estimate killed 700,000 workers in the United States between 1888 and 1908. An estimated half million workers were wounded and 25,000 to 30,000 killed in industrial accidents every year during the early twentieth century. When people struck to protect themselves and for a decent wage, they often faced grave danger. Throughout the nation during strikes, employees and guards hired by their employers faced off, often heavily armed, and people were injured or killed as they did. Vanzetti wrote from jail, "We knew the martyrs of Chicago, the Mooney and Billings frame-up, the Centralia case, the Ettor-Giovannitti case, and the fate of Joe Hillstrom. We had reasons to be afraid, both personal and historical reasons."[65] He mentioned only a few instances of violence and specious charges against labor organizers and radicals, but could have named many others.

They and their compatriots also confronted personal hardship and the threat of violence. Galleani had moved to Barre, Vermont after being wounded in the face and facing arrest during a strike in Paterson, New Jersey. Vanzetti struggled to find work, confronting corrupt hiring agents, economic depression, and unbridled contempt for Italian immigrants. He wandered from town to town, and was homeless for long stretches. It made him very angry. This was an era when Italian immigrants were regarded as racial inferiors, when their racial identity, the quality of their whiteness, was challenged.[66] This was very much a part of Vanzetti's personal experience. In one letter home, in 1911, he wrote,

> I have suffered a great deal on finding myself surrounded by strange, indifferent and sometimes hostile people. I have had to suffer insults from people that I would have left in the dust, if I were a tenth as fluent in English as I am in Italian. . . . Here public justice is based on force and brutality, and woe betide the stranger and particularly the Italian who uses energetic methods to defend his rights, for him there are the clubs of the police, the prisons and the penal codes. Do not believe that the American people are civilized, though they do have many good qualities. If you strip them of their money and their elegant cloths, they are barbarians, fanatics and criminals. . . . No one has ever convinced me that white is black, and if there is somebody who cannot meet my eye, it is because he knows that I despise him.[67]

Vanzetti had faced hardship and contempt, and he blamed not only Americans, but American society and its legal system for the wrongs he endured.

Sacco and Vanzetti each embraced anarchism soon after arriving in the United States in 1908, and knew what they were risking. They both took part in strikes and labor protests, and faced violence or punishment for their participation, prior to their arrests in 1920. Early in 1914, Vanzetti took a job at the Plymouth Cordage Company. In 1916, though no longer employed there, he helped lead a strike at the company. He was convinced he had been blacklisted after the strike. One of Sacco's first personal engagements in anarchist activism came in 1912 during the violent Lawrence strike. Two strikers were killed, women were beaten by policemen with clubs, and two strike leaders' lives were put at risk, accused of a crime they didn't commit. Italian American radicals—and not just the Galleanisti—turned Lawrence into an armed camp. Tresca commented later, "[I]t was war, and in war time, guns play their part."[68] In 1916, the only time Sacco was arrested prior to 1920, he was protesting Tresca's imprisonment. Tresca had been arrested on trumped up charges while leading a strike in the Mesabi iron ranges in Minnesota and was facing the possibility of life in prison. Once the two anarchists were imprisoned, they knew what awaited them. Vanzetti wrote from prison,

"[T]hey convicted us because we were Italian, against war, and anarchist . . . now, to save their faces and uphold their institution they must kill us."[69] For Italian immigrant radicals like Sacco and Vanzetti, fighting for workers' rights, much less fomenting revolution, carried with it the very real possibility of humiliation, loss of livelihood, injury, imprisonment, even death.

Though there is no way to know with any degree of certainty why Sacco and Vanzetti embraced Luigi Galleani's violent version of anarchism, philosophically and possibly actively, there are hints about how to reconcile seemingly paradoxical elements of their character in the literature on the sociology and psychology of political violence. Both men were caring and sensitive in their personal lives. Both men, and especially Vanzetti, faced hardships in their own lives and recognized the privations and dangers that their fellow immigrant workers endured trying to make a living. The injustices that each of them saw and experienced led them to seek out like-minded individuals, and when they met followers of Luigi Galleani, and eventually Galleani himself, they found both an eloquent articulation of their beliefs, and, over time, a plan of action. They recognized the powers allied against them as implacable foes. Industrial (and even culinary) workplaces were desultory and dangerous, and employers routinely, and at times violently, combatted workers' efforts to defend their rights. The state led its soldiers to the slaughter in wars fought on behalf of the rich and powerful, and chased and arrested and deported those who dared even to make this argument.

Their response, cloistered with fellow anarchists and urged on by their leader, was to meet violence with violence. Whereas this response may seem bewildering today, its roots were surprisingly logical. Galleani's followers had no faith in the state. They believed that it would squash any opposition, brutally if necessary. The thousands of arrests of radicals, their sympathizers, and even passers-by during the Palmer raids seemed to bear this out. So too did the arrest of Sacco and Vanzetti for robbing a payroll and killing two men in South Braintree in 1920. Both men continued to proclaim their innocence to the very end, even while proudly defending their anarchist beliefs. But both men were certain of what awaited them. Once they were arrested, Sacco insisted repeatedly, the state would never let them go. Though they were indisputably engaged on some level in violent anarchist activity, those were not the charges they faced, and their involvement in the robbery is far more doubtful. Nonetheless, though it took seven long years, a biased and unfair judge, the involvement of the Justice Department, and prosecutorial manipulation and misconduct, Sacco and Vanzetti had foreseen what their less radical supporters had refused to believe. Once the state had them, it never let them go.

Further Reading

Avrich, Paul. *Sacco and Vanzetti: The Anarchist Background*. Princeton: Princeton University Press, 1991.

Sacco, Nicola and Bartolomeo Vanzetti. *The Letters of Sacco & Vanzetti*. Edited by Marion Denman Frankfurter and Gardner Jackson. New York: Viking Press, 1928; reprint Penguin 1997.

Topp, Michael. *The Sacco and Vanzetti Case: A Brief History with Documents*. Boston: Bedford/St. Martin's Press, 2005.

Watson, Bruce. *Sacco and Vanzetti: The Men, the Murders, and the Judgment of Mankind*. New York: Viking Press, 2007.

Notes

1 The literature on the Sacco and Vanzetti case is voluminous. The most important primary sources include *The Sacco-Vanzetti Case: Transcript of the Record of the Trial of Nicola Sacco and Bartolomeo Vanzetti in the Courts of Massachusetts and Subsequent Proceedings 1920–1927*, 5 vols. plus a supplement (Mamaroneck: Paul P. Appel, Publisher, 1969); Richard Polenberg, ed., *The Letters of Sacco and Vanzetti* (New York:

Penguin Books, 1997); Bartolomeo Vanzetti, *The Story of a Proletarian Life* (Boston: Sacco-Vanzetti-Defense Committee, 1923); John Dos Passos, *Facing the Chair* (New York: Da Capo Press, 1927); Katherine Anne Porter, *The Never-Ending Wrong* (Boston: Little, Brown and Company, 1977); and Felix Frankfurter, *The Case of Sacco and Vanzetti* [1927] (Stanford: Academic Reprints, 1954). The most important secondary sources include Osmond Fraenkel, *The Sacco-Vanzetti Case* (New York: Knopf, 1931); Herbert Ehrmann, *The Untried Case* [1933] (New York: Vanguard Press, 1960); Edmund M. Morgan and G. Louis Joughin, *The Legacy of Sacco and Vanzetti* (New York: Harcourt, Brace and Company, 1948); Robert Montgomery, *Sacco-Vanzetti: The Murder and the Myth* (New York: The Devin-Adair Company, 1960); Francis Russell, *Tragedy in Dedham* (New York: McGraw-Hill Book Company, 1962); Herbert Ehrmann, *The Case That Will Not Die* (Boston: Little, Brown and Company, 1969); William Young and David Kaiser, *Postmortem: New Evidence in the Case of Sacco and Vanzetti* (Amherst: University of Massachusetts Press, 1985); Michael M. Topp, *The Sacco and Vanzetti Case: A Brief History with Documents* (Boston: Bedford/St. Martin's Press, 2005); and Bruce Watson, *Sacco and Vanzetti: The Men, the Murders, and the Judgment of Mankind* (New York: Viking Press, 2007).

2 *The Sacco-Vanzetti Case*, supplement, 128.

3 Ibid., 495–496, 616, 426–427, 417–418, 424.

4 Ibid., 223–224, 294, 296, 1122, 1166, 545, 549, 1353, 1488, 1355, 337, 349, 1308.

5 Ehrmann, *The Case That Will Not Die*, 35.

6 *The Sacco-Vanzetti Case*, 3897–3898.

7 Ibid., 2215, 2212–2213, 2219.

8 Herbert Ehrmann papers, box 14, folder 2, Harvard Law School Library.

9 *The Sacco-Vanzetti Case*, 2255.

10 Young and Kaiser, *Postmortem*, 85–90.

11 *The Sacco-Vanzetti Case*, 3641–3643, 3681.

12 Ehrmann, *The Case That Will Not Die*, 285–286.

13 Young and Kaiser, *Postmortem*, 94.

14 James Starrs, "Once More Unto the Breech. The Firearms Evidence in the Sacco and Vanzetti Case Revisited, Part I," *Journal of Forensic Sciences*, 31.2 (April 1986), 630–654; Starrs, "Once More Unto the Breech: The Firearms Evidence in the Sacco and Vanzetti Case Revisited, Part II," ibid., 31.3 (July 1986), 1050–1078; Young and Kaiser, *Postmortem*, 163–164.

15 *The Sacco-Vanzetti Case*, 1875–1877.

16 Max Shachtmann, *Sacco and Vanzetti: Labor's Martyrs* (New York: International Labor Defense, 1927), 19.

17 Ehrmann, *The Case That Will Not Die*, 114–115, 460.

18 *The Sacco-Vanzetti Case*, 1867–1874.

19 Ibid., 4926, 4928, 4929, 4932, 4946, 5418.

20 Louis Post, *The Deportations Delirium of Nineteen-Twenty* [1923] (New York: Da Capo Press, 1970), 96–101.

21 *The Sacco-Vanzetti Case*, 4500–4506.

22 Ehrmann, *The Untried Case*.

23 Moshik Temkin, *The Sacco-Vanzetti Affair: America on Trial* (New Haven: Yale University Press, 2009). Though flawed in many ways, it is far better than David Felix's cynical and sloppy *Protest: Sacco-Vanzetti and the Intellectuals* (Bloomington: Indiana University Press, 1965).

24 F. Lauriston Bullard, "We Submit," *Boston Herald* (26 October 1926).

25 Morgan and Joughin, *The Legacy*, 261–262.

26 Ibid., 303; Roberta Strauss Feuerlicht, *Justice Crucified: The Story of Sacco and Vanzetti* (New York: McGraw-Hill, 1977), 359.

27 *The Sacco-Vanzetti Case*, 5378i.

28 Eugene Lyons, *Life and Death of Sacco and Vanzetti* (New York: International Publishers, 1927), 199–208; see also Temkin, *The Sacco-Vanzetti Affair*, esp. 32–57.

29 Dos Passos, *Facing the Chair*, 57.

30 Rebecca N. Hill, *Men, Mobs, and Law: Anti-Lynching and Labor Defense in the U.S.* (Durham: Duke University Press, 2008), 194.

31 *Letters*, ed. Polenberg, 172. These letters by Sacco and Vanzetti, written in English, are presented here unedited, as they were in the collection.

32 Watson, *Sacco and Vanzetti*, 15.

33 Paul Avrich, *Sacco and Vanzetti: The Anarchist Background* (Princeton: Princeton University Press, 1991), 42.

34 Ibid., 48–57; Nunzio Pernicone, "Luigi Galleani and Italian Anarchist Terrorism in the United States," *Studi Emigrazione*, 30.111 (1993), 469–487; Nunzio Pernicone, "Carlo Tresca and the Sacco-Vanzetti

Case," *Journal of American History*, 66.1 (December 1979), 535–547; Robert D'Attilio, "La Salute è in Voi: The Anarchist Dimension," in *Sacco-Vanzetti: Developments and Reconsiderations—1979*, ed. Robert D'Attilio and Jane Manthorn (Boston: Boston Public Library, 1982), 75–89.

35 Ibid.

36 Pernicone, "Luigi Galleani," 472–473.

37 Ibid., 475.

38 Topp, *The Sacco and Vanzetti Case*, 63.

39 Luigi Galleani, *The End of Anarchism?* trans. Max Sartin [Raffaele Schiavina] and Robert D'Attillio (Minneapolis: Cienfuegos Press, 1982), 5.

40 Ibid., 95.

41 Ibid., 58–72.

42 Ibid., 137.

43 Ibid., 149.

44 Ibid., 138.

45 Ibid., 204; Pernicone, "Luigi Galleani," 487.

46 *Letters*, ed. Polenberg, 274.

47 Ibid., 19.

48 Ibid., 56.

49 Avrich, *Sacco and Vanzetti*, 160.

50 *Letters*, ed. Polenberg, 313.

51 Ibid., 196.

52 Ibid., 115.

53 Ibid., 147.

54 Ibid., 154.

55 Pernicone, "Luigi Galleani," 488; Avrich, *Sacco and Vanzetti*, 212.

56 Ibid. They had taken action earlier as well. See: Avrich, *Sacco and Vanzetti*, 204–207; Beverly Gage, *The Day Wall Street Exploded: A Story of America in Its First Age of Terror* (New York: Oxford University Press, 2008).

57 Fathali M. Moghaddam, "Cultural Preconditions for Potential Terrorist Groups: Terrorism and Societal Change," in *Understanding Terrorism*, ed. Fathali M. Moghaddam and Anthony J. Marsella (Washington DC: American Psychological Association, 2004), 104.

58 See, for example, Baljit Singh, "An Overview," in *Terrorism: Interdisciplinary Perspectives*, ed. Yonah Alexander and Seymour Maxwell Finger (New York: John Jay Press, 1977), 4; Robert A. Friedlander, "The Origins of International Terrorism," ibid., 32–33; and Jerrold M. Post, *The Mind of the Terrorist: The Psychology of Terrorism from the IRA to al-Qaeda* (New York: Palgrave Macmillian, 2007), 4.

59 Nehemia Friedland, "Becoming a Terrorist: Social and Individual Antecedents," in *Terrorism: Roots, Impact, Responses*, ed. Lawrence Howard (New York: Praeger, 1992), 88.

60 Upton Sinclair, *Boston* (New York: Albert & Charles Boni, 1928).

61 Pernicone, "Carlo Tresca," 545–546.

62 Emma Goldman, "The Psychology of Political Violence," in *Red Emma Speaks: An Emma Goldman Reader*, ed. Alix Kates Shulman (New York: Schocken Books, 1983), 257.

63 Ibid., 261.

64 Pernicone, "Luigi Galleani," 470.

65 Bartolomeo Vanzetti, *Background to the Plymouth Trial* (Chelsea: Road to Freedom Group, 1926), 12.

66 See especially Matthew Frye Jacobson, *Whiteness of a Different Color: European Immigrants and the Alchemy of Race* (Cambridge: Harvard University Press, 1999); Thomas A. Guglielmo, *White on Arrival: Italians, Race, Color, and Power in Chicago, 1890–1945* (New York: Oxford University Press, 2004).

67 Bartolomeo Vanzetti, *Il caso Sacco e Vanzetti: lettere ai familiari* (Rome: Editori Riuniti, 1971), 49.

68 Carlo Tresca, *The Autobiography of Carlo Tresca*, edited with an introduction and notes by Nunzio Pernicone (New York: Calandra Italian American Institute, 2003), 141.

69 *Letters*, ed. Polenberg, 268.

A DIARY IN AMERICA AND A DEATH IN ROME

Francesco Durante

Camillo Luigi Cianfarra was born in Lama dei Peligni in the province of Abruzzo on 1 September 1878. It was an area that saw a conspicuous flux of emigration. In the census of 1881 the commune could count 3,215 inhabitants, whereas the census of 2011 registered fewer than 1,400. The area is one that has contributed much to the history of Italians in America. Tracing their origins to this district were several well-known contemporaries of Cianfarra, including the anarchist Carlo Tresca and labor leader Arturo Giovannitti, as well as numerous famous Italian Americans, including the writers John Fante and Pietro di Donato and singers Perry Como and Madonna.[1]

Once he finished his early schooling, Cianfarra joined his father in America on 27 April 1894. Cianfarra's father was the former mayor of Lama, so it is difficult to explain why a rather well-off family decided to emigrate. There may have been an economic setback or, perhaps more adventurously, a problem of politics. It is difficult to know because the communal archive of Lama was destroyed by retreating German troops as they abandoned the Gustav Line in 1943.

Camillo recounted the very first instances of his "transplanted" life—with, to tell the truth, a certain novelistic liberty—in his only book, published in 1904, *Il diario di un emigrato* [The Diary of an Emigrant]. In these pages, which constitute one of the most atypical and reluctant (and therefore original) of Italian American autobiographies, there is a focus on his experiences in the three years before 1897, when he began to carry out propaganda for the Socialist Labor Party, holding impromptu meetings on the streets of New York. The drafting of the book—which was published as a "novel"—seems to have coincided with the first years of his political work, and in fact Cianfarra says so rather explicitly in the preface:

> Most of these pages were written in a quiet and hard-working town in New Jersey while I was dedicated to a work which perhaps forever rescued me from changed circumstances and different events supervening in my life. Then I was in daily contact with a legion of "losers" who confided to me their fears and defeats (5).[2]

Like the diary's writer, Cianfarra completed most of his political work in Paterson, New Jersey. And the *Diario* is written in the first-person, even if the author conceals himself behind an alter ego and protagonist called "Guidi" who is approximately 20 years old. It seems appropriate to attribute the lived experience of Guidi at least in part to Cianfarra, and therefore the diary helps to clarify circumstances that effectively concerned Cianfarra himself. Guidi alludes to certain "tragic events that have shaken my family—once rich and powerful—and forced me, the last remnant of a noble ruin, to emigrate to America." Events he says he cannot reveal, but which, in the end, he recounts as follows: "I studied. My father was a doctor and could keep me in school as long as he lived. When he died, my mother

found herself without means of support and I was forced to cut short my studies. In the end, between a job for 40 lire a month and the possibility of making my fortune in America, I chose the latter" (26). Although everything—as he writes—might be "only partially true," the diary appears to contain precious biographical elements. For example, when Guidi goes in search of any kind of work in New York, one of the people he encounters notes that he doesn't have calloused hands and tells him: "You need a pen, not *la sciabola*," that is—in colorful Italian American idiomatic language—"the shovel." Or, when a bewildered friend, Savini, warns him, saying "Here no one is as unlucky as the individual who has no more than a high school diploma, or maybe even a degree." Yet he goes to work all the same, something new for him, and he reflects how "until a few months ago there was nothing heavier than a page of mathematics and a translation of Plautus."

In another passage he recalls a friendship, forged in the poor *pensione* where he lodged, with a dignified contemporary: "We sat together discussing literature and art, bickering over Carducci or D'Annunzio, Zola or Tolstoy, calling attention to ourselves." Guidi seems to stand in for Cianfarra again when he becomes nostalgic for his life as a student after finding a job as curator of records and accounts: "Once the pen served me in an entirely different manner: for beautiful translations of Catullus and Lucian—the exquisite poets—for long philological tracts, and for the historical and literary themes which, once engaged, I caressed with the same love with which a mamma caresses her children" (13, 33, 48, 62, 78, 140).

It is not clear if Cianfarra's first employment as a journalist was in editing *Il Proletario* [The Proletarian], whose first issue appeared on 7 November 1896, or if, instead (as one might be inclined to believe on the basis of the concluding pages of the *Diario*), he first began with a daily "colonial" of New York, most probably Carlo Barsotti's *Il Progresso Italo-Americano* [The Italian-American Progress]. The *Diario* describes Guidi arriving at an editorial office where he was received by "an old man who I later learned was the editor-in-chief and for whom today I maintain a sincere filial affection." This could be a reference to Luigi Roversi, who was at the time editor-in-chief of *Il Progresso*, even if it is difficult to call a man who was then barely 40 "an old man."[3]

It seems that Cianfarra reconciled his work as a translator, and perhaps assistant editor at *Il Progresso*, with his work as a political agitator. A certain porosity between the two positions was in no way rare in the first phase of the great Italian migration to the United States. The few testimonies we have lead us to conclude that the young Cianfarra distinguished himself above all by the brilliant vibrancy of his speech.

This was the dawn of Italian socialism in America. *Il Proletario*, in fact, suspended publication in 1897, only a few months after its birth. But the following year it returned as a bi-monthly published in Paterson, New Jersey. And Camillo Cianfarra was named its director.

In October 1904, through the printing press of the *L'Araldo* [The Herald] newspaper, Cianfarra published his only book, *Il diario di un emigrato*. Notwithstanding its journalistic origins and a relatively high print run, his *Diario* has the distinction of being the rarest Italian American book in the world. The only copy in existence may be consulted in the library of the Immigration History Research Center of the University of Minnesota.

It is interesting to note how the publishing venture of the *Diario* was presented to the readers of the daily newspaper:

This novel, which has been acclaimed beautiful and interesting by the entire Italian emigrant press, today goes on sale for 50¢. *Il diario di un emigrato* is the story of the adventures that befall a poor Italian who has come to America seeking work, and is full of happy and sorrowful episodes but all fascinating to the upmost degree. No Italian should fail to read it. By reading it, one gains five years experience. The

manner in which our peasants are robbed; the way they are conned out of their suitcases in New York by the "suitcase knights" [*cavalieri della valigia*]; the gestures of the so-called "bosses," all is recounted here with fidelity and exactitude. Italians who spend $1 or $2 on worthless novels should not fail to buy *Il diario di un emigrato* for the low price of 50¢.[4]

We have already leafed through the book searching for biographical details that possibly concern the author. Now let's examine it from a different perspective, trying to ascertain its literary value. It ought to be considered one of the best books written by the first generation of Italian Americans. And that's how it was soon received.[5]

When compared with other Italian American autobiographies it does seem atypical and reluctant insofar as it is not a story of success. Instead, it is a work that was in tune with the muckraking American journalism of its time, comprising investigations conducted in the most disadvantaged quarters where immigrants gathered in mass numbers. Thus Cianfarra offers his readers above all a portrait of what was, at the end of the nineteenth century, the situation of Little Italy as it was developing around Mulberry Street.

Cianfarra was an eyewitness to this world—part participant, part objective observer. Or better: even-handed, trying to criticize Little Italy's problems, but at the same time knowing how to explain them sympathetically. Considering its strong documentary value and its animating polemical spirit, his book might be described as anticipating Michael Gold's classic novel, *Jews Without Money* (1930). Cianfarra's book differs from Gold's in that he spices his tale with a passionate love story that continues from the first page through to the last, and whose ending is essentially that of a *Bildungsroman*.

After liberating himself (not without pain) from the love of the poor and passionate Maria, whom he had met on the ship bringing him to America, and who has been his companion in nights of quivering erotic transport in the very *pensione* run by Maria's narrow-minded aunt, the narrator begins a new chapter of his American experience as he engages in "bourgeois" journalism—an activity that deepens his understanding of a "colonial" world that in many ways simply horrifies him, but also stimulates his analytical faculties.

The story begins on 28 April of an unspecified year in the last decade of the nineteenth century. Guidi disembarks in New York and begins to seek work. The Italian consul, for whom he has a letter of presentation, advises him to go West. Meanwhile he sees Maria again; she wishes to marry him. But the manner of his feelings for her, though loving, is beyond the girl's comprehension. "Maybe you dreamed of me by your side before the altar in the presence of a blessing priest. But for me there is no altar more sacred than my own conscience, the most authoritative minister of my own heart," he says to her before kissing her (46).

A curious figure, Professor Savini, a cynical and disillusioned "colonial" intellectual, will become his first guide in Italian America, educating him above all with a frightening tirade on the ways for an Italian to make his fortune in America, all of them illegal: the exploitation of immigrant manual laborers; legal fraud at the expense of desperate folk; prostitution; opening a bank like the many that suddenly close, disappearing with the deposits of immigrants. A world created precisely to favor the fortunes of individuals without scruples, those *prominenti* against whom Cianfarra lashes out repeatedly through the words of Savini:

> Everything is forgotten among us, and the crowd of newcomers like the old colony, respectfully greet the former brothel owner who now has a bank office; the former abettor of thieves who is now president of a respected institution: the former dealer of counterfeit coins, who now owns ten or fifteen houses in the middle of the Italian district, and who does not suffer late payment of rents (even of one day). The

names of these individuals are among those of patrons and honorary presidents of all the immigrant feasts, while the survivors of prisons in the homeland and those who left without a passport or crossed the borders of France and Switzerland at night time, you'll find them unfailingly at patriotic celebrations, receptions in honor of this or that illustrious vagabond from home is here for pleasure or otherwise. (. . .) "What a beautiful country," exclaimed the professor as he sat down exhausted. "And to think that a whole legion of police would not be enough to stop all the criminals who are in our colony alone!" (35–36).

Even more frightening though, will be the description of Little Italy, the Italian quarter that Guidi visits with Savini:

From caves where the most disparate foodstuffs were piled up emerged a pestilential stench that forced one to hold one's nose; from the corridors of the houses where the trash was a foot high came groups of women dressed in the strangest fashions, some scantily clad, showing fat and flabby arms; others without bras or corsets, covered only by small red, white or black vests under which one easily saw withered breasts drooping to the waist; others in short skirts, without shoes, exposing black, deformed and hardened feet to the scourge of bad weather; barefoot and dirty children running around half-naked in the street, crawling between the legs of passersby, stealing here a handful of beans, an apple there, chased by the curses and the most vulgar insolence of the robbed sellers.

On the door of other premises marked "Restorante" in shining red and gold there came the strangest nauseating odors along with the cries of the customers bickering over prices; songs and sounds issued forth from basements as they climbed to the street; while from the windows, adorned with pots and pans, all the dialects of Italy rained down into the streets. And on both sides, along the sidewalks, benches and stands of all sizes, loads of fruit, vegetables, dairy products, sausages, sweets, cakes, roasted beans, boiled chickpeas, newspapers, miraculous stories ("Kings of France," "Secrets of the Neapolitan Lottery"), pipes, tobacco, cigars, and step-by-step an exhibition of all manner of goods that resembled the fairs of the small towns of Italy.

Between a brewery and a grocery store, here is a bank. A crowd of individuals is exiting and, one recognizes from their expressions, they are anxious new immigrants. Some are looking in wonder at the US currency they have never seen before in exchange for the Italian; others look around suspiciously, fearing having to find themselves at any moment face-to-face with the infamous "American thief" which the cunning ones have already warned them about. Between a grocery store and a restaurant, here is a shop for lingerie and second-hand garments. From the door a bearded Jew calls passersby using twenty dialect phrases learned after months of effort from the Italian brewer and the newsstand owner (52–53).

This multiethnic dimension clearly stands out in the cramped and crowded world of the Lower East Side of Manhattan. And if Gold in his novel of 1930 found a way to speak of the Italians, here is Cianfarra who writes about the Jews in 1904:

On Mulberry Street, in fact, among the hundreds of carts, I walked by many that were full of handkerchiefs and pieces of cloth of the most lively colors, driven by Jewish merchants who were easily recognizable by their black curly hair, their oval

faces, their protruding cheekbones and aquiline noses. At the carts, the working-class women haggle over fabric or an apron, gesticulating wildly, using gestures and head movements to make themselves understood because of their lack of English. The Jew instead limits himself to looking at them, opening and closing his hand until the sum he wished for is reached, retrieving the object under negotiation in the event the woman has shaken her head to signal her rejection (53).

While Maria strenuously tries to resist the attentions of Cesare, a stonecutter who, with the blessings of her aunt, wants to marry her, Guidi finds work with a vintner and liquor importer whose business methods are hardly ethical. This, and other ways of trying to "honestly" make a living, when compared with the lives of so many outcasts and derelicts (among others events there is a night-time visit to an Italian brothel), begin to dig into the mind of the narrator, and to sow doubts that are corroborated later by the occasional meeting with anarchist and socialist activists. These, though, are branded by the obtuse Manicheanism with which they customarily supply their botched social analysis.

The book proceeds with a number of sketches, like that of the "*cantante sfiatato*" [worn-out singer] who speaks of wonders in his past career while "at eight in the evening he goes to sing Neapolitan songs in a French café that at least pays a decent wage." Or the sketch of the anarchist Gigi with his empty talk of "free love." In the meantime, the stonecutter, Cesare, who doesn't know of the relationship between Guidi and Maria, turns to Guidi asking for advice concerning her. Cesare is a good boy, but when the narrator begins to speak to her of him, Maria begins to cry and continues until her tears are smothered by the narrator's kisses.

Christmas arrives and thoughts go to a mother far away. On our hero's first anniversary in America he begins writing in his diary. Exhausted from too much work, tired of being exploited, he decides to leave. The stage of the story moves to a retreat where a team of laborers are working on the construction of the railroad. There is the boarder in the pay of a Roman *padrone*; there is the story of a certain don Nicola, who was once a priest, but who took on a lover and for this reason had to leave the United States; there is the banker don Raffaele who seeks out workers to collect remittances; and after him arrive other priests, anything but welcome, and black prostitutes. (Here we have surprising evidence of a racist mentality on the part of the progressive Cianfarra: "I never would have supposed the possibility of [sexual] union between a Negress and a white man—even a starving southern Italian peasant," he writes [143–144]). There is, above all, the fiery speech of a socialist agitator and there is admiration for the quiet and heroic way so many mothers and fathers with families decide without hesitation to join a strike.

Guidi returns to New York to work for don Raffaele in the bank. Maria will marry; he advised her to do so. Then don Raffaele flees with the bank's holdings, and our hero suffers three months of unemployment. On the third anniversary of his arrival, he becomes a "colonial journalist."

> No, back then I didn't understand the colony; the *prominenti* who flatter to gain good publicity and those who offer a round of drinks to make friends; the illustrious fat ones who notify us of their seventh heir, and those who announce their imminent matrimony, the unappreciated geniuses who bring us manuscripts to read, the unrepentant amateur actors who pursue us without respite; the barbaric poets and prose writers who poison our dinners, and the inventive shoemakers who want their portrait in the "Supplemento"; the blowhard singers who ask us to announce

their next concert and the angry swordsmen who want us to announce their jousts (173–174).

The salient note of the book is certainly the ferocious portrait of the miseries of Little Italy. Cianfarra is certainly not the only writer who applies himself to this theme. In his case, though, there is a surplus of emotional involvement, something that, secretly, seems the prelude to a detachment long brooded upon and now decided, even though in another passage of the book he succeeds in imagining, and in the most convincing way, a different future for this "displaced" humanity at the mercy of an uncertain fate that they all fail to recognize. The speech, almost a kind way to say farewell, is put in the mouth of an Italian journalist; and Guidi, despite libertarian inclinations, will be satisfied. The journalist says:

> I have a great faith in the virtue and energy of our people. I am a believer in the resurrection of this supposedly-dead Latin soul which will round off the sharp character of the Anglo-Saxon soul, giving them a bit of the enthusiastic and poetic temperament by which we unconsciously exalt virtue more than we should and consider evil always worse than its fatal and painful consequences. When I think how a people like the Irish, whose traditions tie them to a band of shepherds and fishermen as cold and dull as their sky, who not even the vivifying breath of the invading Romans could raise and educate, and whose history never even crossed the English Channel, managed here to become a powerful force; when I reflect that from such a womb today emerge judges and businessmen, writers and scientists, philanthropists and politicians; when I think that at the same time they contribute the most to poverty and prostitution, to criminality and alcoholism, I can do no less than see in my fellow countryman—sober and respectful, energetic and intelligent—the father of an upstanding citizen, of a type higher and more perfect than the American of the future.
>
> Today they call us "dagos"; today they scold us for our lack of hygiene, the frequent use of the knife; but all of this is nothing less than what the Danish shepherds used to say about the Scotch; what the Scotch and the Danish, Americanized and fused, repeated against the Irish, and what all three repeated against the Germans. Today they are four people formed into an homogenous unity, who insult and deride us. But tomorrow we too will become part of this unity and we will make our weight felt, the weight of a strong and healthy race, in whose blood runs infinite generations of vigorous tendencies and inclinations which one day made it glorious, and today render it agreeable; a race that maintains intact its characteristics after a millennium of servitude and infighting; that when it seemed dead knew how to rise and conquer its national independence. The future is ours! (99–100).

With the eruption of World War I in 1914, Cianfarra, back in Italy as manager of the Rome office of William Randolph Hearst's International News Service, was ready to record all the signs pointing to Italy's imminent entrance into the conflict. Italy entered the war in May 1915, and among the most prestigious European authors signed by the International News Service was another Abruzzese, more famous than Cianfarra: Gabriele D'Annunzio.

Near the end of the war, Cianfarra would take on important new professional responsibilities. In April 1918 he was preparing to return to the United State as a correspondent of the new Roman daily *L'Epoca* [The Age], a liberal-democratic publication founded in 1917. But that July he was instead hired by Henry Wood of the United Press for the Rome office of

the agency. It seemed to him a convenient position, since it would enable him to cast off a reputation he had earned as a journalist hostile to Italian interests.

As might be expected, Cianfarra did not present the elections of 1924 in a manner favorable to the Fascist point of view, noting that "the new Italian electoral law was devised to allow the fascists to remain in power whether the country wanted it or not," having to garner only 26 percent of the vote to seat two-thirds of the deputies.[6]

Cianfarra soon left the UP to write for the *Chicago Tribune*. It was there that in the first months of 1925 he first met George Seldes, European correspondent for the paper. The collaboration with Seldes resulted in a great affection for the Italian journalist and the American treasured the memory of "Chan" during his very long life (1890–1995). Several of Seldes's books bear witness to a kind of crash course by Cianfarra on political and social questions. Camillo, "a cultured, broad-minded liberal, a friend of [Giovanni] Amendola and yet no narrow enemy of Fascismo,"[7] taught Seldes everything there was to know on relations between the Fascist regime and the Catholic Church—the two most interesting themes for a foreign correspondent in Rome—in the course of long conversations that took place in his Rome office every week, and that continued for several months, occasionally at other venues, with Seldes always in Cianfarra's tow. (For example they went to Naples to witness the liquefaction of the blood of San Gennaro).

Cianfarra's work on certain subjects potentially led to personal risks in a country that was by now marching inexorably toward totalitarianism. In Seldes's book, *You Can't Print That! The Truth Behind the News, 1918–1928* (1929), there is a chapter titled "Mussolini's Siberia," which speaks of the practice of *confino*, by which political opponents were sent to internal exile in remote places in Italy and to Italian islands.[8] The author tells how journalist James Vincent Sheehan, after having received several clandestine letters describing the living conditions of the *confinati* on one of the islands, tried to disembark on that very island, but then found himself confronting guards in black shirts who had replaced the penitentiary guards and who kept even local islanders from having contact with the political detainees.

"Violence marks the islands as well as the mainland regime" he wrote, but this was, Seldes noted bitterly, a situation of little interest to American editors who did not wish to "offend" Mussolini, even though—as Sheehan had said—a reporter armed with enough cash could easily penetrate the Fascist jails on the islands.[9] It was Cianfarra who explained to him the history of *confino* in Italy: not a new story, because it went back to the years of the repressive Crispi government against subversive movements, and, more generally, against criminality. From the little islands off Sicily, as Cianfarra put it, it might happen that a prisoner was allowed to "escape" to America. Among other things, Seldes had been charged by his Chicago newspaper to investigate the Italian origins of organized crime in that city—this was during Prohibition and the rise of Al Capone. Cianfarra, described by Seldes as "a former member of the Italian embassy in Washington, an expert on emigration, a cultured man and a liberal thinker," gave Seldes "very interesting information." In particular, he explained the earlier manner in which judges, especially Sicilian judges, "made it a practice to suggest to members of the Mafia and other habitual murderers, cut-throats and bandits, to emigrate to the United States." At a time when the death penalty had been abolished in Italy (although Fascism would reintroduce it) *confino*, in addition to being a burden on public expenditures, always carried the risk of escape and a return to one's native town. "The judges therefore suggested the name of a boat a week or so before the criminal was to be sentenced, and in nine cases out of ten Italy thereby rid herself of a bad citizen and the United States gained one."

This practice was common in the last years of the nineteenth century and the beginning of the twentieth. But now, under the Fascist regime, it changed: judges no longer offered

prisoners an alternative, and, with the 1924 passage of the Johnson-Reed Act, the United States imposed rigorous conditions on immigration. In any case, sending criminals abroad, Seldes observed (perhaps primed by Cianfarra), would have been too dangerous, "because in other lands there is freedom, of voice and press, and the exiled editor or politician could remain an active force opposed to Fascism."[10]

Everything exploded on 10 June 1924, the day on which the Honorable Giacomo Matteotti, Socialist Deputy in Parliament, disappeared, initiating a truly "insane period." Matteotti had delivered a blistering speech in the Chamber of Deputies on 30 May, carefully delineating Fascist atrocities in the recent election. These were days of uncertainty and dismay, of wild rumors and sensational news that often could not be verified. The opponents of the regime watched the events, hoping that the fatal hour had arrived for Mussolini. Matteotti's body was found nine weeks later in the Roman countryside. It soon became apparent that some of the highest-ranking members of Mussolini's regime were responsible for his assassination.

Actually, since June the newspapers had speculated on a connection between the kidnapping of Matteotti and Fascist politics. In the *Chicago Tribune*—which still continued to refer to Mussolini as "the leader who saved the nation from communism"—on the same day in which the newspaper had published on its entire front page with large font "Dictator of Italy Totters," there appeared two interesting articles. The first, written by the Paris correspondent, after having explained that the king had considered the possibility of forming a new cabinet (without, however, excluding Mussolini), cited Roman sources to reveal that Matteotti, at the time of his kidnapping was carrying documents proving the culpability of several leading figures of Fascism in the bankruptcy of the Banco di Sconto two years earlier.

The second article, signed by the correspondent from Vienna, informed by a telephone call from Rome that had managed to evade censors, claimed that the fall of Mussolini could now be a question of days, and that the country was tired of the Fascist dictatorship and longed for the return of the Liberal government.[11]

In late December an article appeared in the *Chicago Tribune* reiterating the revelations and enumerated the misdeeds of the Fascists unveiled by former chief of the press office of the Ministry of Internal affairs, Cesare Rossi, referring to all orders given directly by Mussolini or actions he had approved: the "punishment" inflicted on the deputy Misuri by Italo Balbo, the order given to De Bono to punish the minister [Giovanni] Amendola for his firm opposition, the killing in Milan by Cesare Forni, the devastation of [Francesco] Nitti's home; then there was the Paris mission financed by the Secretary [Aldo] Finzi for the murder of an anti-Fascist. A web of crimes that, according to the newspaper, recalled the era of the Borgias.[12]

In his biography of Mussolini in 1936, Seldes would explain how Cesare Rossi, after Mussolini's speech to the Chamber of Deputies on the Matteotti case [3 January 1925], "saw himself made the sacrificial goat of the hierarchy" and that was why he decided to disappear from circulation. Before doing so, however, he wrote a confession that was entrusted to Virgili telling him to make it public only in case the Duce betrayed him. He also sent a similar warning to Mussolini. In that *memoriale* (memorandum) was the list of actions ordered by Mussolini; a second *memoriale* then contained the list of thirty-seven other killings and "clubbing orders or suggestions" of the Duce. Filippo Filippelli, director of the *Corriere Italiano* [Italian Courier], involved in the kidnapping of the Socialist deputy, had become untraceable and had entrusted the journalist Filippo Naldi with a *memoriale* with charges against Mussolini, Amerigo Dumini and Rossi himself. Aldo Finzi, Undersecretary of the Interior, had drawn up a will, and he had given it to his friend Giorgio Schiff-Giorgini and Carlo Silvestri of the Milanese newspaper *Corriere della sera* [Evening Courier]. Finzi's brother, Gino, had told everything to Guglielmo Emanuel, the Rome correspondent of the *Corriere della sera*

and also (after Cianfarra went to the UP) of the International News Service and the *New York American*.[13]

Later, however, Seldes would change his version of the events, asserting that the reason for silence on the Matteotti case was simple: Salvatore Cortesi of the AP was Fascist, and he was Mussolini's "chief publicity man." His son, Arnaldo, was a "super Fascist" and also the Rome correspondent of the *New York Times*. Incidentally, Seldes's predecessor at the *Tribune*, Vincent De Santo, was also a Fascist. As for several other "liberal" journalists living in Rome, every one told Seldes that if he made public the true story concerning Matteotti, "the Duce would not hesitate to have me killed." They had the confessions of Rossi and Filippelli, and everyone also knew that they contained elements of particular interest to the American public, since Amerigo Dumini, the man responsible for the assassination, was a gangster who was born in Saint Louis and bred in the worst slums of America. Most importantly, the speech that Matteotti was preparing to read the day of his abduction proved that Sinclair Oil and its leader Harry F. Sinclair had corrupted men in the government in order to obtain a monopoly over oil in Italy.[14]

> It was indeed a story to rock the world. I sent it by mail via the Paris office of the *Tribune* and warned them not to let the Paris edition print it because I might be killed if they did. The next morning the Paris edition was sold throughout Europe with the Matteotti assassination featured, my name signed to it.[15]

On 6 January 1925 the *Chicago Tribune* published an article with the headline "Fascisti in Rome Imprison *Tribune* Correspondent." The following day the same American daily published another article headlined "Italy Subdued by Fascist Lash of Mussolini." The piece recounted the tranquility in Rome after Prime Minister Mussolini had, apparently, maintained his promise to crush "subversive forces" within 48 hours.

At the same time, the Viminale was conducting its own inquiries. A coded telegram from the Italian embassy in Paris asked if Cianfarra, was either "an Italian or American subject," a detail obviously not irrelevant regarding his legal-judicial fate. The Director of Public Safety consulted with the prefect of Chieti who, after a few days, telegraphed his response: it seemed that Cianfarra had not acquired American citizenship; his name was still listed on the voting lists of Lama dei Peligni.[16]

Seldes reached Rome and his 4 March 1925 article was truly a bombshell. "Link Mussolini With Murder by New Document," presented a copy of Cesare Rossi's second *memoriale* in which the former press secretary of the Ministry of the Interior accused Mussolini with complicity in the assassination of Matteotti as well as other acts of political terrorism. The article explained that the *Chicago Tribune* had come into the possession of the smoking gun, and it presented it as a scoop received from a source in Milan. It reminded the paper's readers that both the first and second documents had been obtained "in an ethical journalistic manner"; and it stated how, after the *Tribune* had revealed the contents of the first Rossi *memoriale*, approximately six thousand homes had been raided, while, in a clear reference to Cianfarra, "one of the *Tribune*'s correspondents, whose house also was searched, was interrogated by the police after his arrest."

The second Rossi *memoriale* was a letter addressed to Mussolini, in which Rossi asked for proof of friendship, not so much on a personal level, but on account of his past as a militant Fascist. If this proof of friendship was not forthcoming, Rossi was prepared to reveal all he knew about Mussolini's complicity in the Matteotti assassination. Seldes would later imply that Rossi's second *memoriale* had been given to him by Cianfarra.[17]

Seldes was expelled from Italy in July 1925. The expulsion was not, however, painless. On the first page of the 28 July 1925 *Tribune* was the headline "Fascisti Oust Seldes for His Tribune Cables." Other journalists had signed a letter to Ambassador Fletcher asking for a meeting with the undersecretary for Foreign Affairs, Dino Grandi, to protest against the treatment reserved for Seldes and threatening to request their editors to recall them in protest if Mussolini's government persisted in their actions against Seldes. The article pointed out that only the correspondents for the Associated Press and the *New York Times*—who were Italian citizens—refused to join the protest.

The next day (29 July) a harshly polemical article was published under the headline "Italian Medievalism Expels a Correspondent." It stated—among other things—that Fascist Italy was aligning with Soviet Russia: both were using a "cheka" [secret police] and whereas one was returning to its barbaric Asiatic roots the other, led by Mussolini who "acknowledges Machiavelli as a tutor and Caesar Borgia as a model," was returning to the Middle Ages, a false step considering Italy's need for credibility in both the tourist industry and foreign affairs.

To the charges that Seldes was prejudiced against the Fascist regime and Mussolini, the journalist replied that his correspondence, subject to systematic censorship, was "fair and impartial." On 30 July, the *Tribune* reported that the expulsion of Seldes "seems now to be the prelude to a revival of Mussolini terrorism in Italy."

Two days later Seldes wrote, "[F]ree now of the Mussolini dictatorship, I am at liberty to tell the truth about the municipal elections which will be held on Sunday in Sicily—facts which no European or American correspondent in Rome could send out without danger or being expelled from the country or of being killed."[18] He also pointed out the mortal danger of Fascism, a regime that represented the liquidation of every ideal and installed a single law: that of the gun.[19]

With Seldes expelled, Cianfarra remained entirely helpless before the aggression of a regime that already had the impudence to arrest him without any real reason. His colleagues at the *Tribune* must have been aware and in great anguish over having no way to help him. An article of 10 August 1925, "Fascist Watchdogs Keep on the Trail of Correspondent," written by an anonymous Roman writer for an English newspaper in its London office explained how "the life of a journalist in Italy, you know, is not particularly pleasant just now. I myself have had occasion several times to realize it. Last year for several weeks I had two *carabinieri* at my house door and two big policemen were drawn up on my movements as if I were a conspirator." The same day Seldes published an article on the obsession of the regime in controlling all means of information. It seemed the prelude to new, ominous news.

The ominous news arrived a few days later when the headline cried "Rome Terror Kills Writer for *Tribune*." Here is the text in full:

PARIS, Aug. 14—Camillo Cianfarra, assistant correspondent of THE TRIBUNE in Rome, died this morning from heart failure and complications resulting from his arrest and mistreatment by the Fascisti. He had been arrested and jailed as the result of his publication of the famous Rossi memorial in January.

Mr. Cianfarra never recovered from the effects of his imprisonment, and the recent expulsion from Italy of his chief, George Seldes, THE TRIBUNE correspondent, undoubtedly had an effect toward hastening his death.

Mr. Cianfarra was born in Abruzzo, of a noble family. He went to America about twenty years ago. He has represented numerous American newspapers and covered J. P. Morgan's death. At one time as a member of the Italian embassy at Washington

he investigated numerous cases of Sicilian murderers who were given opportunities to go to America instead of having to serve in Italian jails.

Last January Mr. Cianfarra obtained a confession from one of the murderers of Giacomo Matteotti, millionaire Socialist deputy, whose death caused a sensation throughout Italy and even rocked the foundation of the Fascisti party. This confession was signed by Sig. Rossi, the head of Premier Mussolini's press bureau of the foreign office, and it betrayed the fact that Sig. Mussolini had approved the murder.

Following the receipt of Mr. Cianfarra's cable in America giving the news of the confession he was arrested. His house and those of 1,200 other non-Fascists were searched in an effort to find the original document. Mr. Cianfarra's release was obtained by John Clayton of THE TRIBUNE staff through the intervention of the American embassy at Rome with the Italian foreign office.

However, Mr. Cianfarra's health was completely ruined by his sufferings in prison. When Mr. Seldes was expelled from Rome some members of the Fascisti openly said that they would have Mr. Cianfarra's life, and he was completely terrorized.[20]

In his 1929 book, Seldes wrote that Cianfarra "died two weeks after my expulsion from Rome, from heart failure, as a result of being beaten up by Fascisti, apparently for the reason that he helped me obtain the documents which charged Mussolini's complicity in the Matteotti assassination" (137).

Much later, recalling that dark season and how he had "escaped being murdered on the *Orient Express* by Mussolini's *squadristi*," he wrote that the Fascists had assaulted Cianfarra and "he could never recover with so many of his bones broken and splintered." Seldes had foreseen that tragedy and had telegraphed Colonel McCormick at the State Department to ensure protection of Cianfarra. But, at the time, Seldes's bitter conclusion was that the embassy in Rome—as so many others—was "in the hands of self-styled diplomats—men who contributed big money and got embassies in exchange from victorious Presidents—who were in reality an American brand of Fascisti. Ambassadors and ministers representing the United States were the worst offenders in labeling, branding, name-calling: liberals and especially Socialists were called 'Reds' and 'Communists' and therefore everything done against them was justified."[21]

Translated by Stanislao G. Pugliese

Further Reading

Cianfarra, Camillo. "An Emigrant's Diary," in Francesco Durante, *Italoamericana: The Literature of the Great Migration, 1880–1940*, edited by Robert Viscusi. New York: Fordham University Press, 2014, 210–230.

Maranzana, Stefano. "Honor and Shame in the Italian Colony: The Diary of Camillo Cianfarra," *South Atlantic Review*, 81.1 (Spring 2016), 157–173.

Marazzi, Martino. "An Immigrant's Memoir: Camillo Cianfarra," in *Voices of Italian America: A History of Early Italian American Literature With a Critical Anthology*, edited by Marazzi, trans. Ann Goldstein. New York: Fordham University Press, 2012, 113–121.

Notes

1 This essay is a translated excerpt from a longer work to be published by Marsilio in 2017.
2 Camillo Cianfarra, *Il diario di un emigrato* (New York: Tipografia dell'Araldo Italiano, 1904). Citations to pages in the diary appear between parentheses in the text.
3 On Roversi, see Durante, *Italoamericana* [American ed.], 26–30.

4 *L'Araldo Italiano* [New York] (4 October 1904).

5 The critical reception of Cianfarra's book, attested over time by several Italian American journalist colleagues, among them Agostino De Biasi, who claimed that it was one of the very few to be saved from "a stupendous and crackling bonfire" ("Il libro della Vita Italiana in America," *Il Carroccio*, 14.5 [November 1921], 631–633), but also in other sources such as the book by Robert Franz Foerster, *The Italian Emigration of Our Times* (Cambridge: Harvard University Press, 1919), 392; and especially as cited recently by several contributions: Marina Cacioppo, "*Se i marciapiedi di questa strada potessero parlare.* Space, Class, and Identity in Three Italian-American Autobiographies," in *Adjusting Sites: New Essays in Italian American Studies*, ed. William Boelhower and Rocco Pallone, "Forum Italicum," Filibrary Series, n. 16; Martino Marazzi, *Misteri di Little Italy: Storie e testi della letteratura italoamericana* (Milan: Franco Angeli, 2001), 30–1; Durante, *Italoamericana* [American ed.], 210–230; Stefano Maranzana, "Honor and Shame in the Italian Colony: The Diary of Camillo Cianfarra," *South Atlantic Review*, 81.1 (Spring 2016), 157–173.

6 The so-called Acerbo Law was an undermining of democracy. Camillo Cianfarra, "Sunday Italians Go to Polls," *Madera Daily Tribune* (5 April 1924), one of the many articles he published in American newspapers.

7 George Seldes, *You Can't Print That! The Truth Behind the News 1918–1928* (New York: Payson & Clarke, 1929), 126.

8 "*Confino*" entailed placing political opponents on hard-to-reach islands (such as Ponza, Ventotene or Lipari) or in remote villages in the Mezzogiorno. Classic examples of the experience are Carlo Levi, *Christ Stopped at Eboli*, trans. Frances Frenaye (New York: Farrar, Straus, Giroux, 2006) and Cesare Pavese's *The Political Prisoner*, trans. Walter J. Strachan (London: Peter Owen Publishers, 2007) and *The House on the Hill*, trans. Strachan (New York: Walker & Co., 1961). Altiero Spinelli's "Manifesto di Ventotene" (1941), in which he and others called for a united, liberal and free Europe, was written while in *confino*.

9 Seldes, *You Can't Print That!*, 136.

10 Ibid., 136–137.

11 Henry Wales, "Mussolini Hit by Kidnaping of Socialist," and John Clayton, "Mussolini in Peril," *Chicago Tribune* (17 June 1924).

12 John Storer, "Italian Premier Is Accused of Fascist Crimes," *Chicago Tribune* (28 December 1924).

13 George Seldes, *Sawdust Caesar: The Untold History of Mussolini and Fascism* (London: Arthur Barker, 1936), 143.

14 On the financial ties between Fascist Italy and the United States, see Gian Giacomo Mignone, *The United States and Fascist Italy: The Rise of American Finance in Europe*, trans. with a preface by Molly Tambor (New York: Cambridge University Press, 2016); in Italian see Mauro Canali, *Il delitto Matteotti* (Bologna: Il Mulino, 2004).

15 Seldes, *Witness to a Century*, 219.

16 Telegram from the Italian Embassy in Paris to the Direzione generale di pubblica sicurezza, 6 January 1925, and telegram from the Direzione generale di pubblica sicurezza to the Italian Embassy in Paris, 10 January 1925, Archivio Centrale dello Stato, Pubblica Sicurezza, cat. A4, busta 87.

17 George Seldes, "Fascisti Organ in Rome Attacks *Tribune* Writer," *Chicago Tribune* (26 April 1925).

18 George Seldes, "Sicily Cowers Under Fascist Ballot Terror," *Chicago Tribune* (1 August 1925).

19 George Seldes, "Fascism Drops Ideals, Rules Italy by Pistol," *Chicago Tribune* (3 August 1925).

20 With the title "Imprisonment Leads to Reporter's Death" (and with a summary that claimed Cianfarra had been "tortured by Fascisti") the same article was published on the same day in *The Washington Post*, and, with the title "Blame Fascisti Tortures for Death of Writer Who Got Murder Confessions," in the *Buffalo Express*. The news of Cianfarra's death was also reported in the *Ogden Standard-Examiner* (16 August 1925), which also mentioned that the house of the journalist had been devastated by Fascists at the time of his arrest.

21 Seldes, *Witness to a Century*, 222.

Part III

BECOMING AMERICAN AND CONTESTING AMERICA

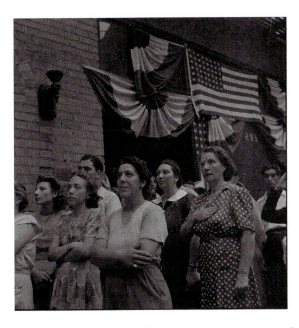

Frontispiece III A Italian Americans in the rain watching a flag raising ceremony at the Feast of San Rocco. New York City, 1942. Photo by Marjory Collins. Library of Congress.

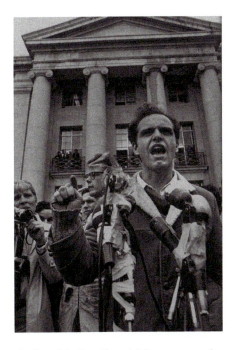

Frontispiece III B Mario Savio, a leader of the Free Speech Movement, on the steps of Sproul Hall, University of California, Berkeley. 1 January 1965. Photo by Bill Ray. The *LIFE* Picture Collection/ Getty Images.

THE BUMPY ROAD TOWARD POLITICAL INCORPORATION, 1920–1984

Stefano Luconi

As newcomers themselves or descendants of immigrants, Italian Americans have engaged in U.S. politics at two different but interrelated levels. On the one hand, they have registered for the vote, cast their ballots on election days, campaigned for public offices, served in legislative and executive posts, and contributed to shaping the policies of their receiving country. On the other, they have exploited their electoral clout and mobilized to lobby the U.S. government and Congress in behalf of the interests and claims of their own ancestral land. Whereas the latter activities have progressively yielded to the former, Italian Americans have increasingly assimilated within their adoptive society. Likewise, candidates of Italian ancestry have reached accommodation, as they have no longer focused on ethnic issues and relied on the votes of the members of their own immigrant minority to get elected. In their case, however, the "Mafia" stereotype, namely the prejudicial view that people of Italian descent are somehow connected to organized crime, has long curbed Italian Americans' rise in politics.

World War I and the Early Interwar Years

World War I marked a major turning point in Italian Americans' political experience after decades of apathy. As their ethnic leaders and newspapers hailed Italy's 1915 entry into the conflict with bombastic patriotism, many immigrants and their children rallied to sustain the military efforts of their motherland.[1] The 1917 U.S. intervention at the side of Italy against Germany and, later on, Austria-Hungary induced newcomers to drop any previous restraint in supporting their native country.[2] Wartime jingoism turned into advocacy of the Italian government's nationalistic demands at the peace conference. Specifically, by a large resort to letters and petitions, Italian Americans and their ethnic organizations endeavored to pressure Washington into allowing the extension of the Italian borders eastward to include the Croatian port city of Fiume. When Democratic President Woodrow Wilson refused to yield to this claim, voters of Italian descent retaliated by going over en masse to the GOP in the 1920 election for the White House.[3] The leitmotif of Republican Fiorello H. La Guardia's campaign, after he had served as a major in the U.S. Air Force on the Italian front, was that "any Italo-American who votes the Democratic ticket this year is an Austrian bastard."[4] Likewise, in Boston the *Gazzetta del Massachusetts* [The Massachusetts Gazette], the leading local Italian-language newspaper, urged its readers to vote a straight Republican ticket to repay Wilson in kind for "the insults perpetrated against Italy and her aspirations."[5] Its counterpart in Chicago, *La Tribuna Italiana Transatlantica* [The Italian Transatlantic Tribune], similarly came out for the GOP.[6] Consequently, between 1916 and 1920, the Italian American vote for the Democratic Party fell from 63 percent to 47 percent in New York City, from 63 percent to 43 percent in Boston, and from 68 percent to 31 percent in Chicago.[7]

On the occasion of the 1928 race for the presidency, Italian Americans' political mobilization got into full swing. This phenomenon arose in response to the ethnic appeal of Alfred E. Smith, the Democratic standard bearer for the White House. The governor of New York State, Smith was a Catholic of Irish ancestry. As such, he was the first presidential nominee of a major party who did not belong to the Anglo-Saxon and Protestant establishment that had theretofore exerted a virtual monopoly over American politics. Therefore, although he was overwhelmingly defeated by his Republican opponent Herbert Hoover, Smith became almost overnight the political champion of voters from ethno-cultural and religious minorities who had until then remained politically apathetic but now crowded the polling places because they were eager to cast their first ballot for a candidate they could eventually identify themselves with.[8] The fact that Smith was of Italian ancestry on his mother's side was still unknown at that time.[9] But, in view of his faith and other-than-Anglo-Saxon roots, "it was as if an Italian was running for president."[10] Especially after the Ku Klux Klan had re-elaborated its prejudicial sense of Americanism and extended the targets of its original anti-black hostility to include white immigrants who were not Protestants, Smith's bid for the White House encouraged Catholic groups to join forces across any national divide against intolerance and xenophobia.[11]

Smith brought out individuals who had previously been inactive in politics. Actually, Italian Americans bulked large among the 1928 new voters. For example, their turnout rose by 21 percent in Philadelphia, by 54 percent in Pittsburgh and by 107 percent in Boston's North End between 1924 and 1928.[12]

Support for Smith also marked the return of the Italian American electorate to the Democratic camp after the 1920 bolt to the GOP. Specifically, with reference to the 1924 presidential election, the following for the Democratic Party increased from 3 percent to 57 percent in Philadelphia, from 31 percent to 63 percent in Chicago, from 6 percent to 67 percent in Pittsburgh and from 48 percent to 77 percent in New York City.[13] In the same years, at the state level, the Italian American vote for the Republican Party dropped from 70 percent to 20 percent in Massachusetts, by 50 percent in New Hampshire, by 60 percent in Rhode Island and by 65 percent in New Jersey.[14]

The New Deal

Democrat Franklin D. Roosevelt built on Smith's large majority in the Little Italies in his 1932 successful bid for president against Hoover in the aftermath of the economic depression ensuing the 1929 collapse of the stock market. Specifically, he outdid his predecessor's performance on the Democratic ticket in Chicago, where Roosevelt polled 64 percent of the Italian American vote, New York City, where he obtained 80.5 percent, and San Francisco, where he received 90 percent as opposed to Smith's 78 percent.[15]

Italian Americans suffered the devastating effects of the Depression from East Harlem to San Francisco's North Beach. They probably "had the highest rates of unemployment of any European ethnic group."[16] Loss of jobs freed working-class voters from the political coercion by employers that had previously caused their allegiance to the GOP. Moreover, the incumbent Republican president was held responsible for the failure both to prevent the downward economic turn and to cope with its consequences effectively. A common joke among voters of Italian ancestry was that "Hoover must have lost the 1928 elections. He promised prosperity if he was elected, but most of us were out of work in a year."[17] The shrinking of the patronage resources of the Republican urban machines in hard times and their consequent troubles in rivaling with their Democratic counterparts in cities such as Pittsburgh and Chicago also loosened the GOP hold over the Italian American electorate.[18]

Indeed, the only large community Hoover managed to carry in 1932, though by a small plurality (52.5 percent), was Philadelphia's Little Italy because the local Republican organization managed to take care of the destitute and the unemployed by operating relief kitchen and welfare committees that distributed food, clothes, as well as buckets of coal besides paying utilities bills.[19] East Harlem voters of Italian descent were so disenchanted with the GOP that they even dumped La Guardia, who lost his 1932 reelection bid to fellow ethnic Democrat James J. Lanzetta amid charges that he had neglected his needy constituents to play "the statesman in Washington."[20]

The protest against Hoover and the GOP in 1932 turned into a mandate for the Democratic Party in 1936. In four years the Italian American vote for Roosevelt grew, for instance, from 46.4 percent to 65.1 percent in Philadelphia and from 62.0 percent to 83.5 percent in Pittsburgh. It also remained stable at around 86 percent in Baltimore.[21] Overall, 88 percent of the Italian American electorate supported the president in cities with more than ten thousand residents.[22] Indeed, this immigrant minority was a key component of the New Deal ethnic coalition that enabled Roosevelt to serve in the White House for four consecutive terms. Yet, the realignment toward the Democratic Party underwent a three-stage process. Italian Americans initially sided with this party in 1928 in response to ethnic motivations, reaffirmed their allegiance in 1932 out of economic determinants, and consolidated their allegiance in 1936 following a combination of both stimuli with a prevalence of the latter. In addition, their Democratic attachment resulted less from the conversion of former Republican supporters to Smith and Roosevelt than from the mobilization of theretofore inactive electors. Actually, the Democratic Party succeeded in gaining the consensus of an emergent cohort of recently eligible Italian Americans. These new voters were the immigrants' U.S.-born and English-speaking children, who enjoyed the citizenship and linguistic qualifications that their fathers and mothers lacked. As the second generation came of age and entered the participating electorate, some of their parents also took action to meet the main requirement for the suffrage. The closing of the era of mass immigration to the United States encouraged those who already resided in the country to settle there permanently and to acquire American citizenship. As journalist Franco Ciarlantini pointed out, "Italians definitively became players in the great game of the powerful Republic." The misperception that foreign nationals would be excluded from public assistance during the Depression also prompted naturalization.[23]

The New Deal largely benefited Italian Americans. Workers of Italian descent profited from its labor legislation and went to the polls to protect its achievements, such as Section 7a of the 1933 National Industrial Recovery Act and its reinstatement with the 1935 Wagner Act. In activist John Ghizzoni's words, these measures, which guaranteed the rights to unionization and collective bargaining, enabled workers to "feel that they are once more free men."[24] As a growing number of Italian Americans joined the labor movement, the unions themselves became key vehicles for their political mobilization. Luigi Antonini played a pivotal role against this backdrop. An immigrant from the province of Avellino, he made Local 89 of the International Ladies' Garment Workers' Union, grouping Italian-speaking dressmakers, into the largest labor organization nationwide with an estimated membership of forty thousand affiliates in 1934. Two years later, in view of the 1936 presidential elections, Antonini was the co-founder and the chairperson for New York State of the American Labor Party, a political house for those workers who wanted to reelect Roosevelt but refused to cast their ballots for the whole Democratic slate.[25]

In addition, an increasing number of immigrants and their children relied upon government assistance. For instance, they accounted for 21 percent of the youth on New York City's relief rolls and for nearly one third of the foreign-born laborers in Pennsylvania's

federal construction projects.[26] They were also overrepresented among the foremen of the Works Progress Administration (WPA) in Pittsburgh and the recipients of federal aid in Providence.[27]

The politicization of relief shifted the hold over the Italian American electorate from the Republican organizations to the Democratic machines. In Providence, for instance, Thomas F. Luongo reportedly controlled about fifteen thousand Italian American votes as the distributor of the federal and state spoils in behalf of Democratic Senator Theodore F. Green.[28] Partisan connections were instrumental to securing fast and good employment with the WPA as well. "If you are qualified—a Bostonian of Italian ancestry was told—you can get on without going to a politician. But it will be four weeks before you get certified, and I can push things through so that you can get on in a week. And I can see that you get a better job."[29]

Lanzetta's previously mentioned experience suggests that the Democratic Party engineered its own tickets in order to mobilize Italian Americans and to consolidate its own following among them. As this immigrant minority complained about its underrepresentation in politics,[30] Roosevelt's party played the trump card of political recognition. It ran a few community leaders in federal and local elections in the hope of inducing their fellow ethnics to cast straight ballots at the polls. This, for instance, was the case of Edward A. Bacigalupo, who successfully stood for the Massachusetts House of Representatives from Boston's North End in 1934.[31] Female candidates—such as Anna Brancato, who became a member of the Pennsylvania General Assembly from South Philadelphia's Little Italy in 1932—were also placed on the Democratic tickets so as to help Italian American women overcome the idea of separate gender spheres that had previously led many to exclude themselves from electoral politics.[32] The Democratic Party further ingratiated itself with residents of the Little Italies by having some of them appointed to public offices at various levels. For example, Governor George H. Earle III of Pennsylvania chose an Italian American, Charles Margiotti, as the state attorney general in 1935.[33] Likewise, the following year, Roosevelt nominated the first federal judge of Italian descent, Matthew Abruzzo.[34]

A few Italian American politicians broke ranks with local Democratic organizations to launch careers of their own. In Baltimore, for instance, Thomas D'Alessandro turned his back at fellow-ethnic Congressman Vincent Palmisano and ran a successful campaign to replace him in the U.S. House of Representatives in 1938.[35] Others managed to reach out to much wider constituencies than the small world of their respective ethnic communities and established themselves at the helm of municipal administrations in large cities. Republican Angelo J. Rossi became mayor of San Francisco in 1931 and retained his post until 1944.[36] La Guardia served in the same position in New York from 1934 to 1945.[37] Democrat Robert Maestri held the identical office in New Orleans between 1936 and 1946.[38] Vito Marcantonio, La Guardia's protégée, defeated Lanzetta and won East Harlem's seat in Congress in 1934 and 1938, after an incidental defeat in the wake of Roosevelt's 1936 landslide. Nominally a Republican, Marcantonio was in fact a maverick who flirted with communism and backed the New Deal from a much more progressive stand. A supporter of independence for Puerto Rico, he capitalized on the growing presence of immigrants from this island among his own constituents. He also forged a well-oiled political machine whose jobs and services kept Marcantonio in Washington until his opposition to the U.S. intervention in the Korean War caused his defeat in 1950.[39]

Other Italian American leaders held no elective offices and confined themselves to the role of brokers between their ethnic community and the political establishment. Most prominent among them was Generoso Pope. A New York City-based wealthy contractor in the field of construction materials who largely profited from political connections and ties to underworld figures for his lucrative business, he also owned the Italian-language daily with

the largest circulation in the North East, *Il Progresso Italo-Americano* [The Italian-American Progress], besides a number of other ethnic newspapers. He resorted to his press chain to bring out the Italian American vote for Roosevelt and the Democratic candidates in local, state, and federal elections. Although Pope's influence among his fellow ethnics was a gross exaggeration that his own propaganda machinery had purposely contributed to making, such an alleged clout was instrumental to his appointment to chairperson of the Italian division of the Democratic Party in 1936.[40]

Italian Americans' political rise and activism in the 1930s induced the Fascist regime to resort again to their lobbying pressures. With Pope's unqualified cooperation, Mussolini's henchmen managed to mobilize voters of Italian ancestry between the fall of 1935 and the winter of 1936 to prevent Congress from passing an embargo on the exports of American oil, scrap metal, and trucks that would have jeopardized the *Duce*'s colonial venture in eastern Africa during the Italo-Ethiopian War. Yet, a similar campaign against changes to U.S. neutrality legislation after the outbreak of World War II resulted in a complete failure. Facing the alternative between the backing of their motherland's expansionistic goals and the allegiance to their adoptive country, Italian Americans chose the latter almost unanimously.[41]

World War II and Its Aftermath

Loyalty to the United States did not mean that voters of Italian descent were impervious to the repercussions of Washington's foreign policy on their own life and standing in American society. Roosevelt's stigmatization of Italy's eleventh-hour attack on France in June 1940 with the reproachful metaphor "the hand that held the dagger has stuck it into the back of its neighbor" triggered fears for the resurgence of anti-Italian xenophobia and intolerance in the United States.[42] In addition, the president's statement seemed the first step toward a declaration of war on Italy, a country where many Italian Americans still had relatives and friends. As a result, their vote for Roosevelt underwent a decline nationwide from 88 percent in 1936 to 75 percent in 1940. In particular, it fell from 85 percent to 63 percent in Boston, from 83.5 percent to 73.8 percent in Pittsburgh, and from 65.1 percent to 53.4 percent in Philadelphia. The president even failed to carry New York City's community, where he obtained only 42.2 percent of the Italian American ballots.[43]

It was the political patronage that helped curb Italian Americans' defection from the Democratic camp in 1940. In Boston, for instance, voters who retained a favorable opinion of Roosevelt were mainly those on federal relief and low-income individuals went over to the GOP in a smaller number than their more affluent fellow ethnics.[44] Similarly, in New York, support for the president was higher than the city average in lower-class neighborhoods where residents still benefited from federal assistance.[45]

The vote for Roosevelt further shrank after the United States found itself at war with Italy. In 1944 the president polled 68.2 percent in Pittsburgh, only 41.2 percent in Philadelphia, and as little as 33 percent in New York City.[46]

Following the outbreak of the military conflict between Italy and the United States, the designation of unnaturalized immigrants as enemy aliens, which also involved restrictions on civil rights, and the relocation of a few of them from the Pacific coast to internment camps in inland areas made the previous fears of anti-Italian intolerance real.[47] The former measure was revoked in less than a year, on the eve of the 1942 mid-term elections. Attorney General Francis Biddle called this decision a deed of "good politics."[48] Actually, Italian Americans had become such a pivotal component of the New Deal ethnic coalition that the Democratic Party did not dare alienate them by discriminating against their unnaturalized relatives. To secure their votes, Roosevelt did not break with Pope either and spared him detention

because the president was advised that the owner of *Il Progresso Italo-Americano* was a key figure to reach out to the electorate of the Little Italies. The Office of War Information made a point of stressing that "Pope's influence upon the opinion of the American Italians, especially in the eastern centers, is considerable."[49] Therefore, notwithstanding the publisher's blatant support of Mussolini before 1941, Roosevelt himself noted in a 1944 memorandum "I do not think it is true that Pope had Fascist tendencies. He merely 'hunted with the hounds' chiefly as a business proposition."[50]

The repeal of the enemy alien status, however, was not enough to reconcile Italian Americans with Roosevelt. To many of them the war with their motherland was "one of fratricide."[51] A Democratic worker recalled that "to these people the war was not against Fascism and Nazism, against Mussolini and Hitler, but against Italy, their real motherland. Campaigning for the Democratic Party was not easy. [...] As soon as they heard Roosevelt's name they got angry and threw me out of their houses. 'Shame on you,' they said. 'You go around to tell us to vote for that damned cripple who sent our sons to kill our people.'"[52]

Italian Americans did not sever their affective ties to their ancestral country and "looked for a mirage: American victory without Italian defeat."[53] Therefore, after Italy signed an armistice with the United States in September 1943 and declared war on Germany the following October to make amends for her very recent pro-Nazi past, voters of Italian descent felt legitimized in lobbying the Roosevelt administration for their native country. They rallied behind a Congressional resolution, introduced by Marcantonio, calling for the formal recognition of Italy as an ally, so that she would qualify for U.S. military assistance and enjoy a better standing at the peace conference. They also urged Washington to deliver significant emergency humanitarian aid to the Italian people in the regions under American and British occupation. The U.S. government ignored the former demand (Italy was recognized only as a co-belligerent, not an ally) and was rather slow and ineffective in dealing with the latter, whereas the Republican presidential candidate seemed more responsive to their claims. Consequently, a few disappointed voters of Italian descent took on Roosevelt at the polls in the 1944 elections.[54]

Partially in response to the encouragement of Rome's ambassador, Alberto Tarchiani, Italian Americans did not scale down their pressures on Washington on behalf of their ancestral country after the end of the war.[55] They protested against the punitive peace treaty imposed on Italy and advocated U.S. concessions that would speed up the material and economic reconstruction of the country as well as restore her status as a Mediterranean regional power, although the Fascist regime had been responsible for a devastating military conflict. To achieve their goals, Italian Americans did not hesitate to appease President Harry S. Truman's international strategy based on the containment of communism and to exploit the dynamics of the Cold War as a political opportunity. They even outdid Washington with their zeal in the anti-Marxist fight. Specifically, on the occasion of Italy's 1948 parliamentary elections, Italian Americans embarked on a letter-writing campaign by which they aimed at persuading their kinsfolk and acquaintances who still lived in their ancestral land not to vote for the candidates of the Communist-led *Fronte Democratico Popolare* (People's Democratic Front). At the same time, however, they continued their efforts to win benefits for Italy from the Truman administration. These two mobilizations usually interwove with each other. Italian Americans participated in the anti-Communist crusade to further the interest of the U.S. government in their ancestral land. They usually argued that, unless the United States intervened to improve Italy's economic conditions and standing in the world arena, the Italian Communist Party would seize power by cashing in on the Italian people's dissatisfaction with their country's domestic hardships and international humiliation. Lawyer Victor J. Anfuso, among others, contended that "the Communists in Italy were taking advantage of

starving Italians by promising them the 'best' providing that they voted on the Communist ticket." The rejection of communism, therefore, became a political asset to show off the loyalty of Italian Americans to the United States after their prewar flirtation with Mussolini, to dispel suspicions about their alleged double allegiance, to legitimize their efforts as a pro-Italy lobby, and to gain a more influential voice in Washington when they advanced Rome's demands at the Department of State, in Congress, and at the White House.[56]

Truman yielded to some of these demands. Most notably, the president included Italy among the beneficiaries of the European Recovery Program, or Marshall Plan, which provided overall for $12 billion (roughly $120 billion in 2016 dollars) in economic aid between 1948 and 1951. In four years Italy received roughly $1.34 billion, namely 10.9 percent of the total amount.[57] As a result, Italian Americans' political dissatisfaction with the Democratic Party did not last long. In 1948 Truman not only carried the Italian American community nationwide, but he also regained a significant share of the votes that Roosevelt had lost in 1940 and 1944. For instance, he obtained 85 percent of the Italian American vote in Boston. Truman succeeded in revitalizing the participation of this nationality group in the New Deal ethnic coalition on the grounds that his administration had both saved Italy from communism and paved the way for her postwar economic reconstruction.[58]

It is likely that Truman also benefited from the gratitude of the Italian American community as the 1944 Servicemen's Readjustment Act, or G.I. Bill, began to take effect and let a growing number of veterans get vocational training, start a business of their own, attend college, and relocate to the suburbs thanks to government low-interest loans and payment of tuition costs. Actually, this piece of legislation made many second- and third-generation immigrants' American dream come true. Angelo Gualdaroni remarked that "when the war ended in 1945, [...] I had basically nothing to show for my life. But then all those G.I. benefits kicked in. I was able to buy a home [...] and enroll in the Robert Morris School of Accounting [...]. I landed a solid, long-term job. [...] my brother [...] was able to purchase a house near mine and to open Gualdaroni's Grocery." His fellow-ethnic working-class veteran Samuel R. Sciullo recalled that he "had entered law school in 1947—taking advantage of the G.I. Bill," which later enabled him to become a successful attorney.[59] For another ex-soldier, the Servicemen's Readjustment Act "made it possible to live in a house that had [at least] three cubic inches of grass and assured status. If you moved to the suburbia, you would finally find the recognition from the larger America that the people in the old neighborhood had always wanted."[60]

A.J.R. Groom has argued that Washington's decision to support Italy's request for a trusteeship in her pre-Fascist colony of Somaliland under the auspices of the United Nations "was very much influenced by the ethnic Italian vote in the 1948 presidential elections."[61] If so, the clout of Italian Americans' transnational political involvement reached its climax in 1948. In the same year, however, their domestic power also gained momentum. Besides the contribution of the Little Italies to Truman's victory, eight candidates of Italian descent won a seat in the U.S. House of Representatives, whereas no more than four Congressmen from Italian background had served in Washington in any previous year. In addition, the number of the Italian American members of the state legislatures in the Northeast doubled after the 1948 elections.[62]

Nonetheless, it was the next couple of years that witnessed Italian Americans' political coming of age. In 1949 Carmine De Sapio snatched the leadership of Tammany Hall from Manhattan borough President Hugo E. Rogers with the backing of mobster Frank Costello, crowning the transition of urban machines from the Irish hold to the Italian American control. But, as partisan organizations were on the verge of collapse, the new ethnic bosses were unable to promote their revitalization and eventually presided over their fall. After serving as secretary of New York State from 1955 to 1959, despite the pretense of being a reformer, De Sapio himself ended his political career in disgrace when he was convicted of bribery in

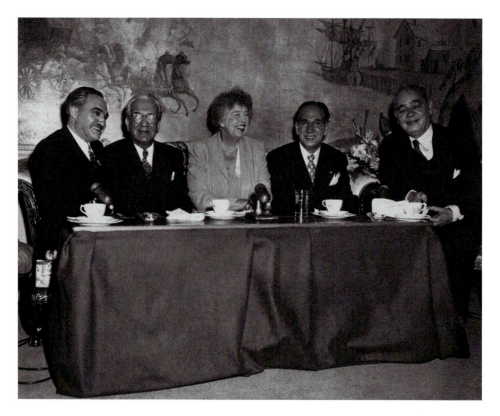

Figure 19.1 During the New York mayoral election of 1950, Eleanor Roosevelt met with the four candidates, three of them Italian American. From left to right: Paul Ross, American Labor Party; Judge Ferdinand Pecora, Democratic Party; Mrs. Roosevelt; Acting Mayor Vincent R. Impellitteri, Experience Party; and Edward Corsi, Republican Party. Impellitteri won. Courtesy of Bettmann/Getty Images.

1969.[63] Yet, his rise to the helm of Tammany Hall epitomized the pinnacle of Italian Americans' power in New York City politics.

It was hardly by a chance that in 1950 all the three major candidates competing in the mayoral election—Democrat Ferdinand Pecora, Republican Edward Corsi, and acting mayor Vincent Impellitteri, who ran and won as an independent—were of Italian extraction (Figure 19.1).[64] In the same year, John O. Pastore, a Democrat from Rhode Island who had risen from very humble conditions, became the first Italian American candidate to win a seat in the U.S. Senate. In 1946 he had also been the first politician of recognized Italian descent to be elected governor of a state after succeeding to that office upon the incumbent's resignation in 1945. Both Pastore's achievements were breakthroughs for his own ethnic minority and have been celebrated as such, but the fact that Rhode Island was the state with the highest concentration of Italian Americans reduced in part the significance of those accomplishments in terms of political accommodation.[65]

The Switch toward Conservatism

In the postwar decades, the progressive relocation from the ethnic enclaves in the inner-city neighborhoods to the suburbs, the growth of home ownership, the larger access to higher

education and, consequently, to professional jobs as well as the steady increase in income implied Italian Americans' assimilation and entry into the middle class. Voters absorbed a conservative political orientation from their new social status. The experience of Alfonse D'Amato was a case in point. Born in Brooklyn in 1937, he moved with his family to Island Park on Long Island following the route "from steerage to suburb" that historian Salvatore J. LaGumina has reconstructed for numerous Italian Americans in the New York City metropolitan area. This trajectory also involved a change of partisan registration from the Democratic Party to the GOP. D'Amato subsequently made his way up the Republican hierarchy. In 1980, after defeating progressive incumbent Jacob Javits in the primaries, he won election to the U.S. Senate, where he served until 1999.[66]

In the 1952 and 1956 presidential elections a slight majority of Italian Americans cast their ballots for Republican candidate Dwight D. Eisenhower.[67] Their conversion to the GOP would have been even greater if outgoing President Truman had not vetoed the McCarran-Walter Act, a piece of legislation that displeased this ethnic minority because it reiterated the discriminatory national origins immigration quota system while a large number of Italians wished to leave their native country for the United States to flee overpopulation, unemployment and destitution.[68] Although both sponsors of the measure—Senator Patrick McCarran and Representative Francis E. Walter—were Democrats and Congress overrode Truman's veto, the president's stand demonstrated that the leader of the Democratic Party was sensitive to Italian Americans' demands and helped hold back a few prospective defectors to the GOP. The Italian consuls in the United States also orchestrated a behind-the-scenes campaign and urged Italian American voters to contribute retaining a Democratic administration in Washington in the hope that it would liberalize immigration legislation and pursue a more favorable foreign policy toward Italy.[69]

The Democratic Party managed again to carry the Italian American community in 1960, thanks to the Catholic faith of its own presidential candidate, John F. Kennedy, who obtained more that 80 percent of the votes of this ethnic group in such states as Illinois, Massachusetts, Ohio, and Rhode Island. Specifically, he was the choice of 85 percent of Italian Americans in Boston and Baltimore as well as 79 percent in Providence.[70] Kennedy further ingratiated himself with members of the Little Italies in 1962, when he nominated one of their political leaders, Cleveland's five-term Mayor Anthony Celebrezze, to the post of secretary of Health, Education, and Welfare, in response to their call for greater consideration in federal appointments. After the case of Pastore, Celebrezze won another breakthrough because he was the first to be elevated to a cabinet position among his fellow ethnics.[71] However, it was Lyndon B. Johnson who reaped the fruits of Kennedy's granting of political recognition to Italian Americans. Capitalizing on both the retention of Celebrezze in his own administration and the emotional tide resulting from Kennedy's assassination, Johnson polled 76 percent of their votes nationwide in 1964.[72] He also made a point of courting Italian Americans' transnational sense of political belonging. When the president of Italy, Antonio Segni, visited the United States in 1964, Johnson maneuvered to have him address a joint session of Congress with the specific purpose of pandering to their ethnic pride and strengthening his own political following within their electorate.[73] After all, Italian Americans continued to be receptive to ethnic politics. In Massachusetts, for instance, they split their ballots in 1960. Whereas 85 percent supported Kennedy for president, at least 50 percent voted for fellow ethnic Republican John Volpe, who made a successful bid for governor of the state.[74]

Yet, the revitalization of a Democratic majority among Italian Americans turned out to be rather shaky as racial identity began to prevail over ethnic affiliation in their voting behavior. They distanced themselves from the Johnson administration in response to the affirmative action programs for disadvantaged groups such as African Americans. These measures

introduced racial quotas for employment with public administrations and access to higher education as means to prevent unfairness and to make amends for pre-civil-rights-era bigotry. Italian Americans failed to be included in those programs. Therefore, they perceived such provisions as reverse discrimination against white minorities of European ancestries that, as in their specific case, had faced intolerance and marginalization upon arrival in the United States in the decades of mass immigration, but had subsequently struggled on their own to win accommodation and had made their way up the social ladder without any particular help from the federal government. Stephen Adubato, the chairperson of Newark's North Ward Committee of the Democratic Party, argued that "Blacks have got all these special programs to help them get to college, or to rehabilitate their houses, or to help them find jobs. We white ethnics don't get any of these things. All we want is equity."[75]

Hubert Humphrey, Johnson's vice president and the 1968 Democratic candidate for the White House, took the electoral brunt of Italian Americans' concerns. He polled a bare 50 percent of their ballots, whereas their support for his Republican opponent, Richard M. Nixon, who had already challenged Kennedy eight years earlier, increased by 10 percent in Cleveland, by 13 percent in Brooklyn, by 15 percent in Newark, and by 22 percent in Philadelphia between 1960 and 1968. Some voters of Italian ancestry even yielded to the racist appeal of Alabama's Governor George Wallace, who ran for the White House on a segregationist platform and obtained respectively 29 percent, 10 percent, 21 percent, and 11 percent in the previously mentioned four communities.[76] Wallace had already carried Baltimore's Little Italy in his 1964 unsuccessful campaign for the Democratic presidential nomination and, two years later, George P. Mahoney gained 75 percent of the Italian American votes in a fruitless run for governor of Maryland.[77]

Fearful of blacks' alleged encroachments in local politics, Italian Americans also joined forces with other cohorts of the electorate from European backgrounds to support white candidates, regardless of their national ancestry, who faced African American challengers in mayoral contests. The enforcement of busing for racial balance in public schools and the desegregation of ethnic neighborhoods animated the worst nightmares about blacks' rise to power in municipal administrations.[78] A Bostonian of Italian descent expressed this sense of racially-based frustration when she argued that "we don't count anymore. Everyone has a feeling it's a black city. Nothing is going our way. Even our husbands are coming home from work saying that every promotion goes to a black." A fellow ethnic echoed similar concerns in the case of busing as she argued that "kids" would not be "safe going into the minority community" to attend school in a black district.[79] In Cleveland, along with the progeny of Irish, Polish and other eastern European immigrants, Italian Americans rallied to support the president of the Board of Education, Ralph McAllister, who opposed school desegregation in the early 1960s and was charged with being "a bigot of rare vintage" on race issues by *Jet*, a magazine for an African American readership.[80] In the face of the racial upheavals of the second half of the 1960s the chances that an African American mayor would restrain the police in the pursuit of black rioters and, therefore, encourage further turmoil spread additional panic. Residents of the surviving Little Italies were afraid that hoodlums could no longer be kept at bay "if in the streets the whites no longer ruled."[81]

Many New Yorkers from Italian, Jewish, and Irish backgrounds bolted from Mayor John Lindsay in 1969 because they perceived him as a supporter of African American aspirations to the detriment of whites' interests. Most Italian Americans cast their ballots for fellow ethnics Mario Procaccino, a Democrat, and John Marchi, a Republican, who both capitalized on anti-black sentiments. The combined Italian American vote for Lindsay's two opponents was 85.7 percent. Historian Maria C. Lizzi has contended that Procaccino's infamous portrait as the "white backlash candidate" arose from a misinformation campaign launched by

Lindsay to discredit his rival in the 1969 mayoral contest. Yet, it was the very perception of Procaccino as a racist that enabled him to carry the Italian American neighborhoods in the Bensonhurst and Bay Ridge neighborhoods of Brooklyn.[82]

The following year, in the aftermath of dramatic rioting that claimed twenty-three dead and more than 750 injured in 1967, 87.5 percent of Newark's Italian American voters cast their ballots for Hugh J. Addonizio, the city's first mayor of their own national ancestry, in the fruitless effort to keep him in office and to prevent his African American opponent, Kenneth A. Gibson, from becoming the next chief executive at City Hall. Police Director Dominick Spina, an Italian American appointee of Addonizio's, defined the runoff between the two candidates a "black-versus-white situation" and urged a vote for the incumbent mayor on the grounds that "for the white man in Newark this is a matter of survival." His fellow ethnics, women included, followed his advice.[83]

In 1971 Philadelphians of Italian ancestry entered a coalition of white ethnic voters with Jews and Irish Americans and elected law-and-order Democrat Frank Rizzo to City Hall. Significantly, Rizzo was a former police commissioner of Italian descent who had won a nationwide reputation for his strong-arm methods against African American activists.[84] The re-elaboration of Italian Americans' identity as white voters reached a climax in Philadelphia in 1978. This year, after gaining a second mandate in 1975, Rizzo promoted a referendum to amend the city charter and let him serve more than two consecutive terms. In an emotional appeal to the electorate from European backgrounds, Rizzo stated that he was tired of his political opponents encouraging African Americans to "vote black" and urged his own supporters to "vote white." As a result, although the amendment was rejected, 85 percent of Italian Americans voted to remove the two-consecutive-term limit.[85]

Italian Americans' support for Rizzo increased as the white-versus-black polarization in Philadelphia became more evident even in symbolic terms. Rizzo made a political comeback in 1983 to challenge African American leader W. Wilson Goode for the Democratic nomination for mayor and, after his defeat, went over to the Republican Party to oppose Goode in 1987. Both Rizzo's bids for City Hall were unsuccessful. But he received 97 percent of the Italian American vote in 1983 and 92 percent in 1987. Conversely, when he ran again for mayor in 1991 against two white candidates in the Republican primaries, Rizzo obtained only 62.5 percent of the Italian American vote.[86]

The new racial identity of voters from Italian background involved support even for politicians who did not share their ethnic extraction but stood out as spokespersons for whites' claims and concerns. For instance, after Louise Gay Hicks came out against busing in Boston, her support in the election for the city's School Committee in the largely Italian American North End jumped from 26.0 percent in 1961 to 56.1 percent two years later.[87] Likewise, in Chicago's 1983 mayoral election, 90.4 percent of the voters of Italian descent cast their ballots for Republican Bernard Epton, joining a roughly 88 percent majority of white ethnics who turned their backs at African American Democratic Congressman Harold Washington in a highly divisive campaign that split the city along racial lines.[88]

Of course, not all Italian Americans, especially among public figures, were conservative on race and other issues. Catholic priests Geno Baroni and James E. Groppi marched with Dr. Martin Luther King, Jr. to support civil and political rights for African Americans. The former helped enforce residential integration as President Jimmy Carter's undersecretary of Housing and Urban Development. The latter organized young blacks to promote racial justice in Milwaukee.[89] Furthermore, Mario Cuomo, who served as Democratic governor of New York State from 1983 through 1994, was one of the few remaining advocates of liberal policies while President Ronald Reagan's Republican minimum-government, tax-cutting, welfare-slashing line dominated American politics in the 1980s and early 1990s. Reputed as

a hypothetical frontrunner for the Democratic nomination for the White House in 1988 and 1992, Cuomo never threw his hat in the ring. He probably wished to avoid falling casualty to the "Mafia"-related innuendoes that had already crashed the hopes for higher offices of Joseph L. Alioto, the Italian American Democratic mayor of San Francisco from 1968 to 1976 and a possible candidate for governor of California and vice president.[90]

Whiteness often interwove with Catholicism in shaping the vote in national politics. Democratic presidential candidate George McGovern's pro-choice stand further undermined the following of his party among Italian Americans in 1972. This year, running for reelection against McGovern, Nixon gained 68 percent of their ballots in New York State, 61 percent in New Jersey, 53 percent in Pennsylvania and 52 percent in Ohio.[91] Democrat Jimmy Carter won a larger share of the Italian vote than McGovern four years later. He lost the New York State community to Republican Gerald Ford by 35 percent to 65 percent, but he carried the Italian American electorate nationwide by 56 percent.[92]

In the wake of the 1973 Roe v. Wade decision barring state and federal regulation of abortion in the first trimester of pregnancy, Carter's personal pro-life stand, though associated with opposition to a Constitutional amendment outlawing that medical procedure, let the Democratic Party win back a few Catholic voters of Italian descent. Reagan's more solid defense of "family values" and uncompromising rejection of abortion brought them back to the Republican camp. Political scientist William W. Carey has suggested that "as a group Italians were among the primary enlistees in the corps of Reagan Democrats," i.e., the voters from strongly Democratic families who supported the GOP in the 1980s.[93] Reagan carried the Italian American community nationwide in 1980 and increased his following to 61 percent four years later, although the Democratic ticket sported Geraldine Ferraro as the vice-presidential nominee in 1984.[94]

Conclusion

Ferraro's experience was a case in point for Italian Americans' eventual political accommodation and final disregard of ethnic factors in voting behavior in the mid 1980s. A three-term Congresswoman of Italian descent, as a candidate for the nation's second-ranking office Ferraro received the highest form of recognition that either major party had ever granted her national minority. Cuomo recommended her to Democratic presidential nominee Walter Mondale in order to appeal not only to women but also to Italian American voters specifically.[95] Ferraro sat on the board of directors of the National Italian American Foundation, an organization that had been established to lobby for the advancement of Italian Americans in U.S. society and, primarily, in politics after Nixon had bypassed Volpe for Greek-American Spiro T. Agnew in the choice of his 1968 running mate.[96] Ferraro appealed to Italian American ethnic pride in her acceptance speech at the Democratic convention and throughout her election campaign, whenever possible and appropriate. But her outspoken pro-choice stand on abortion prevailed over ethnic allegiance and antagonized most Italian American voters on the grounds of the latter's social conservatism and Catholic faith.[97] Not even ethnic defensiveness managed to rally a significant number of Italian Americans behind Ferraro's candidacy. Innuendos that her husband, real estate developer John Zaccaro, was in business with a few underworld bosses because he had lent them a warehouse revived the hackneyed stereotype of Italian Americans' ties to organized crime.[98] Yet such an outburst of blatant bigotry failed to touch a sensitive nerve among most voters of Italian ancestry and few of them showed solidarity for their fellow-ethnic candidate at the polls. In New York State, the home of her Congressional district in Queens, the Republican ticket even received 63 percent of the Italian American vote.[99] As Ferraro herself subsequently complained, "I was out

there all alone, unsupported by other Italian Americans in the barrage of ethnic slurs. [. . .] I didn't expect so many in the Italian American community to retreat in the face of all ethnic slurs."[100]

Yet, the fact that voters of Italian ancestry were not responsive to the ethnic appeal of a candidate who belonged to their own nationality group offered additional evidence that they had completed the process of political incorporation within the United States. So did candidates of Italian descent who managed to break into the highest circles of American politics without significant support from their own fellow ethnics. This was the case of Pete Domenici, a Republican, from New Mexico and Dennis DeConcini, a Democrat from Arizona, who were elected to the U.S. Senate respectively in 1972 and in 1976. Half way in time between these two achievements, in 1974, Ella Tambussi Grasso launched a successful campaign for governor of Connecticut, becoming the first woman to serve in this position in her own right and not as a previous incumbent's wife or widow. But, whereas Grasso run in the state where Italian Americans constituted the largest immigrant minority, neither Domenici nor DeConcini enjoyed a relevant presence of fellow ethnics in their home states.[101]

Italian Americans' imperviousness to the political call of their ancestral land completed the achievement of their post-ethnic approach to politics. The immigrants and their offspring showed empathy in case of humanitarian emergencies. For instance, they not only raised money for homeless people but also pressured the Ford administration into appropriating 25 million dollars in disaster relief for Friuli after an earthquake hit this region in 1976.[102] But they were hardly available as a lobby backing Rome's foreign policy. Specifically, in 1998 the Italian ambassador to the United Nations, Francesco Paolo Fulci, encouraged American voters of Italian ancestry to mobilize against the exclusion of Italy from the new permanent members of the United Nations Security Council within a short-lived plan for the reform of this body. They were specifically urged to send faxes to U.S. President Bill Clinton, defining such an outcome "a slap in the face" of millions of Italian Americans. But as few as roughly fifty thousand people out of a total population of roughly fifteen million took part in this campaign.[103]

Further Reading

Cappelli, Ottorino, ed. *Italian Signs, American Politics: Current Affairs, Historical Perspectives, Empirical Analyses.* New York: John D. Calandra Italian American Institute, 2012.

Krase, Jerome and Charles LaCerra. *Ethnicity and Machine Politics.* Lanham: University Press of America, 1991.

LaGumina, Salvatore J. "Politics," in *The Italian American Experience: An Encyclopedia,* ed. Salvatore J. LaGumina, Frank J. Cavaioli, Salvatore, Salvatore Primeggia and Joseph Varacalli. New York: Garland, 2000, 480–86.

Martinelli, Phylis Cancilla. "The Italian-American Experience," in *America's Ethnic Politics,* edited by Joseph S. Roucek and Bernard Eisenberg. Westport: Greenwood, 1982, 217–32.

Notes

1 "La quarta guerra dell'indipendenza italiana," *Gazzetta del Massachusetts* (29 May 1915), 1; Agostino De Biasi, "La voce dei padri ci chiama," *Il Carroccio,* 1.5 (1915), 3–8; "Little Italy in War Time," *Literary Digest* (12 June 1915), 1409–1414.

2 Christopher Sterba, *Good Americans: Italian and Jewish Immigrants During the First World War* (New York: Oxford University Press, 2003), 133–152.

3 John B. Duff, "The Italians," in *The Immigrants' Influence on Wilson's Peace Policies,* ed. Joseph P. O'Grady (Lexington: University Press of Kentucky, 1967), 111–139.

4 Arthur Mann, *La Guardia: A Fighter Against His Times, 1882–1933* (Philadelphia: Lippincott, 1959), 114.

5 "I connazionali d'America ripagheranno Woodrow Wilson degli oltraggi commessi contro l'Italia e le sue aspirazioni," *Gazzetta del Massachusetts* (20 October 1920), 1.

6 Humbert S. Nelli, "Chicago's Italian-Language P and World War I," in *Studies in Italian American Social History: Essays in Honor of Leonard Covello*, ed. Francesco Cordasco (Totowa: Rowman & Littlefield, 1975), 66–80(72).

7 David Burner, *The Politics of Provincialism: The Democratic Party in Transition, 1918–1932* (New York: Knopf, 1968), 236, 243; J. Joseph Huthmacher, *Massachusetts People and Politics, 1919–1933* (Cambridge: The Belknap Press of Harvard University Press, 1959), 20–22; George J. Martin, *The American Catholic Voter: 200 Years of Political Impact* (South Bend: St. Augustine's Press, 2004), 188.

8 Robert A. Slayton, *Empire Statesman: The Rise and Redemption of Al Smith* (New York: Free Press, 2001), 324–326.

9 Joseph Marc DiLeo, "Governor Alfred Emanuel Smith, Multi-Ethnic Politician," in *Italians and Irish in America*, ed. Francis X. Feminella (Staten Island: AIHA, 1985), 241–258.

10 Interview with Angela G. by the author, Providence, 18 November 1997.

11 Thomas R. Pegram, *One Hundred Percent American: The Rebirth and Decline of the Ku Klux Klan in the 1920s* (Chicago: Ivan R. Dee, 2011), 45, 86–87, 111–112.

12 Stefano Luconi, *Little Italies e New Deal: La coalizione rooseveltiana e il voto italo-americano a Filadelfia e Pittsburgh* (Milan: Franco Angeli, 2002), 239–240, 246; Gerald H. Gamm, *The Making of New Deal Democrats: Voting Behavior and Realignment in Boston, 1920–1940* (Chicago: University of Chicago Press, 1989), 83.

13 Luconi, *Little Italies e New Deal*, 55–56; John M. Allswang, *A House for All the Peoples: Ethnic Politics in Chicago, 1890–1936* (Lexington: University Press of Kentucky, 1971), 42; Burner, *The Politics of Provincialism*, 236.

14 "Summary Report on the 1928 Campaign," Herbert Hoover Papers, Campaign & Transition, box 157, folder "Election Figures—Research Bureau," Herbert Hoover Presidential Library, West Branch, Iowa.

15 Allswang, *A House for All the Peoples*, 42; Ronald H. Bayor, *Neighbors in Conflict: The Irish, Germans, Jews, and Italians of New York City, 1929–1941* (Baltimore: Johns Hopkins University Press, 1978), 147; Frederick M. Wirt, *Power in the City: Decision Making in San Francisco* (Berkeley: University of California Press, 1974), 235.

16 Philip V. Cannistraro and Gerald Meyer, "Introduction: Italian American Radicalism: An Interpretative History," in *The Lost World of Italian American Radicalism: Politics, Labor, and Culture*, ed. Philip V. Cannistraro and Gerald Meyer (Westport: Praeger, 2003), 1–48(9).

17 Interview with Michael T. by the author, Pittsburgh, 18 October 1991.

18 Michael P. Weber, *Don't Call Me Boss: David L. Lawrence, Pittsburgh's Renaissance Mayor* (Pittsburgh: University of Pittsburgh Press, 1988), 46–55; Dominic A. Pacyga, *Chicago: A Biography* (Chicago: University of Chicago Press, 2009), 250–262.

19 Luconi, *Little Italies e New Deal*, 55; John F. Bauman, "The City, the Depression, and Relief: The Philadelphia Experience, 1929–1939" (PhD diss., Rutgers University, 1969), 54–55.

20 Ronald H. Bayor, *La Guardia: Ethnicity and Reform* (Arlington Heights: Harlan Davidson, 1993), 79; Thomas Kessner, *Fiorello H. La Guardia and the Making of Modern New York* (New York: McGraw-Hill, 1989), 194–195 (quotation on 194).

21 Luconi, *Little Italies e New Deal*, 55–56; Jo Ann E. Argersinger, *Toward a New Deal in Baltimore: People and Government in the Great DePion* (Chapel Hill: University of North Carolina Press, 1988), 191.

22 Richard J. Jensen, "The Cities Reelect Roosevelt: Ethnicity, Religion, and Class in 1940," *Ethnicity*, 8.2 (1981), 189–195(192).

23 Franco Ciarlantini, *Incontro col Nord America* (Milan: Alpes, 1929), 275; Thomas J. Guglielmo, *White on Arrival: Italians, Race, Color, and Power in Chicago, 1890–1945* (New York: Oxford University Press, 2003), 97–98.

24 James P. Johnson, "Reorganizing the United Mine Workers of America in Western Pennsylvania during the New Deal," *Pennsylvania History*, 37.1 (1970), 117–132(123).

25 Guido Tintori, "Amministrazione Roosevelt e Labor etnico: Un caso italiano, Luigi Antonini" (PhD diss., University of Milan, 2003).

26 Bayor, *Neighbors in Conflict*, 19; Pennsylvania Committee on Public Assistance and Relief, *The Relief Population in Pennsylvania, 1936* (Harrisburg: Commonwealth of Pennsylvania, n.d.), 34.

27 Agnes Maybeth McRoberts, "Attitudes and Family Situations of Thirty Works Progress Administration Employees" (MA thesis, University of Pittsburgh, 1938), 31–34; David L. Davies, "Impoverished Politics: The New Deal's Impact on City Government in Providence," *Rhode Island History*, 42.3 (1983), 86–100(96).

28 Report by the Federal Bureau of Investigation, 14 July 1942, Department of Justice, Record Group 60, Classified Subject File, 146-6-95, box 53, National Archives II, College Park, Maryland.

29 William F. Whyte, *Street Corner Society: The Social Structure of an Italian Slum* (Chicago: University of Chicago Press, 1955), 197.

30 "Politics," *Atlantica*, 14.5 (1933), 216.

31 Richard D. Brown and Jack Tager, *Massachusetts: A Concise History* (Amherst: University of Massachusetts Press, 2000), 273.

32 Frances L. Reinhold, "Anna Brancato: State Representative," in *The American Politician*, ed. John T. Salter (Chapel Hill: University of North Carolina Press, 1938), 348–358.

33 Paul B. Beers, *Pennsylvania Politics Today and Yesterday: The Tolerable Accommodation* (University Park: Pennsylvania State University Press, 1980), 146.

34 Richard Krickus, *Pursuing the American Dream: White Ethnics and the New Populism* (Bloomington: Indiana University Press, 1976), 178.

35 Miriam Jiménez, *Inventing Politicians and Ethnic Ascent in American Politics: The Uphill Elections of Italians and Mexicans to the U.S. Congress* (New York: Routledge, 2013), 87–89.

36 Joseph M. Cumming, "Angelo J. Rossi, Mayor of San Francisco, California," *Atlantica*, 11.4 (1931), 157–59; Phylis C. Martinelli, "Mayor Rossi—an Ethnic Politician," *Gazzettino*, 2.3 (1975), 10–11.

37 Kessner, *Fiorello H. La Guardia*, 245–578.

38 Edward F. Haas, "New Orleans on the Half Shell: The Maestri Era, 1936–1946," *Louisiana History*, 13.3 (1972), 283–310.

39 Gerald Meyer, *Vito Marcantonio: Radical Politician, 1902–1954* (Albany: State University of New York Press, 1989).

40 Philip V. Cannistraro, "Generoso Pope and the Rise of Italian Americans in Politics, 1925–1936," in *Italian Americans: New Perspectives in Italian Immigration and Ethnicity*, ed. Lydio F. Tomasi (Staten Island: Center for Migration Studies, 1985), 265–88; Alan A. Block, *Perspectives on Organized Crime: Essays in Opposition* (Boston: Kluwer, 1991), 131–133.

41 Stefano Luconi, *La "diplomazia parallela": il regime fascista e la mobilitazione politica degli italo-americani* (Milan: Angeli, 2000), 85–129.

42 *The Public Papers and Addresses of Franklin D. Roosevelt: War and Aid to Democracies, 1940*, ed. Samuel I. Rosenman (New York: Macmillan, 1941), 263; Salvatore J. LaGumina, *The Humble and the Heroic: Wartime Italian Americans* (Youngstown: Cambria Press, 2006), 61–63.

43 Jensen, "The Cities Reelect Roosevelt," 192; Gamm, *The Making of New Deal Democrats*, 83; Luconi, *Little Italies e New Deal*, 55–56; Bayor, *Neighbors in Conflict*, 147.

44 Jeanette Sayre Smith, "Broadcasting for Marginal Americans," *Public Opinion Quarterly*, 6.4 (1942), 588–603 (589); Charles H. Trout, *Boston, the Great Depression, and the New Deal* (New York: Oxford University Press, 1977), 296.

45 Bayor, *Neighbors in Conflict*, 148.

46 Luconi, *Little Italies e New Deal*, 55–56; William Spinard, "New Yorkers Cast Their Ballots" (PhD diss., Columbia University, 1948), 82.

47 Guido Tintori, "Italiani enemy aliens: I civili residenti negli Stati Uniti d'America durante la seconda guerra mondiale," *Altreitalie*, 28 (2004), 83–109; Lawrence DiStasi, "The Internment of Enemy Aliens, East and West," in *The Impact of World War II on Italian Americans: 1935-Present*, ed. Gary R. Mormino (New York: American Italian Historical Association, 2007), 98–116.

48 Francis Biddle, *In Brief Authority* (Garden City: Doubleday, 1962), 229.

49 Office of War Information, "Generoso Pope's Ownership and Interests," 17 August 1943, Philleo Nash Papers, box 24, folder "Pope," Harry S. Truman Presidential Library, Independence, Missouri.

50 Franklin D. Roosevelt to James M. Barnes et al., 4 April 1941, Franklin D. Roosevelt Papers, President's Personal File 4617, Franklin D. Roosevelt Library, Hyde Park, New York.

51 Richard Gambino, *Blood of My Blood: The Dilemma of the Italian-Americans* (New York: Doubleday, 1974), 316.

52 Pietro Riccobaldi, *Straniero indesiderabile* (Milan: Archinto, n.d.), 125.

53 Joseph S. Roucek, "Italo-Americans and World War II," *Sociology and Social Research*, 29.6 (1945), 465–471 (468).

54 James W. Gerald to Franklin D. Roosevelt, 27 May 1944, Roosevelt Papers, President's Secretary's File, box 156, folder "Politics, 1944;" Vito Marcantonio Papers, box 51, folder "International Relations: Italy, Recognition of, 1944," New York Public Library, New York City; James Edward Miller, *The United States and Italy, 1940–1950: The Politics and Diplomacy of Stabilization* (Chapel Hill: University of North Carolina Press, 1986), 96–117; Ennio Di Nolfo and Maurizio Serra, *La gabbia infranta: Gli Alleati e l'Italia dal 1943 al 1945* (Rome and Bari: Laterza, 2010), 167–170.

55 Domenico Fracchiolla, *Un ambasciatore della "nuova Italia" a Washington: Alberto Tarchiani e le relazioni tra Italia e Stati Uniti, 1945–1947* (Milan: Franco Angeli, 2012), 165.

56 C. Edda Martinez and Edward A. Suchman, "Letters from America and the 1948 Elections in Italy," *Public Opinion Quarterly*, 14.1 (1950), 111–125 (112–113) (to which the quotation refers); Wendy L. Wall, *Inventing the American Way: The Politics of Consensus from the New Deal to the Civil Rights Movement* (New York: Oxford University Press, 2008), 247–257; Kaeten Mistry, *Italy and the Origins of Cold War: Waging Political Warfare, 1945–1950* (New York: Cambridge University Press, 2014), 141–143.

57 Francesca Fauri, *Il Piano Marshall e l'Italia* (Bologna: Il Mulino, 2010), 80.

58 Samuel Lubell, "Who Really Elected Truman?" *Saturday Evening Post* (22 January 1949), 15–17, 54–58, 61, 64 (17).

59 *Boundless Lives: Italian Americans of Western Pennsylvania*, ed. Mary Brignano (Pittsburgh: Historical Society of Western Pennsylvania, 1999), 81, 177.

60 Stephen Puleo, *The Boston Italians: A Story of Pride, Perseverance, and Paesani, from the Years of the Great Immigration to the Present Day* (Boston: Beacon Press, 2007), 89–90.

61 A. J. R. Groom, "The Trusteeship Council: A Successful Demise," in *The United Nations at the Millennium: The Principal Organs*, ed. Paul Taylor and A. J. R. Groom (London: Continuum, 2000), 142–176 (158).

62 Aristide R. Zolberg, *A Nation by Design: Immigration Policy in the Fashioning of America* (New York: Russell Sage Foundation, 2006), 302.

63 Warren Moscow, *The Last of Big-Time Bosses: The Life and Times of Carmine DeSapio and the Rise and Fall of Tammany Hall* (New York: Stein and Day, 1971); Steven P. Eire, *Rainbow's End: Irish Americans and the Dilemmas of Urban Machine Politics, 1840–1985* (Berkeley: University of California Press, 1988), 3, 122, 150, 171–174, 225.

64 Salvatore J. LaGumina, *New York at Mid-Century: The Impellitteri Years* (Westport: Greenwood Press, 1992), 103–130.

65 Samuel Lubell, *The Future of American Politics* (New York: Harper & Row, 1965), 80–83; Salvatore J. LaGumina, "John O. Pastore: Italian-American Political Pioneer," in *The Melting Pot and Beyond: Italian Americans in the Year 2000*, ed. Jerome Krase and William Egelman (New York: AIHA, 1987), 1–14; Ruth S. Morgenthau, *Pride Without Prejudice: The Life of John O. Pastore* (Providence: Rhode Island Historical Society, 1989); Jiménez, *Inventing Politicians*, 70–72, 90.

66 Joe Klein, "Senator Fonzie?" *New York* (6 October 1980), 24–27; Alfonse D'Amato, *Power, Pasta & Politics: The World According to Senator Al D'Amato* (New York: Hyperion, 1995); Salvatore J. LaGumina, *From Steerage to Suburb: Long Island Italians* (Staten Island: Center for Migration Studies, 1988).

67 Vincent R. Tortora, "Italian Americans: Their Swing to GOP," *The Nation* (24 October 1953), 330–332.

68 Otis L. Graham, *Unguarded Gates: A History of America's Immigration Crisis* (Lanham: Rowman & Littlefield, 2004), 77–79; Danielle Battisti, "The American Committee on Italian Migration, Anti-Communism, and Migration Reform," *Journal of American Ethnic History*, 31.2 (2012), 11–40.

69 Alberto Tarchiani to Italian consuls, 16 July 1952, Records of the Italian Ministry of Foreign Affairs, series Ambasciata a Washington, box 23, folder 607, Archivio Storico del Ministero degli Affari Esteri, Rome, Italy.

70 Albert J. Menendez, *The Religious Factor in the 1960 Presidential Election: An Analysis of the Kennedy Victory Over Anti-Catholic Prejudice* (Jefferson: McFarland, 2011), 102, 107, 115.

71 Salvatore J. LaGumina, "The Political Profession: Big City Italian American Mayors," in *Italian Americans in the Professions*, ed. Remigio U. Pane (Staten Island: AIHA, 1983), 77–110 (92).

72 Stuart Rothenberg, Eric Licht and Frank Newport, *Ethnic Voters and National Issues: Coalitions in the 1980s* (Washington DC: Free Congress Research & Education Foundation, 1982), 19–20.

73 *Taking Charge: The Johnson White House Tapes, 1963–1964*, ed. Michael R. Beschloss (New York: Simon & Schuster, 1997), 100.

74 Michael C. LeMay, *The Struggle for Influence: The Impact of Minority Groups on Politics and Public Policy in the United States* (Lanham: University Press of America, 1985), 66; Puleo, *The Boston Italians*, 236.

75 Fox Butterfield, "Newark's New Minority, the Italians, Demands Equity," *New York Times* (28 August 1971), 27.

76 Mark R. Levy and Michael S. Kramer, *The Ethnic Factor: How America's Minorities Decide Elections* (New York: Simon & Schuster, 1972), 168–173.

77 Nathan Glazer, *Affirmative Discrimination: Ethnic Inequality and Public Policy* (Cambridge: Harvard University Press, 1987), 170; Levy and Kramer, *The Ethnic Factor*, 174.

78 Ronald P. Formisano, *Boston Against Busing: Race, Class, and Ethnicity in the 1960s and 1970s* (Chapel Hill: University of North Carolina Press, 1991); Jonathan Rieder, *Canarsie: The Jews and Italians of Brooklyn Against Liberalism* (Cambridge: Harvard University Press, 1985).

79 Jeanne F. Theoharis, "'We Saved the City': Black Struggles for Educational Equality in Boston, 1960–1976," *Radical History Review*, 81 (2001), 61–93 (quotations on 76–77, 79).

80 Leonard N. Moore, *Carl B. Stokes and the Rise of Black Political Power* (Urbana: University of Illinois Press, 2002), 30; John H. Britton, "North's First Rights Martyr," *Jet* (23 April 1964), 14–23 (16).

81 Harold R. Isaacs, *Idols of the Tribe: Group Identity and Political Change* (Cambridge: Harvard University Press, 1975), x.

82 Richard M. Scammon and Ben J. Wattenberg, *The Real Majority: An Extraordinary Examination of the American Electorate* (New York: Coward, McCann & Georghegan, 1970), 242–243; Levy and Kramer, *The Ethnic Factor*, 180–183; Maria C. Lizzi, "'My Heart Is Black as Yours': White Backlash, Racial Identity, and Italian-American Stereotypes in New York City's 1969 Mayoral Campaign," *Journal of American Ethnic History*, 27.3 (2008), 43–80; Peter Vellon, "Immigrant Son: Mario Procaccino and the Rise of Conservative Politics in Late 1960s New York City," *Italian American Review*, 7.1 (1999), 117–136.

83 Max Arthur Herman, *Summer of Rage: An Oral History of the 1967 Newark and Detroit Riots* (New York: Peter Lang, 2013); Levy and Kramer, *The Ethnic Factor*, 174–175; Brad R. Tuttle, *How Newark Became Newark: The Rise, Fall, and Rebirth of an American City* (New Brunswick: Rivergate Books, 2009), 192 (with quote).

84 Fred Hamilton, *Rizzo* (New York: Viking, 1973); Sal A. Paolantonio, *Frank Rizzo: The Last Big Man in Big City America* (Philadelphia: Camino, 1993), 17–122.

85 William S. Rosenberg, *Jews, Blacks, and Ethnics: The 1978 "Vote White" Campaign in Philadelphia* (New York: American Jewish Committee, 1979).

86 Sandra Featherman, *Jews, Blacks, and Urban Politics in the 1980s: The Case of Philadelphia* (Philadelphia: American Jewish Committee, 1988), 3–6; Sandra Featherman and Allan B. Hill, *Ethnic Voting in the 1991 Philadelphia Mayoral Election* (New York: American Jewish Committee, 1992), 3–4, 8.

87 Emmett H. Buell, Jr. and Richard A. Brisbin, Jr., *School Desegregation and Defended Neighborhoods: The Boston Controversy* (Lexington: Lexington Books, 1982), 61–66.

88 Paul Kleppner, *Chicago Divided: The Making of a Black Mayor* (DeKalb: Northern Illinois University Press, 1985).

89 Frank Cavaioli, "Geno Baroni: Italian-American Civil Rights Priest," in *Shades of Black and White: Conflict and Collaboration Between Two Communities*, ed. Dan Ashyk, Frad Gardaphe and Anthony Julian Tamburri (Staten Island: American Italian Historical Association, 1999), 45–54; Jackie DiSalvo, "Father James E. Groppi (1930–1985): The Militant Humility of a Civil Rights Activist," in *The Lost World of Italian American Radicalism*, ed. Cannistraro and Meyer, 229–243.

90 Robert S. McElvaine, *Mario Cuomo: A Biography* (New York: Scribner's, 1988); George De Stefano, *An Offer We Can't Refuse: The Mafia in the Mind of America* (New York: Faber and Faber, 2006), 37–38; Timothy J. Meager, "The Importance of Being Italian: Representation of Italian Americans in American Movie and Television from the 1960s to the 1990s," in *Borders, Boundaries, and Bonds: America and Its Immigrants in the Eras of Globalization*, ed. Elliott R. Barkan, Hasia Diner and Alan M. Kraut (New York: New York University Press, 2007), 185–214, 206–207; Sebastian Fichera, *Italy on the Pacific: San Francisco's Italian Americans* (New York: Palgrave Macmillan, 2011), 157–161.

91 Rothenberg, Licht and Newport, *Ethnic Voters and National Issues*, 20.

92 Stephanie Bernardo Johns, *The Ethnic Almanac* (Garden City: Doubleday, 1981), 467.

93 William W. Carey, "Political Ritual on Television: Episodes in the History of Shame, Degradation and Excommunication," in *Media, Ritual and Identity*, ed. Tamar Liebes and James Curran (New York: Routledge, 2002), 42–70 (61); "Beyond Ethnicity," *Attenzione*, 3.4 (1982), 48.

94 Timothy A. Byrnes, "Issues, Elections, and Political Change: The Case of Abortion," in *Do Elections Matter?* ed. Benjamin Ginsberg and Alan Stone (Armonk: M. E. Sharpe, 1996), 101–119 (115); Everett Carll Ladd, "On Mandates, Realignments, and the 1984 Presidential Election," *PSQ: Political Science Quarterly*, 100.1 (1985), 1–25 (14).

95 William V. Shannon, "Election of 1984," in *History of American Presidential Elections, 1972–1984*, ed. Arthur M. Schlesinger, Jr. and Fred L. Israel (New York: Chelsea, 1986), 273–308 (292).

96 Frank Cavaioli, "The National Italian American Foundation: 1975–1985," in *Amadeo P. Giannini: Banker, Philanthropist, Entrepreneur*, ed. Felice A. Bonadio (Washington DC: National Italian American Foundation, 1983), 119–125.

97 Shannon, "Election of 1984," 301–302.

98 Sharon Churcher, "Zaccaro Family Firm Was Landlord to Alleged Mob Figure," *New York* (27 August 1984), 17; Eleanor Clift and Tom Brazaitis, *Madam President: Shattering the Last Glass Ceiling* (New York: Scribner, 2000), 72–73.

99 Ellis Sandoz and Cecil Van Meter Crabb, *Election 84: Landslide without a Mandate?* (New York: New American Library, 1985), 3.

100 Geraldine Ferraro with Linda Bird Francke, *Ferraro: My Story* (Toronto: Bantam, 1985), 235, 315.

101 Anna Maria Martellone, "La presenza dell'elemento etnico italiano nella vita politica degli Stati Uniti: Dalla partecipazione alla post-etnia," in *Gli italiani fuori d'Italia: Gli emigrati italiani nei movimenti operai dei paesi d'adozione (1880–1940)*, ed. Bruno Bezza (Milan: Franco Angeli, 1983), 345–358 (348–349); Richard F. Fenno, Jr., *The Emergence of a Senate Leader: Pete Domenici and the Reagan Budget* (Washington DC: CQ Press, 1991); *Senator Pete Domenici's Legacy*, ed. Jon Hunner (Los Ranchos: Rio Grande Books and New Mexico State University Press, 2009); Dennis DeConcini and Jack L. August, Jr., *Senator Dennis DeConcini: From the Center of the Aisle* (Tucson: University of Arizona Press, 2006); Vaneeta D'Andrea, "The Ethnic Factor and Role Choices of Women: Ella Grasso and Midge Costanza—Two Firsts for American Politics," in *Italian Americans in the Professions*, ed. Pane, 253–264; Jon E. Purmont, "Ella Grasso," in *Italian Americans and Their Public and Private Life*, ed. Frank J. Cavaioli, Angela Danzi and Salvatore J. LaGumina (Staten Island: American Italian Historical Association, 1993), 9–19; Marcella Serpa, *Ella Tambussi Grasso: da figlia di emigranti a prima donna Governatore di uno Stato americano* (Acqui Terme: Impressioni Grafiche, 2007).

102 Anthony Sorrentino, *Organizing the Ethnic Community: An Account of the Origin, History, and Development of the Joint Civic Committee of Italian Americans (1962–1995)* (Staten Island: Center for Migration Studies, 1995), 49; Frank Annunzio to Charles Leppert, Jr., 30 June 1976, Gerald R. Ford Papers, White House Congressional Mail Files, box 29, folder 2, Gerald R. Ford Library, Ann Arbor, Michigan; *Public Papers of the Presidents of the United States: Gerald R. Ford, 1976–1977: Vol. 2* (Washington DC: U.S. Government Printing Office, 1979), 1523–1524, 1769–1770.

103 Ministero degli Affari Esteri, Servizio Stampa e Informazione, *La riforma del Consiglio di Sicurezza: La posizione italiana* (Rome: Istituto Poligrafico e Zecca dello Stato, 1998); Claudio Bisognero, "La battaglia per la procedura di riforma del Consiglio di Sicurezza," in *L'Italia all'ONU, 1993–1999*, ed. Ranieri Tallarigo (Soveria Mannelli: Rubbettino, 2007), 37–48; Camera dei Deputati, Commissione III, Affari Esteri e Comunitari, *Indagine conoscitiva sulle prospettive di riforma dell'Organizzazione delle Nazioni Unite: Resoconto stenografico, seduta del 20 ottobre 2004* (Rome: Istituto Poligrafico e Zecca dello Stato, 2004), 14 (to which the quotation refers); Emilio Franzina, *Una patria espatriata: Lealtà nazionale e caratteri regionali nell'immigrazione italiana all'estero (secoli XIX e XX)* (Viterbo: Sette Città, 2006), 70–71, 85–86; Maddalena Tirabassi, "Interview with Joseph Scelsa," *Altreitalie*, 17 (1998), 52–55 (52–53).

ITALIAN EMIGRATION, REMITTANCES AND THE RISE OF MADE-IN-ITALY

Mark I. Choate

From Italy's perspective, could anything bring an end to the trauma of mass emigration? Only economic development in Italy itself could eventually remove the insatiable demands and incentives for Italians to move across the oceans for labor at triple the wages in their homeland, when such labor could be found at all. For Italy, the short-term and long-term consequences of mass emigration seemed dire. Even fervent advocates of emigration believed that the best possible outcome would be for Italy to develop economically to the point where migration would be a choice, not a necessity.

Italian Americans in their vast numbers thus shaped not only the United States, but also their country of origin. Emigration proved decisive in Italy's industrial "take-off" in the period 1896–1912, which made Italy an industrial nation and laid the basis for the later "Economic Miracle" of 1950–1973. Italy's industrial success lay in producing quality goods in demand across a European and worldwide market. Whereas Italian entrepreneurs competed on price, more effective and lucrative was competition based upon design and reputation: the allure of "Made in Italy."

Italy's reputation was closely tied to the reputation of Italians abroad. As Italian emigrants succeeded as Italian immigrants, by purchasing Italian goods they established a beachhead for Italian exports. Even when they launched emigrant brands, they often increased the reputation and validated overseas demand for Italian exports, through the overlapping transatlantic identities of "Italian" and "American." At the level of individuals, families, and communities, Italian Americans played a significant role in the growth of the global economy. Debates over the economic future of Italian emigrants also drove to the heart of the divide between Italian Liberals and Italian Fascists and Nationalists. "Made in Italy" proved not just a powerful economic banner, but also the cornerstone of a non-Fascist Italian international identity.

Italian Migration Funding Global Ties

Migration and international economics supported each other in a symbiotic relationship in forging an international Italian identity. Italian exporters and shippers relied upon emigrants to purchase Italian products, and Italians abroad relied upon commerce for contact with their native land. When Italian trade failed to flourish in an expatriate colony, emigrants lost vital ties with their mother country. Brazil, Argentina and the United States provide contrasting examples in the early twentieth century. The decline of Italian migration and exports to southern Brazil led to the social and cultural isolation of rural Italian-Brazilian settlements, as they lost regular communications with Italy. At the same time, growth in Italian exports to the United States and Argentina injected capital into the port cities of New York, Buenos Aires, Genoa, Naples and Palermo. Part of this capital funded charities and cultural initiatives on both sides of the Atlantic. The frequent arrival of Italian

ships in the Americas made return migration inexpensive, strengthening intercontinental ties. Those expatriates who sold Italian goods became natural leaders in developing "Italian" communities. Promoting an Italian identity was in their economic interest. Opportunities in Italian trade also provided a strong incentive for second-generation emigrants to learn standard Italian. From the perspective of Italians in the Americas, economic relations substantially justified their "Italian" identity. Vague ideas of *italianità* translated into concrete economic gains.

Economic advantage underpinned the life of flourishing Italian communities abroad. Among many other concerns, trade with Italy was the fundamental tenet of the "New Ten Commandments of Italian Emigrants," published in May 1913 by the leading Italian newspaper of Argentina, *La patria degli italiani* [The Fatherland of the Italians]:

1. There is only one Fatherland, and your Fatherland is Italy. You shall love no other country as much as Italy.
2. You shall never name your fatherland without reverence. Exalt the glories of your Italy, which is one of the most ancient and noble nations in the world.
3. Remember the national holidays, wherever you might be. On these occasions, at least, forget your political party and religious faith; remember only that you are Italian.
4. Honor the official representative [consul] of your fatherland, and respect him as a symbol of the faraway fatherland, even if sometimes he displeases you.
5. You shall not kill a citizen of the Fatherland by erasing in yourself the Italian consciousness, feeling, and citizenship. You shall not disguise your name and surname with a barbaric transcription.
6. You shall not attack out of envy the authority and prestige of your compatriots who hold honorary appointments.
7. You shall not steal citizens from your fatherland, letting your children squander their *italianità* to become absorbed by the people among whom you have emigrated.
8. Be proud to declare yourself always, everywhere and on every occasion, Italian in origin and in sentiment, and be not servile, be not despised by those who host you.
9. You shall always buy and sell, consume and distribute goods and merchandise from your fatherland.
10. You shall marry only an Italian woman. Only with this and by this woman shall you be able to preserve in your children the blood, language, and feelings of your fathers and of your Italy.[1]

The widely circulated decalogue united the cultural and economic fears and desires of Italian immigrant leaders. Newly arrived immigrants affected the prestige and material success of their well-established fellow countrymen. According to these bourgeois leaders, the entire colony ought to unite in speaking well of Italian culture, Italian industry, and especially Italian imports. *La patria* ordered immigrants to preserve the Italian bloodline with marital fidelity to the Italian race. The commandment addressed male readers only, as women could not transmit Italian citizenship to their children until the constitution of the Republic of Italy in 1948.[2] Familial bonds would confirm obedience to the previous nine commandments and prolong immigrants' Italian connections. The newspaper linked immigrants' ethnic "responsibilities" to the ancient biblical injunctions against murder, theft and adultery, while urging them to rise above any particular religion, "remembering only to be Italian." Far from a disinterested appeal, the decalogue reveals the economic motives of Italian importers.

Economic gain provided a fundamental motive for promoting Italian culture among expatriates. Dante meant dollar signs, in the crude formula of Giuseppe Prezzolini, director of New York City's Casa Italiana at Columbia University in 1937:

> as Dante and the Italian language become better known, more Italian products will be sold; in fact, as the prestige of Italian art, history, and literature increases, so much will increase the number of Americans who travel to Italy, who start using Italian products, who become used to Italian tastes and who, after returning home to America, will remain clients of Italian cooking and fashions.[3]

Other Italian writers were more subtle. In his 1913 textbook on "Greater Italy," Piero Gribaudi urged the merchants and industrialists of Italy to "create, with the help of the political and ethnographic Greater Italy of which we have spoken, also a commercial Greater Italy.... Italian trade must follow the emigrants.... Let us set up *made in Italy* against the well-known *made in Germany*; this will not only be patriotic, but also extremely useful for our commercial expansion."[4] From Italy's perspective, the expatriate colonies of New York, Buenos Aires, and San Francisco offered vast economic and commercial opportunities. Gribaudi noted that the nearly six million Italians abroad sent half a billion lire into Italy every year. A Socialist newspaper in Feltre (in the Veneto region) printed the Emigrants' Ten Commandments from Buenos Aires and added an eleventh, calling on emigrants to help end migration by building up their homeland: "Work and contribute with all your strength so that Italy develops its economy to support industry and commerce and gradually lower its emigration."[5] Besides representing Italy effectively abroad, the emigrants could help by sending money home in remittances and by buying Italian products. Italy came to rely upon its ethnic expansion overseas to sustain its domestic economy.

Trade and remittances provided Italy its most tangible benefit from emigration in the prewar period. Migrants sent home millions of lire each year, in a bank channels supported by the Italian state, contributing directly to Italy's industrial "takeoff" in the crucial years before the First World War. Expatriate colonies, guided by official Italian Chambers of Commerce Abroad, provided Italian exports a crucial boost in certain markets. Although later criticized sharply by Italian Nationalists, the growth of remittances and shifts in population proved enormously important for Italy's economic development.

Remittances Building the Italian Economy

The long period of peace from 1870 to 1914 stands out as a crucial pivotal in the Western world's economic history. The technologies of the "Second Industrial Revolution" allowed nations to reinvent their economies on an unprecedented scale; only the computer revolution of the late twentieth century is comparable. Italy's crucial "growth spurt" began in 1896, which marked the end of an international depression and of Italy's first Ethiopian war, and lasted until 1913 and Italy's Libyan War. Italian industrial production doubled in these seventeen years, growing on average between 4.3 percent and 5.4 percent annually. Italy's labor force turned increasingly to industry: between 1901 and 1911, 54 percent of the increase in the population of males over age ten was absorbed by the growth in manufacturing jobs. The power of Italy's industrial plant doubled between 1903 and 1911, reaching 1.17 million horsepower. In this period Italy entered the ranks of the world's wealthiest industrial nations.[6]

Emigrants' remittances were crucial in steadying this historic economic boom, just as remittances have benefitted economic development in the early twenty-first century.[7] Industrializing countries usually face a paradox: building up their technological and industrial base

requires extensive imports, but these imports must be matched by exports or foreign loans to maintain the country's balance of payments in the international economy. Faced with a trade deficit, and forced to maintain their balance of payments, most developing countries suffer a devaluation of their paper currency on the international market, which forces a rise in interest rates and price inflation. Remittances allowed Italy to escape this financial dilemma. In the years before World War I, Italy's exports matched only 60–80 percent of its imports, yet the country enjoyed a steady currency and low interest rates. Before 1890, Italy had financed two-thirds of its trade deficit with foreign loans, but after 1900, remittances balanced out foreign loans, and counterbalanced Italy's spending on imported foreign goods. From 1901 to 1913, against Italy's commercial deficit of 10,230 million lire ($2 billion) stood an "invisible credit" of 12,291 million lire ($2.45 billion). More than half the credit came from remittances, more than a third from tourism, and the rest from shipping. The credit turned Italy from a debtor nation into a modest creditor nation. Directly through remittances, and indirectly through exports and shipping, migration became a decisive factor in Italy's favorable balance of payments, by balancing Italy's internal consumption with external inputs. Thanks to its international credits, Italy was able to industrialize without relying extensively on foreign loans, without serious price tensions, and without lowering real wages.[8]

Remittances flowed through a variety of channels, and included money sent through banks, money donated to the Italian Red Cross and other Italian charities, and money carried home by returning migrants. Up to the end of the nineteenth century, Italian emigrants usually sent money home by postal money orders. For the period 1901–1915, 41.0 percent of Italy's net gain in money orders came from the United States, and 51.6 percent came from Europe and the Mediterranean basin.[9] But even as Italy received tens of millions of lire annually through banks and the postal system, these money transfers presented widespread abuses. Emigrants in the Americas could not normally speak the language of their host country and could not use local banks, who insisted upon English, Spanish, or Portuguese. Especially in the United States, many Italians fell prey to *padroni* or bosses who arranged for immigrants' food, work, housing, and banking, all at exploitative rates. Many bosses in New York City enjoyed international connections to the criminal *camorra* in the port city of Naples. These bilingual bosses were recommended to immigrants by dishonest fellow Italians in the colony, or by emigration agents in Europe. The bosses' greatest opportunity for profit was in banking services, offered conveniently through saloons, grocery stores, and even shoe-shining stands. When sending remittances to Italy, small-scale *banchisti* usually delayed the transfer of funds to allow time for speculation, often resulting in bank failure. From time to time these "bankers" absconded to Europe with the bank's funds. These tragedies are reflected in the song "Se n'è fuiuto 'o banchiere" (The banker has fled), recorded in New York City in the 1920s:

> Cursed neighbor, why did you come to my house, to get me in this mess
> My wife Maria was right, who told me,
> "Oh, watch out for this banker, he is a big scoundrel."
> Friend Antuone told me, "You know, this banker is honest, he has millions" . . .
> Ah, ah, ah, the banker has massacred me! Ah, ah, ah, my neighbor has deceived me!
> My wife was a dishwasher, earning thirty cents a week. . .
> We ate dry bread, to save money.
> Now I am worn out and ruined.[10]

Though many immigrant bankers were honest, scoundrels gave all Italian bankers a bad name. Immigrants had little redress, for the same reason they went to the illegal bank in the first place: local officials did not understand their dialects. Bank fraud among immigrants was

very difficult for local governments to prosecute, since absconders usually fled the country and immigrants rarely testified before authorities. Large Italian communities at least enjoyed a competitive choice between bankers, but Italian bankers in small settlements usually exercised a monopoly, often controlling even the local post office.[11]

The Italian state became directly involved in emigrant banking to rescue migrants from fraud and to protect the financial gains of emigrant colonialism. Legislation for "tutelage of remittances and the savings of Italian emigrants abroad," enacted in Parliament on 1 February 1901, was born as a twin to the emigration law of 31 January. The renowned Banco di Napoli, founded in 1539 as a charitable credit institution for Southern Italy, contracted to transfer remittances from the Americas to Italy at special rates. Inexpensive "emigrant money orders" could be cashed at all local offices of the Banco di Sicilia, Banca d'Italia, all Italian post offices, and of course at the Banco di Napoli. To limit the competition between the nonprofit Banco di Napoli and private banks, and to focus the Banco on money transfers, Parliament did not allow the Banco to extend loans or issue currency overseas. The bank did offer special rates for currency exchange at the port of Naples and at all its branches, and opened its own agency in New York City after a wave of American bankruptcies in the Panic of 1907.[12]

Even though the Banco di Napoli was a nonprofit institution, its involvement in emigration provoked widespread protests and controversy. Bankers and moneychangers in Italy and the Americas faced enormous reductions in their exploitative profits and speculations; after all, this was Parliament's objective. Italian American newspapers sympathetic to the bankers claimed that the project was a tax-accounting scheme, to find out exactly how much each emigrant earned and carried home. Sicilians resisted the Banco di Napoli because of ancient regional antagonisms; the bank had been excluded from business in Sicily since 1848. In contrast to the United States, South American governments opposed Italian intervention as competition against their local businesses. The Banco di Napoli organized a publicity counteroffensive, to appeal to emigrants and to reassure legitimate bankers that the Banco intended only to oppose dishonesty and fraud. Bank examiners in New York and New Jersey welcomed Italy's aid against private, unregulated banks.[13] To limit popular opposition, the Banco selected local bankers within the Italian American community to act as its corresponding representatives overseas, such as the Banco de Italia y Rio de la Plata for Argentina and the Banca Italo-Americana of San Francisco for the Pacific United States. This Italian American Bank competed within the Italian community against A. P. Giannini's Bank of Italy, later Bank of America. Nicola Miraglia, director of the Banco di Napoli, specifically rejected the application of American Express for handling remittances: "we would end up placing ourselves entirely in their hands, perhaps without benefit, certainly raising immense difficulties and uproar . . . it is not intended for this service to be entrusted to foreigners."[14] Instead, the correspondent for the eastern United States was the Italian American Cesare Conti, who went bankrupt in 1914. Despite delays and setbacks with correspondent banks, the Banco di Napoli streamlined its services and processed hundreds of millions of lire in remittance orders.

Thanks to centralized remittances, the Italian government could now transparently gauge the flow of money from emigrant colonies. Emigrants had always sent money home, but after 1902 the Emigration Commissariat relied heavily upon the Banco di Napoli's statistics to justify the importance of migration for Italy. In 1902, its first year of activity, the Banco processed 9.3 million lire in remittances. Volume nearly tripled to 23.6 million lire in the following year. Prewar levels of remittances held at 84 million lire. After 1916, because of wartime inflation and currency fluctuations, remittances soared to a peak of 980 million lire in 1920. For the period 1902 to 1915, a full 70.4 percent of the remittances came from the

United States. The United States Federal Immigration Commission reported that in 1907 alone, fifty-two million dollars were sent back to Italy through 2,625 private banks.[15] The Italian Parliament had intervened to fight injustice, but the Banco created a smooth system for remittances just in time for an unprecedented boom in Italian migration to the United States, and an unprecedented capital transfer into the Italian economy.

Other channels contributed to the inexorable rise of remittances. Other transfers such as international money orders included commercial transactions from imports and exports, whereas money sent in the regular mail was untraceable. Another measure of remittances came from deposits held in Italian postal savings banks by Italians living abroad. Thanks to higher wages abroad and a favorable exchange rate, the percentage of Italian savings deposits held by emigrants increased geometrically from 0.02 percent in 1890 to 31 percent in 1909. Deposits held by expatriates then dropped precipitously to 6.5 percent in 1910, due to the Panic of 1907 in the United States, the resulting unemployment among immigrants, and return migration. The percentage of emigrant-held deposits increased again with revived migration and the emigration wave of 1913 after the Libyan War, rising to 12.3 percent by 1914. When the Italian lira, and other European currencies, collapsed at the end of the First World War, the percentage of deposits in Italy held by expatriates soared to 41 percent in 1919, 61 percent in 1920, and peaked at 63 percent in 1921. Hundreds of millions of dollars, reis and pesos poured into Italy and revolutionized economic life in countless towns and villages. The injection of capital cut local lending rates, permitted the construction of new homes, allowed for richer pageantry at the feasts of local saints, financed tax payments, and raised the value of land, allowing investment in orchards and intensive agriculture.[16]

The Italian Chambers of Commerce Abroad

Emigration offered new opportunities for Italian industry, as optimistic Italian expansionists hoped to link the export of Italian goods with the export of Italian people. The fatherland's industry and agriculture stood to gain or lose a great deal in international markets, particularly in Argentina and the United States. If expatriates did not buy Italian products abroad, but produced their own Italian-style goods overseas and exported them back to Italy, their competition could ruin entire sectors of the national economy. Italy needed to maintain a strong, competitive export presence among expatriate colonies, or any temporary economic gains from emigration could backfire.

Far too important to be left to the "invisible hand" of laissez-faire ideology, the economics of Italy's expansion were coordinated through the Italian Chambers of Commerce abroad. Unlike United States Chambers of Commerce, which are independent and sometimes highly critical of the United States government, the Italian Chambers were actual representatives of the state, entrusted with the nation's export interests. The Ministry of Foreign Affairs first established the international network in 1883, and ordered consuls to establish and support Chambers of Commerce wherever possible. They were maintained by the Ministry of Commerce, which sought their advice and gave them lavish subsidies.[17]

Italian Chambers of Commerce Abroad exerted local influence in their communities, and international influence through a worldwide network. By 1911, Chambers had been established in Buenos Aires and Rosario in Argentina; Montevideo, Uruguay; São Paolo, Brazil; and Mexico City. In Europe, Chambers represented Italian commerce in Berlin, London, Paris, Marseilles, Bruxelles and Geneva; in the Mediterranean Basin, there were Chambers in Constantinople, Smyrna (Izmir, Turkey), Tunis and Alexandria, Egypt. In the United States, Italian Chambers were formed in San Francisco, New York City and Chicago, and later in

Boston, New Orleans and San Antonio. These organizations overseas were the crowning jewels of the *Unione delle Camere di Commercio* [Union of the Chambers of Commerce] in Rome, which represented more than forty chambers in Italy. Italian Chambers abroad published bulletins of regulations, tariffs and trading contacts, and maintained public "museums" of Italian industrial and agricultural samples, on display for local importers and retailers to taste, touch, and feel. The Chambers also sent local products to Italy's "commercial museums" in Milan, Turin and Venice, to encourage Italy's international trade.[18]

To coordinate their strategy and tactics, the Italian Chambers abroad organized a series of international congresses, in cooperation with the chambers of the peninsula. Rome hosted the first conference in 1901, followed by Paris in 1911, Brussels in 1912 and Naples in 1913. The outbreak of war in 1914 shattered the Chambers' cohesion, as each Chamber rallied to the cause of its host country. Before the war, the united Chambers called upon Italy and other countries to lower tariffs, establish Italian credit unions abroad, improve shipping and communications, and make other changes to benefit international commerce. The Chambers abroad worked to break down administrative barriers within "Greater Italy," proposing that the Italian postal service reduce postage rates for foreign mail to domestic letter rates. This measure would have erased national boundaries for postal communications; wherever an Italian mailed a letter, the price would have been the same. Postage between Italy and Eritrea was already at domestic rates. The proposed resolution would have extended the postal regime for Italy's formal colonies also to Italy's expatriate colonies. Although this proposal failed, the Chambers of Commerce advised the Italian government on all its trade policies by offering an independent on-site perspective and providing crucial information and representation for Italian interests abroad.[19]

The Italian Chambers of Commerce in the United States demonstrated the collective diversity and anxieties of the expatriate bourgeoisie. In the United States, the Italians of San Francisco created a Chamber in 1885, but the Italians of New York could not agree how to organize themselves until 1887. At first the New York Chamber only provided information about Italian exports and displayed product samples, but soon the group adopted an activist role in opposing restrictions on immigration, supporting the commemoration of Columbus Day in the State of New York, and lobbying for customs reform and cheap transportation, to better distribute Italian goods throughout the country.[20] The chamber's greatest fear was that Italy and things Italian would hold a poor reputation in North America. The group lobbied the Italian government to set up an affiliate of the Banco di Napoli in New York City, to fight against the illegal Italian bankers.

The Chamber also fought strenuously against the distribution of adulterated and false Italian products, which could give *Made in Italy* a bad name. In the United States, American products could be legally labeled "Florentine" or "Italian," even if they did not come from Florence or Italy. Bars sold "martinis" without a drop of Martini vermouth. Oil wholesalers sold "pure olive oil" that was a third, a half or two-thirds cottonseed oil; wine sellers refilled the distinctive Chianti wine flasks with bad American wines and sold them as Italian. The New York Chamber sought to awaken Italy to the threat of American competition. It urged a ban on bottle-makers' export of empty Italian wine bottles, and convinced the Italian government to ban the export of rennet (*caglio*), essential to the manufacture of Italian cheeses. The Chamber reserved a special invective for the "blind" Italian industrial expositions that had given prizes to American wines, produced in direct competition with Italian wines.[21] In the United States, cheap products were falsely labeled "Italian"; in Britain, however, Italian exports suffered the opposite problem. British retailers did not allow Italian products be judged on their own merits. Italian furniture was marketed as English, silk from Como marked as from Lyons, and Biellese wool sold as Manchester cloth.[22]

The long-sought link between emigration and increasing exports proved tenuous. Nonetheless, certain Italian industries saw a dramatic rise in exports to countries receiving Italian migrants, especially Argentina and the United States. Even as domestic wine and pasta production increased in these two countries across the Atlantic, they imported more and more Italian pasta, wine, vermouth, cheese, and sweets. Adolfo Rossi had noted in 1882 that Italian wines were practically unknown in the western United States, but the Italian vineyards of California persevered in creating a new market for Italian wines in the United States.[23] Other principal Italian exports of the period included cotton cloth and thread, marble, dried fruits, and citrus fruits. Piero Gribaudi noted that Italian American glove makers in the United States took advantage of high tariff protection to beat out Italian imports, but "we should not be so pessimistic to believe that emigration will be more dangerous than useful to Italian exports." Italy had benefitted from a sudden new demand abroad for Parmesan and pecorino cheese, canned tomatoes, salted fish, vegetables, and olive oil.[24] Italian exports to the United States almost doubled between 1901 and 1914, reaching 272 million lire in 1909. This achievement was tightly linked to population migration; importers concentrated almost exclusively on the Italian immigrant market, without reaching out to a broader national market until after the First World War.[25] In its beginnings, emigrant colonialism rested on people, not money.

The clash of perspectives and interests carried over into relations between immigrants and "indigenous" residents. Because of racial and religious prejudice, and competition for labor, many Americans could not see beyond the newcomers' immediate poverty. Despite the collusion of interests between Americans and the Italians, there stood a tragic gulf of misunderstanding. Some Americans thought the immigrants were money-grubbers, ruining themselves for Mammon; many Italians felt the same about America and its culture of infinite monetary gain, without regard for the human spirit. After arranging an art exposition for immigrants in Chicago, Jane Addams noted that "an Italian expressed great surprise when he found that we, although Americans, still liked pictures, and said quite naïvely that he didn't know that Americans cared for anything but dollars—that looking at pictures was something people only did in Italy."[26] Both sides accused the other of unbridled avarice in America, the "land of dollars."

Much of the misunderstanding and controversy over immigration and emigration stemmed from different interpretations, economic, cultural, ethnic, and political, applied to the same phenomenon. Simple "push–pull" economic indicators and income differentials were tempting as an easy explanation, but emigration brought with it much deeper implications. The human costs and liabilities of mass migration unbalanced the tangible assets of remittances, exports, and profits. Mass emigration, with high return migration, combined the problems and opportunities of foreign and domestic policy, through the local and international consequences of population movement. Italy's involvement with emigration thus moved far beyond economics.

Liberalist Principles versus Nationalist Fascism

Emigration proved controversial in Italy, as diametrically opposed political economies developed in the early twentieth century. The Liberal economist Luigi Einaudi enshrined the holistic approach to emigration as an economic, cultural, and symbolic representation of Italy abroad. When he wrote *A Merchant Prince* in the spring of 1899, Einaudi was 25 years old and a junior professor of economics in Turin. The work made him famous and launched a long and illustrious career. After World War II, he became the first President of the Republic of Italy, leading the postwar reconstruction of Italian entrepreneurship, exports, and economic success. Einaudi's inspiration for *A Merchant Prince* was the Exhibition of Italians Abroad at the Italian National Exposition in Turin. As a member of the prize jury for the Emigration

and Colonies section, Einaudi studied all the entries, from Australia to India, from Argentina to Tunisia to New York. To communicate the proud excitement of Italy's worldwide expansion, particularly in South America, Einaudi constructed a narrative around the vision and experience of one "merchant prince," Enrico Dell'Acqua, chosen from among many charismatic "self-made men." Einaudi aimed to revive the glory and prestige of Italy's medieval past, comparing Dell'Acqua to the princes of Genoa and Milan: "the living incarnation of the intellectual and organizational qualities destined to transform today's 'little Italy' into a future 'greater Italy,' peacefully expanding its name and its glorious progeny in a continent more vast than the ancient Roman Empire."[27]

Einaudi frames his story as a national struggle for economic survival: Italy had to attack Britain and Germany's domination of foreign markets. Enrico Dell'Acqua is a brilliant general making plans, rallying resources, and choosing his battleground. Italy's emigrants change from an illiterate rabble into "a disciplined army that moves as one, under the leadership of captains and generals in the conquest of a continent. . . . From the anonymous mass rise the elect, who stamp a new life and potential, earlier unknown, on the mass." These captains open workshops and warehouses by dint of hard work and savings. Einaudi refers to the popular Victorian author Samuel Smiles and the tenacious power of self-help: "will is power." Soon Italy would furnish architects and managers, not common laborers, in the global division of labor: "We continue to furnish soldiers, but we have already begun to export 'captains of industry.'"[28] He boasts, "No longer 'Made in Germany' but 'Made in Italy'—[This is] an Italian who beat the English and the Germans."[29]

Einaudi asserts that the battle had already been won; Italy needed only to preserve its victory. The story of Dell'Acqua disproved accusations that Italians lacked initiative or a sense of solidarity. Nor should Italy fear competition from established expatriates, for example, from Italian vineyards in California or Dell'Acqua's textile factory in Brazil:

> It is the logic of little minds to believe that every factory established by our compatriots, every piece of cultivated land, every hill planted with vines in America represents a subtraction from our activity, a net loss for Italian exports. In reality, those local products accredit Italian brands and awaken latent desires, and as tastes become more refined, the market turns from imitations made by Italians to genuine Italian products.[30]

Einaudi asserted that vineyards in California aroused an interest in Italian wines "which otherwise would not exist."[31] Nor could Italian expatriate products ever replace authentic merchandise from Italy. True to his Liberal principles, Einaudi saw no need to fight economic development within "greater Italy." Rather, the Italian government needed to establish trade treaties and reinforce cultural bonds in the Americas, perhaps even establishing an Italian American university.

Against Einaudi's passionate Liberalism, based upon free trade and independent Italian expansion in the Americas, Enrico Corradini proposed an equally passionate Nationalism, founding Italy's first Nationalist party, which later merged with Fascism in 1923. In lectures, novels and plays, Corradini provided new answers for anyone disaffected or embarrassed by Liberal Italy's compromises and shortfalls. After a tour of South America in 1908, he seized upon emigration as the sign of Liberalism's failed mission. Corradini used emigration as an archetypical symbol, with resonance for all Italians, to translate his arcane, literary theories into a political program of social unity and belligerent national transformation. Corradini depicted miserable, frustrated emigrants, cut off from their families and from the Fatherland because of Liberal policies. He opened his novel of 1910, *La Patria lontana* [The Faraway

Fatherland], with a debate between the Nationalist and Liberalist visions of Italian expansion. Although Luigi Einaudi had claimed that trade with Italian expatriates constituted a Greater Italy, Corradini's protagonist, the imperialist character Piero Buondelmonti, condemns the complex loyalties of an Italian-Argentinian wine producer:

—So, you hope to ruin the sale of Italian wine in Argentina?
—Of course.
—Last night you told me you sent all your children to school in Italy, and you feel you must return to Italy at least every other year.
—That is true.
—But it is also true that you have no right to boast of your *italianità* like you did last night.
—Why?
—Simply because you are a wine producer in Mendoza, and therefore an enemy to the importation of Italian wine in Argentina. You said this yourself.
—But you forget that in Argentina I give work to many Italians, and the more my business grows the more work I will give to my compatriots.
—Yours, but not mine. . . . These gentlemen have placed themselves outside *italianità*: because they no longer belong to the Italian concentration camp [*campo di concentramento italiano*]. Maybe they are still patriots, if you give this word a sentimental meaning, but they will no longer be our co-nationals in the practical, active sense of this word. For them to remain Italians, nationally speaking, the land on which they labor and enrich themselves would have to become Italian. If you don't want to trap the nation in a blind alley, the only way to become nationalists, or patriots, is to be imperialists.[32]

For Corradini, a Greater Italy based on emigration amounted to self-serving hypocrisy: it atomized Italy's national energies and left each emigrant prey to exploitation and disillusionment. Better for emigrants to live under Italian rule in conquered Africa, Corradini urged, to resurrect the glorious triumphs of the Roman Empire. But this path of bloody conquest led to tyranny, isolation, brutalization, death and despair, destroying not just northern and eastern Africa but Italy itself. Within a dozen years of Corradini's death, Italy lay in ruins brought on by Mussolini's military defeats.

For rebuilding Italy from the ashes, Luigi Einaudi emerged as Governor of the Bank of Italy, Minister of Finances and Treasury, and the first elected President of the Republic of Italy. Einaudi implemented his own Liberal political theories, recognizing the invaluable human capital in international migration already evident in 1900. With high rates of international migration and new, internal migration within Italy, the country led the world in economic growth. Italian exports competed successfully in many different sectors and regions. By 1975, fourteen years after Einaudi's death, Italy had become one of the founding members of the G-7, the group of the seven richest democracies in the world.

Italy's economic success, tied to international migration, holds many lessons applicable for the twenty-first century. Italian Americans lived not just as individuals, but as part of major developments in world history.

Further Reading

Cafagna, Luciano. "Italy 1830–1914," in *The Emergence of Industrial Societies*, edited by Carlo M. Cipolla. London: Fontana, 1973.

Choate, Mark I. *Emigrant Nation: The Making of Italy Abroad*. Cambridge: Harvard University Press, 2008.

Zamagni, Vera. *The Economic History of Italy, 1860–1990*. Oxford: Clarendon Press, 1993.

Notes

1 Emphasis added. The decalogue was republished widely in Italian newspapers around the world. Angelo Filipuzzi, ed., *Il dibattito sull'emigrazione* (Florence: Felice Le Monnier, 1976), 397–398; also Mirta Zaida Lobato, "*La Patria degli Italiani* and Social Conflict in Early-Twentieth-Century Argentina," in *Italian Workers of the World*, ed. Donna R. Gabaccia and Fraser M. Ottanelli (Urbana and Chicago: University of Illinois Press, 2001), 63–78. All translations by Mark I. Choate, unless otherwise noted.

2 Sabina Donati, *A Political History of National Citizenship and Identity in Italy, 1861–1950* (Redwood City: Stanford University Press, 2013).

3 *Nel Cinquantenario della Camera di Commercio Italiana in New York* (New York: Camera di Commercio and S. Vanni, 1937), xxxix.

4 Pietro Gribaudi, *La più grande Italia: Notizie e letture sugli Italiani all'estero e sulle colonie italiane (Libia, Eritrea, Somalia)* (Turin: Lib. edit. Internazionale, 1913), 199–200; emphasis in the original.

5 Filipuzzi, ed., *Il dibattito sull'emigrazione*, 399.

6 Luciano Cafagna, *Dualismo e sviluppo nella storia d'Italia* (Venice: Marsilio, 1989), 297–300.

7 Donald F. Terry and Steven R. Wilson, eds., *Beyond Small Change: Making Migrant Remittances Count* (Washington DC: Inter-American Development Bank, 2005).

8 Luciano Cafagna, "Italy 1830–1914," in *The Emergence of Industrial Societies*, ed. Carlo M. Cipolla (London: Collins/Fontana, 1973), 303; Cafagna, *Dualismo e sviluppo nella storia d'Italia*, 297–303; Vera Zamagni, *The Economic History of Italy, 1860–1990* (Oxford: Clarendon Press, 1993), 127; Gianni Toniolo, *An Economic History of Liberal Italy, 1850–1918* (London: Routledge, 1990), 20, 101–102; Gino Massullo, "Economia delle rimesse," in *Storia dell'emigrazione italiana*, ed. Piero Bevilacqua, Andreina De Clementi and Emilio Franzina (Rome: Donzelli, 2001–2002), 1: 161–183; R. J. B. Bosworth, *Italy and the Wider World 1860–1960* (London: Routledge, 1996), 159–181. The lira traded steadily at 5 lire per U.S. dollar on the gold standard, with stable prices for 1882–1914: Istituto centrale di statistica, *Sommario di statistiche storiche italiane 1861–1955* (Rome: Istituto Poligrafico dello Stato, 1958), 196–203.

9 Data from Commissariato Generale dell'Emigrazione, *Annuario statistico della Emigrazione Italiana dal 1876 al 1925* (Rome: Commissariato Generale dell'Emigrazione, 1926), 1641, 1657–1659; Direzione generale della statistica, *Annuario statistico italiano, 1895* (Rome: Tip. Nazionale di G. Bertero e C., 1896), 697–698; *Annuario statistico italiano, 1900* (Rome: Tip. Nazionale di G. Bertero e C., 1900), 746; Ornello Vitali, "Metodi di stima impiegati nelle serie storiche di contabilità nazionale per il periodo 1890–1970," in *I conti economici dell'Italia: Una sintesi delle fonti ufficiali, 1890–1970*, ed. Guido M. Rey, vol. 1 (Bari: Laterza, 1991), 100.

10 Paquito Del Bosco, *Cartoline da Little Italy* (Rome: Nuova Fonit Cetra, 1997), Compact Disc CDFO 3642; Antonio Virgilio Savona and Michele L. Straniero, eds., *Canti dell'emigrazione* (Milan: Garzanti, 1976); Ida M. Van Etten, *Vergogne italiane in America*, trans. "Umano" (Milan: Critica Sociale, 1893).

11 "300 'Fake' Banks in New York City. Hungarian and Italian Emigrants Fleeced Out of $1,000,000 a Year," *The New York Herald* (29 October 1905), 1–2; Vittorio Soldaini, "La raccolta delle rimesse degli emigrati italiani e l'opera del Banco di Naples: 1902–1913," *Revue internationale d'histoire de la banque*, 2 (1969), 137–141.

12 Francesco Balletta, *Il Banco di Napoli e le rimesse degli emigrati, 1914–1925* (Naples: Institut Internationale d'histoire de la Banque, 1972); *The Banco di Napoli* (Naples: Ufficio Studi del Banco di Napoli, 1951), 26–29.

13 The paper *L'Araldo Italiano* and the Italian consul in New York opposed the Banco di Napoli; *Il Progresso Italo-Americano* and the Italian Chamber of Commerce of New York supported it. Luigi De Rosa, *Emigranti, capitali e banche, 1914–1925* (Naples: Banco di Napoli, 1980), 170–172; *The Banco di Napoli*, 5–8; Atti parlamentari, CD Leg. XXI, Sessione 1900, Documenti 62A, 5–21, and Discussioni, 10 December 1900, 1290–1302; Archivio Centrale dello Stato, PCM 1906 2.4.858. Banco di Napoli, Direzione generale, Relazione sulla gestione 1905, 30 May 1906, pp. 2–3, 10–12, 23–24. Brazil required an especially large security deposit, which made it more difficult for the Banco to find correspondent agents.

14 De Rosa, *Emigranti, capitali e banche*, 400; Soldaini, "La raccolta delle rimesse," 147–150; Felice A. Bonadio, *A. P. Giannini, Banker of America* (Berkeley: University of California Press, 1994), Gerald D. Nash, *A. P. Giannini and the Bank of America* (Norman: University of Oklahoma Press, 1992); Archivio Storico del Banco di Napoli, Naples [ASBN], Banco di Napoli Servizio Emigrati Posiz. XIX, 5, 11/1, Agenzia New York to Direttore Banco di Napoli, 28 January and 10 March 1914.

15 [Commissariato Generale dell'Emigrazione], *Notizie sulla emigrazione italiana negli anni dal 1910 al 1917. Estratto dalla "Relazione sui servizi della emigrazione dal 1910 al 1917"* (Rome: Tipografia Cartiere Centrali, 1918), 102; Direzione Generale della Statistica, *Statistica della Emigrazione Italiana per l'Estero negli*

anni 1902 e 1903 (Rome: Tipografia Nazionale di G. Bertero, 1904), 102; *Annuario statistico della Emigrazione Italiana dal 1876 al 1925*, 1637, 1646–1651. This compendium presents the quarterly statistics available to the Italian government in its decisions; for the most definitive statistical treatment, with the full benefit of hindsight, see De Rosa, *Emigranti, capitali e banche*.

16 *Annuario statistico della Emigrazione Italiana dal 1876 al 1925*, 1640, 1652–1653; *Notizie sulla emigrazione italiana negli anni dal 1910 al 1917*, 104; *Inchiesta parlamentare sulle condizioni dei contadini nelle province meridionali e nella Sicilia. Senatore Eugenio Faina, Presidente* (Rome: Tipografia Nazionale di Giovanni Bertero, 1910), 8, 55–58.

17 On the Chambers within Italy: Cesare Mozzarelli and Stefano Nespor, "Amministrazione e mediazione degli interessi: le Camere di commercio," in *L'amministrazione nella storia moderna*, ed. Istituto per la scienza dell'amministrazione pubblica, vol. 2 (Milan: Giuffrè, 1985); Elisabetta Bidischini and Leonardo Musci, eds., *Guida agli archivi storici delle Camere di commercio italiane* (Rome: Ministero per i Beni culturali e ambientali, Ufficio Centrale per i Beni archivistici, 1996); Jonathan Morris, *The Political Economy of Shopkeeping in Milan, 1886–1922* (Cambridge: Cambridge University Press, 1993); [Camera di Commercio Italiana per le Americhe], *I venticinque anni della Camera di Commercio Italiana per le Americhe, 1944–1969: Venticinque anni di scambi commerciali tra l'Italia e le Americhe* (Rome: [n. p.], 1971).

18 Coloniale Italiano, *Annuario dell'Italia all'estero e delle sue colonie* (Rome: Tipografia Istituto dell'Unione editrice, 1911), 582–591; ASBN, Banco di Napoli Servizio Emigrati Posiz. XIX, 5, 5/10, *Bollettino della Camera Italiana di Commercio* 6/9–10 (September–October 1913).

19 Camera di Commercio Italiana nel Belgio, *Atti del Secondo Congresso delle Camere di Commercio Italiane all'Estero* (Bruxelles: Tipografia Luigi Bendotti, 1913); *Nel Cinquantenario*, 132; Camera di Commercio Italiana di Monaco di Baviera, *Relazione per il VI Congresso delle Camere di Commercio Italiane all'Estero, Roma 1931-X* (Trento: A. Scotoni, 1931); Museo Centrale del Risorgimento, Rome [MCRR], Busta 77 n. 54, Oreste Baratieri to Amalia Rossi, 17 April 1892.

20 *Nel Cinquantenario*, 131–138, 199.

21 Ibid., 81, 123–128.

22 Fanny Zampini-Salazar, *L'Italia all'estero—Conferenza tenuta all'Associazione della Stampa in Roma nel maggio 1901, ripetuta a Milano ed a Torino nel dicembre 1901* (Rome: Officina Poligrafica Romana, 1902), 23; Gribaudi, *La più grande Italia*, 200.

23 Fanny Zampini-Salazar, *L'Italia all'estero—Conferenza tenuta all'Associazione della Stampa in Roma nel maggio 1901, ripetuta a Milano ed a Torino nel dicembre 1901* (Rome: Officina Poligrafica Romana, 1902), 23; Gribaudi, *La più grande Italia*, 200.

24 Gribaudi, *La più grande Italia*, 198–199; ISTAT, *Sommario di statistiche storiche italiane 1861–1975* (Rome: ISTAT, 1976), 118.

25 *Nel Cinquantenario*, 65–66.

26 Jane Addams, *Twenty Years at Hull House* (New York: Macmillan, 1910), 372; Neil Larry Shumsky, "'Let No Man Stop to Plunder!': American Hostility to Return Migration, 1890–1924," *Journal of American Ethnic History*, 11 (1992), 56–75; Stephen Michael DiGiovanni, *Archbishop Corrigan and the Italian Immigrants* (Huntington: Our Sunday Visitor, 1994), 142, 193–194; Rossi, *Nel paese dei dollari*.

27 Luigi Einaudi, *Un principe mercante: Studio sulla espansione coloniale italiana* (Turin: Fratelli Bocca, 1900), 18–19.

28 Ibid., 14, 160–161, 16.

29 Ibid., 85.

30 Ibid., 146, 160.

31 Ibid., 146, 166–168.

32 Enrico Corradini, *La Patria lontana* (Milan: Fratelli Treves, 1910), 1–2, 7–8. Corradini does not mention emigration in *La vita nazionale* (Siena: Ignazio Gati, 1907).

FASCISM AND ANTI-FASCISM IN ITALIAN AMERICA

Stanislao G. Pugliese

Prologue: Remembering Fascism[1]

It was not an unusual request. Our Italian street band was playing an annual *festa* in New York, dedicated to the patron saint of a village of the Mezzogiorno. A mass in the church commemorating the martyr's life and death had just concluded and now the band led a procession carrying the saint's statue through the streets of the town. The elderly gentleman approached us and requested we play "Giovinezza," the anthem to "Youth" in Fascist Italy. Since the band had been formed in 1923, we did indeed have "Giovinezza," as well as the "Marcia Reale" (the "Royal March" of the Savoy dynasty, Italy's original national anthem) and even "Marcia su Roma," the Fascist hymn celebrating the March on Rome in October 1922 when Benito Mussolini was appointed prime minister. We played the song (many band members were unaware of its provenance and historical lineage), the old gentleman was misty-eyed, and everyone was happy.

I was struck by the incongruous nature of the request. The old men (and they were always men, never women) hardly seemed like dyed-in-the-wool Fascists although a few admitted admiring the regime. "Mussolini wasn't so bad," they would say, "Hitler and Stalin were much worse." Some insisted that Mussolini had accomplished reforms and programs never completed by the Liberal state. "He made the trains run on time," was still considered a legitimate defense, as was "his only mistake was his alliance with Hitler." Punitive expeditions against socialists, Catholic activists and agrarian leagues were unacknowledged; the assassinations of political opponents (Giacomo Matteotti), unions leaders, intellectuals (Carlo and Nello Rosselli) or even priests (Giovanni Minzoni), unknown or ignored; exile or *confino* for political opponents nonexistent. These elderly gentlemen reveled in a hazy nostalgia for the songs of their long-lost youth. Yet some of the same men would recall the presidency of Franklin Roosevelt or even the mayoralty of Fiorello La Guardia with fondness and admiration. How can we understand these contradictory opinions and values so deeply embedded in Italian American culture and memory?

Supporting Fascism

When Benito Mussolini was called upon by King Victor Emanuel III to come to Rome in October 1922 to form a new government, thereby initiating two decades of Fascist rule, the event had repercussions across the Italian Diaspora, especially thousands of miles away in the United States. The demonstrations, revolts, strikes, beatings and assassinations that had rocked post–World War I Italy now arrived with a certain contained fury in America. Most Italian Americans—workers, intellectuals, Church leaders and *prominenti*—had to choose a political position. And as in Italy, even before the Fascist regime had established itself in power,

an anti-Fascist opposition was formed to challenge it on the fields of politics, culture and society. For Americans and Italian Americans alike, Benito Mussolini's rise to power in 1922 appeared—in the words of Lincoln Steffens—"like thunder on the right."[2]

Italian Americans were engaged in a precarious balancing act in the 1920s and 1930s. On the one hand, they were constantly excoriated for being "too Italian" or "too foreign"; admonished that they should quickly abandon their old ways and assimilate into "Americans." On the other hand, they felt the pull of nostalgia and (belated) patriotism and the exhortations of the Fascist regime to remain "good Italians." But even the Fascist regime itself was in conflict over how to deal with the Italian American colony. Was it best to maintain an Italian grip on the emigrants overseas or better to encourage them to become new citizens and thereby have more influence over American policy toward Italy?[3]

Mussolini's overheated rhetoric to the effect that contemporary Italians were the descendants of the ancient Romans and that modern Italy had been denied its rightful "place in the sun" of imperialism had a powerful attraction to Italians in America. As scholars have noted, emigrants who had originally thought of themselves as Napoletani, Calabresi, Palermitani, etc. only began to think of themselves as Italians once they set foot in the New World. There, they were subject to prejudice, racism and stereotypes, sometimes fostered by an older generation of northern Italian immigrants. Political, legal and immigration authorities and the general culture accepted those negative and pernicious stereotypes. No wonder then that Fascism functioned as an ideology of compensation for the first and second generation of Italian immigrants. It's an ideology that has a long life: today, one could wander the remnants of Italian American shops in New York City's Little Italy and purchase marble busts of Mussolini's famous jutting-jaw profile as well as T-shirts emblazoned with his image and recordings of his more infamous speeches. What had begun as an ideology of compensation in the 1920s and 1930s morphed into a culture of nostalgia at the end of the twentieth century.[4]

Whereas Fascism and anti-Fascism in America oftentimes reacted to events in Italy and Italy's foreign affairs, there were also domestic, indigenous developments (such as the Sacco and Vanzetti case [see Chapter 17] and the Depression) that influenced debates and events in the streets. The struggle for the political allegiance of Italian Americans was fought in the Italian language press, the churches, theaters and union halls, academia, *bocce* courts and around the kitchen table.

During the 1920s and 1930s, there were dozens of Italian-language newspapers (unlike the single one today) that were forced to address the rise of Fascism and attempted to explain this new political movement to their readers (see Chapter 15). Thousands of miles from home and exiled in a strange land, Italian Americans were confronted with a bewildering array of interpretations and explanations. There were three broad categories of response to the new political situation in Italy: the enthusiastic embrace and support of what appeared as a new, activist, and vital regime; a passionate opposition born from the militant anarchist and socialist Italian American communities; and a passive, yet skeptical acceptance. Within these categories there were, of course, varying degrees of commitment. Whereas we would expect immigrants to turn to their native-language newspapers (which ranged from those that energetically endorsed Fascism to the anarchist and socialist papers which vehemently condemned the new movement), Italian Americans were also influenced by *American* perceptions of Mussolini's regime.[5]

American and Italian American newspapers shifted their coverage and commentary of the Fascist regime. The ragged bunch of drifters, visionaries and thugs who marched on Rome while Mussolini himself was safely ensconced in Milan were soon transformed into a political vanguard protecting Italy from a Bolshevik catastrophe. Italian Americans had their first occasion to reconsider their position in 1923 when Fascist Italy bombed the Greek island of

Corfu, replaced proportional representation and ended parliamentary government in Italy. In 1924, Mussolini managed to overcome the most serious challenge to his regime after the Socialist deputy Giacomo Matteotti was assassinated by his henchmen (see Chapter 18). But by 1925, the *New York Times* was singing the praises of the Corporate State as a way to defuse the revolutionary potential of the Left. A year later, the J.P. Morgan Company lent over $100 million to Mussolini's regime.[6] For a struggling immigrant in America earning a few dollars a week, the Morgan imprimatur was indeed impressive proof that the Fascist regime was gaining the respect and admiration of the world.

Once Mussolini had overcome the Matteotti crisis and secured his power with an infamous speech in Parliament on 3 January 1925, the regime turned its attention to Italians abroad and specifically Italians in America. Even before Mussolini's "March on Rome" and his assumption of formal political power, Agostino De Biasi had established a New York *Fascio* in the spring of 1921 and the first Fascist emissary to America, Giuseppe Bottai, arrived that summer. Based on a concept borrowed from the Liberal state, the Fascist regime saw these communities as "colonies" and therefore fostered a colonial mentality in both Italy and America.[7]

Mussolini was always sensitive to the image (if not the reality) of Fascism abroad in the Italian Diaspora. Accordingly, he charged leading members of the Partito Nazionale Fascista (PNF) and diplomats with paying particular attention to the emigrant community in the United States.[8] As early as 1923—just a few short months after Mussolini had assumed power—there were already dozens of loosely affiliated groups in America. In order to consolidate their work and increase their political efficiency, the regime brought them together under the umbrella of the Fascist League of North America (FLNA) in 1924. This though, created tensions with the traditional diplomatic corps and indeed, for the next twenty years there was an always-present conflict between the Foreign Ministry and the attempts of the regime to directly intervene in Italian American affairs.[9] At one point the Italian Ambassador to Washington, DC even offered to disband the FLNA but the American State Department was ambivalent.

In fact, by 1927 the conflict between the FLNA and the Italian diplomatic corps was so acute that Mussolini began to reconsider the value of the FLNA and he finally pulled the plug after an explosive article appeared in *Harper's Magazine*.[10] One suspects that the political and public outrage generated by the article was more a manifestation of anti-Italianism than anti-Fascism. Nonetheless, Mussolini cabled Ambassador de Martino with orders to disband the FLNA, which closed its doors on 31 December 1929. This did not, though, stem the continuing appeal of Fascism among many Italian Americans, and Fascist sympathizers had various venues from which to seek support. Domenico Trombetta created the Lictor Federation and Fascist propaganda moved from the terrain of politics to that of culture, with organizations such as the Casa Italiana at Columbia University, the Dante Alighieri Society and the Order Sons of Italy (with over 300,000 members) taking up the cause and becoming the catalysts for Fascist propaganda. Newspapers and journals such as Agostino De Biasi's *Il Carroccio* [The War Wagon], Trombetta's *Il Grido della Stirpe* [The Ancestral Call] in New York, Francesco Macaluso's *Giovinezza* [Youth] in Boston and Carlo Barsotti's *Il Progresso Italo-Americano* [The Italian-American Progress] (after it came under the editorship of Generoso Pope) became unofficial American mouthpieces of the regime in Italy. Italian diplomats were muzzled while *prominenti* such as Pope gained in stature. Pope at one time controlled 70 percent of the Italian language press in America and his Columbus Day appearances at the Columbus monument in New York City were annual events with the Italian consul general and the city's mayor at his side.[11] Pope had the political instinct—or perhaps just good luck—to renounce Italian Fascism shortly before the attack on Pearl Harbor in 1941.

An FBI report on him sent to FDR had the President concluding "He merely hunted with the hounds chiefly as a business opportunity."[12]

A former Foreign Minister of pre-Fascist Italy, Count Carlo Sforza, pointed to the "melting pot" paradigm of immigration and assimilation as a major reason for the philo-Fascist views of many Italian Americans.[13] Don Luigi Sturzo, the Catholic priest and founder of the *Partito Popolare Italiano* (forerunner of the postwar Christian Democratic Party) believed that the Fascism of the Italian American was "nationalism with a Fascist label." Sturzo had recognized that the immigrant mind conflated nationalism with the Fascist regime. "My order," thundered Mussolini in Biblical terms, "is that an Italian citizen must remain an Italian citizen, no matter in what land he lives, even to the seventh generation."[14] Constantine Panunzio, a sociologist at the University of California, instead optimistically believed that a majority of Italian Americans remained "fundamentally anti-Fascist" in the 1920s and 1930s.[15]

Fascism fulfilled a necessary function in the worldview of the Italian American immigrant: in the hostile terrain of the New World, Fascism developed into an "ideology of compensation," consoling the powerless that their beloved Italy was indeed a world power commanding the respect of other nations. No longer was Italy the land of Neapolitan song, pasta, gondolas and mandolins. Instead, Mussolini could "darken the skies" with the Fascist air force or wield "eight million bayonets" on the field of battle. The myth of ancient Rome was dutifully revived; Italians and their emigrant brothers overseas were constantly reminded of their noble military tradition. History was transformed into myth as the Fascists soon laid claim to the most prestigious epochs of the past, from the Roman Empire to the Risorgimento. Shrewdly reading the immigrants' mind-set, the Fascist regime prominently boasted of the achievements of prominent Italians who were absorbed into the Fascist pantheon. Guglielmo Marconi—father of the "wireless"—was inducted into the Italian Academy; Italo Balbo, the famous trans-Atlantic aviator and Italy's answer to Charles Lindbergh, was accorded a hero's welcome when he led a squadron of planes to Chicago in 1933.[16]

Nor were Italian Americans immune from the hyper-masculinity and supposed Roman virility of Mussolini and Fascism. Typical is this poem by Rosa Zagnoni, born in Bologna in 1888 and poet laureate of Fayetteville, Arkansas, published in *Il Carroccio* on New Year's Day, 1927:

To Mussolini, the Immortal

There is the lure of the jungle in your eyes.
Eagle wings have swept your pensive brow.
You have the untamed majesty of lions
Who scorn to follow, but unconscious reign.
You remind me
Of breakers crashing against the wind swept cliffs
Rising to meet the sun.
You are a man such as is born but once,
But that once born
Shall never taste of death.
Your name shall be as a phosphorous torch
That glows out of the night
Casting eternal light upon your sons.[17]

If we recognize that most Italian Americans supported Fascism because of economic insecurity, class stratification, status anxiety, and wounded nationalism rather than a clear

understanding of the ideology and philosophy of Mussolini and Giovanni Gentile, then the "ideology of compensation" thesis seems to stand on firmer ground. Italian American immigrants created a mythical Italy in their collective consciousness. It was an Italy where Mussolini had eradicated all the traditional evils: unemployment, hunger, malaria, and the Mafia. In 1938, the Roosevelt Administration charged the WPA's Federal Writers' Project to examine the problem of Fascism among Italian Americans. Perhaps for politically sensitive reasons, they concluded that Fascism had not much influence among the emigrant community.[18] Two generations later Richard Gambino came to the same conclusion.[19]

This is not to argue an Italian American variation of *Italiani brava gente*. (The thesis after World War II that "Italians are good people" and the Fascist regime never equaled the Nazi regime's barbarity.) There were Italian Americans who fully understood and supported Fascist ideology. A fundamental tension in Fascist propaganda in the United States was between the competing claims of Fascism and nationalism. Though they almost always overlap, they were not the same thing. As David Aliano has shown in the case of Argentina, (with parallels in the United States) Mussolini's Fascist regime conceived of, and tried to implement, a policy to reach the millions of Italian emigrants to the Americas. Whereas it has long been recognized that the Fascist regime sought to foster (read "manipulate") consensus abroad, Aliano demonstrates that the policy built on Liberal-era polices, oftentimes worked at cross purposes, sometimes fostered unintended consequences, and ultimately failed in its objectives.[20] If the Savoy monarchy and Liberal Italy were never able to completely "make Italians," how would the Fascist regime succeed where they had failed? By conflating the national project with the Fascist project ("the only true Italian was a Fascist Italian"), the regime ensured the failure of both. The decision to reframe the policy as one of nation building, Aliano argues, undermined the goal of ideological conformity.[21]

What archival documents show is that the Fascist regime was torn by internal debate on how to reach the millions of persons of Italian descent around the world. It began by reframing the enormous reality of emigration. Instead of a national catastrophe—an indictment of the new nation-state, the Savoy monarchy and the Liberal regime—emigration would now be thought of as the advance guard of a new Roman Empire reaching around the globe. The Foreign Ministry, the Ministry of Press and Propaganda, the Fasci Italiani all'Estero,[22] together with organizations such as the Dante Alighieri Society, often working in coordination (but sometimes divided by personal turf wars and petty personalities), sponsored newspapers, textbooks, cultural exchanges, language classes, and diplomatic missions. While the Fascist regime attempted to recast the myths of ancient Rome, the Risorgimento (they claimed Garibaldi as a precursor!) and the First World War into a Whig history of national grandeur, they were met at every turn by a minority of vocal and vociferous anti-Fascists ranging from monarchists on the right to republicans, socialists, communists and anarchists.

The apex of support for Mussolini and the Fascist regime came in the period 1929–1936. In February 1929 the world was shocked by the announcement of the Lateran Accords. The Papal State had always been adamantly against the Risorgimento and Italian unification, seeing it rightly as a threat to its temporal power. Pius IX had excommunicated Italians who served the new nation state and declared himself a "prisoner" inside the walls of the Vatican. For nearly seventy years, the Catholic Church was estranged from the new nation. But after years of secret negotiations, the Vatican and the Fascist State reached an agreement. Mussolini, although an avowed atheist, recognized that the support of the Vatican would be fundamental to the success of his regime. In America, Italian American Catholics rejoiced. The Catholic Church in America, long dominated by the Irish, welcomed the Accord. Italian Americans believed that three generations of animosity had been set aside but in reality,

relations between the Fascist regime and the Church would soon deteriorate over Catholic Action and the regime's insistence on indoctrinating the young.

Surely the high point of support for Mussolini's regime among Italian Americans came with the Ethiopian War of 1935–1936. Italian Americans enthusiastically agreed with the regime's argument that for reasons of Realpolitik the "plutocratic" powers of Britain and France had blocked Italy's rightful "place in the sun" on the world's stage. Italian Americans eagerly donated gold wedding rings for the war effort (receiving iron rings in return). Meanwhile, the Italian American anti-Fascist press worked assiduously to publicize Fascist atrocities in Ethiopia, including the use of poison gas and the targeting of civilians by airpower. (Mussolini's son, Vittorio, marveled at how human bodies "opened up like flowering roses" under the bombs of his plane.) Italian American anti-Fascists made common cause with African Americans, resulting in a march of over 25,000 in Harlem.[23]

The Anti-Fascist Response

When the FLNA was formed, anti-Fascists responded in kind with the Anti-Fascist Alliance of North America (AFANA), which outlived the FLNA by several years. But internal ideological fissures also divided the anti-Fascists: monarchists, liberals, socialists, communists and anarchists brought their bitter ideological debates with them to America.

Two different but intertwined sources characterized Italian American anti-Fascism: the Italian American labor movement on the one hand and Italian-American intellectuals and their Italian counterparts in exile. The Italian American labor movement had its roots in the anarchist, syndicalist and socialist traditions of Italy. Beginning in the mid-nineteenth century with Giuseppe Garibaldi, New York had been a magnet for Italians of the Left. The anarchist community was particularly strong in the New York metropolitan region, especially in Paterson and Hoboken across the Hudson in New Jersey. (The anarchist Gaetano Bresci of Paterson returned to Italy in 1900 to assassinate King Umberto). By that year, there were twenty Italian branches of the Socialist Labor Party in the United States. The man directly responsible for the murder of the Socialist deputy Giacomo Matteotti in 1924 that precipitated the worst crisis of the Fascist regime was Amerigo Dumini, an outcast from the radical milieu of the New World. In a bitter twist of irony, anti-Fascists in New York recalled that Mussolini himself had written for the local syndicalist paper *Il Proletario* [The Proletarian] before his conversion to Fascism.

Radical newspapers were revived by the challenge of the new regime. Besides the syndicalist *Il Proletario*, there were the anarchist papers *Il Martello* [The Hammer] and *L'Adunata dei Refrattari* [The Congress of the Disobedient] and the communist *L'Unità del Popolo* [Unity of the People]. These had been established papers with wide circulation; in addition two new papers came into existence as a direct response to the new regime: the daily *Il Nuovo Mondo* [The New World] with a circulation of approximately 30,000 (analogous to the *Jewish Daily Forward*), whose offices were often raided by the police; and a smaller paper, *Giustizia e Libertà* [Justice and Liberty], which was the American counterpart of a newspaper of the same name being published out of Paris by exiled Italian anti-Fascists.

The arrest, trial and execution of the anarchists Nicola Sacco and Bartolomeo Vanzetti (1920–1927) galvanized the Italian American anti-Fascists. Although the Sacco and Vanzetti tragedy unfolded in New England, Italian Americans across the country (indeed Italians throughout the Diaspora) took the case to heart and saw it as a vehicle to criticize both the United States and Fascist Italy. The Sacco and Vanzetti affair became the vehicle for anti-Fascists to depict the very human drama of political redemption. (See Color Plate 12.) When Sacco and Vanzetti drew international attention and support from both Joseph Stalin and

Benito Mussolini, only the anarchists had the courage to point out that both dictators stood diametrically opposed to the principles of the condemned men.

Another event, less serious perhaps but still laden with symbolism, was the death and funeral of film star Rudolph Valentino in 1926. As 75,000 people tried to pay their last respects in New York, Italian American Fascists, complete with Blackshirt uniforms and recognizing the potential propaganda value of the event, attempted to post an honor guard. Italian American anti-Fascists were ready and replied that since Valentino had consistently refused to speak on behalf of the Fascist regime his films were banned in Italy; he had, moreover, allowed his Italian citizenship to lapse and became American. It emerged later that the "honor guard" was composed of hired actors and Valentino's publicity agent paid for the funeral wreath supposedly sent by Mussolini.[24]

Violence between Fascist supporters and anti-Fascists was an ever-present undercurrent, ready to break to the surface. In the 1920s and 1930s police reports reveal almost monthly armed battles between the two sides. In little over a decade, nearly twenty men were killed in such street fighting. In New York, places like Union Square and even Carnegie Hall could be transformed within minutes into armed camps.

For example, a commemoration at the Garibaldi memorial at Rosebank on Staten Island on 4 July 1925 was marred when a contingent of 350 Fascists appeared, only to be held back by the NYPD. The same day, Fascists attacked a *Garibaldino* (as Garibaldi's veterans were called), the 82-year-old Giuseppe Genovese, as he made his way to Carlo Tresca's office at *Il Martello* on 14th Street in Manhattan. An appearance by the aviator Umberto Nobile representing the regime likewise degenerated into a scuffle. When Fascists invaded an anti-Fascist meeting in New Jersey, leaving several with serious injuries, the socialist Vincenzo Vacirca was arrested and held on $50,000 bail while seventeen Fascists were held on $500 bail each. The most infamous affair unfolded in May 1927, when two Fascists were killed in New York. The FLNA attempted to propagandize the murders, insisting anti-Fascists were the perpetrators. But during the ensuing trial of anarchists Calogero Greco and Donato Carrillo, it emerged that the two murdered Fascists had been dissenters and the crime was revealed to be the work of the Fascists themselves.[25]

It was long thought that apolitical immigrants came to America imbued with a deep-rooted skepticism concerning government and the state, embodied in the ideas of *campanilismo* and "amoral familism."[26] Centuries of invasion, oppression, Catholic doctrine and *miseria* had combined to render the southern Italian immigrant both passively fatalistic and prone to sporadic outbursts of impotent rage leading to rebellions, riots, and banditry but not capable of successful political revolution.[27] But Italian American political consciousness did exist and anti-Fascism did not appear in a vacuum. Many immigrants had behind them years (if not generations) of experience in agrarian leagues, *Società di mutuo soccorso* (mutual aid societies, replicated in America), Catholic and socialist cooperatives, or even participation in anarchist circles and socialist party politics.[28]

Anti-Fascism in Italian America was dominated by charismatic men and women forged in the crucible of repression, resistance, the labor movement and exile. Perhaps no single person worked as tirelessly as Gaetano Salvemini in combating Fascism in America.[29] Salvemini estimated that among the Italian American community 10 percent were anti-Fascist, 5 percent "out-and-out" Fascist, 35 percent philo-Fascist, and 50 percent apolitical. Salvemini was providing these estimates in 1940, "anticipating war between Italy and the United States; his inclination was to present Italian-Americans in as favorable a light as possible lest they suffer persecution as supporters of the enemy."[30] Salvemini also shrewdly observed a difference between support for Mussolini and support for the regime; whereas many Italian Americans were vocal in their adulation of the Duce, they were less so with regard to the regime itself.[31]

Within months of "victory" in Ethiopia and the proclamation of the "Empire" in May 1936, Italy was once again at war, this time in Spain. Public opinion and sentiment among Italian Americans seems to have become more ambiguous with Italy's support of Generalissimo Franco in his attempt to overthrow the Spanish Republic. It was one thing to conquer "barbarians" in Africa and bring them "civilization."[32] It was quite another to engage in civil war with other Europeans. Italian American anti-Fascists volunteered with the Abraham Lincoln Brigade in defense of the Spanish Republic, including painter Ralph Fasanella, writer Carl Marzani and Ave Bruzzichesi, who served as a nurse at the front.[33]

In the midst of the Spanish Civil War another historical event passed under the radar of most contemporaries. Few Americans—or Italian Americans for that matter—are familiar with the plight and influence of 2,000 Italian Jews who fled Fascist Italy under the most difficult circumstances after the appearance of the "Manifesto of the Racial Scientists" in the summer of 1938 and the promulgation several months later of anti-Semitic legislation— based on the notorious Nuremburg Laws of Nazi Germany.[34] It was a disparate group. In addition to architects, musicians, artists, journalists, designers, mathematicians, there were no less than three future Nobel Prize winners: Salvador Luria, Franco Modigliani and Emilio Segrè.[35] Enrico Fermi, who won the Nobel Prize for Physics that very year, never returned to Italy from Stockholm, and, instead, with his Jewish wife Laura Capon, emigrated to America where he changed the course of history by working on the Manhattan Project. Other Italian Jewish anti-Fascist exiles included Bruno Foa; Peter Treves who worked in the United States War Department; Enzo Tagliacozzo, a founding member of the Mazzini Society; architect Bruno Zevi; Massimo Calabresi; and journalist Ugo Stille.[36] These Italian Jewish anti-Fascists were instrumental in changing public opinion regarding Fascism in America. Max Ascoli arrived in 1931 and found a position at the University in Exile, part of the New School for Social Research, eventually becoming Dean.[37] Giuseppe Prezzolini, one of the *prominenti* in his role as Director of the Casa Italiana at Columbia University, and hardly an anti-Fascist in the 1930s, later observed that

> These Italian Jews were ... entirely different. They constituted a special emigration. Once arrived they never set about asking for assistance; instead, they actually gave assistance, each helping the others. They didn't mingle with New York Jews or even with Italian-Americans. . . . As far as Jews were concerned, they were Italians, and Italian-Americans considered them Jews. For Americans they were the subject of wonder and awe.[38]

Critical in this group were Jewish women such as Renata Calabresi, Carla Coen Pekelis,[39] and the mother, widows and children of Carlo and Nello Rosselli, two activists who had been assassinated in June 1937 by French Fascists in the pay of Mussolini's regime.[40]

Tullia Zevi was another formidable Italian Jewish woman in exile for her anti-Fascism. She succinctly captured the dilemma of Italian intellectuals and their relationship with Italian Americans:

> Which brings me to our work within the Italian American community. Soon after arriving in the U.S. [1938] I came to understand that no one in Italy was Fascist to the extent that Italian Americans were Fascist. And why? Because what they knew of Fascism was what they had sorted out from the propaganda—that the trains ran on time, that there were no strikes, etc. In the eyes of the American middle class, this proud man with a protruding chest—who commanded respect and flouted international sanctions—inspired fascination and respect, reinforcing—on some

level—their Italian American pride. Our job was to explain to the population—which (at that time) was still concentrated in the old immigrant neighborhoods—how things really were. I remember that the youngest among us were charged with spreading the word on a grass roots level. We commemorated the anniversaries of Matteotti and the Rosselli brothers. We went into the Italian neighborhoods in New York, Boston, and Philadelphia, etc. distributing fliers and pamphlets in the cafés, stores, and barbershops. Often they would chase us out with raised fists yelling, "Traitors! Traitors!" In brief, it wasn't easy to reverse so many years of Fascist brainwashing.[41]

Italian and Italian American women were to play key roles in the anti-Fascist movement. Angela Bambace, born in Brazil, grew up in Italian East Harlem, found work in the garment industry, organized a strike in Elizabeth, New Jersey in 1933, led a walkout of 75,000 dressmakers that year and established the first women's local of the International Ladies Garment Workers' Union in 1936.[42] Anarchist Virgilia D'Andrea spent her last years in American exile, suffering from cancer and various personal and political betrayals. In a lecture delivered at the People's Hall in Philadelphia, D'Andrea insisted that Fascism in Italy was a betrayal of Italy's greatest gift to the world: the humanist progressive tradition.[43]

The Mazzini Society

Intervention in the Spanish Civil War and the growing alliance with Nazi Germany generated some doubts among Italian Americans. Although established relatively late in 1939, the Mazzini Society was the most influential anti-Fascist organization because it espoused a non-Marxist and non-Stalinist Left ideology with support from prominent Italian American intellectuals and Italian intellectuals in exile. The Society was centered in New York—which became the center of Italian exiles after the invasion of France—and published its own newspaper, *Nazioni Unite* [United Nations].[44] The Society was based on the moral and intellectual legacy of Giuseppe Mazzini, the nineteenth-century spiritual architect of Italian unification and could boast of attracting the most eminent and respected *fuorusciti*. The *fuorusciti* (literally "those who are left outside") was the label contemptuously applied to anti-Fascist exiles by the regime; as often happens in such a situation, the outcasts adopted the appellation with a certain sense of fierce pride. They were an eclectic and perhaps incompatible group. Prominent *fuorusciti* included the anarchist Armando Borghi, diplomat Count Carlo Sforza, historian Aldo Garosci, philosopher Nicola Chiaromonte and Catholic priest Luigi Sturzo.[45]

Among those actively supporting the Society were Gaetano Salvemini (formerly teaching history at the University of Florence and now [1930s] at Harvard University); the art historian Lionello Venturi; the journalist Max Ascoli (who was president of the Society); Alberto Tarchiani (who became Italian ambassador to Washington after the war); Giuseppe Borgese (professor of literature and aesthetics); and perhaps most well-known of all: the renowned conductor Arturo Toscanini.[46] In New York, some of these *fuorusciti* such as Ascoli joined their German colleagues who had fled Nazism in teaching at the New School for Social Research. The Mazzini Society forged nineteenth-century liberalism's concern with the rights of the individual with the goal of social justice derived from twentieth-century democratic socialism. The objectives of the Society were clearly spelled out in its constitution: (1) to inform the American public about the real conditions in Fascist Italy, (2) to combat Fascist propaganda in the United States, (3) to defend American democratic institutions against totalitarianism, (4) to assist Italian political refugees who sought asylum in the United States, (5) to establish contact between Italian anti-Fascist intellectuals and American liberals,

(6) to cooperate with the organizations of other nations in the struggle against dictatorship, (7) to undertake cultural and educational activities in the Italian American communities.

From its base in New York City, the Mazzini Society grew to over forty branches with more than a thousand members in the United States and was instrumental in shaping public opinion about Italy and the Italians after Pearl Harbor. Salvemini insisted on distinguishing between the Fascist regime and the Italian people and the Society was successful in conveying this idea to the U.S. State Department, the Roosevelt Administration and the American people.

As a photo from a 1943 meeting makes clear (see Figure 21.1), the Society was politically shrewd in tying the resistance against Fascism to American ideals. Posters onstage quote Patrick Henry ("Give Me Liberty or Give Me Death") alongside an Italian slogan, "*Difendere la democrazia Americana e liberare l'Italia sono un solo compito e un solo fine.*" [Defending American democracy and liberating Italy are a single task and a common goal]. Another pairs a famous line from Abraham Lincoln's Gettysburg Address—"That government of the people, by the people and for the people shall not perish from the earth"—with the words "*Libertà/ Giustizia/Vittoria.*"

But the Society was not without its fault lines: ideological disputes between liberals, socialists, anarchists and communists weakened its power. In 1943, it suffered its worst blow when

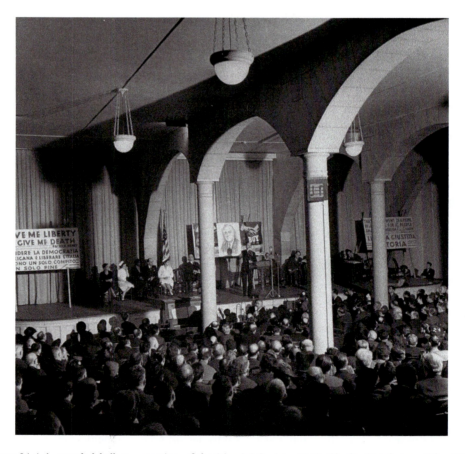

Figure 21.1 A crowded hall at a meeting of the Mazzini Society, 1943. Charles Steinheimer/The *LIFE* Images Collection/Getty Images.

Salvemini and Toscanini—its most respected members—departed in disagreement with the Society's endorsement of the Roosevelt administration's decision to support the royal-Fascist government under Marshal Pietro Badoglio that deposed Mussolini in July 1943. In dealing with Fascist Italy, the United States often deferred militarily and politically to British Prime Minister Winston Churchill. Adamant in maintaining the Italian monarchy and determined that the Left not come to power in Italy, Churchill was suspicious of the anti-Fascist Resistance, often refusing military aid. Eisenhower and Roosevelt were more sympathetic, sometimes because they were being lobbied by political and intellectual figures in the United States, who included Tarchiani and Salvemini.

If Salvemini and Toscanini were the most respected of the anti-Fascist leaders, the one who most captivated the public's imagination and heart was the flamboyant anarchist Carlo Tresca (1879–1943). The Fascists regime's number one enemy, Tresca survived so many attempts on his life from both ends of the political spectrum (Fascist and Stalinist) and had such an insatiable appetite for wine, women, and radicalism, that he acquired the status of a genuine folk hero. As editor of the anarchist paper, *L'Avvenire* [The Future], he was once targeted for assassination by Fascist agents and only escaped because on the very day assigned for his death he bought a pistol for self-protection and shot himself in the foot while stuffing the gun in his pants pocket, thus disrupting his schedule. Max Eastman's profile of him captures the man's charisma:

> Carlo Tresca is the despair of all those young men whose idea of success and glory is to get arrested and sent to jail in the cause of the working class. Tresca holds the international all-time record in his field. He has been arrested thirty-six times. He has been tried by jury seven times. The crimes charged against him run all the way from shouting "Viva Socialismo!" in a cop's face to first-degree murder, taking in on the way blasphemy, slander, libel, disturbing the peace, sedition, disorderly conduct, criminal obscenity, conspiracy, unlawful assemblage, and incitement to riot. He has had his throat cut by hired assassins, been bombed, been kidnapped by Fascisti, been shot four times (once by an Ohio sheriff from a distance of eight feet), been marked for death by agents of Mussolini, and snatched from death's jaws by the magic power of the Black Hand.[47]

On the evening of 11 January 1943, on his way to a meeting of the Mazzini Society, Tresca was assassinated on the corner of Fifth Avenue and 15th Street. The theories that flew about his assailant are still unresolved today: Stalinist, Fascist, Mafia or other anarchists? With the death of Tresca, Italian American anti-Fascism lost its most vital catalyst.[48]

Vito Marcantonio (1902–1954) of East Harlem, New York, was another charismatic Italian American political figure fighting Fascism in all its forms. A chance meeting with Fiorello La Guardia set him on a path to politics as the only communist member of the U.S. House of Representatives (he served for two decades as a member of the American Labor Party). He fought against anti-immigration sentiment and the rights of Italian Americans as well as those of workers, Puerto Ricans and African Americans. An eloquent critic of Fascist Italy, Marcantonio also argued against the designation of more than 600,000 Italian Americans as "enemy aliens" and the internment of several hundred in camps. Once Italy switched sides in World War II, on 8 September 1943, and was declared a "co-belligerent," he argued that the contributions of the anti-Fascist and anti-Nazi Italian Resistance merited humane treatment for Italy.[49]

Fiorello La Guardia (1882–1947) was another representative figure of Italian American political life; however as a congressman from East Harlem (1916–1918/1922–1930) and three-term mayor of New York City starting in 1934, he had to walk a fine line between his instinctive anti-Fascism and the popularity of Fascism among his constituents.[50]

Born in Rome, Carl Marzani arrived in the United States in 1924 at the age of 12. At Williams College in Massachusetts he became a socialist and earned a scholarship to the University of Oxford. He volunteered to defend the Spanish Republic, initially joined the anarchists but eventually enrolled in the CPUSA (Communist Party of the United States of America) on the very day Nazi Germany and Soviet Union signed the Molotov-Ribbentrop Pact. (He resigned his membership when Germany invaded the USSR in June 1941). Notwithstanding his politics, he served in the Office of Strategic Services (the forerunner of the CIA) and the Department of State. Like Peter Treves, he assisted in selecting bombing targets (in his case over Tokyo, Japan). For concealing his membership in the CPUSA, he was sentenced to three years in prison, serving four months. After the war he worked with various unions and as a documentary filmmaker, a writer and publisher.[51] Marzani was one of many Italian Americans working in the OSS.[52]

Italian American anti-Fascism faced a number of handicaps. For instance, the leader of the American Federation of Labor in the 1920s, Samuel Gompers, was not interested in offering material or moral support in combating Fascism. Most importantly, the common Italian American workingman was at best ambivalent about Fascism and often happy to defend Mussolini and his regime. Italian Fascists, their propaganda, and their apologists successfully managed to equate patriotism with Fascism, thus making it easier to win the support of the Italian American working class. This divided consciousness is best seen in the conflict between the *sovversivi* ("subversives") and the *prominenti* (as the Italian American elite were called). The *prominenti* were always of a certain class. If not wealthy (Generoso Pope being the most influential Italian American), then distinguished in academia or politics (Giuseppe Prezzolini, Director of the Casa Italiana at Columbia University) or the Church. The *sovversivi*, instead, were all working class, intent not just in challenging Fascism, joining the Popular Front, maintaining May Day celebrations, but aiming at a social revolution. Poet and "prophet of labor" Arturo Giovannitti, Luigi Antonini, anarchist Maria Roda, Angela Bambace, playwright Riccardo Cordiferro, cartoonist Fort Velonga were all part of the colorful cast of characters. In response to the philo-Fascist Dante Society, the *sovversivi* created a Garibaldi Society; they answered the Casa Italiana with local, working-class *Case del Popolo* based on their experiences in rural Italy and a *Università Popolare*.[53]

World War II and Internment

The Japanese attack on Pearl Harbor on 7 December 1941, Franklin Roosevelt's declaration of war on Japan and, finally, Mussolini's declaration of war against the United States on 11 December precipitated a crisis for Italian Americans. For two decades they had looked across the ocean with a mixture of pride, admiration mixed with antagonism and rising anxiety. Now they were faced with a stark choice. Most were ready to declare openly and full-heartedly their allegiance to the United States. Contrary to traditional historiography, in which it was argued that Italian Americans made a 180 degree about-face after the Pearl Harbor attacks, from fervent defenders and supporters of Fascism to patriotic Americans, the reality is that both the *prominenti* and the ordinary man- or woman-in-the street had already begun to have misgivings about the Fascist regime because of the Pact of Steel with Nazi Germany and support of Franco's coup d'état in Spain.[54]

Even Generoso Pope, as editor and publisher of *Il Progresso*, who had been one of the staunchest defenders of Mussolini and the Fascist regime, had begun to qualify his paper's defense of the Italian leader and the regime. The almost unanimous support of Italian Americans did not stop the federal government from interning Italian nationals—labeled "enemy aliens"—in camps similar to those set up to hold Japanese Americans.[55]

In December 1941 there were approximately 700,000 Italians who had not yet become naturalized. There were a few who were still Fascist sympathizers. In the end, "only" a few hundred Italians were interned (compared to over 100,000 Japanese Americans and nearly 11,000 German Americans). Many more, such as Joe DiMaggio's father, a fisherman in San Francisco, were economically ruined. Curfews, confiscations (boats, land, radios, firearms, even flashlights) and displacement were the order of the day. Ironically, Italian Americans (including Joltin' Joe) were the largest ethnic group fighting in the American armed forces at over 500,000. (Nearly 300,000 had served the American military in World War I.) Ironically, it was not unusual for Italian American GIs to find themselves in their ancestor's hometown while fighting in Italy. (See Photo Essay no. 17.) There, they were embraced not only as prodigal sons but also as liberators.

Various anti-Fascist organizations, from the Mazzini Society to the Italian American Labor Council, raised their voices, insisting a distinction be made between ordinary Italian Americans and those who were adamant Fascists; they opposed "any blanket law for aliens that does not differentiate between those who are subversive and those who are loyal to America." In fact, sensitive to the importance of the Italian American vote in the upcoming November elections, the Roosevelt administration announced, with particularly good timing on Columbus Day of 1942, that most Italian Americans would be released from the camps.[56]

Some didn't get off so easily. Domenico Trombetta, the editor of *Il Grido della Stirpe*, and, according to Salvemini, the *"enfant terrible"* of Fascism, was interned on Ellis Island from September 1942 until May 1945 not just on account of his Fascist propaganda but because the FBI had some evidence that he was engaged in sabotage and a plot to assassinate President Roosevelt.[57]

Mussolini's declaration of war on the United States was the death knell for Fascism in Italian America.

Epilogue: Haunted by the Eternally Present Past

> The past is not dead. It's not even past.
> —Ernest Hemingway, *Requiem for a Nun*, 1951

How Italian Americans remember Fascism and anti-Fascism will be critical in our collective future. We have been forewarned of the persistent nature of ideological extremism and the dangers of political nostalgia: "Every age has its own Fascism," Holocaust survivor Primo Levi wrote in a 1974 essay,

> and we see the warning signs wherever the concentration of power denies citizens the possibility and the means of expressing and acting on their own free will. There are many ways of reaching this point, and not just through the terror of police intimidation, but by denying and distorting information, by undermining systems of justice, by paralyzing the education system, and by spreading in a myriad subtle ways nostalgia for a world where order reigned, and where the security of a privileged few depends on the forced labor and the forced silence of the many.[58]

As if to confirm Benedetto Croce's dictum that all history is contemporary history, several years ago a debate erupted in Chicago over Balbo Drive. Italo Balbo (1896–1940), Italian General and Minister of the Air Force, led a squadron of twenty-four seaplanes from Rome to Chicago for the Century of Progress International Exhibition (also known as the

World's Fair) in 1933. This was a propaganda coup for Mussolini's Fascist regime. Not the Fascist regime of Blackshirts rampaging in the streets of Italy administering castor oil to their opponents or murdering opponents but the technocratic, modernist Fascism derived from Futurism that sought to harness the vitality of modernity: speed, technology, violence and the glorification of war.

Balbo triumphantly landed in Chicago where he was joyously greeted by the masses and the mayor. A parade was held in his honor with the street naming to follow. (Mussolini later sent a Roman column that still stands in Chicago.) President Franklin Roosevelt invited Balbo to lunch at the White House where the Italian was awarded the Distinguished Flying Cross. In New York's old Madison Square Garden, after a tickertape parade down Broadway, the Italian aviator thrilled a large audience of Italian Americans, charging them to be proud of their heritage because "Mussolini has ended the era of humiliations."

In short, the young, dashing and charismatic Balbo (Figure 21.2) and his endeavors (he had already flown to Rio de Janeiro in 1930) were a perfect example of the "new Italy," the

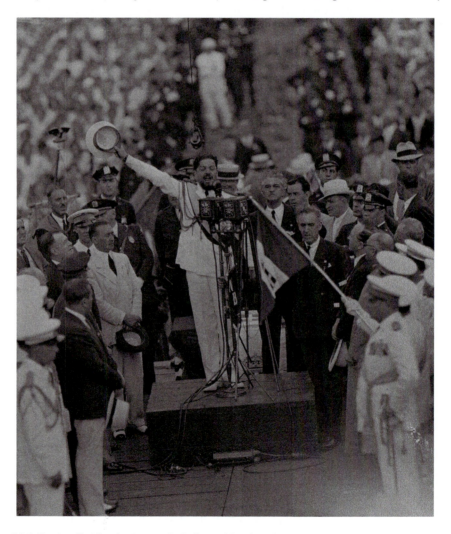

Figure 21.2 Fascist official and aviator Italo Balbo and his flyers honored at Madison Square Garden Bowl, New York City, 21 July 1933. Bettmann/Getty Images.

Italy where "the trains ran on time." It was now modern, technologically advanced, with a political regime that seemed rigorous and energized compared to the seemingly decrepit Western liberal democracies. Hence the street named in his honor, a column near Soldier Field, and a tribute by the side of the Columbus statue in Grant Park. (And all this just in Chicago.) *TIME* magazine featured a heroic photo of Balbo on the cover of its 26 June 1933 issue. More than one Sons of Italy lodge and Italian American society is named after the famed aviator.

The well-intentioned petition drafted to rename the street stated:

> Be it resolved that whereas Balbo Drive in Chicago was named after the most violent of the Fascist warlords, Italo Balbo, who was a founding member of the Fascist Grand Council, who was responsible for the killing of numerous Italian citizens including the parish priest Giuseppe Minzoni, and who as governor of the Italian colony in Libya supervised concentration camps in which thousands of civilians perished, the name of Balbo Drive should be changed. Be it further resolved that the former Balbo Drive be re-named Fermi Drive, after the Italian physicist Enrico Fermi, who won the Nobel Prize in Physics, was driven out of his homeland because his Jewish wife suffered under the Manifesto of Race promulgated by Mussolini, and found refuge in Chicago, where he developed the first nuclear reactor. Whereas in Italy itself, in which Italo Balbo's crimes are well known, no streets are named after him, many are named after Fermi.[59]

This sparked an editorial in the *Chicago Tribune* on 27 June 2011 that also called for the renaming of Balbo Drive in honor of Enrico Fermi. The editorial generated a counter-petition, counter-editorials and letters, most of them in favor of retaining the Balbo name.[60] When contacted by the petitioners who sought to enlist me in their righteous cause, I thought that the situation was a bit more complicated. Though not in favor of a street honoring a notorious Fascist official, I also thought it was problematic to erase an important episode in Italian American history, even if it did not reflect well on our collective past. (We can see echoes of this in the contemporary debate over the removal of Confederate monuments in the American South.)

If Balbo's ghost haunts us still, perhaps as a counterweight we might turn to another ghost, that of Carlo Tresca. Intent on reminding Balbo of his past, in 1933, after his arrival in America, Tresca sent the Fascist aviator a telegram, naming the priest for whose death Balbo was responsible: "I am watching you. [Signed] Don Minzoni."[61]

Tresca's ghost is a character in Anton Coppola's contemporary opera *Sacco and Vanzetti*.[62] Maestro Coppola's magisterial work uses the spirit of Tresca, dressed in white linen suit and fedora, as combination of Virgilian guide, indomitable narrator and Greek chorus, commenting on the political, social and moral repercussions of the action presented on stage.

Upon being informed by telegram of the guilty verdict against Sacco and Vanzetti, the historical Tresca was stunned but not surprised: "This verdict strikes us in our heart," he wrote in *Il Martello*. "It is a terrible blow. There was little to hope for given the political character the trial assumed in recent days, but nevertheless the conscience rebels at the idea that class spirit can so coldly decide the fate of two men."[63] After the verdict both Sacco and Vanzetti wrote to thank Tresca for his work on their behalf. "I have been defeated but not conquered," Vanzetti wrote, exhorting Tresca to "continue the good fight for true liberty and true justice." Sacco reminisced about Tresca's anarchist writing "which I learned to love, which was the first to enlighten my mind, urging me to walk on the path toward the ideal of the human family liberated.... Those were a different time."[64]

In Coppola's opera, the last line is Tresca's as he sits vigil over the coffins of the two anarchists as they are prepared for cremation: "That column of smoke clouds their mystery as it spirals upwards into a dark and dreary sky."[65] I conclude this essay on the 90th anniversary of the executions of Sacco and Vanzetti (23 August 2017) reminded of—and armed with—Ignazio Silone's belief that "A deep knowledge of history makes fanaticism impossible."[66]

Further Reading

Durante, Francesco. "Anarchists, Socialists, Fascist and Antifascists," in Francesco Durante, *Italoamericana: The Literature of the Great Migration*, edited by Robert Viscusi. New York: Fordham University Press, 2014.

Guglielmo, Jennifer. "Red Scare, the Lure of Fascism, and Diasporic Resistance," in *Living the Revolution: Italian Women's Resistance and Radicalism in New York City, 1880–1945*, edited by Jennifer Guglielmo. Chapel Hill: University of North Carolina Press, 2010.

Killinger, Charles. "Fighting Fascism from the Valley," in *The Dispossessed: An Anatomy of Exile*, edited by Peter Rose. Amherst: University of Massachusetts Press, 2005.

Ottanelli, Fraser M. "'If Fascism Comes to America We Will Push It Back Into the Sea': Italian American Antifascism in the 1920s and 1930s," in *Italian Workers of the World*, edited by Donna R. Gabaccia and Fraser M. Ottanelli. Urbana: University of Illinois Press, 2001.

Notes

I am indebted to Dr. Elvira De Fabio and the Department of Romance Languages and Literatures of Harvard University who invited me as Visiting Scholar (Spring 2010) and Dr. Larry Wolff and the Center for European and Mediterranean Studies at New York University for the 2014–15 academic year where I was able to consult the archives of the Tamiment Library. I am indebted to Maestro Anton Coppola for his gracious gift of the libretto of his opera *Sacco and Vanzetti*. Thanks to Alessandro Antonio Pugliese for compiling the list of Italian American volunteers in the Spanish Civil War from ALBA, the Abraham Lincoln Brigade Archive in the Tamiment Library at New York Univesity.

1 Fascism has been a political philosophy that has bedeviled the many attempts at a definition. Perhaps the best taxonomies in English have been Robert O. Paxton's *The Anatomy of Fascism* (New York: Vintage, 2005), and Umberto Eco's essay, delivered first at the Casa Italiana of Columbia University on 25 April 1995 (the fiftieth anniversary of the liberation of Italy), titled "Ur-Fascism" and first published in *The New York Review of Books*, 42.11 (22 June 1995), 12–15; partially reprinted as "Eternal Fascism," in *Fascism, Anti-Fascism and the Resistance in Italy*, ed. Stanislao G. Pugliese (Lanham: Rowman & Littlefield, 2004), 291–295.

2 Lincoln Steffens, *The Autobiography of Lincoln Steffens* (Berkeley: Heyday Books, 1931), 813.

3 Stefano Luconi, "Fascism and Italian-American Identity Politics," *Italian Americana*, 33.1 (Winter 2015), 6–24. See also Matteo Pretelli, *Il fascismo e gli italiani all'estero* (Bologna: Clueb, 2010).

4 See Stanislao G. Pugliese, "The Culture of Nostalgia: Fascism in the Memory of Italian-Americans," *Italian Politics and Society*, 44 (Fall 1995), 12–17; reprinted in *The Italian-American Review*, 5.2 (Autumn/Winter 1996/1997), 16–26.

5 John Patrick Diggins, *Mussolini and Fascism: The View from America* (Princeton: Princeton University Press, 1972).

6 See Gian Giacomo Mignone, *The United States and Fascist Italy: The Rise of American Finance in Europe*, trans. with a preface by Molly Tambor (New York: Cambridge University Press, 2016).

7 See Mark I. Choate, *Emigrant Nation: The Making of Italy Abroad* (Cambridge: Harvard University Press, 2008); and Robert Viscusi, *Buried Caesars and Other Secrets of Italian American Writing* (Albany: SUNY Press, 2006).

8 See the groundbreaking work of Philip V. Cannistraro, *Blackshirts in Little Italy: Italian Americans and Fascism, 1921–1929* (West Lafayette: Bordighera Press, 1999). For a case study or microhistory of Fascism and anti-Fascism, see Stefano Luconi, *From Paesani to White Ethnics: The Italian Experience in Philadelphia* (Albany: SUNY Press, 2001), chapters 4 and 5. For Fascism's effect elsewhere, see Angelo Principe, *The Darkest Side of the Fascist Years: The Italian-Canadian Press, 1920–1942* (Toronto: Guernica, 1999) and David Aliano, *Mussolini's National Project in Argentina* (Madison: Fairleigh Dickinson University Press, 2012).

9 Alan Cassels, "Fascism for Export: Italy and the United States in the Twenties," *American Historical Review*, 69.3 (April 1964), 708. See also Pellegrino Nazzaro, *Fascist and Anti-Fascist Propaganda in America: The Dispatches of Ambassador Gelasio Caetani* (Youngstown: Cambria Press, 2008).

10 Marcus Duffield, "Mussolini's American Empire: The Fascist Invasion of the United States," *Harper's Magazine*, 159 (November 1929), 661–672.

11 Cannistraro, *Blackshirts*, 112.

12 From the memoir of his grandson, Paul David Pope, *The Deeds of My Fathers* (Lanham: Rowman & Littlefield, 2010), 164.

13 Carlo Sforza, *The Real Italians: A Study in European Psychology* (New York: Columbia University Press, 1942), 125.

14 Duffield, "Mussolini's American Empire," 662.

15 Quoted in Philip V. Cannistraro, "Fascism and Italian-Americans," in *Perspectives in Italian Immigration and Ethnicity*, ed. Silvano M. Tomasi (New York: Center for Migration Studies, 1977), 54.

16 On Marconi, see Marc Raboy, *Marconi: The Man Who Networked the World* (New York: Oxford University Press, 2016); on Balbo see Claudio G. Segrè, *Italo Balbo: A Fascist Life* (Berkeley: University of California Press, 1990).

17 Durante, *Italoamericana* [American ed.], 726–727.

18 Federal Writers' Project, *The Italians of New York* (New York: Random House, 1938).

19 Richard Gambino, *Blood of My Blood: The Dilemma of the Italian Americans* (Garden City: Doubleday, 1974).

20 Aliano, *Mussolini's National Project in Argentina*, 12, 18.

21 Ibid., 18.

22 Emilio Gentile, "I fasci italiani all'estero: The 'Foreign Policy' of the Fascist Party," in *The Struggle for Modernity, Nationalism, Futurism, Fascism*, ed. Gentile (Westport: Praeger, 2003), 145–160. See also Matteo Pretelli, *La via fascista alla democrazia americana: Cultura e propaganda nelle comunità italo-americane* (Viterbo: Sette Città, 2012).

23 Mark Naison, "Remaking America: Communists and Liberals in the Popular Front," in *New Studies in the Politics and Culture of U.S. Communism*, ed. Michael E. Brown, Randy Martin, Frank Rosengarten and George Snedeker (New York: Monthly Review Press, 1993), 45–74 (55–56); on relations between Italian Americans and African Americans in the context of the Ethiopian War, see Nadia Venturini, "'Over the Years People Don't Know': Italian Americans and African Americans in Harlem in the 1930s," in *Italian Workers of the World*, ed. Donna R. Gabaccia and Fraser M. Ottanelli (Urbana: University of Illinois Press, 2001), 196–213.

24 Emily W. Leider, *Dark Lover: The Life and Death of Rudolph Valentino* (New York: Farrar, Straus and Giroux, 2003), 392.

25 "Six Men Stabbed in Fascist Riot," *New York Times* (17 August 1925); on the Greco-Carrillo affair, see Cannistraro, *Blackshirts*, 86–87.

26 *Campanilismo* is the theory that Italians have loyalty only so far as they can hear the local *campanile* (church bell). Amoral familism was the theory put forth by Harvard sociologist Edward Banfield to explain the endemic poverty, crime and underdevelopment of the Italian south: act in the long and short term interests of your immediate family, and assume that all others will do the same. Edward Banfield, *The Moral Basis of a Backward Society* (Glencoe: Free Press, 1958). Critics of Banfield argue that he confused cause and effect.

27 See the classic account of this political psychology in Eric Hobsbawm, *Primitive Rebels* (New York: Norton, 1965).

28 *The Lost World of Italian-American Radicalism*, ed. Philip Cannistraro and Gerald Meyer (New York: Praeger, 2003).

29 See the excellent biography (the first in English) by Charles Killinger, *Gaetano Salvemini: A Biography* (Westport: Praeger, 2002) and the important collection of his letters, *Gaetano Salvemini: Lettere americane, 1927–1949*, ed. Renato Camurri (Rome: Donzelli, 2015).

30 Nunzio Pernicone, *Carlo Tresca: Portrait of a Rebel* (New York: Palgrave, 2005), 218.

31 Perhaps his most influential anti-Fascist books were *The Fascist Dictatorship in Italy* (London: Jonathan Cape, 1928; reprint New York Howard Fertig, 1967) and *Italian Fascist Activities in the United States*, ed. Philip V. Cannistraro (New York: Center for Migration Studies, 1977).

32 Emblematic of this "civilizing mission" are the lyrics to the Fascist military hymn "Faccetta nera" (Little Black Face): "Little black face, beautiful Abyssinian/Wait and hope, for the hour is near!/When we will be/Together with you/We shall give you another law and another king/Our law is slavery to love/Our motto is LIBERTY and DUTY/We blackshirts will vindicate/the heroes who died to free you!" See *Fascism, Anti-Fascism and the Resistance in Italy*, 191–192.

33 Ave Bruzzichesi, "I Was a Catholic Nurse in Loyalist Spain," American Relief Ship Publicity Campaign, Box 4, Part O, SRRO (Spanish Refugee Relief Organization), Columbia University Rare Books and Manuscripts Library.

34 For a sophisticated analysis of the impact of the Racial Laws on the attitudes of Italian Americans toward Jews, see Stefano Luconi, "'The Venom of Racial Intolerance': Italian Americans and Jews in the United States in the Aftermath of Fascist Racial Laws," *Revue française d'études américaines*, 1.107 (2006), 107–119.

35 Giovanna Pontecorboli, *Americordo: The Italian Jewish Exiles in America* (New York: Centro Primo Levi Editions, 2015).

36 Alexander Stille, *The Force of Things: A Marriage in War and Peace* (New York: Farrar, Straus & Giroux, 2013).

37 *Max Ascoli: antifascista, intellettuale, giornalista*, ed. Renato Camurri (Milan: Franco Angeli, 2012) and Davide Grippa, *Un antifascista tra Italia e Stati Uniti: Democrazia e identità nazionale nel pensiero di Max Ascoli* (Milan: Franco Angeli, 2009).

38 Giuseppe Prezzolini, *America in pantofole* (Florence: Vallecchi, 1950), 341–375.

39 *My Version of the Facts* (Evanston: Malboro Press, 2004). See also Stefano Luconi, "'Our Life Was Divided in Many Facets': Anna Foa Yona: An Anti-Fascist Jewish Refugee in Wartime United States," *Transatlantica* (2014), http://transatlantica.revues.org/6952; and Catherine Collomp, "'I nostri compagni d'America': The Jewish Labor Committee and the Rescue of Italian Antifascists, 1934–1941," *Altreitalie*, 28 (January–June 2004), 66–82. (Both online at http://primolevicenter.org/printed-matter/)

40 On the Rosselli family see Stanislao G. Pugliese, *Carlo Rosselli: Socialist Heretic and Antifascist Exile* (Cambridge: Harvard University Press, 1999) and Isabelle Richet, "Marion Cave Rosselli and the Transnational Women's Antifascist Networks," *Journal of Women's History*, 24.3 (Fall 2012), 117–139.

41 Tullia Calabi Zevi, "My Political Autobiography," talk given at the Circolo Rosselli, Florence on 15 November 1999; reprinted in *Centro Primo Levi Online Monthly*, March 26, 2011, http://primolevicenter.org/printed-matter/tullia-calabi-zevi/

42 Angela Bambace Papers, Italian American Collection, Immigration History Research Center, University of Minnesota, http://archives.ihrc.umn.edu/vitrage/all/ba/ihrc279.html

43 Franca Iacovetta and Lorenza Stradiotti, "Betrayal, Vengeance, and the Anarchist Ideal: Virgilia D'Andrea's Radical Antifascism in (American) Exile, 1928–1933," *Journal of Women's History*, 25.1 (Spring 2013), 85–110 (100). See also Jennifer Guglielmo, "Donne Ribelle: Recovering the History of Italian Women's Radicalism in the United States," in *The Lost World of Italian American Radicalism*, ed. Philip Cannistraro and Gerald Meyer (Westport: Praeger, 2003), 113–141 and Guglielmo, *Living the Revolution: Italian Women's Resistance and Radicalism in New York City, 1880–1945* (Chapel Hill: University of North Carolina Press, 2010), especially chapter 7, "Red Scare, the Lure of Fascism, and the Diasporic Resistance," 199–229.

44 Most issues have been preserved and are available at the New York Public Library.

45 For representative works see Armando Borghi, *Mussolini: Red and Black* (New York: Freie Arbiter Stimme, 1938); Carlo Sforza, *Contemporary Italy* (New York: E. P. Dutton, 1944); Aldo Garosci, *Storia dei fuorusciti* (Bari: Laterza, 1953); Nicola Chiaromonte, *The Worm of Consciousness and Other Essays* (New York: Harcourt, Brace, Jovanovich, 1976); Luigi Sturzo, *Italy and Fascismo* (London: Faber and Gwyer, 1926).

46 See Harvey Sachs, *Toscanini: Musician of Conscience* (New York: Norton, 2017).

47 Max Eastman, "Troublemaker," *New Yorker* (15 September 1934), 31–36 (31).

48 Dorothy Gallagher, *All the Right Enemies: The Life and Murder of Carlo Tresca* (New Brunswick: Rutgers University Press, 1988).

49 Gerald Meyer, *Vito Marcantonio: Radical Politician, 1902–1954* (Albany: SUNY Press, 1989) and *I Vote My Conscience: Debates, Speeches and Writings of Vito Marcantonio*, ed. Annette T. Rubinstein, with a new Introduction by Gerald Meyer. Reprint. (New York: John D. Calandra Institute, 2002). His legacy is kept alive by the Vito Marcantonio Forum which sponsors readings and commemorations of his life; vitomarcantonioforum.org

50 Thomas Kessner, *Fiorello H. LaGuardia and the Making of Modern New York* (New York: McGraw Hill, 1989).

51 Carl Marzani, *The Education of a Reluctant Radical*, vol. 3 *Spain, Munich and Dying Empires* (Rubery Birmingham: Topical Books, 1990).

52 See Salvatore J. LaGumina, *Italian Americans and the Office of Strategic Services: The Untold Story* (New York: Palgrave Macmillan, 2016).

53 See Marcella Bencivenni, *Italian Immigrant Radical Culture: The Idealism of the Sovversivi in the United States, 1890–1940* (New York: New York University Press, 2011).

54 See the proceedings from the 2002 IASA conference at Loyola University in Chicago *The Impact of World War II on Italian Americans 1935-present*, ed. Gary R. Mormino (New York: John D. Calandra Italian American Institute, 2007) as well as Salvatore J. LaGumina, *The Humble and the Heroic: Wartime Italian Americans* (Amherst: Cambria, 2006); Peter L. Belmonte, *Italian Americans in WWII* (Mount Pleasant: Arcadia, 2001). Two memoirs by Italian American soldiers are and Richard Aquila, *Home Front Soldier: The Story of a GI and His Italian American Family During World War II* (Albany: SUNY Press, 1999) and Albert DeFazio, *The Italian Campaign: One Soldier's Story of a Forgotten War* (Bennington: Merriam Press, 2015).

55 On the internment, see Lawrence DiStasi, *Una Storia Segreta: The Secret History of Italian American Evacuation and Internment During World War II* (Berkeley: Heyday Book, 2001); DiStasi, *Branded: How Italian Immigrants Became 'Enemies' During World War II* (Bolinas: Sanniti, 2016); and Stephen J. Fox: *The Unknown Internment: An Oral History of the Relocation of Italian Americans During World War II* (Boston: Twayne, 1990); Stephen Fox, *UnCivil Liberties: Italian Americans Under Siege During World War II* (North Charleston: CreateSpace Publishing, 2014).

56 *New York Times* (22 February 1942 and 13 October 1942).

57 Cannistraro, *Blackshirts*, 116n.20.

58 Levi's essay was originally published in *Corriere della sera* (8 May 1974); translated as "The Past We Thought Would Never Return," in *The Black Hole of Auschwitz*, trans. Sharon Wood (New York: Polity Press, 2005), 34.

59 "Naming Wrongs: Renaming Balbo Drive," Editorial, *Chicago Tribune*, http://articles.chicagotribune.com/2011-06-27/opinion/ct-edit-balbo-20110627_1_wrongs-balbo-drive-Fascists; The Italic Institute, www.ipetitions.com/petition/balbodrive/.

60 See the debate and revealing comments at Stanislao G. Pugliese, "What Is in a (Street) Name? Too Much History" (12 July 2011), www.i-italy.org/17601/what-street-name-too-much-history-and-italian-americans-chicago-make-headlines.

61 Segrè, *Italo Balbo*, 250.

62 I attended the world premiere on 17 March 2001 as a guest of Maestro Coppola. The opera was performed by Opera Tampa of Florida at the Tampa Bay Performing Arts Center with tenor Jeffrey Springer (Sacco), baritone Emile Fath (Vanzetti), soprano Faith Esham as Rosina (Sacco's wife), alto Hallie Neil (Vanzetti's sister) and Theodore Lambrinos as Tresca. Anton Coppola's nephew, filmmaker Francis Ford Coppola was artistic supervisor for the production, Matthew Lata directed the production. See the extensive review by Eugene H. Cropsey, "Sacco and Vanzetti," *The Opera Quarterly*, 19.4 (2003), 754–780.

63 Quoted in Pernicone, *Carlo Tresca*, 120.

64 Ibid., 120–121. See also Pernicone's essay "Carlo Tresca and the Sacco-Vanzetti Case," *Journal of American History*, 66.3 (December 1979), 535–547.

65 "Sacco & Vanzetti: An Opera by Anton Coppola," (libretto) (Tampa: Tampa Bay Performing Arts Center, 2001), 54.

66 Ignazio Silone, *The School for Dictators*, trans. Gwenda David and Eric Mosbacher (New York: Harper, 1938), 28.

Appendix

ITALIAN AMERICANS WHO SERVED IN ANTI-FASCIST, REPUBLICAN FORCES DURING THE SPANISH CIVIL WAR, 1936–1939

Ersamo Abate, Alfonso Giuseppe Abruzzo, Bruno Agostini, Giuseppe Alaffi, Henry Albertini, Juan Alvarez, Vincenzo Amicarelli, Riccardo Andreoli, Giacomi (Jack) Apice, Pasqual Areta Sangines, Enrico Arrigoni, Vincenzo Carlo Badarello, Mario Baldasso, Giuseppe Baldo, Armando Baracani, Louis Federico Barale, Arsenio Barti, Eugenio Baschiera, Araldo Basso, CorradoBatelli, Antonio Bellati, Mario Benedetti, Edigio Bernardini, Luigi Aldo Bertani, Joseph Bianca, Pierino Bianco, Giuseppe Bianconi, Agostino Boccioni, Giovanni Bombazzi, Livio Edoardo Bonanni, Frank Giuseppe Bonetti, Antonio Boni, Giuseppe Bordoli, Carmelo Bozzetti, Michele Brignoli, Guido Brogelli, Serra Bruno, Ave Bruzzichesi, Enrico Bugatti, Robert Bulgareli, Augusto Burgo, Ernaldo Buzzi, Evaristo Caberera, Giacomino (Victor) Calcagno, Michael A. Vincent Caldarella, Frank Cali, Francesco Calvaruso, Ignacio Camarada, Giovanni Capitano, Bernard Cappadona, Alfonso DiFiorino Caraible, Vigna Antonio (Peter) Casassa, Alfred Castrenuovo, Isaia Cattani, Ubaldo Cazzoli, Giuseppe Celestino, Michele Centrone, Renato Chiappini, Pasquale Cicitta, Libertario Clerico, Francesco Coco, Roger Contento, Andrew Corvetto, Michael Costa, Frank Carl Costanza, Frank Carl Costanzo, Sidney Crotto, Emilio Dalcol, Giuseppe Dalleo, Giovanni Dapello, Haden Daprian, Pietro Deianna, Gastone Del Bianco, Giovanni Devescovi, Francesco Di Santo, Julius DiDenti, Armado DiGiovambattista, Samuel DiLuca, John Alexander DiNardi, Emilio Drioli, Constantino Dubac, Giuseppe Esposito, Ralph Fasanella, George Antonio Ferrari, Frank Louis Ferrero, Jerome Ethan Ferroffiaro, Guerrino Fonda, Ettore Fontana, Giulio Fontini, Carlo Fragiacomo, Rudolph Franchini, Francesco Mario Fulginetti, Pietro Fusari, Biagio Gabriele, Alberto Galassi, Annibale (Humberto) Galleani, Germina Galleani, Patrick J. Garofalo, Alvaro Ghiara, Callisto Giambiasio, Joseph Gianfortoni, Stefano Giordana, Rodolf Gojtanich, Daniel Joseph Grosso, Pio Guaraldo, Andrea Guggia, Simone (Jardino) Iardino, Spartaco Kaiser, Domanick Kresciak, Romano Krstovec, Peter LaRocca, Carmelo Laguaraguella, Lino Lennandi, Mazzo Giuseppe Linoetti, Alois Lucci, Peter H. Magrini, Placido Mangraviti, Aldo Marchinini, Mario Luigi Marletti, William Martinelli, Antonio Martocchia, Carl Marzani, Frank Mazzetti, Domenico Medelin, Antonio Melis, Alfonso Mellina Sartore, Giovanni Menella, Salvatore Menis, Bruno Micor, Felice Montanarella, Benedetto Mori, Giacomo Mortola, Edward Ferdinand Muscala, John Giuseppe Muso, Giuseppe Natalin, Dino Neri, Tersil Obriot, Giuseppe Paliaga, Alberto Pallone, Bartolomeo Patrone, Sala Paufino (Paul Sarti, aka Paolino Sarti), Alfredo Penati, John Perrone, Thomas Daniel Petrella, John Petrullo, Fred Pilato, Rosario Pistone, Giovanni Premoli, Edigio Prevedello, Mercurio Provenzano, Vito Puglia, Gino Rigamonte, Luigi Rigamonte, Anthony Michael Rizzo, Angelo Christo Romani, Domenico Rosati, Venerio Rossetto, Mafaldo Rossi, Emanuel Basil Rovetta, Rudolph Rui, Ricco Joseph Rusciano, Thomas Basil Russiano, Wally Amadeo Sabatini, Stanley Salatino, Frederick Salvini, Pietro Samarati, Enrique Sanchez, Victor Santini,

Paolino Sarti, Giovanni Schembari, Victor P. Schintone, Philip Lugiano Sciarra, Domenico Segalla, Bruno Sereni, Luigi Sironi, Pietro Sisti, Joseph Starini, John Stevens, DionisioStrani, Victor Strukl, John Tisa, Giovanni Tremul, Luigi Vallarino, Gianpaolo Vallon, Niccolò Vascon, Armando Vecchietti, Eugenio Venazano, Giovanni Vinaccia, Albino Giuseppi Zattoni.

Source: Archives of the Abraham Lincoln Brigade www.alba–valb.org/volunteers.

WORLD WAR II CHANGED
EVERYTHING

Dominic Candeloro

World War II changed everything. The two most powerful factors in Italian American history are the migration itself that stretches out over the period 1880–1920 and the collective and individual experiences that Italian Americans endured regarding World War II and its aftermath. It is a drama of alienation that reveals the shortcomings of a democracy in wartime. Yet, it is also a story that reinforces all the positive notions that we have about opportunity and socioeconomic mobility in the United States and the power that lies in diversity. It is an ethnic story of Italians, an American story of internal unity, and an international story of Italy from the Fascist era to the Cold War.

Mussolini Seduces America

From the mid 1920s, the vast majority of Italian Americans were thrilled by the exploits of Benito Mussolini and the "rebirth of Italy." Into the mid 1930s, most of the United States population shared that opinion. (See Chapter 21). The list of American political leaders and public intellectuals who expressed admiration of Mussolini's Italian Fascism is long and impressive.[1] Fascism represented a bulwark against communism and it offered Italian society discipline and progress.

The triumphant flight of Italo Balbo and an Italian Air Force squadron of twenty-four seaplanes to Chicago's Century of Progress World's Fair in 1933 was for many the single proudest moment in Italian American history. A brilliant public relations maneuver, the Balbo flight included tumultuous receptions and parades in Chicago and New York as well as a visit to the White House. This event cemented the relationship between *Il Duce*[2] and the 4.5 million Italian immigrants and their children in the United States. The only exception was a small, but significant group of mostly left wing elements. Italian American organizations, church groups, and leaders at all levels bought into Fascist propaganda 100 percent. Even if almost none of Mussolini's millions of American adherents were spies or secret agents, Mussolini did succeed in building a strong bloc of public opinion—a political force that might be capable of helping the Fascist cause by adding their voices to those of American isolationists who could pressure the United States government not to intervene in the European War. It was this relationship between Italian Americans and Mussolini which would come back to haunt them when the war broke out.

Il Progresso—A Bold Cheerleader

Perhaps the strongest spokesman for Mussolini in America was Generoso Pope, the publisher of *Il Progresso Italo-Americano* [The Italian-American Progress]. The paper had over eighty thousand subscribers, making it the most powerful Italian language media outlet in

the United States. Acquired by Pope in 1928, *Il Progresso* chronicled developments in Fascist Italy consistently in a positive light. Pope's media empire, which included additional newspapers and the Italian language radio station WHOM, took Mussolini's side in the various international controversies like the invasion of Ethiopia in 1935 and the resulting League of Nations sanctions and trade restrictions against Italy. Until just a few months before Italy's declaration of war on the United States on 11 December 1941, *Il Progresso* was Mussolini's biggest cheerleader.

Ironically, while staunchly defending Mussolini in the 1930s, Generoso Pope was also a political ally of Franklin Roosevelt. He had played a large role in steering Italian American voters into the Roosevelt coalition, which dominated American politics from the 1930s into the 1960s. In 1940 things got complicated when Germany invaded France (with an assist from Italy). The event prompted FDR's "Stab in the Back" speech on 10 June 1940.[3] The President portrayed Italy as a predator who had used a stiletto to stab its neighbor in the back. *Il Progresso* gave high prominence to the speech and editor Pope found himself in a dilemma. He ended up supporting Mussolini for protecting Italy's vital interest. Pope also complained that the British and French were using Italy's action as an excuse for dragging the United States into the European war. His position mirrored and shaped opinion in the Italian community that Roosevelt's speech was pushing the nation closer to war. Moreover, FDR's insulting reference to the "stiletto" and the "stab in the back" played into the rhetoric of prejudice against Italians in America. Even though Generoso Pope endorsed Roosevelt for a third term, Italian American voters in the 1940 presidential election shifted toward Wendell Willkie and the isolationists.

President Roosevelt won a third term in that election 55 percent–45 percent, but without the robust support of Pope or the majority of Italian American voters that he received in 1936.[4] The President's drift toward war in 1941, the Lend Lease Act (providing massive armaments to Great Britain and the Soviet Union at little or no cost) and the signing of the Atlantic Charter (which established principles for the postwar world order) almost assured the imminent entry of the United States into the war on the side of the Allies.

In July 1941, with the closing of American consulates in Italy, Generoso Pope was called to the White House. The New York anti-Fascist coalition of Carlo Sforza, Ferdinand Pecora, Max Ascoli, and Luigi Antonini had collaborated with J. Edgar Hoover and the FBI to give evidence that the editorial board of *Il Progresso* was composed of people whose first loyalty was to Mussolini. To avoid full catastrophe, Pope was forced to fire the editorial board and to turn over the production of the newspaper to anti-Fascists and adopt a new editorial policy. Thus, Pope avoided a direct clash between *Il Progresso* and the President.

Pearl Harbor's Impact on Italian Americans

The Japanese attack on the U.S. Navy at Pearl Harbor came on Sunday, 7 December 1941, and four days later Mussolini's Italy declared war on the United States in accordance with the provisions of the Rome-Berlin-Tokyo Axis treaty.[5] Four and a half million people of recent Italian ancestry in the United States in 1941 represented the largest European ethnic group. Perhaps half of them were Italian-born. Most of them knew the "enemy's language," Italian (at least in dialect form), as their mother tongue. Because of lingering aspirations to return to "*Il Bel Paese*," language difficulties, and because Italo-American women did not view citizenship as the proper role for them as wives and mothers, Italian immigrants were perhaps the slowest European immigrants to seek American citizenship. Those who had not secured their United States citizenship numbered 695,000 and under the original Alien and Sedition Acts of 1798 were considered "enemy aliens." The majority of these "enemy aliens" were

middle-aged Italian immigrant housewives. In the run-up to the war, the FBI had created the Custodial Detention Index (CDI) of persons to be arrested in case of a national emergency.

In February 1942 Franklin Roosevelt issued Executive Order 9066 detailing specific practices in the process of detention. As described earlier, there was overwhelming evidence that Italians all over America were (or had been) highly devoted to Mussolini, the leader of one of the nation's major enemies. The percentage of Italian ethnics in the population of the northeastern states varied from 10 percent to 20 percent. In the paranoid atmosphere immediately following the Pearl Harbor attack, the potential for subversion by such a large percentage of the population could truly have been alarming—a major impediment to conducting the war. On the other hand, the impossible logistics of interning or restricting Italian Americans on the East Coast and the reality that the overwhelming majority of Italian ethnics were loyal to the USA, convinced authorities there that the best policy was not mass internment but registration of enemy aliens. In fact, in nine months it became clear that even registration was largely unnecessary. The nation's Italian population proved an important asset rather than a liability in the war effort against Italy and the Axis.

La Storia Segreta

The situation on the West Coast was very different. Panic about the loyalty of Italians was lumped together with the hysteria concerning Japanese Americans in California. Imbued with anti-Asian racism and dominated by the shockingly effective surprise attack on Pearl Harbor, military and civilian policy trampled on the rights of Japanese Americans, interning more than 110,000 in remote relocation centers. It was in this political context that California and the Roosevelt administration dealt with the question of Italian "enemy aliens" in that state.

The Italian presence in California goes back to the Gold Rush era and early vintners in Napa County and Asti were all thriving by 1900. In contrast to the urban pursuits of most Italian Americans, Italians in California (mostly from Genoa, Tuscany and Sicily) found success in growing and marketing the abundant harvest of the Central Valley. In addition, the influence of A.P. Giannini and his Bank of Italy on California's economic growth and the film industry was prodigious. By 1940, according to Mormino and Pozzetta, California, with a total population of 6.9 million, included 100,000 Italian immigrants among its state population of several hundred thousand Italians. San Francisco with an Italian population of 25,000 was the hub of Italian-California.[6]

In the 1930s the Italian community in California also manifested a strong acceptance of Fascist propaganda. The California movement included almost fifty *dopo scuola* (Italian after-school) programs for children of immigrants. California Italo-American culture also included Italian language radio shows and newspapers influenced by Fascist sympathizers, rings for Mussolini promotions, and wholehearted support for Mussolini and the Italian government by the local *prominenti*.[7] Mussolini's California initiative had penetrated the Italian community so effectively that casual observers might reasonably question Italian American loyalty after the war broke out.[8]

Since the West Coast seemed geographically most vulnerable to Japanese attack and because it had two major populations of enemy nationals (not to mention German Americans in the state), and because of the harsh viewpoints of officials directly in charge of internal security, the post–Pearl Harbor panic resulted in extreme measures and internment of thousands of Japanese and hundreds of Italian Americans—one of the most regrettable mistakes by the United States government in that era.

Because the United States Attorney General's office and California Attorney General Earl Warren had conceded jurisdiction to the War Department, the decisive force in the repressive debacle on the West Coast was General John L. DeWitt. He and Warren conducted a very aggressive campaign against the Japanese ethnics that resulted in abusive internments of thousands.[9] DeWitt and Warren were not alone in their approach to the problem. All of California's congressmen were strongly in favor of internment for Japanese, Italian and German ethnics. In fact, some feared that if the government didn't act, people would take repression of aliens into their own hands with the kind of lynching and mob violence as had occurred during World War I against German Americans. For months DeWitt pressed for the massive internment of the Italians and Germans in addition to the Japanese. According to Stephen Fox,

> DeWitt . . . provided an astonishing explanation of his fear: the fact that there had been no sabotage as yet merely proved that " fifth columnists" exercised a sinister control and were waiting for the right moment to strike simultaneously up and down the coast.[10]

Absurdly, the fact that there was no subversive activity was taken as proof that there would be subversive activity!

As for the Italians in California, non-American citizens ("enemy aliens") were less impacted by the internment than by the travel restrictions. In December 1941 and the early months of 1942, wartime regulations were applied to some 50,000 California Italian "enemy aliens." They were required to register at their Post Office to get photo and fingerprint IDs. They were prohibited from living in or traveling to areas west of the Pacific Coast Highway and areas surrounding military installations (which were broadly defined.) This provision applied even to fishermen. "Enemy aliens" were also subject to curfews and were prohibited from owning short wave radios, maps, cameras, guns or from travelling more than five miles without permission. The Italian culture is based on the idea of *bella figura*, the positive presentation of self with pride and reassurance. Public branding that included the word "enemy" was a serious insult on the part of a nation to which the immigrants had sacrificed everything to migrate. The personal insult and shame connected with being classified an "Enemy Alien" hurt. Most of those labeled with that stigma were harmless middle-aged mothers and grandmothers who had made the mistake of thinking it was not necessary for a wife or mother to apply for naturalization. Several Californians were reported to have committed suicide because of their classification as enemy aliens.[11] The most infamous instance of absurd designation of "enemy alien" was the case of Joe DiMaggio's parents, Giuseppe and Rosalia DiMaggio. Giuseppe was banned from Fisherman's Wharf from which he and many Italians conducted their fishing businesses.

In the initial months of World War II, distrust among fellow Californians was rampant. Some Italians in California were interned. According to the Storia Segreta website:

> About 250 individuals were interned for up to two years in military camps in Montana, Oklahoma, Tennessee, and Texas. By June of 1942, the total reached 1,521 Italian aliens arrested by the FBI, many for curfew violations alone. Though most of the latter were released after short periods of detention, the effects on them and others in the community are not hard to imagine.[12]

Some of the anti-Italian hysteria was even used to attack San Francisco Mayor Angelo Rossi. In 1942 he was hauled before California's Un-American Activities committee where he was accused of making the Fascist salute. He was humiliated by the proceedings—a turn of events that soon ended his political career.

Apparently, the San Francisco arrestees were mostly members of the Italian Ex-Combattenti (Veterans) of World War I, identified even before Pearl Harbor by the FBI Custodial Detention Index. In 2001, the United States Attorney General report to Congress admitted mistreatment of Italians during the War. In 2010, the California Legislature passed a resolution apologizing for mistreatment of Italian residents during the war.[13]

The ones who were interned were brought to Fort Missoula, Montana. The bulk of the men at Missoula were Italian citizens—New York World's Fair workers, merchant seamen, and crew members from Italian liners that were in United States jurisdiction when the war broke out. Described by *Il Progresso* ironically as "Bella Vista," the camp housed more than a thousand detainees considered to be dangerous enemy aliens from around the country. Bestselling novelist Lisa Scottoline's *Killer Smile* is based in part on the summary arrest of her grandfather. Action is set in the Montana detention center and reflects the negative and positive aspects of camp life. Although mild when compared to the barbarisms of the Nazis, the treatment of Italians on the West coast was so traumatic that Italians in Northern California repressed the personal memories and the embarrassment. They kept the arrests, internments and humiliation of being labeled "enemy aliens" a secret. Decades later, researchers with the American Italian Historical Association including Rose Scherini and Lawrence DiStasi uncovered this "storia segreta" (secret history).[14]

After Pearl Harbor—Less Panic in the East

Sheer numbers protected Italians in the East from the excesses of California. Those numbers made internment impractical and they gave Italians Americans a much more powerful public voice. More than a year before the outbreak of war, Fiorello La Guardia, a longtime anti-Fascist, had proclaimed to an audience of six hundred Italian American businessmen in Baltimore:

> Italo-Americans are solidly against totalitarian cruelty. I want to appeal to the whole country that there be not one scintilla of doubt against any citizen of Italians blood. . . . The blood and sweat of the Italian people helped build this country and we want every one to know that we are one family together . . . and we all say "hands off" to all dictators.[15]

The *New York Times* ran a story describing the reaction in Little Italies to Mussolini's Declaration of War on the United States as stunned silence, then tears and lamentation of "vergogna" (shame), followed by pledges of loyalty to the United States. Residents tore down Mussolini photos and Italian flags and replaced them with portraits of FDR and small American flags.[16] The Italian American Governor of New York, Charles Poletti,[17] affirmed, "There has never been any doubt that Americans of Italian extraction are loyal and devoted to the principles of freedom and liberty on which America was founded. Thousands and thousands of young Italo-Americans have [already] volunteered in the Army and Navy of the United States. They stand ready to die for victory."[18] The disappearance of Mussolini photos and Italian flags and their replacement by portraits FDR and small American flags reflected the sobering change that had come to the community.

The *New York Times* editorial just two weeks after the attacks on Pearl Harbor welcomed and confirmed Italian American loyalty:

> American citizens of Italian origin were among the first to proclaim their loyalty to this country when war was declared. They are among the first, as a group, to organize formal demonstrations of support of the war efforts and war aims of the United States. Over the weekend, the Supreme Council of the Sons of Italy met in Independence Hall in Philadelphia to swear allegiance and pledge its membership to buy $10,000,000 worth of defense bonds. . . . This is not unexpected, but it is a welcome confirmation of our belief that the great majority of Italian-Americans are wholeheartedly united with all Americans in the struggle to defeat the Axis Powers.[19]

One of the strongest Italian American leaders to emerge was Luigi Antonini, the President of the Italian American Labor Council. Labor unions that served mostly Italian Americans were early to support war bond drives, and the "I Am an American Day" rallies. Slogans like "American Victory—Italy's Freedom" emphasized that the war was against Fascism, not the Italian people. On 2 December 1942 IALC pledged to encourage and finance revolt against the Mussolini regime under the slogan "Enough of war, enough of Fascism."[20]

Questionable acts against the rights of Italian American individuals and institutions by the United States government occurred throughout the nation in 1941–1942, in addition to the repression in California. Singer Ezio Pinza was summarily snatched from his home and detained at Ellis Island for several months; the offices of the Italian Trade Commission in Chicago were ransacked and shut down, but the FBI arrested only five suspected Italian American subversives in Chicago.

The Office of War Information investigated Italian language broadcasters and censored some of the programming. That office also conducted a publicity campaign satirizing Mussolini and the other Axis leaders (Figure 22.1), admonishing, "Don't Speak the Enemy's Language!" and stating that "The Four Freedoms Are Not in His Vocabulary."[21] In this atmosphere, the Italian language in America suffered severely. Italian language courses disappeared from schools on all levels and many Italian parents resolutely determined NOT to teach their children Italian lest they be burdened by the kind of discrimination that they had endured during the "enemy alien" period. Signs were posted in groceries and businesses urging patrons not to speak Italian for the duration of the war. This downgrading of the Italian language and the public *italianità* that goes with it is an example of collateral damage of the war. The message was not only "Don't Speak Italian" but also "Don't ACT Italian." It was only partly repaired by the postwar migration of Italian speakers.

Transforming a People: From Gangsters to Heroes

Fortunately, this 1941–42 period of anxiety for Italians in America lasted less than a year. Italians were not a threat to anyone and their leaders and friends pushed back against the initial hysteria. In fact, Italian immigrants and their descendants proved an important asset in the war effort as soldiers and as voters for the Roosevelt administration.

On Columbus Day 1942, (three weeks prior to the midterm elections), before a full house at Carnegie Hall and broadcast nationwide, Attorney General Francis Biddle announced the dissolution of the enemy aliens restrictions for Italians. Though some irreparable damage had been done and a number of suicides of "alien enemies" have been attributed to the Executive

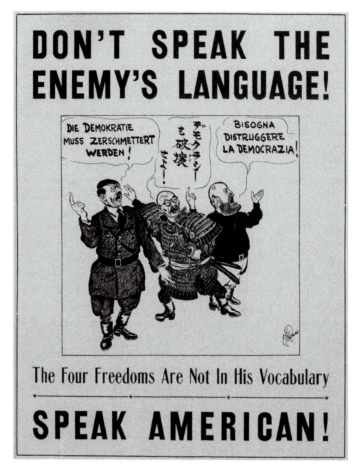

Figure 22.1 "Don't Speak the Enemy's Language! Speak American." Hitler: "Democracy must be destroyed!"; Tojo Hideki: "Destroy democracy!"; Mussolini: "Democracy must be destroyed!" United States Federal Government/Wikimedia Commons.

Order 9066 campaign, victimhood is not the main story of Italian Americans during the World War II period.

The BIG story of Italians in World War II is service in the military. Precise numbers are difficult to reconstruct, but the heaviest emigration out of Italy occurred in the period before 1914. The vast majority of immigrants were young people in their childbearing years. Logically, this demographic produced a baby boom (1914–1920), and in 1940 those boomers became draft age, meaning that Italian Americans were overrepresented in the cohort. Some estimates indicate as many as a million of the fifteen million American servicemen and women were of Italian ancestry.

War is invigorating and in some cases liberating. War takes the soldier out of the humdrum, to exciting and challenging and possibly deadly experiences. Though most people logically say that they hate war, the truth is that it is exhilarating. Italian Americans in the armed services of World War II underwent an average of thirty-three months of what amounted to intensive Americanization training. They emerged from the experience as full-fledged Americans, much more confident than when they entered the service, imbued with American

know-how. The travel (73 percent of GIs went overseas), the interaction with Americans of all backgrounds, the basic training, job training, military discipline, the emotional stress of combat, the exclusive use of the English language—even the food they consumed—and the non-Italian friends and prospective spouses they chose, formed them into very different individuals and groups in 1945 than they had been in 1940. In addition, when the Italian American GIs returned to Little Italies throughout the United States, they discovered that they were *de facto* the new generation in both ethnic and nonethnic organizations in their communities.

The public image of Italian Americans was also enhanced by service in the military. In the 1940s, the armed forces public relations machine was very efficient and consistent in supplying local newspapers with a steady stream of news releases and photos relating to the activities, advancements, transfers and honors received by American GIs. The voluntary work of former enemy alien women of New York was praised in the *New York Times*; the patriotic enthusiasm of Italian American War Bond rallies, and their participation in "I Am An American" extravaganzas were featured in the media.[22] Refreshingly, Italian names and faces began to appear in the nation's newspapers as war heroes, martyrs, women Red Cross volunteers and ordinary guys who had just received a promotion in rank. No gangsters here.

The most important war heroes of Italian origin in World War II were John Basilone and Dominic "Don" Salvatore Gentile. Books, articles, films and YouTube segments about the two abound. Basilone distinguished himself in the Battle of Guadalcanal in a famous firefight in 1942. He cut such a striking figure and his accomplishments were so dramatic that the War Department assigned him to tour the nation to sell War Bonds. He appeared with political figures like Mayor La Guardia and Hollywood personalities like John Garfield. At his homecoming, "The Greatest Day in the History of Raritan," singer Catherine Mastice performed a song especially written for the occasion entitled "Manila John." Dissatisfied with his life as a pitchman, he returned to combat in the Philippines, only to die at Iwo Jima in 1945. His story is well documented in a dozen books, on YouTube and fictionalized in the HBO Series *The Pacific* (2010).[23]

Don Gentile was from Piqua, Ohio. Lacking the formal education to qualify as a United States Army Air Force pilot, he enlisted in 1941 in the Royal Canadian Air Force, then moved to the British and finally to the American Army Air Force. A daredevil, Gentile was ranked as the top scoring 8th Air Force ace with the destruction of twenty-eight enemy aircraft. *Il Progresso* assigned a reporter to chronicle his heroics as he progressed toward his record-breaking performance. He has been described as the "embodiment of the Italian American serviceman" for his awareness of being the son of poor immigrants, his religiosity, and his authentic nature. He was nicknamed "The One Man Air Force," the title of his autobiography.[24]

Another Italian American whose story emerged postwar was Lou Zamperini, a 1936 Olympic runner from Torrance, California who joined the United States Air Force when the war began. After his plane was shot down in May 1943 near the Marshall Islands, he and a comrade survived in a rubber life raft for forty-seven days only to be captured by the Japanese and placed into a POW camp where he defiantly endured brutal torture. A book on his life (2010) and subsequent film (2014) are appropriately titled *Unbroken*.[25] He was awarded a half-dozen military metals, the Ellis Island Medal of Honor and inducted into the National Italian American Sports Hall of Fame.

The one place where significant numbers of Italian Americans were drawn together as a military unit was in the OSS in Italy. The precursor to the CIA, the Office of Strategic Services under "Wild Bill" Donovan and Max Corvo handpicked 350 Italian American GIs with the best IQs and Italian language skills (dialects included) for "extra hazardous duty behind enemy lines." In the spring of 1943, recruits were brought to the Washington, DC; then it was

on to Fort Benning, Georgia. The young people were trained in demolition, small arms, hand-to-hand combat, parachuting, radio operations, camouflage and amphibious operation.[26]

First generation and second generation Chicago Italians like Egidio Clemente and Anthony Scariano worked behind the lines with the Italian partisans (*partigiani*) in the latter part of the war to undermine and drive out the German occupiers of Italy. Clemente, the editor of the socialist *La Parola del Popolo* [The Word of the People] in Chicago was brought to Africa and then Rome to conduct psychological warfare that would damage the enemy's morale. Among his souvenirs from those days, Clemente kept a copy of an eight-page porno-graphic cartoon book, which was air-dropped by the American planes on German soldiers. The black and white and color cartoons depicted the sexual abuse which the propaganda suggested was being endured by German women and children at the hands of the Nazi masters on the home front.[27]

Scariano operated out of Corsica, launching small forays of OSS operatives across the Ionian Sea to Tuscany. A home video shot by Anthony Scariano at the fiftieth reunion of the OSS and the *partigiani* in 1995 in Venice well illustrates warm and lasting relationships between the two groups as they reminisced, touring their old radio bases and attending conference sessions.[28]

The bottom line is that this group of Italian Americans worked very effectively with the Italian partisans to push the German occupiers out of Italy much faster than would have been possible without them. Aside from biographies of Donovan and Corvo and a few others, this enormous and unique contribution to the war effort has not been given adequate recognition. The Italian American OSS contribution in Italy is sometimes completely omit-ted from some discussions of the Italian Americans in World War II.[29]

Italian American Civilians Work to Win the War

World War II was a total war that for four difficult years engaged the whole population of 132 million as well as the military force of 15 million. Civil defense, recycling, rationing, victory gardens, war bond drives and other domestic programs boosted morale and gave the public substantial opportunities to feel involved in the war effort. Perhaps it was the dis-turbing message of the poster that urged the public not to speak the enemy's language. Or perhaps it was the taunting of school children about the incompetence of the Italian Army and the clownish antics of Mussolini, but Italian Americans determined to be super patriots on the home front. The activities that Italian American men and women did in voluntary work on the home front immersed them in voluntary associations and prepared them for full participation in the mainstream American culture.

Even before the formal start of the war, Italian business groups began by making donations to the Red Cross for ambulances. In 1943 on the eve of the Allied invasion of Sicily, the national leader of the Sons of Italy, John Spatuzza, was among the many prominent Italian American who made tape recordings in Italian or Sicilian for broadcast to the Italian public, urging co-operation with American and British Liberators. "Chicago's Army of Italian Folk Out to Win War—Quarter Million Backing Men at Front" in 1942 listed the war bond purchases of Sons of Italy with its 3,100 local members and the Italo-American National Union with its 4800 members. The article also cited the 350 Italian American women who had joined the Red Cross, the work of the Justinian Society of Lawyers, the Arcolian Soci-ety of Dentists, the Italian School Teachers Club, four ladies' clubs, and twenty-nine Italian churches that had organized for the Victory effort. A half dozen Italian American Legion posts, and several women's' groups were supplying bandages, cookies, cakes, and blood plasma for the cause.[30]

When cities and corporations made additional vacant lands available for cultivation in the Victory Garden program, Italian Americans jumped at the opportunity to expand their vegetable patches. People of all ages could help feed the troops by doing what came naturally for them—raising an abundant garden.

Italian American Victory Councils were organized in dozens of cities. At the end of August 1943 the Italian American Victory Council of Chicago organized a massive rally in Grant Park that featured Gold Star Mothers (see a group from the following year in Figure 22.2), opera star Vivian Della Chiesa, movie personalities Victor Mature and Leo Carrillo. Chairman Judge George L. Quilici announced a fundraising goal of $1 million and looking past the end of hostilities, promised to work for a real democracy in a restored Italy—neither Fascist nor Communist.

Italian American support for the war effort wavered on only one major issue. Like most of the rest of the world, Italian Americans were shocked and angered by the massive bombing of the medieval (AD 529) monastery of Monte Cassino in 1943. When it was learned that

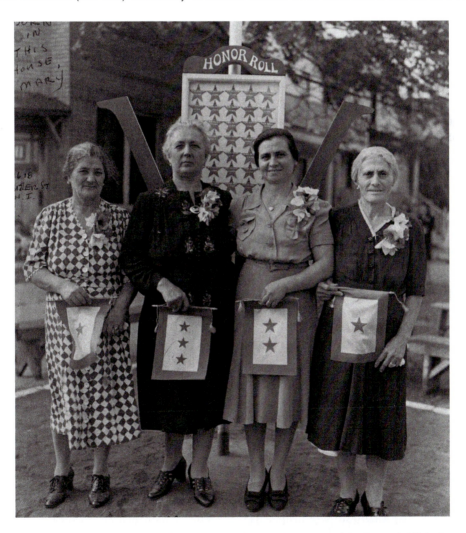

Figure 22.2 Four Italian American Gold Star Mothers: Frances Perozzi, Josephine Patrizzi, Olivia Capacasa and Virginia Prospero. Chicago, *circa* 1944. Photo: Dominic Candeloro.

the mission was based on erroneous information and that no German soldiers were in the Abbey itself, the disappointment and anger grew. These feelings were tempered by the fact that after Monte Cassino, the German lines began to retreat north. Amazingly, restoration of Monte Cassino was completed only twenty years later in 1964.

Worry and anxiety about their sweethearts, husbands, brothers and cousins defined the lives of American women during the war. Fervent prayer, writing and receiving letters, and church visits were a part of their daily routine. During the war, before e-mail and Skype, personal, handwritten letters were the primary means of communication between the servicemen and their families. Richard Aquila has written this about his father, Philip's, daily letters home:

> Writing letters everyday during the war also may have given him a sense of security, making him think that he was in control of his and his family's destiny. He believed that his constant letters would help the morale of his family and friends. In addition, the frequent correspondence enabled him to have a continuing say in family matters, and it guaranteed that loved ones would not forget him.[31]

Amplifying the impact of personal letter writing were newsletters like the *St. Anthony Broadcast* of the Roseland neighborhood in Chicago. The mostly female staff put together snippets from scores of letters received by relatives of servicemen stationed all over the world. The aggregated information was put into the newsletter, which was mailed to parishioners around the world. This precursor of Facebook maintained a strong sense of community for Roseland.

Italian women in New York and Chicago had the leadership of radio broadcasters like Amabile Santacaterina in Chicago. Herself the mother of a GI, Santacaterina's daily morning show shared letters from mothers. Soon she organized mothers' clubs, which would meet to support each other and work together to send small gifts to the servicemen. As the war progressed, the club gravitated toward the task of supplying relief for their war torn Italian towns of origin. They affiliated with Juvenal Marchisio's American Relief for Italy organization and continued active in postwar relief, the letter writing campaign to promote democracy in the 1948 election, in the lobbying for Marshall Plan parity for Italy and later Marchisio's campaign as head of the American Committee on Italian Migration. ACIM was organized to lobby for the expansion of Italian immigration quotas in the 1950s and early 1960s. The work of all these organizations on the local and national levels and well illustrates that some Italian Americans continued their wartime activism and played a continuing role in shaping United States actions toward Italy both during and after the war.

Still other women, like Rosie the Riveter of the famous "We Can Do It!" poster, pitched in to replace men in heavy industry. Many people assumed that Rosie was an Italian American and John Maggio's 2015 PBS documentary *The Italian Americans* identified her as Rosie Bonavita, a 21-year-old from Peekskill, New York.[32] Rosie thus became a powerful symbol of Italian American loyalty during the war.

Working in factory jobs gave the women of that era a new self-image and it also gave them the freedom to dress in trousers and drive cars. The full employment economy of World War II allowed single women to have money of their own in addition to the money they felt obliged to give to their mothers. And it gave them the independence to save money that would be spent after the war.

Three Italian American personalities had a significant influence on wartime events and culture. Film director Frank Capra's series of seven films, *Why We Fight* (1942–1945), summarized and packaged the American mindset regarding the war. Lucy Palermo of Chicago

was a leading advocate of isolationism and later an activist on behalf of the Bataan POWs. And Italian refugee physicist Enrico Fermi's experiment splitting of the atom paved the way for the atomic bomb.[33]

Postwar

The story of Italian prisoners of war who ended up in POW camps in the United States is summed up in the title of Camilla Calamandrei's excellent 2001 film, *Prisoners in Paradise*.[34] Fifty-one thousand Italian POWs, mostly from the various African campaigns early in the war, were relocated in scores of camps located throughout the United States. Later in the war most of them joined Italian Service Units assigned to do paid labor. This opened up a lively period of contact with civilians, especially Italian Americans, *paesani*, relatives, church groups and invitations to Sunday dinners. The friendly reception was especially positive in California, where less than two years previous the enemy alien hysteria had been at its most intense. The prisoners were returned to a war-ravaged Italy in 1946.

In February 1946 some three hundred of the approximately nine thousand Italian war brides reached New York. Since Italy was in social and economic distress, economic desperation was an important factor in many Italian war brides' decision to marry.[35] Their American spouses came from all backgrounds. One of the war brides was Remigia Ferrari-Scacco who married Edward Brooke of Massachusetts, who in 1966 would become the first African American popularly elected to the United States Senate.

Another development that boosted the postwar status of Italian American veterans was the increased importance of veterans' organizations. The majority of all GIs—highly decorated and everyday soldiers, joined veterans' organizations (ethnic and otherwise) which continued permanently to extend respect and prestige to the veterans in their home communities. The American Legion, the VFW, the Catholic War Veterans, and the Italian American War Veterans set the pace for social life and recreational activities in towns and cities across the nation next fifty years. Italian American servicemen returned home "Americanized" by their experiences in the war. Moreover, the reward for their service pushed them ever further in the direction of middle class America. In 1944 Congress passed the G.I. Bill. Those who served at least ninety days were now eligible for home loans at low rates, tuition reimbursement at colleges and trade schools and low interest business startup loans.[36] Italian Americans of that generation were swept into the middle class, out of the Little Italies and into suburbia. Postwar domestic policy included the demolition of substandard housing and the construction of new roads and super highways. Thus, an ex-GI could go to college, get married, leave behind the overcrowded old neighborhood, move to the suburbs and drive their new cars on the new roads quickly back to the city whenever he wanted. By the mid-1960s, most Little Italies were in severe decline.

In the postwar era, United States foreign policy focused on preventing the spread of communism in the world. In 1947 and 1948, with the support of the United States State Department and Generoso Pope's *Il Progresso*, a letter-writing campaign was mounted to get Italian Americans to contact their relatives in Italy to convince them to reject the Communist Party in the 1948 Italian election and vote for the Christian Democrats.[37] Italian Communists complained that the American relatives were bribing their Italian cousins with gift packs and veiled threats that if Italy went communist, the generosity would end. They also portrayed the Marshall Plan as a bribe to all Europe for bases and canon fodder in the conflict with the United States.[38] The Christian Democrats prevailed.

War is confusion. World War II for Italy was comprised of colonial wars in Africa, retreat in the face of Allied forces from North Africa to Russia to Sicily, Armistice in 1943, the

dissolution of the Italian Army. In September 1943, the Germans invaded Italy, rescued Mussolini and propped him up as puppet dictator of the so-called Republic of Salò. The British and American Allied Forces in 1943 began pushing the German Army north and with the subversive help of the Italian partisans in partnership with the (mostly Italian American) OSS. As German influence waned, civil conflict broke out between the partisans and the former Fascist elements.[39] The Allied occupation put that civil war between Fascists, Communists and Christian Democrats on hold. From 1945–1948 the devastation of Italy also triggered new migration worldwide to the point that there are currently as many people of Italian origin living outside of Italy as inside: sixty million each. The election of 1948, heavily influenced by Italian American pressure, brought the Christian Democrats to power.

Migration, including that to the United States, relieved some of the pressure on postwar Italy as did the Marshall Plan, which invested billions to stimulate the economies of Western Europe. The Marshall Plan was such a success that Italy finally reached "*la dolce vita*" (the sweet life) with its "Economic Miracle" in the late 1950s and early 1960s.

To summarize, the coming of World War II brought the Italian American people many troubling moments. It created an identity crisis when the home country declared war on the adopted one. After many tense moments following the Japanese attack on Pearl Harbor, American public opinion eased off of their fear of Italians as enemy aliens. Simultaneously, Italian Americans adroitly turned away from Mussolini and Fascism to immerse themselves in the war effort. They volunteered and served in large numbers; they won combat medals including the Congressional Medal of Honor. The special Italian American OSS unit in Italy performed valiantly. On the home front, Italian Americans pitched in and led the way, shaping postwar aid programs for Italy. The World War II experience Americanized Italians and all the other ethnic groups in America. And it rewarded their efforts with social, economic, and cultural changes that integrated Italians into the mainstream and propelled them into the middle class. And though the new Italian migration 1948–1980 would have its impact, and though Italian Americans would cling to some cultural traditions and language, the die was cast. Italian Americans had become Americans—Americans of Italian ancestry—but Americans nevertheless.

Further Reading

Belmonte, Peter J. *Italian Americans and World War II*. Mount Pleasant: Arcadia, 2001.

LaGumina, Salvatore J. *The Humble and the Heroic, Wartime Italian Americans*. Youngstown: Cambria, 2006.

———. *Italian Americans and the Office of Strategic Services: The Untold Story*. New York: Palgrave Macmillan, 2017.

Notes

The author wishes to thank Salvatore LaGumina and Gloria Nardini for their suggested improvements to early drafts of this article.

1 Salvatore LaGumina, *The Humble and the Heroic, Wartime Italian Americans* (Youngstown: Cambria, 2006), 39–40. LaGumina cites examples of Mussolini's acceptability to American public opinion in positive coverage in the *New York Times, Cleveland Plain Dealer and Washington Post*. LaGumina also mentions President Roosevelt's request that New Deal administrators study Italian Fascism for possible models that could be used in the United States to combat economic depression.

2 *Il Duce* (the leader)—from the Latin *dux*—was Mussolini's preferred title, which he imagined as having the connotation of drawing the best from his followers.

3 Video portions of the speech are available online at www.history.com/topics/us-presidents/franklin-d-roosevelt/videos/franklin-d-roosevelts-stab-in-the-back-speech.

4 Stefano Luconi, "The Impact of World War II on the Political Behavior of the Italian-American Electorate in New York City," *New York History* (Fall 2002), 404–417.

5 The supposed password of the Axis was ROBERTO Vincerà: . . . RO from Rome, BER from Berlin, and TO from Tokyo. "Roberto will win."

6 Gary Mormino and George E. Pozzetta, "Ethnics at War: Italian Americans in California During World War II," in *The Way We Really Were: The Golden State in the Second Great War*, ed. Roger Lotchin (Urbana and Chicago: University of Illinois Press, 2000), 143–163.

7 In the period of the Ethiopian War (1935–1936) when the League of Nations was boycotting Italy, many loyal Fascists in Italy and America responded to the regime's call for supporters to donate their gold wedding rings to Mussolini to finance the War. In return, they were given iron rings or scarves of black silk.

8 Mormino and Pozzetta, "Ethnics at War," 143–163.

9 As is well-known, Warren later became the Chief Justice of the Supreme Court. In his *Memoirs* (1977) Warren expressed regrets for his role in the internment of Japanese Americans.

10 Stephen C. Fox, "General John DeWitt and the Proposed Internment of German and Italian Aliens During World War II," *Pacific Historical Review*, 57.4 (November 1988), 407–438 (412).

11 Stephen C. Fox, "The Relocation of Italian Americans in California during World War II," *Center for Migration Studies Special Issues*, 10 (1993), 199–213. Fox lists Martini Battistessa, Stefano Terranova, Giovanni Sanguenetti, and Giovanni Mecheli as suicides likely motivated by the enemy alien designation.

12 www.segreta.org, accessed January 2015.

13 Steve Chawkins, "State apologizes for mistreatment of Italian residents during WWII Legislature passes resolution expressing 'deepest regret' for the wartime internment, curfews, confiscations and other indignities that thousands of Italian and Italian American families faced," *Los Angeles Times* (2 August 2010).

14 Rose Scherini, "Executive Order 9066 and Italian Americans: The San Francisco Story," *California History*, 70.4 (Winter 1991–92), 367–377 and Lawrence DiStasi, ed., *Una Storia Segreta: The Secret History of Italian American Evacuation and Internment During World War II* (Berkeley: Heyday Books, 2001).

15 "La Guardia Hails Italian Loyalty," *New York Times* (18 June 1940), 20.

16 "Italians in City Back U.S. in War: Populations of 'Little Italys' Stunned But Stress Their Allegiance to America," *New York Times* (12 December 1941), 22.

17 Charles Poletti was elected Lieutenant Governor of New York in 1938, becoming governor upon the resignation of Herbert Lehman in in December 1942. Poletti served as Governor 3 December 1942–31 December 1942.

18 "Italians in City Back United States in War: 'Little Italys' Stunned but Stress Their Allegiance to America," *New York Times* (12 December 1941), 22.

19 "Italian-Americans," *New York Times* (22 December 1941), 16.

20 "Revolt in Italy to Be Pushed Here: Italian-American Labor Group to Mobilize the Opposition to Mussolini Regime," *New York Times* (2 December 1942), 5.

21 A reference to Franklin Roosevelt's "Four Freedoms" speech of 6 January 1941: Freedom of speech, worship, from want and from fear.

22 "Praises Was Work of Italian Women" (19 October 1942), 22; "City's War Activities Assisted by Women Listed as 'Enemy Aliens," *New York Times* (29 January 1943), 16. "Blend of 17 National Groups to be Seen in American Pageant," *Chicago Tribune* (17 May 1943), N7; 'Italians spend $1,000,000 for Bonds at Rally," *Chicago Tribune* (30 August 1943), 4.

23 See www.raritan-online.com/parade-1943.htm; and Jim Proser and Jerry Cutter, "*I'm Staying with My Boys . . .": The Heroic Life of Sgt. John Basilone, USMC* (Hilton Head: Lightbearer Communications Company, 2004).

24 Don S. Gentile, *One Man Air Force* (New York: Fischer, 1944). LaGumina, in *The Humble and the Heroic*, has written compellingly about dozens of the Italian American heroes in World War II and he has organized exhibits to disseminate their stories. In addition to John Basilone, the Medal of Honor winners included Army Master Sergeant Vito R. Bertoldo from Decatur, Illinois, who distinguished himself in France; Army First Lieutenant Willibald C. Bianchi from Ulm, Montana, Bataan; USMC Corporal, Anthony Casamento, from Brooklyn, NY, Guadalcanal; Major, US Army Air Corps Major Ralph Cheli, from Brooklyn, NY, New Guinea; Army PFC Joseph J. Cicchetti from Waynesburg, OH, Luzon; Army PFC Mike Colalillo from Duluth, MN; Germany; Army Technical Sergeant Peter J. Dalessandro from Watervliet, N.Y, Germany; USMC Corporal Anthony P. Damato from Shenandoah, PA, Marshall Islands; Army Staff Sergeant Arthur F. DeFranzo from Saugus, MA, France; Army PFC Gino J. Merli from Peckville, PA, Belgium; Army PFC Frank J. Petrarca from Cleveland, OH, Salomon Islands; Army 2nd Lt. Robert M. Viale from Ukiah, CA, Luzon. Detailed information on each of these heroes is

available in biographies and autobiographies and online. The Italian American Veterans Museum at Casa Italia in Stone Park, IL (Chicago) has displays dedicated to World War II veterans and Italian involvement in all of America's military campaigns. This same group produced an award-winning documentary about Chicago Italian American GIs in World War II entitled *5000 Miles from Home* (2009).

25 Lauren Hillenbrand, *Unbroken: A World War II Story of Survival, Resilience and Redemption* (New York: Random House, 2010).

26 Emilio Caruso, "Italian-American Operational Groups of the Office of Strategic Service," in *Gli Americani e la guerra di liberazione in Italia: OSS e la resistenza italiana*, ed. Giuliano Lucchetta (Rome: Presidenza del Consiglio dei Ministri, Dipartimento per l'informazione e l'editoria, 1994), 219. This volume contains numerous reports given by former OSS operatives relating the stories of their cooperative efforts with the *partigiani* to drive out the Germans.

27 The Italian American Collection, University of Illinois, Chicago Library, Special Collections.

28 The DVD is in the Archives of Casa Italia Library.

29 See now Salvatore J. LaGumina, *The Office of Strategic Services and Italian Americans: The Untold Story* (New York: Palgrave Macmillan, 2016). Nancy Shiesari's website, www.ossinitaly.com, which contains numerous elements for a prospective film documentary on the topic.

30 *Chicago Tribune* (15 June 1942), 16.

31 Richard Aquila, *Home Front Soldier* (New York: SUNY Press, 1999), 7.

32 But see also James J. Kimble and Lester C. Olson, "Visual Rhetoric Representing Rosie the Riveter: Myth and Misconception in J. Howard Miller's 'We Can Do It!' Poster," *Rhetoric & Public Affairs*, 9 (2006), 533–570; and Kimble, "Rosie's Secret Identity, or, How to Debunk a Woozle by Walking Backward through the Forest of Visual Rhetoric," *Rhetoric & Public Affairs*, 19 (2016), 245–274.

33 Candeloro file in the Casa Italia Archives.

34 www.prisonersinparadise.com

35 Susan Zeiger *Entangling Alliances: Foreign War Brides and American Soldiers in the in the Twentieth Century* (New York: New York University Press, 2010), 102.

36 Editors' note: African-American veterans, many of whom had served in the Italian campaign, were not eligible for most of the benefits of the G.I. Bill.

37 "Pleas to Italy Ask Vote Against Reds," *New York Times* (8 April 1948), 8.

38 "U.S. Letters Anger Leftists," *New York Times* (1 April 1948), 3.

39 On the civil war between Fascists and anti-Fascists, see Claudio Pavone, *A Civil War: A History of the Italian Resistance*, ed. Stanislao Pugliese (New York and London: Verso, 2013).

MOTHERS AND DAUGHTERS IN ITALIAN AMERICAN NARRATIVES

Mary Jo Bona

A mia madre, un vero amore.

A woman writing thinks back through her mothers.
—Virginia Woolf[1]

For over a century writers of Italian descent in America have portrayed family relations in response to migration and resettlement in the United States. One durable strand in the fabric of that narrative is the mother-daughter bond. It is no exaggeration to say that mothers and daughters matter deeply to the writers of Italian America. Their narratives devote detailed attention to this dyad, especially in the wake of migration and its many aftershocks.

An emphasis on the specific context of migration in literary portrayals of Italian immigrants has imposed a historical and linguistic differential between immigrant mother and American daughter, often resulting in narratives in which daughters both resist and discover their mothers' gifts. On New World soil, Italian immigrant mothers have been represented by a host of writers as characters who challenge the Eurocentric and middle-class ideologies of motherhood, in which "the cult of true womanhood" assumes, among other things, that "mothering occurs within the confines of a private, nuclear family," and that "motherhood and economic dependency on men are linked."[2] The frequent appearance in literary Italian America of complementary forms of mothering, in which women are assisted by "other-mothers," suggests that responsibilities for childcare extended beyond the boundaries of biologically related families, so as to include fictive kin relationships within the ethnic enclaves of towns and cities in America.

During the decades between 1880 and 1920, southern and eastern Europeans migrated worldwide and in huge numbers. The Italian immigrants who came to American shores were quickly treated as a problem, spawning a number of ethnocentric and racist discourses about Italian unassimilability, since Italians purportedly lacked the racial strain that would make them suitable American citizens. At the time when Italians from the Mezzogiorno (the regions of southern Italy) were immigrated in large numbers, U.S. nativism was peaking. As Katrina Irving writes, "the last great wave of xenophobia had its inception in the early 1890s and centered on a 'scientific' (eugenic) fear of 'mongrelization' from the influx of immigrants from Southern and Eastern Europe."[3] The fear extended to female arrivals, and an image of "primitive maternalism" was liberally applied to immigrant mothers, in negative but also positive ways. An arguably ambivalent example of immigrant motherhood appeared on the front cover of the premier organ of social work, *The Survey's* 1922 issue: a reproduction of Joseph Stella's monotype, "Immigrant Madonna." (See Color Plate 13.) According to Irving, native-born Americans qualified the image of the immigrant mother as a suffering Madonna by suggesting that her desire to assimilate was coeval with her ideal motherhood.

American-born writers such as Willa Cather in *My Ántonia* (1918) equally supported the idea of a "primitive [that was] poised to save U.S. culture from its meretricious tendencies."[4] Irving also explains that in the dominant narrative the immigrant family, as the "site of reproduction . . . is seen as the place where racially inferior individuals are propagated," thus targeting the family home (especially if it is a tenement dwelling) as "dysfunctional," and in need of "native intervention within that space."[5] Italian American writers told a different story about those tenement dwellings.

Accounts of migration often focus on narratives of mobility, change, and agency, but such narratives then undervalue what Irene Gedalof calls the "embodied work of mothering, such as childcare and childbirth, and the work of reproducing cultures and structures of belonging, such as transmitting culturally specific histories and traditions regarding food, dress, family and other inter-personal relationships."[6] Keeping in mind both the hostile reception Italian immigrants received during their greatest period of migration and also the ways in which immigrant mothers managed to maintain maternal authority through cultural retentions, I examine in "Mother's Tongue," (following section) several representative novels that attempt realistic depictions of immigration and readjustment in America, but are inflected simultaneously by the influence of nativist discourse, culturally specific traditions and complementary forms of mothering.

Mother's Tongue

Daughters in Italian American narratives speak their mother's tongue, but also develop code-shifting skills that help them to adapt to American culture. Aware of Italian maternal expectations that they be good daughters (chaste, domestic, industrious, interdependent), they covertly express an American form of individualism that is simultaneously influenced by Italian ways of being. A paradigmatic example from Mario Puzo's *The Fortunate Pilgrim* illustrates this paradox. Objecting to her mother's insistence that she remain a dressmaker rather than attend college, Octavia exclaims to her mother, Lucia Santa: "I want to be happy." Unable to speak English, and unlettered in Italian, her mother responds in scornful imitation "*You want to be happy.*" And then in Italian, with deadly seriousness, "Thank God you are alive."[7] Mother's tongue produces stability through the repetition of old-world thinking. But Lucia Santa is not without the parodic humor of imitation, illuminating her awareness of migration, which requires regular negotiations with her daughter. Drawing on Avtar Brah's notion of "diaspora space," Irene Gedalof examines "what it means to make homes in the context of immigration," a topic of profound concern for writers of Italian America.[8] One of the informing ideas guiding my analysis here is how authors represent mother-daughter relationships in the context of migration, since a "sense of loss [is] often engendered by migration," as Tony Murray discusses in the context of Irish migration experience in the work of Edna O'Brien. Murray argues that for mother and daughter, loss is especially resonant, "because [of] their mutual recognition that they are likely to experience maternal separation twice over, once as child and once as mother. As a result, maintaining the mother/daughter relationship in the context of migration takes on special significance."[9]

Three novels that explore mother-daughter bonds through the lens of migration and the experiences of accompanying loss and retrieval include Garibaldi Lapolla's *The Grand Gennaro* (1935), Mario Puzo's *The Fortunate Pilgrim* (1965) and Mari Tomasi's *Like Lesser Gods* (1949).[10] Maternal separation resonates in each of these novels, as immigrant mothers struggle to maintain authority in a foreign land that does not value them. Lapolla's *The Grand Gennaro*, published in 1935, is set in 1890s Italian Harlem during the peak decades of nativism and follows the destiny of one Gennaro Accuci, a Calabrian immigrant, who

becomes an owner of a junk business, taking unscrupulous measures to make his fortune.[11] Lapolla introduces three Italian families from disparate regions and social classes, who move into a large brownstone owned by Gennaro. One of those families includes the 12-year-old Carmela Dauri, who migrates to Harlem's Little Italy with her parents and brothers. Her immigrant mother's good sense is trumped by old-world notions, which ultimately divide mother and daughter.

Maternal separation is mended through Carmela's relationships with "othermothers" in and outside her Harlem neighborhood. By 20, Carmela becomes a leading businesswoman of Little Italy and a skilled milliner. Because she has been socialized to be a woman of *serietà* (seriousness, reliability), Carmela functions to unite the Harlem Italian enclave through cooperation rather than unbridled competition represented by Gennaro, her future husband. Carmela's expertise in sewing eventually prepares her to assume the millinery business from her neighbor and protector, Donna Maria Monterano, an Italian immigrant mother herself, who intercedes on Carmela's behalf when she is nearly forced into a marriage after she is raped, thus enabling Carmela to escape cultural codes about family honor and shame. For all her forward-thinking qualities, Donna Sofia, Carmela's mother, reverts to outmoded thinking in insisting that her daughter marry her rapist. In good American style, Donna Maria challenges Carmela's mother's insistence that her daughter be immediately married, which she considers immoral, turning for help to a Protestant social worker, who manages to wrest Carmela and her brothers away from their family. Part of the Americanization effort of social reformers, the Juvenile Protective Asylum is a boon for Carmela, and certainly an assimilative gesture on Lapolla's part.

When she returns home, Carmela comes to embody and symbolize the meaning of the name of the brownstone, "Parterre." From the old French, ornamental garden, the word *parterre* describes a flower garden having the beds and paths arranged to form a pattern. Organized, creative, and communicative, Carmela thickens the threads of relationships among the three Italian families living in the brownstone, creating a unified pattern out of diaspora space that is as successful as her millinery business. As Irene Gedalof affirms, beyond reproductive labor (i.e., giving birth), "reproduction in the context of migration" also involves "the work of reproducing heritage, culture and structures of belonging."[12] Carmela recreates a feeling of *campanilismo* (village-mindedness) in Italian Harlem, but she encourages the younger children to become educated and seek other landscapes. She mothers (and eventually adopts) Donna Maria's children after her untimely death. Carmela's enlarged understanding of herself as a mother in the context of migration invites her to redefine ideas on maternity and reproduction, embracing Italian immigrant families from different diasporas and children from other mothers.

The work of reproducing heritage culture and of relaxing the binary between productive and reproductive labor is illuminated in Mario Puzo's *The Fortunate Pilgrim*. The novel explores one family's survival in the tenements of Hell's Kitchen (NYC) in the first decades of the twentieth century and Puzo pays particular homage to his own mother through the book's heroine, Lucia Santa Angeluzzi Corbo. Puzo's fictional representation of Lucia Santa remains the most memorable depiction of migration as a form of resistance for a young girl without a dowry. Migrating without family to America from Naples, Lucia Santa recalls her departure as primarily instigated by the tyranny of the dowry system, exacerbated by poverty. A nubile girl without linen (i.e., without a bridal trousseau) was considered shameful because that signified "the stigma of hopeless poverty."[13] Lucia Santa's rationale is no exaggeration. That Lucia Santa's daughter, Octavia, becomes the expert seamstress in America not only emblematizes the redemption of the mother, but also reveals the symbolic creation of layers traditionally represented by embroidered trousseau between the Angeluzzi-Corbo family and poverty.

Mario Puzo portrays the mother-daughter bond as the narrative foundation of *The Fortunate Pilgrim*, focusing on both women's desire to reproduce culture and embrace change. Second-generational daughter, Octavia's maternal role in the family ensures her mother's financial, social, and emotional stability. Sacrificing for her mother and siblings dreams of becoming a teacher, Octavia's sewing skills keep the family afloat even during the Depression of the 1930s. Twice widowed, Lucia Santa depends on her oldest daughter to function as a second parent, an "othermother," to her four younger children. As such, Octavia's maternal support far exceeds in scope and intensity the help Lucia Santa received from either of her husbands, the first dying in a work accident and the second in an asylum for the mentally ill.

Puzo's choice to focus on the mother-daughter relationship between Lucia and Octavia encourages a reconsideration of maternity that includes both reproduction and the reciprocal work of childcare. For it is Octavia who continuously shoulders not only the financial responsibilities of the family but also those "genuine repetitions,"—teaching, mending, cleaning, sewing—that replicate the body that births and serves as a "model in which proximity, repetition, and inter-dependence all provide dynamic resources for identity constitution."[14] That the family barely survives Octavia's six-month hospitalization for pleurisy is testimony to her role in the reproductive sphere; that she ultimately chooses not to bear children after marrying represents her recognition—and Puzo's, too—of her maternal role in the context of migration. Though it may seem rather effortless for Puzo to suggest Octavia's autonomy in having her choose not to bear children during the era in which much of the novel is set (between the Depression and the Second World War), such decisions were not made easily, especially for a woman of Octavia's generation.

In contrast to the seeming ease with which Mario Puzo decides the reproductive destiny of Octavia, Mari Tomasi's narrative delay of the oldest daughter's decision to marry in *Like Lesser Gods* may reflect the author's concealed fears regarding the relationship between maternity and its entanglement in the Italian immigrant mother's migration to America.[15] The American daughter's delay is a supplement to the Italian mother's migration experience. Memorializing the history of Italian cutters and carvers who migrated from Carrara (in the late nineteenth and early twentieth centuries) to become quarry-workers in Vermont, Tomasi creates an ethnic *Bildungsroman* by tracing the development of Italian families over two generations in Granitetown, a fictionalized Barre, Vermont. Tomasi's creation of Petra, the eldest daughter of the Dalli family, remains both a provocative and perplexing example of assimilation for her most artistic female character. Perhaps in response to her father's illness from what was then called "stonecutters TB," Petra enters one of the few professions open to white women before the Second World War: she becomes a nurse. This vocation extends her mother's role as caretaker into the larger world, but also affords Petra time to consider the alternative option of remaining single, an unconventional choice Tomasi herself made. Nonetheless, Tomasi ultimately selected a traditional route for Petra—marriage, and likely, motherhood—but complicates conventional marriage through a sleight of hand that favors Italian artistic heritage as a response to assimilative pressures. Tomasi implements this maneuver through the mother-daughter plot.

In portraying the depths of emotion and intelligence of the figure of the mother, Maria Dalli, Tomasi legitimizes immigrant motherhood in *Like Lesser Gods*. A model of strength for her daughters, Maria epitomizes the refusal to be crushed by tragedy, despite the fact that she witnesses "the premature death of an entire generation of immigrant stoneworkers [including her husband] . . . [fall] victim to the insidious dust in the [granite] sheds."[16] Maria's eldest daughter, Petra, may be named after her father, but the nomenclature signifies her mother's strength. When the town's *padrino* (godfather) figure discusses Leonardo's role at the

Carrara quarries, he refers to the artist's painting, *Madonna of the Rocks*, connecting stone with women's strength. Maria's namesake reflects an experiential reality that necessitates human resilience just as her migration to America compelled her to reproduce cultural rituals in a new spatial setting and family ties without her own mother or father present.

In order to suggest a complementarity between mother and daughter, Tomasi introduces intermarriage to resolve and complicate Petra's story. Denny Douglas, the son of Scotch quarry owners, has been acculturated into Italian values through his early friendship with the children of Italian immigrants. His first forays into carving include a faithful replica of St. Michael, with Italian and Scottish children huddled underneath its protective wings. Incorporating a healing angel who protects against forces of evil, Tomasi manages to critique the quarrying industry (and Scotch hegemony) without appearing to do so. By integrating Catholic, Italian values with Anglo-American interest in them, Tomasi allows the daughter of Maria to have her cake and eat it too.

After Denny's hand is mutilated when he breaks up a fight at his father's quarry, the injury serves as a synecdoche of the immigrant experience. The stripping of Denny's power of expression (through carving) parallels the consequences for the immigrants of migration, which causes permanent ruptures in language, family, and cultural rituals. Borrowing a cue from Anglo women writers (Elizabeth Barrett Browning, Charlotte Brontë, e.g.), Tomasi's debilitation of an Anglo-American character suggests an awareness that issues of gender, class, and ethnicity need to be taken into consideration when examining Petra's decision to marry outside of her own Italian culture. Maimed before marriage, Denny thus becomes an appropriate helpmate for his Italian American wife. He honors her culture by converting to Catholicism(!) and continues his art by sketching *her* heritage. Whereas Tomasi can leave out neither the official power structure nor the radical politics that punctuate the quarrying history of Barre, Vermont, she focuses more on memorializing Italian cultural values through an artistic heritage (including carving) that is as much Scottish as Italian. Scottish Denny Douglas simultaneously honors the daughter of Italian immigrants, Petra, whose resilience will position her as an equal in marriage. Denny Douglas equally pays homage to Petra's mother('s)-country, Maria Dalli's Italy, in his artistic focus on Italian cultural heritage.

Second-Wave Daughters

Writers who came of age during movements for social change in America reflected changes in familial dynamics, especially with regard to their portrayal of mothers and daughters. Motherhood as a subject of sustained theoretical analysis came into vogue in North America and Europe during the period of what has been called second-wave feminism and the subject continues to gain visibility in a host of popular media venues.[17] Since the 1970s, mother-daughter studies has become an area of scholarly inquiry and creative experimentation, enlarging an understanding of this union that has often been misunderstood and undervalued. It is no exaggeration, as Adrienne Rich famously wrote, that "this cathexis between mother and daughter—essential, distorted, misused—is the great unwritten story."[18] As Patrizia Sambuco reminds us,

> the coincidence of the publication of a corpus of women's writing on the mother-daughter relationship and the development of a feminist theorization of the maternal does not necessarily imply a relation of cause and effect between feminist theories and women's writing but bears witness to a more general cultural sensibility in favour of the revaluation of this formerly neglected relationship.[19]

Italian American writers of the second-wave generation bear witness to the daughter's con-flicted relationship to her mother, portraying this formerly neglected relationship through the daughter's yearning for more nurturance than the mother can give. I examine in particu-lar representative writers from this generation who focus on an unfulfilled desire for mother love removed from extreme forms of patriarchal control.

Without ascribing any politics of blame on mothers or daughters, I want to think back through mothers whose maternal thinking (to use Sara Ruddick's felicitous phrase) has been burdened by extreme forms of patriarchal control within the family.[20] Representa-tions abound in literary Italian America of daughters seeking but not always receiving the maternal support desired. Though the daughters may appear unruly, they are fundamen-tally responding to households governed by tyrannical fathers. As a result of an imbalance between practicing motherhood and dominating fatherhood, daughters respond by dis-identifying with what Marianne Hirsch calls "conventional constructions of femininity," by refusing heterosexual marriage and motherhood and by "replaying classic mythic paradigms" as alternative plot patterns that offer liberation.[21] Representative second and third genera-tion Italian American daughters such as Dorothy Calvetti Bryant, Josephine Gattuso Hendin and Louise DeSalvo emerged as writers at the height of second-wave feminism in America; as a result, women's experience became an informing category of analysis. Such narratives examine the often-fraught intersections between mothers and daughters, and the approaches these writers take to achieve reconciliation and autonomy.

Dorothy Bryant's *Miss Giardino* (1978) examines the brutal childhood of Anna Giardino, whose immigrant father did not "make" America, contemptuously rejected American ways, and viciously transferred his excruciating disappointment onto his terrified wife and chil-dren.[22] As the result of a childhood beset by violent living conditions, Anna Giardino's later choices reflect both the destiny of birth order (she is the last born child and the only child born in America who attends high school), and an inchoate decision not to repeat the agony of her mother's life. Though it can be argued that Anna jettisons conventional heterosexual marriage and motherhood as a negative rejection of her mother's life, it can be equally argued that Anna reproduces maternal care in her forty-year tenure as an English teacher in the underfunded high school of San Francisco's Mission District. Having felt liberated by education, Anna Giardino continues to believe in the salvific value of schooling and, as a result, gets snared by a conviction that she can save children through a belief in upward mobility that is supported by a maternal concept of education. As Valery Walkerdine explains, "women teachers became caught, trapped, inside a concept of nurturance which held them responsible for the freeing of each little individual, and for the management of an idealist dream, an impossible fiction."[23] Authoritative and uncompromising, Anna Giardino none-theless embodies the maternal teacher, which Bryant reinforces textually through a sequence of fire dreams, which signify the protagonist's repressed rage, her desire to save others from a life of confinement, and her ultimate will to be renewed. A two-day hospital stay as a result of transient amnesia forces 68-year-old Anna to reexamine her life. Bryant introduces maternal memories as some of the first and most instrumental Anna recalls, connecting her irresist-ibly to her mother, whom she lived with and cared for until her death eight years before the narrative begins.

Anna's ability to survive the baneful aspects of her father's anger and disillusionment comes at a high price, but it is abetted by her mother's encouragement after one of her father's tirades. Though it was culturally extraordinary that in the 1920s an unmarried high school girl would leave the family home, that is precisely what Anna must do to survive her father's abuse and continue her education. Thus, in an early recalled memory of her father throwing her clothes out the window, Anna simultaneously remembers the words of her

mother, who urges her daughter to go: "Mama, crying, follows me and helps me pick them up. She pushes them at me, pushes me, and says, 'Go.' When I try to answer, she shakes her head and repeats, 'Go.'"[24]

Anna Giardino recuperates from amnesia through regular recursions to a rebirth narrative Bryant establishes by replaying the classical paradigm of the 600-year-old phoenix, the mythical Egyptian bird who built its own funeral pyre, but then rose eternally young from its ashes. Leaving 22 Phoenix Street, the home she worked in first as hired help and thereafter as homeowner, Anna Giardino identifies with her mother's dying words, recalling the colors of the old country, "the bright vision, . . . [l]ike angel wings."[25] Thinking back through her mother allows Anna to recover her repressed memories and reinvest her own life by embracing her mother's Italy. Her father's failed immigration story prepares Anna to reclaim a working-class history reflected in feelings of powerlessness experienced by both parents, and within an institutional system of education not unlike the family, both depending on women's sacrifice and subordination. In the case of the educational structure, women teachers work under the auspice of a "comfortable fiction, a way to keep the poor in their place,"[26] and, I would add, as a woman teaching in the public school system in the decades before the Second World War, Anna was compelled to remain single to maintain her job. Though Anna's choices (to remain unmarried, to stay committed to an idealist dream, to achieve upward mobility, and to support her mother financially) were not all of her own making, she nonetheless releases herself from the punitive tyranny of the familial home and the educational system. Bryant signals Anna's emancipation through a spatial shift by novel's end: Anna leaves her Phoenix Street home and claims an enlarged cultural identity that was mainly privatized by a linguistic connection of speaking only Italian to her mother. On the threshold of a new life, Anna manages to move "beyond the ending" of the punitive plot reserved for "rebellious" autonomous women,[27] growing into a peaceful maturity, which Bryant signifies through Anna's psychic reunion with her mother's vision of flight.

Achieving reconciliation and autonomy are equally the goals of the protagonist, Gina Giardello, of Josephine Gattuso Hendin's *The Right Thing to Do*.[28] On the threshold of autonomous adulthood, Gina's trajectory has been largely determined by a tyrannical father who pursues his daughter with the ferocity of a dictator and the surveillance of a jailor. Like Anna Giardino, Gina Giardello suffers early in life from excessive paternal domination, restricting her relationship to her mother. As college-aged women, both Anna and Gina experience their dying fathers as jail wardens whose dominating bodies enthrall their prisoner. Both daughters are penalized for challenging the very patriarchal norms that control their mothers; internalizing a kind of Foucauldian panopticism, Anna and Gina struggle to define themselves as acting subjects in world conditioned by similar forms of behavioral aggression, especially toward women.

Describing mother-daughter tensions through the lens of male domination, Josephine Hendin has suggested that such conflicts are diminished because both women share the larger problem of male authoritarianism. In *The Right Thing to Do*, both mother and daughter expend excessive energy negotiating the demands of a man. Their "shared impatience" compels each to discover ways to cope with a controlling male figure.[29] Laura (Gina's mother) nurses Nino through each stage of his debilitating illness; she refuses to succumb to the disillusionment from which her husband has always suffered. In her mother, Gina finds "a stream of small satisfactions, a gift for finding amusement and meaning in daily things, that gave her a steady joyousness."[30] Unlike her mother, however, Gina can achieve autonomy only outside her father's grasp. Ironically, though Gina has absorbed her father's low opinion of women, she has used it to counter her own vulnerability and to construct some armor for herself.

Similar to her second-wave sisters, Josephine Hendin reprises a classic mythical paradigm in *The Right Thing to Do* as an alternative plot pattern that offers her protagonist liberation at the same time that it offers her some understanding of her mother's uncompromising marital situation. In her landmark study on motherhood, *Of Woman Born: Motherhood as Experience and Institution*, Adrienne Rich explains "it was not enough to *understand* our mothers; more than ever, in the effort to touch our own strength as women, we *needed* them. The cry of that female child in us need not be shameful or regressive; it is the germ of our desire to create a world in which strong mothers and strong daughters will be a matter of course."[31] In her chapter "Motherhood and Daughterhood," Rich urges women to retrieve "the loss of the daughter to the mother, the mother to the daughter, [which] is the essential, female tragedy."[32] Referencing the myth of Demeter and Korê as "the most forbidden and secret of classical civilization, never acted on the stage, open only to initiates who underwent long purification beforehand," Rich explains that this classical separation of mother and daughter "is an unwilling one."[33]

Josephine Hendin examines this classical separation between mother and daughter by reprising the myth of Demeter-Persephone, which achieves important aims for her protagonist. Gina's intention to experience a life different from her mother is supported by the urban milieu itself. Born and raised in a Queens Little Italy (Astoria), Gina's upbringing in the 1950s and 1960s reinforces an emphasis on both the restrictions and rewards of such ethnic enclaves. Described as both sanctuary and prison, Little Italies depict youthful characters struggling to adjust to the requirements of American culture as they seek the adventure of independence through education and work, places outside the circumscribed world in which they were born. Manhattan looms large in Gina's mind and her physical mobility has fostered an independence supported by formal (college) education and employment outside the enclave.

Despite ill health, Gina's father insists on following his daughter on the subway and city streets, which makes chaperonage nearly impossible. Gina's cognizance of her father's surveillance intensifies her desire for freedom, which an urban milieu enables. When Gina boards the train on elevated tracks in Queens, it plunges into the subterranean tunnel that carries it under the river and streets into Manhattan. Below it all, Gina recalls the myth of Hades and Persephone, focusing on Hades' kidnapping of Persephone, a story that infuses her ruminations as her father sits in a separate car. That the mother-daughter plot is entirely absent in Gina's thoughts underpins the way in which the father's excessive domination has prevented mother-daughter bonding. Nonetheless, toward novel's end, Gina clarifies her position as a daughter *and* she returns to her mother, having accepted personal responsibility for the good of her family, an ethos in harmony with a working-class emphasis on relations between rather than separation from the family and the surrounding culture. Gina's clarification of her role required separation from a home dominated by male power. At her father's wake, Gina realizes that defying him meant challenging a patriarchal code that became both provincial and destructive in a postwar America that increased opportunities for women. Gina will not live her mother's life, but like Persephone, she will make regular returns home, enriched by cultural traditions steadfastly enjoyed by her mother.

Thinking back through the mother remains preeminent in these second-wave narratives, but often mother-daughter connections remain covert due to the problem of male authoritarianism. For memoirist Louise DeSalvo, mother-daughter tension is exacerbated not only by a patriarchal family structure in post–World War II America, but also by the specter of clinical depression, from which her mother suffers. DeSalvo's first memoir, *Vertigo* (1996), examines the autobiographical journey taken by the author to understand herself as a daughter of two maternal precursors: her mother and Virginia Woolf, both of whom suffered

from depression.[34] In her depiction of both maternal figures, DeSalvo offers a sophisticated rather than a stereotyped depiction of the complicated intersections between mothering and mental illness. In addition, because DeSalvo chose the genre of memoir to pursue her examination of Italian American family life, she simultaneously exposed first-hand the turmoil that profoundly affected mother-daughter relations. Writing a species of autobiography close to the hearts of second-wave feminists, DeSalvo's feminist confession foregrounds intimate and uncensored detail to portray her rebellion against both parents.

As for many feminist autobiographers, Louise DeSalvo's *Vertigo* is motivated by "a personal crisis that acts as a catalyst," and the author uses a brand of literary confession less concerned with an appeal to a higher authority (as in religious confession) and more focused on "the affirmation and exploration of free subjectivity."[35] Two traumatizing events—her sister's suicide in 1984 and her mother's death in 1990—oblige DeSalvo to evaluate her status as an Italian American daughter and sister. The author manages to do this emotional work in conjunction with her scholarly role as a literary critic turned sleuth. Trained to analyze the relationship between writers' lives and their works, DeSalvo frames her memoir with an early chapter called "My Sister's Suicide" and a final chapter dedicated to her mother, "Personal Effects." DeSalvo's memoir functions elegiacally, as she struggles to examine the mental instability of her mother and sister, both of whom suffered from clinical depression all their lives. Coming out on the topic of mental illness is DeSalvo's strategy not only to honor their lives but to save her own. Through the process of writing about her mother's anguish, DeSalvo casts herself in the role of family member cured by the autonomy that comes with becoming a scholar. DeSalvo's decision to complete a PhD in English while married (and pregnant) is not without conflict and aspersion, rendered in a humorous chapter, "Portrait of the *Puttana* as a Woman in Midlife."[36] Through the process of writing on Virginia Woolf's literary life and suicide, DeSalvo recognizes a continent away and a half-century later her own struggle for independence and sanity as a soon-to-be mother and woman writer. Through the process of confessional discourse, DeSalvo saves herself from a similar familial trajectory of both biological and literary mothers, identifying the act of writing as both sacred and curative.

By the time Louise DeSalvo writes her second memoir, *Crazy in the Kitchen: Food, Feuds, and Forgiveness in an Italian American Family*, she has shifted generically from feminist confessor to ethnic autobiographer.[37] *Crazy in the Kitchen* (2004) enabled DeSalvo to shift from a drama of incoherence to one of healing as fuller excavation of her ethnic history helped her affectively to grasp her mother's unbridled anger and inconsolable grief. Since DeSalvo was never told as a child that her beloved step-grandmother was not her biological grandmother, her mother's fury at the older woman lacks context, resulting in the daughter's constant exposure to extreme emotional outbursts from her mother. These disturbing eruptions remain unanchored. They occur amid a lack of awareness concerning emigration and its history, amid ignorance concerning prejudice against Italian Americans, and, because of an arranged marriage of convenience, in an atmosphere deprived of mother love. Once cultural context takes precedence, however, DeSalvo reexamines and offers a more intricate interpretation of the maternal—specifically in relation to her mother's depression. Through the embedded discourse of food, DeSalvo revisits the topics she examined in *Vertigo*, producing a narrative that itself becomes, "a kind of recipe—[on] how to survive."[38]

As DeSalvo attests, if feminism informs all of the writing she does, then cooking makes that writing possible. In attempting to reverse the culinary history bequeathed to her by a depressed mother, DeSalvo takes charge of her nourishment in adulthood, remembering a hunger never sated, emotionally or physically, throughout her childhood. By developing into a literary ethnographer who explores the effects of Mezzogiorno culture on immigrants and their progeny, DeSalvo shifts her agenda from the pursuit of writing herself into subjectivity

to the pursuit of cultural investigation of her extended family. DeSalvo's *Crazy in the Kitchen* reveals food as a means through which one may reclaim family and ethnic history; for DeSalvo, this is largely a maternal inheritance marred by hunger, anger, mental illness, and death. Steeped in a culture of indiscretion, the women in DeSalvo's Italian American family mediate conflict through food. For these women (who have lost the native tongue), food becomes a means of communication, a language used when there are no spoken words of mutual understanding. When the opportunities for communion with food are absent (as they are with DeSalvo's mother), the author believes there is hope for healing in the printed word. Writing about food helps to uncover the past, the words on the page nourishing living and dead, as do the biscotti she pushes "deep into the soil" of her family's grave, insisting that people should bring food instead of flowers.[39] An Italian version of Mrs. Ramsay, Louise DeSalvo weaves relationships between the recalcitrant, partakes of "eternity," communing with maternal and literary precursors.[40] As Adrienne Rich said of Virginia Woolf's *To The Lighthouse* (1927), the novel stands as "testimony not merely to the power of [Woolf's] art but to the passion of the daughter for the mother, her need . . . to understand, in all complexity, the differences that separated her mother from herself."[41] Second-wave daughters achieve maternal reconciliation through literary reconstruction of Italian American family life, in homage to mothers whose lives were not blessed by the freedoms these writers fought to attain.

Queer Daughters

In search of my mother's garden, I found my own.

—Alice Walker[42]

Unlike their foremothers, writers such as Mary Cappello and Carole Maso identify as lesbians, and this is no small matter. These writers embrace strong mothers, both biological and literary, which becomes instrumental in supporting writing that reflects a continued desire for women, suggesting "other possible subjective economies based in women's relationships," as Marianne Hirsch explains in her examination of mother-daughter plots.[43] Although she maintains normative heterosexuality in her observation that girls define themselves relationally, having more "permeable ego boundaries," Nancy Chodorow's feminist revision of object relations theory is exhibited by writers such as Cappello and Maso, who subvert dominant patterns of behavior experientially and narratively.[44] Chodorow's trailblazing 1978 book, *The Reproduction of Mothering*, examines how women's mothering reproduces itself cyclically, and is a "central and defining feature of the social organization of gender and is implicated in the construction and reproduction of male dominance itself."[45] Employing a feminist revision of Freudian psychology, Chodorow carefully separates biological determinism from the requirements of social reproduction, examining the sex-gender system as a socially constructed phenomenon. As a result of the social fact that women mother, Chodorow revises essentialist theories about maternity to explain how mother-daughter relationships systemically differ from mother-son bonds such that "girls come to define and experience themselves as continuous with others; their experience of self contains more flexible or permeable ego boundaries."[46]

Unsettling what Biddy Martin describes as "homogenous conceptions of identity," Mary Cappello and Carole Maso de-emphasize through their experimental narratives a "totalizing self-identification" with regard to any one category of difference, be it ethnicity or gender.[47] Thus boundaries between mothers and daughters are more continuous and permeable,

intensifying the daughter's relationship to her mother. This vital intervention of feminist psychoanalysis gave creative writers such as Mary Cappello and Carole Maso a more flexible language in which to reassess the representation and experiential reality of mothers and daughters across a spectrum of behaviors within and outside the family home. Besides resisting many forms of male domination in their lives, establishing primary relations with women, these writers wage an ongoing critique of normative heterosexuality in order to perform a paradigmatic shift from traditional patriarchal roles designated by wifehood and motherhood to the female figure of the lover and/as artist. (Artist Christine Perri unsettles a homogenous conception of Catholic iconography, inclusive of mother and child, in her experimental sculpture titled *Blue Mom*: see Color Plate 19.)

Mary Cappello's memoir, *Night Bloom* (1999), is a case in point. Her bond with her biological mother is reinforced textually with her literary foremother, Louise DeSalvo, to whom she directly pays homage.[48] From a strictly psychoanalytical and male-centric perspective, Cappello over-identifies with her biological mother in *Night Bloom*, gesturing primarily toward a subjective economy based on women's relationships, increasing the magical potential of this mother-daughter union. Mary Cappello's level of commitment to absorbing her mother's life only grows stronger as she enters adulthood. Rather than dis-identifying with her mother's choice of marriage and motherhood, Cappello focuses instead on her own mother's disconnection from Italian American family life, experienced first through depression and agoraphobia, and later, through divorce and literary creativity. In effect, Cappello's mother, Rosemary, becomes more like her author/daughter than the unhappily married mother Cappello recalls from childhood.

Applying a fusion of postmodern feminism and queer theory allows Cappello to challenge monolithic models of sexuality, arguing à la Judith Butler, that such a category as heterosexuality is regulated through constant reiterations of sexual norms that are merely social constructs and not biological determinants.[49] Cappello's memoir constructs sexuality along the lines of family genealogy, identifying her queerness *within* family personalities, modeling her development on their nonconventional habits of mind and heart. Cappello de-centers authorial control by placing her maternal grandfather's and mother's stories next to hers, destabilizing hierarchical notions of family over selfhood. In an attempt to link her story to his, Cappello incorporates her cobbler grandfather's journal entries, his daily acts of survival written on the materials of his trade—the tabs used to mark down the repair job to be done—alongside his hopeless feelings of vulnerability when struggling to feed an impoverished, immigrant family. Absorbing her grandfather's working-class ethos and aesthetic activity of journal writing, Cappello creates a literary collage by uniting the voices of three generations of writers: grandfather, mother and daughter.

Such a structure emulates the forms that many traditional immigrant novels take; however, as third-generation queer daughter, Mary redeems not only immigrant ancestors, but also those represented by her mother's second generation, who inherited "the pain or deformation caused by the material or laboring conditions" of her peasant forbears.[50] Including excerpts from her mother's journals and poems, Cappello reverses the traditional sloughing off the parental generation, attributing her mother's artistry to an indigent childhood and a strategy she adopted to cope with an untenable marriage. Likewise, Cappello interprets traditionally unheralded women's art—gardening, quilting and cooking—as part and parcel of her mother's creative development. In doing so, Cappello pays equal homage to another literary foremother, Alice Walker, whose earlier work on the intersection between artistry and her mother's creativity made visible women's resistance to oppression through unrecognized creative acts. Walker honors her mother's creativity, explaining, "our mothers and grandmothers have . . . handed on the creative spark, the seed of the flower they themselves

never hoped to see: or like a sealed letter they could not plainly read."[51] Cappello opens up her mother's sealed letter and finds an artistic precursor even closer to home and in a space of beauty and possibility: the garden.

The artistry of Rosemary Cappello's gardening (ritualized through the Night-Blooming Cereus plant) becomes an act of communion with her daughter, replacing old-world fatalistic fears and silences with exuberant observation. In *Night Bloom*, Cappello presents an example of a new-world Italian American mother, who instills artistic vitality in her child. Rather than tell her child to "*Mangia! Mangia!* (Eat! Eat!), my mother told me in English to '*look.*' She was always commanding me thus, with exuberance, and especially before flowers and paintings. . . . One must always retain the capacity to be astonished."[52] In search of her mother's garden, Mary Cappello finds her own. For the queer daughter, the mother becomes the subject of "her own story, an artist in her own right."[53]

Carole Maso's *Ghost Dance* (1986) tries to answer the question surrounding the artist in her own right, Christine Wing, an extraordinarily gifted poet whose mental illness recalls literary precursors, Anne Sexton and Sylvia Plath.[54] Maso's focus on Vanessa Turin, a daughter in search of her artist-mother, Christine Wing, complicates the myth of Demeter-Persephone, but Vanessa's journey into adulthood reveals the difficult intersections between maternity and artistry. By novel's end, Vanessa's relationship to her mother is strengthened through the erotic, which will enable Vanessa to piece together through image patterns and narrative fragments, her family's sorrow. Unable to maintain corporeal closeness to her mother in a traditional sense, Vanessa's imaginative capacity to heal through storytelling allows her to embrace and mourn mother-daughter intimacy. In *Ghost Dance* Maso narrativizes the theories of French feminist intellectuals, particularly Luce Irigaray, and principally regarding the winsome intimacy desired by the daughter for the mother. As Irigaray writes, "And what I wanted from you, Mother, was this: that in giving life to me, you still remain alive."[55] *Ghost Dance* is Maso's narrative response to this maternal paradox.

Carole Maso explores the development of Vanessa's narrative voice by interlacing multiple strands, all focusing on one theme: loss. In its technical virtuosity, Maso's *Ghost Dance* reconstructs fragments of family lives, revealing intersecting patterns unified by metaphor and according to the logic of lyrical fiction, the genre to which Vanessa Turin is dedicated. In this way, *Ghost Dance* functions as a maternal *Künstlerroman*; however, Vanessa is the one who functions as the maternal daughter in search of the always-leaving mother. In order to remake herself, Vanessa must heed the narrative she invents "out of the remnants of competing myths of origin."[56] Divided into five parts, *Ghost Dance* traces Vanessa's complex relationship with her famous poet-mother, Christine Wing, whose untimely death by fire at a toll-booth (the family's Ford Pinto is rear-ended), compels her to understand the struggles within her family, with specific emphasis on her mother's bouts of mania and the art she creates to convert pain into beauty. The child of German and Armenian ancestry on her mother's side and Italian ancestry on her father's side, first-person narrator, Vanessa Turin, probes the silences inhering in intricate family histories. Father (Michael) and brother (Fletcher) have disappeared before the narrative begins, compelling Vanessa to express her sorrow through language that ultimately helps her return to her (now dead) mother, a dangerous journey threatening self-abrogation.

Vanessa's journey to be like her beautiful, talented, but mentally unstable mother, leads her into risky, dangerous territory, so unlike the level-headed daughter she developed into as a response to her mother's "shifting moods, . . . inexplicable sadness or rage or joy."[57] Succumbing to heroin use and anonymous sex, Vanessa's subterranean odyssey occurs as a felt-response to her mother's tragic death, despite the fact that Christine's mothering when present was

feckless at best. Vanessa's depth of despair illuminates an unrelenting sorrow over the loss of her mother, a response that brings her close to death. As Louise DeSalvo explains,

> if Vanessa is to grow beyond the world of her mother and beyond her tortured life of drugs and abusive sex to a creative life, to a fulfilling sexual life (like the one her mother had for years with her lover Sabine), she will have to manage the very difficult task of separating what can be useful to her in the example of her mother's life and what is potentially harmful, perhaps even lethal.[58]

Despite her isolation, Vanessa achieves autonomy and reconstitutes herself through memory and sharing rituals with those she loves.

Paternal grandmother, Maria Turin, offers her granddaughter the consistency, good sense, and order lacking in Vanessa's upbringing; fully schooled in the discipline of *serietà*, Maria gives Vanessa a legacy that embraces living well in the physical world. Standing over her bed at night when Vanessa visits during summers, the grandmother repeats by rote practical information, as, item, how to grow a garden, giving her granddaughter literal recipes for living.

> At night my grandmother stands over my bed and repeats things she thinks I should know—useful things like when to sow vegetables. "Sow hardy vegetables when apple blossoms show pink, tender vegetables with the first color in lilacs. . . . " Life is understandable was what my grandmother was trying to say. You can understand your life.[59]

Even though she rejects her grandmother's pragmatism, Vanessa carries it with her as a reminder that observed life is beautiful, and consciously "choosing a life" may trump floating along "recklessly till death."[60]

In effect, this is the advice given her when Vanessa visits her mother's long-time lover, Sabine. By making love to her mother's lover, Vanessa attempts a psychic return to the maternal through the erotic, but Sabine's words provide the nurturance the daughter needs in order to move forward. For Sabine informs Vanessa that Christine's desire to be a mother and a poet, despite precarious mental health, is the choice for which she and her children deeply suffered, but for which she fought and insisted upon: "I will have children. I will write poetry."[61] Despite the fact that Christine's mothering was not regularly available, Sabine assures Vanessa that her mother would not have approved her daughter's nihilistic choices:

> "Ah Vanessa," she said in the quietest voice, running her finger up my arm, my needle-marked arm, the punctured vein, "this would break your mother's heart. Your mother was not afraid to suffer. She never gave up, even in the face of terrible sadness. She was always brave. And she asked that we be brave with her. . . . " "Vanessa," she says, and her voice is strong, fierce. "We must learn to love her from here now . . . we must learn to love her from here."[62]

Despite a sense of loss and exile, Vanessa Turin must ultimately embrace a mother–daughter bond that is both isolating *and* reciprocal. In *Ghost Dance*, Maso encapsulates the daughter's struggle to maintain closeness with the mother, causing her emotional turmoil and paralysis. Nonetheless, Maso explores this bond through a coded and erotic language of French feminist

thought, taking a cue from Luce Irigaray, who imagines for mothers and daughters this crucial paradox:

> And the one does not stir without the other. But we do not move together. When the one of us comes into the world, the other goes underground. When one carries life, the other dies. And what I wanted from you, Mother, was this: that in giving life to me, you still remain alive.[63]

Maso describes Vanessa's move toward emotional fluidity and imaginative independence as both an artistic rebirth and a reunion with her beloved brother, Fletcher. In order to recombine the fragments of her past, Vanessa and Fletcher reunite in order to create a space that is no longer self-nullifying. The brother-sister tie is one of the narrative strategies Maso takes to replace traditional narrative and cultural orders of fiction, such as romance, marriage and motherhood. The bond between brother and sister, Rachel Blau DuPlessis explains, not only de-emphasizes traditional narrative sequences (and endings) but also embraces narrative strategies germane to *Ghost Dance*: lesbian ties and "re-parenting." DuPlessis describes re-parenting as a collaboration of mother-daughter as artists:

> [T]he female artist is given a way of looping back and reenacting childhood ties, to achieve not the culturally approved ending in heterosexual romance, but rather the reparenting necessary to her birth as an artist.[64]

Thus when sister and brother reunite, they do so in order to learn to love their mother from afar. Together they perform the ghost dance ritual (learned from their paternal grandfather). During the ceremony, Vanessa and Fletcher are nearly blinded by the Topaz Bird, the mother's invented symbol of poetic imagination. Brother and sister envision their mother dressed in white, invoking the paradoxical refrain from their childhood: "I have loved you my whole life"; however, in this ceremony, Christine pleads to be let go, allowing her children to say good-bye as they must.[65] With Fletcher's help, Vanessa learns to live "side by side with the sorrow,"[66] allowing her to engage the brilliant Topaz Bird of their childhood, but to live through it to tell the story of the tragically foreshortened life of their artist-mother. In Irigarayan fashion, Maso reiterates the maternal paradox that informs *Ghost Dance* and the daughter's desire: that in giving her life, the mother would remain alive.

Conclusion

Mothers and daughters have deeply mattered in the narrative lives of Italian Americans. Over the course of a century, writers have examined this essential relationship through the lens of migration within both conventional and unconventional family stories. Due to the invaluable contributions of the feminist movement, mother/daughter studies emerged as a discipline within academia and a discourse more largely in the world of letters and popular culture. Certainly attitudes have shifted about the role of mothers, inviting a more porous appreciation of the intimacy between mothers and daughters.[67] Second- and third-wave feminist narratives by Italian Americans insist on the importance of desire between mothers and daughters, which should be a source of joy not shame. For only then can strong women influence through love and respect the futures of their daughters, inviting independence and creativity within a refashioned family institution. Italian American writers have embraced both artist and mother, respecting both the distinction and the consanguinity of these roles.

Refusing to idealize motherhood, Italian American writers explore with practicality and poetry an enduring attachment, a pledge of unity: the mother-daughter bond.

Further Reading

Bona, Mary Jo. *By the Breath of Their Mouths: Narratives of Resistance in Italian America*. Albany: SUNY Press, 2010.

Caroli, Betty Boyd, Robert F. Harney and Lydio F. Tomasi. *The Italian Immigrant Woman in North America*. Toronto: Multicultural History Society of Ontario, 1978.

Ruddick, Sara. *Maternal Thinking: Towards a Politics of Peace*. Boston: Beacon Press, 1989.

Notes

1 Virginia Woolf, *A Room of One's Own* [1928] (New York: Penguin Books, 1963), 96. I would like to thank Roseanne Giannini Quinn for her constructive suggestions during the writing of this essay.

2 Patricia Hill Collins, "The Meaning of Motherhood in Black Culture and Black Mother/Daughter Relationships," *SAGE*, 4.2 (1987), 4–11 (3). In her foundational article on black mother-daughter relationships, Patricia Hill Collins introduces the term "othermothers" to reveal a contrast between the privatized nurturing expected of biological mothers and "interdependent, complementary dimensions of motherhood" that include women who "assist blood-mothers by sharing mothering responsibilities, traditionally . . . central to the institution of Black motherhood." Novels written from the Italian American tradition often represent complementary forms of mothering in their works. For a historical overview of the phrase "the cult of true womanhood," see Barbara Welter's *Dimity Convictions: The American Woman in the Nineteenth Century* (Athens: Ohio University Press, 1976).

3 Katrina Irving, *Immigrant Mothers: Narratives of Race and Maternity, 1890–1925* (Urbana: University of Illinois Press, 2000), 1. Irving's central thesis is concerned with delineating how "immigrant femininity, particularly immigrant maternity, became an entrenched site of representational struggle within the public discourse of immigration" (3). Irving examines popular racializing discourses of the day in order to provide detailed readings of specific novels written by Anglo American writers, including Willa Cather, Stephen Crane, Harold Frederic, Frank Norris, and, also, the work of photojournalist, Jacob Riis, in particular his *How the Other Half Lives* of 1890.

4 Irving, *Immigrant Mothers*, 9. According to Irving, "The Americanizers' immersion in sentimental 'ways of seeing' produced a thorough ambivalence in their representation of the immigrant mother. Whereas nativists had posited an antithetical relationship between the immigrant woman and sentimental maternity, Americanizers stressed her aspirations toward that ideal and read those aspirations as a testament to her desire to assimilate . . . Their texts frequently depicted her as a suffering Madonna in order to convey that pathos" (73).

5 Ibid., 12–13.

6 Irene Gedalof, "Birth, Belonging and Migrant Mothers: Narratives of Reproduction in Feminist Migration Studies," *Feminist Review*, 93 (2009), 81–100 (82).

7 Mario Puzo, *The Fortunate Pilgrim* [1965] (New York: Ballantine, 1997), 13. The blueprint for Mario Puzo's creation of Octavia is the character Carmela in Garibaldi Lapolla's *The Grand Gennaro*, a novel discussed in this essay.

8 Gedalof explains in "Birth, Belonging and Migrant Mothers" that "In Brah's version of diaspora space, 'home' and 'dispersal' are in creative tension so that it is possible to desire and imagine a home, a site of belonging and cohesion, while 'simultaneously critiquing discourses of fixed origins'" (89). See Avtar Brah's *Cartographies of Diaspora* (London: Routledge, 1996).

9 Tony Murray, "Edna O'Brien and Narrative Diaspora Space," *Irish Studies Review*, 21.1 (2013), 85–98 (88).

10 For biographical overviews and sociological interpretations of the narratives of Italian America, beginning with early autobiographical accounts of Italian immigrants, see Rose Basile Green's *The Italian American Novel: A Document of the Interaction of Two Cultures* (Rutherford: Fairleigh Dickinson University Press, 1974). Two anthologies of writings by Italian Americans that also include instructive introductions are Helen Barolini, ed., *The Dream Book: An Anthology of Writings by Italian American Women* [1985], rev. ed. (New York: Syracuse University Press, 2000); and Anthony J. Tamburri, Paolo A. Giordano and Fred L. Gardaphé, eds., *From the Margin: Writings in Italian Americana*, rev. ed. (West Lafayette: Purdue University Press, 2000).

11 For a chronology and biographical information about Lapolla's early life and his wide-ranging interests in teaching and writing, see Steven J. Belluscio, "Introduction: Making America in Garibaldi M. Lapolla's *The Grand Gennaro*," in *The Grand Gennaro*, ed. Garibaldi M. Lapolla and Steven J. Belluscio (New Brunswick: Rutgers University Press, 2009), xv–xxxvi.

12 Gedalof, "Birth, Belonging, and Migrant Mothers," 81.

13 Jane Schneider, "Trousseau as Treasure: Some Contributions of Late Nineteenth-Century Change in Sicily," in *Beyond the Myths of Culture: Essays in Cultural Materialism*, ed. Eric B. Ross (New York: Academic, 1980), 335.

14 Gedalof, "Birth, Belonging, and Migrant Mothers," 94.

15 Mari Tomasi's *Like Lesser Gods* [1949] (Shelburne: New England Press, 1988). For biographical information on Tomasi and historical information about the quarrying industry in Vermont, see Alfred Rosa's informative afterword. For an analysis on genre innovation in this novel, see Mary Jo Bona's *Claiming a Tradition: Italian American Women Writers* (Carbondale: Southern Illinois University Press, 1999), 23–56.

16 In *Like Lesser Gods*, Tomasi suppresses the radical antecedents of first-generation northern Italian immigrants, expressed in radical politics (i.e., anarchism) and anti-clericalism. For an interpretation of the "historical amnesia" from which old-time residents of Barre, Vermont, suffered, see Rudolph Vecoli's, "Finding, and Losing, the Gems of Barre's Italian Immigrant Past: Anarchism, Silicosis, and a Slip of the Community Mind," *The Barre-Montpellier Times Argus* (26 October 1989), 7.

17 Heather Hewett, "Mothering Across Borders: Narratives of Immigrant Mothers in the United States," *Women's Studies Quarterly* 37.3 & 4 (Fall/Winter 2009), 121–139 (121): "Increased media coverage of celebrity moms, the development of targeted marketing strategies, the appearance of mommy lit and mommy memoirs, the prominence of mama bloggers in cyberspace, and the growing political advocacy of mother's rights—has propelled increasing numbers of images of motherhood, as well as mother's voices in the public sphere."

18 Adrienne Rich, *Of Woman Born: Motherhood as Experience and Institution*, 10th Anniversary ed. (New York: Norton, 1986), 225. According to Brenda Silver, Rich's statement on the relationship between mothers and daughters is "one of the most widely cited statements to come out of the women's movement." "Mothers, Daughters, Mrs. Ramsay: Reflections," *Women's Studies Quarterly* 37, 3 & 4 (Fall/Winter 2009), 265.

19 Patrizia Sambuco, *Corporeal Bonds: The Daughter-Mother Relationship in Twentieth-Century Italian Women's Writing* (Toronto: University of Toronto Press, 2012), 6, 25. For a fine overview of mother-daughter studies and their intersection with Italian feminism, see Sambuco's chapter 1, "Psychoanalytic Accounts of Sexual Difference: Luce Irigaray and Italian Feminism." See also Adalgisa Giorgio, "Writing the Mother—Daughter Relationship: Psychoanalysis, Culture and Literary Criticism," in *Writing Mothers and Daughters: Renegotiating the Mother in Western European Narratives of Women*, ed. Adalgisa Giorgio (Oxford: Berghahn Books, 2002), 11–46.

20 I take the phrase "the politics of blame" from Molly Ladd-Taylor and Lauri Umansky, eds., *"Bad" Mothers: The Politics of Blame in Twentieth-Century America* (New York: New York University Press, 1998). Offering a historical overview of the development of the "bad" mother label, the editors analyze the social, cultural and political purposes of mother-blaming, locating its historical roots in "new ideas about motherhood and childhood innocence that accompanied industrialization, the American Revolution, and Protestant Evangelicalism . . . Vestiges of the Victorian ideal of motherhood persist: the 'good' mother remains self-abnegating, domestic, preternaturally attuned to her children's needs, the 'bad' mother has failed on one or more of these scores" (6).

21 Marianne Hirsch, *The Mother/Daughter Plot: Narrative, Psychoanalysis, Feminism* (Bloomington: Indiana University Press, 1989), 11, 10. Hirsch's study continues to be essential reading for an interpretation of the ideology of motherhood, as it intersects with a range of nineteenth and twentieth-century novels by women, and for feminist revisions of psychoanalytic thought within that literature. In reinterpreting Freud's concept of the "family romance," Hirsch examines alternate plot patterns that go beyond Oedipus and serve as models for female writers, examining mother-daughter plots in relation to specific classical origins, including Clytemnestra/Electra, Demeter/Persephone and Jocasta/Antigone.

22 Dorothy Bryant, *Miss Giardino* (New York: Feminist Press, 1997). For an autobiographical essay, see "Dorothy Bryant," in *Contemporary Authors Autobiography Series*, 26 (Detroit: Gale Research, 1997), 47–63.

23 Valery Walkerdine, "Progressive Pedagogy and Political Struggle," in *Feminisms and Critical Pedagogy*, ed. Carmen Luke and Jennifer Gore (New York: Routledge, 1992), 30.

24 Bryant, *Miss Giardino*, 34.

25 Ibid., 4, 160.

26 Ibid., 111.

27 Rachel Blau Du Plessis, *Writing Beyond the Ending: Narrative Strategies of Twentieth-Century Women Writers* (Bloomington: Indiana University Press, 1985), 5.

28 Josephine Gattuso Hendin, *The Right Thing to Do* [1988] (New York: Feminist Press, 1999). See also my afterword to the 1999 edition, "Escaping the Ancestral Threat?" 213–239.

29 Josephine Gattuso Hendin, "*VIA* Interviews Josephine Gattuso Hendin," *Voices in Italian Americana*, 1.1 (1990), 59.

30 *The Right Thing to Do*, 47.

31 Adrienne Rich, *Of Woman Born: Motherhood as Experience and Institution* [1976] (New York: Norton, 1986), 225.

32 *Of Woman Born*, 237.

33 Ibid., 238, 240.

34 Louise DeSalvo, *Vertigo: A Memoir* (New York: Dutton, 1996).

35 Rita Felski, "On Confession," in *Women, Autobiography, Theory: A Reader*, ed. Sidonie Smith and Julia Watson (Madison: University of Wisconsin Press, 1998), 83, 87.

36 DeSalvo's "A Portrait of the *Puttana* as a Middle-Aged Woolf Scholar," first appeared in *Between Women: Biographers, Novelists, Critics, Teachers and Artists Write About Their Work on Women*, ed. Carol Ascher, Louise DeSalvo and Sara Ruddick (Boston: Beacon Press, 1984), 35–54. An excerpted version later appeared in Barolini, ed., *The Dream Book*, 93–99. In her *Vertigo* (220), DeSalvo recalls what women are called in her culture who do *anything* without their husbands: "*Puttane*. Whores. I remember hearing stories in my childhood about how women like that were stoned to death in the old country. Well, given a background like that, you can imagine the way I felt [in 1975] as we flew high above the Atlantic. There I was, a *puttana*, alone at last."

37 Louise DeSalvo, *Crazy in the Kitchen: Food, Feuds, and Forgiveness in an Italian American Family* (New York: Bloomsbury, 2004). For an essay on both of DeSalvo's memoirs, see Mary Jo Bona and Jennifer-Ann DiGregorio Kightlinger, "The Fruits of Her Labor: Louise DeSalvo's Memoirs of Food and Family," in *Personal Effects: Essays on Memoir, Teaching, and Culture in the Work of Louise DeSalvo*, ed. Nancy Caronia and Edvige Giunta (New York: Fordham University Press, 2015), 189–209.

38 Susan Leonardi, "Recipes for Reading: Summer Pasta, Lobster à la Riseholme and Key Lime Pie," *PMLA*, 104.3 (1989), 340–347 (346).

39 *Crazy in the Kitchen*, 229.

40 Virginia Woolf, *To the Lighthouse* (New York: Harcourt, Brace, & World, 1927), 158.

41 As quoted in Brenda R. Silver, "Mothers, Daughters, Mrs. Ramsay: Reflections," *Women's Studies Quarterly*, 37.3 & 4 (Fall–Winter 2009), 259–274 (265).

42 Alice Walker, *In Search of Our Mothers' Gardens: Womanist Prose* (New York: Harcourt, Brace Jovanovich, 1983), 243.

43 Marianne Hirsch, *The Mother/Daughter Plot*, 10.

44 Nancy Chodorow, *The Reproduction of Mothering: Psychoanalysis and the Sociology of Gender* (Berkeley: University of California Press, 1978), 169.

45 Chodorow, *The Reproduction of Mothering*, 9.

46 Ibid., 169. In the essay that set the groundwork for her longer study, Chodorow exclaimed that the "embeddedness in relationships to others" is "described particularly acutely by women writers"; see her "Family Structure and Feminine Personality," in *Women Culture & Society*, ed. Michelle Zimbalist Rosaldo and Louise Lamphere (Stanford: Stanford University Press, 1974), 43–66 (59).

47 Biddy Martin, "Lesbian Identity and Autobiographical Differences[s]," in *Life/Lines: Theorizing Women's Autobiography*, ed. Bella Brodzki and Celeste Schenck (Ithaca: Cornell University Press, 1988), 82.

48 Mary Cappello, *Night Bloom: A Memoir* (Boston: Beacon, 1998). For an extended analysis of the literary relationship between Louise DeSalvo and Mary Cappello, see my "Mother's Tongue: Italian American Daughters and Female Precursors," in Bona, *By the Breath of Their Mouths: Narratives of Resistance in Italian America* (Albany: SUNY Press, 2010), 141–173.

49 Judith Butler, "Introduction to *Bodies That Matter*," in *Women, Autobiography, Theory: A Reader*, ed. Sidonie Smith and Julia Watson (Madison: University of Wisconsin Press, 1998), 367–379.

50 Mary Cappello, *Night Bloom*, 43.

51 Alice Walker, *In Search of Our Mothers' Gardens* (San Diego: Harcourt Brace Jovanovich, 1983), 240. In an early version of this chapter of Cappello's memoir, "My Mother Writes the Letter that I Dream," *VIA: Voices in Italian Americana*, 7.2 (Fall 1996), 125–137, Cappello writes: "Alice Walker's mother's garden reverberates for me in the survival lines I trace through my Italian-American immigrant family," 125.

52 Cappello, *Night Bloom*, 252.

53 Nancy Gerber, *Portrait of the Mother-Artist: Class and Creativity in Contemporary American Fiction* (Lanham: Lexington Books, 2003), 5.

54 Carole Maso, *Ghost Dance* (Hopewell: Ecco Press, 1986). For biographical and interpretive background on Carole Maso's work, see Mary Frances Pipino's *"I Have Found My Voice": The Italian-American Women Writer* (New York: Peter Lang, 2000); and Roseanne Quinn, "'We Were Working on an Erotic Song Cycle': Reading Carole Maso's *Ava* as the Poetics of Female Italian-American Cultural and Sexual Identity," *MELUS*, 26.1 (Spring 2001), 91–113.

55 Luce Irigaray, "And the One Doesn't Stir without the Other," *Signs*, 7.1 (Autumn 1981), 60–67 (67). Published contemporaneously with important works by Nancy Chodorow and Adrienne Rich, this, and another essay by Luce Irigaray, remain instructive reading for recognizing the barriers erected by structures of patriarchy that prevent dialogue and mutuality between mother and daughter. The second essay is Irigaray's "When Our Lips Speak Together," in Irigaray, *This Sex Which Is Not One*, trans. Catherine Porter (Ithaca: Cornell University Press), 205–218. When several essays by French women intellectuals were translated into English in the 1980s, they were embraced by many North American scholars and creative writers—including Italian American women writers—because their theories allowed writers to explore and better understand the coded language and intricate psycho-dynamics of ethnic/immigrant women in particular.

56 Fred Gardaphé, *Italian Signs, American Streets: The Evolution of Italian American Narrative* (Durham: Duke University Press, 1996), 142.

57 Maso, *Ghost Dance*, 8.

58 Louise DeSalvo, "'We Will Speak and Bear Witness': Storytelling as Testimony and Healing in *Ghost Dance*," *Review of Contemporary Fiction*, 17.3 (1997), 145.

59 Maso, *Ghost Dance*, 175.

60 Ibid., 176.

61 Ibid., 256.

62 Ibid., 257–258.

63 Irigaray, "And the One Doesn't Stir Without the Other," 67. The essay's translator, Hélène Vivienne Wenzel, explains that the sentence in French, "*Mais ce n'est ensemble que nous nous mouvons*," imparts "a sense of ambiguity since it suggests as well that 'it is only together that we (can) move.'"

64 Blau DuPlessis, *Writing Beyond the Ending*, 94.

65 Maso, *Ghost Dance*, 275.

66 Ibid., 274.

67 Consider the mother-daughter writing duo of best-selling author, Lisa Scottoline, and her daughter, Francesca Serritella, who cowrite a weekly column, "Chick Wit," for the Art and Entertainment section of the *Philadelphia Inquirer*.

THE ITALIAN AMERICAN FAMILY AND TRANSNATIONAL CIRCUITS

JoAnne Ruvoli

In essence, nostalgia is strongly present in the cinema of third generation, Italian-American film artists. It's not the grandparents, who still embody the traditions of their land of origin; it's not the parents, who often reject it because of their intense desire to assimilate in the New World; it's the children who want to return to their roots and their ancestral homeland

—Vito Zagarrio[1]

Nostalgia is the subject of Vito Zagarrio's classic 2007 essay on Italian American cinema, "Their Voyage to Italy," and he writes about these films in the family terms that have been naturalized in the last decades of scholarly critical writing on Italian American literature and film. The concept of different family generations has become a powerful trope for how we organize the themes and the chronology of this rich narrative tradition. Zagarrio's essay goes beyond generations to illustrate nostalgia as a force. In his analysis, the filmmakers depict nostalgia for Italian cinema, for the Italian homeland, for the urban "Little Italies" in the United States, and for the Italian language.[2] This nostalgia is a current that flows through not only the films and literature but also the criticism.

In the second decade of the twenty-first century, everything moves so fast that we are now more apt to discuss generations of cellphones and computers than we are of families, and yet the nostalgia we have for the family or the home does still construct meaning for us. In fact, with the global reach of social media, we are now able to find and follow the family members who stayed in Italy, the ones who moved throughout the world—especially to South America and other continents—or the local family that was dispersed throughout the suburbs when the "Little Italy" was razed. More than ever, we are able to map the history of our own family's past and, in the present, share the documents, stories and photographs digitally. Michelle Orange, in her essay on technology, "The Uses of Nostalgia and Some Thoughts on Ethan Hawke's Face," defines nostalgia as a case of "individuals and collectives looking back to sustain a sense of identity; of pooling memory funds from which to draw meaning; and of shrinking time's unwieldy continuum to deflect a specific situation, specific values, and specific ideals."[3] Orange forces us to question what these "specific" conditions are that need to be "deflected." She traces the word back to its Greek origins—*nostos* meaning "to return home" and *algia* meaning "longing or sickness"—and explains how "the first Americans considered nostalgia to be a weakness of the Old World."[4] For both Orange and Zagarrio, nostalgia is inextricably connected to the concepts of family and home, two abstract yet material entities that are so important to how we define Italian American ethnicity.

As we hear during every election cycle, there is no issue that is not also a family issue. Jobs, the wider economy, crime, police protection, schools, education, healthcare, sexuality,

housing, retirement, military, marriage rights, climate change, globalization and foreign relations; families have stakes in each and every issue. Politicians and writers frame these issues in the media around how "the average family" will be impacted. Therefore, there is no subject more ubiquitous in our national news, film, and literature narratives. In the case of Italian American studies, no less is true. Family issues and family values appear in most major studies of Italian American literature, film, history, psychology and sociology. Fictional families like the Corleones and the Sopranos are as real to mainstream society as the Kennedys, the Bushes or the Clintons.[5] To a different audience, the Mulligan-MacChesney and the Rosato families are just as beloved.[6] Although less popular, other fiction writers have told the epic stories of many, many Italian American families including those of the Bellacasas, the Santuzzus, the Bandinis, the Giardanos, the Costanza Shays, the Bartolai-Gimorris and the Pascalas.[7] Historical studies of Italian Americans have assessed influential families like the Gianninis, the Astis, the Cuomos, and the Trescas and have charted the contributions of smaller family experiences in politics and business.[8] Psychologists have studied Italian American family dynamics, and outlined strategies for individual treatment and group therapy.[9] Sociologists have detailed the economic and regional settling patterns of family migration as well as the cultural patterns of private behavior.[10] These previous studies work to delineate how the Italian American historical and cultural experiences are set apart from a sometimes vague, unquestioned, American experience as if either that American experience or that Italian American experience is unified and definable on its own.

The extensive coverage done by previous generations of writers and scholars now allows for a way to map how the Italian American family has functioned in reality and in representation as a transnational commodity, an ideological contact zone and a method for critiquing the ideas that construct both the American and the Italian Nation.

At the height of the mass migration to the United States, by the mid 1920s, five million Italian migrants had arrived amid increasingly hostile Nativist attitudes. One of the central metaphors of the Nativist movement was the National Family. As Walter Benn Michaels discusses in *Our America*, in the 1920s, the idea of a "collective national identity" started to take on more importance as a "central position in American culture," and writers set out to conceptually define both "American" and "culture." Nativists like Charles W. Gould and anti-Nativists like Horace Kallen both settled on the metaphor of the family to articulate the idea of a collective national identity.[11] In this symbolic yet material reality, individuals were thought to be born and bred with American characteristics, and therefore immigrants could never become part of the American National Family. The metaphor was a holdover from the earlier nineteenth century and held imaginative power that encouraged at best a benign exclusion and at worst violent prejudice and discrimination against Nativist-era immigrant families.[12]

On the other side of the Atlantic Ocean, Italian migrant families were leaving Italy because they had been denied economically, politically and socially; especially south of Rome, families faced unemployment, hunger and illiteracy.[13] The newly unified Italian nation did not have a strong impact physically or imaginatively on the small villages to which the migrants retained their loyalty; the sound of the church bells or *campanilismo* defined the space of the migrants' public affiliation.[14] Luigi Barzini's study of Italy and its culture defined Italians in Italy and in the United States for a generation of popular readers in the post–World War II era. One of his most quoted statements is: "Italy has often been defined, with only slight exaggeration, as nothing more than a mosaic of millions of families, sticking together by blind instinct, like colonies of insects, an organic formation rather than a rational construction of written statutes and moral imperatives."[15] As Barzini and other writers have noted, the unification of Italy in the years prior to the first mass migration period left Italians,

especially Southerners and Sicilians, with strong extended family and village identifications but little sense of their place in the "imagined community" of a collective Italy.[16]

Excluded from a "major" American and a "major" Italian National Family then, the migrants experienced what Lionnet and Shih have described as "minor transnationality"—that is, they move from a minor position in one culture to a minor position in a new society. As Lionnet and Shih explain, "This cultural transversalism includes minor cultural articulations in productive relationship with the major (in all its possible shapes, forms, and kinds), as well as minor-to-minor networks that circumvent the major altogether."[17] In other words, the Italian American migrant family, as an abstract concept and a physical entity comprised of individual people, intersects with the real and imagined facets of major national cultures by both contributing to and remaining outside of the systems that produce, police and support those major national cultures.

Instead of trying to define family in ethnic or transnational terms, I am more interested in examining the work that the self-identified Italian American family does as a unit in the larger context. On an external level, examining the Italian American family's minor transnationality can "poin[t] toward and mak[e] visible the multiple relations between the national and the transnational" as well as reveal how these "moment[s] and space[s] are structured by uneven power relations."[18] On the internal level, Mary Jo Bona's work on the "ethnic Bildungsroman" examines what happens within the family and powerfully argues that in Italian American fiction, writers "focus not solely on a particular individual coming of age, but rather on the complications involved in the family itself as it develops an Italian American identity."[19] As Bona states, individual members "struggle to achieve an identity amenable both to their cultural traditions and to the American society at large."[20] That is, within the family, generational, cultural, sexual, gender-based, political or personal ideas can clash and/or cohere in a kind of contact zone of differing points of view. However, the family unit dominates and eases the struggle for a meaningful place; "What the protagonist in the Italian American coming-of-age novel does," Bona writes, "is revalue the primacy of family and community, aware of the fact that to be without origins, without a sense of place, is to live a life without identity."[21]

Historically, in Italy's honor and shame society, the family's status was governed by the regional cultural codes that had a very real impact on the family's survival.

The dialectic of ideas and opinions are worked out under cover of the family and kept private or silent by the rules of *omertà*. If revealed publicly, the ongoing discussion of conflicting ideas is treated according to the family's adherence to what best befits the family's interests or *bella figura*. The internal dialogue and external public performance then combines for the protection of the family and its structures, what scholars call the *ordine della famiglia*, which functions to establish and to protect the family's boundaries, hierarchy, and relationships. Honor is the cultural code that underlies these others and historically allowed families to survive the economic and political climate in Italy. The scholars of Sicily, Jane and Peter Schneider, write, "Honor asserts the primacy of the nuclear family in society and establishes women as symbols of familial worth."[22] Defined in relation to the man, a wife and a daughter are the two biggest threats to a family's honor. According to Pino Arlacchi, the capacity to act honorably or to preserve the honor of the family above all meant that often a double moral system developed in the competition for and among individual families.[23] A family's honor was also tied to their economic survival, for a shamed family would find it difficult to secure work in the feudal systems of Italy's large plantations or fishing villages. Edward C. Banfield studied the negative effects of the Southern Italian family's economic struggle in his study of "amoral familism," where he posited that the family will act to "Maximize the material, short-run advantage of the nuclear family; [and] assume that all others will do likewise."[24]

The significance of Italian American identity then is always already constructed within the limited, sovereign, "imagined community" of family, separate from the larger national contexts of the United States or Italy.

Excluded and freed from the "finite, if elastic, boundaries" of nation,[25] in Benedict Anderson's terms, the migrant family's minor transnationality physically moves across borders on the various circuits of migration while refracting the internal dialectics as it travels. In the context of these global circuits, representations of the Italian American family connect to wider conversations of cultural exchange, and can articulate the vitality of alternative geopolitical landscapes, critical positionalities and community affinities in both the past and present. Families are pushed or pulled around global circuits created for the intersection of labor, commerce, and war. By keeping up the exclusionary psychological and material conditions that impose a minor status on groups like Italian Americans (or any hyphenated Americans), the major elements that comprise the collective National Family profit from the devaluation of minoritized space, mindset, and work abilities of these groups. In a revised matrix that combines Bona's focus "on the family unit itself as it comes of age,"[26] the generational family model of migration over time, and the circuits of transnational space, the articulation of the Italian American family's "imagined community" remains an important public and private political community that is both a discursive space and an entity that circulates, disrupts, and can challenge the assumptions of the major or dominant American National Family identity.

Examining the larger circuits that moved families around illuminates the dynamics of how the minor and the major are defined against each other. As Robert Viscusi has explained, a nostalgic immigration/assimilation model of looking at how families experienced life in the United States simplifies a stable view of ethnicity that supports and conforms to that unexamined concept of American National collective identity. Once settled, the trope claims, a family could lose those elements such as language, customs, and traditions to assimilate into that major American National Family. Yet, many families continue to claim a distinct Italian American identity despite several generations of assimilation. Viscusi states, "The familiar expressions *immigration* and *assimilation*, useful as they are, focus on destination, as if travel moved in one direction and did not affect or reflect relations in larger circles."[27] In reality, Italian families move(d) globally to follow work, language, commerce, educational opportunities, political ideas and other members of their communities. They move to new places *and* return back to their places of origin either temporarily or permanently. They move around their new countries, from urban areas to rural areas to suburbs, from East to Midwest to West, North to South, and back again. As many scholars have pointed out, each generation renegotiates its own relationship to place, family and ethnicity. In the wider global circuits, across time and space, the minor transnationality of Italian Americans continues recursively to assert ethnic identity primarily through the "imagined community" of family.

Examining one category of transnational migration routes—in this case, labor circuits can show the geopolitical, economic and intersectional diversity that Italian American migrant families transversed over time. Italian American fictional families travel the circuits of labor that actual migrant families historically followed as well.[28] Characters based on lived experience bring the skills undervalued and unutilized in Italy to bear on regional communities throughout the United States. The work that Italian American families contribute to the wider society shows how alliances and conflicts keep families in the minor mode while contributing to the major culture.

Texts like Steven Varni's *The Inland Sea* (2001), Guido D'Agostino's *Olives on the Apple Tree* (1975) and Mary Bucci Bush's *Sweet Hope* (2011) illustrate families that migrated to work in U.S. agricultural regions. Bush draws from her own family history to construct the story of the Pascala family, which in 1900 is tricked into peonage on the Mississippi Delta. Pulled by

the Sweet Hope plantation company, pushed, but then abandoned by the Italian government, the Italian migrant family allies with sharecropping African Americans, like the Hall family, whose expertise keeps the Pascalas from starving on the cotton farm. Step Hall, the African American foreman put in charge of the Italians has to enlighten the father, Serafin Pascala, of their mutual misery; "'You see us?' Step shouted at Serafin, 'Open your eyes. We been here more'n two hundred years. We still here. We still workin. You been here one year and you cryin.'"[29] Readers view the Italian migrant families on the planation as a continuation of the exploitative slave labor that sustained the agricultural Southern regions of the United States, and also the counterparts on the *latifundia* of southern Italy. Internally, the Pascala family is conflicted, and debates what should be done. Serafin's wife suffers a miscarriage and depression, but uses her sewing skills to add income when she can. As the Pascala progeny start interacting with and following the example of the Hall children, values clash and cause even more trouble. As Jessica Maucione points out, "The Italians' perilous ignorance of the history of slavery and its ramifications sadly endangers their African American counterparts for whose guidance they are so grateful. The Pascalas cannot predict, for example, the violent white Southern reaction to their daughter falling in love with the Halls' son."[30] Bush's *Sweet Hope* shows the slave-like conditions that the Pascalas experience and the tragic losses that occur when change is attempted. Bush connects the Pascalas to the global circuits that support the agricultural labor and racial violence that dominate American economic and social history.

In D'Agostino's *Olives on the Apple Tree*, the main character Marco travels throughout the pre–World War II United States for six years in search of meaningful work when his own family's land in Italy is chopped into parcels too small to support a living. Like the Pascala family in *Sweet Hope*, he is forced to leave or starve when the Italian land cannot feed him. After wandering the circuit—from Italy, around the United States, and finally to New York— he meets the Gardellas in a small upstate town. The Gardella family has acquired property, but the second-generation son pursues an education to become a doctor, and the family has let the farmland lie fallow. Marco convinces the Gardella daughter, Elena, to return to farming, which D'Agostino connects to a return to Italian values. In one rallying speech, Marco states of the Italian men like himself, "But these are peasants, men of the ground, and they need the ground to make their life full. . . . They need the earth to turn and the things to grow and the feeling inside they are doing what they are meant to do, and what their fathers did and the fathers before that."[31] Marco speaks in family terms of fathers instead of using the rhetoric of Italian patriotism to describe the underemployed Italian men. Internally, the two generations of the Gardella family clash with Marco's ideas in D'Agostino's novel. Externally, the other doctors of the "country club set" keep the Gardella son in a minor position and excluded even though he is a skilled doctor. When Marco and Elena forge a bond over how to use the land, he is invited to join the family and his Italian family values become a foil to the son's unsuccessful American ways. D'Agostino uses Marco and the Gardella family to critique both American and Italian agricultural practices, and presents the family's future farming endeavors as an opportunity to transform their relationship with the major American culture.

Set on the West Coast, Varni's novel *The Inland Sea* illustrates three generations of the Californian Torno family whose San Joaquin Valley farmland evolves and modernizes as the family does.[32] The novel sets three third-generation siblings into dialogue during the 1970s and 1980s when each takes a different approach to their family's land and history. By the time Mary and her two brothers, Paul Jr. and Vincent, rebel against their parents' expectations, the farm has evolved into an agribusiness and distribution warehouse, but the three work out the conflicting ideas through their own travels, education and relationships to

the land, their parents and each other. Kenneth Scambray discusses the generations of the Torno family in terms of the land's layers: "Those great grandparents [in Italy] are the Italian subsoil of the family history, however overwritten it may be by succeeding Italian American generations. They remain present in the multiform, heterogeneous family genome."[33] As the Torno siblings travel, marry non-Italians and professionalize in their careers, they interact directly with majority American culture, yet, as their family name predicted all along, each returns like Marco's "men of the ground" in *Olives on the Apple Tree*, to an ethnic identity materially evoked through the orchards, trees and buildings of their "childhood landscape" recalled repeatedly by fading photographs and animated storytelling.[34] These three novels of agricultural work across diverse regions show how the matrix of individual family dynamics, over generations and time, engage the heteroglossia of minor transnationality to challenge the uniformity and ethnic erasure assumed by the American national identity. In these family novels, the more generations a family has in the major culture, the more complex and dynamic the family relationships to Nation.[35]

In addition to agricultural labor circuits that move Italian migrant families from fields in Italy to fields in the United States, novels, memoirs and oral histories illustrate industrial labor circuits that families followed. As in the Bush, D'Agostino and Varni novels, both paid and unpaid women's work contributes to the quotidian welfare of the Italian American family and especially when trauma threatens. Two more novels serve to illustrate these global work circuits and represent how Italian American families navigate space over time. Tony Ardizzone's *In the Garden of Papa Santuzzu* (1999) and Adria Bernardi's *Openwork* (2007) take a more expansive look at the multiple generations of families in a postmodern mode that uses storytelling as just one of the tools to transverse time and space, while asserting analysis and critique of the conditions migrant families experienced throughout their lives in both the United States and Italy.

The scope of Tony Ardizzone's postmodern *In the Garden of Papa Santuzzu*, like Bernardi's *Openwork* and Varni's *The Inland Sea*, covers three generations of the Santuzzu family and shows how the global circuits intersect for the seven Santuzzu siblings and their progeny. The Sicilian patriarch and sharecropper, Papa Santuzzu harvests only stones from his fields, so, like the families in the other agricultural novels, he sends his seven children to North America to escape the hard poverty and starvation. Instead of continuing the agricultural labor of his father, the oldest son Gaetannu, and Teresa, the woman who becomes his wife, find work in New York and then Massachusetts factories, where, like the Pascalas of Bush's *Sweet Hope*, they are in deep debt to the company despite the long hours of dangerous work. Ardizzone uses the trope of storytelling throughout the novel, specifically engaging the multiple and conflicting points of view of his other family members through the tales that each sibling conveys in his or her own chapters to the next generation of children. Gaetannu's and Teresa's tales specifically reflect the family's experiences in the industrial factories and the couple's role in protesting the harsh labor conditions through rallies, strikes and union organizing.

The industrial circuits started in Italy as Ardizzone shows through Gaetannu's story; he tells of being recruited on the docks of Palermo and tricked into signing a contract to work off his steerage fare once he arrives in "La Merica." Ardizzone writes in Gaetannu's point of view, "All I had to do was mark the papers and I'd be guaranteed passage over and a job in the Golden Land! So I borrowed money from the *patruni*'s partner, the *struzzeri*, not realizing until later that I was only exchanging the slavery my family endured under the *baruni* for the slavery beneath this moneylender."[36] The moneylender charges him a "king's fortune in interest" and threatens the Santuzzus' safety as leverage; Gaetannu states, "if ever I were to break my promise to him he knew where he could find my family."[37] Gaetannu's story to the children includes gruesome details of the labor strikes, the austere living conditions and

rotted food, excessive taxes, police violence and industrial accidents.[38] Teresa's story to the children builds on Gaetannu's, but provides the point of view of a female worker caught up in the industrial labor circuit. Before she meets him and joins the Santuzzu family by marriage, Teresa disguises herself as a man in order to travel to the United States and then secures employment in the factory. She works along side Gaetannu in pantaloons, teaches him how to read and calculate, and attends labor speeches arguing "that a woman needs to be able to afford trousers before she can wear them."[39] When her first pregnancy forces her to "work as a woman in the factory, they cut [her] pay in half."[40] Through Gaetannu's and Teresa's stories, Ardizzone shows how the Santuzzu family resists their minor transnationality and how they challenge the major society that depends on and exploits their labor. The tales of their resistance are conveyed to the next generation of children as bedtime stories and coded fairytales which pass on the contentious relationship between the minor Italian American family, and the major American national institutions of law, government and corporations which continue to exploit the family.

Ardizzone's novel is just one of many that represent Italian American families that followed the industrial labor circuits in search of construction and factory work. Pietro di Donato's classic depression-era novel, *Christ in Concrete* (1939), depicts bricklaying jobs on skyscrapers and women's home piecework in the urban, East Coast, big city. Although fictionalized, di Donato chronicles the death of his father on Good Friday by impaling and suffocation in the cement forms of a half-finished skyscraper.[41] Other writers show how artesian labor, such as masonry, drew families to Colorado in John Fante's *Wait Until Spring, Bandini* (1938), and to Vermont in Mari Tomasi's *Like Lesser Gods* (1988) and result in similar illnesses, alienation and trauma.[42]

Bernardi's *Openwork* closely examines how the cloth and childcare work of women intersect with the work that men are called to do in mines. Like the novels that map how families migrated to work in agriculture and manufacturing, another major American industry that requires cheap labor is mining. In other novels and oral histories, families travel to work in the diverse mining towns located throughout the United States. Dorothy Bryant's two novels, *Miss Giardino* (1997) and *The Berkeley Pit* (2007), describe difficult and fatal mining conditions in Colorado and Montana where the families' women have to pick up the pieces when inevitable sickness from working in the underground mines takes its toll.[43] Antonia Pola's *Who Can Buy the Stars* (1957) shows a family that realizes the dangers of Indiana mines very quickly and, instead of continuing that work, opens up a store to serve the men who do persevere with the tunnel work.[44] Marie Hall Ets' oral history, *Rosa: The Life of An Italian Immigrant* (1999) chronicles Rosa Cavalleri's arranged marriage to a miner who paid for her immigration in order for her to keep house and cook for the men in the Missouri mining camp.[45] As women contributed greatly to the agricultural and industrial work in addition to keeping Italian American families fed, clothed, sheltered and secure, in the novels and oral histories of the mining experience, women's work also keeps the families functioning and growing. Bernardi's *Openwork* juxtaposes the work done by migrant men and women most directly as the narrative moves back and forth between Italy and the United States in the first decades of the 1900s, as well as from city to city as family members fight for sustainable work.

Also narrated by several generations, Bernardi writes in the postmodern mode, which allows her to depict the differing points of view of the family's internal contact zone despite the family members' external geographic separation. *Openwork*'s family extends from the sister Imola Bartolai Martinelli who remains in Italy, her brother Egidio Bartolai who works and dies in a New Mexico coal mine, and their childhood friend Antenore Gimorri who travels the United States to work as a union organizer. Imola is married to a much older man who stays in Rome for months to work road construction. To support her children, she earns money through needlework and as a wet nurse and "child carrier"; she transports unwanted

babies to orphanages. She is exhausted by her poverty but takes advantage of the local networks to find ways to earn money. Her other brothers followed work to Africa and northern parts of Europe, but keep in contact through the postcards they send.[46] Egidio works in what he tells her is a "good mine"; the company has provided doctors, a washhouse and a theater for opera performances.[47] Antenore disagrees with Egidio's assessment of the mining company and leaves New Mexico to work for the union, which the company has blocked from the mine. In the first half of the novel, the chapters switch back and forth between these three narrators as each describes their work and defends their choices to each other in the effort to remain connected as a family despite their geography. Utilizing the labor circuits, they are kept in their minor status while contributing the work that supports the major culture. Antenore's running critical commentary makes the issues clear—he organizes for the union and learns English by reading political pamphlets.[48] Imola's needlework is in high demand for its artistry, and as she nurses her own children she takes in the others as well. Like the Santuzzu siblings, each of Bernardi's narrators tries to make sense of the toll that work takes on the family. When Egidio is killed in the infamous 1913 Dawson Mine explosion, Antenore must carry the news back to Italy.

The second half of Bernardi's novel shows the cost of the tragedy on the subsequent generations of Imola's children and needlework students, as well as Antenore and his children as they continue to struggle with their relationship of place, work and ethnicity over time. The work contributions of migrants have a lasting effect on the Nation, but the Nation also changes the course of families. *Openwork*, more than most Italian American novels, illustrates the minor transnational mobility of the Bartolai-Gimorri forged family, as it is dispersed across three continents over and in between four generations. Unlike the immigration-assimilation model of a family that settles in one "Little Italy," Bernardi depicts a family that moves from city to city within Nation to find the material and psychological resources that will sustain its future.

It would be wrong not to include mention of how military service also runs throughout so many of these family narratives. In Bernardi's novel, Antenore is marginalized by both nations when he consciously avoids service in the United States Army and then later spends time in an Italian Fascist prison. Ardizzone's Gaetannu fights during World War I, and his wife Teresa describes how he refused to take off his uniform upon return because he was so proud.[49] Contributing direct labor for the government, Italian American families in fiction and in actuality have had members work for all branches of the United States Armed Services; in many cases, men and women served to gain citizenship as new immigrants still do today. Family contributions to the war effort run through many novels as secondary threads to the narratives, but cannot be ignored in a discussion of Italian American families, minor transnationality, and their relationship to collective National identity. In Adriana Trigiani's *The Shoemaker's Wife* (2012), the Lazzari family patriarch suffers epic losses from mustard gas injuries while fighting for the United States during World War I.[50] Mario Puzo's *The Dark Arena* (1971), Octavia Waldo's *A Cup of the Sun* (1961), and Guido D'Agostino's *The Barking of a Lonely Fox* (1952) all illustrate the traumatic psychological and physical after effects of World War II; Lisa Scottoline's *The Vendetta Defense* (2001) follows up on damage done a generation later.[51] The family in Salvatore Scibona's *The End* (2009) sacrifices a son to the Korean War, whereas Kym Ragusa's memoir of 2006, *The Skin Between Us* (see her photograph in the Frontispiece to Part IV) explores the devastating effects of a father's Vietnam service on a daughter's life.[52] Whereas few Italian American writers make war the sole focus of their narratives, Philip Caputo's *DelCorso's Gallery* (1984) and John Del Vecchio's *Carry Me Home* (1996) write directly from the soldier's point of view and explore the aftermath of fighting for the United States in Vietnam.[53]

By mapping the labor circuits, the contributions of Italian American families in fiction and in reality emerge with more complexity and connection to the wider context of the American and the Italian nation building. The work of Italian American families fed, clothed, sheltered individuals, corporations, and government entities in times of peace and war. Such wide spread contributions across a variety of endeavors show the often fatal sacrifices that these labor circuits demanded of migrants through depictions of industrial accidents, contaminations, illnesses and plainly being worn down mentally and physically from the work. As Benedict Anderson distinguishes, the imagined community of a nation does not so much require a member "to kill" for it (although the soldiers from many Italian American families did), but it does ask that the member to be "willing to die for" such a nation.[54] Despite the depths of these contributions to the collective Nation, however, Italian American families still resist entering fully into the collective American or Italian identity, and instead retain their distinct minor transnational status in both Nations.

Looking at examples of fictional families that migrated through the global labor circuits shows possibilities for how actual Italian American families negotiated their internal debates and external conflicts with the collective American national culture while prospering, sacrificing and sustaining deep connections across generations. There are many, many other novels, memoirs, short stories and poems that illustrate how families navigate the typical problems that engage quotidian family life. Overall, as in the texts discussed here, though characters do search for place, there are few positive depictions of homesickness for a place of origin—no nostalgia for an Italian Nation that, like the United States, has equally exploited the families' talents and abilities.

The question that remains is whether Italian Americans value the concept of "the Family" or rather the reality of their own specific families? In fiction and film, there is often little regard for another person's Italian American family when defending one's own family's interests. Puzo's and Coppola's *Godfather* franchise illustrate the most extreme example of Banfield's "amoral familism." To avenge the Corleone family empire, newly ascended Michael murders the heads of the other five families in the climactic scenes of *Godfather I*, but even within his family, brothers and brothers-in-laws attempt and ultimately kill each other in defense of their individual family interests.[55] The preservation of the family justifies the extreme exclusion of family members who no longer abide by the Italian family cultural codes or adhere to the Italian American family consensus. Also, women's interests are routinely sacrificed for men's in the family narratives as when Vito Corleone will not interfere to stop the abuse that his daughter Connie receives from her new husband Carlo. Although extremely stereotypical and sensationalized examples from fictional movies, *The Godfather* films do depict the troubling issue of where the Italian American family's allegiances start or end. These cinematic scenes have historical roots and connect to modern day dilemmas.

Italian American families in fiction and nonfiction have functioned outside of nation, and the stereotype of the family's vigorous defense of self-interests has been criticized repeatedly time and time again. According to William Connell, stereotypes about the destructiveness of individual family honor date to John Calvin and are continued in Shakespeare plays like *Romeo and Juliet* and in accounts of Italy's experiments in republicanism.[56] Another way to think about the Italian American family's advocating for itself above all and in spite of the well being of other families, is again to place it in the context of minor transnationality. The minor status in a major culture disrupts connections to a communal cause. Operating in an honor and shame societal mode in Italy and bringing those cultural codes along as the family migrated continued to have very real economic consequences for the individual family.

Fred Gardaphé has pointed out to readers that the family in general is losing its ability to effectively "transmit" heritage to its members: "The transmission of anyone's heritage is

more and more being controlled by institutions; artistic, educational, economical, political, and religious institutions have replaced the family as the means of conveying cultural values."[57] For Italian Americans, this institutionalization of cultural heritage illustrates how their relationship to major American culture has changed and how major American national collective identity has evolved to include more of the experience of minor groups. Whereas the Italian American family still resists being fully subsumed into the American national family by asserting its distinction, Italian Americans have also worked to build their collective and representative history and experience into those institutions. In addition, individual Italian American families are still actively pursuing an understanding of their past stories through the tools of this new generation.

It is true that families gather less frequently to circle around dining room tables to exchange food and stories, but that does not mean that they are not coming together to share stories, gossip, history, or accomplishments. As Italian American families traverse global circuits more and more frequently through technology, they recover and pass along the family stories with more detail and complexity. With the Internet, family archival documents, photographs, video and films travel to fill in the narrative gaps for families in Italy and in the diasporas. Secrets, forgotten experiences, and misplaced papers are recovered and shared on the evolving software platforms of the web's social media. In addition, Internet archives and databases make accessible the ways in which both the popular and elite cultures of the United States and of Italy have depicted Italian American families in television programs, radio shows, films, advertisements, song lyrics, stage productions, comics and literature. Shared across the global circuits through cell phones, tablets and computers, these representations continue to expand and complicate the multiple ways of understanding the Italian American family and the contributions of the millions of Italian American families.

Further Reading

Basile Green, Rose. *The Italian American Novel: A Document of the Interaction of Two Cultures*. Rutherford: Fairleigh Dickinson University Press, 1974.

Gardaphé, Fred L. *Italian Signs, American Streets: The Evolution of Italian American Narrative*. Durham: Duke University Press, 1996.

Juliani, Richard N., ed. *The Family and Community Life of Italian Americans: Proceedings of the Thirteenth Annual Conference of the American Italian Historical Association*. Staten Island: AIHA, 1983.

Notes

1 Vito Zagarrio, "Their Voyage to Italy: New Hollywood Film Artists and the Theme of 'Nostalgia,'" in *Mediated Ethnicity: New Italian-American Cinema*, ed. Giuliana Muscio, Joseph Sciorra and Giovanni Spagnoletti, trans. Maria Enrico (New York: John D. Calandra Italian American Institute, 2010), 119.

2 His essay (cited in translation in the previous note) appeared originally as Vito Zagarrio, "Il loro viaggio in Italia. Il tema della 'nostalgia' nei cineasti della New Hollywood," in Giuliana Muscio and Giovanni Spagnoletti, eds., *Quei bravi ragazzi. Il cinema italo-americano contemporaneo* (Venice: Marsilio, 2007).

3 Michelle Orange, "The Uses of Nostalgia and Some Thoughts on Ethan Hawke's Face," in her collection *This Is Running for Your Life: Essays* (New York: Farrar, Straus and Giroux, 2013), 17. See also Orange, *The Sicily Papers* (Ann Arbor: Short Flight/Long Drive Books, 2006), as well as a twelve-part series of essays, *Travels with My Antecessors: Michelle Orange Goes in Search of Her Name* (San Francisco: McSweeneys, 2002–2004), at www.mcsweeneys.net/columns/travels-with-my-antecessors-michelle-orange-goes-in-search-of-her-name.

4 Orange, "The Uses of Nostalgia," 17–18.

5 Beyond the scope of this essay is the idea of the Italian American "Crime Family," but even without the criminal aspects of Puzo's novel, Coppola's films, and Chase's television series, the family dynamics in

The Godfather and *The Sopranos* represent the stereotypes of Italian American extended family culture for a large part of the global popular audience. For more on the Italian American "Crime Family" see Chris Messenger, *The Godfather and American Culture* (Albany: State University of New York Press, 2002); Fred Gardaphé, *From Wiseguys to Wise Men* (New York: Routledge, 2006); and Ilaria Serra, "Italian American Cinema: Between Blood Family and Bloody Family," in *Mediated Ethnicity*, ed. Muscio.

6 See Adriana Trigiani's *Big Stone Gap* series; Lisa Scottoline's Rosato & Associates series.

7 Tina De Rosa's *Paper Fish* [1980] (New York: Feminist Press, 2003), features the Bellacasas; Tony Ardizzone's *In the Garden of Papa Santuzzu* (New York: Picador, 1999), follows the Santuzzus; John Fante's *Wait Until Spring, Bandini* [1938] (Santa Rosa: Black Sparrow Press, 1989), depicts the Bandinis; Dorothy Bryant's *Miss Giardino* [1978] (New York: Feminist Press, 1997), recalls the history of the Giardanos; Don DeLillo's *Underworld* (New York: Scribner, 1997), maps the Costanza Shay family; Adria Bernardi's *Openwork* (Dallas: Southern Methodist University Press, 2007) represents the Bartolai Martinellis; and Mary Bucci Bush's *Sweet Hope* (Toronto: Guernica, 2011), describes the Pascalas.

8 See especially Jerre Mangione and Ben Morreale, *La Storia: Five Centuries of the Italian American Experience* (New York: HarperPerennial, 1993); Andrew Rolle, *Westward the Immigrants: Italian Adventurers and Colonists in an Expanding America* (Niwot: University Press of Colorado, 1999); David A.J. Richards, *Italian American: The Racializing of an Ethnic Identity* (New York: New York University Press, 1999); Donna Gabaccia, *Italy's Many Diasporas* (New York: Routledge, 2000); and Ilaria Serra, *The Value of Worthless Lives: Writing Italian American Immigrant Autobiographies* (New York: Fordham University Press, 2007).

9 See Aileen Riotto Sirey, Anthony Patti and Lisa Mann, *Ethnotherapy: An Exploration of Italian-American Identity* (New York: National Institute for the Psychotherapies, 1985); and Joe Giordano, Monica McGoldrick and Joanne Guarino Klages, "Italian Families," in *Ethnicity and Family Therapy*, ed. Giordano McGoldrick and Nydia Garcia-Preto, 3rd ed. (New York: Guilford Press, 2005), 616–628.

10 See especially Phyllis H. Williams, *South Italian Folkways in Europe and America: A Handbook for Social Workers, Visiting Nurses, School Teachers, and Physicians* (New Haven: Yale University Press, 1938); Leonard Covello, *The Social Background of the Italo-American School Child: A Study of the Southern Italian Family Mores and Their Effect on the School Situation in Italy and America* (Totowa: Rowman and Littlefield, 1972); and Richard Gambino, *Blood of My Blood: The Dilemma of the Italian Americans* (Garden City: Doubleday, 1974).

11 Walter Benn Michaels, *Our America: Nativism, Modernism, and Pluralism* (Durham: Duke University Press, 1995), 6, 8.

12 Ibid., 10–11.

13 Mangione and Morreale, *La Storia*, 70.

14 Frances M. Malpezzi and William M. Clements, "Bread and Wine in Italian American Folk Culture," in *The Italian American Heritage: A Companion to Literature and Arts*, ed. Pellegrino D'Acierno (New York: Garland Publishing, 1999), 109.

15 Luigi Barzini, *The Italians* (New York: Atheneum, 1964), 190.

16 Benedict Anderson, *Imagined Communities: Reflections of the Origin and Spread of Nationalism*, rev. ed. (New York: Verso, 1991), 6–7. Anderson's now classic text defines nation as "an imagined political community—and imagined as both inherently limited and sovereign" (6).

17 Francoise Lionnet and Shu-mei Shih, "Introduction: Thinking through the Minor Transnationally," in *Minor Transnationalism*, ed. Lionnet and Shih (Durham: Duke University Press, 2005), 8.

18 Ibid., 7, 8.

19 Mary Jo Bona, "The Italian American Coming-of-Age Novel," in *The Italian American Heritage*, ed. D'Acierno, 323. See also Bona's *Claiming a Tradition: Italian American Women Writers* (Carbondale: Southern Illinois University Press, 1999), where she develops a book length approach to family narratives with an emphasis on feminist issues and relationships.

20 Bona, "The Italian American Coming-of-Age Novel," 324.

21 Ibid., 326.

22 Jane Schneider and Peter Schneider, *Culture and Political Economy in Western Sicily* (New York: Academic Press, 1976), 2.

23 Pino Arlacchi, *Mafia Business: The Mafia Ethic and the Spirit of Capitalism*, trans. Martin Ryle (New York: Verso, 1987), 4.

24 Edward C. Banfield, *The Moral Basis of a Backward Society* (Glencoe: The Free Press, 1958), 85.

25 Anderson, *Imagined Communities*, 7.

26 Bona, "The Italian American Coming-of-Age Novel," 327.

27 Robert Viscusi, "The History of Italian American Literary Studies," in *Teaching Italian American Literature, Film, and Popular Culture*, ed. Edvige Giunta and Kathleen Zamboni McCormick (New York: Modern Language Association, 2010), 44.

28 I am limiting the majority of the subsequent discussion to novels, although there are many films (as well as poems, memoirs, and historical documents) that could also provide similar evidence. Whereas film is a collaborative art, fictional narratives often draw from the novelist's actual family history.

29 Bush, *Sweet Hope*, 129.

30 See Maucione's "Mary Bucci Bush, Sweet Hope," *Altreitalie*, 45 (2012), www.altreitalie.it/Pubblicazioni/Rivista/N_45/Rassegna/Libri/Mary_Bucci_Bush_Sweet_Hope.kl

31 Guido D'Agostino, *Olives on the Apple Tree* [1940] (New York: Arno Press, 1975), 162, 165. For more on agriculture in each of D'Agostino's novels, see Mary Jo Bona and JoAnne Ruvoli, "Land/Terra: Village People in Guido D'Agostino's Novels," in *By the Breath of Their Mouths: Narratives of Resistance in Italian America*, ed. Bona (Albany: State University of New York Press, 2010), 95–118.

32 Steve Varni, *The Inland Sea* (New York: William Morrow, 2000).

33 Kenneth Scambray, "'This Country of Palimpsests': The Italian American Experience in Steven Varni's *The Inland Sea*," in *Queen Calafia's Paradise: California and the Italian American Novel*, ed. Scambray (Madison: Fairleigh Dickinson University Press, 2007), 114.

34 Varni, *The Inland Sea*, 239.

35 However similar to the film texts discussed in the Zagarrio essay quoted previously, these novels on whole are not nostalgic. In fact when a character does express nostalgia, it is more than likely connected to that character's depression and dysfunction.

36 Ardizzone, *In the Garden of Papa Santuzzu*, 39.

37 Ibid.

38 Ibid., 31–36.

39 Ibid., 65–67.

40 Ibid., 68.

41 Pietro di Donato, *Christ in Concrete* [1939] (New York: Signet Classic, 1993).

42 Mari Tomasi, *Like Lesser Gods* [1949] (Shelburne: The New England Press, 1988).

43 Dorothy Bryant, *The Berkeley Pit* (Livingston: Clark City Press, 2007).

44 Antonia Pola, *Who Can Buy the Stars* (New York: Vantage Press, 1957).

45 Marie Hall Ets, *Rosa: The Life of an Italian Immigrant*, 2nd ed. (Madison: University of Wisconsin Press, 1999).

46 Bernardi, *Openwork*, 12.

47 Ibid., 20.

48 Ibid., 24, 73.

49 Ardizzone, *In the Garden of Papa Santuzzu*, 72.

50 Adriana Trigiani, *The Shoemaker's Wife* (New York: Harper Collins, 2012).

51 Mario Puzo, *The Dark Arena* [1955] (New York: Ballantine Books, 2001); Octavia Waldo, *A Cup of the Sun* (New York: Harcourt, Brace and World, 1961); Guido D'Agostino, *The Barking of a Lonely Fox* (New York: McGraw-Hill Book Company, 1952); Lisa Scottoline, *The Vendetta Defense* (New York: Harper Torch, 2001).

52 Salvatore Scibona, *The End* (Saint Paul, Minnesota: Graywolf Press, 2008); Kym Ragusa, *The Skin Between Us* (New York: Norton, 2006).

53 Philip Caputo, *DelCorso's Gallery* (New York: Holt, Rinehart and Winston, 1983); John Del Vecchio, *Carry Me Home* (New York: Bantam, 1996). For an important comparative discussion of Puzo, Del Vecchio and Caputo, see Josephine Gattuso Hendin, "The Dark Arena and the Italian-American Literature of War," *Voices in Italian Americana*, 19.2 (2008), 43–60.

54 Anderson, *Imagined Communities*, 7.

55 *The Godfather: The Coppola Restoration*, filmed, directed/performed by Frances Ford Coppola [1972] (Hollywood: Paramount Pictures, 2007), DVD.

56 William J. Connell, "Darker Aspects of Italian American Prehistory," in *Anti-Italianism: Essays on a Prejudice*, ed. Connell and Fred Gardaphé (New York: Palgrave Macmillan, 2010), 11–22 (15–16).

57 Fred Gardaphé, "Invisible People: Shadows and Light in Italian American Writing," in *Anti-Italianism*, ed. Connell and Gardaphé, 1–10 (9).

25

GROOVIN'

A Riff on Italian Americans in Popular Music and Jazz

John Gennari

"Something in the Heart"

The story of Italian Americans and popular music begins with an Italian immigrant to America, the product of a Naples slum, who became the first international pop star of the twentieth century.

In 1903, Enrico Caruso made his debut in a production of Giuseppe Verdi's *Rigoletto* at the Metropolitan Opera in New York. A year later, he recorded "Vesti la giubba," the tenor aria from Leoncavallo's *I Pagliacci*, for the Victor Talking Machine Company of Camden, New Jersey. By 1907 "Vesti la giubba" became the first million-selling record in history. Before his death in 1921 (back home in Naples, from complications related to peritonitis, at age 48), Caruso made more than eight hundred appearances at the Met, recorded close to three hundred 78-rpm discs for Victor, and toured widely throughout North America, South America and Europe. Lacking the benefit of radio or television, and with only a marginal presence in the new visual medium of cinema, Caruso nevertheless became a household name—indeed, he was the first global media celebrity. Photographs of his fleshy visage appeared in newspapers and magazines the world over alongside articles detailing his fastidious attention to dress and his insatiable appetite for the foods of his native city. A chain of restaurants bearing the singer's name and featuring his favorite dish, spaghetti with chicken livers, sprang up across the country.[1]

Opera had been a part of America since the birth of the republic, and as American cities and towns developed a national musical culture throughout the nineteenth century, audiences came to know the works of Italian, German, French, and English composers. "I was fed and bred under the Italian dispensation, and absorbed it, and doubtless show it," wrote Walt Whitman, recalling the opera quadrilles and medleys he heard in the Brooklyn promenade concerts of his youth.[2] Opera was then still a popular art heard by all classes at a variety of public venues; only late in the nineteenth century did it become associated exclusively with a classical music establishment financed by Gilded Age moneyed elites. During this time of sharpening cultural hierarchy, Caruso was a force of Whitmanesque cultural democracy, a bridge between the elite and the popular, as comfortable on stage in an ornate concert hall as on city streets chatting and backslapping with his fans.

In a culture rife with anti-immigrant fear and prejudice, Caruso's amiable, generous spirit contradicted widespread stereotypes of southern Italians as sullen, antisocial, criminal and violent. Caruso instead became an exemplar of other, relatively benign Anglo/Nordic notions of Italians (and of blacks, and of other "darker" peoples): the Italian as innately musical, physically emotive, sensual, primitive in the sense of retaining a healthy animal vitality against modernity's bloodless rationalism. Asked what made a great singer, Caruso quipped, "A big chest, a big mouth, ninety percent memory, ten percent intelligence, lots of hard

work, and something in the heart."[3] It was said that Caruso sang from his heart: his voice, the image suggests, was a blood-pumping artery. A thrilling belter whose records brought the impassioned *verismo* style of Italian opera to the masses, Caruso consolidated a shift in popular taste for opera away from a Germanic text-centered approach to an emphasis on the spectacle of vocal display. Voice and performance became more important than text, sound more important than sense. This aesthetic shift was perfectly in tune with the conditions of an early twentieth-century American popular culture whose burgeoning mass audience consisted of immigrant working classes speaking in a multitude of tongues but often remaining illiterate in their native and adopted languages. Caruso's phonogenic voice, the vocal blood he pumped through the acoustic technology of early recording, became a universal sound of desire and longing.

Caruso's trademark was the soaring crescendo, the dramatization of intense feeling, the feeling of passionate love, and even more, of love's betrayal and loss. In this, the famous tenor gave the world something fundamental to the tradition of *canzone napoletana* (Neapolitan song), something that became a cliché of Italianness writ large: the Italian as acutely sensitive, hyperbolically emotional in matters of the heart. With male singers, this entailed a masculine affect quite distinct from the Anglo-Victorian model of stoical, stiff-upper-lipped restraint. In "Core 'ngrato" (Ungrateful Heart), recorded by Caruso in 1911, the singer addresses the lover who has spurned him, pleading for recognition of his pain and suffering ("Traitor, you don't know how much I love you/ Traitor, you don't know how much you hurt me"). The male protagonist in this drama of amorous rapture assumes the more conventionally "feminine," abject position—not just spurned, but forgotten—whereas the female is figured as heartless, bereft of sentiment, able to blithely move on ("You've taken my life, and it's over, and you don't think about it anymore").

Pellegrino D'Acierno writes of Neapolitan song as a "music of *passione* (the Italian equivalent of "soul") and exacerbated *malincunia* (the Naples equivalent of "blues").[4] We find similarly explicit analogizing between African American and southern Italian music in some of the responses to the film *Passione* (2010), John Turturro's ode to the music and people of Naples. "The music in *Passione*," wrote *New York Times* film critic A. O. Scott, "combines sensual suavity with raw emotion, mixes heartbreak with ecstasy, acknowledges the hard realities of poverty and injustice and soars above them. I suspect that if artists like Marvin Gaye, Otis Redding or Aretha Franklin were to see this film, they would recognize their own art within it."[5] Songs of yearning, of fleshly pleasure, of love and love lost, bilateral aggression and derision, betrayal and revenge; songs that speak frankly about the intrigue and the anguish of personal intimacy—this is the domain of the blues, soul, and Neapolitan music alike. The art in each of these idioms is a ritual of confrontation and catharsis, a sharing of feelings so deep as to exceed the capacity of verbal language—hence the power of this music even among listeners who may not understand the lyrics. In Neapolitan discourse, the term of art is "*la comunicativa*," an act of communication that is contagiously expressive.[6]

In the first decades of the twentieth century, the music of southern Italy circulated in a Mediterranean/Atlantic orbit connecting the peninsula and its islands to Africa, the Middle East, the Caribbean and both South and North America. Naples and Palermo were cultural crossroads where European, African, and Arab music had intermixed for centuries; the migrants who passed through these port cities on their way to the New World participated in the process of intercultural synthesis that produced jazz, the tango, the rhumba and other new song forms and dance styles which in turn traveled from New Orleans, Buenos Aires, Havana and other cities back across the Atlantic. The growing phonograph record and music publishing industries commercialized this process and quickened its cultural impact. "Core 'ngrato" was composed and recorded in New York, then returned to Italy to enter the *canzone*

napoletana canon and serve over the next century as a symbol of authentic *italianità*.[7] In New Orleans, a teenager named Louis Armstrong went to work in Henry Matranga's honky-tonk saloon; there, among Sicilians and blacks, he first heard Caruso on record (soon he'd buy his own copies, along with recordings of the coloratura sopranos Luisa Tettrazini and Amelita Galli-Curci). This helps account for the operatic bravura of Armstrong's trumpet style, his red hot high-register pyrotechnics, and his cagy habit of sneaking opera sound bites into his solos (the so-called "*Rigoletto* break" in his 1927 recording "New Orleans Stomp," the quotation of "Vesti la giubba" in his 1930 and 1932 recordings of "Tiger Rag"). Once, in response to a journalist's question about his early musical influences, Armstrong spontaneously burst out singing the melody of Maddalena's opening line from *Rigoletto*.[8] Armstrong knew a lot of opera aside from his Caruso favorites (and it's interesting to think about him channeling female soprano opera voices and not just male tenors), but it was from Caruso, above all, Ben Ratliff provocatively suggests, that Armstrong absorbed the "long tones and flowing annunciatory statements" that the trumpeter used "to change the jerky, staccato nature of early jazz."[9]

Millions of immigrant Italian laborers buttressed distressed agricultural economies in Louisiana and Mississippi; forged new agricultural trades in California; executed massive infrastructure and residential construction projects that turned provincial U.S. cities into teeming metropoles; and built hospitality, grooming, and entertainment trades that decisively shaped the cultural texture of America's cities and towns alike. Italian neighborhoods in New York, Philadelphia, Boston, Chicago, Pittsburgh, Cleveland, San Francisco, New Orleans and smaller cities teemed with music cafés theaters, concert halls, dance halls and wedding halls. Barbershops hosted impromptu concerts. Street vendors hawked fish and produce in melodious song. Men and women sat on balconies and porches harmonizing folk tunes from the old country. Street corner teenage vocal quartets hustled tips. Troubadours serenaded. Brass bands paraded.

In New Orleans, Sicilian open-air *festa* bands, funeral corteges, and processions on Catholic saints' days joined U.S. military bands, wagon advertisements, Mardi Gras revelers, and African American "second line" parades to make that city's street soundscape the most polyphonic and polyrhythmic in the western hemisphere. The Jim Crow color line that had taken hold in New Orleans in the 1890s flew in the face of the city's long history of racial mixing, but musicians of all backgrounds continued to listen to and learn from each other. As Bruce Boyd Raeburn has written, "perceptions that Sicilians, Jews, Creoles, and light-skinned African-Americans inhabited the penumbra between whiteness and blackness sometimes allowed them to manipulate racial boundaries to their own advantage, swinging in both directions."[10] Raeburn has coined the phrase "bel canto meets the funk" to characterize the New Orleans-based synthesis of an Italian vocal aesthetic of melodic beauty with a black vernacular emphasis on earthy, sensual vitality. This joining of lyricism and rhythmic groove—characteristic of the *alto basso* dynamics of Italian culture writ large—would become an essential feature of jazz, rhythm-and-blues, doo wop, and soul.

Sicilians like trumpeter Nick La Rocca, drummer Tony Sbarbaro, and clarinetist Leon Roppolo were part of the same fertile New Orleans musical environment that produced Buddy Bolden, Freddie Keppard, Joe Oliver, Sidney Bechet, Jelly Roll Morton, Louis Armstrong, Kid Ory and other of the great African American figures of early jazz. In 1917 La Rocca's Original Dixieland Jazz Band cut the first commercially released jazz record, with "Dixie Jass Band One-Step" on the A-side and "Livery Stable Blues" on the B-side, then went on to tour American and Europe to much renown. Many jazz historians have derided the ODJB as a reactionary, whiteface minstrel outfit that capitalized on the racist bias of the recording industry to eclipse the groundbreaking and ostensibly more authentic jazz of black musicians. This was a position La Rocca helped encourage when he petulantly disparaged black musicians and insisted that jazz was an entirely white invention. Alas, the ODJB records

reveal a band with little rhythmic finesse and a penchant for hokum like tailgate trombone simulations of barnyard animal flatulence. Still, the ODJB's recordings influenced and abetted the best black jazz bands, such as King Oliver's Creole Jazz Band, by modeling the instrumentation that would become the standard for "real" jazz (a five-piece horn-centered lineup, sans strings), and by enlarging the audience for collectively improvised, ragtime-style music.[11]

The most famous jazz musician to hail from New Orleans's "Little Palermo" neighborhood was Louis Prima (Figure 25.1), a fiery trumpeter, a flamboyant singer, and altogether

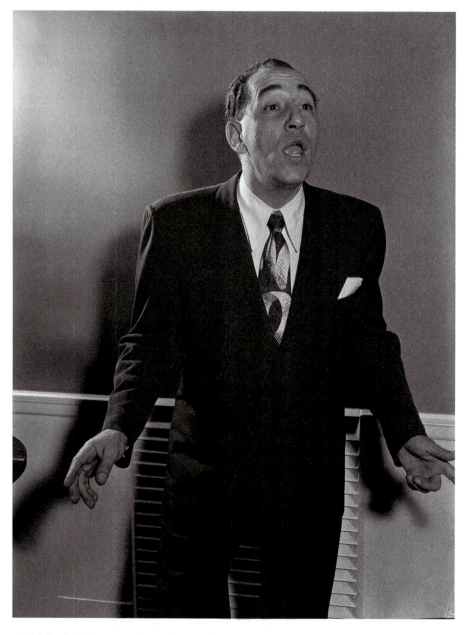

Figure 25.1 Louis Prima, *circa* June 1947. William P. Gottlieb Collection/Library of Congress LC-GLB13–0716.

a singularly dynamic showman. Like his idol Louis Armstrong, Prima embraced his role as an entertainer with an infectious joy and an intuitive gift for humor; unlike Nick La Rocca, Prima showed no interest in claiming a white identity and was proud to often be mistaken for black. Discovered by the Italian Canadian bandleader Guy Lombardo and brought to New York in 1934, Prima became the headliner at the Famous Door, one of the clubs anchoring the 52nd Street swing scene that included *paesani* such as fellow New Orleans trumpeter Joe "Wingy" Manone and the Philadelphia-reared string players Eddie Lang (Salvatore Massaro) and Joe Venuti, pioneers of jazz guitar and violin. Prima's 52nd Street act featured small-group, Dixieland-style hot jazz punctuated by comic patter delivered in an endearingly raspy voice. During a two-year stint in Hollywood, where he opened a West Coast version of the Famous Door and appeared in several movies, Prima wrote "Sing, Sing, Sing," which became the Benny Goodman Orchestra theme song and a swing-era anthem.

In the 1940s, back in New York, Prima led a swing big band on 52nd Street and at uptown venues like the Apollo Theater. During the World War II years in which the complexities of identity, loyalty and citizenship intensified for Italian Americans as scores of families saw their sons take up battle against Mussolini's Fascist regime, Prima introduced into his repertoire material that drew on Italian folk music and riffed on Italian American nomenclature, slang and accent. With songs like "Angelina," "Please No Squeeza Da Banana," "Felicia No Capicia" and "Baciagaloop," Prima helped Italian Americans laugh and sing during hard times and, through the wide commercial appeal of this material, to hear and see themselves represented in the nation's multiethnic popular culture.[12]

Ethnicity is a concept of many different meanings (heritage, culture, identity, and more), but in the context of American entertainment it is perhaps best understood as an act, a performance, and very often a performance meant to induce laughter. Prima worked at the intersection of music, comedy, and theater, in the expressive territory of minstrelsy and vaudeville where Irish, Italians, blacks, Jews and other "ethnics" built the nation's formidable tradition of popular live entertainment. Like the Brooklyn-born Italian American vaudevillian Jimmy Durante—"The Great Schnozzola," an ample-nosed, gravel-voiced, language-butchering wisecracker who started as a ragtime pianist with the Original New Orleans Jazz Band, one of the first New York-based bands to identify with the new music—Prima was largely ignored by critics and historians bent on canonizing jazz as a high art.

With a gift for shtick matched by a savvy business sense, Prima responded to the postwar collapse of the big band swing economy and the advent of bebop by pioneering a stage act for Las Vegas, a desert outpost soon to become an unlikely mecca of gambling and entertainment. Sharing the spotlight with female sidekick singer Keely Smith (his wife during this period) and The Witnesses, an instrumental combo featuring saxophonist Sam Butera, a fellow New Orleans Sicilian, the now middle-aged Prima jumped and jived with manic exuberance to a 6/8 *tarantella*-inflected shuffle rhythm. Butera's molten sax lines—especially his soloing on the sultry "Fever"—provided soft-core ambience for Smith and Prima's erotic burlesque of a stoic, icy ingénue deflecting the come-ons of a smitten, lecherous older man.[13] The 1956 Capitol LP *The Wildest*, with "Jump, Jive n' Wail," "Just a Gigolo," "The Lip" and "Buona Sera," beautifully captures this group's innovative synthesis of jazz, jump blues and rock-and-roll.

That kind of stylistic hybridization was characteristic of the innovative work of another second-generation New Orleans Sicilian, Cosimo Matassa, the recording engineer and studio owner most responsible for creating the "New Orleans sound" of 1950s and 1960s rhythm-and-blues and rock-and-roll. Matassa grew up in a typically musical Sicilian family, ears full of New Orleans street music as well as the commercial fare that blared out of the jukebox in his father's French Quarter grocery store. One of Matassa's first recordings

was the ethnic novelty "Pizza Pie Boogie" by New Orleans jazz trumpeter Joe "Sharkey" Bonano and his Kings of Dixieland. Better known to history are the string of hits he later recorded with Fats Domino ("Ain't that a Shame" and "Blueberry Hill" among many others), Big Joe Turner ("Shake, Rattle, and Roll"), Little Richard ("Tutti Frutti," "Good Golly Miss Molly"), Lee Dorsey ("Working in the Coal Mine"), Aaron Neville ("Tell it Like it Is"), and other African American performers.[14]

Italian Hot/Italian Cool

Louis Prima's "hot" affect (fervent, animated, carnal) moved diverse audiences in a now fully urbanized, post–World War II America; the urban culture it invoked was the World War I-era one of clamorous streets, crowded living spaces, sweaty work, and of ecstatic liberation pursued in clamorous, crowded, and sweaty speakeasies and dance halls. The Witnesses' 6/8 shuffle captured both the joyous pulse of Italian wedding dancing and the rolling rhythm of industrial work (shoveling coal, laying railroad track, etc.) by laborers reared in an agricultural economy who became the builders of the infrastructure of American modernity. Saddled to the Witnesses' boisterous swing groove, Prima's hotness inhered in his ability to arouse excitement in others through his own high-affect frenzy. In this fashion, Prima, like Louis Armstrong, translated into American vernacular the kind of intense feeling that Caruso expressed in his naturalistic, *verismo* vocalizing.

In jazz history, "hot" refers to the small-group, collectively improvised, syncopated music that originated in New Orleans and Chicago and served as the soundtrack for the bouncy, frolicsome spirit of Roaring Twenties youth culture. In the 1930s, "sweet" emerged as a style distinct from "hot" in its use of written charts, a sumptuous instrumental blend woven from the sonority of string instruments (violins, harp), a patina of smooth polish, and a decorous air suitable for the high-toned hotel ballrooms where the music was played for polite social dancing. Big band swing grew out of this bipolar paradigm: most bands advertised their sound as hot or sweet, whereas the very best bands, like those led by Duke Ellington and Benny Goodman, devised a brilliant synthesis of both styles. Meanwhile, these bandleaders and other of the most compelling, original swing performers, notably Lester Young and Billie Holiday from the Count Basie band, chafed at the minstrelsy tinged dynamics of the music business, with its image of the musician as a happy-go-lucky servant-entertainer rather than a serious and challenging artist. A new performance persona and cultural style arrived with this change in attitude, a change that coincided with World War II-era demands for racial equality. Called "cool" (even when the music itself burned hot, as with bebop's blistering tempos and mercurial chord changes), it was defined by an ineffable charisma, an air of mystery, a relaxed intensity; at the practical level, an ability to create excitement without showing excitement.

The Italian term for this quality is *sprezzatura*: making hard work look easy, affecting a casual nonchalance even while conveying deep passion; answering the mandate, as the old Italian adage goes, to "never let them see you sweat."[15] Not surprisingly, jazz's post–World War II shift from the sweating brow of the fervent entertainer to the furled brow of the contemplative artist included a number of Italian American musicians of distinction. These included Lennie Tristano, a pioneer in the late 1940s of a post-bebop "progressive" jazz full of intricate contrapuntal voicings and rich chromatic harmonies; William Russo, a Tristano student who became a noted jazz composer, arranger and teacher; Buddy (Boniface) De Franco, by general critical consensus the most adroit of the bebop clarinetists; Tony Scott (Anthony Joseph Sciacca), a bebop clarinetist and saxophonist who gravitated to folk music, backing Harry Belafonte's break-out calypso recordings in the 1950s and then traveling to Africa and Asia

for pioneering work in what later came to be called "world music"; Jimmy Giuffre, also a clarinetist and saxophonist, as well as a composer and arranger (author of "Four Brothers," a key piece in Woody Herman's book), a central figure in the West Coast cool jazz scene of the early 1950s, then later in the decade the key innovator in a chamber-jazz style of free interplay; trumpeters Pete and Conte Candoli and trombonist Frank Rosolino, stalwarts on the West Coast scene; Joe Morello, drummer with the classic Dave Brubeck Quartet, a master technician best known for his "three plus two" 5/4 groove on the hit single "Take Five"; and Scott La Faro, bassist in a classic trio with pianist Bill Evans and drummer Paul Motion, where he moved beyond the traditional time-keeping role of his instrument to pioneer a new approach of playing lyrical counter-melodies.

Like jazz, mid-twentieth-century Italian American popular music registered changes in temperament and attitude driven by evolving social, cultural and political aspirations. From the 1940s to the 1960s, as many second-generation Italian Americans realized their American Dream in the security of automobile and home ownership, Italian American popular singers virtually defined the way America dreamed about love and romance. If they often did so in a way that sublimated their immigrant, working-class origins, they just as often delivered style, soul, sensuality and even an edge of danger to the anodyne mainstream culture of the Organization Man and the suburban happy homemaker. Paralleling what Robert Farris Thompson has theorized as a core African aesthetic of "high-affect juxtaposition,"[16] the best of Italian American song and performance commingled and fused Italian cool and Italian hot (Italians being, in Pellegrino D'Acierno's words, "the hottest of the white ethnics," white but "temperamentally and erotically dark").[17] On stage, record, radio and television, the voices and the personae of Italian Americans tantalized America and the world with their powerfully affecting juxtapositions of hot and cool, hard and easy, happy and sad, cocksure and vulnerable, tough and tender.

American popular music—like American popular cinema—has always expressed the romanticism of the wider culture, and since the 1920s, when the motion picture, the radio and the phonograph conjoined to produce our modern mass media, Italians have been conspicuous as both symbols and enablers of amorous enchantment. With the advent of electronic recording, radio broadcasting, and the microphone, it became possible for singers to project a more intimate, seductive sound than had been possible for opera singers like Caruso. This brought a new vocal approach, "crooning" as it was called, in which the microphone served as a kind of electronic ear connected to each and every listener. Whereas the great male opera singers were usually tenors, crooning found its ideal in the baritone voice, whose lower register hews closer to the sound of normal everyday speech.

One of the masters of the new style was Russ Columbo (Ruggiero Eugenio di Rodolfo Colombo), a singer, composer, violinist and actor from Camden, New Jersey. A pioneer of the pop romantic ballad, Columbo scored big hits with "You Call it Madness, But I Call it Love," "Too Beautiful for Words," and "Prisoner of Love," the last of which became a standard later recorded by everyone from Frank Sinatra, Perry Como, and Jo Stafford to James Brown and Tiny Tim. The leading radio crooners of the early 1930s were Columbo, Rudy Vallee and Bing Crosby. In 1934, with Columbo on NBC and Crosby on CBS, the networks publicized their rivalry as "The Battle of the Baritones." Dubbed "The Romeo of Song" and "The Vocal Valentino" in publicity hype for his radio appearances and his small roles in a handful of Hollywood films, Columbo was a new kind of male pop star: the dreamy heartthrob with a legion of young female fans. Columbo was poised for long-lasting Hollywood celebrity—a romance with famous actress Carole Lombard seemed to ensure this—when he died tragically following a freakish firearm accident in 1934. Bing Crosby would emerge as the unrivaled king of Depression-era pop and one of the singular figures in twentieth-century

American culture (if for no other reason that Sinatra, Como, Dean Martin and every other mid-century popular singer embraced him as a model). An Irishman from the Northwest, Crosby became a paragon of Middle American whiteness, an insouciant, pipe-smoking lounger, as casual in dress and demeanor as in his buttercream smooth vocal delivery.

Henry Pleasants, a trained classical singer who wrote standard reference works on the history of singing from the dawn of opera down to Elvis Presley and Aretha Franklin, has said that as a young music critic in the 1930s he and his fellow longhairs found Crosby's voice "saccharine, lugubrious, callow, maudlin, musically slovenly, lacking in vocal virility and incisiveness, short of range—in brief, just something tasteless for schoolgirls to become excited about." Still, with Crosby, the art of singing had not quite reached its nadir. "Then came the young Sinatra," Pleasants continued, "and our worst fears seem to have been realized." Pleasants recalled this bout of critical dyspepsia by way of explaining his transformation from a classical music snob to an evangelist for the excellence, even technical superiority, of singers like Crosby, Sinatra, Billy Eckstine, and Elvis Presley. Once his epiphany arrived, Pleasants would hear in these singers "a wonderfully relaxed, intimate vocal communication, a feeling for rhythm, phrase and line rarely matched by classical singers, and a smooth, often lively, almost always pleasing vocal tone."[18] In Sinatra (Figure 25.2), Pleasants and other critics would come to realize, we find a particularly extraordinary synthesis of the classical and the popular, the European and the American: a restoration of the *bel canto* ("beautiful song") principles of eighteenth-century Italian opera (well-rounded tone, eloquence of phrase and cadence, purity of intonation) combined with the air of casual ease introduced by the radio crooners.

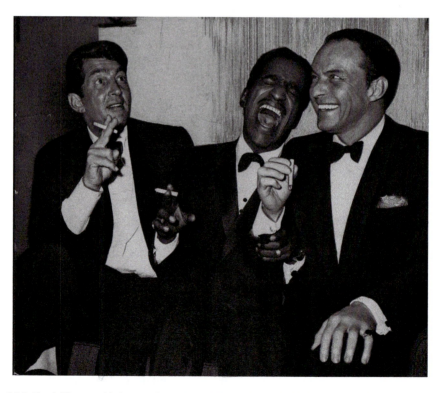

Figure 25.2 Frank Sinatra with Sammy Davis, Jr. and Dean Martin, 1961. United Press International/Library of Congress Prints and Photographs Division, LC-DIG-ds-03671.

Born and raised in Hoboken, New Jersey, the only child of Italian immigrants, Sinatra began singing for tips in a neighborhood saloon when he was 8 years old. His break into show business came in 1935 when a local singing group Sinatra had recently joined, the Hoboken Four, won first prize on the *Major Bowes Amateur Hour*, garnering a contract for stage and radio appearances across the country. From 1939 to the mid-1940s, first as a featured vocalist in the swing bands of Harry James and Tommy Dorsey and then as a solo artist, Sinatra perfected a style of singing romantic ballads that attracted a massive audience of avid teenage girls that the astonished press dubbed "bobbysoxers." By the end of the 1940s, Sinatra had also established himself in Hollywood, costarring with Gene Kelly in the popular musicals *Anchors Away* (1945), *Take Me Out to the Ballgame* (1949) and *On the Town* (1949).

Sinatra spoke openly about his reverence for Crosby, even as he rivaled and eventually eclipsed his idol in critical and popular acclaim. He was also indebted to Tommy Dorsey, not just a shrewd bandleader but also a superb trombonist whose breath control technique Sinatra studied and turned to his own account in honing his ability to sustain long, legato-phrased vocal lines. Yet the most powerful influences on Sinatra's specific style were the jazz singer Billie Holiday, whom he heard on 52nd Street in the early 1930s, and the cabaret chanteuse Mabel Mercer, whose performances in Upper East Side Manhattan supper clubs he frequented in the late 1940s. Combining the careful phrasing he learned from Holiday and, later, the sensitivity to nuances of lyric and narrative modeled by Mercer, Sinatra, at his best, delivered deeply moving, intimately personalized interpretations of the most beautiful, sophisticated material in the canon of American popular song.

There are no few number of embarrassing clinkers in the Sinatra discography—not surprising given the sheer volume of his output—but what is generally distinctive about the career is its emphasis on fine taste and collaboration with only the very best musical professionals (this, in high-affect juxtaposition to the many unsavory features of his personal life). Sinatra preferred to sing from what became known as the Great American Songbook: Cole Porter's "Night and Day," "What Is This Thing Called Love," "I've Got You Under My Skin"; Jerome Kern and Ira Gershwin's "Long Ago and Far Away": Kern and Oscar Hammerstein's "The Song Is You"; Kern and Dorothy Field's "The Way You Look Tonight"; Harry Warren (Salvatore Antonio Guaragna)'s "I Only Have Eyes for You"; Frank Loesser's "Luck Be a Lady"; Richard Rodgers and Lorenz Hart's "The Lady Is a Tramp"; Jimmy Van Huesen and Sammy Kahn's "All the Way"; "Come Fly with Me," "(Love Is) the Tender Trap" and many, many more. Such songs constitute an American literature on the vicissitudes of romance, a canon studied and essayed by virtually every important modern popular singer (including rock icons like Bob Dylan, Paul McCartney, Linda Ronstadt and Rod Stewart) and absorbed into the popular consciousness as a common cultural inheritance. And yet such songs will always be known as Sinatra's songs, so singular and memorable were his performances of them.

This has less to do with the particular grain of Sinatra's high baritone than with the distinctive persona he constructed with his voice, coupled with the way, as actor as much as musician, he dramatized shared emotion and made listeners feel he was singing directly to them. The Sinatra croon of the 1940s was the sound of a tender, precarious love perfectly attuned to the collective heartache of a nation of young women whose boyfriends and husbands were off fighting the war. In the early 1950s, following a devastating downturn marked by a hemorrhaging of his vocal cords and an ill-fated foray into early television, Sinatra's career rebounded with an Oscar-winning portrayal of the Italian American G.I. Maggio in the movie *From Here to Eternity* (1953); over the next decade and a half, the rejuvenated singer would record a remarkable series of albums for Capitol and Reprise with top-drawer arrangements by Billy May (*Come Fly with Me*), Nelson Riddle (*Songs for Young Lovers, In the*

Wee Small Hours, Nice 'n Easy), Gordon Jenkins (*September of My Years*), and Quincy Jones (*Sinatra at the Sands*), reinvigorating swing music and heralding a new style of sophisticated, adult-oriented popular entertainment.

The young Sinatra, the skinny songbird of the Paramount Theater, sang primarily to women while embodying characteristics (emotionality, frailty) socially coded as feminine. The fully ripened Sinatra—the saloon singer, the free-spirited swinging bachelor, the icon of urbane cool, the self-described "18-karat manic depressive" with "an over-acute capacity for sadness as well as elation"—sang primarily to men with a combination of brassy ebullience and fragile tenderness that captured the tensions and ambivalences of an American masculinity both exalted and traumatized by the war and the period of official national happiness that followed. Sinatra's courtly art put popular music and jazz in conversation (Sinatra has often been left out of the "jazz tradition" constructed by critics and historians, but jazz musicians of every generation have considered him one of their own). Tackling the same universal subject as the blues, the darkness of amorous loss and erotic dependency, Sinatra's art created its own sensibility of urban loneliness and existential mystery.

Sinatra occupied so much space in the national media, one wonders how there was any bandwidth left over for his musical *paesani*. So deep was the talent pool, however, even if Sinatra had never made it out of Hoboken, the term "Italian American singer" still would make for legible ethnic shorthand alongside "Jewish comedian" and "Irish cop." During Sinatra's early 1950s slump, the most adored Italian American singer was Perry (Pierino) Como, his popularity generated by the new mass medium of television. Como, a licensed barber from Canonsburg, Pennsylvania, had moved in and out of the music business in the 1930s and early 1940s, gaining national exposure as a Crosby-style crooner with the Ted Weems Orchestra, recording for Decca in 1936 (three years before Sinatra's first record with Harry James) and appearing that year and the next on a weekly radio show on the Mutual Broadcasting System. In spite of this modest but promising commercial success, Como left show business in the early 1940s when he started a family (ten years later, his image as an All-American family man was a key factor in his enormous commercial success). Como finally put away his barber's scissors when he was offered a radio program on CBS that allowed him to move his family to New York and avoid the touring grind. In New York, as a fill-in for Sinatra at the Paramount, Como attracted his own contingent of swooning bobbie soxers. In nightclubs like the Copacabana, Como honed his casual style and won the interest of television producers hunting for programming ideas for the new mass medium.

Como went on to pioneer and blueprint the role of the musical variety show host, holding primetime slots on CBS and NBC from 1949 to 1967. Sinatra had his own shot at this role and failed; among other problems, his high-strung personality did not play well on the small screen. Como, by contrast, came across as a warm and gentle paterfamilias making everyone in the living room feel safe and comfortable. Singing in his virtually edgeless, borderline tranquilizing baritone, Como opened his show with "Dream Along with Me" and closed with "You Are Never Far Away from Me," effectively wrapping his arms around the audience in an encouraging and reassuring sonic hug. In the show's most popular segment, called "Sing to Me, Mr. C," Como, sporting one of his trademark cardigan sweaters, sat comfortably and unpretentiously on a stool, crooning viewer-requested songs. Como's soothing sound matched his middle-of-the-road lifestyle: an avid golfer (with his own line of sportswear and equipment), he was the clean-living Eisenhowerian antidote to Sinatra's high-living, Kennedy-esque swinger.

Suspended somewhere between these two poles, cocktail in hand, floated Dean Martin (Dino Crocetti), the dark and handsome prince of *sprezzatura*. Martin, the "King of Cool," was in many ways the most intriguing talent of all Italian American entertainers. The son of

a Steubenville, Ohio barber—barbershops, butcher shops and bakeries, street corners, front stoops and other smaller-scaled versions of the Italian *piazza* have always been fertile spaces of Italian American music-making—Martin bootstrapped his way through the Rust Belt as a steel worker, welterweight boxer, casino croupier, and journeyman crooner in the mold of Crosby and Harry Mills of the Mills Brothers vocal harmony quartet. While working the East Coast nightclub circuit in the late 1940s, Martin met comedian Jerry Lewis and the two developed an act—a romp of vaudeville-style slapstick and improvised sketches—that triumphed on stage and screen over the next decade. Martin (a comic genius, according to Lewis, who himself was canonized as such by the ever-discerning French) played cool to his partner's lunatic hotness. Martin's good looks, charisma, and serviceable acting talent landed him a variety of Hollywood film roles. In Las Vegas, headlining the Rat Pack stage show with Sinatra and Sammy Davis, Jr., Martin found the perfect platform for his striking versatility. Here he hatched the role that became his trademark, the convivial, stumbling drunkard, while (paradoxically) showing deft improvisatory chops and a nimble sense of timing. Martin was funnier, sexier and cooler than Sinatra and Davis, the coolness being best described by his biographer Nick Tosches as a form of Italian *menefreghismo*, an "I don't-give-a-damn" posture of nonchalance.[19]

The Rat Pack was an alluring spectacle of outcast ethnic excess and gangster glamour, a flat rejection of the Cold War-era ideals of assimilation, honest work, virtue and conformity.[20] And yet it colonized the mainstream popular imagination, helping consolidate Sinatra and Martin's economic power as titans of stage, film, recording and television. It enabled men who were viewed as womanizers, mob lackeys, and (in Sinatra's case) crypto-Communists to make millions of dollars on their recordings of Christmas songs. It helped Martin succeed Perry Como as singer-host of America's most popular music and comedy variety television shows, with NBC's *The Dean Martin Show* (1965–1974) and *The Dean Martin Celebrity Roast* (1974–1985). And it abetted Martin's fame as a singer of songs he made among the most popular of their time: "Memories Are Made of This," "That's Amore," "Everybody Loves Somebody," "Ain't that a Kick in the Head." Comparisons with Sinatra are inevitable, and though Martin will never command similarly avid attention from music critics, in certain respects he was a more touching singer than The Voice. Ironically, in spite of (or as part of) his regal cool, Martin suffused vocal warmth in a way that eluded Sinatra. Martin could be winningly self-effacing and poignantly resigned in a way that was difficult for Sinatra. Martin was sentimental in a way Sinatra chose not to be: he sang Italian love songs in the native tongue, songs like "Arrivederci Roma" and "Non Dimenticar" and "'O Sole Mio." And even when Martin crooned a song like "Everybody Loves Somebody" in English, he sounded like someone who had grown up in an Italian-speaking household, something Sinatra worked assiduously to hide.

The Italian golden age in American popular music of the 1950s and early 1960s was part of a larger movement of postwar transatlantic culture driven, among other forces, by the American role in underwriting the reconstruction of war-ravaged Italy and restoring it to its role as an international symbol of aesthetic prestige. This was evidenced in burgeoning art history programs and study abroad opportunities ("American Girl in Italy"); the cultural cachet of the American Academy in Rome; Peggy Guggenheim's Venetian ventures; and a cosmopolitan film culture linking Italy and Hollywood (*Roman Holiday*, Fellini, Sophia Loren, spaghetti westerns). Frank Sinatra, Perry Como, and Dean Martin (who enjoyed great success in Italy and other countries) likewise exemplified this Italianization of the art and entertainment worlds and were joined by a number of other notable singers. Among them: Vic Damone (Vito Rocco Farinola), perhaps the most exquisitely pure singer of all, credited by Sinatra with owning "the best pipes in the business"; Mario Lanza (Alfredo

Arnold Cocozza), repopularizer of the tenor aria, topping the charts in 1951 with "Be My Love," the first million-selling operatic record since Caruso; Jerry Vale (Genaro Louis Vitaliano), a virtuoso of *canzone napoletana* who charted with "Inammorata," "Mama," and Mala Femmena"; Frankie Laine (Francesco Paolo LoVecchio), a rhythm-heavy, husky blues belter pliable enough to capitalize on the cowboy-and-western vogue with "Mule Train" and "Rawhide"; Joni James (Giovanna Carmella Babbo), who topped the *Billboard* chart in 1952 with "Why Don't You Believe Me?" and scored more than twenty Top 40 hits over the next decade; Connie Francis (Concetta Rosa Maria Franconera), the top charting female vocalist of the late 1950s and early 1960s, who bridged the diverging sophisticated pop and teenage rock-and-roll audiences with "Who's Sorry Now?" and "Where the Boys Are"; Bobby Darin (Walden Robert Cassotto), another crossover stylist whose chutzpah and charisma made him the latest racy heartthrob, and whose hits with "Splish, Splash," "Dream Lover," "Mack the Knife," and "Beyond the Sea" made him rich.

The figure who most gloriously bestrides the postwar Italian American golden age and our own is Tony Bennett (Anthony Dominick Benedetto). Raised in the Astoria neighborhood of Queens, Bennett returned to the New York jazz and supper club scenes after seeing significant combat action in the European theater in World War II. He used his G.I. benefits to receive formal training in *bel canto* principles while making informal studies of jazz greats like Lester Young, Stan Getz and Art Tatum. Discovered by comedian Bob Hope in a Greenwich Village club, Bennett soon secured a contract with Columbia and a mandate from producer Mitch Miller (Sinatra's arch-nemesis) to concentrate on commercial pop. Jukebox fame came quickly with a pair of Crosby-styled ballads, followed in 1953 by "Rags to Riches," a brassy big band number featuring the impassioned vibrato Bennett often favored in this part of his career. In the late 1950s, Bennett migrated more deeply into the jazz world, cutting highly regarded LPs (*The Beat of My Heart; Basie Swings, Bennett Swings*) that paired his husky vocal timbre with the assertive rhythms of percussionists Art Blakey, Jo Jones, Candido and Chico Hamilton. Guided by his musical director, the English jazz pianist Ralph Sharon, Bennett polished his nightclub and concert acts in the early 1960s and found his signature song in the 1962 recording "I Left My Heart in San Francisco." Like American jazz writ large, Bennett struggled against the rock juggernaut in the late 1960s and 1970s but made a celebrated comeback in the 1980s and 1990s. Shrewdly managed by his son Danny, Bennett found a new audience on MTV, becoming the preeminent custodian and proselytizer of the pre-rock Great American Songbook among fans raised on classic rock, soul, funk, disco, hip hop and alt-rock.

Ethnic Soul

Consider: Although many Italian American singers Anglicized their names so as to optimize mainstream appeal, what ended up making them appealing was a palpable verve and vitality that could only be read as "ethnic." Consider further: Early career success for the Irish-English-Native American singer Keely Smith came from hitching herself to Louis Prima's wagon, whereas for the Irish-English-German-American singer Rosemary Clooney, it came from recording the festive Italian-themed tunes "Come On-a My House," "Botch-a-Me (Ba-Ba-Baciami Piccina)" and "Mambo Italiano." This complicates the notion that Italians could assimilate into American whiteness simply by changing their names, or that they— or American culture—would be better off if they did so. The relationship between Italian Americans and whiteness had always been complicated and unsettled: stigmatized as wops and dagoes, yet putative heirs to Renaissance high culture; historically subject to lynchings, discrimination and other forms of racism, yet categorically privileged vis-a-vis African

Americans and sometimes active agents of racism against them. Jazz had shown (in the stylistic rapport between Louis Armstrong and Louis Prima, in the collaborations between Count Basie and Tony Bennett, among many examples) what marvelous cultural alchemy occurs when the race line is breached, assaulted, or simply ignored. Early rock-and-roll (Elvis Presley channeling rhythm-and-blues, Fats Domino and Chuck Berry crooning country) showed the same thing, and it did so in a heightened political context, with the Civil Rights Movement mounting its assault on Jim Crow segregation and white supremacy. As rock-and-roll evolved amidst the most stirring convulsions in American race relations since the Civil War and Reconstruction, the positioning of Italian Americans in the nation's highly racialized popular music culture became a more pressing and intriguing matter.

"There was something about the sight of those four Italians, decked out in city slicker clothes, snapping their fingers and acting like Negroes, that must not have set too well with the folks in the Midwest. We were kind of exotic, which meant foreign, and that, in turn, meant dangerous."[21] This is Dion DiMucci decoding the cultural significance of his appearance, with Dion and the Belmonts, on Dick Clark's *American Bandstand* in 1958. Dion and the Belmonts (Carlo Mastrangelo, Fred Milano, Angelo D'Alea) had been street gang members in the Bronx, dark-haired teenage toughs with a love for the vocal group harmonizing of black rhythm-and-blues groups like the Orioles, the Ravens, the Flamingoes, the Wrens, the Cadillacs, and the Teenagers, fronted by Frankie Lymon, later a close friend of DiMucci's. The Belmonts were one of a slew of Italian-led New York groups (Nino and the Ebbtides, Vito and the Salutations, Johnny Maestro and the Crests, the Capris, the Elegants) performing in the style that was later dubbed "Italo-doo-wop," or simply "doo wop." Drawing on the traditions of barbershop *a cappella*, gospel falsetto, jazz scatting and jump blues, doo wop groups sang simple love ballads and upbeat numbers energized by nonsense syllable vocal riffing in the tenor, baritone and bass registers. The Belmonts and their confreres combined the romance and elegance of standards-centered pop with a grit and moxie born of hard-scrabble urban, working class, youth experience. Doo wop resonated organically out of the New York City soundscape; the songs literally were created on street corners and subways, in apartment vestibules and public school hallways and bathrooms—any space with warm acoustics and social intimacy.[22]

Elvis Presley, Chuck Berry, Little Richard, Bo Diddley, Buddy Holly and other early rock-and-rollers had attracted a huge audience of white teenagers, promising a boon market for record companies, radio and television stations, and Hollywood studios—but only if they survived a national moral panic over the interracial intimacy generated by the music. The virtue of American white womanhood supposedly at stake, the culture industry responded by camouflaging the blackness intrinsic to the music. This meant conservative white southerner Pat Boone doing cleaned-up covers of Fats Domino and Little Richard. In Philadelphia, home of *American Bandstand*, it meant de-ethnicizing the local Italian American teenagers who constituted a majority of the "white" dancers on the show, and turning a few South Philly dreamboats—Fabian (Fabiano Anthony Forte), Bobby Rydell (Robert Louis Ridarelli), and Frankie Avalon (soon to pair up with Annette Funicello in the 1960s beach movies)—into wholesome teen idols.[23] As teenage culture thus skewed whiter and more homogenous, and as Sinatra and other singers of his generation voiced bitter contempt for rock-and-roll, Dion DiMucci pivoted in the direction of rock's roots in blues, country (he'd nursed a love for Hank Williams since childhood) and New Orleans shuffle rhythm. "Because I was Italian," DiMucci said, "they all wanted me to sound like Vic Damone—someone who sang is if all he did was take voice lessons. No, for me it was the energy of Louis Prima." Billed as Dion in his solo act, DiMucci, strumming a guitar à la Muddy Waters, scored big hits with "Runaround Sue," "Ruby Baby" and especially "The Wanderer," a blues tale about a rambling man and his

many loves, set to a Prima-style *tarantella* groove. DiMucci described the song as "black music filtered through an Italian neighborhood that comes out with attitude."[24]

Across the Hudson River in New Jersey, other working class and poor Italian neighborhoods, usually abutting black neighborhoods of similar class texture, also produced music with attitude. From a housing project in Newark came Frankie Valli (Francesco Castelluccio), a scrappy go-getter who trained to be a hair stylist—baby boom-era women's and men's coiffure converged in the form of beehives and pompadours—as he was polishing his falsetto croon in a group with keyboardist and songwriter Bob Gaudio, guitarist Tommy DeVito and bassist Nick Massi. First called the Four Lovers, then the Four Seasons, the group concocted a tasty blend of doo wop style pop crooning and rock-and-roll, hitting the top of the charts in the early 1960s with "Sherry," "Big Girls Don't Cry" and "Walk Like a Man." Among harmony-based early rock groups, the Four Seasons' only serious rivals were the Beach Boys and the Beatles (in 1964, Vee-Jay Records released a double-album called *The Beatles vs. The Four Seasons: The International Battle of the Century*). The group continued to amass huge radio and recording success through the mid-1960s with hits like "Let's Hang On" and "Working My Way Back to You." At the end of the decade, as rhythm-and-blues-inspired British Invasion rock gave way to psychedelia and hard-edged proto-heavy metal, and as pop-oriented Motown competed with the deeper-grooved southern soul music coming out of Memphis and Muscle Shoals, the Four Seasons found themselves out of sync with nascent trends. Soon enough, however, the huge popularity of disco in the mid-1970s reopened a space for their formula: With a reshuffled lineup that included drummer Gary Polci sharing lead vocals, the Four Seasons struck gold again with "Who Loves You" and "December, 1963 (Oh, What a Night)."

As a solo act, meanwhile, Frankie Valli cannily worked the same emotional territory as Frank Sinatra, albeit through musical textures and grooves shaped by doo wop, Motown, middle-of-the-road pop and (later) disco rather than through the big band swing aesthetic Sinatra continued to rely on under this and that "Old Blue Eyes Is Back" legacy banner. In his 1967 hit "Can't Take My Eyes Off You," when the soaring brass section bridge carries Valli into the chorus ("I love you baby and if it's quite all right / I need you baby to warm the lonely nights."), his beseeching voice avidly conjures surging dramas of deep feeling and desire that hit audiences in much the same the same way as the elegant crescendos in Sinatra's "Fly Me to the Moon." Valli returned to stardom in 1974 with "My Eyes Adored You" and in 1978 with the disco-style title song to the motion picture *Grease*.

It was another New Jersey band, The Rascals, that (along with The Righteous Brothers) gave rise to the term "blue-eyed soul," a designation for white performers of black music certified with a stamp of approval by music industry arbiters of racial authenticity. Known first as The Young Rascals, the quartet consisted of keyboardist and songwriter/singer Felix Cavaliere, percussionist and songwriter/singer Eddie Brigati, guitarist Gene Cornish and drummer Dino Danelli. The first three were refugees from the multi-racial pop group Joey D (Joseph DiNicola) and the Starlighters, best known for the 1961 dance hit "Peppermint Twist"; Danelli was a prodigy who had played with jazz icon Lionel Hampton as a teenager and later worked in New Orleans rhythm-and-blues bands. The Rascals were the first white band signed by Atlantic Records, the premier jazz and R&B label whose roster included the likes of John Coltrane, Ray Charles, the Drifters and Aretha Franklin. They cracked the pop charts in 1965 with "I Ain't Gonna Eat Out My Heart Anymore," then rocketing to the top in 1966 with "Good Lovin'," the cover version of a mid-charting song by the Los Angeles doo wop/rhythm-and-blues band The Olympics. A remarkable run of hits followed with "You Better Run" (1966), "Groovin'" (1967), "How Can I Be Sure?" (1967), "I've Been Lonely Too Long" (1967) and "A Beautiful Morning" (1968). Brigati's erotically imploring voice on "I Ain't Gonna Eat Out My Heart Anymore" and Cavaliere's soulful pleading and

sweet elation on "I've Been Lonely Too Long" and "Groovin'" ("life could be ecstasy/you and me endlessly") brought to rock a combination of swagger and tenderness, warm desire and cool aplomb, characteristic of both the earlier generation of Italian American pop singers and the contemporary one of black rhythm-and-blues/soul singers like Smoky Robinson, Marvin Gaye and Otis Redding. And it came here wrapped in the velvety gospel overtones of Cavaliere's B-3 Hammond organ, the zest and sinew of Cornish's guitar, and the tattooed precision of Danelli's superb rock/swing drum groove. The group's political consciousness manifested itself in their 1968 hit "People Got to Be Free," a tribute to slain civil rights leader Martin Luther King; in their refusal to perform before racially segregated audiences; and in their practice (unique among successful white rock groups of the day) of pairing themselves with black groups on concert tours.[25]

"To sound that black, they had to be Italian," Stevie Van Zandt quipped in his induction speech when The Rascals entered the Rock and Roll Hall of Fame in 1997.[26] Van Zandt (born Steven Lento to a Calabrian and Neapolitan family) has long been a missionary for what he calls "New Jersey Soul," a genre whose origin he locates in the first notes of Eddie Brigati's vocal on "I Ain't Gonna Eat Out My Heart Anymore" ("the sexiest record I ever heard"). Van Zandt has played guitar in bands with Bruce—Italian son of Adele Zerilli—since the two were childhood friends in Freehold, New Jersey. Springsteen, Van Zandt and the E Street Band (see Color Plate 26) came together in the Jersey Shore's vibrant boardwalk bar music scene, releasing their first album, *Greetings from Asbury Park, N.J.* in 1973, after Springsteen had been signed to Columbia Records by John Hammond, the legendary talent scout whose earlier finds included Billie Holiday, Count Basie, Aretha Franklin and Bob Dylan. Over the next decade, Springsteen would become the biggest rock star in the world with a string of best-selling LPs (*Born to Run* [1975], *Darkness at the Edge of Town* [1978], *Born in the U.S.A.* [1984]) and a spectacular live show.

Springsteen's songwriting and stagecraft incorporated disparate American vernacular sources—he counted Hank Williams, Jr., Bob Dylan, Frank Sinatra and James Brown as his musical heroes and exemplars—into his exhilarating rock-and-roll aesthetic. In "Born to Run," especially, Springsteen brought an operatic sensibility to life along the highways and the byways of his home turf, the so-called Garden State. As his vision expanded, Springsteen ripened into a populist rock voice for all manner of the dispossessed and downtrodden: migrant workers, Vietnam Veterans, victims of Rust Belt deindustrialization and police brutality.[27] His shows became marathon rituals of emotional and physical catharsis, four-hour displays of energetic showmanship akin to the legendary performances of James Brown. Sinatra sang to the masses but gave every listener the sensation of a private conversation; Springsteen, through his Brown-influenced gestures of intense exertion and exaggerated depletion, his athletic dancing and crowd-surfing, made every person in the audience feel viscerally connected to the throbbing mass. Joel Dinerstein traces Springsteen's "high-energy concert communion" to soul music's "gospel-derived theatricality" and its "musical philosophy of community."[28] Tom Ferraro locates Springsteen's art in New Jersey blue-collar Catholicism: Springsteen, that is, as a "renegade priest turned prophet to the East Coast working classes," redeeming broken American dreams through concert rituals modeled on the High Masses of the Feast days.[29]

Caruso to Springsteen and Lovano: The Operatic in American Pop and Jazz

Of course, the path from Caruso's soaring crescendos to Springsteen's Turnpike operas is much messier and curvier than the foregoing clean linear narrative suggests. The making of culture, perhaps especially the popular culture of a nation as demographically diverse and

fluid as the United States, is a process that by its very nature reshapes the boundaries of group identity. I have told this story in such a way as to emphasize what I believe to be undeniable affinities and continuities marking the musical sounds of Italian America and African America, shared dispositions toward voice, body and community born of intersecting social and political histories. In doing so, I have given only incidental attention to other groups whose modes of musicality have also contributed mightily to America's multicultural traditions of song and dance (a process of cultural syncretism tightly connected to the one in which the Queen's English, through accretions of Scots-Irish, Welsh, Yiddish, Sicilian, Neapolitan, West African, Caribbean, Hawaiian and South Asian dialect, morphed into American English, the hippest, most vital and inventive English of all). And I have just barely hinted at the fact that most artists, imbued with the Romantic ideology that continues to dominate how we think of art, consider it intrinsic to their calling to create solidarities across ethnic, racial and national lines, to resist obligations to family and community-of-origin that get in the way of their primary loyalty to their art and fellow artists. In practice, the day-to-day lived experience of musicians is in the first instance a matter of working and creating among other musicians: this is their tribe, their heritage, their culture. The culture Springsteen shares with Sinatra, and the one Dion shared with Louis Prima, is the same one they all shared with Hank Williams, Jr.: the tribal culture of the working American musician.

But musicians, like everyone else, are multicultural actors for whom the dynamics of racial and ethnic sameness and difference *do* matter very much. I have tried to suggest how this is so at the level of aesthetic style (e.g., *bel canto* meeting the funk), social history (e.g., the forces that put Louis Prima and Louis Armstrong's families in the same city at the same time), cultural representation (e.g., how Perry Como, Dean Martin and Dion DiMucci shaped American whiteness) and economics (e.g., what did it mean for a pop singer to be Chairman of the Board?). They matter in the realm of the private and personal in ways that make it difficult for the historian to fully capture. They matter perhaps more transparently when showbiz Italian Americans and other ethnics Anglicize their names, but they matter no less when Italian Americans (including many with non-Italian birth names bequeathed them by their multiethnic parents) lament that their ethnic identity goes no deeper than Sunday dinner with *nonna* and *nonno*.

In our purportedly post-ethnic age, it may be especially interesting and revelatory to apply a critical ethnic studies lens to the musical culture of recent decades. This will help us ask more penetrating questions than most music fans, critics, and musicians themselves are accustomed to asking. We may ask (with Pellegrino D'Acierno) whether Frank Zappa's "freaking out" of rock conventions—his Fluxus-influenced sonic collage, surrealism, social satire, and avant-garde jazz-style improvisations—constituted not just a third-generation Italian American's rejection of the second-generation's ardent assimilationism, but also an implied critique of the 1960s counterculture's aesthetic timidity.[30] We may ask whether Chick Corea's (Armando Anthony Corea) innovative hybridizations of Latin, free jazz, classical and rock represent not merely the marketing genre called "fusion" but also a deeper vein of high-affect juxtaposition born of his training in a Sicilian musical family. We may ask how the Pizzarelli family—father Bucky (guitarist), sons John (guitarist) and Martin (upright bassist)—has operated as a New Jersey Italian analogue to the New Orleans Marsalis family in achieving high visibility for its tasteful neoclassical approach to the canons of jazz and American pop. We may ask what tools of gender and performance studies analysis we need to reckon with the flagrant theatricality of the post-1980 Italian American pop divas and divettes—Madonna (Madonna Louise Ciccone) and Lady Gaga (Stefani Joanne Angelina Germanotta) above all (see Color Plate 28)—but also Gwen Stefani, Cyndi Lauper, Toni Basil (Antonia Christina Basilotta) and the Italian American arena cock-rockers Steven Tyler (Steven Tallarico) and Jon Bon Jovi (Jon Francis Bongiovi, Jr.).

As we ponder such questions, let us listen to something that will keep our ears attuned to the echoes resonating throughout this musical history. I propose something from jazz saxophonist Joe Lovano's 2002 CD *Viva Caruso*: specifically, his reading of "Vesti la giubba." Joe Lovano was born in 1952 in Cleveland, Ohio, where his Sicilian father Tony (aka "Big T"), a barber by day (!) and a big-toned tenor player at night, introduced him to bebop. Through the years, Lovano has worked in a staggeringly wide array of styles and instrumental combinations, from rhythm-and-blues-flavored organ trios to modal harmony-infatuated Third Stream ensembles, all the while searching for a way to incorporate the fire and spirituality of 1960s free jazz into more traditional settings. In Lovano's horn, we often hear the passion, opulence, grandeur, and soaring virtuosity associated with opera, but we just as often hear an expressive texturalist given to a quizzical, abstract tone. In this recording, he treats "Vesti la giubba" like a minor key folk theme, saturating the aria with aching feeling. Listen, and exult in Lovano, yes, but hear in him distinct echoes of John Coltrane at his most bracingly searching, and of Enrico Caruso at his most poignant.

Further Reading

Bennett, Tony with Will Friedwald. *The Good Life*. New York: Pocket, 1998.

Boulard, Gary. *Louis Prima*. Urbana: University of Illinois Press, 2002.

Dal Cerro, Bill and David Anthony Witter. *Bebop, Swing and Bella Musica: Jazz and the Italian American Experience*. Chicago: Bella Musica Publishing, 2015.

Friedwald, Will. *Sinatra! The Song Is You: A Singer's Art*. New York: Da Capo Press, 1995.

Rotella, Mark. *Amore: The Story of Italian American Song*. New York: Farrar, Strauss, and Giroux, 2010.

Notes

1 Simona Frasca, *Italian Birds of Passage: The Diaspora of Neapolitan Musicians in New York* (New York: Palgrave Macmillan, 2014), 39–76 (43).

2 Lawrence Levine, *Highbrow/Lowbrow: The Emergence of Cultural Hierarchy in America* (Cambridge: Harvard University Press, 1990), 85.

3 Henry Pleasants, *The Great Singers: From Jenny Lind and Caruso to Callas and Pavarotti* (New York: Simon and Schuster, 1981), 296.

4 Pellegrino D'Acierno, "Italian American Musical Culture," in *The Italian American Heritage: A Companion to Literature and Arts*, ed. D'Acierno (New York: Garland, 1999), 447.

5 A.O. Scott, "Soaring From Poverty All the Way to Ecstasy, *New York Times* (22 June 2011).

6 Pellegrino D'Acierno, "Cultural Lexicon: Italian American Key Terms," in *The Italian American Heritage*, ed. D'Acierno, 717.

7 Joseph Sciorra, "'Core 'ngrato,' a Wop Song: Mediated Renderings and Diasporic Musings," Conference Paper (Washington DC: American Studies Association, November 2013).

8 Joshua Berrett, "Louis Armstrong and Opera," *The Musical Quarterly*, 76.2 (Summer 1992), 216–241.

9 Ben Ratliff, "Music in Review: Joe Lovano," *New York Times* (24 May 2000).

10 Bruce Boyd Raeburn, "Italian Americans in New Orleans Jazz: Bel Canto Meets the Funk," *Italian American Review*, 4.2 (Summer 2014), 87–108 (96).

11 Bruce Boyd Raeburn, "Jazz and the Italian Connection," *The Jazz Archivist*, 6.1 (May 1991).

12 Raeburn, "Italian Americans in New Orleans Jazz," 102–106.

13 George Guida, "Las Vegas Jubilee: Louis Prima's 1950s Stage Act as Multicultural Pageant," *The Journal of Popular Culture*, 38.4 (2005), 678–697.

14 George De Stefano, "Addio, Cosimo," *i-Italy* (13 September 2014), www.i-italy.org/blog/24/archive/2014/9.

15 D'Acierno, "Cultural Lexicon," 754.

16 Robert Farris Thompson, *Flash of the Spirit: African and Afro-American Art and Philosophy* (New York: Random House, 1983).

17 D'Acierno, "Italian American Musical Culture," 447.

18 Henry Pleasants, *The Great American Popular Singers* (New York: Simon and Schuster, 1974), 27.

19 Nick Tosches, *Living High in the Dirty Business of Dreams* (New York: Bantam Doubleday, 1992), 324–325.

20 Rocco Marinaccio, "I Get No Kick From Assimilation," in *Frank Sinatra: History, Identity, and Italian American Culture*, ed. Stanislao G. Pugliese (New York: Palgrave Macmillan, 2004), 179–197; Laura Cook Kenna, "The Promise of Gangster Glamour: Sinatra, Vegas, and Alluring, Ethnicized, Excess," UNLV Center for Gaming Research Occasional Paper Series, 6 (August 2010).

21 Dion DiMucci and Davin Seay, *The Wanderer: Dion's Story* (New York: Beech Tree Books, 1988), 75.

22 Simone Cinotto, "Italian Doo Wop: Sense of Place, Politics of Style, and Racial Crossovers in Postwar New York City," in *Making Italian America: Consumer Culture and the Production of Ethnic Identities*, ed. Cinotto (New York: Fordham University Press, 2014), 163–177.

23 Matthew Delmont, *The Nicest Kids in Town: American Bandstand, Rock n' Roll, and the Struggle for Civil Rights in 1950s Philadelphia* (Berkeley: University of California Press, 2012).

24 Mark Rotella, *Amore: The Story of Italian American Song* (New York: Farrar, Strauss, and Giroux, 2010), 216, 234.

25 Tony Sciafani, "The Cost of Freedom: The Rascals Struggle for Change," *PopMatters* (21 November 2007), www.popmatters.com/feature/the-cost-of-freedom-the-rascals-struggle-for-change/

26 Steven Van Zandt's Rock and Roll Hall of Fame induction speech for The Rascals, www.youtube.com/watch?v=HYZlOodmbwI.

27 David Remnick, "We Are Alive: Bruce Springsteen at Sixty-Two," *The New Yorker* (30 July 2012).

28 Joel Dinerstein, "The Soul Roots of Bruce Springsteen's American Dream," *American Music*, 25 (Winter 2007), 441–476.

29 Thomas Ferraro, "Catholic Ethnicity and Modern American Arts," in *The Italian American Heritage*, ed. D'Acierno, 331–352 (347).

30 D'Acierno, "Italian American Musical Culture," 441–443.

ITALIAN AMERICANS AND CINEMA

Giuliana Muscio

The most obvious approach to this subject would have been to discuss the representation of Italian Americans in cinema, but a vast bibliography already deals with this issue. Instead, in this chapter, the diasporic community will be cast in an active role, focusing on the cinema Italian Americans have made. The analysis is not limited to Italian American films made after the 1970s—again a topic that has received extensive attention—it also reconstructs a past that has been ignored. There were Italian American film directors in Hollywood in silent cinema: Robert Vignola, Gregory LaCava, Frank Borzage (Borzaga) and Frank Capra. And there were actors: from the important role played by Enrico Caruso in the cultural legitimation of American silent cinema, to Rudolph (Rodolfo) Valentino. Others included Frank Puglia, who made his debut as a co-protagonist in Griffith's *Orphans of the Storm* (1921), Cesare Gravina (von Stroheim's favorite performer), Paul Porcasi, Eduardo Ciannelli, Jack La Rue (Gaspare Biondolillo) and Henry Armetta. There were important directors of photography (Tony Gaudio and Sol Polito), art directors (Albert D'Agostino, Gabriel Scognamillo) and music composers, from Salvatore Guaragna (better known as Harry Warren), the author of the songs "Lullaby of Broadway" and "That's Amore," to Henry Mancini: and many others, in different capacities.

Their names ending in vowels popped up in film credits from the silents to the 1950s, when Frank Sinatra won the first Oscar as an Italian American in *From Here to Eternity* (1953), and when and *Marty* received several Oscars in the same year (1955) in which Anna Magnani won an Oscar for her role in *The Rose Tattoo*. In addition to the influence of neo-realism on American social cinema, the 1950s and 1960s saw a regular presence of Italian performers (and a few filmmakers) in Hollywood, but this story is well known, too.

What most histories ignore is that, at the advent of sound, Italian immigrants, counting on the strength of their lively *cultura dello spettacolo* (performance culture) made several films in the United States.[1] The American Film Institute (AFI) catalog of ethnic cinema, *Within Our Gates*, lists seventeen films in the Italian language known to have been made in the 1930s.[2] Three were filmed in Hollywood (*Sei tu l'amore?* [Is This Love?], *The Queen of Sparta* and *Tormento* [Torment]), whereas the other titles, along with several musical shorts, were made by artists of the Italian immigrant stage on the East Coast. Their titles were *Pagliacci, Così è la vita* [That's Life], *Santa Lucia Luntana* [Santa Lucia Is Far Away] *Amor in montagna* [Love in the Mountains], *Senza mamma e 'nnammurata!* [Without Mamma and in Love!], *'O festino e 'a legge* [The Party and the Law], *Amore e morte* [Love and Death], *Genoveffa* and *The Movie Actor*. *Amore che non torna* [Love that Doesn't Return] and *I due gemelli* [The Twins], both produced in 1938, reveal that this activity continued throughout the 1930s.

The first surprising finding is that the two earliest examples of spoken films in the Italian language to be made anywhere—*La canzone dell'amore* [The Love Song] and *Sei tu l'amore?*—were made at almost the same time, one in Italy and the other in Hollywood: *Canzone*

premiered in Rome on 7 October 1930; *Sei tu l'amore?* in New York on 14 November 1930. This chronological detail alone indicates that the films made by the diasporic community were far more important in the history of Italian culture than might be expected given the silence surrounding it on both sides of the ocean. This very silence underscores a shameful ignorance concerning Italian cultural productions abroad that still characterizes Italian culture, and, unfortunately, seems to be rooted in the Southern Question. It is an ignorance that has hindered research in many ways: both by limiting the availability of sources and by imposing prejudices and commonplaces on our historical interpretation of them.

The immigrants' attachment to (Southern) Italian culture should not be interpreted as a form of self-isolation, in reaction to the virulent anti-Italian prejudice that characterized American society, but rather as a choice, as a form of cultural persistence related to statistics that are impressive: more than 60 percent of Italian migrants to the United States returned home.[3] Return for these migrants was usually not the result of difficulties encountered in the receiving country, but rather a part of their overall plans. (A comparison with Italian emigration to Latin America confirms the overall significance of these data on returns, although it does appear that the slightly smaller number of returns from South America, 44 percent, was motivated by the better reception immigrants received there.) This cultural factor, whose implications are largely ignored, even found direct expression in the finale of one of these films, *Santa Lucia Luntana*, in which the dream of the Neapolitan migrant family was not the "American Dream," but, as in the lyric of the popular song, the dream of returning home, to the Santa Lucia neighborhood in Naples.

In the early 1930s the introduction of sound in cinema deeply affected a number of non-assimilated ethnic communities, but especially Italians. Talking pictures stimulated two simultaneous linguistic processes: an increased proficiency in the English that was spoken in American media (film and radio) and encouraged by the New Deal's assimilationist politics; and the abandonment of dialects in favor of the standard Italian that was supported by the Fascist regime. Though immigration quotas limited new arrivals, numerous Italian immigrants in the early 1930s did not speak English. The *lingua madre* of most of these immigrants was not even Italian, but a mix of southern Italian dialects, with a dominant Neapolitan component and a smattering of American English–Napolgish. The issue of language became more evident (and not only for Italians) when the immigrant stage started to depend less on live audiences and more on other media, in particular radio and film. But although the three films made by immigrant artists in Hollywood used Italian, most film production on the East Coast favored Napolgish, or dialect.

In order to overcome these linguistic obstacles, immigrant culture made innovative use of the new media, with its synergy of music, cinema, radio and theater, resulting in creative tensions between both Italian and American culture, and regional and national identity that passed via Hollywood and New York. Thus this is not only a crucial chapter in the cultural history of Italians abroad, but it also documents the formation of Italian American culture in the very moment in which sound questioned both its linguistic and its national identity.

The first film in Italian made in the United States, *Sei tu l'amore?* (Figure 26.1), was the result of an adventurous enterprise. In 1928, two Italian performers in Hollywood, Guido Trento and Alberto Rabagliati, met on the set of *Street Angel* (directed by Frank Borzage) where they both played *carabinieri* in a story set in Naples.[4] In 1929, lacking continuous employment in Hollywood, the two actors decided to make a film in Italian, targeted to both the immigrant and the national market, where the talkies had started circulating but no sound film in Italian had yet been made. In a battered Ford they toured California to find financing from the (numerous) winemakers of Italian origins.[5] They collected enough money to form Italotone Film Production and made their film. The director was actor

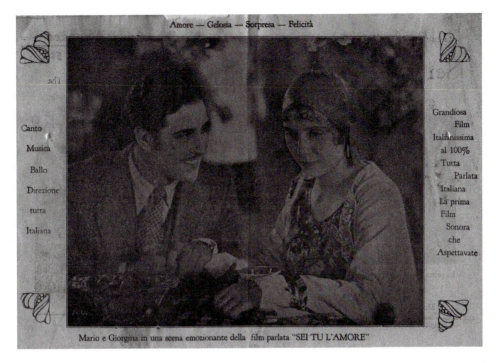

Figure 26.1 Handbill for *Sei tu l'amore?* (1930), directed by Alfredo Sabato and Guido Trento, produced in Hollywood. Photo: Eastman Museum.

Alfredo Sabato, while Rabagliati and the contralto Luisa Caselotti (whose sister, Adriana, sang the role of *Snow White* in Disney's 1937 film) were the protagonists. *Sei tu l'amore?* cast Hollywood Italian immigrant performers Henry Armetta, Augusto Galli and Inez Palange (who later played Tony's mother in Howard Hawks's *Scarface* [1932]). The film had an Italian source in that Trento adapted a play by Piero Mazzoletti that had been staged in Italy by the famous Menichelli-Falconi company in 1925. It was a recent example of Italian middle-class culture, but its protagonist was a working girl with aspirations of social mobility, thus in tune with American ideology. *Sei tu l'amore?* actually prefigured the "white telephone" movies[6] and Mario Camerini's petty bourgeois films of the 1930s, since it was a musical comedy about the dream of upward mobility.

The films produced in Italian immigrant communities in the United States evidenced two different modes of production and approaches to cultural identity: the Italian films made in California integrated the Hollywood experience with elements of coeval Italian middle class culture, whereas the East Coast films expressed the popular culture of the Neapolitan stage, favoring the *sceneggiata* format.

American reviews of *Sei tu l'amore?* were positive and the film was distributed both in the United States and in Italy, since Rabagliati personally took a print of the film home. *Sei tu l'amore?* was not only one of the first films with Italian dialogue, but, in some Italian cities, one of the first to be projected with sound. In the mother country, however, it was criticized for the accents, especially "the terrible accent of Armetta, one of those artists that for decades lived in America . . . and only remembers some phrases in dialect."[7] Italian critics would later make similar comments when reviewing the Italian versions of American films dubbed in Italian *in loco*, expressing irritation with the dialect accents of the

Italian immigrant performers. Their criticism expressed Italian anti-emigrationist (and anti-Southern) attitudes which, together with nationalism, help to explain the silence surrounding *Sei tu l'amore?*, a film with Italian dialogue, made in Hollywood by emigrant performers, before any film spoken in Italian had been shot in Italy.[8]

The Queen of Sparta was a "synchronization" with sound in Italian of an existing Italian silent film, one "of the earliest historical epics made in Italy under the title of *The Fall of Troy*."[9] Synchronizing a popular silent film with sound was a widespread practice in all film industries in the early 1930s; however it is strange that the sound was added in Hollywood, not in New York, where most of the distributors of Italian cinema were located.

Tormento was a film directed by Bruno Valletti (1932), who also made *The Movie Actor* with Farfariello on the East Coast. According to a surprisingly positive American review,

> The story is of a student of music who is torn between her great love of her art and her love for a music teacher, who is responsible for her success. The production is lavish in every sense and some of the scenes in and around the theatre, where she makes her great success, are splendidly done. Livia Maracci is the Italian star featured and she possesses both talent and great beauty.[10]

Thus the Italian films made in Hollywood in the early 1930s combined features of both Italian and American cinema, quite different from most of the titles made in New York.

Naples as Italian Culture

The important centuries-old Neapolitan contributions to music, art, literature and theater supplied southern Italian artists in New York with a rich *cultura dello spettacolo*, thus supporting a proud resistance to cultural assimilation. In fact, for both historical and statistical reasons, because of its prominent traditions and the predominance of southern Italians within the diasporic community, Neapolitan culture became the main shared "Italian" culture in the United States.

On the strength of the cosmopolitan nature of the music and theater traditions of Naples, the only Italian "metropolis" at the time of Unification and at the birth of the modern culture industry,[11] the immigrant stage in New York exploited its cohesive and cross-class force that united High and Low, and was noted for its naturalist (*verista*) style of performance and the versatility of its artists, features it inherited from the *commedia dell'arte* tradition. This linguistic-cultural identification of the immigrant *spettacolo* with the Neapolitan tradition in the United States was in sharp contrast to the process of "nationalization of the masses" being attempted by Fascism in those very years.[12] Indeed the Fascist project seems to have encouraged several artists to leave Naples for New York, and led to the fusion of the image of the Southern Italian with the very idea of Italianess, transforming "'O Sole Mio" into something like a national anthem.

Thus Italians in the United States not only did not "Italianize" but also identified with Mediterranean food and cultural traditions; and they did not "Americanize" either, as New Deal ideology intended. Instead the Italians created a complex synergy of their own rich and varied traditions with the adjoining cultures of the Lower East Side (in particular, the Yiddish one) and in Harlem (with Latin Americans and African Americans), giving birth to a composite *cultura dello spettacolo*. It was a cosmopolitan process—not however one of integration or assimilation, but rather one that stimulated a creative coexistence of diverse identities. Indeed it remains a model for what might be desired of a mixture of migrant and ethnic cultures anywhere in the world.

After the Great Migration and before World War II, Italians in the United States constructed a cultural world of their own. If, to recover the flavor of tomato sauce, spaghetti and wine, they created their own food industry (tomatoes canned by Progresso and Del Monte; pasta manufactured by La Rosa, Atlantic or Ronzoni; Mondavi, Sebastiani and Gallo wines; Ghirardelli chocolates),[13] so also, to preserve the experience of the *macchietta* and *sceneggiata*, they developed their own industry of popular entertainment.

The (southern) Italian theater community on the East Coast created a local *industria dello spettacolo* (performance industry) that rivaled the coeval Italian media in its output. More Neapolitan music was published and recorded in the United States than in Naples. Italian American radio reached a much wider audience than did elitist Fascist radio in Italy.[14] In the 1930s, the Italian immigrant community made thirteen films and several musical shorts, all spoken and sung in Italian or Neapolitan, whereas the film industry in Italy produced only twenty-seven titles. The immigrants were constantly in touch with Italian traditions because performers, films and recordings travelled from Naples to New York in an uninterrupted transatlantic flow.[15] Several Italian language newspapers, which regularly advertised these shows, were among the local media that helped spread Neapolitan traditions in the United States.[16]

Music played a key role on American radio, where bands and orchestras were multiethnic. This interaction with Latin American, African American, Cuban and eastern European artists in bands accompanying performers or recordings, influenced the composition of Italian songs. Conversely the Neapolitan tradition, its style of singing and playing, penetrated popular music everywhere, from tango to American pop songs.[17] In the Prohibition era Italian musicians performed in jazz bands in speakeasies and nightclubs. This interplay of organized crime, contraband alcohol and entertainment created a network of relations that cannot be ignored, although certainly it should not lead to facile conclusions.

The music publishing industry was also active. The Francesco Pennino Collection, now preserved in Napa Valley, California, contains several programs of the New York Piedigrotta festivals, which replicated the Neapolitan event.[18] They reveal that Maestro Pennino was active in multimedia activities, from the composition of theatrical *sceneggiate* to work in the movie business.[19] In the 1930s the *maestro* managed three theaters and distributed the Italian sound film *La vecchia signora* [The Old Lady] (1931) by Amleto Palermi, together with *Veneziana*, an "illustrated song," with words by Pennino and music by his son-in-law Carmine Coppola—perhaps a musical short—that was shot in New York.

Neapolitan impresario Clemente Giglio owned a theater in Little Italy, where he produced stage shows with his son Sandrino and his daughter Adele (Perzechella) in association with Radio WOW. The Giglio Theatre regularly screened Italian films. Italian stage companies were characterized by the fact that, until the late 1940s, they offered a show first on radio and only later on stage, not *vice versa*.

During the 1930s, through diverse media, this Neapolitan-Italian-American *cultura dello spettacolo* reached a wider Italian American audience, not limited anymore to Manhattan, with excursions to Philadelphia, Boston and Chicago. In this way the diasporic performers stemmed Fascist efforts to control culture by creating instead an Italian American counterculture—modern, popular and rooted in the glorious Neapolitan tradition.

When making its films, the New York immigrant community mainly adopted the Neapolitan formats of *sceneggiata* and *macchietta*, but with American variants. These Neapolitan forms derived from Italian stage tradition: *macchietta* from *commedia dell'arte* and *opera buffa*; *sceneggiata* and the "dramatic song" from melodrama. These formats combined popular music with either popular drama or ironic social commentary, using the euphonic Neapolitan dialect, the *lingua franca* of the community.

The lyrics of Neapolitan dramatic songs—the sources of the *sceneggiate*—narrated stories of jealousy, of *guapparia* (*camorra*), of a man wrongly jailed, and they ended in tragedy with the knifing of the *malafemmina*, the woman who betrayed her lover, or of the antagonist. These dramatic songs, true to the tradition of Italian performances that included singing and acting, already contained a narrative structure, which was easy to transform into a theatrical (or cinematic) format. As a theatrical format the *sceneggiata* became popular in Naples after World War I, and it immediately reached the United States.[20]

As Francis Ford Coppola's homage to his work in *Godfather II* (1974) revealed, Francesco Pennino was the main author of *sceneggiate* composed in the United States. He wrote three *sceneggiate*: *Senza Mamma* [Without Mamma], *Senza Perdono* [Without Pardon] (the sequel to *Senza Mamma*) and *Povera Canzona* [A Poor Song] but the *libretto* that documents their dramatization reads: "three acts and a musical intermission by A. Cennerazzo and F. Nino Pen"; and elsewhere, "three dramatic works taken from the homonymous songs by Francesco Pennino." This indicates that Pennino did not write the dramatization but composed the songs that inspired the *sceneggiate*, while Armando Cennerazzo did the "dramatic work." This "detail" does not disprove his "authorship," however, since in the Neapolitan tradition the author of the dramatic song would be considered the author of the *sceneggiata* too. Indeed, Pennino's famous song "Senza Mamma" narrated the plot of the *sceneggiata*: a young Neapolitan man loves a girl who betrays him by marrying his friend while he is doing military service, thus forcing him to leave, so as not to commit *vendetta*, abandoning his beloved mother. When he learns that his mother has died, he puts a gun to his head and commits suicide.

One document in the Pennino Collection indicates that he composed the song "Senza Mamma" in 1917 in New York, and then copyrighted it in Washington DC. Thus his work overlaps chronologically with the Neapolitan development of *sceneggiata*, confirming that he was always in touch with the musical world of the home country. The act of copyrighting reveals an entrepreneurial instinct that matured during his twelve years in the United States.

All three of Pennino's *sceneggiate* are set in Naples;[21] they do not deal with the condition of Italian emigrants. As in a traditional *sceneggiata*, the narrative addresses family relations, love and betrayal; the melodramatic tone is excessive, and culminates in the final dramatic song. In the *sceneggiata* format *Senza Mamma* does, however, show signs of a culture acquired through the immigrant experience, for instance in dialogue in which Rosa regrets not having completed her studies so as to be able to maintain herself: a woman becoming independent of the family would not have been a common character on a Neapolitan stage at that time.

Films in Italian Made in New York

Giuliana Bruno's book, *Streetwalking on a Ruined Map*, documents the activities of Dora Films of America, one of the early companies to produce motion pictures in New York.[22] It is hard to know how its procedures interacted with contemporary experiments of this type,[23] but after the introduction of sound, Clemente Giglio, Angelo De Vito, Rosario Romeo and other impresarios of the immigrant stage moved into film production. Like other non-assimilated ethnic groups, they used facilities in New York State and New Jersey where American companies had made silent films in the pre–World War I era.[24] The sharing of facilities and technical personnel meant that they interacted with other ethnic cultures with which they were already familiar from the immigrant stage of the Lower East Side and from the radio channels they shared.

According to their plots, as published in AFI's *Within Our Gates*, these were mostly *sceneggiate*, whereas *The Movie Actor* was a compilation of Farfariello's *macchiette*. Thus they represented the translation of Neapolitan popular formats into modern (Italian) American media products.

Most of the ethnic films made in the United States with the advent of sound did not focus on the immigrant experience. Rather they nostalgically recounted tales and legends of the motherland, accompanied by folk song. Still, a few Italian American films, such as *Santa Lucia Luntana* and *Senza mamma e 'nnammurata!* were *sceneggiate* that were set in New York.

Like most popular cultural forms, the traditional format of the Neapolitan *sceneggiata* addressed the tension between individual and society in terms of social codes and morality. Indeed, Italian American *sceneggiate* confronted cultural and generational conflicts during what was clearly a phase of traumatic social transformation for the Italian American community. *Santa Lucia Luntana*, for instance, narrates the troubles of a Neapolitan immigrant family in New York during the Depression. Don Ciccio is the devoted father, working hard to support his family, but disappointed with the American experience; the good daughter Elena, loyal to her Neapolitan fiancé Mario, is fired by a molesting Italian boss; her Americanized siblings, her sister Elsie, who sees a rich American boyfriend, and Mickey, the black sheep, who fires a gun off-screen at the beginning of the film, do not work.

The protagonists of the American *sceneggiate* were often second-generation Italian women who were facing the socio-generational conflicts of cultural integration.[25] In Pennino's *Senza Mamma*, Rosa is aware of the difference it would make in her life to be working, and yet she prefers to be spoiled by her father and to wear nice clothes; in *Santa Lucia Luntana*, Elena, the good daughter, works hard, dresses simply, speaks Neapolitan and shows respect toward her father, whereas her sister Elsie likes to dance, gets up late, dresses up and polishes her nails. Work plays a crucial role: Don Ciccio and Elena work hard while Elsie and Mickey do not "earn" their living: they stay in bed late, smoke cigarettes and have American friends.

Unexpectedly, the film has a happy ending because Don Ciccio, Elena and Mario return to Naples. They wait for Mickey in a beautiful villa on the Neapolitan coast and together they sing the title song, which becomes a true manifesto of the immigrant dream of returning home. When Mickey arrives he explains to his worried father how he was able to make the money that he sent to the family to purchase the villa: he worked, as hard as his father had, because he finally learned that work is what makes "a man" (*ommo*). The work ethic is juxtaposed with an implicit expectation that in the meantime Mickey may have been involved in organized crime and made "easy" money. The narrative suggests awareness but rejection of the association of Italians with the Mafia in U.S. popular culture. (Interestingly, no such association exists in Latin American culture, where Italians benefit from positive associations).

Senza mamma e 'nnammurata! was another film–*sceneggiata* made in New York in 1932. As the title suggests, it was a sort of sequel to Pennino's *Senza Mamma*, although the original dramatic song was composed by Luigi Donadio not Pennino. But since Pennino kept the music of *Senza mamma e 'nnammurata!* among his papers, it might perhaps be considered an authorized sequel to his *Senza Mamma*. Both *Senza Mamma* and *Senza mamma e 'nnammurata!* share the same tragic ending: the suicide of the protagonist.

Produced by Angelo De Vito, *Senza mamma e 'nnnammurata!* was shot at the RCA Sound Studios, the prime site for the interaction of film and music on the East Coast. A star of Neapolitan music in the United States, Rosina De Stefano, interpreted the role of Matalena, the mother, since she had already recorded this dramatic song in New York. Catherine Campagnone, the winner of the 1932 Miss Italy beauty pageant, was cast in the tragic role of Maria.

Pasquale, a rich immigrant restaurant owner has prepared a big wedding party for Ciccillo and Maria, although his daughter, Annarella, is in love with the groom. Maria is late for the wedding and arrives by boat, but Ciccillo becomes jealous of a friend and throws her and her mother Matalena out, thus interrupting the party to Annarella's satisfaction. Maria cries in her mother's arms, while her rival sails away with Ciccillo. Matalena suspects that the jealousy scene was an excuse to "break the promise," but faints when Maria confesses that she has

lost her virginity—and her job. The heartbroken Matalena dies, while Ciccillo and Annarella get married. A headline in the newspaper *Il Progresso Italo-Americano* [The Italian-American Progress] then reports Maria's suicide. Wedding parties, broken promises and tragic deaths were typical elements of Neapolitan *sceneggiate* too, but, as in *Santa Lucia Luntana*, the drama of girls losing their jobs becomes as tragic as losing their virginity—a "sin" that Matalena, a Neapolitan woman of another generation, could never forgive.

In this *sceneggiata* the end is a violent death, but suicide in particular functions as a dysphoric element commenting on the southern Italian migration in the United States, and the hopeless feeling of having been abandoned by the motherland ("senza mamma") that accompanied it.

In the same years that the Fascist regime tried to impose nationalist values in the South and harshly repressed Neapolitan culture—even the Neapolitan music being recorded in the U.S.—Italian *carabinieri* confiscated recordings of politically controversial songs composed in the United States with titles like *Il brigante Musolino* [Musolino[26] the Brigand], *L'assassinio di Matteotti* [The Assassination of Matteotti] and *La morte di Sacco e Vanzetti* [The Death of Sacco and Vanzetti], but they also confiscated Pennino's *Senza Mamma* and *Senza perdono*,[27] because they ended in suicide—a word and a concept (*stanchi della vita* "people tired of living") that were banned from the media by Fascism.

Così è la vita, with Eduardo Ciannelli, Augusta Merighi[28] and Miriam Battista was also produced on the East Coast.[29] The (confused) script by Armando Cennerazzo, also the writer of Pennino's *Senza Mamma*, features the character Armando, who departs from Naples on a business trip to the States, leaving behind an aristocratic friend who seduces his wife. When he returns, the heartbroken woman dies, while her daughter, Immacolata, grows up and falls in love with Salvatore, the gardener's son. But Armando forces her to marry a rich nobleman, who kills Salvatore in self-defense. A trial reveals that the young man was actually Immacolata's brother, and she resigns herself to a Catholic wedding with the count! It is an improbably happy ending that dilutes class conflict with regressive values. Interestingly, the film is not set in the "lower," urban world of the *sceneggiata*, but within the modern Neapolitan upper class; Armando, furthermore, visits the United States not as an emigrant but as a businessman. The character of the illegitimate child, however, suggests a fear of changing sexual behavior, or, perhaps, a fear of not being perceived as "legitimate" children of Italy.

When Eduardo Ciannelli played in *Così è la vita* he was no longer associated with the immigrant stage but was already working in prestigious Broadway productions.[30]

Popular Sicilian impresario and radio star Rosario Romeo produced *Amore e morte*, a "rural melodrama with songs."[31] Set in Sicily in the 1890s and spoken in Sicilian, the film was reviewed by the American press too. *Film Daily* (6 October 1932) summarized the melodramatic plot:

> The story is about a rich landowner, played by Romeo, whose chief joy in life is a young daughter. One of the employees, abandoning his wife and children, has an affair with the girl and gets her into trouble. When her father learns about it, he flies into a mad rage, causing the daughter to die from fright. The girl's despoiler is then killed by lightning just as he is being pursued by the father seeking vengeance. Some native songs and a slight bit of comedy are interpolated.

The *New York Times* appreciated how set design transformed New Jersey into a "striking illusion of the approaches to Etna in Eastern Sicily."[32] Quite unexpectedly, several of these films received ample coverage (not always laudatory) in the American press, but they were never mentioned in the Italian press.

The cast of *Amore e morte* included Raffaele Bongini[33] and several performers from the prestigious Italian American Teatro d'Arte, managed by Giuseppe Sterni.[34] Victory in a beauty contest also won the role of the daughter for Clara Diana, an Italian American girl from the Bronx. As in the case of *Senza mamma e 'nnammurata!*, Italian impresarios increasingly used modern approaches to media production in their work.

The premier of *Amore e morte* at the Selwyn Theatre in Times Square included Farfariello's *The Movie Actor*, another Aurora Film product, thus following (in film) a format typical of southern Italian theater programs, which would usually offer a *sceneggiata* plus a *macchietta*.

Amor in montagna narrates a complicated love story involving Selvaggia, Piero, Eola and Tonio, who spend most of their time singing in the fields in the Catskill Mountains. Countess Giraldi throws a party in her elegant villa and discovers that Piero is actually her illegitimate son, believed to be dead, while Selvaggia and Tonio decide to get married. Class differences are overcome by the love of music and the force of emotions, but it is hard to establish whether this is a rural musical comedy or a *sceneggiata*.

The New York immigrant stage also produced films replicating such prestigious genres of Italian cinema as the operatic film or the historical drama. Audio Film in Long Island produced *Pagliacci* with the Italian American San Carlo Opera Company, directed by Fortune Gallo, anticipating the popularization of opera in sound cinema, albeit with a trite narrative solution. In the film, an opera company performs Leoncavallo's melodrama, while the singers are involved in jealous rivalries. Owing to its higher cultural profile, *Pagliacci* enjoyed a special premier at the Central Park Theatre, with the participation of New York's mayor, Jimmy Walker.[35] It was the only contemporary Italian American film to be distributed in Italy too, where it received positive reviews.

The costume drama *Genoveffa* (Figure 26.2) was directed and interpreted by the popular radio star Giulio Amauli. Originally *Genoveffa di Brabante* was a Teutonic poem about "Saint"

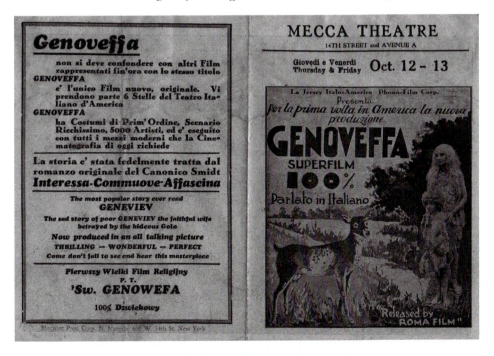

Figure 26.2 Handbill for *Genoveffa* (1932), director Giulio Amauli, produced in the Newark Motion Picture Studio. Photo: Eastman Museum.

Genevieve that had already appeared in popular stage and book adaptations. Beyond its religious content, which included naïve miracles, it also comprised scenes of voluptuous seduction, of knights dueling and of treacherous servants: narrative elements that explain its lasting popularity, not only among Catholics.

Genoveffa was shot at Lambert Castle, in Paterson, New Jersey, and in the Newark Motion Picture Studio, with a creative use of costumes and design. The spectacular battle scenes, however, were lifted from an Italian silent film on the life of Saint Genevieve.[36] *Genoveffa* is an example of the most popular of all Italian silent film genres: spectacular historical films, often with religious undertones, creating the genre that would later include such classics as *Quo Vadis* and *Last Days of Pompeii*.

Other films "made" in New York in the early 1930s were actually "synchronizations" of silent films with music and sound, as in the case of *'O festino e 'a legge*, produced by Clemente and Sandrino Giglio and shot in Fort Lee, New Jersey. As the title suggests, this was the famous film-*sceneggiata* done by Elvira Notari and distributed in the United States by Dora Film in 1921, but with the addition of a narrative framework set in New York. A prologue or a narrative device introducing the story was commonly used in early ethnic sound films, which often added a spoken introduction of a legend or event from the old country to an existing silent film containing that story. According to the text of the songs as documented in the AFI catalog, one of the Italian American musical compositions in the prologue compared a trip by ferryboat in the New York harbor to a boat trip in the Gulf of Naples, thus welcoming some compatriots returning from Naples. The newer production thus transformed the plot into a story that had happened in Naples, the news of which reached the United States. Another song, "'O festino e 'a legge," was the original theme composition of a Neapolitan *sceneggiata* of the same title that told of a woman knifed on the night of her wedding. Until the advent of sound, silent "musical" films, such as those produced by Notari, were screened either with singers performing live or with amplified musical recordings. Sound made it possible to present movies with the songs directly in the soundtrack: a matter that became quite simple in this case, since Roberto Ciaramella had already recorded "'O festino e 'a legge" with his company at Columbia Records, in New York City.

The synergies between the music industry and the immigrant stage, and their interaction with Neapolitan analogs, complicate the classification of these media products, encouraging us to adopt a broader definition of a transatlantic, cosmopolitan "Neapolitanism."

Macchietta on Film: Farfariello in *The Movie Actor*

In recent years Eduardo Migliaccio, alias "Farfariello" (the "little butterfly"), has received considerable critical attention,[37] thus detailed analysis of his language, songs and sketches is less urgent. Fortunately, one film documenting his performances has survived: a short, titled *The Movie Actor* (1932), has been preserved by the Film Foundation. In this work, Farfariello visits the real production company Aurora Film, looking for employment, and proposes a Neapolitan song, but the impresario (Bongini again) chases him away because "the studio is looking only for character-types." Farfariello exits, but then he returns in the costumes of his most popular impersonations: as the *chanteuse* Mademoiselle Fifi (illustrated above in Chapter 14: Figure 14.1); as a *racchettiere* (gangster) who shoots his *rivoltella* (gun); and as a *cafone*, an ignorant immigrant, who refuses to learn American—as he explains performing a famous poem "by Farfariello": *A' Lingua 'taliana*, to the notes of "'O Sole Mio." This *macchietta*, which extolls the Italian language but by using Neapolitan, represents one of the several instances in which there is a metonymic use of Neapolitan culture (lyrics and music) to signify Italy, or the motherland.

Farfariello's short enables us to appreciate both his ability as a *trasformista* (quick-change artist) and the warm humor that made him so popular. The finale shows him in close-up, stating "Aggiufatt a 'merica" (literally "I've made it in America," that is, "I've succeeded"), his signature line, which could also be used for the collective achievements of these immigrant performers.

As well as making a decisive contribution to the creation of Napolgish, Farfariello also reinvented the format of the *macchietta* within the Italian diaspora in New York, dealing with the problems of daily life, in the *jobbo,* or with generational or gender conflicts. With both humor and evident pride, he confronted the problematic issue of national identity within the difficult times of the Depression and in the deep socio-ethnic transformations induced by the New Deal.

Thus Farfariello single-handedly advanced the construction of Italian American culture. The impact of his adoption of modern American musical rhythms should not be under-valued either, since it became the foundation of a very lively form that would be continued in the songs of Jimmy Durante, Louis Prima, Lou Monte and Dean Martin, influencing even gangsta rap.

The films made by the immigrant community in the U.S. document not only its reaction to the linguistic issues raised by the introduction of sound, but also to the question of national identity, affected by Fascism and the New Deal. Sound cinema and radio supplied ethnic communities with new means of communication that were particularly welcomed by Italians, given their musical inclinations. They innovated and preserved *sceneggiate* and *macchiette,* since these regional cultural forms were severely repressed in Italy by the Fascist regime.

The organization of the immigrant stage based on theatrical families and the attachment to the tradition of Neapolitan *spettacolo* later produced a continuity in performers and genres that is exemplified by the Coppola family and by numerous surnames ending in vowels in Hollywood credits or record labels since the 1950s. Furthermore, the creative interaction between music and dramaturgy, that descends from melodrama and *sceneggiata,* remains char-acteristic of the work of some Italian American filmmakers: in the operatic tone of the *God-father* trilogy, in Martin Scorsese's modern *sceneggiata,* the movie *Casino* (1995), in the intense working class musical *Romance and Cigarettes* by John Turturro (2005), and in the unexpected use of Puccini at the ending of De Palma's *Redacted* (2007).

Contemporary Italian American Cinema

The Renaissance of American cinema in the 1970s coincided with Scorsese's *Mean Streets* (1973) and Coppola's *The Godfather* (1972) but this Italian American primacy in cinema is not at all a chance coincidence, given the transformation of the sociocultural scene in the United States and the constant presence of Italian performers and creative personnel in the credits of the American media in the past. The collaboration of Italian American directors and actors—Martin Scorsese with Robert De Niro in *Goodfellas* being a classic example—spurred a golden age of cinema (see Figure 26.3).

After World War II, Italian American *cultura dello spettacolo* interacted with Italian cinema, not only because of a fascination with the Italian films successfully distributed in the United States, but also because of interactions with Italian performers, both in Hollywood and in Italy's "Hollywood on the Tiber."[38] A push to change the standing of *Italian American* culture, however, depended on historical context and on the changing sociopolitical role of the com-munity in the United States after World War II, as Italian Americans became progressively better educated and more affluent.[39]

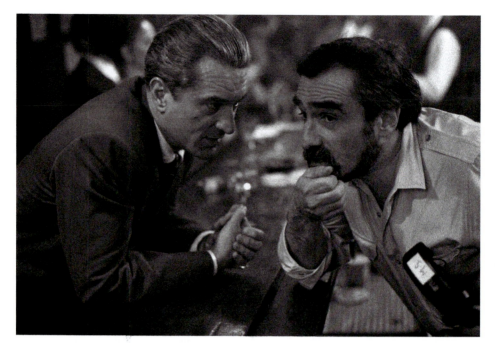

Figure 26.3 Actor Robert De Niro with director Martin Scorsese during the filming of *Goodfellas* (1990). AF Archive/Alamy Stock Photo.

A special characteristic of contemporary Italian American cinema is its cultural and generational continuity with Italian American theatrical families that were active in the 1930s, for example the Barbato, the Gardenia, and the Cecchini-Aguglia families, and most notably, the Pennino-Coppola family. Olga Barbato performed with the family company on stage and radio in New York in the 1930s and 1940s, and much later interpreted Angelina the medium in Woody Allen's *Broadway Danny Rose* (1984) and Bella in *Destination Anywhere* (1997). Mimi Cecchini Romeo of the Aguglia dynasty, interpreted Italian American roles in *The Godfather*, *The Gang that Couldn't Shoot Straight* (1971), *Slow Dancing in the Big City* (1979), *Wise Guys* (1986), *Moonstruck* (1987), *Dominick and Eugene* (1988) and *Cadillac Man* (1990). She was also the President of the Italian Actors Union.

The Coppolas come from the theatrical family established by Francesco Pennino, who gave the first film camera to Francis, the director, while he was bedridden with polio. The family included and includes both performers and directors. After training in the Actors Studio, Francis's sister, Talia Coppola (Shire), interpreted Adrianna (Adriane) in the *Rocky* series, Connie in *The Godfather*, and was the protagonist of the small cult movie *Old Boyfriends* (1979). Her sons are the Schwartzman brothers: Jason, who interpreted parts in *Marie Antoinette* (2006), *Darjeeling Express* (2007), *The Grand Budapest Hotel* (2014) and a recent television series *Mozart in the Jungle* (2014–), created with his cousin Roman Coppola, and Robert Schwartzman, musician with his band Rooney and actor (*Pretty Princess* [1993]). The well-known Oscar-winner Nicolas Cage, like his brother, the actor and filmmaker Christopher Cage, is a son of the late August Coppola. Francis's daughter, Sofia, and his granddaughter, Gia, are filmmakers as well.

Vincent Gardenia (1920–1992) was the son of Gennaro, a famous *impresario* of the immigrant stage, and he worked in his father's Italian company in Brooklyn as a child. A much

appreciated stage actor, in 1972 he won a Tony Award for *The Prisoner of Second Avenue*. On television and in film he has played both policemen and wiseguys: the "New Hollywood" with its good-bad characters, found much use for his wide spectrum of expressions.[40] In *Moonstruck* he was cast as Cosmo Castorini, an Italian American man dealing with the changing roles of women in an Italian American family, and won an Academy Award nomination. In Italy, Gardenia worked both in quality films, for instance interpreting Colonel Charles Poletti in Francesco Rosi's *Lucky Luciano* (1973), and in a number of unremarkable B-movies.

Contemporary American cinema is directed and interpreted by a huge number of performers who are Italian not only because of their family roots and blood relations, but because they are heirs to a cultural tradition that nurtured American media until they took creative and artistic control of the field. The list of performers with Italian last names is impressive as well as extensive: De Niro, Pacino, Turturro, Travolta, Stallone, Gazzara, Aiello, Sciorra, Tucci, Mantegna, Liotta, Pesci, Sarandon, Mastrantonio, Gandolfini, the Sorvinos, Tomei, Shire, Palminteri, Sinise, Buscemi, D'Onofrio, DeVito, Cannavale, Falco and so on[41]—too long a list to examine individual personalities' careers.

Contemporary American cinema is not only populated by a crowd of actors who demonstrate the apparently natural ability of Italians in acting but also by Italian American filmmakers, both in Hollywood and in independent cinema. In addition to those whose names are immediately recognizable as Italian and who often associate themselves with Italian American narratives, like Scorsese, Coppola and Abel Ferrara (*The King of New York* [1990] and *The Funeral* [1996]) there are directors whose names do not sound Italian, and/or who rarely deal with Italian American characters. Penny and Garry Marshall are highly successful but less identifiable as Italian American because their name, Marasciuli or Masciarelli, was Anglicized in the past; furthermore their mother was not of Italian ancestry. However Penny, initially popular as the TV character Laverne DeFazio, besides directing the hugely successful *Big* (1988) and *Awakenings* (1990), also directed *A League of Their Own* (1992), with Madonna (in the role of "All the Way" Mae Mordabito) and her daughter Tracy (in the role of Betti "Spaghetti" Horn) as softball players; *Riding in Cars with Boys* (2001) from the book by Beverly D'Onofrio, with Drew Barrymore and Lorraine Bracco, and *Renaissance Man* (1994) with Danny DeVito. Her brother Garry Marshall directed *Pretty Woman* (1990), *Frankie and Johnny* (1991) with Al Pacino and Michelle Pfeiffer, and *The Other Sister* (1999) with Juliette Lewis and Giovanni Ribisi.

Although Brian De Palma and Michael Cimino are immediately recognizable as being of Italian descent, their films have not often centered on Italian American characters, although De Palma made *Wise Guys*, *The Untouchables* (1987) and *Snake Eyes* (1998), and Cimino made a romantic fantasy tale of the life of Salvatore Giuliano in *The Sicilian* (1987). Quentin Tarantino too is not immediately identifiable with Italian Americanness, but for the actors cast in his films: Steve Buscemi in *Reservoir Dogs* (1992), the reinvention of John Travolta in *Pulp Fiction* (1994) and De Niro's role in *Jackie Brown* (1997). Tarantino has paid homage to Italian action B-movies too, a "cult" he shares with another part-Italian filmmaker, William Lustig, the nephew of boxer Jake LaMotta. Lustig directed *Maniac* (1980), various porn flicks and some popular horror movies, but he also filmed documentaries about Italian B-movies long before Tarantino showed interest in the subject.

In the case of both performers and filmmakers, I think that the relation with Italian American culture depends mainly on the mother and on having eaten Italian food at home (!), far more than on an Italian surname received from the father. De Niro acquired his Italian Americanness from Scorsese's mother, whereas neither Di Caprio nor Tarantino had an Italian *mamma*, so from a cultural point of view I would tend not to consider them Italian American.

David O. Russell (Italian mother) made *Spanking the Monkey* (1994) about a peculiar Italian American family, before directing the hugely successful *Three Kings* (1999) and *American Hustle* (2013); and *Joy* (2015) is the story of Joy Mangano who invented the Miracle Mop.

Richard LaGravanese is more known for his work as a screenwriter but his debut as a director is an very interesting sentimental comedy, *Living Out Loud* (1998) with Holly Hunter and Danny DeVito in the role of an Italian American lift boy: the latter affects the younger (and rich) woman with the warmth of an Italian American family man. The other films he has directed are not about Italian American narratives. The fact that the debut film for these filmmakers often deals with Italian American themes expresses a sense of belonging, makes a statement about their identity even though later in their careers they do not continue along the same lines.

Working mainly in commercial, mainstream media, these directors have contributed to the creation of a new American cinema by proposing interesting nonlinear characters and reformulating film genres, by combining noir, crime and melodrama, by adding more than a touch of irony to gangster films, by revolutionizing the musical (Scorsese), war movies (Coppola, Cimino), and action films (Tarantino, Scorsese, De Palma, Russell). Indeed the work of David Chase in television, and of Coppola and Scorsese in film has profoundly influenced the output of American media, affecting mode of production, formats, themes and style. These filmmakers have also experimented creatively with media technologies, and like the Renaissance artists have been able to work within the commercial system while maintaining their own individual hallmarks.

Some Italian American directors work independently or at least not regularly with the major studios: Michael Corrente, for example, who directed *Federal Hill* (1994; from the name of the Italian neighborhood in Providence, Rhode Island), the film version of David Mamet's *American Buffalo* (1996), *Outside Providence* (1999), and *A Shot at Glory* (2000). Both his *Brooklyn Rules* (2007) and *Loosies* (2011; written and interpreted by Peter Facinelli) focus on Italian American characters. In *Brooklyn Lobster* (2005; a film "presented" by Martin Scorsese) Kevin Jordan narrated the difficulties of his family (the Giorgios) with the lobster business in Brooklyn. Nick Stagliano directed *The Florentine* (1999), about a group of losers in a steel town in Pennsylvania. More marginal are Francesca Gregorini (Ringo Star's stepdaughter) who wrote and directed *Tanner Hall* (2009) and *The Truth about Emanuel* (2013), and guerilla punk filmmaker, Matt Pizzolo.

A very interesting aspect of Italian American cinema has been the prominence of director-actors like Danny DeVito, John Turturro, Steve Buscemi, Vincent Gallo, Al Pacino, Stanley Tucci, Robert De Niro, Sylvester Stallone, Gary Sinise, Anne Bancroft and Madonna. In Italian theater the *capocomico* traditionally fused the function of the actor with that of director-producer. The choice of these actors to go behind the camera has been particularly significant when, as filmmakers, they have chosen to narrate stories related to their Italian American origins, thus making a cultural statement about Italian Americanness that can be projected back onto their work as actors.

Robert De Niro, in addition to his more recent *The Good Shepherd* (2006) on the origins of the CIA, directed *A Bronx Tale* (1993), from a text written by another Italian American actor, Chazz Palminteri. The film is set in the Italian American community, with young Calogero divided between his fascination with the neighborhood boss and loyalty to his father, a bus driver interpreted by De Niro himself.

The actor Steve Buscemi interpreted and directed some episodes of *The Sopranos* (1999–2007), for example the award-winning "Pine Barrens" episode (2001), in which the characters Pauley and Christopher are lost in the snow. In his directorial debut, the movie *Tree's Lounge* (1996), Buscemi describes a dysfunctional Italian American family achieving a delicate

balance between identification and irony, for instance in a funeral sequence that avoids the embarrassing Italian American folklore of Hollywood films. The particular mix of naturalism and directness, which permits identification with the characters, with irony that favors lightness even when the film deals with complex social issues or family problems, appears to be a characteristic of Italian American cinema.

Vincent Gallo directed *Buffalo'66* (1998), a dysphoric road movie, which climaxes in a disquieting family dinner. Although the family name, Brown, does not identify them as Italian Americans, the cast—Ben Gazzara, Angelica Huston and Christina Ricci—suggests an ethnic setting. The portrait of the mother as a baseball fanatic, unaffectionate toward her son, one who does not cook for the family, disturbingly overturns the stereotype of the Italian "mama." Gallo composed and played the musical soundtrack too.

On the other hand, all of Turturro's films as director deal with Italian American characters: *Mac* (1991), with its working class family, focuses on the father/son relationship. The playwright "Tuccio" is the protagonist of *Illuminata* (1998), which narrates the glorious experience of the immigrant stage and its culture in the early 1900s. *Romance and Cigarettes*, a true rock opera with the actors singing and dancing, features James Gandolfini as an unfaithful working class husband and Susan Sarandon (also Italian American) as the strong-willed Italian wife, narrating an Italian American mature "romance" with empathetic humor. Turturro revealed a strong tendency toward grotesque and self-irony both in his *Fading Gigolo* (2013) with Woody Allen, and in his work as an actor with the Coen brothers. He has worked in Italy too (he appeared in Rosi's *La tregua* [1997] and Nanni Moretti's *Mia madre* [2015]) and directed a fascinating documentary on Neapolitan songs, *Passione* [2010].

Away from Hollywood, the independent cinema made by Italian American filmmakers has produced a less stereotypical portrait of Italian American culture. Given the characteristics of its mode of production, this is a cinema that tends to be more intimate, since it cannot afford expensive spectacular action scenes. Character-oriented, it functions with particular efficacy in narrating stories of friendship, love and interpersonal relations. These are perfect topics for Italian American cinema, presenting a more nuanced image of the community, as in the films by Nancy Savoca, Tom DiCillo, Raymond De Felitta, Michael Corrente and Marylou Tibaldo-Bongiorno.

Thus Tom DiCillo, an NYU graduate (and Jim Jarmusch's cinematographer), shot his film *Living in Oblivion* (1995) as an independent. It is an ironic take on Federico Fellini's *8½* in which an intellectual film director (Buscemi) struggles with personal and creative difficulties. As well as later working on TV series, DiCillo shot the documentary *Down in Shadowland* (2014) in the New York City subway over a five-year period.

In addition to an original and mature debut, *Two Family House*, that dealt with family relations, music and race issues, Raymond De Felitta has also directed *City Island* (2009) about a working class New York family, an ironic crime thriller, *Rob the Mob* (2014), and he is currently developing a project about singer Jimmy Roselli, *Make the Wiseguys Weep*.

Gender too, plays a significant role in Italian American filmmaking. As in Italian American literature, women often offer a more subjective, intimate and articulated view of the community. In her film debut, *True Love* (1989), Nancy Savoca focused on Donna (Annabella Sciorra), a young Italian American girl about to marry Michael, who is dealing both with the typical problems of young lovers, and with her own uncertainty, provoked by the immaturity of the young man, who is more interested in going out with his friends than in the wedding. The protagonist of this important film is a girl, who, on the one hand belongs to a culture that attributes great importance to (embarrassing) wedding rituals, including blue mashed potatoes to match the color of the bridesmaids dresses (!), whereas, on the other, she seeks authenticity in her relationships. Savoca's later films, such as *Household Saints* (1993, Color Plate 25) and

TV shows have taken up issues of gender, homosexuality, race, class and ethnicity, with both empathic humor and notable courage, in terms of content, mode of production and style.

From the point of view of themes and content, family and gender relations play a key role in Italian American cinema. The transformation of the mechanisms of character motivation that cast the family and moral issues such as loyalty as the driving force behind the drama, deeply affected the structure even of crime films. But at last Italian American dedication to a "job well done"—in fashion, food, constructions, vegetable gardening and even in art and theater—is gradually replacing the values associated with the conventional depiction of the Mafia as Family Business. In the more intimate cinema, from Savoca's *True Love* to Marylou Tibaldo-Bongiorno's *Little Kings* (2003) and Turturro's *Romance and Cigarettes*, the family is not a romanticized institution made of paternal patriarchs and maternal angels (*angeli del focolare*, literally "angels of the hearth"), but a realistic context for affection, bad tempers and solid loyalty. The maturity of Donna's relationship with her mother in the first film reminds one of Anna Magnani and Marisa Pavan in the finale of *The Rose Tattoo*. The contradictions in the marital relations of the three "little kings" or the reactions of Kitty (Sarandon) to her husband's betrayal and to his lung cancer propose a more lifelike image of gender roles and family values—one not biased by Hollywood conventions. In *Fatso* (1980) with Dom DeLuise, actress-director Anne Bancroft (Anna Italiano) confronts the relation food/family/feelings of an overweight Italian man. Less expected, yet culturally accurate, is the mature point of view of race, which some of these films express, in the "twilight of ethnicity."[42]

Most Italian American filmmakers have in common a fascination with Italian cinema and a preference for naturalistic acting, as well as making creative use of music. Indeed, in their work one could even discern analogies with *sceneggiata* given the use of popular songs in the narrative (*Mean Streets* is a manifesto of this practice)[43] and the choice of characters predestined for violence. The epic score by his father Carmine, together with the use of rock songs, whose text advances the narrative in Coppola's *Apocalypse Now* (1979), are intensely operatic elements.

Contemporary Italian American cinema has not yet been considered a specific cultural product and filmmakers and performers do not seem to perceive themselves as a homogeneous artistic community. Italian individualism plays a key role in this perception. However their work, with its multifaceted characters, has been able to address gender, social and racial tensions in contemporary America in articulated ways, proposing a less stereotyped image of Italian Americans. Their films represent, in a unique way, the complexities of emotional and affective life, the very elements that once were considered the "weak point" of Italian characters, subject to passions and emotions. This cinema, populated by interesting human beings, living out complex personal and social situations, does stand out in a panorama dominated by special effects, useless remakes and teenage spectacles.

The vitality of the *cultura italiana dello spettacolo* has been a constant in the history of American cinema since the silent film era. Today Italian American filmmakers and performers pay homage to this heritage through a return, not only cultural but also physical to Italy, for instance, the Coppolas, Turturro and the *Sopranos* (which has been a success on Italian television). Or by preserving it, as in the case of Martin Scorsese, who sponsored the preservation of *Santa Lucia Luntana* and *The Movie Actor*. It is a virtuous circle, which explains how the Big Wave of Italian American cinema is not a chance phenomenon, but one that is rooted in its own glorious past.

Further Reading

Bertellini, Giorgio. *Italy in Early American Cinema: Race, Landscape, and the Picturesque* (Bloomington: Indiana University Press, 2010).

Bondanella, Peter. *Hollywood Italians: Dagos, Palookas, Romeos, Wise Guys and Sopranos*. New York: Continuum, 2004.

D'Acierno, Pellegrino. "Cinema Paradiso: The Italian American Presence in American Cinema," in *The Italian American Heritage*, edited by Pellegrino D'Acierno. New York: Garland, 1999, 563–690.

Giuliana Muscio, Joseph Sciorra and Giovanni Spagnoletti, eds. *Mediated Ethnicity: New Italian-American Cinema*. New York: John D. Calandra Italian American Institute, 2010.

LaGumina, Salvatore. *Hollywood's Italians: From Periphery to Prominenti* (Amherst: Teneo Press, 2012).

Notes

1 On this subject see Giuliana Muscio, *Napoli / New York / Hollywood*, forthcoming from Fordham University Press.

2 Alan Gevinson, *American Film Institute Catalog: Within Our Gates: Ethnicity in American Feature Films, 1911–1960* (Berkeley: University of California Press, 1997).

3 Francesco Paolo Cerase, "L'onda di ritorno: i rimpatri," in *Storia dell'emigrazione italiana*, Partenze, 115; Donna R. Gabaccia, "Is Everywhere Nowhere? Nomads, Nations, and the Immigrant Paradigm of United States History," *Journal of American History*, 86.3 (December 1999), 1115–1134.

4 Trento's role in *Street Angel* (1928) was relevant, with his silhouette in the *carabiniere* uniform as a menacing shadow, following Angela (Janet Gaynor) in the streets of Naples. But since these scenes made fun of the *carabinieri*, the Italian regime cut them. This is why Italian critics never mention Trento's role in this significant film.

5 Gloria Ricci Lathrop, ed., *Fulfilling the Promise of California* (Spokane: California Italian American Task Force and the Arthur Clark Co., 2000); Andrew Rolle, *Westward the Immigrants* (Niwot: University Press of Colorado, 1999); and Simone Cinotto, *The Italian American Table: Food, Family, and Community in New York City* (Urbana: University of Illinois Press, 2013).

6 Italian comedies of the 1930s about the upper middle class were called *Telefoni Bianchi* because of their art deco interiors that featured "white telephones" into which the characters often spoke.

7 Mario Quargnolo, *La parola ripudiata* (Gemona: Cineteca del Friuli, 1986), 32.

8 See Emilio Franzina, "Italian Prejudice against Italian Americans," in *Mediated Ethnicity: New Italian-American Cinema*, ed. Giuliana Muscio, Joseph Sciorra, Giovanni Spagnoletti and Anthony Tamburri (New York: Calandra Institute, 2010), 17–32; and William J. Connell and Fred Gardaphé, eds., *Anti-Italianism: Essays on a Prejudice* (New York: Palgrave, 2010).

9 According to *The Film Daily* (25 May 1931). In the Homeric legend, Helen of Troy was "Queen of Sparta" before being kidnapped to Troy, hence the movie's title and the synchronization with the earlier film.

10 *Hollywood Filmograph* (5 March 1932).

11 Nelson Moe, *The View from the Vesuvius: Italian Culture and the Southern Question* (Berkeley: University of California Press, 2002); Tommaso Astarita, *Between Salt Water and Holy Water: A History of Southern Italy* (New York: Norton, 2005); Robert Lumley and Jonathan Morris, eds., *The New History of the Italian South: The Mezzogiorno Revisited* (Devon: University of Exeter Press, 1997).

12 Mark I. Choate, *Emigrant Nation: The Making of Italy Abroad* (Cambridge: Harvard University Press, 2008); Jacqueline Reich and Piero Garofalo, eds., *Re-Viewing Fascism: Italian Cinema 1922–1943* (Bloomington: Indiana University Press, 2010), Ruth Ben-Ghiat, *Fascist Modernities: Italy, 1922–1945* (Berkeley: University of California Press, 2001); David Forgacs and Stephen Gundle, *Mass Culture and Italian Society from Fascism to Cold War* (Bloomington: Indiana University Press, 2008).

13 Cinotto, *The Italian American Table*; and Edvige Giunta and Samuel J. Patti, eds., *"A Tavola": Food, Tradition and Community Among Italian Americans* (Staten Island: American Italian Historical Association, 1998).

14 Gianni Isola, *Abbassa la tua radio per favore . . .* (Florence: Nuova Italia, 1990); Stefano Luconi, "The Voice of the Motherland: Pro-Fascist Broadcast for the Italian-American Communities in the United States," *Journal of Radio Studies*, 8.1 (Summer 2001), 161–181.

15 Simona Frasca, *Birds of Passage* (Lucca: Libreria Musicale Italiana, 2010).

16 Giorgio Bertellini, "Sovereign Consumption: Italian Americans' Transnational Film Culture in 1920s New York," in *Making Italian America*, ed. Simone Cinotto (New York: Fordham University Press, 2014), 83–99.

17 Recent publications discuss the southern Italian contribution to American music: Luciano J. Iorizzo, "Jazz, the Early Years, and Eddie Lang," in *Italian Americans: Bridges to Italy, Bonds to America*, ed. Iorizzo and Ernest E. Rossi (Youngstown: Teneo Press, 2010), 183–208; Richard Sudhalter, *Lost Chords: White*

Musicians and Their Contribution to Jazz, 1914–1945 (New York: Oxford University Press, 1999); Marc Rotella, *Amore: The Story of Italian American Song* (New York: Farrar, Straus and Giroux, 2010).

18 Francis Coppola preserved his grandfather's collection in his mansion in Napa Valley and made it accessible to this writer.

19 He was a film distributor for American Biograph in 1908, and represented Italian Caesar Film in 1932.

20 Pasquale Scialò, ed., *Sceneggiata* (Naples: Guida, 2002).

21 The scene in *Godfather II*, where Peppino sings *Senza Mamma*, is actually an Intermezzo outside the narrative. A dialogue taking place in Naples reveals that Peppino did commit suicide.

22 Giuliana Bruno, *Streetwalking on a Ruined Map* (Princeton: Princeton University Press, 1993).

23 "There was an Italian colony in San Francisco, where Hal Mohr had the idea of setting up Italo-American Films in 1914 to make Italian subjects in America. He put his own money, and that of his father, into it: his main supporter was Johnny DeMaria, who owned most of the real estate on the old Barbary Coast." Quoting Kevin Brownlow, *Behind the Mask of Innocence* (Berkeley: University of California Press, 1990), 310.

24 Richard Koszarski, *Hollywood on the Hudson* (New Brunswick: Rutgers University Press, 2008); and Koszarski, *Fort Lee: The Film Town* (Rome: John Libbey CIC Publishing, 2004).

25 Elizabeth Ewen, *Immigrant Women in the Land of Dollars* (New York: Monthly Review Press, 1985); Donna R. Gabaccia and Franca Iacovetta, *Women, Gender, and Transnational Lives: Italian Workers of the World* (Toronto: University of Toronto Press, 2002).

26 Not to be confused with Mussolini. Giuseppe Musolino (1876–1956) was a brigand who was popular in the South and the subject of many folk tales.

27 Scialò, *Sceneggiata*, 135.

28 In the 1950s and 1960s Merighi acted in such American films as *Catered Affair* (1956) and *This Earth is Mine* (1959), and she also appeared on television.

29 Italian American Miriam Battista was a child star in silent cinema who acted in Albert Capellani's *Eye for Eye* (1918), Borzage's *Humoresque* (1920) and Sidney Franklin's *Smilin' Through* (1932).

30 See *Omaggio a Eduardo Ciannelli*, Premio Ischia, Lacco Ameno 31 May/1 June, 1984 and Ciannelli's biographies in *Filmlexicon* and the *Enciclopedia dello Spettacolo*.

31 According to the AFI's *Within Our Gates*, 33–34.

32 *New York Times* (4 October 1932).

33 Bongini was a star of the immigrant stage, appearing with the Compagnia Drammatica Siciliana Aguglia-Cecchini. He also appeared in silent films, such as *Humming Bird* (1924) with Gloria Swanson and Italian American William Ricciardi, and *A Sainted Devil* (1924), with Valentino and Nita Naldi.

34 Giuseppe Sterni had been part of important Italian companies, toured North and South America with Mimì Agulia, and directed several silent films in Italy. In 1926 he moved to New York and revived there his prestigious Teatro d'Arte, which premiered Pirandello in America. Sidney Howard chose him for the role of Tony in his play *They Knew What They Wanted*.

35 *Within Our Gates*, 758.

36 According to a review in the *Film Daily* (22 August 1932).

37 See Hermann Haller, *Tra Napoli e New York: Le macchiette italo-americane di Eduardo Migliaccio* (Rome: Bulzoni, 2006); Deanna P. Gumina, "Connazionali, Stenterelli, and Farfariello: Italian Variety Theater in San Francisco," in *Fulfilling the Promise of California*, ed. Ricci Lothrop, 157–168; and Nancy Carnevale's essay in Chapter 14.

38 Stefano Della Casa and Dario Viganò, eds., *Hollywood sul Tevere* (Cinecittà LUCE, Milan: Electa, 2010), 15–21; Hank Kaufman and Gene Lerner, *Hollywood sul Tevere* (Milan: Sperling & Kupfer, 1982).

39 Stefano Luconi, "Anti-Italian Prejudice in the United States," in *Mediated Ethnicity*, ed. Muscio et al., 33–44 (43).

40 The many films in which Gardenia appeared included *Where's Poppa?* (1970), *Little Murders* (1971), *Bang the Drum Slowly* (1973) with De Niro and Danny Aiello, *Death Wish* (1974), Warren Beatty's *Heaven Can Wait* (1978), *Firepower* (1979) with Sophia Loren, De Palma's *Home Movies* (1980), Blake Edwards' *Skin Deep* (1989) and the cult film *Little Shop of Horrors* (1989).

41 The list should continue with John Cazale, Michael Imperioli, Vincent Gallo, Rene Russo, Joe Pantoliano, Christina Ricci, Maria Bello, Greta Scacchi, David Caruso, Linda Fiorentino, Vincent Schiavelli, Anthony La Paglia, Lorraine Bracco, Joe Piscopo, Giancarlo Esposito, F. Murray Abraham, Tony Lo Bianco, Michael Rispoli, Michael Badalucco, Tea Leoni, Steven Van Zandt, Nicholas Colasanto, Santo Loquasto, Jeneane Garofalo, Jon Polito, Laura San Giacomo, Armand Assante, Robert Loggia. . .

42 Richard Alba, *Italian Americans: Into the Twilight of Ethnicity* (New York: Prentice Hall, 1985).

43 Giuliana Muscio, "Scorsese Rocks," in *A Companion to Martin Scorsese*, ed. Aaron Baker (New York: Wiley Blackwell, 2015), 259–276.

ITALIAN AMERICANS AND TELEVISION

Anthony Julian Tamburri

As one attempts to unfurl a history of Italians and/or Italian Americans in any of the major mediatic forms, what becomes apparent is that, by no means are they a paltry presence in cinema, music, or television; nor have they ever been, be it from the perspective of their actual presence or simply their mere representation in all media as portrayed by others. I make this distinction if only because it is difficult to find Italian actors on a large scale within U.S. cinema until the 1940s. Before then, except for someone like Rudolph Valentino or Eduardo Migliaccio, for the most part non-Italians portrayed Italians (read, also Italian Americans). "A problem?" one might ask. Although this is not the venue for such a discussion, let me simply suggest at this juncture that the lack of Italians in such roles, as well as in positions behind or beyond the camera, can surely create a vacuum when it comes to some sort of sensitivity vis-à-vis not just Italians in our case, but with regard to any group in question.[1]

Be it Anna Demetrio, Ezio Pinza or Madonna, Italian Americans have had a conspicuous presence on TV from its beginning, and, with the onset of the 1980s, they have also been present in music videos, even though, as we have seen over the years, their presence and representation in all venues have been debatable. Such debates have proven to be a constant, and, regardless of where one might stand on Italian anti-defamation, one can readily approach it from different viewpoints. As I have mentioned elsewhere,[2] a monolithic perspective may not be the most constructive of manners to carry forward the debate, if not at least mitigate it to some degree. Jonathan Cavallero, in turn, had indeed underscored as much a decade ago:

> In recent years, groups such as the American Italian Defense Association and the National Italian American Foundation have protested the depiction of Italians in the HBO television series *The Sopranos* (1999–2007) while ignoring most contemporary presentations of Italian ethnicity and even applauding the depictions of Italians in television commercials for Ragu, radio advertisements for Sprint PCS, and television programs such as the NBC series *Friends* (1994–2004). Such choices indicate a double standard on the part of these groups as they disparage the gangster but fail to provide the same degree of scrutiny for non-gangster Italian stereotypes.[3]

We may indeed question some of the more popular Italian American TV characters and shows that seem to populate the small screens and enjoy, even among Italian Americans, a certain privilege among viewers.[4]

Cavallero is correct to mention *Friends*, a show whose Italian American character is a dim-witted wannabe actor who, in the interim, goes around trying to pick up women with the least imaginative and, dare I say, stereotypical phraseology, "How ya' doin'?" But Joey Tribbiani is not the first in contemporary times to use such language in both lexicon and cadence. One need only recall Albert Herbert Fonzarelli, aka the Fonz, of *Happy Days*

(1974–1984). With similar tone and vocabulary, the Fonz was actually a successful mechanic who, as proved indeed to be his more able talent, was also a womanizer, though the term womanizer was never articulated.

This is what the audience of these two shows saw on a weekly basis vis-à-vis the late adolescent to thirty-something Italian male: attractive men with a seemingly limited vocabulary and exaggerated speech pattern who were part of professions that did not exhibit at first blush qualities of intellectual prowess. But the audience of *Happy Days* saw something else: one of two characters in the spin-off *Laverne and Shirley* (1976–1983), Laverne De Fazio, is depicted as a tough young woman who hangs out with tough guys—e.g., Fonzie—and is not afraid to pick up guys she does not know. Of the two, Laverne comes off as the more daring in her presumed sexual interactions with men. So, though appealing to some degree, these Italian Americans, especially in *Happy Days* and *Laverne and Shirley*, also exhibit negative stereotypes of both a threateningly violent (Fonzie) and sexual (Fonzie, Laverne) nature.[5] In the end, the Italian American remains steeped in the negative representation of these main characters.

A similar question mark might be raised about the ever popular *Everybody Loves Raymond* (1996–2005), in which mother and father, together with their two sons, might be seen to impute a certain amount of buffoonery and *fesseria* (foolishness) to Italian Americans, to continue with Cavallero's intuitive vocabulary. Ray Barone (Ray Romano's TV name), we come to understand early on, is anything but a "baron" in his own household. Stereotypes of overbearing women and meddling parents abound; this is especially true with regard to Ray's mother, who lives across the street and is often meddling into the younger couple's business and, as stereotypical as can be, proves to be the ever-doting mother to her son Ray.

Within this general context of popular "Italian" characters on TV, I would also remind the reader of another TV character whom the majority of the Italian American community has ignored. Jason Alexander's socially inept character, George Costanza on *Seinfeld* (1989–1998) is portrayed as a complete loser, someone who is constantly lying about his successes or lack thereof. That said, I am aware of the fact that this character, like many of the others in *Seinfeld*, often reflects the true-life experiences of the writers who were not Italian Americans. However, we cannot dismiss the semiotic juncture of more general, negative character traits that can readily be impugned to Italians by way of this character's surname, Costanza. As compared to other ambiguous surnames—e.g., Costello, which can also be Irish—Costanza is readily associated as an Italian name with very little to no room for equivocation, In fact, in some episodes he has even told people that he is Italian.

So then what can be done about such representation? Should anything be done at all? Or better, whose responsibility is it to check ethnic content in such situations? Surely, one might say it lies with the producers and actors of such TV programs. But let me suggest that it also lies with the Italian American viewing public as well as with the Italian American intelligentsia, and on an equal plane. It is the responsibility of this second group, especially—the cultural brokers of Italian Americana—to construct a discourse that is well researched and profoundly rigorous: one that examines all viewpoints in a respectful and non-dismissive manner, and, lastly, accessible to all.

We find ourselves almost through the second decade of the third millennium—one hundred thirty years after the onset of the great wave of immigration to the United States—and Italian Americans have yet to come together as one group—inclusive of all Italian Americans—and plan a rhetorical strategy and ultimately construct, once and for all, as Robert Viscusi has so eloquently articulated, a group narrative.[6] Such a narrative would, indeed should, also include the so-called *blasphemers* of Italian America such as Francis Ford Coppola and Martin Scorsese, or Mario Puzo, Al Pacino, and Robert De Niro, just to name a few of those

who seem to be left on the margins of courtly Italian America by its mainstream interlocutors.[7] Instead, what we still have at this time in our history is a group of small organizations or parts thereof that engage only in decrying what they consider to be negative representations of Italian Americans. Such an act of protest is surely warranted. How else might the non-Italian come to understand what offends? But the mere act of protest, or the seemingly successful receipt of a letter of apology, should not be the end game.[8] On the contrary, it should be the first step in a more concerted effort to counter such stereotyping. We cannot speak of the representation of Italian Americans in any of the media, especially in terms of negative stereotypes, without also discussing possible remedies to such depictions and what responsibility lies within the Italian American community.

Sitcoms, Drama, and Variety Shows

Italian Americans first appeared in primary roles on TV in the United States in 1950 with two shows. Frank Sinatra debuted with his variety show, *The Frank Sinatra Show* (CBS, 1950–52), which he later revived on other occasions.[9] Anna Demetrio, in turn, appeared as Mama Rosa in a short-lived sitcom (*Mama Rosa* [ABC, 1950]) set in a Hollywood boarding house that catered to theater people. These two shows are intriguing for a number of reasons. First, the variety show stars the Italian American crooner par excellence of the era, and, in turn, the sitcom deals with an Italian American female whose storyline is set within the world of entertainment. Such self-reflexivity should not be lost on the reader at this juncture. Early on we saw on television the relationship between Italian Americans and the entertainment world; we did not see this, instead, in the early years of U.S. cinema.

Much more popular, and still alive in the memory of many Italian Americans are two programs: *Life with Luigi* (Figure 27.1) and *Bonino* (1953; widower Bonino played by Ezio Pinza). These are two shows that portrayed single fathers, each of whom was Italian, raising children. In this case, we have both the non-Italian and Italian actor in the major role, a slightly different practice from the absence of the Italian or Italian American actors at the beginning of cinema's century-long existence in the United States. These two shows underscored positive characteristics that countered a plethora of Italian stereotypes that abounded within U.S. society. As such, episodes of *Life with Luigi* often took place during Luigi's English classes, punctuating his desire to learn the language of his host country, in order to acculturate, we might say.[10] Babbo Bonino, in turn, abandons his opera career after his wife's death in order to attend to his six children, even though they seemed more self-sufficient than he has initially realized. Both roles represented positive, concerned family men willing to make sacrifices for the betterment of their family. Further still, both shows, we might presume, laid the groundwork for a much more successful program that was to begin only seven years later, *My Three Sons* (1960–1972).

Yet, in spite of the previously mentioned and other positive programs of the time, there were outcries over the negative portrayal of Italians and Italian Americans on the small screen. One of the earlier occasions of the stereotype was the "Latin lover," as portrayed in *The Continental* (CBS & ABC, 1952–53). A nickname of the suave, debonair, Italian-born Renzo Cesana, he was promoted as an Italian count and member of Rome's high society. To quote one later description of the character and his show, "In reality, *The Continental* was a video gigolo whose job was to 'woo' the bored housewife with 15-minutes of intriguing conversation (one-sided as it was)."[11] So, though we still have to wait a few years for the most popular of stereotypes vis-à-vis Italians and Italian Americans in the United States—i.e., the Mafia—as with film, the over-sexed Italian is introduced early on into the medium of television.

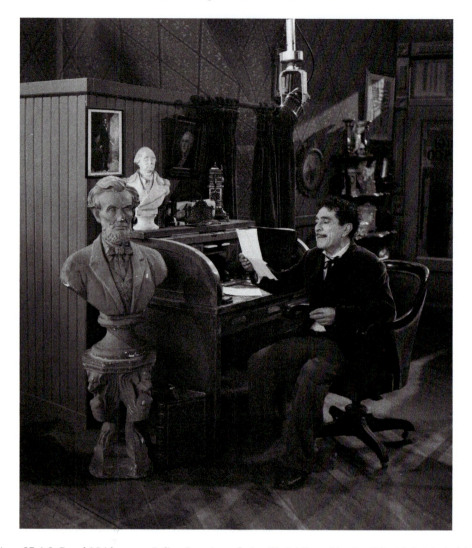

Figure 27.1 J. Carrol Naish, a non-Italian American playing "Luigi Basco" in the *Life with Luigi* television series. New York City, 4 April 1952. CBS/Getty Images.

Indeed, the show that most likely contributed to "Mafia" stereotyping on TV was *The Untouchables* (1959–63), a series that highlighted the criminal element of Chicago during the roaring twenties, with Al Capone and Frank Nitti as staple hoodlums, thus adding to the mythology of Italian Americans as Mafiosi. These are programs that have occasionally been referred to as "cops and wops" shows. *The Untouchables*, to a certain degree, is the television analogue to the earlier feature-length films *Little Caesar* (1930) and *Scarface* (1931). Like these two movies, *The Untouchables* hit a nerve with Italian Americans at the time. Frank Sinatra saw it as negative representation of Italian Americans;[12] reputed mobster Anthony Anastasio, paradoxically, picketed ABC, convincing Liggett and Myers Tobacco to drop its sponsorship of the show.[13] The result was a de-emphasis on Italian Americans as gangsters and an increase of attention to the many Italian Americans who fought criminal activities in the United States, which included, in the show's case, more light shed on the role of Eliot Ness's right-hand man, Rico Rossi.

Though the situation seemed to change in the aftermath of such things as the aforementioned rebirth of ethnic sensitivity in the 1960s, due primarily to the Civil Rights movement, Italian Americans continued to appear on a fairly regular basis in a negative role: gangster, villain, buffoon, inarticulate, blue-collar worker only. Light at the end of the tunnel, however, appeared in the form of the policeman or detective: and here the list goes from *Columbo* (1971–1978, 1989–2003) to *Toma* (1973–1974), from *Baretta* (1975–1978) to *Petrocelli* (1974–1976), culminating in some ways with Captain Frank Furillo (Daniel Travanti) of *Hill Street Blues* (1981–1987). *Toma* was based on true-life police officer, David Toma, an extremely successful undercover cop. What also distinguishes this show from most others of this type is that Italian American Tony Musante played Toma. We had an Italian American in the role of a famous, popular real-life police detective. *Toma* only ran for one season; Musante declared from the outset that he would only do it for one year. The show was followed by yet another Italian American detective, this time, Anthony Vincenzo Baretta, lead character of *Baretta*. Not the most articulate of TV characters, Baretta's speech pattern might be questionable vis-à-vis Italian Americans. I have in mind his dentalization in such phrases as "You can take dat to the da bank," for instance.

At the same time, the series *Columbo* enjoyed sustained popularity. A somewhat scruffy wardrobe that included nevertheless suit, tie, and his trademark wrinkled raincoat, Columbo was more articulate than his TV colleague Baretta and, in his own manner, a much more thoughtful detective who, through his seemingly rambling manner of thinking aloud, was acutely adept at solving crime. His *brutta figura* (his superficial scruffiness), in fact, led to his success. His viewer, we can confidently state, was witness to a thoughtful analysis of how to solve the episode's crime, showing Columbo, in the end, as a most able detective.

Another most qualified law enforcement agent, this time in the role of captain, was Frank Furillo of *Hill Street Blues*. Played by Daniel Travanti (see Figure 27.2), Captain Furillo was one of a few Italian American characters in the series, the others usually in lesser roles: Fay Furillo, officer Tina Russo, officer Sal Benedetto, officer Robin Tataglia, detective Harry Garibaldo and Gina Scrignoli, for instance. Frank and his wife Fay, however, were the constants; he often dealing with her for family reasons, they having had a son together. Furillo, we saw, was the consummate detective. Debonair in his dress and articulate in speech, he lived by a certain code of ethics that seemed to guide him well through his daily life. His secret relationship with assistant district attorney Joyce Davenport was a curious one. Both not married, because of their professional positions, they could only continue their relationship unbeknownst to all. Her moniker for him, "Pizza Man," was the constant that reminded viewers that Furillo was indeed Italian. But this was not the only biographical fact Travanti displayed as Furillo: as "pizza man," we are reminded of his working-class roots. Further, like Travanti in real life, Furillo was a recovering alcoholic who also attended AA meetings.

Italian Americans populated other TV worlds. In the 1970s and 1980s we found ourselves reliving the 1950s and 1960s with the previously mentioned *Happy Days* and *Laverne and Shirley*. We also witnessed during this time a new generation of single parents such as Joe Vitale (Richard Castellano) and Ann Romano (Bonnie Franklin). *Joe and Sons* (1975–76) is a clear continuation of what we saw in the 1950s with *Life with Luigi* and *Bonino*. Here, too, we have a widower who dedicates himself to his sons' welfare. Though there was no live-in helper in this series; rather there was a female neighbor who helped Joe in certain situations. Dealing with issues of the day, themes such as the existence of God, teen sexuality, and marijuana became topics some episodes explore.

Also dealing with a single parent, *One Day at a Time* (1975–84) debuted the same year and, one might say, proved bolder in social issues in presenting a single mother who is divorced,

Figure 27.2 Daniel J. Travanti playing "Captain Frank Furillo" in the *Hill Street Blues* television series, 1984. Photo: AF archive/Alamy Stock Photo.

not widowed, and has two teenage daughters. This general scenario laid the groundwork for the show to deal with more pressing issues of the times, especially those dealing with gender issues that surround both young women—i.e., the two daughters—and more mature women—i.e., the mother, Ann Romano.

As we move forward in the years, we find more professionals alongside working-class Italians. Ernest Borgnine is Dominic Santini, an Italian American helicopter pilot who owns an Air Charter Service (*Airwolf* [CBS & USA, 1984–1988]). In *Family Law* (1999–2002) Tony Danza is lawyer Joe Celano, a Brooklyn-born Italian American in a Los Angeles-based law firm. Consonant with Italian Americana, he specializes in labor law with a special sympathy for the underdog. In similar fashion, Mark Ruffalo is an Italian American beat cop in *The Beat* (UPN, 2000). Law enforcement Italian Americans continued to abound. Michael Chiklis played Tony Scali on *The Commish* (1991–1995); and Jon Polito, in turn, played detective Steve Crosetti in *Homicide: Life on the Street* (1993–1999). We may look to the *Law and Order* franchise, however, that has truly included numerous Italian Americans among law enforcement. The original *Law and Order*, which began in 1990, included Phil Cerreta, Joe Fontana, Nick Falco and Alexandra Borgia as regular characters. The various spin-offs—*Law and Order: SVU*; *Law and Order: Criminal Intent*; *Law and Order: Trial by Jury*; *Law and Order: LA*—have also included Italian Americans among their characters, including detectives Dominick Carisi and Nola Falacci.[14]

Of course, no discussion of Italian Americans on television can ignore David Chase's drama series *The Sopranos*, which ran from 1999 to 2007 on HBO. Having won a plethora of

awards, the series has been considered by many as the greatest of all time. One apparent original aspect of the show's casting is that Italian American actors portrayed the majority of the series' Italian American characters. Further still, a number of actors hired for some primary and secondary roles subsequently became better known to the public at large and, as a result, actually spring-boarded from *The Sopranos* to other shows. Nonetheless, given the show's premise—an Italian American mobster and his trials and tribulations both at home and at work—the show has been criticized often, especially from members of the Italian American community both within and outside the academy. A series of Italian American community organizations vilified both the show and its creator David Chase, whereas within the academy Camille Paglia stated that though "the Mafia theme per se did not" offend her, she found an "inaccuracy with which Italian-American culture was depicted"; so much so that when she first turned on one of the episodes, within minutes she felt like "throwing a brick through the screen."[15] David Chase, in turn, defends *The Sopranos* as a "show [that] reflects 'a kind of reality,' a tiny subculture and is not meant to stereotype all Italian-Americans."[16]

Moving on from the sitcom and the drama, we come to the one TV genre in which Italian Americans abounded with great success: the variety show. Numerous are the names of those who had their own shows as well as those who were regulars not just on the Italian American variety show; they also appeared often on other shows such as the canonical *The Ed Sullivan Show* (1948–1971).[17] These include Tony Bennett, Perry Como, Jimmy Durante, Dean Martin, Julius La Rosa, Liza Minnelli, Henry Mancini, Guy Lombardo, Frank Sinatra and, last but not least, Sonny Bono.

Como, Sinatra and Martin, for example, each had successful runs of variety shows that featured theirs and other non-Italians' singing talents: *The Perry Como Show* (1948–1963), the aforementioned *Frank Sinatra Show* (1950–1952) and *The Dean Martin Show* (1965–1974) spanned more than a quarter century of Italian American variety shows, at times overlapping. In other instances, Italian American entertainers like as La Rosa and Minnelli were frequent visitors if not regulars on other people's variety shows. Guy Lombardo ushered us into many a New Year; and Henry Mancini serenaded us through his numerous scores for TV. Finally, Sonny Bono, along with his wife Cher, transformed the classic variety show into what was considered a more "hip" rock'n roll show with *The Sonny & Cher Comedy Hour* (1971–1974). (See Color Plate 23.) The show included a series of regular skits, one being "Sonny's Pizza," a pizza place that, paradoxically, had terrible food. There is also an interesting extra-mural ethnic referent to *The Sonny & Cher Comedy Hour.* Although Cher's father was Armenian, her mother, who was of mixed European ancestry, claimed also to be part Cherokee. Cher's hit song "Half-Breed" reinforced the notion that she was in some manner Native American, to the point that it became embedded in the *Comedy Hour*'s DNA. Sonny and Cher's act was strikingly reminiscent of the act of a genuine Italian American–Native American duo: Louis Prima and Keely Smith. In both cases, the man played the comic and the woman the so-called straight person. Placing videos of both acts side by side underscores such uncanny similarities.

Music Videos and Beyond

The world of music videos and Italian Americans—here I use 1981 (the launching of MTV) as my point of departure—conjures up, first and foremost, Madonna (with Lady Gaga in Color Plate 28). From her earliest video performances and/or productions of the 1980s to today, Madonna continues to push the envelope, challenging all notions of traditional thought and often investing her work with themes central to Italian Americana. Of the numerous things Madonna calls to the fore is how little society tends to tolerate ambition (and success) in women. Too sexual; too provocative; too much skin; provocative clothing;

undergarments as outerwear; little boys in peep shows; women in submissive positions; etc. The litany is ever long. A Madonna video back in the late 1980s and early 1990s—*Like a Prayer* (1989) and *Justify My Love* (1990) especially—often exudes a female *sui generis* ideology independent of the usual patriarchal control. This female ideology defies the typical male gaze in not affording the male his usual position of control. In a Madonna video, in fact, if the male does gaze, his control of the gaze is often reappropriated by Madonna the protagonist.[18]

Sexuality constitutes both a prominent and problematic theme of Madonna's music/ performance. Religion and race also play equally important and integral parts in her videos. In the first video mentioned, *Like a Prayer*, all three themes reoccur: sexuality, religion and race. They serve as integral components of Madonna's *visione del mondo* and figure, at the same time, as reasons for which some of her videos ruffle the dominant culture's feathers.[19] Thus it is that sexuality, religion and gender combine with race to form a radically different perspective, which now surpasses in its provocative nature most of the so-called *mainstream* videos that have thus far appeared. The second video, *Justify My Love*, abandons the religious theme, bringing to the fore notions of sexuality, race and sexual orientation. Together, both videos offer a *visione del mondo* that transgresses and rejects all that is traditional, conformist and racially masculinist.[20]

Madonna had already pushed the envelope with earlier videos, some of which we can readily identify as Italian American. Take, for example, her *Like a Virgin* (1984), shot entirely in Venice with a thematic underpinning that calls to the fore Catholic notions of sexuality. Similarly, *Papa Don't Preach* (1986), much more of a "narrative" video, examines out-of-wedlock pregnancy; and as if to underscore the ethnic, Italian American tone, we see the ever familiar Italian American actor Danny Aiello in the role of the father. Finally, *Open Your Heart* (1986), a video set in a peep-show ambience, has Madonna, initially a stripper being watched by the little boy, ultimately and literally skip off into the sunset with her child voyeur, both dressed alike in a type of children's suit and derby hat. What then underscores an Italianness to this video, which to this point had obviously played off the theme of sexuality bordering on porn, is the appearance of the old man whose voice we do not hear but whose words appear as subtitles at the bottom of the video: "*Madonna, Madonna, ritorna, ritorna! Abbiamo bisogno di te!*" (Madonna, Madonna, come back, come back! We need you!).

Indeed, Madonna is not alone in this celluloid world of music. Jon Bon Jovi (originally Bongiovi) and Steven Tyler (originally Talarico, of Aerosmith) are two of the many rock singers of Italian descent who have inhabited over the years the music video world. Though overt Italian signs seem not to be necessarily present, themes such as the working class, the "old neighborhood," and the like also populate a good number of their videos. Other performers continue to abound, and one of the most prominent, alongside Madonna, is, of course, Bruce Springsteen, also known for both his sociopolitical and working-class thematics, issues that have proven to be significant within the social history of Italians (read, also Italian Americans) in twentieth-century America. When Bruce Springsteen broke onto the national scene in 1975, he had reverted to a type of rock & roll, blending different styles of the preceding two decades into his *own sui generis* working-class music. This, combined with later songs like "Born in the USA," could only solidify his status as full-blooded American in all that this entails, investing his songs with the everyman's sense of ethics. Jon Bon Jovi, in turn, founded the hard rock band Bon Jovi, which went on to win numerous awards and accolades. Like his predecessor from New Jersey, Springsteen, Bon Jovi informed much of his music with working-class sensibilities. Also similar to Springsteen, Bon Jovi went out on his own, with the album *Blaze of Glory* (1990), only to return, again like his New Jersey predecessor, to reformulate Bon Jovi the band. In both singers there is an uncanny resemblance in *modus*

operandi in their ability and desire to have launched a solo career yet also remain faithful to their respective bands, their metaphorical "tribe," if you will, sticking ever close to the group in spite of the occasional solo act. A general difference, I would contend, between these artists and the likes of a Madonna, for instance, is that a good number of her videos are indeed narrative structures similar, I believe, to a good number of Michael Jackson's videos, which tend to be much more of a narrative act than mere filmic rendition of a musical performance.[21]

Analogous to the wannabe phenomenon of the 1980s that surrounded Madonna, Gwen Stefani, first lead singer for No Doubt and now soloist, has had her imitators as well. Her in-your-face attitude of self-control of her own body and an accompanying, playful defiance of a type of anti-gaze were apparent from the beginning of her presence within the world of music videos. Madonna-like in an uncanny manner, we need not ignore the likeness in dress, hair and, to some degree, sound—such as her occasional borrowing from other artists, including the singer from Detroit—of what we had already witnessed in Madonna, especially during the second half of the 1980s and the early 1990s. Truly brought to another level with much more flamboyance both in dress and in performance, Lady Gaga first appeared on MTV back in 2005. At that time, she was still Stefani Germanotta on MTV's *Boiling Points*, when she was disqualified because of ill-tempered language. Of course, not too long thereafter, she was to debut as Lada Gaga with her album *The Fame* (2008), which met with immediate critical success. In subsequent years she appeared on MTV garnerning a series of awards.

Finally, let us not forget those who predated the world of music videos and yet, through longevity and rediscovery, have also been present. Here, I would mention a few "classics" who have appeared, if ever so briefly, on MTV and other video outlets: Jim Croce, Dion (as soloist as well as with Dion and the Belmonts), Connie Francis, Frankie Valli (and the Four Seasons) and Frank Zappa.

Scholarship on Italian Americans in Television

The world of television and Italian Americans enjoys a history similar to that of the silver screen.[22] From the outset of the television age, Italian Americans have been a presence both in front of and behind the camera. The literature with specific regard to Italians on TV is scant. In addition to John Lent's entry in *The Italian American Experience*,[23] the only other specific study is the hard-to-find *Italian American Characters in Television Entertainment*, co-authored by Robert and Linda Lichter.[24] Finally, there is a website that lists the various shows in which "Italian" characters have appeared since the onset of television in the United States. Entitled "Italian (Includes Sicilians)," this site claims to be approximately 90 percent complete.[25]

Such a paucity of studies dedicated to Italian Americans on TV emphasizes, to be sure, two general issues: (1) the seemingly ever-existent problem of scarce attention paid to the Italian American vis-à-vis his/her American status, and (2) the very lack of interest that seems to exist within the Italian American community in such a distinction. If the latter does indeed obtain, we surely cannot lament the former; if members of the very community do not engage in critical studies, how then can we expect members of mainstream to do so, since it is our responsibility initially to impart knowledge of our own culture. There is, for sure, a plethora of cultural critics—journalistic and academic—whose ethnic heritage is Italian and who find themselves in positions of authority. The issue is that they do not seem to pay homage to their heritage as, for instance, other "ethnic" cultural critics seem to do. Indeed, the question of self-identity may contribute to the situation. Namely, Italian Americans tend to self-identity as Americans and Italian Americans, contributing, possibly, to the practice of not always emphasizing the ethnic.

The amount of creative, cultural productions is innumerable, whereas the number of critical studies, especially books, remains small. The end result, of course, is that we are left with a dearth of sustained studies of Italians on TV. What we find, instead, is a series of books on management, life style, philosophy, cooking and the like based on *The Sopranos*. Even the very few that are serious in intent, such as Regina Barreca's *A Sitdown with The Sopranos*, raise a plethora of questions. Why, for instance, just *The Sopranos*? Cannot—indeed, should not—a show of this nature provoke more general questions about the overall representation of Italians and Italian Americans on television? The risk of books such as Barreca's, even in their seriousness, is that they willy-nilly reinforce old stereotypes, especially when they open with sentences as the following: "A signature phrase of *The Godfather*, the gun/cannoli line is emblematic of what Tony and his family are fitfully trying to accomplish in *The Sopranos*: they want to seize what is best of Italian American culture—the appetites, the passions, the affections, the humor—while leaving behind on the table the bitterness, the alienation, the crime, and the violence."[26] I would submit that the best of Italian American culture includes more than the "appetites, the passions, the affections, the humor." As I have stated elsewhere,[27] more work lies ahead.

Lent's contribution is a typical encyclopedic entry that offers a history and, as best one can, an analysis of the presence of the many Italian Americans on TV. Robert and Linda Lichter's analysis looks at the Italians on TV through 1982, demonstrating how TV has continued to perpetuate a stereotype. Andrew Brizzolara's article, in turn, speaks to the stereotype and how it might have had a negative impact on, for instance, Italian American youth. He bounces off of two essays from the earlier-cited Miller collection, underscoring TV's continued depiction of negative imagery of Italian Americans. Citing the late New York State Senator John D. Calandra, young Italian Americans run the risk of suffering the "emotional handicap of a negative self-conduct," having been assailed by so many negative stereotypes.[28]

To its own admission, the web-site "Italian (Includes Sicilians)" claims to be approximately 90 percent complete. The site consists of short descriptions of the many TV programs that dealt with, directly and indirectly, the figure of the Italian and Italian American since the advent of television. The basic information the reader culls from it offers a nice snapshot of what was being aired on TV, especially during the early years. Thus, as we saw earlier, Italian Americans first appeared in primary roles on TV in the United States in 1950 with Frank Sinatra and Anna Demetrio. We also found entries on *Life with Luigi* and *Bonino*, shows discussed earlier. Information about these and other television shows is readily available from this website "The Italians." Its thought-provoking "Includes Sicilians" (in parentheses), we need to remember, underscores, I would contend, the ignorance of the North American mind-set in wanting to distinguish Sicilians from Italians. This alone presents a major challenge and, at the same time, complicates the larger issue of negative imagery.

An essay that deals with both film and television, Woll and Miller's "The Italians" both rehearses a history of the representation of Italians and Italian Americans and provides an in-depth bibliography through the mid-1980s when the essay was completed.[29] Constructed as it is, this binary view of the two media nicely offers a dual perspective on the history of the visual representation of "Italians" in the movies and on the TV. The authors are exhaustive in both bibliography and criticism. They offer an analysis of the literature on the movies as well as an analytic reading of the more popular films about Italian Americans. What comes through in the end is a keenly sensitive, rigorous reading of the Italian American visual depiction on both the silver screen and television.

Literature on the presence of Italian Americans in the world of music videos is scant, to be sure. Though there are a few essays or journalistic articles on various entertainers of Italian descent within this medium, anything of substance with particular regard to Italian

Americans has yet to be drafted.[30] We are left, instead, with the task of piecing together an overview by gathering the various single elements available to us.

End Thoughts

The actors and other types of entertainers who appeared on the small screen, too numerous to mention here, contributed on the whole to a positive imagery of the Italian American, if only because there is no overabundance of the gangster, small-time hoodlums, or dimwit; or, in the case of the female, not relegated solely to the role of wife, factory worker or gum-snapping girlfriend.

Though one might argue that the Italian American has much more control of his/her image, for example, in the world of music videos, the same might not necessarily be true for both the large and small screens of entertainment. And though it might also be argued that the negative depiction of Italians and Italian Americans has been mitigated to some degree by the new ethnic sensitivity that seems to have its origins in both the Civil Rights of the 1960s and the mega-success of the TV serial *Roots* in 1977, one might counter such argument by pointing to some of the movies by Coppola and Scorsese—especially *Goodfellas* (1989) and *Godfather III* (1990)—and the more recent portrayals we saw in *The Sopranos*.

The website "Italians (Includes Sicilians)" lists 209 shows in which Italians and Italian Americans have appeared either in major or minor roles on television. As with cinema and music videos, the opportunities seem innumerable, the showcasing frequent. But it is the *type* of portrayal that has now taken on greater significance, and rightfully so; as we have well entered into this age of identity politics and subsequently crossed over the threshold into the second decade of the twenty-first century, the issue of ethnicity begs numerous questions among which we find, first and foremost: Who can represent the ethnic and what are the boundaries this person should not transgress, if any? The jury is surely out on this matter, as it is still out on the matter of the degree of validity of such arguments, since one might indeed resort to the old adage that "bad" publicity is better than no publicity at all, further lending fuel willy-nilly to the ongoing debate.

Indeed, within the United States mainstream the Italian American has enjoyed a great deal of success, be it in business, education, the scientific community, and politics, to list just a few of the major arenas in society at large. The issue we might still need to revisit is the seemingly inexplicable disconnect between the magnitude of such successes and the restricted horizon of the collective imaginary vis-à-vis visual culture in the United States. There is, indeed, room for more book-length studies on a variety of themes; and the rigor of such future books should surpass, by all means, much of what we have seen thus far. This need is, to be sure, more pressing for the figure of the Italian and Italian American on television. A variety of images have, throughout the years, been considered "positive" only because they did not underwrite the Mafia figure. Nevertheless, some of these seemingly positive portrayals might end up proving just as damaging. At the outset of this overview I mentioned George Costanza from *Seinfeld*; a more cumbersome figure would be difficult to create. He is socially awkward, self-loathing, stingy, neurotic and dominated by his parents, characteristics readily associated with the Italian "*mammone*" (mamma's boy). In turn, such buffoonery, simplicity of thought, and, to some extent, goofiness proved to be part and parcel of the Italian family of *Everybody Loves Raymond*. The question then becomes one of choice, measure and comprehension: namely, what do we choose to accept or reject; how and in what way do we critique what we choose to reject; and how do we deal with those who decide to depict such figures on either the large or small screen. These are the issues that have not yet been explored in a rigorous, dispassionate manner, for the most part; and it is precisely such objectivity that we need to make part of our interpretive arsenal.

Further Reading

Bondanella, Peter. *Hollywood Italians: Dagos, Palookas, Romeos, Wise Guys, and Sopranos*. New York: Continuum International Publishing Group, 2005.

Cavallero, Jonathan J. and Laura E. Ruberto, eds. Special Issue of the *Italian American Review* on "Italian Americans and Television," 6.2, (Summer 2016).

Miller, Randall M., ed. *Ethnic Images in American Film and Television*. Philadelphia: Balch Institute, 1978.

Tamburri, Anthony Julian. *Re-Viewing Italian Americana: Generalities and Specificities on Cinema*. New York: Bordighera Press, 2011.

———. *Italian/American Short Films & Videos: A Semiotic Reading*. West Lafayette: Purdue University Press, 2002.

Notes

This overview has its origins in three previous essays of mine on the subject, which were separately published over a five-year span (see notes 2 and 27 and Anthony Julian Tamburri, "The History of Italian Americans Film and Television Studies," in *Teaching Italian-American Literature, Film, and Popular Culture*, ed. Edvige Giunta and Kathleen McCormick (New York: MLA, 2010), 59–69. I have added herein critique of a series of sitcoms, dramas and other programming that I could not add in the past.

1 Italian Americans were also abundant behind the camera. In the earlier days of television we find technical director O. Tamburri, who worked from 1953 (*The Goodyear Playhouse*) to 1990 (*The Golden Girls*). And how uncanny that he ends his career with this show, four women inclusive of a mother-daughter team of Sicilian origins. More recently, from *House of Cards* (2013) we find set director Tiffany Zappulla and executive producers John Melfi and Dana Brunetti, for instance. So it is not just the actors or directors, but Italian Americans have and continue to be quite numerous in various positions behind the camera as well.

2 Anthony Julian Tamburri, "Italian Americans and the Media: Cinema, Video, Television," in *Giornalismo e letterature tra due mondi*, ed. Franco Zangrilli (Caltanissetta: Sciascia, 2005), 274–93; Tamburri, *Re-Viewing Italian Americana: Generalities and Specificities on Cinema* (New York: Bordighera Press, 2011).

3 Jonathan J. Cavallero and George Plasketes, "Gangsters, Fessos, Tricksters, and Sopranos: The Historical Roots of Italian American Stereotype Anxiety," *Journal of Popular Film and Television* 32.2 (Summer 2004), 50–73.

4 For my use of the slash (/) in place of the hyphen (-), see Tamburri, *To Hyphenate or Not to Hyphenate: The Italian/American Writer: An Other American* (Montreal: Guernica Editions, 1991).

5 Although it is true that the role of the over-sexed Italian American is reserved mostly for the male, Laverne in the 1970s and Carla Tortelli of *Cheers* (1982–1993) were two highly sexual females. Though divorced and the mother of four children, Carla continues to bed her ex-husband among others, and has had four more children along the way. A most curious fact is that while her children are basically an unruly bunch, one is not; he is the child of a very successful professor.

6 Robert Viscusi, "Breaking the Silence: Strategic Imperatives for Italian American Culture," *Voices in Italian Americana*, 1.1 (1990), 1–13.

7 I have already dealt with this notion of an inclusive concept of Italian/American cultural studies in a previous venue: Tamburri, *A Semiotic of Ethnicity: In (Re)cognition of the Italian/American Writer* (Albany: SUNY Press, 1998).

8 In some cases, the letter of apology expressed "sorrow" at the fact that Italian Americans were offended, not that what the writer did was offensive. An insignificant difference, one might muse? Not by any means!

9 Subsequently, he hosted the variety drama *The Frank Sinatra Show* (ABC, 1957–58); and the musical variety shows, *The Frank Sinatra Times Show* (ABC, 1959–60).

10 On the radio show *Life with Luigi*, which preceded the television show, see Dominic Candeloro, "What Luigi Basco Taught America about Italian Americans," in William J. Connell and Fred Gardaphé, eds., *Anti-Italianism: Essays on a Prejudice* (New York: Palgrave Macmillian, 2010), 77–85.

11 See "Italian (includes Sicilian)," www.tvacres.com, whose author tells us that the "series inspired 1950s comedian Ernie Kovacs to do a parody called 'The County-Nental' about a country-bumpkin gigolo who wore overalls, and poured moonshine from a jug. Whereas Renzo Cesana would say, 'Don't be afraid, darling, you're in a man's apartment,' The County-Nental would look into the camera lens and with whisky-soaked breath say 'Don't be feared, this is only a man's silo.' Both comedian Billy Crystal

and later actor Christopher Walken revived this romantic character on skits written for NBC's *Saturday Night Live*." Harry Castleman and Walter J. Podrazik, *Watching TV: Eight Decades of American Television*, 3rd ed. (Syracuse: Syracuse University Press, 2016), stated the following (70): "One of the worst shows was CBS's gauche attempt at sophistication, *The Continental* . . . One critic labeled this [show] 'the most needless program on television.'"

12 Gay Talese, "Frank Sinatra Has a Cold," *Esquire* (April 1966), 27.

13 This second protester recalls the subsequent Italian-American Civil Rights League, founded in 1970 by Joseph Colombo to protest his son's arrest for extortion.

14 Nick Amaro is a popular character on *Law and Order: SVU*. But it is unclear whether he is Italian or Latino, even though he speaks Spanish. He does, nonetheless, struggle occasionally with issues of Catholicism.

15 Kerry Lauerman, "In "Glittering" return, Paglia lets loose." See www.salon.com/2012/10/10/camille_paglias_glittering_images/

16 Jeffrey C. Mays, "Italian-American Targets Stereotypes," *Newark Star-Ledger* (20 May 2001).

17 In this regard, one must not forget Ed Sullivan's occasional sidekick Topo Gigio, the Italian mouse dressed in black, who spoke English with an Italian accent.

18 E. Ann Kaplan, "Feminist Criticism and Television," in *Channels of Discourse*, ed. Robert C. Allen (Chapel Hill: University of North Carolina Press, 1987), 211–253.

19 Today, to be sure, the notion of "dominant culture" or "canon," as we knew it until not so long ago, may now be placed into question: Who are the members of the dominant culture? What constitutes the canon today as opposed to ten or twenty years ago? These questions notwithstanding, I shall use these terms as aesthetic points of comparison in so far as for "dominant culture" or "canon" I understand that which is considered *correct, right, artistic*, etc. by that community of people that has the power to decide (read, impose?) such issues.

20 For more on these two videos, see Tamburri, *Italian/American Short Films and Videos*, 55–75.

21 By "narrative" video, I refer more to those music videos that actually contain a story line of sorts, as opposed to a mere celluloid representation of a musical performance.

22 For an overview, see Tamburri, *Re-Viewing Italian Americana*, 13–59.

23 John A. Lent, "Television," in *The Italian American Experience: An Encyclopedia*, ed. Salvatore J. LaGumina, Frank J. Cavaioli, Salvatore Primeggia and Joseph A. Varacalli (New York: Garland, 2000), 625–628.

24 Robert and Linda Lichter, *Italian American Characters in Television Entertainment* (West Hempstead: OSIA, 1982).

25 The complete listings can be found at the website, www.tvacres.com, which brings the surfer to the webpage www.tvacres.com/ethnic_italian_a_e.htm, which then directs to three subsequent pages. A webpage named with the thought-provoking "(includes Sicilians)"—in parentheses—only underscores, I would contend, the ignorance of the North American mind-set in wishing to distinguish Sicilians from Italians.

26 Regina Barreca, *A Sitdown with The Sopranos: Watching Italian American Culture on TV's Most Talked-About Series* (New York: Palgrave, 2002).

27 Anthony Julian Tamburri, "A Contested Place: Italian Americans in Cinema and Television," in *Teaching Italian-American Literature, Film, and Popular Culture*, ed. Giunta and McCormick, 209–216.

28 Andrew Brizzolara, "The Image of Italian Americans on U.S. Television," *Italian Americana*, 6.2 (Spring/Summer 1980), 160–168.

29 Allen L. Woll and Randell M. Miller, *Ethnic and Racial Images in American Film and Television: Historical Essays and Bibliography* (New York: Garland, 1987), 275–307 ("The Italians").

30 Robert Connolly and Pellegrino D'Acierno, for instance, have an exhaustive piece on Italian American musical culture, but it does not directly address music videos per se. See their "Italian American Musical Culture and Its Contribution to American Music," in D'Acierno, ed., *The Italian American Heritage*, 387–490.

ITALIAN AMERICANS IN SPORT

Lawrence Baldassaro

Not bad for two immigrants.
—Diana Taurasi to coach Geno Auriemma following their gold medal victory
in basketball at the 2016 Summer Olympics in Rio de Janiero[1]

The vast majority of Italians who immigrated to the United States in the late-nineteenth and early twentieth centuries brought with them no sporting tradition other than *bocce*. Yet sports would come to play a significant role in the integration of Italian Americans into mainstream society, so much so that the legacy of Italian Americans in sports includes some of the most notable figures in the history of American popular culture. The extent of that legacy is tangibly evident in the National Italian American Sports Hall of Fame in Chicago. Founded in 1978 by George Randazzo, by the end of 2016 the NIASHF had enshrined more than 250 inductees from a broad spectrum of sports and amassed a vast array of memorabilia.[2]

The journey to success was neither swift nor easy. Immigrants who were struggling to survive in the new world objected to their children's interest in sports, which they considered a waste of time. In addition, especially in the decades prior to World War II, Italian American athletes faced obstacles similar to those their immigrant forebears encountered. The target of ethnic slurs, many changed their names to avoid discrimination. In spite of the obstacles, those with determination as well as talent succeeded. Eventually Italian Americans would make their mark in virtually every sport, amateur and professional, and in so doing they helped change public perceptions. In time they would assume managerial and executive positions. In other words, the gradual progress of Italian Americans in the world of sports more or less mirrors the evolution of the Italian American population as a whole.

Baseball

No sport has played a more essential and longstanding role in the assimilation and acculturation of Italian Americans than baseball. By the time of the mass migration of Italians in the late-nineteenth and early twentieth centuries, baseball had become so entrenched in popular culture that journalists imbued it with symbolic import, both as a means of teaching newcomers and their children how to become Americans and as a model of fair play and opportunity.

The first player of indisputably Italian descent to make it to the major leagues was Ed Abbaticchio, an infielder who had a nine-year career between 1897 and 1910. The high point came with the Pirates in 1907, when he finished second in the league in RBIs. Abbaticchio was also the first two-sport professional athlete. From 1895 to 1900, he was the star fullback and kicker for his hometown Latrobe (Pennsylvania) Athletic Association team, generally acknowledged as the first professional football team.

The first major leaguer of Italian descent to garner national attention was outfielder Francesco Pezzolo, who played under the name of Ping Bodie for nine years between 1911 and 1921. One of the most colorful characters in baseball history, he may be best remembered for his reply when asked what it was like to room with Babe Ruth: "I don't room with him, I room with his suitcase."[3] Bodie was also the first of many Italian Americans from the San Francisco Bay area to play in the majors. He was followed in 1924 by infielder Babe Pinelli (born Rinaldo Angelo Paolinelli) who spent eight years in the majors before becoming the first Italian American major league umpire and enjoying a distinguished twenty-two-year career (1935–1956).

Seeking to attract fans from New York's large Italian American population, the Yankees signed Tony Lazzeri, who in 1925 hit sixty home runs in the Pacific Coast League. In 1926 the rookie from San Francisco quickly became the first Italian American to achieve star status. A key member of the "Murderers' Row" lineup that featured Babe Ruth and Lou Gehrig, Lazzeri was idolized by Italian American fans who came to Yankee Stadium in large numbers and waved the Italian flag to salute their new hero. The starting second baseman from 1926 to 1937, Lazzeri, who played his entire career while afflicted with epilepsy, was not only one of the game's most elite sluggers, he was also considered one of the smartest players in baseball. He was elected to the Hall of Fame in 1991. With his strong work ethic and quiet leadership, Lazzeri helped counter the stereotypical media portrayal of Italians as hot-blooded and temperamental. Since his career began shortly after anti-immigrant sentiment had led to restrictive immigration laws in 1921 and 1924 and at a time when the best known Italian American was Al Capone, it is likely that Tony Lazzeri did more to enhance the public perception of Italian Americans than anyone before him.

Lazzeri was joined in the Yankees lineup in 1932 by another San Franciscan, shortstop Frank Crosetti. After seventeen years as a player, Crosetti served as New York's third base coach through 1968. His thirty-seven consecutive years in a Yankees uniform remains a franchise record.

In 1936 a highly touted rookie became the third member of the Yankees' San Francisco triumvirate. He would prove to be not only the greatest Italian American athlete but also one of the most famous and admired celebrities of the twentieth century. The son of Sicilian immigrants, center fielder Joe DiMaggio (Figure 28.1) quickly established himself as the successor to Babe Ruth. Acknowledged by his peers as the best player in the game, "Joltin' Joe" was a three-time American League Most Valuable Player and he holds what many consider to be the most remarkable baseball record of all: a fifty-six-game hitting streak in 1941.

One of those rare athletes who transcend sports, DiMaggio became a folk hero celebrated in music and literature. But before he became a national hero, DiMaggio was an ethnic hero. No one, before or since, gave Italian Americans a greater sense of pride. "He was our god, the god of all Italian Americans," said famed actor Ben Gazzara.[4] Following DiMaggio's death on 8 March 1999, the House of Representatives passed a resolution honoring him "for his many contributions to the nation throughout his lifetime, and for transcending baseball and becoming a symbol for the ages of talent, commitment and achievement."

Whereas Joe stole the headlines, his older brother Vince and younger brother Dom were also major league outfielders. Dom was a seven-time All-Star in his ten full seasons with the Boston Red Sox, whereas Vince was a two-time All-Star in his ten-year career.

1930s

A combination of economics and demographics contributed to a dramatic increase in the number of Italian American major leaguers in the 1930s. The Great Depression forced many

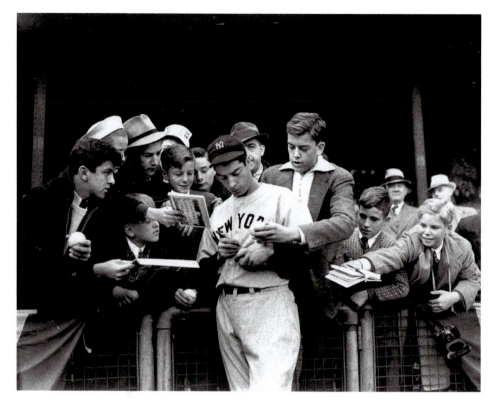

Figure 28.1 Joe DiMaggio signing autographs, 1941. *The Sporting News*/Baseball Hall of Fame.

owners to sell off their well-established players, thus opening the door to new recruits. And since the peak of Italian immigration came in the first decade of the twentieth century, by the late twenties there were more Italian Americans reaching the age when they could become professional ballplayers. In fact, the number of Italian Americans who entered the major leagues in the 1930s was more than double the number who had ever played in all previous years.

In addition to DiMaggio, there were three other future MVP Award winners among those making their debuts in the 1930s. In 1938, after winning the first of two National League batting titles, Hall of Fame catcher Ernie Lombardi became the first Italian American to win the MVP Award. Dolph Camilli won the award in 1941 after leading the National League in home runs and RBIs as captain of the pennant-winning Brooklyn Dodgers. In his MVP season of 1945 Chicago native Phil Cavarretta led the Cubs to the pennant while winning the NL batting title. In 1952 he became the first Italian American to manage a major league club for a full season.

When Italian Americans began to appear in the major leagues in increasing numbers in the 1930s, media portrayal of their arrival was often ambivalent. Several stories that claimed to celebrate the sudden surge of Italian players were written in a style that was patronizing and slightly derogatory, suggesting that these athletes, routinely referred to as "dagos' and "wops" in even the most prestigious publications—a pattern that would not change until the 1950s—remained on the fringes of the American mainstream.

Postwar Boom

It was in the years following World War II that Italian American major leaguers attained their highest level of achievement and prominence. Between 1947 and 1957 they won eight of the twenty-two MVP Awards. In addition to DiMaggio, other Italian Americans were key figures on Yankee teams that dominated baseball in the postwar years, winning ten pennants and eight World Series between 1947 and 1957. Vic Raschi posted a 92–40 pitching record between 1949 and 1953 when the Yankees won five straight World Series, and infielder Billy Martin won the Series MVP Award in 1953 before going on to a distinguished, if volatile, career as a manager.

Two of DiMaggio's teammates had Hall of Fame careers. In eighteen years with the Yankees (1946–1963), Yogi Berra, one of baseball's most beloved figures, won three MVP Awards, was an All-Star catcher for fifteen consecutive seasons, and played on more World Series winners (ten) than any other player in history. Berra was also the first Italian American manager to win a pennant (Yankees, 1964). Phil Rizzuto, a dazzling 5-foot 6-inch shortstop who spent thirteen years with the Yankees before and after the war, won the MVP Award in 1951. After retiring he spent forty years as a popular Yankees broadcaster.

New York was the center of the baseball universe in the postwar era. The Brooklyn Dodgers, who faced the Yankees in six World Series between 1947 and 1956, and the New York Giants, who won two pennants and one World Series between 1951 and 1954, both featured Italian American stars. The son of an Italian American father and an African American mother, Hall of Fame catcher Roy Campanella won three MVP Awards in his ten-year career, which was cut short at the age of 35 by an automobile accident that left him paralyzed. Right fielder Carl Furillo won the NL batting title in 1953 and had a lifetime average of .299. Though Ralph Branca is best known for giving up the Bobby Thomson home run that won the 1951 playoff for the Giants, in 1947 he won twenty-one games at the age of 21. Two of the star pitchers for the Giants were Sal Maglie, who won an average of nineteen games between 1950 and 1952, and Johnny Antonelli, who won twenty-one, twenty, and nineteen games in three of his seven seasons with the team (1954–1960).

The Sixties and Beyond

As postwar prosperity provided unprecedented opportunities for upward social and economic mobility, the number of Italian Americans in Major League Baseball gradually declined. Nevertheless, several Italian Americans were among the most talented and popular players of the second half of the twentieth century. A six-time All Star, slugging outfielder Rocky Colavito won the AL home run title in 1959, the same year he hit four homers in one game. In 1965, 20-year-old Red Sox outfielder Tony Conigliaro became the youngest player ever to lead the majors in home runs. But a probable Hall of Fame career was cut short when, on 18 August 1967, he was hit in the face by a pitch. After an attempted comeback, he retired at the age of 30.

Both Ron Santo and Joe Torre began their major league careers in 1960, and both ended up in the Hall of Fame. Santo was a nine-time All-Star and won five consecutive Gold Gloves at third base with the Cubs, all while playing with diabetes. He found renewed fame and popularity as a Cubs radio broadcaster from 1990 to 2010. As a catcher and third baseman Torre was a nine-time All-Star with a batting title, Gold Glove and 1971 MVP Award to his credit.

Third baseman Sal Bando was the captain of the Oakland A's teams that won three straight World Series titles beginning in 1972. Jim Fregosi (1961–1978), a six-time All Star shortstop

whose number was retired by the California Angels, went on to manage for fifteen years. Other multiple-time All-Stars in the decades following the war were Frank Malzone, Rico Petrocelli, Joe Pepitone, Larry Bowa, Steve Sax and Jack Clark. Notable pitchers included Dave Giusti, Dave Righetti, Andy Pettitte and John Franco.

Though diminished in number and attuned to their ethnic heritage to varying degrees, players of Italian descent continued to excel into the early decades of the twenty-first century. Frank Viola won the 1988 AL Cy Young Award followed in 1996 by NL winner John Smoltz, who was elected to the Hall of Fame in 2015. Ken Caminiti was the American League MVP in 1996. In the first decade of the twenty-first century, three players won the most prestigious awards in baseball: Barry Zito (NL Cy Young, 2002), Dustin Pedroia (AL MVP, 2008) and Joey Votto (NL MVP, 2010).

Two players distinguished themselves at the end of the twentieth century. Craig Biggio (Houston Astros, 1988–2007) was a seven-time All-Star, both as a catcher and as a second baseman. When he retired his 3,060 hits ranked twentieth in major league history. Ranked by noted baseball analyst Bill James as the fifth-best second baseman of all time, Biggio was elected to the Hall of Fame in 2015. Mike Piazza (1992–2007) is widely considered to be the greatest offensive catcher ever. A twelve-time All-Star with the Dodgers and Mets, he had a lifetime average of .308 with 427 home runs (including a record 396 as a catcher). In addition, Piazza has been involved with efforts to develop baseball in Italy and has played and coached for Team Italy in the World Baseball Classic. He is now also majority owner of a professional Italian soccer team, Reggiana.

Managers

After Yogi Berra became the first Italian American manager to win a pennant (1964), Billy Martin became the first to win a World Series title in 1977, followed by Tommy Lasorda (1981 and 1988) and Joe Altobelli (1983). By the last decade of the twentieth century several managers of Italian descent ranked among the best in the game. Between 1998 and 2008, six were named Manager of the Year: Joe Torre, Tony La Russa, Joe Maddon, Larry Bowa, Mike Scioscia and Joe Girardi. Torre led the Yankees to four World Series titles between 1996 and 2000, whereas Scioscia won in 2002 and Terry Francona won in 2004 and 2007. When three-time World Series winner La Russa retired in 2011 he ranked third in all-time wins. Both Torre and La Russa were inducted into the Hall of Fame in 2014, joining 1997 inductee Lasorda.

Boxing

Though Italian Americans have made their greatest mark in baseball, they first became prominent in prize fighting, the preferred sport of those at the bottom of the socioeconomic ladder. Taking advantage of urban rivalries among ethnic groups, boxing promoters sought out street fighters in impoverished neighborhoods, molded them into professionals, then pitted Irish, Italian and Jewish boxers against each other in local gyms and arenas. Except for baseball, no other sport has produced so many outstanding athletes. In the twentieth century more than fifty, several of whom are ranked among the all-time greats, won or laid claim to world championships.

Italian American fighters rose to prominence in the 1920s; they won no fewer than fourteen world titles and there was at least one titleholder every year between 1917 and 1929. However, in order to avoid discrimination or to appeal to fans from other ethnic groups, many Italian Americans fought under assumed names. For example, the only fighter ever to

knock out Jack Dempsey—in a 1917 bout in Utah—was Fireman Jim Flynn, who was born Andrew Chiariglione.

The first to be universally recognized as a titleholder was Pete Herman (born Peter Gulotta), the bantamweight champion from 1917 to 1920 and again in 1921. Nat Fleischer, the longtime editor of *The Ring* magazine, the "Bible of boxing," ranked the New Orleans native as the second-best bantamweight of all time. Known as "The Scotch Wop," Johnny Dundee (Giuseppe Curreri) held the junior lightweight and featherweight titles between 1921 and 1924. Rocky Kansas (Rocco Tozzo) won the lightweight crown in 1925, and Salvatore Mandala, fighting under the name of Sammy Mandell to appeal to Jewish fans, was the lightweight champion from 1926 to 1930. Tony Canzoneri won the world featherweight title in 1928, the lightweight crown in 1930, and the junior welterweight title in 1931, becoming only the second fighter, and the first American, to win world championships in three weight classes. Considered one of the best lightweights ever, he was also one of the most popular fighters of his time.

Other title holders during the 1920s and 1930s were flyweights Fidel LaBarba, Frankie Genaro and Midget Wolgast (Joseph LoScalzo), featherweight Battling Battalino (Christopher Battaglia), lightweight Lou Ambers (Luigi D'Ambrosio), welterweight Young Corbett III (Raffaele Giordano) and middleweight Alfredo "Fred" Apostoli.

Postwar Era

Italian American fighters continued to be prominent through the middle of the twentieth century. Title holders included lightweight Sammy Angott (Salvatore Engotti), light heavyweight Joey Maxim (Giuseppe Berardinelli) and featherweight Willie Pep (Guglielmo Papaleo), whose career record was 229 wins, eleven losses and one draw. In 1999 the Associated Press named him the greatest featherweight and the fifth greatest boxer of the century.

Between the mid-1940s and mid-1960s Italian Americans were particularly prominent in the middleweight class. Rocky Graziano (Rocco Barbella), Jake LaMotta, Carmen Basilio and Joey Giardello (Carmine Tilelli) all won the middleweight crown. In 1956 Graziano's autobiography, *Somebody Up There Likes Me*, became a hit movie starring Paul Newman. LaMotta's rugged life was depicted in director Martin Scorsese's acclaimed 1980 film, *Raging Bull*, which earned Robert De Niro an Oscar as best actor. Basilio, a native of Canastota, New York, now the site of the International Boxing Hall of Fame, was named "Fighter of the Year" in 1955 and 1957.

For all the success attained from the 1920s on by fighters of Italian descent, the ultimate prize of their profession, and one of the most distinguished titles in all sports, eluded them until 23 September 1952. That night 29-year-old Rocky Marciano (Rocco Marchegiano) (Figure 28.2), the son of immigrants, knocked out Jersey Joe Walcott to become the first Italian American heavyweight champion.[5] At 5 feet 10 inches and 180–190 pounds, he was small for a heavyweight, but the stocky native of Brockton, Massachusetts, possessed uncommon punching power in both hands. Marciano, who defended his title six times before retiring in 1956, is the only undefeated heavyweight champion in history, winning all forty-nine of his bouts, forty-three by knockout. Both in popularity and acclaim, he eclipsed all other Italian American boxers. On 31 August 1969, the day before his forty-sixth birthday, Marciano died in a plane crash near Des Moines, Iowa.

There were other champions in the 1950s and later, including Tony DeMarco, Willie Pastrano, Vito Antuofermo, Arturo Gatti, Ray ("Boom Boom") Mancini and Vinny Pazienza. But the glory days for Italian American fighters essentially ended in the 1950s. Between 1945 and 1959, in all but two years an Italian American was involved in *Ring* magazine's "Fight of

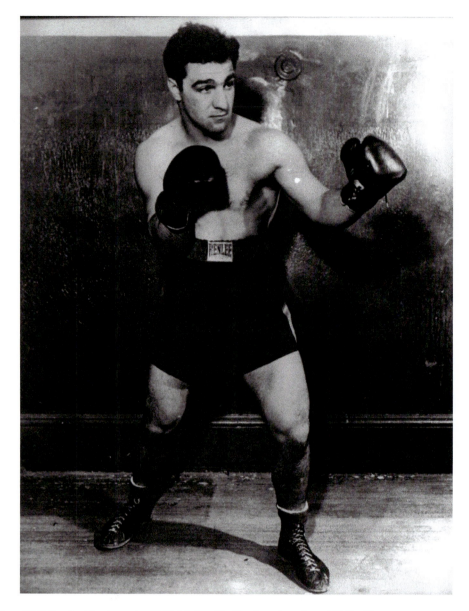

Figure 28.2 Rocky Marciano, *circa* 1949. National Italian American Sports Hall of Fame.

the Year." With the exception of Flynn, DeMarco, Antuofermo and Pazienza, all the fighters named earlier are in the International Boxing Hall of Fame. In addition, three renowned trainers/managers have also been inducted: Cus D'Amato, Angelo Dundee (Angelo Merena) and Lou Duva. Another non-combatant Hall of Famer is Paul Gallico, one of the most famous sportswriters of the 1920s who later became a successful fiction writer. In 1927, while working as the sports editor of the New York *Daily News*, he created the Golden Gloves amateur boxing tournament.

Football

Though not as numerous as boxers or baseball players, Italian Americans have made significant contributions to both college and pro football. Seven have won the Heisman Trophy and no fewer than twelve are in the Pro Football Hall of Fame. In addition, Italian Americans have been among the most notable college and pro coaches.

College football, which was much more developed in the late-nineteenth century than the professional game, continued to hold its edge in popularity until the National Football League became prominent in the mid-twentieth century. Vincent "Pat" Pazzetti was an All-American quarterback for Lehigh University in 1912. Frank Carideo, the Notre Dame quarterback during Knute Rockne's last two years as coach (1929–30), was a unanimous All-American both years. In 1943 senior quarterback Angelo Bertelli played in only six of Notre Dame's ten games before being drafted into the Marines, but his performance was so impressive—he completed twenty-five of thirty-six passes for ten touchdowns to lead the eventual national champions to a 6–0 start—that he became the first Italian American to win the Heisman Trophy.

A two-time All-American at Georgia, running back Charley Trippi was the MVP of the 1943 Rose Bowl. In a 2007 ESPN list of the top twenty-five college players of all time Trippi was ranked number twenty. Francis "Hank" Lauricella was Tennessee's primary runner, passer, punter and kickoff returner from 1949 to 1951. When the team won the national championship in 1951, Lauricella was an All-American and the runner-up for the Heisman Trophy. Pazzetti, Carideo, Bertelli and Lauricella are all in the College Football Hall of Fame. Subsequent winners of the Heisman Trophy were Alan "The Horse" Ameche (1954), Joe Bellino (1960), Gary Beban (1968), John Cappelletti (1973), Vinny Testaverde (1986) and Gino Torretta (1992).

Professional Football

Though formed in 1920 (as the American Professional Football Conference), the National Football League (NFL) did not gain widespread popularity until the 1960s, when it became the nation's most-watched sport. Numerous Italian Americans are among the league's all-time greats, including the following inductees in the Pro Football Hall of Fame.

In eleven years with the Green Bay Packers between 1941 and 1952, Tony Canadeo ran with the ball, threw, caught and intercepted passes, punted, and returned punts and kickoffs. One of the greatest all-around players in Packers history, to date he is one of only six to have his number retired. Nicknamed "Gluefingers," Dante Lavelli was a sure-handed receiver who helped the Cleveland Browns win seven championships in his eleven-year career (1946–1956). Upon retiring he ranked second in professional football history in touchdown receptions and third in passes caught and receiving yards. Leo Nomellini, a 260-pound lineman known as "the Lion," never missed a game in his fourteen-year career with the San Francisco 49ers (1950–1963). One of the few players ever to win All-NFL honors both on offense and defense, in 1969 he was selected as defensive tackle for the NFL's fiftieth anniversary team.

Gino Marchetti played for the Baltimore Colts for thirteen seasons (1953–1964, 1966). Named the top defensive end of the NFL's first fifty years, the eleven-time Pro-Bowler helped the Colts win two Super Bowl Championships. One of the best defensive ends in pro football history and a seven-time All-NFL player with the Los Angeles Rams and New York Giants (1951–1964), in 1962 Andy Robustelli received the Bert Bell Award as the best player in the NFL. At 5 feet 11 inches and 220 pounds, Nick Buoniconti was considered too small to play pro football. But the middle linebacker had a fourteen-year Hall of Fame career

(1962–1976) with the Boston Patriots and Miami Dolphins and was a key member of the Dolphins team that appeared in three straight Super Bowls and went undefeated in 1972. The son of an African American father and an Italian-born mother, running back Franco Harris was a nine-time Pro Bowl selection and won four Super Bowl titles in his twelve seasons (1972–1983) with the Pittsburgh Steelers.

Two of the greatest quarterbacks in NFL history were Joe Montana and Dan Marino. In his fifteen-year career (1979–1994) Montana led the San Francisco 49ers to four Super Bowl titles, was a three-time Super Bowl MVP, and was selected to eight Pro Bowls. Playing his entire career with the Miami Dolphins (1983–1999), Marino became one of the most prolific passers in NFL history; in 1984 he became the first to pass for 5,000 yards in a season and his 420 touchdowns were the most ever at the time he retired.

Coaches

Two coaches in the College Football Hall of Fame are Lou Little (Luigi Piccolo) and Joe Paterno. Little was a legendary figure who coached at Georgetown and Columbia from 1924 to 1956. Named *Sports Illustrated*'s Sportsman of the Year in 1986, Joe Paterno led Penn State to four undefeated seasons, twenty-four bowl wins and two national championships between 1966 and 2011. In 2001, he passed Paul "Bear" Bryant as college football's all-time winningest coach. Paterno, who contributed millions to the university and its academic programs, was dismissed in 2011 for allegedly concealing facts relating to sexual abuse of young boys by a former defensive coordinator.

Though he never played in the NFL, Vince Lombardi is one of the most distinguished members of the Pro Football Hall of Fame. (See Color Plate 21.) Widely considered the greatest coach in football history, in nine years (1959–1967) he led the Green Bay Packers to five straight NFL titles and victories in the first two Super Bowls. In recognition of Lombardi's stature as a symbol of excellence, in 1971 the NFL renamed the Super Bowl Trophy in his honor. Also in the Pro Football Hall of Fame is Bill Parcells, who coached four NFL teams and won two Super Bowls with the New York Giants.

Basketball

Although basketball was popular with second-generation Italian Americans, there have been few standout players of Italian descent. This was primarily due to the relatively small number of Italian Americans who went to college prior to World War II. Many immigrants, skeptical of the value of education, preferred that their sons work to help support the family. In recent decades, however, coaches of Italian descent have been among the most prominent in the game, especially at the collegiate level.

Three players have been inducted into the Naismith Memorial Basketball Hall of Fame. Forrest DeBernardi, an All-American at Westminster College in 1920 and 1921, went on to be named to the AAU All-America Team seven times, five times playing on national championship teams. A three-time All-American at Stanford (1936–1938), Hank Luisetti changed basketball forever by pioneering the running one-handed shot. On 1 January 1938, the San Francisco native became the first college player to score fifty points in a game. In a 1950 Associated Press poll to select the best basketball player of the first half of the twentieth century, only George Mikan finished ahead of Luisetti. An outstanding player in the early days of pro basketball, Al Cervi won all-league honors five times in his nine-year career and was the National Basketball League MVP in 1946–1947. In 1948–1949, the 5 foot 11 inch guard became a player/coach and led Syracuse to the NBA title in 1955.

Coaches

The first coach to get to the NCAA Division I title game was Ben Carnevale, whose North Carolina team lost to Oklahoma A&M in 1946. He then coached Navy from 1946–1956 and was inducted into the Hall of Fame in 1970. In 1958 John Castellani took Seattle University, led by future Hall-of-Famer Elgin Baylor, to the title game, which was won by Kentucky. Jim Valvano became the first to win an NCAA title when his North Carolina State team beat heavily-favored Houston in 1983.

Subsequent coaches to win the NCAA title were Rollie Massimino (Villanova, 1985), and Hall of Fame inductees Tom Izzo (Michigan, 2000), John Calipari (Kentucky, 2012) and Rick Pitino, the first coach to win the title at two different schools (Kentucky, 1996; Louisville, 2013). In twenty-four seasons between 1965 and 1992, Hall-of-Famer Luigi "Lou" Carnesecca led St. John's to the postseason every year while compiling eighteen 20-win seasons. At the professional level, Dick Motta coached in the NBA for twenty-five years (1968–1997), winning the championship in 1978. Other notable NBA coaches include Mike Fratello, Al Bianchi, Mike D'Antoni and Vinny Del Negro.

When it comes to winning titles, no Italian American coach can match Geno Auriemma. In 2016 his University of Connecticut team won an unprecedented fourth straight Division 1 NCAA Women's championship. It was Auriemma's eleventh national title at UConn, moving him past legendary UCLA coach John Wooden for the most championships by any Division 1 coach in college basketball history. He also coached the U.S. women's squad that won the gold medal at the 2012 and 2016 Olympic Games. A seven-time Naismath Women's College Coach of the Year, he is enshrined in both the Naismath Hall of Fame and the Womens' Basketball Hall of Fame. Two of the stars on Auriemma's Connecticut teams were Jennifer Rizzotti and Diana Taurasi. The starting point guard on Connecticut's first championship team in 1995, Rizzotti was the Associated Press Player of the Year in 1996. The AP Player of the Year in 2003, Taurasi led the team to three consecutive championships (2002–2004) and was a member of the USA women's gold medal Olympic teams in 2004, 2008, 2012 and 2016. In 2009 she was named MVP of the WNBA.

Others inducted into the Hall of Fame include Dick Vitale, a former college coach who made his mark as a television analyst with his energetic broadcasting style and inventive catch phrases; John Nucatola, a founder of the College Basketball Officials Association, an NBA Supervisor of Officials, and one of the most influential referees in basketball history; Daniel "Danny" Biasone, president and founder of the Syracuse Nationals who introduced the 24-second shot clock in the 1954–1955 NBA season. Though not at this time a Hall of Fame inductee, Dick Bavetta holds the record as the longest-tenured NBA referee: thirty-nine years (1975–2014). Over that span he refereed a record 2,635 consecutive regular season games.

Other Sports

Olympic Games

Ray Barbuti, who captained both the football and track teams at Syracuse University, won gold medals in the 400-meter run and the 1,600-meter relay at the 1928 Summer Olympics and is enshrined in the National Track and Field Hall of Fame. After setting the national high school record in the mile in 1934—which stood for twenty years—Louis Zamperini finished eighth in the 5,000-meter race in the 1936 Berlin Olympics. In 1938, he set a national collegiate mile record of 4:08.3, which stood for fifteen years. The story of his survival as a

World War II prisoner was documented in the best-selling book, *Unbroken*, later made into a film.

Olympic gold medal winners include Matt Biondi, eight gold medals in swimming between 1984 and 1992; Mary Lou Retton, the first American woman to win the individual all-around gold medal in gymnastics and AP Female Athlete of the Year in 1984 (whose family surname "Rotunda" was changed by her paternal grandfather); Brian Boitano, figure skating, 1988; Jennifer Azzi, women's basketball, 1996; Catherine "Cammi" Granato, women's hockey, 1998; Julia Mancuso, alpine skiing, 2006. A silver medalist at the 1980 Winter Olympics, figure skater Linda Fratianne won four consecutive U.S. championships (1977–1980).

Ice Hockey

Three Italian American stars of the National Hockey League, all Canadian-born, are in the Hockey Hall of Fame: Phil Esposito (1963–1981), one of the all-time greats, led the NHL in goals six times; his younger brother Tony (1968–1984) was a pioneering goaltender; Alex Delvecchio had a sterling twenty-four-year career (1951–1974) with the Detroit Red Wings before serving as their coach. At the amateur level, Mike Eruzione was the captain of the "miracle" U.S. hockey team that won the gold medal in the 1980 Olympics.

In 2010 Catherine "Cammi" Granato became the first woman inducted into the Hockey Hall of Fame. The captain of the 1998 U.S. team that won the first-ever Olympic gold medal in women's hockey, she is the all-time leading scorer in women's international hockey. Angela Ruggiero, a 2015 Hall of Fame inductee, was a four-time medal winner (gold, two silvers and a bronze) with the U.S. Olympic women's hockey team (1998–2010). In 2003 *The Hockey News* named her the Best Female Hockey Player in the World.

Auto Racing

Winning events at all levels of competition over five decades, Mario Andretti became one of the most famous race car drivers in the world. He is the only driver to win the Indianapolis 500 (1969), Daytona 500 (1967) and the Formula One World Championship (1978). In a 1999 Associated Press poll, he and A. J. Foyt tied for the title of best driver of the century. Prior to Andretti, two other Italian Americans had won the Indianapolis 500: Ralph De Palma in 1915, and Peter De Paolo in 1925.

Golf and Tennis

Italian Americans came late to golf and tennis, two sports historically associated with the more affluent sporting community. Nevertheless, between 1922 and 1935 Gene Saracen (born Eugenio Saraceni) became the first golfer to win the career Grand Slam. The winner of 38 PGA Tour events, he is a charter member of the World Golf Hall of Fame. Other Hall-of-Famers followed. Doug Ford (Douglas Fortunato) won 19 PGA titles (1952–1963), including the Masters and PGA, and Donna Caponi won the U.S. Women's Open and LPGA titles twice each between 1969 and 1981. Phil Mickelson, Italian on his mother's side, has won more than forty tournaments, including three Masters titles. Also in the Hall of Fame are Ken Venturi (thirteen PGA titles) and Fred Couples (fourteen PGA titles), whose original family name was Coppola. In tennis, Jennifer Capriati won three Grand Slam titles and an Olympic Gold Medal, leading to her induction into the International Tennis Hall of Fame. Nick Bollettieri, another Hall of Fame inductee, is recognized as one of the leading coaches in tennis history, having coached ten world No. 1 players.

Thoroughbred Racing

Eddie Arcaro, acknowledged as one of the greatest jockeys, won five Kentucky Derbys and six Preakness and Belmont Stakes, and is the only two-time winner (1941, 1948) of horse racing's Triple Crown.

Body Building

Beginning in the 1930s, generations of boys grew up dreaming of changing from ninety-pound weaklings to he-men after seeing the comic book ads for the mail-order course of pioneer body builder Charles Atlas, born Angelo Siciliano. In 1973–1974, Lou Ferrigno won back-to-back Mr. Universe titles.

Bowling

Andy Varipapa (1891–1984) was not only a champion bowler but also a world-famous master of trick shots and one of the great ambassadors of the sport. Buzz Fazio, Dave Ferraro, Johnny Petraglia and Carmine Salvino are members of the Professional Bowlers Association Hall of Fame.

Billiards

Between 1941 and 1957, Willie Mosconi was a fifteen-time world's pocket billiards champion.

Women in Sports

For much of the twentieth century women found little encouragement and few opportunities to participate in organized sports. Nevertheless, there have been several notable Italian American pioneers in women's sports. Clementina Brida, a famous pitcher who began her long career in 1897 playing for the Boston Bloomer Girls, went on to pitch for, manage, create and own several of the leading women's teams in the country. But like several male ballplayers of that era, she masked her ethnic identity, playing under the name of Maud Nelson. Baseball historian Barbara Gregorich called her a "legend who dominated the early years of women at play."[6]

Margaret Gisolo was 14 years old when she helped lead her Blanford, Indiana (boys) team to the state American Legion Junior tournament championship in 1928 by hitting .429. She later played professionally from 1930 to 1934 for the All-Star Ranger Girls, a barnstorming team co-owned by Maud Nelson, before becoming a college coach. Agnes Iori (married name Iori Robertson) was a pioneer who led the way for future basketball stars. After starring in high school in the small coal-mining town of Cockerill, Kansas, she played for the Dallas Golden Cyclones, a company-sponsored team that won the 1931 AAU national championship. From 1929 to 1932, Iori was named to the first four AAU All-American teams.

In the 1928 Olympics, swimmer Eleanor Garatti won a silver medal in the 100-meter freestyle and a gold in the 4x100 meter freestyle relay. Then, in 1932, competing under her married name of Garatti-Saville, she took bronze in the 100 meter freestyle and gold in the 4x100 meter freestyle relay, becoming the first woman to win two individual medals in the 100-meter freestyle. At 17, gymnast Concetta "Connie" Caruccio was one of the youngest athletes competing in the 1936 Berlin Olympics. Twelve years later, competing as Connie Lenz, she won a bronze medal in the team all-around competition.

Few if any Italian American women athletes have enjoyed such wide-ranging success and influence as Donna Lopiano. (See Color Plate 22.) Barred from playing Little League baseball because of her gender, as a teenager she turned to fast pitch softball. From 1963 to 1972 she was a nine-time All-American and three-time MVP as a pitcher (183–18 record) and infielder for the renowned Raybestos Brakettes of Stratford, Connecticut. The most elite team in women's sports, the Brakettes won six national American Softball Association championships in her ten years with the team. After obtaining a PhD from the University of Southern California, Lopiano served as Director of Women's Athletics at the University of Texas (1975–1992), president of the Association for Intercollegiate Athletics for Women, and CEO of the Women's Sports Foundation (1992–2007). Named by *The Sporting News* as one of the "100 Most Influential People in Sports," she has been internationally recognized as a leading advocate for gender equity in sports.

Executives

As they did in other professions, Italian Americans in sports gradually made the transition from labor to management. Not surprisingly, baseball has produced the largest number of executives. It was a gradual evolution, with Italian Americans initially earning on-field jobs as coaches and managers, especially in the post–World War II era. In time, others, mainly late in the twentieth century, made it to the front office as general managers and owners.

A notable exception to this trend was Lou Perini, who became the first Italian American owner in Major League Baseball well before anyone else. The Massachusetts native was the principal owner of the Boston/Milwaukee Braves from 1944 to 1962. An innovator, Perini was an early proponent of expansion and the first owner to move a team since 1900. In 1953 he moved his struggling franchise to Milwaukee, where the Braves drew two million fans and won the 1957 World Series. Buzzie Bavasi was another exception. In 1951, more than twenty years before any other Italian American, he became the general manager of the Brooklyn Dodgers, a post he held until 1968 when he became half owner of the expansion San Diego Padres. Two of his sons, Peter and Bill, followed in their father's footsteps as general managers. Since the 1990s there have been at least eight other GMs of Italian descent.

Cleveland native Nick Mileti headed a group that purchased the struggling Cleveland Indians in 1972, two years after he brought professional basketball to his hometown when he was awarded an NBA expansion team (Cavaliers). Jerry Colangelo was also a multiple-franchise owner. Named general manager of the expansion Phoenix Suns in 1968, he went on to become the team's chief executive officer and a four-time NBA Executive of the Year. In 1998 he brought major league baseball to Arizona with the expansion Arizona Diamondbacks, as well as a WNBA team and an arena football team. His son, Bryan, was twice named NBA Executive of the Year as the general manager of the Toronto Raptors. Others who became baseball owners at the turn of the twenty-first century were Vince Naimoli (Tampa Bay Rays), Larry Lucchino (Boston Red Sox), Mark Attanasio (Milwaukee Brewers), and Robert Castellini (Cincinnati Reds). In 2011 Joe Torre was named Major League Baseball's Executive Vice President of Baseball Operations, responsible for overseeing On-Field Operations, On-Field Discipline and Umpiring.

Football, Hockey and Basketball

Tony Morabito, the founder of the San Francisco 49ers franchise, was the team owner until his death in 1957. His brother, Vic, then controlled the team until his death in 1964. Edward DeBartolo, Sr. purchased the 49ers in 1977, then turned the team over to his son, Edward

J. DeBartolo, Jr. Under the son's leadership the 49ers won five championships during the 1980s and 1990s. The family also owned the Pittsburgh Penguins of the NHL (1977–1991); DeBartolo Sr.'s daughter, Denise DeBartolo York, served as the team's president.

Other executives of professional franchises include Franklin Mieuli, principal owner of the NBA Golden State Warriors (1962–1986); Blase "Tom" Golisano, former co-owner of the NHL Buffalo Sabres; Stephen J. Bisciotti, principal owner of the NFL Baltimore Ravens since 2000; Tom Gagliardi, owner of the NHL Dallas Stars since 2011. In 2011, Terry Pegula bought the NHL Buffalo Sabres from Golisano, then purchased the NFL Buffalo Bills in 2014.

Auto Racing

Andy Granatelli (1913–2013), a member of the International Motor Sports Hall of Fame, did just about anything that could be done in auto racing; he was a driver, promoter, owner and designer. An innovative engineer, in 1967 he built a radically new turbine-engine race car, and in 1969 and 1973 his team won the Indy 500. Chip Ganassi, a former race car driver and part owner of the Pittsburgh Pirates, founded the Chip Ganassi Racing Team in 1990. Among the team's many titles are four Indy 500 wins and a Daytona 500.

Commissioners

Two executives of Italian descent rose to the highest position in their respective sports as commissioner: Paul Tagliabue in the NFL and A. Bartlett Giamatti in Major League Baseball.

A graduate of Georgetown University, where he was captain of the 1961–1962 basketball team, Tagliabue received a law degree from New York University. After representing the NFL for a Washington, DC law firm for several years, he served as NFL Commissioner from 1989 to 2006. Adopting a low-key approach, Tagliabue maintained peace between labor and management, oversaw expansion from twenty-eight to thirty-two teams, created the NFL Network and generated unprecedented growth in revenue and fan enthusiasm.

The grandson of immigrants, A. Bartlett Giamatti represents as well as anyone the culmination of the evolution of Italian Americans in sports. A well-known Renaissance scholar at Yale, in 1977, at the age of 39, he became the youngest person to be named president of that university. But in 1986, Giamatti, an avid baseball fan who frequently wrote about the game's role as an American institution, gave up one of the most prestigious positions in academia to become president of the National League. Then, on 1 April 1989, he succeeded Peter Ueberroth as Commissioner of Major League Baseball. On 1 September, nine days after announcing a lifetime ban on Pete Rose—the holder of the all-time record for career hits who had been accused of gambling on baseball—Giamatti died of a heart attack at the age of 51.

Even though he had little chance to demonstrate what his contributions might have been, his intellect and his love of baseball, evident in his defense of its traditions and his eloquent celebrations of its meaning, were enough to convince many of his unique status in the game. *New York Times* columnist Ira Berkow speculated that Giamatti "might have become the best baseball commissioner we've ever had. He had brains, sinew, and the best wishes of the game."[7] The significance of Giamatti's impact on baseball is not just that he rose to its highest office, but that he was also one of its most passionate and articulate proponents. For Giamatti, baseball was symbolic of the American Dream, not as material success but as a spiritual quest for home. "The concept of home," he wrote, "has a particular resonance for a nation of immigrants, all of whom left one home to seek another."[8]

Giamatti also understood the broader meaning of sports in society. In *Take Time for Paradise*, his celebration of sports in America, he wrote: "It has long been my conviction that we can

learn far more about the conditions, and values, of a society by contemplating how it chooses to play, to use its free time, to take its leisure, than by examining how it goes about its work."[9]

Further Reading

Baldassaro, Lawrence. *Beyond DiMaggio: Italian Americans in Baseball*. Lincoln: University of Nebraska Press, 2011/2013.

Gems, Gerald R. *Sport and the Shaping of Italian American Identity*. Syracuse: Syracuse University Press, 2013.

Hauser, Thomas and Stephen Brunt. *The Italian Stallions: Heroes of Boxing's Glory Days*. Wilmington: Sport Classic Books, 2003.

Padurano, Dominique. "Charles Atlas and American Masculinity, 1910–1940," in *Making Italian America: Consumer Culture and the Making of Ethnic Identities*, edited by Simone Cinotto. New York: Fordham University Press, 2014, 100–16.

Renoff, Richard. "Sports," in *The Italian-American Experience: An Encyclopedia*, ed. Salvatore J. LaGumina, Frank J. Cavaioli, Salvatore Primeggia and Joseph A. Varacalli. New York: Garland, 2000, 608–15.

Vitale, Rolando. *The Real Rockys: A History of the Golden Age of Italian Americans in Boxing 1900–1955*. Delavan, Wisconsin: RV Publishing, 2014.

Notes

1 *Italian America* (Fall 2016), 5.
2 For a complete list of inductees, see www.niashf.org
3 Robert Creamer, *Babe: The Legend Comes to Life* [1974] (New York: Penguin, 1983), 222.
4 *The New Yorker* (15 September 2003), 38.
5 Italian heavyweight Primo Carnera had won the title in 1933, but his record was later discredited when it was alleged that many of his bouts had been fixed by New York mobsters.
6 Barbara Gregorich, *Women at Play: The Story of Women in Baseball* (San Diego: Harcourt Brace, 1993), 6.
7 *New York Times* (2 September 1989), 41.
8 A. Bartlett Giamatti, *Take Time for Paradise: Americans and Their Games* (New York: Summit Books, 1989), 92.
9 Ibid., 13.

ORGANIZED CRIME AND ITALIAN AMERICANS

Antonio Nicaso

More than the Mafia as we know it today, the earliest form of organized crime in America was a brotherhood of evil, similar to the one created in the Bourbon prisons, before the unification of Italy. It was a criminal melting pot with rituals and codes almost identical to those of the Bella Società Riformata, the "Beautiful Reformed Company," as the Neapolitan Camorra of the 1800s was known.[1] There was no room for regional discrimination among criminals of Italian descent. The competition, particularly with Irish and Jewish gangs, was feared and brutal.

Between 1890 and 1913, mobsters from several regions of Italy joined the great emigration, often with the help of the Italian authorities. In March of 1905, one of the first to raise this issue in the Italian Parliament was Senator Baldassarre Odescalchi from Rome. In a note to the Minister of Foreign Affairs, he blamed prefects and police of "getting rid of the people of ill fame" by granting them "permission to leave the country."[2] Senator Odescalchi, who was returning from a trip to St. Louis, Missouri, asked the Government to react against this questionable practice and to apply the most stringent provisions to prevent the emigration of undesirable people to the United States of America. "It is not right that, for a few troublemakers, many honest and hardworking people such as the majority of our emigrants, are labeled unfairly."[3] A year later, on 12 October 1906, the same concern was expressed by Antonio Filastò, a judge in Calabria. In an article published in the *Gazzetta di Messina e delle Calabrie*, Filastò accused the police of favoring "the departure of the most turbid individuals,"[4] a large crew of undesirable subjects accustomed to all forms of violence.

In those years, many criminals came to America leaving behind unpunished crimes and long trails of blood. Others entered, mingling among many immigrants, in search of fortune.

Antonio Musolino, brother of Giuseppe, the father of the modern 'Ndrangheta (the Calabrian Mafia), and several cousins, including Francesco Filastò, arrived from Calabria. From Sicily, among others, came Vito Cascio Ferro, Ignazio Lupo, Giuseppe Fontana (one of the alleged killers of the former mayor of Palermo and former chairman of the Banco di Sicilia, Emanuele Notarbartolo), Gaetano Badalamenti (exporter of citrus fruits and a convicted murderer) and Francesco Mottisi, who was considered the boss of one of the largest clans in Palermo where he served as an alderman. Enrico Alfano and Giosuè Gallucci, known as "The King of Little Italy," arrived from Campania.

Despite the criminal mosaic, the brotherhood of evil soon realized the opportunities offered by the New World. While maintaining contacts with Italy, the godfathers with handlebar moustaches began to create an organization to establish itself in the United States.

The first destinations were New York City and New Orleans. Violence, as had happened with the Irish and Jewish gangs, soon began to spread. On 14 October 1888, Antonio Flaccovio, a Sicilian fruit dealer, was assassinated in New York. "They are Sicilians from Palermo, the main port of Sicily," commented the inspector who investigated the murder, evoking the

existence of groups linked to the Mafia. "They are intelligent people who received some education. They escaped from their native country, where they were involved in criminal activities and crimes of various kinds."[5]

Before this murder, American newspapers had treated the Mafia as a problem confined to Southern Italy. On 2 September 1874, the *New York Times* published a short story in which this criminal organization was described as "the Sicilian form and name corresponding to what in Naples was so long and so ominously known as the Camorra." For the New York based newspaper, the Maffia [sic] was regarded as "a vast organization of 'the dangerous classes,' of all who prefer living by the defiance of, and trampling upon, the law to earning their bread by honest means."[6]

Three years later, on 27 May 1877, in another article, the same newspaper regarded the Mafia as "the spontaneous organization of those whose trade is crime; not a sect or secret society, any more than the highwaymen of Hounslow in former days, or the pickpockets of St. Giles' and Whitechapel in our own." Explaining what the Mafia was all about, the same *New York Times* article added, "Every one of the 350 communes of Sicily has its own Mafia, of which the character varies according to local tendencies and interests. In one place its energies are devoted to the conduct of the elections and the manipulation of the ballot box; in another to directing, by means of a Camorra, the sale of Church and Crown lands; in a third to the apportionment of contracts for the public works."[7]

For many Americans, it was a great surprise to find that the Mafia had replicated its evil model even in America, with the support of unscrupulous Americans. There were forty murders in New Orleans between 1888 and 1890.

New Orleans

At the end of the 1800s, many Italians were unloaded from steamships in their thousands at the New Orleans harbor to replace African Americans in their back-breaking labor on the cotton, rice and sugar farms following the abolition of slavery. Amongst the ordinary citizens, however, the state of Louisiana would also be the destination of mobsters affiliated with the Sicilian Mafia, the Calabrian 'Ndrangheta, and the Neapolitan Camorra. The illegal management of the harbor was controlled by the Matranga crime family, which had close ties with Joseph Macheca, a former supporter of Presidential candidate Horatio Seymour in 1868, regarded as the king of citrus fruits, and by the Provenzano clan. Between the two groups there was bad blood and hatred that began years earlier in Monreale, a small town in Palermo province. On 6 April 1890, the Provenzano clan killed two Matranga affiliates.

David C. Hennessey was the local chief of police at the time. He was considered a questionable character by the Matrangas, who unlike the Provenzano clan, were often the targets of his investigations. His shady character eventually caught up with him. On 15 October 1890, while returning home, Hennessey was gunned down by two men. While taking his last few breaths, he was able to whisper a few words to a colleague who had responded to the scene, saying, "Dagos did it. It was the dagos," or rather the Southern Italians, as the local slang terminology would call them.[8]

This was the start of a xenophobic bomb in the multi-racial city of New Orleans wherein southern Italians were unpopular compared to the dominant Irish community. The mayor, Joseph Shakespeare, added fuel to the fire by describing the Italians as "the most violent and unworthy people that exist in the world, worse than the African Americans" and to whom "must be taught a lesson that they should never forget." A thorough police search led to the arrest of about fifty Sicilians, from which eleven were part of the nineteen accused in the Hennessey murder case. According to Roberto Ciuni, "within the accused there were:

the boss of the Matranga family, who was playing cards on the evening of 15 October; gangsters Rocco Geraci and Antonio Scafidi and the so-called professional troublemaker Emanuele Polizzi."[9] Among them, however, were also the shoemaker Pietro Monasterio; the fugitive Bastiano Incardona with his 14-year-old son Gaspare; and the fruit vendors Antonio Marchesi and Antonio Abbagnato.

In March 1891, at the end of a hearing fueled by weak evidence and testimonies from about sixty witnesses, the jury of the Criminal District Court of New Orleans released a not-guilty verdict for eight of the eleven accused persons, without reaching a verdict for the others. But under judicial pressure, they remained in temporary custody on a legal technicality. As a result of the disappointment felt by the people of New Orleans, the Sheriff Gabriel Villere fueled the fire and called for "all the good citizens" to "take action against the failed justice system." This led to about three thousand people armed with guns, rifles and bats, to congregate at the Parish Prison. Under the assault, the side doors were taken down. The first to be killed by gunfire was Scafidi. Incardona's son, Gaspare, was trampled to death by the ferocious crowd. Macheca was slaughtered along with six other prisoners who were shot in the courtyard. Monasterio, who was severely beaten, begged his assailants to end his suffering by shooting him. Abbagnato was hung from a tree. Polizzi was hung from a street lamp and killed by gunfire. The only ones who managed to survive were Matranga and Incardona.

According to the *American Heritage Review*, the prominent lawyer W. S. Parkerson, who was the leader of the uprising, spoke to the people after the events, saying, "I called upon you to fulfill your duty, and this duty has now been completed. Go back to your homes and may God bless you all."[10]

As a result of these events, the relationship between Italy and the United States was severely strained. The Italian Ambassador Francesco Saverio Fava was recalled to Italy. The hearings ended without any guilty verdicts, yet the media and politicians justified the massacre. United States President Benjamin Harrison declared the bloodshed "an offence of the law and a crime against humanity." In the aftermath, the White House ended up settling the massacre with the payment of a $25,000 indemnity.

The Black Hand

It was at this time that the word Mafia was flagged in public discourse by the expression "Mano Nera" or Black Hand, a definition that appeared in Chicago around 1892 and in New York around 1903 at the bottom of extortion letters addressed to Italian businessmen. The idea was so successful that it was repeated in many other American cities and even in regions like West Virginia. (See no. 15 in the Photo Essay.) Threats, bombings, kidnappings and assassinations of a wide variety were attributable to Italians.

According to Salvatore Lupo "the Mafia was imagined as a secret society led by a great leader hiding in Sicily, strong in numbers, ancient like the Old World that originated it."[11] Even more serious, the roots of the Black Hand and the Mafia were considered contrary to the American way of life and "tied to the cultures of specific ethnic groups who brought organized crime with them when they immigrated to the United States."[12]

In his essay on "How the Mafia Came to America," Frederic Sondern Jr. stresses the importance of the symbolic aspect of this extortion strategy: "Mafia extortion gangs simply used the imprint of a hand and a signature on their warnings, ransom notes and other demands. In Sicily for decades they had signed with a skull, a dagger or a hand. In America they discovered [. . .] that the hand was, for some reason the most effective symbol."[13]

Decades earlier the Molly Maguires (an Irish secret society active in Ireland, England, Canada and the United States, particularly in Pennsylvania), were drawing "coffin-notices"

with guns to extort money.[14] The Italian mobsters brought with them codes, rituals, symbols, (things that made them feel different), which justified every wickedness. They swore an oath committing to a life of partaking in illegal activities, similar to the whitewashed organizations that were determined to restore white rule to the South, or many other secret societies.

Criminal groups are what the sociologist Émile Durkheim referred to as "segmentary society." This "segmentary society" is composed of groups whose survival depends on producing "mechanical solidarity" through a ritualistic replication of existing cultural forms.[15] Rituals are the first phase in achieving replication and obtaining consensus to the cause from new recruits. It thus recreates the identity of new members, fashioning it in conformity to the expectations of the group. The objective is to impart the participant with a new belief system and role as part of a new family, as well as how he is supposed to relate to others.

Two of the codes similar to the one used in the 1800s in Italy by the Bella Società Riformata were found in United States. The first code was published in December 1910 by noted journalist Amy Bernardy in a Rome-based newspaper *Il Giornale d'Italia* [The Newspaper of Italy].[16] The second was discovered in 1930 in Olean, New York, by Detective Alberto Verrusio Ricci while searching the belongings and trunk of John Rotundo, an alleged member of the organization and suspected murderer. The "little black book," the code found by Detective Verrusio Ricci, was translated into English and published in the October 1930 edition of *True Detective Mysteries*.[17] The Code, similar to the one still in use today by the 'Ndrangheta in Italy, refers to "three Spanish Chevaliers named respectively Gaspare, Melchiorre and Baldassarre [the Biblical three Wise Men], that in jargon were called Osso, Mastrosso and Carcagnosso, gifted with a lot of energy and cunning. The organization had five different degrees to climb (from bottom to top): Youth of honor (intern), *picciotto* (soldier), *camorrista* (senior member), *contaiolo* (accountant) and *capo* (boss)."

In 1915, Michael Nottaro, one of the first police informants in the United States, revealed that in New York during the initiation ritual, mobsters engaged in a special fight with a knife called the "*tirata*," which was traditionally used within the Camorra and the 'Ndrangheta during a member's induction ceremony. The knife used was covered with rope to the tip so that the wound inflicted would not be deep and lethal.[18]

Petrosino Murder and Pellaro Massacre

Although there was not a united and strategic direction, nor a boss of bosses who had the last word on everything, there was a kind of solidarity among criminal clans in Italy and the United States. Many cases show this "criminal solidarity," but two in particular aroused public interest around the world. The first was the murder of New York Police Detective Joe Petrosino (Figure 29.1) and the second was the massacre of a family of eight in Calabria, Italy.

Joseph Petrosino was killed in Piazza Marina, in Palermo, on 12 March 1909. He was the first to understand the criminal links between the United States and Italy. Petrosino was gathering evidence to seek the extradition of many gangsters who had immigrated to New York from their native country. He expected his mission would be kept secret, but before he had even arrived in Italy, information about his trip had already been published in many New York newspapers. News of the killing also spread fast.

"I can't say anything except to express my deepest regret," said former U.S. President Theodore Roosevelt. "Petrosino was a great man, a good man. I knew him for years, and he did not know the name of fear. *He was a man worthwhile.* I regret most sincerely the death of such a man as Joe Petrosino."[19] Later in 1910, a man named Antonio Comito, while he was being interviewed by the New York Secret Service about his involvement in counterfeiting Canadian and U.S. currency, gave information regarding Petrosino's murder. Referring to the

Figure 29.1 Lieutenant Joseph Petrosino (left), New York City Police Department, 1903. Library of Congress Prints and Photographs Division, LC-USZ62–137644.

Morello gang, he said: "I also heard from time to time that they expected news of a certain Calabrian who was sent to Palermo, and that he left before Petrosino did. When news arrived that Petrosino was dead, they were all elated, and celebrated by consuming wine, and had a feast, shooting at bull eyes."[20]

The Calabrian man mentioned in Comito's statement was never charged for this crime. His name was revealed, however, to Italian authorities on 15 April 1930 by his cousin, Antonio Musolino, the brother of Giuseppe Musolino, known as the father of the modern

Calabrian Mafia called 'Ndrangheta. While in jail and before his death, Musolino made the following statement:

> One day Filastò Francesco told me what we were going to do the next day [. . .]
> go to draw a watch and I would just announce and call out the numbers I drew.
> He informed me that among the wooden numbers, like the ones from Bingo, two
> were slightly affected at the edge, leaving an indent, and so it would be easy to
> tell which numbers were indented. I felt that, in regards to the drawing, I should
> absolutely avoid drawing any of those numbers. Even better, to help me accomplish
> this, he made me practice several times and I always managed to avoid drawing the
> numbers with the indent. The next day there was a meeting. There were 24 people
> there and not one *picciotto* among them because I knew all of the *picciotti* of my rank.
> They were all *camorristi* and *sgarristi*, the latter being a higher rank than that of the
> *camorristi*. Of all people in the room I knew only my cousins Filastò Antonio and
> Francesco, Gaetano Tripodi [. . .] Saccà Antonio di Giuseppe from Podargoni [a
> small village in Calabria] was there and some other Sicilians that I don't remember
> their names. There was also one man from Favazzina [another village near Scilla,
> in Calabria] they called zio Mico and some strangers were present that usually do
> not frequent the bar. I could see in the middle of the table there were two daggers
> and that at certain times the guys would take an oath that involved the name of an
> American Police Lieutenant named Petrosino. I was then called to extract numbers
> from a white silk handkerchief, with the guys all sitting at a table. I remember that
> I took out the number 9 that came from Filastò Francesco who held the handker-
> chief placed in front of one of the people sitting. I extracted the second number, not
> noticing the indentation on the card, pulling out a number that Filastò Francesco
> wanted me to avoid. I noticed that his face turned pale. I took out the third number
> that was twelve and placed that on the table in front of Gaetano Tripodi, and finally
> the fourth, which I can not remember what number it was, and that was placed in
> front of a Sicilian. Then I left. From that day on the home of Filastò became hell:
> Filastò Francesco was a nervous wreck and one day he slapped me and reprimanded
> me for not carefully executing what he had prescribed, he had lost the watch. He
> told me that he had to travel to the distant land of America and refused to tell his
> wife where he was going, due to this she started crying frequently. After three or
> four days Filastò Francesco disappeared and he returned after less than a month. It
> was precisely during his absence, when he arrived in America, that the news came
> out of the killing of Lieutenant Petrosino in Palermo.[21]

Filastò was not only a prominent member of the 'Ndrangheta, but also a special deputy under Sheriff Julius Hamburger, delegated with the task of maintaining order and peace. In New York, Filastò was a partner in Filastò Bros. Commission Merchants, located at 293 Mott Street in Brooklyn, specializing in the sale of wine and fruit. Filastò was convicted on February 1913 for violating the federal statute against white slavery and was eventually deported to Italy.[22]

The second case was one of brutal carnage. On 5 September 1910, Giuseppe Rogolino, his wife and six children were hacked to pieces with a hatchet. The youngest victim was a ten-month-old baby. Rogolino spent a number of years in the United States, but returned to Pellaro, in Calabria, and was appointed to the regional forestry corps. The massacre was a deed of revenge on the part of what was mistakenly known as the Black Hand. Italian police discovered that nearly two years earlier Giuseppe Rogolino was implicated with other

countrymen in a big bank robbery in New York. He was able to avoid charges, however, by revealing the identity of the other principal culprits. The order for the massacre was dispatched from New York City to a group of Calabrian associates. Some local mobsters were arrested for the brutal carnage. They were later acquitted for lack of evidence.[23]

Black Handers: Vito Cascio Ferro and Ignazio Lupo

The most famous Black Hander was Vito Cascio Ferro, who emigrated from Sicily in 1901. He understood the need to coordinate the various gangs that used extortion and were often competing amongst themselves. Cascio Ferro is considered to be the mastermind behind the murder of Detective Petrosino. According to Arrigo Petacco in his 1972 book on Joe Petrosino, Cascio Ferro said: "In my whole life I have killed only one person, and I did that disinterestedly ... Petrosino was a brave adversary, and deserved better than a shameful death at the hands of some hired cut-throat."[24]

Vito Cascio Ferro left New York in the hands of his most trusted men and began going back and forth between America and Sicily, where about a decade prior, he had masterminded the murder of Emanuele Notarbartolo, the former chairman of the Banco di Sicilia, who dared go against the Mafia. He had tried to stop the Mafia's money laundering practice that took place within his bank. For this reason, he was fired from his position but he continued investigative work in secret to try and discover the ties between the Mafia and the banking system. Notarbartolo was killed one evening in February 1893, suffering from multiple stab wounds while taking the train from Termine Imerese to Trabia. Notarbartolo was Italy's first "eminent corpse"—its first Mafia victim from among the social elite.[25]

Raffaele Palizzolo, a member of the Italian parliament, was accused of having ordered the murder. Palizzolo was a follower of Don Vito Cascio Ferro, who helped him get elected. The Member of Parliament was found guilty twice in the first big case against the Mafia. At that point, Don Vito put into action all of his connections. The strongest sections of Sicilian society mobilized and some intellectuals accused the Italian government of racism against Sicily. As a result of this pressure, Palizzolo's lawyers had the case reviewed by the Court of Appeal of Florence and the politician was eventually acquitted of wrongdoing due to the lack of evidence. Don Vito organized a triumphant return to celebrate the event and then brought Palizzolo to the United States. All of Don Vito's most secretive and unsuspected men were mobilized, and assemblies were organized in New York, Boston, Chicago, New Orleans, Pittsburgh and Philadelphia. The same points were discussed at every location: it was necessary to organize an association comprised of Sicilians, a true state-within-a-state with its own internal laws, and therefore the Union of Sicily. Such a discourse was in line with Don Vito Cascio Ferro's ideas. Constructed with ambiguous phrases which had double meanings and hidden phrases, the message was that the godfathers need to know how "to do politics" and needed to create the largest possible social consensus to hide their criminal power.

Another famous Black Hander was Ignazio Lupo, aka "Lupo the Wolf." He had fled from Sicily to avoid prison after a conviction for murder, and was the first to challenge the power of the Irish and Jewish gangs, creating a structured organization, with the collaboration of his brother-in-law, Nicholas Morello, who later become the first great boss of the New York Mafia. According to David Southwell, the growth of Morello's power perfectly illustrated the origin of the American Mafia, and why it was so successful:

> Like other Italian gangs throughout America, it started out protecting its own community before exploiting them and turning the Italian immigrants' distrust of authority into an effective barrier of silence. It then used its Black Hand profits

to expand into other criminal areas, benefiting greatly from the established gang structure and loyalty that had already been developed through hundreds of years of Italian history. It was these combined factors that gave not only Morello, but also the developing Mafia as whole, an organizational edge over its ethnic rivals and the perfect launch pad for further success.[26]

Even famous Italian celebrities, such as the opera singer Enrico Caruso, received a letter signed with a black handprint. The first time he paid $2,000, and then when he received another request for $15,000, he reported the threat and was able to call upon police protection.

Prohibition

What would become the Black Hand was clearly understood after the introduction of the Volstead Act, the "Noble Experiment." Martin Short emphasizes the consequences of that controversial legislation, stating: "Prohibition was a disaster for America because it turned mobsters into public servants."[27] How was such a law ever passed? Short explains: "Prohibition, in the words of a prominent temperance leader, was 'an honest effort to do away with a terrible evil.' The Prohibition movement had grown steadily over many years. It exploited many fears: some were real; others were based on ignorance or prejudice. It symbolized rural America against the big city, native America against immigrant, Puritans against Catholics, put-upon women against drunken men, whites against blacks. Above all, it personified the church against the saloon."

For criminal organizations, the Volstead Act was a springboard. Gangs restricted and confined in slums and peripheral neighborhoods became effective and efficient criminal networks. One of the most popular bosses during Prohibition was Al Capone (Figure 29.2), the son of a Neapolitan immigrant. He once said: "I make my money by supplying a public demand. If I break the law, my customers, who number hundreds of the best people in Chicago, are as guilty as I am. The only difference is that I sell and they buy. Everybody calls me a racketeer. I call myself a businessman. When I sell liquor it's bootlegging. When my patrons serve it on a silver tray, it's hospitality."[28] Capone is forever linked to the St. Valentine's Day massacre. It was 14 February 1929, when his men (some disguised as police, others in elegant suits) killed a mechanic and six mob associates of the North Side Irish gang led by Bugs Moran. The killings were dramatized in the 1967 movie *The St. Valentine's Day Massacre* by Roger Corman, and in "Some Like It Hot," in which the two main characters, who witnessed the shooting, hide and dress like women in a chorus of female singers. (Even the music world paid tribute to the bloodbath. In 1998, Mark Foggo's Skaksters named one of their albums and a song after "The St. Valentine's Day Massacre.")

Capone, who succeeded Jim Colosimo in Chicago, a man who was killed because he did not comprehend the importance of Prohibition, opened a dining hall for the unemployed during the great economic crisis of 1929. He wanted to think big and he was an exhibitionist. He never imagined being imprisoned in Alcatraz because of a simple case of tax evasion. As a prisoner of his own myth, Capone's decline became increasingly evident as neurosyphilis progressively eroded his mental faculties.

One of the most notorious American gangsters of the twentieth century, Capone has been the subject of numerous articles, books, and films. He and other gangsters of Italian descent, in reality, were not the only bootleggers, but were the ones who remained etched in the collective imagination, the ones who forever epitomize both bootlegging and Prohibition, thanks to movies like Mervyn LeRoy's *Little Caesar* (1930) or Howard Hawks' *Scarface*

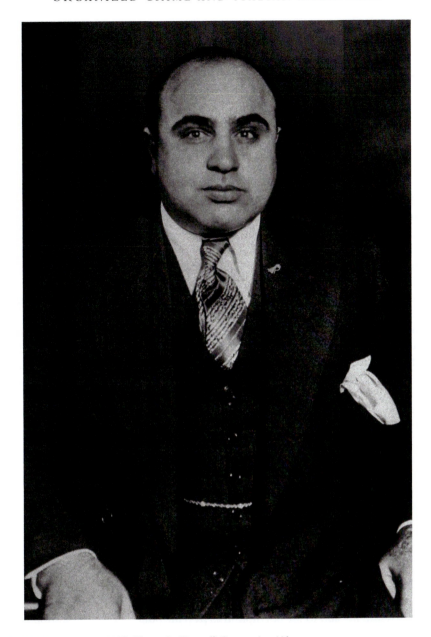

Figure 29.2 Al Capone, *circa* 1930. Photo: IanDagnall Computing/Alamy.

(1932), in a highly questionable logic that has almost always seen Italians as the villains in Hollywood productions.

In 2014, The Italic Institute of America completed an analysis of the portrayal of Italian Americans and Italian culture in Hollywood movies over the past century (1914–2014). Of the 1,512 film titles that were researched, the results revealed an overall negative attitude toward Italian Americans and Italian culture in general (68.5 percent). Images of Italians as violent criminals predominate (34.9 percent), followed by images of unsavory characters

(33.6 percent). Images of Italians in positive, heroic, or complex roles occur less often (31.5 percent).[29]

However, regarding stereotypes of any nature, Prohibition made clear to gangsters that even in America corruption would open every door. This was also well understood by the Irish gangs during the time of Tammany Hall, the political machine of the Democratic Party, ensuring whole neighborhoods voted the way they wanted them to.

The Castellammarese War

By the end of Prohibition, Joe Masseria was the most powerful boss in New York. He preferred to be called "The Boss" instead of Don. To him it seemed more American. He was so overweight that he would require the help of his men (Salvatore Lucania, Carlo Gambino and Vito Genovese) to get off the couch in the evening. In 1930, to gain territorial control, he started going against Salvatore Maranzano, the most ruthless among Vito Cascio Ferro's men. For a while, Maranzano and Masseria confronted one another in silence. Then, they moved into action, giving life to what is remembered as the Castellammarese War, named after the area from which many of the mobsters involved in the war came. While many were embroiled in the battle, a young man from Lercara Friddi, Sicily, raised on Manhattan's Lower East Side, a popular destination for Italian immigrants, was dreaming big. His name was Salvatore Luciano, but everyone called him Lucky Luciano for having miraculously survived an attempted murder. His supposed killers, convinced of his death on 16 October 1929, left him hanging from a hook with a slit throat.

Meyer Lansky, a Jewish friend from childhood, supported Lucky Luciano, together with other emerging youngsters, like Carlo Gambino. Luciano's dream was to eliminate Joe "The Boss" Masseria and Salvatore Maranzano, and to create "a lasting national organized crime network where Italian and Jewish gangs co-operate and that was administered by a 'Commissione,' a board of directors. They wanted it to be purely American operation with no loyalty owed to or control by Sicilian Mafia and without all of the old baggage of rituals, oaths and ancient blood vendettas."[30] He succeeded in his goal by killing Masseria first, then Maranzano. Lansky convinced him to keep the necessary rituals alive in order to give the young followers something in which to believe and be fearful of.

The Atlantic City Conference

The new godfathers met in Atlantic City. Luciano told the other bosses, "The State organizes public virtues and we shall organize private vices."[31] Business required tranquility. There was no room to improvise in the drug market. It was necessary to have order within organizations to bypass searches and to use corruption to stop the police. The Commission was therefore instituted. In order to be a part of it, it was necessary for one to be a recognized boss and to have a territory. The "boss of all bosses" position was abolished. The other members of the Commission proposed that Luciano name the newly restructured organization. "No names," he replied, "so that our thing [cosa nostra] cannot be called upon by anyone and so that we may remain invisible."[32]

From Sicily to America, magistrates and police officers repeatedly stated that the Mafia did not exist. It was repeated often even by J. Edgar Hoover, the Director of the Federal Bureau of Investigations (1935–1972), who spent his free time gambling on horses in a ring led by boss Frank Costello. While Luciano and the other godfathers enjoyed the invisibility of the Mafia, Hoover unleashed manhunts in various communities against single acting bandits, like John Dillinger, and would celebrate each capture with propaganda film reels.

Surrounded by this great silence, the American Mafia was prosperous and gained years of advantage on law enforcement agencies. Suddenly, in October 1929, the New York stock exchange crashed. Everyone was in a state of panic and despair. Everyone, that is, except the Mafia. The Mafia used this as an opportunity to recruit new soldiers from those unemployed by the Great Depression. In 1933, when Franklin D. Roosevelt won the election and announced the New Deal, the Mafia understood the importance of that moment. The New Deal meant dams, harbors, roads and railroads, parks, labor contracts and the growth of unions. It meant getting their hands on great sums of money. In controlling labor, they could control the transportation companies, the building industry, and the east coast harbors of the United States. Since the times of the *Fasci Siciliani* (a popular movement of democratic and socialist inspiration, which arose in Sicily between 1889 and 1894), mobsters had learned how to play the role of fake labor unionist.

In the International Brotherhood of Teamsters, the main point of contact was James "Jimmy" Hoffa from Indiana. He should have guaranteed the maximum invisibility of the business of the godfathers. Instead, however, he was often under investigation. He became an uncomfortable point of contact, to the point where he just disappeared. The infiltration into various syndicates was the main tool used by the bosses of the Cosa Nostra to enter the world of politics.

Operation Underworld

On 7 June 1936, Luciano was convicted on sixty-two counts of compulsory prostitution and five weeks later sentenced to thirty to fifty years in state prison. Vito Genovese fled to Italy to avoid a murder sentence. In Rome he was able to enter the entourage of Count Galeazzo Ciano, the husband of Edda Mussolini, the Duce's favorite daughter. Genovese financed the construction of a *Casa del Fascio* and allowed for the arrival of cocaine, the drug of choice amongst the intellectual elite. As if the drugs and money were not enough to consolidate his connection with the Fascist regime, he pursued other criminal venues. In New York City, Carlo Tresca, an anti-Fascist editor and enemy of Mussolini, was living as a refugee. Convinced he was doing a favor for *Il Duce*, Vito Genovese gave the order to one of his men to kill Tresca as he was leaving the office of his paper *Il Martello* on Fifth Avenue in Manhattan in January 1943.[33]

When the United States entered the Second World War, they discovered that their ports were not secure. There were strikes in the factories and enemy submarines were able to reach the American coast. Many attempted plots spread fears that numerous spies had entered the United States. Many saboteurs were captured, tried, and sentenced. In this atmosphere, the Cosa Nostra of Lucky Luciano demonstrated its capability in functioning like an autonomous state.

The Navy shipyards of New York were busy working on the *Normandy*. It was at the time the fastest transatlantic ship in the world and could evade German submarines in bringing military troops to Europe. Early one morning, the city was awakened to a blanket of smoke over an overturned ship. The idea of sabotage had come to the mind of one of Luciano's men, Albert Anastasia. Therein was born the very secretive Operation Underworld. The Secret Service got the contacts of the boss of the harbor, Joseph Lanza. When he saw the curious agents sniffing around, he sent them immediately to Frank Costello. Costello let them speak and referred them to Meyer Lansky. Lansky listened to their proposal, raised his eyes to the sky and said that only Lucky Luciano could decide on such a deal. The night of 11–12 July 1942, the great godfather began to negotiate and raise the stakes. As a first step, the harbors became safe and the sabotage ended, along with the strikes. Luciano was released from prison and sent back to Italy. The Allied Military Government, led by Colonel Charles Poletti, hired Genovese as a translator, notwithstanding his problems with the American

justice system. At Poletti's side, the Sicilian Mafia did its part to aid the Americans' arrival in Sicily. After the war, under the orders of Poletti, certain mobsters were appointed as mayors for their ability to maintain order. Don Calogero Vizzini, the most powerful boss in Sicily, was appointed mayor of Villalba.

Apalachin 1957

Not everything, however, went smoothly. On 14 November 1957, more than one hundred big Mafiosi were surprised by the police in a country home in Apalachin, in upstate New York, where they were meeting to discuss how to manage the heroin trafficking business with their Sicilian cousins. The house belonged to Joseph Barbara, a member of the Buffalo crime family, another important branch of the Cosa Nostra. Although bosses like Sam Giancana, and about 40 others were able to avoid arrest, 58 presumed Mafiosi did not. Among those arrested were Joe Profaci, Vito Genovese, Santo Trafficante Jr., and Carlo Gambino. Many justified themselves by saying that they had gone to visit an old friend who was sick. Although most presumed bosses were arrested and subsequently released, that event served as a message that the nation was once again paying attention to the American Mafia. Nobody could deny the existence of the Mafia anymore, not even FBI Director J. Edgar Hoover, who for decades maintained that the Mafia was a media invention.

It was in those years that the families went on to take the last names of their old bosses, such as Genovese, Lucchese, Gambino, Bonanno and Colombo. But there were also Cosa Nostra families with roots in Buffalo, New Orleans, Detroit, Los Angeles and Las Vegas. Las Vegas was pretty much created by the mobsters who understood the potential of gambling, casinos and other forms of entertainment.

The Kefauver Committee

The idea of the super-enemy stubbornly returned after the Second World War, thanks to politicians like the U.S. Senator Estes Kefauver, Chairman of a Special Committee called upon to investigate organized crime (1950–1951). In its final report, the Committee focused on the existence of a crime syndicate "spread all over America," wherein the bosses, "the various impeccable and polished Frank Costellos," had learned to "mimic the ways and customs of CEOs and businessmen."

The Kefauver Committee recalled the concept of the "alien conspiracy," concluding that "such a syndicate was dominated by a mysterious international crime organization known . . . under the name Mafia," that was "so fantastic that the majority of Americans find it hard to believe in its existence." Thus, ignoring the outcome of the many investigations that in the 1930s and 1940s had demonstrated the dissolution of the foreign clans, the Committee, by using the words "Mafia" and "Black Hand," into a modern, interethnic, and therefore American, syndicate.[34]

The Kefauver Committee proved that it had not understood the essence and the complexity of the Mafia phenomenon: that to affirm itself it has to build ties with those who control money and power. It is a system built on complicity and relationships that has nothing to do with cultural interpretations on which certain sociological explanations were founded: the mentality, the territory, amoral familism, the absence of civic pride and *omertà*.

Cosa Nostra Today

Today, Cosa Nostra in America is weaker as a result of its decimation due to the many investigations by the FBI and the Drug Enforcement Agency, and the emergence of 'Ndrangheta,

the Calabrian Mafia that currently controls most of the cocaine trafficking in Europe. There is much less discourse about the Mafia, even though it is a topic that has a certain appeal. In New York, the last real boss, John Gotti, who was incarcerated in 1992, died in prison in 2002. In the same year in Tucson, Arizona, Joseph Bonanno, one of the founding fathers of Cosa Nostra, passed away at the age of 97. In 2004, the boss of the Bonanno family, Joseph Massino, decided to collaborate with the justice system by exposing many names of one of the five Mafia families most tied to Sicily. This led to many arrests, trials, and sentences. Although Cosa Nostra is down, it is never out. Their corruptive influence is still deep and pervasive and extends well beyond drug trafficking, extortion, and the more traditional forms of vice.

It is, however, also opportune to remember that there were many men of Italian origin from various institutions who fought against the Mafia. Many investigators were involved in undercover activities, often risking their lives, like Joe Pistone, made famous by the 1997 movie *Donnie Brasco*. Others died, like Joe Petrosino from Padula, considered to be the first detective to understand the complexities of the American Mafia and the need to investigate in both Italy and the United States. Also of Italian origin was Fiorello La Guardia, mayor of New York until 1945. One year after his election in 1933, he banished the slot-machine business, which was led by Frank Costello and Lucky Luciano. (See no. 11 in the Photo Essay.)

Furthermore, not many people are aware that Al Capone had a brother who was not tied to criminal activities, and was a police officer who contributed greatly to the arrest and sentencing of mafiosi and bootleggers during Prohibition. There was also Louis Freeh, who had an Italian mother, and was the Director of the FBI from September 1993 to June 2001. Most importantly, he was a very capable and trustworthy collaborator of men who in Italy made history in the fight against the Mafia, like Giovanni Falcone, the magistrate who was killed in a bomb explosion near Palermo in 1992.

Finally, there was Rudolph Giuliani, one of the most effective District Attorneys in the fight against Cosa Nostra in the United States. (See no. 16 in the Photo Essay.) Though many Italian American public figures avoided the word Mafia, saying it reinforced stereotypes; Giuliani used it repeatedly at news conferences. "By using the word Mafia correctly," he insisted, "you actually help to end the unfair stereotype."[35] This is one way to end the original sin that Italian Americans think they have inherited with the arrival of the Mafia into the New World. To talk about the Mafia does not mean, in any way, to criminalize Italian Americans, but rather to invite them to take a united stand against stereotypes, and most importantly, against those who continue to think that to guarantee the success of the Mafia, it is sufficient to have a last name that ends with a vowel.

Further Reading

Abadinsky, Howard. *Organized Crime*. Belmont: Wadsworth, 2007.

Dainotto, Roberto. *The Mafia: A Cultural History*. London: Reaktion Books, 2015.

De Stefano, George. *An Offer We Can't Refuse; The Mafia in the Mind of America*. New York: Faber & Faber, 2007.

Lombardo, Robert M. *The Black Hand, Terror by Letter in Chicago*. Chicago: University of Illinois Press, 2010.

Lupo, Salvatore. *The Two Mafias: A Transatlantic History, 1888–2008*. New York: Palgrave Macmillan, 2015.

Notes

Special thanks to Daniele Bozzelli, Anthony Tamburri, Donato Santeramo, Devin McDonald, Maria Barillà, Vittorio Amaddeo, and Antonella Nicaso.

1 John B. Trumper, Antonio Nicaso, Marta Maddalon and Nicola Gratteri, *Male Lingue, Vecchi e nuovi codici delle mafie* (Cosenza: Pellegrini Editore, 2014), 230–231.

2 Ferdinando Cordova, *Il Fascismo nel Mezzogiorno: le Calabrie* (Soveria Mannelli: Rubbettino Editore, 2003), 27.

3 "Gazzetta Ufficiale del Regno d'Italia" (4 March 1905), 971–973 e "Per l'emigrazione negli Stati Uniti," in *La Stampa* (4 March 1905).

4 Antonio Filastò in *Gazzetta di Messina e delle Calabrie* (12 October 1906), cit. in Antonio Nicaso, *Alle origini della 'ndrangheta: La Picciotteria* (Soveria Mannelli: Rubbettino, 1990), 33.

5 "By the Order of the Mafia," *New York Times* (22 October 1888).

6 "The Sicilian Maffia—a New Camorra in Italy—Organizing," *New York Times* (24 September 1874).

7 "The Mafia," *New York Times* (27 May 1877).

8 Martin Short, *Crime Inc.* (London: Thames Mandarin, 1984), 23.

9 Roberto Ciuni, in *Enciclopedia della Sicilia*, ed. Caterina Napoleone and Franco Maria Ricci (Milan: Franco Maria Ricci Editore, 2007).

10 John Persico, "Vendetta in New Orleans," *American Heritage Review Magazine* (June 1973).

11 Salvatore Lupo, *Quando la mafia trovò l'America, Storia di un intreccio intercontinentale, 1888–2008* (Turin: Einaudi, 2008), 12–13.

12 Robert M. Lombardo, *The Black Hand, Terror by Letter* (Champaign: University of Illinois Press, 2010), 4.

13 Frederic Sondern Jr., "How the Mafia Came in America," in *Mafia U.S.A.*, ed. Nicholas Gage (Chicago: Playboy Press, 1972), 78.

14 On the "coffin notices" given as warnings by the Molly Maguires, see Kevin Kenny, *Making Sense of the Molly Maguires* (New York: Oxford University Press, 1998), 173–175, 198, 216, 307–310.

15 Emile Durkheim, *The Elementary Forms of Religious Life* (New York: Collier, 1912) in Antonio Nicaso and Marcel Danesi, *Made Men, Mafia Culture and the Power of Symbols, Rituals and Myth* (Lanham: Rowman & Littlefield, 2013), 53.

16 *Male lingue*, 152. On Amy Bernardy, see Chapter 8.

17 *True Detectives Mysteries*, 13.7 (October 1930), 49–51, 68–73.

18 Marc Monnier, *La Camorra* (Lecce: Argo,1994), 34.

19 Arrigo Petacco, *Joe Petrosino: l'uomo che sfidò per primo la mafia italoamericana* (Milan: Mondadori, 1972/2001), 167–168.

20 Joe Petrosino Murder, GangRule, www.gangrule.com/events/petrosino-murder-1909.

21 Archivio di Stato di Palermo, Questura, Archivio Generale, Busta 1584.

22 "Find White Slavers Guilty In Quick Time," *New York Tribune* (2 February 1913), 18.

23 Archivio di Stato di Reggio Calabria, inv. 68, Tribunale Penale di Reggio Calabria, Processi, bb. 1135–1136, f. 17852.

24 Arrigo Petacco, cit., 199. Cascio Ferro pleaded his innocence and provided an alibi for the entire period when Petrosino was assassinated. He stayed in the house of Domenico De Michele Ferrantelli, a member of Italian Parliament. In 2014, more than a century after the assassination, the Italian police overheard a tapped phone conversation in which a relative claimed that Paolo Palazzotto had been the killer on the orders of Cascio Ferro. Palazzotto had been arrested after the shooting, but had been released for lack of evidence.

25 The phrase "*cadaveri eccellenti*" was later used as the title of Alexander Stille's book on the subject, *Excellent Cadavers* (New York: Vintage, 1996), and also of a documentary based on the book.

26 Sondern Jr., "How the Mafia Came in America," 28.

27 Short, *Crime Inc.*, 68.

28 Ibid.

29 Italic Institute of America website. See www.italic.org/mediaWatch/filmStudy.php

30 David Southwell, *The History of Organized Crime* (London: SevenOaks, 2006), 36.

31 Quote attributed to Lucky Luciano by Joseph Bonanno, during an interview with the author of this essay in 2000. Parts of this interview were published in Antonio Nicaso, *Rocco Perri: The Story of Canada's Most Notorious Bootlegger* (Mississauga: Wiley, 2004).

32 Antonio Nicaso, *La mafia spiegata ai ragazzi* (Milan: Mondadori, 2010), 18.

33 On the Tresca assassination see Dorothy Gallagher, *All the Right Enemies: The Life and Murder of Carlo Tresca* (New Brunswick: Rutgers University Press, 1988) and the biography by Nunzio Pernicone, *Carlo Tresca: Portrait of a Rebel* (New York: Palgrave Macmillan, 2005).

34 United States, Congress. Senate. Special Committee to investigate Organized Crime in Interstate Commerce. Estes Kefauver. Didier, 1951.

35 Larry McShane, "Giuliani: Mob Buff/Buster," *The Associated Press* (10 September 2007).

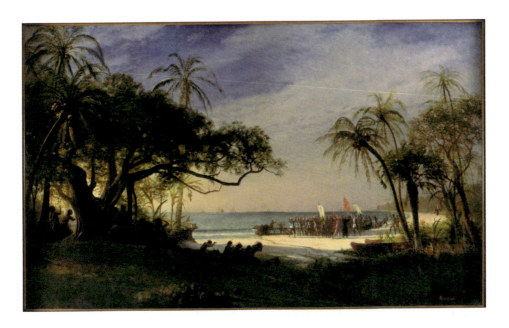

Plate 1 The Landing of Columbus. An oil painting by Albert Bierstadt, *circa* 1893. Collection of the Newark Museum 20.1167. Gift of Dr. J. Ackerman Coles, 1920. Photo: Newark Museum.

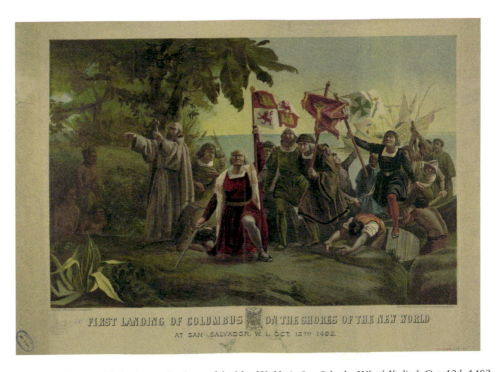

Plate 2 First landing of Columbus on the shores of the New World: At San Salvador, W[est] I[ndies], Oct. 12th 1492. A Currier & Ives print of 1892, after a painting of 1862 by the Spanish artist Dióscoro Teófilo Puebla Tolín. Photo: Library of Congress, LC-USZC2–3385.

Plate 3 Filippo Mazzei. A portrait by Jacques-Louis David, 1790. Musée du Louvre, Paris. Photo: Art Resource. © RMN-Grand Palais/Art Resource NY.

Plate 4 Lorenzo Da Ponte. A portrait by Samuel F. B. Morse, *circa* 1830. Italian Academy for Advanced Study in America. Photo: Art Properties, Avery Architectural & Fine Arts Library, Columbia University.

Plate 5 Pietro Bachi. A portrait by Albert Gallatin Hoit, *circa* 1851–1853. Harvard Art Museums. Photo: © President and Fellows of Harvard College.

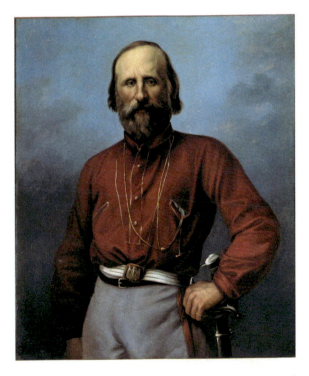

Plate 6 Giuseppe Garibaldi. A portrait in uniform with his red shirt, *circa* 1860. Photo: Universal Images Group/Art Resource NY.

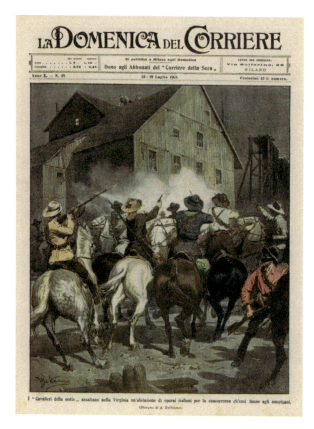

Plate 7 "Night Riders attack the lodging of a crew of Italian workers in Virginia on account of their competition for work with Americans." A cover illustration by Achille Beltrame for *La Domenica del Corriere* (5 July 1908). Photo: Mary Evans Picture Library/Alamy Stock Photo.

Plate 8 "The Fooled Pied Piper." A cartoon by Samuel D. Erhart, published in the magazine *Puck* (2 June 1909), centerfold. Photo: Library of Congress Prints and Photographs Division, LC-DIG-ppmsca-26380.

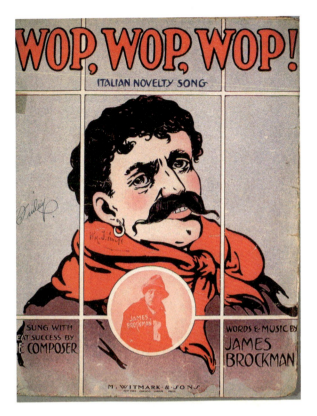

Plate 9 The song "Wop, Wop, Wop!" by James Brockman. Sheet music cover, 1908. Photo: Sheridan Librar‐
ies/Levy/Gado/Getty Images.

Plate 10 Italian American Directory, 1905, with advertisements printed on the cover, published by the Ital‐
ian American Directory Company of New York. Collection of James J. Periconi. Photo: Robert
Lorenzson.

Plate 11 The Passion of Sacco and Vanzetti. Mosaic depicting the 1920–1927 trial by artist Ben Shahn, 1967. Photo: Syracuse University Art Galleries/VAGA.

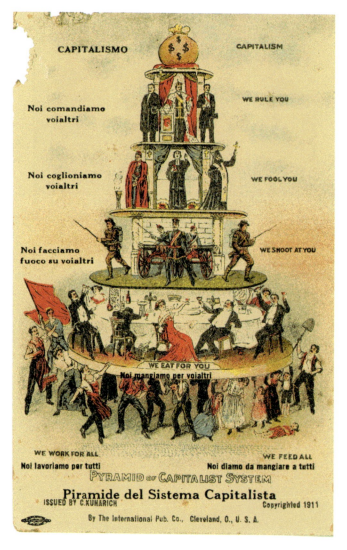

Plate 12 The "Pyramid of [the] Capitalist System." A postcard printed in Italian and English by the International Publishing Company of Cleveland in 1913. Biblioteca Franco Serantini, Pisa, Sezione Archivio, Fondo J. Cono, Sezione cartoline.

Plate 13 Immigrant Madonna. A color monotype by Joseph Stella. Published on the cover of *The Survey*, graphic number (1 December 1922). © 2008 by Vincenza Scarpaci used by permission of Pelican Publishing Company, Inc.

Plate 14 Blue Mom, detail. A sculpture by Christine Perri, 2006. Mulberry logs, pine boards, plywood, salvaged wood crate; oil, pencil. Photo: © Christine Perri.

Plate 15 *Hyena Stomp*, a painting by Frank Stella, 1962. Photo: Art Resource NY.

Plate 16 The Watts Towers. Constructed by architect/sculptor Simon (Sabato) Rodia between 1921 and 1954. Wire mesh, porcelain, tile, mortar, glass and steel. Watts, Los Angeles. Photo: © Luisa Del Giudice, Coordinator, Watts Towers Common Ground Initiative & Watts Towers-UNESCO Committee, 2016.

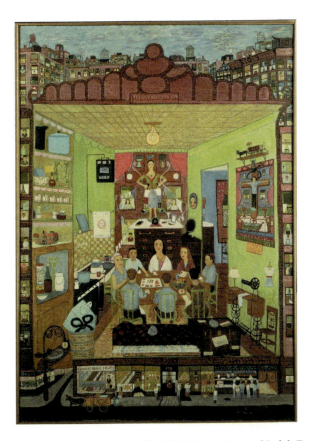

Plate 17 *Family Supper*, a painting by Ralph Fasanella, 1972. Photo: Estate of Ralph Fasanella.

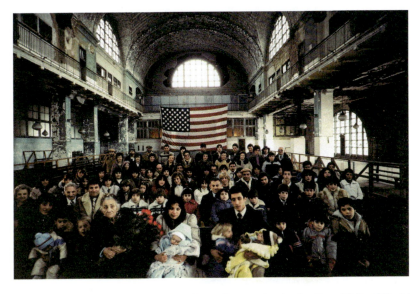

Plate 18 Esterina Mazucca (front left) with her descendants posing in the Great Hall at Ellis Island. Published as the centerfold of *LIFE* magazine, July 1983, for an article about the Ellis Island restoration project. Photo: Arnold Newman/Getty Images.

Plate 19 Mott and Grand Street (aka The Order Sons of Italy Way). Little Italy, Manhattan, New York City, 2006. Photo: Jerome Krase.

Plate 20 "Little Italy in the Bronx." Arthur Avenue, Belmont, Bronx, NY, 2007. Photo: Jerome Krase.

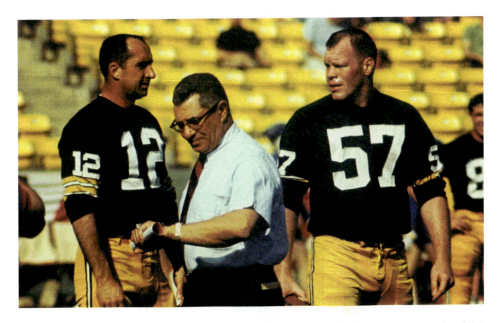

Plate 21 Coach Vincent Lombardi of the Green Bay Packers checks his watch before Super Bowl I, Los Angeles, 15 January 1967. The Packers won. Photo: Bettmann/Getty Images.

Plate 22 Donna Lopiano, former fast pitch softball star and champion of gender equity as CEO of the Women's Sports Foundation. Lifting a 25-pound barbell in a gym, Trumbull, Connecticut, 14 October 2012. Photo: Stan Grossfeld/Boston Globe/Getty Images.

Plate 23 Sonny Bono and Cher (Sarkisian) peforming on *The Sonny & Cher Comedy Hour, circa* 1972.
Photo: Pictorial Press Ltd/Alamy Stock Photo.

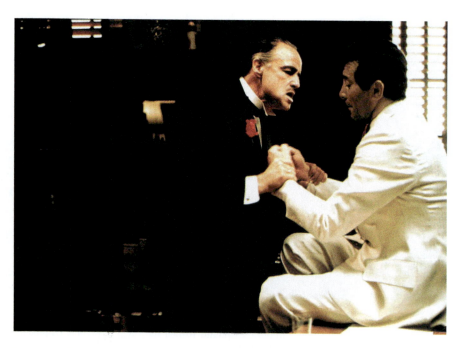

Plate 24 Marlon Brando as "Don Vito Corleone," and singer Al Martino playing "Johnny Fontane," in *The Godfather* (1972). Photo: AF archive/Alamy Stock Photo.

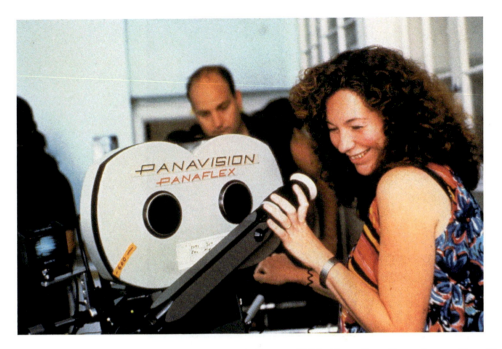

Plate 25 Director Nancy Savoca on the set of *Household Saints* (1993). Photo: Jones Entertainment/Ronald Grant Archive/Alamy Stock Photo.

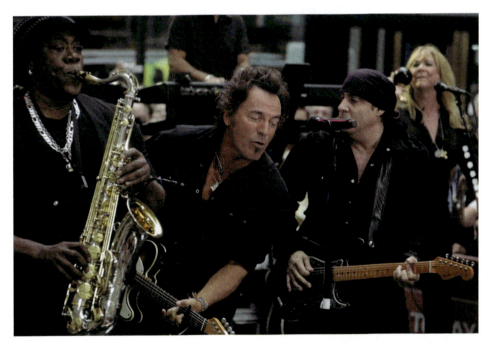

Plate 26 Bruce Springsteen, performing with Clarence Clemons and Steve Van Zandt as the E Street Band, on the TODAY Show, Rockefeller Center, New York City, 28 September 2007. Photo: © Nancy Kaszerm/ZUMA Press, Inc./Alamy.

Plate 27 San Gennaro Offering, New York City, September 1998. Photo by Robert Forlini.

Plate 28 Lady Gaga (Stefani Germanotta) and Madonna (Madonna Louise Ciccone) attend the Marc Jacobs 2010 Spring Fashion Show, New York City, 14 September 2009. Photo: Dimitrios Kambouris/ WireImage for Marc Jacobs/Getty Images.

Plate 29 Maria Di Fiore in her garden, Nassau County, New York, 2015. Photo: Giuseppina Mazzola.

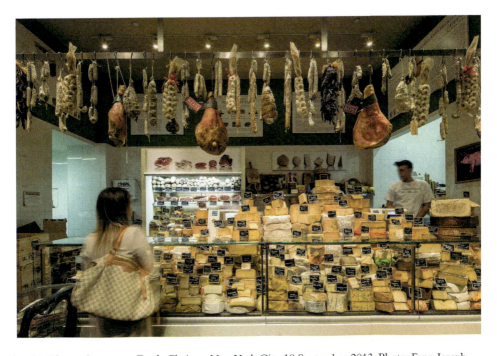

Plate 30 Cheese Counter at Eataly, Flatiron, New York City, 18 September 2013. Photo: Evan Joseph.

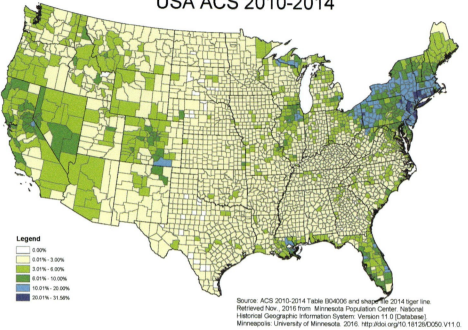

Distribution of Italian Americans within County
USA ACS 2010-2014

Legend
- 0.00%
- 0.01% - 3.00%
- 3.01% - 6.00%
- 6.01% - 10.00%
- 10.01% - 20.00%
- 20.01% - 31.56%

Source: ACS 2010-2014 Table B04006 and shape file 2014 tiger line.
Retrieved Nov., 2016 from Minnesota Population Center. National
Historical Geographic Information System: Version 11.0 [Database].
Minneapolis: University of Minnesota. 2016. http://doi.org/10.18128/D050.V11.0.

Prepared by Itala Pelizzoli and Dr. Vincenzo Milione, The Calandra Institute.

Plate 31 Percentage of Italian American residents, county-by-county data from 2010–2014. Courtesy Dr. Vincenzo Milione, John D. Calandra Italian American Institute, Queens College, CUNY.

Plate 32 Castello di Amorosa, Napa Valley, California, 2010. Photo: Jim Sullivan, Castello di Amorosa.

Part IV

POSTWAR TO POST-ETHNIC?

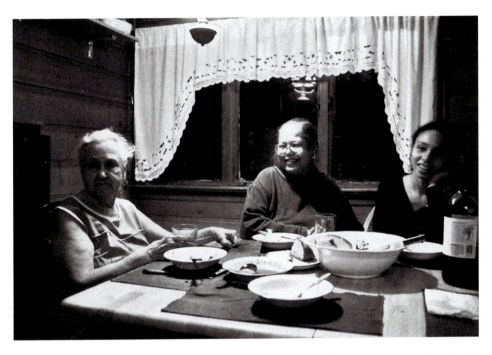

Frontispiece IV Kym Ragusa, author of *The Skin Between Us*, with her African American grandmother Miriam Christian (center) and her Italian American grandmother Gilda Ragusa (left), Thanksgiving, 1996. Photo: Vivek Bald.

30

ITALIAN AMERICANS AND ASSIMILATION

Richard Alba

Italian Americans are a paradigmatic case for American assimilation. Not only did the great initial distance of the group from mainstream America test the reach of assimilation pathways, but its patterns of assimilation, especially during the several decades after the middle of the twentieth century, have contributed to redefining the concept's meaning. Italians demonstrate the falsity of a core assumption—still widely accepted—of the classical assimilation model, according to which assimilation remade an immigrant group into a copy of the majority population. What the Italian American experience reveals is the ultimate success of a gritty struggle to gain acceptance and middle-class status without surrendering valued aspects of identity, with each generation reaching beyond the achievements of the preceding one. The Italians are *the* paragon of generation-by-generation progression into the mainstream.

Italians as Outsiders

The prospects for Italian assimilation seemed meager at the outset. Though like most immigrations the Italian inflow was heterogeneous, its heavy concentration lay clearly at the lower end of the socioeconomic scale. In American eyes, the immigrants stood out in gangs of men doing manual labor on docks, streets, railroads and construction worksites—"peek and shuvil" work—and were willing when necessary to stoop to the lowest, most degrading forms of labor, such as rag picking.[1]

The humble position of the group—its seeming inability to move en masse into the middle class—appeared confirmed in the second generation. Past the middle of the twentieth century, the educational record of the children of the immigrants lagged noticeably behind the standards set by the average white American, though there were also numerous exceptions, as young Italian Americans succeeded in school, earned college and university degrees, and entered the professions. But in many immigrant families, the expectations of parents coming predominantly from the Mezzogiorno, the economically backward Italian south, which in the late nineteenth century possessed no more than a rudimentary educational system, set up a series of clashes with American schools. In many big cities like New York, the Italian second generation stood out as a problem group, with high rates of truancy and dropout, motivated frequently by a desire to work and earn money as early as possible.[2] Juvenile delinquency and gang formation were also prominent among young Italian Americans. As Nathan Glazer and Daniel Patrick Moynihan put it, writing about New York City before mid-century, "when you talked about criminals and juvenile delinquents in this city until twenty-five years ago, you *did* mean Jewish and Italian kids" [italics in original.][3]

In the world of work, the second generation by and large improved on the low status of its immigrant parents, but remained stuck in the working class. At mid-century, Glazer and

Moynihan found the majority of second-generation Italian American men doing some form of blue-collar work or holding low-level office jobs.[4] This seeming immobility attracted the attention of numerous social scientists interested in "social problems," and some classic studies took the group as their subject; these included William Foote Whyte's *Street Corner Society* (1943) and Herbert Gans's *The Urban Villagers* (1962), both very widely read.[5] A theme of these and other studies concerned the aspects of Italian American culture that, though attractive in the abstract, impeded the steps necessary to mobility: above all, loyalty to family and community, traits undoubtedly beneficial in the southern Italian context from which most immigrant came, held back many in the second generation.

From its beginnings on American soil, the group acquired a stigma that seemed to mark it with inferiority. Italians were quickly associated with criminality, a linkage that solidified early on with the famous killing of New Orleans police chief, David Hennessey, in 1891, and the subsequent lynching of eleven Italian immigrants. Organized crime was seen as the special forte of southern Italians, exemplified during the early years of the century by Black Hand crime and then, beginning with the Prohibition years, by large-scale criminal enterprise, as personified by Al Capone. After mid-century, the Italians stood alone as the gangsters *sui generis*, and Mafia and La Cosa Nostra became household synonyms for organized crime. Again social science entered the scene to provide a theoretical framework (in particular, Donald Cressey's *Theft of the Nation*) to account for what seemed like the unique abilities of the group in this field.[6]

Italian inferiority in the American mind also had racial features. This is not to deny the group's place among whites; but Americans in the early twentieth century recognized quasiracial distinctions, graded in terms of superiority and inferiority, among Europeans. Certainly, in the crucial legal sense, Italians retained the status of whites, able therefore to naturalize (racial barriers to U.S. naturalization existed until 1952), to serve in white military units during World War II, and to marry other whites (anti-miscegenation laws remained on the books in some states until a 1967 Supreme Court decision). But one of the most common derogatory epithets for Italians—"guinea"—expresses a doubt about full whiteness, as this is a word of color, derived from the name for a part of the west African coast and employed during American slavery.[7] The stereotypes about the group also had a prominent physical dimension: The immigrants were "swarthy" and seemed to bear other signs of physical degradation, such as low foreheads.[8] For many Americans, Italians were an inferior form of white person.

The Mid-Century Turning Point

The quarter century following the end of World War II was a turning point in the ethnoracial history of the United States. Before the war, not only Italians but also other second and third generation ethnics from late nineteenth and early twentieth century immigrations were outsiders looking in. The reasons for exclusion included religion as well as ethnicity. Catholic, Jewish and Orthodox ethnics were "here under sufferance" and subordinated to white Protestant leadership, as President Franklin Roosevelt put it bluntly to a confidante during a conversation in 1942. By the mid-1960s, that view had changed. A Catholic president had been elected, and a Judeo-Christian mainstream had emerged, announced in a famous 1955 book, *Protestant-Catholic-Jew*, by Will Herberg.[9]

Undoubtedly, several factors were at work. The restrictive immigration legislation of the 1920s meant that most ethnic communities were no longer receiving fresh infusions of new immigrants; acculturation was the order of the day. The national solidarity achieved by the World War II had included the white ethnics in its embrace, and their contributions to

victory were celebrated in numerous films and novels about the war experience, to say nothing of journalistic accounts from the front.[10]

But there was something else, too. A socioeconomic opening up took place, facilitated by the paramount position of the victorious and relatively undamaged United States in the world economy. Mass higher education was inaugurated, as the number of college students increased an astonishing five-fold between 1940 and 1970. The labor market was transformed through a decline of its bottom strata and an expansion in its middle and upper-middle tiers. A sort of "non-zero-sum" mobility became possible: the mobility of ethnic and others from modest backgrounds did not appear to come at a cost for the opportunities available to the already privileged and their children.[11]

Italian American educational attainment caught up to (and eventually surpassed) white mainstream norms. For the Italian children born on American soil during the period of mass immigration (which ended by the late 1920s), the gap separating them from the education of whites of British ancestry, was very large: 2-to-1 in terms of college attendance, and even larger when it came to graduation. A substantial narrowing of the gap occurred for the cohort born during the late 1930s, a group whose education took place mainly after the war. For those born after 1950, who were leaving school in the late 1960s and early 1970s, the gap had vanished, not to return.[12]

In tandem with their greater educational qualifications, the occupational status of many young, third-generation Italian Americans took a leap beyond what their elders could achieve. In terms of the percentages placed in professional, technical and managerial occupations and also in terms of average occupational prestige, the gains made by young, later-generation men pointed to a severe contraction of the inequality that previously separated the group from white Protestants of British ancestry. By the late 1970s, the labor-market position of young Italian American women had also improved but the gap with their WASP counterparts had not closed as it had for their brothers.[13]

The Italians were also participants in the major realignment of residential space that began in the postwar period, spurred by the rapid postwar development of the suburbs and, starting in the 1960s, the potent catalyst of competition with racial and new immigrant minorities over urban turf. The new suburban communities, exemplified by Levittowns, were crucibles for the mixing across ethnic and religious lines of white families coming from urban communities, including ethnic neighborhoods. That the suburbs were racially exclusive—African Americans especially were kept out by discrimination—fed the sense among the white suburbanites that ethnic differences were mostly of minor significance.[14]

As Italians were gaining socioeconomic parity with other whites and more and more mixing with them in neighborhoods and schools, more intimate forms of integration were not far behind. Intermarriage by Italian Americans soared, rising sharply between the second and third generations and over time. For the cohorts born during the 1940s and later, intermarriage was the dominant pattern, with rates varying between 50 percent and 75 percent depending on the generation, decade of birth and gender. Intermarriage was common with other Catholic groups. Irish American partners were especially notable because of the previous antagonisms between the two groups. Yet the Irish, as another large Catholic group settled in many of the same cities as the Italians, were abundant in the pool of potential partners. But intermarriage was not restricted to fellow Catholics. About half of the intermarried Italian Americans born in the aftermath of the war took non-Catholic, mainly Protestant, partners.[15]

Despite the powerful statistical evidence of major assimilation trends impacting on Italian Americans after World War II, it is important not to fall into two errors by thinking: that assimilation affects everyone in a group to the same extent, and that assimilation means the

obliteration of all traces of ethnicity, including family memories and personal identities. With respect to the first error, the assimilation currents had powerful effects on younger members of the group; they were, after all, the ones who could respond to shifting opportunities, in education, the labor market and social relationships. The lives of older members of the group were more or less set, though the marriage choices of their children affected the family circle.

Age, moreover, in the Italian group, corresponded rather strongly with generation (this relationship results from the highly compressed character of the Italian immigration, the majority of the immigrants arriving in the 1900–1914 period). Hence, throughout the second half of the twentieth century, there were marked strata of assimilation visible among the immigrants and their descendants. Distinctions in experiences and embeddedness in Italian American sociocultural worlds were notable among older, first or second generation Italian Americans who had grown up in the immigrant settlements before the closure of the mass immigration period in the mid-1920s; second and third generation Italian Americans of varied ages who had been raised in Italian American families and communities; younger, third and fourth generation Americans of Italian descent with non-Italian parentage who grew up in mixed neighborhoods and possibly away from any Italian concentration.

It's also important to avoid the second error, of seeing assimilation as an all-or-nothing proposition. Assimilation has its variants and degrees. Even individuals of mixed Italian ancestry married to non-Italians and with lives that are remote from Italian American communities and environments can—and often do—feel Italian at moments. Indeed, an argument often made during the late twentieth century was that assimilation had not extinguished what for many can be an intense sense of Italian American identity.[16] The argument is true, but it doesn't negate the power and long-term consequences of the assimilation patterns powerfully set in motion during the mid-twentieth century.

Into the Twenty-First Century

If demography is not destiny when it comes to ethnic groups, it comes as close to it as anything else. Since mid-century, decades of socioeconomic and spatial mobility, along with high rates of marriage to non-Italians, are shifting the center of gravity of the group and tilting the content and significance of its collective experience.

These changes are apparent in the family backgrounds of contemporary Americans of Italian descent (whom I will continue to call "Italian Americans" for simplicity, although the degree of affiliation of some with this group is dubious). According to the Census Bureau's American Community Survey (2013), the majority (61 percent) of the nation's 17.4 million Italian Americans now come from ethnically mixed backgrounds. This aspect of the group looked rather different just three decades ago, when the census ancestry question was first asked in 1980: then the majority, 56 percent, had unmixed ancestry.[17]

Mixed ancestry is concentrated among younger Italian Americans, the ones currently in the ages of marriage and child rearing. Since, moreover, as much research establishes, individuals with mixed ancestry are likely to cross ethnic lines when marrying, today's children who have Italian ancestry are predominantly being raised in families that trace their ethnic roots to several different countries and many—perhaps a majority—have only a single grandparent from an Italian background. Such family environments obviously affect the level of exposure to such ethnicity-kindling experiences as hearing the language or participating in holiday customs.

Given the mixing taking place in families, it should not be surprising that the Italian language—or, better put, languages, since so many of the immigrants spoke dialects—has fallen into widespread disuse. The decline of Italian generally conforms to the three-generation

model of linguistic assimilation first put forward by the linguist Joshua Fishman. In this model, English monolingualism, with perhaps some fragmentary knowledge of words and phrases of the immigrants' tongue, is the dominant pattern in the third generation, among the immigrants' grandchildren, in other words. According to the Census Bureau, Italian is still the tenth most common foreign language spoken in the United States, but it had only 724,000 speakers in 2011.[18] The figure implies that less than 5 percent of Italian Americans today speak Italian at home.

In other ways, too, the assimilation that became evident at mid-century has continued to develop. The socioeconomic advance of the group has progressed. The average educational attainment of young-adult Americans (ages 25–34) with Italian ancestry is now higher than that of other white Americans. In recent census data, about 40 percent of the group's young men and 50 percent of its young women had earned college degrees; in both cases, the figures are about 10 percentage points higher than their equivalents for other whites.[19] The Italian American educational "advantage"—a remarkable turnaround from the deficit at mid-century—is probably due as much to the group's concentration in states and regions where educational attainment is high as it is to anything else. The group is also quite affluent. The median income of households headed by individuals with Italian ancestry was recently estimated at $64,300, placing the group near the front of a larger cluster of other European-descent groups (e.g., Scottish, at $64,400; Irish, at $58,600); a few groups, such as British and Russian Americans (the latter mostly Jewish), are significantly ahead of the Italians, however.[20]

These changes, along with the lack of appreciable immigration from Italy, have been steadily weakening Italian neighborhoods (such as New York's Bensonhurst in South Brooklyn), perhaps the most prominent collective feature of Italian ethnicity in many American cities, especially along the Northeastern seaboard. To earlier observers, such as Nathan Glazer and Daniel Patrick Moynihan, the stability of Italian American urban communities was one of the most distinctive traits of the group. As of 1990, such neighborhoods were still quite discernable in the ethnic landscape of the region centered on New York City, although only a quarter of the area's residents with Italian ancestry lived in them. Overall, the residential distribution of the group was not very different from that of the white population, in part because of its concentration in suburbs and the level of residential integration there.[21]

Since 1990, there has been further erosion of the region's Italian American neighborhoods. Ironically, Bensonhurst, the site of the infamous 1989 racist killing of Yusuf Hawkins by a group of Italian American youth acting, they thought, to protect the neighborhood from outsiders, is a prime exemplar of this process. (See no. 10 in the Photo Essay). The pressures affecting this change are: on the one hand, the demographic implosion of the Italian American resident population, as young adults depart for opportunities elsewhere, leaving behind households with mainly elderly parents; and, on the other, gentrification and the in-migration of Asian and other new immigrant groups. In the Bronx, in the well-known Italian neighborhood of Belmont, around Arthur Avenue, a transformation is taking place among residents, as Albanians and Hispanics replace disappearing Italian Americans. These changes are not visible at the street level, as the neighborhood, like Manhattan's Little Italy, has so far retained an Italian character in its stores and restaurants. (In the case of Little Italy, though, one study has found that most of the workers in the Italian restaurants now are Albanian.[22]) Commercial considerations account for the persistence of some ethnic street facades after the departure of the residents who created them. Neighborhoods like the Bronx's Belmont (see Color Plate 20), convenient by car from New York's northern suburbs, continue to function as ethnic meccas, where suburban ethnic families can visit to re-experience the "old neighborhood" and resupply their pantries with ethnic products.

Italian Americans have become prominent in many areas of American life. One of the most telling is the political domain, since the public careers of Italian Americans have long suffered from stereotypes, especially the suspicion of Mafia connections. Italian American political prominence is found across the political spectrum, pointing up how thorough is the group's political integration.

Though there has not yet been an Italian American President (and this should not be the standard for group success in any event), Rick Santorum, the son of an Italian immigrant father, has run twice for the Republican nomination, coming in second to Mitt Romney, the eventual nominee, in 2012. Samuel Alito and Antonin Scalia until his death were a duo anchoring the conservative wing of the nine-member Supreme Court. Nancy Pelosi, a liberal Democrat, became the first female Speaker of the House of Representatives in 2007, a position she held for four years, putting her two heartbeats from the presidency, i.e., the next in line after the vice president to succeed to the Oval Office. (See no. 12 in the Photo Essay). In 2013, Bill de Blasio, who took the name of his Italian American mother after his German-surnamed father left the family, was elected Mayor of New York and immediately became a leader of the progressive wing of the Democratic Party.

A noticeable change in the public perception of Italian American public officials has taken place since the mid-1990s. Prior to that point, they were frequently—and successfully—tagged by their opponents with Mafia allegations. This happened to Geraldine Ferraro, when she was selected as the vice presidential nominee in 1984, creating an uproar that helped to sink the Democratic ticket in the election. When she subsequently ran for the New York Democratic nomination for the Senate in 1992, one of her opponents relentlessly ran a television ad that featured a cover of the *Village Voice* newspaper alleging numerous gangland ties; she lost. Even Rudolph Giuliani (see no. 16 in the Photo Essay), famous as a prosecutor of mobsters, was victimized by such insinuations when he was New York City Mayor. But Mafia suspicions have not arisen recently in the public lives of successful Italian American public figures.

In the meantime, Italian American organized crime is in steep decline as a consequence of vigorous law enforcement but also assimilation—why should young and ambitious Italian Americans choose the risky route of what Daniel Bell described as the "queer ladder of mobility" when opportunities for education and the professions or business success are available to them? According to a National Institute of Justice estimate, La Cosa Nostra (LCN) has about 1100 "made" members, 80 percent of them belonging to the five families of the New York region. This is a considerable falloff since the 1960s, when the President's Crime Commission estimated total LCN membership at five thousand as a minimum, and the concentration in the New York area means that many of the twenty or so families in other parts of the country are feeble or moribund.[23]

Yet these manifold signs of assimilation do not translate into an equivalent decline in Italian American identities, which remain personally meaningful for many Americans of Italian descent. One study from the mid-1980s found that Italian American identities were more salient than other white-ethnic identities (except for Jewish). The vividness of ethnic identity can create a sense of contradiction between more or less objective social patterns and subjective meanings. However, two points should be kept in mind: First, personal ethnic identities often take root in experiences of ethnic family and community contexts during childhood, but the bases for these experiences are being eroded for new generations by assimilation. Second, ethnic identities among whites increasingly have taken on a symbolic or optional character; that is, they tend to be occasional in nature (most intense in family settings or on holidays) and to take forms compatible with interethnic sociability (expressed in food, for example). Italian American identities are evolving in these ways.[24]

The current situation of widespread assimilation, combined with a persisting, if diminished core—that is, the minority of the ancestry group who remain embedded in an Italian American sociocultural world—and the sense of ethnic identity felt by many, lends itself to paradox. On the one hand, signs of ethnic vitality are the popularity of celebrations accompanying feasts of hometown Italian patron saints, such as the famous Festa di San Gennaro (see Color Plate 27) and the familiarity of the phenomenon of Italian American religious folk art.[25] On the other hand, the adherence of Italian Americans to Catholicism, the religion, at least nominally, of the overwhelming majority of immigrants, has been weakening with each generation. In the fourth generation, there is no longer a clear majority of Catholics. The drift into other religious categories, especially Protestant denominations but also the growing group of Americans who declare "no religion," has been promoted by intermarriage, especially across religious lines.[26]

The Significance of the Italian Case

The Italian case has proven to be significant for assimilation theories and has contributed to so-called neo-assimilation theory, which has attempted to refurbish assimilation ideas for the new era of mass immigration. For one thing, the Italian experience of assimilation disproves one of the most common ideas about this process—namely, that it eradicates ethnic traces and remakes individuals and groups into carbon copies of the societal mainstream. This idea was expressed in Milton Gordon's canonical, mid-century book, *Assimilation in American Life*, in terms of a "one-way process" of acculturation, which involved immigrant-origin minorities accepting the culture of the white Anglo-Saxon middle class as their own and jettisoning the cultural remnants they have adopted from immigrant ancestors.[27] It is without question that immigrants and, even more, their children and grandchildren, absorb a great deal from the mainstream of the new society. But the Italian American experience shows that, even as the ethnics become more like the mainstream, they often retain some sense of identity and some cultural expressions of identity. Assimilation, in other words, has been shown to be compatible with a degree of ethnic retention, so long as this is not a barrier to navigating ethnically mixed social worlds.

Even more, immigrant-origin groups may influence the societal mainstream, so that the processes that increase the similarity between majority and minority may be two-way. In the Italian case, food is an obvious domain of minority influence, and dishes that started out in the immigrant culture, like spaghetti, have thoroughly penetrated mainstream American cuisine and spawned further innovations there, as a glance at any food column of a newspaper will show. Immigrant language, too, has been a source of borrowing by American English (throughout American history), and Italian has contributed its share. In recent years, for instance, the Italian-American word, *agita*, has become popular among educated Americans as a way to express mild distress.[28]

By far the most profound impact on the mainstream that occurred as part of the post–World War II assimilation of Italian Americans and other ethnics was in the domain of religion. In the early twentieth century, when Jewish and Catholic immigrants from southern and eastern Europe were landing in American ports in unprecedented numbers, the U.S. mainstream was defined as "Christian," a term opposed to Roman Catholicism as well as non-Christian religions. Non-Protestants were seen as outsiders, and the boundary that excluded them was defended by such actions as restrictions on the admission of Jews to elite universities, where privilege was minted, and the mass mobilization of white Protestants to defeat the Catholic presidential candidate, Al Smith, in the election of 1928.[29] Yet, in the end, the mainstream expanded and was redefined as "Judeo-Christian," an expansion

that accompanied post–World War II mass assimilation. To be sure, during that period Judaism and Catholicism in the United States underwent changes that made them resemble American Protestant models more. But Jews and Catholics did not become carbon copies of Protestants. The crucial point is that the once salient boundaries separating them from Protestants faded while, at the same time, they retained distinctive religious identities, beliefs and practices.

With the Italian experience in mind, Richard Alba and Victor Nee conceived a definition of assimilation that has become the touchstone of neo-assimilation theory: "the decline of an ethnic distinction and its corollary cultural and social differences." And they add: "'Decline' means in this context that a distinction attenuates in salience, that the occurrences for which it is relevant diminish in number and contract to fewer and fewer domains of social life. Individuals' ethnic origins become less and less relevant in relation to the members of another ethnic group (typically, but not necessarily, the ethnic majority group): individuals from both sides of the boundary see themselves more and more as alike, assuming they are similar in terms of some other critical factors such as social class; in other words, they mutually perceive themselves with less and less frequency in terms of ethnic categories and increasingly only under specific circumstances. To speak in terms of extremes, at one time an ethnic distinction may be relevant for virtually all of the life chances of members of two different groups—where they live, what kinds of jobs they get, and so forth—while at a later time it may have receded to the point that it is observed only in occasional family rituals. Yet assimilation, as we define it, does not require the disappearance of ethnicity, and the individuals and groups undergoing assimilation may bear a number of ethnic markers. It can occur on a large scale to members of a group even as the group itself remains as a highly visible point of reference on the social landscape, embodied in an ethnic culture, neighborhoods, and institutional infrastructures."[30]

A paradigmatic case of assimilation like the Italian one also contains lessons for the contemporary period, when the integration of major immigrant populations, like the Mexicans, is often put in doubt. The Italians were the Mexicans of their time, as far outside the mainstream as any other European-origin immigrant group.[31] The Italian catch-up in education looks quite remarkable from today's perspective, when there are stubborn and substantial educational inequalities among groups—between non-Hispanic white youth and their Latino counterparts, for example—and a great deal of pessimism about the ability of the educational system to reduce them.

Undoubtedly, there are any number of differences between the big-city schools of the postwar period, where the children of Italian immigrants were educated, and the urban and suburban schools attended by the children of today's immigrants. To be sure, there are also differences in the societal context—most notably, that the United States of the postwar decades was enjoying not just a period of rapidly advancing prosperity, but one of unusually low economic inequality; neither is true today. But, from the perspective of educational systems, two differences seem especially relevant: one has to do with "quality," that is, the academic skills and proficiencies, of teachers; the other with public investment in educational opportunity.

Public investment was critical and was particularly potent at the post-secondary level. It began with the G.I. Bill of 1944, which led to a higher level of attendance at colleges and universities just after the war. This momentum was accelerated by the enormous expansion of higher education, almost entirely due to growth in the publicly funded portion. Many students from homes with limited educational horizons, including many second and third generation Italian Americans, were able to enter higher education. The dimension of teacher quality is one that appears to have experienced decline in the United States since the post–World War period, when the predominant aspiration of the select group of female college

students was to enter the teaching profession. There are still many excellent teachers in American schools, but teacher quality is more uneven than in the past. Owing to expanding occupational opportunities for women and the declining prestige and working conditions of teaching, there has been a downward trend in the measured academic skills of the men and women recruited into teaching during the past half-century. In a system with great variation in teacher pay and working conditions, schools that can offer superior opportunities recruit the better teachers; these are typically schools that also serve advantaged students. Since there is compelling evidence that the quality of teachers matters—that students learn more when their teachers have better credentials, more teaching experience, and higher levels of verbal skill according to standardized test scores—the sorting of teachers among schools creates a handicap for students from low-status immigrant backgrounds that was not so significant in mid-twentieth-century America.[32]

Finally, there is the puzzling vigor of stereotypes about Italian Americans. The stereotypes are not new creations; the writer Bill Dal Cerro has documented the long history of Italian American stereotypes in the movies.[33] These prejudices show no sign of fading in the mass media—perhaps they are even reviving, aided in part by the programming freedom and cultural-niche innovations of cable television. A number of recent and popular television shows, ranging from "high-culture" drama, *The Sopranos* (1999–2007), to reality television, *Jersey Shore* (2009–2012), *Mob Wives* (2011–2016), and *The Real Housewives of New Jersey* (begun in 2009 and renewed in 2017), trade in Italian stereotypes, whose common denominator is working-class boorishness and/or vulgar striving—characteristics often attributed to socially ascending groups whose economic mobility has brought them into new milieus. In the United States, ethnicity has long provided an idiom for talking about social class and inequality that popular culture has difficulty in facing; but that observation aside, we do not yet have a theory to explain the persistence of stereotypes as the group distinctions they embody are fading. Nor does social science understand their possible effects, though since the stereotypes denigrate the intellectual abilities of Italian Americans, one would think that they would affect the chances of members of the group to obtain some kinds of positions, such as elite academic posts.[34]

This complex picture—massive entry into the mainstream and social integration with mainstream Americans, combined with the visible persistence of a core group embedded to a greater or lesser extent in Italian American sociocultural worlds, the felt salience of Italian-American identities for many others, and the lingering of demeaning stereotypes—summarizes the nature of contemporary assimilation in the United States. The Italian American experience has tutored scholars about the on-the-ground nature of assimilation, as opposed to their *a priori* conceptions of it, and it will provide important lessons about the hows and whys of assimilation for many of the newest immigrant groups.

Further Reading

Alba, Richard and Victor Nee. *Remaking the American Mainstream: Assimilation and Contemporary Immigration.* Cambridge: Harvard University Press, 2003.

Laurino, Maria. *Were You Always an Italian? Ancestors and Other Icons of Italian America.* New York: W.W. Norton, 2000.

Perlmann, Joel. *Italians Then, Mexicans Now: Immigrant Origins and Second-Generation Progress, 1890–2000.* New York: Russell Sage Foundation, 2005.

Notes

1 Thomas Kessner, *The Golden Door: Italian and Jewish Immigrant Mobility in New York City* (New York: Oxford University Press, 1977).

2 Leonard Covello, *The Social Background of the Italo-American School Child* (Totowa: Rowman & Littlefield, 1972).

3 Nathan Glazer and Daniel Patrick Moynihan, *Beyond the Melting Pot* (Cambridge: MIT Press, 1970), xxvii.

4 Ibid.

5 William Foote Whyte, *Street Corner Society: The Social Structure of an Italian Slum* (Chicago: University of Chicago Press, 1943); Herbert Gans, *The Urban Villagers: Group and Class in the Life of Italian-Americans* [1962] (New York: Free Press, 1982).

6 Donald Cressey, *Theft of the Nation: The Structure and Operations of Organized Crime in America* (New York: HarperCollins, 1969).

7 Richard Alba, *Italian Americans: Into the Twilight of Ethnicity* (Englewood Cliffs: Prentice-Hall, 1985), 68.

8 John Higham, *Strangers in the Land: Patterns of American Nativism, 1860–1925* (New York: Atheneum, 1970); Thomas Guglielmo, *White on Arrival: Italians, Race, Color, and Power in Chicago, 1890–1945* (New York: Oxford University Press, 2003).

9 Gary Gerstle, *American Crucible: Race and Nation in the Twentieth Century* (Princeton: Princeton University Press, 2001); Will Herberg, *Protestant-Catholic-Jew* (New York: Anchor Books, 1955).

10 Richard Alba, *Blurring the Color Line: The New Chance for a More Integrated America* (Cambridge: Harvard University Press, 2009); Gerstle, *American Crucible*.

11 Alba, *Blurring the Color Line*.

12 Alba, *Italian Americans*.

13 Ibid., 122–129.

14 Herbert Gans, *The Levittowners: Ways of Life and Politics in a New Suburban Community* (New York: Pantheon, 1967).

15 Alba, *Italian Americans*, 145–50; Paul Moses, *An Unlikely Union: The Love-Hate Story of New York's Irish and Italians* (New York: New York University Press, 2015).

16 Maria Laurino, *Were You Always an Italian? Ancestors and Other Icons of Italian America* (New York: W.W. Norton, 2000).

17 American Community Survey data about ancestry can be obtained through the Census Bureau's Factfinder: www.factfinder.census.gov.

18 Joshua Fishman, *Language Loyalty in the United States* (The Hague: Mouton, 1966); Camille Ryan, "Language Use in the United States: 2011," United States Census Bureau (August, 2013).

19 My calculations from American Community Survey data.

20 Wikipedia, "List of Ethnic Groups in the United States by Household Income" (accessed 15 July 2015).

21 Richard Alba and Victor Nee, *Remaking the American Mainstream: Assimilation and Contemporary Immigration* (Cambridge: Harvard University Press, 2003), 86–90; Glazer and Moynihan, *Beyond the Melting Pot*.

22 Elizabeth Becker, "Little of Italy? Assumed Ethnicity in a New York City Neighborhood," *Ethnic and Racial Studies*, 38 (2015), 109–124.

23 James Finckenauer, "La Cosa Nostra in the United States," International Center, National Institute of Justice (2007); cf., Cressey, *Theft of the Nation*.

24 Richard Alba, *Ethnic Identity: The Transformation of White America* (New Haven: Yale University Press, 1990); Mary Waters, *Ethnic Options: Choosing Identities in America* (Berkeley: University of California Press, 1990).

25 Joseph Sciorra, *Built with Faith: Italian American Imagination and Catholic Material Culture in New York City* (Knoxville: University of Tennessee Press, 2015); see also Robert A. Orsi, *The Madonna of 115th Street: Faith and Community in Italian Harlem, 1880–1950* [1985], 3rd ed. (New Haven: Yale University Press, 2010).

26 Richard Alba and Robert Orsi, "Passages in Piety: Generational Transitions and the Social and Religious Incorporation of Italian Americans," in *Immigration and Religion in America: Past and Present*, ed. Richard Alba, Albert Raboteau and Josh DeWind (New York: New York University Press, 2008), 32–55.

27 Milton Gordon, *Assimilation in American Life: The Role of Race, Religion, and National Origin* (New York: Oxford University Press, 1964).

28 Peter D'Epiro, "'Agita' Spells No Relief in Any Language," *New York Times* (11 September 1991), letters page. See also Pellegrino D'Acierno's "Cultural Lexicon" in *Italian American Heritage*, ed. D'Acierno (New York: Garland, 1999), 703–766.

29 Gerstle, *American Crucible*; see also Stephen Steinberg, *The Academic Melting Pot: Catholics and Jews in American Higher Education* (New York: Transaction, 1977).

30 Alba and Nee, *Remaking the American Mainstream*, 11.

31 Joel Perlmann, *Italians then, Mexicans Now: Immigrant Origins and Second-Generation Progress, 1890–2000* (New York: Russell Sage Foundation, 2005).

32 For a more thorough discussion of these issues, see Richard Alba and Jennifer Holdaway, eds., *The Children of Immigrants at School: A Comparative Look at Integration in the United States and Western Europe* (New York: New York University Press, 2013).

33 See his website: www.stereotypethis.com/index.php.

34 Richard Alba and Dalia Abdel-Hady, "Galileo's Children: Italian Americans' Difficult Entry into the Intellectual Elite," *Sociological Quarterly*, 46 (January 2005), 2–18.

ITALIAN AMERICANS IN THE SUBURBS

Transplanting Ethnicity to the Crabgrass Frontier

Donald Tricarico

With more Americans living in the suburbs than in the city in the post–World War II period, the suburbs were idealized as a "manifestation" of the "fundamental characteristics of American society."[1] A new mainstream narrative had two interrelated sociocultural themes. The suburbs were imagined as "the distinctive residential landscape" of an expanding middle class defined by consumption.[2] And middle class suburban lifestyles were believed to afford an opportunity to jettison European ethnicities embedded in the city for "the white house."[3]

Italian Americans have embraced the suburban landscape in greater proportions than the American population as a whole and, in particular, "other white Americans."[4] A few empirical studies have interpreted this as consistent with "spatial assimilation" and the straight-line model that dominates the approach to European immigrant groups in establishment sociology.[5] Although a later study acknowledges the increasing "ethnic concentration" of Italian Americans in the suburbs of New York City at the end of the twentieth century, the possibility of an ethnic way of life in the suburbs is precluded by theoretical limitations.[6]

This chapter makes a case for a suburban Italian American way of life, especially for the suburbs of New York City which is the "center" of Italian American ethnicity and "a critical test case" for the group's assimilation in the United States.[7] It questions the facile assumption of "spatial assimilation," instead raising the possibility of Italian American "ethnoburbs."[8] Suburban densities are interpreted as an artifact of structural conditions promoting the segmented assimilation of a population continuing to rely on ethnic social and cultural capitals centered on the family. With an Italian ancestry population in place, the following sections draw on the sparse research record to support an ethnic way of life, rooted in and even referenced to nearby urban enclaves, in a suburban landscape that is far more complex socially than both the early social science research and popular stereotypes would allow.[9] In conclusion, a theoretical approach to a suburban Italian American way of life reconciles assimilation with ethnic group difference.

Demography of Italian American Settlement in the Suburbs

The consideration of Italian American suburbanization has to parse distinctions in settlement types. Whereas certain cities received the bulk of mass immigration from Italy between 1890 and 1920, there was some movement to "towns on periphery" that were predicated on a more measured demand for lower status immigrant labor and resulted in small colonies in contrast to large urban Little Italies.[10] Nancy Carnevale points out that the Italian settlement in Montclair, New Jersey, in the 1880s revolved around municipal projects for the installation of water and sewer lines.[11] Salvatore LaGumina portrays a smattering of Italian enclaves on Long Island in the early 1900s in relation to opportunities to a local economy of private estates and regional industry like the sand and gravel pits of the island's North Shore.[12] M. P.

Baumgartner traces the Italian American population of an "outlying suburb" of New York City with 16,000 people to a late nineteenth-century settlement providing domestic services to wealthy estates.[13]

More formally *sub*urban settlements can be described for areas just outside official city limits that offered proximity to urban employment. Dominic Candeloro describes Chicago Heights as a suburb that grew around "heavy industry" in the 1890s.[14] For the upwardly mobile, these locations featured opportunities for home ownership away from congested tenement districts. Susan Eckstein studied an "inner suburb" of Boston that became predominantly Italian between 1920 and the mid-1960s. In 1970, a mainly working and lower middle class Italian American community was characterized by home ownership and intergenerational residential stability accompanied by socioeconomic mobility.[15] Victor Lidz also documents a similar Italian American settlement outside of New Haven during the same time period that was subsequently thrown into relief by new arrivals with higher social status.[16]

There is wide agreement among historians that the "modern suburbs" are linked to "the ubiquity of the automobile in the early 1920s."[17] The post–World War II period witnessed large-scale development in the outer suburbs, as the Federal government subsidized roads and highways built to facilitate the exodus from the city and mortgage programs through the G.I. Bill and FHA insurance.[18] In contrast to older suburbs, families arrived en masse and within a short period of time, a scale made possible by the construction of tract houses in subdivisions.[19] In contrast to peripheral settlements hard by immigrant labor, the new "bedroom suburbs" prescribed a pattern of commuting to the city that supported a lifestyle oriented to the new consumer culture.[20]

Formidable Italian American population densities in the suburbs of New York City were evident by 1970, a generation after the end of World Two and Federal government policies promoting suburbanization. In 1970, there were 390,000 persons in the eight New Jersey counties closest to New York City that were either born in Italy or born to Italian-born parents (a ratio of 1:3); 91,400 resided in Bergen County, 81,000 resided in Essex and 68,000 in Hudson; Italians were one-quarter of the "foreign-stock" population of the region.[21] The next largest European ancestry group was the Poles with a total of 172,000. The Italian ancestry population in Bergen and Essex Counties outnumbered the next two largest foreign-stock populations combined.[22]

People claiming Italian ancestry were 27 percent of the total population of Long Island in 1990, the largest ethnic group in the two counties comprising the Island with a 3 percent increase between 1980 and 1990.[23] In the latter decades of the twentieth century, the Italian ancestry population in the outer suburbs of the greater New York metropolitan area increased with the contraction of populations in inner suburbs and central cities.[24] Here, too, the Italian ancestry population was not randomly distributed throughout suburban counties, but concentrated in certain towns. Massapequa on the border of Nassau and Suffolk Counties is noteworthy and, a bit further east into Suffolk County, is the south shore town of Babylon with almost 60,000 persons claiming Italian ancestry in 2010, which was 40 percent of all white residents.[25]

Italian American suburbanization is understated by the failure to consider outer city limits that blur with inner suburbs. This typically occurred as towns on the periphery were frequently annexed by the expansion of cities.[26] Simone Cinotto points out that one-third of households headed by a person born in Italy owned homes as early as 1930, overwhelmingly in the outer boroughs.[27] The edges of New York City's outer boroughs, for example, are poorly served by mass transit that allowed for suburban tract development after World War II. Eastern Queens, running along the border with Nassau County, features one-family

ranch and split-level houses on 60 feet by 100 feet lots. The predominantly Italian American section of Howard Beach, Queens which lies just east of JFK airport is an affluent postwar suburb of one-family ranch and split-level houses.

Ethnic Chains

Italian Americans cannot be lumped into a mass trek to the suburbs. Rather, a pattern of suburbanization can be discerned that reflects ethnic difference. The sheer size of an urban population has allowed for substantial flows into the greater metropolitan area. Large numbers of Italian Americans shared a market position, notably income status. For example, inner suburbs like Lyndhurst and Mineola and tract developments in northern Bergen County towns like Paramus were attractive to blue-collar and lower middle class families from urban neighborhoods. The automobile factored heavily in large-scale suburbanization after the war, making jobs in the city accessible from an expanding periphery.[28]

Rather than making a break with ethnic culture situated in the city, Italian American suburbanization should be viewed as an extension of the latter. This is suggested by a residential pattern that links particular suburbs to urban neighborhoods. Thus, southern Brooklyn residents appear more disposed to Long Island, whereas Bronx residents have looked north toward Westchester and Rockland. A list for a 1975 reunion of relocated Greenwich Village Italian Americans showed a preference for northern New Jersey, perhaps owing to the proximity of bridges and tunnels on the west side of Manhattan.[29] The transformation of Staten Island into "Staten Italy," which in 2000 had the highest Italian ancestry population of any other county in the country at 37 percent, has to take into account of its proximity to Bensonhurst, with the largest Italian ancestry population in the city in the waning decades of the twentieth century.[30] Before World War II, Staten Island offered a rural escape from the tenement neighborhoods in lower Manhattan—a place to forage for wild mushrooms and the harvesting of shellfish. The island, which was accessible to lower Manhattan via ferry, supported summer bungalow colonies in south-facing shore towns like Great Kills. The construction of the Verrazano [sic] Bridge in 1964 furnished a land connection to southern Brooklyn including Bensonhurst. Residential development in Staten Island offered a variety of housing choices including high density row houses more likely to be within the price range of blue-collar and lower middle class families.

Like the "village chains" that channeled *paesani* to particular cities, local social ties probably influenced relocation decisions. Proximity to urban ethnic institutions mattered to the extent that new arrivals were only becoming integrated into a suburban way of life. Proximity allowed the ethnic neighborhood institutions to exert some sway, helping fill the vacuum in tract developments in burgeoning suburbs like Paramus that were building community from celery and rhubarb farms in the 1950s.[31] The principal link was to kin remaining, at least temporarily, in the ethnic neighborhood. The presence of an Italian American population also seems to matter. Herbert Gans claimed that "urban villagers" in the West End of Boston in the late 1950s preferred a high concentration of Italian Americans when they considered leaving.[32] In addition to ethnic group steering based in vernacular networks including formal organizations like churches and temples, a New York metropolitan area real estate web site "Neighborhood Scout" draws on ethnic solidarity to market "neighborhoods," for example, calling attention to a concentration of Italian Americans in towns and villages like Massapequa.[33] The high prices and median household income reported for this location reflects an Italian American market large enough to be stratified by class. Indeed, there are numerous upscale suburban communities with significant Italian American representation and even profiles.

At the core of this Italian American suburban settlement pattern is a kinship strategy. Kin became localized in Italian immigrant settlements like the South Village and East Harlem and kinship chains are evident in decisions to relocate to second settlements inside city limits. Despite the portrayal of post–World War II suburbs as atomized by a mass of individual households that has implications for the construction of a suburban culture unencumbered by preexisting cultures, Italian Americans arrived in kinship chains. This reflects the ability to capitalize on traditional social networks and attendant cultural codes at the core of ethnic group life. Phylis Cancilla Martinelli ascertained "some chain migration of family members" for a sample in a Phoenix suburb in the 1980s, including the expectation of an expanding network with "relatives planning to move."[34] I previously examined a representative ethnic family system in the South Village on the verge of suburbanization in the mid-1950s.[35] Its oldest member arrived in the lower Village in 1882 from Montemurro in Basilicata at the age of 3. A freeze frame of this family, which spanned four generations, reveals 13 separate households residing in tenement flats. Households were formed by a marriage, reflecting the increasing prominence of the nuclear family. Still, an American pattern of romantic-companionate mate choice typically occurred within a framework of ethnic endogamy and was firmly embedded in a localized kinship structure. Movement out of the neighborhood began in the late 1950s, representing a community pattern that was accelerated after the war. Relocation followed a chain that was similar to patterns of immigrant settlement. The most closely related households, that is, those with parent-child and sibling ties, followed each other to the same suburban locations. In one case, a widowed mother was taken to live with a married daughter's family. All of the related households remained within the metropolitan area, specifically Northern New Jersey and Eastern Queens/ Nassau County. They were joined by households linked to the spouse's kinship network. Not every related household participated in the relocation that was a restructuring of kinship around generational change. Family members not participating in the move cited proximity to work or lacked financial resources. However, the suburbs became a communal ideal that troubled those remaining in the ethnic neighborhood.[36]

Another example examined for this chapter traced the maternal and paternal lineages of a married couple in their early sixties documents proliferation over successive generations. Both husband and wife moved to Rockland County from the Bronx with their nuclear families as teenagers in the 1960s; their respective kinship chains were independent of one another, but part of a neighborhood chain from the Bronx to towns in southeast Rockland. The husband's father was one of ten siblings, seven of whom moved with their households to Rockland County during the 1960s from the North Bronx; their parental family moved from East Harlem in the 1930s. These siblings raised seventeen children in Rockland County whom, with the exception of one cousin, began their married lives in the area. The couple's localized kinship network was padded by the husband's maternal lineage that sent four siblings households to Rockland during this time. The wife's maternal and paternal lineages similarly regrouped in Rockland County. In the 1990s, the couples' generation saw their children beginning to marry and settle in Rockland County, and the beginning of movement away from the new kinship locus.

These cases suggest that a kinship connection may have been necessary to explain the choice of a suburban venue and that proximity to this new residential center was compelling, making it necessary to account for the choice to live elsewhere and the implication of ethnic deviance (e.g., family tension). They also call attention to the ongoing connection between suburban households and the urban neighborhood. Finally, this new data indicates a relatively high degree of residential stability.

The Italian American House

Did kinship chains merely deposit Italian Americans in the suburbs where ethnic family culture withered away? In Greenwich Village, a major Italian settlement on the Lower West Side of Manhattan by 1900, family traditions did not disintegrate in the second generation. As in the urban enclaves, it should not be surprising that Italian American family culture was projected on to the suburban landscape.[37] Whereas the postwar suburbs may have been scripted for "a white house," families that left the urban neighborhood exercised ethnic agency to build a home-centered ethnic culture: an Italian American *house* rooted in the primordial social and emotional concept of the "domus."[38] Home ownership is key, according to Cinotto, since it is "rooted in the rural background" of Italian immigrants, thus enhancing the family's "autonomy" and "security."[39] The suburbs provided a setting for the quintessential Italian American house because it afforded the family enhanced privacy (if not the promise of autonomy). This strategy is consistent with the desire to position the family favorably in relation to consumer markets as well as mainstream institutions, notably relatively privileged school systems.

The sparse empirical research on suburban Italian American families suggests an ethnic pattern. Micaela Di Leonardo maintains that Italian American kinship in the suburbs of Northern California is evidenced in the reciprocal transfer of resources notably finances and services like childcare and handy work; notwithstanding greater individualization, suburban children derive material benefits by staying close to the family—benefits that articulate with distinctive affective ties.[40] Colleen Johnson singles out the sibling relationship rather than "generational linkage" as key to Italian American kinship solidarity. Cousins also become close as the children of adult siblings.[41]

The relocation of related households to the suburbs put kin in place to interact within underlying cultural expectations. The family's ethnic cultural capital did not dry up in the suburbs. Ethnic family traditions were able to furnish a measure of stability for Italian American identities upon arrival in the suburbs. The private suburban home became a site for the construction ethnicity by staging a range "ritualized symbolic practices."[42] The historian Elizabeth Pleck views ritual in the family as a link to the past created by groups and individuals in the present; although ritual meaning is vulnerable in modern society, it remains a source of meaning when change is institutionalized and accelerated.[43]

Judith Goode and her co-authors have shown the adaptation of Italian American foodways in an older suburb of Philadelphia.[44] The study underscored the key sociocultural dynamic in ethnic change as "menu negotiation" which reconciled mainstream food items with the central importance of "good maternal nurturance" and other traditional rules.[45] Traditional food practices persist because they are learned early and represent ethnic family bonds.[46] Although Italian American foodways are evident in everyday cycles, they are accorded public and communal importance for special occasions. With higher status and the erosion of women's kin work, bigger celebrations like weddings have been outsourced to restaurants and catering halls; affluence can subsidize more frequent get-togethers of the kinship network, including events marking participation in mainstream culture like Sweet 16 parties. Traditional celebrations, like the dinner of Seven Fishes (Sette Pesci) on Christmas Eve or Easter dinner, appear to be reserved for the home even as they become more bountiful and effortful.

Women have been expected to perform work that is at the core of an ethnic heritage, notwithstanding increased assimilation including intermarriage and employment outside the home. (See Color Plate 29: Maria Di Fiore in her garden.) In a study of 301 Italian American women in Nassau County in the early 1980s, Mary Jane Capozzoli depicts an agenda to reconcile acculturation with traditional family norms which, for example, restricted educational

and occupational choices in favor of kinship solidarity for males as well as females.[47] Males augmented the household production of females to produce the suburban domus. Home-ownership tapped traditional masculine roles deactivated in tenement neighborhoods. Italian American men with working class and rural roots possessed not only an array of manual craft skills (e.g., carpentry, masonry) but also a tolerance for physical labor necessary to maintain and add value to the home.

Embedded rural knowledge and a tradition of scarcity can explain the outsized tomato gardens and fruit trees planted in the Italian American yard, including the improbable but iconic fig tree (Figure 32.1) that gets wrapped in tar paper for the northern winter—a utilitarian landscape that clashed with the suburban aesthetic of the manicured lawn and flower garden. The household production of men and women joined for the fall harvest. As with traditional women's work, masculine skills were exchanged across households, making kinship solidarity. These "neo-agrarian features" rooted in a scarcity culture distinguished the Italian American house on "the urban fringe."[48]

Italian Americans have enlisted consumption to fortify the ethnic values of the domus by association with "symbolic capital." Domestic rituals restructured around a higher standard

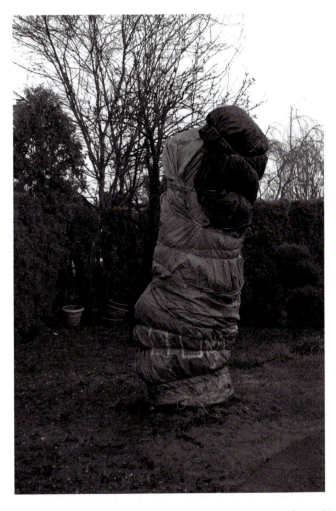

Figure 31.1 Fig tree wrapped for the winter, Nassau County, New York, 2015. Photo: Giuseppina Mazzola.

of living "produced the home" as "an ethnic haven."[49] In a "food-involved" culture, more economic capital has been invested in meals as a focal point of family solidarity.[50] Increased expenditure is also directed to home upkeep and improvement. This is seen not only in additions to the house itself, but the transformation of yard space to accommodate frequent sociability, as with patios and outdoor furniture, pools and decks, and privacy fences. There is a reputation for conspicuous consumption among the nouveau riche, in particular, for example in the outdoor marble and brick work and the backyard wood ovens (for pizza) imported from Italy and the backyard kitchens protected by pergolas. The practice of elaborate and costly outdoor Christmas decorations, which provided another occasion for household production, illuminate the Italian American house as a model of conspicuous seasonal consumption and status display.[51]

Capozzoli measured Italian American ethnic difference relative to a non-Italian American sample including a "stronger sense of ethnic identity."[52] Moreover, this was intergenerational; although the younger generation was less in accord with traditional culture, a pattern of ethnic difference was evident for daughters as well as mothers. This kept them from going away to college as often; although they went away to college more often than their parents, they were more likely to stay home and commute than non-Italian American daughters in the sample.[53] It is possible that greater affluence can be strategically used in the establishment of an Italian American pattern of attending local colleges like St. John's University in Queens and Hofstra University in Hempstead, Long Island. Older, married children are enticed by domestic services that more traditional elders are able and willing to perform, like childcare and home improvement. Another important change in kinship solidarity seems to revolve around the increased importance of intergenerational solidarity, especially parents and children, reflecting the ascendance of a companionate family culture. This may weaken the sibling solidarity that Leahy-Johnson found at the center of Italian American kinship structure in response to patriarchal parenting styles.[54]

Wider Ethnic Institutions

Although centered on the family, urban Italian American neighborhoods possessed a wider institutional order that became more rooted in the locality in the second generation.[55] Place-based communal institutions are not as likely to be transplanted from the suburbs.[56] The contrast that Jordan Stanger-Ross finds for Philadelphia and Toronto can be attributed to the latter's role as a venue for post-1945 immigrants that were able to transplant a solidarity based on the *paese*, or *paesani* ties.[57] A reference to *paesani* and the old country (the *paese*) rather than the urban neighborhood can explain the solidarity of Toronto's Italians outside the urban enclave in contrast to the older cohorts in South Philadelphia. Urban ethnic institutions were constrained by geography, like district politics and the Catholic parish that, in contrast to the synagogue, did not travel to the suburbs with mobile ethnic populations.[58] Italian American neighborhood institutions like street corner groups and youth gangs were less likely to be transplanted because they were also lower class, slum institutions.

Whereas ethnic neighborhood institutions did not travel well, suburbanites did. Proximity to the city and access to the automobile made for a fluid connection between suburb and neighborhood. The focus was links to kin and, to a lesser extent, old friends and neighbors. The neighborhood church has cultivated a relationship to former parishioners. St. Anthony's in the South Village of New York City staged a variety of old-world rituals, most notably an annual street *festa*, explicitly intended to bring suburbanites back. Families returned for already established life-crises rituals, notably funeral masses for elderly members who were

also waked in local funeral parlors. Suburban families also participated in the moral order of "paying respects" to neighborhood families.[59]

Routinized connections to the ethnic neighborhood are more than a "symbolic ethnicity" based on nostalgia and expressive individualism. This is also evident in the relationship with the urban ethnic economy. Italian food purveyors based in the neighborhood delivered to suburban clients and went on to relocate once a critical mass had formed, although the ethnic neighborhood provided a more specialized market. Mafia families have extended their business interests to the suburbs; in the 1990s, the Genovese crime family dominated the garbage hauling business in the suburbs west and north of New York City.[60] The suburbs denied the Mafia a street culture that fed and camouflaged its business practices although it was preferred to the "mean streets" as a milieu for raising children.[61]

A critical mass of Italian Americans has also generated wider ethnic social patterns in the suburbs. Cancilla found a pattern of "ethnic friendships" among "primarily white collar" Italian Americans that tended to be "formed in (suburban) Scottsdale."[62] There appears to be a greater likelihood of wider ethnic solidarity in the "suburban city/inner suburbs" like Staten Island and in "rurbans" established as early immigrant colonies.[63] Thus, Goode, Curtis and Theophano found that Italian American foodways in an older suburb of Philadelphia were reinforced "above the level of the household" because they were shared with fellow ethnics in informal placed-based networks—findings that point to the capacity of Italian American family culture to germinate wider ethnic solidarity as in the city.[64]

There are two notable ethnographies that document ethnic community among Italian Americans in older suburbs. A study by Susan Eckstein of an "inner suburb" in metropolitan Boston documents the emergence of a placed-based ethnic community that coalesced between 1920 and the mid-1960s.[65] In 1970, a mainly working and lower middle class Italian American community was characterized by home ownership and residential stability accompanied by socioeconomic mobility. Eckstein discerns thriving communal solidarity manifest in formal groups organized around fund raising and volunteer labor. Core groups included a local chapter of the Sons of Italy and immigrant mutual benefit societies, the Catholic parish, and national voluntary organizations like the American Legion and the Boys Club. Eckstein attributes the high level of communal solidarity to the distinctive demography of the suburb, in particular ethnic and class homogeneity. The dense social networks characterized by strong rather than weak social ties supported an ethnic heritage of local family values that encouraged reciprocity and even a "generosity" that tended to "blur boundaries between kin, (voluntary) group, and neighborhood." Eckstein calls attention to changes in ethnicity in "successive generations" which engaged them in local group patterns "even though many residents by the 1990s had the human capital and economic resources to assimilate fully." Eckstein's study is noteworthy in light of the legacy resulting from Edward Banfield's thesis of "amoral familism"[66] and suggests that the creation of "residential bonds conducive to group-based community giving appear to be exceptionally strong among Italian Americans" relative to other white ethnics.

Another notable community study is Mary Pat Baumgartner's ethnography of "Hampton," an "outlying suburb" of New York City with a population of 16,000 in 1980 and an Italian American community that can be traced to the late nineteenth century. According to Baumgartner there is a distinctive moral order in Hampton associated with Italian Americans.[67] Blue collar and lower middle class Italian Americans subscribed to a normative order that contrasted with the "distinctive pattern of interpersonal attachment" or "social morphology" of the suburbs characterized by weak ties and transiency.[68] This system of social control extends from the household into relations to neighbors, many of whom are kin.[69]

Baumgartner maintains that Italian American families in "Hampton" stood out in both the intensity of their consensus and their disputes. Though Baumgartner attributes this to social class, localized family solidarity was found to imprint on "the moral order of a suburb." Elsewhere, defended neighborhood institutions have emerged in inner suburbs. The suburban outer borough area of Howard Beach, Queens has a national reputation for local social control and conflict resolution assumed by young male peer groups. This can be explained by institutions with deep roots in urban Italian American communities like Brownsville and Canarsie which are in close proximity. Informal turf defense was backed up by the institutional agendas of a major crime family headed by John Gotti.[70]

Moral order in the suburbs typically depends less on local institutions than a market in private home ownership that filters patterns of urbanism like anonymity and heterogeneity; because the suburbs keep the city at a distance, there is no need for an "urban village." In the suburbs, "good fences"—single-family houses with yards—is typically sufficient "make good neighbors"—individuals acting with limited communal liability. Whereas the "moral minimalism" of middle class suburbia is predicated on individuation, or greater separation of individuals from the group, and privatized resources which restrict public interactions, it also allows for an ethnic agenda that privileges family over other relationships. Further, wider ethnic solidarity may be a byproduct of Italian American family culture as in the ethnic neighborhood.[71] To this extent, there is recognition of a shared ethnic moral order that includes a respect for core ethnic values and practices like "good maternal nurturance" and the home as a "haven."

Finally, expanded leisure opportunities have been an important site for the reconstruction of Italian American ethnicity in the suburbs. The civic organizations like the Sons of Italy identified by Eckstein were perhaps primarily sites of sociability including card playing with space rented to members for large gatherings like christenings and bridal showers. Country club memberships afford opportunities to make status claims for more affluent Italian Americans. A private golf club in North Hills, Long Island that excluded Italian Americans a generation ago now has eight out of nine "governors" with Italian surnames and an Italian ancestry membership as high as 80 percent in 2014.[72] Upper middle class prestige is delivered by heritage associations like the Westchester Italian Cultural Center in Tuckahoe that showcases documentary films on regional Italian cuisine and wine tastings.[73] The Columbian Lawyers Association of Westchester County, which was founded in 1982, combines ethnic civic interests with the mobilization of ethnicity for upper middle class occupational interests.[74] Leisure scenes organized around high Italian culture that appeal to Italian American adults are typical for the suburban middle class.[75] Exercising an ethnic claim to prestige based on consumption and taste reflects the segmented assimilation of an elite Italian American status group that should not be trivialized as "symbolic ethnicity."[76]

A specific, bounded Italian American style of consumption is evidenced by the diffusion of a Guido youth style from its working class, urban origins. Transported to the suburbs by Italian American youth, Guido scenes thrive in south shore Long Island towns with large and dense Italian American populations like Massapequa and Franklin Square, and are in evidence on suburban college campuses like Hofstra University. The reality TV show *Growing Up Gotti* (2004–2005) portrayed Guido as a nouveau riche style connecting the city (Howard Beach, Queens) and the old money town of Old Westbury in Nassau County, and capitalized on for business ventures like a tanning salon on Long Island marketing the look of stylish Italian American youth. A Guido scene in suburban New Jersey dance clubs was coordinated on the Internet by the organization called "New Jersey Guido." MTV's *Jersey Shore* (2009–2012) accentuated and diffused an awareness of Italian American youth culture in the suburbs.[77]

Rethinking the Suburbs: Some Theoretical Considerations

Straight-line assimilation has been forecasting the eclipse of Italian American ethnicity since the end of mass immigration. Caroline Ware maintained that the Italian community in Greenwich Village in the 1920s was left in disarray by the influence of American culture on the second generation. However, Ware overlooked developments leading to a restructured ethnic community in the locality beyond the immigrant generation well into the second half of the twentieth century.[78] Richard Alba's quantitative portrait of Italian Americans in the "twilight of ethnicity" more than fifty years later similarly overlooks vernacular cultures.[79] The subsequent discovery of concentration in the suburbs of New York City appears to be a contradiction of the twilight hypothesis. However, the deal is sealed by a theoretical model that precludes the recognition of change in ethnic institutions and the special circumstances of Italian American assimilation in New York City and other urban centers.[80]

Rather than slotted into an assimilationist black hole, Italian American suburbanization should be placed on a continuum of ethnic adaption that includes the immigrant colony and second and third settlements on the urban periphery (e.g., outer boroughs like the North Bronx) and now the suburbs. The assimilation model prescribes a false dichotomy between suburban and urban venues. Alba assumes the urban enclaves were ethnically "homogeneous," which accounts for their "solidarity," whereas the suburbs are heterogeneous yet demand a level of conformity that jettisons ethnicity.[81] On the one hand, urban enclaves were far more diverse than previously thought and were cheek-by-jowl with diverse urban cultures.[82] On the other hand, ethnic solidarity, as Stanger-Ross shows, is possible without spatial concentration.[83] The issue critical to Italian American ethnicity is a family culture and that seems to have been transplanted to the suburbs, perhaps more effectively than to tenement neighborhoods from the Italian *paese*. Finally, Alba expects far too much conformity in the suburbs given a climate of moral minimalism; good fences can make good Italian Americans.

Rather than assume that Italian Americans left their ethnicity behind in the city, it would appear that ethnic institutions centered on the family system have further adapted in the suburbs. Moreover, it is possible to see ethnic agency in this process—choices guided by capital, of course, but also by ethnic interests that extend beyond the family. Consider, for instance, an institution like the suburban *bocce* court (see Figure 31.2), and the ethnic interest in building and maintaining it. *Institutions* are "sets of relationships" created to realize specific purposes and interests.[84] Social institutions are established and predictable ways for people to provide for one or more basic need. Individuals and groups that share a common culture typically organize in ways to pursue concrete interests. Institutions strengthen the shared culture and the bonds with individuals that share a culture.

At the center of Italian American suburban strategy is a transplanted kinship network that is the historical center of an ethnic culture. There appears an ethnic affinity for the suburbs as a way of life that enhances the domus, especially because of the private space afforded by home ownership and the yard. A kinship network furnishing traditional social and cultural resources, perhaps in articulation with the ethnic neighborhood, coalesced around the domus. The suburbs provide a more fertile setting for a family agenda than the tenement neighborhood especially when the suburban exodus distilled a higher rate of social problems like elderly poverty, elevated school drop-out rates, and drug use; the suburbs have also been preferable to the succession by new immigrant minorities and to the related trajectories of gentrification and globalization.[85] The suburbs, at this point, become a buffer against a disorganized urban ethnic community. Increased material consumption has been enlisted in the service of family cohesion and status in late capitalism.[86] On the other hand, ethnicity serves

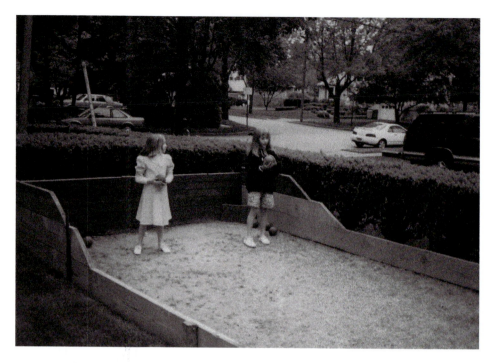

Figure 31.2 Suburban *bocce* court, Paramus, New Jersey, *circa* 2010. Photo: Giuseppe Vitolo.

as an ideology of family cohesion that purports to stanch "dilemmas of suburban socialization" associated with child-centered childrearing, careerism and personal consumption.[87] The mobilization of ethnic capital can account for the residential stability that distinguishes even younger, second generation Italian American adults.[88] This is in marked contrast to the "organization men" forming "stopover communities" with "no clear-cut norms."[89] Indeed, if Whyte's organization men constituted "a special category of suburbanites," the same can be said of Italian Americans with kin in tow and solidarity rooted in a traditional ethnic culture.[90]

The concentration of Italian Americans in the suburbs can be understood as a *collective* ethnic strategy. A critical mass of second and third generation Italian Americans choosing the suburbs is a function of large populations in central cities—moving through stages of assimilation, including class mobility, en masse. In contrast to other European ethnic groups, an Italian American way of life in metropolitan New York City is refreshed by new arrivals from Italy after 1945 which significantly replenished urban communities in New York City like Bensonhurst with a population of 100,000 in 1980.[91] The size and density of an ethnic population better supports an institutional infrastructure that can temper assimilation including the effects of intermarriage.

Ethnic preference also factors into suburban residential choice. Ming Wen and colleagues describe "in-group attraction" or "resurgent ethnicity" among affluent, non-white post-1965 immigrant populations in contemporary multiethnic suburbs, resulting in a pattern they refer to as an "ethnoburb."[92] The formation of "ethnoburbs" is a cultural choice that is further enhanced by proximity to urban centers. In the process, groups are differentiating themselves in relation to other groups. Rather than confound residential movement away from the urban neighborhood with assimilation, suburban densities of Italian Americans can similarly be characterized as "ethnoburbs." They are so extensive in metropolitan New York

City that they offer a range of lifestyle choices referenced to geography, class, and level of assimilation. This includes upscale communities like Malba and Howard Beach at the edges of Queens and south shore Long Island towns like Massapequa. The post–World War II immigrant cohort arrives in the suburbs with more immediate connections to Italy as well as the ethnic neighborhood. Renewed immigration has postponed the twilight of ethnicity experienced by other European nationality groups and contributed to "fragmentation of ethnicity along the lines of class, generation, and ancestry."[93]

As with the creation of urban ethnic enclaves, ethnic agency in choosing the suburbs occurs within structural conditions. A structural explanation is found in the theory of *segmented assimilation* that recognizes variable social and cultural patterns as *groups* assimilate into different segments of a highly stratified society.[94] Thus, the aggregation of Italian Americans in the suburbs reflects a shared structure of opportunities, in particular market constraints. In older suburbs, Italian immigrants arrived as a low status minority referenced to the city recruited to perform dirty jobs on the urban periphery. In the newer dormitory or automobile subdivisions proliferating after World War II, Italian American ethnicity has overlapped with class markers such as education, occupation, and consumption style. Ethnic group identity has been fostered by an "ethnic niche" in occupations like contracting and in small businesses like body shops and pizzerias—an ethnic economy that propels families toward home ownership. Similarly, an educational niche exists where the opportunities of Italian American students in the suburbs are shaped by parental capitals (cultural and social as well as economic) in contrast to the strategies of other ethnic groups. Dense Italian American settlements on the south shore of Long Island are found within public school districts that are less regarded academically than the North Shore districts historically identified with Ashkenazi Jews and now with the succession of "model" Asian groups like the Chinese and Indians. In this scenario, ethnicity signifies "a collective notion of place" that intersects with (rather than is subsumed by) class, race and religion.[95]

The segmented assimilation model can account for *status group* development among Italian Americans in the suburbs. Status groups form in the context "consciousness of social differentiation separable from that generated by class position."[96] Thus, the arrival of an urban minority group ethnicity magnified the arrival of large numbers of Italian Americans in the suburbs. Labeling the Verrazano [sic] Bridge as "the Guinea gangplank" expressed fear and loathing for an urban ethnic minority identified with suburbanizing semi-rural Staten Island in the 1960s. The police department of Belmar, a New Jersey shore town, targeted Guidos for surveillance because they were "from the city," while explicitly denying ethnic hostility. The fact that this assurance was given by the Mayor, with an Italian surname, of a town that would soon change its name to Lake Como, suggests status differences inside the ethnic boundary.[97] More recently, animus for Italian American ethnicity reverberates in the web site *Get Off Our Island*, which is focused on Italian American youth culture. Here, Guido is a lightening rod for an arriviste ethnic minority that clashes with a post-ethnic white suburban way of life.[98] Anti-urban sentiment is reinforced by a racialized nativism that resonates with the historical enmity between Irish and Italian immigrant groups in New York City.[99]

The status dilemmas identified with Italian American ethnicity in the suburbs is well-represented in the mainstream media. Fictional and nonfictional narratives have identified the shift from the urban neighborhood to the suburbs, stereotyping suburban Italian Americans as a status group with an arriviste taste culture (see reality TV shows like *Growing Up Gotti*, *Mob Wives*, and *The Real Housewives of New Jersey*).[100] Although traditional values are depicted as imperiled (e.g., children spoiled by materialism), this genre uses mainstream consumption to recreate the perception of Italian American difference within late capitalism. References to minority group ethnicity, spiced with Mafia stereotypes, invoke an otherness that cannot be

accommodated within a pluralist mainstream. This depiction of minority group ethnicity at odds with a middle class "symbolic ethnicity" is perhaps the gist of the anti-defamation complaints of organizations like NIAF and UNICO National, revealing an Italian American group identity "rife with internal divisions, conflicts, contradictions, and tensions."[101]

If the suburbs are a "significant stage of spatial assimilation,"[102] they are also a "structurally defined stage" of ethnic adaptation.[103] This perspective moves beyond the static understanding of ethnicity in the straight-line model which privileges first generation culture like Italian language (dialect) use and the urban immigrant neighborhood. Since assimilation is a process, ethnicity reflects relative differences, such as generation and class, as it negotiates with mainstream institutions; there is the theoretical possibility of "syncretization, a blending of culture to produce a new result" as with Italian American foodways in a Philadelphia suburb.[104] This is impossible to ignore considering the impressive demography of Italian American suburbanization in metropolitan New York City. Historians have to revisit the past. With a suburban Italian American diaspora still discernible, ethnography is necessary to document the thick descriptive detail in local social processes, within an interpretive framework that references social structure and history—the signature approach of the community studies subfield of sociology.[105] In this scenario, the suburbs are not a cul-de-sac but rather a vibrant and evolving social stage for Italian American ethnicity.

Further Reading

Capozolli, Mary Jane. "Nassau County's Italian American Women: A Comparative View," in *The Melting Pot and Beyond: Italian Americans in the Year 2000*, edited by Jerome Krase and William Egelman. Staten Island: Italian American Studies Association, 1987, 285–296.

LaGumina, Salvatore. *From Steerage to Suburb: Long Island Italian*. Staten Island: Center for Migration Studies, 1988.

Stanger-Ross, Jordan. *Staying Italian: Urban Change and Ethnic Life in Postwar Toronto and Philadelphia*. Chicago: University of Chicago Press, 2010.

Notes

1 Kenneth T. Jackson, *Crabgrass Frontier: The Suburbanization of the United States* (New York: Oxford University Press, 1985), 4.
2 Lizabeth Cohen, *Consumers' Republic: The Politics of Mass Consumption in Postwar America* (New York: Knopf, 2003), 195–196.
3 David R. Roediger, *Working Toward Whiteness: How America's Immigrants Became White* (New York: Basic Books, 2005), 159–177.
4 Richard D. Alba, *Italian Americans: Into the Twilight of Ethnicity* (Englewood Cliffs: Prentice-Hall. 1985), 43.
5 Ibid.; James A. Crispino, *The Assimilation of Ethnic Groups: The Italian Case* (Staten Island: Center for Migration Studies, 1980); John P. Roche "Suburban Ethnicity: Ethnic Attitudes and Behavior Among Italian Americans in Two Suburban Communities," *Social Science Quarterly*, 63.1 (March 1982), 145–153. The straight-line assimilation model confines ethnicity, notably an "institutional infrastructure," to working-class urban enclaves.
6 Richard Alba, John Logan and Kyle Crowder, "White Ethnic Assimilation: The Greater New York Region, 1980–1990," *Social Forces*, 75.3 (March 1997), 884.
7 Ibid., 886.
8 Ming Wen, Diane Lauderdale and Namratha Kandula, "Ethnic Neighborhoods in Multi-Ethnic America, 1990–2000: Resurgent Ethnicity in the Ethnoburbs?" *Social Forces*, 88.9 (September 2009), 425–460.
9 Cohen, *Consumers' Republic*, 401–407; Jessie Bernard, *The Sociology of Community* (Glenview: Scott Foresman and Company, 1973), 117.
10 Gerald H. Gamm, *Urban Exodus: Why the Jews Left Boston and the Catholics Stayed* (Cambridge: Harvard University Press, 1999), 178.

11 Nancy C. Carnevale, "Italian American and African American Encounters in the City and in the Suburb," *Journal of Urban History*, 40.3 (2014), 545.

12 Salvatore LaGumina, *From Steerage to Suburb: Long Island Italian* (Staten Island: Center for Migration Studies, 1988).

13 Mary Pat Baumgartner, *The Moral Order of a Suburb* (New York: Oxford University Press, 1988), 16.

14 Dominic Candeloro, "Suburban Italians: Chicago Heights, 1890–1975," in *Ethnic Chicago: A Multicultural Portrait*, ed. Melvin G. Holli and Peter d'A. Jones, 4th ed. (Grand Rapids: W. B. Eerdmans, 1994), 235–269.

15 Susan Eckstein, "Community as Gift-Giving: Collective Roots of Volunteerism," *American Sociological Review*, 66 (December 2001), 802.

16 Victor Lidz, "Socialization to Class, Ethnicity, and Race in the New Haven Area During the 1950s: Sociological Remembrances," *Ethnography*, 11.1 (March 2012), 109–125.

17 Gamm, *Urban Exodus*, 185.

18 Cohen, *Consumers' Republic*, 74.

19 Bernard, *Sociology of Community*, 116.

20 Cohen, *Consumers' Republic*, Introduction.

21 Edward C. Burks, "Jersey Suburbs Are 35% Foreign," *New York Times* (24 July 1972), 16.

22 Ibid.

23 Vincenzo Milione, "The Changing Demographics of Italian Americans in New York State, New York City and Long Island: 1980 and 1990," http://qcpages.qc.cuny.edu/calandra/sites/calandra.i-italy.org/files/files/Changing%20Demographics.pdf

24 Alba, Logan and Crowder, "White Ethnic Assimilation," 894–898.

25 Town of Babylon, Long Island, "Demographics," www.townofbabylon.com/index.aspx?nid=102; Suffolk County Dept. of Planning. "Demographic, Economic and Development Trends," www.suffolk countyny.gov/Portals/0/planning/Publications/demoecon_all_012309.pdf

26 Gamm, *Urban Exodus*, 178.

27 Simone Cinotto, "All Things Italian: Italian American Consumers, the Transnational Formation of Taste, and the Commodification of Difference," in *Making Italian America: Consumer Culture and the Production of Ethnic Identities*, ed. Cinotto (New York: Fordham University Press, 2014), 1–31 (9).

28 Cohen, *Consumers' Republic*, chapter 1.

29 Donald Tricarico, *The Italians of Greenwich Village* (Staten Island: Center for Migration Studies, 1984), 96.

30 NIAF, www.niaf.org/culture/statistics/u-s-counties-with-high-percentage-of-italian-americans/

31 Cohen, *Consumers' Republic*, 5.

32 Herbert Gans, *The Urban Villagers: Group and Class in the Life of Italian-Americans* [1962] (New York: Free Press, 1982), 23.

33 *Neighborhood Scout*: Massapequa, NY (Nassau Shores), www.neighborhoodscout.com/ny/massapequa/nassau-shores/#desc; and *Neighborhood Scout*: Massapequa, NY (Biltmore Shores), www.neighborhood scout.com/ny/massapequa/biltmore-shores/#desc

34 Phylis Cancilla Martinelli, "Exploring Ethnicity in the Sunbelt: Italian Americans in Scottsdale, Arizona," *Humboldt Journal of Social Relations*, 12.2 (Spring/Summer 1985), 143–162 (150).

35 Tricarico, *Italians of Greenwich Village*, 88–89.

36 This evidence contrasts with the preference of Gans's urban villagers to remain in the urban ethnic enclave in lieu of home ownership in the suburbs. See Gans, *Urban Villagers*, 64–70. One explanation may be that the connection to the land withered as Italian Americans became urbanized in the second and third generation. Residents of fading Italian American neighborhoods have overstated its cultural importance for suburbanites. In New York, the Little Italy Restoration Association (LIRA) formulated a proposal for "modern apartment buildings" to secure "the return" of suburbanites to the lower East Side, based on the assumption that the suburbanites craved an authentic ethnic experience that only the old neighborhood could provide. The idealization of ethnic community was a status defense against an ideology that equated middle class mobility and whiteness with moving out to the suburbs. Still, Italian Americans in the South Village (i.e. southern Greenwich Village) never lost sight of the suburbs as a preferred alternative to the lower standard of living associated with the tenement neighborhood. See Tricarico, *Italians of Greenwich Village*, 84–95.

37 Ibid., 20–32.

38 Robert A. Orsi, *The Madonna of 115th Street: Faith and Community in Italian Harlem 1880–1950* [1985], 3rd ed. (New Haven: Yale University Press, 2010). Orsi frames consumption within the family as a sacred ritual involving food prepared in the kitchen.

39 Simone Cinotto, "All Things Italian," 9.

40 Micaela di Leonardo, *The Varieties of Ethnic Experience: Kinship, Class, and Gender among California Italian-Americans* (Ithaca: Cornell University Press, 1984), 206–213.

41 Colleen Leahy Johnson, "Sibling Solidarity: Its Origin and Functioning in Italian-American Families," *Journal of Marriage and Family*, 44.1 (February 1982), 155–167 (156).

42 J. David Knottnerus and David G. Loconto, "Strategic Ritualization and Ethnicity: A Typology and Analysis of Ritual Enactments in an Italian American Community," *Sociological Spectrum*, 23 (2003), 447.

43 Elizabeth Pleck, *Celebrating the Family: Ethnicity, Consumer Culture, and Family Rituals* (Cambridge: Harvard University Press, 2000), 20.

44 Judith Goode, Karen Curtis and Janet Theophano, "Meal Formats, Meal Cycles, and Menu Negotiation in the Maintenance of an Italian American Community," in *Food in the Social Order*, ed. Mary Douglas (New York: Russell Sage, 1984), 143–218; Goode, Curtis and Theophano, "A Framework for the Analysis of Continuity and Change in Shared Sociocultural Rules for Food Use: The Italian American Pattern," in *Ethnic and Regional Foodways in the United States*, ed. Linda K. Brown and Kay Mussel (Knoxville: University of Tennessee Press, 1984), 66–88.

45 Goode, Curtis and Theophano, "Meal Formats," 175.

46 See Simone Cinotto's Chapter 10.

47 Mary Jane Capozolli, "Nassau County's Italian American Women: A Comparative View," in *The Melting Pot and Beyond: Italian Americans in the Year 2000*, ed. Jerome Krase and William Egelman (Staten Island: AIHA, 1987), 290.

48 Bernard, *Sociology of Community*, 116.

49 Cinotto, "All Things Italian," 10.

50 Goode, Curtis and Theophano, "A Framework," 67.

51 "Dyker Lights," BKLYNR, http://bklynr.com/dyker-lights/

52 Capozzoli, "Nassau County's Italian American Women," 290.

53 Ibid., 286–288.

54 Leahy Johnson, "Sibling Solidarity," 156–159.

55 Tricarico, *Italians of Greenwich Village*, 15–19.

56 Gamm, *Urban Exodus*, 185.

57 Jordan Stanger-Ross, *Staying Italian: Urban Change and Ethnic Life in Postwar Toronto and Philadelphia* (Chicago: University of Chicago Press, 2010).

58 Gamm, *Urban Exodus*, 185–189.

59 Tricarico, *Italians of Greenwich Village*, 72–168. The literature otherwise says little about relationship to the ethnic neighborhood from the standpoint of Italian Americans in the suburbs.

60 Don Van Natta Jr., "Garbage Hauling is Tied to Mafia in Suburbs," *New York Times* (25 June 1996).

61 Mafioso Roy De Meo commuted from bedroom suburbs in New Jersey and Long Island to the ethnic neighborhood. See Albert De Meo with Mary Jane Ross, *For the Sins of My Father* (New York: Broadway Books, 2002).

62 Martinelli, "Exploring Ethnicity," 152.

63 Bernard, *Sociology of Community*, 16.

64 Goode, Curtis and Theophano, "A Framework," 86; also see Tricarico, *Italians of Greenwich Village*, 20–32.

65 Eckstein, "Community as Gift Giving," 832–848.

66 Editors' note: Harvard sociologist Edward Banfield's *The Moral Basis of Backward Society* (Glencoe: Free Press, 1958), coined the term "amoral familism" to explain the lack of economic and political development in southern Italy. Banfield argued that working in the immediate, short-term interests of the nuclear family deprived southern Italian society of an ethos necessary to progress. For a critique, which argued that Banfield confused cause and effect, see Sydel Silverman, "Agricultural Organization, Social Structure, and Values in Italy: Amoral Familism Reconsidered," *American Anthropologist*, 70 (February 1968), 1–20.

67 Baumgarter, *Moral Order*, 88.

68 Ibid., 6.

69 Ibid., 98.

70 Donald Tricarico, "Read All About It! Representations of Italian Americans in the Print Media in Response to the Bensonhurst Racial Killing," in *Notable Selections in Race and Ethnicity*, ed. Adalberto Aguirre and David V. Baker (Guilford: McGraw-Hill/Dushkin, 2001), 291–319.

71 Tricarico, *Italians of Greenwich Village*, 30–32.

72 Interview with club member, 4 June 2014.

73 Westchester Italian Cultural Center, http://wiccny.org/category/events/lectures/

74 Columbian Lawyers Association of Westchester County, www.columbianlawyers.org/wcincludes/wchist.php

75 Joseph Bensman and Arthur Vidich, *The New American Society: The Revolution of the Middle Class* (Chicago: Quadrangle, 1971), 192.

76 Taste in commodities functions as a marker of class. See Pierre Bourdieu, *Distinction: A Social Critique of the Judgment of Taste* (Cambridge: Harvard University Press, 1984); and Mike Featherstone, *Consumer Culture and Postmodernism*, 2nd ed. (London: Sage, 2007). The intersection of tasteful consumption and Italian American ethnicity demarcated the market segment for the coffee table magazine *Attenzione* in the 1980s. See Donald Tricarico, "In a New Light: Italian American Ethnicity in the Mainstream," in *The Ethnic Enigma: The Salience of Ethnicity for European-Origin Groups*, ed. Peter Kivisto (Philadelphia: Balch Institute for Ethnic Studies, 1989), 24–46.

77 Donald Tricarico, "Dressing Italian Americans for the Spectacle: What Difference Does Guido Perform?" in *The Men's Fashion Reader*, ed. Andrew Reilly and Sarah Cosbey (New York: Fairchild, 2008), 265–278; Tricarico "Guido: Fashioning an Italian American Youth Identity," *Journal of Ethnic Studies*, 19.1 (Spring 1991), 41–66; Tricarico, "Narrating Guido: Contested Meanings of an Italian American Youth Subculture," in *Anti-Italianism: Essays on Prejudice*, ed. William J. Connell and Fred Gardaphé (New York: Palgrave Macmillan, 2010), 163–199 (177–178); and Tricarico, "Bellas and Fellas in Cyberspace: Mobilizing Italian Ethnicity for Online Youth Culture," *Italian American Review*, new series, 1 (Winter 2011), 1–34.

78 Tricarico, *Italians of Greenwich Village*.

79 Alba, *Italian Americans*.

80 Alba, Logan and Crowder, "White Ethnic Assimilation," 908.

81 Alba, *Italian Americans*, 88.

82 Tricarico, *Italians of Greenwich Village*, 1984.

83 Stanger-Ross, *Staying Italian*, 8–11.

84 Stephen E. Cornell and Douglas Hartmann, *Ethnicity and Race: Making Identities in a Changing World* (Thousand Oaks: Pine Forge, 2007), 86.

85 Tricarico, *Italians of Greenwich Village*, 95–111.

86 Donald Tricarico, "Consuming Italian Americans: Invoking Ethnicity in the Buying and Selling of Guido," in *Making Italian America*, ed. Cinotto, 178–192.

87 Maurice Stein, *The Eclipse of Community: An Interpretation of American Studies* (New York: Harper & Row, 1964), 218.

88 Alba, *Italian Americans*, 88.

89 Stein, *Eclipse of Community*, 204–211.

90 Ibid., 200.

91 Donald Tricarico, "New Second Generation Youth Culture in the Twilight of Italian American Ethnicity," in *New Italian Migrations to the United States: Vol. 1: Politics and History Since 1945*, ed. Joseph Sciorra and Laura E. Ruberto (Urbana: University of Illinois Press, 2017).

92 Wen, Lauderdale and Kandula, "Ethnic Neighborhoods," 453.

93 Douglass Massey, "The New Immigration and Ethnicity in the United States," *Population and Development Review*, 21.3 (September 1995), 643–645.

94 See Alejandro Portes and Min Zhou, "The New Second Generation: Segmented Assimilation and Its Variants," *Annals of the American Academy of Political and Social Science*, 530 (1993), 74–96. The segmented assimilation model delineates a course for the post-1965 immigration, which is predominantly nonwhite, a racial status that hinders assimilation and is further disadvantaged by an economic context that retards upward mobility for low status workers. It has not been made available to older European immigrant groups based on the assumption of successful assimilation into the American mainstream.

95 Ashley Doane, "Dominant Group Ethnicity in the United States: The Role of 'Hidden' Ethnicity in Intergroup Relations," *Sociological Quarterly*, 38.3 (1997), 377.

96 Anthony Giddens, *The Class Structure of the Advanced Societies* (New York: Harper, 1978), 80; see also Carl Bankston and Jacques Henry, "Endogamy among Louisiana Cajuns: A Social Class Explanation," *Social Forces*, 77.4 (1999), 1317–1338.

97 Tricarico, "Narrating Guido," 163.

98 Bensman and Vidich, *The New American Society*, 119–121.

99 See www.Getoffourisland.com including the reference to a demographic trend that is "darkening our Island" (accessed 8 October 2014). Also see Jackson, *Crabgrass Frontier*, 88, on a pattern of "suburban resistance" to urban culture.

100 Tricarico, "Consuming Italian Americans," 187–191. It is noteworthy that similar representations do not exist for other European ancestry groups except for Ashkenazi Jews—on the short-lived 2013 reality cable-TV show "Long Island Princesses."
101 Massey, "The New Immigration," 645.
102 Wen, Lauderdale and Kandula, "Ethnic Neighborhoods," 428.
103 Stanger-Ross, *Staying Italian*, 137.
104 Goode, Curtis and Theophano, "Meal Formats," 241.
105 Stein, *Eclipse of Community*, 99.

"WHATEVER HAPPENED TO LITTLE ITALY?"

Jerome Krase

At first thought the question "What ever happened to Little Italy?" seems a bit silly, since they seem to be all over the country. Little Italies have long been the subject of study by historians and social scientists, but equally important have been their value to novelists, journalists, and Hollywood as well as television screenwriters. Despite all the attention to the subject however, their existence is no longer merely a matter of history and demography but increasingly one of definition, and for want of a better word, "authenticity." Although most studies of Little Italy are singular if not unique, all of them are valuable as noted by Richard N. Juliani:

> While a complex synthesis is ultimately desirable in order to understand the overall Italian-American experience, it is equally important that we construct the smaller, basic pieces that would make it possible. For this reason, detailed studies focused upon specific locations of Italian settlement in the United States for limited periods of time are essential.[1]

In a similar vein, Robert F. Harney and J. Vincenza Scarpaci argued that despite their obvious presence in virtually every city:

> Scant attention has been given to drawing a historical and sociological profile of the Little Italy in North America. No comparative studies of Little Italies exist, and the sources upon which such study could be based on a combination of associational papers, parish records, the memory culture of those who grew up in the neighborhoods and the ethnic press—are rarely, and never systematically preserved.[2]

As have other scholars of the Italian American experience, Harney and Scarpaci also complained that much writing about Italian enclaves is "filio-pietist." As an antidote to these and other less objective works they called for serious detailed studies that would make fruitful comparisons possible. As an example they offered the broadest anthology on the subject in which they sampled nine of the most prominent Little Italies in North America.

Over the course of four decades (1970–2010) I took it upon myself to find, read about, visit and photograph thirty places in American and a few Canadian cities that boasted as having an historically identifiable Italian neighborhood. A comprehensive list of all would include the most famous such as New York City's Mulberry Street, Boston's North End, Philadelphia's Bella Vista, St. Louis' The Hill, and San Francisco's North Beach. Some of the less known and even the somewhat obscure include those in New Orleans, Portland, Maine, and Wilmington, Delaware. In the process I discovered they shared many visual characteristics and made similar historical and contemporary claims about their authenticity. Beyond

counting the number of scholarly and non-scholarly studies of individual Little Italies one might argue that the total number of such places is at least equal to the number of mid-sized cities on the continent. In 2013 the U.S. Census Bureau estimated that there were almost three hundred mid-sized cities (100,000 or more population).

One caution must be made at the outset. If you asked someone in 1910 the question "what is Little Italy?" they would likely answer "That's where the Italians live." And they would be right. However, if you asked someone in 2010 the same question, they might give you the same reply, but the more accurate answer would be "That's where the Italians used to live." This common sense question depends on how "Italians" are defined. Using any of the following U.S. Census criteria: Foreign Born, Foreign Stock, use of Italian Language at Home, or Ancestry produces a different result.[3] To complicate matters even further, the criteria have varied greatly over the century of record keeping.

"Little Italy" is not only a place. (See Color Plates 19 and 20.) Today many people use online searches to find things. Inserting "Little Italy" into Google's search engine, one finds thirteen million results that offer urban neighborhoods around the globe, but mostly places to eat. The most visited (as of May 2017) is, as expected, "The Official Website for Manhattan's Little Italy District."[4] There is even a chain of Italian restaurants claiming the name— "Maggiano's Little Italy" with fifty locations in twenty-two states.

Little Italies, or rather "Italian colonies" in America existed prior to the great waves of immigration from Italy began crashing upon the shores of America in the first two decades of the twentieth century. By the time of the catastrophic stock market crash in 1929, and subsequent Great Depression, Little Italies or variations on that theme such as Little Calabrias or Little Sicilies were ubiquitous in virtually every medium and large-size city throughout the United States. Some of America's largest cities, especially those that served as entrepots on the Eastern seaboard, offered more than one.

Most of these first and second-generation immigrant enclaves grew by natural increase into the 1950s. They persisted because Italian Americans were laggards when it came to joining the middle-class movement to the suburbs in the 1960s, and the "white flight" of the 1970s. However, by the turn of the twenty-first century the vast majority of the most famous Little Italies remained centered around their historical "core," but in a much different form being almost devoid of Italian residents.

For many, Italian America and the Italian American neighborhood are virtually synonymous. Ethnic urban villages, initially established to provide mutual assistance and support among immigrants, have survived despite upward social mobility, suburban migration, urban renewal, and invasions by subsequent groups. Interestingly, the local Italian community (as a congeries of families) has been better suited than many others to survive the transformations, having evolved over centuries within a variety of oppressive social, political, and economic structures. Until recently, most predicted the imminent disappearance of Italian ethnic neighborhoods, thus producing a large collection of studies on the birth and death of one or another Little Italy. These pessimistic analyses were based on various theories that predicted the "Twilight" of Italian American ethnicity.

For historians the major rubric under which Italian residential communities are discussed is that of Little Italy. For other social scientists it is the *urban village*. Although most of these, almost stereotypical enclaves, are still found in the central areas of large metropolises, many others can be found in smaller cities, and virtually every location where heavy industry, construction, sewer, road, or canal work, or major railroad or seaport connections required immigrant labor. Also, a sizable percentage of Italians have lived and worked in small factory towns, mining villages, and in rural America. Although these Italian American neighborhoods have many variations based on such things as size, concentration, and immigrant

generation; from tiny California fishing villages to the huge concentration of Italians in New York City's East Harlem, it is possible to speculate about what they have in common.

Not all of the neighborhoods in which Americans of Italian descent reside are regarded as Little Italies. Ironically, it is possible that an area in which all of the residents are Italian might not be called a "Little Italy" whereas another locale at which there is not a single Italian resident will be so regarded. Little Italies are frequently described as having an "Old World Italian air," although in most cases what is defined as *Old World*, or even *Italian* is arbitrarily ill-defined, if defined at all. People just seem to intuitively know when they are in a *real* Italian neighborhood.

Origins: 1880–1924

The story of Little Italy has been told many times and in many different languages by historians or social scientists. No matter when or where they take place however they share several elements in common which have become almost tropes. The core of Little Italy has always been the street and seldom did researchers talk about the interior spaces. Starting with the writing and images of Jacob Riis and Lewis Hine to current preservation efforts and museums, social and cultural life is described in the sights, sounds and smells of the world outside, on the streets. Against all odds some ethnic urban villages, initially established to provide mutual assistance and support among immigrants, have survived. Because of their situational longevity, Italian American neighborhoods have been the venues for the complete, and still ongoing, series of urban transformations; from the "new" immigration of the turn of the nineteenth and twentieth centuries, through the Melting Pot of assimilation, the uprooting of urban renewal, the tensions of racial change, the displacement of gentrification, and the multicultural confusion of the newest "new" immigration.

The evolution of Italian American ethnic neighborhoods is frequently described as taking place in stages roughly corresponding to broad periods of immigration; 1880–1930, 1930–1960, and post-1960 decades. Another way to think about them is their somewhat equivalent generation of immigrant residents, i.e., first generation Italian-born, second-generation American-born of Italian parents (sometimes referred to as Foreign Stock) and third, or subsequent generation American Italians. This crude rubric provides a range of stereotypical settings from those of first generation Italians in teeming ports of entry in 1880, to those of the third generation in middle-class suburbs in 1990.

The U.S. Census (1975) provided a great deal of data on Italian immigration to the United States, 1820–1975.[5] Between 1880 and 1930 over four million Italian immigrants flooded America. The rise and fall of identifiable Italian ethnic enclaves can also be understood demographically. Between 1820 and 1879 less than 100,000 Italians were recorded as immigrating to the United States, therefore during this period they are seldom noted as significant settlements. In contrast, between 1880 and 1929 about four million emigrated to America and they became a common feature of the urban landscape. The Great Depression and World War II in the period from 1930 to 1949 cut the number of new Italian immigrants to a little more than 100,000 and growth in the enclave was dependent on natural increase. More substantial replenishment from the homeland came between 1950 and 1975 (about 600,000). After that permanent resident admissions of Italians have been coming only at the rate of approximately four thousand per year. The newcomers were hardly enough to refill empty spaces or create new ones of significant proportion, and historical central city Little Italies contracted and many others disappeared.

The most active period for the establishment and growth of Little Italies is also easier to understand by looking at "Italian Immigrants in Selected Cities, 1870–1910." The data also explain why the Little Italies of New York, Philadelphia, Chicago, and Boston are the most

well known and are often thought of as the most "typical." The most important cities and those designated after 1890 by the U.S. Government as immigrant inspection stations such as Ellis Island were also the places where immigrants disembarked. Although many stayed in those initial ports of entry, more traveled elsewhere to towns small and large in search of work and relatives. During the most intensive period, Italian migration to New York City (541,166) was by far been the most. This was followed by Philadelphia (72,109), Chicago (68,742), Boston (54,357), San Francisco (33,751), New Orleans (21,119) and finally Baltimore (8,420). These figures of course do not include the tens of thousands of Italians from other countries to which they migrated before coming the United States, but they are nevertheless a good general sense of proportion.

Richard N. Juliani wrote about the Italians in 1886 Philadelphia when the population grew rapidly and diversified.

> As the boarding house population of male laborers was being augmented by the arrival of women and children, the reconstitution of families contributed to the development of community life. Similarly, with the formation of mutual aid societies, another step was taken toward community normalization. In these organizations, as well as other communal institutions, would soon be found the earliest signs of a shift in leadership from the Genoese to Southern Italians such as the Baldi and DiBerardino families. But the Italians remained for the most part, as they would for some years, members of a community marked widely by poverty and often-brutal violence—circumstances that would attract the unfavorable attention of other Philadelphians. In short, it was a period of great material difficulty for many individuals and families from the emerging Italian sections of the city. But it was also a time of expansion, transition and maturation for the Italian community as a whole which could begin to serve as a foundation for the success and well being of later generations.[6]

Harney and Scarpaci noted among ethnic enclaves found in great cities "Little Italies are probably the most ubiquitous. . . . Discernible clusters of Italian settlement seem to appear in every town with heavy industry, construction, sewer, road or canal work, or major railroad or seaport connections."[7] Initially mostly male Italian immigrants formed enclaves of first settlement near their work in multiethnic neighborhoods sharing streets and buildings with other groups. Others followed these pioneers using informal networks to attract fellow workers, relatives, and family members from their hometowns or regions. This chain migration led to the building of what Jerre Mangione and Ben Morreale called "tight little islands" of varying sizes with regional and smaller divisions such as Little Calabrias, and Little Sicilies. They quote from a letter of Bartolomeo Vanzetti wrote upon his arrival in 1908:

> Until yesterday I was among folks who understood me. This morning I seemed to have awaken in a land where my language meant little more to the native (as far as meaning was concerned) than the pitiful noises of a dumb animal. Where was I to go? What was I to do? Here was the promised land. The elevated rattled by and did not answer. The automobiles and trolley sped by, heedless of me.[8]

Donna R. Gabaccia demonstrated how disadvantaged immigrants can change spaces to meet their cultural demand by comparing Sicilians in agrotowns with those in New York City tenements. Gabaccia found that although Sicilians were somewhat satisfied with their houses they also recognized and resented them as indicators of their obvious social failures.

Therefore she concluded, "Their migration was as much a response to residential as to occupational dissatisfaction."[9] In both Sicily and New York City, peasants and ex-peasants were collected into places that made it possible to better exploit their labor. Despite the romantically pleasant stereotype of southern Italian village environments, Humbert Nelli wrote that on the contrary they were "miserable and wretched places in which to live."[10]

Intellectuals and higher class Italians were often embarrassed by their fellow countrymen and therefore claimed that the first enclaves were *aberrant, temporary, marginal and anachronistic.* Simultaneously, many American critics of immigration saw these settlements as *colonies* that served the interests of an increasingly imperial Italy's foreign policies. Referred to as "Birds of Passage," initially, many, if not most, Italians in America were sojourners who came to earn money and return home to Italy. This attitude toward their American residence also had a profound affect on the structure of their local communities, which were weak and vulnerable to exploitation. In 1911 the widely accepted, but severely flawed, "scientific" results of the Dillingham Commission not only led to restrictions on "lesser" immigrants, but also labeled Italian enclaves as pathogenic environments. Incidents such as the Palmer Raids, as part of the anti-immigrant, anti-left hysterias of the 1920s made Italians even more defensive toward outsiders and isolated them even further.

Despite the intense hostility toward them, the colonies grew and multiplied. The vast majority of the four million Italian immigrants were from the rural Italian south, the Mezzogiorno, whose traditions contrasted and conflicted with American norms. The development of each enclave varied as each city drew a different type of immigrant from Italy or elsewhere. This resulted in a wide range of dominant occupational structures and degrees in the extent and intensity of Italian ambience. Over-generalizing about New York's Little Italies has had a long and venerable history. Antonio Mangano, a Protestant missionary, wrote at the turn of the century:

> It is generally supposed by those unfamiliar with actual conditions, that the Italian colony of the Borough of Manhattan is a well organized and compact body of people, having a common life and being subject to the absolute control and leadership of some one person or group of persons. To the reader of popular articles describing Italian life and customs, in these days so frequently appearing in newspapers and magazines; to the enthusiastic and romantic slum visitor, who walks through Mulberry street, and possibly peeps into the dark and dismal hallway of some dilapidated tenement and feels that he knows just how Italians live and act; to the theoretical sociologist, to whom Italians look alike and in whose estimation all Italians are alike, think alike, and act alike—to such persons the mere mention of the Italian colony inevitably suggests unity of thought and action as well as of mode of life on the part of all who belong to that colony. And yet nothing is further from the truth.[11]

As the local populations grew and the length of tenure in the United States increased, so did the associations that helped create a fuller community life; mutual aid societies, fraternal organizations, Roman Catholic churches (and Protestant missions), political and/or *paese* clubs, Italian speaking local unions, and other related entities, parochial schools, sodalities, sports teams and credit unions. These community centers in turn attracted businesses, ethnic newspapers and restaurants.

Within the dominant framework of the Melting Pot, and periodic nativist xenophobia, Little Italies were seen by the most generous commentators as places in which newcomers prepared for eventual entrance into the dominant society. As the flood of immigrants slowed to a trickle, they expected, and hoped for, a gradual process of increasingly successful

individuals moving outward from central city slums to newer and better areas. However, as conditions for the group improved, conditions in the enclaves also improved, and they were not abandoned wholesale. Other factors such as the onset of the Great Depression also made it increasingly unlikely that Italians would easily improve their occupational or residential status in a general stagnating economy.

Dominic Candeloro argued that had Italian immigrants to Chicago concentrated in one Little Italy, they would have been a powerful political force. However:

> Though in its heyday the Taylor Street area contained some 25,000 people—a third of the city's Italian population, there was almost from the beginning an absence of one large and densely populated Italian district. Into the 1920s people moved around a lot. In fact, no Chicago neighborhood was ever exclusively Italian. Following the ladder of ethnic succession, there were always remnants of previous ethnic populations mixed with the current dominant ethnic populations, with a sprinkling of families from the ethnic group that might become the majority in a generation or two. Though the core Italian neighborhoods remained Italian, it was often different Italians who lived there, since earlier settlers were likely to have moved west to more desirable neighborhood.[12]

It was during this period of rapid enclave formation that University of Chicago sociologist Ernest W. Burgess studied the "Zone of Transition" where one found roomers, hoboes, addicts, poor folks, nonwhite minorities, and lower class immigrants who lived in the ghetto, slum, Black Belt, Chinatown, underworld, vice and Little Sicily.[13]

1930–1960

The first Great War in Europe (World War I) had already effectively cut off large-scale immigration a decade before the radical immigration law changes in the 1920s. The cut-off also meant that cultural replenishment would depend more on impersonal forms (foreign language newspapers, radio, touring Italian officials) of contact with a rapidly changing Italy. By 1930, most Italian residents in America had probably already made a commitment to stay. The severe limitations on the number of Italians who could legally enter meant the end of rapid growth and expansion into new areas, such as the fringe and near suburban areas where a few more successful Italian communities had already emerged.

Between 1900 and 1930 the number of Italians in New York City had exploded from 219,000 to 1,511,800 even as the mass migration of Italians had ended. One of the job-creating efforts of the Federal Works Progress Administration during the Depression was the Federal Writers' Project. Writers were given the opportunity for employment and were assigned various projects including writing the history of *The Italians of New York*[14] in which they described ten large Little Italies in New York City. Four were located in Manhattan, three in Brooklyn, two in Queens, and one in the Bronx.

In most of the major cities, the reception by the non-Italian Roman Catholic hierarchy of the Catholicism practiced by southern Italians was less than enthusiastic. As the enclaves matured, the occasional demands for Italian-speaking pastors and Italian parishes caused considerable friction, and fertile ground for Protestant missions, as well. Only begrudgingly did the hierarchy recognize the critical value of town and regional *feste* that many in the American clergy saw as pagan rituals. It is institutions such as these that are critical for the development and maintenance of ethnic enclaves. Finding Italians during the first part of the century was a relatively simple matter; almost all were Roman Catholics who were still

speaking their native tongue, and occasionally celebrating their local *feste*. Consequently, Italians could be found wherever masses were being said in Italian.

The eventual domination by native-born residents affected the traditional family system, especially the roles of women and children. The process of Americanization was greatly enhanced by compulsory education and the public school system. The intrusion of other American institutions into the locality produced strain, and eventual adjustments. Ironically, one of the most powerful of these was Prohibition, which brought together the police and organized crime whose enterprises frequently found a home in Italian neighborhoods. By this time few Italians thought seriously of going "home," and as the second generation population of native-born citizens reached majority age, participation in electoral and party politics increased and Italian ethnic neighborhoods became an integral part of the urban political machine system.

At first the deprivations of the Great Depression were a counterforce of Americanization as it made people rely on co-ethnics. By the end of the 1930s, the distributive programs of the New Deal brought government into the community but did not totally eliminate ethnic-centeredness as local distribution of assistance was funneled through ethnically sensitive machine politicians. The greatest shift in neighborhood patterns came with the onset of World War II. Although both World Wars greatly increased the rate of cultural assimilation, in the Second, Italy was an enemy, and for a short time foreign-born Italians were enemy aliens. Prior to the war, large Italian American neighborhoods in major cities were staging areas for Fascist outreach to the Italian community.

Fears of a subversive Fifth Column, and government-sponsored efforts at increasing solidarity led to a lessening of ethnic divisions among Americans, as indicated by decreases in foreign language newspapers and radio stations. In multiethnic cities all immigrant neighborhoods became more American and visible signs of Italian ethnicity were muted, as was the Italian language. More isolated areas in the suburbs, small towns, and rural areas became even less Italian in operation and appearance. During the war, direct contact between Italy and the community was virtually nonexistent. The end of the war brought thousands of Italian American servicemen back home, many of whom had served in Italy. Films from and about Italy and other contact with postwar Italy also increased, but the Italian American community had been irreversibly changed. Like other Americans they saw Italy as foreign and, except for older generations, they lacked an understanding of their own connection. Immigration from Italy surged again for a short time, but as economic conditions in Italy gradually improved, the impetus to emigrate lessened. Since then much smaller numbers have come to America and wide fluctuations of immigration can be easily correlated with the variations in the two economies.

Other factors which affected the evolution of Little Italies were domestic in origin. The loan policies of the Federal Housing and Veterans Administrations encouraged the rapid growth of suburbs and mass exodus of the white population from the central city. Being less geographically mobile than other white ethnics of the same immigrant generation, Italian Americans were more likely than others to resist the trend. In the first Little Italies, before transportation technology made commuting easier, poor immigrants had to live near the availability of work. But Italian Americans preferred to stay close to home, not only because of economics but also because of cultural propensities and family values. Those millions who stayed behind were faced with many other problems such as assaults on their neighborhoods by programs such as urban renewal and highway construction that began in the 1950s and continued into the next decade. These factors set the stage for later decades when urban Italian Americans, as the last of the white ethnics, occupied a diminishing number of variously defended neighborhoods.[15]

Some of southern Italian community practices were not easily understood in the American context. For example, historically, poor Italian peasants tried to hide assets from neighbors and officials. At first this tradition was directly imported to the United States, and American urbanists as late as the 1950s commented on the especially shabby appearance of working-class Italian American areas and were surprised when they discovered well-kept or even luxurious accommodations inside "slum" buildings in Italian colonies.[16]

Giulio E. Miranda saw insularity more positively as:

> The tenacity in clinging to the old neighborhoods, partly sentimental, but also derivative from the extended family pattern, can act as a glue to hold the cities from becoming racial ghettos. The Italians have shown a readiness to live in neighborhoods adjacent to those of blacks and Puerto Ricans and fight it out for the turf. This is more promising than the discreet avoidance practiced by the groups who deplore the rumbling and name calling of black—Italian confrontation. The resistance to change is an index of inner strength.[17]

Robert Orsi commented on intergroup relations in Italian Harlem:

> In the earliest days of the community, before East Harlem had become an Italian colony, the festa was a brave declaration of presence, proclaiming to Irish and German Catholics and to American Protestants that the Italians had arrived and they would do things their way. By celebrating the Madonna of 115th Street, the Italians claimed the neighborhood for themselves. The wealthy of West Harlem and the Catholics of East Harlem soon knew where the Italians lived. The procession emphasized this claim by marking the boundaries of Italian Harlem each year and giving those boundaries divine sanction. Later in the history of East Harlem, when the Puerto Ricans began arriving in the 1940s and 1950s, the procession and the devotion intimidated the newcomers.[18]

Post-1960

During World War II, large numbers of African Americans had migrated from the South to industrial cities in pursuit of job opportunities previously denied them. The 1950s witnessed further large-scale migration of African Americans and Hispanics. By the 1960s most Italian American neighborhoods in the central city uneasily coexisted with substantial minority populations. Mandated integration of public schools and government efforts to end discrimination in employment and housing made relations between Italian Americans and nonwhites more problematic. Philip F. Napoli wrote of the Asian "invasion" of Mulberry Street.[19] To set the tone he quoted Pietro di Donato:

> What keeps Little Italy there? Cheap rent? Choice of any superlative food? Family ties? National pride? Social life of the tenement? Or the personal patron saints? In my heart of hearts I belong there too and not among chilling other races and in a mixed neo-community that my soul disdains to digest. I remember what the pigeon fancier on the Mulberry Street roof said, "Sure I like it here. Why should I leave, I'm with my own people. Is there any place better?"[20]

Italian immigration is no longer a major demographic factor in the dynamics of Italian America. Although the 1965 Immigration and Nationality Act eliminated the old discriminatory

preference system, the yearly numbers since then have varied only in the thousands. New Italians settling in Italian American neighborhoods did not mix easily with locals, and cultural divisions (especially based on language use) between the two groups persist. These post-1965 Italian American enclaves, whether in the central city, fringe, or suburbs maintain a greater connection to Italy. Varieties of more and less "Italian" neighborhoods are possible because the ease of air travel makes it possible for Italians to maintain residences in Italy or frequently travel between the two countries.

The New York region, as the most important center of Italian ethnics, can be used as a model. Recent studies show that Italian American neighborhoods continue as visible features of the center and fringe of the city. Concentrations of Italian American population (neighborhoods) are however rapidly increasing in the near and far suburbs as the population in general disperses from the Northeast. These postmodern Italian American neighborhoods have many varieties but whether urban or suburban, Italian-Italian, Italian American, or American Italian they still share a few elements of appearance and traditions such as interest in ethnic foods, which results in the opening of Italian groceries and delicatessens. Except for the touristy Little Italies, these constantly evolving neighborhoods are not like the enclaves of the past, but are somewhat distinct variants of American and Italian residential cultures.

In 1973 Gary Mormino set out to find "remnants of another lost little Italy" in St. Louis's The Hill neighborhood, but instead found one overcoming urban changes with "resurgent ethnicity."

> Since the late 1960s the clearly defined neighborhood has provided a varied format for insiders and outsiders. The Hill offers a colorful ethnic atmosphere where St. Louisans play *bocce* under grape arbors and sample panettone and cannoli in one of then many mom-and-pop grocery stores. The neighborhood has become a cultural mecca, an asylum where outside Italian Americans may walk the streets, testing their traditions and ethnicity through the spectrum of living history. The Hill has become an ethnic Williamsburg, a living laboratory and a time warp enshrining elements of modernity and community. Incredibly, in a nation dedicated to novelty and newness, the Hill has retained the essential vestiges of its ancestors: the neighborhood remains working class *and* Italian. Its greatest threat is not isolation but overexposure, the danger of ethnic chic, of becoming the trendy attraction for urban gentry. But that hasn't happened . . . not yet at least.[21]

As once "The Ghetto" stood for Jews,[22] and "The Dark Ghetto"[23] still stands for African Americans; Little Italy stands for Italian America. Even Richard Alba, who has persuasively argued that Italian Americans are moving into the "twilight" of their ethnicity, noted that "the concentration of Italian American loyalists in neighborhoods with a definite ethnic character keeps alive the notion of an Italian-American ethnicity, even in the midst of widespread assimilation."[24] The centrality of territory in Italian culture was established in a compendium of leading research by the Giovanni Agnelli Foundation.[25] The research showed that the central factor in all models of cultural and structural metamorphosis of Italian Americans has been the role of the neighborhood.

Italians, like all other migrants, carried designs for living from their original home environments and adapted them to the resources and opportunities in new locales. Therefore only limited "traces" of the environmental values they brought with them are found in their hyphenated-American neighborhoods. American residential traditions are easily contrasted to those of southern Italy with its wooden as opposed to stone houses, and picket fences, versus high stone walls respectively. The styles of Italian ironworks, stone, stucco and ceramics

came by way of the Mediterranean and North Africa, which also imparts an exotic, perhaps even "oriental" quality. The central elements of Italian American neighborhoods are represented in vernacular landscapes. For example: Italian enclaves tend to be small scale and arranged so to facilitate intra-family and interpersonal relations; Italians have a great tolerance, if not a preference, for high human density; Italian communities endorse the supremacy of private (family) over public (nonfamily); individuality and competitiveness are emphasized over conformity and cooperation; and the physical and symbolic defense of individual, family and neighborhood spaces is the most important feature.[26]

In Italian American neighborhoods a great deal of effort is expanded toward shielding the family from the outside world, yet the cues to boundaries are seldom recognized by those outsiders who wander across them. Homes are guarded physically by walls and fences, and symbolically by lettered signs, which say "Keep Out." Hostility may also be seen in the stares of old timers who are on guard while sweeping the curbs in front of their houses, or the comments of young men who congregate at the street corner portals into their blocks. One of the most common images of Italian neighborhoods is the "social club," or as defined by Gerald Suttles in the Addams area of Chicago as the "social and athletic club."[27] Most urban sociologists of my generation were introduced to a rather deracinated Boston version of SACs by William Foote Whyte in the classic *Street Corner Society*.[28] The "college boys in Street Corner society were more likely to be recognized as "American" than the "corner boys." The more sinister—and popular version—of the club is promoted by writers in popular Mafia movies and books such as Mario Puzo's *Godfather* series, which is quite accomplished in spatial semiotic imagery. The most "accurate" vision of this local social phenomenon is an unremarkable storefront of a regionally or town-based immigrant organization which provides a place for mature males to drink, play cards and share conversation.

Little Italy: Literature and Media

Little Italy is often totally a figment of a writer's imagination. Sometimes it is somewhat grounded in personal experience, or much less often based on scholarly investigation. Just as in much nonfiction writing about Little Italy, it is a place in which Italians seem to be confined and can't leave until they become Americans. They may also feel guilty for escaping or even simply wanting to leave. Those that have "escaped" however often express remorse or nostalgia for an idealized past. Little Italy can also be thought of dramaturgically, or as a stage upon which people can act Italian. In American fiction it seems to be the only place where being Italian is possible. The stereotypical Italian American lives in a stereotypical big city Little Italy, or otherwise "typical" Italianate setting. Italians of course inhabit a wide range of cities, small towns, and suburbs. For example, in the popular HBO series *Sopranos* (1999–2007), mob-leader Tony Soprano owned a stereotypical upper-middle-class suburban New Jersey McMansion, so the backroom office of his "Bada Bing" strip club served the role of the mob clubhouse in one or another Little Italy.

The difference, or "distance," between the Italian neighborhood and the outside world has also been a central feature in fiction. In both Arthur Miller's play *A View from the Bridge* (1955) and the film *Saturday Night Fever* (1977) getting out of their Brooklyn enclaves, and going to Manhattan, is the pathway to success in American society. The social and geographic boundaries are clear to writers such as Pietro di Donato who while writing about his early life wandering in West Hoboken (now Union City), New Jersey noted:

> One day we ascended the sloping highway from Hoboken to Weehawken. At the summit of the Palisades was Kings' Woods overlooking the Hudson River and the

exalted towers of New York City. Across from Kings' Woods we came upon a tree-shaded street called Landscape Avenue and on Landscape Avenue was a big, smiling, white Edwardian house with bays, porches, and attached green house, gables and chimneys. Surrounding it were lawns, trees, bushes and flowerbeds. On the carriage steppingstone at the curb was the name Duane. Stella sighed: "Ah, how sympathetic is this American home."[29]

Probably the most well-known uses of this geographic device are the films based on the work of Mario Puzo, such as *The Godfather* (1969). They all seem to convey a wide range of appropriate venues for low and high level mobsters. The symbolic distance between Italians and America is shown by Don Corleone's upward mobility from Mulberry Street to his Long Beach, Long Island mansion. Many other well-known, especially mobster, stories take place in or about Little Italy, but few provide an intensive understanding of the place itself and the social relationships that create and maintain it. Little Italy is not simply a location.

A Bronx Tale (1993) it is not a simple "crime drama," but rather represents Little Italy in the turbulent 1960s. The cheek-by-jowl coexistence of good and bad influences are represented by hard-working bus driver Lorenzo Anello, played by the film's director Robert De Niro, and gangster Sonny LoSpecchio, played by the film's writer, Chazz Palminteri. The Anello family lives in an apartment a few floors above Sonny's bar, which also serves as his mob's headquarters. Lorenzo's son Calogero literally but uneasily occupies the space between them. The story emerged in part by Palminteri's childhood experiences and also depicts violence between Italian and African Americans in a racially changing urban neighborhood.

When Italian Americans write of their home, it is simultaneously the neighborhood, and the whole world in microcosm. Fred Gardaphé introduced the Italian American narrative autobiographically:

I grew up in a little Italy (not Little Italy but a little Italy) in which not even the contagiously sick were left alone. The self-isolation that reading requires was rarely possible and was even considered a dangerous invitation to blindness and insanity (this was evidenced by my being the first American born in the family to need glasses before the age of ten). There was no space in my home set aside for isolated study. We were expected to come home from school, drop our books on the kitchen table, and begin our homework. It was difficult to concentrate with four children at the table, all subjected to countless interruptions from the family and friends who passed through the house regularly. We returned home from school every day to scenes that most of our classmates knew only on weekends or holidays.[30]

Long after they were demographic fictions, Little Italies continued to attract the attention of journalists as well as writers of advertising copy. Most were both iconic as well as ironic. In "A Romantic Ideal of Italy, Over a Samba Beat," David Gonzalez reported that Francesco Castiglione hoped to "save" the Italian character of Belmont (see Color Plate 20) by adapting to the changing ethnic composition of the neighborhood and by singing musical blends on the local sidewalk café music scene. Castiglione explained, "Just as Astoria isn't just Greek anymore, Arthur Avenue probably has more Albanians, Mexicans, Dominicans and Puerto Ricans than Italians. But romantic notions—of food, the old days and older ways—still sell." Another local, Nick Santilli, said: "The Italian soul is here, but it is disappearing"; and café owner, David Greco, wanted his place to stay as an Italian bar: "What I do not want is to sell this so it becomes another Albanian club."[31]

Similarly, Jacqueline Gold's story "Love, Discord and Cannoli" concludes Belmont's "Arthur Avenue has long ceased to be solely the province of Italians, as it was for about three-quarters of a century, but places like Egidio's have endured as treasured repositories of the neighborhood's authenticity."[32] "Well, the Ices are still Italian" is the way that Joseph Berger framed his article about how Bensonhurst, Brooklyn—New York City's largest Italian neighborhood—was losing its Italians: "The 2000 Census shows the number of residents of Italian descent is down to 59,112, little more than half that of two decades ago, and departed Italians have been replaced by Chinese and Russian families."[33] Despite the shrinking population, Bensonhurst's major commercial street, 18th Avenue, still carries the title Cristoforo Colombo Boulevard, which provides a sharp contrast to the ethnic changes.

Although most people don't think of the American West as a "proper" venue for Italian immigrants, actually Italians settled in virtually every state in the union at one time or another. For example a quarter century ago I found Baldi's Grocery store and other Italian "Ruins" after reading a column in *The Rocky Mountain News* entitled "Spicy Meatballs Order of the Day" which represented the Highlands neighborhood of North Denver as a place "where old Italian men play *bocce* in the park, and where geraniums still bloom in window boxes."[34] Following his street references, and signified by the Our Lady of Mount Carmel Church (est. 1899), I discovered the "ruins" of the original Italian settlement in "The Bottoms," which was then occupied by Mexican Americans. Most of the Italians had moved up the hill to a "better neighborhood" where the vernacular landscape was so un-stereotypical that the mail carrier denied that it was an "Italian" neighborhood despite all the Italian names on the mailboxes.

Even Sam Roberts of the venerable *New York Times* had to use a visual stereotype in order to provide the feeling of loss while writing an article with the headline "New York's Little Italy, Littler by the Year."

> In 1950, nearly half of the more than ten thousand New Yorkers living in the heart of Little Italy identified as Italian American. The narrow streets teemed with children and resonated with melodic exchanges in Italian among the one in five residents born in Italy and their second- and third-generation neighbors. By 2000, the census found that the Italian American population had dwindled to 6 percent. Only 44 were Italian-born, compared with 2,149 a half-century earlier. A census survey released in December determined that the proportion of Italian Americans among the 8,600 residents in the same two-dozen-square-block area of Lower Manhattan had shrunk to about 5 percent. And, incredibly, the census could not find a single resident who had been born in Italy. Little Italy is becoming Littler Italy. The encroachment that began decades ago as Chinatown bulged north, SoHo expanded from the west, and other tracts were rebranded more fashionably as NoLIta (North of Little Italy) and NoHo seems almost complete.[35]

The Spatial Semiotics of Little Italies and Italian Americans

As with all idealized ethnic enclaves, not all of the places where Americans of Italian descent reside are regarded as "typical." Only those that fit the stereotype are recognized as Little Italies thus creating an interesting paradox for students of Italian Americana: even though the most celebrated Little Italies are actually teetering on the brink of extinction, virtually they linger on as models in the American ethnic collective consciousness. Although stereotypically ethnic neighborhoods may admittedly be of less immediate and practical importance to assimilated individuals, new, often symbolic, functions for them have evolved. Many

ex-urban villagers periodically return from the suburbs to their own and others' old neighborhoods to visit, shop and recharge their "soul." They may attend celebrations, buy things unavailable in their own deracinated settlements, visit old relatives, occasionally demonstrate ethnic pride and increasingly to rediscover their roots. Many visitors use the feast as a reason to return to the "old" neighborhood. While recognizing the merely entertainment value of ethnic festivals, Salvatore Primeggia and Joseph Varacalli argue strongly that such local activities synthesize old and new qualities to provide an important dimension to an enduring Italian American ethnicity. They note especially early immigrant humor and entertainment as well as contemporary ethnic expressions that are evident in the street celebrations that take place today.[36] Local feasts draw tourists as well as old timers back to the neighborhood. Some returnees, who are landlords, may attend to the needs and demands of tenants who now occupy their once venerated homesteads. Finally, in the postmodern world which allows for "symbolic ethnicity," those who wish to be ethnic can choose to live in an enclave among more or less voluntary and "authentic" co-ethnics.[37]

Little Italy as a Spatial Semiotic

Like all real and imagined ethnic neighborhoods, Little Italy is a product and source of both social and cultural capital. Although the ordinary people who live in them ultimately are at the mercy of distant forces, in their naïveté they continue to create and modify local spaces allocated to them. In spite of and because of their efforts they become part of the urban landscape. Urban residents and the spaces they inhabit become symbols. Ironically, they come to represent themselves and thereby lose their autonomy as the enclave comes to symbolize its imagined inhabitants and stands for them independent of their residence in it. Localized reproductions of cultural spaces can also be easily commodified. For example, the expropriated cultural capital of the Italian American vernacular such as resistance to diversity, cultural insularity, and perhaps even racial intolerance becomes a sales point in real estate parlance as a quaint "safe" neighborhood, with "old world charm," and romantically symbolizing the "way it used to be."

My idealized Little Italies fall into categories: Oblivion, Ruination, Ethnic Theme Parks, Immigration Museums and Anthropological Gardens.[38]

1. *Oblivion* means "the state of being forgotten." Every day thousands of trucks and cars drive through spaces which once contained vital and vibrant Italian American neighborhoods; communities of homes and businesses which were destroyed in their prime to make way for "improvements." Razing neighborhoods and tearing wide gashes in the fabric of local Italian American life was a common pattern in major cities. For the most part, this urban renewal merely enabled other, more geographically mobile city residents to flee more quickly to the suburbs.

2. *Ruins.* The rubble of ancient Rome or Pompeii is no match for that of the stores, businesses, and homes in Italian American neighborhoods abandoned in anticipation of "renewal," cleared of misnamed "slums," and still awaiting new uses. In most cases, these "liminal" zones of "in betweeness" had already taken their first step toward oblivion. Italian American ruins contain crumbling traces of vernacular architecture, faded signs that once announced active commerce and business, and fig trees growing in the wilds where little else other than various forms of low-income public housing were constructed to replace Italian villages.

3. *Ethnic Theme Parks.* Despite displacement of most of the "natives," the most famous of American Little Italies are preserved as spectacles for the appreciation of tourists, and the streetscapes that are used by film crews shooting "locations" for Mafia movies. Manhattan's Mulberry Street, and the world famous Feast of San Gennaro takes place in an Asian neighborhood decorated with "Italian" store fronts, street furniture, and outdoor cafés where

restaurateurs recruit "swarthy" waiters from Latino communities. A few ethnically sympathetic vendors might attempt to recreate Italian markets, but many are more likely to unashamedly hawk "Kiss Me I'm Italian" buttons, ethnically offensive bumper stickers, miniature Italian flags and almost anything else in red, white and green.

Most Theme Parks contain (4) *Assimilation Museums* and (5) *Anthropological Gardens*. Assimilation Museums are places for the preservation and display of inanimate objects whereas Anthropological Gardens (Human Zoos) are places where the subjects of curiosity are maintained in their live state. In Assimilation Museums we find Memorabilia Exhibits, Archives, and Galleries run by groups devoted to the "Preservation of **OUR** Ethnic Heritage," ubiquitous monuments to Christopher Columbus, homes of the famous such as Mayor Fiorello La Guardia and the infamous, like Al Capone.

Anthropological Gardens are usually crisscrossed by Naples Streets and Columbus Avenues. There one can observe "Local Italians" at memorial *bocce* courts, senior citizen centers, and social clubs. Video journalists use them as repositories for on-camera interviews about organized crime. Those left behind are the keepers of the tradition who can tell you how it was in the "good old days" in the old neighborhoods.[39]

According to Deanna Paoli Gumina, Italians from the provinces of Liguria, Sicily, Calabria and Naples were attracted to San Francisco, California, by the fishing, and had established their hegemony in the industry between 1850 and 1870.[40] It was the Sicilians, at first with Genoese agents, who developed the business into one of the most profitable in California. During the latter part of the nineteenth century this particular space near Fisherman's Wharf was known as "Italy Harbor" as Italians, originally crammed into the steep sides of the bay side of Telegraph Hill overflowed into the valley and formed the North Beach Italian Colony. A hundred years later in the Ethnic Theme Park I found only faint carnivalesque traces of the illustrious maritime Italian Colony remaining near the wharves at the base of Columbus Avenue, such as numerous Italian restaurants and boats with "Italian sounding" names. In 1989, "Italian" North Beach was compressed by an expanding Chinatown and a rapidly gentrifying Telegraph Hill.

The North End of Boston is another tourist space with a split personality. All year long, most of the visitors come in search of American Colonial and Revolutionary War landmarks such as the Old North Church, and follow one or another variant of the Freedom Trail walking tour. For many others, the North End Italian Theme Park is a place to find "real" Italian restaurants, and, in season, observe an Italian feast. The ethnic composition of Philadelphia's Bella Vista neighborhood has been ethnically mixed and changing for almost a century and a half. Italian Americans comprise the one European group that stayed in large numbers after Irish Catholics and Russian Jews moved away.[41] Yet the neighborhood is still described in tourist brochures as a "Little Italy." Black, Chinese, Jewish, Korean, Lebanese, South Asian, Vietnamese and other merchants bring their ethnic foods and other products to sell at the famous Ninth Street "Italian Market" and the area shrinks by gentrification and the spread of Chinatown.

Why Study

Little Italies are important places to study not only because they are venues for assimilation and acculturation but also because the spatial "idea" of the ethnic neighborhood alone is a powerful force in American culture and society. It is critical to not only consider the places where Italians demographically dominate, but where Italians live as minorities, where they once lived, and where they never lived at all. Actual and virtual spaces help us to understand ethnic America's past, present and future. Generally, Italian inner-city areas survived

in better physical condition for subsequent residential transitions, whereas parallel Irish and Jewish areas did not. Ironically, maintaining the physical environment encourages invasion and defense. Today's Little Italies have attracted the most residentially successful newcomers whether they are Yuppies and urban gentry, or Asian, Caribbean and Latino immigrants. Paradoxically, many of the most "Italian" of neighborhood spaces are in census tracts and zip codes where Italians are a minority.

Today's immigrant neighborhoods can be created almost overnight. Inexpensive regular air transportation, telephone, fax, modem, and electronic access to funds make it possible for Italian extended families, clans and virtually whole villages to alternate the continents on which they live. Because of this mobility, small but thriving enclaves can even remain unseen. The appearances of more recent Italian neighborhoods reflect the continuities and changes of residential life in Italy about which most students of Italian America are unaware.

The exaggerated positives of Little Italy are still represented by a persistent nostalgia for a mythic Camelot-like neighborhood where old people played *bocce*, stickball was played in the streets, mothers made sauce on Sundays, and pork stores and bakeries abounded. There is some truth in all of this. The greatest truth I found in all my research, listening, reading and seeing is that Italians made the best of it (which often was the worst of it).

Further Reading

Krase, Jerome. *Seeing Cities Change: Local Culture and Class*. Farnham: Ashgate, 2012.
Mormino, Gary R. and George E. Pozzetta, *The Immigrant World of Ybor City: Italians and Their Latin Neighbors in Tampa 1885–1985*. Champagne: University of Illinois Press, 1987.
Tricarico, Donald. *The Italians of Greenwich Village*. Staten Island: Center for Migration Studies, 1984.

Notes

1 Richard N. Juliani, "Immigrants in Philadelphia: The World of 1886," in *Italian Americans: The Search for a Usable Past*, ed. Richard N. Juliani and Philip V. Cannistraro (Staten Island: AIHA, 1989), 5–15.
2 Robert F. Harney and J. Vincenza Scarpaci, eds., *Little Italies in North America* (Toronto: The Multicultural Historical Society of Ontario, 1981), 2.
3 U.S. Bureau of the Census, *Italian Immigrants in Selected Cities*. U.S. Census Reports, 1870, 1880, 1890, 1900, 1910.
4 www.littleitalynyc.org
5 U.S. Bureau of the Census, Italian Immigration to the United States, 1820–1975; *Historical Statistics of the United States: Colonial Time to 1970* (Washington DC, 1975), I, 105–106 and U.S. Immigration and Naturalization Service, Annual Reports, 1971–1975.
6 Juliani, "Immigrants in Philadelphia," 11–12.
7 Harney and Scarpaci, *Little Italies in North America*, 2.
8 Jerre Mangione and Ben Morreale, *La Storia: Five Centuries of the Italian American Experience* (New York: Harper Collins, 1992), 130.
9 Donna R. Gabaccia, *From Sicily to Elizabeth Street: Housing and Social Change Among Italian Immigrants, 1880–1930* (Albany: SUNY Press, 1984), xx.
10 Humbert S. Nelli, *From Immigrants to Ethnics* (New York: Oxford University Press, 1983), 2.
11 Anthony Mangano, "The Associated Life of the Italians in New York City," in *The Ordeal of Assimilation: A Documentary History of the White Working Class*, ed. Stanley Feldstein and Lawrence Costello (Garden City: Anchor Books, 1974), 107–111.
12 Dominic Candeloro, "There never was ONE Little Italy in Chicago," in *Reconstructing Italians in Chicago: Thirty Authors in Search of Roots and Branches*, ed. Candeloro and Fred Gardaphé (Chicago: Italian Cultural Center at Casa Italia, 2011), 13–29.
13 Ernest W. Burgess, "The Growth of the City," in *The City*, ed. Robert E. Park, Burgess and Roderick Duncan McKenzie (Chicago: University of Chicago Press, 1925), 114–123.

14 Federal Writers' Project, *The Italians of New York* (New York: Random House, 1938).

15 Cf. Judith N. DeSena, *Protecting One's Turf* (Washington DC: University Press of America, 1990) and Gerald D. Suttles, *The Social Order of the Slum: Ethnicity and Territory in the Inner City* (Chicago: University of Chicago Press, 1968).

16 See especially Herbert Gans, *The Urban Villagers: Group and Class in the Life of Italian-Americans* [1962] (New York: Free Press, 1982).

17 Giulio E. Miranda, "Ozone Park Revisited," in *The Ordeal of Assimilation*, 443–449.

18 Robert A. Orsi, *The Madonna of 115th Street: Faith and Community in Italian Harlem, 1880–1950* [1985], 3rd ed. (New Haven: Yale University Press, 2010), 182–183.

19 Philip F. Napoli, "Little Italy: Resisting the Asian Invasion, 1965–1995," in *Race and Ethnicity in New York City (Research in Urban Sociology, Volume 7)*, ed. Jerome Krase and Ray Hutchison (Bingley, UK: Emerald Group Publishing, 2004), 245–263.

20 Pietro di Donato, *Three Circles of Light* (New York: Messner, 1960), 149.

21 Gary Mormino, *Immigrants on the Hill: Italian Americans in St. Louis, 1882–1992* (Urbana: University of Illinois Press, 1986), 246–247.

22 Louis Wirth, *The Ghetto* (Chicago: University of Chicago Press, 1928).

23 Kenneth B. Clark, *The Dark Ghetto* (New York: Harper and Row, 1965).

24 Richard A. Alba, *Italian Americans: Into the Twilight of Ethnicity* (Englewood Cliffs: Prentice-Hall, 1985), 162.

25 *Italy Today: Social Picture and Trends, 1989*. Centro Studi Investimenti Sociali (Milan: Franco Angeli, 1990).

26 Jerome Krase, "Traces of Home," *Places: A Quarterly Journal of Environmental Design*, 8.4 (1993), 46–55.

27 Suttles, *The Social Order of the Slum*, 89.

28 William Foote Whyte, *Street Corner Society* (Chicago: University of Chicago Press, 1943).

29 Di Donato, *Three Circles of Light*, 134.

30 Fred Gardaphé, *Italian Signs, American Streets: The Evolution of Italian American Narrative* (Durham: Duke University Press, 1996), 1.

31 David Gonzalez, "A Romantic Ideal of Italy, Over a Samba Beat," *New York Times*, (18 May 2004).

32 Jacqueline E. Gold, "Love, Discord and Cannoli," *New York Times* (17 October 2004).

33 Joseph Berger, "Well, the Ices Are Still Italian," *New York Times*, (17 September 2002).

34 Gene Amole, "Spicy Meatballs Order of the Day," *Rocky Mountain News* (16 August 1983), 4.

35 Sam Roberts, "New York's Little Italy, Littler by the Year," *New York Times*, (22 February 2011).

36 Salvatore Primeggia and Joseph A. Varacalli, "The Sacred and Profane Among Italian American Catholics: The Giglio Feast," *International Journal of Politics, Culture and Society*, 9.3 (1996), 423–449.

37 Cf. Mary C. Waters, *Ethnic Options: Choosing Identities in America* (Berkeley: University of California Press, 1990) and Herbert Gans, "Symbolic Ethnicity: The Future of Ethnic Groups and Cultures in America," in *Majority and Minority: The Dynamics of Race and Ethnicity in American Life*, ed. Norman R. Yetman, 5th ed. (Boston: Allyn and Bacon, 1991), 430–443.

38 Krase, "The Present/Future of Little Italies," www.brooklynsoc.org/blog/semiotics/v1n1/index.html

39 Ibid., 104–105.

40 Deanna Paoli Gumina, *The Italians of San Francisco, 1850–1930* (Staten Island: Center for Migration Studies, 1978), 79.

41 Richard J. Juliani, *Building Little Italy: Philadelphia's Italians Before Mass Migration* (University Park: Pennsylvania State University Press, 1998).

ITALIAN AMERICAN FEMININITIES

Ilaria Serra

Italian American women's memoirs open traditionally locked doors. Though an Italian American feminine monolithic identity does not exist, memoirs offer multiple shades of chosen metaphors of self.[1] With unexpected honesty and sincerity, memoirs unveil hidden secrets no one dared to admit before, let alone make public.[2] It was in the 1970s that accounts of women's lives started to materialize in fictional novels or in poetical verses, but not until the 1990s that a large number of book-length memoirs by Italian American women were published. This *outing* was revolutionary.[3] From the silence of their homes, women started choosing new roles and determining their own descriptions. In a joyful assertion of self-expression, they appropriated the pronoun *I* to express their own first-person discourse, as opposed to the ageless "third-person definitions of who they are, cultural prescriptions that are transmitted in oral tradition and private writing as well as written and published work."[4] Thus, Johanna Klapps Herman starts her memoir by reflecting on her decade-long mutism: "It took the largest part of twenty years to be able to fully loosen my word hoard against this wordlessness."[5] The same silence amazed the poet Sandra Mortola Gilbert who wondered: "I am always struck by how few people have written about what it means to be *us!*"[6]

In order to delineate Italian American femininities, I will choose a specific itinerary through their memoirs, one that passes through the doors of their homes. It is not unusual for shreds of recollections to remain hooked to nooks and crannies of the places we lived, homes, streets, gardens and cities. Even stronger is the spatial dimension of Italian American women's memoirs that open the rooms of memory, in a personal method *loci*, a Ciceronian trick of memorization. Over and over again, with an unexpected gesture, women memoirs disclose the curtain that separates public and private space. They welcome guests beyond the cellophane-wrapped furniture of the living rooms, into the vulnerable living quarters otherwise inaccessible to strangers, into the intimacy of the basements, the bedrooms, and the kitchens. Thus, if Italian American women have "the '*sta' casa*' [stay-at-home] gene,"[7] the house may offer the overarching metaphor to explain fundamental identity knots, one room at a time. Each room encloses the main "metaphors of self," a *chronotopos*, an architectural space of Italian American femininity.[8] Barbara Grizzuti Harrison's *An Accidental Autobiography* (1996) directly organizes her memories around the rooms of her youth ("Rooms, Signs and Symbols"). Louise DeSalvo's abundant and self-reflective work also supports this critical choice: "For this house is not merely a house. It has become imbued with spirit," she writes.[9] Interlacing literary criticism with autobiographical threads, DeSalvo's many memoirs traverse all rooms of the house: from the bedroom—*Vertigo. A Memoir* (1997), *Breathless: An Asthma Journal* (1998), and *Adultery* (2000)—to the kitchen—*Crazy in the Kitchen: Food, Feuds and Forgiveness in an Italian American Family* (2008)—and the study—*On Moving: A Writer's Meditation on New Houses, Old Haunts and Finding Home Again* (2009). Far from

wanting to relegate women back to the home, the critical slant of this essay exposes the way these domestic spaces have been lived in while witnessing the flourishing of their feminine identities.

The Vestibule

Right on the threshold of this *narrative house*, in a liminal zone, stand the first-generation immigrant women. They face the American street with fearful curiosity, and thus create the boundaries of their new Italian American home. Not many among these pioneers left traces of their lives. They were the silent, "lost generation," according to Giuseppe Prezzolini, too occupied with earning a living and too humble to think of using a pen to write their lives.[10] The few published works include two as-told-to stories: Rosa Cavalleri in *Rosa: The Life of an Italian Immigrant* (1970) and Giuseppina Liarda Macaluso in *My Mother: Memoir of a Sicilian Woman* (1992); the memories of a miner's daughter, Bruna Pieracci ("Bruna Pieracci," 1979), a resilient entrepreneur from Vicenza, Amabile Peguri Santacaterina (*Il calicanto non cresce a Chicago*, 1992), and a seamstress from Cairano, Leonilde Frieri Ruberto (*Such Is Life: A Memoir*, 2010).[11] The rare times those immigrant women wrote, they assumed a peculiar ethos: not the American ethos of the master of destiny, secure in his position in culture and history, but that of the *quiet individual* who survived.[12] In place of listing their accomplishments, they remember how bad or good "*fortuna*" shaped their lives, or how many times "fate had decreed otherwise." Words of resignation are their mantra, in a soft-spoken tone, *sottovoce*. Uprooting is their life metaphor: "I cannot say I am integrated in this environment. The trees, if transplanted old, grow with difficulty," writes Amabile Santacaterina.[13] Their language is full of Italian sayings and syntactic echoes, uncertain, original, and even graphically chiseled as a cross-stitched work. Their narrative structure is linear and chronological, without the surprising time leaps of their granddaughters. Wanting to serve as a bridge to the past, their life narratives include birth and death dates on lines that resemble rows of tombstones. The reluctant immigrant Leonilde Frieri Ruberto sums up the feminine ethos of the first generation: "'O tanto lavorato e avuto tanti dispiaceri" ("I've worked a lot and have had many displeasures").[14]

At the same time, first generation women start tracing the bright itinerary to their self-discovery. All of them, for the first time, experience the satisfaction of working and supporting their family outside the house. Most of them learn a new self-respect. Rosa Cassettari, a cleaning lady who survived men and poverty, and enchanted her American clients with her storytelling, explains: "I wasn't afraid now. . . . In America the poor people do get smart."[15] The bravest of these pioneers, in her missionary zeal, is Sister Blandina Segale, the author of the exceptional journal, *At the End of the Santa Fe Trail* (1932). This work is all veered toward the outside, the trail, the wild West in which this brave nun lived her life at the turn of the nineteenth century, building schools and missions from the ground up. "Here is a heart for every fate" is her motto, keenly aware to be an uncommon sight: "I doubt not the men think I am either a saint or a witch."[16] In the metaphorical house of women's memoir, sister Blandina stands right outside.

Second and third generation women may also occupy the threshold, a space of negotiation between worlds. Some look for their identity through memoir/travelogues that bring them back to the origins, such as Theresa Maggio's *Stone Boudoir: Travels through the Hidden Villages of Sicily* (2002) or *Mattanza. Love and Death in the Sea of Sicily* (2000). Other times, liminality becomes their identity, as for Kym Ragusa, filmmaker and writer, who lives her triple dimension—Italian, African and American—as a constant uneasiness, a desire to "climb out of my skin, to be invisible."[17] In *The Skin Between Us: A Memoir of Race, Beauty, and Belonging* (2006),

she adopts spatial strategies to describe her identity: "I don't know where I was conceived but I was made in Harlem. Its topography is mapped on my body: the borderlines between neighborhoods marked by streets that were forbidden to cross, the borderlines enforced by fear and anger, and transgressed by desire."[18] Her whole life shifted between different worlds, as she crossed the streets between her grandmothers' homes: "Miriam and Gilda had been the unwavering magnetic forces of the two poles that defined my life.... The neighborhoods where they each lived in Harlem a few avenues away from each other, yet worlds apart.... I had spent most of my childhood and young adulthood traveling between their homes."[19] (See the Frontispiece to Part IV.)

The Kitchen

The memoirs of all Italian American women memoirs pass through the kitchen, some lingering in it, some escaping from it. The most important room in an Italian American house, the kitchen contains most female memories. Not a stereotypical blissful space reeking with the garlic smell of a trite TV commercial, the kitchen is a place of work and toil but also creativity and warmth. Seen through women's eyes, it becomes a colorful palace of imagination, a small universe of social relations and self-expression: "New and often subversive cultural meanings [derive] from the simplest of subjects."[20] Plain acts become meaningful in these memoires, as in Valerie Waldrop's short story, "Il pasto che parla" (The Speaking Meal) which is built around a narrative close up on the hands of mother and daughter, simply making gnocchi, side-by-side.[21]

The kitchen is where women create their selves as new dishes, as Louise DeSalvo notices in *Crazy in the Kitchen*: "I admit that yes, I am crazy in the kitchen, and one day, I hope I will not be. I hope that I can become, in the kitchen, the person I am in other places. I can work on this, I know. Can work on it the way I work in perfecting my breads, my muffins, my minestrones, my pastas, my risottos. With care, attention, reverence, and discipline."[22] DeSalvo comes to explore her own history, her grandmother and mother's femininities, from their relationship to different foods and preparations. In these memoirs, daughters may refuse to identify with their mothers' pots and pans, but learn everything through them. Among kitchen cabinets, femininities are taught and sometimes harshly negotiated. Maria Laurino's *Were You Always an Italian? Ancestors and Other Icons of Italian America* returns to the kitchen in her trip of self-discovery, unflinchingly facing questions about what it means to be Italian American ("Each of us constructs an identity, cuts and tailors it to suit our needs").[23] She is reconciled with her past in the kitchen, while observing "the small acts that composed my relatives' days ... My mother's approach to life exists in the shadows of my own, a life that is different from hers. I have inherited her sense of work's importance, have great difficulty imagining a right to pleasure, and know the security that sorrow holds."[24]

As the generational fights appease and the domestic demands on women relent, many Italian American women return to the kitchen as a sacred place where they reconnect with their foremothers, in an almost supernatural way. Making bread becomes a spiritual reconnection with grandmother's hands. Ravioli tell a sisterhood story, artichokes stir the memory of a neighbor and for filmmaker Nancy Savoca figs are sweet as a mother's love.[25] An "exegesis of eating" becomes possible: "Nourishment is spiritual, metaphorical, yet palpable and real.... Eat slow, my grandmother would say, and tell me afterwards."[26] Proving the unrelenting connection between food and Italian American family history, women's cookbooks have been contaminated by the force of memories, sealing the inextricability of the two genres. *The Scent of Italian Cooking* by Rose Marie Dunphy (2014) and *Festa: Recipes and Recollections from Italian Holidays* by Helen Barolini (1988) intersperse memories and family pictures with

recipes. Enriched with handwritten or signed recipes, pictures and oral histories, these books "celebrate the private worlds of home, kitchen, family, and neighborhood."[27] On the other hand, memoirs leave ample space to food and food preparation: Donna Caruso's *A Journey Without a Map* (2008) start with instructions on how to make pasta and then plunges into the boiling environment of Italian New Jersey. Gina Cascone's *Life al Dente: Laughter and Love in An Italian American Family* (2009) inserts a chapter titled, "You Are What You Eat." When reflecting about their identity, all Italian American women return to the kitchen, in one way or another.

The Work Room

Besides cooking, menial work marks an Italian American feminine world. Leonilde Frieri chants her litany of a life of work: "I continued to do everything my mother had taught me, cook, make bread, make pasta by hand, and sew some things for myself. . . . I crocheted, I knitted, worked in the yard, cut the grass, grew flowers, and had a vegetable garden."[28] Sadie Penzato, author of *Growing Up Sicilian and Female in America, in a Small Town, in the 30s* (1991), almost naïvely draws attention to the hard work in an apple farm in Upstate New York. Her therapeutic memoir brings her back to the loving/menacing presence of her illiterate parents and the work-filled days of her youth: "Looking back now, I can see that not only did I grow up Sicilian and female, I actually survived it."[29]

In an unexpected creative turn, Italian American women find new meaning in old chores, and turn small tasks into identity markers—choices and not duties. Sewing and washing become enlightening acts for Rose Marie Dunphy (née Rosa Maria Gradilone), author of the memoir *Orange Peels and Cobblestones* (2013), a book centered on forgiving a mother who sent her to live with an American aunt. In short autobiographical pieces, Dunphy sings the creativity hidden in simple acts, like sewing: "When I sew, more things happen to me than to the fabric. Sewing soothes my soul. . . . A foot presses on the pedal, fabric, foot and needle, in hands to perform one function in the process, they become one, and, as in alchemical reaction, a totally different thing emerges. Not just a dress or curtain, but a new me."[30] Also hanging clothes on the line becomes for Dunphy "a freeing experience," "almost a ritual" that poetically retells her life:

> I carry the basket balanced on my hip and feel a strong attachment to all the women who went before me. . . . I place the basket on the ground, respectful of all there is. I begin to hang my husband's shirt, my daughter's pants, my son's tattered jeans, the baby's dress. Everything is individual. I have to touch it, shape it, fasten it. It's a reminder of those I love. . . . It's nice to look at them. The past week spreads out before me—the outfit worn to the concert, the shirt that went to the movies, the dress that soaked up spaghetti sauce at Grandma's house.[31]

Another singer of humbleness is Joanna Clapps Herman when she reflects on house tools like kitchen rags: "Slung over our shoulder it is a mantle conferring affiliation to our female world. . . . Our rags are our implements—the female equivalent of hammers, chisels and saw—but the *mappin'* is first among these, the most important tool in our polished female world."[32] The importance of such small things become crucial for recovering the world of the Italian American woman who lived in them, and was buried by them. In these small acts was her voice, as Herman affirms: "The ancient mores of our culture preserve something so old it doesn't have a written record, only a song here and a rag there."[33] Recent scholarship seems to be aware of this: needlework is to be read as the written story of silent women,

in Edvige Giunta and Joseph Sciorra's *Embroidered Stories: Interpreting Women's Domestic Needlework from the Italian Diaspora* (2014). The trousseau with a daughter's dowry, a common possession of Italian households, may become a chest full of stories, "material of memory work."[34]

The Bedroom

The space of the bedroom holds the most private dimensions of women's lives—family, dreams, sexuality and disease—that are not avoided in memoir writing. The bedroom gives secrecy and protection in a world where women are easily besieged. Mary Saracino wished to hide in her closet, when facing problems bigger than herself in *No Matter What* (1993), the autobiographical novel in which she reveals a dark family secret: her mother abandoning her family for a Catholic priest. When her father comes to ask the little girl for an explanation, she remembers: "I want to pretend I am lost in the closet. Swallowed up in the dark. I hear his footsteps on the stairs, and I know he is coming to get me. I don't want him to open the closet door, find me in my secret place."[35] The bedroom is also a room on her own, a shelter for the repressed self of an Italian American daughter in Orienta Badia Johnson's self-published autobiographical novel, *Rina* (2007).[36] Transgressing her parents' will, she toured the States with a small variety company. Dance is Badia's metaphor of life, and her truer self remains enclosed in the boudoir among her sequined costumes.

Bedrooms are also places of diseases that afflict many personal narratives. The guilt of revealing her mother's secret brings Saracino a physical punishment: she becomes sick with a rare voice condition at the very moment she has to start her book tour. Her *Voices of the Soft-Bellied Warrior* is a journal/memoir on the process of recovering her lost voice: "I have paid a high cost for this silencing. My voice is raw. My emotions stretched to a thin slit of air, a violin string taut against the bones in my neck, screeching its painful aria. . . . I am afraid to meet the world."[37] Dealing with disease and sickness, the very act of writing is part of a healing therapy. Stories focus on surviving cancer, like Marisa Acocella Marchetto's *Cancer Vixen: A True Story*, where a New Yorker's cartoonist recounts her 11-month fight with breast cancer (2006), or Mary Cappello's *Called Back: My Reply to Cancer, My Return to Life* (2009). Other times, they tell stories of addictions, as in Domenica Ruta's *With or Without You* (2013), her memoir of growing up with a drug-addicted mother, fighting her own alcoholism.

Three books by Louise DeSalvo emerge from the depth of private rooms—but all three end up as uplifting demonstrations of a woman's strength. *Vertigo. A Memoir* (1997) unleashes the ghosts of a sister's suicide by hanging, a violent father and a depressed mother. Though deeply personal, the book becomes a defense of writing as growth: in the darkest situation, DeSalvo is able to thrive in the linguistic crux between *vertigo* and *verse*, between uneasy dizziness, crazy whirling and versifying, narrating by turning a phrase. *Breathless: An Asthma Journal* (1998) deals with the author's condition which, far from enveloping her in protective isolation, brings her to civic commitment, to research asthma in literature and to reflect on her own writing process. Finally, *Adultery* (2000) brings to light an unspeakable side of marriage, and departing from her own experience, manages to reflect on the theme of betrayal in literature. The asset of DeSalvo's style is her delicate drawing of lines between the most sensitive personal life events and the universality of art, thus escaping the claustrophobia of memoirs. She delves into the secret of her bedroom, but is not swallowed up in self-searching. Her final movement is toward the larger world that touches everyone, the fictional world of art.

Familial relationships are always in the foreground in women's lives: the relationship with a father who is a Vietnam veteran, in Danielle Trussoni's *Falling Through the Earth* (2006) or with a brother who dies of lung cancer, in Jean Feraca's *I Hear Voices. A Memoir of Love, Death and*

the Radio (2007); the death of an identical twin, in Christa Parravani's *Her. A Memoir* (2013), or growing up with a family of hunters and gatherers, in Cris Mazza's *Indigenous, Growing up Californian* (2003). Several women's memoirs linger on the door of their children's bedroom; desired, unbearable, beloved children, such as Susanne Antonetta's *Make Me a Mother* (2014) and Maria Laurino's *Old World Daughter, New World Mother* (2009). The works contemplate childbearing and motherhood, however, are not mere narratives of the nursery, because these authors juggle different roles and most they discover themselves through their relationship with sons and daughters. Having a child may mean giving up the project of a novel for Carol Maso who, in *A Room Lit by Roses. A Journal of Pregnancy and Birth* (2000), drowns in poetical style her self-abnegation at the birth of Rose: "The sadness after song. I would not mind. If song it was I got to sing."[38] A child means a stall in the life of Beverly D'Onofrio, too young and too unprepared for motherhood, in the successful *Riding in the Car with Boys* (1968): "In the end, that sentence from promiscuous behavior, that penance (to get Catholic here for a minute, which I had the fortune or misfortune of being, depending on the way you look at it)—that kid of mine to be exact—would turn out to be a blessing instead of a curse."[39] The maternal theme is further developed by D'Onofrio in *Looking for Mary: Or, the Blessed Mother and Me* (2000), the description of her own relationship with the mother-of-mothers, the Virgin Mary. Mother Mary is present also in the disarmingly honest, *Knowing Jesse: A Mother's Story of Grief, Grace and Everyday Bliss* (2010), by actress Marianne Leone, which tells the pain of losing her 17-year-old child who had cerebral palsy, and describes the ancient ritual of the "running Madonna" in her mother's hometown, Sulmona, in Abruzzo.

Confidential revelations may pour out of women's memoirs, as in *Under the Rose: A Confession* (2001), the dense chronicle of Flavia Alaya's twenty-year relationship with a Catholic priest with whom she had three children and many fights, while working as an activist and a professor. "Operatically" and "radically" Italian, Alaya uses larger-than-life opera titles to break apart the chapters of her life defined by love ("Our lives are what they are. Mine was defined by love, and still is. Almost unbearably so.")[40] Guilt never leaves her: "Bad enough to commit the sins I committed. Worse the effrontery of making them public. . . . If only it were fiction! . . . But I could no more make it fiction than I could live another life."[41] Short, private confessions are also Maria Laurino's "Sacrifice," a short story describing the familial demands on a sister of a disabled sibling, "a thorn in the side of reason, a balm to life's unfairness,"[42] or Regina Barreca's "Jealousy, or The Autobiography of an Italian woman," on a feeling that Barreca finds strongly Italian and related to the fear of the evil eye: "Jealousy emerged from the most buried part of ourselves. We carry it with us from the oldest of old neighborhoods, the oldest of old countries."[43] Deeply intimate is also Maria Laurino's reflection on body and hair, smells and cleanliness, "in that lonely space between me and the bathwater."[44] In her life, she passes from being defined a "smelly Italian girl" to having a fear about smells: "I wonder what has become of my own smell, what it would be like to drip in sweat and to uncover a voice that could tell the stories of my past."[45]

The Study

At her desk, "at the dim lighting of the kerosene lamp," sits Bruna Pieracci, first generation immigrant, daughter of a miner in Iowa.[46] She is not the only first generation immigrant who, despite scant possibilities, believed in the importance of education. Pieracci walked two miles to reach a school in the Iowa fields, and studied through family turmoil. She gave up college to assist her sick mother, whereas her sisters became schoolteachers. Even the cleaning lady Rosa Cassettari struggled to attend evening classes but fell asleep after working long hours. Maria Parrino's study of ordinary early women autobiographers points out that

education was the way and the tool for Americanization and ethnic affirmation.[47] Women who write memoirs are women who believe in the written word. Not a few of them are defined by their work as scholars who often defy expectations and cultural demands. Louise DeSalvo's essay, "A Portrait of a *Puttana* as a Middle-Aged Woolf Scholar" (1984) is set on an airplane, leaving the prison-house of social expectations: "I come from a family, from a cultural heritage, where women simply don't go away to do things separately from men."[48] Her conclusion is triumphant as she realizes that it is possible "to be brilliant, to be working, to be happy, and to be pregnant. And all at the same time."[49]

In a pile of court cases and newspaper clippings, sits Mary Anne Tirone Smith. In *Girls of a Tender Age* (2005), she recounts growing up in a Connecticut blue-collar neighborhood with a mentally disturbed brother, and uses archival research to shed light on cases of sexual assault and a murder at the expense of young girls. Detailing the story of the killer, until his execution, is a purging act that reclaims a silenced voice: "I want to go back and read those newspapers my father didn't let me read. I want to find out what happened. . . . Irene was killed twice, murdered by a horrific man, and then erased by the era that was the fifties—all who needed to talk about her silenced."[50]

Marianna de Marco Torgovnick's double identity as a professor and a working class Italian girl marks her critical persona so much that she titles her critical essays, "Readings by an Italian American Daughter." They are a part of *Crossing Ocean Parkway* (1994) where she curiously blends her recollections and her interpretations of Camille Paglia, Dr. Doolittle and *The Godfather* novel. She also reflects on the difference which earned her the stigmata of the "mala Strega" or the "brazen whore," because "knowing the rules, I have broken them,"[51] and is a source of pain: "When Italian American daughters rebel, their 'I-ness' comes through loud and strong—but so too does their remembrance of the 'we'. . . . I want the 'I' to linger along with the 'we.'"[52] Her sin was leaving the neighborhood, studying and marrying a Jewish man, or, in spatial terms, crossing Brooklyn's Ocean Parkway.

With a reputation that rests on more than forty authored books, Diane di Prima was named Poet Laureate of San Francisco in 2009. Her identity as an author blooms together with womanhood in her memoir, *Recollections of My Life As a Woman, the New York Years* (2001). Those years of formation in a dinky New York apartment, among poets and intellectuals, still throb in her present tenses. Her home is now full of books but devoid of mirrors, almost as if she wanted to forget her own awkwardness: "Better forget it. Better not see who you are. My houses have always had a paucity of mirrors. Better not to see at all."[53] Her intellectual persona grew far from her Italian American roots:

> In my childhood home there was no room for the soul. . . . Or so I was given to understand. The world, you see, was packed so close with matter, every crevice filled, that nothing else would fit, neither soul nor spirit, no angels or saints . . . Every cupboard filled. "Knickknacks" on every shelf. Drawers filled to overflowing with pins, with twine. . . . Time was filled that way, too: no free ruminating moments. Only the next task: dinner, dishes, sweeping.[54]

The Balcony

By paving the way up, education earns the right to appropriate the narrative of the balcony. Italian American women who are politically or socially active look at the world outside and address it directly and openly. They attained a public position and hold the uncontested right to tell their own tale. Thus, Geraldine Ferraro climbed the political ladder and ran for the

U.S. Senate twice, becoming the first female vice president candidate of a major party: "Education was the difference between controlling your life or having it controlled by others."[55] Throughout her memoir, *Framing A Life: A Family Memoir*, she acknowledges her female ancestors as the inspiration for her success: "As long as I have the strength, I can do nothing but fight on in their memory."[56]

Ella Visono Dodd was one of the first Italian American women to earn a law degree, becoming a public figure in the Communist Party. Her gloomy and controlled autobiography, *School of Darkness: The Record of Life and of a Conflict Between Two Faiths* (1954), unveils the black side of the glory she achieved: losing her ties with her own family only to be cast out of the party and remaining childless and divorced by her non-Italian husband. Catholicism is a late consolation in life and her cautionary tale reflects on her education in unassuming style: "I saw how meaningless had been my own education, how like a cafeteria of knowledge, without purpose or balance. . . . It was not until I met the Communists that I had a standard to live by, and it took me years to find out it was a false standard."[57]

On the balcony with Ferraro and Dodds stand also those Italian American women who have infused their own memoir writing with a spirit of activism. Some of them defend gender fluidity, like Annie Lanzillotto's *L is for Lion: An Italian Bronx Butch Freedom Memoir* (2013) in which she roars all her unconventional life. Some personal narratives are used to address public health issues and environmental abuse, like DeSalvo's *Breathless* or Sandra Gilbert's *Wrongful Death. A Memoir* (1995), which deals with the death of her husband in a case of medical malpractice. Even more somber is Susanne Antonetta's *Body Toxic: An Environmental Memoir* (2001), a "self-portrait in a nuclear mirror."[58] In an unusual comparative narrative, the immigrant families—one from Italy and one from Barbados—come to find that their American dream is poisoned. Nuclear waste, clouds of DDT, and "the water we drank, in a body-obliterating communion, from a well declared contaminated," bring physical malformations and asthma.[59] Just by picking up a pen and telling their own tale, these authors perform a politically charged act. For Edvige Giunta, memoirs give voice to the exiled, the marginal and the outcast by resorting to "the transformative and redemptive power of creative work."[60] Maria Mazziotti Gillan cries out such pride in her autobiographical poem "Where I Come From" (1995): "And I celebrate/my Italian American self (. . .)/and today, I take back my name/and wave it in their faces/like a bright, red flag."[61]

The Backyard

At the opposite corner of the house, far from the prose of the street, is the backyard, the poetic oasis within a house. "The backdoor, ever subordinated, is so much more interesting in what it might reveal," affirms Mary Cappello.[62] The narrative of the backyard mainly belongs to the third generation. It is defined by a lyrical prose where the self is fluidly created. Chronological order is abandoned in favor of wandering on mossy paths, in a positive condition of awkwardness—the "un-towardness" of walking by exploring new directions—which is the theme of Cappello's dictionary/memoir, *Awkward: A Detour* (2007). Cappello's memoir, *Night Bloom: An Italian American Life* (1999), perfectly belongs to this private space. Through a composite of old articles, her mother's poems, her grandfather's journal entries, and her own memories and dreams, she tells her family story in a Philadelphia working-class, "hopeless neighborhood where nothing was meant to bloom."[63] Flowers of the backyard bloom instead on the pages, as metonymies.[64] The slender iris conjures her father's violence, beating her brothers blue, and reminds her of her own boldness: "Indigo was my favorite color because it was unallowed." The soft-mouthed snapdragons speak in poetry, and may reveal the unspeakable, the author's homosexuality, which in her

Catholic upbringing becomes unabashedly "nothing to confess." Most of all, the "family plant," the "remarkable flower," the Night-Bloomer Cereus, becomes the metaphor of Cappello's life. It blooms at night, in secrecy. She keeps it growing and takes it with her even in her academic career as the expression of an unforgettable cultural background: "The Night-Blooming Cereus was one expression of my mother's passion; it summoned her into open spaces; it tempted us not to fear being alive even as it lived and died before our eyes. The Night-Blooming Cereus was my father's yelling temporarily transmuted into a loud flower."[65]

Backyard leaves and berries are ingredients of memory potions. A short piece by Sandra Mortola Gilbert, "Bitter Herbs?," elegiacally revives her family history through the smell of garden's spices: basil, tarragon—"my mother's solitude"—and rosemary—"for remembrance."[66] Scents reawaken "the alienating sense of loss that accompanies cultural displacement," and represent "the mouthful of bitter herbs that immigrants swallow as they journey from the known to the unfathomable, from the table of the familiar to the walls of estrangement."[67] A quintessentially Italian garden produce, garlic, is the protagonist of the short story "Allium Longicuspis," in which Stephanie Susnjara reflects on garlic and family history, rejection, sensuality, and a learned taste which becomes her obsession with identity.[68]

Also wavering between memoir and novel, Tina De Rosa's *Paper Fish* (1986) is a "prismatic text,"[69] fragmentary and modernist. The book is the result of a delving in the backyard in the literal and metaphorical sense, in the space where grandmother reigns uncontested in a fantasy world: "Grandma would ask Carmolina to sit with her on the back porch and crush the peppers like dust or like nothing between their fingers, letting the red pepper stuff fall into the Mason jars on their laps. . . . Grandma was making the world for her between her shabby old fingers."[70] Italian American women often return to the theme of the backyard, and adopt its narrative of hybridity, creativity and poetry: It is the safe haven where ethnic culture is kept alive, embodied in a coddled fig tree (Figure 31.1) or in rows of tomato plants, and where women find a shady freedom to dream.

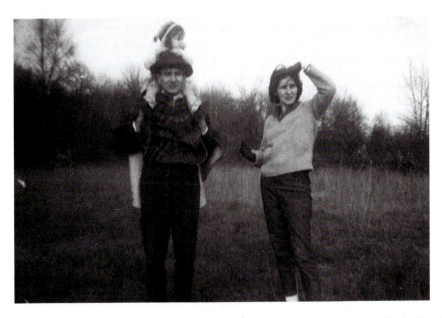

Figure 33.1 Writer Helen Barolini with her husband Antonio and daughter Nicoletta at Shady Lane Farm, Ossining, New York, 1964. Photo: Barolini family.

The Fence

Critical books have helped plant a fence around Italian American women's autobiographical writings, with the purpose of making it a recognizable and worthy field of study: "When the record is not recognized," notes Helen Barolini (Figure 33.1), "it is in fact denied."[71] A peculiar aspect of memoir criticism is that authors are often prompted to creatively mingle the scholarly with the autobiographical. Edvige Giunta, one of the main researchers of Italian American memoir, is also author of memoir pieces. Her "The Walls of Gela" (2006) defines her hyphenated ambiguity, between exile and migration, Sicily and New Jersey, family and academia, in spatial terms: "I no longer know where home is. The two strains of my father's family, agoraphilia and agoraphobia, meet in me, in my wandering, my self-imposed exile, my dread of departures."[72] Mary Frances Pipino highlights the oddity of female authorship in Italian culture, and underlines how autobiographical urgency is the source of much of women's writing, in *I Have Found My Voice* (2000).[73] In the same book, she includes her own story and that of her grandmother. Mary Ann Mannino's collection of essays, *Breaking Open: Reflections on Italian American Women Writings* (2003) starts with a personal recollection: "When I was a child, I was American during the week and Italian during week-ends and holidays."[74] In the writers she studies, Mannino finds reflected her own lingering question between autonomy and dependency: "How far does one go without leaving home?"[75]

Finally, an important warning. The fence around the house of Italian American femininity needs to be open. Critics themselves warn against the danger of self-marginalizing in an Italian American cultural milieu. In 2010, Louise DeSalvo repeated Barolini's admonition: "Teaching these works [memoirs] in Italian American studies isn't sufficient; unless they are taught in survey courses, the work of Italian Americans will remain marginalized."[76]

Italian Americans built skyscrapers and pined to own a two-family house with a backyard. Italian American women, in turn, struggled to demolish an oppressive architecture that confined them in fixed roles by exploring new identities. While they tell "what it means to be *us*," memoirs also provide "shelter in the alphabet." Carol Maso concludes her autobiographical essay on the continual movement necessary to find her freedom, with the statement: "Home is an ordinary, gorgeous sentence that is doing its work. Home for me is the syntax, is the syllables."[77] Memoir writing is thus an imaginative tool for the creation of Italian American femininities. And their new sheltering home.

Further Reading

Bonomo Ahern, Carol and Christina Palmidessi Moore, eds. *American Woman, Italian Style. Italian Americana's Best Writings on Women.* New York: Fordham University Press, 2010.

Giunta, Edvige. *Writing with an Accent: Contemporary Italian American Women Authors.* New York: Palgrave, 2002.

Romeo, Caterina. *Narrativa tra due sponde.* Rome: Carocci, 2005.

Notes

1 "To suggest that women of Italian American heritage possess unique attributes is problematic." So writes Mary Jo Bona, "On Being an Italian American Woman," in *The Italian American Heritage: A Companion to Literature and Arts*, ed. Pellegrino D'Acierno (New York: Garland, 1998), 61.

2 Definitions of memoirs vary and they may include writings by someone who is not an established author, someone who searches his/her own identity in intimacy, or someone who lives in the margins. According to Nancy Caronia and Edvige Giunta, "Habit of Mind," in *Personal Effects: Essays on Memoir, Teaching and Culture in the Work of Louise DeSalvo*, ed. Caronia and Giunta (New York: Fordham University Press, 2014), 1, "Memoir, unlike autobiography, does not offer an account of individual emergence, a narrative of the self-retracing the steps that led to its present, socially and culturally recognized success;

memoir is more than a coming of age narrative or a story of survival. Memoir, with its associative spiral narrative, seeks to illuminate and understand the ties between the self and the world."

3 Italian women characters were virtually absent in the American literary scene. Alessandro Portelli, "Nella letteratura di lingua inglese," in *Storia dell'emigrazione*, 2: 613–629 (616), comments: "the Mary Cuccios are much more numerous than John Fante's Bandinis. And it is not sure they are less interesting."

4 Judy Long, *Telling Women's Lives: Subject/Narrator/Reader/Text* (New York: New York University Press, 1999), 8.

5 Johanna Klapps Herman, *The Anarchist Bastard: Growing Up Italian in America* (Albany: SUNY Press, 2011), 9.

6 As quoted in Helen Barolini, *The Dream Book: An Anthology of Writing by Italian American Women* [1985] (Syracuse: Syracuse University Press, 2000), xi. In her famous Introduction to this 1985 collection Barolini gave the reasons for this silence: Italian American women belonged to a culture of deprivation and hard work, male-dominated, uneducated and distrustful of words. They were hindered by self-deprecation, internal blocks and the lack of inspirational models. Mary Jo Bona argues in her books *Claiming a Tradition: Italian American Women Writers* (Carbondale: Southern Illinois University Press, 1999) and *The Voices We Carry: Recent Italian American Women's Fiction* (Toronto: Guernica, 2007) that they were additionally bound to respect *la via vecchia* (the old ways) and to obey a code of *omertà* (a code of silence).

7 The gene is defined by Marianna De Marco Torgovnick, "Selling the House," in *Our Roots Are Deep with Passion*, ed. Lee Gutkin and Joanna Klapps Herman (New York: The Other Press, 2006), 235.

8 See James Olney, *Metaphors of Self: The Meaning of Autobiography* (Princeton: Princeton University Press, 1972).

9 Louise DeSalvo, *On Moving: A Writer's Meditation on New Houses, Old Haunts and Finding Home Again* (New York: Bloomsbury, 2009), 210.

10 Giuseppe Prezzolini, *I trapiantati* (Milan: Longanesi, 1963).

11 Mary Hall Etts, *Rosa: The Life of an Italian Immigrant* (Madison: University of Wisconsin Press, 1999); Giuseppina Liarda Macaluso, *My Mother: Memoir of a Sicilian Woman*, ed. Mario Macaluso (New York: EPI, 1998); Bruna Pieracci, "Bruna Pieracci," in *The Immigrants Speak*, ed. Salvatore LaGumina (Staten Island: Center for Immigration Studies, 1979); Amabile Peguri Santacaterina, *Il calicanto non cresce a Chicago* (Vicenza: La Serenissima, 1992); Leonilde Frieri Ruberto, *Such Is Life: A Memoir* (New York: Bordighera Press, 2010).

12 See Ilaria Serra, *The Value of Worthless Lives: Writing Italian American Immigrant Autobiographies* (New York: Fordham University Press, 2010). The chapter on women's writing includes the unpublished memoirs by Anna Yona, Elvezia Marcucci, Elisabeth Evans, Maria Bottiglieri.

13 Amabile Santacaterina, *Il calicanto*, 12.

14 Leonilde Ruberto, *Such is Life: A Memoir*, 48.

15 Mary Hall Etts, *Rosa: The Life of an Italian Immigrant*, 191.

16 Blandina Segale, *At the End of the Santa Fe Trail* (Santa Fe: University of New Mexico Press, 1999), 179.

17 Kym Ragusa, *The Skin Between Us: A Memoir of Race, Beauty, and Belonging* (New York: Norton, 2006), 26.

18 Ibid., 18–19.

19 Ibid., 19.

20 Edvige Giunta and Louise DeSalvo, *The Milk of Almonds: Italian American Women Writers on Food and Culture* (New York: Feminist Press, 2003), 11.

21 Valerie Waldrop, "Il pasto che parla," in *Our Roots Are Deep with Passion*, ed. Gutkin and Herman, 223–233.

22 Louise DeSalvo, *Crazy in the Kitchen: Food Feuds and Forgiveness in an Italian American Family* (New York: Bloomsbury, 2004), 166.

23 Maria Laurino, *Were You Always an Italian? Ancestors and Other Icons of Italian America* (New York: Norton, 2001), 202.

24 Ibid., 201.

25 Nancy Savoca, "Ravioli, Artichokes and Figs," in *The Milk of Almonds*, ed. Giunta and DeSalvo, 216–221.

26 Alane Salierno Mason, "The Exegesis of Eating," in *The Milk of Almonds*, ed. Giunta and DeSalvo, 269.

27 Donna Gabaccia, "Italian American Cookbooks: From Oral to Print Culture," in *American Woman, Italian Style. Italian Americana's Best Writings on Women*, ed. Carol Bonomo Albright and Christine Palamidessi Moore (New York: Fordham University Press, 2010), 138.

28 Ruberto, *Such Is Life,* 61.

29 Sadie Penzato, *Growing Up Sicilian and Female in America, in a Small a Town, in the 30s* (Highland: Penzato Enterprises, 1991), 313.

30 Rose Dunphy, "Why I Sew," *Christian Science Monitor* (20 May 1985).

31 Rose Dunphy, "Am I an Endangered species?" *Christian Science Monitor* (25 January1984).

32 Joanna Klapps Herman, "Words and Rags," in *Our Roots*, ed. Gutkin and Herman, 16.

33 Ibid., 27.

34 Edvige Giunta and Joseph Sciorra, "Introduction," in *Embroidered Stories: Interpreting Women's Domestic Needlework from the Italian Diaspora*, ed. Giunta and Sciorra (Jackson: University of Mississippi Press, 2014), 4.

35 Mary Saracino, *No Matter What* (San Francisco: Spinster Ink Books, 1993), 219.

36 See Ilaria Serra, "The Last Dance: Orienta Badia's Autobiographical Novel, *Rina*," *Italian Americana*, 32.2 (Summer 2014), 146–171.

37 Mary Saracino, *Voices of the Soft-Bellied Warrior* (San Francisco: Spinster Ink Books, 2001), 3.

38 Carol Maso, *A Room Lit by Roses: A Journal of Pregnancy and Birth* (Washington DC: Counterpoint, 2000), 2.

39 Beverly D'Onofrio, *Riding in the Car with Boys* (New York: Penguin, 1968), 13.

40 Flavia Alaya, *Under the Rose: A Confession* (New York: Feminist Press, 2001), xi.

41 Ibid., x.

42 Maria Laurino, "Sacrifice," in *Our Roots Are Deep with Passion*, 86.

43 Regina Barreca, "Jealousy, or the Autobiography of an Italian Woman," in *Our Roots Are Deep with Passion*, ed. Gutkin and Herman, 222.

44 Laurino, *Were You Always an Italian?* 29.

45 Maria Laurino, "Scents," in *Beyond the Godfather: Italian American Writers on the Real Italian American Experience*, ed. Kenneth Ciongoli and Jay Parini (Lebanon: University Press of New England, 1997), 106.

46 Pieracci, "Bruna Pieracci," 43.

47 See Maria Parrino, "Education in the Autobiographies of Four Italian American Women Immigrants," *Italian Americana*, 10.2 (Spring/Summer 1992), 126–146.

48 Louise DeSalvo, "A Portrait of a *Puttana* as a Middle-Aged Woolf Scholar," in *The Dream Book*, ed. Barolini, 94.

49 Ibid., 99. Flavia Alaya also values such multiplicity of identities when she laments: "My identity might include my scholarship, I thought, but it didn't need to be impaled on it." *Under the Rose*, 389.

50 Mary Anne Tirone Smith, *Girls of a Tender Age* (New York: Free Press, 2005), 177.

51 Marianna de Marco Torgovnick, *Crossing Ocean Parkway* (Chicago: University of Chicago Press, 1994), 18.

52 Ibid., 153.

53 Diane di Prima, *Recollections of My Life as a Woman: The New York Years* (New York: Viking, 2001), 36.

54 Ibid., 45.

55 Geraldine Ferraro, *Framing a Life: A Family Memoir* (New York: Scribner, 1998), 102.

56 Ibid., 198.

57 Ella Visono Dodd, *School of Darkness: The Record of Life and of a Conflict Between Two Faiths* (New York: P.J. Kennedy, 1954), 136.

58 Susanne Antonetta, *Body Toxic: An Environmental Memoir* (Berkeley: Counterpoint, 2002), 208.

59 Ibid., 234.

60 Edvige Giunta, *Writing with an Accent: Contemporary Italian American Women Authors* (London: Palgrave, 2002), 125.

61 Maria Mazziotti Gillan, *Taking Back My Name* (Bloomington: Lincoln Springs Press, 1992), 3.

62 Mary Cappello, *Awkward: A Detour* (New York: Bellevue Literary Press, 2007), 10.

63 Mary Cappello, *Night Bloom: An Italian American Life* (Boston: Beacon Press, 1999), 259.

64 Ibid., 14.

65 Ibid., 252.

66 Sandra Mortola Gilbert, "Bitter Herbs?" in *Our Roots Are Deep with Passion*, ed. Gutkin and Herman, 164, 173.

67 Ibid., 157.

68 Stephanie Susnjara, "Allium Longicuspis," in *Our Roots Are Deep with Passion*, ed. Gutkin and Herman, 199–210.

69 Edvige Giunta, "Afterwords" to Tina De Rosa, *Paper Fish* (New York: Feminist Press, 2000), 128.

70 Ibid., 15.

71 Helen Barolini, *The Dream Book*, x.

72 Edvige Giunta, "The Walls of Gela," in *Our Roots Are Deep with Passion*, ed. Gutkin and Herman, 67.

73 Mary Frances Pipino, *I Have Found my Voice* (New York: Peter Lang, 2000).

74 Mary Ann Mannino, *Breaking Open: Reflections on Italian American Women Writings* (West Lafayette: Purdue University Press, 2003), 1.

75 Ibid., 4.

76 Louise DeSalvo, "When the Story Is Silence. Italian American Student-Writers and the Challenges of Teaching—and Writing—Memoir," in *Teaching Italian American Literature, Film and Popular Culture*, ed. Edvige Giunta and Kathleen Zamboni McCormick (New York: Modern Language Association, 2010), 158.

77 Carole Maso, *Break Every Rule: Essays on Language, Longing and Moments of Desire* (Washington DC: Counterpoint, 2000), 18.

ITALIAN AMERICAN MASCULINITIES

Fred Gardaphé

Because masculinity tries to retain its hegemony by passing itself off as normal and
universal, rendering masculinity visible becomes essential for its analysis and critique.
—Josep M. Armengol[1]

The Italian American man is the result of the interaction of centuries of Italianate mascu-
linities coming into contact with the variety of masculinities that have come to make up
the American man. The results of these encounters are more varied and complex than the
stereotypical art and media representations of the Latin lover, the brutish bully, and the flashy
gangster that have dominated American culture since the early 1920s. Over the years, theo-
ries of masculinity have all fallen short of describing the plurality of possiblities of Italian
American masculinity, and in fact provide us with nothing more than categories that confine
explanations and distort the very realities they try to describe. I offer the following discussion
of historical performances of Italian American masculinities in the hopes that they will help
us better understand the complexities involved in gender identity and the politics implicit in
the creation and expression of gendered identities.

Roots

A quick look at history reveals the Italian roots of these masculinities and helps us under-
stand its evolution from Europe to the United States. Descriptions of Italian masculinity go
back as far as ancient Roman times. The writings of Cicero and Tacitus tell us that men were
expected to protect the honor of the family and preserve their public esteem by monitoring
the purity of their wives and daughters. Any instance of dishonor, or *injuria*, required that the
offended man take responsive action—often violent—against the woman (daughter, wife or
sister) and the man who had lead her into dishonor. Such action was not only expected but,
until recently, sanctioned by Italian law.

After the fall of the Roman Empire, Italian manhood became an ever-changing distillation
of all the cultures that invaded and occupied the Italian peninsula. Codes of Italian manhood
as they had developed by the sixteenth century were outlined in Baldassare Castiglione's
The Book of the Courtier (1528) and Niccolò Machiavelli's *The Prince* (1532), both originally
designed for nobility but eventually influential at all levels of Italian society. According to
these works, a man was expected to handle his problems with coolness and detachment and
to control his public behavior. This idea meant not simply looking good in public but keep-
ing strangers from knowing what was going on in one's mind.

The concept of *figura*—one's "public figure"—stemmed from the need to protect oneself
from one's enemies. Self-control had to be achieved in such a way as to appear effortless—an

achievement called *sprezzatura*. Another imperative of Italian manhood was *omertà*, or silence—a term derived from *ombredad*, the Spanish word for "manhood," that actually means more than simply keeping quiet. Italian men have been expected to express their manhood through actions rather than through words. An Italian saying is that "Le parole sono femmine e i fatti sono maschi": words are feminine, actions are masculine. Masculine action was to be displayed publicly.

Because Italy was constantly invaded and ruled by foreign powers, the Italians found social stability through *l'ordine della famiglia* ("the order of the family"), in which the father was patriarch and the rest of the family deferred to his authority. Richard Gambino saw traditional relationships between Italian males and females as "the product of centuries of pragmatic experience":

> males and females are not contradictory beings (or "classes" caught in some historical dialectic where gender is the equivalent of Hegel's war between spirit and matter or of Marx's warring economic classes). Instead, the concept is that males and females are complementary. True, they have not been equal. But in our efforts toward equality, it makes all the difference whether we see the genders as doomed to eternal power struggles or as complementary expressions of the same species.[2]

Within this order, the mother, who ruled within the home, set up a relationship with her male children quite different from those of other cultures. Responsible for socializing the children, the Italian mother used her sons as buffers between home and the outside world, between her and other men. Through devoted attention extending into adulthood she exacted unconditional and unwavering loyalty, resulting in the son's perception of having incurred an irreparable debt requiring constant attention to the family's and her needs. Mass emigration during the late nineteenth and early twentieth century would threaten this long-standing order of the family and bring Italian notions of masculinity into contact with those of the United States.

Forging Masculinity in America

Most Italian immigrants were men who came to make money and return to Italy. Many of these men lived with fellow Italian workers or boarded with Italian families. Those back home thought that the absence of women's refining influences and traditional social control would leave immigrant men susceptible to corruption and inclined to turn their corrupting behavior toward American women. Similar concerns among Americans generated literary and media characterizations of Italian immigrant men as dark, dirty and dangerous strangers.

Newspapers and other popular accounts frequently associated Italian immigrants with urban crime and disorder. In the late nineteenth century, Henry James depicted Italian workers in Boston as physically intimidating;[3] film images of the 1920s and 1930s emphasized the exotic, oversexed sensuousness of Rudolph Valentino and the crude criminality of Rico Bandello in *Little Caesar* (1931). The news of the 1920s offered sensationalized accounts of presumed anarchists Nicola Sacco and Bartolomeo Vanzetti, and of the dapper lifestyles and defiant masculine behavior of such gangsters as Al Capone, Lucky Luciano and Frank Costello. Through these accounts, the American media used the Italian American man—and especially his body—to symbolize hypersexuality, crime and other breaches of status quo civility.

While thousands of Italian men were busy leaving Italy, popular models for masculinity developed through the figure of the Maciste.

> Maciste, by the actor Bartolomeo Pagano, appears for the first time in the 1914 film *Cabiria*, then he starred in five movies during the war and another twelve between 1919 and 1926. He became a character loved by the public, a reassuring icon of powerful and muscular masculinity through his body shape and statuesque poses, because of this, it seems difficult not to compare this image with another of his contemporary, the also powerful and muscular Benito Mussolini.[4]

The Maciste of Fascist-era Italy found its way into American culture through the figure of Charles Atlas. As early twentieth-century industrialization brought more women into areas that were traditionally male, men began to depend on physical development to maintain a sense of power and manliness. The dehumanizing effects of industrialization decreases the need for skilled labor, and the mass influx of immigrants all created new challenges for young boys trying to become men. Bodybuilder Charles Atlas—born Angelo Siciliano in Acri, Italy—preached that the road to economic and social success began with physical development. His popular fitness and health program offered a way for millions of young men trapped in factory and office jobs to achieve this new masculinity through exercise.[5]

Renaming himself Charles Atlas after spotting a poster of the Greek god Atlas holding the world, he won the "World's Most Beautiful Man" contest in 1921, and went on to win a national muscle-building contest the next two years in a row, earning him the title of "World's Most Perfectly Developed Man." At 5 feet 10 inches and 180 pounds, with a forty-seven-inch chest, his physical measurements were judged by experts to be masculine perfection. Atlas modeled for artists; parts of his body have been reproduced for more than seventy-five statues around the world. In 1927 he published his total fitness and health program and created a correspondence course that promised to help other "weaklings" transform their bodies as well. Ads were placed in boy's magazines and comic books with headlines like "Are You a Red-blooded Man?," and "Yes! I Turn Weaklings into He-Men, " suggesting that young boys could become self-dependent, powerful and attract women just like their favorite superheroes.

Social expectations of masculine performance in Italy did not conform to this body-building figure of the macho man. Public displays of homosocial physical affection among men—including greetings with hugs, kisses on the cheeks, and sometimes, even on the mouth—were common in Italy and continued in the United States. Considered entirely compatible with heterosexual masculinity in Italian and Italian American culture, such gestures further fueled suspicions of Italian Americans' manhood among American non-Italians, especially in the context of rising concerns over homosexuality in the late nineteenth and early twentieth centuries. This public behavior was often displayed during religious festivals as the men who would share the burdens of carrying statues, huge platforms and towers, would hug, kiss and cry in each other's arms at the culmination of rituals. Young boys selected to participate demonstrated their manliness by enduring Christ-like pain and suffering with other men. With roles for men and women separated, these events reveal the order of the community and serve as opportunities for gender training that often countered American expectations of manhood.

Connections to the family order remained as central to Italian American manhood as it had been to Italian manhood. Similarly, the traditional Italian gender dichotomy, by which the world outside the home was considered a manly domain, whereas the domestic front belonged to women, as in most Western societies, survived during the earliest immigration

to the cities of the United States. Because movement outside the home raised the potential danger of moving into neighborhoods controlled by other ethnic groups, Italian women were more likely to bring work into the home than to work outside the home, whereas men publicly displayed their manhood by protecting the home turf from external threats. Young Italian American men sometimes formed street gangs for this purpose. This expression of traditional Italian manhood in the American city soon attracted the attention of sociologists interested in such urban problems as juvenile delinquency, and the resulting studies reinforced stereotypical associations of Italian American men with criminality.

During and after World War II, Americanization increasingly transformed traditional Italian manhood and drew Italian American men from the margins of American life to positions of public fame and middle-class respectability. Nearly five hundred thousand Italian Americans sought to prove their masculinity, their dedication to the American way of life, and their loyalty to the United States by serving in the armed forces. Old fashioned male/female divisions of domain and labor began to break down as women started taking jobs traditionally held by men. Increasingly, public images of Italian American manhood, based on the examples of men who succeeded economically and in popular culture, became more positive: Joe DiMaggio and Frank Sinatra, for example, brought the Italian *bella figura* into a national spotlight for emulation by American men. When increasing numbers of Italian American men joined the exodus from ethnic urban neighborhoods to suburbia and work took the fathers away from the home, Italian family dynamics changed dramatically as the foundations of the old world patriarchy began to weaken.

Post–World War II developments in Italy brought out images of masculinity that countered the Fascist Maciste, through the daring and cunning actions of the Resistance fighters and through the deconstruction of the body powerful hero via the *inetto* (the inept, incompetent version of masculinity). Film scholar Jacqueline Reich sees the *inetto* of twentieth-century Italy as emerging "beneath the façade of the bella figura. The Italian male is 'good at being a man' precisely because he masks the *inetto* through the performance of hyper-masculinity: protection of honor, procreation, and sexual segregation."[6] The *inetto* surfaces in characters played by the likes of Alberto Sordi and Marcello Mastroianni—who combined with it qualities of the Latin lover.

Popular culture representations of Italian American masculinity continue to stereotype it, but they nonetheless provide useful windows on ethnicity and masculinity in contemporary American culture. Such 1970s figures as Don Vito Corleone (*The Godfather*, 1972), Rocky Balboa (*Rocky*, 1976) and Tony Manero (*Saturday Night Fever*, 1977)—all defined through physical power and aggressiveness, criminality or overt sexuality—can be seen as attempts by Hollywood filmmakers to ethnicize troublesome characteristics of traditional patriarchy under feminist attack by associating them with old world ethnic cultures.

Franco La Cecla in his study of Italian manhood, *Modi Bruschi* [Rough Manners, 2000], provides one of the most useful approaches to the study of contemporary Italian masculinities: "One becomes a man only by strenuously working to escape maternal influence. Adolescent males face an extremely difficult and painful passage. They must erase from their bodies the 'effeminate' influence of their mothers and the other women of their community, replacing them with 'rough manners.'"[7] Thus, the rough play of childhood gives way to the tough work of manhood. La Cecla, through a Freudian lens, theorizes that since the state of grace is perceived as feminine, the young man must find a way to be, in a sense, "disgraced"; this state of disgrace, according to La Cecla, must be achieved alongside of and in front of other men. In brief, masculinity is a public performance, and until a young boy displays his manhood through disgrace, he is considered to be a boy. La Cecla goes on to say that this form of masculinity manifests itself in the Macho pose; the origins of machismo can

be found in Mexican culture. Chicana scholar and writer Ana Castillo tells us, "The word macho means to be male or masculine. Machismo then is that which is related to the male or to masculinity. Machismo, as associated with Mexican culture for the social scientist, is the demonstration of physical and sexual powers and is basic to self-respect."[8]

As we know through Freudian thought, in almost all cases the rough boys must separate themselves from the world of women in order to achieve the label of man, and yet once they enter this world of men, they seldom develop skills that would move them beyond settling solely for simple survival in a material world. This limited development manifests itself in the growing distance between men and their feelings simply because sensitivity to others' needs challenges the logic that built patriarchal power in the world. To protect males from the "contamination" of feelings, society fosters the separation between what is male and what is female.

La Cecla helps us to see this need for separation when he speaks of masculinity in Sicily during his youth:

> Masculinity at that time and in that place . . . expressed itself as a strange combination of boldness and isolation. . . . One became a male "jerkily," reacting to and never escaping the physical embarrassment of adolescence. A real male is a bit awkward, rough, tough with his body. If he remains graceful—Peter Pan, who could fly—or rounded in his movements, then he would remain in sweet childhood, dream in his mother's lap. He must lose that "grace"; he must become "graceless," "disgraceful."[9]

One of the ways this state of "disgrace" can be achieved involves a man's position regarding physical and psychological violence.

Challenging Masculinity

Contemporary images of Italian American manhood have surfaced in reaction to women's, gay, and men's liberation movements which have increasingly challenged male monopolies on economic opportunity by calling on men to become more domestically engaged, urging them to become more sensitive and emotionally expressive, and by suggesting that breadwinning and heterosexuality does not define all the possibilities for male identity. Recent studies have shown that performances of Italian masculinity are changing. David Tager and Glenn E. Good of the University of Missouri—Columbia, conducted what has been called the first empirical study of Italian masculinity. Entitled "Italian and American Masculinities: A Comparison of Masculine Gender Role Norms in University Students," their findings "cast doubt on the accuracy of prevalent American stereotypes of Italian men as patriarchal, macho, violent, and domineering, the type of Mafioso image presented in *The Sopranos* and *The Godfather*," and young Italian men feel less threatened by the gay, lesbian, bisexual and transgender communities.[10]

Al Pacino and John Cazale, known for their portrayals of tough (or in Cazale's case, trying to be tough) gangster sons in *The Godfather*, reflected these changes in the roles they played in the film *Dog Day Afternoon* (1975). Pacino as Sonny Wortzik, a bisexual man and Cazale as Sal Naturile, a transgender man (see Figure 34.1) rob a bank in order to pay for Sal's transgender operation. From 1981 through 1987, Daniel J. Travanti portrayed the soft-spoken and sensitive anti-macho police lieutenant Francis (Frank) Xavier Furillo in the television series *Hill Street Blues* (Figure 27.2). These depictions challenged earlier monolithic notions of the tough Italian American male.

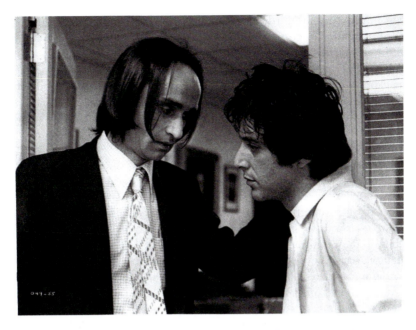

Figure 34.1 John Cazale and Al Pacino in *Dog Day Afternoon* (1975). Photo: Artists Entertainment Complex/Ronald Grant Archive/Alamy Stock Photo.

In spite of the changes in mediated Italian masculinity, many Italian American men continue to evidence traditional European patriarchy, and this is often perceived as the "natural" order of human life, something passed on from generation to generation within a society based on patriarchal power relations. The result is that young men rarely challenge this system simply because they can't see it, something brought out by Josep M. Armengol in "Gendering Men: Re-Visions of Violence as a Test of Manhood in American Literature":

> Very often, men do indeed appear to remain unaware of their gender, probably because the mechanisms that make us privileged beings tend to remain invisible to us. Nevertheless, the traditional conception of masculinity as the "invisible" norm only helps perpetuate social and gender inequalities. After all, invisibility is the very precondition for the perpetuation of male dominance, since one cannot question what remains hidden from view.[11]

When all you can see in major media are stereotypical representations of system-approved versions of masculinity, it's no wonder that young men grow up to defend and maintain the hegemonic system of power. What's needed for things to change is exposure to alternative ways of performing masculinity. In the space that remains I bring your attention to some alteratives presented in Italian American literature.

By mid-twentieth century, traditional notions of American manhood began to be challenged by the sociopolitical ramifications of feminism and gay liberation. The Italian American man evidenced a traditional communal sense of manhood derived from a European model that confronted an American individualistic model of manhood. Therefore, he made a good foil for these new ideologies. The idea of using violence to establish and maintain honor was still being clung to, even as the efficacy of patriarchy was disappearing as early

as the eighteenth century in Northern Italy, and more than a century later in Italy's South. The failure of traditional notions of Italian masculinity can be found in many novels about the Italian American experience, especially in authors such as John Fante and Mario Puzo.

Rocco Marinaccio, in his essay, "'Tea and Cookies. Diavolo!': Italian American Masculinity in John Fante's *Wait until Spring, Bandini*," has identified one of the reasons traditional Italian masculinity did not work in the United States. Svevo, the father of the novel's protagonist Arturo, is an immigrant from Abruzzo who attempts to adapt to the American ways of men and fails.

> To be an American man risks failing as an Italian man. But continued allegiance to Italian values risks a potentially more, dire fate. As the quasi-sexual imagery of the phrase implies, "making America" secures for the immigrant man fruits of conquest that testify to his masculinity. Assimilation thus becomes a test of manhood, and failure to assimilate is failure to be a man in the cultural context that seems to matter most: the dominant American one. From this cultural logic emerges what we might call an ethno-misogyny, in which aspects of a devalued Italian identity become feminized; thus Svevo, in his pursuit of assimilation, consistently repudiates Italian values as unmanly, a repudiation that involves repressing his Italian identity as a threat to his tenuous self-conceptions not simply as an American but as an American man. *Wait Until Spring, Bandini* is Fante's response to this ethno-misogyny, an impassioned defense of traditional modes of Italian masculinity devalued in American culture and a blistering condemnation of the American values adopted by the ultimately tragic Svevo.[12]

Svevo is very much like many of the male characters in Italian American literature who lack the power to succeed in America by performing Italian masculinity.

From the very opening of Mario Puzo's *The Godfather* (1969), we gain a sense of the author's concern that the ability of an Italianate sense of masculinity cannot survive transplantation to the United States. Recalling David Gilmore's three roles that have defined masculinity in many of the world's cultures—their ability to demonstrate that they can procreate, provide for and protect their families—we can see that fulfilling those responsibilities becomes a challenge to the Italian immigrant male in Puzo's novel.[13] The undertaker, Amerigo Bonasera, cannot protect his daughter, singing sensation Johnny Fontane cannot provide for his family, and Nazorine, the humble but noble baker, cannot enable his daughter to procreate with the man of her choice. These are problems that these men wouldn't face in Italy, or if so, not on their own. To solve these problems in the United States, they must go to see Don Vito Corleone, the head of the symbolic larger family. But what kind of man is Don Corleone? When his beloved godson Johhny Fontane is reduced to a whimpering fool, Don Vito violently shakes him demanding "What kind of a man are you? Is this how you turned out, a Hollywood *finocchio* who cries like a woman?" (See Color Plate 24.)

What a surprise it must be to all those who modeled their manly American literary, film and television gangsters on Don Vito Corleone to find out that his character was really based on a woman! Women have always had a hand in fashioning the male identity, but in *The Godfather*, novel and films, the great American gangster was humanized in ways never before imagined. Puzo's revealed this in the Foreword to the 1996 reprint of *The Fortunate Pilgrim* (1965):

> Whenever the Godfather opened his mouth, in my own mind I heard the voice of my mother. I heard her wisdom, her ruthlessness, and her unconquerable love

for her family and for life itself, qualities not valued in women at the time. The Don's courage and loyalty came from her; his humanity came from her. Through my characters, I heard the voices of my sisters and brothers, with their tolerance of human frailty. And so, I know now, without Lucia Santa, I could not have written *The Godfather*.[14]

Puzo does present us with quite a different male in the figure of Don Corleone. From the outset of *The Fortunate Pilgrim*, Puzo developed female masculinity through the figures of Lucia Santa and her daughter Octavia in ways that suggest that the women are enacting masculine roles quite naturally to fill voids left by the men in their lives, who ultimately present masculinities that have failed to perform. If the home is the place where the family is nourished and strengthened, traditionally through acts performed by women, then Vito Corleone represents a male version of this role, just as Lucia Santa in *The Fortunate Pilgrim* was a female version of a man's role. Yet, Puzo is too traditional, at least in his drama, to stray far from the violence-based identity of Italian American masculinity; he was trying to create a bestseller with his novel and in the United States that meant his protagonist had to be male. In this way, he follows the traditional ways of depicting men in America's mass media.

The Italian American man has usually signified nothing but trouble in American culture. From the sweaty workers on the Boston Common who frightened Henry James, to the exotic Rudolph Valentino's sensuous strides across the silver screen into the hearts of American women, from the cocky strut of dapper gangsters across television screens, to the gold-chained disco dude played by John Travolta, the Italian American man has been called upon whenever a breach of status quo civility needed to be displayed, especially through the body.

Proper social places for the Italian American male and female is the central problem of Louisa Ermelino's first novel, *Joey Dee Gets Wise* (1991). In the Prologue, a woman who lives in the Little Italy of New York City's Greenwich Village gives birth to a girl and asks that the afterbirth be taken outside. Alfonsina, the Italian born midwife, refuses to do that because she believes that the afterbirth must remain in the home, for "the woman stays in the house." The afterbirth of a male child can be taken outside because, as Alfonsina says, "No one wants a man who stays home, a *ricchione*, under his mother's skirts."[15] The word *ricchione* is an important choice here, for it is derived from the Calabrian word *arricchià*, which means to wish for the *irco* (male goat). A *ricchione* refers to a female goat in heat (the Italian suffix *-one* is often used to derive a derogatory word), and in this case refers to a man who wishes to mount another man. Thus, in the Old World ways, a mother who wanted a strong son would not want him to be associated with the place and work of women.

Joey Dee, the novel's protagonist, begins as a gangster "wannabe" and ends up defying the tradition in which he was raised. Not wanting to be a "pantspresser," like his father—a man who does the same thing over and over each day to make a living—Joey Dee drifts toward the gangster types who run his neighborhood. In the hands of Ermelino, Joey Dee transitions from gangter-in-training to new Italian American man. Joey Dee, in fact, becomes wise by learning the power of women and then using it to defy the patriarchal power forces of his neighborhood. This change is reflected as his religious allegiances shift from God the Father, to female saints like St. Lucy. In the end, he learns to feel, and ultimately must leave his neighborhood to understand those feelings.

In spite of public displays of often intense affection between men, a great deal of homophobia exists within Italian American male culture, though not always to the same extent as found in other ethnic American cultures. Homosexuality, though more accepted in the Greco-Roman-based culture of Italy than the United States, represents a threat to the family order because it does not contribute to the strengthening of the family though procreation.

Still, many Italian American homosexuals have gained acceptance from their families who become supportive of their sexuality and invite their contributions to the family.

One of the ways traditional models of masculinity are deconstructed through fiction is by exposing the prison that socially acceptable ideals of masculinity create around the very people who seem to benefit most by the power dynamics they create. Work by gay writers reveals this prison. As long as the gay community is ignored, heterosexuality and its discontents remain in the forefront of social consciousness. Much energy is expended at keeping the gay community out of public discourse and social consciousness. Pierre Bourdieu points this out when he writes:

> The particular form of symbolic domination suffered by homosexuals, who are marked by a stigma which, unlike skin color or female gender, can be concealed (or flaunted), is imposed through collective acts of categorization which set up significant negatively marked difference, and so create groups—stigmatized social categories. As in some kinds of racism, this symbolic domination takes the form of a denial of public, visible existence. Oppression in the form of "individualization" comes through a refusal of legitimate, public existence.[16]

Robert Ferro, a gay writer of Italian American descent captures this dynamic in his novel, *The Family of Max Desir* (1983). The novel focuses on the mother/son relationship as she buffers his father's fear of Max's homosexuality and reveals the father trapped by his own expectations of what a man should be.

> It had been clear to him since high school that all directions toward intimacy with men were strictly policed—all the mis- or half-understood expressions, gestures, symbols and rituals that represented sex and that, if pursued at length, might lead to it. For Max this meant the existence of a line down the middle of all his connections with men, a point beyond which it was forbidden, or at least dangerous, to go. . . . It was clear also that he had no choice in the matter other than the repression or manifestation of these desires, for they came unbidden; they could not be change or altered, only repressed or disguised.[17]

Although Max's father comes to tolerate, if not totally accept, his son's homosexuality and his relationship to his male lover within the confines of the family, he fears how this will be perceived by his male friends and business associates. This is revealed when a tapestry of the family tree that includes Max and Nick hangs on a ground-floor wall of the family's home. The father moves it upstairs before he entertains other men from the community; when Max confronts his father, he justifies his action by saying: "Whoever heard of two men being on a family tree together?"[18] This act causes an estrangement between father and son that is resolved only after the mother's death and after the father has served a stint as a Catholic monk. So the man who believes in and performs traditional and socially acceptable models of masculinity is trapped by the narrow confines of such definitions of manhood. And nowhere is this trap more obvious than in Rachel Guido deVries novel *Tender Warriors* (1986).

The focus of the novel is the father's mistreatment of his son because he doesn't conform to the old man's sense of masculinity: "The old man never liked Sonny, just because he hadn't been able to be just like him. As though that were something to wish on anybody. All that macho Italian stuff and Sonny just too sweet for it."[19] His sister Rose, who has left the home, wishes "she had it in her to save him from what she knew was inevitable, because even then the old man was ridiculing Sonny for being skinny or afraid of things, calling him a sissy

and a crybaby when all Sonny was, was soft on the inside and filled with a lot of love that wouldn't come out right except with Momma."[20] DeVries recognizes the damage that men who can only see traditional macho as the model for manhood can do to young boys as they grow into their own.

With Sonny, though, Dominic's rage took on a different more insidious form: one of ridicule and the art of humiliation, of emasculation in its purest, most vicious manner, as only male can do to male. Rose had thought about this often, the small and more deep ways her father had tormented Sonny—laughing at his sensitivity; calling him a sissy or a girl; trying, forever trying, to impose on his son that limited social imperative of prescribed maleness. Rose remembered her father's stories about growing up Italian during the Depression and thought she could in some way understand Dominic's need to be so rigid in his definitions. She also thought the time had come for her father to at least begin to evaluate those definitions.[21]

In response to his father's endless ridicule, Sonny begins to gain weight, and finds that his father doesn't let up the psychological torment. What deVries captures here, better than most writers, is the insanity created by narrow notions of Italian American masculinity. The reader sees the father as the one who needs help. Later on we learn that Sonny suffers from an illness created by a condition that had gone undiagnosed and untreated until his early adulthood. By then, his mother is dead, and his only way of coping is to leave his father's home. When he does, and he stays on his medication, Sonny can survive, but when he goes off his medications, he loses touch with reality. That's when he begins to search for his dead mother, and in the process, devolves through violence into the type of man his father once wished he was; the trouble is, Sonny's violence threatens the very lives of the old man, as well as his sisters. Through this alternative image of masculinity, deVries brings us closer to seeing the danger that monolithic notions of manhood have on individuals and their family.

Whereas Puzo may have modeled Don Corleone on his mother, Annie Lanzillotto presents a real case of what happens when a woman performs aspects of masculinity. Judith Halberstam's work on female masculinity prepares us to read the power play involved when this happens.

> I have no doubt that heterosexual female masculinity menaces gender conformity in its own way, but all too often it represents an acceptable degree of female masculinity as compared to the excessive masculinity of the dyke. It is important when thinking about gender variations such as male femininity and female masculinity not simply to create another binary in which masculinity is not simply the opposite of female femininity, nor is it a female version of male masculinity . . . very often the unholy union of femaleness and masculinity can produce wildly unpredictable results.[22]

In her memoir *L is for Lion* (2013), Lanzillotto (see her photo in the next chapter: Figure 35.1) creates just such a male identity by sporting a mustache made for her by a gay hairstylist from New York that she wears during her trip to Cairo, Egypt. Through it she enacts a female masculinity that fools many—but not all—of those she encounters. In her description of the experience she identifies and criticizes traditional Italian American performances of masculinity.

> I felt like he just saved my life. Without knowing it, he gave me freedom. I walked out onto Atwells Avenue. Now I could be an asshole Italian American man just like the rest of them. Even the giant iron pine cone hanging under the arch over the

avenue looked smaller to me now. The moustache felt about as comfortable as a bra, it had the same gender-signifying tug. But I was pleased. I had to try it out. I crossed the street, got into my car, and drove slowly. At the red light, I stared at a man in the car next to me. He looked away. Is that all men had to do? Just stare you down? This was powerful. I looked in the rearview mirror. Even in the rearview mirror I could exude the power to the driver behind me. The moustache looked like I was born with it. It was me.[23]

When she arrives in Cairo, she experiences a few days as a woman and finds that she is constantly harassed by men who stalk her and expose themselves. After she dons the moustache and male garb, she passes rather successfully as a man in the Arab country while walking down the street with her friends, so much so, in fact that she has to remove her disguise when the local police do an about-turn to investigate why a "native" man is walking down the street with nonnative women. Through this and other examples of female masculinity enacted by Lanzillotto, we see macho posturing as performance, something that helps us ask the right questions that will help us reframe what we see as Italian American male.

Conclusion: Recreating Italian American Masculinity

> To change men's lives [one needs] more than recognition of the limitations and negative effects of our present ideals of manhood. There also must be a recognition and reinforcement of positive alternatives to traditional masculine ideals and behaviors.
> —Josep M. Armengol[24]

We need to understand that variations of performing masculinity have always existed, as R. W. Connell tells us:

> The history of masculinity . . . is not linear. There is no master line of development to which all else is subordinate, no simple shift from "traditional" to "modern." Rather we see, in the world created by European empires, complex structures of gender relations in which dominant, subordinated and maginalized masculinities are in constant interaction, changing the conditions for each others' existence and transforming themselves as they do.[25]

To map out new ways of thinking about Italian American masculinity we need to know history, as Rudolfo Anaya suggests, in order to move beyond it: "The essence of maleness doesn't have to die, it merely has to be understood and created anew. To recreate is evolution's role. We can take an active role in it, but to do so we have to know the history of false behavioral conditioning."[26] We can see this "false behavioral conditioning" by looking at the way the Italian American male has functioned in American storytelling.

For many years the macho had been the predominant way Italian American masculinity has been portrayed in literature and film. However, over time, many male writers have been involved in redefining Italian American masculinity, but their work has remained in the shadows. What interests me, and for the purposes of my argument here, is what it is Italian American artists are saying, and how they are redesigning notions of Italian American masculinity. There are many doing the brave work of dismantling the armor of macho with a sensitivity that enables them to connect to what they feel and to express those feelings.

Notions of masculinity may be changing ever so slowly in the real world, but in the world of fiction, they've been shifting away from the old fashioned notion of the dominance of heterosexuality as the major way of determining U.S. manhood. Early Italian American writers knew the power of the mother and novelists like Puzo celebrated it before they felt the pressure to perform a version of masculinity that was more expected and accepted in the United States. The masculinities of the gangster have long overshadowed the works of Italian American writers that present different views of Italian American masculinity. Greater exposure to public versions of masculinity that include the importance of intellectual development and sensitive expression of thoughts will go a long way in enlarging the scope of possible masculinities presented as models for young boys.

In the works I have just presented the protagonists come to such a development through a serious consideration of what has traditionally been called feminine. The way to new performances of masculinity begins with a better sense of the impact a mother has had on the development of a young man. As the connection between young men and their mothers is brought out in the creative works of men and women, I believe the notion of what it means to be a man, in Italian American, or any other ethnic American culture, will change from the violent type of the traditional male into a more mature figure of masculinity.

Further Reading

Bellassai, Sandro. *La mascolinità contemporanea*. Rome: Carocci, 2004.

Gardaphé, Fred. *From Wiseguys to Wise Men: Maculinities and the Italian American Gangster*. New York: Routledge, 2006.

Reich, Jacqueline. *The Maciste Films of Italian Silent Cinema*. Bloomington: Indiana University Press, 2015.

Notes

1 Josep M. Armengol, "Gendering Men: Re-Visions of Violence as a Test of Manhood in American Literature," *Atlantis*, 29.2 (December 2007), 75–92 (76).

2 Richard Gambino, "Gender Relations Among Italian Americans," *Italian Americana*, 16.2 (Summer 1998), 196–207 (197).

3 See Henry James, *The American Scene* (New York: Harper and Brothers, 1907), 223.

4 Elena dell'Agnese, "'Tu vuo' fa l'Americano': la costruzione della mascolinità nella geopolitica popolare italiana," in *Mascolinità all'italiana. Costruzioni, narrazioni, mutamenti*, ed. Elena dell'Agnese and Elisabetta Ruspini (Turin: UTET, 2007), 3–34 (12–13); Pierre Sorlin, *Italian National Cinema 1896–1996* (New York: Routledge, 1996).

5 Dominique Padurano, "Charles Atlas and American Masculinity, 1910–1940," in *Making Italian America: Consumer Culture and the Production of Ethnic Identities*, ed. Simone Cinotto (New York: Fordham University Press, 2014), 100–116.

6 Jacqueline Reich, *Beyond the Latin Lover: Marcello Mastroianni, Masculinity and Italian Cinema* (Bloomington: Indiana University Press, 2004), 9–10.

7 Franco La Cecla, *Modi bruschi: antropologia del maschio* (Milan: Bruno Mondadori, 2000), 39.

8 Ana Castillo, *Massacre of the Dreamers* (New York: Penguin, 1995), 66.

9 La Cecla, *Modi bruschi*, 41.

10 David Tager and Glenn E. Good, "Italian and American Masculinities: A Comparison of Masculine Gender Role Norms," *Psychology of Men and Masculinity*, 6.4 (2005), 264–274 (270).

11 "Gendering Men," 2. Armengol draws from two sources in this quote: Anthony Easthope, *What a Man's Gotta Do: The Masculine Myth in Popular Culture* (Boston: Unwin Hyman, 1986); and Sally Robinson, *Marked Men: White Masculinity in Crisis* (New York: Columbia University Press, 2000).

12 Rocco Marinaccio, "'Tea and Cookies. Diavolo!': Italian American Masculinity in John Fante's "*Wait Until Spring, Bandini*," *MELUS*, 34.3, *Racial Desire(s)* (Fall 2009), 43–69.

13 David Gilmore, *Manhood in the Making: Cultural Concepts of Masculinity* (New Haven: Yale University Press, 1990), 48.

14 Mario Puzo, "Preface," in *The Fortunate Pilgrim* [1965] (New York: Random House, 1997), xii.

15 Louisa Ermelino, *Joey Dee Gets Wise* (New York: Kensington Publishing, 1991), 1.

16 Pierre Bourdieu, *Masculine Domination* (Stanford: Stanford University Press, 1998), 118–119.

17 Robert Ferro, *The Family of Max Desir* (New York: Plume, 1983), 53.

18 Ibid., 119.

19 Rachel Guido deVries, *Tender Warriors* (Ithaca: Firebrand Books, 1986), 19.

20 Ibid., 49.

21 Ibid., 100–101.

22 Judith Halberstam, *Female Masculinity* (Durham: Duke University Press, 1998), 28–29.

23 Annie Rachel Lanzillotto, *L Is for Lion: An Italian Bronx Butch Memoir* (Albany: SUNY Press, 2013), 194–195.

24 Armengol, "Gendering Men," 79–80.

25 R.W. Connell, "The History of Masculinity," in *The Masculinity Reader*, ed. Rachel Adams and David Savran (Malden: Blackwell Publishing, 2002), 245–261 (254).

26 Rudolfo Anaya, "'I'm the King':The Macho Image," in *Muy Macho: Latino Men Confront Their Manhood*, ed. Ray Gonzalez (New York: Anchor/Doubleday, 1996), 57–74 (73).

35

FUORI PER SEMPRE

Gay and Lesbian Italian Americans Come Out

George de Stefano

> We now have to reconceptualize identity as a process of identification . . . It is something that happens over time, that is never absolutely stable, that is subject to the play of history and the play of difference.
>
> —Stuart Hall[1]

Who, or more precisely, what, is an Italian American? What attributes constitute this identity, and who determines what they are? Until fairly recently, one construction of Italian American identity enjoyed near-absolute hegemony: Roman Catholic, politically conservative, and indisputably heterosexual. This construction has been articulated and reinforced through culture, religion and politics, and those who do not conform to its dictates have been deemed not only inauthentic but also subversive, traitors to their ethnic culture and its traditions. A contributor to a 1999 book about the religious and civic lives of Italian Americans gave as unequivocal a statement of this exclusionary mentality as one could ask for. In his essay, he referred to lesbianism as "man-hating" and deplored secularism, leftist politics, feminism and gay liberation as examples of a "radical multiculturalism" that was entirely alien to Italian America.[2]

Italian Americans who are not heterosexual or who do not conform to prevailing conceptions of proper gender behavior have felt the pain of intolerance and stigma from their co-ethnics—from the everyday slights and insults to rejection by family and friends to communal exclusion. It is not farfetched to claim that most gay, lesbian and gender nonconforming Italian Americans have experienced some form of disapproval, even condemnation, from their families, peers and communities. Consider the following examples, which come from my own experience.

- In 2007, at a conference of the American Italian Historical Association (AIHA),[3] I presented a paper that examined the treatment of homosexuality in the HBO series, *The Sopranos*, focusing on the character of Vito Spatafore, a closeted mobster whose hidden sexuality becomes common knowledge among his Mafia associates and his family.[4] In my paper, I argued that the reactions to Vito's sexuality—shock, disgust and loathing— were typical, if extreme, expressions of attitudes common to many Italian Americans, not only mobsters. I subsequently learned that my paper upset a number of conference attendees; they took offense that I would even broach such a topic. Some went so far as to approach one of the conference chairs, a distinguished academic and author, to demand "something be done" about me.
- In 1999, the journal *Voices in Italian Americana* (VIA) published an essay of mine that recounted a trip to Sicily I took with my partner. In the essay, I discussed gay life on

the island, with a description—candid, but by no means pornographic—of gay Sicilians cruising and having sex at a beach near Palermo. Although the journal's editors received letters praising the essay, and the editors for having published it, other readers decided to register their disapproval in a manner intended to punish the publication: They cancelled their subscriptions.

- A gay and lesbian contingent participated in one of the marches held in Bensonhurst, Brooklyn in 1989 to protest the murder of a young black man, Yusuf Hawkins, in that predominantly Italian American neighborhood. Pugnacious neighborhood residents subjected them to a barrage of homophobic abuse that rivaled in ferocity the racism directed at the African American marchers. (See Photo Essay no. 10). When the aggrieved young men observing the march weren't screaming crude sexual taunts, they chanted, "No homos in Bensonhurst!" That would seem to mean, "Homos get out of Bensonhurst." However, the chant also suggests that there are no—or should not be any—"homos" in Bensonhurst. That, of course, flouts reality—in researching a magazine article about the Hawkins murder and the march, I interviewed several gay men and lesbians from Bensonhurst.[5] One of my informants, "Jim," told me, "There's lots of gay people in this neighborhood. But everybody's scared and covering up." When this man—tall, handsome, his gender presentation entirely in conformity with the masculine image prized in his community—came out to his parents, his father told him, "You got five minutes to pack your stuff and get out of here."

I was fortunate not to have experienced the rejection that "Jim," and countless other Italian American gay sons and lesbian daughters have suffered. (The literature that they have produced is replete with such narratives.) But I didn't disclose my sexuality to my family until I was nearly 30 years old and living in another city, with my partner. As an adolescent in the sixties, I knew quite well how American society—and my ethnic community—regarded my sexuality: as sin, disease and crime. There were no "positive images" of homosexuality in the media or in popular culture, no gay role models to admire and emulate. Homosexuals were, in the words of my parents and every adult in my world, "fruits," "fags" and "finooks."

Yet the history of homosexuality among Italian immigrants and Italian Americans is more complex than one might think, at least in terms of males. If a family-centric conception of the proper expression of sexuality, rooted in Roman Catholicism, has been dominant among Italians and Italian Americans, actual sexual behavior has not always conformed to normative expectations. Historian George Chauncey, in his groundbreaking 1994 book, *Gay New York: Gender, Urban Culture, and the Making of the Gay Male World, 1890–1940*, unearthed a thriving homosexual subculture among Italian immigrants in New York City. "Fairies," the prevailing designation for homosexuals whose effeminacy was a public declaration of their orientation, constituted a colorful thread in the social fabric of immigrant communities. Chauncey notes that Italian sections of Manhattan's Lower East Side had numerous saloons where fairies congregated. They tended to seek sex partners not among their own ranks but among masculine same-sexers and heterosexual men. Straight Italian men, Chauncey found, interacted with "fairies" more readily than did Jewish immigrants, and were more likely to respond to their sexual advances. A 1921 study of men arrested for homosexual behavior noted that "the Italians lead" in the number of arrests; "at a time when the numbers of Italians and Jews in New York were roughly equal, almost twice as many Italians were arrested on homosexual charges. More significant is that turn-of-the-century investigators found a more institutionalized fairy subculture in Italian neighborhoods than in Jewish ones."[6]

Chauncey cites several factors to account for the willingness of Italian men to engage in homosexual relations. The Catholic Church was so intent on condemning sexual "sin"

between men and women that "it may implicitly have made sexual contact between men seem relatively harmless."[7] He also notes that whereas Jews left their villages for good with their family members, most Italian immigrants were single men or married men unaccompanied by their families. Italian men in large numbers participated in "bachelor subcultures," i.e., "distinct but overlapping social spheres centered in the poolrooms and saloons where many workingmen spent their time, in the cellar clubrooms and streets where gangs of boys and young men were a ubiquitous presence, and in the lodging houses that crowded the Bowery and the waterfront."[8] Chauncey suggests that sexual behavior patterns among immigrants in New York may have originated in southern Italy: "By the late nineteenth century, southern Italian men had a reputation in northern Italy and in the northern European gay world for their supposed willingness to engage in homosexual relations."[9]

The Australian historian Robert Aldrich has offered similar observations about southern Italian male sexuality.[10] For an extraordinarily long period, from the 1750s to the 1950s, homosexual writers and artists from Northern Europe (and to a lesser degree, North America) were drawn to southern Italy by what they perceived to be its more open and hedonistic sexual culture—what Aldrich calls "the myth of a homoerotic Mediterranean." The German baron Wilhelm von Gloeden, one of the best known of these figures, lived and worked in Taormina for four decades, where he took hundreds of photographs of nude Sicilian youths and men. (He tended to shoot his models, sons of fishermen and peasants, in kitschy tableaux meant to evoke Greek and Roman antiquity as well as North Africa.) Visitors to Gloeden's home "counted among Europe's most notorious homosexuals, including Oscar Wilde."[11] The baron's closest friend, a local man named Pancrazio Bucini, "organized late-night sexual escapades with local youths" for Gloeden and his friends.[12] Gloeden practiced what one might call a "classical" Mediterranean model of homosexuality, in which older men mentor and provide economic support to younger, often predominantly heterosexual males. The baron trained his favored lovers, including Bucini, in photography, and even set up some of them in their own businesses. Today one can purchase Gloeden's photographs, as postcards and in expensive coffee table books, in shops all over Sicily.

Southern Italian culture could accommodate (to some extent) not only homosexual desire and activity but also exceptions to traditional gender roles and behavior. In Naples, the *femminiello* was a recognized, accepted and sometimes valorized figure in working-class neighborhoods. *Femminielli* were effeminate homosexuals who cross-dressed or wore articles of female clothing; some were prostitutes. They have a lengthy history—Giovan Battista Della Porta wrote about them in 1586[13]—and they figure prominently in Campanian folklore, mainly for their participation in religious celebrations like the *Candelora* at the Montevergine shrine and the *tammurriata* during the Madonna dell'Arco *festa*.

Same-sex behavior among women prior to the mass migrations from southern Italy is much harder to document, given that women mainly were relegated to the domestic sphere and had less public presence than did men. (Even Italian law ignored them, to concentrate on male homosexuality.) The scant literature comprises accounts of "lesbian" nuns during the Renaissance; foreign women who visited or took up residence in Italy; or famous Italians like the actor Eleanora Duse, who had numerous female lovers. Lesbians didn't escape the attention of the positivist social scientist Cesare Lombroso, who classified them as a criminal "type" along with prostitutes. The feminist historian Nerina Milletti, however, has written about women who seem like lesbian analogs to Naples' *femminielli*: the *sbraie*, masculine-appearing women living in isolated, mountainous areas of Calabria who eschewed men and engaged in same-sex relations.[14]

If male southern Italian immigrants brought a sexual culture that was less restrictive than that of Protestant Northern Europe and more tolerant of relations between men[15] to America,

it became difficult to sustain. The conditions that fostered same-sex relations between immigrants and "fairies"—particularly the greater gender segregation in Italian enclaves than among Jews, and a flourishing "bachelor subculture" of unattached Italian men—waned as immigrants and their descendants assimilated to American life. Chauncey tellingly observes, "The prewar sexual regime would have made it easier for men to engage in casual homosexual behavior in the 1930s than in the 1980s, when such behavior would ineluctably mark them as homosexual."[16] In the late nineteenth century, German social reformer Karl Maria Kertbeny coined the term "homosexual," an historic shift from a mainly behavioral concept of same-sex relations, as a matter of acts ("sodomy"), to one in which sexual behavior was a marker of identity.[17] Medical, psychological, religious, and legal discourses employed the term as part of a larger project of classification and social control. However, being classified as "homosexual" actually helped those so classified to develop a sense of themselves as a social minority, even a community—a prerequisite for political action.[18] Homosexual emancipation efforts emerged in the late nineteenth century, mainly in European and North American cities, and continued through the early decades of the twentieth century, often meeting with governmental repression, whether in Nazi Germany or in McCarthy-era America.

In the late 1960s, a time of intense cultural and political ferment, a sea change occurred in homosexuals' sense of themselves. With the 1969 "Stonewall Rebellion" in New York City (and similar, albeit more low-key protests in other cities, such as Los Angeles and San Francisco), a "new homosexual" emerged, one who refused to stay in the closet for self-protection. Men and women rejected the clinical-sounding term "homosexual" and instead defined themselves as "gay" or "lesbian," and they organized their social, cultural, and political lives around these identities. To put it somewhat simplistically, whereas homosexuality had been seen as something one did, after Stonewall it became who one was.[19] By rejecting the distinction between acts and identity (which could lead to ahistorical claims that figures from the past were "gay" if they had engaged in same-sex relations), gay liberation undermined the old sexual regime in which nonhomosexuals could engage in sexual relations with homosexuals while retaining their heterosexual status. A sexual binary took hold; if you engaged in fellatio or anal intercourse with another man, you were gay, regardless of whether you were the "active" or the "passive" partner.

Gay and lesbian liberation did not entirely displace older, non-"identitarian" social constructions of homosexuality; men and women still engaged in same-sex relations without defining themselves as a particular type of person. And given that homosexuality remained stigmatized, condemned by church, state and custom, embracing a public gay or lesbian identity carried significant risks. If there had existed some tolerance for the discreet neighborhood "queer" or the two cohabiting "old maids," the emergence of what historian John D'Emilio has called "sexual communities"[20] of gay males and lesbians was a change too far. A backlash against gay and lesbian assertion materialized, and continues to this day. And particularly in communities where religiosity and conservative sexual morality prevail, the prospect of a son or daughter becoming this type of person—someone who lives publicly what should be private and hidden—remains frightening, and unacceptable: "No homos in Bensonhurst."

The gay or lesbian experience in America is, of course, far from unitary; it is conditioned by such social categories as class, race and ethnicity, gender and religion. In the decades after Stonewall, gays and lesbians increasingly began to examine, discuss and theorize their multiple identities, and particularly how sexuality was articulated to other categories. These efforts combined what historian Henry Steele Commager called "the search for a usable past"[21] with postmodern inquiry into the nature of identity. It was, and continues to be, a project to "reconceptualize identity as a process of identification," as cultural theorist Stuart

Hall put it.[22] Gays and lesbians sought to draw upon those aspects of their ethnic, racial or religious heritages that remained meaningful to them while discarding those they found archaic and oppressive. Writing and the arts became key vehicles for exploring the intersections of race, ethnicity, religion and sexuality. Latina/o, African American, Jewish and Asian American gays and lesbians produced anthologies, novels, poetry, critical essays, plays and documentary films.[23]

Italian American gays and lesbians also have sought to develop an identity that reconciles inherited cultural traditions with newer concepts of sexual identity, politics and community. They "emerged out of the shadows of nonexistence" and "began an interior journey to interrogate the meaning of their joint identities, a journey that eventually expressed itself through a growing body of literature."[24] That literature often centers on the relationship between the gay son or lesbian daughter and the Italian American family. "Homosexuality has traditionally been perceived in literature and culture as incompatible with family life," but Italian American gay writers "have used this incompatibility continuously in their writings and along with the coming out novel, sexual exploration and celebration and testimonial literature emerging from the AIDS crisis, the family remains a principal theme."[25]

Italian American gay and lesbian writers have produced anthologies comprising various genres: memoir, essays, fiction and poetry. The first was *Fuori: Essays by Italian/American Lesbians and Gays*.[26] Mary Jo Bona, in her introduction, observed that for the contributors, "coming out as gay or lesbian is a process of discovery and recovery, not only of their sexual selves, but of their relationship to more than one family: to the Italian/American family reconstituted; and to a community of gays and lesbians, to which there are varying degrees of loyalty and connection."[27] She further noted that because Italian American gays/lesbians have the double burden of "coming from a patriarchal familial structure and living in a homophobic society," they also "recognize that their revelation may not only hurt themselves, but may also injure family members." In his essay, "Memoirs of a South Philly Sissy," Tommi Avicolli Mecca recounted how his coming out caused an irreparable breach between him and his father. His mother, though "torn between her love for me and her loyalty to Poppa," managed to keep "the lines of communication open with her son without alienating her husband."[28] Avicolli Mecca acknowledges he could have behaved differently, in a manner that would have been less disruptive to his family and ethnic community:

> I could have been one of those nice, conservative Italiano homosexuals who never flaunt their sexuality, who remain the family's "nasty little secret," those "nice boys" who never marry and spend hours at family gatherings sitting in the kitchen among the women. I could have settled for a quiet life with a "roommate" in an apartment in South Philly—near my parents' house, of course. Eventually my father might have grown to accept the situation, as other Italian parents have. But that wasn't me. Whatever I did, I did passionately.[29]

As his essay makes evident, however, it wasn't only passion that inspired his very public coming out (Avicolli Mecca became a prominent gay activist and performance artist in Philadelphia) or his flamboyant style of dress and gender presentation (as a young man exploring his sexual identity, he experimented with drag). Just as critical were his need for personal authenticity and his rebellion against the oppressive sexual and gender imperatives of both a "patriarchal familial structure" and a "homophobic society."

Several years later, Avicolli Mecca, along with another contributor to *Fuori*, poet and essayist Giovanna Capone, and Denise Nico Leto, a poet, edited the anthology, *Hey Paesan! Writing by Lesbians and Gay Men of Italian Descent*. The book, comprising poetry, essays, and

short stories, was published in 1999 and was a finalist for the 2000 Lambda Literary Awards. Avicolli Mecca, Capone, and Leto intended the book to continue *Fuori*'s discourse on ethnic identity and gay and lesbian experience. The editors sought contributors from across the United States and found a small press to publish the book.[30] In their introduction, they further developed the themes of alienation from family and Roman Catholicism, as well as what they regarded as a distorted conception of Italian (and specifically, southern Italian and Sicilian) history and culture prevalent in both mainstream American society and in the lesbian and gay community. Most of the contributors to *Hey Paesan!* wrote of being the descendants of poor immigrants from the Mezzogiorno, and how they felt aggrieved, misunderstood and stereotyped—by mainstream American society, by their Italian American families and by other gays and lesbians. "We can't always talk about being a lesbian with our families and we can't always talk about being Italian with other lesbians," wrote Denise Nico Leto.[31] Some writers deplored the fact that lesbian and gay political activists tended to view them as privileged white people, regardless of the ethnic bias and economic struggle their immigrant families experienced in America. As Linda Catalano observed, "My family's struggles were too old, and my own too diluted by class and light skin privilege (signs of definite assimilation) to align me with members of current disenfranchised groups. However, neither did I feel that being classed as Anglo was authentic for me."[32]

A number of themes recur throughout *Hey Paesan!*: family, of course, with intolerant and rejecting parents, and grandmothers who more often are accepting and supportive. The contributors confront the baleful influence of the Catholic Church, the cultural losses associated with assimilation, and WASP lovers who are appalled by the "noise" of Italian American family life. The writing collected in *Hey, Paesan!* attests not only to individual and collective selfdiscovery; the authors also seek to reimagine what it means to be Italian American—an identity too often conceived as a fixed destination reached via the narrowest of paths. They refuse to be defined by the stereotypes and prejudices of their ethnic community and they want their work to be appreciated in its proper context—what Catalano termed "a lesbian and gay *italianità*."[33]

The third anthology published to date is *Our Naked Lives: Essays from Gay Italian American Men* (2013).[34] As the title indicates, the collection is narrower in scope than its two predecessors. Edited by Michael Carosone and Joseph Lo Giudice, *Our Naked Lives* comprises fourteen essays by gay men of full and partial Italian ancestry. The gay journalist Michelangelo Signorile—famous for having invented the term and practice of "outing"[35]—applauded the book for having brought forth "the stories of so many of us who've often felt left out in gay culture as well as in Italian-American culture."[36] Many contributors wrote of the difficulties they experienced in reconciling their sexuality and their ethnicity, in varying tonal registers—sorrowful, angry and accusatory, reflective and humorous.[37]

One of the contributors to *Our Naked Lives* is among America's leading historians of homosexuality, John D'Emilio. His books are landmark works of original research and penetrating analysis. But, as he recounts in his contribution to *Our Naked Lives*, this eminent gay intellectual was, as a young man, terrified of coming out to his Sicilian American family. As an undergraduate at Columbia University, he embraced the gay liberation imperative to come out of the closet—he made no effort to conceal his relationship with his then-boyfriend and he cofounded the Gay Academic Union at Columbia. "Even with all this," D'Emilio acknowledges, "coming out to my Italian Catholic parents was beyond imagining."[38]

When he informed his parents that the topic of his dissertation was to be gay liberation, he found himself unable to explain why he had chosen it. His father provided the perfect opening for his son's disclosure by asking how he would find a sampling of "those people" to interview. But the budding gay historian became tongue-tied. "I couldn't face their reaction;

I couldn't face the fight that I knew we'd have. I wasn't up for the fury that I felt sure my announcement would spark in each one of us."[39] To D'Emilio's surprise, his mother eventually raised the issue, directly and without equivocation: "John, your father and I have been talking. There's something we have to ask you, and I want you to tell me the truth. Are you a gay person?" He replied, "Yes, Mom, I am."[40] But this was not the breakthrough, and resolution, D'Emilio had hoped for. After his affirmative response to her question, his mother dropped the subject and resumed preparing dinner. *A tavola*, his father asked the same question. When D'Emilio again answered affirmatively, his father reacted with far less equanimity than had his mother: "The color drained from his face and he started jerking his head rapidly from side to side. 'No, no, no,' he repeated. 'That can't be true. It can't be. You can't be gay.'"[41] But with time, and continued engagement—D'Emilio neither rejected, nor was rejected by, his parents—he realized that he was "winning them over." "Dinner by dinner, I could see their resistance wearing down." He began to consider his relationship with his parents "a gay liberation success." But he realized just how successful only when they informed him that they intended to tell other relatives: "We just have to let everyone else know."[42] After they broke the news to D'Emilio's paternal relatives in Bensonhurst, they informed their son, with considerable amusement, how their kin had reacted. D'Emilio's father had opened the conversation by remarking, "There's something we have to tell you about Johnny." A high-decibel Sicilian chorus of woe broke out among the assembled aunts, who assumed their nephew had been in a terrible accident, was addicted to drugs or had cancer. D'Emilio's parents interrupted the "screaming" and "shouting" to say, "no, no, everything's fine, there's nothing wrong . . . he's just gay." D'Emilio happily concludes his essay, "Could I have asked for a better outcome?"

The three anthologies discussed here hardly represent the entirety of Italian American gay and lesbian literary production. Novelists, poets, playwrights and essayists have created a corpus that expands and enriches not only LGBT (lesbian, gay, bisexual and transgender) writing but also Italian American and American literature. One of the most prominent was the novelist Robert Ferro, a founding member of the Violet Quill, an informal circle of New Yorkers; other members included the novelists Andrew Holleran, Felice Picano and Edmund White—who were important figures in the creation of post-Stonewall gay literature. Ferro's *The Family of Max Desir* (1983) and *Second Son* (1988) portrayed relationships between Italian American gay men and their families. In both books, the gay protagonists travel to Italy to connect with their ethnic heritage. They are not alienated from their families, but instead are deeply enmeshed with them, full participants in family life. Which is not to say that there are no conflicts. The women and children accept the gay sons and their lovers; fathers and brothers are more likely to reject them, sometimes with shocking cruelty. Both books are death-haunted; in *The Family of Max Desir*, the mother's illness and death from cancer, powerfully rendered by Ferro, tears apart the fabric of family life. Mainstream critics praised *The Family of Max Desir*—the *Los Angeles Times* called it "a stunningly beautiful book"—and some compared it favorably to James Agee's classic, *A Death in the Family*. In *Second Son*, both lovers are afflicted with AIDS. Ferro's novels drew heavily from his own life. His difficult relationship with his father inspired the conflicts between the gay son and his rejecting father in *The Family of Max Desir*. Like the central couple in *Second Son*, Ferro and his partner, writer Michael Grumley, both suffered from AIDS; Grumley died from the disease in 1988; Ferro survived him by only three months.

A number of other Italian American gay writers made their mark during the decades following Stonewall. Felice Picano, a poet, novelist, short-story writer and essayist, is, like Ferro and Edmund White, a key figure in American gay literature. Picano founded Sea-Horse Press and co-founded Gay Presses of New York, imprints that published many major

post-Stonewall works.[43] He has contributed to both *Hey Paesan!* and *Our Naked Lives*, but as the title of his essay in the latter collection—"Growing Up *Un*-Italian American"—suggests, he has had a fraught relationship with his ethnicity. The son of an immigrant father, Picano speaks Italian and he has lived in Italy; he even acknowledges having "been the victim of anti-Italian prejudice." He nonetheless insists, "For an Italian American, I am about as *Un*-Italian American as you can get!"[44] He explains that he has never been involved with any Italian American literary, cultural, or community organizations, rejects Catholicism, and feels more at home in Manhattan and Fire Island than in Rome or Brooklyn. But when it came to sex, his ethnicity has proved an asset; he used his "ethnic card . . . to get laid" because he knew that many non-Italian gay men "fantasized about having sex with a 'Bensonhurst Guido.'"[45]

Victor Bumbalo, born in Utica, New York, began his career as a theater director. Frustrated with the dearth of plays about gay experience, he began to write them, beginning in 1979 with *Niagara Falls*, a two-part dark comedy about an Italian American family, the Polettis. In the play, the family members refer to the gay son as "him," and the discomfiting issue of his homosexuality as "it." The play's central conflict revolves around whether "him" should attend the wedding of his sister, Jackie. Bumbalo's subsequent works include *Kitchen Duty* (1981), *After Eleven* (1983), and *Adam and the Experts* (1989). *Adam and the Experts* was a critical and Off Broadway box office success; the *New York Times* hailed it as "the most important play to deal with the AIDS crisis in gay society since William Hoffman's 'As Is' and Larry Kramer's 'Normal Heart.'"[46] In 1995, Bumbalo moved to Los Angeles, where he writes for network and cable television.

Philip Gambone wrote about Italian American gay men in several stories in his 1991 debut, *The Language We Use Up Here and Other Stories*.[47] In his contribution to *Fuori*, Gambone, like Felice Picano, acknowledges ambivalence about his ethnicity. Although he is "as 'pure' Italian American as you can get," with all four of his grandparents having emigrated from Naples, he does not "feel any particular affinity with Italian Americans. The people who are my true *paesani*, my true *compari* are not those with whom I share a common ethnic bloodline but those with whom I experience a consanguinity of education and interests and ways of being in the world."[48]

Two gay Italian American playwrights, Albert Innaurato and Joseph Pintauro, attained commercial and critical success with works that explored themes of separation and rejection among family members. Innaurato's 1970s plays *Gemini* and *The Transfiguration of Benno Blimpie* were major successes, with the former enjoying a four-year Broadway run and an Off-Broadway revival. *Gemini*'s Italian American family is wracked with conflicts over ethnic assimilation, upward mobility and sex, with the playwright dramatizing his themes through food metaphors. (A generation of New York theatergoers no doubt fondly remembers the television commercial for *Gemini*, which featured one of the characters remarking, "I'm not hungry—I'll just pick.") The play's central character, Francis, is a Harvard student who, although involved with a woman, fears he may be gay. His working-class father haltingly but sincerely assures Francis that he can confide in him about anything, but Francis brushes him off, and at the end of the play, returns to Harvard with his girlfriend.

The prolific and versatile Pintauro—he also is a novelist and a photographer—often dramatizes what critic Stephen Holden has called "visions of homosexual eruptions in the bosom of the family and church."[49] Pintauro, a former Roman Catholic priest, is a fearless writer, as he demonstrated with *Wild Blue*, eight one-act plays presented Off Broadway in 1987. In the most provocative of the vignettes, a young woman seduces the proprietor of a bar. After sex, she informs him that she used to be his son, pointing out the pre-surgery high school graduation photograph on the barroom wall. Pintauro's other works include *Cacciatore* (1977),

three one-act, Italian American-themed plays; *Snow Orchid* (1986), centering on a Brooklyn Italian American family buffeted by mental illness; *Men's Lives* (1992), a stage adaptation of Peter Matthiessen's 1986 book about the declining fortunes of a Long Island fishing community, and *The Raft of the Medusa* (1992), about a diverse group of New Yorkers struggling to survive with AIDS.

Born in 1930, Pintauro comes from a pre-Stonewall generation of gay men; he was nearly forty years old when the patrons of a Mafia-owned, Greenwich Village bar, the Stonewall Inn, erupted in violent fury when police raided the premises one June night in 1969. The seeds of the gay cultural revolution in New York, however, were planted a decade earlier by, among others, one of Pintauro's peers, Joe Cino. A Sicilian American from upstate New York, Cino in 1958 opened his Caffe Cino on Cornelia Street, in the midst of the Village's Italian American enclave. "The Cino," generally acknowledged as the birthplace of both Off Off Broadway and gay theater, was "perhaps the first Italian American site to be associated with gay activism."[50] From its opening until Joe Cino's suicide ten years later, the Caffe[51] presented work by gay playwrights such as Lanford Wilson, Robert Patrick, Tom Eyen, Doric Wilson, and Pintauro, as well as John Guare and Sam Shepard. Al Pacino and Bernadette Peters are just two of the now-famous actors who, early in their careers, performed at the Cino.

Although men dominated gay literature and arts in the decades after Stonewall, Italian American lesbians also produced a significant body of creative work. Rose Romano, a poet and essayist, focuses on the interplay of sexual and ethnic identity, engaging in "a complex, and, at times, highly debatable identity politics."[52] Romano takes on sexism, homophobia, and political conservatism in the Italian American community and what she sees is as condescending and discriminatory attitudes of lesbian feminists toward Italian Americans. Romano "crafted a poetic persona so idiosyncratic that she gained a reputation as the *enfant terrible* of Italian-American literature."[53]

In poems such as "There Is Nothing in This World as Wonderful as an Italian American Lesbian" and "To Show Respect" she envisions a utopian community in which ethnicity and lesbian sexuality are reconciled and celebrated. In her controversial essay, "Coming Out Olive in the Lesbian Community" (subtitled, "Big Sister Is Watching You"), Romano described herself as "olive" rather than white; she complained of having been "censored in the lesbian press and ostracized in the lesbian community" because of this self-identification.[54] Romano, in addition to her own writing, launched an imprint, malafemmena press, which published the literary journal, *la bella figura*. Her efforts "helped create a sense of a distinctive culture and tradition of Italian American women writers that would serve as models."[55]

Dodici Azpadu, a Sicilian American novelist, debuted with *Saturday Night in the Time of Life* (1983), which centers on two women, Neddie and Lindy, who are coping with Neddie's difficult mother Concetta and the damage the old woman wreaks on her family. Apzadu has written two more novels, *Goat Song* (1984) and *Living Room* (2010). Also a poet, Azpadu has published numerous chapbooks, as well as the collection, *Wearing The Phantom Out* (2013). Rachel Guido deVries's work includes four poetry collections, *How to Sing to a Dago* (1996), *Gambler's Daughter* (2001), *The Brother Inside Me* (2008) and *A Woman Unknown in Her Bones* (2014), and the novel, *Tender Warriors* (1986). She also has written a children's book, *Stati Zitta, Josie* (2014). Vittoria repetto,[56] the daughter of northern Italian immigrants, has published her work in books, journals, and chapbooks. Her 1994 chapbook, *Head for the Van Wyck*, included poems based on her experiences as a New York taxi driver. She published her first full-length poetry collection, *Not Just a Personal Ad*, in 2006. Repetto's writing has appeared in the anthologies *Hey Paesan!; Unsettling America: An Anthology of Contemporary Multicultural Poetry; The Milk of Almonds: Italian American Women Writers on Food and Culture;*

and the *Harrington Lesbian Fiction Quarterly*. Repetto, the self-described "hardest-working guinea butch dyke poet on the Lower East Side," has curated since 1999 a "poetry jam and open mike" series at the feminist bookstore Bluestockings.

Maria Fama, a Sicilian American poet who grew up in an immigrant family in Philadelphia, has published the collections *Currents* (1988), *Identification* (1991), *Italian Notebook* (1995), *Looking for Cover* (2007) and *Mystics in the Family* (2013). Robert Viscusi, the poet, author, and literary critic, called Fama's "Anthony," in which the poet riffs on the many variations of the name, "the best Italian American poem there is." Giovanna Capone, a poet, essayist and political activist, has published in many collections, including *Curaggia: Writing by Women of Italian Descent; Unsettling America: An Anthology of Contemporary Multicultural Poetry; Avanti Popolo: Italian-American Writers Sail Beyond Columbus; Fuori: Essays by Italian/American Lesbians and Gays*; and *Hey Paesan!*, which she co-edited. *In My Neighborhood* (2015) is composed of poetry, essays and memoir that explore her experiences as an Italian American, a lesbian and an activist.

Annie Rachele Lanzillotto's unique work, as well as her forthright public persona, have established the Bronx-born author, poet, and performance artist as a singular figure in both gay and lesbian and Italian American culture. Lanzillotto (Figure 35.1) offers original and challenging perspectives on gender, sexuality, and ethnicity. In the 1990s, she created a site-specific performance art project, *a 'Schapett!* at the indoor Arthur Avenue retail market, in the formerly majority-Italian Belmont neighborhood in the Bronx. Lanzillotto brought opera singers, trapeze artists, musicians, dancers and performance artists into the market and she directed scripted and improvised scenarios involving the artists with market customers and merchants.

Lanzillotto published two books in 2013, *L Is for Lion: An Italian Bronx Butch Freedom Memoir*, and the poetry collection, *Schistsong*. One could call the former a lesbian *Bildungsroman*; it is that, but much more. In vivid, poetic language, and with the narrative flair of a great storyteller, Lanzillotto recounts her extraordinary life. She relates how she impressed the stern nuns at her elementary school in the 1960s with her precocious talent for public

Figure 35.1 Annie Lanzillotto performing with her grandmother Rosa Marisco Petruzzelli in a production of *a 'Schapett!* (1996). Photo: Andrew Perret.

speaking; the breakup of her parents' marriage due to her father's abuse of her mother; her struggles with cancer, which began when she was in her first year of college; visits to her grandparents' village in Puglia; and a stay in Cairo, where she cross-dressed as a young man. *L Is for Lion* blends humor, pathos, and hard-won wisdom in an "ethnography of the self and of an era"[57] that qualifies as a classic of both Italian American and gay and lesbian literature.

Race and religion are two of the most volatile issues in the Italian American community, and for gay and lesbian Italian Americans. Filmmaker Tom De Cerchio, in his short film, *Nunzio's Second Cousin* (1994), managed, in a mere eighteen minutes, to dramatize, with candor and insight, the intersections of race, sexuality, and ethnicity in a vignette about Anthony Randazzo, a closeted Italian American police officer (played by film and TV actor Vincent D'Onofrio) whose lover is a black man. De Cerchio's film illustrates how "ethnic boundaries are also sexual boundaries—erotic intersections where people make intimate connections across ethnic, racial, or national borders."[58] The boundaries may be "surveilled and supervised, patrolled and policed, regulated and restricted"—De Cerchio's film makes clear that neither an openly gay Anthony nor his boyfriend would be welcome in Anthony's neighborhood—but they are "constantly penetrated by individuals forging sexual links with ethnic 'others.'"[59]

For gay Italian American Catholics, their Church's stance that homosexuality and Catholicism are incompatible has caused considerable anguish. In his book, *Hidden: Reflections on Gay Life, AIDS, and Spiritual Desire* (2012), Richard Giannone offered a compassionate portrait of Italian American gay men, including his partner, an ex-Catholic priest, struggling with issues of religion, ethnicity and sexuality.[60] *Saints and Sinners* (2003), a documentary by Abigail Honor, depicts the tenacious—but ultimately unsuccessful—efforts of two gay Italian American men, Vinnie and Eddie, to be wed in a Catholic ceremony.

Gay and lesbian Italian Americans have produced much more creative work, and have had greater cultural influence, than can be fully captured here. But I would be remiss not to acknowledge the following instances. Anthony J. Wilkinson's *My Big Gay Italian Wedding* (2003), a play that satirizes opposition to same-sex marriage and sends up gay and Italian American stereotypes, is a long-running Off Broadway hit that has played in other U.S. cities and abroad. Daniel Franzese, an openly gay actor born in Bensonhurst, Brooklyn, acts in films (*Mean Girls*), television (the HBO series, *Looking*), and on stage (*Jerseyshorsical: A Frickin' Musical*), and his video parodies, "Shit Italian Moms Say," with Franzese in drag as Italian Mom, have been seen by millions on YouTube. From 1991 to 1996, cartoonist Diane DiMassa, from New Haven, Connecticut, published *Hothead Paisan: Homicidal Lesbian Terrorist*, a popular underground zine that featured the eponymous character, a fiery Italian American lesbian enraged by injustice. Lea DeLaria, a Brooklyn-born standup comedian who also is a highly regarded jazz singer, has won accolades for her portrayal of a butch lesbian behind bars on the popular Netflix series *Orange Is the New Black* (2013–). Michael Musto, a Bensonhurst-born columnist and author best known for his reporting on New York night life; Frank DeCaro, a humorist; and Mo Rocca, a standup comedian and TV commentator, have created comic personas that draw on their gay and Italian American identities.

Gay and lesbian Italian Americans also have been involved with activist and electoral politics. Vito Russo (Figure 35.2), born and raised in East Harlem, was a beloved and highly influential intellectual-activist, and one of America's most prominent gay public figures. His book, *The Celluloid Closet: Homosexuality in the Movies* (1981; revised 1987) was a landmark study of Hollywood's treatment of homosexuality and gender variance. An early gay liberation advocate, Russo was a co-founder in the 1980s of two major activist organizations, the Gay and Lesbian Alliance Against Defamation (GLAAD), which protests distorted media representations; and the AIDS Coalition to Unleash Power (ACT UP), a direct action

Figure 35.2 Gay activist and author Vito Russo, *circa* 1981. Photo: Lee Snider/Photo Images.

advocacy group. Russo, who died from AIDS in 1990 at age 44, was the subject of a biography, *Celluloid Activist: The Life and Times of Vito Russo* (2011), by Michael Schiavi, and a documentary, *Vito* (2012), based on Schiavi's book and directed by Jeffrey Schwarz. Both the biography and the film convey the Russo family's love and support for their son, who had challenged them to accept him for who he was.

Virginia Apuzzo, born in 1941 in the Bronx, achieved national prominence in lesbian and gay activism and as a public official. A Roman Catholic nun for three years, she came out publicly after leaving the convent and became involved in political advocacy. Representing the National Gay Task Force, she worked to have a gay and lesbian plank included in the Democratic Party's 1976 platform. That effort failed, but four years later, the Democrats adopted such a policy position, co-written by Apuzzo. She was the executive director of the Task Force (renamed to include "Lesbian" in its name) for three years. New York Governor Mario Cuomo invited her to join his administration; she served in various capacities, including as executive director of the New York State Consumer Protection Board. In 1996, President Clinton appointed her associate Deputy Secretary of Labor. The following year she became a senior White House aide, as assistant to the President for administration and management.

Tom Ammiano, born in 1943 in New Jersey, relocated to San Francisco in the 1960s to escape the homophobia and stultifying conservatism he experienced growing up in a working class Italian American community. After several decades as an activist whose inclusive, leftwing politics helped him build a diverse constituency, Ammiano was elected as a Democrat to the California State legislature, where he served three terms. (Term limits ended his Assembly tenure in 2014.) An uncommonly successful legislator who advanced progressive and even radical political positions as an elected official, Ammiano might be regarded as "the gay Vito Marcantonio." Like the U.S. Congressman from East Harlem, Ammiano is a leftist maverick who has put dedication to principle above party loyalty, often challenging his party's leadership and the Democratic establishment.

Grassroots social and political organizing by Italian American gays and lesbians has been limited. One such effort, however, Bay Area Sicilian and Italian Lesbians (BASIL), achieved

a significant public profile. Founded in 1988, BASIL served as a social, cultural and support group for women in San Francisco and its environs, for twenty-two years. The genesis of the group was a newspaper advertisement that Rose Romano placed in a local gay newspaper calling for "Italian American lesbians to get together, eat pasta, drink wine, and connect," according to Giovanna Capone.[61] (Romano, who wanted BASIL to be a political activist group, quit shortly after its founding.) At first, it seemed that BASIL would not cohere as an organization. "Women would show up to my house and we'd have Italian dinners together, and these fantastic conversations about our grandmothers, the language we heard growing up, our families, our coming out experiences, our female partners, whether we grew up Catholic or not. Great discussions, and then the women would split," Capone recalled. The group continued to have monthly meetings and group dinners, but it also started a newsletter, recruited a native Italian-speaking woman to teach language classes, and marched as a contingent in San Francisco's Pride Parade. "At one point, we had members from seven different counties in the Bay Area, and gradually women started hanging out with each other outside of BASIL, going to Italian cultural events like opera and films," Capone said. After twenty-two years, BASIL dissolved. "We never formally ended; we just kind of tapered off," Capone says. "I think it was just that after twenty-two years, we all started getting involved in different things. The experience of BASIL really put us on the map, at least in the Bay Area. In the lesbian feminist community, people became more respectful and curious about what they might not know about us."

New York City may have been the place where the Stonewall rebellion occurred, spawning a new political consciousness. But Italian American gay and lesbian organizing never took off there, unlike the success of BASIL in the San Francisco Bay area. Several veteran activists formed Gay and Lesbian Italians (GLI) in 1985; the group lasted until 1992, followed by Lavender Paesans in 1994, which lasted about two years before dissolving. (Surprisingly, virtually no documentation exists for either group.) Members of both groups sometimes participated in the Pride Parade but the contingents always were small, with a dozen participants at most. Neither GLI nor Lavender Paesans was able to clearly define its purpose: was it to socialize? Raise consciousness and provide mutual support? Political activism? The groups were unable to retain those who showed up for meetings at Manhattan's LGBT Community Services Center, or to attract new and committed members. Unlike the Irish American gays and lesbians who rallied around their exclusion from the St. Patrick's Day Parade, New York gay Italian Americans never found a compelling reason to come together.[62]

Now, well into the twenty-first century, one might ask whether the concerns of those who are gay, lesbian, gender nonconforming and Italian American—the conflicts with family and religion, the attempts to synthesize ethnic heritage and sexual identity to arrive at an integrated identity—will continue to be salient. Most of this essay focuses on first-, second- and third-generation Italian Americans, for whom immigration, assimilation, and ethnicity have been lived experiences. Cultural imperatives regarding sexuality and family life will carry less weight, or may even become irrelevant, to future generations. Moreover, American society in general has experienced a remarkable shift regarding homosexuality. Prejudicial attitudes persist, as do significant obstacles to full legal equality. (No federal law protects gay, lesbian, bisexual and transgender Americans from employment discrimination, and twenty-nine states do not prohibit discrimination based on sexual orientation.) But, as opinion polls consistently demonstrate, the overall trend is toward acceptance. The trend holds even among Roman Catholics, particularly younger ones, who reject the Church's condemnation of homosexuality.[63] Since most Italian Americans identify as Roman Catholic, this means that they, too, have become more accepting. That is not to suggest that *la via vecchia*—the socially conservative beliefs and practices that originated in southern Italy—exerts no influence

over the lives of gay and lesbian Italian Americans. In fact, an acquaintance of mine, a son of immigrants, attests to its durability: though gay, he insists that one day he will be *sistemato*— married to a woman.

Still, it is not over-optimistic to assume that another scenario will prove more typical. The gay African American athlete Michael Sam made headlines in 2014 with his efforts to join the National Football League, but his relationship with his Italian American partner also generated extensive media coverage. When Sam learned that the St. Louis Rams had drafted him, he kissed his boyfriend while the TV cameras rolled. After he identified his "cute little Italian boy" as Vito Cammisano, a 23-year-old from Kansas City, Missouri, the media reported that Cammisano's family had been involved in organized crime. His late grandfather was a leading Kansas City mobster and his father served prison time on gambling charges.[64] The media of course couldn't resist the story: an openly gay, African American football player dating an Italian American offered a perfect trifecta of race, ethnicity, and sex, with the added allure of the Mafia mystique. But what of *la famiglia Cammisano*? If stereotypes predict behavior, then Vito's kin should have ostracized him when they learned about his sexuality and choice of partner. Instead, they seem to have accepted him and his relationship with Sam. "I was very proud of them both," Cammisano's aunt, Cathy Nigro, informed the media. "I think the whole family is."[65]

Further Reading

Bram, Christopher. *Eminent Outlaws: The Gay Writers Who Changed America*. New York: Twelve/Hatchett, 2012.

D'Emilio, John and Freedman, Estelle B. *Intimate Matters: A History of Sexuality in America*. New York: Harper and Row, 1988.

De Stefano, George. "Identity Crises: Race, Sex and Ethnicity in Italian American Cinema," in *Mediated Ethnicity: New Italian American Cinema*, edited by Giuliana Muscio, Joseph Sciorra, Giovanni Spagnoletti and Anthony J. Tamburri. New York: John D. Calandra Italian American Institute, 2010.

Giannone, Richard. *Hidden: Reflections on Gay Life, AIDS and Spiritual Desire*. New York: Fordham University Press, 2012.

Stone, Wendell C. *Caffe Cino: The Birthplace of Off-Off-Broadway*. Carbondale: Southern Illinois University Press, 2005.

Notes

1 Stuart Hall, "Ethnicity: Identity and Difference," *Radical America*, 23.4 (June 1991), 9–20 (16).

2 Joseph V. Varacalli, "A Realistic Multiculturalism," in *The Saints in the Lives of Italian-Americans*, ed. Varacalli, Donald J. D'Elia, Salvatore Primeggia and Salvatore LaGumina (Stony Brook: Forum Italicum, 1999), 231–249.

3 In 2013 the organization's name was changed to the Italian American Studies Association (IASA), www. italianamericanstudies.net

4 The paper was published, in an expanded and revised version, as "A 'Finook' in the Crew: Vito Spatafore, The Sopranos, and the Queering of the Mafia Genre," in *The Essential Sopranos Reader*, ed. David Lavery and Douglas L. Howard (Lexington: University Press of Kentucky, 2011), 114–123.

5 George de Stefano, "La Dolce Bensonhurst," *Outweek* (8 October 1989), 34–37.

6 George Chauncey, *Gay New York: Gender, Urban Culture, and the Making of the Gay Male World, 1890–1940* (New York: Basic Books, 1994), 72.

7 Ibid., 74.

8 Ibid.

9 Ibid.

10 Robert Aldrich, *The Seduction of the Mediterranean: Writing, Art and Homosexual Fantasy* (London: Routledge, 1993).

11 Ibid., 146. For a non-erotic photo by Van Gloeden, see Figure 6.1.

12 Ibid.

13 Giovan Battista Della Porta, *Della fisionomia dell'uomo* (Milan: Longanesi, 1971), 813.

14 Nerina Milletti, "Calavrisella mia, facimmu 'amuri? La storia delle lesbiche contadine italiane attraverso le tradizioni orali," *Quir: mensile fiorentino di cultura e vita lesbica e gay, e non solo. . .*, 11 (October 1994), 23–26 (26).

15 It is important not to overstate how "gay friendly," to use contemporary parlance, southern Italian society was during the decades when homosexual northern Europeans flocked to its cities and towns. A strict active/passive dichotomy often dictated the terms of sexual encounters: the southern Italian man or youth generally would engage in sex with homosexual foreigners as a "top," i.e., the one penetrating his partner, orally or anally. In Mediterranean cultures, sexual role positioning was gendered; the "passive" partner was seen as feminine whereas the "active," penetrating partner retained his masculinity and even his heterosexuality. Sexual positioning also was a marker for identity, since only the penetrated partner was deemed homosexual. In such a sexual economy, the "passive" partner risked the loss of his masculine status. Also, given the primacy of the family as a social, cultural and economic institution, even those southern Italian men who were homosexually inclined had little opportunity to develop a social identity premised on their sexuality.

16 Chauncey, *Gay New York*, 71.

17 Kertbeny also coined the term "heterosexual." See Hannah Blanke, *The Surprisingly Short History of Heterosexuality* (Boston: Beacon Press, 2012).

18 Harry Hay, a Communist who was one of the founders of the Mattachine Society in the 1950s, adapted the Marxist distinction between a class "in itself" and a class "for itself" to gay and lesbian liberation, i.e., the movement's task was to mobilize homosexuals to recognize and defend their group interests. See John D'Emilio, *Sexual Politics, Sexual Communities: The Making of a Homosexual Minority in the United States, 1940–1970* (Chicago: University of Chicago Press, 1983).

19 *Sexual Behavior in the Human Male*, the 1948 study by sexologist Alfred Kinsey and his associates, did not report that 10 percent of American men were homosexual, as is commonly believed. Kinsey and his team reported that 4 percent of the men they interviewed were exclusively homosexual. However, 37 percent of his interviewees acknowledged having engaged in at least one homosexual encounter, with a quarter of them acknowledging having had "more than incidental homosexual experience or reactions."

20 D'Emilio, *Sexual Politics, Sexual Communities*.

21 Henry Steele Commager, "The Search for a Usable Past," *American Heritage*, 16.2 (February 1965).

22 That process has led to the creation of new identity categories, such as LGBT (lesbian, gay, bisexual and transgender), "queer," "genderqueer," etc.

23 Key works include *This Bridge Called My Back: Writings by Radical Women of Color* (1981), *Nice Jewish Girls* (1982), *Twice Blessed* (1992), *Queer Jews* (2002); the novels of African Americans Larry Duplechan and E. Lynn Harris; the anthology *Brother to Brother: New Writings by Black Gay Men* (1991); Audre Lorde's *Sister Outsider: Essays and Speeches* (1984) and *Zami: A New Spelling of My Name* (1983); and *Afrekete: An Anthology of Black Lesbian Writing* (1995). Latino gay and lesbian writers include the Colombian-American novelist Jaime Manrique (*Latin Moon in Manhattan*, 1992); the Mexican-Americans Richard Rodriguez, a highly regarded if controversial essayist, and novelist Michael Nava; the lesbian feminists Cherie Moraga, a Mexican-American, and the Mexican-born Gloria E. Anzaldúa.

24 Philip Cannistraro and Gerald Meyer, "Introduction," in *The Lost World of Italian American Radicalism*, ed. Cannistraro and Meyer (Westport: Praeger Publishers, 2003), 28.

25 *The Greenwood Encyclopedia of Multiethnic American Literature: I*, ed. M. Nelson (Westport: Greenwood, 2005), 1089–1091.

26 *Fuori: Essays by Italian/American Lesbians and Gays*, ed. Anthony Julian Tamburri (West Lafayette: Bordighera, Press, 1996).

27 Mary Jo Bona, "Gorgeous Identities: Gay and Lesbian Italian/American Writer," in *Fuori*, 4–5.

28 Tommi Mecca Avicolli, "Memoirs of a South Philly Sissy," in *Fuori*, 24.

29 Ibid., 22.

30 Tommi Avicolli Mecca, Giovanna Capone and Denise Nico Leto, eds., *Hey Paesan! Writing by Lesbians and Gay Men of Italian Descent* (Oakland, CA: Three Guineas Press, 1999); author's interview with Giovanna Capone, October 2014.

31 Denise Nico Leto, "Anna Magnani at the Castro," in *Hey Paesan!*, 12.

32 Linda Catalano, "The Survival of My Name," in *Hey Paesan!*, 205.

33 Ibid.

34 *Our Naked Lives: Essays from Gay Italian American Men*, ed. Joseph L. Lo Giudice and Michael Carosone (New York: Bordighera Press, 2013).

35 In his column with the now-defunct magazine *OutWeek*, Signorile, an Italian American from Staten Island, "outed" powerful, closeted gays and lesbians who not only refused to declare their homosexuality but who, in their public and professional lives, distanced themselves from or even attacked gays and lesbians.

36 Michael Signorile, promotional quote for an interview on Stonewall Live: http://hosts.blogtalkradio.com/stonewalllive/2013/06/21/our-naked-lives-gay-italian-american-essays-620-9pm-est (accessed 8 May 2017).

37 I contributed "*Fuori* in Italia: A Gay Grandson Encounters *La Madrepatria*." In the essay, I recount experiences I had in Italy over a span of some twenty years, mainly in the South and Sicily, with gay Italian friends.

38 John D'Emilio, "More Italian American than Catholic: Coming Out to My Parents, 1974," in *Our Naked Lives*, 30.

39 Ibid., 34.

40 Ibid., 37.

41 Ibid., 38.

42 Ibid., 42.

43 They include playwright Harvey Fierstein's *Torch Song Trilogy*; Dennis Cooper's transgressive novels *Safe* and *Closer*; Brad Gooch's collection *Jailbait and Other Stories*; and the anthology *A True Likeness: Lesbian and Gay Writing Today*.

44 Felice Picano, "Growing Up *Un*-Italian American," in *Our Naked Lives*, ed. Lo Giudice and Carosone, 123.

45 Ibid., 131.

46 Stephen Holden, "How the Hysteria of Denial Conceals Fears and Desires," *New York Times* (23 November 1989).

47 Philip Gambone, *The Language We Use Up Here, and Other Stories* (New York: Dutton, 1991).

48 Philip Gambone, "Learning and Unlearning and Learning Again the Language of *Signori*," in *Fuori*, 62.

49 Stephen Holden, "Short Plays on Gay Themes," *New York Times* (20 September 1987).

50 Cannistraro and Meyer, "Introduction," 28–29.

51 Cino left off the final accent from "Caffè."

52 Chiara Mazzucchelli, "The Scum of the Scum of the Scum: Rose Romano's Search for Sisterhood," *Journal of Lesbian Studies*, 18.3 (2014), 298–309.

53 Ibid.

54 Rose Romano, "Coming Out Olive in the Lesbian Community: Big Sister Is Watching You," in *Social Pluralism and Literary History: The Literature of the Italian Emigration*, ed. Francesco Loriggio (Toronto: Guernica, 1996), 161–175.

55 Fred L. Gardaphé, *Leaving Little Italy: Essaying Italian American Culture* (Albany: SUNY Press, 2009), 46.

56 Editors' note: Repetto spells her surname with a lowercase "r." "Two reasons for lower case . . . disemphasis of patriarchal line . . . at one point, I thought of using my mother's maiden name then realized that surnames are all patriarchal. Second reaction vs emotionally abusive and reactionary father." E-mail communication, 11 September 2016.

57 Mary Cappello, book jacket blurb for *L Is For Lion: An Italian Bronx Butch Freedom Memoir* (Albany: SUNY Press, 2013).

58 Joanne Nagel, "Ethnicity and Sexuality," *Annual Review of Sociology*, 26 (2000), 107–133.

59 Ibid.

60 Richard Giannone, *Hidden: Reflections on Gay Life, AIDS, and Spiritual Desire* (New York: Fordham University Press, 2012).

61 Author interview, October 2014.

62 Author interview with Vittoria repetto, January 2015. According to repetto, neither GLI nor Lavender Paesans attempted to organize a contingent in New York's Columbus Day Parade.

63 A 2014 Pew Research Center survey found that 85 percent of self-identified Catholics ages 18–29 said that society should accept homosexuality, compared with just 13 percent who said it should be discouraged. Older age groups are less likely to favor acceptance. But even among Catholics ages 65 and older, 57 percent say that homosexuality should be accepted.

64 George de Stefano, "Michael and Vito," *I-Italy* (14 May 2014), www.i-italy.org/bloggers/38026/michael-and-vito

65 Ibid.

36

IMMIGRATION FROM ITALY
SINCE THE 1990s

Teresa Fiore

From Immigration Data to Immigrant Stories

Quantification is a technology of distance.
—Theodore Porter[1]

In a 2010 vignette (Figure 36.1) by illustrator Pat Carra (aka Pat), a young Italian woman looking for a job says good-bye to her mother as she steps out the door for the day: "Ciao mamma, I am off to go job hunting." To which the mother dryly retorts: "Don't forget to take your passport."[2] In line with Carra's gender-attentive approach, the vignette focuses on a woman since women are particularly affected by unemployment in Italy, especially in the South. Yet her experience is applicable to young Italians at large given that high unemployment is a widespread phenomenon among the youth. The vignette functions as a snapshot of this disquieting trend and its link to emigration, particularly in the period under consideration in this essay.

Since the 1990s unemployment has only risen, reaching a historical high of 12.8 percent in 2013, which equates to almost eight million people in a country of roughly sixty million, with peaks of 20 percent in the South and 40 percent in the 15–24 age range nationwide.[3] Global and national economic crises, structural inequalities in the Italian system that provide significant job security for the older generation at the expense of the new, as well as a generalized culture of nepotism and favoritism, have all contributed to this paucity of jobs over time, and recent attempts toward reform are causing profound social tensions. Carra's choice in the early part of 2010 to connect this spiraling reduction in the number of available jobs to the pressing need to emigrate is not coincidental: since the beginning of this decade, the number of people leaving the country has increased exponentially precisely because of the lack of opportunities.

In reality, emigration from Italy has never stopped: it continued even after 1988—the official date that many demographers identify as marking the end of the outbound flows[4]—and, whereas the phenomenon was initially more or less circumscribed to the "brain drain" at the beginning of the 1990s, it has since evolved to embrace people with different backgrounds and life projects. Estimating the magnitude of these migration flows continues to be frustratingly approximate at best, given the inadequacy of the prevailing survey methodologies.

In 1990, the AIRE (Registry of Italians Residing Abroad) was instituted in order to monitor the size of the Italian population outside the national borders. However, the voluntary nature of the notification of the change of address from Italy to the new country at the City Records offices, as well as the low rate of registration due to the lack of clarity over its

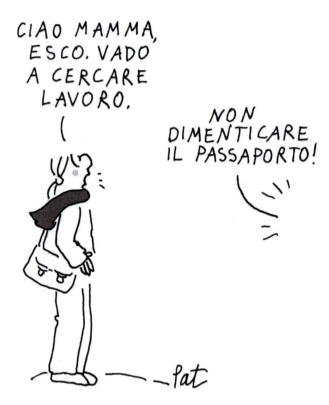

Figure 36.1 "Ciao Mamma, I am off to go job hunting." "Don't forget to take your passport!" A cartoon by Pat Carra, 2013. © Pat Carra.

benefits and costs in terms of fiscal, property and health insurance matters, make the AIRE records a necessarily incomplete snapshot of actual migration flows. In fact, several research-ers hold that the AIRE data could easily be doubled before a true picture emerges of the dimensions of "Italy abroad." In any case, going by the available official statistics, the "La fuga dei talenti" (The flight of talent) website run by journalist Sergio Nava[5] reports AIRE data showing a total of 2,379,977 Italians registered as moving their residence abroad between 1990 and 2013, of which roughly one quarter was in the 20–40 age bracket.[6] Over the course of the decade 2004–2014, the exodus has accelerated: 60,000 people left Italy in 2011 and this number had increased to annual outbound flow of 101,207 by 2014. As a result of these sharp increases, by 2012 net flows in migration had turned negative again (more people were leaving rather than entering Italy) for the first time in decades, due to the precarious political, economic and social situation in the country, as well as the easy mobility granted by the EU. The majority of the emigrants of the past few years come from Lombardy, Sicily and Veneto, with the regions of the Center-North representing the main areas of departure (unlike the oversized role played by the South in historical emigration flows). These emi-grants are for the most part between the age of 18 and 34 and choose primarily between Germany, the United Kingdom and Switzerland, although the United States does constitute one of the main overseas choices.[7]

These "new Italians abroad" are effectively the latest wave of an emigration of massive proportions that has been defined as the largest emigration from any country in modern his-tory[8] (27 million people left Italy between 1876 and 1988)[9] and constitutes the foundation

for a population of Italian descendants in the world that already in 1996 corresponded to that of the entire population of Italy[10]—and it is most likely larger today. Within this global phenomenon of demographic and cultural dispersion, the United States has played a fundamental role as both a traditional and a contemporary destination for Italian emigrants: its current magnetism builds off the mythical aura it has acquired over time, as its pull factors continue to be practically the same. Specifically, the United States holds a powerful attraction to potential emigrants as a land of freedom, creativity and possibility for the individual, and well as a dynamic political and economic system where persistence, self-sacrifice, energy and clarity of goals are generally rewarded. As a result, the lure generated by U.S. cultural products—whether mainstream or alternative—convinces many Italians to study, research and work in what is still called "America."

Historical emigration from Italy to the United States amounts to over 5.5 million arrivals in the period 1876–1976.[11] The data available since then is less systematic and clear in part because of the inadequacy of official government data, as mentioned above. Even more recent attempts at surveying the phenomenon have yielded only partial results. A 2013 survey by Centro Altreitalie collected information from only 89 respondents about their U.S. experiences (8.2 percent of the survey population). Within this subsample, the vast majority (90 percent) of immigrants from Italy is between the ages of 25 and 45, comes primarily from Lombardy and Lazio, and for the most part (70 percent) works instead of studying given their high level of education (56 percent hold at least a BA). Among the workers, 87 percent are employees (versus being self-employed); 50 percent have a long-term contract whereas, interestingly, 38 percent only have a temporary job (the remainder corresponds to incomplete survey responses). The distribution between men and women is roughly equal.[12]

As I have maintained in another article,[13] the slippery nature of the statistics prompts researchers toward a qualitative assessment of the phenomenon. Though relying on data and statistics when possible, this essay remains aware of the fact "that quantitative manipulation minimizes the need for intimate knowledge and personal trust,"[14] as historian of science Theodore Porter writes in order to privilege a scientific approach. To avoid the loss of full knowledge often produced by this scientific quantification, this essay also aims at mapping the phenomenon of immigration through human stories as they are recounted in written, oral or visual texts. Since immigration is intrinsically so much about distance—geographical, cultural and emotional—this essay instead aims to serve as a countervailing force for a closeness defined by points of contact across differences.

A number of books on the subject of Italian emigration have already attempted to document this complex phenomenon through the collection of personal stories. Published between the early 2000s and 2010, these books are galleries of individual portraits, which sewn together aim at furnishing a panoramic view.[15] Written by journalists for the most part, these works generally show a shift from the focus on the university-related brain drain to that on the layered and constantly changing nature of the community of Italians who recently moved abroad, as the titles of the books suggest (for instance, from *Brain Exports* to *Rootless Youth*). All these publications include references to the U.S. experience among the different portraits, whereas some books are fully devoted to the United States, as is the case for Maurizio Molinari's *The Italians of New York* (2012) and Elena Perazzini's *Far from Us* (2016).[16] A variety of websites and blogs cover personal stories of Italians who have relocated to the United States;[17] a play humorously illustrates the travails of young Italians trying to adapt to New York life;[18] whereas a couple of recent documentaries and novels have focused specifically on New York by either adopting the technique of the collage of individual tales[19] or revolving around the existential quest of the protagonists.[20]

This essay utilizes a similar technique in the awareness that personal stories shed light on the larger scenario. Yet, given the abundance of stories already available in these books, blogs and videos, this essay privileges personal accounts that lie at the intersection of different experiences and/or tell less common stories: their uniqueness seems to provide a fuller sense of the reasons for leaving Italy, choosing the United States, and, when applicable, giving back to both Italy and the United States in original ways. In light of the low rate of return to Italy and the more limited opportunities for circulation of ideas and creation of opportunities across borders within the Italian diaspora, which makes it radically different from other diasporas such as the Indian one for example, in this essay I will try to highlight the unique nature of the relationship between Italy and its people abroad, emphasizing in particular the profound bond between Italy and the United States.

Migration Italian Style:
The Overlapping of Old and New Modes of Relocation

When looked at it in its entirety, the current phenomenon of immigration from Italy to the United States shows both characteristics that are common to the traditional patterns and also new modes that are shaped by specific socioeconomic circumstances. Three main categories of "new Italians" in the United States are discernable: (1) Italians with extremely high academic qualifications who continue to fall under the category of "brain drain" as they have for the past twenty or more years (post-docs and researchers in a wide variety of fields as well as business people who relocate as part of their jobs in Made-in-Italy sectors recognized for their excellence—from fashion to food and design—or other sectors); (2) those with adequate qualifications who nonetheless lie in an in-between area where training and professional opportunities are possible but not necessarily guaranteed (students, artists, temporary workers in the service or creative sectors); and (3) those with relatively low qualifications who leave in search of economic opportunities in ways comparable to those of historical migrants (for instance, workers in the restaurant business who often move as part of family chains). By no means are these three general categories easily definable or rigorous as people may move from one to the other by losing or acquiring status. Moreover, some of these categories overlap thus confirming the multi-faceted nature of the migration phenomenon.

Much literature has been produced on the first category of "new Italians." The early publications by Augusto Palombini and Claudia Di Giorgio were exclusively focused on the exodus of scientific talent, whereas portraits of established restaurateurs, managers and artists abound in both the American and Italian media. Similarly, the second one has received increased attention among young journalists and researchers especially in blogs and recent books, since there is a growing awareness of the shift from the brain drain to a diversified emigration in terms of both the economic class of origin and the level of education. The third category is the least addressed primarily because it encompasses work sectors such as window cleaning that are not considered to be worth recounting in the media,[21] or because these "new Italians" work "under the table" in a gray economy.[22]

For the purpose of this essay I have selected three stories that, without matching the three categories laid out earlier in mechanical ways, allow me to delve into a wide range of issues related to migration from Italy to the United States, while simultaneously paying attention to less-heard voices: a university professor of Italian Studies who has adopted a child within a same-sex marriage in California; a former law graduate turned horticulturist in Hawaii who resorted to a marriage of convenience to step out of his undocumented status; and a New York-based video maker who, after acting as an informal service provider for recent Italian immigrants, channeled his creative energy into a photography project that cleverly connects

old and new ways of migrating from Italy to the United States. These are not necessarily stories of linear success or polarized emotions toward Italy or the United States. They are instead stories of personal quests, compromises, and the desire to learn from life while maintaining a sense of self-irony and adaptation. Ultimately, they exemplify the characteristic Italian "arte dell'arrangiarsi" (the art of getting by), a form of creativity relocated in the diaspora.

An Accidental Italian Cultural Ambassador: Sociopolitical Engagement in Italian Studies and at Home

But I have lived only a bit so far, they say the best will come from now on.
But I have made many mistakes so far, and learned a lot,
But I am still making mistakes, and then
I would like to become an old lady with no hurry and with you.

—Erica Mou[23]

I am an Associate Professor of Italian with a B.A. in foreign languages and postcolonial literatures in English from the Università degli Studi of Bologna, an M.A. in Women's Studies from the University of Cincinnati, and a Ph.D. in Literature from the University of California San Diego where I focused on the regional and transnational dimensions of Italian culture in Italy and abroad throughout the twentieth century. At San Diego State University I teach Italian language and culture, conduct research on Italian migrations and pop culture, organize Italian cultural events with an impact both on campus and in the local community, lead digital initiatives in language acquisition, and direct the study abroad program in Florence. I moved to the U.S. in 1995 from a small village near Modena, where I was raised in a family of "operai" (factory workers) with a strong attachment to their rural roots and a commitment to their children's intellectual education. I have made of California my new home roughly two decades ago along with my female partner who became my official wife in 2013 thanks to the state law on same-sex marriage. In 2013 we also finalized the adoption of a bright young girl. My life is informed by a belief in cultural enrichment across boundaries, a political engagement in defense of migrant, LGBTQ, and women's rights, and the promotion of Italy in its multi-faceted forms. Had I stayed in Italy, would I have done something similar in my professional and private life? Most likely so, but in a much more precarious position professionally and in a more covert way privately. Despite the awareness that my country of origin would deny me full recognition as an intellectual worker and a person, I have ironically become a cultural ambassador of Italy in a foreign institutional environment that supports its promotion and visibility, without any resources coming from Italy. Life for me, itinerant as it has been, continues to be a surprise.

—Clarissa Clò

The highly skilled Italian immigrants in the United States, whether temporary or long-term, have for decades found work opportunities in academia, where they constitute 20 percent of all immigrant workers in this sector according to 2008 National Science Foundation (NSF) data.[24] Although after the 11 September 2001 attacks the trend has changed somewhat, some studies quote a flow of 3,500 scholars per year.[25] The presence of Italian researchers in American universities is registered primarily in large or well-known cities (Boston, Los Angeles, Houston) and culturally or economically vibrant regions (Northern California, the greater New York City area) that house research centers. Active in all kinds of fields ranging from astrophysics to the arts and humanities, these Italian "university exiles" have often earned undergraduate and graduate degrees in Italy and moved to the United States as postdocs and often stayed as full-time professors or researchers in the private sector. Although

Italy has invested in all of these people as part of their education, it has failed to keep hold of them due to a stagnant and self-interested system that tends to privilege *protégés* instead of the best candidates for research and teaching positions. In the eyes of this cohort, the United States is an alluring country for its level of technological advancement, its openness toward cutting-edge fields that are not as well-supported in Italy (e.g., stem cell research and women's studies), its meritocracy and its dynamic cosmopolitan environment.

As the stories contained in the various books and videos on the subject demonstrate,[26] the flight of the "brains with wings" cannot be simply identified as an easy movement toward achievement and recognition, nor as a pursuit of research-related goals since immigration entails a broad range of personal and social questions. The new system is one of opportunities (use of new technologies, access to luminaries, ample financial resources) for which these exiles are extremely grateful; yet, it is also a source of pressure due to productivity expectations, which risk privileging quantity over quality and compartmentalizing knowledge. Additionally, life in the United States may deprive Italians of occasions for socialization and cultural engagement that their places of origin offer in irreproducible ways, according to the interviewees. Despite these challenges and losses, they continue to see the benefits of their choice. A number of them over time have found true recognition in the United States,[27] and interestingly Italy has claimed them as nationals when their discoveries have achieved fame.[28]

Next to the hard and soft sciences, which are much discussed for their socioeconomic impact and media visibility, lies a less noticeable academic field that in my view actually represents a much more direct engine for the expansion of Italy abroad from a cultural and economic point of view: Italian Studies. Ironically the Italian discipline *par excellence* for Italian scholars active in foreign universities is rarely examined in the reports, books, and videos on "new Italians" abroad. Hence, the decision to briefly showcase the story of Clarissa Clò, whose professional trajectory is shared by many peers who left Italy after completing their initial degrees and pursued an academic career in the United States, which in Italy would have been mostly likely denied or partially achieved. This is why, even if just based on a cursory survey of Italian Studies departments in the United States, at least one-third of the faculty appears to consist of Italians of fairly recent arrival (regardless of their age) who in many cases have ironically earned a PhD in Italian in the United States. (The language instructor contingent is often exclusively made up of Italians who for family or professional reasons have relocated and bank on their native-speaker advantage and Italian university degrees in the humanities.) This presence is of crucial importance in the assessment of the impact of Italian emigration abroad: Italian Studies department are the places where Italy is preserved and (re-)created, nurtured and discussed, and last but definitely not least, promoted. Simply put, professors as well as PhD students of Italian Studies are consciously and even unconsciously ambassadors of Italy. They keep its language alive and support the circulation of its books, films, arts and foods; they embody a certain lifestyle and worldview that is in large part affected by their upbringing in Italy and their regular visits to the country; they are instrumental in the exchange of the largest groups of scholars between Italy and the United States; and they lead groups of students in their study abroad experience (Italy is still the top foreign-language destination for U.S. students),[29] which often represents the beginning of lifetime visits if not professional careers for these undergraduates. Unlike other fields ranging from physics to engineering, Italian Studies is actually the one that gives back to Italy both directly and indirectly in systematic ways, even though this contribution remains unaddressed relative to those fields where economic gain can be expressed via patents, scientific awards and investments.

Clò's story is also an interesting window on another less commonly addressed topic: emigration as a flight from a societal and cultural structure that tends to exclude "difference" in

the defense of the normative family. Sexuality as well as gender issues are also at the root of the choice of so many Italians to live abroad in countries where gay and women's rights are better protected by the local system. Despite its contradictions and shortcomings, the United States represents a country where personal choices such as Clò's are generally respected and supported. Data about gender and sexuality as an engine for emigration are hard to gather but it is clear that women and gay people can count on more opportunities in the United States. Ironically, the stories of these "new Italians" are less reported in books and videos that tend to privilege portraits of male heterosexual Italians. Clò's story is emblematic of a path in which the private and the professional are both political, and are able to challenge Italy's resistance to change in certain aspects of social life, while still supporting the country and its culture at large. Thus, although Italy has passively witnessed a massive exodus of academics and researchers in the past thirty years or so, it has also ironically been able to rely on a collection of accidental ambassadors in the field of Italian Studies as part of this outflow.

The Secret in the Garden:
An Unlikely Undocumented Italian Immigrant

Someday . . . I don't know when
We're gonna get to that place
Where we really wanna go
And we'll walk in the sun.

—Bruce Springsteen[30]

It's called American Dream because
You have to be asleep to really believe it!

—George Carlin

I am from a large town in Northern Italy where I completed a degree in law, yielding to family and social pressures, while in reality the most meaningful work experience during my under-graduate years was my civic service in the city park nursery. I left Italy ostensibly because of the lack of job opportunities but I was really fleeing nepotism and provincialism. A week after defending my thesis in the mid-1990s, I left for the U.S. in order to find a natural environ-ment that would nurture both my love for surfing and my desire to become a horticulturalist. Hawaii has been able to make both dreams come true: it is quite ironic, though, since in Italy my image of the U.S. was originally mediated by Bruce Springsteen's songs about a gritty America. If anything, I listened to his heartrending call to leave one's place of origin: his "bad-lands" evoked my gloomy region in the North. I felt an attraction towards the U.S. but never had a romantic view of the American Dream, which turned out to be a glittering magnet with a price to pay. My first jobs, secured in construction and packaging companies run by Italians here, showed me how the worst aspects of the Italian system (exploitation and underpayment) at times travel in the diaspora. In the late mid-2000s, due to an oversight, I failed to leave the country in order to keep my visa valid and turned "illegal" without even realizing it for a while. Until I tried to travel out of the country and discovered I was trapped in it with no legal papers. After attempting various routes, I realized that a marriage of convenience with a U.S. citizen was the only way out. Through my circle of friends I was able to find a woman who, despite the substantial compensations expected in these days, agreed to do it at no cost: we have lived together pretending to be a couple for 30 months and sharing the secret until the green card, and later U.S. citizenship, arrived. In the process, I was quite uncomfortable, yet I was aware that I did not have to live in perpetual fear since Italians are not associated with undocumented immigrants or "fake" spouses. In the end, I became legal and gained a

new friend in her. The planned dissolution of the marriage is now postponed because she wants to acquire Italian (read E.U.) citizenship. Due to the intrinsic delays of the Italian system, my full legal independence is now ironically deferred, even if I live in the U.S. taking care of my peaceful fulfilling solitude among ocean waves, exotic gardens, and close friends. I have no nostalgia for Italy.

—Davide[31]

If calculating the number of new Italians in the United States continues to prove a chimera, quantifying the presence of the undocumented ones is even more challenging, yet these do represent a growing reality as data and personal stories attest. The daily *La Repubblica* in a 2014 article estimated that half a million Italians between the age of 18 and 45 live in this ghost condition, from Angola to Australia. In the United States, the most coveted destination,[32] up to 150,000–250,000 Italians allegedly live clandestine lives: of them 20,000 just in the State of New York, and 3,000 in Queens and Brooklyn alone.[33] According to the article, these underground Italians work in restaurants and bars for the most part, occupations that in large American cities allow them to earn appealing amounts of money under the table, thanks to the tips. On the surface this life is presented as manageable, and the media's and the Italian institutions' resistance to talk about this phenomenon openly and in depth makes this option appear as viable since its disadvantages are not fully disclosed.

Yet, real testimonies of people who have lived in this condition shed light on a challenging existence. Contained in Molinari's *Italians of New York* and Perazzini's *Far from Us* and *Tre Stop a New York* as well as fictionalized tales such as the one at the heart of Emanuele Crialese's film *Once We Were Strangers* (1997),[34] they show how these "clandestine lives" are prompted by the complexity of the legal routes to secure a job and by the magnetism of the United States. Italians travel to this country with tourist visas and overstay, and are willing to endure "invisibility," while paradoxically they continue to hold jobs and have families in the United States. These contemporary "illegal" immigrants are the latest instantiation of a long history of unauthorized Italian emigration toward both Europe and the United States;[35] yet their condition is particularly ironic given the current status of Italy as a G7 country, i.e., a departure place considered privileged, as well as the fact that in the past twenty-five years Italy has articulated a growing criticism against undocumented immigrants arriving at or living in Italy. In the United States, Italian "irregular" immigrants know they can count on a certain degree of "racial" privilege vis-à-vis Mexican and Chinese "illegals" working in the restaurant business: their physical traits and dress styles make them less of a target for the police.

Davide's story is emblematic of this underground life, pregnant with anxiety and waiting, driven by creative solutions and made possible thanks to a network of support. His story not only challenges widespread perceptions about "new Italians" but it also reminds us of the resilience of the immigrant who is often driven by a desire to leave rather than a clarity over the arrival. In her book *Far from Us*, Perazzini remarks that Italians today also leave for existential reasons: "exploring the feeling of restlessness, the universal impulse that drives to seek 'more' elsewhere, to stave off complacency and resignation."[36] Whereras forms of personal displacement, such as discomfort in the milieu of origin, constitute the engine for the departure, professional stability is the necessary condition for the permanence abroad: the two quests are hardly separate. In the case of Davide, this has implied becoming clandestine when circumstances did not allow for a legal route (his accidental "fall" into irregularity), and disentangling the situation through the adaptation to a creative solution, the professional help of effective lawyers and the courageous generosity of friends.

The striking contradiction between Davide's social background and the acrobatics required by the system points to the complexity of class belonging and social integration: moving to the United States is no easy route for Italians even in the global era of the brain drain and managerial relocation. Ultimately, notwithstanding their self-perception as being different from the historical Italian immigrants in the United States, "new Italians" often experience similar conditions: *mutatis mutandis*, they essentially remain subject to the regulations of the immigration office until they obtain a green card or citizenship, and start becoming even more obviously the Italian Americans they often refuse to be compared to.

My Story Is Your Story, Our Story Is Our Predecessors': Collapsing Time in a Photographer's View of Italian Immigration

Perché qui sto bene, è bello quassù
Non ho più le catene che avevo laggiù
Che avete laggiù.
— Antonio Di Bella[37]

I am a photographer and filmmaker who has always entertained the dream of moving to New York (practically since I watched the film Superman *at the age of six). I come from a large and lively family from Campania and relocated to Rome, where I studied film, television and photography. In 2003, after a holiday in the Big Apple during which I dropped my resume off at the RAI TV office, I received a job offer from it and promptly moved. At the age of 30 my curiosity and exhilaration about New York made me overcome to a high degree the nostalgia for Italy and my family. My first few years were utterly thrilling: great projects, exciting trips, professional gratification, good friends who became my new family, as my visits home became quite infrequent. New York turned into a home so profoundly that after a while I became a support system to those who like me were also trying to build a life in my new city: I would help procuring initial jobs and apartments for rent, and to those with fewer resources I offered my own space for temporary stays, despite the fact I had only exchanged a few emails with them through common acquaintances. In the process, I heard a plethora of stories: regardless of the different specifics about professional or social backgrounds and actual goals, their common theme was the desire to accomplish something. This archive of stories later turned into a visual project that is meant to document these experiences and their protagonists: "Good Bye, My Love"[38] is a series of snapshots of new immigrants from Italy dressed like those who reached "America" a century or so ago with the so-called cardboard suitcases. I find that their motivations are not dissimilar from those of the initial wave of emigrants who, when they left their homes and families, were looking not just for a job but also for a dream because a country like Italy back then, as is the case today, seldom allowed its people to find stability or pursue a dream. Since they cannot emerge, or rather they risk drowning, these adventurous Italians stop complaining, and leave. In the process of making their "dream" come true, they struggle, wobble, and sometimes fail, or succeed but at a high price. Certainly they are more "alone" than the historical immigrants from Italy: they rarely relocate with or are joined by their families. Part of their story of migration has also entailed the ability to live and make it by themselves, at least for while. I am one of them at the moment, and from this divided perspective of an established professional and artist who is increasingly homesick about Italy, I continue to tell their stories with my camera.*
— Michele Petruzziello

The vast and varied galaxy of "new Italians" in the Unites States continues to be documented through different media, mostly because it continues to grow and consequently inspires researchers, artists, and journalists to collect stories through words and images. In the process, as much as the emphasis continues to be on the "different" nature of the contemporary emigration vis-à-vis the past (mostly in terms of levels of education and global

mobility), the human threads running through these stories often resonate as a historical déjà vu. Both the flight from Italy—a country that offers less than it is expected at a personal, social, and professional level—and the desire to embark on a new life adventure look similar to the ones that characterized the historical flow of immigration: they embody a form of liberation from the chains Di Bella refers to in the epigraph. Also similar is the struggle to find one's route, achieve stability, and manage to find a balance between different traditions, languages, and customs. Despite the easy access to transportation and communication, which are both providing ways to shorten the distance between the place of departure and that of arrival, a certain sense of separation cannot be fully erased. Equally comparable is the need for informal networks of support ranging from noninstitutional websites to family members and recent immigrants who act as information and service providers. Petruzziello's story is quite telling as it points to present-day forms of empathy and solidarity that to a degree are not too unlike those of Italians who hosted newly arrived immigrants in a city like New York in the early 1900s.

Yet, as Petruzziello highlights, today's immigrants often embrace this life project alone. They cannot count on immediate family members to join and help, whereas in the past the family unit, both close and distant, constituted the infrastructure of the project. Thus his photographs of the recent immigrants (see, for example, Figure 36.2) betray moods of isolation quite different from the feeling evident in the familiar photos of crowded streets in Little Italy in the early 1900s (compare, for instance, Figure 8.1 in Chapter 8 above). If it is true that a new trend can be identified of families relocating to vibrant and thriving urban centers to provide opportunities for their children through schooling abroad at an earlier age,[39] today's immigrants are individuals relying on an infrastructure that is the result of

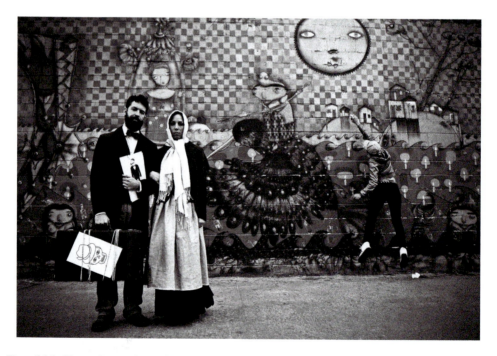

Figure 36.2 Giovanni, a graphic/web designer and photographer, with his wife Cristina, Coney Island, New York, 2015. Courtesy of Michele Petruzziello.

invention and adaptation. The early Little Italies that Italians were able to form as a mosaic of Italian families have been substituted by fluid points of social aggregation, not coinciding with neighborhoods, and often transcending national traits. Contemporary immigrants gravitate toward people of the same nationality only to a point and for specific needs: their communities of reference are much more international and cosmopolitan, especially in large metropolitan centers. Another interesting difference between the past and present flows of immigration is that the possibility of return is more of a chimera. If in the past, it was the lack of adequate financial resources that barred a relocation in Italy, today it is the lack of opportunities that ensures that Italy is not available as an option for resuming a professional route (a notable exception being the controversial project of the "Return of the Brains,"[40] which in some cases failed as those very brains never readapted to the Italian system and migrated again). Exchanges are certainly taking place: The majority are linked to the commercial import-export sector; a number of people travel back and forth in dynamic professional areas; and new projects are bound to thrive on the trajectory that links Italy and the United States. Yet, these contacts continue to happen in a scattered form; no systematic attempt to organize people, ideas, and resources has taken place; and individual and institutional projects unfold without the support of a national or binational infrastructure of support through governmental initiatives, foundation programs, etc., as is instead the case for other countries.

As much as these "new Italians" in the United States appear to our eyes through widespread media representations as "digitally globalized" in the era of "post-modern nomadism," to use the sociologist Domenico De Mais' definitions,[41] attentive readings of the phenomena prompt us to paradoxically see the past in the present. In his *Good Bye, My Love*, Petruzziello's desire to highlight the closeness of today's Italian immigration to the United States to that of one hundred years ago takes shape in a visual language replete with reverberations. Struck by the analogies, Petruzziello has since 2011 dressed "new Italians" as the immigrants we have grown accustomed to recognizing even at a quick glance for their outfits and their facial expressions: the collective imaginary is so full of Ellis Island arrival shots that Petruzziello had to simply borrow a very common idiom and insert a living subject in a contemporary environment. The friction between the reproduction of the historical memento, relying on a shared idiom that is often acritically experienced due to the viewer's overexposure and thus desensitization, and the realization of the "live" nature of the image prompts unlikely connections and ultimately generates empathy. The apparent friction is actually a language of conjunction and continuity across the time continuum and human experience.[42]

Good Bye, My Love comprises two phases that are merged in the final album of shots with no clear distinction. The artist started with immigrants embracing jobs and experiences that make them into acrobats. The most striking one is that of the actress (Sara) standing in the middle of the street in the Theater District holding a Shakespearean skull, where the location and the prop hint at the danger and questioning implicit in her choice of moving to New York. This phase also includes recently arrived Italians whose educational background proved to be useful in finding a job in the creative and dynamic environment of New York City. The representative shot of this subcategory is the image chosen for this essay where Giovanni and his wife Cristina embody modern professionals active in design and photography, and yet their lives are as exposed to external factors and are as short-lived as a work of graffiti—as a matter of fact the couple now lives between Italy and the U.S. The second phase of Petruzziello's project involved well-known names of the Italian panorama of New York City: from the Consul General Natalia Quintavalle to the RAI correspondents Giovanna Botteri and Tiziana Ferrario. Strident as the contrast may be between the established professional roles of these people and the outfits and postures they inhabit in the photographs, these "new

Italians" convey perhaps in even more effective ways the link between past and present and the inescapable nature of migrating from Italy to the United States, where the stories of "new Italians" are also the stories of those who preceded them. This historical imbrication is indirectly yet quite tellingly reflected in the demographic records of Italians abroad and the electoral law, which lump all of them together.

At the end of 2013, the AIRE records registered 4,636,647 Italians as living abroad. This number includes both Italian citizens who recently relocated to a foreign country and residents of a foreign country who have acquired the Italian citizenship by taking advantage of the 1992 Law n. 91, which allows for dual citizenship and defines eligibility via blood-based lines. The AIRE records also function as voters' lists for the Italian national elections. According to Law 459/2001, implemented for the first time in 2006, Italian citizens listed in the AIRE have the right to vote in national elections and referendums, and can elect their representatives in the Parliament based in Rome (two members of the House and one senator). The AIRE records do not clearly distinguish between the categories of "newly relocated Italian citizen" and "new Italian citizen" which makes the analysis of the general data partial or superficial with reference to actual immigration flows as well as voting trends. It is not clear why "emigrating" and "emigrated" Italians, to use Enrico Pugliese's apt expression,[43] are often lumped together in the official records, yet the resulting effect is one of a community defined by migration *tout court*, whether historical or contemporary. I argue that Italianness abroad, in places such as New York City, for example, and by extension the United States, cannot be understood without these linkages, uncomfortable or unreadable as they are when solely addressed at a superficial level.

Petruzziello's project with its dose of lightness and irony reminds us of the weight of a migration story that is and will continue to be a national story in the transnational space of the diaspora. The new challenges at the horizon are those of overcoming the classical polarized representation of Italians abroad as either traitors of a country like Italy that needs them in order to be revitalized[44] or as heroes who courageously make it abroad and become ambassadors of their homeland. These fruitless dichotomies—often fostered by the absence of a structured brain gain in Italy that can compensate for the brain drain, as well as by a myopic take on the actual reinvigorating role of economic immigrants in Italy—will be overcome once Italy itself becomes more open to seeing itself as part of a global model of circulation of people, ideas and goods within networks of exchange: "for the Italians moving around is an opportunity for learning and for taking Italy around the world."[45] In turn, if Italy understands that its "dynamic 'other Italy' abroad needs to be embraced by the homeland,"[46] relocating will not just mean migrating with no option of return due to economic and political instability but an opportunity to transmit experience and knowledge in a fluid way that enriches the culture of departure as well as that of arrivals via dynamic projects. Only then may Italy be able to gain a more profound awareness of its migratory history (past and present) and understand the richness it carries today.

Further Reading

Milio, Simona et al. "Brain Drain, Brain Exchange, and Brain Circulation: The Case of Italy Viewed from a Global Perspective," Aspen Institute Italia: Italian Leaders Abroad Community (March 2012), www.lse.ac.uk/businessAndConsultancy/LSEEnterprise/pdf/Brain-Drain-%28English%29.pdf

Molinari, Maurizio. *The Italians of New York*. Washington DC: New Academia Publishing/Vellum Books, 2012.

Tirabassi, Maddalena and Alvise Del Pra'. *La meglio Italia: Le mobilità italiane nel XXI secolo*. Turin: Centro Altreitalie/Accademia University Press, 2014.

Notes

This essay was written while I was a Visiting Scholar at CEMS (Center for European and Mediterranean Studies) of New York University in the academic year 2014–15. I would like to thank the Center's director (Larry Wolff), the faculty, and the staff for their support. This essay can be regarded as complementary to another article of mine: "Migration Italian Style: Charting The Contemporary U.S.-Bound Exodus (1990–2012)" in Laura Ruberto and Joseph Sciorra, eds., *Real Italians: Post-World War II Italian Emigration to the United States*, vol. 2 (Cultural Expressivity) (Champaign: University of Illinois Press, 2017). I am profoundly grateful to Clarissa Clò, Davide, and Michele Petruzziello for sharing their stories in such a generous and delicate way: They have enriched this essay as well as myself as a "new Italian" in the United States.

1 Theodore Porter, *Trust in Numbers: The Pursuit of Objectivity in Science and Public Life* (Princeton: Princeton University Press, 1996), ix.

2 The vignette was published in the digital magazine *in Genere* in October 2013.

3 See ISTAT data at www.istat.it/it/archivio/91565.

4 Antonio Golini and Flavia Amato, "Uno sguardo a un secolo e mezzo di emigrazione italiana," in *Storia dell'emigrazione*, 1: 45–60.

5 See http://fugadeitalenti.wordpress.com/centro-studi-fdt

6 In reality, annual numbers do not only register new arrivals, but also people who notify the consulate after having entered the country for an unregistered amount of time. It is therefore not quite correct to state that these numbers reflect the annual exodus *tout court*.

7 See *Rapporto Italiani nel mondo 2014*. Fondazione Migrantes. "Sintesi." Web. (12 July 2015), www.chiesacattolica.it/pls/cci_new_v3/V3_S2EW_CONSULTAZIONE.mostra_pagina?id_pagina=60261&rifi=guest&rifp=guest

8 Rudolph Vecoli, "The Italian Diaspora, 1876–1976," in *The Cambridge Survey of World Migration*, ed. Robin Cohen (Cambridge: Cambridge University Press, 1995), 114–122 (114).

9 Golini and Amato, "Uno sguardo," 50.

10 Ibid., 59.

11 Luigi Favero and Graziano Tassello, "Cent'anni di emigrazione italiana (1876–1976)," in *Un secolo di emigrazione italiana 1876–1976*, ed. Gianfranco Rosoli (Rome: Centro Studi Emigrazione, 1978), 9–64 (16).

12 The survey was published in Maddalena Tirabassi and Alvise Del Pra', *La meglio Italia: Le mobilità italiane nel XXI secolo* (Turin: Centro Altreitalie/Accademia University Press, 2014).

13 Teresa Fiore, "Migration Italian Style: Charting the Contemporary U.S.-Bound Exodus (1990–2012)," in Laura Ruberto and Joseph Sciorra, eds., *Real Italians: Post-World War II Italian Emigration to the United States*, vol. 2 (Cultural Expressivity) (Champaign: University of Illinois Press, 2017).

14 Porter, *Trust in Numbers*, ix.

15 Augusto Palombini, ed., *Cervelli in fuga: Storie di menti italiane fuggite all'estero* (Rome: Avverbi Edizioni, 2001); Claudia Di Giorgio, *Cervelli export. Perché l'Italia regala al mondo i suoi talenti scientifici* (Rome: Nuova Iniziativa Editoriale, 2003); Beppe Severgnini, *Italians: Il giro del mondo in 80 pizze* (Milan: Rizzoli, 2008); Sergio Nava, *La fuga dei talenti: Storie di professionisti che l'Italia si è lasciata scappare* (Cinisello Balsamo, Milan: Edizioni San Paolo, 2009); Claudia Cucchiarato, *Vivo altrove: Giovani senza radici: gli emigranti italiani di oggi* (Milan: Mondadori and Pearson, 2010); Enzo Riboni, *Addio per sempre? Storie di giovani all'estero* (Milan: Ide, 2013). *Vivo altrove* is also a website (www.vivoaltrove.it) with constantly updated stories and information. In addition, there are also special news reports, such as Daniele Vulpi's "Italians di Silicon Valley," published in the newspaper *La Repubblica* (2011).

16 Maurizio Molinari, *The Italians of New York* (Washington DC: New Academia Publishing/Vellum Books, 2012) and Elena A. Perazzini, *Far from Us: Personal Journey of Those Who Left* (New York: Equilibrium Publishing, 2016), originally published as *Via da noi: Italiani ma in America* (Siena: Barbera Editore, 2013). Perazzini is also the author of a novel that embraces among other stories that of a recent Italian immigrant to New York: Elena Attala-Perazzini, *Tre Stop a New York* (Siena: Barbera Editore, 2009).

17 "Biglietto di solo andata" for America24.com; the portal i-Italy.org; Natascia Lorusso's by-now-defunct column "Sfida New York" on the digital newspaper *La Voce di New York* (www.lavocedinewyork.com/SFIDA-NEW-YORK/column/39/); and the section USA/Canada of the portal "Voglio vivere così" (www.oglioviverecosi.com/index.php?italiani-che-vivono-negli-stati-uniti-e-in-canada_340/) are some of these examples. Other sites offer information on specific job opportunities (www.inewyork.it/category/lavoro-studio/lavorare-a-new-york), logistical needs (www.italiansonline.net, which features

city-specific sections), or visa applications (www.inewyork.it/come-rimanere-e-lavorare-negli-usa-con-il-visto-o-1.html).

18 Francesco Meola and Irene Turri, *Neighbors (An Anti-Romantic Comedy)*, directed by Ilaria Ambrogi, and presented at *In Scena!* Italian Theater Festival, New York in 2015, www.inscenany.com/archivio-2013/festival-2014/events-2014/neighbors

19 Marina Catucci' and Daniele Salvini's 2001 *Italoitaliani* compiles a patchwork of stories of New York-based turn-of-the-millennium new Italians by paying attention to the magnetic power of American culture in Italy, and the language and social identity of these immigrants vis-à-vis Italy and Italian America (http://daniele.freeshell.org/docu/italoitaliani/; see also its 9/11 sequel under the title *Manhattan amore mio*: www.youtube.com/watch?v=5y39qZDWof0). Alex Kroke's and Gianluca Vassallo's 2013 *Hope: Le Nuove migrazioni* (http://hope.vxkfilms.com/) is a visually sophisticated documentary about highly skilled Sardinians in New York, whereas Cristian Piazza's 2015 *Waiting* (http://waiting documentary.com/) is an extended look at three men from different regions of Italy who are working in New York restaurants and waiting for their big break.

20 Chiara Marchelli, *L'amore involontario* (Segrate, Milan: Piemme, 2014) and *Le mei parole per te* (Segrate, Milan: Piemme, 2014).

21 A notable exception is Piazza's documentary *Waiting*.

22 A reference to contemporary undocumented immigrants active in manual jobs such as construction work or welfare can be found in Giovanni Russo, *I cugini di New York: Da Brooklyn a Ground Zero* (Milan: Schwiller, 2003), 30–31.

23 Erica Mou, "Nella vasca da bagno del tempo," *Sugar Music* (2011).

24 Simona Milio et al., "Brain Drain, Brain Exchange, and Brain Circulation: The Case of Italy Viewed from a Global Perspective," Aspen Institute Italia: Italian Leaders Abroad Community (March 2012), 27, www.lse.ac.uk/businessAndConsultancy/LSEEnterprise/pdf/Brain-Drain-%28English%29.pdf

25 Gianmario Maffioletti, "Gli italiani negli USA," *Studi Emigrazione/Migration Studies*, 61.154 (2004), 449–475 (454, 461).

26 Palombini, Nava, Cucchiarato, A. Perazzini, Kroke, among others.

27 The annual list of the "Brilliant 10" published by the magazine *Popular Science* features one Italian in 2008, two in 2010, and one in 2011 as the most promising under-40 scientists in the United States (www.popsci.com). A special episode of the popular TV program *Porta a porta* on the vocal trio Il Volo, has become an opportunity to feature "famous" Italians in New York: from Monica Mandelli, Managing Director of Investment Banking at Goldman Sachs, to Fabrizio Ferri, fashion photographer and entrepreneur, Antonio Monda, journalist, writer, professor, and cultural promoter, and Sirio Maccioni, owner of the famed restaurant Le Cirque in New York City.

28 The most notable examples are the Nobel Prize in Physics recipients Carlo Rubbia (1984) and Riccardo Giacconi (2002) who have spent their professional lives either partially or entirely in the United States.

29 "Open Doors 2013 Report on International Educational Exchange—Briefing Presentation," 26, www.iie.org/Research-and-Publications/Open-Doors

30 Bruce Springsteen, "Born to Run," *Born to Run*, CBS Records (1975).

31 This story is true but is being presented with adapted geographical and personal information in order to protect the protagonist's identity.

32 Paolo Berizzi, "Quando i clandestini eravamo noi: Italiani senza permesso di soggiorno," *La Repubblica* (19 February 2014), 21–23.

33 In the early 1990s, Italians were the second largest group of undocumented immigrants in New York City according to the City Planning Department: Deborah Sontag, "Study Sees Illegal Aliens in New Light," *New York Times* (2 September 1993).

34 *Once We Were Strangers*. 1997. Dir. Emanuele Crialese. Perf. Vincenzo Amato. 96 minutes. John P. Adams and Domenica Albonetti, Italy/USA. See Fiore in Ruberto and Sciorra for a more extensive treatment of the subject.

35 See Sandro Rinauro, *Il cammino della speranza: L'emigrazione clandestina degli italiani nel secondo dopoguerra* (Turin: Einaudi, 2009); and Edoardo Corsi, "Racketeers and Human Contraband," *In the Shadow of Liberty*, in *Voices of Italian America: A History of Early Italian American Literature with a Critical Anthology*, ed. Martino Marazzi (Teaneck: Farleigh Dickinson University Press, 2012).

36 Perazzini, *Far from Us*, viii.

37 "Because here I feel good, it's nice up here/ I don't have the chains that I had down there/that you have down there." The song was performed by the writer himself, RAI TV NYC office director Antonio Di Bella on this radio program in 2011, www.youtube.com/watch?v=CQeQlpw_zHc

38 The description of the photography project and the entire set of pictures can be accessed at www.michelepetruzziello.com/good-bye-my-love/

39 Attala-Perazzini, *Via da Noi*, 10.

40 "Rientro dei cervelli," 2013, www.rientrodeicervelli.net/english.html (accessed 21 December 2014).

41 Preface to Riboni (no page indicated in digital edition).

42 For an extensive treatment of the theme of connection between current and past forms of migration from as well as to Italy, see Teresa Fiore, *Pre-Occupied Spaces: Remapping Italy's Transnational Migrations and Colonial Legacies* (New York: Fordham University Press, 2017).

43 Enrico Pugliese, *L'Italia tra migrazioni internazionali e migrazioni interne* (Bologna: Il Mulino, 2006), 161.

44 In this sense, best-selling writer Andrea Camilleri's statement was particularly unforgiving, especially given his progressive philosophy: "abandoning one's country equals desertion." *Italy: Love It or Leave It*. 2011. Dir. Gustav Hofer and Luca Ragazzi. 75 minutes. Prod. Vania Del Borgo, Italy.

45 Giorgio Van Straten and Maurita Cardone, "La cultura italiana secondo Giorgio van Straten: Intervista al nuovo direttore dell'Istituto di New York," *La Voce di New York* (3 August 2015).

46 Marco Massola, "Embracing the Other Italy," *New York Times* (9 March 2015).

CONTEMPORARY ITALIAN AMERICAN IDENTITIES

Rosemary Serra

Interpreting Italian American Identity

Through several generations, Italian American identity has endured many conflicts, ambivalence and losses; and Italians in America have regularly renegotiated the relationship between local cultures and their origins.[1] This relationship has been reconstructed and reinvented by each generation and it has been marked by fragmentations and divergence among them because—over the course of time—values have changed just as much as the very myths and metaphorical interpretations that have constituted the foundations for entry of first-generation immigrants into American society.[2] Over the years, many of the interpretations of Italian American identity that have been advanced fall within the context of the dominant theoretical views in the debate on American ethnicity—that is, assimilation and pluralism.

According to the melting pot theory, ethnicity was to play an ever-more secondary role within American life, at least for white ethnic groups that descended from European immigrants. This phenomenon was seen as a consequence of America's openness to social mobility in the children and grandchildren of European immigrants, and as a result of increased contact across ethnic lines, which was reflected by the rise in the number of mixed marriages.

Both cultural and structural assimilation were to have made inroads into the ethnic Italian American community, to the point that Italian American attitudes would not have differed much, relatively, from those of the WASPs. In the mid-1980s, the issue of ethnicity was entering a sort of twilight—as Richard Alba defined it[3]—but this phase of decline could have lasted for a long period, perhaps indefinitely.

Assimilationist theorists held the belief that the structural forces that maintained group solidarity and cohesion would decline as well. Thus, the flight from ethnically homogenous ghettos in urban areas would have rendered the social environments of ethnic groups ever more mixed, and the ties with their culture of origin would have weakened. No longer relying on economic and political motivations to maintain ethnic solidarity, the importance of ethnic identity for the individual would have tended to diminish and other means of identification and political and economic organization would have developed.

In the 1960s there occurred an ethnic revival throughout the United States, and numerous scholars challenged the earlier predictions, according to which ethnic concerns would have lessened in importance.[4] The rediscovery of ethnic connections originated from empirical pressures, owing to a growing number of ethnically based collective movements, or because the framework of modernization was called into question.[5]

One fundamental question that scholars tried to answer remained open: how was it that ethnic identity continued to exist and endure despite the fact that ethnic groups had adapted to American society? According to Alba, the greatest contributing factor in the renewed attention toward ethnic identity in the 1960s was an expanding definition of what was

"American" and that of having changed the meaning of "melting pot," resulting in more room for ethnic identity. Alba interpreted this ethnicity as intermittent and not particularly demanding, and focused on the symbols of ethnic culture, rather than on the cultures themselves. Furthermore, ethnicity was expressed in the context of leisure time activities rather than in the fabric of daily life.[6]

The suburbanization that characterized the 1950s and 1960s, and that led to a geographic dispersal of the descendants of European immigrants, marked a significant turning point in the study of ethnicity through empirical research. As Mary Waters has highlighted, it was, by then, no longer possible to use an ethnic profile when studying potential subjects through the observation of geographically condensed groups—e.g., in any of the many Little Italies. So the studies no longer concentrated on the ethnic group as a collective and the focus shifted to the ethnic identity of individuals. Instead of a participant observation method, the sampling survey became the preferred research method.[7]

Beginning in the 1970s, various interpretations of Italian American identity were proposed. Richard Gambino introduced the concept of "creative ethnicity" to indicate a condition in which an individual learns to live not only by taking as a given that one has roots, but that the individual goes beyond these roots and is capable of synthesizing the contributions from various ethnic groups.[8]

In 1980 James Crispino conducted a survey in Connecticut based on a sample of Italian Americans. The resulting portrait of the third generation highlighted how it had reached prominent socioeconomic positions and how it had abandoned many of the behavioral models that had been learned by the second generation. The third generation would select its groups and its friends primarily based on connotations of class, and on personal interests, rather than on national origin. Furthermore, the third generation displayed a pronounced tendency toward exogamy. Ethnicity had become a phenomenon associated with the working class: the third generation of blue-collar workers was just as ethnic as their second-generation counterparts in its behaviors and in its attitudes.[9]

Ethnicity remained vital even in the middle class and manifested itself primarily as awareness and pride in Italian American identity. Therefore, a new form of ethnicity began to emerge, one that was characterized by being voluntary, instead of obligatory, expressive rather than instrumental. Herbert Gans defined this as "symbolic ethnicity"[10] because it spoke through and with symbols, rather than by means of cultural practice or group membership. Precisely because it was easy and pleasant to express and because it would not have impeded social mobility, it was to have endured through the fourth and fifth generations.

By the mid-1980s, Michael Fischer's interpretation, explained through the concept he calls the "reinvention of ethnicity," evokes the temporal connection among the past, the present and, above all, the future, something already brought to the fore by Gambino. This ethnicity was determined by means of retrospection and memory, making it possible to retrace manifestations of *italianità* in the past, and its purpose was to pinpoint the necessary cultural components for developing a complete identity. In that way, it would have been possible to orient ethnic memory toward the future and not toward the past.[11]

According to a study from the 1980s conducted by Waters on certain components of the third- and fourth-generations descendants of European origin, it became apparent that ethnic identity was a constantly changing social process, a dynamic and complex social phenomenon. Changes in ethnic identity were tied to different ages over the course of a lifetime and to the structural changes that beset people's lives. Moreover, ethnic identification entailed a wide scope of choices on the part of the majority of those who are conscientious in their selections.[12]

More generally, though, the common view among Americans was that ethnicity was a primordial, personal and hereditary characteristic; many thought that ethnic groups were permanent classifications and that ethnic and racial categories constituted fixed, biological attributes. Ethnicity was seen as an objective fact even when it appeared in a highly symbolic way. Individuals considered themselves part of these ethnic groups by virtue of the fact that their ancestors, in turn, had been members of them, and their behavior was influenced by this view. Therefore, many Americans were conditioned in their choices of ethnicity by this limiting aspect, despite the great leeway involved in how much they decided to identify ethnically or even whether to do so at all.[13]

In general, from the turn of the twentieth century until today, ethnicity, as understood in the field of ethnic studies, has gone from being considered a genetic condition to being viewed as a symbolic condition.[14] Furthermore, since the 1980s greater strides have been made with the idea that ethnic identification might become more and more a question of defining oneself through a process of individualization, composed of conscious and unconscious elements, and with regard to which subjectivity assumes major importance. Such a process prompts one to place greater value on the individual aspects of decision making.

The element of individual decision making appears crucial in Rudolph Vecoli's interpretation of ethnicity.[15] The generations born in America—unlike their immigrant forefathers—had the possibility of choosing. To form the Italian part of their identity, the later generations had different ingredients at their disposal, including, as he writes, the

> peasant values of *la Nonna*; the media images of *The Godfather*; the classic heritage of Leonardo Da Vinci; and the contemporary Italy of Federico Fellini. Folk, popular and high cultures, all meld in the miniature melting pot of the Italian American identity. Italian Americans, in greater or lesser degree, hold these discordant elements in their psyches, and it is the need to reconcile, to synthesize them which energizes their search for identity.[16]

Alba also endorsed the notion, regardless of how Italian Americanness was expressed, that the individual would decide and the decision made by one person would not be identical to that of another. The ethnicity that would survive the melting pot was seen by Alba as being private and voluntary, and the ethnic identity that characterized white Americans had "moved from the status of an irrevocable fact of birth" to an "ingredient of lifestyle."[17]

For John Mitrano, at the end of the twentieth century Italian American identity found itself at a crossroads. Some held that, in the assimilation process, it would fall under the inclusive label of "European American"; others, instead, held that it would persist and prosper in the future, if it were cultivated actively.[18]

More Recent Interpretations

The themes of the current debate on Italian American identity hinge on concepts such as Italianness, Italic culture, Italicity, all of which figure, more generally, in the way Italian heritage is represented in today's America. Over the course of time, Italian America "continued to change and is struggling with its ties to an outdated notion of Italianness."[19] Consequently, the significance of what was Italian or Italian American was called into question, even though these terms subsumed a logic of ethnic identification that was important in all of the immigrant generations.

Based on research conducted with a group of young Italian Americans who belonged to Generation X (born between 1965 and 1980) at the end of the 1990s, Mitrano observed how they were rather passive in the process of their ethnic identity formation. These young subjects exhibited a desire to actively create an ethnic identity, but in doing so, "[t]hey continue to desperately cling to cultural, physiological, psychological, and personality elements, essentially *reactively maintaining* Italian American identity."[20] According to the author, in that moment, the effort of actively creating an ethnic identity composed of new elements remained a question without an answer.

Italianness, or "the taste for things Italian," resists a uniform definition and comprises within it a series of meanings.[21] Reiterating the words of Anthony Julian Tamburri, Paolo Giordano and Fred Gardaphé, we notice that this concept combines in itself "real and mythical images of the land, the way of life, the values, and the cultural trappings of [the writers'] ancestors."[22] Moreover, it contains within it "language, food, a way of determining life values, a familial structure, a sense of religion."[23]

Piero Bassetti's proposal refers to the concepts of "Italic" and "Italicity," a construct that goes beyond Italianness. Italicity, which is the development of Italianness, amounts to a global community: "the Italic is a member of a vast network, or global aggregation, based on morals shared by a civilization."[24] Furthermore, as Tamburri summarizes it, for Bassetti the members of this network can be "inhabitants of Italy [. . .] citizens, emigrants or their children [. . .] immigrants of native ancestry and Italian speakers [. . .] people who neither have any Italians in their family tree nor any Italian spouse, but who have embraced the Italian way of life out of enthusiasm or economic and professional interest."[25] Italicity, therefore, tends to go beyond national identity and represents a meta-national identity of pluralistic belonging.

In Tamburri's words, "What Bassetti is [. . .] underscoring speaks directly to the concept that Italian and/or Italic identity is not based on some monolithic notion of what it means to be Italic. [. . .] The notion of Italicity cannot be 'constructed as an internally coherent object of theoretical knowledge' and hence identity."[26]

In his book, *Feeling Italian*, Thomas Ferraro tells us that his purpose is to "examine the evolution and persistence of Italian Americanness; how it developed [. . .]; how it has influenced the nation at large [. . .]; and [how] it continues to exercise such an appeal."[27] "To 'feel like an Italian,'" Ferraro claims, "means, first, to feel the way Italians feel, to have Italian or Italianate types of feelings, whether recognized or not; and, second, to feel that one's identity is Italian or Italian-like, no matter the ancestry. The phrase invokes cultural continuity over distance and across time, including the *mystique* of such continuity, without relying on credentials of blood."[28] Furthermore, Ferraro points out "feeling Italian is not by birthright so much as it is by choice, a map for educating desire."[29]

Today, feeling Italian in America depends on how particular personal experiences, positive and negative images of Italy, impressions tied to media representations, and many other factors, are combined and interpreted by an individual. Therefore, "there is no homogeneity of Italian 'Americanness,' no place of ethnic convergence as a community with a shared identity or shared purposes. Individuals pick and choose what aspects to incorporate into the personal narrative as these images are bumping up against all the other dimensions that contribute to identity formation."[30]

Survey Conducted with Young Italian Americans in the Greater New York Area

In contemporary American society we find ourselves reappraising and rediscovering ethnicity, as well as reaffirming our ties to a culture of the past on the part of many ethnic and racial

minorities. This goes also for Italian Americans, and for this reason it is crucial to understand how the young generations attribute meaning to this cultural heritage.

The question is whether there is still a relevant link to this cultural legacy; and if so, what sort of link? In the future, will this connection attenuate and even disappear? Or, will the next generations preserve it? How is it possible to transmit this cultural patrimony? Are the newer generations even interested in preserving it? And, finally, which elements of concern are tied to the future and which strategic choices can be undertaken in order to preserve and renew it in a proactive way?

The purpose of studying young Italian Americans can be found in the importance of envisioning a future for Italian American culture as well as for the Italian American community, and, in order to do this, it is necessary to be familiar with the present period of those who will hand down this heritage to future generations. Consequently, it is appropriate to understand how they characterize themselves relative to their Italian heritage, and how that characterization intersects with their identity-making awareness and how they conceive of the way in which other Americans see them.

Following these cognitive goals, over the course of 2013, I conducted a survey based on a sampling of young people in the 18–34 age bracket, all of whom were residents of New York City or the greater New York City area and identified as Italian Americans.[31] Because the label "Italian American" includes a wide range of meaning, it allowed people to take part in the survey who descended from Italians, even if only on one side of the family—either the maternal or paternal side—and who, regarding this identification, fall into the second[32] and subsequent generations of emigration—that is, those who did not themselves emigrate from Italy to the United States. The "first generation" has been considered, in sociological terms, the generation composed of immigrants who hale from a foreign country.

The young respondents who were interviewed represent a cohort of subjects who have self-identified as Italian American (even if some did so with a critical mindset) and, as such, the research was conducted—by definition—"within" the Italian American community.

The sampling is composed of interviewed subjects who displayed a heightened critical sensibility and a solid capacity for self-reflection. They were people with a high level of education who occupy high-profile positions in the United States job market and who largely come from the middle and upper-middle classes and from families that, in turn, are highly educated and who have an elevated status in the social stratification of America. Moreover, they do not have to struggle to reach a distinguished position in the social hierarchy and they are completely assimilated in a society that accommodates their ethnic heritage.

The principal objective of this study was to arrive at an elucidation of these opinions, mindsets, behaviors and perceptions that young people hold regarding a lineage that finds common ground in their familial past and regarding that culture that still strives to be acknowledged by the dominant culture.[33] The fundamental underlying question of this research pertained to changes in the way in which young people fail to identify with, or feel themselves a part of, this background or Italian cultural heritage.[34]

Given the sampling methods that do not reflect probabilistic sorts of criteria and considering the total number of questionnaires analyzed—277—the study has an exploratory aspect and, therefore, the results cannot be generalized—even considering margins of error—to the entire target population. Thus, they should be interpreted as tendential trends.

In the organization of the questionnaire, five principal dimensions became the focal points around which the components and symbols of ethnicity were aligned: physical, personality, cultural, psychological and emotional-affective traits.

Confluence of Meanings in Being Italian American Today: Interpretative Categories That Arose from the Study

One item from the questionnaire asked interviewees to specify whether they considered themselves to be Italian Americans, or, alternatively, under which ethnic profile they might place themselves—even though, to be comprised within the survey, they had already self-identified as such.

From other studies conducted, it became clear that young Italian Americans tend to position themselves and other Italian Americans "along an ethnic continuum. There are degrees of Italianness. One is more or less 'Italian' based upon the number and degree of (a) personality, (b) cultural, and (c) physiological elements that he or she possesses."[35] In the context of the present study, 85.6 percent claimed to identify as Italian Americans, whereas 11.6 percent expressed something contrary to this self-definition. The answers of those who chose NOT to self-identify as Italian American were especially interesting. The respondents who stated on the questionnaire that they did not consider themselves "Italian American" were then asked, "How do you identify?" Their answers are presented here in Table 37.1.

Though this is a limited sample, it is interesting to analyze the alternative modalities proposed by the young subjects as they defined their ethnic identity, since their comments imply a continuum through which ethnic identity may be represented. If we imagine a continuum that connects two opposite poles—where on one end we have "feeling Italian" and on the other "feeling American"—we will notice gradations that accentuate or attenuate the sense of belonging to one or the other nationality.

So, through certain modalities—such as "Italian," "Italian born abroad," and "removed from Italian ancestry"—an extreme position on the Italianness pole is perceived, whereas other modalities reveal an intermediary position, or a balance between the two extremes—as in the case of "Italian *and* American"—and, finally, there are modalities that demonstrates an imbalance toward the Americanness pole—positions expressed by "American with an Italian background," "American Italian" and, lastly, "American."

In order to more profoundly penetrate the attribution of meanings in these identifications, all of the interviewees were asked open questions that invited them to freely express their interpretation.

The overview of responses—in total 220—has an abundance of causes for reflection and of meanings that allow a broad mosaic image—both complex and fragmentary—to emerge and show how today's young Italian Americans represent their Italian cultural heritage taking into account their connection with country of their origins. Diversity, as one of the subjects points out, characterizes the descriptions that were supplied: "It's different for everyone. Perhaps diversity [itself] is a characteristic."

Table 37.1 Alternative terms of young Italian Americans who do not think of themselves as "Italian American."

Alternative to "Italian American"	Frequency	Percentage
Italian *and* American	6	18.8
Italian, Italian born abroad	10	31.3
American with an Italian background	4	12.5
American	4	12.5
American Italian	2	6.3
Other (e.g., white)	5	16.7
Removed from Italian ancestry	1	3.1
Total	32	100

The responses were then sorted into thirteen interpretive categories; from there the categories were further broken down by using the words of those who were interviewed, by including, for the categories—and their respective internal specifications—one or two quotations to serve as representative samples.

Descendants or Non-Descendants?

The two referenced concepts can be tied to the two current principles of interpretation in the debate on ethnic identity—that is, essentialism and constructivism. Despite the fact that the first approach has been widely criticized and that the second is dominant in contemporary debate on ethnicity, in common usage the primordialist (essentialist) interpretation of ethnicity is the prevalent one.

For some young people, the element that typifies identity as Italian American is that of being descendants of Italian emigrants:

> Being Italian American is when both your parents are of Italian descent with a bloodline that can be traced back to Italy.

For others having one parent of Italian descent is enough:

> Having at least one parent that has immigrated to this country who holds the values, traditions, and culture of Italy while embracing the traditions, and culture of America.

For others still, the Italian American can also be someone born in Italy but who came to America and embraced American culture:

> Any person born in Italy who has come to America and adopted American culture, while holding on to their native Italian identity and traditions.

Some young people believe that one's being Italian American is connected to the fact of being born in America but feeling deeply Italian:

> In my opinion, being Italian American is when you are born in America but have a strong connection to being Italian, whether it be through upholding traditions or learning from those who personally lived there.

Others maintain that whoever wants to embrace and respect Italian culture can be considered Italian American:

> Anyone who wants to embrace and honor Italian culture should be considered Italian American.

Others believe that being Italian American means—above all—familiarity with the cultural heritage:

> I feel that being Italian American doesn't just mean that you are of Italian descent, but that you have an understanding of your cultural heritage, or at least of the values, customs, and traditions of your ancestors.

For others, being Italian American represents a mere label that implies no particular connection to a genuine acquaintance with Italian culture and heritage. But, despite that, one feels a belonging in that culture and heritage and a sense of pride:

> I believe now, more than ever, that it is harder to define what it is to be Italian American because those children who are fourth or fifth generation, like myself, are losing the family members or have lost the family members that originally immigrated to the US. These stories unfortunately are lost from one generation to another generation. You may have some memories, but families no longer adhere to the traditions like Sunday dinner, or value family time as much as they used to. Now, Italian American for this upcoming generation is simply a label, less a culture.

Choice or No Choice: Conscious and Unconscious Aspects of Ethnic Identity

As scholar A. L. Epstein argues,

> For the individual [. . .] whether, and to what extent, he acquires a sense of ethnic identity always involves some element of choice. But such choice is subject to a number of constraints. Some of these are clearly social, and relate to certain features of the social system. [. . .] The more the freedom of choice in this regard, the greater the importance that is assumed by a second set of constraints: the various elements, particularly unconscious ones, that have entered into the building up of one's image of self.[36]

And he continues:

> The delineation of social categories is always a two-way process. In differentiating others, that is to say, one is also defining oneself. Hence, ethnic categories always have a dual aspect: they are at one and the same time both "objective," this is external to, or independent of, the actor, and "subjective," that is internal to the actor, a perception of the self. To this perception, moreover, both conscious and unconscious mental processes contribute. For just as certain behavioral traits [. . .] are often rooted in infantile identifications, so the sense of self may also be shaped in ways of which one is not consciously aware. From this perspective then, the sense of ethnic identity appears as a function of the interplay of external and internal perceptions and responses.[37]

The conscious and unconscious dimensions of Italian American identity are exemplified in the context of the critical history of Italian American literature. According to Fred Gardaphé, contemporary Italian American writers can be divided into "visible" and "invisible" with respect to their Italian American cultural "awareness" and these two extremes depict how these writers might relate to their ethnicity through their work. The "visible" writers are those who choose to deal with Italian American experiences in their works, by choosing Italian American subjects. Among these, Gardaphé refers to Giose Rimanelli. The "invisible" ones are the Italian American writers who avoid depicting the Italian American experience as a principle topic of their works. A representative of this category is, for Gardaphé, Don DeLillo. In the works of "visible" writers, Italian Americanness is more explicit, whereas in the words of the "invisible" ones, this is more implicit, subtle, even buried. Despite this, Gardaphé highlights the fact that even the "invisible" authors can

belong to the old world more than they might think or acknowledge. This is precisely the case of some young people who have a scarce awareness of how these cultural trappings influence their lives.[38]

Here is how one respondent phrases it:

> The problem now is that the Italian culture and traditions are slowly fading away because of the lack of knowledge and appreciation of the culture by the younger generations. As the generations increase, if parents don't preserve and celebrate the Italian customs and traditions, most likely, their children won't pick up on it and the Italian culture and language will become part of the past. However, if the children are aware of the history and traditions, then it is up to them whether to carry it on to their children; but because of a lot of young people being absorbed in other things and not caring as much about their family history and genealogy, as well as the Italian language, this is where it all comes to an end.

Knowledge of the Italian Language and Dialects

For some, language represents a distinctive feature of identification, whereas for others this is not the case:

> It is very important to maintain one's Italian-American identity as the generations who emigrated from Italy are lost over time and it's crucial to maintain our culture & identity. For example, many 3rd 4th 5th, etc. generations do not speak Italian. It should be a priority to keep the Italian language alive on this side of the Atlantic.

Yet according to another respondent,

> It means submerging yourself in the culture, practices and values of your Italian heritage as much as possible, you do not need to be able to speak Italian to be considered Italian American.

Values and Strong Sentiments

The connotation associated with values, for many respondents, is the determining characteristic of being Italian American. The greatest emphasis is placed on the family. The connection with values is quite often associated with, and reinforced by, sentiments that one relates to identifying as Italian:

> Being Italian American means having a strong relationship with your family, and extended family. It means having Sunday dinner every week, and making sauce with your mother. Being Italian means yelling to everyone to express every emotion, even positive emotions. It means having very strong feelings of protectiveness, strength, and suspicion. Being Italian means having a connection to the motherland, Italy, and knowing that no matter where you live, that is the amazing and beautiful place that your family originated from years and years ago.

> Today it means being part of an ethnic group that has significantly influenced American culture. Despite the negative stereotypes, many positive contributions have also been made, especially in the culinary industry. Being Italian American

today also means being part of a culture that values family and love. Despite the negative representations of Italian Americans on popular television, I do notice some elements that are positive when it comes to showing how devoted Italians are to their relatives, especially the image of the quintessential over-bearing Italian mother. [...] For many Americans seeing a young man spend so much time with his relatives is quite foreign. Many Americans ridicule how Italian Americans live with their parents until they are 30 years old, but behind that I think many Americans admire the closeness of the Italian family.

Food: A Value All Its Own

As one knows, a group, in its own collective image, often presents as its own unmistakable distinguishing features, attachment and interest in cooking and the notion of food's centrality in the ethnic experience, as well as the importance of social gatherings in the life of a community.[39] Cuisine represents a metaphor of cultural baggage that the immigrants brought with them to America and food plays a significant symbolic role in defining collective and subjective identities. "Family dishes—understood as the sum total of sensorial experiences, of flavor and aroma; ethnic food, with its tradition, typically symbolizes [...] the wealth of a family. [...] It represents an essential and distinctive part of the Italian American experience."[40] One study conducted by Mitrano showed, moreover, the persistence of family food as the symbol of ethnic cultural identity among young Italian Americans of the third and fourth generations:

> Remembering the food your family carried over from their specific region I think is the most important part. And also seeing ourselves in history books because most Italians came over a long time ago.

Traditions and Relationships with Ancestors; Knowing One's Own Personal and Collective History

The feeling of pride in one's ancestors is an element that shines through indirectly in many reflections offered by the respondents, and being Italian American means also realizing the American Dream, just as their forerunners have shown:

> Not only being of Italian descent but also embracing and taking the time to learn about some of the cultural traditions, the history of Italy and your own family's history. Having a desire to keep those traditions alive within your family.

> Today, being an Italian American means what I like to call "Patriotism Through Heritage." By understanding where we came from, the sacrifices that were made, and the values we hold dear, we can see how our people helped build this country into what it is today. We have to remember that our ancestors came to America for opportunity, and even though it wasn't always easy, I'd say we made it.

The Difference between Italians and Italian Americans

Some young people highlight the differences between their culture and that of Italy and Italians. Quite often, in fact, what happens is that Italian American culture can be confused

with Italian culture when one believes them to be one and the same. In discussing Italian values and traditions, some young people claim they feel closer to them than do Italians themselves. In other words, they feel almost "more Italian than Italians." That is the case for one respondent:

> When I visit my family in Italy I often come to the realization that we Italian Americans are a separate culture from Italians, in many ways we have retained more of the values and traditions of Italy than the Italians in Italy now do.

Another writes,

> Not knowing the language, eating the food or cooking the food that we all know Italian American cuisine to be (lasagna, pizza, etc.). Living separately in Italian or white-only communities. It's a pride thing but it's hollow because people do not know themselves. And of course, people assume certain things with pop culture the way it is (Sopranos and Corleones). And being Italian American doesn't mean to actually go to Italy—it's a transplanted culture that severed most ties to the homeland, but still is happy to wave the flag here—if only to differentiate themselves in America from others, which is what most people like to do (any ethnicity will wave their flag but may not know what that represents).

Relationships with Italy

Italy is represented through an image that is, in most cases, real—the result of having lived it and having had experiences there; in other cases, however, we have an "imagined Italy" based on what one has learned of Italy through one's cultural and emotional experiences with Italy, even if one has never visited it personally; in yet other cases, there is a reinvented, reinterpreted, revised and even mythologized image of Italy:

> Unfortunately I think that popular culture has type-cast Italian Americans as ignorant, obnoxious people, who are all in the mob. That has absolutely no bearing on what my culture means to me. For me, being Italian American means that I have strong connections to Italy the way it was 100 years ago when my grandparents left it. Having lived in Italy, I know that the culture we have preserved is not really similar to current Italian culture, but is rather very antiquated. I do, however, obnoxiously believe that I am the heir of a culture that greatly shaped, through both the Romans and the Renaissance, the way the entire world is today.

Past, Present and . . .

Another key to interpreting what it means to be Italian American can be located in a diachronic perspective: it is founded, in some cases, on the past, whereas others recognize in the present certain elements that characterize the significance of this way of identifying. Some also stress the importance of disseminating cultural heritage to the future generations and to their children. The three dimensions can coexist within the same definition of what it means to be Italian American:

> There are two types of Italian American. The older, more traditional, definition is descendants of Italian immigrants who were born here before the 80s or 90s and

grew up in their family's "idea" of Italian living. Most of the time this was not "generally Italian" but rather specific to a town or regional idea that they left with when they left Italy. These descendants grew up in Italian American communities which held on to some old world traditions but also created new ones native only to their own local communities in America. The other, newer definition, is young professionals who are highly educated and intermingle with many people of other ethnicities who create a new life in America. However, do to higher education levels, coming over as adults, and with easier and cheaper travelling (back home) possibilities, as well as Internet and globalization, these future parents can show their children a more "truer," "real" Italian culture instead of an American-made Italian American culture of years ago.

. . . Future

Just as with the other characteristics considered thus far, even the image of a future tied to Italian American culture presents contradictions and discordant expectations. There are forces at play that can enter into competition with one another when "these" young people are faced with actually determining this future through their choices, their personal achievements, and the goals that they will pursue:

> I think that being Italian-American is when you are born in America but follow Italian traditions and customs learned from your parents and relatives. By following these Italian traditions, you insure that these traditions will be passed on to future generations.

Socialization and the Dissemination of Ethnic Identity: Heredity and Learning

A sense of belonging and ethnic identification are transmitted through the process of socialization on the part of significant family figures (among whom parents occupy the foremost position), through contact and growth within a community where there is the presence of members with the same ethnic background, and on a basis of one's desire and choices in learning and research:

> I think family history, genealogy, and trying to learn the language play a big part in it too. In some cases, young people can become interested in the culture themselves, but most of the time, it is the parents' role to introduce the Italian culture and language to their children.

> Being Italian American means having one's own unique blend of characteristics and traditions—both learned and inherited—in a sea of other Italian Americans, whose experiences are not always the same. Much of Italian American identity has to do with where one grew up in the U.S. This is perhaps how Italian Americans first find commonalities with one another—through geographic location. Then we reach out to other Italian Americans through common knowledge of traditions.

Negative Aspects of Identifying: Stereotyped Images

For some, being Italian American has a negative connotation. Problematic aspects are often associated with the negative stereotypes that are introduced and reinforced in the media.

From this, the necessity to combat negative stereotypes emerges through different behavioral models that can be observed from the outside:

> The media has done a very good job of screwing up people's perceptions of Italian-American culture. In the late 20th century, we were all mobsters and now we're arrogant, vain party-animals who only care about dancing, drinking, having sex and shopping. It's unfortunate that many Italian Americans in the younger generations have actually found appeal in and created this type of life for themselves and this is what challenges my pride in my Italian-American culture. However, I feel as if through myself, I can help change this perception (and growing reality) by maintaining the values and beliefs that my ancestors had when they came to America: being hard-working and responsible will lead to success and a better life for you and your family. Being Italian-American also means coming from a culture and group of people who were victims of discrimination and racism but were strong enough to overcome these obstacles and gain equality in the perception of a major part of other Americans.

Group Belonging: Which Community / Communities?

The extension of this relational aspect to a wider context leads many to refer to the concept of community. Even in this case, the interpretations differ, based on the personal perception that each individual had. So, for some the community exists and is a site of legitimacy and cohesion, whereas for others it exists, albeit in a fragmentary way: divided and insufficiently cohesive.

The sense of belonging to one culture and to one group is perceived by many to be a source of pride:

> It is a way of life; it is something ingrained into our DNA. However, here in America it has been forgotten and it is evident from the fact that we do not have a strong community feeling. Is our presence still strong in the major areas of America? Yes, as in politics, industry, business, and so on. But are we a unified people who speak the language, keep in contact with what is going on back in the motherland, know the current status of life and culture there? No and by a long shot. I envy other hyphenated Americans who stay true to who they are. Yet we Italians who have so much more to boast about and be proud about do very little. I envy seeing other hyphenated Americans speak their native tongues and here I am, not able to find one person I can speak to. Language is the main carrier of culture in my opinion and we have lost it.

The Plurality of Italian American Identities: Reflecting on the Survey Results

The relationship between an Italian background and being American rests in a delicate equilibrium. As these two components of identity come into contact with each other, the balance assumes different forms of stability that can be expressed in multiple discreet forms of identification.

The first is the *dual ethnicity* model. In the majority of cases, young people define their condition as one of an integrated identity composed of two ethnicities—a double inclusion

that is the dynamic union of two worlds (the Italian and the American one), which are simultaneously present and perceived as an advantage.

This confirms an idea that Jean Phinney and others maintain: a strong ethnic identity along with a strong national identity is the most suitable road to success for the immigrant. As such, a hyphenated identity is required in order to achieve educational and economic success.[41]

Coexistence of two cultures can possibly lead to a subdivision of spheres of influence, which follow distinct but intermittent connotations, where Italian heritage is lived privately in the familial sphere (private ethnicity), while outside of the domestic confines, the codes of American society prevail:

> To be an Italian American means to live both an American and an Italian lifestyle equally. Whether it be doing Italian things at home and living an American life outside of the home. I also think being Italian American means that you live a better life than if you lived an Italian lifestyle because you still have the freedom of being an American and the culture of Italy.

If in the majority of cases the two cultures blend in an integrated formula that for each subject acquires a different nuance of meaning, in some cases a conflict arises between the two cultures, as does an ambivalence that can generate identity confusion. Such a situation can also produce a sense of marginality, exclusion, diversity seen as inferiority, a *double exclusion*. Some feel they are neither fish nor fowl:

> Sometimes I feel that I am not quite Italian and I am not quite American; I don't fit into either group.

> I feel split between Italian and American (partly because I have dual citizenship and I grew up between the two places). Whenever I'm in one country, I miss the other one. I don't know where I will choose to settle when I grow up, because either way I worry that I will be missing certain places, people and customs.

In some cases, Italian heritage and culture have been scorned and rejected, or reduced to a role in the background where the young ones have embraced the American culture exclusively. For this reason, Robert Viscusi notes that a hidden problem among Italian Americans is Italy itself, which is hidden in two ways: "Many Italian Americans have forgotten all about Italy. It has nothing to do with them, they suppose, even if they still keep their Italian names. They are Americans, pure and simple, and glad of it."[42] For Viscusi, "it amounts to a massive act of denial [. . .] Italian is the difference-marker in the expression *Italian American*; and for a long series of reasons, Italy continues to play a role in giving that expression its meaning as a social and historical fact."[43]

> Italian American to me means someone who has come from Italy, and lives as a citizen of the United States. Being third generation, it is hard to feel like I can claim "Italian-American" status. It almost feels like I'm not "Italian" enough to use that term, even though I identify with Italian culture and heritage. I'm the only person in my family who speaks Italian, who has lived in Italy, and yet, I still see myself as plainly "American." It is difficult to know what gives you that identity . . . much like being a "New Yorker." Five years? Ten years? Who knows. . .

On the contrary, other young people feel more Italian than they feel Italian American or American:

> Being an Italian American is very different than being an Italian. I sometimes tend to consider myself more of an Italian than an Italian American because American influences usually do not portray Italians in the best light. Shows like *Jersey Shore* and *Mob Wives* have given our culture a bad name. The Italian American youth population has created an image that is actually very "un-Italian" but people who do not know any better believe it to be true.

The perspective of the new second generation assumes its own particular physiognomy, which is worth mentioning. This is a matter of children of parents who by and large immigrated to the United States between the 1960s and the 1980s; for these youths, identifying with Italian heritage is above all the fruit of familial socialization—knowledge of Italian culture passed on in a direct and heart-felt way, considering that one or both of the parents were Italian; of personal interest—which leads to an enhancement of cultural awareness through the use of the Italian language as understood by the majority; by feelings of emotional attachment that graft themselves onto the different personality structures of individuals. For the new second generations, Italy is not a memory handed down, nor is it an imagined and reinvented land, but a well-known place, in many cases visited multiple times, and in which one is connected with very close contacts. These generations tend very often to distinguish themselves from the previous generations of young Italian Americans, based, above all, on their direct knowledge of Italy and of the Italian language. Frequently, they look at other Italian Americans as having only a superficial understanding of their own Italianness, removed from any true picture of Italy and of Italians, and accompanied also by the lack of any proficiency in the mother tongue:

> It's hard to define Italian American because I believe there are two kinds. The first kind is the Italian American like me. I've been travelling to Italy since I was born. I spent months there before I started going to school. Once I started school, my family and I would travel to Italy every summer and spend at least 3 months there. We all have dual citizenship. My siblings and I grew up bilingual. We only speak Italian at home. I travel to Italy several times a year. I lived in Milan, studying and working, for almost 6 years. I know there's more to the Italian culture than just pizza, pasta and bocce ball. The second kind of Italian Americans are more of the third and fourth generation Italian Americans, who perhaps have never been to Italy. Or they've been only once. Their idea of "Italian" is pasta, pizza and bocce ball. They think wearing the "corno" means that they're Italian. And they certainly don't speak the language.

Concluding Reflections

As we have seen, there are many ways to be an Italian American and they are part of a virtual community composed of people, ideas, and different ways of interpreting Italianness. It is an extraterritorial Italianness that can be located in a history and a common past—foundational elements, among others—and in a culture made up of various components of which some are retained, whereas others are relinquished.

The reading and the interpretation of the data have shed light on the articulated power of this identification in multiple and complex forms and facets. The connotations that emerge

lead to a more broad range of inclusion in the definition of identity regarding Italian cultural heritage.

In coexistence are both ascribed and acquired traits, conscious and unconscious elements, some deliberately chosen and others unaware; at times, this identity-making process can be intermittent. The main question in the debate on ethnicity is whether or not it is tied mainly to ancestry or whether it is largely a choice. Being of Italian heritage does not imply one's having introjected it as part of one's own identity. Ways of understanding and interpreting one's Italian Americanness are not only different from one individual to another, but even the pathway that leads to one's self-identification varies from one individual to another. For some, in fact, who have no connection to Italian heritage by birth, being Italian American can coincide with a chosen lifestyle, with a template to follow.

What emerges from the study underscores how it is, by now, necessary to break away from essentialist visions of identity and the acceptance of a broad interpretative range of Italian heritage. And not only that: this identity lives alongside many other identities at the same time, with other affinities and identifications.

Bassetti points out that

> multiple loyalties are inevitable. By now we live in a world in which each one of us has a plurality of identities; each one of us belongs to more than one aggregating dimension, not just in terms of ethnicity, nationality and religion, but even in terms of taste, culture, passions, interests [. . .] The globalized world [. . .] will be a mixture of communities, which will no longer aggregate on the basis of old territorial criteria of borders that are decided by the State-Nation, but rather on connections that go beyond geographical limits.[44]

At the same time, what has arisen is a metaphorical image of a multicultural humanity with an identity based not on belonging but on the ability to consciously place oneself above notions of membership: a fluid and mobile individual who lives on a borderline, able to confront differences and similarities among all human beings. This type of human constructs its own identity at the juncture of two or more cultures, not considering any one of them to be central, being that it positions itself on a meta-level that locates it above affiliations.[45]

What emerges from the study is how young people express—in most of the cases—their own way of understanding their own condition as a "mash-up"—that is, as the putative union of two worlds, the Italian one and the American one, simultaneously present and perceived as an "added value" in their life experiences.

For others, however, this double affiliation does not play out in the best of ways. Instead, it creates identity confusion and makes it so that the individual appears to be living in a sort of "terra di mezzo"—a land in between, or a no-man's-land. For yet others still, the singularity of individual identity clashes with the plural image of the group, in which the former has no expressive possibilities and becomes suffocated and depersonalized by the latter.

Also emerging from the research are five "points of attention" on which the identity of young people and the representation of their Italian heritage are based. The first is the values-based connotation, which represents for many the key Italian American qualification. The two components most often associated with the perception of one's Italianness are family and food. The greatest emphasis is placed on the family and it is recognized in the Italian American community for its stability: it is seen as a foundational value, as unity and cohesion, as a lasting bond with its members. It seems evident how, despite the family having undergone major transformations during the last century and how it had profoundly changed in its structure and shape, it remains incredibly meaningful in the imagination of young Italian Americans.

The second point is connected to misrepresentations of Italian Americans. Being Italian American, for some respondents, is associated with negative connotations that often make references to the negative stereotypes surrounding their image—stereotypes often reinforced by the media. Some television programs focus on a segment of Italian American culture that glorifies materialism and aggression and quite often Italian Americans are represented deplorably through the media. For this reason, many young people distance themselves from these negative connotations that are linked to Italian origins and in which they do not see themselves. Between the perceived image of Italian Americans and reality, there are clear-cut differences and it has been widely demonstrated that negative stereotypes that have been attributed to them do not correspond to reality or to the majority of their experiences. Though many of the respondents confirm the strong influence of the media in upholding and advancing such representations, they admit that these imaginary constructions find some basis in the effective reality of the facts. The connection between the Mafia and Italian America is, to this day, pervasive in the collective American mind, and Italian Americans desire very much to be liberated from this stereotype.[46]

Also from the research, it is evident how the stereotypes that cloak the media-driven image of Italian Americans might be "consumer products" just like any other and that—as such—they drive up the ratings with audiences. Many Italian Americans watch these shows and recognize certain aspects of themselves that really characterize them; others, conversely, struggle to have them cancelled. Though many young Italian Americans enjoy watching television shows like *The Sopranos* (1999–2007) or *Everybody Loves Raymond* (1996–2005)—which regularly appear as reruns on American channels—they possess the requisite detachment to "look beyond what they are seeing" and to affirm in real-life interactions that which they hold to be their idiosyncratic ways as Italian Americans. Unfortunately, others, lacking guides to emulate during the process of forming their adult identity, see themselves in, and adapt to, these stereotypical images produced by others.

The third observational point of identification alludes to the recognition and sense of belonging within the Italian American community. Taking into account the collective group image, young people use the community as a reference point. Even in this case, the interpretations of the community are discordant, based on perceptions and personal experiences that bind them to this context; and their own identification with the Italian American community, at large, becomes problematic. The community is, in fact, a context in which one finds discontinuities and disconnections that can lead to intergenerational conflicts. For some young people the community exists as a space of acceptance and cohesion, whereas for others it is—though alive—fragmented and divided. Others have claimed that they do not feel a part of it and, at the same time, feeling lost and disoriented. For others still, identification with the communal context leads to a feeling of pride. In general, the image that results is one of a divided community that reveals within it distinct groups—more communities, one might say—that do not necessarily want to interact or, if they attempt to do so, demonstrate a mindset of mutual distrust.

A fourth cardinal point is the participation of the young generations in the life of Italian American social organizations, which seem to be diminishing and declining. The average age of those who participate tends to continually rise and, in general, support reveals a propensity toward decline. The social organizations, as such, need a generational renewal. On the one hand, young people manifest a sense of exclusion from the organizations that, at times, seem to be centered around the "rhetoric of immigration," which does not allow for new ideas and inroads for the latest generations. On the other hand, there seems to be an emergent passive mindset on the part of the youngsters who do not assume the responsibility and the commitment to change them.

Among the suggestions that the younger generations have verbalized with the scope of achieving this change and renewal, there is one that seeks to provide initiatives more in keeping with the interests, the demands and the needs of the budding generation. What many young people would expect is greater support—be it from the organizations or from the entire Italian American community—in general, for developing youth-oriented forms of expression and creativity.

The last crucial dimension is the one tied to the connection/reconnection with Italy. The image of Italy is a composite: in some cases, it reflects reality; in others, it is just a concept; for others still, we are talking about a reinvented, mythologized, idealized concept. At any rate, Italy plays a terribly important role in the search for identity by Italian Americans. What has happened many times is that young people traveling to Italy have understood the difference between being Italian and Italian American by comparison and through a comprehension of what the two nations might have in common or not. It is a question of being aware that the comparison can occur in many ways—one being the trip to Italy—and that it can allow for coming to the conclusion that we are not "Italians"—as one had believed perhaps through the transmission of collective images of the past from one generation to the other—but Italian Americans:

> It mostly became apparent when I lived in Italy (Perugia) for six months. The feeling is hard to characterize. It was a mixture of wanting to be completely immersed in the "Italian" way of being in the world but always being aware of a disconnect that existed between myself and native Italians. A lot of times it was a sad feeling of nostalgia for something I could have been had circumstances been different. Other times, or simultaneously, it was a firm realization of my American-ness.

In interpreting the significance of travel, Pierluca Birindelli stresses its dual import, as a stimulating experience and as a pleasure in and of itself. Moreover, precisely for its characteristics, travel is a "powerful means for the discovery and construction of one's self-identity."[47]

The traveler who finds themself far from his or her protected environment (family, friends, habits, etc.) encounters the unknown and the experience of diversity generates in him the capacity to compare and contrast. Under this profile, travel can be considered one of the principal modes of having profound experiences. When brought out of his ordinary environment, a young man is obliged to have direct experiences that lead him to an awareness of "who is having this experience." It is a matter of identifying one's character, which would otherwise not be visible in his familiar world. "Travel is a paradigmatic experience, the model of a direct and genuine experience, which transforms the person having it," Erich Leed writes.[48] In the case of a young person, a reason to travel abroad is the one that brings him out of his comfort zone. The character changes that take place through traveling are not the introduction to something new in the personality of the traveler, but the revelation of something that was already present: "In the difficult and dangerous journey, the self of the traveler is impoverished and reduced to its essentials, allowing one to see what those essentials are."[49]

The journey by Italian Americans in search of their most profound roots in Italy closes the circle, placing them in that voyage that their ancestors made in the opposite direction. It is seeking to reconnect with something greater than what might be behind personal and family stories; with the Italian culture; with its richness and history. At the same time, what surfaces are the painful memories that many Italian Americans have tried to erase, withholding them from their own children and grandchildren. They are memories that, however, must

be relived by historicizing them, in order for them to be understood and become a collective, shared legacy.

Translated by Gregory Pell

Further Reading

Gardaphé, Fred. "Running Joke: Criticism of Italian American Culture Through Comedy in *The Sopranos*," *Between*, 6.11 (2016), http://ojs.unica.it/index.php/between/article/view/2138

Sciorra, Joseph. *Built with Faith: Italian American Imagination and Catholic Material Culture in New York City*. Knoxville: University of Tennessee Press, 2016.

Tamburri, Anthony J. *A Semiotic of Ethnicity: In (Re)cognition of the Italian/American Writer*. Albany: SUNY Press, 1998.

Tricarico, Donald. "Narrating Guido: Contested Meanings of an Italian American Youth Subculture," in *Anti-Italianism: Essays on a Prejudice*, edited by William J. Connell and Fred Gardaphé. New York: Palgrave Macmillan, 2010, 163–199.

Notes

1 Fred Gardaphé, *Leaving Little Italy: Essaying Italian American Culture* (Albany: SUNY Press, 2004).
2 Ibid., 13.
3 Richard Alba, *Italian Americans: Into the Twilight of Ethnicity* (Englewood Cliffs: Prentice Hall, 1985).
4 Nathan Glazer and Daniel Moynihan, *Beyond the Melting Pot* (Cambridge: MIT Press, 1963).
5 Giuseppe Sciortino, "La sociologia delle relazioni etniche tra primordialismo e multidimensionalità: una rassegna," in *Migrazioni, risposte sistemiche, nuove solidarietà*, ed. Achille Ardigò, Maura De Bernart and Giuseppe Sciortino (Milan: Franco Angeli,1993).
6 Alba, *Italian Americans*, 171.
7 Mary C. Waters, *Ethnic Options: Choosing Identities in America* (Berkeley: University of California Press, 1990).
8 Richard Gambino, *Blood of My Blood: The Dilemma of the Italian-Americans* [1974], 2nd ed. (Toronto: Guernica, 2010).
9 James A. Crispino, *The Assimilation of Ethnic Groups: The Italian Case* (Staten Island: Center for Migration Studies, 1980).
10 Herbert J. Gans, "Symbolic Ethnicity: The Future of Ethnic Groups and Cultures in America," *Ethnic and Racial Studies*, 2.1 (1979), 1–20.
11 Michael M.J. Fischer, "Ethnicity and the Post-Modern Arts of Memory," in *Writing Culture: The Poetics and Politics of Ethnography*, ed. James Clifford and George E. Marcus (Berkeley: University of California Press, 1986), 194–233.
12 Waters, *Ethnic Options*, 16.
13 Ibid., 17.
14 Jerome Krase, "Italian American Urban Landscapes: Images of Social and Cultural Capital," *Italian Americana*, 22.1 (2003), 17–44.
15 Rudolph J. Vecoli, "The Search for an Italian-American Identity: Continuity and Change," in *Italian Americans: New Perspectives in Italian Immigration and Ethnicity*, ed. Lydio F. Tomasi (Staten Island: Center for Migration Studies, 1985), 88–112.
16 Ibid., 106.
17 Alba, *Italian Americans*, 173.
18 John R. Mitrano, "The Garbage Can Model of Ethnic Identity Formation: A Case Study of Generation X Italian Americans," *Italian American Review*, 7.1 (1999), 83–102; Richard D. Alba, *The Transformation of White America* (New Haven: Yale University Press, 1990); Rudolph J. Vecoli, "The Significance of Immigration in the Formation of an American Identity," *The History Teacher*, 30.1 (1996), 9–27.
19 Jerome Krase, "Little Italy, identità e semiotica spaziale," in *Merica: Forme della cultura italoamericana*, ed. Nick Ceramella and Giuseppe Massara (Isernia: Cosmo Iannone Editore, 2004), 115–141 (136).
20 Mitrano, "The Garbage Can Model," 100, italics in the original.

21 Mary Jo Bona, "Rivendicare una tradizione: Le scrittrici italoamericane," in *Cultura e politica nell'America italiana*, ed. Ottorino Cappelli (Florence: Franco Cesati Editore, 2015), 177–204 (186).

22 Anthony Julian Tamburri, Paolo Giordano and Fred L. Gardaphé, eds., *From the Margin: Writings in Italian Americana* (West Lafayette: Purdue University Press, 1991), vi.

23 Ibid.

24 Paolino Accolla and Niccolò d'Aquino, *Italici: An Encounter with Piero Bassetti*, trans. Robert Brodie Booth (New York: Bordighera Press, 2008), 63.

25 Niccolò d'Aquino, "From Globalization to Glocalization," in *Italic Lessons: An On-Going Dialog*, ed. Piero Bassetti and Niccolò d'Aquino, trans. Gail McDowell (New York: Bordighera Press, 2010), 4.

26 Anthony Julian Tamburri, "Preface," ibid., x.

27 Thomas J. Ferraro, *Feeling Italian: The Art of Ethnicity in America* (New York: New York University Press, 2005), 2.

28 Ibid., 3.

29 Ibid., 7.

30 Donna M. Chirico, "Italian Identity in the Third Millennium: How to Claim an Italian American Identity," in *Meditations on Identity/Meditazioni su Identità*, ed. Anthony Julian Tamburri (New York: Bordighera Press, 2014), 65–76 (68).

31 During this period, I was a visiting research scholar at the John D. Calandra Italian American Institute, which is affiliated with Queens College of the City University of New York.

32 In this case, we are talking about a full-fledged second generation, composed of those who were born into the host society, which Rubén G. Rumbaut calls "generation 2." See Rumbaut, "The Agony of Exile: A Study of the Migration and Adaptation of Indochinese Refugee Adults and Children," in *Refugee Children: Theory, Research and Practice*, ed. Frederick L. Ahearn and Jean L. Athey (Baltimore: John Hopkins University Press, 1991), 53–91; Rumbaut, "Ages, Life Stages, and Generational Cohorts: Decomposing the Immigrant First and Second Generations in the United States," *International Migration Review*, 38.3 (2004), 1160–1205.

33 Ottorino Cappelli, ed., *Cultura e politica nell'America Italiana* (Florence: Franco Cesati Editore, 2015).

34 The tool used to acquire information is a self-report questionnaire, which was made available on line. The complete results of this study will be published in a forthcoming volume.

35 Mitrano, "The Garbage Can Model," 93.

36 Arnold L. Epstein, *Ethos and Identity: Three Studies in Ethnicity* [1978], 2nd ed. (New Brunswick: Transaction Publishers, 2006), xxvi; translated in Italian as *L'identità etnica. Tre studi sull'etnicità* (Turin: Loescher, 1978).

37 Ibid., 14.

38 Fred L. Gardaphé, "Visibility or Invisibility: The Postmodern Prerogative in the Italian/American Narrative," *Almanacco*, 2.1 (Spring 1992), 24–33.

39 Simone Cinotto, *The Italian American Table: Food, Family and Community in New York City* (Urbana: University of Illinois Press, 2013), originally published as *Una famiglia che mangia insieme: cibo ed etnicità nella comunità italoamericana di New York, 1920–1940* (Turin: Otto Editore, 2001).

40 Ibid., 2.

41 Jean S. Phinney, "When We Talk About American Ethnic Groups, What Do We Mean?" *American Psychologist*, 51.9 (1996), 918–927, cited in Chirico, "Italian Identity."

42 Robert Viscusi, "I Cesari sepolti ed altri segreti dell'America Italiana," in *Cultura e politica*, ed. Cappelli, 116.

43 Ibid., 117.

44 Bassetti, *Italic Lessons*, 44.

45 Tiziana Mancini, *Psicologia dell'identità etnica. Sé e appartenenze culturali* (Rome: Carocci Editore, 2006).

46 Ottorino Cappelli, "Introduzione: Tracce politiche nella letteratura italoamericana," in Cappelli, ed., *Cultura e politica*, 36.

47 Pierluca Birindelli, "Playing as Reality: Youngsters Experience in Late Modernity," in *I giovani e le sfide del futuro*, ed. Marisa Ferrari Occhionero and Mariella Nocenzi (Rome: Aracne, 2011), 120.

48 Erich J. Leed, *The Mind of the Traveller: From Gilgamesh to Global Tourism* (New York: Basic Books, 1991), 5.

49 Ibid., 8.

THE ORPHANAGE

Encounters in Transnational Space

Robert Viscusi

Things We Never Talk About but Never Forget

Relations between Italians and Italian Americans are often uncomfortable. Italians find Italian Americans embarrassing—illbred *cafoni* with country manners and loud voices. The *arriviste* who returns to Italy in the guise of a freespending braggart who puts his relatives to shame has a name in Italian: *lo zio Americano* (the American uncle). Italian Americans find Italians equally embarrassing, though for different reasons: Italians are too dressy and too lofty by half. Their politics appear both incomprehensible and unrespectable. Think Silvio Berlusconi. Italy's behavior in the Second World War inspired neither trust nor admiration. Think Benito Mussolini.

What lies under this mutual distaste? For many Italians and Italian Americans, this relationship retains the bitterest flavor of sibling rivalry, a condition where mutual distrust, envy, spite and name calling are endemic. I suggest that we isolate from other transnational spaces the one that Italians and Italian Americans share. This space has a specific character. It is an orphanage.

What You See and What You Don't

The Columbus Day Parade, as celebrated in New York City, is a triumphal march where Italian Americans display the trophies of their victories alongside trophies of Italian commerce. There are marching bands playing familiar anthems. There is an abundance of energetic youths, displaying the fecundity and flowering of the tribe, cavorting on floats that represent the caravels of Columbus; there are strings of Ferraris and Lamborghinis, reminding everyone of Italian mastery in international trade; there are politicians (themselves a show of force); there are Sicilian painted donkey carts where scantily dressed young lovers toast one another with imported wines; there are dancers and singers and movie stars. This spectacle of Italian America, as florid as a pizza and almost as familiar, celebrates a show of abundance.[1] Not especially a comprehensive portrayal. Carnival, not Lent. Far more expressive of the soul of Italian Americans—of their emotional and affective truth—are the processions in which they carry the statue of a saint through the streets, praying for help like orphans crying out for their mothers.[2] (See no. 8 in the Photo Essay.) Between Italy and Italian America there lies a wide void where suffering and uncertainty have made themselves known and felt throughout the history of this transnational space, which I believe changed its shape after Italy signed the Maastricht Treaty in 1993.

In this essay I have painted in miniature the internal dynamics of the relations between Italians in Italy and Italians in the United States of America during the long twentieth century—roughly 1891 to 1993—when Italians went everywhere, to be sure, but discovered a distinct destiny in the United States as it became the megalith of the contemporary world.

My privileged witnesses are memoirists and novelists and essayists and poets, those who concern themselves with the geography of the inner world.

From Italy to Transnational Space

Italy may or may not be a failed state, but it is certainly a failed revolution. The Risorgimento (1821–1861) promised a great deal to Italy's poor and excluded populations. It expressed their emotions in its ideology. Indeed, it stood on a long history that joined the sorrows of the poor with the frustrations of well-to-do Italians:

> Noi fummo da secoli
> Calpesti, derisi,
> Perché non siam popolo,
> Perché siam divisi.
> [We were for centuries
> Trampled, scorned,
> Because we weren't a people,
> Because we were divided.][3]

Rich or poor, whoever sang this war anthem recognized its thumbnail sketch of post-Imperial Italian failures. These failures inspired the diplomats, soldiers and guerrillas who populated the nineteenth century insurrection that aimed to produce a nation. The military and diplomatic successes of the Risorgimento were at best implausible. To be sure, when seen against the long background of ignominy that preceded them, these victories now seem almost uncanny. The Risorgimento raised great hopes, but these were destined to go largely unfulfilled. Indeed, United Italy, whether as a kingdom (1861–1947) or as a republic (1948–present), has yet to conduct its civil and political affairs with a level of distinction (whether real or imagined) remotely comparable with the brilliance of its war of unification. During its first fifty years of existence, the Regno proved itself unable to fulfill its promise to the poor of Italy, who left in droves, depopulating whole provinces in the search of a more generous destiny—in the Americas south and north, in Italy's doomed African colonies, in Scotland and Switzerland, France and Belgium and Germany.

There are many ways to think of where they were going. Yes, they were definitely leaving Italy, entering a large variety of national and subnational cultures, climates and microclimates of invention and habitation. But many were not really leaving at all. Italian Americans, in particular, were entering instead a large transnational and transactional space, full of destinations and crosshatched with vectors, where many of them would continue to work directly with Italy as a nation, a partner and a metropole.

Relations between Italians inside Italy and Italians outside of it are a large subject that can be approached in many ways. Migration historians tell us that 50 percent of the Italians who left during the years of the Great Migration (1880–1924) returned to Italy at least once, sometimes more than once, sometimes permanently. Though the Fascist regime and the Second World War sharply interrupted this rhythm of return, the liberalization of U.S. immigration quotas in the 1950s primed the pump from Italy with relatively well-educated migrants, and the economic progress of Italians outside Italy enabled them to engage in a new level of reconnection with the roots of their national culture and the branches of their families, towns and provinces in the *madrepatria*. That their social ambitions should involve renewed involvement with a nation they had abandoned calls for some comment.

It is clear that most Italian emigrants did not choose to settle in the United States, but went instead to many other countries in the Americas and in Europe. These settlers soon enough lost their sense of belonging to Italy with any sort of anagraphic filiation. They came to identify themselves as Argentines, Brazilians, Germans and Swiss without the need of the prefix *Italian*, let alone a hyphen to bundle two identities together. In the United States, this adoption of a new identity did not always take place so cleanly. Donna Gabaccia's explanation of what happened instead is enlightening. She underlines that "the United States shares with Canada and Australia a long history of subjecting and conquering the indigenous peoples it conquered." She adds the following:

> France, Canada, Germany, Australia, and Argentina are just as much nations of immigrants as the United States is, yet none has generated an equivalent of the immigrant paradigm as symbol of their nation's distinctiveness.
>
> [. . .]
>
> Histories of Argentina, Brazil, and France show limited interest in migrants once they have become citizens and entered the nation.
>
> [. . .]
>
> What makes the United States different from Canada and Australia is its long history of slavery as a source of significant national disunity. It is this history . . . that explains the creation of the immigrant paradigm in the United States and not in other English-speaking countries.[4]

In the United States, the Italians came to occupy an ethnic silo homologous with, and often physically adjacent to, the one to which African Americans were consigned. Their condition was not quite the social death of slaves, but it was hardly that of the American citizen freely enjoying the rights to life, liberty and the pursuit of happiness. Immigrants who settled in the United States who remained attached to a national identity they had supposedly left behind were marking themselves and their posterity with the signs of their civil disabilities and their abject condition. The complexity of their situation stands forth in the sequence of events surrounding the lynching of eleven Sicilian immigrants in New Orleans in 1891 (see Chapters 12 and 29). Clearly, the Sicilians were despised much as the African Americans who lived in the same neighborhoods. The lynching followed the pattern of African American lynchings, with approval at the highest level. In this case, the mayor, one Joseph Shakespeare, was the responsible party. For justice the Sicilians had to appeal to the Italian government, which placed an embargo on exports of American pork until such time as the United States paid the families of the lynched men an indemnity. Only over the objections of some in Congress, who accused him of "unconstitutional executive usurpation of Congressional powers" and threatened impeachment, did President Benjamin Harrison pay the indemnity for a crime he called an "offense against law and humanity."[5] This narrative, with its appeal to Italy from across the ocean, provided a template that was roughly followed ever afterward. Italian immigrants secured their civil rights in the United States with the term "Italian American," which tied them together with their co-nationals on the other side of the ocean.

Transnational Space

That solution has only worked at the price of locating Italian Americans (*qua* Italian Americans) firmly in transnational space, not entirely here and not entirely there. Transnational

space is both full and empty. On the one hand, it is thick with commerce: oils and silks and manufactures of every kind, wines and children and priests and women; paintings and sculptures and richly wrought caskets filled with treasures. On the other hand, transnational space is a void. It is that aspect of national space where no one, in fact, belongs. It is, clearly, an aspect of the national system. Before there were nations, the ocean and the sky belonged to the gods. But afterward they became wastes, where no one had roots or parents.

The twentieth century, with its vast multitudes in flight from improvident regimes and malignant states, has become a chronotope where the transnational void afflicts not only those who are driven out of their homes but also, by a well known reflexive mechanism of self-awareness, it afflicts those who initiate, and even those who passively witness, the driving out of others. The encounter of those who stay with those who go is so persistent, so ubiquitous, that it renders transnational space a site where dispossession is sometimes universal. I say *sometimes* because we are speaking of a way of seeing, a way of feeling that underlies other dynamic emotions. How large is this *regno doloroso* remains to be seen.

Transnational space is a void, where many things have been removed that can never actually be replaced. When Italian Americans consider Italy, they are working with a drastically reduced encyclopedia. They may know the name of the town, let us say, but do they know who lives there any more? Do they still speak the dialect? Do they speak the standard dialect, or even a regional variety, of Italian? Do they know the names of the merchants in the town? What ideas do they have of the political life of the town, the region, the province, the nation? Do they know the names and programs of the political factions? On the other side of the map, the Italians are working with an equally inadequate toolkit. Do they know even the names of any relatives or friends in the United States? Where do they get their ideas of American local, state, regional, national, or international concerns and policies? These are just a few of the things that are often missing. On the one side, when people leave a place they have known intimately, they will miss it on the most intimate levels of cognition. All of the senses will feel the lack: the garlic has a different taste, the air another perfume, the weather has new rhythms of change, the trees and the flowers and the heights of the hills, the colors of the skies and mountains are all strangers. On the other side, if one does not know the language of the new place, one slips into a tiny world of discourse. If one learns the language, the process has many levels of mastery. Daily life, in the rites of food and love and work and rent, presents the most isolating lessons in language, either sending the migrant back to the familiar words of the mother tongue, or narrowing the focus of discourse in the new language. In one's native place, wider concerns—legal, narrative, interpersonal, theoretical, theological—more readily come to the tongue, and thus, to the mind.

Images cross the ocean in drastically reduced forms and give way to lurid distortions. Popular ideologies deal in schematic notions and industrialized nostalgia. The transatlantic space is intellectually thin, but emotionally it is a force field of considerable intensity. Its gravitational pull arises from unfathomable depths of political culture, where institutional, legal, and ideological histories mingle and breed continuously, always producing new forms with deep ties to their predecessors. At the bottom of the transatlantic space, there is a seam from which emerges a steady flow of indelible stereotypes.

We have a metaphor to explore, outlining some ways that Italian and Italian American writers have dealt with the ideological force fields of the transnational space they share. A complete survey of so complex a terrain is impossible, but I will focus on the peculiar history that attaches to the orphanage, which amounts to a figure for this particular transnational situation. In the orphanage, the winds that blow speak of the remembered or dismembered world of the past, or they tell of the possible or impossible world of the future. The

local world, the present time, of the orphanage is more than anything else the crossing place of ideological programs which may, and indeed do, arise from every quadrant of the chart.

The Raised Fist

Edmondo De Amicis (1846–1908) describes the departure of emigrants on a steamship leaving Genoa for Buenos Aires. They have been loaded into the steerage they will share with livestock and every other sort of cargo, and now they turn to face the city they are leaving:

> The city already glowed with lights. The steamer glided silently through the half-darkness of the port, almost furtively, as if it carried away a cargo of stolen human flesh. I pushed myself towards the bow, into the thick of the crowd, which was all turned towards the land, to watch the amphitheater of Genoa, which was now rapidly lighting up. A few of them spoke in a low voice. Here and there in the dark, I could make out seated women, babies at the breast, with their heads in their hands. Near the forecastle, a rough and solitary voice cried out in sarcastic tones—"Viva l'Italia!"—and lifting my gaze, I saw a tall old man who raised his fist to the fatherland. When we were beyond the port, it was night.[6]

De Amicis the observant nationalist takes ship with a load of immigrants and sails with them all the way to Buenos Aires, providing a brilliant account of life in steerage—seen, as it were, from above—for his bourgeois readers. The preceding passage is a supreme sample drawn from the large archive left behind by journalists and novelists with good educations going among the *terroni* and *emigrati* and reporting back to their metropolitan readers in the pages of newspapers and travel books: Dario Papa (1846–1897), Adolfo Rossi (1857–1921), Ferdinando Fontana (1850–1919). They were anthropologists in everything—in class, in sympathy for the oppressed, in prose style—in everything, that is, except method. Unlike the cagey social scientists of those days, these writers included in their kits the arts of dramatizing their own positions, of rendering scenic and even comic the differences between themselves and the people whose hopes and sorrows they were observing. They were not so much dispassionate observers as they were *simpatici* among friends, cabin class passengers sharing their observations with their companions in the lounge.

The old man with his fist in the air spoke for the mass of poor emigrants, whose disappointment with Italy would not leave them for a long time. There were many such among the Italians in the United States. They became socialists, communists, union organizers, anarchists. Gaetano Bresci (1869–1901), a silk weaver from Coiano near Prato in Tuscany, migrated to the United States in 1896, fresh from imprisonment on the island of Lampedusa for his anarchist activities. By 1898, he was married and living in Paterson, New Jersey, where he found work in his craft and companions in his struggle for justice and equality among the anarchist silk workers of that town. That same year, events in Milan posed a definitive challenge to him. Bread prices rose, leading to mass protests. King Umberto (known as "Humbert" in America) ordered General Fiorenzo Bava Beccaris to put down the strike, and the officer responded by having his soldiers open fire on the protesters with rifles and cannon. At least four hundred people were hit, and at least ninety of them died, including the sister of Gaetano Bresci. Some might have expected the king to reprimand the general for his excess. But Umberto was grateful to the general for defending the royal family, and awarded him the highest military honors. Bresci, like radicals around the world, was outraged. Telling no one of his plan, he went back to Milan. On the night of 29 July 1900, near the royal villa in

Monza, he shot the king three times in the head, killing him instantly. Bresci was immediately apprehended, soon tried and found guilty. "I have not shot Umberto. I have killed the king; I have killed a principle," was his defense. Among the many who condemned Bresci for his act of summary justice was Edmondo De Amicis, whose sympathies, although broad, not surprisingly did not embrace terrorists. There was no capital punishment in Milan, so Bresci was sentenced to life in prison, where there was no sympathy awaiting him, either. The following year he was found hanged in his cell. He became a martyr of anarchism and the first Italian American to intervene decisively in the history of the country he had left.

The Pick and Shovel Poet and the Missionary's Wife

Many voyages become acts of vengeance. They inflict unforgivable losses whose memory colors the transnational space that Italians and Italian Americans share in markedly different modes. It may seem that Italian Americans make more of these memories, the ocean with its size and its sorrows rolling on in the background of many of their twentieth-century recollections. Many of these migrants, living as well as dead, wash up on the shores of New York and New Jersey—and they are alone, their families having been left behind or, just as frequently, splintered while trying to gain a foothold on the steeps of American livelihood. Pascal D'Angelo, the "pick and shovel poet" in his memoir *Son of Italy* (1924) writes of struggling to make his way as a laborer in the United States alongside his father. The two have come to America together with others from the pastoral poverty of Introdacqua in Abruzzo. His father eventually gives up the struggle and returns to Introdacqua, but Pascal makes his way, partly in the company of fellow laborers and largely all alone in the public libraries—and at a fateful performance of *Aida* he attends one summer evening at the Sheepshead Bay Racetrack. His is the perfect orphanage life recounted by many Horatio Alger types in immigrant literature—shoeshine boys, farmhands, hoboes, streetcorner philosophers. This displaced shepherd's discovery of *Aida* is a belated encounter with his Italian national identity. This meeting makes him a poet, according to his own accounting of its effect upon him. It does not heal the breach or answer the aloneness.

Nor is this aloneness a curse that afflicts only the poor immigrant. In the 1920s, the distinguished Italian journalist Luigi Barzini, Sr. (1874–1947), moved with his family to New York, where he founded and directed the *Corriere d'America* [American Courier] from 1922 to 1931. In the memoir of his son, the even more distinguished Luigi Barzini, Jr. (1908–1984), the sorrows and frustrations of wellbred Italians in the United States get full attention. In a tourdeforce of understatement, he describes his mother's difficulties with American life:

> For some reason, she never felt happy in the United States. She had few friends and it was difficult for her to meet the well-travelled, wellread, wellmannered Americans with whom she could have exchanged *mots d'esprit*, obscure quotations, rare kitchen recipes, reminiscences, and anecdotes. She thought such Americans did not exist. She had a group of European lady friends who, when they gathered around the tea table, talked of nothing but the barbaric habits of the natives. What disturbed her about Americans was their lack of interest in the things that filled her life—books, poetry, history, and well-turned phrases—their indifference to the virtues she cultivated: moderation, discipline, skepticism, prudence, thrift, patience, and understanding. She was frightened by their noisy and indiscriminate enthusiasms. She lived in the United States eight months a year (she went back to Italy every summer) as resignedly and courageously as the wife of a missionary in an incomprehensible and practically uninhabitable country.[7]

The last touch in that paragraph is the summary gesture in this character sketch: Barzini, Sr. and his wife were colonists in the strictest sense of the word, people who had little to do with the natives, whether these were Italian immigrants or indigenous Americans. It is unsurprising that Barzini, Sr. returned to Italy as a faithful servant of the Mussolini regime, a role he would continue to occupy even after the Duce had been deposed in Rome and the German Army had reinstalled him as Capo of the Repubblica di Salò which from 1943 until the arrival of the American Army in 1945 controlled most of Northern Italy.

Luigi Barzini, Jr., lived much of his life between the United States and Italy—for a long time, he revisited America almost every year—interpreting America for Italians and Italy for Americans. His bestseller *The Italians* (1964) was an introductory guidebook for Americans who wanted a key to the ideological histories embedded in Italian art and culture. Some years earlier he had written a work intended both for Americans and for everyone else. "The Americans inherited Christendom in 1945 because they not only are able to design and build wonderful machines but can also reproduce them in great quantity, at great speed, and at a low cost."[8] This unexceptionable observation leads him to a memorable vision:

> It took the Americans three years [after the war]—too late to save China and Eastern Europe—before they began to suspect what had happened, that *they were alone in the world* [italics mine], that history was to be shaped by their decisions, the decisions of the President, of the Secretary of State, the generals in the Pentagon, the senators and the representatives.[9]

This categorical vision can be read on two levels: for his readers, it is a standard sample of early Cold War rhetoric; for Barzini himself, it expresses his immersion in transnational space, where Americans may be alone in the world, but they are alone together with the other orphans of history:

> Americans forget that the United States is also an ancient European nation. Morally, if not geographically, she should be placed in the North Sea, with borders touching Great Britain, Normandy, Belgium, Holland, Germany, and the Scandinavian countries, with a long tail reaching into the Mediterranean, where the California vineyards and the sun-baked plains of the Southwest could find room. [. . .] Now that many Americans have reached a dead end, and the old simple rules have shown themselves to be useful but insufficient, they are looking for some new assurances, for new guides, and they will remember that they are part of a vaster world and that they have never really broken away from an experience which goes back many centuries.[10]

A baroque argument for Barzini's personal resolution of the Italian + American question, this transnational brotherhood of orphans appears at the intellectual convergence of parallel lines that recurs frequently in the more hopeful and sentimental of writers on either side of the empty transatlantic space.

America Is an Orphan

Author Ignazio Silone (1900–1978) foregrounds the emptiness that Italians in Italy share with Italians in the United States. He focuses on survival, which he places within the

constricting frame of daily life among the desperately poor. In his first novel *Fontamara* (1933), the narrator pauses during a walk through a halfempty town in the mountains of Abruzzo:

> We stopped to rest for a bit in the shade of the cemetery wall. Against that wall there stood a few mausoleums belonging to peasants who had grown rich in America. Not rich enough to buy a house and land and to live better, but enough for a tomb that after death would make them equal with the gentry.[11]

In the killing fields of transnational space, not only the immigrants but also their dreams and ambitions lie under the monuments of their failure.

Of the Italians to come to America and then return defeated to Italy, none had a sharper disillusion than the poet Emanuel Carnevali (1897–1942). Here he is, sailing up the Hudson:

> This was New York. This was the city we had dreamed so much about, and these were the fabulous skyscrapers. It was one of the great disillusions of my entire unhappy life. These famous skyscrapers were nothing more than great boxes standing upright or on one side, terrifically futile, frightfully irrelevant, so commonplace that one felt he had seen the same thing somewhere else.
>
> This was the long-dreamed-of New York, this awful network of fire escapes. This was not the New York we had dreamed of, so dear to the imagination, so cherished among all the hopes a man may hope: this dream of the dreamless, this shelter of the homeless, this impossible city. This miserable panorama before us was one of the greatest cities in the world.[12]

"This miserable panorama before us was one of the greatest cities in the world." That remarkable sentence is a sarcastic oxymoron opened up, unfolded, and splayed before us like the innards of a fish. It is a mistake to read such prose as simply a fortunate example of immigrant writing. This prose strikes at the heart of the human condition and belongs to world literature. Carnevali recognizes the massive disillusion (*delusione* in Italian) of this moment on the Hudson River as a moment of naked revelation. Behold the transnational space. Its towering illusions collapse under the gaze of the cleareyed pilgrim.

Possibly the best known of Carnevali's poems makes it clear that he had found his world orphanage in America. After his meteoric career as a young poet in his early twenties, Carnevali returned to Italy desperately ill, filled with a sarcastic hope:

> Italy is a little family;
> America is an orphan,
> Independent and arrogant,
> Crazy and sublime,
> Riding headlong in a mad run which she calls progress.
> Tremendously laborious America,
> Builder of the Mechanical cities
> But in the hurry people forget to love;
> But in the hurry one drops and loses kindness.

And hunger is the patrimony of the emigrant;
Hunger, desolate and squalid—
For the fatherland,
For bread and for women, both dear.
America, you gather the hungry people
And give them new hungers for old ones.[13]

These new hungers are what he has brought back with him to Italy:

I have come back and found you
All new and friendly, O Fatherland!
I have come back with a great burden,
With the experience of America in my head—
My head which now no longer beats the stars.

O Italy, O great shoe, do not
Kick me away again![14]

Whereas feelings run both east and west across the transnational void, their most striking characteristics are their mutual similarities. Almost as striking as "America is an orphan" is the line that precedes it: "Italy is a little family," which speaks from the perspective of the veteran who has seen New York and Chicago, "Tremendously laborious America / Builder of Mechanical cities." This little family is not the Italy that the Risorgimento aimed to build, but rather the Italy that the returning migrant sees with his American eyes.

The Italian American in Italy

In the 1920s and 1930s, the sense of a universal homelessness begins to spread. In 1936, the Sicilian American writer Jerre Mangione (1909–1998), still a young man, decides to visit the Sicily that his parents had left behind. Before Mangione embarks, his friend Carlo Tresca, the most notorious Italian anarchist in America, throws him a going-away party, to which many well-known radicals are invited. By this time, Tresca is already a target of Mussolini's, and Mangione can't help wondering whether there are any Fascist informers hiding among the guests at this party. But he buries his doubts and concentrates upon family investigations. His uncle Stefano in Rochester, New York, has charged him particularly to ask after Zio Vincenzo, a relative who returned to Sicily some years earlier, giving shape to an ambition that Stefano has been harboring for himself. Mangione visits Agrigento and finds Zio Vincenzo. They pack a lunch and take a bus out to the Valley of the Temples. "There," he writes, "with our backs resting against a column of the Temple of Concordia and our eyes on the sea, we ate and conversed."

[Vincenzo] asked about his old friends [in Rochester] and wanted to know if Uncle Stefano was still talking of returning to Sicily. I told him it was still his dream; in Rochester he would never stop feeling like a foreigner.

"I used to feel that way there," [Zio Vincenzo] said. "But actually I feel much more foreign here. Tell Stefano to stay where he is. Things have changed here. There is still beauty, of course, especially in the spring when this valley is filled with wild-flowers, but I find that beauty is not enough for me. The neighborhood in Rochester where I lived is far from beautiful, but I would rather be there. There is a blight on all of Italy and it seems to be getting worse. The newspapers claim there won't be

another war, but I don't believe it. I can see it coming closer all the time, the biggest war the world has ever known, and I curse the day when I decided to come back to this benighted land."[15]

Here the narrator enters a transoceanic hall of mirrors. He has come to Italy with a vast curiosity that in short order receives an abrupt reply. He sees that his uncle misses "his old cronies" and, more important, "the American prerogative of speaking one's mind without fear of being reported to the authorities as a subversive." Now that he is actually in Italy, he finds himself continually surrounded by informers, some of them his own relatives, who are shocked to learn that he has written critically of the regime and of its great writers, including Luigi Pirandello. He discovers that his letters are being opened and read before he has received them. "Perhaps they think you are American spy," his cousin suggests. This terrifies him. "I bitterly pictured myself answering [my] letters from a Fascist jail cell." His cousin tries to reassure him. "If they wanted to nab you, they would have by now. They must have decided you aren't a spy."[16] His distress does not abate, however, and it leads to something he finds even more unsettling:

> The opened letters were not my only concern. I was also upset by the frequency with which Italians mistook me for a native. In the fever of my anxiety, I began to feel I was gradually losing my identity as an American. The most shattering of these experiences took place in the Palermo train station when an elderly, well-dressed traveler, to whom I had turned for assistance in unraveling the mysteries of the timetable for Rome, began berating me for trying to make a fool of him by pretending I was a foreigner.[17]

Though Mangione tries desperately to explain himself, even showing the man his American passport, the man just grows angrier. "He left without apologizing, still angry, declaring at the top of his voice that Americans had no business being in Italy."[18] After that, Mangione speaks in broken Italian and wears loud neckties, hoping to make it clear he is not an Italian. "Although I hungrily sought the company of American tourists as a means of asserting my birthright, at times they only emphasized my sensation of not really being one of them."[19] Though he continues his travels, visiting Florence and Venice, he never quite recovers from this loss of "birthright" and leaves for America sooner than he had planned. This episode is a bitter foreshadowing of what was about to happen when the war began. Italian Americans, many like Zio Vincenzo, had kept warm in their hearts an image of Italy, now furbished with the glory of Mussolini's relentless publicity about Fascism's achievements. When Mussolini declared war on the United States three days after the bombing of Pearl Harbor, he expected Italians to return to Italy and fight for their "fatherland," but things had changed. Almost immediately, Uncle Sam told Italian Americans to stop speaking the "enemy's language" and to "speak American" instead. Many of them were rounded up and sent to internment camps. Italy, that had stood behind Italian Americans in New Orleans in 1891, now wanted them to fight against the country where their children had been born. They did not heed the appeal. In the end, Mussolini felt betrayed, and the Italian Americans felt abandoned.

Rehoming

In the postwar transnational space, the paranoia and despair of wartime seemed to have become chronic conditions. In the United States, the McCarthy purges caused many Americans, Italian Americans among them, to repent and to eradicate their prewar political

affiliations. Vito Marcantonio, the Socialist who represented Italian Harlem in the House of Representatives, saw his career go down in a storm of redbaiting when he ran for Mayor of New York City in 1950. Unions began to weaken and wither in the deadening regressive atmosphere of the 1950s. In Italy, the Italian Americans came to be framed by their participation in the American Army that had invaded Italy in the 1940s. These historical transformations registered in the imaginations of Italian Americans and Italians as betrayals, in a map of reflections, projects, and actual treasons too complex to map and best registered in the fantasy world of fable.

The best portrait of this ideological hall of mirrors is Leonardo Sciascia's *Candido, ovvero un sogno fatto in Sicilia*.[20] The eponymous hero of this novel of 1977 is born in the heart of the particular transnational situation we have been following:

> Candido Munafò was born on the night of July 9–10, 1943, in a grotto that opened, wide and deep, at the foot of a hillside of olive trees. Nothing was easier than to be born in a grotto or in a stable that summer and especially that night in Sicily, as it was fought over by the American Seventh Army under General Patton, the British Eighth Army under General Montgomery, the Hermann Goering Division, and several almost invisible Italian regiments.[21]

"Born in a grotto" in the middle of an epic transnational battle—American, British, German, Italian—led by famous commanders—Patton, Montgomery, Goering and the invisible Italian—Candido's biblical and epic qualifications are ironic: "There was . . . no supernatural or premonitory sign in Candido Munafò's being born in a grotto," nor in any of the other accidents of his birth. This is a fable that begins, at least, in real time, on a specific historical date, and proceeds to weave its peculiar notions on ideological themes richly familiar to readers who had lived through this period.

The decisive encounter occurs between the lawyer Munafò (Candido's father) and John H. Dykes (the American captain). The lawyer's family is bereft of everything, especially proper food for the baby.

> The Captain was moved; he had powdered milk, condensed milk, evaporated milk, sugar, coffee, oatmeal, graham crackers, and canned meat sent to the house. Manna from Heaven, even for a house with a larder as well-supplied as was that of Munafò.[22]

This munificence draws a visit from the lawyer, who discovers that Captain Dykes in civilian life is a professor of Italian literature in a university. A long-lost twin indeed. And there's more: "He spoke of his mother . . . His mother was a Sicilian; from a village nearby, only fifteen kilometers away." Though the lawyer has no luck finding any relatives for the captain, he tells his wife of his discovery, uttering the fateful cliché, "It's a small world." Signora Munafò promptly concurs.

> She wished ultimately to make the world even smaller by inviting Captain John H. Dykes to dinner. The *H* stood for Hamlet, a revelation that so enchanted Maria Grazia that when they had reached a point of sufficient familiarity, she ended up calling the Captain simply "Hamlet." This pleased the Captain greatly, for, he said, this was what his mother used to call him.[23]

These are all steps in a magical transformation suggestive of Gabriel García Márquez. Next step:

> Thanks to the milk and other prodigious American foodstuffs, Candido was becoming quite different from the swarthy baby he had been in the first days of his life; he was growing both rosy and blond. More and more, he resembled John H. Dykes.[24]

This resemblance, plus the growing friendship between Maria Grazia and Captain Dykes leads the lawyer to a strange suspicion: "that John H. Dykes might be the father of Candido," a physical impossibility.[25] Nonetheless, it leads to a divorce. Maria Grazia marries Dykes and moves to the United States. The divorce is the most Voltairean moment in this novel named for Voltaire's *Candide*. Neither parent wants the child but both vehemently assert their desire to raise him. The lawyer "wins."

> With due respect for law and appearance, the lawyer Munafò appeared to be vindictively pleased, vindictively happy to have won the match to keep Candido himself, while Maria Grazia appeared dolorous in defeat. However, the person truly defeated was the lawyer: he was forced to keep the son he did not love, the son he could not feel was his son, and whom, unspeakably, in his secret rage, he did not call "Candido" but "the American."[26]

Candido, in accordance with his name, is remarkably forthright. Overhearing one of his father's clients confess to the lawyer that he has in fact committed a murder for which a lieutenant of the *carabinieri* had arrested another person, Candido hastens to tell the lieutenant's son, his nursery school classmate, that his father the lawyer has made a mistake and that the lieutenant is innocent. "Pandemonium ensued." In short order, the lawyer Munafò commits suicide, leaving Candido for all practical purposes an orphan. His mother does not want him. So Candido's father's maid and his Fascist-turned-Demo-Christian politician grandfather take him on. This is the first in a series of rehomings (a practice developed to deal with failed pet adoptions; the term is now used in dealing with unwanted children as well).

Like many a chastened pit bull and pomeranian, Candido learns to thrive by respecting his new owners and his own nature. The orphaned Sicilian who becomes an American without leaving Sicily is a fantasy that had its own brief half-life in postwar Sicily, where some inhabitants wished for their island to become the forty-ninth state of America.

That solution soon enough became a curiosity. Instead of becoming Americans by joining the United States, the Italians became Europeans, first by enthusiastically accepting American aid in all its forms, from powdered milk to Otis elevators, later by joining the European Union, a plausible double to the American confederation. The late songwriter Gianni Buoncompagni (1932–2017) acidly summarizes the situation:

> E se vai a cercar fortuna in America
> Ti accorgi che l'America sta qua.[27]
> [And if you go to seek your fortune in America,
> you realize that America's right here.]

This is another story. The orphanage twins are accustomed to one another by now, their bitterness amounting to sarcasms and other forms of wit and flirtation they use when, visiting Turin, they drink at the gleaming Bar Gramsci.

Figure 38.1 Unframed—Ellis Island, by artist JR, 2014. Photo: JR-art.net.

Further Reading

Cinotto, Simone, ed. *Making Italian America: Consumer Culture and the Production of Ethnic Identities*. New York: Fordham University Press, 2014.

Durante, Francesco. *Italoamericano: The Literature of the Great Migration, 1880–1943*. Edited by Robert Viscusi. New York: Fordham University Press, 2014.

Viscusi, Robert. *Astoria*. Toronto: Guernica, 2003.

———. *Buried Caesars and Other Secrets of Italian American Writing*. Albany: SUNY Press, 2006.

Notes

1 On the progressively commercial character of the celebration see Marie-Christine Michaud, *Columbus Day et les italiens de New York* (Paris: Presse universitaire Paris-Sorbonne, 2011).

2 There are fewer and fewer of these processions nowadays. Their emotional accuracy still strikes a recognizable chord. The classic version is portrayed in Robert Orsi, *The Madonna of 115th Street: Faith and Community in Italian Harlem, 1880–1950* [1985], 3rd ed. (New Haven: Yale University Press, 2010).

3 Goffredo Mameli, "Il Canto degli italiani." (All translations mine).

4 Donna Gabaccia, "Is Everywhere Nowhere? Nomads, Nations, and the Immigrant Paradigm of United States History," *Journal of American History*, 86.3 (1999), 1115–1134 (1132–1133).

5 Richard Gambino, *Vendetta: The True Story of the Largest Lynching in U.S. History* [1977] (Toronto: Guernica, 2000), 126–127.

6 Edmondo De Amicis, *Sull'Oceano* [1889], intro. Franco Custodi (Milan: Garzanti, 1996), 8.

7 Luigi Barzini, Jr., *Americans Are Alone in the World* [1953] (New York: The Library Press, 1972), 58.

8 Luigi Barzini, Jr., *The Italians* [1966] (New York: Touchstone, 1996), 88.

9 Ibid., 91.

10 Ibid., 178–179.

11 Ignazio Silone, *Fontamara* [1933] (Milan: Arnoldo Mondadori, 1971), 56.

12 Emanuel Carnevali, *The Autobiography of Emanuel Carnevali*, compiled and prefaced by Kay Boyle (New York: Horizon, 1967), 73.

13 Ibid., 198.

14 Ibid., 201.

15 Jerre Mangione, *An Ethnic at Large: A Memoir of America in the Thirties and Forties* (New York: G. P. Putnam's Sons, 1978), 186–187.

16 Ibid., 188–189.

17 Ibid., 189.

18 Ibid.

19 Ibid., 190.

20 Leonardo Sciascia, *Candido* (Turin: Einaudi, 1977); *Candido, or A Dream Dreamed in Sicily*, trans. Adrienne Foulke (New York: Harcourt Brace Jovanovich, 1979).

21 Ibid., 3.

22 Ibid., 10.

23 Ibid.

24 Ibid.

25 The provenance of Captain Dykes's mother in a village fifteen miles away might, of course, contain enough genetic material to account for Candido's striking resemblance to Dykes, but no one scouts this possibility. The lawyer particularly obsesses over a more direct genetic line, even though there is no chance of events that would have caused it.

26 Sciascia, *Candido*, trans. Foulke, 18.

27 Gianni Buoncompagni (lyrics), Toto Cutugno (music), "Una Domenica Italiana": a song that satirizes the Italians' addiction to American food, television and other habits of daily life. See Barbara Alfano, *The Mirage of America in Contemporary Italian Literature* (Toronto: University of Toronto Press, 2013). Alfano's contemporary Italian literature begins just about where the bulk of this essay concludes.

CONCLUSION

The Future of Our Past

Stanislao G. Pugliese

We didn't know that we didn't know.
— Lawrence DiStasi, author of *La Storia Segreta*, in
Little Italy, dir. Will Parrinello, 1995

In 1966, a small group of dedicated scholars—several of whom are contributors to this volume—established the American Italian Historical Association. At a time when Italian American Studies were not recognized in the academy either in America or Italy, this was a courageous act. Yet as one of the founding members writes in an institutional history of the association,

> Today . . . a systematic program of Italian American Studies stands on its own merits as an academic discipline worthy of scientific research and constant revision in search of objective knowledge. As a result, the gathering of data and documents in archival centers, the accumulation of contemporary publications, and the universe of original research in Italian American Studies have supplied present and future students a solid foundation on which to nurture seminal studies and to compose a much needed definitive synthesis on Italian American history.[1]

Editors and contributors hope that this volume provides that "needed definitive synthesis" of our collective history. One guiding principle has been an understanding that Italian American history must also perform a simultaneous collaboration with a panoply of ethnic studies, American studies, women's studies, labor studies and LGBT studies.[2] At the same time, we are conscious that Italian American history must reestablish a dialogue with Italian history by asking new questions.

For example, what is the significance of the fact that, as soon as it was physically possible (via steamship, travel agents, the telegram), millions of Italians left the new nation-state only one generation after its supposedly longed-for founding? The departure of its citizen-subjects is perhaps the greatest indictment of the failures of modern Italy. For much of the last century, these emigrants were seen as the dregs of Italian society: poor, often illiterate, bound to a semi-feudal society defined by patriarchy and superstition, scorned by Italians as their "*cafoni*" cousins and ignored by Italian historians. Robert Viscusi writes how "A whole nation walked out of the middle ages, slept in the ocean and awakened in New York in the twentieth century."[3] Yet these very emigrants—for the most part and not without failures[4]—somehow managed not just to abide but to succeed. In the common phrase, "*Aggiu fatt' a 'Merica*"; they had "made America," but at what price? What was it in Italian peasant society that endowed these folk with the tools for material, social and political success? What resources remained in the case of failure? What historical, cultural and psychological

attributes permitted the various levels of attachment or divorce from Italy? Only the latest generation of Italian scholars—several contributing to this volume—have taken up a serious study of Italian Americans.

Today, there are as many Italians outside the country as within and emigration continues apace. A father's letter published 30 November 2009 admonished: "My son, leave this country." This was no desperate landless peasant beseeching an illiterate son but the General Director of RAI, the Italian state radio and television network, writing to his university-educated son. What does it mean for Italian Americans when such person says to his own progeny "This country, your country, is no longer a place where you can remain with pride."[5] Contributor Fred Gardaphé has provocatively and ironically argued that to save Italian America we must "leave Little Italy."[6] In the same vein, perhaps it may be necessary that Italians leave Italy to save it.

What does it mean for Italian Americans when the face of Italy is rapidly changing with new waves of immigrants? Will we still look back with nostalgia and look forward with hope, historically aware that Italy has always been a country of constant new "Italians"?

<p style="text-align:center">★ ★ ★</p>

For this project, the editors took as a starting point one of the founding principles of the Italian American Writer's Association: "write or be written." That is, it is imperative that Italian Americans be the authors of their own story in collaboration with other scholars. "Italian Americans need to write their own realities," the Association insists, "rather than waiting for others to do it for them."[7] This idea does not endorse hagiography but rather a critical reflection and thoughtful analysis of a complicated journey from steerage, prejudice and violence to the suburbs and corporate offices and Supreme Court of the United States as well as a willingness to acknowledge the complexities, problems, paradoxes and ironies. The central fact that many Italian Americans are today writing their own stories has been foundational for the development of these studies into the transnational field, comprising scholars of the most diverse nationalities and ethnic origins, that is has now become.

Immigration historians have mapped out their historiography in metaphor. From the "melting pot" imperative of the era of mass immigration and forced assimilation, to the "salad bowl" model of ethnic preservation to the "gorgeous mosaic" to the "trash can" model of selectively retrieving what we want to preserve or consume from the past. But there is a danger that without history and archaeology, the past produces not understanding and knowledge but only kitsch. Witness the Venetian casino in Las Vegas, built to resemble a palazzo on the Grand Canal, complete with gondolas imported from Venice. Less objectionable but still problematic is the Italy pavilion at Disney's Epcot Center in Orlando, Florida. Here, simulacra of Venetian gothic, Tuscan classicism and Roman baroque have been plucked and rescued from the dustbin of history for our enjoyment (and consumption). In California—that utopia of reinvention—there is a city of Naples, founded as a simulacrum of nearby Venice, California, itself supposedly a copy of the original city. The Eataly phenomenon represents a more complicated negotiation between the past, the present and consumption. (See Color Plate 30.) Here, a heroic effort has been made to reclaim an authentic culinary past, but with the irony that "la cucina povera" has now been appropriated by young urban professionals, hipsters and tech millionaires with the result that the "cuisine of the poor" commands astonishing prices.[8]

A more interesting and complicated example of the preservation of the past is the Castello di Amorosa winery in Napa Valley, California. Using authentic materials and ancient building techniques, Dario Sattui has recreated a Tuscan winery, complete with a replica thirteenth-century castle and chapel that seems lifted from Quattrocento Florence.[9] (See Color Plate 32.) Sattui, born in San Francisco in 1941, is the great-grandson of Vittorio Sattui, an Italian

emigrant and one of the pioneering fathers of the wine industry in California. Having lived to age 94, Vittorio passed on to his great grandson a love of vineyards and wineries. Travelling in Italy after earning a degree at Berkeley, Dario developed a passion for medieval Italian architecture, especially that of castles, monasteries and convents. In 1972, he returned to California and revived Vittorio's vineyard and winery, which had been dormant for half a century.

How can Italian Americans reestablish a historical, cultural, and linguistic link with Italy? How can we *ricordare*? The Italian word "to remember" contains within it a revealing pun: ri-cuore-dare: "to give back to the heart." This question haunted me as I visited Sabato Rodia's extraordinary Towers in the Watts district of Los Angeles. (See Color Plate 16.) Taking a triangle-shaped plot of land, Rodia, who had emigrated from the province of Avellino in 1895 at age 14, spent eight hours a day—every day for thirty-three years—conjuring up a wonderland of three steel-reinforced towers resembling the famous *giglio* towers of Nola, outside Naples. Using broken glass, tile, seashells and other found objects, Rodia sublimated the tragedy of the death of his young daughter and other heartbreaks into sublime art. Having escaped demolition, damage and neglect, today, through the heroic efforts of Luisa Del Giudice, local activists, as well as state and municipal authorities, Rodia's Watts Towers are beginning their journey to being considered as a UNESCO World Heritage site.[10]

Rodia's Towers—which he tellingly named *Nuestro Pueblo*—brings to mind the concepts of "elective affinities" and "imagined communities." Elective affinities is a term borrowed from chemistry, describing the propensity of certain chemicals to bond with specific other chemicals. The German writer Goethe borrowed the term for his third novel (1809), whose title is sometimes translated in English as *Kindred By Choice*. The idea was then taken up by sociologist Max Weber. How is it that we choose ("elect") the groups we identify with? Does an affinity with one ethnic, racial, religious group necessarily prohibit a larger affinity, say, with humankind? How—and at what price for Italy and other ethnic groups in America—have Italian Americans constructed their "imagined community?"[11]

One extraordinary site of Italian American history though, is threatened by the twin wrecking balls of historical amnesia and commercial development. Italian American civic groups, allied with their African American and Latino neighbors, have spent several years in a desperate endeavor to save an important piece of our collective history. In the Brownsville section of Brooklyn, at 124 Sackman Street, Italian emigrants—in their "spare time"—built the neo-Renaissance Lady of Loreto Church. (See Figures C.1 and C.2.) The Church's rectory (shown right in early photo) and school (built in 1925) have already been torn down and are now a parking lot and affordable housing, respectively. In late 2016 the Archdiocese of Brooklyn obtained permission to demolish the church and all appeals appeared to have been exhausted. But in the spring of 2017, a judge issued a restraining order and the church granted a reprieve. But by the time you—good reader—see these words, this magnificent church may in all probability no longer exist.[12]

In one of the many ironies of history, the Bishop of Brooklyn who ordered the demolition of the church is Nicholas A. DiMarzio, whose four grandparents emigrated from southern Italy. Bitter irony is further compounded by the fact that Bishop DiMarzio is currently on the Vatican's Pontifical Council for the Pastoral Care of Migrants and Itinerant People, chairman of the board of the Center for Migration Studies, and the Migration Policy Institute board.[13] Perhaps Bishop DiMarzio needs to contemplate Fra Angelico's *Flight into Egypt* (1451–1452), the painting that John Cadel embedded in his own painting of *The Migrants* that graces the cover of this book.

During a last pilgrimage, standing on the street corner diagonally across from the church, I met Roberto Colon. His family had emigrated to New York City from Puerto Rico in 1919 and he recounted with pride how he had been baptized in this church and educated

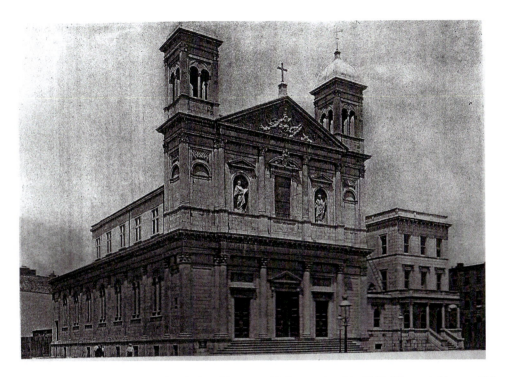

Figure C.1 Our Lady of Loreto Church, Brooklyn, New York, completed in 1906. Photo: *Architecture*, 18.3 (15 September 1908), 147.

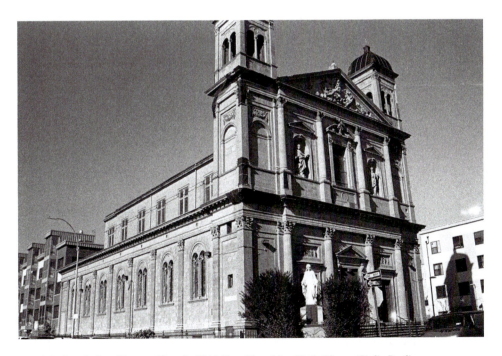

Figure C.2 Our Lady of Loreto Church, 2016, Brooklyn, New York. Photo: Giulia Pugliese

at its school (already demolished). We stood side-by-side for a few minutes in the brilliant morning sunshine, shaking our heads at the forlorn structure, its precious stained glass windows gone and façade crumbling as the melancholy of ruins came over us both. We took leave of each other with mutual sadness at the precariousness of even those things that once seemed powerful and eternal.

★ ★ ★

We can no longer claim—as we once did—"we didn't know." Irrevocably expelled from a blissful Garden of Eden, burdened and armed with knowledge and consciousness, Italian Americans must now abandon a comforting nostalgia and instead engage the contemporary world of ethnicity without fear. The prophet Micah (*circa* 750–700 BCE) promised the ancient Hebrews that "they shall all sit under their own vines and under their own fig trees and no one shall make them afraid." So yes, let us tend our old vines and fig trees but let us also seek out new gardens to cultivate.

This book is a paradox that mirrors the experience of the Italian American Diaspora: epic in scale yet composed of myriad scintillating tesserae that work together forming a panorama of loss and redemption, hope and struggle, forgetting and remembering—a chorus of voices that sings the song of the Italian Americans.

Notes

1 Frank J. Cavaioli, "The American Italian Historical Association at the Millennium," www.italianamericanstudies.net/cpages/about.

2 This is the reason that the American Italian Historical Association, after years of internal debate and discussion, changed its name in 2010 to the Italian American Studies Association.

3 Robert Viscusi, *Astoria* (Toronto: Guernica Editions, 2003), 17.

4 See Stanley Tucci's magnificent film *Big Night*; a work that addresses many issues in Italian American culture, including self-delusion and failure.

5 Pier Luigi Celli, "Figlio mio, lascia questo paese," *La Repubblica* (30 November 2009).

6 Fred Gardaphé, *Leaving Little Italy* (Albany: SUNY Press, 2003), especially 151–161.

7 The Italian American Writers Association was founded in 1991 in response to the disturbing racial events unfolding in Brooklyn. For this history and the three rules of IAWA, see http://iawa.net/. As editors we embrace the second and third rules of IAWA. 2: "Buy each others' books. If we want publishers to publish Italian American books, we need to be sure that we can show them a market for those books." 3: "Read each other. We can't expect other people to read the books of Italian American writers if we don't read them ourselves."

8 In a similar vein, Neiman Marcus now charges $66 (plus $15.50 shipping) for collard greens; the item is often sold out, www.neimanmarcus.com/Collard-Greens/prod191750156/p.prod

9 See www.castelloamorosa.com for the project's complete history and Miles Ryan Fisher, "Castello di Amorosa: A Tuscan Castle in Napa Valley," in *Italian America* (The official publication of the Order Sons of Italy in America), Vol. 23, n. 2 (Spring 2017): 16–19.

10 See *Sabato Rodia's Towers in Watts: Art, Migration, Development*, ed. Luisa Del Giudice (New York: Fordham University Press, 2014).

11 The concept is from Benedict Anderson, *Imagined Communities: Reflections on the Origin and Spread of Nationalism* [1983] (New York: Verso, 2016).

12 Paul Vitello, "A Fight for a Church Is Invoking Introspection," *New York Times* (26 March 2010); Megan Jula, "Brooklyn Church, Over a Century Old, Likely to Make Way for Affordable Housing," *New York Times* (7 August 2016). Visit the coalition's website at http://saveourladyofloreto.org/saveourladyofloreto/Save_Our_Lady_of_Loreto.html. For works of Italian American religious material culture on a smaller scale—from Christmas presepi to backyard Madonna shrines, see Joseph Sciorra, *Built With Faith: Italian American Imagination and Catholic Material Culture in New York City* (Knoxville: University of Tennessee Press, 2015).

13 See DiMarzio's biography at http://dioceseofbrooklyn.org/bishop-dimarzio/ and https://en.wikipedia.org/wiki/Nicholas_Anthony_DiMarzio

GLOSSARY

Compiled by William J. Connell

AIRE (*Anagrafe degli Italiani residenti all'estero*). The Italian government's "Registry of Italians Residing Abroad," initiated in 1990.

alto basso. An adjectival term indicating a mix of "high" and "low" influences, usually in a cultural context.

American Committee on Italian Immigration (ACIM). Founded in 1952 by Juvenal Marchisio, a judge from Brooklyn who previously directed **American Relief for Italy** (see), the ACIM lobbied to loosen and reform the existing immigration quota system in ways that resulted ultimately in the **Immigration and Nationality Act of 1965** (see).

American inferiority, theory of. The idea, commonly held in Italy and Europe from the sixteenth to the eighteenth centuries, that products of nature from the Americas (plants, animals, people) were inferior to what was born or produced in the Old World.

American Italian Anti-Defamation League. Founded in 1967, with Frank Sinatra as its national chairman, in order to combat anti-Italian discrimination. Forced to change its name by the Anti-Defamation League of B'nai B'rith, the organization renamed itself Americans of Italian Descent and thereafter quietly declined, with the exception of a brief moment of notoriety when mobster Joey Gallo joined.

American Relief for Italy (ARI). Led by Juvenal Marchisio, a judge from Brooklyn, the organization raised $40 million for the relocation and support of Italians in the period 1944–1949.

amoral familism. A term used by political scientist Edward Banfield, in his book *The Moral Basis of a Backward Society* (1958), to describe the family-centered value system he claimed to have found in Southern Italy. "Maximize the material, short-run advantage of the nuclear family; assume that all others will do likewise" (p. 85), was how he summarized the ethos. According to Banfield this prevented the growth of community values and a shared moral system, thus stunting modernization and economic development in the Italian South.

banchisti. Entrepreneurs who, along with other activities, made loans, accepted deposits and sent remittances to Italy on behalf of immigrants.

baruni. Sicilian dialect for the Italian *baroni*, or "barons." A common way of referring to powerful persons, most of whom were not titled barons in the feudal sense, although some were.

bella figura. Taste, style, class. Often in the expression *fare bella figura*: to make a good impression, to exhibit style or class. Sometimes abbreviated in the injunction "*Fare figura!*": Make a good impression! Mind your manners! The opposite is *fare brutta figura* (sometimes, in dialect, *mala figura*): to leave a poor impression.

Bella Società Riformata. The name of the Neapolitan Camorra in the nineteenth century. Translates as "The Beautiful Reformed Company."

Black Hand. Italian: *mano nera.* Sicilian: *manu niura.* A term for the extortion practiced by gangs of criminals in Italian immigrant communities in the late nineteenth and early twentieth centuries. Letters threatening assassination, kidnapping or arson unless a specified sum was paid were usually signed with a drawing of a black hand. (NOT to be confused with a Serbian nationalist secret society, also called the Black Hand that was famous for a series of terrorist actions in Europe in the second decade of the twentieth century.)

Blackshirts. Mussolini's early Fascist supporters organized themselves into paramilitary groups wearing black shirts that became part of the official Fascist uniform. Worn also in the U.S. by the members of certain Italian American groups, including Scout troops, in the 1920s and 1930s.

bordanti. Italian American dialect word for "boarders." These were usually unmarried male workers who paid a family for room and board.

bossatura. The fee paid by Italian workers in America to the *padrone* who found them work.

Bourbon dynasty. The Bourbons were a European royal family, originally French. Bourbons ruled in Naples and Sicily from 1734 to 1860, with the exception of the period 1806–1816, when they lost control of Naples to the French, although they retained Sicily.

brava gente. Great people. Originally an expression of sincere admiration. But today the phrase "*Italiani brava gente*"—Italians are a great people—is often used with a tinge of sarcasm that acknowledges failings along with positive qualities.

Bruccolino. Dialect for "Brooklyn." Used also as an adjective, especially referring to the Italian Americans of Brooklyn and their dialect.

cafone. An unlettered and ill-mannered peasant.

Camorra. The Camorra is a secret society of criminal clans originating in Naples. There are various theories concerning the historical derivation of the word *camorra*, but probably it is related to street gambling around the game of *morra.* In *morra* all of the players at the same time toss out some of the fingers on one hand. Whoever correctly guesses the total of the fingers displayed by all players wins a point.

campanilismo. The attachment felt toward the bell tower (*campanile*) of one's hometown. The word refers by extension to the often-fierce rivalries between nearby Italian towns. Townspeople grew up recognizing the sound of their own bell (*campana*). Sometimes towns were situated within sight of one another's bell towers. Local chronicles, going back to the Middle Ages, are filled with accounts of the raids involving cattle and crops, and the public insults and vendettas engendered by these neighborly hatreds. In political, historical and sociological studies, the term refers to a person having loyalty only to the area in which he or she could hear the church bells.

canzone napoletana. The tradition of Neapolitan song (*canzone*), promoted in the early twentieth century by Enrico Caruso among others.

Capitulations of Santa Fe. The formal agreement between Ferdinand and Isabella of Spain and Christopher Columbus, signed on 17 April 1492, that stipulated the grounds on which the monarchs would support Columbus's expedition to the New World later that year. Columbus, the son of a Genoese weaver, was given the titles of Admiral of the Ocean Sea, Viceroy and Governor General of any lands he discovered, the noble honorific "Don" and one-tenth of the riches to be obtained from his intended voyage. As a consequence of his disastrous governorship on Hispaniola Columbus lost the titles of

Viceroy and Governor General, but his and his family's noble status and wealth (if not one-tenth of the profits from the New World) remained secure.

carabiniere. A member of the Italian national police force charged with maintaining the social order. (The original literal meaning was "man armed with a carbine rifle.") The *carabinieri* (plural) were established originally in the Kingdom of Sardinia in 1814 on the model of the French *gendarmerie.* After Unification their role was extended to the entire national territory. Along with the Army, Navy and Air Force, the *carabinieri* are the fourth of Italy's "armed forces." By way of contrast, the United States has local police forces, but not a uniformed and armed national police force. The *carabinieri* are often depicted in rivalry with the other Italian armed forces or as figures of ridicule in Italian popular culture.

Carbonari. A network of secret revolutionary societies in Italy, active from 1800 to 1831, that hoped to create constitutional governments and unify the nation. Their efforts reached a high point in failed revolutions in Naples and Turin in 1820–1821, and they led more failed uprisings in 1831. Pope Pius VII condemned them in 1821 as societies of Freemasons and excommunicated their members.

casa. Italian for "house," "household" or "home." Historian Donna Gabaccia used the term to refer to the Sicilian family and its system of values.

chain migration. A term referring to the process by which immigrants from a particular place who settle in a new location attract further immigrants from the same original place to follow them in settling in the same location, with kinship and occupation as major factors.

Chicago School. The Chicago School of sociology in the 1920s and 1930s was a group of social scientists centered at the University of Chicago who treated the urban environment as a laboratory for studying social phenomena.

Columbian Exchange. The broad transfer of plants, animals, populations, diseases and technologies between the Americas and the Old World (Europe, Africa and Asia) in the century after the 1492 voyage of Columbus.

comare. (Dialect: *commare*). Literally "co-mother." A woman who, by becoming a godparent, becomes "co-mother" with the child's parents. By extension it often refers to long-time female friends and neighbors. In Italian American slang "goomah" or "gooma" may also mean "mistress."

commedia dell'arte. An enduring form of drama, originating in the sixteenth century, in which stock characters—the shrewd Pulcinella, the servant Arlecchino (Harlequin), the maid Colombina and the old and wealthy Pantalone—perform simple plays (sometimes improvised) about such themes as love and jealousy.

compare. (Dialect: *cumpà*). Literally "co-father." A male godparent who is thus "co-father" with the child's parents. In Italian American slang "goombah" means "friend" or "associate," usually with some affective tie (a relative, a common hometown, raised in the same neighborhood) extending beyond ordinary business.

confino, **also known as** *domicilio coatto.* A measure by which the Italian government could require citizens charged with subversive activity to live in distant, restricted areas and on islands. Imposed on numerous opposition figures in the Fascist period.

contadino. A peasant farmer.

Cosa Nostra. Also La Cosa Nostra (LCN). In Italian *cosa nostra* means "our thing," or "our affair." In the Mafia, in both Sicily and the United States, the term refers to the business of organized crime.

cultura dello spettacolo. Literally "performance culture," although the Italian phrase refers more broadly to the ways in which a civilization understands itself and builds meaning through performance, whether in theater, film, television, street art, etc.

dago. An ethnic slur originally used by British sailors in the eighteenth century to refer to Spaniards (from the common Spanish name "Diego"). *Circa* 1900 in the U.S. it became a common derogatory word for Italian immigrants.

Dante Alighieri Society. The *Società Dante Alighieri* was founded in Italy in 1889 to promote the study of Italian language and culture around the world. It became a vehicle for disseminating Fascist propaganda in the 1920s and 1930s and in the United States, after World War II broke out, it was labeled an un-American organization and forced to disband. The Society was only removed from the government's list of subversive organizations in 1962, when the Massachusetts chapter was refounded.

diaspora. A Greek word referring either (1) to the scattering or dispersion of a population from its ancestral homeland or (2) to a population that now lives in many places after such a dispersion has taken place. The Italian Diaspora, in the first sense of the term, is generally considered to have begun with the Great Migration of the late nineteenth and early twentieth centuries. Migration out of Italy continues down to the present day, however, and in recent years the term Italian Diaspora has become a helpful term for speaking about the large communities of persons of Italian descent that are now scattered around the globe.

Dillingham Commission. The United States Immigration Commission was chaired by Vermont Senator William Paul Dillingham. Established in 1907 to conduct an intensive study of immigration to the United States, in 1911 the Commission published its findings which were critical of "new" as opposed to "old" immigrants on racial grounds.

domicilio coatto, **see** *confino.*

domus. The Latin word *domus,* for "house" or "household," was used by historian of religion Robert Orsi to refer to the value system of Italian Americans in East Harlem. He borrowed the usage from a French historian, Emmanuel Le Roy Ladurie, who used the term in his influential 1975 study of a late medieval village, *Montaillou: The Promised Land of Error.*

Duce, Il. Italian dictator Benito Mussolini was known as *Il Duce,* "the Leader." He came to power in October 1922 and ruled until he was deposed and placed under arrest by the king and the Fascist Grand Council in July 1943. Rescued shortly afterward by the Germans, he was made dictator of a Fascist puppet state with its capital in the northern city of Salò. In April 1945 he was captured and killed by partisans.

Economic Miracle. Refers to a period of tremendous growth in the economy of Italy between 1950 and 1973.

Emergency Quota Act of 1921. Restricted the annual number of immigrants from any given country to 3 percent of the total number of people from that country living in the United States in 1910, thus preferring northern and western Europe.

enemy alien. A status involving many restrictions imposed on nonnaturalized Italians (and Japanese and Germans) resident in the United States after the attack on Pearl Harbor and the declarations of war on the U.S. by Germany and Italy. Historically, among the ethnic groups arriving in the late nineteenth and early twentieth centuries, Italians were among the least likely to apply formally for naturalization.

Ethiopian War. In 1935–36 Fascist-ruled Italy waged a successful war of conquest against Ethiopia. In May 1936, King Victor Emmanuel III proclaimed an "Italian Empire," and Ethiopia was ruled by Italy until 1941, when British forces restored Ethiopian independence.

ethnoburbs. Term from the ethnic segmentation by choice often found in the suburbs of metropolitan areas. The move from urban to suburban environments should not be seen as an automatic step toward assimilation.

fascio. The Italian word for a tied "bundle," usually of sticks, with rich historical connotations. In ancient Rome the consuls were accompanied by guards carrying the *fasces* (Latin), bundles of rods and axes (which could theoretically be untied and wielded to quell miscreants) that became symbols of law and order later adopted in the twentieth century by the **Fascist Party** (see). Earlier, in the nineteenth century, the *Fasci Siciliani* (see) used to say "It is easy to break one stick, but not a bundle," to emphasize worker solidarity.

Fasci Siciliani. Workers' leagues in Sicily known as *Fasci dei lavoratori*. From 1889 to 1894, beginning in the cities and sulphur mines and then spreading throughout agricultural areas, the workers of Sicily organized themselves into a movement that sought better working conditions. The *Fasci* were crushed and their leaders were imprisoned under Prime Minister Francesco Crispi in 1894.

Fascist League of North America. Established in 1924 by the Fascist Party to give a pro-government direction to Italian organizations and societies in the United States and Canada.

Fascist Party. The *Partito Nazionale Fascista* (PNF) of Italy, founded by Benito Mussolini in 1915 (but under a different name), formally re-organized in March 1919, came to power in 1922. Its nationalist message and claims of Italian greatness won sympathy for Fascism in many Italian American communities during the 1920s and 1930s.

femminiello. An effeminate, male homosexual generally accepted in working class neighborhoods in Naples.

festa. Italian for "festival," most usually the public celebration of a saint's day. In the Catholic Church, saints are celebrated on the days of their death or martyrdom, not their birth.

Fifth Column. A term for a group that in wartime undermines a state from within. Mussolini claimed that Italians living abroad would be his "Fifth Column" in World War II.

filiopietism. A worshipful, uncritical approach toward one's own ancestry and heritage.

Filippini Sisters. The *Maestre Pie Filippini* (M.P.F.), or Religious Teachers Filippini, founded in 1692 by St. Lucy Filippini, is a teaching order of nuns that became especially important in the Italian American community of New Jersey in the early twentieth century.

finocchio. Italian for "fennel." Slang term for a male homosexual. Italian American dialect: "finook."

Freemasonry. Freemasonry, organized into Masonic Lodges in which members met secretly and were pledged to uphold such principles as the freedom of conscience and the separation of church and state. Originating in England in the early 1700s, the movement soon spread to the continent, becoming influential in France and Italy.

Galleanisti. Anarchist followers of Luigi Galleani who advocated revolutionary violence. These included Sacco and Vanzetti.

generation (first, second. . .) . As used by social scientists, "first generation" immigrants are residents who were born in a foreign country. The "second generation" consists of the children of immigrants who were born in the new country. The "third generation" consists of the grandchildren of the original immigrants.

giornaliero. Italian for "day laborer."

Giovine Italia, see Young Italy.

Great Migration, The. In Italian American history the term refers to the great out-migration from Italy that took place between 1880 and 1924. Approximately nine million Italians left Italy in this period, with most of them going to the Americas and the largest share to the United States. [NOT to be confused with what African American

historians call "The Great Migration," which was the movement of six million blacks from the states of the southern U.S. to northern states between 1915 and 1960].

guapparia. Another name for **Camorra** (see) activity. In seventeenth-century Naples the "*guappo*" (dialect for the Italian *capo*, meaning "head" or "chief") of a neighborhood would resolve disputes among *morra* gamblers. *Guappo* came to be a word for an arrogant man, prone to violence, but also proud and fearless. *Guappo* is the likely source of the derogatory word "**wop**" (see).

guido. The Christian name Guido is derived from the Germanic name Wido, which came into use in Italy after the fall of the Roman Empire. Most famous was the eleventh-century reforming bishop St. Guido of Acqui. The name became common in Italy and later among Italian Americans. In the 1970s "guido," and later "guidette," became derogatory terms for younger Italian Americans who sported gold chains and rings (men and women), big hair (women), slicked-back or spiked hair (men), and showed "muscle" (men) and "skin" (women). In the early 2000s some younger Italian Americans began using these terms as self-identifiers.

guinea. A derogatory term for Italians since the 1890s. Derived from the name of the African coastal region Guinea, it suggests that Italians are dark-skinned like blacks. The variant "ginzo" crossed the Pacific from Australia at the time of World War II.

immigrant/emigrant/migrant. An "immigrant" is someone who comes to a new country, whereas an "emigrant" is someone who leaves his or her country. Since both words may be applied to the same person, depending the writer's point of reference, to the casual observer these words may appear to be used interchangeably, although scholars try to use them with some care. When describing transnational mobility many scholars prefer the terms "migrant" and "migration," since these more open-ended terms comprise movements like the return to a place of origin, the multiple displacements, and the seasonal or patterned displacements that are very real possibilities for persons moving from one country to another.

Immigration Act of 1924. Also known as the "Johnson-Reed Immigration Act." Limited the annual number of immigrants who could be admitted from any country to 2 percent of the number of people from that country who were already living in the United States according to the 1890 census, thus limiting immigration from southern and eastern Europe even more severely than the **Emergency Quota Act of 1921** (see).

Immigration and Nationality Act of 1965. Did away with the quota system based on national origins imposed by the **Immigration Act of 1924** (see). There was a restriction on visas at 170,000 per year, with a per-country-of-origin quota, but there were preference categories for visas depending on the skills of immigrants and their family relationships with citizens or U.S. residents. Immediate relatives of U.S. citizens had no restrictions.

Inchiesta Faina. An Italian parliamentary commission, 1906–11, directed by Eugenio Faina, that investigated social conditions in the Italian South and Sicily.

Inchiesta Jacini. An Italian parliamentary commission, 1877–86, directed by Stefano Jacini, that investigated rural social conditions throughout Italy.

Industrial Workers of the World (IWW). International labor union, founded in Chicago in 1905, that sought to organize industrial workers regardless of nationality, race or sex. Also known as the "Wobblies." Italian Americans played leading roles.

inetto. An incompetent male.

internment. After the Japanese attack on Pearl Harbor and after the German and Italian declarations of war on the United States, on 19 February 1942, President Franklin Roosevelt signed Executive Order 9066 authorizing military authorities to deport to internment camps on grounds of national security persons of Japanese, German and

Italian background. The largest numbers of the internees were Japanese: roughly 70,000, two-thirds of whom were American citizens. Approximately 11,000 persons of German ancestry were interned. Estimates of the number of Italian and Italian American internees range from several hundred to 3,000.

Italglish. The combination of Italian and English words and grammar, sometimes to overcome a language barrier and sometimes for comic effect. Also called Italglese, Italiese, or, in the case of Neapolitan dialect, Napolgish.

Italian American Civil Rights League. Established in 1970 to combat anti-Italian discrimination. Its founder, mobster Joseph Colombo, was shot in 1971 at the League's second annual Unity Day Rally.

Kefauver Committee. The United States Senate Special Committee to Investigate Organized Crime in Interstate Commerce was chaired by Senator Estes Kefauver of Tennessee. In 1950–1951, in televised hearings, it interrogated a series of Italian Americans associated with organized crime.

Kingdom of Italy. Proclaimed in 1861 by King Victor Emmanuel II, after the successful Unification campaigns of 1860. In 1946 Italian voters decided by referendum that the country should become a Republic and the monarchy was abolished.

Kingdom of the Two Sicilies. The revolt of the Sicilian Vespers in 1282, when the French were expelled from Sicily, created a situation in which there were two people who claimed to be "King of Sicily": a Spanish king who actually ruled Sicily and a French king who continued to rule Southern Italy, a kingdom sometimes called "peninsular Sicily." In 1442 the ruler of Sicily, Alfonso V of Aragon, conquered Southern Italy and thus became "King of Both Sicilies." But in subsequent centuries there were sometimes different kings, and the two kingdoms remained legally separate. In 1816 Ferdinand IV united Southern Italy and Sicily as the single Kingdom of the Two Sicilies. After Garibaldi's seizure of the Kingdom in 1860, Francis II abdicated and the Kingdom of the Two Sicilies was absorbed by the **Kingdom of Italy** (see) that was proclaimed in 1861.

Lateran Pacts. A series of agreements signed in 1929 between the Papacy and the Kingdom of Italy, negotiated by Mussolini, that settled a series of outstanding issues resulting from the annexation of Rome by the Kingdom of Italy in 1870.

latifondo. A large agricultural estate, typical in the Italian South, worked by day-laborers and local peasants for landlords who were often absentee and invested little in improving their property. In the plural one often encounters the Latin form, *latifundia.*

lazzaroni. Also *lazzari.* A name given to lowest social class in Naples: "street people," perhaps, although in Naples there was a rich street culture akin to what one finds in the Arab Middle East.

macchietta coloniale. A theatrical skit featuring immigrant types.

madrelingua. The mother tongue (i.e., Italian). Also *lingua madre.* Used as an adjective *madrelingua* means "native speaker." *madrepatria.* The motherland. More specifically, the country of origin for someone who lives abroad (in a different *patria*).

Mafia. A criminal organization with origins in nineteenth-century Sicily. With immigration a number of Mafia criminals came to the United States, and over time, an American Mafia came to exist. The Sicilian word *mafiusu* (mafioso) first appears in print in the title of an 1863 play, *I mafiusi di la Vicaria* [The mafiosi of the Vicaria]. Like the *guappo* (see) in Naples, and the *bravo* in northern Italy, a *mafiusu* was an ambiguous figure, sometimes a bully but also proud and fearless. In 1865 the word *mafia* first appeared in an official report sent to Rome. [The word is NOT derived from an imaginary slogan popularly believed to have been invented at the time of the Sicilian Vespers: "*Morte Alla Francia, Italia Avanti!*"].

malafemmina. In Neapolitan dialect, a woman who betrays her lover.

mammone. A "mamma's boy."

Manifesto of the Racial Scientists. Issued in Italy on 14 July 1938 and signed by 42 scientists in fields like medicine, anthropology, zoology and statistics, the Manifesto declared Italians to be descendants of the Aryan race. It prepared the way for Mussolini's **Racial Laws** (see).

Mazzini Society. An anti-Fascist organization founded by Italian exiles in the U.S. in 1939.

melancolia **(Italian) or** *malincunia* **(Neapolitan).** Italian for "melancholy." A feeling and mode of expression in Neapolitan music both analogous with and a source of American music's "blues."

Mezzogiorno. The name commonly applied to the Italian South. In practice it includes the territory south of Rome plus the islands of Sicily and Sardinia. The Italian word *mezzogiorno* means "mid-day," so the term captures the notion of the South as the "land of the mid-day sun."

Mille, I. Italian for "The Thousand," referring to the thousand or so volunteers who sailed in 1860 with Garibaldi to Sicily to overturn the Kingdom of the Two Sicilies.

miseria. Italian for "poverty."

Missionary Sisters of the Sacred Heart of Jesus. A female religious congregation founded in 1880 by Mother Frances Xavier Cabrini. In 1899, at the suggestion of Pope Leo XIII, the Sisters arrived in New York, where they did especially important work in Italian American neighborhoods. They soon established convents in Chicago, Newark, Scranton and elsewhere.

mutual aid societies. Italian: *società di mutuo soccorso.* Organizations established often on a neighborhood basis, or for the benefit of immigrants from the same Italian town or region, to provide such services as support in case of injury or burial insurance.

Napolgish. (See **Italglish.**)

National Italian American Foundation (NIAF). Founded in 1975 to represent the interests of Italian Americans with both the federal government and the Italian embassy in Washington DC.

nationality parishes. In the years before and after 1900, over considerable resistance from the American hierarchy, the Roman Catholic Church established parishes in the United States that ministered to immigrant constituencies with services in their own languages.

Nativism. The hostility of people born in America toward new immigrant groups.

naturalization. The process of by which an immigrant becomes a citizen of the nation to which he or she has immigrated.

'Ndrangheta. The Calabrian version of the **Mafia** (see). The word derives from the Greek *andragathía,* meaning "manly virtue."

nonna. Italian for "grandmother"; *nonno* means "grandfather."

omertà. A code of silence involving non-cooperation with the authorities and an unwillingness to interfere with the wrongdoing of others. Derived from the Spanish *ombredad,* meaning "manhood."

opera buffa. A form of comic opera, with characters from everyday life, in contrast to the heroic and historical plots of *opera seria* (tragedy) that was developed in eighteenth-century Italy. Exemplified in the work of Carlo Goldoni.

Order Sons of Italy in America. Founded in 1905 in New York City with the goal of assisting Italians in joining American society. The largest Italian American fraternal organization.

ordine della famiglia. The hierarchical structure of the Italian family.

padrone. Sicilian: *patruni.* English: "patron." The *padrone* system involved a manager or "boss," almost always himself Italian American, who would recruit contract laborers in Italy, often advancing the expense for steamship passage to the United States, and then find them lodging and work, in exchange for a regular fee to be paid back from their wages.

paese. A person's hometown or town of origin. A *paesano* is a person from the same hometown.

picciotto. A lower-order Mafia "soldier."

Progresso Italo-Americano, Il. The most widely circulated Italian American daily newspaper, published in the Italian language in New York between 1880 and 1989. Its title translates as "The Italian–American Progress." A successor publication is the newspaper *America Oggi.*

prominenti. English: "prominent men." A term referring to the leading members of the Italian American community. Usually wealthier than other Italian Americans, among the earlier immigrants to an area and hence better established, and generally on good terms with local officials.

Racial Laws. Passed by Fascist Italy in October 1938, these laws banned Jews and Africans from banking, government and education, while their property became liable to confiscation. Marriages between Italians and Jews or Africans were abolished.

Regno. Italian for "kingdom." In colloquial speech it refers either to the **Kingdom of the Two Sicilies** (see) or the Savoy dynasty's **Kingdom of Italy** (see).

remittances. Funds sent back to Italy by Italians living abroad.

Risorgimento. Italian for "resurgence." The movement for Unification that ultimately created the Kingdom of Italy (proclaimed in 1861).

sbraie. In Calabrian folklore these were masculine-looking lesbians who lived in isolation in the mountains.

Scalabrini Fathers. Known formally as the Congregation of the Missionaries of St. Charles Borromeo. Founded in 1889 during the Great Migration by Giovanni Battista Scalabrini, the bishop of Piacenza, Italy, with a particular mission to care for the needs of immigrants.

sceneggiata. A popular form of musical drama originating in the Naples in the nineteenth century.

serietà. Italian for "seriousness."

sgarrista. A term for a Mafia soldier or wiseguy.

sistemato. Taken care of; sometimes "married off." From the verb *sistemare.*

Southern Question. In its most simple form, a search for the reasons of economic backwardness in the Italian South, but, more generally, a question concerning cultural and social differences between the South and the rest of Italy, and the possibility/impossibility of integration.

sovversivi. Italian for "subversives." Usually referring to socialists, anarchists and communists.

sprezzatura. An Italian word originally meaning "disdain," transformed in the sixteenth century to the modern meaning of "nonchalance"—the art of making the difficult look simple.

struzzeri. Sicilian dialect for the Italian *strozzino,* meaning "loanshark." The verb strozzare means "to strangle."

syndicalism. A movement of the early twentieth century that attracted many Italian and Italian American workers that sought to make workers, not capitalists, the owners of industrial enterprises.

tenement. Large buildings that were divided into numerous rental apartments, often with substandard construction and living conditions. In New York, reports on the poor quality of these buildings resulted in the Tenement House Act of 1901 that made greater allowances for air and light, mandated running water in every apartment, and required a window in every room.

terrone. A derogatory term derived from *terra* (soil, dirt) used by Northern Italians to refer to Southerners.

UNICO National. Italian American charitable and service organization. UNICO was founded as an Italian American community service organization in Waterbury, Connecticut in 1922. The National Civic League was founded in Omaha, Nebraska in 1931 as an Italian American organization dedicated to civic work. The organizations merged as UNICO National in 1931.

urban villagers. A term introduced by sociologist Herbert Gans referring to the way certain ethnicities—Italian Americans in particular—recreate in an urban environment the inward-looking environment, rituals and mindset of villages in their country of origin.

verismo. A naturalist style typical of the Neapolitan stage—and of Italian opera circa 1900—that emphasized emotional force.

via vecchia, la. The old way of doing things. Tradition.

visione del mondo. Way of seeing the world. Worldview.

Volstead Act. Legislation passed in 1919 that put into effect the prohibition on the production, sale and consumption of "intoxicating liquors" as required by the Eighteenth Amendment to the U.S. Constitution which had been ratified that year. Prohibition came into effect in January 1920. Prohibition was repealed by the 21st Amendment in December 1933.

wop. Derived from the Neapolitan "*guappo*," from the Italian *capo* (head), meaning "dude" or "tough guy." [NOT an acronym for "Without Papers" or "Without Passport," as sometimes believed.]

Young Italy or, in Italian, Giovine Italia. A political organization founded in 1831 by Giuseppe Mazzini, who was then in exile in Marseilles. Its aim was to establish Italy as a unitary democratic republic. Members were supposed to be 40 years old or younger. Mazzini hoped Young Italy would be more successful than the **Carbonari** (see), which lacked central direction and whose members were by then aging.

zio Americano, lo. The "American uncle." A stock figure in Italian humor—a loud spendthrift.

INDEX

Boldface references indicate a glossary term. CP references indicate a Color Plate number.